ENCYCLOPEDIA OF AFRICAN-AMERICAN CULTURE AND HISTORY

EDITORIAL BOARD

ENCYCLOPEDIA OF AFRICAN-AMERICAN CULTURE AND HISTORY

Edited by

JACK SALZMAN
DAVID LIONEL SMITH
CORNEL WEST

Volume 3

MACMILLAN LIBRARY REFERENCE USA
SIMON & SCHUSTER MACMILLAN
NEW YORK

SIMON & SCHUSTER AND PRENTICE HALL INTERNATIONAL
LONDON MEXICO CITY NEW DELHI SINGAPORE SYDNEY TORONTO

Copyright © 1996 by Simon & Schuster and The Trustees of
Columbia University in the City of New York

All rights reserved. No part of this book may be
reproduced or transmitted in any form or by any means,
electronic or mechanical, including photocopying,
recording, or by any information storage and retrieval
system, without permission in writing from the Publisher.

Simon & Schuster Macmillan
866 Third Avenue, New York, NY 10022

PRINTED IN THE UNITED STATES OF AMERICA

printing number

1 2 3 4 5 6 7 8 9 10

LIBRARY OF CONGRESS CATALOGING-IN-PUBLICATION DATA
Encyclopedia of African-American culture and history /
 edited by Jack Salzman, David Lionel Smith, Cornel West.
 p. cm.
 Includes bibliographical references and index.
 ISBN 0-02-897345-3 (set)
 1. Afro-Americans—Encyclopedias. 2.
Afro-Americans—History—Encyclopedias. I. Salzman,
Jack. II. Smith, David L., 1954– . III. West, Cornel.
E185E54 1995
973'.0496073'003—dc20 95-33607
 CIP

This paper meets the requirements of ANSI / NISO Z39.48-1992
(Permanence of Paper)

ENCYCLOPEDIA OF AFRICAN-AMERICAN CULTURE AND HISTORY

H

Hackley, Emma Azalia Smith (June 29, 1867–December 13, 1922), singer and educator. Born in Murfreesboro, Tenn., E. Azalia Hackley grew up in Detroit, where she received private music instruction, completed high school, and in 1886 graduated from Washington Normal School. She then taught school, sang soprano with the Detroit Choral Society, and performed as a soloist. In 1894, she married Edwin Hackley of Denver. Both became activists for African-American affairs through organizational work and his newspaper. Concurrently, Azalia Hackley directed choirs, gave recitals, and earned a music degree from the University of Denver (in 1900). The musical and social objectives she established became her mission.

Moving to Philadelphia in 1901, she directed a prominent church choir, organized the influential People's Chorus, and gained recognition as a singer. Vocal study in Paris followed in 1906, but then her humanitarian activity intensified. For young African-American musicians, she secured performance opportunities, scholarship funds, and teaching positions in black colleges. From 1910 to 1921 she traveled widely, giving lecture-demonstrations to stimulate pride in African-American culture and music. Though a vocal institute Hackley founded in Chicago was short-lived, she conducted an acclaimed series of folk-song festivals throughout the United States until her return to Detroit in 1921 when illness ended her touring. She died one year later.

REFERENCES

DAVENPORT, M. MARGUERITE. *Azalia: The Life of Madame E. Azalia Hackley.* Boston, 1947.
LOVE, JOSEPHINE HARRELD. "Emma Azalia Smith Hackley." In Edward T. James, ed. *Notable American Women.* Cambridge, Mass., 1971, pp. 106–108.

GEORGIA A. RYDER

Hagler, Marvelous Marvin (May 24, 1954–), boxer. The oldest of seven children, Marvin Hagler was born in Newark, N.J. He legally added "Marvelous" to his name in the early 1980s. His family moved to Brockton, Mass., when he was seventeen. As a teenager, Hagler won 57 amateur fights and captured the Amateur Athletic Union middleweight championship in 1973. He turned professional one week after winning the AAU title.

The powerfully built, 5′9½″, 160-pound lefthander won his first 26 professional fights, 19 by knockout. Hagler was known for his plodding defense and potent punching. Among the top-rank boxers he defeated were Sugar Ray Seales, Bennie Briscoe, Kevin Finnegan, Doug Demings, Mike Colbert, Willie Monroe, Eugene "Sugar" Hart, and Johnny Baldwin.

Hagler fought for the world middleweight title in 1979, in Las Vegas, against champion Vito Antuo-

fermo. The match was declared a draw. Hagler had to wait until September 27, 1980, for his title fight against world champion Alan Minter, whom he knocked out in the third round.

Over the next six years, Hagler successfully defended his championship twelve times, twice against Fulgencio Obelmejias, once in a rematch with Antuofermo, twice against Mustafa Hamsho, and against William "Caveman" Lee, Tony Sibson, Wilford Scypion, Roberto Duran, Juan Domingo Roldan, Thomas "Hit Man" Hearns, and John "The Beast" Mugabi.

The most famous fight in Hagler's career came in April 1987, when he took on Sugar Ray LEONARD, the welterweight champion who had just come out of retirement. The bulked-up Leonard managed to match Hagler blow-for-blow in a twelve-round split decision, thus dethroning the champion and effectively ending Hagler's career. The fight carried the largest purse in boxing history to that time, with Hagler earning $12 million.

Hagler retired from boxing in June 1988 with a lifetime professional record of 61 wins, 3 losses, 2 draws, and 51 knockouts. Since then he has appeared in television commercials and as an announcer for televised boxing matches.

REFERENCES

1983 Ring Record Book. New York, 1983.

PORTER, DAVID L., ed. *Biographical Dictionary of American Sports: Basketball and Other Indoor Sports.* Westport, Conn., 1988.

THADDEUS RUSSELL

Hair and Beauty Culture. African-American men and women have often used their hair and faces as sites of artistry and as a means of self-expression. Enslaved Africans brought diverse notions of beauty to North America. In America, African hair and beauty traditions underwent a complex process of cultural continuity, acculturation and transformation. Although there was much diversity in black skin color and hair texture and curl structure, to whites, black hair type—generally thick, tightly curled hair—rivaled skin color as one of the most distinctive features of Africans. These physical characteristics were perceived as the very antithesis of beauty by many whites who conformed to a European standard of beauty that placed primacy upon white skin and straight hair. For many whites, blacks' social, economic, and political subordination as slaves was justified by physical appearance. The images, drawings,

and depictions of slave men and women's hair that remain in the historical record are often colored by these racist assumptions. Stereotypical caricatures (*see* STEREOTYPES) about African Americans that relied on exaggerated depictions of thick black lips, unkempt black hair, and dark black skin—most notably in minstrel shows (*see* MINSTRELS/MINSTRELSY)—pervaded white popular cultures in the eighteenth and nineteenth centuries. Advertisements for runaway slaves, for example, often contained descriptions of black hair characterizing it as "bushy" or "woolly."

Slaves in close contact with whites—northern slaves, urban slaves, and house slaves—were constantly confronted with white beauty aesthetics and at times adopted white beauty practices. Evidence exists, for example, that urban male slaves in New York in the seventeenth century styled their hair to resemble the popular wigs worn at the time by white men. However, the vast majority of African Americans maintained their own conception of hairstyle and adornment. Forced into an unfamiliar environment, slave men and women became innovators, using natural substances such as berries and herbs for hairdressing and skin care. The hair of slave women was often covered and wrapped with rags and other pieces of cloth. Hair braiding, a strong tradition in West Africa, remained common for slave women.

Some slave men and women served as stylists and barbers for other blacks, as well as some whites, during slavery. Northern free black men and women, such as Pierre Dominique TOUSSAINT and the sisters Cecilia, Caroline, and Maritcha Remond Putnam, pioneered in white hair care in the nineteenth century and continued in that role after EMANCIPATION. Barbering, in particular, was an occupation that provided crucial economic support for many black men. In 1885, there were 500 black barbers—300 of whom ran their own shops—in Philadelphia. About 150 or so were able to attract white customers. Barbering was also a preferred occupation for free blacks in the South (*see* FREE BLACKS, 1619–1860). Many barbers, including William Johnson of Natchez, Miss., made barbering a stepping-stone to later entrepreneurial success. Others, such as Robert DELARGE and Joseph RAINEY, both RECONSTRUCTION congressmen from South Carolina, used barbering to further their political ambitions. The successful early twentieth-century insurance company founders John Merrick and Alonzo Herndon both received their start in business through the ownership of barbershops. These politicians made use of the political contacts they were able to make as barbers for whites to familiarize themselves with white elites.

The solidification of JIM CROW segregation by the turn of the twentieth century resulted in black beauty

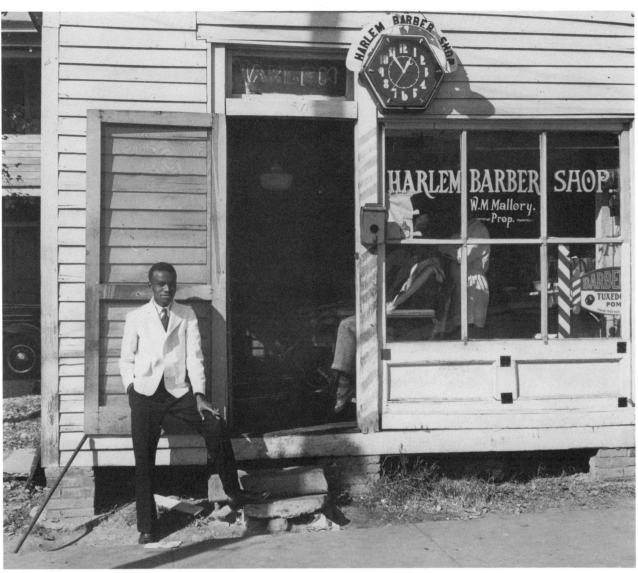

Despite its name, the Harlem Barber Shop was in Oxford, N.C. By the time of this photograph in 1939, urban northern ideals of hair and beauty styling had become popular with African Americans throughout the rural south. (Prints and Photographs Division, Library of Congress)

salons and barbershops losing their white client base. For example, Philadelphia's black population had doubled by the early twentieth century, but the number of barbershops had been reduced to 116. This factor, coupled with rising spending power among a growing black middle class, led to the genesis of a formalized black hair and beauty culture industry offering commercial beauty products and services to the growing market.

After slavery, many black men and women—who equated grooming with respectability and freedom—experimented with a vast array of hairstyles and beauty techniques. Both black-owned and white-owned companies responded to the diverse hair and beauty needs of black consumers. Black entrepreneurs vigorously competed for dominance in the

black hair and beauty culture industry. In the early twentieth century, the Overton Hygienic Manufacturing Company, founded in 1898 by entrepreneur Anthony OVERTON, became successful when it expanded into the cosmetics industry selling "High Brown" facial powder. Annie Turnbo MALONE's Poro Company was one of the leading manufacturers of hair-care products for black women. In 1905, Madam C. J. WALKER revolutionized the hair and beauty culture industry by creating a treatment for hair loss—a common ailment that plagued black women as a result of poor diet, dandruff, scalp disease, and harsh hair-care treatments. She also pioneered a hair-straightening system for black women's hair called the Walker system, which used a heated metal comb to straighten black women's hair.

European aesthetics pervaded the black community in many ways—from social hierarchies based on SKIN COLOR to cultural expressions categorizing hair as "good" or "bad" based on its texture—and shaped the context in which African Americans made their hair and beauty choices. There was much debate about hair and beauty within the black community. Black men also had a crucial stake in these debates. Although skin lighteners and hair straighteners found their greatest market among black women, some black men chemically processed their hair to relax the curl structure. Skin care was relatively simple for black men. However, razor-shaving facial hair was often a painful process for black men. The tight curl pattern of their hair resulted in ingrown hairs, informally known as "razor bumps," on the face and neck. This condition was irritated each time the shaving process was repeated. To avoid this, many black men turned to harsh chemical depilatories or chose to wear a beard.

Many in the beauty culture industry argued that the standards of beauty they promoted—lighter skin and straighter hair—were linked to personal success and racial progress and could therefore counter negative stereotypes about black people. Some blacks agreed, arguing that altering the natural state of their hair and skin was a way to challenge the correlation between black hair and unkemptness, poor grooming, or a lack of professionalism in an employment situation. Others saw a direct link between hair straightening and skin-lightening creams and cosmetics—often with names such as "Black-No-More" and "No Kink"—and the acceptance of white standards of beauty and a lack of black self-esteem. Pointing out the often painful and damaging effects of chemicals on black hair, scalp, and skin, these blacks argued that leaving hair in its unprocessed state was a way to embrace their African heritage and challenge white domination by reversing notions of beauty. In the 1920s, Marcus GARVEY, black activist and advocate of PAN-AFRICANISM, refused to accept advertisements for hair straighteners and skin lighteners in his publication *Negro World*.

Hair straightening, however, cannot simply be equated with the adoption of a European aesthetic and the rejection of African cultural heritage. Many Africans conceptualized their hair as a headdress to be adorned and manipulated as a site of artistic and cultural construction. Through the styling of their straightened hair, African Americans struggled to define a space for themselves within the framework of the dominant aesthetic that could challenge, oppose, and undermine it while reaffirming black cultural values. Although some middle-class blacks wore their straightened hair in styles similar to those popular among middle-class whites, others combined their

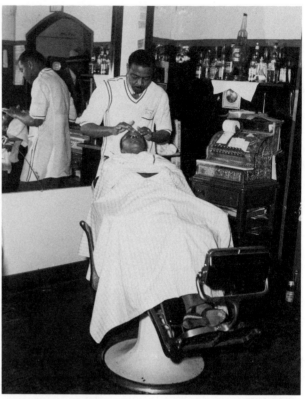

Requiring relatively little capital, barbershops have been one of the mainstays of small black businesses since the middle of the nineteenth century. In this photograph, Oscar J. Freeman attends a customer in his Chicago shop in 1942. (Prints and Photographs Division, Library of Congress)

straightened heads of hair with pomades and hairdressing creams to explore bold, innovative, and creative styling options.

Often, the straightening of hair was a statement of rebellion. Finger waves and pin curls (waves and circular curls sculpted on hair slicked close to the scalp), popular among black women and some men, were emblematic of the HARLEM RENAISSANCE period. The process—a style, called the "conk," achieved by using a lye-based chemical to straighten black men's hair—was integral to the subculture that formed among many young, black urban males during the 1940s. Although conks were popular among the black middle class, working-class blacks styled their conks with heavy pomade, a center part, and a ducktail, often pairing them with flamboyant zoot suits to articulate an oppositional political and cultural identity that challenged both white and black middle-class sensibilities.

Beauty parlors and barbershops were important within the internal African-American service economy of the middle decades of the twentieth century. In the 1940s, black women owned 96.7 percent of black-held beauty shops, and 88 percent of related

business schools. Black beauticians criticized the racist assumption in the beauty-culture industry that black beauticians could style and care for only black hair and agitated against segregated beauty schools. They fought for equality in training and licensing for black and white beauticians, and argued that black beauticians should be held to the same standards as white ones. Beauty trade associations often took public positions on civil rights matters. The National Beauty Culturalists League, founded in 1919, for example, adopted the slogan "Every Beautician a Registered Voter" in the 1950s.

Beauty parlors and barbershops were sites of debates and information sharing, where black people created networks of mutual support that could be used in social fraternization or political organizing. Black politicians, for example, often targeted beauty parlors and barbershops as key community institutions on the campaign trail. Poorer black men and women often opened unlicensed beauty parlors and barbershops in their homes as a vehicle toward economic self-sufficiency. Unable to afford professional beauty schools, these men and women passed on skills of hairstyling and haircutting through apprenticeships. These unlicensed shops were criticized as unprofessional and unqualified by many middle-class shop owners who resented the competition they believed was unfair. Despite these challenges, however, unlicensed shops continued to survive alongside licensed shops as community institutions.

In the 1960s, hairstyle took on additional meaning for both blacks and whites who defined hair not only as a badge of self-identity, but as an indicator of political consciousness. During the period of militant pride and cultural awareness that characterized the Black Power movement of the mid-1960s, many African Americans began to style their hair in an unprocessed state to symbolize the connection to their African past and challenge white beauty standards. In 1966, Black Power leader Stokely CARMICHAEL militantly asserted, "We have to stop being ashamed of being black. A broad nose, a thick lip and nappy hair is us, and we are going to call that beautiful . . . we are not going to fry our hair anymore." Guided by the slogan "Black is beautiful," many black men and women abandoned hairstyles that required chemical processing.

The Afro—unprocessed black hair arranged in a circular symmetry around the head—was one of the most popular hairstyles of the mid- to-late-1960s for both men and women. Afros—also called "naturals"—varied with black hair texture and ranged in height from low, scalp-hugging cuts to styles elaborately shaped and coiffed several inches away from the scalp. Political activist Angela DAVIS's large Afro was a political statement that symbolized her mili-

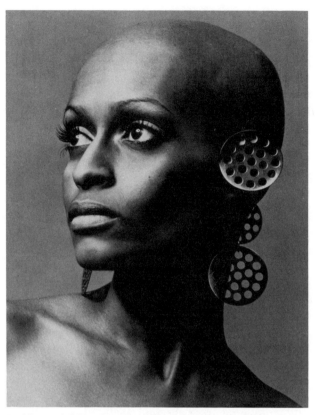

Bald model Pat Evans. (Photographs and Prints Division, Schomburg Center for Research in Black Culture, The New York Public Library, Astor, Lenox and Tilden Foundations)

tance and her rejection of the conventional cultural practices of mainstream America.

The beauty industry created new products aimed at the maintenance of natural hairstyles and marketed them alongside its more traditional products. In the late 1960s, for example, JOHNSON PRODUCTS, the leading black-owned company in the beauty culture industry, introduced a no-lye relaxer (thought to be less damaging to the scalp) to straighten hair, as well as the popular Afro-Sheen line of products aimed at the maintenance of Afros. Advertisements in black magazines such as EBONY and JET began to feature darker-skinned models with unprocessed hair and slogans such as "Rows. Fros. Anything Goes." Cornrows—a hairstyle traditionally worn by black girls in which hair is braided in rows along the scalp and often weaved into elaborate designs and decorated with ornaments ranging from beads to cowrie shells to tinfoil—became popular among many black women and some black men. In the early 1970s, for example, Stevie WONDER was one of many musicians who donned intricately styled and adorned braided hairstyles. White actress Bo Derek's cornrows in the 1979 movie *10* caused outrage among many in the black community, who believed that

she had appropriated the style devoid of its cultural meaning.

Facial hair was integral to black men's self-presentation in the early 1970s. For some black men, moustaches were more than an aesthetic choice, but instead a symbol of virility. Black actor Richard Roundtree's character Shaft—popularized in the blaxploitation film genre of the 1970s—sported a thick moustache that was as integral to his depiction of black male power as his leather jacket and streetwise attitude. Isaac Hayes, who achieved considerable renown as the composer and performer of the Academy Award–winning title song from *Shaft* (1971), helped pioneer another popular black male style of the 1970s, the shaved head. Jheri Curls, a chemical process that loosened and lengthened the curl pattern in the hair, and required that the hair be constantly saturated by a curl-activating lotion, was popular for both men and women in the late 1970s and early '80s. During this period, the Afro—especially in its lower-cut form—achieved a more mainstream acceptance.

In the 1980s and early '90s, a rising cultural-consciousness movement created space for a diversity of natural hairstyles for blacks. Although this movement continued in the tradition of the "Black is Beautiful" movements of the mid-1960s, the popularity and limited mainstream acceptance of unprocessed hairstyles made the former link between hairstyle and political consciousness a hotly debated issue in the black community. There was a rise in popularity and cultural acceptance of dreadlocks—a style common among Jamaican RASTAFARIANS, in which unprocessed hair is sectioned off and long braids of it are allowed to grow together unhampered. These sections "lock" because of black hair's tight curl pattern. Folksinger Tracy Chapman and author Alice WALKER are two prominent black women who have embraced this hairstyle.

Hair braiding was increasingly accepted as a skilled art form as braids grew in popularity, diversity of style, and form in the 1980s and '90s. The use of human or synthetic hair extensions for braiding to augment the length or the width of the individual braids increased in the 1980s. Hair weaves (extensions of synthetic or human hair either sewn or glued on the scalp) were used by some black women to achieve straight-textured, long hair. Others used extensions to add flexibility in the creation of elaborately braided Afrocentric hairstyles and boldly sported styles called "Senegalese twists" or "African goddess braids." Other women chose to wear their hair closely cropped and low to the scalp, unprocessed or slightly relaxed in a process called "texturization."

Hair braiding for African-American men had increased visibility as well. Hip-hop culture of the 1980s and early '90s popularized daring haircuts for young African-American men that ranged from

Hairstyle advertisement featuring braids, made for the John Atchison Beauty Salon, c. 1980. (Photographs and Prints Division, Schomburg Center for Research in Black Culture, The New York Public Library, Astor, Lenox and Tilden Foundations)

shaved heads—a style long embraced by many older black men as an alternative to thinning hair—to a texturized version of the Afro called the "blow out." Also popular was the fade haircut, in which the sides and back of the hair are cut lower than the top, and the back of the head is used as a palette for everything from intricate designs to commercial symbols or even the wearer's initials. A new generation of stylists specializing in the maintenance of unprocessed black hair and the creation of bold new cuts for men developed alongside traditional salons as the hair and beauty culture industry created new products to meet the needs of these consumers.

These products were increasingly supplied by white-owned companies such as Revlon and Alberto Culver. These white companies—often better financed than their black counterparts and therefore able to offer lower prices—adopted aggressive Afrocentric marketing strategies to attract black consumers. By 1988, the white companies controlled 50 percent of the black hair-care market. By 1993, fourteen of the nineteen cosmetics companies in the lucrative black hair-care market were white-owned.

Hair and beauty culture remained a creative area for black men and women in the early 1990s. Acutely aware that physical appearance has an impact on almost every arena, from social life to employment opportunities, black people have always had to grapple with the broader implications of their hair and beauty culture. In the 1980s and '90s, an increasing number of black men and women took to the courts to register complaints about discrimination in employment due to hairstyle. Issues of politics, economics, and aesthetics—along with age, regional location, and class—continue to guide the choices black men and women make for their hair and beauty needs.

REFERENCES

JONES, LISA. *bulletproof diva: tales of race, sex and hair.* New York, 1994.

MORROW, WILLIE. *400 Years Without a Comb.* San Diego, Calif., 1973.

PEISS, KATHY. "Making Faces: The Cosmetics Industry and the Cultural Construction of Gender, 1890–1930." *Genders* (Spring 1990).

WEATHERS, NATALIE R. "Braided Sculptures and Smokin' Combs: African-American Women's Hair Culture." *SAGE* 8, no. 1 (Summer 1991): 58–61.

WHITE, SHANE. *Somewhat More Independent: The End of Slavery in New York City, 1770–1810.* Athens, Ga., 1991.

WOLF, NAOMI. *The Beauty Myth: How Images of Beauty Are Used Against Women.* New York, 1991.

ROBYN SPENCER

Hairston, Jestie "Jester" (July 9, 1901–), choral conductor, composer, actor. Jester Hairston was born in Belews Creek, N.C. When he was less than a year old he moved with his family to Connersville, Pa., and he attended school in Hempstead, Pa. Hairston entered the University of Massachusetts at Amherst in 1920, but a shortage of money forced him to drop out after two years. A few years later, Anna Laura Kidder, a former teacher who recognized his talent for music, offered to sponsor his education. Beginning in 1927, she paid his tuition at Tufts University in Boston, and Hairston completed requirements for his degree in 1930.

After graduating, Hairston began his performing career as a singer with the Dixie Jubilee Singers (later called the Eva Jessye Choir) and in the Broadway show *Hello, Paris* (1930). Later that year he appeared on Broadway again in *The Green Pastures.* Early in the 1930s he joined the Hall Johnson choir, where he received his training in performing and arranging African-American spirituals and, in 1936, became Johnson's assistant conductor. In 1938 he joined the Armitage production of *Porgy and Bess* as the Undertaker. Hairston also studied at Juilliard during this period and worked as a music instructor at a conservatory in Harlem through the federal WORKS PROJECT ADMINISTRATION (WPA).

In 1935 Hairston went to Hollywood to act and to assist with the music in the film version of *The Green Pastures* (1936), after which he stayed on both as an actor and choral arranger/director, often working with film composer Dimitri Tiomkin. Among the more than forty films on which Hairston worked in the latter capacity are *Lost Horizon* (1937), *Portrait of Jennie* (1948), *Carmen Jones* (1954), *Land of the Pharaohs* (1956), and *Friendly Persuasion* (1956). As an actor, he appeared in *She Wore a Yellow Ribbon* (1949), *Summer and Smoke* (1961), *To Kill a Mockingbird* (1962), *In the Heat of the Night* (1967), *Lady Sings the Blues* (1972), *The Last Tycoon* (1976), and other films. In 1963 he arranged the choral music for the film *Lilies of the Field* and supplied the singing voice for Sidney Poitier. Hairston's acting career also extended to radio and television. He played the occasional roles of Henry Van Porter and Leroy, Sapphire's brother, on *Amos 'n' Andy,* both on radio and on television (1951–1953). He also appeared on *That's My Mama* (1974–1976) and *Amen* (1986–1991).

Hairston has continued to work as a conductor and arranger of and lecturer on African-American choral music. Since the 1960s he has been sent abroad periodically by the State Department to serve as a goodwill ambassador. In this capacity he has conducted choirs in Western and Eastern Europe, Scandinavia, Russia, Africa, and Mexico. Recognized as one of the preeminent composers, arrangers, and conductors of

African-American spirituals and choral music, Jester Hairston has received five honorary doctorates for his work.

REFERENCES

KNIGHT, ATHELIA. "Jester Hairston: Living Memoir on 'Amen'—The Life and Times of Jester Hairston." *Washington Post TV Week,* January 8–14, 1989, pp. 7, 8, 9, 32.

LOVELL, JOHN, JR. *Black Song: The Forge and the Flame.* New York, 1972.

JAMES STANDIFER

Haitian Revolution. The Haitian Revolution of 1789–1804 began as a political struggle among the free inhabitants of Saint Domingue, a French colony on the island of Hispaniola. The French Revolution of 1789 provided the occasion for class and racial antagonisms to surface in Saint Domingue. Each of the colony's social castes seized the moment to address its grievances. The *grand blancs*—planters and wealthy merchants—sought greater autonomy in managing the colony's economic and political affairs. The French Revolution's declared egalitarianism appealed to the *petit blancs*—lower class whites—as it did to the *gens de couleur*—the mulattoes and free blacks who resented the barriers of legal and social discrimination. While colonial representatives solicited support from various political factions in Paris, the struggle turned violent on the island. The *gens de couleur*, led by Vincent Ogé, attempted an unsuccessful revolt in the spring of 1791. In August, the colony's slave population joined in the struggle and turned the Haitian Revolution into a war for emancipation and national independence.

Saint Domingue's slave population—over 400,000 —produced the sugar, coffee, cotton, and indigo that made it the richest colony in the French Empire. Estimates suggest that a third of France's foreign trade in the 1780s came from this one colony. The constant toil in a tropical climate and the brutality of the slaveowners made conditions for the slaves among the worst in the Western Hemisphere. The slave insurrection of August 1791 began with attacks against several plantations. Among the leaders in the initial uprising, the most prominent was a Jamaican fugitive and VOODOO priest, John Boukman. Voodoo practices, widespread among the slaves, provided a means for defining leadership, organizing, and communicating among the insurgents. Within a few months the insurrection had engulfed the entire colony. The Haitian Revolution primarily divided the inhabitants along racial lines, but political and military exigencies led to shifting alliances that at times pitted free blacks against insurgent slaves and poor whites against wealthy planters.

The success of the slave insurrection was due in large part to the leadership of Toussaint Louverture (c. 1744–1803). Although born a slave, he benefited from paternalistic owners. He acquired a rudimentary education and assumed steward's responsibilities on the plantation. Toussaint joined the slave insurrection of August 1791 as an aide to one of the insurgent commanders. At first Toussaint was recognized for his skills as an herbalist and healer, but he quickly established his reputation as a military organizer and battlefield tactician. He molded the black insurgents into a military force capable of challenging the best troops of Europe. Through the 1790s, he successfully opposed the armies of England, Spain, and France as they intervened in the colony's revolution.

Toussaint's efforts to rid the island of slavery were inexorably bound to European imperial rivalries and the politics of the French Revolution. Toussaint initially sided with the Spanish in Santo Domingo, but he went over to the French side when the National Convention in Paris, controlled by the Jacobin faction, abolished slavery in February 1794. French co-

In this French lithograph by Villain, Toussaint Louverture proclaims the constitution of the Haitian Republic on July 1, 1801. For nineteenth-century American blacks, no one was more of an inspiration in the struggle against slavery than Toussaint. (Prints and Photographs Division, Library of Congress)

lonial authorities rewarded their new ally by making him lieutenant governor and allowing him to expand his army to 20,000. In May 1797, Toussaint became governor general of Saint Domingue. That same year, he thwarted a British invasion and two years later, in a rare outburst of vindictiveness, he brutally suppressed the mulatto opposition led by André Rigaud. In 1801, Toussaint invaded Santo Domingo, and with this quick, relatively bloodless campaign, he brought the entire island of Hispaniola under his control.

Toussaint's regime was tainted by authoritarian tendencies and corruption in the military. Nor did former slaves find relief from oppression; despite the benefits of emancipation and progressive labor reforms, they remained tied to the plantation through long-term contracts, vagrancy laws, and government oversight. Under the Constitution of 1801, Toussaint ruled as governor-general for life, but Saint Domingue remained a French colony. Toussaint apparently believed that total independence from France was untenable without the support of Britain or the United States, and he also hoped that French planters and professionals would remain on the island. He was one of the few leaders who seemed insulated from the intense hatreds generated by decades of slavery and oppression, and a brutal ten-year race war. His rule held out genuine prospects for racial reconciliation among former slaves, mulattoes, and whites.

In his tireless work habits, administrative skills, and military genius, Toussaint mirrored his contemporary and adversary, Napoleon Bonaparte. The army of 40,000 sent by Napoleon to reestablish slavery and direct French control over the island forced Toussaint's capitulation in May 1802. He retired to his plantation, but French authorities, perceiving him as a lingering threat, had him arrested and deported. He spent his last months confined in a prison near the French-Swiss border.

Following Toussaint's deportation, Jean-Jacques Dessalines (1758–1806) gained overall command of the insurgent army. Charismatic and militarily astute, Dessalines had been one of Toussaint's most loyal and capable military commanders. He harassed the French forces while tropical diseases decimated their ranks. The heavy losses forced the French to withdraw, and Dessalines inaugurated the independent republic in January 1804. The new nation adopted the indigenous Arawak name for the island, Haiti. By the new constitution Dessalines held the position of governor-general, but in September he assumed the title Emperor Jacques I. His intense hatred of the French and fear of a pro-French sentiment in Haiti led him to carry out a systematic extermination of the remaining white inhabitants. The massa-

cre was the final chapter in a vicious race war that at times seemed genocidal. Dessalines had little education or understanding of government administration. His regime, authoritarian and built on personal loyalties and family ties, provided a troubling precedent for Haitian political life. Dessalines's rule ended abruptly in 1806, when he was assassinated near Port-au-Prince by several military leaders opposed to his dictatorship.

Haitian-American relations in the early 1800s were tied closely to U.S. relations with the European powers and territorial expansion on the North American continent. American designs on the Louisiana Territory and the Floridas meant conceding at times to French, English, and Spanish concerns in the Caribbean. Ironically Napoleon's failure to reestablish slavery in Haiti opened the way for the total withdrawal of French interests in North America and the sale of the Louisiana Territory in 1803. Pressure to improve relations with Haiti came from New England merchants who had developed a lucrative trade with the former French colony. But southern slaveholders generally carried the debate on Haitian-American relations in the antebellum period. Southern congressmen were particularly appalled by the prospect of a Haitian diplomatic presence in Washington, D.C., and blocked initiatives to normalize relations with the new nation. In the end, the United States refused to recognize the Haitian government, despite compelling economic and diplomatic considerations, until 1862.

Americans discovered in the Haitian Revolution their deepest fears and aspirations. Southern slaveholders, ever haunted by the specter of slave revolt, saw this apparition materialize in Haiti. The "horror stories" from white colonial refugees, graphically detailed in the southern press, fueled obsessive fears of a bloody race war. During the 1790s, southern states increased slave patrols, restricted importation of slaves from Hispaniola, and readily attributed any sign of slave discontent to the insidious influence of Haitian agents. Even those Southerners troubled by the existence of slavery harbored greater anxieties about a large, free black population in the South. The Haitian Revolution penetrated deep into southern consciousness, hardening proslavery convictions and stifling sentiment for gradual emancipation. The memory of the Haitian revolution was heightened by the emigration of thousands of refugees—slaves, free blacks, and whites—to the United States, especially to Louisiana.

Proslavery apologists saw in the Haitian Revolution the triumph of barbarism over civilization. Through the antebellum period, they pointed to Haiti's economic and political failures to foster the theory that slavery was a positive good. The results of

the Haitian Revolution, they insisted, demonstrated that African slaves were a dependent people, unfit for freedom. Abolitionists (*see* ABOLITION) countered these proslavery myths by arguing that the Haitian Revolution was the inevitable result of slavery. Most white abolitionists carefully avoided any endorsement of slave violence, but they suggested that the revolution's brutality and terror were a natural consequence of a brutal and oppressive institution. Moreover, they considered any progress in Haiti remarkable given the island's uneducated and politically inexperienced population.

African Americans were even more forthright in celebrating the Haitian Revolution. The "second republic" in the Western Hemisphere provided an unprecedented example of black political achievement. African-American writers and speakers frequently invoked the Haitian Revolution and its leaders to generate a sense of racial pride and accomplishment. The Haitian Revolution was a landmark in the history of black nationality. Many African Americans, despairing of any hope for racial progress in the United States, looked to Haiti as a place to create a viable black nation. The Haitian government supported several initiatives beginning in the 1820s to encourage African-American settlement. Several thousand immigrants accepted the invitation. J. Theodore Holly, an Episcopal priest, was foremost among the advocates of Haitian immigration. On the eve of the Civil War, he helped revive interest in Haiti and founded an African-American colony on the island. Most of the surviving immigrants eventually returned from the island disillusioned by their experience. The Civil War diverted the attention of African Americans from Haiti, but despite its diminished appeal as an African homeland, Haiti has remained an influential source of black political life and culture.

REFERENCES

FICK, CAROLYN E. *The Making of Haiti: The Revolution from Below.* Knoxville, Tenn., 1990.

HUNT, ALFRED N. *Haiti's Influence on Antebellum America.* Baton Rouge, La., 1988.

JAMES, C. L. R. *The Black Jacobins: Toussaint L'Ouverture and the San Domingo Revolution.* 1938. Reprint. New York, 1963.

JORDAN, WINTHROP. *White Over Black.* Chapel Hill, N.C., 1968.

MILLER, FLOYD J. *The Search for a Black Nationality.* Urbana, Ill., 1975.

OTT, THOMAS O. *The Haitian Revolution, 1789–1804.* Knoxville, Tenn., 1973.

ROBINSON, DONALD R. *Slavery and the Structure of American Politics, 1765–1820.* New York, 1971.

MICHAEL F. HEMBREE

Hale, Clara McBride "Mother" (April 1, 1905–December 18, 1992), social activist. Clara McBride was born in Philadelphia. Her father died when she was an infant, and she and her three siblings were raised by their mother. After finishing high school, she married Thomas Hale and they moved to New York City. Her husband's floor-waxing business was not profitable, so Clara Hale worked nights as a domestic, cleaning theaters to help support their three children, Lorraine, Nathan, and Kenneth. Widowed at age twenty-seven, she began cleaning homes during the day to supplement her income. She abandoned this arrangement, however, since it forced her to leave her children alone all day, and she began to care for other people's children in her home. She also took in foster children and over the next two decades eventually raised forty children.

In 1968, Hale retired as a foster parent, but the following year, when she found a young heroin-addicted mother and baby on her doorstep, her career resumed. The mother and child had been sent to her by her daughter, Lorraine, who had discovered them on a park bench. Clara Hale agreed to care for the baby while the mother sought help for her addiction. News of her generosity spread, and within two months she was caring for twenty-two children, with only the financial support of her own children.

In the early 1970s New York City agreed to fund her, and in 1975 a federal grant made it possible for her to renovate an entire building in Harlem, which became the Hale House Center for the Promotion of Human Potential. By 1992 Hale House had cared for 1,000 children born with chemical dependencies, most of whom were returned to their mothers once the children had gone through withdrawal and their mothers were able to care for them.

Mother Hale, as Clara Hale came to be known, became a symbol for people of all political persuasions. She addressed the enduring problems of poverty and drug addiction, brought attention to the lack of services available to the needy, and exemplified the virtue of individual responsibility. In February 1985, President Ronald Reagan honored Clara Hale as "a true American hero" in his State of the Union Address. She was also awarded two of the highest distinctions given by the Salvation Army, the Leonard H. Carter Humanitarian Award in 1987 and the Booth Community Service Award in 1990. After Clara Hale's death in 1992, Hale House continued operating under the direction of her daughter, Lorraine Hale.

REFERENCES

"Clara Hale Dies; Cared for 1,000 Drug-Addicted Babies." *Jet* 83 (January 11, 1993): 56–57.

HINE, DARLENE CLARK, ed. *Black Women in America.* Brooklyn, N.Y., 1993.

LYDIA MCNEILL
PAM NADASEN

Haley, Alexander Palmer "Alex" (August 11, 1921–February 10, 1992), journalist and novelist. Alex Haley was born in Ithaca, N.Y., and raised in Henning, Tenn. He attended Elizabeth City State Teachers College in North Carolina from 1937 to 1939. At age seventeen he left college and enlisted in the Coast Guard, where he eventually served as editor of the official Coast Guard publication *The Outpost.* In 1959 he retired as chief journalist, a position that had been expressly created for him.

After leaving the Coast Guard, Haley became a freelance writer, contributing to *Reader's Digest, The New York Times Magazine, Harper's, Atlantic,* and *Playboy* (for which he inaugurated the "Playboy Interview" series). He first received widespread attention for *The Autobiography of Malcolm X* (1965). His collaboration with the black nationalist MALCOLM X consisted of a series of extended interviews transcribed by Haley; the result was an autobiography related to Haley that was generally praised for vibrancy and fidelity to its subject. The book quickly achieved international success and was translated into many different languages, selling millions of copies in the United States and abroad. As a result, Haley received honorary doctorates in the early 1970s from Simpson College, Howard University, Williams College, and Capitol University.

Haley is best known, however, for his epic novel *Roots: The Saga of an American Family* (1976). Based on Haley's family history as told to him by his maternal grandmother, *Roots* traces Haley's lineage to Kunta Kinte, an African'youth who was abducted from his homeland and forced into slavery. Combining factual events with fiction, *Roots* depicts the African-American saga from its beginnings in AFRICA, through SLAVERY, EMANCIPATION, and the continuing struggle for equality. The novel was an immediate bestseller, and two years after its publication had won 271 awards, including a citation from the judges of the 1977 National Book Awards, the NAACP's SPINGARN MEDAL, and a special Pulitzer Prize. Presented as a television miniseries in 1977, *Roots* brought the African-American story into the homes of millions. The book and the series generated an unprecedented level of awareness of African-American heritage and served as a spur to black pride.

The reception of Haley's book, however, was not devoid of controversy. Two separate suits were

Alex Haley's best-known work is *Roots,* a novel of the progress of one African-American family from its homeland in West Africa to the end of the Civil War. He also was the ghostwriter of *The Autobiography of Malcolm X.* (Photographs and Prints Division, Schomburg Center for Research in Black Culture, The New York Public Library, Astor, Lenox and Tilden Foundations)

brought against Haley for copyright infringement: one was dismissed, but the other, brought by Harold Courlander, was settled after Haley admitted that several passages from Courlander's book *The African* (1968) appeared verbatim in *Roots.* In addition, some reviewers expressed doubts about the reliability of the research that had gone into the book and voiced frustration at the blend of fact and fiction. After Haley's death, more evidence came to light to suggest that he had inflated the factual claims and plagiarized material for *Roots.*

The unparalleled success of *Roots* gave rise to a widespread interest in genealogy as well as to a proliferation of works dealing specifically with the African-American heritage. *Roots: The Next Generation* was produced as a miniseries in 1979. Haley formed the Kinte Corporation in California and became involved in the production of films and records, the first of which was *Alex Haley Speaks,* which included advice on how to research family histories. In 1980 Haley helped produce *Palmerstown U.S.A.,* a television series loosely based on his childhood experiences in the rural South in the 1930s. In the 1980s Haley lectured widely, made numerous radio and television appearances, and wrote prolifically for popular magazines.

In his last years he concentrated on writing a narrative of his paternal ancestry, *Queen: The Story of an American Family.* The book, which Haley intended to be a companion volume to *Roots,* was published and adapted for television the year following his 1992

death in Seattle. Since his death, Haley's reputation, which had suffered in the late 1970s due to previously mentioned charges of plagiarism, was again attacked, as information came to light that he may have invented parts of his story as presented in *Roots* and presented them as fact.

REFERENCES

BAYE, BETTY WINSTON. "Alex Haley's Roots Revisited." *Essence* 22, no. 10 (February 1992): 88–92.

FIEDLER, LESLIE A. *The Inadvertent Epic: From Uncle Tom's Cabin to Roots.* New York, 1982.

NOBILE, PHILIP. "Uncovering Roots." *Village Voice* 38, no. 8 (February 23, 1993): 31–38.

ALEXIS WALKER

Hall, Arsenio (February 12, 1957–), actor, talk show host. Arsenio Hall was born in Cleveland, Ohio, the only child of Fred Hall, a Baptist preacher, and his wife, Annie. When Hall was nine, his parents divorced, and he was raised by his mother, grandmother, and godmother. As a young child, he performed as a magician at weddings, birthday parties, and talent shows. He took a lively interest in *The Tonight Show* and idolized the show's host, Johnny Carson, realizing at the age of twelve that he "wanted to do what Johnson Carson does."

In 1977, Hall received a B.A. from Kent State University, where he became involved in theater arts and worked as a deejay for the campus radio station. Following graduation, Hall worked briefly in advertising. Then, on a dare from a friend, he started doing stand-up comedy routines in 1979. He subsequently moved to Chicago, where he was discovered by singer Nancy WILSON, who aided his move to Los Angeles. Hall quickly became one of the rising young comedians on the stand-up circuit, opening for such top-name concert performers as Aretha FRANKLIN, Neil Sedaka, Tina TURNER, and Patti LABELLE.

In 1983, Hall became host of the ABC summer series *The Half-Hour Comedy Hour.* A year later, he became a regular on the syndicated series *Thicke of the Night,* and went on to cohost the music/variety show *Solid Gold.* In 1987, Hall served as the host of the talk show *The Late Show.* On the strength of his performance, he was signed to an exclusive two-year, multifilm agreement with Paramount Pictures, which led to his performance as Eddie Murphy's costar in *Coming to America* (1988). Hall also appeared in two other films: *Amazon Women on the Moon* (1987), and *Harlem Nights* (1989).

In 1989, Hall became the host, as well as executive producer, of his own late-night talk show. Nominated for three Emmy awards during its first season, *The Arsenio Hall Show* garnered consistently high ratings and was one of the most watched late-night talk shows of the early 1990s. Hall also worked on TV and film projects, served as the National Ambassador of DARE (Drug Abuse Resistance Education), and worked on behalf of Make-a-Wish and the Starlight Foundation, two organizations that benefit terminally ill children.

REFERENCES

COOPER, BARRY MICHAEL. "Big Daddy Hall's New Jack Chit Chat." *Village Voice,* May 23, 1989, pp. 27–31.

NORMAN, MICHAEL. "Late-Night Cool." *New York Times Magazine* (October 1, 1989): 29–31.

KEITH ROONEY

Hall, George Cleveland (February 22, 1864–June 17, 1930), physician, civic leader. Born in Ypsilanti, Mich., George Hall attended public school in Chicago and graduated with a B.A. from Lincoln University in Pennsylvania in 1886. He returned to Chicago to study at Bennett Medical College, from which he received an M.D. in 1888. He was a surgeon at Chicago's PROVIDENT HOSPITAL, a two-story, twelve-bed facility founded in 1891 by Dr. Daniel Hale WILLIAMS. In 1894, Hall became the hospital's chief of staff, and he remained in that position until his death in 1930. He was successful in raising funds for the institution, enabling it to move in 1928 into a new building with room for sixty-five beds. Provident Hospital served as a teaching institution for black nurses and physicians who were denied access to instruction at white facilities. Hall organized postgraduate courses and eventually received approval from the American College of Surgeons and the American Medical Association for the hospital's internship program.

Hall was active in the black community in many ways. He was Booker T. WASHINGTON's personal physician. In 1915, he helped found the ASSOCIATION FOR THE STUDY OF NEGRO LIFE AND HISTORY with Carter G. WOODSON, and served as the organization's first president. In 1917, he was one of the organizer's of the Chicago branch of the NATIONAL URBAN LEAGUE, while in 1920 he was elected national vice president of the league. In addition, the governor of Illinois appointed him to the Commission on Race Relations after the CHICAGO RIOTS of 1919. Hall founded the Cook County Physicians Association, was a member of the National Medical

Association, and was on the boards of trustees of both Provident Hospital and Lincoln University.

REFERENCES

HINE, DARLENE CLARK. *Black Women in White: Racial Conflict and Cooperation in the Nursing Profession, 1890–1950*. Bloomington, Ind., 1989.
SAMMONS, VIVIAN OVELTON. *Blacks in Science and Medicine*. New York, 1990.

LYDIA McNEILL

Hall, Lloyd Augustus (June 20, 1894–1971), chemist. Lloyd A. Hall was born in Elgin, Ill. After receiving a B.S. degree from Northwestern University in 1916, he began his career as a chemist at the Chicago Department of Health Laboratories from 1916 to 1918 and was the chief chemist at the John Morrell Company in Ottumwa, Iowa, from 1918 to 1921 and at Boyer Chemical Laboratory in Chicago from 1921 to 1922. He became the president and chemical director of a consulting laboratory, Chemical Products Corporation, in Chicago, from 1922 to 1925. He then assumed the position of chief chemist and director of research of Griffith Laboratories in Chicago from 1925 to 1946, which he held until his retirement. At Griffith he undertook the research for which he later became recognized.

At Griffith, Hall's most important work, which revolutionized the meatpacking industry, involved the improvement of curing salts for the preserving and processing of meats. He also developed a method to sterilize spices in the meatpacking industry with ethylene oxide; this method is currently in general use in the sterilization of medicines, medical supplies, cosmetic materials, and dentifrices, among other products. Hall also produced an antioxidant salt mixture that is today used throughout the food industry to prevent rancidity in fats and oils. Hall patented a process that reduced the time needed to cure meat from six to fifteen days to a few hours. He was the author of approximately fifty papers and held more than one hundred patents in the United States, Great Britain, and Canada.

In 1955, he was elected the first black member of the National Board of Directors of the American Institute of Chemists and was twice awarded the Honor Scroll by the Chicago chapter of that organization, in 1956 and 1959. After retiring in 1959 and moving to Pasadena, Calif., he spent six months in Indonesia as a consultant to the Food and Agriculture Organization (FAO) of the United Nations in 1961. He was appointed by President John F. Kennedy as a member of the American Food for Peace Council, on which he served from 1962 to 1964.

REFERENCE

HABER, LOUIS. *Black Pioneers of Science and Invention*. New York, 1970.

SIRAJ AHMED

Hall, Prince (1735?–December 4, 1807), civic leader. The place and date of Prince Hall's birth are not known. Recent research has cast doubt on the traditional versions of his early years, which placed his birth in the West Indies. Current evidence indicates that Hall became a member of the School Street Congregational Church of Boston in 1762. In 1770 he was manumitted by William Hall, a Boston craftsman, who probably had owned him since the 1740s. In 1775 Hall petitioned to join Boston's St. John's Lodge of freemasons and was turned down. Hall and fourteen other free African-American men then sought and received admission to a masonic lodge affiliated with an Irish regiment in the British Army stationed in Boston. Obtaining a permit from the military lodge to participate in some masonic activities as an independent body, Hall and the others continued as masons in a limited capacity throughout the Revolutionary War (see AMERICAN REVOLUTION).

Throughout his adult life Hall worked in the Boston area, both as a leather crafter in his shop, the Golden Fleece, and as a caterer. During the Revolutionary War he supplied leather drumheads to the Continental Army, and it is also possible that he joined it as a combatant. Discussions of him in the letters of his white and black contemporaries show that they looked upon him as the social and political leader of African Americans in Boston. Thus in the early years of the war Hall signed petitions to the Continental Congress requesting permission for African Americans to fight in the war. Employing arguments analogous to those used by the revolutionaries to justify their revolt against the British, on January 13, 1777, Hall and others also petitioned the Massachusetts legislature to outlaw slavery.

In 1784 Hall, as master of the provisional African Lodge, applied for a charter from the London Grand Lodge. Although the charter establishing African Lodge 459 was granted in September of that year, Hall did not receive it until April 1787. He then served as its Grand Master until his death at the age of seventy-two. (Several of his annual addresses to the lodge, placing the history of the lodge in the context

of masonic and African history, were published during his lifetime.) In the year after his death, Hall's followers adopted his name for what remains the largest and most highly regarded African-American FRATERNAL ORDER, the Prince Hall Masons.

During Shays's Rebellion in 1786, Hall, acting as a spokesperson for Boston's black community, wrote to assure the Massachusetts state government of his and his fellow masons' political loyalty and willingness to serve against Shays's followers. However, only months later, Hall formally submitted a suggestion to the legislature that it consider financially assisting blacks who wished to return to Africa and establish an independent state. In both instances the state government declined to act on Hall's petitions.

In his capacity as Grand Master and leader of Boston's African-American community, Hall protested the seizure of three free blacks (one a mason) in Boston by slave traders, and in February 1788 successfully petitioned the Massachusetts government for their return. In the same document he denounced the SLAVE TRADE, which contributed significantly to the March 26, 1788 decision banning such trade in Massachusetts. In other letters and petitions to the state government, the politically active Hall demanded full citizenship and the establishment of public schools for blacks. (In 1800 Hall opened in his own home one of the first schools in Boston for free black children.) Hall died in Boston in 1807.

REFERENCES

GRIMSHAW, WILLIAM H. *Official History of Freemasonry Among the Colored People in North America.* New York, 1903.

LOGAN, RAYFORD W. and MICHAEL R. WINSTON. *Dictionary of American Negro Biography.* New York, 1982.

WESLEY, CHARLES H. *Prince Hall: Life and Legacy.* 2nd ed. Washington, D.C., 1983.

PETER SCHILLING

Hamer, Fannie Lou (Townsend, Fannie Lou)

(October 6, 1917–March 14, 1977), civil rights activist. Fannie Lou Townsend was born to Ella Bramlett and James Lee Townsend in Montgomery County, Miss., in 1917. Her parents were sharecroppers, and the family moved to Sunflower County, Miss., when she was two. Forced to spend most of her childhood and teenage years toiling in cotton fields for white landowners, Townsend was able to complete only six years of schooling. Despite wrenching rural poverty and the harsh economic conditions of the Mississippi Delta, she maintained an enduring optimism. She learned the value of self-respect and outspokenness through her close relationship with her mother. In 1944, she married Perry Hamer, moved with him to Ruleville, and worked as a sharecropper on a plantation owned by W. D. Marlowe.

During her years on the Marlowe plantation, Hamer rose to the position of time- and record-keeper. In this position she acquired a reputation for a sense of fairness and a willingness to speak to the landowner on behalf of aggrieved sharecroppers. She began to take steps to directly challenge the racial and economic inequality that had so circumscribed her life after meeting civil rights workers from the Student Nonviolent Coordinating Committee (SNCC) in 1962. In Mississippi, SNCC was mounting a massive voter registration and desegregation campaign aimed at empowering African Americans to change their own lives.

Inspired by the organization's commitment to challenging the racial status quo, Hamer and seventeen other black volunteers attempted to register to vote in Indianola, Miss., on August 31, 1962, but were unable to pass the necessary literacy test, which was designed to prevent blacks from voting. As a result of this action, she and her family were dismissed from the plantation, she was threatened with physical harm by Ruleville whites, and she was constantly harassed by local police. Eventually, she was forced to flee Ruleville and spent three months in

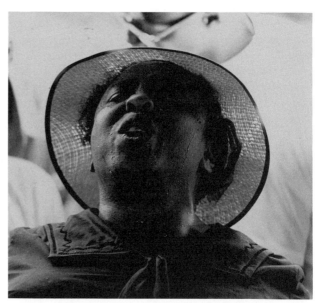

Fannie Lou Hamer singing at a gathering at Enid Dam Campsite, Miss., on June 12, 1966, during the march to Jackson, Miss., in the wake of the attack on James Meredith. (© Charmian Reading)

Tallahatchie County, Miss., before returning in December.

In January 1963 Hamer passed the literacy test and became a registered voter. Despite the persistent hostility of local whites, she continued her commitment to civil rights activities and became a SNCC field secretary. By 1964, Hamer had fully immersed herself in a wide range of local civil rights activities, including SNCC-sponsored voter registration campaigns, and clothing- and food-distribution drives. At that time she was a central organizer and vice-chairperson of the Mississippi Freedom Democratic Party (MFDP), a parallel political party formed under the auspices of SNCC in response to black exclusion from the state Democratic Party. Hamer was one of the sixty-eight MFDP delegates elected at a state convention of the party to attend the Democratic National Convention in Atlantic City in the summer of 1964. At the convention the MFDP delegates demanded to be seated and argued that they were the only legitimate political representatives of the Mississippi Democratic Party because unlike the regular party which formed and operated at the exclusion of blacks, their party was open to all Mississippians of voting age.

Hamer's televised testimony to the convention on behalf of the MFDP propelled her into the national spotlight. A national audience watched as she described the economic reprisals that faced African Americans who attempted to register to vote and recounted the beating that she and five other activists had received in June 1963 in a Winona County, Miss., jail. Hamer's proud and unwavering commitment to American democracy and equality inspired hundreds of Americans to send telegrams supporting the MFDP's challenge to the southern political status quo. Although the MFDP delegates were not seated by the convention, Hamer and the party succeeded in mobilizing a massive black voter turnout and publicizing the racist exclusionary tactics of the state Democratic Party.

By the mid-sixties, SNCC had become ideologically divided and Hamer's ties to the organization became more tenuous. However, she continued to focus her political work on black political empowerment and community development. Under her leadership, the MFDP continued to challenge the all-white state Democratic party. In 1964 Hamer unsuccessfully ran for Congress on the MFDP ticket, and one year later spearheaded an intense lobbying effort to challenge the seating of Mississippi's five congressmen in the House of Representatives. She played an integral role in bringing the Head Start Program for children to Ruleville, and organized the Freedom Farm Cooperative for displaced agricultural workers. In 1969 she founded the Freedom Farm

Corporation in Sunflower, a cooperative farming and landowning venture to help poor blacks become more self-sufficient. It fed well over 5,000 families before collapsing in 1974. Three years later, after over a decade of activism, she died from breast cancer and heart disease.

Fannie Lou Hamer was a symbol of defiance and indomitable black womanhood that inspired many in the civil rights movement. Morehouse College and Howard University, among others, have honored her devotion to African-American civil rights with honorary doctoral degrees. Her words "I'm sick and tired of being sick and tired" bear testament to her lifelong struggle to challenge racial injustice and economic exploitation.

REFERENCES

CRAWFORD, VICKI L., JACQUELINE ANNE ROUSE, and BARBARA WOODS. *Women in the Civil Rights Movement.* New York, 1990.

HAMER, FANNIE LOU. *To Praise My Bridges: An Autobiography.* Jackson, Miss., 1967.

JORDAN, JUNE. *Fannie Lou Hamer.* New York, 1972.

KLING, SUSAN. *Fannie Lou Hamer.* Chicago, 1979.

CHANA KAI LEE

Hamilton, Virginia (March 12, 1936–), author. Born and raised in Yellow Springs, Ohio, Virginia Hamilton traces her ancestry to a slave who escaped to Ohio, settling land on which she now lives. Her parents were Kenneth Hamilton and Etta Belle (Perry) Hamilton.

A reader and writer as a child, Hamilton excelled in school, winning a scholarship to Antioch College in Yellow Springs. She studied writing there, graduating in 1955. She studied further at Ohio State University (1957–1958) and the New School for Social Research in New York, concentrating on writing short stories. In March 1960, she married the writer Arnold Adoff and traveled with him to Spain and North Africa.

An editor encouraged Hamilton to write book-length fiction for young people; the result was her award-winning *Zeely* (1967), written while she was in the south of France. It was chosen as an American Library Association Notable Book in 1967. In 1970, *The House Dies Drear* received positive reviews and Hamilton's reputation as a writer became established. Between 1968 and 1980, she wrote twelve books, including biographies of W. E. B. DU BOIS and Paul ROBESON. *M. C. Higgins the Great* (1974) won the Newbery Medal and the National Book Award.

From 1980 to 1991, Hamilton wrote fourteen more books, many receiving awards. Notable for sophisticated subjects and style, her books convey strong

values and a commitment to informing young audiences of aspects of the African-American experience largely unexplored by other writers of young-adult literature.

REFERENCE

APSELOFF, MARILYN. *Virginia Hamilton, Ohio Explorer in the World of Imagination.* Columbus, Ohio, 1979.

JANE L. BALL

Hamilton, William (1773–December 9, 1836), abolitionist. Born in New York sometime in 1773, William Hamilton was reputed to be the illegitimate son of Alexander Hamilton, though evidence for the accuracy of this rumor is lacking. He made a living as a carpenter, but he made his name as a powerful orator working to improve the conditions of African Americans. In 1808 he cofounded and became president of the New York African Society for Mutual Relief, which provided funds for the widows and children of its members.

One of the country's earliest black abolitionists, Hamilton delivered an antislavery speech, *An Address to the New York African Society for Mutual Relief,* on January 2, 1809, which was published a week later at his listeners' request. In that speech Hamilton celebrated the recent ending of the American slave trade and promoted the education of African Americans. He expressed confidence that "soon shall that contumelious assertion of the proud be proved false, to wit, that Africans do not possess minds as ingenious as other men."

In 1820 Hamilton was one of the founding members of the AFRICAN METHODIST EPISCOPAL ZION CHURCH in New York City. On July 4, 1827, he gave a major oration at the church to commemorate the New York State EMANCIPATION statute. While in his earlier speech he insisted on the equality of the races, in this oration he proclaimed the superiority of blacks, noting that "if there is any difference in the species, that difference is in favour of the people of colour." Arguing that no white American could claim superiority to African Americans as long as he continued to hold slaves, Hamilton asked, "Does he act in conformity to true philosophy?"

Having made clear his contempt for the true motives of white men—"authority and gold"—and having accomplished his expressed goal "to unravel this mystery of superiority," Hamilton proceeded to exhort the young men of his audience to further study and education, and to rouse themselves from "frivolity and lethargy."

Giving the lie to the supposed lethargy of African Americans, Hamilton was tireless in his endeavors on their behalf. He helped to organize the first annual Convention for the Improvement of Free People of Color held in Philadelphia on September 20, 1830. As president of the fourth annual convention, held in New York in June, 1834, he gave a well received speech published as *Minutes of the Fourth Annual Convention, for the improvement of the free people of color.* As a member of the Phoenix and Philomathean societies he worked towards improving the education of African Americans.

Strongly opposed to the American Colonization Society, Hamilton was a staunch supporter of William Lloyd Garrison, whom he knew personally. He publicized Garrison's *Liberator,* and helped in the publication of *Garrison's Thoughts on Colonization.* Hamilton died in or near New York City in 1836. His sons, Robert and Thomas, established *The People's Press* and *The Anglo-African* newspapers.

REFERENCES

BOARDMAN, HELEN M. "First Families of Manhattan." *Phylon* (Second Quarter 1944): 138–142.

OTTLEY, ROI, and WILLIAM J. WEATHERBY. *The Negro in New York.* New York, 1967.

PORTER, DOROTHY, ed. *Early Negro Writing: 1760–1837.* Boston, 1971.

RIPLEY, C. PETER, ed. *The Black Abolitionist Papers.* Volume III. *The United States, 1830–1846.* Chapel Hill, N.C., 1991.

WALLS, WILLIAM. *The African Methodist Episcopal Zion Church: Reality of the Black Church.* Charlotte, N.C., 1974.

LYDIA MCNEILL

Hammon, Briton (mid-18th century), writer. All that is known about Briton Hammon is gleaned from his publication *A Narrative of the Uncommon Sufferings, and Surprising Deliverance of Briton Hammon, A Negro Man,—Servant to General Winslow, of Marshfield, in New England; Who Returned to Boston, after Having Been Absent almost Thirteen Years* (Boston, 1760).

Hammon was a servant or slave of General Winslow of Marshfield, Mass. In 1747 he sailed with Winslow's consent from Plymouth, Mass., to the West Indies. He stayed several weeks in Jamaica, was shipwrecked on the coast of Florida, and was captured by Native Americans. He escaped with a Spanish schooner and was imprisoned in a Spanish dungeon in Havana for almost five years because he refused to serve on board a Spanish ship. Hammon then escaped again and went to England; he signed on a ship bound for

Boston and found his former master, General Winslow, also on board. Both returned to Marshfield, where Hammon wrote his account of thirteen years of traveling.

Hammon's *Narrative* has long been considered the first prose work by an African-American writer. Some literary historians credit him with writing the first SLAVE NARRATIVE. His status is vague. In the title he used the word "servant," and from his description it is not clear whether he was a privileged slave or a servant in a more modern sense. According to Hammon, he was paid to be a cook and to do other jobs. There is no information about the purposes of his travels. In the preface to his *Narrative,* Hammon explains "To the Reader" that his "capacities and conditions of life are very low" and asks for the reader's understanding.

REFERENCE

LOGAN, RAYFORD W., and MICHAEL R. WINSTON, eds. *Dictionary of American Negro Biography.* New York and London, 1982.

DORIS DZIWAS

Hammon, Jupiter

Hammon, Jupiter (1711–c. 1806), poet, preacher. Jupiter Hammon was born on Long Island, N.Y., and raised in slavery to the Lloyd family. Little is known about his personal circumstances; scholars speculate that he attended school and was permitted access to his master's library. He is known to have purchased a Bible from his master in 1773. A favored slave in the Lloyd household, he worked as a servant, farmhand, and artisan. In early 1761, Hammon published the first poem by a black person to appear in British North America, titled "An Evening Thought. Salvation by Christ with Penitential Cries: Composed by Jupiter Hammon, a Negro belonging to Mr. Lloyd of Queen's Village, on Long Island, the 25th of December, 1760." When British troops invaded Long Island, Hammon fled with the Lloyd family to Hartford, where he remained for the duration of the Revolutionary War. His second extant poem, "An Address to Miss Phillis Wheatly [sic], Ethiopian Poetess, in Boston, who came from Africa at eight years of age, and soon became acquainted with the gospel of Jesus Christ," was published there in 1778 (*see* PHILLIS WHEATLEY). In 1779, a work called *An Essay on Ten Virgins* was advertised, but no copy of it remains. Hammon's sermon, *A Winter Piece: Being a Serious Exhortation, with a Call to the Unconverted; and a Short Contemplation on the Death of Jesus Christ,* to which is appended the seventeen-quatrain verse, "A Poem for Children, with

Thoughts on Death," appeared in Hartford in 1782. Hammon returned to Oyster Bay, Long Island, later that year, and a second prose work, *An Evening's Improvement, Shewing the Necessity of Beholding the Lamb of God,* which concludes with "A Dialogue, Entitled, the Kind Master and the Dutiful Servant," was published in 1786. Hammon spoke to members of the African Society in New York on September 24, 1786. The text of that speech, *An Address to the Negroes of the State of New York,* was printed in New York early in 1787.

Hammon's poems follow a strict, mechanical rhyme scheme and meter, and, like his sermons, exhort the reader to seek salvation by obeying the will of God. He appears to have extended this notion of Christian piety to his domestic situation, and refused to speak out in public against slavery. However, even as he urged African Americans to "obey our masters," he questioned whether slavery was "right, and lawful, in the sight of God." "I do not wish to be free," he said at age seventy-five, "yet I should be glad, if others, especially the young negroes were to be free." The exact date of his death, and the place of his burial, are not known.

REFERENCES

KAPLAN, SIDNEY. *The Black Presence in the Era of the American Revolution 1770–1800.* Greenwich, Conn., 1973.

QUANDRA PRETTYMAN

Hammons, David

Hammons, David (1943–), artist. Born in Springfield, Ill., David Hammons moved to Los Angeles to study graphic design and fine arts in 1964. He met his most influential teacher, Charles WHITE, at Otis Art Institute, where he studied from 1968 to 1972. In the late 1960s and early 1970s, Hammons produced body prints that investigated African-American identity. Recurring motifs included self-portraiture, the American flag, and the spade shape. In the early and mid-1970s, Hammons moved into assemblage sculpture, continuing the use of culturally charged symbols for African Americans including spades (shovels), chains, barbecue bones, and African-American hair.

Hammons moved to New York City in 1975. He showed in galleries but also on the streets of Harlem and the East Village. Well-known to the avant-garde art world and in the African-American art community, he took on something of legendary status, amplified by his inaccessibility (he never had a telephone) and his flair for the dramatic. Benchwork works included *Higher Goals* (1983), a series of six-

story-tall basketball hoop sculptures with a typically punning title, and *How Do You Like Me Now?*, a controversial portrait of the Rev. Jesse JACKSON as a white man with blonde hair.

In the early 1990s, Hammons reluctantly accepted international recognition with shows at venues such as the Museum of Modern Art (New York) and Documenta (Kassel, Germany) and grants including the MacArthur Award.

REFERENCES

CANNON, STEVE, TOM FINKELPEARL, and KELLIE JONES. *David Hammons: Rousing the Rubble.* Cambridge, Mass., 1991.

TOM FINKELPEARL

Hampton, James (April 8, 1909–November 4, 1964), artist. A friendless Washington, D.C., janitor, James Hampton collected discarded furniture, burned-out light bulbs, used jelly glasses, gold- and silver-colored aluminum foil, and other trash from government offices and over many years built a throne for Christ's second coming, a construction generally considered the finest piece of religious visionary folk sculpture in America. Born April 8, 1909, in Elloree, S.C., to an itinerant Baptist preacher, Hampton received a tenth-grade education, served in the army, and was employed as a short-order cook before he secretly began to work in a rented garage on *The Throne of the Third Heaven of the Nations' Millennium General Assembly*. His massive, radiant creation now virtually fills a permanent gallery nineteen by twenty-one feet in size in the Smithsonian Institution's National Museum of American Art in Washington.

The center of Hampton's construction is an armchair throne surrounded by three parallel rows of nearly two hundred perfectly symmetrical and highly decorated accoutrements. Some of these objects seem to be side tables and lecterns, but their purposes are in fact unknown. Birdlike angels' wings are the dominant decorative motif. The whole construction glistens and glitters, covered as it all is in foil from cigarette packs and wine bottles. A hand-lettered sign over the throne proclaims "Fear Not." The art world has spoken admiringly of Hampton's eccentric improvisation, ingenious selection, and innate feeling for design. He believed he was inspired and directed by God in his work, and indeed has left a notebook of divine revelations in an undecipherable script. He also left a record in English of religious experiences, beginning with a visit of Moses to Washington on April 11, 1931. It is thought Hampton may have been inspired also by Rev. A. J. Tyler of Mt. Airy Baptist

Church, who was fond of pointing out that there was no monument to Jesus in Washington.

A slight, quiet, hardworking man, Hampton spoke of finding a holy woman to assist him in his life's work, but he never married. His project was unknown until his death in 1964, when his sister discovered the unheated garage. A Washington photographer happened to answer an advertisement for renting the garage, and Hampton's work came to the attention of the public and of museum administrators. Lynda Roscoe Hartigan pointed out that Hampton's artistic genius should not detract from his own intentions of creating a religious object. "*The Throne*," she wrote, "stands as a remarkable testimony to his devotion, patience, faith, and imagination."

REFERENCES

GOULD, STEPHEN JAY. "James Hampton's Throne and the Dual Nature of Time." *Smithsonian Studies in American Art* 1:1 (Spring 1987): 47–57.
HARTIGAN, LYNDA ROSCOE. *The Throne of the Third Heaven of the Nations' Millennium General Assembly.* Montgomery, Ala., 1977.

RICHARD NEWMAN

Hampton, Lionel Leo (April 12, 1908–) jazz vibraphonist, bandleader. Lionel Hampton was born in Louisville, Ky., and raised in Birmingham, Ala., and then in Chicago. Most sources list his birth year as 1909; his autobiography, however, states that he was born in 1908. Hampton introduced the vibraphone to jazz and is widely regarded as a virtuoso performer. Like many jazz musicians, he received his first musical experiences in the black church, learning to play drums in his grandmother's Birmingham Holiness congregation. He received his first formal lessons on percussion while in elementary school. Hampton later joined the Chicago Defender Youth Band, directed by Major N. Clark Smith, an influential educator who nurtured many famous jazz musicians, among them Milt Hinton and Nat "King" COLE. By his second year of high school, Hampton was playing drums regularly with local musicians, including Les Hite and Detroit Shannon.

In the mid-1920s, Hampton moved to Culver City, Calif., where he joined Reb's Legion Club Forty-Fives and made some of his first recordings. On the West Coast he met Gladys Riddle, who later became his wife and business partner until her death in 1971. In 1930 he began a series of recordings with Louis ARMSTRONG and His Sebastian's Cotton Club Orchestra, his first recordings on vibraphone. During this time, he also made appearances in movies with Les Hite (the Columbia film *Depths Below*) and Louis Armstrong (*Pennies from Heaven*).

Lionel Hampton playing the vibraphone in New York City in 1988. Hampton emerged as one of the most distinctive jazz soloists of the swing era during the 1930s and spent more than fifty years as a bandleader. (AP/Wide World Photos)

In the mid-1930s, Hampton formed his own group and worked regularly along the West Coast. In 1936, he joined Benny Goodman's Quartet, which included Teddy Wilson, Gene Krupa, and later guitarist Charlie CHRISTIAN. The series of Goodman engagements (such as the famous 1938 Carnegie Hall concert) and recordings catapulted him to stardom as jazz's most influential vibraphonist. Through Hampton's performances, the vibraphone became a jazz instrument of recognition. During this same period, he also continued to record as the leader of his own sessions until leaving Goodman in 1940. Hampton performed and recorded continuously with great commercial success for the next forty-five years in the United States and abroad with various groups, one of the jazz world's most popular and highly regarded musicians.

Throughout his long career, Hampton recognized and nurtured young talent. A partial list of musicians who have played in his groups over the years reads like a Who's Who of jazz history: Howard McGhee, Dexter GORDON, Fletcher HENDERSON, Oscar PETERSON, Ben Webster, Coleman HAWKINS, Johnny Griffin, Quincy JONES, Benny CARTER, Dinah WASHINGTON, Betty CARTER, Nat "King" Cole, and Joe

WILLIAMS, among others. Hampton is perhaps best known for his showy, energetic stage presence and his hard-driving swing style, which can be heard in such compositions as "Flying Home," "Stompology," and "Down Home Stomp." Over the years, he joined Goodman and Wilson for reunion concerts and remained actively engaged in philanthropic and civic activities.

REFERENCE

HAMPTON, LIONEL, with James Haskins. *Hamp: An Autobiography*. New York, 1989.

GUTHRIE P. RAMSEY, JR.

Hampton Institute. In 1868 in Hampton, Va., Samuel Chapman Armstrong founded Hampton Normal and Agricultural Institute as a nondenominational and coeducational school where young African Americans were to be trained as teachers. Armstrong, a white man, was convinced that most freedmen's schools were failures because they did not address blacks' most pressing needs. He believed that the experience of slavery had caused African Americans to degenerate into a morally deficient caste, and he accepted the stereotypical image of the freedman as poor, lazy, insolent, and lawless. To succeed, he argued, educators had to respond to these harsh realities by developing an entirely new approach to education for blacks. In addition to offering academic instruction, schools had to contribute to their pupils' moral development and had to help them attain material prosperity. Armstrong intended Hampton to be a model school, where generations of black teachers would be indoctrinated with his ideas.

Because Armstrong believed that blacks would continue to serve as the South's laboring class in the foreseeable future, Hampton Institute became the first school for African Americans to adopt a comprehensive system of industrial education. All students were required to labor in the school's farms and trade shops for two full days each week. The stated goal of this manual-education program was not to train skilled craftsmen but to develop "character" and to foster a spirit of self-reliance among the students. Hampton's white teachers reported that the work system helped their pupils to appreciate the dignity of labor and to understand that prosperity could be gained only through hard work.

Students' academic pursuits were closely coordinated with their work in the shops and fields. Hampton's supporters argued that "book learning" was useful to most African Americans only to the extent

Founded by Gen. Samuel Chapman Armstrong in 1868, Hampton Institute became the model for industrial education for African Americans throughout the South. These four images, all photographed by Francis Benjamin Johnson, depict (from top left) primary school students at Hampton saluting the flag; a student assembly; a mathematics class pacing off distances; and students in the carpentry shop. (Prints and Photographs Division, Library of Congress)

to which it could make them more productive and prosperous workers. Therefore, the institute's teachers emphasized only the development of "practical" skills like writing, botany, and simple arithmetic. As a result, by the time students completed the three-year normal program, they had received educations equivalent only to grammar-school programs in the North.

To supplement the institute's academic and industrial work, Armstrong developed a system of social instruction designed to "civilize" the students. Since Hampton was primarily a boarding school, its teachers could control their students' behavior every hour of the day. In their dormitories, students received instruction in Christian morality, personal hygiene, housekeeping, and etiquette. Above all, they learned to emulate the behavior and seek the respect of their white neighbors.

The influence of Armstrong's educational philosophy, known as the Hampton Idea, soon spread throughout the South as Booker T. WASHINGTON and hundreds of other graduates applied the lessons they had learned at the institute to their own schools. Substantial financial support from whites in the North enabled Hampton and its imitators to grow rapidly. Many whites found Hampton's pragmatic approach, with its emphasis on manual labor and self-help rather than social and political activism, enormously appealing. The institute offered the hope that the nation's "race problem" could be solved without disrupting the socioeconomic status quo. The General Education Board and other philanthropic foundations used their financial influence to guide Hampton's growth along even more conservative directions, and to encourage other schools to adopt similar curriculums. Their support helped the institute to develop into one of America's largest and wealthiest black schools, and guaranteed that the Hampton Idea would become ascendant in the field of African-American education by the start of the twentieth century.

Hampton Institute has always been criticized by African Americans who believed that it served only to perpetuate their socioeconomic subordination. The school appeared to be training its students to fill precisely the same roles that blacks held under slavery. As the Hampton Idea gained widespread support among whites, it seemed increasingly likely that industrial education would soon be the only form of schooling available to blacks. As a result, criticism of the institute grew sharper, especially among black intellectuals.

In 1903 W. E. B. DU BOIS published his first major attack on industrial education, and was soon recognized as the leading critic of the Hampton Idea. While Du Bois and other critics conceded that many Afri-

can Americans could benefit from "practical" education, they felt that blacks also needed access to higher education in order to progress. They urged the institute to place greater emphasis on academics and to encourage its students to aspire to something more than life as manual laborers. They complained that in its pursuit of material prosperity and white approval, Hampton too often sacrificed black dignity.

These criticisms had little direct impact on the institute's curriculum until the 1920s. After World War I, many states embarked on crusades of educational reform, and began to demand that teachers be better educated. Increasing numbers of Hampton's graduates failed to meet these higher standards. Institute officials first attempted to solve the problem by making only slight modifications to the academic program; eventually, however, they were forced to raise their admissions standards and to offer college-level courses. By 1927, over 40 percent of Hampton students were enrolled in the collegiate program. These students, who were more sympathetic to Du Bois's arguments than their predecessors had been, became increasingly critical of their school.

In 1927, a protest over a relatively minor social issue quickly grew into a general strike. Student leaders demanded that the institute raise the quality of its teaching, abolish key elements of the industrial system, hire more African Americans, and grant students an expanded role in administration. The strike was quickly crushed, but Hampton officials had no alternative but to respond to the students' demands. In 1929, the institute declared that it would no longer accept students who had not already completed high school. The following year, to emphasize its shift from Armstrong's industrial model to a more traditional program of higher education, the school formally changed its name from Hampton Normal and Agricultural Institute to Hampton Institute. In 1984, the school—having developed into a prominent liberal-arts and teachers' college with over four thousand students—changed its name to Hampton University.

REFERENCES

ANDERSON, JAMES D. *The Education of Blacks in the South, 1860–1935.* Chapel Hill, N.C., 1988.
PEABODY, FRANCIS G. *Education for Life: The Story of Hampton Institute.* Garden City, N.Y., 1919.

GREGORY J. MURPHY

Hancock, Gordon Blaine (June 23, 1884–July 24, 1970), sociologist and minister. Gordon Hancock was born in rural Ninety-Six, a township in Greenwood County, S.C. He was educated in Newberry,

a neighboring town, by a private instructor and acquired a teacher's certificate in 1902. In 1904 Hancock matriculated at Benedict College in Columbia, S.C., receiving a bachelor of arts degree in 1911 and a bachelor of divinity in 1912. Ordained in 1911, he became pastor of Bethlehem Baptist Church in Newberry. He was named principal of Seneca Institute, a Baptist coed boarding school for blacks in Seneca, S.C., in 1912. Hancock left South Carolina in 1918 to attend Colgate University in Hamilton, N.Y. One of only two blacks enrolled in the school, Hancock earned his second B.A. in 1919 and his second B.D. in 1920.

That same year Hancock entered Harvard as a graduate fellow in sociology and earned a master's degree in 1921. Shortly thereafter, Hancock accepted a professorship at Virginia Union University in Richmond, Va., where he organized one of the first courses on race relations at any black college. In 1925 he accepted the pastorship at Richmond's Moore Street Baptist Church. Hancock also wrote a weekly column for the Associated Negro Press that appeared in 114 black newspapers and preached the merits of interracial cooperation and black self-help.

In 1931 Hancock founded the Torrance School of Race Relations at Virginia Union. During the depression, Hancock originated the "Double Duty Dollar" idea, encouraging blacks to patronize black-owned businesses. Disdainful of what he viewed as overambitiousness among blacks, he also promoted a "Hold Your Job" campaign, emphasizing the importance of maintaining a solid black working class.

Characterized by some as an "accommodationist" (see ACCOMMODATIONISM), Hancock looked to support from southern white moderates in trying to end segregation without sacrificing black identity, self-help, and racial solidarity. Hancock believed that blacks should be accorded full equality, and he advocated black economic, cultural, social, and political self-development.

Alarmed by the growing racial tension and aggression in the South during WORLD WAR II, Hancock convened fifty-two black southern leaders at the Southern Conference on Race Relations in Durham, N.C., in October 1942 to propose a "New Charter of Race Relations" for the South. Serving as director of the conference, Hancock helped produce the DURHAM MANIFESTO, a statement issued by the conference in December of that year that outlined the leaders' carefully nuanced demands for improvements in the position of African Americans in the South. Following this the black leaders met with white moderates at a conference in Richmond and, with Hancock again serving as director, agreed to form the SOUTHERN REGIONAL COUNCIL.

Hancock took a slightly more aggressive approach to racial issues in the years following the Durham conference, questioning the merits of interracial cooperation with southern whites and more openly attacking racial segregation. Hancock's position as a spokesperson for the black community began to fade just as the CIVIL RIGHTS MOVEMENT started to receive national attention. He was named professor emeritus at Virginia Union and subsequently retired from there in 1952, removing himself almost entirely from the public spotlight. In 1963, Hancock left his pastorship at Moore Street Baptist Church. He spent his later years collecting black spirituals as well as composing and publishing his own songs (*Two Homeward Songs,* 1965). Hancock died at his home in Richmond, Va., in 1970.

REFERENCE

GAVINS, RAYMOND. *The Perils and Prospects of Southern Black Leadership: Gordon Blaine Hancock, 1884–1970.* Durham, N.C., 1977.

LOUISE P. MAXWELL
LYDIA MCNEILL

Hancock, Herbert Jeffrey "Herbie" (April 12, 1940–), jazz pianist, composer. Born and raised in Chicago, Hancock started formal piano lessons at the age of seven and became a prodigy, performing the first movement of Mozart's D major "Coronation" piano concerto (K. 537) with the Chicago Symphony Orchestra at the age of eleven. He formed his own jazz ensemble at Hyde Park High School, and went on to study engineering while he wrote for the big band at Grinnell College (1956–1960) and attended Roosevelt University (1960).

After graduation, he played as a sideman in Chicago for saxophonist Coleman HAWKINS, and in 1961 he was hired by trumpeter Donald Byrd. Hancock also played with saxophonist Phil Woods and bandleader and saxophonist Oliver Nelson, and in 1962 he made his recording debut as a leader on *Takin' Off,* which featured his gospel-tinged "Watermelon Man," a tune later popularized by percussionist Mongo SANTAMARIA.

In 1962 Hancock moved to New York and worked with Eric DOLPHY and Clark TERRY before joining Miles DAVIS's quintet in 1963, contributing artfully atonal improvisations and modal compositions to the trumpeter's *My Funny Valentine* (1964), *E.S.P.* (1965), *Miles Smiles* (1966), *Nefertiti* (1967), *In a Silent Way* (1969), and *Big Fun* (1969). During this time Hancock continued recording as a leader on *Empyrean Isles* (containing his "Cantaloupe Island," 1964), *Maiden Voyage* (including "Dolphin Dance," 1965), and *Speak Like a Child* (1968).

Introduced to electric instruments during his eight years with Davis's landmark quintet, Hancock formed his own sextet, and from 1971 to 1973 further explored the assimilation of the rhythms and electric textures of rock and funk with jazz, a style that came to be known as "fusion." In 1973 Hancock released *Headhunters,* an album that gained him a wider audience, and gave him his first hit single, "Chameleon." His subsequent albums, *Thrust* (1974) and *Manchild* (1975), experimented with popular rhythm-and-blues dance idioms, and were deplored by many jazz critics. During this time, however, Hancock led a double career as he continued to work in the same hard-bop vein he had pursued with Davis in the 1960s. In 1976 and 1977 he reunited with his former colleagues from Davis's quintet, touring and recording under the name V.S.O.P. In 1983 Hancock released his second hit single, "Rockit," on the rap-influenced *Future Shock* (1983). Hancock has also gained renown as a composer for films, including *Blow Up* (1966), *Death Wish* (1975), *A Soldier's Story* (1984), and *Round Midnight,* for which he won an Academy Award for best score in 1986. In the 1990s he continues to pursue parallel careers with his own electric groups, as well as in mainstream jazz contexts that include solo performances, duos with Chick Corea, a trio with bassist Buster Williams and Al Foster, and with V.S.O.P.

REFERENCES

MANDEL, HOWARD. "Herbie Hancock: Of Films, Fairlights, Funk . . . and All That Other Jazz." *Down Beat* 53, no. 7 (July 1986): 16–19.

MEHEGAN, JOHN. "Discussion: Herbie Hancock Talks to John Mehegan." *Jazz* 3, no. 5 (1964).

TOWNLEY, R. "Hancock Plugs In." *Down Beat* 41, no. 17 (1974).

SCOTT DEVEAUX

Handy, William Christopher "W. C." (November 16, 1873–March 28, 1958), anthologist and composer. While a child in his native Alabama, W. C. Handy studied music in school; in his teens, he joined a traveling minstrel show as a cornetist. After returning to finish his basic schooling, Handy embarked on a varied career as a teacher, factory worker, college bandmaster, dance-orchestra leader, and minstrel musician. He eventually settled in Memphis in 1908, where he cofounded a music-publishing company with Harry PACE.

After moving to New York in 1918, the Pace and Handy Music Company became the leading publisher of music by African Americans. In 1920, the two owners discontinued their partnership and started separate enterprises, Pace his Black Swan Records, and Handy his Handy Brothers, Inc., and short-lived Handy Record Company. In addition, Handy served variously as a musical consultant, concert program producer, and booking agent. Meanwhile, he continued playing trumpet, composing, arranging, touring, and recording. During his life as a performer, Handy played with such popular groups as W. A. Mahara's minstrels, with Jelly Roll MORTON, and with other jazz and popular-music luminaries. He appeared at theaters, dance halls, and concert venues as an instrumentalist and as a bandleader.

Handy's first published blues (*see* BLUES), "Memphis Blues," in 1912, started a fad; by 1914 he had published the song for which he is best known, "St. Louis Blues." Later he published "Beale Street Blues," making a third Handy "standard" in America's published blues canon. A consensus among jazz historians is that some compositions popularly attributed to Handy are derivative. Some esteem him more highly as a collector, publisher, and popularizer than as a creator of blues. His transcribing and arranging of blues and spirituals led to his books *Blues: An Anthology* (1926; reprinted as *Treasury of the Blues,* 1930), and *Book of Negro Spirituals* (1938).

Handy was a pioneer in bringing folk blues to the public. This led to his being called "the Father of the Blues," which was later used as the title of his autobiography. In 1928, Handy organized a concert at Carnegie Hall to present black music from plantation songs to concert compositions. During the 1930s he organized other concerts of black music for the Chicago World's Fair, the New York World's Fair, and the Golden Gate Exposition in San Francisco.

Handy's productivity declined after he was accidentally blinded in 1943. He died in New York in 1958 of bronchial pneumonia, having suffered an impairing stroke several years earlier. He was honored and memorialized by, among other things, all-Handy musical programs; a movie, *St. Louis Blues;* a 1957 birthday party attended by over eight hundred persons; W. C. Handy Park in Memphis; a postage stamp; and names of institutions and places, including a housing development in his hometown of Florence, Ala.

REFERENCES

HANDY, W. C. *Father of the Blues: An Autobiography.* New York, 1941.

KAY. G. W. "William Christopher Handy: Father of the Blues." *Jazz Journal* 24, no. 3 (1971): 10.

SOUTHERN, EILEEN. *The Music of Black Americans: A History.* 2nd ed. New York, 1983.

THEODORE R. HUDSON

The widespread dissemination of the blues outside of its Mississippi Delta birthplace began in earnest with the publication of W. C. Handy's compositions *Memphis Blues* (1912) and *St. Louis Blues* (1914). By 1932, when this photograph was taken, Handy was a successful composer and music publisher in New York City. (Frank Driggs Collection)

Hansberry, Lorraine (May 19, 1930–January 12, 1965), playwright. Lorraine Hansberry was the youngest child of a nationally prominent African-American family. Houseguests during her childhood included Paul Robeson and Duke Ellington. Hansberry became interested in theater while in high school, and in 1948 she went on to study drama and stage design at the University of Wisconsin. Instead of completing her degree, however, she moved to New York, worked at odd jobs, and wrote. In 1959 her first play, *A Raisin in the Sun*, was produced and was both a critical and commercial success. It broke the record for longest-running play by a black author and won the New York Drama Critics Circle Award. Hansberry was the first African American and the youngest person ever to win that award. The play,

based on an incident in the author's own life, tells the story of a black family that attempts to move into a white neighborhood in Chicago. Critics praised Hansberry's ability to deal with a racial issue and at the same time explore the American dream of freedom and the search for a better life. The play was turned into a film in 1961, and then was adapted as a musical, *Raisin*, which won a Tony Award in 1974.

Hansberry's second play, *The Sign in Sidney Brustein's Window*, focuses on white intellectual political involvement. Less successful than *A Raisin in the Sun*, it closed after a brief run at the time of Hansberry's death from cancer in 1965. After her death, Hansberry's former husband, Robert B. Nemiroff, whom she had married in 1953, edited her writings and plays, and produced two volumes: *To Be Young, Gifted and Black* (1969) and *Les Blancs: The Collected Last Plays of Lorraine Hansberry* (1972). *To Be Young, Gifted and Black* was presented as a play and became

Lorraine Hansberry's first play, *A Raisin in the Sun* (1959), was a success on its Broadway debut and has endured as a classic work of American theater. Hansberry's early death in 1965 deprived American literature of one of its most powerful and penetrating voices. (Estate of Robert Nemiroff)

the longest-running Off-Broadway play of the 1968–1969 season.

REFERENCE

METZGER, LINDA, ed. *Black Writers: A Selection of Sketches from Contemporary Authors.* Detroit, 1989.

LILY PHILLIPS

Hansen, Austin (January 28, 1910–), photographer. Austin Hansen was born in the Danish West Indies (now the U.S. Virgin Islands) in 1910. In 1928, Hansen moved to Harlem in New York City and took jobs as a pharmacy deliverer and elevator operator. He also played drums in local bands. In 1929, he sold a print of Charles Lindbergh visiting the island of St. Croix in the *Spirit of St. Louis* to the *New York Amsterdam News.*

By the early 1930s, Hansen was an active photographer of Harlem's vibrant social scene, selling his photographs to the *New York Age, African Opinion,* and *People's Voice.* Frequenting the Renaissance Casino and other Harlem clubs, Hansen and his brother Aubrey compiled a vast pictorial collection of such performers as Lena HORNE, Count BASIE, Ella FITZGERALD, and Duke ELLINGTON. Austin Hansen enlisted in the Navy during World War II; he was assigned the rank of photographer's mate, second class, because he was not permitted the full rank of photographer. During the final year of the war, he became a darkroom technician for the Office of War Information.

When the war ended, Hansen returned to Harlem and set up his own photography studio on West 135th Street, where he continued to photograph portraits of families, Harlem street scenes, and celebrities such as Emperor Haile Selassie of Ethiopia.

Hansen compiled such an extensive record of everyday life in Harlem between 1945 and 1965 that his work was compared to that of photographer James VANDERZEE. Although Hansen shared VanDerZee's enthusiasm for depicting Harlem as a proud and vibrant community, there are many differences in the oeuvres of the two photographers. Unlike VanDerZee, Hansen made very few photographs in his studio. Adapting the "straight print" approach used by other WORKS PROJECT ADMINISTRATION (WPA) photographers in Harlem, such as Sid Grossman, Hansen took most of his pictures outdoors and on site, taking advantage of smaller cameras and faster film-development technology. Hansen and his contemporaries represented a transition from the large, formal studio of VanDerZee's era to a new representation of Harlem.

Harlem's social structure continued to decline in the 1960s and '70s, and Hansen's style and approach were superseded by those of other artists who were more interested than Hansen in the grittier aspects of Harlem life. Hansen himself became recognized as one of the leading photo historians of the community's "post-Renaissance" era. In 1986, Hansen arranged for more than 50,000 photographs from his collection to be donated to the Schomburg Center for Research in Black Culture. Forced to leave the site of his studio on West 135th street when the building was condemned in 1987, he set up a new studio in the Bronx. In 1989, the Schomburg Center paid tribute to him with an exhibition of his photographs entitled, "Hansen's Harlem." Following a fire in the Bronx studio, Hansen established a new studio residence on St. Nicholas Avenue in 1993.

REFERENCES

Schomburg Center for Research in Black Culture. *Hansen's Harlem: A Retrospective of One of Harlem's Oldest Studio Photographers, Austin Hansen.* Companion publication to photographic exhibition, June 23, 1989–September 24, 1989. New York, 1989.

WILLIS-THOMAS, DEBORAH. *Black Photographers, 1840–1940: An Illustrated Bio-Bibliography.* New York, 1985.

DURAHN TAYLOR

Haralson, Jeremiah (1846–1916), congressman and state legislator. Born to slave parents in Muscogee County near Columbus, Ga., Jeremiah Haralson was brought to ALABAMA when he was thirteen by his master John Haralson. Reputedly illiterate at the end of the war, Haralson became one of the leading African Americans in Alabama politics by 1868. Under somewhat unclear circumstances, he accepted money to stump for Democratic candidates in the 1868 election, but supposedly secretly urged his audiences immediately afterward to vote Republican.

After an unsuccessful bid for the U.S. Congress in the same year, Haralson won a seat in the state House in 1870, and then a seat in the state Senate in 1872. Failing to secure the REPUBLICAN PARTY nomination, he won a seat in Congress in 1874 as an independent. Haralson's politics and goals were never very clear. While he emphasized peace between the races and advocated racial harmony, he proudly utilized his self-description as a "full-blooded Negro" as a selling point during his political campaigns. His friendship with Jefferson Davis, former president of the Confederacy, and other influential white politicians caused some people to doubt his commitment to

African-American and Republican issues. At the same time, he believed in civil rights and was an advocate of universal male suffrage.

Haralson's election to Congress was immediately challenged. Despite the statement by one of the Democrat-dominated committee members that the election exhibited frauds "as flagrant and abuses as violent as have ever been committed in this country upon the electoral franchise," Haralson was seated. The committee reasoned that even after the questionable votes were disallowed, Haralson retained a majority.

During his tenure in Congress, Haralson drafted few bills, sat in the back of the chamber, and rarely spoke. He was, however, to prove a valuable friend to the Republican establishment. When Charles Sumner began to try to recruit support for a splinter group opposed to President Ulysses S. Grant and the more moderate wing of the party, Haralson responded that the Republican party, as the party of EMANCIPATION, would always command his loyalties.

Haralson's loyalty was not always returned in kind. After gerrymandering in Alabama, there remained only one predominantly black district, putting Haralson at odds with the powerful James T. RAPIER in the 1876 election. Although Rapier won the Republican nomination, Haralson ran as an independent. The two Republicans split the black vote, and the white Democratic challenger won the seat.

After his defeat in the 1876 election, Haralson worked for the U.S. Customs Service in Baltimore and several government bureaus in Washington. He also continued to vie for political office, losing Congressional elections in Alabama in 1878 and 1884. Afterward, he drifted around the country working at various occupations. He became a farmer in Louisiana and later a pension agent in Arkansas. Between 1904 and 1916, he lived in Texas, Oklahoma, Alabama, and Colorado. In 1916, while working as a coal miner in Colorado, he disappeared under mysterious circumstances, reportedly "killed by wild beasts."

REFERENCES

CHRISTOPHER, MAURINE. *Black Americans in Congress.* New York, 1976.

MCFARLIN, ANNJENNETTE SOPHIE. *Black Congressional Reconstruction Orators and Their Orations, 1869–1879.* Metuchen, N.J., 1976.

ALANA J. ERICKSON

Hardaway, Steveland Judkins Morris. *See* Wonder, Stevie.

Hardrick, John Wesley (September 21, 1891–October 18, 1968), painter. John Wesley Hardrick was born in Indianapolis, Ind., where he lived his entire life. He studied painting, sculpture, and drawing from 1910 to 1918 at the John Herron Art Institute under William Forsythe and Otto Stark. Between 1928 and 1933, Hardrick exhibited his work with the Harmon Foundation, winning early recognition for his realistic and expressive portraits of African Americans. He received a Bronze Award from the Harmon Foundation for his 1927 *Portrait of a Young Girl* and a blue ribbon at the 1933 Indiana State Fair for his "outstanding portrait," *Mammy*. In order to support himself, Hardrick worked as a part-time employee of the Herron Institute and as a manual laborer; he also managed an Indianapolis trucking agency.

Hardrick worked primarily in the genres of portraiture, figure composition, and landscape. *Aunty* (1933) depicts a reflective and melancholy old woman, her downcast face covered in shadows. Another portrait, depicting the head of Robert I. Todd (n.d.), shows a black worker at the Indianapolis Street Railway Company. Landscapes like *Blue Lagoon* (n.d.) and *Salt Lick Creek–Brown Country* (n.d.) display an impressionist style with their visible brushwork and concern with the changing effects of light on leaves and water. Hardrick also painted murals in several high schools and churches in and around In-

Two Boys Fishing by John Wesley Hardrick. (National Archives)

95-340

dianapolis. In addition to the Harmon exhibitions, his work was shown in the "Negro in Art Week" exhibition at the Art Institute of Chicago in 1927, at a Harmon show at the Smithsonian Institution in 1929, and at the American Negro Exposition in Chicago in 1940. Although his paintings received critical recognition in the 1920s and '30s, little is known about his life or work after 1940. Hardrick died in Indianapolis in 1968.

REFERENCE

REYNOLDS, GARY A., and BERYL J. WRIGHT. *Against the Odds: African-American Artists and the Harmon Foundation.* Newark, N.J., 1989.

SHIRLEY SOLOMON

Harlem, New York. Roughly bounded by 110th Street and running north to 155th Street, bordered on the west by Morningside Drive and St. Nicholas Avenue and on the east by the East River, Harlem during the twentieth century became the most famous African-American community in the United States. Prior to 1900, Harlem had been primarily a white neighborhood. In the 1870s it evolved from an isolated, impoverished village in the northern reaches of Manhattan into a wealthy residential suburb with the growth of commuter rail service.

With the opening of the Lenox Avenue subway line in the early years of the twentieth century, a flurry of real estate speculation contributed to a substantial increase in building. At the time the population of Harlem was largely English and German, with increasing numbers of Jewish immigrants. By 1904, however, the economic prosperity and expansion ceased as a result of high rental costs and excessive construction. In that same year, Phillip A. PAYTON, Jr., a black realtor, founded the Afro-American Realty Company with the intention of leasing vacant white-owned buildings and then renting them to African Americans. Although the Realty Company survived for only four years, due to Payton's unwise financial investments, it played a pivotal role in opening up the Harlem community to African Americans.

Coupled with this development, black migration from the South during the early years of the new century dramatically altered Harlem's composition, until by 1930 it had become a largely all-black enclave. In 1890 there were approximately 25,000 African Americans in Manhattan. By 1910 that number had more than tripled to 90,000. In the following decade the black population increased to approximately 150,000 and more than doubled by 1930 to over 325,000. In Harlem itself the black population

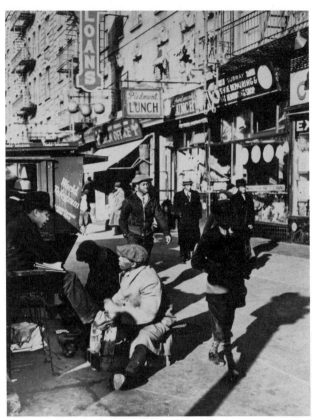

Harlem street scene in the 1920s. (Photographs and Prints Division, Schomburg Center for Research in Black Culture, The New York Public Library, Astor, Lenox and Tilden Foundations)

rose from approximately 50,000 in 1914 to about 80,000 in 1920 to about 200,000 by 1930.

From a social perspective, Harlem was labeled a "city within a city," because it contained the normal gamut of classes, businesses, and cultural and recreational institutions traditionally identified with urban living. By the 1920s, moreover, Harlem's place in American intellectual and political history had progressed significantly. This transition was fueled on the cultural scene by the literary and artistic activity which is collectively called the HARLEM RENAISSANCE. Emerging after the promise of racial equality and egalitarianism in return for black military service in WORLD WAR I had been squelched by renewed racism and a series of race riots during the RED SUMMER of 1919, the Renaissance reflected the evolution of a "New Negro" spirit and determination. As one of its acknowledged leaders, Alain LOCKE, explained, self-respect and self-dependence became characteristics of the NEW NEGRO movement, which were exemplified in every facet of cultural, intellectual, and political life.

Represented by poets such as Claude MCKAY, Langston HUGHES, and Countee CULLEN; novelists

like Zora Neale HURSTON, Jean TOOMER, and Jessie FAUSET; artists like Aaron DOUGLAS; photographers like James VANDERZEE; and social scientists and philosophers like E. Franklin FRAZIER, Alain Locke, and W. E. B. DU BOIS, the Renaissance was national in scope, but it came to be identified with the emerging African-American cultural capital, Harlem. The outpouring of literary and artistic production that comprised the Renaissance led as well to a number of social gatherings at which the black intelligentsia mingled and exchanged ideas. Many of the most celebrated of these events were held at the home of A'Lelia Walker Robinson (see A'Lelia WALKER), daughter of Madame C. J. WALKER, who had moved the base of her multimillion-dollar beauty care industry to Harlem in 1913.

Also fostering Harlem's growth in the 1920s were a series of political developments. Both the NATIONAL ASSOCIATION FOR THE ADVANCEMENT OF COLORED PEOPLE (NAACP) and the NATIONAL URBAN LEAGUE established offices in the area. Moreover, by 1920 two major New York black newspapers, *The New York Age* and *The New York Amsterdam News*, (see AMSTERDAM NEWS) moved their printing operations and editorial offices to Harlem. Socialists A. Philip RANDOLPH and Chandler OWEN established their offices in Harlem as well and from there they edited and published their newspaper, the MESSENGER, after 1917. Nothing, however, caught the attention of Harlemites as quickly as the arrival in 1916 of Marcus GARVEY, who established the headquarters of the UNIVERSAL NEGRO IMPROVEMENT ASSOCIATION (UNIA) in the district. Garvey's emphasis on race pride, the creation of black businesses and factories, and his appeal to the masses awakened and galvanized the Harlem community.

By 1915, in fact, Harlem had become the entertainment capital of black America. Performers gravitated to Harlem and New York City's entertainment industry. Musicians such as Willie "The Lion" SMITH, Fats WALLER, and James P. JOHNSON created a version of early JAZZ piano known as the Harlem Stride around the time of World War I. After 1920, bandleaders such as Fletcher HENDERSON, Duke ELLINGTON, and Chick WEBB laid the foundation for big-band jazz. (Early in the 1940s, at clubs such as Minton's Playhouse and Monroe's, a revolution would occur in jazz. Individuals such as Thelonious MONK, Charlie PARKER, and Dizzy GILLESPIE moved away from swing, using advanced harmonies and substitute chords, creating be-bop jazz.)

Harlem also became a major center of popular dance. On the stage, Florence MILLS was perhaps Harlem's most popular theatrical dancer in the 1920s; 150,000 people turned out for her funeral in 1927. TAP DANCE flourished in Harlem as well. The roster of well-known performers included the WHITMAN SISTERS, Buck and BUBBLES, the NICHOLAS BROTHERS, Earl "Snake Hips" Tucker, and Bill "Bojangles" ROBINSON, who carried the honorary title of "The Mayor of Harlem."

Theatrical life was also vibrant in Harlem. From the early years of the century through the GREAT DEPRESSION, the center of popular entertainment in Harlem was the LINCOLN THEATRE on 135th Street off Lenox Avenue. After 1934, the Lincoln was superseded by the APOLLO THEATER. Harlem attracted vaudevillians such as Bert WILLIAMS, George W. WALKER, Flournoy Miller, and Aubrey Lyles, and a later generation of comedians including Dewey "Pigmeat" MARKHAM and Dusty Fletcher, who popularized the "Open the Door, Richard" routine.

After 1917, the Lafayette Theater grew in prominence as a home of serious drama, due to the success of such actors as Paul ROBESON, Richard B. HARRISON (famous for his role as "De Lawd" in *Green Pastures*), and Abbie MITCHELL. Harlem was also a center of nightclubs. The best known included the black-owned Smalls Paradise, the COTTON CLUB, and the mobster-connected and racially exclusive Connie's Inn. The best-known dance hall was the SAVOY BALLROOM, the "Home of Happy Feet," which presented the best in big-band jazz after 1926. Harlem's cultural vitality was celebrated in plays including Wallace THURMAN's *Harlem* (1929), Langston Hughes's *Mulatto* (1935), *Little Ham* (1935), and *Don't You Want to be Free?* (1936–1937), and Abram Hill's *On Strivers' Row* (1939). Musical performers celebrated Harlem's social scene through such compositions as "The Joint is Jumping," "Stompin' at the Savoy," "Harlem Airshaft," "Drop Me Off in Harlem," and "Take the A Train."

As Harlem became a political and cultural center of black America, the community's black churches became more influential as well. Most were Protestant, particularly BAPTIST and METHODIST, and the ABYSSINIAN BAPTIST CHURCH became the most famous during the interwar period. The Rev. Adam Clayton POWELL, SR. moved the church from West 40th Street in midtown Manhattan to West 138th Street in Harlem in 1923. He combated prostitution, organized classes in home economics, built a home for the elderly, and organized soup kitchens and employment networks during the GREAT DEPRESSION. He was succeeded as senior pastor in 1937 by his son, Adam Clayton POWELL, JR., who expanded the scope of the Abyssinian church's community activism. Harlem's scores of storefront churches, many of which proliferated during the interwar period, imitated Abyssinian's community aid efforts on a smaller scale. Harlem's most famous heterodox religious leader of the 1930s, FATHER DIVINE, established a

One of Harlem's main intersections, 125th Street and 7th Avenue, in 1943. On the left is Blumstein's Department Store, the site of a major "Don't Buy Where You Can't Work" protest in 1934. The picketing continued for two months until the management agreed to hire African-American sales help. On the right, further up the block, is the Apollo Theater, where singer Ethel Waters and tenor saxophonist "Big Al" Sears headlined the show. (Photographs and Prints Division, Schomburg Center for Research in Black Culture, The New York Public Library, Astor, Lenox and Tilden Foundations)

series of soup kitchens and stores in the community through his Peace Mission and his Righteous Government political organization.

The 1930s were a period of stagnation and decline in Harlem, as they were throughout the nation. Civil rights protest increased during the decade, and much of it originated in Harlem. In response to white businessmen's unwillingness to hire black workers for white-collar jobs in their Harlem stores, a series of "Don't Buy Where You Can't Work" boycott campaigns commenced in 1933 and became an effective method of protesting against racial bigotry throughout the decade. Harlem community leaders such as Adam Clayton Powell, Jr. often joined with the NAACP, the National Urban League, the COMMUNIST PARTY OF THE U.S.A., and the Citizens' League for Fair Play (CLFP) in leading these protests. Under the aegis of the Communist party, major demonstrations were also held on Harlem streets in the early 1930s in support of the Scottsboro Boys and Angelo HERNDON (see SCOTTSBORO CASE).

Major party politics thrived in Harlem as much as radical politics did during the first half of the century. In the 1920s the REPUBLICAN PARTY (led in black communities by Charles ANDERSON) and the DEMOCRATIC PARTY (led by Ferdinand Q. Morton under Tammany Hall's UNITED COLORED DEMOCRACY), competed fiercely for black votes. Within the black community itself, African Americans and Caribbean Americans competed for dominance over the few available instruments of political control. Caribbeans were particularly prominent in the struggle to integrate Harlem blacks into the main organization of the Democratic party; J. Raymond JONES (an immigrant from the Virgin Islands who would ultimately become head of Tammany Hall) led an insurgent group called the New Democrats in this effort during the early 1930s.

Civil disturbances played an important role in Harlem's growing political consciousness. In 1935 a riot, fueled by animosity toward white businesses and the police, left three dead, and caused over 200

million dollars in damage. New York City Mayor Fiorello LaGuardia later assigned his Mayor's Commission on Conditions in Harlem (led by E. Franklin Frazier) to study this uprising; the commission revealed a great number of underlying socioeconomic problems that were giving rise to racial animosities in Harlem. In 1943 Harlem experienced another major race riot, which left five dead. This second riot was fueled by race discrimination in war-related industries and continuing animosities between white police officers and Harlem's black citizens.

These events helped shape the emerging political career of Adam Clayton Powell, Jr., who was elected to the New York City Council in 1941 and to the United States Congress in 1944, representing Harlem's newly created Eighteenth District. Powell's intolerance of race discrimination, and his vocal and flamboyant style brought national attention to the community, and he remained a symbol of Harlem's strength and reputation until his expulsion from Congress in 1967. He was reelected by his loyal Harlem constituency in 1968.

By the end of World War II, Harlem experienced another transition. The migration of middle-class blacks to more affluent neighborhoods destabilized the class balance of earlier decades. Many of the remaining businesses were owned not by black residents but by whites who lived far removed from the ghetto. At the same time, most of the literati associated with the Renaissance had left the district. However, Harlem's literary life was preserved by a number of dedicated authors, such as Ralph ELLISON (whose 1952 novel *Invisible Man* was centered in Harlem) and Harlem native James BALDWIN. The HARLEM WRITERS GUILD was founded in 1950 by John KILLENS, Maya ANGELOU, John Henrik Clarke, and others, and has for over four decades offered writers in the community a forum for the reading and discussion of their works. Photographers such as Austin HANSEN and Gordon PARKS, SR. continued to capture and celebrate Harlem's community on film.

For most of those who remained in Harlem after the war, however, a sense of powerlessness set in, exacerbated by poverty and a lack of control over their community. The quality of Harlem housing continued to be an acute problem. Paradoxically, as the quality of Harlem's inadequately heated, rat-infested buildings continued to deteriorate, and as housing health ordinances were increasingly ignored, the rents on those units continued to rise. People were evicted for being unable to keep up with the costs, but having no other place to go, many either entered community shelters or joined the swelling ranks of the homeless.

Heroin addiction and street crime were increasingly serious problems. The 1950s saw Harlem dete-

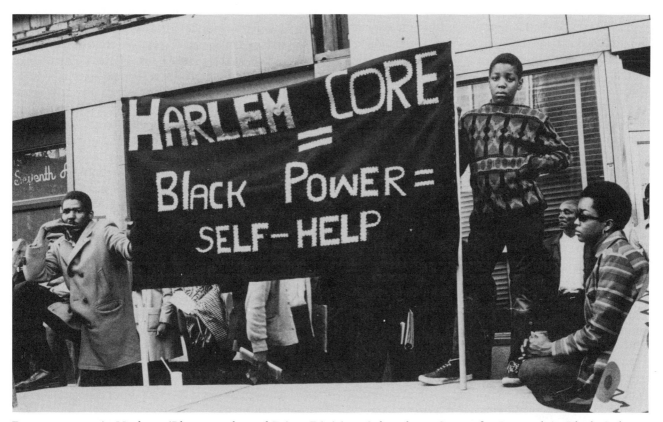

Demonstrators in Harlem. (Photographs and Prints Division, Schomburg Center for Research in Black Culture, The New York Public Library, Astor, Lenox and Tilden Foundations)

riorate, both spiritually and physically. Dependent on welfare and other social services, many Harlemites longed for a chance to reassert some degree of hegemony over their community.

The 1964 Harlem Youth Opportunities Unlimited Act (HARYOU) represented an attempt to provide solutions. After an intensive study of the community from political, economic, and social perspectives, HARYOU proposed a combination of social action for the reacquisition of political power and the influx of federal funds to redress the increasing economic privation of the area. From the beginning, however, the project suffered from personnel conflicts at the leadership level. Social psychologist Dr. Kenneth B. CLARK, who originally conceived and directed the project, resigned after a struggle with Congressman Adam Clayton Powell, Jr. Following Clark's tenure, a Powell ally, Livingston Wingate, led the project through a period of intensifying government scrutiny regarding its financial administration.

As a political attempt to increase local control through community action while remaining dependent upon government largess for funding, HARYOU failed. It was also unable to ameliorate the alienation and decline into delinquency that plagued Harlem's youth. Illustrative of its failure was the 1964 riot, ignited like its predecessors by an incident of alleged police brutality; this latest riot underscored the troubles that continued to plague the community.

By the late 1960s, Harlem precisely fit the conclusion reached by the 1968 National Commission of Civil Disorders report. It was a ghetto, created, maintained, and condoned by white society. Literary works of the postwar era, from Ann L. PETRY's *The Street* (1946) to Claude BROWN's *Manchild in the Promised Land* (1965), reflected this progressively deteriorating state of affairs as well.

It was in this period of decay that another charismatic organization emerged in the community, the NATION OF ISLAM (NOI). MALCOLM X, the head of Harlem's mosque, blended the intellectual acumen of the literati of the 1920s with the political sophistication and charisma of Garvey. Malcolm X galvanized the masses and rekindled in them a sense of black pride and self-determination, appealing to their sense of disgruntlement with a message that was far more angry and less conciliatory than that offered by other major civil rights leaders. He was assassinated on February 21, 1965, in the Audubon Ballroom in Upper Manhattan.

Harlem since the 1960s has been severely affected by the same external forces that plagued many other American urban centers. As the mainstay of the United States economy underwent a critical transition from heavy manufacturing to service and information technologies, large-scale industry left urban areas. Large numbers of the Harlem population followed this exodus from the community, settling in suburban areas in Queens, the Bronx, and other boroughs. The resultant unemployment among those who remained further eviscerated Harlem. The community had long lost its position as the population center of black New York to the Bedford-Stuyvesant area of Brooklyn. Community vital statistics have been no more encouraging; it was estimated in 1992 that the average African-American male born in Harlem would have a life expectancy of sixty-four years, dying before becoming eligible for most Social Security or retirement benefits.

The HARLEM COMMONWEALTH COUNCIL (HCC), a nonprofit corporation begun in 1967 and founded through the Office of Economic Opportunity and the private sector, sought to develop Harlem economically and empower its community leaders politically. Yet, in its first twenty-five years, bad investments and an uncertain economy have reduced its real estate holdings, and virtually all its large-scale enterprises have gone bankrupt.

In 1989 David N. DINKINS, a product of Harlem's Democratic clubs, became the first African-American mayor of New York City. One of his biggest supporters was Charles RANGEL, who in 1970 had succeeded Adam Clayton Powell, Jr., as Harlem's congressman. In his four years as mayor, Dinkins sought to reestablish an atmosphere of racial harmony and cooperation, to realize his vision of New York City as a "gorgeous mosaic" of diverse ethnicities.

Residents continued to reassert control over their community in the 1990s, as the Harlem Chamber of Commerce led efforts to revitalize Harlem's businesses and reclaim the community's physical infrastructure (a process sometimes referred to as "ghettocentrism"). A plan to spend over 170 million dollars to build permanent housing for the poor and homeless began early in the decade, and such landmark structures as the Astor Row houses on West 130th Street were rehabilitated as well. The Schomburg Center for Research in Black Culture, established in 1926 on 135th Street as a branch of the New York Public Library, remained the nation's leading resource of African-American scholarship, as well as the location of academic conferences and meetings of the HARLEM WRITERS GUILD. The Studio Museum of Harlem on 125th Street was a focus for African-American and Caribbean-American folk art. The Apollo Theater on 125th Street was reopened in 1989, and it continued to showcase the current and future leaders of black entertainment. The nearby Hotel Theresa no longer served as a hotel but continued as the Theresa Towers, a modern office center and community landmark.

Throughout Harlem's history there has been a wide gap between the social, intellectual, and artistic

accomplishments of the community's elite and the poverty and neglect of its masses. At the same time, however, there remains in Harlem, as there has been in every decade of its existence, an inner energy and spirit.

See also NEW YORK CITY.

REFERENCES

ANDERSON, JERVIS. *This Was Harlem: A Cultural Portrait, 1900–1950.* New York, 1981.

CAPECI, DOMINIC. *The Harlem Riot of 1943.* Philadelphia, 1977.

CLARKE, JOHN HENRIK, ed. *Harlem: A Community in Transition.* New York, 1969.

CRUSE, HAROLD. *The Crisis of the Negro Intellectual: From Its Origins to the Present.* New York, 1967.

GREENBERG, CHERYL. *"Or Does It Explode?" Black Harlem in the Great Depression.* New York, 1991.

HAMILTON, CHARLES V. *Adam Clayton Powell, Jr.: The Political Biography of an American Dilemma.* New York, 1991.

HUGGINS, NATHAN. *The Harlem Renaissance.* New York, 1971.

JOHNSON, JAMES WELDON. *Black Manhattan.* 1930. Reprint. New York, 1991.

LEWIS, DAVID LEVERING. *When Harlem Was in Vogue.* New York, 1981.

LOCKE, ALAIN, ed. *The New Negro.* Reprint. New York, 1925.

McKAY, CLAUDE. *Harlem: Negro Metropolis.* 1940. Reprint. New York, 1968.

NAISON, MARK. *Communists in Harlem During the Depression.* Urbana, Ill., 1986.

OSOFSKY, GILBERT. *Harlem: The Making of a Ghetto.* New York, 1963.

MARSHALL HYATT

Harlem Boycotts (1934, 1941). During the 1930s, African Americans in several cities organized boycotts of stores in black neighborhoods which refused to hire blacks. In New York City's Harlem neighborhood, the center of America's black life, pressure for a boycott movement had begun after 1929, when a successful boycotting campaign was organized in Chicago under the slogan "Don't Buy Where You Can't Work." In 1931, black nationalists called for a cross-class campaign, but Harlem businessmen and influential ministers refused. During the summer of 1933, members of the Negro Industrial and Clerical Alliance, led by Sufi Abdul Hamid, a black nationalist disciple of Marcus GARVEY and veteran of the Chicago campaign, picketed small stores on Harlem's 135th Street in order to obtain jobs for blacks. His boycotts were accompanied by anti-Semitic speeches against Jewish merchants.

In 1934, at the height of the GREAT DEPRESSION, members of St. Martin's Protestant Episcopal Church complained to their minister, the Columbia University–trained Rev. John H. JOHNSON, about the conspicuous absence of black salespeople at Blumstein's department store, the largest store on Harlem's 125th Street. Johnson approached the owner of the store, William Blumstein, and requested that he hire black salespeople, since the majority of his customers were black. When the owner refused, Johnson appealed to the Harlem community to create a united front to protest Blumstein's hiring practices. The newspaper *New York Age* actively took up the cause, and as a result, the Citizen's League for Fair Play (CLFP) was established. The League, whose members included sixty-two of Harlem's social, religious, and business groups, was committed to ending job discrimination and obtaining white-collar jobs for blacks. The CLFP also included some radical black nationalists such as Sufi Hamid, Arthur Reed, and Ira Kemp.

The boycott began in June 1934. It became known as the Jobs-for-Negroes-Campaign, and borrowed the slogan that had been used in Chicago. After six weeks of active picketing, mostly by the more radical

Sufi Abdul Hamid, photographed by Morgan and Marvin Smith in 1939. (Photographs and Prints Division, Schomburg Center for Research in Black Culture, The New York Public Library, Astor, Lenox and Tilden Foundations)

members of the CLFP, Blumstein capitulated. On July 26, 1934, an agreement was reached in which Blumstein agreed to hire blacks as sales clerks. After the success of the boycott, a number of other stores along 125th Street, such as Koch's, began to employ blacks in clerical positions.

After this initial success, the CLFP fell into disunity. The radical nationalists, such as Sufi Hamid and Kemp, charged that middle-class, light-skinned blacks, who had been trained by the Urban League, were being hired over the dark-skinned, lower-class blacks who had actually done the picketing. A "Rebel Picketing Committee" separated itself from the CLFP, and began picketing small stores along 125th Street, even those that had just hired light-skinned blacks. They recommended that merchants hire only dark-skinned blacks. This new movement, led by the CLFP's radicals, agitated for all jobs in Harlem, rather than just a few token positions. When the other members of the CLFP discovered that Sufi Hamid had collected dues from picketers in return for promising them jobs, they accused him of "racketeering" and expelled him from the group. Kemp and Reid then made the "Rebel Picketers" an entirely dues-paying organization. When they approached A. S. Beck shoe store demanding it hire black workers, the store sued the picketers, stating that they were not a labor union and had no right to make such demands. In November 1934, the New York courts decided the dispute in favor of A. S. Beck. Until the decision was overturned the next year, the movement ebbed. The NAACP and moderate leaders, disgusted by the radicals' mercenary actions, supported the court action. At the same time, Sufi Hamid began to call himself the "Black Hitler," and became more openly hostile to Jews. He was arrested for "spreading anti-Semitism in Harlem," but was later acquitted.

Meanwhile, in 1935, the COMMUNIST PARTY started its own boycott of the Empire Cafeteria. Party activists, who favored interracial labor organization, had participated in small numbers in the Blumstein's boycott, carrying signs demanding no white workers be fired. Their success in securing jobs for four black countermen at Empire, without any other workers losing jobs, made the party a power in boycott organizing.

In 1936, Kemp and Reid obtained a charter for the Harlem Labor Union (HLU), and resumed picketing on a small scale as part of their goal of becoming sole bargaining agent for black workers. The HLU was not really a labor union. Middle-class in its objectives, it aimed to build up black business power through worker dues. Labor leaders and the NAACP decried the HLU's strikebreaking and sweetheart contracts to business, which assured that HLU members would be hired over other workers. However,

Kemp and Reid remained popular with the workers for whom they found jobs.

The next large boycott was not organized until 1938, when two of Harlem's influential ministers, the Rev. Adam Clayton POWELL, JR., of the Abyssinian Baptist Church, and the Rev. Lloyd Imes of St. James Presbyterian Church, provided the impetus for the formation of the Greater New York Coordinating Committee for Employment (GNYCC). Within his CLFP-like coalition of some 200 groups, Powell secured the backing of both the HLU and the communists, who despised each other. Neither of them could afford to oppose the popular Powell. The GNYCC was committed to fighting discriminatory practices throughout the city, including in the utility companies. After some unsuccessful attempts by the GNYCC to force the New York Telephone Company to hire blacks, a rival group was formed, which was called the Harlem Job Committee (HJC). Led by A. Phillip RANDOLPH of the BROTHERHOOD OF SLEEPING CAR PORTERS, the HJC began to boycott stores around Harlem, and suggested the GNYCC confine itself to the utility companies. Eventually, under pressure from GNYCC, Consolidated Edison Electric Company agreed to hire a few trainees. In 1939, a GNYCC boycott of the New York World's Fair resulted in the hiring of 700 blacks. While most of the jobs were menial, this represented a much higher number than the organizers' target of forty.

The last major boycott of the era was of the Fifth Avenue Coach Company and the Omnibus Corporation, which began in 1941. Powell led the United Negro Bus Strike Committee, which brought together the HLC and the Communists, whose NATIONAL NEGRO CONGRESS participated. After months of active boycotting and intermittent violent confrontations with white unionists, Powell announced victory. The bus companies agreed to hire thirty-two black trainees immediately and set a black employment quota.

The boycotts' results were mixed. The coalitions that fostered them were unstable, and their leaders were not always motivated by principle in conducting them. They did help break the job ceiling and discriminatory hiring practices which either kept blacks in menial jobs or excluded them completely. However, in 1941, African-American social scientist Ralph Bunche concluded that the "Don't buy where you can't work" boycotts and other racial campaigns had mostly aided middle-class blacks. During the depression their long-term effect on poor blacks was simply to increase competition with displaced white workers, which meant that wages dropped and blacks working in white areas would be fired. Perhaps its most important legacy was that, by the 1940s, blacks

could be seen working in white-collar positions all over the city.

REFERENCES

HAMILTON, CHARLES V. *Adam Clayton Powell, Jr.: The Political Biography of an American Dilemma.* New York, 1991.

MURASKIN, WILLIAM. "The Harlem Boycott of 1934: Black Nationalism and the Rise of Labor Union Consciousness." *Labor History* 13, no. 3 (1972): 361–373.

NAISON, MARK. *The Communists in Harlem During the Great Depression.* New York, 1984.

MANSUR M. NURUDDIN
GREG ROBINSON

Harlem Commonwealth Council.

The Harlem Commonwealth Council (HCC) is a non-profit corporation, designed to bring about economic development in Harlem, in New York City, and foster community empowerment. Originally founded in 1967 by a combination of leaders, of the CONGRESS OF RACIAL EQUALITY, Roy INNIS and Marshall England, African-American foundation executives such as Isiah Robinson, Jr., community leaders and local businessmen, the HCC was designed to revitalize the depressed Harlem economy. The HCC's goals and strategies prefigured the creation of a "minority enterprise zone" and efforts at inner-city economic development in the 1990s.

The original HCC board worked from a black nationalist perspective. They viewed Harlem's economy as similar to that of a colonized county, whose property and wealth were controlled by foreigners. With the aid of government antipoverty money and private sector funding, the HCC planned to facilitate economic growth through opening both large business operations such as factories and franchise stores, and by developing small businesses. The jobs created would make use of the local labor force, and reduce high unemployment and declining commercial activity in Harlem. Control of the HCC would promote the political empowerment of community members. The Office of Economic Opportunity (OEO), the major agency of the Johnson administration's "War on Poverty," gave the HCC a grant for initial funding; the HCC invested money in real estate and planned joint ventures and other large-scale visible commercial development efforts.

Despite its ambitious plans, its achievements in its first twenty-five years of operation have been minimal. Bad investments and an uncertain economy reduced its real estate holdings, and virtually all its large-scale enterprises have gone bankrupt. The organization, run on the income from real estate investments, was largely inactive by the 1990s.

REFERENCE

"Harlem Commonwealth Council." *New York Amsterdam News,* September 5, 1992, p. 10.

PETRA E. LEWIS

Harlem Globetrotters.

The Harlem Globetrotters were founded in 1926. At that time, Abe Saperstein (1902–1966), an English-born Jewish Chicagoan who had coached semipro basketball in the Chicago area, took over coaching duties of an African-American team, the Savoy Big Five (formerly Giles Post American Legion). Saperstein decided the team would be more popular with better marketing. To emphasize its racial composition and its barnstorming, he renamed the team the Harlem Globetrotters, though they had no connection to the New York City neighborhood. The newly-renamed team debuted on January 7, 1927, in Hinckley, Ill., wearing read, white, and blue uniforms that Saperstein had sewn in his father's tailor shop. The first starting team consisted of Walter "Toots" Wright, Byron "Fat" Long, Willis "Kid" Oliver, Andy Washington, and Al "Runt" Pullins.

The Globetrotters played the itinerant schedule of barnstorming basketball teams, taking on black and white squads of greatly varying levels of ability, with many memorable games against their archrivals, the New York Rens. Players boosted the team's popularity by clowning—drop-kicking balls, spinning them on fingertips, and bouncing them off teammates' heads. In 1939, the Globetrotters finished third in the *Chicago Herald American*'s World Professional Tournament; in 1940, they became World Champions. In 1943, the team traveled to Mexico City (the first indication that the team would soon justify their "Globetrotter" name) and won the International Cup Tournament. During the mid-1940s, a white player, Bob Karstens, joined the Globetrotters (the team has briefly had two other white players).

After World War II, as professional all-white basketball leagues began slowly integrating, the Globetrotters, led by Marques Haynes, were so popular that rumors spread that Saperstein opposed integration in order to keep control of the market for black players. Meanwhile, they continued to hold their own against white teams in exhibition games. In February 1948, the Globetrotters, following a 52-game winning streak, played George Mikan and the Minneapolis Lakers evenly in two exhibition games in Chicago. The team's skill and popularity belied black exclusion policies.

The Harlem Globetrotters Basketball Team, 1930-1931 season. Standing (left to right) Abe Saperstein, Toots Wright, Byron Long, Inman Jackson, William Oliver; seated is Al Pullins. (Photographs and Prints Division, Schomburg Center for Research in Black Culture, The New York Public Library, Astor, Lenox and Tilden Foundations)

By 1950, NBA teams had three black players, including ex-Globetrotter Nat "Sweetwater" Clifton. After the integration of professional basketball, the Globetrotters' playing style changed dramatically. Clowning now became predominant. Players such as Reece "Goose" Tatum, Meadowlark Lemon, and Fred "Curly" Neal were hired not only for playing ability but for trick shooting, dribbling, and comedic talent. The Globetrotters, now billed as "The Clown Princes of Basketball," became best known for already familiar routines, such as the pregame "Magic Circle." In this act, players stand in a loose circle and display their skill and deftness with the ball, accompanied by the team's theme song, "Sweet Georgia Brown."

In 1950, the Globetrotters began annual coast-to-coast trips with squads of college All-Americans, which lasted until 1962. The same year, the team began annual European summer tours, playing to enormous crowds. In 1951, they played before 75,000 spectators in Berlin's Olympic Stadium, still one of the largest crowds ever to see a basketball game. During this period, they appeared in two movies, *Go Man Go* (1948) and *The Harlem Globetrotters* (1951). In the early 1950s, after the Globetrotters lost con-

secutive games to Red Klotz's Philadelphia Spas, Abe Saperstein decided to dispense with playing local teams and to barnstorm with the Spas (later renamed the Washington Generals), who play some 250 games with the Globetrotters each year, and serve as straight men for their stunts. The Generals, following an agreement with the Globetrotters, allow several trick-shot baskets per game. The last time the Generals beat their rivals was in 1971. In the 1950s, the Globetrotters split into two squads, one of which played on the East coast, while the other focused on the West. In 1958–1959, the same year that Wilt CHAMBERLAIN, after the end of his college career, spent playing with the team (often as a 7'1″ guard!), the Globetrotters toured the Soviet Union as goodwill ambassadors. Other famous athletes who played with the team included Bob GIBSON and Connie Hawkins. The team has retained its interracial popularity, though during the 1960s some blacks criticized team members for their clownish image, which reinforced racial stereotypes, and the team's silence on civil rights issues.

After Abe Saperstein's death in 1966, the team was sold to three Chicago businessmen for $3.7 million. In 1975, Metromedia purchased the team for $11 mil-

lion. The Globetrotters remained popular into the 1970s, when they starred in cartoon and live-action TV series, but their popularity declined some years later, especially after stars such as Meadowlark Lemon left the team after contract disputes. In 1985, the first female Globetrotter, Lynette Woodward, was hired. In December 1986, Metromedia sold the team (as part of a package that included the Ice Capades) to International Broadcasting Corp. (IBC) for $30 million. In 1993, IBC entered bankruptcy and Mannie Johnson, a former Globetrotter, bought the team. It was another Globetrotter, Curly Neal, who best captured the team's appeal: "How do I know when we played a good 'game'?" he said. "When I look up at the crowd and I see all those people laughing their heads off. It's a hard world and if we can lighten it up a little, we've done our job."

REFERENCES

GUTMAN, BILL. *The Harlem Globetrotters.* Champaign, Ill., 1977.
LEMON, MEADOWLARK. *Meadowlark.* Nashville, Tenn., 1987.
WEINER, JAY. "Meadowlark Lemon Comes Home to Roost with Globetrotters." Chicago *Star Tribune,* March 1, 1993.

GREG ROBINSON

Harlem Renaissance. If the Harlem Renaissance was neither exclusive to Harlem nor a rebirth of anything that had gone before, its efflorescence above New York's Central Park was characterized by such sustained vitality and variety as to influence by paramountcy and diminish by comparison the similar cultural energies in Boston, Philadelphia, and Washington, D.C. During its earliest years, beginning about 1917, contemporaries tended to describe the Harlem phenomenon as a manifestation of the New Negro Arts Movement. However, by the time it ended in the winter of 1934–1935—with both a whimper and a bang—the movement was almost universally regarded as indistinguishable from its Harlem incarnation.

As the population of African Americans rapidly urbanized and its literacy rate climbed, HARLEM, NEW YORK, the "Negro capital of America," rose out of the vast relocation under way from South to North. A combination of causes propelled the Great Black Migration: southern white mob violence, the economics of discrimination, crop failure, the interruption of European immigration after 1914 and a consequent labor vacuum in the North, and the aggressive recruitment of black labor for work at wartime wages by northern industrialists. With the vast welling of black people from Georgia, the Carolinas, Virginia, and elsewhere, their numbers rose from 60,534 in all of NEW YORK CITY in 1910 to a conservative 1923 estimate of the NATIONAL URBAN LEAGUE (NUL) that placed the number at 183,428, with probably two-thirds in Harlem. Although this section of the city was by no means wholly occupied by people of color—never more than 60 percent during the 1930s—it soon became distinctively black in culture and in the mainstream perception. If the coming of black Harlem was swift, its triumph had been long anticipated by the increasing numbers of African Americans living in midtown Manhattan's teeming Tenderloin and San Juan Hill districts. The Tenderloin (so called from a police captain's gustatory graft), stretching roughly from West Fourteenth to Forty-second streets, had become home to the city's nonwhites during the early nineteenth century, after they forced their way out of the old Five Points area east of today's Foley Square, where City Hall stands.

By the 1890s, blacks were battling the Irish for scarce turf north of Fiftieth Street in what came to be called San Juan Hill, in honor of African-American troops in the Spanish-American War. Influx and congestion had, as the African-American newspaper the *New York Age* predicted, great advantages: "Influx of Afro-Americans into New York City from all parts of the South made . . . possible a great number and variety of business enterprises." The example of Lower East Side Jews accumulating money and moving on, in the 1890s, to solid brownstones on wide, shaded streets in Harlem was enviously watched by African Americans. The area had undergone a building boom in anticipation of the extension of the subway, but by the turn of the century many apartment buildings were sparsely occupied. A few white landlords broke ranks around 1905 to rent or sell to African Americans through Philip A. Payton's pioneering Afro-American Realty Company.

Two institutional activities were outstandingly successful in promoting the occupation of Harlem—churches and cabarets. Saint Philip's Episcopal Church sold its West Twenty-fifth Street holdings for $140,000 in 1909 and disposed of its Tenderloin cemetery for $450,000 two years later. The ABYSSINIAN BAPTIST CHURCH, presided over by the charismatic Adam Clayton POWELL, SR., negotiated a comparable disposal of its property in order to build one of Protestant America's grandest temples on 138th Street. Nightclubs such as Banks's, Barron's, and Edmond's transported music and a nightlife style from the Tenderloin that gave Harlem its signature. Barron's Little Savoy featured "Jelly Roll" MORTON, Willie "the Lion" SMITH, James P. JOHNSON, Scott JOPLIN, and other legends of the era. Barron Wilkins

Group portrait, including (back row, left to right) Ethel Ray (Nance), Langston Hughes, Helen Lanning, Pearl Fisher, Dr. Rudolf Fisher, Clarissa Scott, Hubert Delany. (Front row, left to right) Regina M. Anderson (Andrews), Luella Tucker, Esther Popel, Jessie Fauset, Mrs. Charles S. Johnson, E. Franklin Frazier. (Photographs and Prints Division, Schomburg Center for Research in Black Culture, The New York Public Library, Astor, Lenox and Tilden Foundations)

took his club uptown before the country entered the European war.

Precisely why and how the Harlem Renaissance materialized, who molded it and who found it most meaningful, as well as what it symbolized and what it achieved, raise perennial American questions about race relations, class hegemony, cultural assimilation, generational-gender-lifestyle conflicts, and art versus propaganda. Notwithstanding its synoptic significance, the Harlem Renaissance was not, as some students have maintained, all-inclusive of the early twentieth-century African-American urban experience. There were important movements, influences, and people who were marginal or irrelevant to it, as well as those alien or opposed. Not everything that happened in Harlem from 1917 to 1934 was a Renaissance happening. The potent mass movement founded and led by the charismatic Marcus GARVEY was to the Renaissance what nineteenth-century populism was to progressive reform: a parallel but socially different force, related primarily through dialectical confrontation. Equally different from the institutional ethos and purpose of the Renaissance was the black church. An occasional minister (such as the father of poet Countee CULLEN) or exceptional

Garveyites (such as Yale-Harvard man William H. Ferris) might move in both worlds, but black evangelism and its cultist manifestations, such as Black Zionism, represented emotional and cultural retrogression in the eyes of the principal actors in the Renaissance. If the leading intellectual of the race, W. E. B. DU BOIS, publicly denigrated the personnel and preachings of the black church, his animadversions were merely more forthright than those of other New Negro notables like James Weldon JOHNSON, Charles S. JOHNSON, Jessie Redmon FAUSET, Alain LOCKE, and Walter Francis WHITE.

The relationship of music to the Harlem Renaissance was problematic, for reasons exactly analogous to its elitist aversions to Garveyism and evangelism. When Du Bois wrote, a few years after the beginning of the New Negro movement in arts and letters, that "until the art of the black folk compels recognition they will not be rated as human," he, like most of his Renaissance peers, fully intended to exclude the blues of Bessie SMITH and the jazz of "King" OLIVER. Spirituals sung like lieder by the disciplined Hall Johnson Choir—and, better yet, lieder sung by conservatory-trained Roland HAYES, recipient of the NAACP's prestigious SPINGARN MEDAL—were deemed appro-

priate musical forms to present to mainstream America. The deans of the Renaissance were entirely content to leave discovery and celebration of Bessie, Clara, Trixie, and various other blues-singing Smiths to white music critic Carl Van Vechten's effusions in *Vanity Fair*. When the visiting film director Sergei Eisenstein enthused about new black musicals, Charles S. Johnson and Alain Locke expressed mild consternation in the Urban League's OPPORTUNITY magazine. They would have been no less displeased by Maurice Ravel's fascination with musicians in Chicago dives. As board members of the Pace Phonograph Company, Du Bois, James Weldon Johnson, and others banned "funky" artists from the Black Swan list of recordings, thereby contributing to the demise of the African-American–owned firm. But the wild Broadway success of Miller and Lyles's musical *Shuffle Along* (it helped to popularize the Charleston) or Florence MILLS's *Blackbirds* revue flaunted such artistic fastidiousness.

The very centrality of music in black life, as well as of black musical stereotypes in white minds, caused popular musical forms to impinge inescapably on Renaissance high culture. Eventually, the Renaissance deans made a virtue out of necessity; they applauded the concert-hall ragtime of "Big Jim" EUROPE and the "educated" jazz of Atlanta University graduate and big-band leader Fletcher HENDERSON, and they hired a Duke ELLINGTON or a Cab CALLOWAY as drawing cards for fund-raising socials. Still, their relationship to music remained beset by paradox. New York ragtime, with its "Jelly Roll" Morton strides and Joplinesque elegance, had as much in common with Chicago jazz as Mozart with "Fats" WALLER. The source of musical authenticity and the reservoir of musical abundance lay in those recently urbanized and economically beleaguered men and women whose chosen recreational environments were raucous, boozy, and lubricious. Yet these were the men and women whose culture and condition made Renaissance drillmasters (themselves only a generation and a modest wage removed) uncomfortable and ashamed, men and women whose musical pedigrees went back from Louis ARMSTRONG and Sidney BECHET through Chicago to New Orleans's Storyville and its colonial-era Place Congo.

The Renaissance relished virtuoso performances by baritone Jules BLEDSOE or contralto Marian ANDERSON, and pined to see the classical works of William Grant STILL performed in Aeolian Hall. It took exceeding pride in the classical repertory of the renowned Clef Club Orchestra. On the other hand, even if and when it saw some value in the music nurtured in prohibition joints and bleary rent parties, the movement found itself pushed aside by white ethnic commercial co-optation and exploitation—by Al Capone and the mob. Thus, what was musically vital was shunned or deplored in the Harlem Renaissance from racial sensitivity; what succeeded with mainstream audiences derived from those same shunned and deplored sources and was invariably hijacked; and what was esteemed as emblematic of racial sophistication was (even when well done) of no interest to whites and of not much more to the majority of blacks. Last, with the notable exception of Paul ROBESON, most of the impresarios as well as the featured personalities of the Renaissance were more expert in literary and visual-arts matters than musical.

The purpose of emphasizing such negatives—of stressing whom and what the Harlem Renaissance excluded or undervalued—serves the better to characterize the essence of a movement that was an elitist response to a rapidly evolving set of social and economic conditions demographically driven by the Great Black Migration, beginning in the second decade of the twentieth century. The Harlem Renaissance began "as a somewhat forced phenomenon, a cultural nationalism of the parlor, institutionally encouraged and constrained by the leaders of the civil rights establishment for the paramount purpose of improving 'race relations' in a time of extreme national reaction to an annulment of economic gains won by Afro-Americans during the Great War" (Lewis 1981). This mobilizing elite emerged from the increasing national cohesion of the African-American bourgeoisie at the turn of the century, and of the migration of many of its most educated and enterprising to the North about a decade in advance of the epic working-class migration out of the South. Du Bois indelibly labeled this racially advantaged minority the "Talented Tenth" in a seminal 1903 essay. He fleshed out the concept biographically that same year in "The Advance Guard of the Race," a piece in *Booklover's Magazine:* "Widely different are these men in origin and method. [Paul Laurence] DUNBAR sprang from slave parents and poverty; [Charles Waddell] CHESNUTT from free parents and thrift; while [Henry O.] TANNER was a bishop's son."

Students of the African-American bourgeoisie—from Joseph Willson in the mid–nineteenth century through Du Bois, Caroline Bond Day, and E. Franklin FRAZIER during the first half of the twentieth to Constance Green, August Meier, Carl Degler, Stephen Birmingham, and, most recently, Adele Alexander, Lois Benjamin, and Willard Gatewood—have differed about its defining elements, especially that of pigment. The generalization seems to hold that color was a greater determinant of upper-class status in the post–Civil War South than in the North. The phenotype preferences exercised by slaveholders for house slaves, in combination with the relative advantages enjoyed by illegitimate offspring of slave-masters, gave a decided spin to mulatto professional

careers during Reconstruction and well beyond. Success in the North followed more various criteria, of which color was sometimes a factor. By the time of Booker T. WASHINGTON's death in 1915, however, a considerable amount of ideological cohesion existed among the African-American leadership classes in such key cities as Atlanta, Washington, Baltimore, Philadelphia, Boston, Chicago, and New York. A commitment to college preparation in liberal arts and the classics, in contrast to Washington's emphasis on vocational training, prevailed. Demands for civil and social equality were espoused again after a quietus of some fifteen years.

The once considerable power of the so-called Tuskegee Machine now receded before the force of Du Bois's propaganda, a coordinated civil rights militancy, and rapidly altering industrial and demographic conditions in the nation. The vocational training in crafts such as brickmaking, blacksmithing, carpentry, and sewing prescribed by Tuskegee and Hampton institutes was irrelevant in those parts of the South undergoing industrialization, yet industry in the South was largely proscribed to African Americans who for several decades had been deserting the dead end of sharecropping for the South's towns and cities. The Bookerites' sacrifice of civil rights for economic gain, therefore, lost its appeal not only to educated and enterprising African Americans but to many of those white philanthropists and public figures who had once solemnly commended it. The Talented Tenth formulated and propagated the new ideology being rapidly embraced by the physicians, dentists, educators, preachers, businesspeople, lawyers, and morticians comprising the bulk of the African-American affluent and influential—some 10,000 men and women, out of a total population in 1920 of more than 10 million. (In 1917, traditionally cited as the natal year of the Harlem Renaissance, there were 2,132 African Americans in colleges and universities, probably no more than 30 of them attending "white" institutions.)

It was, then, the minuscule vanguard of a minority—0.02 percent of the racial total—that constituted the Talented Tenth that jump-started the New Negro Arts Movement. But what was extraordinary about the Harlem Renaissance was that its promotion and orchestration by the Talented Tenth were the consequence of masterful improvisation rather than of deliberate plan, of artifice imitating likelihood, of aesthetic deadpan disguising a racial blind alley. Between the 1905 "Declaration of Principles" of the NIAGARA MOVEMENT and the appearance in 1919 of Claude MCKAY's electrifying poem "If We Must Die," the principal agenda of the Talented Tenth called for investigation of and protest against discrimination in virtually every aspect of national life. It lobbied for racially enlightened employment poli-

cies in business and industry; the abolition through the courts of peonage, residential segregation ordinances, JIM CROW public transportation, and franchise restrictions; and enactment of federal sanctions against lynching. The vehicles for this agenda, the NAACP and the NUL, exposed, cajoled, and propagandized through their excellent journals, the CRISIS and OPPORTUNITY, respectively. The rhetoric of protest was addressed to ballots, courts, legislatures, and the workplace: "We urge upon Congress the enactment of appropriate legislation for securing the proper enforcement of . . . the thirteenth, fourteenth and fifteenth amendments," the Niagara Movement had demanded and the NAACP continued to reiterate. Talented Tenth rhetoric was also strongly social-scientific: "We shall try to set down interestingly but without sugar-coating or generalizations the findings of careful scientific surveys and facts gathered from research," the first *Opportunity* editorial would proclaim in January 1923, echoing the objectives of Du Bois's famous Atlanta University Studies.

It is hardly surprising that many African Americans, the great majority of whom lived under the deadening cultural and economic weight of southern apartheid, had modest interest in literature and the arts during the first two decades of the twentieth century. Even outside the underdeveloped South, and irrespective of race, demotic America had scant aptitude for and much suspicion of arts and letters. Culture in early twentieth-century America was paid for by a white minority probably not a great deal larger, by percentage, than the Talented Tenth. For those privileged few African Americans whose education or leisure inspired such tastes, therefore, appealing fiction, poetry, drama, paintings, and sculpture by or about African Americans had become so exiguous as to be practically nonexistent. With the rising hostility and indifference of the mainstream market, African-American discretionary resources were wholly inadequate by themselves to sustain even a handful of novelists, poets, and painters. A tubercular death had silenced poet-novelist Dunbar in 1906, and poor royalties had done the same for novelist Chesnutt after publication the previous year of *The Colonel's Dream*. Between that point and 1922, no more than five African Americans published significant works of fiction and verse. There was *Pointing the Way* in 1908, a flawed, fascinating civil rights novel by the Baptist preacher Sutton GRIGGS. Three years later, Du Bois's *The Quest of the Silver Fleece,* a sweeping sociological allegory, appeared. The following year came James Weldon Johnson's well-crafted *The Autobiography of an Ex-Colored Man,* but the author felt compelled to disguise his racial identity. A ten-year silence fell afterward, finally to be broken in 1922 by McKay's *Harlem Shadows,* the first book of poetry since Dunbar. In "Art for Nothing,"

a short, trenchant think piece in the May 1922 *Crisis,* Du Bois lamented the fall into oblivion of sculptors Meta Warwick FULLER and May Howard JACKSON, and that of painters William E. SCOTT and Richard Brown.

Although the emergence of the Harlem Renaissance seems much more sudden and dramatic in retrospect than the historic reality, its institutional elaboration was, in fact, relatively quick. Altogether, it evolved through three stages. The first phase, ending in 1923 with the publication of Jean TOOMER's unique prose poem *Cane,* was dominated by white artists and writers—bohemians and revolutionaries—fascinated for a variety of reasons with the life of black people. The second phase, from early 1924 to mid-1926, was presided over by the civil rights establishment of the NUL and the NAACP, a period of interracial collaboration between "Negrotarian" whites and the African-American Talented Tenth. The last phase, from mid-1926 to 1934, was increasingly dominated by African American artists themselves—the "Niggerati."

When Charles S. Johnson, new editor of *Opportunity,* sent invitations to some dozen African-American poets and writers to attend an event at Manhattan's Civic Club on March 21, 1924, the movement had already shifted into high gear. At Johnson's request, William H. Baldwin III, white Tuskegee trustee, NUL board member, and heir to a railroad fortune, had persuaded *Harper's* editor Frederick Lewis Allen to corral a "small but representative group from his field," most of them unknown, to attend the Civic Club affair in celebration of the sudden outpouring of "Negro" writing. "A group of the younger writers, which includes Eric WALROND, Jessie Fauset, Gwendolyn BENNETT, Countee Cullen, Langston HUGHES, Alain Locke, and some others," would be present, Johnson promised each invitee. All told, in addition to the "younger writers," some fifty persons were expected: "Eugene O'Neill, H. L. Mencken, Oswald Garrison Villard, Mary Johnston, Zona Gale, Robert Morss Lovett, Carl Van Doren, Ridgely Torrence, and about twenty more of this type. I think you might find this group interesting enough to draw you away for a few hours from your work on your next book," Johnson wrote the recently published Jean Toomer almost coyly.

Although both Toomer and Langston Hughes were absent in Europe, approximately 110 celebrants and honorees assembled that evening, included among them Du Bois, James Weldon Johnson, and the young NAACP officer Walter Francis White, whose energies as a literary entrepreneur would soon excel even Charles Johnson's. Locke, professor of philosophy at Howard University and the first African-American Rhodes scholar, served as master of ceremonies. Fauset, literary editor of the *Crisis* and

Phi Beta Kappa graduate of Cornell University, enjoyed the distinction of having written the second fiction (and first novel) of the Renaissance, *There Is Confusion,* just released by Horace Liveright. Liveright, who was present, rose to praise Fauset as well as Toomer, whom he had also published. Speeches followed in rapid succession—Du Bois, James Weldon Johnson, Fauset. White called attention to the next Renaissance novel: his own, *The Fire in the Flint,* shortly forthcoming from Knopf. Albert Barnes, the crusty Philadelphia pharmaceutical millionaire and art collector, described the decisive impact of African art on modern art. Poets and poems were commended—Hughes, Cullen, Georgia Douglas JOHNSON of Washington, D.C., and, finally, Gwendolyn Bennett's stilted yet appropriate "To Usward," punctuating the evening: "We claim no part with racial dearth, / We want to sing the songs of birth!" Charles Johnson wrote the vastly competent Ethel Ray Nance, his future secretary, of his enormous gratification that Paul Kellogg, editor of the influential *Survey Graphic,* had proposed that evening to place a special number of his magazine at the service of "representatives of the group."

Two compelling messages emerged from the Civic Club gathering. Du Bois asserted that the literature of apology and the denial to his generation of its authentic voice were now ending; Van Doren said that African-American artists were developing at a uniquely propitious moment. They were "in a remarkable strategic position with reference to the new literary age which seems to be impending," Van Doren predicted. "What American literature decidedly needs at this moment is color, music, gusto, the free expression of gay or desperate moods. If the Negroes are not in a position to contribute these items," Van Doren could not imagine who else could. It was precisely this "new literary age" that a few Talented Tenth leaders had kept under sharp surveillance and about which they had soon reached a conclusion affecting civil rights strategy. Despite the baleful influence of D. W. Griffith's *The Birth of a Nation* and the robust persistence of Uncle Tom, "coon," and Noble Savage stereotypes, literary and dramatic presentations of African Americans by whites had begun, arguably, to change somewhat for the better.

The African American had indisputably moved to the center of mainstream imagination with the end of the Great War, a development crucially assisted by chrysalis of the Lost Generation—Greenwich Village bohemia. The first issue of Randolph Bourne's *Seven Arts* (November 1916), featuring, among others of the Lyrical Left, Waldo Frank, James Oppenheim, Paul Rosenfeld, Van Wyck Brooks, and the French intellectual Romain Rolland, incarnated the spirit that informed a generation without ever quite cohering

into a doctrine. The inorganic state, the husk of a decaying capitalist order, was breaking down, these young white intellectuals believed. They professed contempt for "the people who actually run things" in America. Waldo Frank, Toomer's bosom friend and literary mentor, foresaw not a bloody social revolution in America but that "out of our terrifying welter or steel and scarlet, a design must come." There was another Village group decidedly more oriented toward politics: the Marxist radicals (John Reed, Floyd Dell, Helen Keller, Max Eastman) associated with *Masses* and its successor magazine, *Liberator,* edited by Max and Crystal Eastman. The inaugural March 1918 issue of *Liberator* announced that it would "fight for the ownership and control of industry by the workers."

Among the Lyrical Left writers gathered around *Broom, S4N,* and *Seven Arts,* and the political radicals associated with *Liberator,* there was a shared reaction against the ruling Anglo-Saxon cultural paradigm. Bourne's concept of a "trans-national" America, democratically respectful of its ethnic, racial, and religious constituents, complemented Du Bois's earlier concept of divided racial identity in *The Souls of Black Folk.* Ready conversance with the essentials of Freud and Marx became the measure of serious conversation in MacDougal Street coffeehouses, Albert Boni's Washington Square Book Shop, or the Hotel Brevoort's restaurant. There Floyd Dell, Robert Minor, Matthew Josephson, Max Eastman, and other *enragés* denounced the social system, the Great War to which it had ineluctably led, and the soul-dead world created in its aftermath, with McKay and Toomer, two of the Renaissance's first stars, participating.

From such conceptions, the Village's discovery of Harlem followed logically and, even more, psychologically. For if the factory, campus, office, and corporation were dehumanizing, stultifying, or predatory, the African American—largely excluded from all of the above—was a perfect symbol of cultural innocence and regeneration. He was perceived as an integral, indispensable part of the hoped-for design, somehow destined to aid in the reclamation of a diseased, desiccated civilization. The writer Malcolm Cowley would recall in *Exile's Return* that "one heard it said that the Negroes had retained a direct virility that the whites had lost through being overeducated." Public annunciation of the rediscovered Negro came in the fall of 1917, with Emily Hapgood's production at the old Garden Street Theatre of three one-act plays by her husband, Ridgely Torrence. *The Rider of Dreams, Simon the Cyrenian,* and *Granny Maumee* were considered daring because the casts were black and the parts were dignified. The drama critic from *Theatre Magazine* enthused of one lead player that "nobody who saw Opal Cooper—and heard him as the dreamer, Madison Sparrow—will

ever forget the lift his performance gave." Du Bois commended the playwright by letter, and James Weldon Johnson excitedly wrote his friend, the African-American literary critic Benjamin BRAWLEY, that *The Smart Set*'s George Jean Nathan "spoke most highly about the work of these colored performers."

From this watershed flowed a number of dramatic productions, musicals, and several successful novels by whites, and also, with great significance, *Shuffle Along,* a cathartic musical by the African Americans Aubrey Lyles and Flournoy Miller. Theodore Dreiser grappled with the explosive subject of lynching in his 1918 short story "Nigger Jeff." Two years later, the magnetic African-American actor Charles GILPIN energized O'Neill's *The Emperor Jones* in the 150-seat theater in a MacDougal Street brownstone taken over by the Provincetown Players. *The Emperor Jones* (revived four years later with Paul Robeson in the lead part) showed civilization's pretensions being moved by forces from the dark subconscious. In 1921, *Shuffle Along* opened at the 63rd Street Theatre, with music, lyrics, choreography, cast, and production uniquely in African-American hands, and composer Eubie Blake's "I'm Just Wild About Harry" and "Love Will Find a Way" entering the list of all-time favorites. Mary Hoyt Wiborg's *Taboo* was also produced in 1921, with Robeson in his theatrical debut. Clement Wood's 1922 sociological novel *Nigger* sympathetically tracked a beleaguered African-American family from slavery through the Great War into urban adversity. T. S. Stribling's *Birthright,* that same year, was remarkable for its effort to portray an African-American male protagonist of superior education (a Harvard-educated physician) martyred for his ideals after returning to the South. "Jean Le Negre," the black character in e. e. cummings' *The Enormous Room,* was another Noble Savage paradigm observed through a Freudian prism.

But Village artists and intellectuals were aware and unhappy that they were theorizing about Afro-America and spinning out African-American fictional characters in a vacuum—that they knew almost nothing firsthand about these subjects. Sherwood Anderson's June 1922 letter to H. L. Mencken spoke for much of the Lost Generation: "Damn it, man, if I could really get inside the niggers and write about them with some intelligence, I'd be willing to be hanged later and perhaps would be." At least the first of Anderson's prayers was answered almost immediately, when he chanced to read a Jean Toomer short story in *Double-Dealer* magazine. With the novelist's assistance, Toomer's stories began to appear in the magazines of the Lyrical Left and the Marxists, *Diak, S4N, Broom,* and *Liberator.* Anderson's 1925 novel *Dark Laughter* bore unmistakable signs of indebtedness to Toomer, whose work, Anderson stated, had given him a true insight into the cultural energies that

could be harnessed to pull America back from the abyss of fatal materialism. Celebrity in the Village brought Toomer into Waldo Frank's circle, and with it criticism from Toomer about the omission of African Americans from Frank's sprawling work *Our America*. After a trip with Toomer to South Carolina in the fall of 1922, Frank published *Holiday* the following year, a somewhat overwrought treatment of the struggle between the races in the South, "each of which . . . needs what the other possesses."

Claude McKay, whose volume of poetry *Harlem Shadows* made him a Village celebrity also (he lived on Gay Street, then entirely inhabited by nonwhites), found his niche among the *Liberator* group, where he soon became coeditor of the magazine with Michael Gold. The Eastmans saw the Jamaican poet as the kind of writer who would deepen the magazine's proletarian voice. McKay increased the circulation of *Liberator* to 60,000, published the first poetry of e. e. cummings (over Gold's violent objections), introduced Garvey's UNIVERSAL NEGRO IMPROVEMENT ASSOCIATION (UNIA), and generally treated the readership to experimentation that had little to do with proletarian literature. "It was much easier to talk about real proletarians writing masterpieces than to find such masterpieces," McKay told the Eastmans and the exasperated hard-line Marxist Gold. McKay attempted to bring Harlem to the Village, as the actor Charlie Chaplin discovered when he dropped into the *Liberator* offices one day and found the editor deep in conversation with Hubert HARRISON, Harlem's peerless soapbox orator and author of *When Africa Awakes*. Soon all manner of Harlem radicals began meeting at the West Thirteenth Street offices, while the Eastmans fretted about Justice Department surveillance. Richard B. MOORE, Cyril BRIGGS, Otto Huiswood, Grace Campbell, W. A. Domingo, *inter alios*, represented Harlem movements ranging from Garvey's UNIA and Brigg's AFRICAN BLOOD BROTHERHOOD to the Communist party, with Huiswood and Campbell. McKay also attempted to bring the Village to Harlem, in one memorable sortie taking Eastman and another Villager to Ned's, his favorite Harlem cabaret. Ned's, notoriously antiwhite, expelled them.

This was part of the background to the Talented Tenth's abrupt, enthusiastic, and programmatic embrace of the arts after World War I. In 1924, as Charles Johnson was planning his Civic Club evening, extraordinary security precautions were in place around the Broadway theater where *All God's Chillun Got Wings,* O'Neill's drama about miscegenation, starring Paul Robeson, was playing, With white Broadway audiences flocking to O'Neill plays and shrieking with delight at *Liza, Runnin' Wild,* and other imitations of *Shuffle Along,* the two Johnsons, Du Bois, Fauset, White, Locke, and others saw a unique opportunity to tap into the attention span of white America. If they were adroit, African-American civil rights officials and intellectuals believed, they stood a fair chance of reshaping the images and repackaging the messages out of which mainstream racial behavior emerged.

Bohemia and the Lost Generation suggested to the Talented Tenth the new approach to the old problem of race relations, but their shared premise about art and society obscured the diametrically opposite conclusions white and black intellectuals and artists drew from it. Stearns's Lost Generation *révoltés* were lost in the sense that they professed to have no wish to find themselves in a materialistic, Mammon-mad, homogenizing America. Locke's New Negroes very much wanted full acceptance by mainstream America, even if some—Du Bois, McKay, and the future enfant terrible of the Renaissance, Wallace THURMAN—might have immediately exercised the privilege of rejecting it. For the whites, art was the means to change society before they would accept it. For the blacks, art was the means to change society in order to be accepted into it.

For this reason, many of the Harlem intellectuals found the white vogue in Afro-Americana troubling, although they usually feigned enthusiasm about the new dramatic and literary themes. Most of them clearly understood that this popularity was due to persistent stereotypes, new Freudian notions about sexual dominion over reason, and the postwar release of collective emotional and moral tensions sweeping Europe and America. Cummings, Dreiser, O'Neill, and Frank may have been well intentioned, but the African-American elite was quietly rather infuriated that Talented Tenth lives were frequently reduced to music, libido, rustic manners, and an incapacity for logic. The consummate satirist of the Renaissance, George SCHUYLER, denounced the insistent white portrayal of the African American in which "it is only necessary to beat a tom tom or wave a rabbit's foot and he is ready to strip off his Hart, Schaffner & Marx suit, grab a spear and ride off wild-eyed on the back of a crocodile." Despite the insensitivity, burlesquing, and calumny, however, the Talented Tenth convinced itself that the civil rights dividends of such recognition were potentially greater than the liabilities were.

Benjamin Brawley put this potential straightforwardly to James Weldon Johnson: "We have a tremendous opportunity to boost the NAACP, letters, and art, and anything else that calls attention to our development along the higher lines." Brawley knew that he was preaching to the converted. Johnson's preface to his best-selling anthology *The Book of American Negro Poetry* (1922) proclaimed that nothing could "do more to change the mental attitude and raise his status than a demonstration of intellectual

parity by the Negro through his production of literature and art." Reading Stribling's *Birthright,* an impressed Fauset nevertheless felt that she and her peers could do better. "We reasoned," she recalled later, " 'Here is an audience waiting to hear the truth about us. Let us who are better qualified to present that truth than any white writer, try to do so.' " The result was *There Is Confusion,* her novel about genteel life among Philadelphia's aristocrats of color. Walter Francis White, similarly troubled by *Birthright* and other two-dimensional or symbolically gross representations of African-American life, complained loudly to H. L. Mencken, who finally silenced him with the challenge, "Why don't you do the right kind of novel. You could do it, and it would create a sensation." White did. The sensation turned out to be *The Fire in the Flint* (1924), the second novel of the Renaissance, which he wrote in less than a month in a borrowed country house in the Berkshires.

Meanwhile, Langston Hughes, whose genius (like Toomer's) had been immediately recognized by Fauset, published several poems in the *Crisis* that would later appear in his collection *The Weary Blues.* The euphonious "The Negro Speaks of Rivers" (dedicated to Du Bois) ran in the *Crisis* in 1921. With the appearance of McKay's *Harlem Shadows* in 1922 and Toomer's *Cane* in 1923, the officers of the NAACP and the NUL saw how real the possibility of a theory being put into action could be. The young New York University prodigy Countee Cullen, already published in the *Crisis* and *Opportunity,* had his mainstream breakthrough in 1923 in *Harper's* and *Century* magazines. Two years later, Cullen won the prestigious Witter Bynner poetry prize, with Carl Sandburg as one of the three judges. Meanwhile, the *Survey Graphic* project moved apace under the editorship of Locke.

Two conditions made this unprecedented mobilization of talent and group support in the service of a racial arts and letters movement more than a conceit in the minds of its leaders: demography and repression. The Great Black Migration produced the metropolitan dynamism undergirding the Renaissance. The Red Summer of 1919 produced the trauma that led to the cultural sublimation of civil rights. In pressure-cooker fashion, the increase in Harlem's African-American population caused it to pulsate as it pushed its racial boundaries south below 135th Street to Central Park and north beyond 139th ("Strivers' Row"). Despite the real estate success of the firms of Nail and Parker and the competition given by Smalls' Paradise to the Cotton Club and Connie's (both off-limits to African-American patrons), however, this dynamic community was never able to own much of its own real estate, sustain more than a handful of small, marginal merchants, or even

control the profits from the illegal policy business perfected by one of its own, the literary Caspar Holstein. Still, both the appearance of and prospects for solid, broad-based prosperity belied the inevitable consequences of Harlem's comprador economy. The Negro Capital of the World filled up with successful bootleggers and racketeers, political and religious charlatans, cults of exotic character ("Black Jews"), street-corner pundits and health practitioners (Hubert Harrison, "Black Herman"), beauty culturists and distinguished professionals (Madame C. J. WALKER, Louis T. WRIGHT), religious and civil rights notables (Reverends Cullen and Powell, Du Bois, Johnson, White), and hard-pressed, hardworking families determined to make decent lives for their children. Memories of the nightspots in "The Jungle" (133rd Street), of Bill "Bojangles" ROBINSON demonstrating his footwork on Lenox Avenue, of raucous shows at the Lafayette that gave Florenz Ziegfeld some of his ideas, of the Tree of Hope outside Connie's Inn where musicians gathered as at a labor exchange, have been vividly set down by Arthur P. Davis, Regina Andrews, Arna BONTEMPS, and Hughes.

In the first flush of Harlem's realization and of general African-American exuberance, the Red Summer of 1919 had a cruelly decompressing impact on Harlem and Afro-America in general. The adage of peasants in Europe—"City air makes free"—was also true for sharecropping blacks, but not even the cities of the North made them equal or rich, or even physically secure. Charleston, S.C., erupted in riot in May, followed by Longview, Tex., and Washington, D.C., in July. Chicago exploded on July 27. Lynchings of returning African-American soldiers and expulsion of African-American workers from unions abounded. In the North, the white working classes struck out against perceived and manipulated threats to job security and unionism from blacks streaming north. In Helena, Ark., a pogrom was unleashed against black farmers organizing a cotton cooperative; outside Atlanta the Ku Klux Klan was reconstituted. The message of the white South to African Americans was that the racial *status quo ante bellum* was on again with a vengeance. Twenty-six race riots in towns, cities, and counties swept across the nation all the way to Nebraska. The "race problem" definitively became an American dilemma, and no longer a remote complexity in the exotic South.

The term "New Negro" entered the vocabulary in reaction to the Red Summer, along with McKay's poetic catechism: "Like men we'll face the murderous, cowardly pack / Pressed to the wall, dying, but fighting back!" There was a groundswell of support for Marcus Garvey's UNIA. Until his 1924 imprisonment for mail fraud, the Jamaican immigrant's

message of African Zionism, anti-integrationism, working-class assertiveness, and Bookerite business enterprise increasingly threatened the hegemony of the Talented Tenth and its major organizations, the NAACP and NUL, among people of color in America (much of Garvey's support came from West Indians). The UNIA's phenomenal fund-raising success, as well as its portrayal of the civil rights leadership as alienated by class and color from the mass of black people, delivered a jolt to the integrationist elite. "Garvey," wrote Mary White Ovington, one of the NAACP's white founders, "was the first Negro in the United States to capture the imagination of the masses." The *Negro World,* Garvey's multilingual newspaper, circulated throughout Latin America and the African empires of Britain and France. To the established leadership, then, the UNIA was a double threat because of its mass appeal among African Americans and because "respectable" civil rights organizations feared the spillover from the alarm Garveyism caused the white power structure. While Locke wrote in his introductory remarks to the special issue of *Survey Graphic* that "the thinking Negro has shifted a little to the left with the world trend," he clearly had Garveyism in mind when he said of black separatism, "this cannot be—even if it were desirable." Although the movement was its own worst enemy, the Talented Tenth was pleased to help the Justice Department speed its demise.

No less an apostle of high culture than Du Bois, initially a Renaissance enthusiast, vividly expressed the farfetched nature of the arts movement as early as 1923: "How is it that an organization of this kind [the NAACP] can turn aside to talk about art? After all, what have we who are slaves and black to do with art?" Slavery's legacy of cultural parochialism, the agrarian orientation of most African Americans, systematic underfunding of primary education, the emphasis on vocationalism at the expense of liberal arts in colleges, economic marginality, the extreme insecurity of middle-class status: all strongly militated against the flourishing of African-American artists, poets, and writers. It was the brilliant insight of the men and women of the NAACP and NUL that although the road to the ballot box, the union hall, the decent neighborhood, and the office was blocked, there were two paths that had not been barred, in part because of their very implausibility, as well as their irrelevancy to most Americans: arts and letters. These people saw the small cracks in the wall of racism that could, they anticipated, be widened through the production of exemplary racial images in collaboration with liberal white philanthropy, the robust culture industry located primarily in New York, and artists from white bohemia (like themselves, marginal and in tension with the status quo).

If in retrospect, then, the New Negro Arts Movement has been interpreted as a natural phase in the cultural evolution of another American group—a band in the literary continuum running from New England, Knickerbocker New York, and Hoosier Indiana to the Village's bohemia, East Side Yiddish drama and fiction, and the southern Agrarians—such an interpretation sacrifices causation to appearance. The other group traditions emerged out of the hieratic concerns, genteel leisure, privileged alienation, or transplanted learning of critical masses of independent men and women. The Renaissance represented much less an evolutionary part of a common experience than it did a generation-skipping phenomenon in which a vanguard of the Talented Tenth elite recruited, organized, subsidized, and guided an unevenly endowed cohort of artists and writers to make statements that advanced a certain conception of the race—a cohort of whom most would never have imagined the possibility of artistic and literary careers.

Toomer, McKay, Hughes, and Cullen possessed the rare ability combined with personal eccentricity that defined them as artists; the Renaissance needed not only more like them but a large cast of supporters and extras. American dropouts heading for seminars in garrets and cafés in Paris were invariably white, and descended from an older gentry displaced by new moneyed elites. Charles Johnson and his allies were able to make the critical Renaissance mass possible. Johnson assembled files on prospective recruits throughout the country, going so far as to cajole Aaron DOUGLAS and others into coming to Harlem, where a network staffed by his secretary, Ethel Ray Nance, and her friends Regina Anderson and Louella Tucker (assisted by the gifted Trinidadian short story writer Eric Walrond) looked after them until a salary or fellowship was secured. White, the self-important assistant secretary of the NAACP, urged Robeson to abandon law for an acting career, encouraged Nella LARSEN to follow his own example as a novelist, and passed the hat for artist Hale WOODRUFF. Fauset continued to discover and publish short stories and verse, such as those of Wallace Thurman and Arna Bontemps.

Shortly after the Civic Club evening, both the NAACP and the NUL announced the creation of annual awards ceremonies bearing the titles of their respective publications, *Crisis* and *Opportunity.* The award of the first *Opportunity* prizes came in May 1925 in an elaborate ceremony at the Fifth Avenue Restaurant with some 300 participants. Twenty-four judges in five categories had ruled on the worthiness of entries. Carl Van Doren, Zona Gale, Fannie Hurst, Dorothy Canfield Fisher, and Alain Locke, among others, judged short stories. Witter Bynner, John Far-

rar, Clement Wood, and James Weldon Johnson read the poetry entries. Eugene O'Neill, Alexander Woollcott, Thomas M. Gregory, and Robert Benchley appraised drama. The judges for essays were Van Wyck Brooks, John Macy, Henry Goodard Leach, and L. Hollingsworth Wood. The awards ceremony was interracial, but white capital and influence were crucial to success, and the white presence in the beginning was pervasive, setting the outer boundaries for what was creatively normative. Money to start the *Crisis* prizes had come from Amy Spingarn, an accomplished artist and poet and the wife of Joel Spingarn, chairman of the NAACP's board of directors. The wife of the influential attorney, Fisk University trustee, and Urban League board chairman L. Hollingsworth Wood had made a similar contribution to initiate the *Opportunity* prizes.

These were the whites Zora Neale HURSTON, one of the first *Opportunity* prize winners, memorably dubbed "Negrotarians." These comprised several categories: political Negrotarians such as progressive journalist Ray Stannard Baker and maverick socialist types associated with *Modern Quarterly* (V. F. Calverton, Max Eastman, Lewis Mumford, Scott Nearing); salon Negrotarians such as Robert Chanler, Charles Studin, Carl and Fania (Marinoff) Van Vechten, and Elinor Wylie, for whom the Harlem artists were more exotics than talents; Lost Generation Negrotarians drawn to Harlem on their way to Paris by a need for personal nourishment and confirmation of cultural health, in which their romantic or revolutionary perceptions of African Americans played a key role—Anderson, O'Neill, Georgia O'Keeffe, Zona Gale, Frank, Louise Bryant, Sinclair Lewis, Hart Crane; commercial Negrotarians such as the Knopfs, the Gershwins, Rowena Jelliffe, Liveright, V. F. Calverton, and music impresario Sol Hurok, who scouted and mined Afro-America like prospectors.

The philanthropic Negrotarians, Protestant and Jewish, encouraged the Renaissance from similar motives of principled religious and social obligation and of class hegemony. Oswald Garrison Villard (grandson of William Lloyd Garrison, heir to a vast railroad fortune, owner of the New York *Evening Post* and the *Nation,* and cofounder of the NAACP), along with foundation controllers William E. Harmon and J. G. Phelps-Stokes, and Mary White Ovington of affluent abolitionist pedigree, looked on the Harlem Renaissance as a movement it was their Christian duty to sanction, as well as an efficacious mode of encouraging social change without risking dangerous tensions. Jewish philanthropy, notably represented by the Altmans, Rosenwalds, Spingarns, Lehmans, and Otto Kahn, had an additional motivation, as did the interest of such scholars as Franz Boas and Melville Herskovits, jurists Louis Brandeis, Louis Marshall, and

Arthur Spingarn, and progressive reformers Martha Gruening and Jacob Billikopf. The tremendous increase after 1900 of Jewish immigrants from Slavic Europe had provoked nativist reactions and, with the 1915 lynching of Atlanta businessman Leo Frank, both an increasingly volatile anti-Semitism and an upsurge of Zionism. Redoubled victimization of African Americans, exacerbated by the tremendous outmigration from the South, portended a climate of national intolerance that wealthy, assimilated German-American Jews foresaw as inevitably menacing to all American Jews.

The May 1925 *Opportunity* gala showcased the steadily augmenting talent in the Renaissance—what Hurston pungently characterized as the "Niggerati." Two laureates, Cullen and Hughes, had already won notice beyond Harlem. The latter had engineered his "discovery" as a Washington, D.C., bellhop by placing dinner and three poems on Vachel Lindsay's hotel table. Some prize winners were barely to be heard from again: Joseph Cotter, G. D. Lipscomb, Warren MacDonald, Fidelia Ripley. Others, such as John MATHEUS (first prize in the short story category) and Frank HORNE (honorable mention), failed to achieve first-rank standing in the Renaissance. But most of those whose talent had staying power were also introduced that night: E. Franklin Frazier, winning the first prize for an essay on social equality; Sterling BROWN, taking second prize for an essay on the singer Roland Hayes; Hurston, awarded second prize for a short story, "Spunk"; and Eric Walrond, third short-story prize for "Voodoo's Revenge." James Weldon Johnson read the poem taking first prize, "The Weary Blues," Hughes's turning-point poem combining the gift of a superior artist and the enduring, music-encased spirit of the black migrant. Comments from Negrotarian judges ranged from O'Neill's advice to "be yourselves" to novelist Edna Worthley Underwood's exultant anticipation of a "new epoch in American letters," and Clement Wood's judgment that the general standard "was higher than such contests usually bring out."

Whatever their criticisms and however dubious their enthusiasms, what mattered as far as Charles Johnson and his collaborators were concerned was success in mobilizing and institutionalizing a racially empowering crusade, and cementing an alliance between the wielders of influence and resources in the white and black communities, to which the caliber of literary output was a subordinate, though by no means irrelevant, concern. In the September 1924 issue of *Opportunity* inaugurating the magazine's departure from exclusive social-scientific concerns, Johnson had spelled out clearly the object of the prizes: they were to bring African-American writers "into contact with the general world of letters to

which they have been for the most part timid and inarticulate strangers; to stimulate and foster a type of writing by Negroes which shakes itself free of deliberate propaganda and protest." The measures of Johnson's success were the announcement of a second *Opportunity* contest, to be underwritten by Harlem "businessman" (and numbers king) Caspar Holstein; former *Times* music critic Carl Van Vechten's enthusiasm over Hughes, and the subsequent arranging of a contract with Knopf for Hughes's first volume of poetry; and, one week after the awards ceremony, a prediction by the New York *Herald Tribune* that the country was "on the edge, if not already in the midst of, what might not improperly be called a Negro renaissance"—thereby giving the movement its name.

Priming the public for the Fifth Avenue Restaurant occasion, the special edition of *Survey Graphic* edited by Locke, "Harlem: Mecca of the New Negro," had reached an unprecedented 42,000 readers in March 1925. The ideology of cultural nationalism at the heart of the Renaissance was crisply delineated in Locke's opening essay, "Harlem": "Without pretense to their political significance, Harlem has the same role to play for the New Negro as Dublin has had for the New Ireland or Prague for the New Czechoslovakia." A vast racial formation was under way in the relocation of the peasant masses ("they stir, they move, they are more than physically restless"), the editor announced. "The challenge of the new intellectuals among them is clear enough." The migrating peasants from the South were the soil out of which all success would come, but soil must be tilled, and the Howard University philosopher reserved that task exclusively for the Talented Tenth in liaison with its mainstream analogues—in the "carefully maintained contacts of the enlightened minorities of both race groups." There was little amiss about America that interracial elitism could not set right, Locke and the others believed. Despite historical discrimination and the Red Summer, the Rhodes scholar assured readers that the increasing radicalism among African Americans was superficial. The African American was only a "forced radical," a radical "on race matters, conservative on others." In a surfeit of mainstream reassurance, Locke concluded, "The Negro mind reaches out as yet to nothing but American events, American ideas." At year's end, Albert and Charles Boni published Locke's *The New Negro,* an expanded and polished edition of the poetry and prose from the *Opportunity* contest and the special *Survey Graphic.*

The course of American letters was unchanged by the offerings in *The New Negro.* Still, the book carried several memorable works, such as the short story "The South Lingers On," by Brown University and Howard Medical School graduate Rudolph FISHER;

the acid "White House(s)" and the euphonic "The Tropics in New York," poems by McKay, now in European self-exile, and several poetic vignettes from Toomer's *Cane.* Hughes's "Jazzonia," previously published in the *Crisis,* was so poignant as to be almost tactile as it described "six long-headed jazzers" playing while a dancing woman "lifts high a dress of silken gold." In "Heritage," a poem previously unpublished, Cullen outdid himself in his grandest (if not his best) effort with its famous refrain, "What is Africa to me." The book carried distinctive silhouette drawings and Egyptian-influenced motifs by Aaron Douglas, whose work was to become the artistic signature of the Renaissance. With thirty-four African-American contributors—four were white— Locke's work included most of the Renaissance regulars. (The notable omissions were Asa Randolph, George Schuyler, and Wallace Thurman.) These were the gifted men and women who were to show by example what the potential of some African Americans could be and who proposed to lead their people into an era of opportunity and justice.

Deeply influenced, as were Du Bois and Fauset, by readings in German political philosophy and European nationalism (especially Herder and Fichte, Palacky and Synge, Herzl and Mazzini), Locke's notion of civil rights advancement was a "cell group" of intellectuals, artists, and writers "acting as the advance guard of the African peoples in their contact with Twentieth century civilization." By virtue of their symbolic achievements and their adroit collaboration with the philanthropic and reform-minded mainstream, their augmenting influence would ameliorate the socioeconomic conditions of their race over time and from the top downward. It was a Talented Tenth conceit, Schuyler snorted in Asa Randolph's MESSENGER magazine, worthy of a "high priest of the intellectual snobbocracy," and he awarded Locke the magazine's "elegantly embossed and beautifully lacquered dill pickle." Yet Locke's approach seemed to work, for although the objective conditions confronting most African Americans in Harlem and elsewhere were deteriorating, optimism remained high. Harlem recoiled from Garveyism and socialism to applaud Phi Beta Kappa poets, university-trained painters, concertizing musicians, and novel-writing officers of civil rights organizations. "Everywhere we heard the sighs of wonder, amazement and sometimes admiration when it was whispered or announced that here was one of the 'New Negroes,'" Bontemps recalled.

By the summer of 1926, Renaissance titles included the novels *Cane, There is Confusion, The Fire in the Flint,* and Walter White's *Flight* (1926), and the volumes of poetry *Harlem Shadows,* Cullen's *Color* (1924), and Hughes's *The Weary Blues* (1926). The

second *Opportunity* awards banquet, in April 1926, was another artistic and interracial success. Playwright Joseph Cotter was honored again, as was Hurston for a short story. Bontemps, a California-educated poet struggling in Harlem, won first prize for "Golgotha Is a Mountain," and Dorothy West, a Bostonian aspiring to make a name in fiction, made her debut, as did essayist Arthur FAUSET, Jessie's able half-brother. The William E. Harmon Foundation transferred its attention at the beginning of 1926 from student loans and blind children to the Renaissance, announcing seven annual prizes for literature, music, fine arts, industry, science, education, and race relations, with George Edmund HAYNES, African-American official in the Federal Council of Churches, and Locke as chief advisors. That same year, the publishers Boni & Liveright offered a $1,000 prize for the "best novel on Negro life" by an African America. Caspar Holstein contributed $1,000 that year to endow *Opportunity* prizes; Van Vechten made a smaller contribution to the same cause. Amy Spingarn provided $600 toward the *Crisis* awards. Otto Kahn underwrote two years in France for the young artist Hale Woodruff. There were the Louis Rodman Wanamaker prizes in music composition.

Both the Garland Fund (American Fund for Public Service) and the NAACP's coveted Spingarn Medal were intended to promote political and social change rather than creativity, but three of eight Spingarn medals were awarded to artists and writers between 1924 and 1931, and the Garland Fund was similarly responsive. The first of the Guggenheim Fellowships awarded to Renaissance applicants went to Walter White in 1927, to be followed by Eric Walrond, Nella Larsen (Imes), and Zora Neale Hurston. The Talented Tenth's more academically oriented members benefited from the generosity of the new Rosenwald Fund fellowships.

The third *Opportunity* awards dinner was a vintage one for poetry, with entries by Bontemps, Sterling Brown, Hughes, Helene JOHNSON, and Jonathan H. Brooks. In praising their general high quality, the white literary critic Robert T. Kerlin added the revealing comment that their effect would be "hostile to lynching and to jim-crowing." Walrond's lush, impressionistic collection of short stories, *Tropic Death,* appeared from Boni & Liveright at the end of 1926, the most probing exploration of the psychology of cultural underdevelopment since Toomer's *Cane.* If *Cane* recaptured in a string of glowing vignettes (most of them about women) the sunset beauty and agony of a preindustrial culture, *Tropic Death* did much the same for the Antilles. Hughes's second volume of poetry, *Fine Clothes to the Jew* (1927), spiritedly portrayed the city life of ordinary men and women who had traded the hardscrabble of

farming for the hardscrabble of domestic work and odd jobs. Hughes scanned the low-down pursuits of "Bad Man," "Ruby Brown," and "Beale Street," and shocked Brawley and other Talented Tenth elders with the bawdy "Red Silk Stockings." "Put on yo' red silk stockings, / Black gal," it began, urging her to show herself to white boys. It ended wickedly with "An' tomorrow's chile'll / Be a high yaller."

A melodrama of Harlem life that had opened in February 1926, *Lulu Belle,* produced by David Belasco, won the distinction for popularizing Harlem with masses of Jazz Age whites. But the part of Lulu Belle was played by Lenore Ulric in blackface. Drama quickened again in the fall of 1927 with Harlemite Frank Wilson (and, for one month, Robeson) in the lead role in Du Bose and Dorothy Heyward's hugely successful play *Porgy. Porgy* brought recognition and employment to Rose MCCLENDON, Georgette Harvey, Evelyn Ellis, Jack Carter, Percy Verwayne, and Leigh Whipper. Richard Bruce Nugent, Harlem's most outrageous decadent, and Wallace Thurman, a Utah-born close second, newly arrived from Los Angeles, played members of the population of "Catfish Row." Frank Wilson of *Porgy* fame wrote a play himself, *Meek Mose,* which opened on Broadway in February 1928. Its distinction lay mainly in the employment it gave to Harlem actors, and secondarily in an opening-night audience containing Mayor James Walker, Tuskegee principal Robert Russa Moton, Alexander Woollcott, Harry T. Burleigh, Otto Kahn, and the Joel Spingarns. There was a spectacular Carnegie Hall concert in March 1928 by the ninety-voice Hampton Institute Choir, followed shortly by W. C. HANDY's Carnegie Hall lecture on the origins and development of African-American music, accompanied by choir and orchestra.

Confidence among African-American leaders in the power of the muses to heal social wrongs was the rule, rather than the exception, by 1927. Every issue of *Opportunity,* the gossipy *Inter-State Tattler* newspaper, and, frequently, even the mass-circulation Chicago *Defender* or the *soi-disant* socialist *Messenger* trumpeted racial salvation through artistic excellence until the early 1930s. *Harper's* for November 1928 carried James Weldon Johnson's article reviewing the strategies employed in the past for African-American advancement: "religion, education, politics, industrial, ethical, economic, sociological." The executive secretary of the NAACP serenely concluded that "through his artistic efforts the Negro is smashing" racial barriers to his progress "faster than he has ever done through any other method." Charles Johnson, Jessie Fauset, Alain Locke, and Walter White fully agreed. Such was their influence with foundations, publishing houses, the Algonquin Round Table, and various godfathers and godmothers of the Renais-

sance (such as the mysterious, tyrannical, fabulously wealthy Mrs. Osgood Mason) that McKay, viewing the scene from abroad, spoke derisively of the artistic and literary autocracy of "that NAACP crowd."

A veritable ministry of culture now presided over African America. The ministry mounted a movable feast to which the anointed were invited, sometimes to Walter and Gladys White's apartment at 409 Edgecombe Avenue, where they might share cocktails with Sinclair Lewis or Mencken; often (after 1928) to the famous 136th Street "Dark Tower" salon maintained by beauty-culture heiress A'Lelia WALKER, where guests might be Sir Osbert Sitwell, the crown prince of Sweden, or Lady Mountbatten; and very frequently to the West Side apartment of Carl and Fania Van Vechten, to imbibe the host's sidecars and listen to Robeson sing or Jim Johnson recite from "God's Trombones" or George Gershwin play the piano. Meanwhile, Harlem's appeal to white revelers inspired the young physician Rudolph Fisher to write a satiric piece in the August 1927 *American Mercury* called "The Caucasian Storms Harlem."

The third phase of the Harlem Renaissance began even as the second had just gotten under way. The second phase (1924 to mid-1926) was dominated by the officialdom of the two major civil rights organizations, with their ideology of the advancement of African Americans through the creation and mobilization of an artistic-literary movement. Its essence was summed up in blunt declarations by Du Bois that he didn't care "a damn for any art that is not used for propaganda," or in exalted formulations by Locke that the New Negro was "an augury of a new democracy in American culture." The third phase of the Renaissance, from mid-1926 to 1934, was marked by rebellion against the civil rights establishment on the part of many of the artists and writers whom that establishment had promoted. Three publications during 1926 formed a watershed between the genteel and the demotic Renaissance. Hughes's "The Negro Artist and the Racial Mountain," appearing in the June 1926 issue of the *Nation,* served as a manifesto of the breakaway from the arts and letters party line. Van Vechten's *Nigger Heaven,* released by Knopf that August, drove much of literate Afro-America into a dichotomy of approval and apoplexy over "authentic" versus "proper" cultural expression. Wallace Thurman's *Fire!!,* available in November, assembled the rebels for a major assault against the civil rights ministry of culture.

Hughes's turning-point essay had been provoked by Schuyler's *Nation* article "The Negro Art-Hokum," which ridiculed "eager apostles from Greenwich Village, Harlem, and environs" who made claims for a special African-American artistic vision distinctly different from that of white Americans. "The Aframerican is merely a lampblacked Anglo-Saxon," Schuyler had sneered. In a famous peroration, Hughes answered that he and his fellow artists intended to express their "individual dark-skinned selves without fear or shame. If white people are pleased we are glad. . . . If colored people are pleased we are glad. If they are not, their displeasure doesn't matter either." And there was considerable African-American displeasure. Much of the condemnation of the license for expression Hughes, Thurman, Hurston, and other artists arrogated to themselves was generational or puritanical, and usually both. "Vulgarity has been mistaken for art," Brawley spluttered after leafing the pages of *Fire!!* "I have just tossed the first issue of *Fire!!* into the fire," the book review critic for the Baltimore *Afro-American* snapped after reading Richard Bruce Nugent's extravagantly homoerotic short story "Smoke, Lillies and Jade." Du Bois was said to be deeply aggrieved.

But much of the condemnation stemmed from racial sensitivity, from sheer mortification at seeing uneducated, crude, and scrappy black men and women depicted without tinsel or soap. Thurman and associated editors John Davis, Aaron Douglas, Gwendolyn Bennett, Arthur Huff Fauset, Hughes, Hurston, and Nugent took the Renaissance out of the parlor, the editorial office, and the banquet room. *Fire!!* featured African motifs drawn by Douglas and Nordic-featured African Americans with exaggeratedly kinky hair by Nugent, poems to an elevator boy by Hughes, jungle themes by Edward Silvera; short stories about prostitution ("Cordelia the Crude") by Thurman, gender conflict between black men and women at the bottom of the economy ("Sweat") by Hurston, and a burly boxer's hatred of white people ("Wedding Day") by Bennett; and a short play about pigment complexes within the race (*Color Struck*) by Hurston, shifting the focus to Locke's "peasant matrix," to the sorrows and joys of those outside the Talented Tenth. "Let the blare of Negro jazz bands and the bellowing voice of Bessie Smith . . . penetrate the closed ears of the colored near-intellectuals," Hughes exhorted in "The Negro Artist and the Racial Mountain."

Van Vechten's influence decidedly complicated the reactions of otherwise worldly critics such as Du Bois, Jessie Fauset, Locke, and Cullen. While his novel's title alone enraged many Harlemites who felt their trust and hospitality betrayed, the deeper objections of the sophisticated to *Nigger Heaven* lay in its message that the Talented Tenth's preoccupation with cultural improvement was a misguided affectation that would cost the race its vitality. It was the "archaic Negroes" who were at ease in their skins and capable of action, Van Vechten's characters

demonstrated. Significantly, although Du Bois and Fauset found themselves in the majority among the Renaissance leadership (ordinary Harlemites burned Van Vechten in effigy at 135th Street and Lenox Avenue), Charles Johnson, James Weldon Johnson, Schuyler, White, and Hughes praised the novel's sociological verve and veracity and the service they believed it rendered to race relations.

The younger artists embraced Van Vechten's fiction as a worthy model because of its ribald iconoclasm and its iteration that the future of African-American arts lay in the culture of the working poor, and even of the underclass—in bottom-up drama, fiction, music, poetry, and painting. Regularly convening at the notorious "267 House," Thurman's rent-free apartment on 136th Street (alternately known as "Niggerati Manor"), the group that came to produce *Fire!!* saw art not as politics by other means—civil rights between book covers or from a stage or an easel—but as an expression of the intrinsic conditions most people of African descent were experiencing. They spoke of the need "for a truly Negroid note," for empathy with "those elements within the race which are still too potent for easy assimilation," and they openly mocked the premise of the civil rights establishment that (as a Hughes character says in *The Ways of White Folks*) "art would break down color lines, art would save the race and prevent lynchings! Bunk!" Finally, like creative agents in society from time immemorial, they were impelled to insult their patrons and to defy conventions.

To put the Renaissance back on track, Du Bois sponsored a symposium in late 1926, inviting a wide spectrum of views about the appropriate course the arts should take. His unhappiness was readily apparent, both with the overly literary tendencies of Locke and with the bottom-up school of Hughes and Thurman. The great danger was that politics was dropping out of the Renaissance, that the movement was turning into an evasion, sedulously encouraged by certain whites. "They are whispering, 'Here is a way out. Here is the real solution to the color problem. The recognition accorded Cullen, Hughes, Fauset, White, and others shows there is no real color line,'" Du Bois charged. He then announced that all *Crisis* literary prizes would henceforth be reserved for works encouraging "general knowledge of banking and insurance in modern life and specific knowledge of what American Negroes are doing in these fields." Neither James Weldon Johnson nor White (soon to be a Guggenheim fellow on leave from the NAACP to write another novel in France) approved of the withdrawal of the *Crisis* from the Renaissance, but they failed to change Du Bois's mind.

White's own effort to sustain the civil-rights-by-copyright strategy was the ambitious novel *Flight*, edited by his friend Sinclair Lewis and released by Knopf in 1926. A tale of near-white African Americans of unusual culture and professional accomplishment who prove their moral superiority to their oppressors, White's novel was considered somewhat flat even by kind critics. Unkind critics, such as Thurman and the young Frank Horne at *Opportunity*, savaged it. The reissue the following year of *The Autobiography of an Ex-Colored Man* (with Johnson's authorship finally acknowledged) and publication of a volume of Cullen's poetry, *Copper Sun*, continued the tradition of genteel, exemplary letters. In a further effort to restore direction, Du Bois's *Dark Princess* appeared in 1928 from Harcourt, Brace; it was a large, serious novel in which the "problem of the twentieth century" is taken in charge by a Talented Tenth International whose prime mover is a princess from India. But the momentum stayed firmly with the rebels.

Although Thurman's magazine died after one issue, respectable Afro-America was unable to ignore the novel that embodied the values of the Niggerati—the first Renaissance best-seller by a black author: McKay's *Home to Harlem*, released by Harper & Brothers in the spring of 1928. No graduates of Howard or Harvard discourse on literature at the Dark Tower or at Jessie Fauset's in this novel. It has no imitations of Du Bois, James Weldon Johnson, or Locke—and no whites at all. Its milieu is wholly plebeian. The protagonist, Jake, is a Lenox Avenue Noble Savage who demonstrates (in marked contrast to the book-reading Ray) the superiority of the Negro mind uncorrupted by European learning. *Home to Harlem* finally shattered the enforced literary code of the civil rights establishment. The *Defender* disliked McKay's novel, and Du Bois, who confessed feeling "distinctly like needing a bath" after reading it, declared that *Home to Harlem* was about the "debauched tenth." Rudolph Fisher's *The Walls of Jericho*, appearing that year from Knopf, was a brilliant, deftly executed satire that upset Du Bois as much as it heartened Thurman. Fisher, a successful Harlem physician with solid Talented Tenth family credentials, satirized the NAACP, the Negrotarians, Harlem high society, and easily recognized Renaissance notables, while entering convincingly into the world of the working classes, organized crime, and romance across social strata.

Charles Johnson, preparing to leave the editorship of *Opportunity* for a professorship in sociology at Fisk University, now encouraged the young rebels. Before departing, he edited an anthology of Renaissance prose and poetry, *Ebony and Topaz*, in late 1927. The movement was over its birth pangs, his preface declared. Sounding the note of Hughes's manifesto, he declared that the period of extreme touchiness was

behind. Renaissance artists were "now less self-conscious, less interested in proving that they are just like white people. . . . Relief from the stifling consciousness of being a problem has brought a certain superiority" to the Harlem Renaissance, Johnson asserted. Johnson left for Nashville in March 1928, four years to the month after his first Civic Club invitations.

Meanwhile, McKay's and Fisher's fiction inspired the Niggerati to publish an improved version of *Fire!!* The magazine, *Harlem,* appeared in November 1928. Editor Thurman announced portentously, "The time has now come when the Negro artist can be his true self and pander to the stupidities of no one, either white or black." While Brawley, Du Bois, and Fauset continued to grimace, *Harlem* benefited from significant defections. It won the collaboration of Locke and White; Roy de Coverly, George W. Little, and Schuyler signed on; and Hughes contributed one of his finest short stories, based on his travels down the west coast of Africa—"Luani of the Jungles," a polished genre piece on the seductions of the civilized and the primitive. Once again, Nugent was wicked, but this time more conventionally. The magazine lasted two issues.

The other Renaissance novel that year from Knopf, Nella Larsen's *Quicksand,* achieved the distinction of being praised by Du Bois, Locke, and Hughes. Larsen was born in the Danish Virgin Islands of mixed parentage. Trained in the sciences at Fisk and the University of Copenhagen, she would remain something of a mystery woman, helped in her career by Van Vechten and White but somehow always receding, and finally disappearing altogether from the Harlem scene. *Quicksand* was a triumph of vivid yet economical writing and rich allegory. Its very modern heroine experiences misfortunes and ultimate destruction from causes that are both racial and individual; she is not a tragic mulatto, but a mulatto who is tragic for both sociological and existential reasons. Roark Bradford, in the *Herald Tribune,* thought *Quicksand*'s first half very good, and Du Bois said it was the best fiction since Chesnutt.

There were reviews (*Crisis, New Republic, New York Times*) that were as laudatory about Jessie Fauset's *Plum Bun,* also a 1928 release, but they were primarily due to the novel's engrossing reconstruction of rarefied, upper-class African-American life in Philadelphia, rather than to special literary merit. If Helga Crane, the protagonist of *Quicksand,* was the Virginia Slim of Renaissance fiction, then Angela Murray (Angele, in her white persona), Fauset's heroine in her second novel, was its Gibson Girl. *Plum Bun* continued the second phase of the Renaissance, as did Cullen's second volume of poetry, *The Black Christ,* published in 1929. Ostensibly about a lynch-

ing, the lengthy title poem lost its way in mysticism, paganism, and religious remorse. The volume also lost the sympathies of most reviewers.

Thurman's *The Blacker the Berry,* published by Macaulay in early 1929, although talky and awkward in spots (Thurman had hoped to write the Great African-American Novel), was a breakthrough. The reviewer for the Chicago *Defender* enthused, "Here at last is the book for which I have been waiting, and for which you have been waiting." Hughes praised it as a "gorgeous book," mischievously writing Thurman that it would embarrass those who bestowed the "seal-of-high-and-holy approval of Harmon awards." The ministry of culture found the novel distinctly distasteful: *Opportunity* judged *The Blacker the Berry* to be fatally flawed by "immaturity and gaucherie." For the first time, color prejudice within the race was the central theme of an African-American novel. Emma Lou, its heroine (like the author, very dark and conventionally unattractive), is obsessed with respectability as well as tortured by her pigment. Thurman makes the point on every page that Afro-America's aesthetic and spiritual center resides in the unaffected, unblended, noisome common folk and the liberated, unconventional artists.

With the unprecedented Broadway success of *Harlem,* Thurman's sensationalized romp through the underside of that area, the triumph of Niggerati aesthetics over civil rights arts and letters was impressively confirmed. The able theater critic for the *Messenger,* Theophilus Lewis, rejoiced at the "wholesome swing toward dramatic normalcy." George Jean Nathan lauded *Harlem* for its "sharp smell of reality." Another equally sharp smell of reality irritated establishment nostrils that same year with the publication of McKay's second novel, *Banjo,* appearing only weeks after *The Blacker the Berry.* "The Negroes are writing against themselves," lamented the reviewer for the *Amsterdam News.* Set among the human flotsam and jetsam of Marseilles and West Africa, McKay's novel again propounded the message that European civilization was inimical to Africans everywhere.

The stock market collapsed, but reverberations from the Harlem Renaissance seemed stronger than ever. Larsen's second novel, *Passing,* appeared. Its theme, like Fauset's, was the burden of mixed racial ancestry. But, although *Passing* was less successful than *Quicksand,* Larsen again evaded the trap of writing another tragic-mulatto novel by opposing the richness of African-American life to the material advantages afforded by the option of "passing." In February 1930, white playwright Marc Connelly's dramatization of Roark Bradford's book of short stories opened on Broadway as *The Green Pastures.* The Hall Johnson Choir sang in it, Richard HARRISON

played "De Lawd," and scores of Harlemites found parts during 557 performances at the Mansfield Theatre, and then on tour across the country. The demanding young critic and Howard University professor of English Sterling Brown pronounced the play a "miracle." The ministry of culture (increasingly run by White, after James Weldon Johnson followed Charles Johnson to a Fisk professorship) deemed *The Green Pastures* far more significant for civil rights than Thurman's *Harlem* and even than King Vidor's talking film *Hallelujah!* The NAACP's Spingarn Medal for 1930 was presented to Harrison by New York's lieutenant governor, Herbert Lehman.

After *The Green Pastures* came *Not Without Laughter,* Hughes's glowing novel from Knopf. Financed by Charlotte Osgood Mason ("Godmother") and Amy Spingarn, Hughes had resumed his college education at Lincoln University and completed *Not Without Laughter* his senior year. The beleaguered family at the center of the novel represents Afro-Americans in transition within white America. Hughes's young male protagonist learns that proving his equality means affirming his distinctive racial characteristics. Not only did Locke admire *Not Without Laughter,* the *New Masses* reviewer embraced it as "our novel." The ministry of culture decreed Hughes worthy of the Harmon gold medal for 1930. The year ended with Schuyler's ribald, sprawling satire *Black No More,* an unsparing demolition of every personality and institution in Afro-America. Little wonder that Locke titled his retrospective piece in the February 1931 *Opportunity* "The Year of Grace." Depression notwithstanding, the Renaissance appeared to be more robust than ever.

The first Rosenwald fellowships for African Americans had been secured, largely due to James Weldon Johnson's influence, the previous year. Beginning with Johnson himself in 1930, most of the African Americans who pursued cutting-edge postgraduate studies in the United States over the next fifteen years would be recipients of annual Rosenwald fellowships. Since 1928 the Harmon Foundation, advised by Locke, had mounted an annual traveling exhibition of drawings, paintings, and sculpture by African Americans. The 1930 installment introduced the generally unsuspected talent and genius of Palmer HAYDEN, William H. JOHNSON, Archibald MOTLEY, Jr., James A. PORTER, and Laura Wheeler Waring in painting. Sargent JOHNSON, Elizabeth PROPHET, and Augusta SAVAGE were the outstanding sculptors of the show. Both Aaron Douglas and Romare BEARDEN came to feel that the standards of the foundation were somewhat indulgent and therefore injurious to many young artists, which was undoubtedly true. Nevertheless, the Harmon made it possible for African-American artists to find markets previously wholly closed to them. In 1931, more than 200 works

of art formed the Harmon Travelling Exhibition of the Work of Negro Artists, to be seen by more than 150,000 people.

Superficially, Harlem itself appeared to be in fair health well into 1931. James Weldon Johnson's celebration of the community's strengths, *Black Manhattan,* was published near the end of 1930. "Harlem is still in the process of making," the book proclaimed, and the author's confidence in the power of the "recent literary and artistic emergence" to ameliorate race relations was unshaken. In Johnson's Harlem, redcaps and cooks cheered when Renaissance talents won Guggenheim and Rosenwald fellowships; they rushed to newsstands whenever the *American Mercury* or *New Republic* mentioned activities above Central Park. In this Harlem, dramatic productions unfolded weekly at the YMCA; poetry readings were held regularly at Ernestine Rose's 135th Street Public Library (today's Schomburg Center); and people came after work to try out for Du Bois's Krigwa Players in the library's basement. It was the Harlem of amateur historians such as J. A. Rogers, who made extraordinary claims about the achievements of persons of color, and of dogged bibliophiles such as Arthur Schomburg, who documented extraordinary claims. It was much too easy for Talented Tenth notables Johnson, White, and Locke not to notice in the second year of the Great Depression that for the vast majority of the population, Harlem was in the process of unmaking. Still, there was a definite prefiguration of its mortality when A'Lelia Walker suddenly died in August 1931, a doleful occurrence shortly followed by the sale of Villa Lewaro, her Hudson mansion, at public auction.

Meanwhile, the much-decorated Fifteenth Infantry Regiment (the 369th during World War I) took possession of a new headquarters, the largest National Guard armory in the state. The monopoly of white doctors and nurses at Harlem General Hospital had been effectively challenged by the NAACP and the brilliant young surgeon Louis T. Wright. There were two well-equipped private sanitariums in Harlem by the end of the 1920s: the Vincent, financed by numbers king Caspar Holstein, and the Wiley Wilson, equipped with divorce settlement funds by one of A'Lelia Walker's husbands. Rudolph Fisher's X-ray laboratory was one of the most photographed facilities in Harlem.

Decent housing was becoming increasingly scarce for most families; the affluent, however, had access to excellent accommodations. Talented Tenth visitors availed themselves of the Dumas or the Olga, two well-appointed hotels. By the end of 1929, African Americans lived in the 500 block of Edgecombe Avenue, known as "Sugar Hill." The famous "409" overlooking the Polo Grounds was home at one time or another to the Du Boises, the Fishers, and the

Whites. Below Sugar Hill was the five-acre, Rockefeller-financed Dunbar Apartments complex, its 511 units fully occupied in mid-1928. The Dunbar eventually became home for the Du Boises, E. Simms CAMPBELL (illustrator and cartoonist), Fletcher Henderson, the A. Philip RANDOLPHs, Leigh Whipper (actor), and, briefly, Paul and Essie Robeson. The complex published its own weekly bulletin, the *Dunbar News,* an even more valuable record of Talented Tenth activities during the Renaissance than the *Inter-State Tattler.*

The 1931 *Report on Negro Housing,* presented to President Hoover, was a document starkly in contrast to the optimism found in *Black Manhattan.* Nearly 50 percent of Harlem's families would be unemployed by the end of 1932. The syphilis rate was nine times higher than white Manhattan's; the tuberculosis rate was five times greater; those for pneumonia and typhoid were twice those of whites. Two African-American mothers and two babies died for every white mother and child. Harlem General Hospital, the area's single public facility, served 200,000 people with 273 beds. Twice as much of the income of a Harlem family went for rent as a white family's. Meanwhile, median family income in Harlem dropped 43.6 percent in two years by 1932. The ending of Prohibition would devastate scores of marginal speakeasies, as well as prove fatal to theaters such as the Lafayette. Connie's Inn would eventually migrate downtown. Until then, however, the clubs in "The Jungle," as 133rd Street was called (Bamville, Connor's, the Clam House, the Nest Club), and elsewhere (Pod's and Jerry's, Smalls' Paradise) continued to do a land-office business.

Because economic power was the Achilles' heel of the community, real political power also eluded Harlem. Harlem's Republican congressional candidates made unsuccessful runs in 1924 and 1928. Until the Twenty-first Congressional District was redrawn after the Second World War, African Americans were unable to overcome Irish, Italian, and Jewish voting patterns in order to elect one of their own. In state and city elections, black Harlem fared better. African-American aldermen had served on the City Council since 1919; black state assemblymen were first elected in 1917. Republican party patronage was funneled through the capable but aged Charles W. ("Charlie") Anderson, collector of Internal Revenue for the Third District. Although African Americans voted overwhelmingly for the Republican ticket at the national level, Harlemites readily voted for Democrats in city matters. Democratic patronage for Harlem was handled by Harvard-educated Ferdinand Q. Morton, chairman of the Municipal Civil Service Commission and head of the UNITED COLORED DEMOCRACY— "Black Tammany." In 1933, Morton would bolt the Democrats to help elect Fusion candidate Fiorello La Guardia mayor. Despite a growing sense of political consciousness, greatly intensified by the exigencies of the depression, Harlem continued to be treated by City Hall and the municipal bureaucracies as though it were a colony.

The thin base of its economy and politics eventually began to undermine the Renaissance. Mainstream sponsorship, direct and indirect, was indispensable to the movement's momentum, and as white foundations, publishers, producers, readers, and audiences found their economic resources drastically curtailed (the reduced value of Sears, Roebuck stock chilled Rosenwald Fund philanthropy), interest in African Americans evaporated. With the repeal of the Eighteenth Amendment, ending Prohibition, honorary Harlemites such as Van Vechten sobered up and turned to other pursuits. Locke's letters to Charlotte Osgood Mason turned increasingly pessimistic in the winter of 1931. In June 1932, he perked up a bit to praise the choral ballet presented at the Eastman School of Music, *Sahdji,* with music by William Grant Still and scenario by Richard Bruce Nugent, but most of Locke's news was distinctly downbeat. The writing partnership of two of his protégés, Hughes and Hurston, their material needs underwritten in a New Jersey township by "Godmother," collapsed in acrimonious dispute. Each claimed principal authorship of the only dramatic comedy written during the Renaissance, *Mule Bone,* a three-act folk play that went unperformed (as a result of the dispute) until 1991. Locke took the side of Hurston, undermining the affective tie between Godmother and Hughes, and essentially ending his relationship with the latter. The part played in this controversy by their brilliant secretary, Louise Thompson, the strong-willed, estranged wife of Wallace Thurman, remains murky, but it seems clear that Thompson's Marxism had a deep influence on Hughes in the aftermath of his painful breakup with Godmother, Locke, and Hurston.

In any case, beginning with "Advertisement for the Waldorf-Astoria," published in the December 1931 *New Masses,* Hughes's poetry became markedly political. "Elderly Race Leaders" and "Goodbye Christ," as well as the play *Scottsboro, Limited,* were irreverent, staccato offerings to the coming triumph of the proletariat. The poet's departure in June 1932 for Moscow, along with Louise Thompson, Mollie Lewis, Henry Moon, Loren Miller, Theodore Poston, and thirteen others, ostensibly to act in a Soviet film about American race relations, *Black and White,* symbolized the shift in patronage and the accompanying politicization of Renaissance artists. If F. Scott Fitzgerald, golden boy of the Lost Generation, could predict that "it may be necessary to work inside the Communist party" to put things right again in America, no one should have been surprised that Cullen

and Hughes united in 1932 to endorse the Communist party candidacy of William Z. Foster and the African American James W. Ford for president and vice-president of the United States, respectively. *One Way to Heaven,* Cullen's first novel—badly flawed and clearly influenced by *Nigger Heaven*—appeared in 1932, but it seemed already a baroque anachronism with its knife-wielding Lotharios and elaborately educated types. An impatient Du Bois, deeply alienated from the Renaissance, called for a second Amenia Conference (*see* AMENIA CONFERENCE, 1933) to radicalize the ideology and renew the personnel of the organization.

Jessie Fauset remained oblivious to the profound artistic and political changes under way. Her final novel, *Comedy: American Style* (1933), was technically much the same as *Plum Bun.* Once again, her subject was skin pigment and the neuroses of those who had just enough of it to spend their lives obsessed by it. James Weldon Johnson's autobiography, *Along This Way,* was the publishing event of the year, an elegantly written review of his sui generis public career as archetypal Renaissance man in both meanings of the word. McKay's final novel also appeared that year. He worried familiar themes, but *Banana Bottom* represented a philosophical advance over *Home to Harlem* and *Banjo* in its reconciliation through the protagonist, Bita Plant, of the previously destructive tension in McKay's work between the natural and the artificial, soul and civilization.

The publication at the beginning of 1932 of Thurman's last novel, *Infants of the Spring,* had already announced the end of the Harlem Renaissance. The action of the book is in the characters' ideas, in their incessant talk about themselves, Booker T. Washington, W. E. B. Du Bois, racism, and the destiny of the race. Its prose is generally disappointing, but the ending is conceptually poignant. Paul Arbian (a stand-in for Richard Bruce Nugent) commits suicide in a full tub of water, which splashes over and obliterates the pages of Arbian's unfinished novel on the bathroom floor. A still legible page, however, contains this paragraph that was in effect an epitaph:

> He had drawn a distorted, inky black skyscraper, modeled after Niggerati Manor, and on which were focused an array of blindingly white beams of light. The foundation of this building was composed of crumbling stone. At first glance it could be ascertained that the skyscraper would soon crumple and fall, leaving the dominating white lights in full possession of the sky.

The literary energies of the Renaissance finally slumped. McKay returned to Harlem in February 1934 after a twelve-year sojourn abroad, but his creative powers were spent. The last novel of the move-

ment, Hurston's beautifully written *Jonah's Gourd Vine,* went on sale in May 1934. Charles Johnson, James Weldon Johnson, and Locke applauded Hurston's allegorical story of her immediate family (especially her father) and the mores of an African-American town in Florida called Eatonville. Fisher and Thurman could have been expected to continue to write, but their fates were sealed by the former's professional carelessness and the latter's neurotic alcoholism. A few days before Christmas 1934, Thurman died, soon after his return from an abortive Hollywood film project. Ignoring his physician's strictures, he hemorrhaged after drinking to excess while hosting a party in the infamous house at 267 West 136th Street. Four days later, Fisher expired from intestinal cancer caused by repeated exposure to his own X-ray equipment. A grieving Locke wrote Charlotte Mason from Howard University, "It is hard to see the collapse of things you have labored to raise on a sound base."

Locke's anthology had been crucial to the formation of the Renaissance. As the movement ran down, another anthology, English heiress Nancy Cunard's *Negro,* far more massive in scope, recharged the Renaissance for a brief period. Enlisting the contributions of most of the principals (though McKay and Walrond refused, and Toomer no longer acknowledged his African-American roots), Cunard captured its essence, in the manner of expert taxidermy.

Arthur Fauset attempted to explain the collapse to Locke and the readers of *Opportunity* at the beginning of 1934. He foresaw "a socio-political-economic setback from which it may take decades to recover." The Renaissance had left the race unprepared, Fauset charged, because of its unrealistic belief "that social and economic recognition will be inevitable when once the race has produced a sufficiently large number of persons who have properly qualified themselves in the arts." James Weldon Johnson's philosophical *tour d'horizon* appearing that year, *Negro Americans, What Now?,* asked precisely the question of the decade. Most Harlemites were certain that the riot exploding on the evening of March 19, 1935, taking three lives and causing $2 million in property damage, was not an answer. By then, the Works Progress Administration had become the major patron of African-American artists and writers. Writers like William ATTAWAY, Ralph ELLISON, Margaret WALKER, Richard WRIGHT, and Frank YERBY would emerge under its aegis, as would painters Romare Bearden, Jacob Lawrence, Charles SEBREE, Lois Maillou JONES, and Charles WHITE. The COMMUNIST PARTY was another patron, notably for Richard Wright, whose 1937 essay "Blueprint for Negro Writing" would materially contribute to the premise of Hughes's "The Negro Artist and the Racial Moun-

tain." And for thousands of ordinary Harlemites who had looked to Garvey's UNIA for inspiration, then to the Renaissance, there was now FATHER DIVINE and his "heavens."

In the ensuing years much was renounced, more was lost or forgotten; yet the Renaissance, however artificial and overreaching, left a positive mark. Locke's *New Negro* anthology featured thirty of the movement's thirty-five stars. They and a small number of less gifted collaborators generated 26 novels, 10 volumes of poetry, 5 Broadway plays, countless essays and short stories, 3 performed ballets and concerti, and a considerable output of canvas and sculpture. If the achievement was less than the titanic expectations of the ministry of culture, it was an artistic legacy, nevertheless, of and by which a beleaguered Afro-America could be both proud and sustained. Though more by osmosis than by conscious attention, mainstream America was also richer for the color, emotion, humanity, and cautionary vision produced by Harlem during its golden Age. "If I had supposed that all Negroes were illiterate brutes, I might be astonished to discover that they can write good third-rate poetry, readable and unreadable magazine fiction," was the flinty judgment of a contemporary white Marxist. That judgment was soon beyond controversy largely because the Harlem Renaissance finally, irrefutably, proved the once-controversial point during slightly more than a single decade.

REFERENCES

BONTEMPS, ARNA, ed. *The Harlem Renaissance Remembered: Essays Edited with a Memoir.* New York, 1972.

HUGGINS, NATHAN I. *Harlem Renaissance.* New York, 1971.

———, ed. *Voices from the Harlem Renaissance.* New York, 1976.

LEWIS, DAVID L. *When Harlem Was in Vogue.* New York, 1981.

WAGNER, JEAN. *Black Poets of the United States: From Paul Laurence Dunbar to Langston Hughes.* Urbana, Ill., 1973.

DAVID LEVERING LEWIS

Harlem Riots of 1935 and 1943.

In 1935, a riot broke out in HARLEM, N.Y., the "capital" of African-American life. Harlem had been hard hit by the GREAT DEPRESSION. White storeowners, despite a black majority clientele, often refused to hire African-American clerks. Boycotts and picketing, beginning in 1933, had forced some stores to hire black workers, but in 1935 several shopkeepers obtained an injunction against picketers, stalling the boycott movement. The injunction was enforced, often with some brutality, by New York police.

On March 19, 1935, a ten-year-old dark-skinned Puerto Rican boy, Lino Rivera, was caught shoplifting a small knife by a white storeowner at the S. H. Kress store on 125th Street. A scuffle ensued, and the boy hit a clerk. Police were called, and the boy was taken into custody and later released. Wild rumors spread that the boy had been beaten, especially after an ambulance arrived for the clerk. Soon after, a hearse parked by chance in front of the store, led to rumors of the boy's death. Harlemites, egged on by streetcorner speakers, surrounded the store and took to the streets, smashing windows and looting. Passing city buses were attacked. Police arrived to relieve the besieged storeowners. The following day, rioting resumed. By the end of the disturbance, three blacks had been killed, two hundred wounded, and $2 million of damage had been done, mostly to white-owned property.

Immediately following the disturbance, New York Mayor Fiorello La Guardia appointed a biracial Mayor's Commission on Conditions in Harlem, which commissioned a panel of experts, led by sociologist E. Franklin FRAZIER, to investigate the events. In the report, entitled "The Negro in Harlem: A Report on Social and Economic Conditions Responsible for the Outbreak of March 19, 1935," Frazier recommended vigorous antidiscrimination efforts by city housing, relief, and police authorities, and fair hiring in municipal jobs. La Guardia enlisted scholar Alain LOCKE to advise on implementing the report. Over the following years, La Guardia led efforts to enlarge Harlem Hospital, build public housing for blacks, convince city agencies to curb official racism, and train city police.

Nevertheless, conditions in Harlem remained tense through the early 1940s. Harlemites, led by City Councilman Adam Clayton POWELL, JR., complained constantly of police brutality and housing and economic discrimination. Blacks resented the hypocrisy of fighting a war for democracy in the segregated Army (*see* WORLD WAR II). In 1943, La Guardia infuriated blacks by approving a whites-only downtown housing project, Stuyvesant Town, and allowed segregated naval personnel to use facilities at city-owned Hunter College. City authorities temporarily closed down the SAVOY BALLROOM, a leading Harlem nightspot, on the grounds that it was a center of drug use and prostitution.

In July 1943, New Yorkers learned of the massive race riot and police repression in Detroit (*see* DETROIT RIOT OF 1943), and many people feared a similar disturbance in New York. Powell warned repeatedly of tensions in Harlem. He called for black

self-defense efforts. La Guardia, who denounced Powell as a demagogue, attempted to reduce tension and train security forces in proper riot control.

On August 1, 1943, Harlem "boiled over," in NAACP leader Walter WHITE's words. An African-American woman, Majorie Polite, became involved in an argument at the Braddock Hotel, and grew disorderly and profane. The management called the police when she refused to leave, and a police officer arrested her. Florine Roberts and her son Robert Bandy, a uniformed soldier, observing the action, demanded her release. Bandy then either grabbed the policeman's stick or hit him and ran. The officer called for him to stop, then opened fire, wounding him slightly. Bandy then went to be treated at Sydenham Hospital.

Rumors soon spread that police officers had killed a black soldier who was trying to protect his mother. Crowds of blacks surrounded the hotel, Sydenham Hospital, and the 28th Police Precinct. Three thousand blacks called out threats to the arresting officers. Around 10:30 P.M., crowds began breaking windows, vandalizing streets, and setting fires. La Guardia called out 5,000 police, who exercised great restraint in dealing with rioters, and firemen. He also toured the riot-torn streets pleading for calm in the company of such prominent African Americans as Max YERGAN, a well-known Harlem political figure. During the next twenty-four hours, the mayor made five separate radio broadcasts, calling on Harlemites to return to their homes. After midnight, the mayor ordered the area closed to nonresidents, banned street assembly, and closed all establishments serving liquor. Walter White and others rode in city sound trucks through the area to help restore order. The riot ended before dawn. Six African Americans had been killed, 185 injured, and 500 arrested.

The next day, fearing a recurrence, La Guardia imposed a partial curfew, lifted the wartime dimout, and brought emergency food supplies to relieve burned out shops and houses. The mayor called in 8,000 state guard troops (including an all-black regiment), 6,000 police, and 1,500 volunteers, almost all black, to stand by in case of trouble, though none were actually called on to patrol in Harlem.

White city authorities and black Harlemites who feared negative repercussions from the riot sought to blame the disturbance on "hoodlums," and denied that ordinary citizens took part in the riot. Even Powell sought to minimize the disturbance, denying it was a "race riot" or that racial tension was responsible. Despite his own admission that he did no more—though no less—for Harlem than for other sections of the city, the mayor was popular among New York's black population, and his swift, impartial reaction to the riots served further to increase his standing. La Guardia convened an Emergency Conference for Interracial Unity, chaired by singer Marian ANDERSON and William Jay Schieffelin, which brought together 200 distinguished New Yorkers, including Powell, Stanley M. Isaacs, Duke ELLINGTON, Ruth Benedict, and others, to suggest ways to reduce racial tension. La Guardia soon reopened the Savoy Ballroom, and opened a branch of the Office of Price Administration in Harlem to check on price-gouging merchants.

Like the Detroit riot of 1943, the Harlem riots of 1935 and 1943 began with blacks unleashing anger at police brutality and economic discrimination by destroying property. However, they were smaller affairs than the fearsome explosion in Detroit. Despite tensions between La Guardia and Powell, this was due in part to the relative restraint and responsiveness of New York officials and their cooperation with the local black leadership. The unusual level of cooperation between black Harlemites and city authorities was significant, as was the willingness of black leaders to pretend that the riots were the work of a few troublemakers rather than the community at large. The explanation probably lies in a combination of factors: fear of Detroit-style bloodshed; a desire to avoid giving America's wartime enemies propaganda points; respect for La Guardia and for moderate civil rights leadership; and confidence in the possibilities for peaceful change far greater than that present in the 1960s riots.

See also HARLEM RIOTS OF 1964, and URBAN RIOTS AND REBELLIONS.

REFERENCES

CAPECI, DOMINIC J. *The Harlem Riot of 1943*. Philadelphia, 1977.

HAMILTON, CHARLES V. *Adam Clayton Powell, Jr.: The Political Biography of an American Dilemma*. New York, 1991.

NAISON, MARK. *The Communists in Harlem During the Great Depression*. Urbana, Ill., 1983.

 GAYLE T. TATE

Harlem Riot of 1964. In July 1964, Harlem and several other African-American neighborhoods of New York City erupted in violence over police brutality, in demonstrations that prefigured the major urban rebellions later in the decade. In 1964, Harlemites had been involved in many large-scale protest activities, which had heightened their racial consciousness and militancy. On July 16, 1964, a fifteen-year-old African American, James Powell, was shot and killed by Thomas Gilligan, an off-duty police

officer in Manhattan's Yorkville neighborhood. That night, there was a peaceful student protest march in Harlem. Two days later, the combined New York chapters of the CONGRESS OF RACIAL EQUALITY (CORE) sponsored a protest march and rally. Black leaders had repeatedly urged the creation of a civilian review board to investigate mounting complaints of police brutality in Harlem. Posters referred to Gilligan as a "murderer," and speakers called for a review board and the firing of the city police commissioner.

After the rally, militant CORE speakers regrouped, and a crowd marched to the Harlem police precinct on 123rd Street to press their demands. When minor skirmishes began between demonstrators and police, police set up barricades and sixteen leaders were arrested and brought into the police station. Demonstrators charged that the protesters were being beaten and that their cries could be heard. Another skirmish broke out between police and demonstrators, with both groups gaining reinforcements. At approximately 10:30 P.M., a riot began with youths pelting police with missiles and Molotov cocktails, and police shooting over protesters' heads in an unsuccessful attempt to disperse them.

The rebellion continued for four nights, and spread to Brooklyn's Bedford-Stuyvesant neighborhood, where there was further rioting during the next two nights. Blacks roamed the street, carrying bottles and bricks. White-owned businesses were vandalized and burned by arsonists. Whites entering Harlem unguarded were beaten. CORE chairman James FARMER organized squads from CORE chapters and walked through Harlem's streets urging an end to the violence. He was ignored by the crowd and jeered by black militants, who called the riot a justified protest.

The uprising finally petered out on July 23, but even as New York City calmed down, related rioting struck Rochester, N.Y., and three cities in New Jersey: Jersey City, Elizabeth, and Paterson. Altogether, the violence left one man killed, 144 people injured, and resulted in 519 arrests. While the explosion seems small when compared to the urban riots that were to come in the next few years, it was the first major outbreak of urban violence in a generation.

See also HARLEM RIOTS OF 1935 AND 1943, and URBAN RIOTS AND REBELLIONS.

REFERENCES

MEIER, AUGUST, and ELLIOTT RUDWICK. *CORE: A Study in the Civil Rights Movement, 1942–1968.* Urbana, Ill., 1973.

RITCHIE, BARBARA. *The Riot Report: A Shortened Version of the Report of the National Advisory Commission on Civil Disorders.* New York, 1969.

GAYLE T. TATE

Harlem Writers Guild. In the late 1940s, a number of talented and ambitious young African Americans were seeking a way to simultaneously express their creativity and promote social change. Two such figures were Rosa GUY and John Oliver KILLENS, who had studied literature and writing at prominent institutions like New York University, but realized that the mainstream literary world was largely inaccessible to blacks. Consequently, they began meeting with Walter Christmas and John Henrik Clarke in a HARLEM storefront to critique each other's ideas and stories. By the early 1950s, this workshop became known as the Harlem Writers Guild. During the Guild's early years, meetings were frequently held in Killens's home as well as the home of artist Aaron DOUGLAS. As membership grew, the Guild influenced several generations of African-American writers, whose work spanned many genres.

Killens's *Youngblood* (1954) was the first novel published by a Guild member. Appearing to critical acclaim at the beginning of the CIVIL RIGHTS MOVEMENT, it told the story of a Southern black family struggling for dignity in the early twentieth century. Although Killens was a native of GEORGIA and a tireless voice protesting racial injustice in the United States, he was also involved in left-wing politics as a young man, and Guild participants, many of whom were union organizers or Progressive party members, were encouraged to think globally. Christmas and Clarke were both contributors to communist periodicals, while other writers, such as novelists Julian MAYFIELD and Paule MARSHALL, called attention to the lives and struggles of slave descendants in Cuba and the West Indies.

Although its main goals were literary, the Guild believed in political action. In 1961, for example, Guy, Marshall and Maya ANGELOU staged a sit-in at the United Nations to protest the assassination of the first Congolese premier, Patrice Lumumba. That same year, when Fidel Castro and Nikita Khrushchev met in Harlem, Guild members joined another organization, Fair Play for Cuba, in welcoming them to the African-American capital of the world.

During the 1960s, a number of Guild members found work as professional writers, journalists, and editors in the publishing industry. As a consequence, the Guild, in addition to workshops, began sponsoring writers' conferences and book parties (the celebration at the United Nations for Chester HIMES'S *The Quality of Hurt* drew 700 people). More than a thousand people attended a 1965 conference, "The Negro Writer's Vision of America," which was cosponsored by the New School for Social Research. This event featured a widely reported debate between Killens and Clarke and two white intellectuals, Her-

bert Aptheker and Walter Lowenfels, on the proper role of the artist in the fight against racism. Playwright Ossie DAVIS, a participant at the conference, summed up his viewpoint when he wrote in *Negro Digest* that the black writer "must make of himself a hammer, and against the racially restricted walls of society he must strike, and strike, and strike again, until something is destroyed—either himself—or the prison walls that stifle him!"

In 1970 Louise MERIWETHER published *Daddy Was a Numbers Runner,* and the next two decades saw the publication of acclaimed books by Grace Edwards-Yearwood, Doris Jean Austin, Arthur Flowers, and Terry MCMILLAN, famed for her popular third novel, *Waiting to Exhale* (1992). Other Guild members, such as Guy, Joyce Hansen, Brenda Wilkinson, and Walter Dean Myers, focused on writing literature for children and young adults.

In the early 1990s the Guild sponsored several literary celebrations: a centennial salute to Zora Neale HURSTON, "The Literary Legacy of Malcolm X," and two tributes to Rosa Guy for her leadership in the organization. Some former Guild members also received national attention after the election of Bill Clinton as U.S. president. Essayist and poet Maya Angelou was chosen to read her poem "On the Pulse of the Morning" at the 1993 presidential inauguration. In addition, Clinton made it known that his favorite mystery character was Walter Mosley's Easy Rawlings.

In 1991 Guild Director William H. Banks Jr. began hosting "In Our Own Words" for the *MetroMagazine* section on WNYE. This weekly television program brought many Guild members exposure in six viewing areas in the United States and Canada.

Since 1988, writing workshops have met most frequently at the SCHOMBURG Center for Research in Black Culture of the New York Public Library.

REFERENCES

CRUSE, HAROLD. *The Crisis of the Negro Intellectual.* New York, 1967.

JOHNSON, ABBY ARTHUR and RONALD MABERRY. *Propaganda & Aesthetics.* Amherst, Mass., 1979.

SHARON M. HOWARD

Harleston, Edwin Augustus (March 14, 1882–May 15, 1931), painter. Edwin A. Harleston was one of eight children born to Louisa Moultrie and Edwin Gaillard Harleston in Charleston, S.C. His father was a rice planter, a sea captain, and owner of a funeral home. Harleston received a scholarship to study at the Avery Normal Institute, a college preparatory and teacher training school in Charleston, and graduated as valedictorian in 1900. From 1900 to 1904 he attended Atlanta University where he was on the football team and sang in a quartet. He relocated to Boston in 1905 and attended the art school of the Boston Museum of Fine Arts until 1913 as a student of William Paxton and Frank Benson. The seven-year course was grounded in the Beaux Arts tradition, which formed the basis of Harleston's artistic style.

In 1913, Harleston reluctantly returned to South Carolina to help his father manage the funeral home. He became active in local civil rights groups, and by 1916 became president of the newly formed Charleston branch of the NAACP, which met at Avery Institute. Harleston led the 1919 campaign that forced the city's public school system to hire black teachers.

In 1920, Harleston married Elise Forrest, a photographer, and two years later they opened a studio which produced painted and photographed portraits. Often using his wife's photographs as models for his paintings, Harleston developed a highly realistic and academic style of portraiture. He painted many commissioned portraits, including images of Alonzo F. Herndon, president of the Atlanta Life Insurance Co. (1919), Myron Adams, president of Atlanta University (1919), and Pierre S. Dupont, a philanthropist who purchased many buildings for black public

Self Portrait by Edwin Harleston. (National Archives)

school students in South Carolina (1924). Harleston's other paintings included *The Bible Student* (1924), a series of images of street vendors including *The Shrimp Seller* (1924), *Miss Bailey (Sue Thurman) with the African Shawl* (1930), and *Aaron Douglas* (1930).

During the summers of 1924 and 1925, Harleston lived in Chicago and studied at the Chicago Art Institute. In 1930, Aaron DOUGLAS requested Harleston's assistance in painting murals for FISK UNIVERSITY Library. The murals, which presented a panoramic view of African-American history from slavery days to the present, were completed in 1931. Later that year, shortly before he died of pneumonia, Harleston won the Alain Locke Prize for Portrait Painting at the exhibition of the Harmon Foundation for his work *The Old Servant*. A retrospective of Harleston's work was held at Your Heritage House in Detroit in 1983.

REFERENCES

ALLISON, MADELINE G. "Harleston, Who Is E. A. Harleston?" *Opportunity* 2 (January 1924): 21–22.

SHANNON, HELEN. "Edwin A. Harleston: Painter of an Era," In *Edwin A. Harleston: Painter of an Era, 1882–1931.* Detroit, 1983, pp. 29–43.

WHITLOCK, EDWINA HARLESTON. "Edwin A. Harleston," In *Edwin A. Harleston: Painter of an Era, 1882–1931.* Detroit, 1983, pp. 9–28.

BETTY KAPLAN GUBERT

Harmon Foundation, philanthropic and educational organization. The Harmon Foundation was the most important foundation for sponsoring African-American artists during its heyday from the 1920s to the early 1930s. It was located in lower Manhattan in New York City and was organized in 1922 by William Elmer Harmon (1862–1928), a wealthy white businessman who developed real estate in Cincinnati, Boston, and New York. Harmon grew up in the Midwest, where his father was an officer of the 10th Cavalry, a black unit. After years of business success, Harmon created his namesake organization to finance neighborhood playgrounds, provide college loans to economically disadvantaged students, and create films on biblical themes for church services.

Harmon's commitment to black artists arose out of a personal experience when he met a black painter who could not sell his work at value price because of his race. Harmon was also influenced by intellectual trends during the 1920s that viewed art as a vehicle for promoting social betterment and interracial harmony. He was aided by Mary Beattie Brady, a white Vassar graduate who directed the Harmon Foun-

dation until it closed in 1967. Harmon and Brady believed that the creative achievements of blacks, particularly in the realm of high art, would stand as evidence for the vital role of African Americans in America's culture and economy.

In 1925, the Harmon Foundation began presenting financial awards for distinguished achievement among blacks in various categories, but the organization became best known for its prizes in visual arts. In 1928, due to the number and quality of entries, the Harmon Foundation decided to organize an exhibit to coincide with the announcement of awards, and until 1932 exhibits were held primarily in the Harlem area. Many artists who had their first exhibitions as part of the Harmon awards developed careers as acknowledged, highly gifted artists and art teachers, including Samuel Joseph BROWN, Beauford DELANEY, Palmer HAYDEN, William H. JOHNSON, James A. PORTER, Elizabeth PROPHET, Augusta SAVAGE, and Hale A. WOODRUFF. The jury that selected the winners consisted of five members, with one mandatory slot for a black juror.

In 1933, after some administrative and financial changes, the Harmon Foundation no longer exhibited or presented awards for recent artworks. The organization continued its mission of educating a multiracial audience on the value of African-American art by organizing traveling exhibitions of older works, renting exhibition materials to small groups for as little as one dollar, distributing publications on black artists, renting and selling lecture slides, and creating educational films such as *A Study of Negro Artists* (1934).

Despite its undoubted achievements, the foundation was sometimes criticized for encouraging questionable artistic values. Painters such as Romare BEARDEN characterized Harmon artists as "hackneyed and uninspired," devoid of a critical standard and social philosophy. The organization was also accused by some of perpetuating segregation by exhibiting black artists separately from white artists, and for assigning inherent stylistic traits to black artists regardless of where or when they had lived. The Harmon Foundation stood at the center of the debate over the role of race in artistic production, trying to articulate, through curatorial and pedagogical decisions, an African-American aesthetic while educating Americans about the achievements of black artists.

REFERENCES

LEWIS, DAVID LEVERING, and DEBORAH WILLIS RYAN eds. *Harlem Renaissance Art of Black America.* New York, 1987.

REYNOLDS, GARY, and BERYL WRIGHT. *Against the Odds: African-American Artists and the Harmon Foundation.* Newark, N.J., 1989.

A Study of Student Loans and their Relation to Higher Education Finance. New York, 1943.
Visual Aids in the Service of the Church. New York, 1938.

RENEE NEWMAN

Harper, Frances Ellen Watkins (September 24, 1825–February 20, 1911), writer and activist. One of the most prominent activist women of her time in the areas of abolition, temperance, and women's rights, Frances Ellen Watkins Harper also left an indelible mark on African-American literature. Frances Watkins was born in Baltimore and raised among the city's free black community. She was orphaned at an early age and her uncle, the Rev. William Watkins, took responsibility for her care and education, enrolling her in his prestigious school for free blacks, the Academy for Negro Youth. Here Watkins received a strict, classical education, studying the Bible, Greek, and Latin. Although she left school while in her early teens in order to take employment as a domestic, she never ceased her quest for additional education. She remained a voracious reader; her love of books contributed to her beginnings as a writer.

Frances Watkins published her first of several volumes of poetry in 1845. This early work, *Forest Leaves,* has been lost, however. From 1850 until 1852, Watkins taught embroidery and sewing at Union Seminary, an African Methodist Episcopal Church school near Columbus, Ohio. She then moved on to teach in Pennsylvania. Both teaching situations were difficult, since the schools were poor and the facilities overtaxed. During this period, she was moved by the increasing number of strictures placed on free people of color, especially in her home state of Maryland, a slave state. From this point, she became active in the antislavery movement (*see* ABOLITION).

In 1854, Watkins moved to Philadelphia and became associated with an influential circle of black and white abolitionists. Among her friends there were William Still and his daughter Mary, who operated the key UNDERGROUND RAILROAD station in the city. The same year another collection of Watkins's verse, *Poems on Miscellaneous Subjects,* was published. Many of the pieces in this volume dealt with the horrors of slavery. The work received popular acclaim and was republished in numerous revised, enlarged editions. Watkins also published poems in prominent abolitionist papers such as *Frederick Douglass' Paper* and the *Liberator.* Later would come other collections— *Sketches of Southern Life* (1872), the narrative poem *Moses: A Story of the Nile* (1889), *Atlanta Offering: Poems* (1895), and *Martyr of Alabama and Other Poems* (1895).

Frances Ellen Watkins Harper. (Photographs and Prints Division, Schomburg Center for Research in Black Culture, The New York Public Library, Astor, Lenox and Tilden Foundations)

With her literary career already on course, Watkins moved to Boston and joined the antislavery lecture circuit, securing a position with the Maine Anti-Slavery Society. She later toured with the Pennsylvania Anti-Slavery Society. Watkins immediately distinguished herself, making a reputation as a forceful and effective speaker, a difficult task for any woman at this time, especially an African American. Public speaking remained an important part of her career for the rest of her life, as she moved from antislavery work to other aspects of reform in the late nineteenth century.

In 1860, Frances Watkins married Fenton Harper and the two settled on a farm near Columbus, Ohio. Their daughter, Mary, was born there. Fenton Harper died four years later, and Frances Harper resumed her public career. With the close of the Civil War, she became increasingly involved in the struggle for suffrage, working with the American Equal Rights Association, the American Woman Suffrage Association, and the National Council of Women. Harper also became an active member of the Women's Christian Temperance Union. Despite her disagreements

with many of the white women in these organizations and the racism she encountered, Harper remained steadfast in her commitment to the battle for women's rights. She refused to sacrifice any aspect of her commitment to African-American rights in seeking the rights of women, however. She was also a key member of the NATIONAL FEDERATION OF AFRO-AMERICAN WOMEN and the NATIONAL ASSOCIATION OF COLORED WOMEN.

In addition to the many poems, speeches, and essays she wrote, Frances Ellen Watkins Harper is probably best known for her novel, *Iola Leroy; or, Shadows Uplifted,* published in 1892. The work tells the story of a young octoroon woman who is sold into slavery when her African-American heritage is revealed. It is a story about the quest for family and for one's people. Through Iola Leroy and the characters around her, Harper addresses the issues of slavery, relations between African Americans and whites, feminist concerns, labor in freedom, and the development of black intellectual communities. In this book, she combined many of her lifelong interests and passions.

Harper's public career ended around the turn of the century. She died in Philadelphia in 1911, leaving an enduring legacy of literary and activist achievement.

REFERENCES

CARBY, HAZEL V. *Reconstructing Womanhood: The Emergence of the Afro-American Woman Novelist.* New York, 1987.

SMITH, FRANCES FOSTER, ed. *A Brighter Coming Day: A Frances Ellen Watkins Harper Reader.* New York, 1990.

JUDITH WEISENFELD

Harper, Michael Steven (March 18, 1938–), poet, professor, and editor. Born in Brooklyn, as a boy Harper was a habitué of Ebbetts Field (his poem "Blackjack," was written for Jackie ROBINSON), the Polo Grounds (see his poem "No. 24"), and the JAZZ joints on 52nd Street. In 1951 he moved to Los Angeles. "I wouldn't have become a poet had I not moved from Brooklyn to Los Angeles," he recounts. "At thirteen the world was both collapsing and full of possibilities." Harper's education was formal (California State University at Los Angeles, where he received a B.A. in 1961 and an M.A. in 1963; the University of Iowa, where he received an M.F.A. in 1963) as well as informal (sports, music, books, the tensely integrated streets of Los Angeles). At California State, Christopher Isherwood urged Harper to write one-act plays about jazz musicians, and intro-

duced him to W. H. Auden and Stephen Spender. In Iowa City Harper began to write a poetry full of the repetitions, riffs, and syncopations of jazz. All the while he worked at eye- and ear-opening jobs: paperboy, lifeguard, airmail sorter in the Los Angeles post office; in Iowa City he sold pennants at football games and tutored athletes in English and math.

After a stint at Wiltwyck school for boys in New York State, and nightly forays into Manhattan seeking tunes in John Coltrane's heyday, Harper moved to San Francisco in 1964. There he married Shirley Anne Buffington. They had three children.

Harper was a visiting assistant professor at Lewis and Clark and Reed colleges in Portland in 1968–1969; during this time he finished *Dear John, Dear Coltrane,* his first volume of poems. Back in California in 1969, he was appointed associate professor of English at Cal State, Hayward, and completed *History Is Your Own Heartbeat,* a collection influenced by Oregon and Minnesota as well as California; blues and painting as well as jazz; Africa as well as America. After a year at the Center for Advanced Study at the University of Illinois in Urbana-Champaign, Harper moved to Brown University, where he was appointed a university professor in 1990. In the meantime he bought a home in Minnesota, on land adjacent to his wife's family homestead.

Song: I Want a Witness (1972) announces Harper's and the country's changing moral landscape in the 1970s; it is a volume of witnessing and remembrance. So is *Debridement* (1973), a volume of three long poems in fragments reconstructing John Brown, Richard WRIGHT, and a black Vietnam veteran whom Harper—melding history and folk tradition—names John Henry Louis. *Nightmare Begins Responsibility* (1975) relocates Harper's exploration of the painful struggles of African-American experience into private as well as public arenas. His style here relies more on understatement for its rhythmic intensity than it does in his earlier work; the dramatis personae are relatives, writers, or athletes—those whose lives touched Harper's, added stops to the range of his voice, widened the lens of his point of view on the often unexpected kinships of American life. *Images of Kin: New and Selected Poems* (1977) accentuates the theme of kinship and is a sampler of Harper's poetry. Between producing that book and the volume of poems *Healing Song for the Inner Ear* (1985), Harper co-edited *Chant of Saints: A Gathering of Afro-American Art, Literature and Scholarship* (1979) and the Ralph ELLISON issue of the *Carleton Miscellany*; selected the *Collected Poems* of Sterling A. BROWN for the National Poetry Series (1980); edited the Robert HAYDEN issue of *Obsidian* (1981); and guest-edited selections of poetry for numerous literary magazines, including the *Iowa Review* and the *Indiana Review.* A

special issue of *Callaloo* in 1990 featured a selection of new poems, an interview with Harper, and ten essays on the man and his work.

In *Healing Song for the Inner Ear* and his new poems to be published in a volume called *Honorable Amendments*, Harper's donnée is the music of relationships. His melodic voice is more and more matter-of-fact, deceptively easygoing. In the bass line, Harper is a caretaker of those he's known and knows; he is a caretaker, too, of the language, music, and history that he makes his own. Throughout his evolving body of work, Michael Harper is a poet of kinship—of "race and soul," blood and experience—and he holds his kin close in the centering time and space of his poems.

REFERENCES

CALLAHAN, JOHN F. "The Testifying Voice in Michael Harper's *Images of Kin.*" *Black American Literature Forum* 13 (Fall 1979): 89–92.
CALLALOO 13, no. 4 (Fall 1990).
STEPTO, ROBERT B. "After Modernism, After Hibernation: Michael Harper, Robert Hayden, and Jay Wright." In *Chant of Saints*. Urbana, Ill., 1979, pp. 470–486.

JOHN F. CALLAHAN

Harper, Solomon (October 8, 1895–December 8, 1980), electrical engineer and inventor. Born in Poplar Grove, Ark., Solomon Harper left home at the age of twelve. He worked as an iron molder and then did construction work for various railways. He filed his first patent application in 1914. During WORLD WAR I he served as a technical sergeant with the U.S. Army in France. After the war he attended the University of California at Berkeley, returning east to graduate from the New York Electrical School in 1920. He worked as an electrician and an engineer for various manufacturing companies in the Northeast.

During the 1920s Harper worked on his own inventions. Among his inventions are a block system for preventing railroad train collisions, a shock-resistant thermostat, relays used in submarines, a version of the hot comb, and the triple-chamber airplane bomb. The extent to which these designs were ever implemented is unclear, but Harper claimed that they were worth $500 million. He often claimed in his later years that he never received adequate compensation for his patents, which he had mistakenly assigned to others. However, his achievements did not go entirely without recognition. In 1927 the U.S. government recommended his election to the American Society of Safety Engineers. He was also a member of the American Association for the Advancement of Science.

Harper was a reporter for the *New York Weekly News* from 1930 to 1935. During this time, as a member of the Workers Ex-Servicemen's League, he led demonstrations for increased veterans' benefits. From 1939 to 1942 he worked as a research editor for the Soil Conservation Services at Columbia University. In 1953 he was awarded patents for thermostatic hair curlers. In 1973 Harper received considerable media attention when New York Liberal party mayoral candidate Albert H. Blumenthal championed his cause as an "example of a neglected senior citizen" who was reduced to living in subways because he could not afford to pay rent from his inadequate Social Security pension and veteran's benefits. Harper died in Harlem Hospital in 1980.

REFERENCES

"Mastermind of Invention Resorts to Life in Subway." *Jet* (September 6, 1973).
New York Times. August 17, 1973, p. 20.
Obituary. *New York Times*. December 18, 1980, p. D23.

LYDIA McNEILL

Harper, William A. (1873–1910), landscape painter. He was born to working-class, racially mixed parents in Cayuga, Ontario. In the early 1880s, his family emigrated to a farm in Petersburg, Ill. After one year at Illinois College in Jacksonville, Ill., Harper began to study drawing at the Art Institute of Chicago and worked as a janitor by night. In 1901 the Art Institute exhibited three of his oil paintings and graduated him with second honors.

Harper taught drawing in the public schools in Houston, then traveled to Paris via England in 1903. He painted from dawn to dusk in his Montparnasse studio, in the countryside, and in the Louvre, where he copied works by French masters. His diligence so impressed two classmates at the Julian Academy that they nominated him to the American Art Association. Thirteen prejudiced members, however, blocked his candidacy.

Early in 1904, Harper considered returning to the United States when the Art Institute exhibited three of his works and TUSKEGEE Institute offered him a position as instructor of drawing. Instead, he traveled throughout France and England, painting landscapes in Barbizon and along the Cornish coast. He went back home in 1905 when the Annual Exhibition by Artists of Chicago and Vicinity displayed nine of his

works, of which one, *Early Afternoon at Montigny,* won a thirty-dollar special prize for most worthy landscape. Later that year, Harper received the Municipal Art League Prize.

With sales of works exhibited at the Annual Exhibition of American Paintings and Sculpture, the Annual Exhibition of Works by Artists of Chicago and Vicinity, and the Society of Western Artists in 1906, Harper returned to Paris in 1907 for a year of study, partially with Henry O. TANNER. In 1908 he won the Young Fortnightly (first) Prize of $150 for *Old House and Vines* from the Chicago Municipal Art League. The same organization exhibited his last paintings of Mexican scenes in 1909 and 1910. Harper died prematurely of tuberculosis while on a sketching tour in Mexico City.

REFERENCES

BENTLEY, FLORENCE LEWIS. "William A. Harper." *Voice of the Negro* (February 1906): 118–122.
PORTER, JAMES A. *American Negro Art.* New York, 1943.

THERESA LEININGER-MILLER

Harpers Ferry, Virginia. *See* John Brown's Raid at Harpers Ferry, Virginia.

Harrington, Oliver Wendell "Ollie" (February 14, 1912–), cartoonist and expatriate. Harrington was born in Valhalla, N.Y., and raised in the South Bronx, the first of five children of Herbert Harrington, an African American from North Carolina, and Eugenia Tarat, of Jewish descent from Budapest, Hungary. He graduated from DeWitt Clinton High School in 1929 and moved to Harlem, where he came to know Langston HUGHES and other figures in the HARLEM RENAISSANCE. While doing odd jobs, he studied drawing and painting at the National Academy of Design, and in 1936 he began to work his way through the Yale University School of Fine Arts to receive his BFA degree in 1940.

He began contributing COMIC STRIPS in 1932 to several black newspapers, such as *The National News, New York State Contender, Pittsburgh Courier, Baltimore Afro-American,* and *New York Amsterdam News,* for which he created the character Bootsie featured in a panel cartoon set in Harlem called *Dark Laughter.* The Bootsie cartoons gained popularity as honest satires of the fads and foibles of the urban black community, and he would continue drawing the feature until the 1960s. A collection, *Bootsie and Others,* was published in 1958 with an introduction by Langston Hughes.

Harrington was the art director for *The People's Voice,* a weekly begun by Adam Clayton POWELL, JR., in 1942, and he served as a war correspondent in Italy and France in 1944. Beginning in 1943, he produced an adventure comic strip about a black aviator named *Jive Gray.* After World War II, he worked as a journalist and book illustrator, and in 1946 he agreed to organize a public relations department for the NAACP. During the McCarthy era, he found that he was under investigation, so in 1951, he moved to Paris to pursue painting. He met Richard WRIGHT in the Café Tournon, where black expatriates gathered, and became his closest friend for the remainder of the novelist's life.

After Wright's death in 1962, Harrington moved to East Berlin for a job illustrating classic novels and unexpectedly found himself behind the Berlin Wall. He met his future wife, Helma Richter, there and has remained in East Berlin until the present, contributing political cartoons to several German publications, such as *Eulenspiegel* and *Das Magazine.* Beginning in 1968, his political cartoons have appeared in the *New York Daily World.*

While the Bootsie cartoons used black experience and human nature as sources of humor, they were gently satiric in their orientation, but his political cartoons have been more militant and specific in their criticism of American racism and foreign policy. His use of exaggeration and caricature, combined with a

Ollie Harrington (standing), teacher of art in the Hudson Avenue Boys' Club, Brooklyn, N.Y., supervises a class studying mural work. (Photographs and Prints Division, Schomburg Center for Research in Black Culture, The New York Public Library, Astor, Lenox and Tilden Foundations)

gritty sense of reality, lend his work a powerful appeal and impact. Harrington was called America's greatest black cartoonist by Langston Hughes.

REFERENCES

HARRINGTON, OLIVER. *Bootsie and Others.* New York, 1958.

———. *Why I Left America and Other Essays.* Jackson, Miss., 1993.

INGE, M. THOMAS, ed. *Dark Laughter: The Satiric Art of Oliver W. Harrington.* Jackson, Miss., 1993.

M. THOMAS INGE

Harris, Abram Lincoln, Jr.

(January 17, 1899–November 16, 1963), economist. Born in Richmond, Va., Abram Harris left his mark on developments in the areas of economic anthropology, black studies, institutional economics, and the history of economic thought.

A 1922 graduate of Virginia Union University in Richmond, he completed an M.A. in economics from the University of Pittsburgh in 1924, and received his Ph.D. in economics in 1930 from Columbia University. After teaching briefly at West Virginia State (1924–1925) and working for the Minneapolis Urban League (1925–1926), Harris taught at HOWARD UNIVERSITY from 1927 to 1945. Thereafter until his death, he was at the University of Chicago. Although his appointment was in the undergraduate college and he never taught graduate courses, appointment at Chicago was highly unusual for a black scholar in the 1940s.

In his early years at Howard, Harris and his colleagues Ralph BUNCHE and E. Franklin FRAZIER were the leading figures among the young intellectuals who attacked the traditional tactics and outlooks of the older generation of "race men." In 1931 Harris published, in collaboration with the Jewish political scientist Sterling Spero, his most famous work, *The Black Worker,* discussing race relations in labor movements. In 1935, following preliminary discussion at the NATIONAL ASSOCIATION FOR THE ADVANCEMENT OF COLORED PEOPLE'S AMENIA CONFERENCE OF 1933, he was the main author of the so-called Harris report, which urged the NAACP to adopt a more active protest strategy and a class-based rather than race-based approach. While the report was not enacted, Harris continued to advocate a multiracial working-class movement as the only real solution to race problems in the United States.

In 1935, Harris and Bunche sponsored a conference at Howard University on the condition of blacks in the Great Depression, out of which came a special issue of the *Journal of Negro Education* (1935). The

During the Great Depression, Howard University economist Abram Harris was in the forefront of black activists who worked to reorient the civil rights movement to reflect economic and labor issues. (Moorland-Spingarn Research Center, Howard University)

issue contained an article inspired by Harris, developed further the next year in *The Negro as Capitalist* (1936), in which he argued that black businessmen and black-owned financial institutions were as harmful to the black masses as white capitalists. Harris declared that civil rights efforts by black organizations were inadequate in light of fundamental economic inequalities between the races.

Into the 1940s, Harris was the intellectual leader of the left-leaning Social Science Division at Howard, which he helped found in 1937. In 1945, however, he left to accept an appointment at the University of Chicago, where he underwent an intellectual conversion to anti-Marxism. He had never been naive in his earlier endorsement of radical change, and had expressed deep concerns about the totalitarian direction of the Soviet revolution as early as 1925, when he wrote "Black Communists in Dixie" for the Urban League magazine *Opportunity.*

During Harris's years at Chicago, he became largely silent on the race question. His published re-

search efforts concentrated on the history of economic theory, notably in *The Social Philosophy of Karl Marx—Ethics* (1948) and *Economics and Social Reform* (1958), an exploration of John Stuart Mill's moderate liberalism. Harris also wrote on Mill's views of mid-nineteenth-century British colonial policy, chiefly with regard to India. He had begun to write a reinterpretation of *The Black Worker*, to be called *The Economics and Politics of the American Race Problem*, when he died. In keeping with his later views, his thesis in this work was that blacks had to improve their own skills and "human capital" in order for integration efforts to succeed.

Harris had a marked influence on both black radical and neoconservative thought, and his works display one of the most discerning critical voices of the twentieth century.

REFERENCES

DARITY, WILLIAM, JR., and JULIAN ELLISON. "Abram Harris, Jr.: The Economics of Race and Social Reform." *History of Political Economy* 22, no. 4 (1990): 611–627.
HARRIS, ABRAM L., JR. *Race, Radicalism, and Reform: Selected Papers.* New Brunswick, N.J., 1989.

WILLIAM A. DARITY, JR.

Harris, Andrew (1810–December 1841), abolitionist. Andrew Harris, a free African American born in New York in 1810, became prominent in the ABOLITION movement of the first half of the nineteenth century as an agent and speaker for various antislavery societies. Though Union and Middlebury Colleges had refused Harris admission due to his race, he succeeded in attending the University of Vermont, and graduated from there in 1838.

An educator and pastor, Harris led a black school in Troy, N.Y., and after settling in Philadelphia in April 1841, became ordained as pastor of the Second African Presbyterian Church. A member of the AMERICAN MORAL REFORM SOCIETY, Harris outspokenly opposed SLAVERY and colonization. In 1840, he joined the AMERICAN AND FOREIGN ANTI-SLAVERY SOCIETY.

As a speaker at the AMERICAN ANTI-SLAVERY SOCIETY's meeting in 1839 in New York City, Harris addressed about five thousand abolitionists, drawing connections between slavery and prejudice against free African Americans. Speaking out against colonization, Harris also commented that despite the prejudice and injustice African Americans suffered in the United States, he would rather stay with his people in America than emigrate to a foreign shore. Harris died in December 1841, only a few months after becoming a pastor.

REFERENCE

RIPLEY, C. PETER, ed. *The Black Abolitionist Papers. Vol. 3, The United States, 1830–1846.* Chapel Hill, N.C., 1991, pp. 294–297.

MARGARET D. JACOBS

Harris, Barbara Clementine (June 12, 1930–), Episcopal Bishop. Barbara Harris was the first female bishop of the Protestant Episcopal Church. She was born in Philadelphia, where her father, Walter Harris, was a steelworker and her mother, Beatrice, was a church organist. A third generation EPISCOPALIAN, Harris was very active in the St. Barnabas Episcopal Church. While in high school, she played piano for the church school and later started a young adults group.

After graduating from high school, Harris went to work for Joseph V. Baker Associates, a black-owned public relations firm. She also attended and graduated from the Charles Morris Price School of Adver-

Episcopal bishop Barbara Harris. (© Rick Friedman/Black Star)

tising and Journalism in Philadelphia. In 1968 she went to work for Sun Oil Company and became community relations manager in 1973.

During the 1960s, Harris participated in several civil rights events. She was part of the 1965 Freedom March from Selma, Ala., to Montgomery, Ala., with the Rev. Dr. Martin Luther KING, Jr., and was also a member of a church-sponsored team of people who went to Mississippi to register black voters. Harris began attending North Philadelphia Church of the Advocate in 1968. That same year, the Union of Black Clergy was established by a group of black Episcopalian ministers. Harris and several other women lobbied for membership. Eventually, they were admitted and the word laity was added to the organization's name. Later it became the Union of Black Episcopalians.

Once the Episcopal Church began to ordain women in 1976, Harris began to study for the ministry. From 1977 to 1979 she took several courses at Villanova University in Philadelphia, and spent three months in informal residency at the Episcopal Divinity School in Cambridge, Mass. She was named deacon in 1979, served as a deacon-in-training in 1979–1980, and was ordained to the priesthood in 1980. She left Sun Oil Co. to pursue her new career full-time.

The first four years of Harris's ministry were spent at St. Augustine-of-Hippo in Norristown, Pa. She also worked as a chaplain in the Philadelphia County Prison System, an area in which she had already spent many years as a volunteer. In 1984 she became the executive director of the Episcopal Church Publishing Co. Her writings were critical of church policies, which she believed to be in contrast to social, political, and economic fairness.

In 1988 the Episcopal Church approved the consecration of women as bishops. Harris was elected to become bishop to the Massachusetts diocese in the fall of 1988. Her election was ratified in January 1989 and she was ordained in a ceremony in Boston on February 11, 1989 with over 7,000 in attendance.

As the first female Episcopal bishop, Harris was surrounded by controversy centered on three issues: her gender, her lack of traditional seminary education and training, and her liberal viewpoints. Policies toward women, black Americans, the poor, and other minorities were always at the forefront of Harris's challenges to the church and its doctrines. Harris overcame the objections and focused her attention on her duties as a bishop. She has served the diocese of Massachusetts, where she has been extremely active in local communities and prison work. Greatly concerned with the prison ministry, she represents the Episcopal Church on the board of the Prisoners Visitation and Support Committee.

REFERENCES

"Harris, Barbara (Clementine)." *Current Biography* 5 (June 1989): 24–28.
JESSIE CARNEY SMITH, ed. *Notable Black American Women*. Detroit, 1992.

DEBI BROOME

Harris, Hilda (January 25, 1936–), opera singer. Hilda Harris was born in Warrenton, N.C. She was educated at North Carolina State University, then studied in New York with Jonathan Brice and Lola Hayes. Her career began in 1963 on Broadway, where she went on to appear in shows such as *Mame* (1966). In 1967, she made a Carnegie Hall debut. Her European debut followed in 1971 in Switzerland with the title role in Bizet's *Carmen*. Her debuts as a mezzo-soprano with the New York City Opera and Metropolitan Opera were in 1974 and 1977, respectively. In the 1970s, she appeared frequently with Opera Ebony. In 1977, Harris premiered the role of Vyry in Ulysses KAY's *Jubilee* with Opera/South. She is best known for her performances as Tituba in Robert Ward's *The Crucible,* as Siébel in Gounod's *Faust,* in the title role of Puccini's *Madama Butterfly,* and as Carmen.

REFERENCE

SHERMAN, ROBERT. "Miss Harris, Mezzo, Triumphs in Debut." *New York Times,* January 23, 1967.

A. LOUISE TOPPIN

Harris, Patricia Roberts (May 31, 1924–March 23, 1985), educator, lawyer, and politician. Patricia Roberts was born in the blue-collar town of Mattoon, Ill., where her father was a Pullman porter. She attended high school in Chicago and then enrolled at Howard University in Washington, D.C. She became active in civil rights causes at Howard, participating in one of the nation's first student SIT-INS at a segregated Washington cafeteria and by serving as the vice chairman of a student chapter of the NATIONAL ASSOCIATION FOR THE ADVANCEMENT OF COLORED PEOPLE (NAACP).

After graduating in 1945, Roberts returned to Chicago where she briefly attended graduate school at the University of Chicago and worked as program director of the Chicago Young Women's Christian Association. In 1949 she returned to Washington and accepted a position as the assistant director of the American Council on Human Rights. In 1953 she

became executive director of Delta Sigma Theta, a black sorority, and two years later, she married Washington lawyer William Beasley Harris.

Patricia Roberts Harris entered George Washington Law School in 1957. Upon graduation in 1960, she accepted a position as an attorney at the U.S. Department of Justice. In the following year, Harris joined the Howard University Law School faculty where she also served as the associate dean of students. In 1963, with the support of the Kennedy administration, Harris was chosen to cochair the National Women's Committee for Civil Rights, a clearing house and coordinating committee for a wide range of national women's organizations. She also served on the District of Columbia advisory committee to the UNITED STATES COMMISSION ON CIVIL RIGHTS.

In 1965 Harris became the first African-American woman to hold an ambassadorship when she was appointed envoy to Luxembourg. She held the post until September 1967, when she rejoined the faculty at Howard University. In 1969 she was appointed Dean of Howard Law School, becoming the first black woman to head a law school, but her tenure lasted only thirty days. Caught between disputes with the faculty and the president of the university over student protests, Harris resigned.

She accepted a position with a private law firm—Fried, Frank, Harris, Shriver, Kampelman—and also held a number of positions in the DEMOCRATIC PARTY during the 1970s, such as the temporary chairmanship of the credentials committee. Harris became the first black woman cabinet member when she was nominated by President Jimmy Carter to head the Department of Housing and Urban Development in 1976. She held the job for two years, and in 1979 she became secretary of health, education, and welfare (renamed the Department of Health and Human Services in 1980), serving until 1981.

In 1982 Harris ran for mayor of Washington, D.C. Running against Marion S. BARRY in the Democratic primary, she lost a bitter contest in which she was depicted as an elitist who could not identify with the city's poorer blacks. She spent her remaining years as a professor at George Washington National Law Center before her death in 1985.

REFERENCES

BOYD, GERALD M. "Patricia R. Harris, Carter Aide, Dies." *New York Times Biographical Service* (March 1985): 366–367.

GREENFIELD, MEG. "The Brief Saga of Dean Harris." *Washington Post,* March 23, 1969, pp. C1, C5.

HARRIS, PATRICIA ROBERTS. Papers. Library of Congress, Washington, D.C.

JAMES BRADLEY

Patricia Harris. (Photographs and Prints Division, Schomburg Center for Research in Black Culture, The New York Public Library, Astor, Lenox and Tilden Foundations)

Harris, Wesley Leroy (October 29, 1941–), mechanical and aerospace engineer. Noted for his research on rarefied gas dynamics, unsteady transonics (the sonic boom), and helicopter rotor noise, Wesley Harris was born and raised in Richmond, Va. He received a bachelor's degree in aeronautical engineering from the University of Virginia (1964) and his M.A. (1966) and Ph.D. (1968) degrees from Princeton University. After teaching at Southern University and at the University of Virginia, he joined the faculty at Massachusetts Institute of Technology (MIT) in 1972.

There Harris founded and directed the MIT Helicopter Rotor Acoustics Laboratory, from which came important data on rotor performance. His research contributed to a new understanding of the sources and mechanism of helicopter noise generation. He pioneered the use of a highly instrumented scale model of a helicopter blade that pinpointed blade-vortex interaction and the related aerodynamics stall as reasons for helicopter rotor noise.

In 1975 Harris accepted the directorship of the Office of Minority Education at MIT. From 1979 to 1981, while on leave from MIT, Harris was Manager

of Computational Methods at the National Aeronautics and Space Administration (NASA), and beginning in 1979 he also served as a member of the Army Science Board. In 1985 Harris was appointed Dean of the School of Engineering and Professor of Mechanical Engineering at the University of Connecticut, where he served for five years. In July 1990 he was appointed Vice President of the University of Tennessee Space Institute.

REFERENCE

American Men and Women of Science. 17th ed. Vol. 3. New York, 1989, p. 534.

ROBERT C. HAYDEN

Harrison, Hazel (1883–1969), concert pianist. Born in La Porte, Ind., Hazel Harrison received her early piano training from the well-known local teacher Victor Heinz. Through his contacts and the generosity of anonymous Chicago donors, Harrison was able to study with the great German-Italian pianist Ferruccio Busoni during several trips to Germany from 1904 to 1914. She performed two piano concertos with the Berlin Philharmonic in 1904 (the Chopin e minor and the Grieg) under August Scharrer, becoming the first American-trained soloist to perform with a European orchestra. In the United States she also studied with Percy Grainger.

Starting in 1914 Harrison concertized extensively in the United States, playing Romantic piano works, works of contemporary composers such as Stravinsky and Ravel, as well as works by African-American composers, including William Levi DAWSON and Hall JOHNSON. In 1926, she returned to Europe for a year to study with the well-known Busoni pupil Egon Petri. She resumed an active concert career, playing at Town Hall in New York City and at Jordan Hall in Boston.

Harrison performed with American orchestras, including the Minneapolis Symphony Orchestra under Eugene Ormandy and the Hollywood Bowl Symphony Orchestra under Izler Solomon. During her concert career she performed nationwide at colleges, universities, churches, and YMCA's, frequently at the request and with the support of black institutions. She held teaching posts at the Tuskegee Institute (1931–1936), Howard University (1936–1955) and Alabama State College (1958–1963). Despite her acclaim, Harrison was never given a chance to record her performances.

OTHA DAY

Harrison, Hubert Henry (April 27, 1883–December 17, 1927), writer, orator, and political activist. Born in Concordia (St. Croix), in the Danish West Indies (now the U.S. Virgin Islands), H. H. Harrison came to New York at age seventeen, where he worked at menial jobs, participated in black intellectual circles, and attended high school before becoming a postal worker in 1907. During his first decade in New York, Harrison became an agnostic and humanist, studied history, and social and literary criticism, and was attracted to the protest philosophy of W. E. B. DU BOIS, free thought, and SOCIALISM. In 1909 he married Irene Louise Horton and in 1911, after he had published letters critical of Booker T. WASHINGTON, he was fired from the post office and hired by the Socialist party.

From 1911 to 1914 Harrison served as a leading Socialist party speaker, writer, campaigner, organizer, and theoretician. His lectures throughout the city were widely attended and he was famous for his spellbinding oratory on Wall Street, at Madison Square, and in Harlem. In his theoretical series on "The Negro and Socialism" (*New York Call*, 1911) and on "Socialism and the Negro" (*International Socialist Review*, 1912), Harrison advocated that socialists champion the cause of the Negro as a revolutionary doctrine, develop a special appeal to African Americans, and affirm the duty of the socialists to oppose race prejudice. He initiated the Colored Socialist Club, a pioneering effort by U.S. socialists to organize African-Americans, but soon concluded that party leaders put the white "Race first and class after." Harrison increasingly supported the more egalitarian, action-oriented Industrial Workers of the World and spoke at the 1913 Paterson Silk Strike. He also taught at the Modern School. After Socialist party leaders moved to restrict his speaking, he left the party, developed his own Radical Lecture Forum, and soon began indoor and outdoor lectures in Harlem.

In June 1917 Harrison launched the Liberty League of Negro-Americans with a mass meeting in Harlem, attended by a cross-section of black activists, including Marcus GARVEY. The League's program aimed at the "common people" and pushed internationalism, political independence, and class and race consciousness. The League's paper, *The Voice*, called for a "race first" approach, enforcement of civil and voting rights, federal antilynching legislation, and armed self-defense against racist attacks. The Liberty League developed the core features (race radicalism, self-reliance, tri-color flag, outdoor and indoor lectures, a newspaper, and protests in terms of democracy) and the core leadership individuals that were soon used by Marcus Garvey in his UNIVERSAL NEGRO IM-

Hubert Henry Harrison. (Photographs and Prints Division, Schomburg Center for Research in Black Culture, The New York Public Library, Astor, Lenox and Tilden Foundations)

PROVEMENT ASSOCIATION (UNIA). Harrison later claimed that from the Liberty League, "Garvey appropriated every feature that was worthwhile in his movement."

The League began to break apart in the late summer of 1917, and in November *The Voice* failed. In 1918, after doing organizing work for the American Federation of Labor, Harrison chaired the Colored National Liberty Congress, which petitioned Congress for federal lynching legislation. He also briefly rejoined, then left, the Socialist party. After a resurrected *Voice* failed in 1919, he became editor of the *New Negro*, "an organ of the international consciousness of the darker races." Harrison was an important influence on a generation of race and class radicals, including Garvey and A. Philip RANDOLPH (in his early socialist radical days). Selections of Harrison's writings were collected into two books, *The Negro and the Nation* (1917) and *When Africa Awakes* (1920). During the heyday of 1920s black radicalism, Harrison was the most class-conscious of the race radicals, and the most race-conscious of the class radicals.

In January 1920 Garvey hired Harrison as principal editor of the *Negro World* and Harrison reshaped the paper into a powerful organ of the UNIA. In August 1920, as his criticism of Garvey grew, he ceased his major editorial duties and began to work against Garvey while attempting to build a Liberty party. He continued to work as a contributing editor and to write columns and book reviews for the *Negro World* until 1922.

In 1922 Harrison became an American citizen and from 1922 to 1926 he was a featured lecturer for the New York City Board of Education. In 1924 he founded the International Colored Unity League which stressed the need for Blacks to develop "race-consciousness," and advocated unity of action and a separate state within American territory for African-Americans. He also helped develop the Negro Collection of the New York Public Library, worked with the American Negro Labor Congress and the Urban League, and lectured and wrote widely. In 1927, Harrison launched an unsuccessful publication, *The Voice of the Negro*. He died later that year after an appendicitis attack. He left a wife and five children.

REFERENCES

JAMES, PORTIA. "Hubert H. Harrison and the New Negro Movement." *The Western Journal of Black Studies* 13 (1989): 82–91.

PERRY, JEFFREY B. Hubert Henry Harrison, the Father of Harlem Radicalism. Ph.D. diss., Columbia University, 1986.

ROGERS, JOEL A. "Hubert Harrison: Intellectual Giant and Free-Lance Educator." In Joel A. Rogers, ed. *World's Great Men of Color*. Vol. 2. 1947. Reprint. New York, 1972, pp. 432–442.

SAMUELS, WILFORD D. "Hubert H. Harrison and 'The New Negro Manhood Movement.' " *Afro-Americans in New York Life and History* 5 (January 1981): 29–41.

JEFFREY B. PERRY

Harrison, Paul Carter (March 1, 1936–), playwright. Born in New York City, Paul Harrison attended New York University, Indiana University (B.A., 1957), Ohio University, and the New School for Social Research (M.A., 1962) before embarking on a career in theater and television in Europe. He spent seven years in Amsterdam, producing and writing plays and television programs, as well as staging readings of black poetry. During this period he wrote *Pavane for a Dead-Pan Minstrel* (1964) and *Tophat* (1965), which explored traditional gender and racial roles by reversing them. On a visit to the United States, Harrison witnessed the HARLEM RIOT OF 1964

which became the subject of *Tabernacle* (1965). The play, which traced the causes of the riots, resembled much of the political theater of the 1960s in its extensive use of audience-involvement techniques. It broke theatrical ground in its integration of African rituals, rhythms, myths, speeches, and tradition with familiar European forms.

In *Ain't Supposed to Die a Natural Death* (1970), based on writings by Melvin VAN PEEBLES, Harrison explored the uses of environmental theater, filling the stage and auditorium with actors playing the various denizens of black urban life. He won an Off-Broadway (Obie) Award for *The Great McDaddy* (1974), which featured mythic figures from black American folklore, based on Amos Tutola's novel. After returning to the United States, Harrison wrote numerous television programs and screenplays, directed, and taught extensively. He was literary adviser to the Lincoln Center Repertory Theatre Company in 1972 and 1973. In 1976, he began producing and teaching for the theater/music department at Columbia College in Chicago. There he directed over a dozen plays, including *No Place to Be Somebody* (1983), *The River Niger* (1987), and *Anchorman* (1988). Harrison published a photo documentary in 1985, *Chuck Stewart's Jazz Files*, with Chicago firefighter Charles Stewart, and edited a collection of plays, *Totem Voices*, in 1988. He has been a writer in residence at Columbia College since 1980.

REFERENCES

METZGER, LINDA, ed. *Black Writers. A Selection of Sketches from Contemporary Writers*. Detroit, 1989.
PETERSON, BERNARD L., JR. *Contemporary Black American Playwrights and Their Plays*. New York, 1988.

MICHAEL PALLER
JEFF ENCKE

Harrison, Richard Berry (1864–March 14, 1935), actor. Richard B. Harrison was born in London, Canada West (now Ontario), the son of FUGITIVE SLAVES. While still in his teens, he worked as a bellhop and a newspaper hawker. A stagestruck youth, he won prizes for oratory in local churches and studied acting in Detroit. He developed a one-man show, reciting Shakespeare and the work of other poets to black audiences, and toured the nation several times starting in 1891. A close friend of Paul Laurence DUNBAR, he promoted Dunbar's book, *Oak and Ivy,* on a tour with the author in 1893. After several decades of touring and appearing on the Lyceum and Chautauqua circuit, Harrison was famous in black communities across the nation for his dra-

matic readings and his interpretations of Shakespeare, which provided education, entertainment, and inspiration to audiences in need of all three. He offered short training courses in drama from the early 1890s, but felt that such training would be more effective in an institutional setting; in 1922 he persuaded the North Carolina Agricultural and Technical College at Greensboro to establish a program in theater arts, and he taught there until 1929.

Harrison is best remembered for the role of "De Lawd" in Marc Connelly's 1930 play *The Green Pastures,* a Pulitzer Prize–winning account of a southern black preacher's vision of heaven. Dressed in the simple dark suit of a black preacher, Harrison played God 1,657 times during the next five years. It was to be his only role in a fully staged dramatic production. In 1931 Harrison was awarded the SPINGARN MEDAL from the NAACP, both for his performance in *The Green Pastures* and for his lifelong commitment to black theater. Harrison died four years later in New York City at the age of seventy-one.

REFERENCES

LOGAN, RAYFORD W., and MICHAEL R. WINSTON, eds. *Dictionary of American Negro Biography*. New York, 1982.
WOLL, ALLEN. *Dictionary of the Black Theatre*. Westport, Conn., 1983.

LINDA SALZMAN

Hastie, William Henry (November 17, 1904–April 14, 1976), lawyer and educator. William Hastie was considered one of the best legal minds of the twentieth century. He was once suggested for the presidency of Harvard University and twice considered as a nominee for the U.S. Supreme Court, reflections of the high regard in which he was held.

Hastie was born in Knoxville, Tenn., where he spent his early years. His father, a clerk in the United States Pension Office, and his mother, a teacher until his birth, offered him early examples of resistance to discrimination. Rather than ride on segregated streetcars, they provided alternative means for young Hastie to go to school, which sometimes meant walking.

In 1916 the family moved to Washington, D.C., which gave Hastie the opportunity to attend Dunbar High School, the best secondary school in the nation for African Americans. There he excelled athletically and academically, graduating as valedictorian of his class in 1921. He went on to Amherst College, where he again established an excellent athletic and academic

record. In addition to winning prizes in mathematics and physics, he was elected to Phi Beta Kappa as a junior, and served as its president during his senior year. In 1925, he graduated magna cum laude as class valedictorian.

After teaching mathematics and general science for two years at the Bordentown Manual Training School in New Jersey, Hastie pursued legal studies at Harvard Law School, where he distinguished himself as a student. He was named to the editorial board of the *Harvard Law Review,* the second African American to earn that distinction, and was one of its most active editors. Hastie received his LL.B. degree from Harvard in 1930 and returned there to earn an S.J.D. in 1933.

His academic career close followed that of his second cousin Charles Hamilton HOUSTON, who had also excelled at Dunbar High, Amherst College, and Harvard Law School. Upon completion of his legal studies, Hastie became a lawyer and went into practice with his father William in the Washington, D.C., firm of Houston and Houston. He also became an instructor at Howard University Law School, where Houston was vice dean. Working together, the two men transformed the law school from a night school to a first-class institution. As Robert C. Weaver recalled, "It was during this time that the Houston-Hastie team became the principal mentors of Thurgood MARSHALL, as well as symbols for, and teachers of, scores of black lawyers, many of whom played a significant role in Civil Rights litigation" (Weaver 1976, p. 267).

In 1930, the year that Hastie completed his first law degree, the NAACP decided on its legal strategy for fighting against racism: to attack the "soft underbelly" of segregation—the graduate schools. Hastie, Houston, and Thurgood Marshall became the principal architects of that strategy. In 1933, Hastie was one of the lawyers who argued the first of these cases: *Hocutt* v. *University of North Carolina.* Although the case was lost, his performance won him immediate recognition; more important, it laid the groundwork for future cases that would lead to the end of legal segregation in the United States.

As assistant solicitor for the Department of the Interior (1933–1937), Hastie challenged the practice of segregated dining facilities in the department. He also played a role in drafting the Organic Act of 1936, which restructured the governance of the Virgin Islands. In 1937, as a result of his work on the Organic Act, he was appointed federal judge of the U.S. District Court for the Virgin Islands, the first African American to be appointed a federal judge. He left this post in 1939 and returned to Howard Law as a professor and dean. In 1946, he went back to the Virgin Islands as its first black governor.

The first African-American federal appeals judge, William Hastie (left) is congratulated on his appointment by Chief Judge John Biggs, Jr., of the Third Circuit in Philadelphia in 1949. (AP/Wide World Photos)

In 1940, Hastie was appointed civilian aide to the secretary of war and given the charge of fighting discrimination in the armed services. While he was able to make some progress after a little more than two years, conditions remained intolerable. Hastie decided that he could fight segregation more effectively if he were outside the constraints of an official position, and he resigned in January 1943.

In 1949, Hastie left the position of governor of the Virgin Islands to take a seat as judge on the Third Circuit Court of Appeals, where he established a positive reputation. His cases were never overturned, and they often established precedents that were upheld by the Supreme Court. He served the Third Circuit as chief justice for three years before retiring in 1971 and taking a position as senior judge.

Hastie received over twenty honorary degrees, including two from Amherst College (1940, 1960) and one from Harvard (1975). He was the recipient of the NAACP's SPINGARN MEDAL (1943), the Philadelphia Award (1975), and the Washington Bureau Association's Charles Hamilton Houston Medallion of Merit (1976). He was elected a fellow of the American Academy of Arts and Sciences (1952) and was made a lifetime trustee of Amherst College (1962). His alma maters have also honored him with portraits: One, dedicated in 1973, hangs in the Elihu Root Room of the Harvard Law Library; the other, a gift of the Amherst College class of 1992, hangs in the Johnson's Chapel.

REFERENCES

WADE, HAROLD, JR. *Black Men of Amherst*. Amherst, Mass., 1976.

WARE, GILBERT. *William Hastie: Grace under Pressure*. New York, 1984.

WEAVER, ROBERT C. "William Henry Hastie, 1904–1976." *The Crisis* (October 1976): 267–270.

ROBERT A. BELLINGER

Hatcher, Richard Gordon (July 10, 1933–), politician. Richard Gordon Hatcher was born and raised in Michigan City, Ind., the son of Carleton and Catherine Hatcher. Hatcher received his bachelor of science degree from Indiana University in 1956. In 1959 he earned a law degree from Valparaiso University in Indiana. From 1961 to 1963 he served as a deputy prosecuting attorney in Lake County, which includes the city of Gary, Ind. In 1963 he became a member of Gary's city council. In 1967, as an independent Democrat, Hatcher defeated both his Republican opponent and the regular Democratic party machine when he was elected mayor of Gary. With Carl STOKES, who was elected mayor of Cleveland, Ohio, on the same day, Hatcher became one of the first two African Americans elected mayor of a major city. In all, Hatcher served a five-term, twenty-year tenure in office.

When Hatcher came into office, Gary was suffering from the decline of the local steel industry, which was the core of the town's economy. This decline led to a loss in factory jobs and the exodus of the middle class from the city. These trends caused Gary's total population to decrease from 180,000 in the late 1960s to 116,000 in the late 1980s. During the same period, however, the city's African-American population rose from about 50 percent of the total to more than 80 percent. Hatcher sought to deal with the resulting racial tensions by integrating the police force and encouraging black businesses, but these efforts often brought him into conflict with white neighborhoods in surrounding suburbs.

Hatcher's leadership role in Gary's black community led him to address racial issues in a national context. In 1969 Hatcher joined a citizens' investigation of violence against the BLACK PANTHER PARTY. In 1972, he presided over the plenary session of the first National Black Political Convention, held in Gary. Although he supported the convention's moves to establish a new black political agenda, distinct from the agendas of the two major parties, he rejected the convention's resolution against busing to achieve integrated schools as well as its attacks on the state of Israel.

Hatcher was a close associate of the Rev. Jesse JACKSON. From 1982 to 1984 Hatcher was chairman of the National Board of Directors for OPERATION PUSH (People United to Save Humanity), resigning his chairmanship (but retaining his board membership) to assist Jackson's presidential campaigns. In 1984 Hatcher was national chairman of the Jackson for President Committee, and in 1988 he served as national vice chair of the Jackson for President Campaign.

Hatcher lost the Democratic primary for reelection in 1987 to Thomas V. Barnes, an African American who promised new economic initiatives and whose supporters believed that Hatcher was racially divisive. Hatcher saw Barnes elected mayor in November 1987 and failed in his attempt to take the nomination back from Barnes in 1991.

Following his electoral defeat in 1987, Hatcher became president of his own law firm in Gary, known as Hatcher and Associates. Nelson Mandela invited Hatcher to South Africa in 1991 and praised him for helping convince the United States to impose sanctions on the apartheid regime. Hatcher also began work in 1991 on a "black common market" program for the purpose of strengthening and coordinating black businesses nationwide.

REFERENCES

CLAY, WILLIAM L. *Just Permanent Interests: Black Americans in Congress, 1870–1991*. New York, 1992.

TERRY, DON. "Hatcher Begins Battle to Regain Spotlight in Gary." *New York Times*, May 6, 1991, p. A12.

DURAHN TAYLOR

Havens, Richard Pierce "Richie" (January 21, 1941–), folksinger. Born in New York, Richie Havens began singing in church choirs and street-corner boys' groups. While in high school, he formed the McCrea Gospel Singers and performed locally. A self-taught guitarist, Havens began working professionally in 1962, singing in Greenwich Village coffeehouses. He first recorded in 1963, and came to national attention through an appearance on *The Tonight Show* in 1967 and his performance at Woodstock in 1969. He continued to record and tour through the 1970s, as well as sing in musicals such as *Peter and the Wolf* (1969) and *Tommy* (1972).

Known for his straightforward, simplified guitar playing and hoarse, bluesy voice, Havens expressed the concerns of a young generation. Although he was brought up in the volatile African-American ghetto of Bedford-Stuyvesant in Brooklyn, Havens's atti-

tude toward humanity transcended the presupposed barriers of racial separation. He claimed once, "I didn't choose to be a Negro. I'm all mankind. I'm balanced, a peaceful man." This attitude allowed the hippie movement of the 1960s to identify easily with his style. Havens's best-known albums include *Mixed Bag, Somethin' Else Again,* and *Richard Havens 1983.*

REFERENCE

SOUTHERN, EILEEN. *Biographical Dictionary of Afro-American and African Musicians.* Westport, Conn., 1982.

WILLIAM C. BANFIELD

Hawaii. The earliest settlers of African ancestry arrived in Hawaii, then called the Sandwich Islands, well before the missionaries' arrival in 1821. Black "beachcombers" serving on whaling and other vessels jumped ship and remained on the islands. A man named Black Jack or Mr. Keak'ele'ele was already living on Oahu when Kamehameha I conquered the island in 1796. It is said he helped to build a storehouse for Queen Ka'ahumanu in Lahaina, Oahu, and probably made his living in the maritime industry. Another individual, known as Black Joe, who came about 1813, was a longtime resident, trader, and sailing master for King Kamehameha II, working with his trading vessels and acting as an advisor and interpreter for the king. He died in 1828. A black man named Anderson, the "armourer" of a white adventurer named Ross Cox, competed against Krikapooree, King Kamehameha II's nephew, in a "grand pedestrian racing match" in 1812.

An outstanding early black Hawaiian was Anthony D. Allen, an ex-slave who came to the island of Oahu from New York. In 1813 he took a Hawaiian wife, had three children (one of whom later became a *paniolo* [cowboy]), and was granted six acres of land in Waikiki. There he established a boarding house, bowling green, "dram shop" (saloon) and the first hospital for American seamen in Pawa'a. He was also a dairyman, farmer, landlord, blacksmith, and supplier of vegetables, livestock, alcohol, and service to residents and ship captains. His boarding house became widely known for its excellent cuisine and entertainment.

Allen is given credit for building one of the first schools in the islands and the first carriage road to Manoa valley. He was so highly respected by the Hawaiian royalty that they gave him land to pass on to his descendants. That land is the present site of Oahu's Washington Intermediate School. Allen died

in 1836. Many other early black settlers were active in business matters on Oahu. Records exist of bakers, boarding house keepers, barbers, and tailors.

Blacks also helped make up the musical world of early Honolulu. Four blacks formed a royal brass band for King Kamehameha III in 1834, and the king hired America Shattuck as first master and David Curtis as second master. Another black, George Washington Hyatt, organized a larger band, the Royal Hawaiian Band, in 1845 with Charles Johnson as bandleader and Hyatt as Second bandmaster. There has been a long and complex relation between Hawaiian and African-American music. Experts on the roots of the blues maintain that travelling Hawaiian guitarists in vaudeville shows introduced the use of guitar slides to southern guitarists.

Betsey Stockton, a missionary teacher, founded an important school. An educated and dignified ex-slave of the president of Princeton University, she sailed to Hawaii in 1823, becoming probably the first African-American woman on the Islands. She became a teacher in the Missionary School in Lahaina, Maui, learned the Hawaiian language, and in 1824 helped found the Lahainaluna school on Maui, probably the first school for Hawaiian commoners (maka'ainana), where she spent two years as a teacher of English, Latin, history, and algebra before her return to the East Coast. Her school emphasized discipline and moral uplift, and was later used as a model by Gen. Samuel Armstrong for the founding of Hampton Institute in Virginia.

Though individual African Americans (sometimes known as *haole eleele,* "black foreigners") were accepted into the Hawaiian community on the same basis as white foreigners, black settlement was discouraged. In 1854–1855, fearing conquest by white foreigners, King Kamehameha III was petitioned by Americans to accept annexation by the United States. He refused in part because he feared the extension of black slavery and color bars to Hawaii.

Despite repeated attempts by white Americans to import black labor, there were no significant numbers of black immigrants until after Hawaii became a U.S. Territory in 1900. In the 1850s, when the Kingdom of Hawaii sought laborers, blacks were intentionally excluded from proposed lists of immigrant groups by missionaries and abolitionists opposed to black contract labor. As a result, Chinese laborers were eventually imported in large numbers. In 1874, after the Civil War, U.S. Secretary of War William Belknap suggested that the rich soil and climate of Hawaii would be ideal for the "discontented colored people" of the South. Six years later, J. C. Merritt and Co. of San Francisco asked the Hawaiian assembly for permission to import one thousand black plantation workers. The Assembly refused.

In 1881, U.S. Secretary of State James Blaine's agent, James M. Comly, reported that blacks, Japanese, and Portuguese (some of the latter black Cape Verdeans, who came on whale ships throughout the century and remained) were more desirable workers than the Islands' growing Chinese labor force, and could fortify the dwindling native Hawaiian population through intermarriage. Blaine, fearing British moves to make Hawaii a protectorate and import Indian labor, urged African Americans to settle in Hawaii. There were no homestead laws or land for sale to immigrants, so few emigrated. After sugar planters asked permission to bring black laborers, Hawaiians, averse to black settlement, passed laws against their entry the same year.

Following the deposition of Queen Liliuokalani in 1893, Lorrin A. Thurston, U.S. Commissioner to Hawaii, renewed the call for black labor. U.S. Interior Secretary Hoke Smith so favored black resettlement that he dropped his opposition to the annexation of Hawaii. However, Sanford B. Dole, president of the provisional government, refused to take on such a "great responsibility" since it would have a bad effect on natives and would cheat the South of a productive labor resource. Furthermore, Booker T. WASHINGTON, during a trip to Hawaii in the late 1890s to investigate the possibilities for black workers, discovered to his surprise that working conditions were in many ways worse than in the South.

The U.S. annexation of Hawaii in 1898 ended legal barriers to black settlement, and in the next several years groups of African-American laborers and middle-class professionals migrated. The first laborers came in 1901. The Hawaiian Sugar Planters' Association brought a group of about 200 blacks to join the Asian plantation labor force on the islands of Maui and Hawaii. Many later returned to the South or were amalgamated into the local community. A group of Puerto Rican laborers, many partly black, also arrived. The same year, Col. W. O. Bean of Brewer & Co. brought over twenty-one black workers from Tennessee, including six women, on the ship *Zealandia*.

The relative lack of color prejudice in Hawaii made it possible for small groups of educated blacks to prosper and advance in ways unimaginable on the mainland. In 1898, African-American attorney T. McCants STEWART arrived in Hawaii, and became active in politics and government. Stewart worked in the cabinet of Hawaiian King Kalakaua, where he helped draft the Organic Act of the Territory, and on several occasions aided Hawaiians in regaining their lost *kuleanas* (property and titles). While Stewart left by 1903, his daughter, Carlotta Stewart-Lai, remained. She graduated from Oahu College (now Punahou School) in 1902. She then became an English

teacher, and in 1909, at the age of 27, she became the principal of Kauai's Hanamaulu School. Several other black Hawaiians made names for themselves, including William F. Crockett, another attorney, who came to Hawaii in 1901, and very soon was named district magistrate of Wailuku, Maui, then a judge, and then territorial senator; his son Wendell Crockett, deputy county attorney of Maui; Nolle R. Smith, an engineer and fiscal expert who settled in Honolulu in the early 1900s, became a large landowner, served several terms in the territorial House of Representatives, and later was appointed assistant director of Hawaii's Budget Bureau; and Eva B. Jones Smith—known as Eva Cunningham—owner of a popular piano school in the 1910s, and the first woman in Hawaii to have a radio program.

The 1900 census, the first in Hawaii after annexation, and the first to include blacks as a distinct category, listed 233 black Hawaiians. Forty years later, there were only 255. However, such statistics undercounted mixed descendents of African Americans who usually listed themselves as "mixed" or "other" in census records.

While there was no JIM CROW barrier to achievement for Hawaii's small black population, the island was not a paradise of interracial harmony. When President William Howard Taft appointed African American Charles Cottrell as Collector of Internal Revenue, Hawaiian leaders protested. However, Cottrell soon became so popular that many Hawaiians protested his removal by President Woodrow Wilson. In 1913, there were strenuous efforts to keep the twenty-fifth Negro Infantry Regiment from being stationed on the Islands; yet they came and remained for several years without trouble, and made quite a favorable impression. Similarly, in 1941, before the U.S. entry into WORLD WAR II, a mass movement of Hawaiian government, business, and labor organizations came together in an unsuccessful attempt to deter the War Department from sending a labor battalion of 600 African Americans to unload ships. Yet with the coming of the war, several thousand African American men and some women came as soldiers and defense workers. During the Japanese attack on Pearl Harbor on December 7, 1941, Dorie MILLER, a navy messman, shot down four enemy planes and was awarded the Naval Cross.

During the war, there was much friction between white and African-American soldiers, which ended in fights, racial slurs, and near riots. The army, navy, and marines mostly maintained segregated living quarters. Only at the Schoefield Barracks could men live, work, and play together without restriction. Unfortunately, as the military established itself, and tourism increased, the local populace learned of the inferior position of blacks on the mainland, and na-

Carlotta Stewart-Lai (far right) was a teacher and principal in Hawaii's integrated school system for more than forty years. This photograph dates from 1933, when she was principal of the Hanamaulu School in Kauai, Hawaii. (Moorland-Spingarn Research Center, Howard University)

tives increasingly adopted the stereotypes and attitudes of the economically and socially dominant whites. In 1948 noted poet and journalist-editor Frank Marshall Davis moved to Hawaii from Chicago with his wife and remained there with his wife until his death in 1987. In 1962 the newly established NAACP chapter in Honolulu did a study for the Hawaii advisory branch of the U.S. Civil Rights Commission in which it discovered that 60 percent of people offering living accommodations in newspapers did not desire black tenants.

After the war, most blacks returned to the mainland, and conditions became less strained. Those who remained and those who subsequently arrived most often blended into the local community, limiting the possibility of forming a definable black community. After several failed attempts by black servicemen to hold services in navel housing, the first black churches, including Honolulu's Prayer Center Church of God in Christ and Maile's St. John the Baptist Church, were created in the mid-1950s. In 1990, there were eleven black congregations in the state. GOSPEL MUSIC, accompanied by ukeleles, remains popular among blacks and others.

In the years since 1959, when Hawaii became a state, African-American residents have been active as military personnel, such as Vice Admiral Samuel L. Gravely, Jr., the nation's first black admiral; businesspersons, such as Wally "Famous" Amos; and as educators and politicians. Charles Campbell became a teachers' union leader, a Honolulu city councilman and a state senator during the 1970s; and Helene Hale was a Hawaii (island) council member and conven-

tion delegate in the 1950s. Others have been successful in the fields of government employment, the arts, entertainment, science, and sports (notably the starting players of the University of Hawaii's 1972 "Fabulous Five" championship basketball team).

Under the influence of the civil rights movement and of a growing black population living in Hawaii, African Americans have grown more interested in their black identity and in creating black institutions. In 1977, the annual Miss Black Teenage Hawaii Pageant was inaugurated. Also, during the 1980s, an oral history project on black Hawaiians was begun at the University of Hawaii's Manoa branch. In June 1987, the magazine *Afro-Hawaii News* published its first issue. According to the 1990 U.S. census, the approximately 27,700 African Americans residing in Hawaii comprise 2.5 percent of the total population, up from 17,384 in the 1980 Census. More than one third are in the armed forces, and almost fifty percent are military dependents. This leaves about 4000 civilians on the islands. Members of the civilian population, concentrated in Honolulu, are active in government work, science, and education.

Sadly, however, the obstacle of racism has not completely disappeared. Employment data in 1988 showed that blacks had an 8.8 percent unemployment rate, the highest of any group. Black females had an unemployment rate of 11.4 percent, also higher than that of any other ethnic group, despite the recent trend of well-educated, well-trained immigrants. Hawaii does offer a model of racial harmony to the world, but its peaceful race relations do not imply complete racial equality. Until the Hawaiian

economy includes African Americans in a more equitable way, the state will not have achieved total racial harmony.

REFERENCES

"Afro-Americans in Hawaii." Special issue. *Afro-Hawaii News* (February 1988).

GREER, R. A. "Blacks in Old Hawaii." *Honolulu* (November 1986).

LEE, LLOYD L. "A Brief Analysis of the Role and Status of the Negro in the Hawaiian Community." *American Sociological Review* (August 1948).

NORDYKE, ELEANOR C. "Blacks in Hawai'i: A Demographic and Historical Perspective." *Hawaiian Journal of History* (1988).

SCRUGGS, MARC. "A Black Friend of Hawaii Missionaries." *Honolulu Star Bulletin,* January 12, 1987, p. 10.

STEPHENS, MICHAEL JEROME. The Function of Music in Black Churches on Oahu, Hawaii, as Illustrated at Trinity Baptist Missionary Church. M.A. thesis, University of Hawaii, 1990.

TATE, MERZE. "Decadence of the Hawaiian Nation and Proposals to Import a Negro Labor Force." *Journal of Negro History* (October 1962).

———. "Slavery and Racism as Deterrents to the Annexation of Hawaii, 1854–55." *Journal of Negro History* (January 1962).

KATHRYN WADDELL TAKARA

Hawkins, Augustus Freeman (August 31, 1907–), politician. Augustus F. Hawkins was born in 1907 in Shreveport, La., the son of an English-born pharmacist who had settled in Shreveport after traveling in Africa. When Hawkins was seven, his family moved to California. He attended high school in Los Angeles and earned his bachelor's degree in economics at the University of California at Los Angeles in 1931. Hawkins then pursued further study at the University of Southern California in Los Angeles, but did not complete a graduate degree.

In 1934, Hawkins was elected as a Democrat to the California State Assembly, in which he served from 1935 to 1963. During his tenure in the assembly, he drafted more than one hundred pieces of legislation. These included bills that provided minimum-wage rates for women, workers' compensation for domestic workers, enhanced pensions, and disability insurance. His most notable piece of legislation was California's Fair Housing Act. In 1962, Hawkins was elected to the House of Representatives as a Democrat from California's Twenty-ninth Congressional District in Los Angeles. He became the first African-American representative from a western state. A leading advocate of civil rights legislation, he guided into passage the Juvenile Justice and Delinquency Prevention Act and the Community Service Act during the Ninety-third Congress (1973–1975). In 1973, he secured posthumous honorable discharges for the 167 black soldiers of the Twenty-fifth Infantry Regiment, who had been dismissed in 1906 from the U.S. Army due to a false charge of public disturbance in the notorious BROWNSVILLE, TEXAS, INCIDENT.

Hawkins sponsored the Economic Opportunity and Vocational Education acts during the mid-1970s and became chair of the House Committee on Education and Labor, as well as chair of the House Subcommittee on Elementary, Secondary, and Vocational Education. In 1978, with Sen. Hubert H. Humphrey (D–Minn.), he coauthored the Humphrey-Hawkins Full Employment and Balanced Growth Act. In its original form, this legislation required that the federal government provide jobs for all people who could not find work in the private sector. In its final version, it had qualifications and preconditions for the provisions to go into effect that essentially gutted the legislation.

Despite these legislative gains, Hawkins went on to sponsor other federal legislation affecting pregnancy disability, job training, youth employment, and school development. In the congressional session of 1985–1987, Hawkins wrote and helped pass a bill to renew the School Lunch and Nutrition Program. He also helped amend the Higher Education Act to further assist traditionally minority colleges.

In January 1990, after twenty-eight years of service in the House, Hawkins announced his retirement from Congress. After retiring, he worked closely with his Hawkins Foundation, which was established to equalize and improve educational opportunities for American youth. Hawkins remained involved with congressional politics as a private citizen, urging the federal government to continue to enforce educational equality for all American children.

REFERENCES

CLAY, WILLIAM L. *Just Permanent Interests: Black Americans in Congress, 1870–1991.* New York, 1991.

RAGSDALE, BRUCE A., and JOEL D. TREESE. *Black Americans in Congress, 1870–1989.* Washington, D.C., 1990

DURAHN TAYLOR

Hawkins, Coleman Randolph (November 21, 1904–May 19, 1969), jazz saxophonist. Hawkins was born and raised in St. Joseph, Mo. His mother, a schoolteacher and organist, introduced him to music.

By the age of nine, he had studied piano, cello, and tenor saxophone, and by the age of fourteen he was playing frequently at dances in Kansas City. By 1921 he was performing with the orchestra of the 12th Street Theatre in Kansas City, and at the same time studying music theory both at the Industrial and Educational Institute, and at Washburn College, in Topeka, Kans.

In 1921, Hawkins quit school to tour with Mamie SMITH's Jazz Hounds ("I'm Gonna Get You," 1922) and two years later he moved to New York City, where he played with clarinetist Wilbur Sweatman at Connie's Inn. That year he was hired by bandleader Fletcher HENDERSON. His eleven-year engagement with Henderson's orchestra made him a star. Through touring and frequent recording, both with Henderson, a Benny CARTER-led group known as the Chocolate Dandies, and other ensembles ("Dicty Blues," 1923; "The Stampede," 1926; "Sugar Foot Stomp," 1931; and "New King Porter Stomp," 1932), Hawkins became one of the dominant tenor saxophonists in jazz, proving that the instrument could produce more than novelty effects. Hawkins was also a progressive composer, whose "Queer Notions" (1933), with Fletcher Henderson's orchestra, featured unusual harmonies.

In 1934, Hawkins took a six-month leave from the Henderson band, never to return. He went to England to work for British bandleader Jack Hylton, and toured Europe to tremendous acclaim. Hawkins spent five years touring Europe. "Honeysuckle Rose" and "Crazy Rhythm" document his 1937 collaborations with fellow expatriate saxophonist Benny CARTER and French guitarist Django Reinhardt. With war threatening Europe, Hawkins returned to the United States in 1939 to lead a nine-piece band at Kelly's Stable. That engagement immediately reestablished his reputation as the preeminent saxophonist in jazz.

In October 1939 Hawkins recorded "Body and Soul," which became one of the great musical landmarks of the twentieth century, demonstrating the extent to which Hawkins had elevated the tenor saxophone to a central place in jazz. With its ripe tone, jagged rhythm, and arresting harmonies, "Body and Soul" remains his best known and most identifiable recording. The recording also caps a major shift that had taken place in Hawkins's solo style. Whereas his early recordings with Henderson feature his big, powerful sound, and the so-called "slap-tongue" technique, characterized by rapid syncopations and arpeggiations that produced a "herky-jerky" sound, by the late 1920s Hawkins was developing the more swaggering, legato execution of tones first heard on "One Hour" (1929), with the Mound City Blue Blowers. That mature style, with its rough tone and

Coleman Hawkins. (Photographs and Prints Division, Schomburg Center for Research in Black Culture, The New York Public Library, Astor, Lenox and Tilden Foundations)

vertical or chordal approach to harmony, established one of the two major schools of saxophone playing; the other school was that of Lester YOUNG, with his light, vibratoless tone, and melodic, or horizontal, style of improvisation.

Always a restless experimenter, Hawkins was one of the few swing era musicians to gain new distinction during the bebop era. In 1940 he organized his own big band, one of the first to record bebop, and during the next decade he performed with bebop musicians such as Thelonious MONK, Miles DAVIS, Max ROACH, Kenny CLARKE, and Dizzy GILLESPIE and with Fats NAVARRO. Hawkins's "Picasso" (1948) is thought to be the first unaccompanied saxophone recording in jazz.

In the late 1940s and '50s Hawkins used New York City as a base from which to tour the United States and Europe, often with trumpeter Roy ELDRIDGE. He also toured with the "Jazz at the Philharmonic" all-star jam sessions organized by Norman Granz (1945), and appeared on the 1957 television program "The Sound of Jazz."

Although his own playing was always firmly rooted in the traditions of the swing era, Hawkins kept up with new developments. He recorded with

Thelonious Monk and John COLTRANE (1957), Bud POWELL (1960), Duke ELLINGTON (1962), and Sonny ROLLINS (1963). He also recorded prolifically as a leader, including on *Hawk Eyes* (1957), *Night Hawk* (1960), and *Wrapped Too Tight* (1965). In the late 1960s Hawkins continued to appear at major jazz festivals and to perform in jazz clubs in New York. However, liver problems due to alcoholism made his behavior increasingly erratic. He died in New York in 1969.

REFERENCES

CHILTON, JOHN. *The Song of the Hawk: The Life and Recordings of Coleman Hawkins.* Ann Arbor, Mich., 1990.

JAMES, B. *Coleman Hawkins.* Tunbridge Wells, 1984.

WILLIAMS, MARTIN. "Coleman Hawkins: Some Comments on a Phoenix." In *The Jazz Tradition.* New York, 1970, pp. 64–70.

EDDIE S. MEADOWS

Hawkins, Edler Garnett (1908–December 18, 1977), Presbyterian minister. Edler G. Hawkins was the founder and first pastor of the Saint Augustine Presbyterian Church, Bronx, N.Y., and an outspoken leader in New York City politics. After thirty-two years in the pastorate, he retired in 1970 to become professor of black studies at Princeton Theological Seminary. Hawkins led the black caucus and the Presbyterian Interracial Council that pushed his denomination into the forefront of the civil rights movement. In 1964, he was elected the first African-American moderator of the General Assembly of the United Presbyterian Church.

GAYRAUD S. WILMORE

Hawkins, Edwin R. (August 18, 1943–), gospel singer. Edwin Hawkins was born and reared in Oakland, Calif., where he was associated with the CHURCH OF GOD IN CHRIST. In 1967, he and his associate Betty Watson formed a group of young singers called the Northern California State Youth Choir. Hawkins served as pianist and director. He received wide recognition in 1969 with the recording of eight traditional songs, including the Baptist hymn "Oh Happy Day," which was an instant success and became a Top Ten hit on the pop charts. Due to the wide influence of the recording through its use of pop/soul harmonies and jazz rhythms, the release of "Oh Happy Day" marked the beginning of the contemporary period of gospel music (*see* GOSPEL).

Hawkins is the leader of a family of gospel musicians called the Edwin Hawkins Singers, who have been well received in performances around the world. By 1980, the group included brothers Edwin, Walter, and Daniel; sisters Carole, Lynette, and Freddie; cousin Shirley Miller; and Walter's wife Tramaine Davis Hawkins, who was the lead singer and later established a successful solo career. Walter, an ordained minister, organized the family-based Love Center Choir (named after the church he pastors in Oakland) in the 1970s; it performs when Edwin makes solo appearances. The choir soon became one of the leading contemporary-gospel ensembles. In addition to Tramaine and Edwin, other family members have also recorded solo albums. The Hawkins family has won many awards and honors, including several Grammys. Their contemporary-gospel sound is characterized by a combination of traditional gospel with harmonies and rhythms borrowed from secular forms such as jazz, soul, and rock. Among their best-known recordings are *Changed, Goin' Up Yonder,* and *Be Grateful.* Throughout the 1980s and '90s, Hawkins periodically led workshops known as the Music and Arts Seminar, events that produced well-received recordings and provided aspiring songwriters and singers with a national audience.

REFERENCES

BROUGHTON, VIV. *Black Gospel.* Poole, Dorset (U.K.), 1985.

HEILBUT, ANTHONY. *The Gospel Sound: Good News and Bad Times.* 1971. Revised. New York, 1985.

GUTHRIE P. RAMSEY, JR.

Hawkins, Walter Lincoln (March 21, 1911–August 20, 1992), inventor. Walter Hawkins was born in Washington, D.C. Having obtained a bachelor's degree in chemical engineering from Rensselaer Polytechnic Institute in 1932 and an M.S. from Howard University in 1934, he received a Ph.D. in chemistry from Canada's McGill University in 1938. Hawkins began his career as a lecturer at McGill (1938–1941), and was National Council Research Fellow at Columbia University in 1941, before becoming the first black hired by the technical staff at AT&T's Bell Laboratories, Murray Hill, N.J., in 1942. While there, he served as supervisor (1963–1973) and department head (1972–1974) of applied research, and finally as assistant director of the chemical research lab from 1974 until 1976, when he retired. He thereafter served as a consultant to Bell on educational and employment opportunities for minorities and as research director, a part-time position,

at the Plastics Institute of America, in Montclair, N.J.

While at Bell Laboratories in the late 1940s, Hawkins developed an additive that extended the life of plastic coatings for shielding wire cables, revolutionizing the communications industry and enabling the international expansion of telephone services. He held 18 patents in the United States and 129 from foreign countries, and published 55 papers and 3 books, including *Polymer Degradation and Stabilization* (1984). In addition to undertaking research, he was in 1968 one of the first contributors to, and in 1981 served as the first chairman of, the American Chemical Society's Project SEED, which introduced chemistry to disadvantaged students during summer work experiences. As a participant in the Urban League's Black Executive Exchange Program in both 1970 and 1976, he worked with educators to expand science programs at predominantly black colleges. His honors include the National Medal of Technology, presented to him by President George Bush on June 23, 1992, for his work in polymers and efforts on behalf of minority youth. He died at his home in San Marcos, Calif., in 1992.

REFERENCE

Obituary. *New York Times,* August 23, 1992.

SIRAJ AHMED

Hayden, Palmer C. (1890–1973), painter. Born Peyton Cole Hedgeman, in Widewater, Va., Palmer Hayden was the fifth of twelve children. As a teenager, he went north to Washington, D.C., where he was a roustabout and did graphic design for the Ringling Brothers Circus. In 1912, Hayden joined the army in New York. While in the Philippines, he received a commendation for mapmaking. When World War I prevented him from studying abroad in 1915, he reenlisted and took correspondence courses in drawing while on West Point guard duty. At some point, a commanding officer had difficulty pronouncing Hayden's birth name; hence the change.

From 1920 to 1924, Hayden took summer art classes at Columbia University and delivered letters in New York. He then cleaned homes part-time, including those of the wealthy Alice Miller Dike. After his first solo exhibition at the Civic Club in 1926, Dike encouraged Hayden to enter a painting—a waterfront scene of Boothbay Harbor, Maine—to the Harmon Foundation. When it won first prize, Dike gave him $3,000 to go to Europe.

Hayden studied privately in Paris and traveled throughout Brittany while in France from 1927 to 1932. He exhibited harbor scenes and works of African-American people at Galerie Bernheim-Jeune (1927), the Salon des Tuileries (1930), and the American Legion (1931). His well-known painting *Fetiche et fleurs* (c. 1932), with its Fang head and Kuba textile, reflects both the influence of African art on modern European painting and Alain Locke's call for racially representative art.

Back in New York, Hayden worked for the FEDERAL ARTS PROJECT of the WORKS PROJECT ADMINISTRATION from 1934 to 1940, when he was disqualified for marrying an employed schoolteacher. Almost exclusively, he depicted African-American folk culture in a celebratory, caricature-like manner. In 1944 he gathered material in West Virginia for his *Ballad of John Henry* series. Argent Galleries of New York exhibited twelve of these paintings in 1947. Just days before his death, Hayden received a Creative Artists Public Service Program Foundation commission to paint a black soldier series.

REFERENCES

GORDON, ALLAN M. *Echoes of Our Past: The Narrative Artistry of Palmer C. Hayden.* Los Angeles, 1988.

THERESA LEININGER-MILLER

Hayden, Robert Earl (August 4, 1913–February 25, 1980), poet. Born in Detroit, Mich., he wrote nine volumes of poetry and taught literature at Fisk University and the University of Michigan. Although his career began in the 1930s during the realist and protest period of African-American writing and reached its height in the decade following the BLACK ARTS MOVEMENT, Hayden consistently pursued his own unique poetic muse. Distinguished by complexity and precision, his poetry expresses the diversity of the American experience. In 1966, Hayden received the grand prize for poetry in English at the First World Festival of Negro Arts, and he became a fellow of the American Academy of Poets in 1975. One year later, he became the first African American to serve as poetry consultant to the Library of Congress.

Hayden's childhood and his complex relationship to his family and ancestry were often the subjects of his poems, as was his early life in the Detroit ghetto known as "Paradise Valley." His early love of literature won him a scholarship to attend Wayne City College (later Wayne State University), where he majored in Spanish and immersed himself in the theater, cultivating the dramatic instincts that shaped much of his later multivoiced poetry. The depression forced him to leave college just before completing his studies, yet this abrupt move was crucial to his de-

velopment as a poet. He joined the FEDERAL WRIT-ERS' PROJECT (FWP), where he researched local history and black folklore, concentrating on the UNDERGROUND RAILROAD and the antislavery movement in Michigan. Enrolling as a part-time student at the University of Michigan in 1938, he went on to work for the Federal Historical Records Survey for several months processing the correspondence of several abolitionists. His major contribution to the FWP was the manuscript "The Negro in Michigan." His historical research informed much of his work as a poet.

In 1941, Hayden and his wife, Erma, moved to Ann Arbor so that he could begin graduate study in English at the University of Michigan, where he worked with the poet W. H. Auden. After receiving an M.A. in 1944, Hayden moved to Nashville in 1946 to teach at FISK UNIVERSITY, where he remained for twenty-two years before returning to the University of Michigan as a professor of English. While Hayden authored three chapbooks in the 1940s and '50s, his mature work did not appear until 1962 with the publication of *A Ballad of Remembrance. Angle of Ascent,* his best-known volume, was published in 1975; his *Collected Poems* was published posthumously in 1985.

Hayden probed his craft in search of universal truths, only to find the forms of revelation in the voices of the African-American historical landscape. His major contribution to American literature is those poems that reach down in search of the obsidian of history, the smoky shards of the black experience. In these historical poems, which include "Middle Passage," "The Ballad of Nat Turner," "Runagate Runagate," "Frederick Douglass," "The Dream (1863)," and "John Brown," the subjects of African-American history give a thematic focus while allowing him the freedom to discover his own identity. Hayden most distinguishes himself as an artist of the African-American experience.

His poetry is also rich in its variety of aesthetic and intellectual concerns. In "The Night-Blooming Cereus," "For a Young Artist," "The Peacock Room," "Kodachromes of the Island," "The Diver," and " 'An Inference of Mexico,' " Hayden writes as a modern poet who commands a unique sense of the importance of the imagination in confronting and transforming everyday life. His religious poems constitute the final major grouping of his work. His poems on the Baha i Faith, including "Dawnbreaker," "Bahá'u'lláh in the Garden of Ridwan," and "Words in the Mourning Time," help him to locate his spiritual bearings as an artist. As he reveals in his "Statement on Poetics," Hayden viewed the writing of poems as "one way of coming to grips with inner and outer realities—as a spiritual act, really, a sort of

prayer for illumination and perfection." His poetry revels in the multiple possibilities of racial and spiritual identity.

REFERENCES

HATCHER, JOHN. *From the Auroral Darkness: The Life and Poetry of Robert Hayden.* Oxford, U.K., 1984.
WILLIAMS, PONTHEOLLA T. *Robert Hayden: A Critical Analysis of His Poetry.* Urbana, Ill., 1987.

MARCELLUS BLOUNT

Hayes, Robert Lee "Bob" (December 20, 1942–), track and field athlete and football player. Bob Hayes was born and raised in Jacksonville, Fla. He starred in baseball, basketball, football, and track at Matthew Gilbert High School. Following graduation from high school in 1960 Hayes enrolled at

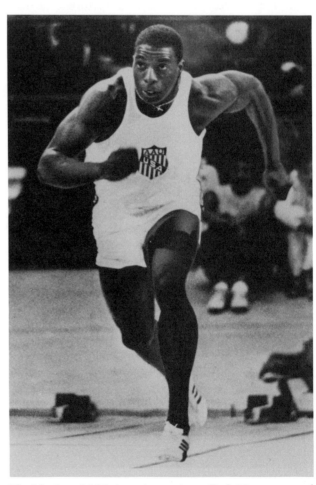

Florida A & M University sprinter Bob Hayes earned the honorary title "The World's Fastest Human" in winning the 100-meter dash at the 1964 Tokyo Summer Olympics. Hayes went on to a successful career with the Dallas Cowboys in the NFL. (AP/Wide World Photos)

Florida A & M University in Tallahassee, a historically black institution. There he excelled on the track team as a sprinter and on the football team as a halfback and split end.

At the 1963 Amateur Athletic Union championships Hayes set a world record in the 100-yard dash with a time of 9.1 seconds. The following year Hayes won gold medals in the 100-meter dash and the 4 by 100 meter relay at the Olympic Games in Tokyo.

Drafted by the Dallas Cowboys after his junior year at Florida A & M, Hayes joined the team for the 1965 season and quickly became a star pass receiver. He established a club record sixty-four receptions for 1,232 yards in 1966 and was elected All-Pro for the 1966 and 1968 seasons. Hayes's speed forced opposing teams to adopt zone defenses, which revolutionized defensive strategy in the NFL. Hayes played for Dallas until 1975, then spent his last season with the San Francisco 49ers.

After retiring from football Hayes moved back to Dallas, where he co-owned a computerized marketing company. In 1979 he was convicted of selling cocaine to an undercover police officer and served eleven months of a five-year prison sentence. In the 1980s Hayes spent time in drug and alcohol rehabilitation programs, successfully recovered, and earned a living by giving lectures on substance abuse to corporate employees. In the early 1990s he published an autobiography, *Run, Bullet, Run: The Rise, Fall, and Recovery of Bob Hayes*, and operated the Daytop Village drug treatment program in Dallas.

REFERENCES

HAYES, BOB, with Robert Pack. *Run, Bullet, Run: The Rise, Fall, and Recovery of Bob Hayes*. New York, 1990.

PORTER, DAVID L. *Biographical Dictionary of American Sports: Outdoor Sports*. New York, 1989.

THADDEUS RUSSELL

Hayes, Roland Willsie (June 3, 1887–December 31, 1976), concert singer. Roland Hayes was the first African-American singer in the classical tradition to receive international acclaim. Heralded as one of the great singers of the twentieth century, he was at the height of his career one of the world's most celebrated interpreters of German lieder. Born in a two-room log cabin near Curryville, Ga., Hayes lived on his parents' farm with six siblings. When he was eleven, his father died, forcing him to quit school to help support the family. He moved with his family to Chattanooga, Tenn., in 1900, and attracted the attention of Arthur Calhoun, who introduced him to the basics of music and singing.

In 1905, Hayes entered Fisk University. Although he had only a fifth-grade education, his determination and musical talent were enough to warrant a probationary admittance. He excelled in his studies and worked at odd jobs to support himself. In his fourth year, the director of music, a woman unsympathetic to Hayes's participation in the FISK JUBILEE SINGERS, had him expelled from school on the grounds of neglect of his musical studies. Undaunted, he continued to pursue a professional career, and in 1911 moved to Boston, where he became a student of Arthur Hubbard (himself a pupil of Francesco Limpertie). For the next eight years he studied with Hubbard while establishing himself on the local concert circuit, particularly in black churches. Unable to acquire management with any white agency, he began in 1915 to manage his own concerts. Even in the face of adversity, Hayes remained a man of determination, humility, and compassion. Although he had financial losses, the success of a concert in Boston's Symphony Hall in 1917 enabled him to travel to Europe for further study.

Roland Hayes. (Photographs and Prints Division, Schomburg Center for Research in Black Culture, The New York Public Library, Astor, Lenox and Tilden Foundations)

In Europe, as in America, Hayes's success was not immediate. Despite difficulties, a recital in 1921 at London's Wigmore Hall settled him securely into an international career that lasted more than thirty years. Possessed of a voice of beauty and purity, Hayes was aware very early of the uniqueness his ethnicity brought to the music he performed. He studied intensely throughout his career, and not only excelled in the interpretation of European art songs, but was the preeminent force in bringing the African-American spiritual to recognition on the solo concert stage. In Europe, Hayes studied with Sir George Henschel, Theodore Lierhammer, and Gabriel Fauré. Having achieved acclaim in Europe, in 1923 Hayes returned to an enthusiastic American public. So great was his influence that he performed for a forcibly integrated audience at Washington's Constitution Hall many years prior to the indignity inflicted there upon Marian ANDERSON at the hands of the Daughters of the American Revolution.

The first African-American singer to perform with a major American orchestra, Hayes performed with all the major orchestras and conductors of his time, including Koussevitzky, Walter, Stokowski, Monteux, and Klemperer. Among his numerous awards were the SPINGARN MEDAL, awarded in 1924, and the Purple Ribbon, awarded by the French government in 1949. The first of many honorary degrees was awarded him by Fisk University in 1932, the same year in which he married Helen Alzada Mann, with whom he had one child, Africa Franzada Hayes. A scholar and accomplished composer, Hayes accepted a professorship at Boston University in 1950, although he also continued to sing for many years afterward.

REFERENCES

HAYES, ROLAND. *My Songs: Afro-American Religious Folk Songs Arranged and Interpreted by Roland Hayes*. Boston, 1948.

HELM, MACKINLEY. *Angel Mo' and Her Son, Roland Hayes*. Boston, 1942.

MAURICE B. WHEELER

Haynes, Elizabeth Ross (July 30, 1883–October 26, 1953), activist. A native of Alabama and the daughter of former slaves, Elizabeth Ross Haynes became an expert in urban affairs and applied her skills to assist urban blacks to better their living conditions. Elizabeth Ross attended the Alabama State Normal School and graduated from Fisk University in 1903. She went on to teach in various schools in the South, spending summers doing graduate work

at the University of Chicago from 1905 to 1907. In 1910 she married George Edmund HAYNES, a sociologist and executive director of the National Urban League. She went on to receive an M.A. in sociology from Columbia University in 1923. During this period, she was the domestic service secretary of the U.S. Employment Service.

Haynes was an active member of women's groups, working with the YWCA, the NATIONAL ASSOCIATION OF COLORED WOMEN, and the Women's Bureau of the Department of Labor. In 1920 she was one of four African-American women to speak at the Women's Inter-Racial Council Conference in Memphis. Four years later she became the first black woman elected to the national board of the YWCA. When she finished her work with the national board in 1934, Haynes successfully campaigned to be co-leader of the twenty-first Assembly District in New York. Here she applied her expertise in labor and housing issues to the benefit of the entire city.

Haynes was also a scholar, publishing two books, *Unsung Heroes* (1921) and *The Black Boy of Atlanta* (1952), a biography of Mayor Richard Robert WRIGHT. Her other publications in journals dealt with issues of black women and labor. Among these were "Two Million Negro Women at Work," in *Southern Workman* (1922), and her master's thesis, "Negroes in Domestic Service in the U.S.," published in the *Journal of Negro History* (1923).

REFERENCES

GIDDINGS, PAULA. *When and Where I Enter: The Impact of Black Women on Race and Sex in America*. New York, 1984.

LERNER, GERDA, ed. *Black Women in White America: A Documentary History*. New York, 1972.

JUDITH WEISENFELD

Haynes, George Edmund (May 11, 1880–January 8, 1960), social researcher. George E. Haynes was born in Pine Bluff, Ark. He grew up in Pine Bluff and Hot Springs, Ark., and at the 1893 Chicago World's Fair heard his first professional discussions about African-American migration and the problems of race relations. After a year at the Agriculture and Mechanical College in Normal, Ala., he transferred to Fisk University, where he earned his bachelor's degree in 1903. Two years later he received his master's degree in sociology from Yale University. He pursued further study at the University of Chicago during the summers of 1906 and 1907. In 1908 he began to conduct research on the impact of migration

to the North on employment opportunities for blacks, and he graduated from the New York School of Philanthropy in 1910. Later that year Haynes traveled throughout Europe, became an original member of the NATIONAL ASSOCIATION FOR THE ADVANCEMENT OF COLORED PEOPLE (NAACP) and cofounded the Committee on Urban Conditions Among Negroes (the forerunner of the NATIONAL URBAN LEAGUE, of which Haynes served as the first executive director from 1910 to 1917). In 1910 he also married Elizabeth Ross; she would later become the first African-American national secretary of the YOUNG WOMEN'S CHRISTIAN ASSOCIATION (YWCA).

As chairman of Fisk University's social science department from 1910 to 1921, Haynes developed new programs for training social researchers. In 1912 he completed his dissertation, on "The Negro at Work in New York City," and became the first African American to be awarded a Ph.D. from Columbia University. Haynes's research drew the attention of labor economists in the Wilson administration. He served as director of the Division of Negro Economics, a section of the U.S. Department of Labor, from May 1918 to May 1921. Haynes helped organize the Department of Race Relations within the Federal Council of the Churches of Christ in America in 1921. This council, established in 1908, was an association of nonsectarian church congregations and organizations. Haynes served as the first executive secretary of the Department of Race Relations from 1921 to 1947.

Believing that involvement in industry, education, and fine arts by African Americans would increase racial tolerance, Haynes gave annual awards through the race relations department to individuals who had distinguished themselves in these areas. The department was vigorous in working to ensure fair and equitable implementation of government relief programs during the Great Depression. Haynes and the department also initiated Race Relations Sunday, celebrated on the second Sunday of each February. During World War II, Haynes sought to improve race relations in urban centers by developing forums called "interracial clinics."

After the war, Haynes conducted a series of surveys concerning the work of the YOUNG MEN'S CHRISTIAN ASSOCIATION (YMCA) in African countries. He completed his first such survey in South Africa in 1930, and in 1947 undertook surveys of Angola and the Belgian Congo. From 1948 to 1955, Haynes also assisted the World Committee of YMCAs as consultant on Africa.

Haynes served on the first board of trustees of the State University of New York from 1948 to 1953. From 1950 to 1959, he taught courses in race relations, African-American history, and African inter-national affairs at the City College of the City University of New York.

Haynes's first wife died in 1953, and he married Olyve Love Jeter in 1955. Haynes died in Brooklyn, N.Y., in 1960.

REFERENCE

PERLMAN, DANIEL. Stirring the White Conscience: The Life of George Edmund Haynes. Ph.D. diss., New York University, 1972.

SAMUEL K. ROBERTS

Haynes, Lemuel (July 8, 1753–September 28, 1833), minister. Born in West Hartford, Conn., the child of a black father and a white mother, both of whom abandoned him, he was raised as an indentured servant by a sympathetic white Evangelical family. Haynes was a soldier in the Continental Army who believed the American Revolution should have widened to free the enslaved. About 1776 he wrote "Liberty Further Extended," a pioneering essay spelling out his antislavery position on the basis of natural rights; it was unknown and unpublished

Lemuel Haynes. (Photographs and Prints Division, Schomburg Center for Research in Black Culture, The New York Public Library, Astor, Lenox and Tilden Foundations)

until 1983. Haynes served as pastor of several white Congregational churches, notably in Rutland, Vt., where race apparently played a role in his dismissal. He was socially conservative and supported the Federalists politically and the strict "Separates" within Congregationalism. He published "Universal Salvation" (1805), a caustic Calvinist assault on Universalism, and "Mystery Developed" (1820), a narrative of the famous Boorn murder case. Haynes was presumably the first African American ordained by a mainstream denomination (1785) and the first to receive a college degree, an honorary M.A. from Middlebury College (1804). At Haynes's death the *Colored American* claimed he was "the only man of *known* African descent who has ever succeeded in overpowering the system of American caste."

REFERENCE

NEWMAN, RICHARD. *Black Preacher to White America: The Collected Writings of Lemuel Haynes, 1774–1833.* Brooklyn, N.Y., 1990.

RICHARD NEWMAN

Haywood, Harry (February 4, 1898–1985), communist activist and theoretician. Born in South Omaha, Nebr., Harry Haywood was the youngest child of former slaves. In 1913 Haywood's family moved to Minneapolis, and in the same year, at the age of fifteen, Haywood dropped out of school and acquired a string of menial jobs, including bootblack, barbershop porter, bellhop, and busboy. In 1914 he moved to Chicago, where he worked as a waiter on the Michigan Central Railroad. During World War I he fought in France with the 370th Infantry. After the war Haywood settled in Chicago, and in 1923 he was recruited into the African Blood Brotherhood, a secret black nationalist organization, and then the Young Workers League, both associated with the COMMUNIST PARTY OF THE U.S.A. (CPUSA). Two years later he became a full-time party worker. Haywood soon came to be a leading proponent of black nationalism and self-determination within the party and sought to reconcile Marxism-Leninism with "the national-colonial question."

Haywood traveled with a delegation of young black cadres to the Soviet Union in 1926 and studied there until 1930 when he returned to the U.S. While in the Soviet Union, Haywood was strongly influenced by the first generation of anticolonial revolutionaries who were his fellow students, including M. N. Roy of India, Tan Malaka of Indonesia, and the future Vietnamese revolutionary Ho Chi Minh. In 1928 Haywood authored a resolution on the "Negro question" that was presented to the Comintern's Sixth World Congress. Haywood argued for the "national minority status" of the African-American people. He advocated a "national revolutionary" movement for self-determination and an autonomous republic to be established in the "black belt" of the American South. By 1930 Haywood's formulation became the official position of the party in its attempt to organize African Americans.

In 1931 Haywood was chosen to head the Communist party's Negro Department. He helped lead the party's campaign to defend the SCOTTSBORO BOYS, eight black teenagers convicted and sentenced to death for allegedly raping two white women in Alabama. In 1934 Haywood was appointed to the politburo of the CPUSA and became national secretary of the party's civil rights organization, the League of Struggle for Negro Rights. In 1937 he fought in the Spanish Civil War with the Abraham Lincoln Brigade, a volunteer force organized by the CPUSA to aid the Spanish Republic against the insurrection by Francisco Franco's fascist armies. In 1938 Haywood was removed from the politburo for alleged "mistakes" in Spain, but Haywood suspected that this removal was due to his uncompromising support of black nationalism, which was losing favor in the party leadership. During World War II, Haywood served as a seaman in the Merchant Marines and worked as an organizer for the Communist-led National Maritime Union from 1943 until the war ended.

The Communist party's support of national self-determination in the black belt was officially dropped in 1944, but had been muted since the adoption of the "Popular Front" strategy in 1935. Despite this shift in party policy, Haywood continued to vigorously promote his theory that the black population in the United States represented a colonized people who should organize as a nation before being integrated into American society. He argued that self-determination and territorial autonomy were the only mechanisms that would guarantee the security of African Americans. His position on "the Negro question" finally caused him to be expelled from the party in 1959.

Haywood lived in Mexico City from 1959 to 1963 and thereafter returned to Chicago. In the 1960s Haywood supported various black nationalist movements, such as the NATION OF ISLAM under the leadership of MALCOLM X, the REVOLUTIONARY ACTION MOVEMENT, and the LEAGUE OF REVOLUTIONARY BLACK WORKERS. Throughout his later years, Haywood remained critical of the integrationist politics of "petit-bourgeois" civil rights leaders such as the Rev. Dr. Martin Luther KING, Jr. and the Rev. Jesse JACKSON. In the 1970s Haywood was a leading figure

in the small Maoist organization, the Communist party (Marxist-Leninist), which called for self-determination for African Americans in the deep South. Haywood attempted to apply Mao Zedong's theories of peasant revolutionism to African Americans, which influenced a number of younger black nationalists, including Amiri BARAKA (LeRoi Jones) and Stokely CARMICHAEL (Kwame Toure). His public activities declined in his final years, and he died in Chicago in 1985.

REFERENCES

BUHLE, MARI JO, PAUL BUHLE, and DAN GEORGAKAS. *Encyclopedia of the American Left.* New York, 1990.
HAYWOOD, HARRY. *Black Bolshevik: Autobiography of an Afro-American Communist.* Chicago, 1978.

THADDEUS RUSSELL

Health and Health Care Providers.

The ability of a population to maintain itself relatively healthy and free of disease is an important index of social progress. For African Americans, the struggle has been a difficult one. There have been notable successes and significant failures—a mixed record complicated by factors rarely within the control of African Americans individually or as a group.

Health in the Antebellum Period

Under slavery, living and working conditions had a deep impact on black health. These conditions included housing, sanitation, food intake, labor, physical treatment, and clothing. While they varied from state to state and from plantation to plantation, conditions on the whole were poor, and certainly unstable and unpredictable. Slaveholders paid scant attention to how such conditions might influence the health of slaves, even though economic interests alone suggested the importance of maintaining a decent standard. Consequently, morbidity and mortality rates among blacks far exceeded those of whites. Medical treatment for slaves was provided by contract physicians who worked one or more plantations (often to supplement income from private or hospital practice among whites), and usually only in severe cases. Preventive medicine was rarely practiced. On any particular plantation, inoculation or vaccination programs against epidemic diseases such as smallpox usually began only after a sizable portion of slaves were affected. A few Southern health-care establishments, such as the Georgia Infirmary (founded in Savannah in 1832), offered treatment exclusively for blacks—both free and bonded.

Some slaves practiced therapies based on herbal, magico-religious, and other customs brought from Africa. Planters often relied on these slaves as cheap, effective surrogates for white practitioners. In Virginia, for example, a slave known as "old Man Docr. Lewis" had a reputation for successfully treating ailments using a "decoction of herbs." A so-called "hoodoo doctor" in Georgia was believed to have applied in certain instances an effective combination of fetishes, incantations, and sprinkling powder (ingredients unknown). A special class of female practitioners—known as "Negro doctoresses"—evolved within the ranks of slaves. These women, who combined obstetric duties with the preparation and dispensing of medicinal herbs, were the starting point for traditions of black midwifery and root doctoring that thrived well into the twentieth century. African-American midwives and root doctors provided important health-care alternatives, particularly for poor and rural blacks whose access to regular practitioners was limited at best.

Slaves are known to have contributed to the larger body of medical theory and practice. Onesimus, a slave belonging to the eminent Bostonian cleric Cotton Mather, taught his master the live-virus principle of inoculation against smallpox. "I do assure you," Mather wrote in 1716 to an officer of the Royal Society, "that many months before I met with any Intimations of treating ye Small-Pox with ye Method of Inoculation, I had from a Servant of my own, an account of its being practised in Africa." Nevertheless, Mather received the credit and Onesimus's role was ignored. Another case involved a slave named Cesar, from South Carolina. This practitioner developed an apparently effective antidote for rattlesnake poison—a concoction of roots compounded with rum and lye—that was widely publicized in the mid- and late-eighteenth-century popular press. Unlike Onesimus, Cesar received not only due credit, but also, by vote of the state legislature, his freedom and an annual stipend of one hundred pounds sterling. James Durham, born into slavery in 1762, learned medicine by observing a succession of physician-masters. After purchasing his freedom in 1783, he established his own practice in New Orleans and maintained a correspondence (1789–1802) with Benjamin RUSH, one of the foremost physician-scientists of the day.

As a group, free blacks did not fare much better than slaves. In northern urban centers, where many lived and worked, the medical establishment paid little attention to their plight; for the most part, they had to fend for themselves. Black patients were denied access to Bellevue Hospital in New York City until 1841, when a group of public-spirited citizens succeeded in persuading the administration to set

aside a few (albeit carefully segregated) beds. Even in relatively enlightened cities like Philadelphia, populated by prominent white liberals, Quakers, and abolitionists, the vast majority of blacks remained isolated on the bottom rung of the social and economic ladder, employed primarily as day laborers or domestic servants, or in small business. This form of segregation took a curious twist during the Philadelphia yellow fever epidemic of 1793, when blacks, originally thought to have been immune from the disease, were coopted into nursing and corpse-disposal service in infected city houses. Even as their own people started succumbing to the disease, blacks continued a vigorous campaign to provide relief not only to black victims but to white as well. Under the auspices of the African Society, and the inspired leadership of two of its officers, Absalom JONES and Richard ALLEN, the campaign was marked by acts of individual heroism and group commitment that were not always appreciated by whites who benefited. Blacks stood accused, for example, of using the epidemic as an opportunity for extortion and other forms of exploitation. Such charges were especially hurtful considering that the African Society, an organization established for the relief of destitute Negroes, had gone beyond its normal call of duty to serve whites during the crisis. Jones and Allen responded to the charges in a 1794 pamphlet entitled *A Narrative of the Proceedings of the Black People, During the Late Awful Calamity in Philadelphia, in the Year 1793: and a Refutation of Some Censures, Thrown Upon Them in Some Late Publications.*

Early African-American Practitioners

Before the Civil War, only a handful of blacks practiced medicine in the sense of participating as part of a discrete professional class within mainstream established traditions. Those who did were often denied access to normal lines of professional discourse, including membership in medical societies, or were shunted to the periphery of accepted medical practice. Nevertheless, their routes of entry to the profession tended to follow the pattern of their white counterparts. The three major routes at the time were self-education, apprenticeship, and attendance at medical school.

Among the prominent self-taught African-American practitioners in the antebellum period was James STILL. Still's herbal remedies became popular, among both whites and blacks in rural New Jersey, as an alternative to the surgical and other radical techniques commonly used by school-trained physicians. Other self-taught black practitioners included David RUGGLES, a hydrotherapist whose "water-cure establishment" near Northampton, Mass., attracted an interracial clientele from throughout the country; and

William Wells BROWN, who practiced in Boston under the self-coined designation "dermapathic and practical physician." All had close ties to the abolitionist movement. Still's brothers, William and Peter, were known for their antislavery writings, while Ruggles wrote articles for *The Emancipator* and William Brown served as an agent of the Underground Railroad.

Blacks who trained for medical careers via the apprenticeship route included John Sweat ROCK. Rock acquired the rudiments of the trade while serving under white practitioners in Salem, N.J. Although he was denied admission to at least one medical school because of his race, Rock finally earned the M.D. at American Medical College, Philadelphia, in 1852 or 1853. He settled in Boston, Mass., where he practiced medicine and dentistry before taking up law in 1861. An active abolitionist, in 1865 he became the first African American admitted to argue cases before the U.S. Supreme Court. The experience of Martin Robison DELANY was similar. After serving apprenticeships and under several white physicians in Pittsburgh, Delany was denied admission to medical schools in Pennsylvania and New York. The Harvard Medical School admitted him and two other blacks in 1850, but refused to let them re-register after the first term, when white students petitioned for their dismissal on racial grounds. Although he never earned a medical degree, Delany alternated the practice of medicine in Pittsburgh, Chatham (Ontario), and Charleston (S.C.) with other interests as a writer, lecturer, and antislavery activist.

A small number of blacks managed to overcome the medical school color bar and acquire formal academic training. Among these were David John PECK, who in 1847 earned the M.D. at Rush Medical College, Chicago. James Skirving Smith attended courses at Berkshire Medical College (Pittsfield, Mass.) in 1848, shortly after earning the M.D. at Vermont Medical College. In 1849, Bowdoin Medical College awarded M.D.s to John Van Surley De Grasse (1825–1868) and Thomas Joiner White, while a third student, Peter William Ray, completed medical studies without taking a degree. Rebecca LEE, believed to have been the first African-American woman to earn the M.D., graduated from New England Female Medical College in 1864.

These, however, were unusual cases. African-Americans sometimes sought professional or educational opportunity abroad. James McCune SMITH attended the University of Glasgow, where he earned the B.A. (1835), M.A. (1836), and M.D. (1837) before returning to New York City to set up practice. As with Delaney and other black physicians of the time, Smith's commitment to the antislavery movement occupied at least as much time and energy as his

John De Grasse was one of the first African Americans known to have completed recognized medical training. (Photographs and Prints Division, Schomburg Center for Research in Black Culture, The New York Public Library, Astor, Lenox and Tilden Foundations)

professional duties. He achieved a degree of notoriety in the early 1840s for his public rebuttals of Senator John C. Calhoun's attempts to rationalize the institution of slavery by portraying blacks as mental defectives. Calhoun had based his ideas on the work of a white New Orleans physician, Dr. Samuel Adolphus Cartwright (1793–1863), who, among other things, believed that slaves suffered from drapetomania, "a disease causing [them] to run away . . . as much a disease of the mind as any other species of mental alienation." Besides James McCune Smith, foreign-trained African-American physicians included Alexander Thomas AUGUSTA, who earned his medical degree in 1856 at Trinity Medical College, Toronto, after being denied admission to schools in Philadelphia and Chicago. John H. Rapier, Jr. (1835–1865), migrated to Jamaica, where he served dental and medical apprenticeships and made plans to attend the medical school of Queen's University (Kingston, Ont.) and one of the Royal Colleges in England before finally earning his degree in 1864 at the College of Physicians and Surgeons, Keokuk, Iowa.

The Civil War and Its Aftermath

At least nine African-American physicians served with the Union Army during the Civil War. These included Rapier, Augusta, and De Grasse, along with Charles Burleigh PURVIS, M.D., Charity Hospital Medical College, Cleveland, 1865; Courtland Van Rensselaer CREED, M.D., Yale University, 1857; Alpheus W. Tucker; William Ellis; William POWELL; and Anderson Ruffin ABBOTT, M.D., University of Toronto, 1863. The relatively high casualty rate among black troops was a reflection not on the competence of these practitioners, but rather on the War Department's unwillingness to aggressively seek out, train, and commission more African-American physicians. This unwillingness illustrated, in microcosm, the diffident—if not uniformly hostile—attitude of the larger society (both northern and southern) toward the health needs of African Americans.

In fact, morbidity and mortality rates among blacks soared for a decade or so after the Civil War. Health-care services on the plantation may have been meager, but at least they had been available and provided in essential cases. As emancipated slaves (the so-called "freedmen") adjusted to their new station in life, they found themselves without access to such services. Smallpox, yellow fever, and cholera epidemics took a heavy toll among them. In Charleston, S.C., the death rate for blacks between 1866 and 1871 was twice that for whites, and the disparity was even greater for children under the age of five. According to some estimates, one-quarter to one-third of the former slaves in particular locales died during the early years of Reconstruction. The BUREAU OF FREEDMEN, REFUGEES, AND ABANDONED LANDS, established in March 1865 to help emancipated slaves adjust to new conditions, quickly turned its attention to the issue of health. The Bureau established fifty-six hospitals and forty-eight dispensaries, the largest the Freedmen's Hospital in Washington, D.C., and over a four-year period was said to have provided medical assistance to at least a million African Americans.

African-American Medical Schools, Hospitals, and Professional Societies

Health issues remained a major concern for blacks as they sought access to the social and professional mainstream of American life. With education widely perceived as a critical component in this struggle, medical schools were among the earliest programs to be established—either independently or with existing African-American institutions of higher learning. HOWARD UNIVERSITY (Washington, D.C.), founded in 1867, opened its medical department on November 9, 1868 with five professors and eight students. One antebellum black college, LINCOLN UNIVERSITY

(Oxford, Penn., 1854), operated a medical department briefly from 1870 to 1872. Meharry Medical College (Nashville, Tenn.) opened its doors in 1876. The next quarter century saw the establishment of other black medical schools in Southern or border states. These included Leonard Medical School of Shaw University (Raleigh, N.C., 1882); Louisville National Medical College (Louisville, Ky., 1888); Flint Medical College of New Orleans University (1889); Hannibal Medical College (Memphis, Tenn., 1889); Knoxville College Medical Department (Knoxville, Tenn., 1895); Chattanooga National Medical College (Chattanooga, Tenn., 1899); State University Medical Department (Louisville, Ky., 1899); Knoxville Medical College (1900); Medico-Chirurgical and Theological College of Christ's Institution (Baltimore, 1900); and the University of West Tennessee (Jackson, 1900; Memphis, 1907).

Small health-care facilities were commonly established in connection with these schools. The Auxiliary Hospital, for example, was attached to Louisville National Medical College and administered for many years by a black woman doctor, Sarah Helen Fitzbutler (M.D. Louisville, 1892). Such institutions served two purposes—to provide clinical material for students and to fill the void created by white hospitals, which either refused to admit blacks or offered them inferior treatment relative to that for whites. Black hospitals also provided suitable sites for the establishment of nursing schools. The schools offered opportunities for African-American women, whose important role in health care—stretching at least as far back as the traditions of the slave midwife and root doctor—would not have been realized otherwise because of the racially exclusionary policies exercised by white nursing schools. Such policies had hardened in the years following Black Reconstruction (the period of the so-called White Redemption), and were reinforced as a result of the Supreme Court's 1896 "separate but equal" decision in the case of *Plessy* v. *Ferguson*.

As the color line separating white from black grew sharper toward the end of the nineteenth century, and through the first half of the twentieth century, African-American health practitioners established their own professional societies in addition to medical schools and hospitals. Three highly regarded black physicians—Purvis, Augusta, and Tucker—were denied admission to membership in the all-white Medical Society of the District of Columbia in 1870. A biracial medical society, the National Medical Society (NMS), was established in response. NMS members could not attend conventions of the American Medical Association, however, because the AMA recognized only a single majority society from each state or locale—a technicality that hindered blacks in

certain states from gaining access to the AMA as late as the 1950s. The Medico-Chirurgical Society of the District of Columbia, a successor to the NMS, was founded on April 24, 1884. Other early black medical societies included the Lone Star State Medical Association (Texas, 1886) and the Old North State Medical Society (North Carolina, 1887). The national African-American counterpart to the AMA, the National Medical Association, was established in 1895. Its charter states that it was born out of "the exigencies of the American environment [to] band . . . together for mutual cooperation and helpfulness the men and women of African descent who are legally and honorably engaged in the practice of the cognate professions of Medicine, Surgery, Dentistry and Pharmacy." Such organizations represented means by which critical health-care and professional issues facing blacks could be tackled.

Health Status and Progress in the Twentieth Century

The decades leading up to World War I presented a series of disturbing developments. First, the health status of African Americans appeared to be making little progress despite the fact that the number of black physicians more than tripled in twenty years (from 909 in 1890 to 3,409 in 1910). A 1906 monograph by W. E. B. DU BOIS, *The Health and Physique of the Negro American*, used statistical analysis to demonstrate that disparities between the health of whites and blacks had remained stable (or had even increased slightly) and that African Americans were dying in large numbers from a variety of conditions, primarily tuberculosis. Secondly, an influential policy document, the FLEXNER REPORT (1910), called for sweeping changes in medical education throughout the United States and Canada. The report declared that the black medical schools were so weak that only two—Howard and Meharry—were worth salvaging. As a result, all but Howard and Meharry were closed by 1923, leaving these two institutions with the awesome task of training the bulk of African-American physicians. Third, hospital experience became an integral component of medical training, reflecting new and demanding requirements developed by state boards with regard to individual licensure and institutional accreditation. This development severely limited postgraduate opportunities for African Americans, whose small hospitals could not generally meet the required standards and who continued to be denied internships and residencies at white hospitals. FREEDMAN'S HOSPITAL, one of the few black institutions offering postgraduate training in the school year 1909–1910, had only eight openings that year.

These problems persisted between the world wars, and the African-American community did not

Midwives graduating from Edwards College, Jacksonville, Fla. (Florida State Archives)

present a united front on how to tackle them. The question was how to transform a two-tiered health system—one for whites, one for blacks—into something more equitable and just. Some African Americans urged the establishment of more and better black hospitals and medical colleges, while others suggested that such measures were short-sighted and would only detract from efforts to deal with larger, more endemic issues of discrimination and segregation. A heated medico-political dialogue ensued between black health professionals in the 1930s and 1940s. The African-American surgeon Louis Tompkins WRIGHT, for example, was critical of foundations—like the Julius Rosenwald Fund—which provided monies to revamp existing black health-care institutions and to establish new ones. The only solution, Wright felt, was radical action: desegregation of white hospitals and medical schools. On the other hand, African-American surgeon Peter Marshall MURRAY argued that the key to improving black health and to increasing access of African Americans to careers in the health professions was not racial integration—or the merging of African Americans into the majority community—but rather what he termed "the proper development" of uniquely black institutions.

This dialogue paralleled the debate begun years earlier by W. E. B. Du Bois and Booker T. WASHINGTON over what the goals and ambitions of African Americans should be. Du Bois insisted that blacks demand equal social status and services—without

compromise, without being discouraged by the depth of racial separatism in the society—while Washington advocated a separatist model of gradual improvement through self-help programs and, most important, the avoidance of racial conflict. As a matter of fact, Washington and Du Bois had much to say themselves on the subject of African-American health. In 1915, Washington initiated a Negro Health Program at Tuskegee Institute (Ala.) to raise consciousness among African Americans about the need for sound health practices. This program blossomed into the National Negro Health Movement, which was placed on a permanent year-round basis with support from the U. S. Public Health Service and other organizations. The program was phased out in 1950, at a time when it was believed that a racially separatist approach had run its course and that American society was gearing up "to work together for mutual welfare."

W. E. B. Du Bois, on the other hand, questioned the premises on which black and white health interests were separated to begin with, and doubted the view of optimists who felt that mid-century marked a new era of racial cooperation. He argued in *The Crisis,* the official organ of the NAACP, and in other forums, for a uniform, equitable system of health care regardless of race. Du Bois shared the principles of progressives who promoted comprehensive, anti-discriminatory health legislation during the 1940s. Their proposals, including the Truman-era Wagner-Murray-Dingell Bill (which was decried by the AMA

and other establishment groups as a "socialist" evil), died with the advent of the Cold War and McCarthyism. They were revived, albeit in modified form, in the establishment of the Medicare and Medicaid systems during the 1960s and '70s.

Civil Rights, Health Care, and Medicine

A system that routinely excluded African Americans from most medical schools, that denied them admission to medical societies and recognition by some specialty boards, and that channeled them into segregated health-care facilities proved resilient to change. When Louis T. Wright was elected a fellow of the American College of Surgeons in 1934 (the first African-American fellow since the noted surgeon Daniel Hale WILLIAMS became a charter member in 1913), several voting members staged a walkout in protest and some threatened to rescind their own fellowships. The National Medical Association and the National Association of Colored Graduate Nurses struggled, with mixed success, to persuade the government to admit African-American physicians and nurses to service in the armed forces during World War II. Black health professionals could serve, the government finally allowed, but only within segregated units such as the 93rd Division at Fort Huachuca, Ariz. In 1947 Charles Richard DREW, head of surgery at Howard University, wrote to the editor of the *Journal of the American Medical Association,* Morris Fishbein, urging an end to what Drew termed the "repeated humiliation" of African-American physicians resulting from the AMA's by-law that required a member first to join a constituent state society. A decade later Dr. Leonidas Berry, the lone black fellow of the American College of Gastroenterology, boycotted the College's 1958 convention in New Orleans to protest the hotel's refusal to provide him with accommodations.

Such incidents were common well into the 1960s, and underscored the tortuous path that the nascent civil rights movement had yet to negotiate. Some African-American health professionals developed their own brand of social activism. As part of the Medical Committee for Civil Rights, a biracial group founded in 1963, they organized a petition drive urging the AMA "to speak out immediately and unequivocally against racial segregation and discrimination . . . wherever [they] exist in medicine and health services" and to terminate "the racial exclusion policies of State and County medical societies." African-American physicians picketed the AMA convention in Atlantic City in 1963 to protest that organization's lack of progress on such issues. They also demonstrated outside the conventions in New York City (1965) and Chicago (1966). The MEDICAL COMMITTEE FOR HUMAN RIGHTS (founded 1964), succes-

Physician with patient. (Allford/Trotman Associates)

sor to the Medical Committee for Civil Rights, became an important source of health-care support for workers during the civil rights movement.

Social activism in the 1960s may have stimulated legislation, modified certain attitudes, and reduced obvious inequities, but it did not eliminate barriers to health services for African Americans. The period from the 1970s to the 1990s contained disturbing trends. In 1993, a quarter of a century after the KERNER REPORT (issued by a commission appointed by President Lyndon B. Johnson) warned of the consequences of a racially separate and unequal society, there is evidence to suggest that little has changed—and, in some instances, it has changed for the worse. The evidence is found in health-care data as much as in statistics relating to unemployment, poverty, income, crime, and violence. African Americans who suffer heart attacks, for example, are less likely than whites to be aggressively treated with bypass surgery. Unequal access to prenatal care is demonstrated in the finding that African-American women with small babies are nearly three times as likely to undergo premature birth as white women in the same

condition. In 1989, the overall infant mortality rate for blacks was more than twice that for whites. Life expectancy for African Americans peaked at 69.5 years in 1985 and declined to 69.2 years in 1991, while that for whites was both higher and on the increase during the same period. A 1991 study found that whites suffering from AIDS were 73 percent more likely than nonwhites to procure access to the drug AZT, then thought to be an effective treatment for the disease. Thousands of African Americans, a 1990 epidemiological survey found, die in the prime of life—and at rates more than twenty times that for whites—of health conditions that could be cured or treated by routine medical care. These conditions include appendicitis, pneumonia, gall bladder infection, hypertensive heart disease, asthma, influenza, and hernia.

African-American Contributors to Modern Medicine

No overview of health and medicine in the African-American community would be complete without a glance at some of the major accomplishments of black physicians. That many struggled against the currents of racial discrimination to acquire medical training and to establish themselves as clinical practitioners is significant enough, but it is truly remarkable that some also contributed to advancing the frontiers of medical knowledge.

Among the early pathbreakers was Daniel Hale Williams, a surgeon and founder of Provident Hospital, which served primarily the African-American community in Chicago. On July 9, 1893, Williams performed one of the earliest recorded cases of successful open-heart surgery. He entered the thoracic cavity of a stabbing victim and sutured the pericardium (the sac enclosing the heart), after which the patient recovered fully. Other notable African Americans included William Augustus HINTON, a bacteriologist specializing in research on venereal disease. A member of the Harvard Medical School Faculty and (from 1915) director of the Wassermann Laboratory of the Massachusetts Department of Public Health, Hinton developed a flocculation method for detecting syphilis. This became known as the "Hinton test," which, along with the Wassermann and Kahn tests, served as a standard diagnostic technique in laboratories throughout the United States and abroad. Largely for racial reasons, Hinton felt obliged to eschew public recognition of his achievement. His fear was that the Hinton test would not gain general acceptance, should it become too widely known that its originator was an African American.

As in the white medical community, major advances tended to come out of the work of African Americans located in urban centers, where research

and clinical facilities were relatively abundant. Solomon Carter FULLER, a staff member at the Westborough State Hospital near Boston, Mass., wrote widely on neurologic, pathologic, and psychiatric subjects and became known for his work on dementias and Alzheimer's disease. He was one of the earliest researchers to suggest that Alzheimer's did not result from arteriosclerosis. William Harry BARNES, an otolaryngologist attached to hospitals in Philadelphia, devised several instruments that came into widespread surgical use. The most notable, perhaps, was his hypophyscope (1926) providing easier access to the pituitary gland. Louis T. Wright, whose career at Harlem Hospital covered more than three decades (1919–1952), displayed an unusual versatility of interests. Highly regarded as a surgeon, he proposed new perspectives on skull-fracture treatment, devised implements for dealing with knee-joint and cervical vertebrae fractures, developed a method for intradermal vaccination against smallpox, oversaw the first tests on humans of the antibiotic aureomycin, and conducted important cancer research at a center founded expressly for that purpose at Harlem Hospital. The dermatologist Theodore Kenneth LAWLESS (1892–1971), a staff member of Cook County Hospital (Chicago) and faculty member at Northwestern University Medical School until 1941, proposed helpful correctives for tissue damage resulting from the use of new arsenical preparations in syphilis treatment during the 1920s.

Noteworthy results came out of research conducted by African-American medical scientists at predominantly black educational institutions. Charles Richard Drew and Edward William Hawthorne (1921–1986), for example, served as faculty members at Howard University. Drew is best remembered for his work in "blood banking," or methods to preserve blood for subsequent use in transfusions. His 1940 treatise, *Banked Blood: A Study in Blood Preservation* (for which he was awarded the Sc.D. degree at Columbia University), was recognized as a pioneering and definitive study. Drew headed the "Blood for Britain" project at the height of the German blitzkrieg during World War II, and in 1941 was appointed director of the American Red Cross Blood Bank. He returned to Howard following a dispute with Red Cross officials over his refusal to condone the policy of segregating blood by race of donor and recipient. Hawthorne, an acknowledged leader in the area of cardiovascular-renal physiology, pioneered the use of electronically instrumented techniques to record heart function in conscious mammals during the 1950s and 1960s. When heart surgery in humans developed to the point where diseased valves could be replaced, Hawthorne helped to advance knowledge about the relationship of valve closure to the

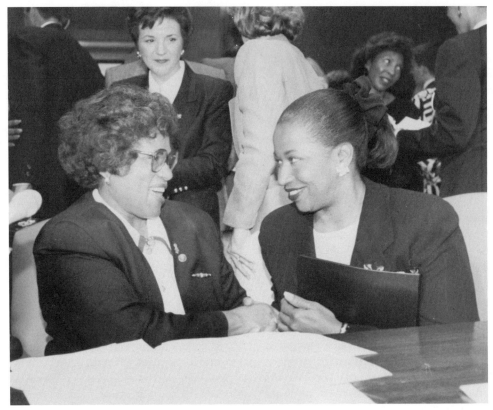

U.S. Surgeon General nominee Dr. Joycelyn Elders (left) talks to Sen. Carol Moseley-Braun (D-Ill.) prior to the start of Elders's confirmation hearings before the Senate Labor Committee, July 23, 1993. (AP/Wide World Photos)

tension of connecting cords, shortening of the papillary muscles, and pressure of blood inside the heart chambers. His interest in the relationship between stress, the cardiac cycle, and the development of high blood pressure arose out of clinical observations of a health problem affecting African Americans in disproportionately large numbers.

Women Physicians

African-American women have also played an important role in medicine. Among the nineteenth-century pioneers, in addition to Rebecca Lee (mentioned above), were Rebecca J. COLE and Susan Smith McKinney Steward (1848–1919), who earned M.D.s at the Woman's Medical College of Pennsylvania (1867) and New York Medical College for Women (1870), respectively. Over a hundred black women earned medical degrees by the turn of the twentieth century. This was possible in part because the two major medical schools open to blacks—Howard University Medical School and Meharry Medical College—had admissions policies that were relatively liberal on the issue of gender. In 1878, Eunice P. Shadd (1848–1887) became the first African-American woman to earn the M.D. at Howard (two white women had taken M.D.s there in 1872 and 1874).

The first woman physician to graduate at all-black Meharry was Georgia Esther Lee Patton (1864–1900), in 1893.

The activities of these early professional women were broad—ranging from missionary work and general practice to obstetrics, nurse training, and social service—but inevitably circumscribed by limits that the society had placed on women, black and white alike. This pattern changed gradually in the twentieth century, as African-American women physicians joined their white counterparts in entering leadership positions in medical administration, research, clinical work, teaching, and specialist fields. Two early examples were May Edward CHINN and Ernest Mae MCCARROLL. In 1926, Chinn became the first black woman graduate of University and Bellevue Hospital Medical College (New York University). In addition to her private practice, she carried out research and clinical work on early cancer detection and care of the terminal patient. McCarroll, who earned the M.D. at Woman's Medical College of Pennsylvania in 1925, was the first African American appointed (in 1946) to the staff of Newark (N.J.) City Hospital. Margaret Morgan LAWRENCE, psychiatrist, was in the vanguard of developments in the field of child psychiatry. Angela Dorothea FERGU-

SON, a faculty member in the department of pediatrics at Howard University, worked with Roland Boyd Scott (b. 1909) to unravel problems in the etiology and treatment of sickle cell disease. Helen Octavia DICKENS, Dorothy Lavinia BROWN, and Myra Adele LOGAN were the first African-American women elected to the coveted fellowship of the American College of Surgeons. When pediatrician Agnes Lattimer (b. 1928), a specialist in the effects of lead poisoning on child development, served as head of Cook County Hospital, Chicago, in the mid-1980s, she was believed to be the only black woman to hold chief executive status in a major hospital in the United States. The National Aeronautics and Space Administration (NASA) appointed surgeon Irene Long (b. 1951) to head its medical operations branch in 1982. These and other African-American women have been part of a professional community dedicated to improving the health of Americans, black and white alike.

REFERENCES

BEARDSLEY, EDWARD H. *A History of Neglect: Health Care for Blacks and Mill Workers in the Twentieth-Century South.* Knoxville, Tenn., 1987.

COBB, W. MONTAGUE. "The Black American in Medicine." *Journal of the National Medical Association* 73 (1981), suppl.

———. *Medical Care and the Plight of the Negro.* New York, 1947.

———. *Progress and Portents for the Negro in Medicine.* New York, 1948.

CORWIN, EDWARD HENRY LEWINSKI, and GERTRUDE E. STURGIS. *Opportunities for the Medical Education of Negroes.* New York, 1936.

CURTIS, JAMES L. *Blacks, Medical Schools and Society.* Ann Arbor, Mich., 1971.

GAMBLE, VANESSA NORTHINGTON. *The Black Community Hospital: Contemporary Dilemmas in Historical Perspective.* New York, 1989.

HANFT, RUTH S., LINDA E. FISHMAN, and WENDY J. EVANS. *Blacks and the Health Professions in the 80s: A National Crisis and a Time for Action.* Washington, D.C., 1983.

HAYDEN, ROBERT C., and JACQUELINE HARRIS. *Nine Black American Doctors.* Reading, Mass., 1976.

HINE, DARLENE CLARK. *Black Women in White: Racial Conflict and Cooperation in the Nursing Profession, 1890–1950.* Bloomington, Ind., 1989.

JONES, JAMES H. *Bad Blood: The Tuskegee Syphilis Experiment.* New York, 1981.

KENNEY, JOHN ANDREW. *The Negro in Medicine.* Tuskegee, Ala., 1912.

LAMB, DANIEL SMITH, comp. and ed. *Howard University Medical Department, Washington, D.C.: A Historical, Biographical, and Statistical Souvenir.* Washington, D.C., 1900.

LIGHTFOOT, SARA LAWRENCE. *Balm in Gilead: Journey of a Healer.* Reading, Mass., 1988.

MCBRIDE, DAVID. *Integrating the City of Medicine: Blacks in Philadelphia Health Care, 1910–1965.* Philadelphia, 1989.

"Minorities and Medicine." *New York State Journal of Medicine* 85 (April 1985): 125–166.

MORAIS, HERBERT MONTFORT. *The History of the Afro-American in Medicine.* New York, 1968.

ORGAN, CLAUDE H., and MARGARET M. KOSIBA, eds. *A Century of Black Surgeons: The U.S.A. Experience.* 2 vols. Norman, Okla., 1987.

POSTELL, WILLIAM DOSITE. *The Health of Slaves on Southern Plantations.* Baton Rouge, La., 1951.

SAVITT, TODD L. *Medicine and Slavery: The Diseases and Health Care of Blacks in Antebellum Virginia.* Urbana, Ill., 1978.

SUMMERVILLE, JAMES. *Educating Black Doctors: A History of Meharry Medical College.* University, Ala., 1983.

WYNES, CHARLES E. *Charles Richard Drew: The Man and the Myth.* Chicago, 1988.

KENNETH R. MANNING

Health Legislation. The impact of federal health legislation on the health care of African Americans has been significant, perhaps more so than for any other group in the United States because of the historical legacy of slavery, racial discrimination, and poverty. A brief overview of the history of federal involvement in health care for black Americans, both before and after the 1930s, when widespread government involvement in the field began, illustrates the problems, their effect, and efforts to solve them.

The earliest federal health statutes date from the late eighteenth century, including a 1798 act "for the relief of sick and disabled seamen." In 1801, President Thomas Jefferson took an important step in government dissemination of medical knowledge. At the urging of Dr. Benjamin Waterhouse, he used his family and slaves to test Edward Jenner's newly discovered vaccine for smallpox. The success of this experiment led to a presidential endorsement of vaccination.

President Abraham Lincoln authorized the establishment of the United States Sanitary Commission in 1861. One of the commission's activities was to assess the physical and moral condition of the troops. The commission undertook studies of black and white soldiers, using anthropometry, the pseudoscience of body measurements, to determine levels of intelligence by race. One investigator inferred from autopsies on several hundred soldiers that the average African-American brain weighed five ounces less than the average white brain, which "proved" that blacks were less intelligent than whites. These studies

subsequently provided racists with an allegedly scientific basis for their beliefs and actions.

During the next half century, health legislation contained certain benefits for African Americans—benefits that were essentially inadequate, however, and that reflected an evolving pattern of racial segregation and discrimination in medical and other social services. The Reconstruction Act of 1865 provided money for health care for freed slaves, and the Freedmen's Bureau sent nurses into black communities. The Freedmen's Hospital and Asylum in Washington, D.C. (now Howard University Hospital), was established on June 10, 1872. The 46th Congress (1879–1881) extended medical relief to blacks migrating north, and the 53rd Congress (1893–1895) authorized funds to construct shelters for aged, infirm, and indigent blacks. But many white legislators considered black health problems a natural result of racial genetics or of blacks' allegedly immoral lifestyle, and hence untreatable. Attention to improving sanitation and health conditions for the African-American community was designed for the most part to limit the infection of adjacent white neighborhoods. The U.S. Public Health Service (USPHS), established in 1912 as a reorganization of the old Marine Hospital Service, placed little emphasis on black health issues during its first decade of operation.

Following World War I, the federal government took a few initiatives to improve health conditions for blacks, although within segregated and unequal facilities. In March 1921, President Woodrow Wilson signed legislation to develop a national hospital system for veterans. While the legislation did not mention separate facilities for black veterans, the commission appointed to oversee implementation recommended the establishment of an all-black hospital, and garnered support from both black and white groups. Veterans' Bureau Hospital No. 91 was opened in 1923 in Tuskegee, Ala. In the face of determined and occasionally violent resistance by the Ku Klux Klan, the hospital was staffed by black doctors and nurses. A vocal minority of African Americans opposed this segregation on principle, but many conceded the practicality of an all-black facility as whites stubbornly pressed for preservation of the racial status quo.

In 1919, the USPHS appointed Roscoe Conkling BROWN, a black dentist and public health specialist, as a lecturer on "colored work" (later, he headed USPHS's Office of Negro Health Work). Brown's primary function involved educational outreach and community relations, including (as of 1921) development and promotion of the "health-week movement" originally adopted by Booker T. Washington as part of his effort at Tuskegee Institute to instill in African-American youth standards of effective service and wholesome living. Other programs supported by the USPHS included the Tuskegee Study of Untreated Syphilis in the Negro Male (popularly referred to as the Tuskegee Syphilis Experiment), which monitored the progress of syphilis in several hundred black "experimental subjects," who were denied treatment in the interest of scientific inquiry.

The New Deal provided funding for improvements in African-American health during the 1930s, but efforts were hindered by Jim Crow customs in many areas. The Federal Emergency Relief Administration (FERA), created in March 1933, provided relief money for health care. At first, FERA allotted funds to hospitals to extend free services, but this proved so costly that the strategy was abandoned and funds were made available directly to physicians and dentists who served FERA clients. FERA also provided money to state boards of health for antimalarial and other work. Its successor, the Works Progress Administration (WPA), gave money for free clinics, school medical and dental inspections, prenatal and postnatal care, and other projects.

Meanwhile, Congress considered a more radical proposal. The Wagner-Murray-Dingell Bill, introduced in 1943, included a national health insurance plan as part of an extended social security program. It offered not only universal health care coverage, but strict nondiscrimination provisions as well. The National Medical Association, the black doctors' association, urged passage of the legislation, as did the NAACP. The white leadership of the American Medical Association opposed the measure as "socialism," and helped to kill the bill.

The Hill-Burton Hospital Construction Act (1946) channeled nearly two billion dollars into the construction of hospitals between 1948 and 1961. However, while it required hospitals to provide a reasonable amount of free care for indigent patients, the act permitted states to avoid compliance with universal access provisions "in cases where *separate* hospital facilities are provided for *separate* population groups." Consequently, if no local black hospital existed, African Americans were admitted to white institutions on a segregated basis, and often given inferior care. This circumstance helped to galvanize black opposition to segregated health care.

During President Truman's unsuccessful effort to implement a plan for universal medical insurance in 1949, his administration obtained the support of black leaders by describing the proposal as part of a larger civil rights effort. Fifteen years later, Congress passed the Civil Rights Act (1964), which banned racial discrimination in all programs receiving federal funds. This may have been the most important piece of legislation in the improvement of black health. Judicial action based on the act opened hospitals, nursing

homes, and other facilities for the first time to African-American clients. However, integration also had the effect of closing many black-run hospitals, which were always poorly funded and which could not compete successfully for the client population.

Elements of earlier national health proposals were revived in the 1960s as Medicare, an insurance program for the elderly, and as Medicaid, a program for the poor. These programs included non-discrimination clauses, and represented important advances in the ability of African Americans to secure adequate health care. They tended to focus on treating acute infection, however, and were less helpful at remedying unhealthful diet and environmental factors which lowered resistance to disease. Also, because physician reimbursement formulas were not founded on any uniform rate but were indexed partly to a patient's ability to pay, these systems (especially Medicaid) resulted in discrimination based on economic status. The resulting burdens have fallen hard on African Americans, a disproportionately poor population group. As with other federal health initiatives such as the Women, Infants and Children (WIC) and immunization programs, cutbacks in funding during the 1980s represented a serious blow to the already fragile state of health of many African Americans.

In the early 1990s, focus again turned to proposals for universal health care. African Americans, whose communal health remains poor and who often cannot afford health insurance, are an important client group for such a system, and black legislators have been active in helping to design proposals. Drafts of the Clinton administration's proposed Health Security Act (1993) contain language prohibiting discrimination on the basis of race, gender, ethnicity, religion, and other factors.

REFERENCES,

BEARDSLEY, EDWARD H. *A History of Neglect: Health Care for Blacks and Mill Workers in the Twentieth Century South*. Knoxville, Tenn., 1987.

HAMILTON, MADRID TURNER. *Erosive Health: A Sociological Study of the Health and Well-Being of Black Americans*. New York, 1986.

MORAIS, HERBERT M. *The History of the Negro in Medicine*. New York, 1968.

RICE, MITCHELL H. *Black American Health: An Annotated Bibliography*. New York, 1987.

PHILIP N. ALEXANDER

Health Professions. The most visible health professions are medicine (*see* HEALTH AND HEALTH CARE PROVIDERS), DENTISTRY, PHARMACY, and NURSING, although others such as osteopathic medicine, PODIATRY, optometry, chiropractic, MIDWIFERY, dietetics, physical therapy, acupuncture, and VETERINARY MEDICINE play significant roles in shaping approaches to health issues. For African Americans, such professions often have been closely allied. The work of preserving health in minority urban and rural communities might devolve to a physician, nurse, dentist, or pharmacist—whoever was in closest proximity. Ordinarily there were few options. Because of their relatively small numbers, black health practitioners recognized interprofessional cohesiveness as a key element in achieving their goals.

Unlike their white counterparts, black professional associations concerned with health issues often included several fields or specialties under a single rubric well into the twentieth century. The National Medical Association, for example, maintained sections on dentistry and pharmacy as well as medicine from its inception in 1895, when it was known as the National Association of Colored Physicians, Dentists, and Pharmacists.

These sections continued even after the formation of a separate National Dental Association and National Pharmaceutical Association in 1932 and 1933, respectively. By way of contrast, the white-dominated American Medical Association (founded 1847), American Pharmaceutical Association (1852), and American Dental Association (1859) always focused on a narrower range of specialties.

The ongoing pressure for standardization and the elimination of legal racial segregation ultimately rendered obsolete such distinctions between the black and white professional groups. This adjustment generated both opportunities and challenges. Once black health professionals gained access to training programs and career openings that had previously been denied them, many no longer practiced primarily among blacks. Thus, the services available to an already underserved clientele were further eroded.

Moreover, the ratio of black health professionals to the black population, always small, showed few signs of improvement following civil rights legislation in the 1960s. U.S. Census figures for 1980 show that while blacks accounted for 11.7 percent of the total population, only 2.6 percent of physicians, 2.9 percent of dentists, and 2.3 percent of pharmacists were black. The figure for physicians was essentially the same as in 1910 (2.5 percent), lower than in 1930 (5.8 percent), and higher than in 1950 (1.9 percent). These figures belie the traditional notion that civil rights activism in the twentieth century produced a linear pattern of professional advancement for blacks. On the contrary, the pattern is characterized more by a complex ebb-flow momentum than by a uniformly rising tide of opportunity.

Lincoln School for Nurses graduating class. (Photographs and Prints Division, Schomburg Center for Research in Black Culture, The New York Public Library, Astor, Lenox and Tilden Foundations)

The marked underrepresentation of blacks in the health professions raises concerns about access to (and standards of) health care among the black population, where illness levels are higher and life expectancies lower than for whites. Trends and forecasts suggest continuing personnel shortages. Federal estimates for the year 2000, for example, indicate that in medicine and dentistry the practitioner-to-population ratio for blacks will be less than half what it is for whites. Some allied health fields, due to lower status and relative ease of access, attract proportionately more blacks. In 1980–1981, blacks accounted for 6.1 percent of graduates from dental-assistant programs and 10.1 percent of dental laboratory technology graduates.

REFERENCES

HANFT, RUTH S., LINDA E. FISHMAN, and WENDY J. EVANS. *Blacks and the Health Professions in the 80's: A National Crisis and a Time for Action.* Washington, D.C., 1983.

U.S. DEPARTMENT OF HEALTH AND HUMAN SERVICES. *Estimates and Projections of Black and Hispanic Physicians, Dentists, and Pharmacists to 2010.* Washington, D.C., 1986.

PHILIP N. ALEXANDER

Health Surveys. A common tool of health-policy analysts, health surveys were first implemented in a systematic way in the nineteenth century—though not always for noble purposes. Sen. John C. Calhoun, the proslavery advocate from South Carolina, used statistics from the 1840 U.S. Census to "prove" that free blacks were more likely than slaves to be mentally defective. Calhoun also drew on the work of Samuel A. Cartwright, a New Orleans physician whose prolific writings (based on anatomical and epidemiological surveys) aimed to reinforce the notion of the black as an inferior, if not subhuman, species. Although in 1844 an African-American physician, James McCune SMITH, publicly demonstrated the flaws in Calhoun's analysis, the use of statistics to establish racial inferiority continued during and after the Civil War.

Health-survey techniques were not used to positive effect for blacks until the turn of the twentieth century, when W. E. B. DU BOIS edited and published *The Health and Physique of the Negro American* (1906). This work compared mortality and morbidity rates for whites and blacks, pointing to environmental factors—poverty, discrimination, inadequate personnel and facilities—as important ingredients in any analysis of health. Among the statistics cited were death rates for the year 1900 of 27.4 per thousand for blacks and 19.5 for whites. Du Bois's publication helped stimulate an awareness that led to the launching of health-improvement and -education campaigns throughout the black community.

Paul B. CORNELY, the first African American to earn a doctorate in public health (1934), was a pioneer in the application of scientific research techniques to the study of health problems among the

disadvantaged. Under the auspices of the NATIONAL URBAN LEAGUE, he participated in a survey of the health status and needs of twelve cities during the 1940s. He was later commissioned to carry out surveys on behalf of various federal agencies.

While health surveys may have raised consciousness, they have not always generated the political will necessary to tackle (much less solve) the problems identified. In 1992, the National Center for Health Statistics determined that blacks between the ages of 25 and 34 had 2.4 times the mortality risk of whites.

REFERENCES

CORNELY, PAUL B. "Community Relations Project of the National Urban League: Report on the Field Services of the Specialist in Health." Houston, 1945.

DU BOIS, W. E. BURGHARDT, ed. *The Health and Physique of the Negro American*. Atlanta, 1906.

PHILIP N. ALEXANDER

Healy Family, The, including James Augustine (April 6, 1830–August 5, 1900); Hugh Clark (April 16, 1832–September 17, 1853); Patrick Francis (February 27, 1834–January 10, 1910); Alexander Sherwood (known by his middle name, January 24, 1836–October 21, 1875); Michael Augustine (September 22, 1839–August 30, 1904); Eliza Dunmore (December 23, 1846–September 13, 1919); Martha Ann (March 9, 1838–1920); Eugene (June 30, 1842–1842); Amanda Josephine (January 9, 1845–July 23, 1879); and Eugene [II] (June 23, 1849–?).

Born in County Roscommon, Ireland, in 1796, Michael Morris Healy came to Georgia around 1816, purchased almost 400 acres of land, which eventually became a 1,600-acre plantation, a few miles north of Macon, and became wealthy raising cotton and corn. In 1829, he began a monogamous relationship with a sixteen-year-old mulatto slave he owned, Mary Eliza Smith, whom neither the state nor the church would have allowed him to marry. Healy raised his children as members of his family, but was unable to free them. Beginning in 1837, when his oldest son, James, enrolled in a Quaker School on Long Island, N.Y., Healy sent his children north for education, thereby also ensuring their freedom. In the summer of 1844, Healy enrolled James and his next three sons, Hugh, Patrick, and Sherwood, at the newly established Holy Cross College, in Worcester, Mass., on the advice of the new bishop of Boston, John Fitzpatrick, a personal friend whose patronage would be essential to the early professional success of both James and Sherwood. Mary Eliza Smith and Michael Morris Healy died in May and August 1850, respectively. Once

Patrick Healy, second president of Jesuit-run Georgetown University in Washington, D.C. (Prints and Photographs Division, Library of Congress)

their father's estate had been settled, and his plantation and fifty-seven slaves sold, the children had enough money to live on for the rest of their lives and to pay for their education, which enabled James, Patrick, and Sherwood to become the first three black Catholic priests in the United States—where blacks then could neither study for the priesthood nor be ordained—and the only ones until 1886.

Because no American seminary would accept blacks, the Healy children pursued their clerical studies in Europe and Canada. James Healy entered the Sulpician Seminary in Montreal in 1849, received the subdiaconate on June 5, 1852, and then transferred to the Sulpician Seminary at Issyles-Molineaux outside of Paris. After being ordained a priest in the Cathedral of Notre Dame on June 10, 1854, he returned to Boston. Until 1866, when he became pastor of St. James, Boston's largest parish, he moved gradually up the diocesan hierarchy. In February 1875, Pope Pius IX named him bishop of the Portland diocese, which included New Hampshire as well as Maine, making him the first black Catholic bishop in the United States.

As a consequence of his work both as pastor and as bishop, James Healy is associated with a commit-

ment to Catholic children and to an extension of Catholics' legal rights. While pastor, he was involved in the establishment of an orphanage, a home for abandoned children and unwed mothers, and a home for wayward girls. While bishop, he founded an orphanage in Portland. He secured the right of worship for Catholics in Massachusetts state orphanages, nursing homes, and penal institutions, as well as access to these institutions for Catholic clergy; after a struggle that began in the early years of his episcopate, Maine also finally granted Catholic clergy access to its institutions in 1899.

James Healy was selected to serve on a special subcommittee on black and Native American missions at the Third Plenary Council of Baltimore in 1884, which led to a decree by the council that each bishop must meet the institutional needs of the blacks in his diocese and ensure that the sacraments be administered to them without discrimination. At that time, blacks in general received communion only after all the whites had. This subcommittee established a permanent commission for the Negro and Indian Missions, on which Healy served seven years. His com-

James Augustine Healy, the first African-American bishop of the Roman Catholic church in the United States, was one of six members of a remarkable family devoted to religious vocations. (Prints and Photographs Division, Library of Congress)

mitment to this movement was qualified by his concern that the black movement for equality in Catholicism would reinforce distinctions among Catholics, distinctions that Catholicism should not tolerate. Hence, while he gave verbal support to the black Catholic Congress—a group which met annually between 1889 and 1894 to insist upon an end to discrimination within the church—he declined to participate in their annual conventions.

After completing his studies at Holy Cross in 1850, Patrick Healy began further studies at the Jesuit novitiate in Frederick, Md., taking his first vows in 1852. After teaching one year at St. Joseph's College in Philadelphia, he was reassigned to Holy Cross from 1853 to 1858, where he taught rhetoric, French, mathematics, grammar, poetry, English, and accounting. Returning to his studies, he went to Europe at the end of 1858, receiving his ordination to the priesthood in September 1864, and a doctorate in philosophy from the University of Louvain, in Belgium, on July 26, 1865. He returned to the United States during the summer of 1866, and assumed the position of Professor of Rational Philosophy at Georgetown College, teaching ethics and metaphysics. Having become vice president in 1869, and vice rector in 1873, he was inaugurated as president of the college on July 31, 1874, the first black to serve as president of a white college.

Georgetown was then a small liberal arts college. Patrick Healy modernized its curriculum, increased the number of departments, particularly in the natural sciences, and built a seven-story, 209-foot building at the center of the campus, which was completed in 1881 and named Healy Hall after his death.

On February 10, 1882, Patrick Healy was forced to retire because of his health. He accepted various assignments within the Catholic church during his retirement, the last at the Georgetown infirmary, where he died. He is also known as Georgetown's second founder for the changes he brought to it. This, however, did not include the admission of blacks, who were not accepted to Georgetown until after World War II.

Sherwood Healy also left Holy Cross in 1850, but without finishing his studies, to work as a warehouse clerk in Manhattan, where Hugh lived. In September 1852, Sherwood entered the Sulpician Seminary in Montreal, and in the fall of 1853 he joined James at the Sulpician Seminary outside of Paris. In 1855 he transferred to Lateran University in Rome, where he was ordained a priest on December 15, 1858. He received a Doctor of Divinity at that time, and a doctorate in canon law from Lateran University in 1860, probably becoming the first African American to receive a doctorate. He returned to Boston in the fall of that year, serving as an assistant within that diocese

until April 24, 1864, when he was designated professor of moral theology, of church music, and of rites and rubrics at the newly established seminary in Troy. He composed a *Magnificat* and original hymns which were sung in churches throughout New England. John Williams, the new bishop of Boston, chose him to be his personal theologian—that is, to help him understand the issues of church dogma on which he had to vote—at the Second Plenary Council in Baltimore in 1866, and at the First Vatican Council in Rome in 1870. On September 27, 1870, after the Vatican Council, he was named the rector of the Boston Cathedral, and in March 1875, after James assumed his episcopate, Sherwood became the pastor of St. James. But, bothered by bad health throughout his life, he died within the year.

Michael Healy was his parents' fifth son and sixth child. He began his studies at Holy Cross in 1848, was sent to Montreal in 1855, and Douai, Belgium in 1856, but after this third attempt to run away, his brother decided to let him realize his dream to be a sailor. Having begun as a cabin boy, Michael was officer of a merchant vessel by 1864, and entered the U.S. Revenue Cutter Service, a precursor of the U.S. Coast Guard, in 1865. He made his first trip to Alaska in 1858, and received his first major command in 1883 as captain of the U.S. Revenue Cutter *Corwin*, whose purpose was to protect American whalers, sealers, and fishermen in Alaska. In 1885 he received a congressional citation praising his heroic deeds aboard the *Corwin* during rescue operations in and pioneer explorations of Alaska, described in his 1884 and 1885 *Report of the Cruise of the Corwin.*

In 1885 Michael Healy received command of a larger ship, the U.S. Revenue Cutter *Bear*. As commander of the *Bear*, he not only continued to protect commercial ships, captaining the *Bear* when it saved 160 men from five wrecked ships of the Alaskan whaling fleet in 1888, but was also expected to enforce federal law in the waters off Alaska. In February 1890, he was court-martialed, accused by the Women's Christian Temperance Union and by the Coast Seamen's Union of drunkenness and of torturing whale ship mutineers he had been asked to discipline; the court, however, found his disciplinary action justified and the charge of drunkenness unsubstantiated. In 1896, after his twenty-second cruise in the Arctic, he was court-martialed again, this time for abusing his inferiors and being drunk while in command. As a consequence of the trial, he was suspended for four years and lost rank.

After first having been given command of the new cutter *McCulloch* in 1900 during the Nome Gold Rush, Michael Healy was demoted to a smaller cutter in the Boston Harbor, the *Seminole,* because of the court-martial. In 1902, after he had twice attempted suicide during his first cruise on the *Seminole,* the Department of the Treasury, which oversaw the U.S. Revenue Cutter Service, reviewed his case, restored his original rank, and gave him command of the *Thetis.* He underwent mandatory retirement on September 22, 1903.

Throughout his career in the Arctic, Healy showed particular concern for the native population. Among his law enforcement activities, he attempted to prevent whalers from selling liquor or alcohol distilleries to the Inuit, acts which were illegal and had led to the impoverishment of their communities. He reported illegal acts to the Secretary of the Treasury, including rape as well as the sale of liquor, committed by private individuals and government employees against the Inuit. Dismissing the claim that the Inuit had threatened whites with violence, he wrote the Secretary that "where trouble comes between white men and natives the white men are always wrong." In order to alleviate the scarcity of food, clothing, and transportation among the Alaskan Inuit, he shipped five hundred Siberian reindeer to Alaska from 1892 to 1895. Although this project was not entirely successful because it obligated the Inuit suddenly to become herdspeople rather than hunters, by 1930 more than 600,000 domesticated reindeer served the needs of the 13,000 Inuit. Healy was famous both among the Inuit and in the United States, and is thought to have been the model for characters in Jack London's *Sea Wolf* and James A. Michener's *Alaska.* Throughout his life, he remained guarded about his own race.

The seventh and final son, Eugene [II] (named after the sixth Healy son who died while still an infant), was a professional gambler, and generally thought of as a ne'er-do-well. The three Healy sisters, Martha Ann, Eliza Clark, and Amanda Josephine, all became nuns, although Martha later renounced her vows. Among them, Eliza became the most well known. She was a boarding school student in the Congregation of Notre Dame, St. John's, Quebec, and at the Villa Maria, Montreal, and took her vows as a nun at the Congregation of Notre Dame in Montreal. In addition to being a teacher at various Catholic schools in Quebec and Ontario from 1882 until 1903, she was the mother superior of a community of French Canadian nuns in Huntingdon, Quebec (1895–1897), and at the Congregation of Notre Dame Convent School in St. Albans, Vt. (1903–1918), becoming the first black woman to be the superior of a white convent in that state's history. She is remembered for having taken both convents from debt to prosperity. The humility within which nuns were expected to live has obscured some of the general facts of her career.

Throughout their careers, the Healy family members remained ambivalent about their racial identity.

While Patrick's and Michael's physical appearance allowed them to pass as white, James and Sherwood succeeded professionally despite their African features. One scholar, Cyprian Davis, has suggested that the Catholic hierarchy overlooked James and Sherwood's race because they did not identify themselves with the black community or with black causes within the church. The older Healy brothers never disclosed publicly nor told their younger siblings or their descendants that their mother was a slave, claiming instead that she was the child of an aristocratic southern family.

REFERENCES

COCKE, MARY and ALBERT COCKE. "Hell Roaring Mike: A Fall from Grace in the Frozen North." *Smithsonian* 13 (1983): 119–137.

DAVIS, CYPRIAN. *The History of the Black Catholics in the United States.* New York, 1990.

FAIRBANKS, HENRY G. "Slavery and the Vermont Clergy." *Vermont History* 27 (October 1959): 305–312.

FOLEY, ALBERT S., S. J. *Bishop Healy: Beloved Outcaste.* New York, 1954.

OCHS, STEPHEN J. *Desegregating the Altar: the Josephites and the Struggle for Black Priests, 1871–1960.* Baton Rouge, La., 1970.

SIRAJ AHMED

Hearns, Thomas (October 18, 1958–), boxer. Thomas Hearns was born in Memphis. He lived with his parents and grandfather on a farm in Grand Junction, Tenn., until he was four, when the family moved to Detroit.

Hearns began his career as an amateur welterweight in 1975, while a member of the Kronk Gym in Detroit. At 6' 1" and 145 pounds, Hearns was thin but packed a powerful knockout punch in his right hand. In 1977 he won the U.S. National Amateur Athletic Union Light Welterweight Championship and the National Golden Gloves Welterweight Championship. Hearns turned professional as a welterweight that year, when he began a string of seventeen straight victories by knockout. In 1980 Hearns's perfect professional record of 28 wins, 26 by knockout, earned him a title fight with World Boxing Association (WBA) welterweight champion Pipino Cuevas. "The Hit Man," as Hearns was nicknamed, knocked out Cuevas in two rounds.

Hearns sought to unify the welterweight title in a 1981 bout with World Boxing Council (WBC) and North American Boxing Federation (NABF) champion "Sugar" Ray LEONARD, but Leonard prevailed with a fourteen-round technical knockout. In 1982

Hearns moved up to the junior middleweight division and captured the WBC championship with a fifteen-round decision over Wilfred Benitez. He then unified the junior middleweight title by knocking out WBA champion Roberto Duran in 1984. Hearns made an unsuccessful attempt to move up another weight class in 1985, when he was knocked out by world middleweight champion Marvin HAGLER in a furiously fought three-round bout. The following year, however, Hearns captured the NABF middleweight title in a first-round knockout of James Shuler. In 1987 Hearns once again put on weight and won the WBC light heavyweight title from Dennis Andries with a tenth-round technical knockout. Hearns met Leonard again in 1989, this time with Leonard's WBC super middleweight title at stake. The two fought to a draw and Leonard retained the championship.

In 1991 Hearns defeated Virgil Hill in a unanimous twelve-round decision to capture the WBA light heavyweight title. In his last fight to date, Hearns lost that title in a 1992 split decision to challenger Iran Barkley. As of March 1994 Hearns's record stands at 50 wins, 40 by knockout, 4 losses, and 1 draw.

REFERENCES

ASHE, ARTHUR R., JR. *A Hard Road to Glory: A History of the African American Athlete Since 1946.* New York, 1988.

PUTNAM, PAT. "Back with a Bang." *Sports Illustrated* (March 30, 1992): 24–25.

———. "The Last of the Legends." *Sports Illustrated* (June 17, 1991): 61–62.

WILEY, RALPH. "The Hit Man." *Sports Illustrated* (June 5, 1989): 48–50.

THADDEUS RUSSELL

Hedgeman, Anna Arnold (1899–1990), civil rights activist. Born in Marshalltown, Iowa, Anna Arnold was the first black student at Hamline University in St. Paul, Minn. In 1922, after receiving a B.A. she moved to Holly Springs, Miss., to teach at Rust College, having been unable, because of her color, to find a teaching position in the North. However, the segregation in the South disheartened her, and in 1924 she went to work for the YOUNG WOMEN'S CHRISTIAN ASSOCIATION (YWCA) in Springfield, Ohio.

In 1927, she began working for the YMCA in Harlem in New York City. She was named a consultant on racial matters to New York City's government in 1934. This was a year after her marriage to Merritt A. Hedgeman. In 1937 she briefly returned to the YMCA in Brooklyn, but resigned shortly

thereafter, when the directors of the YMCA expressed their disapproval of her organizing picket lines to urge the hiring of blacks.

In 1944, Hedgeman was named executive director of the National Council for a Permanent Fair Employment Practices Committee. Two years later she became Dean of Women at Howard University. In 1949, after campaigning for Harry S. Truman, she received a federal appointment as assistant to the administrator of the Federal Security Agency, later part of the Department of Health and Human Services.

From 1954 to 1958, as an assistant to New York City Mayor Robert F. Wagner, Hedgeman became the highest ranking black woman in the history of New York City government. She was the only woman on the organizing committee of the August 1963 March on Washington. That year she was appointed to the commission of religion and race of the National Council of Churches, retiring in 1967.

Hedgeman received many honors in her lifetime. In 1948 she became the first female graduate of Hamline University to be named an honorary Doctor of Humane Letters by her alma mater. She also was the recipient of the Avon/COCOA Pioneer Woman Award (1983) and the YMCA's Dr. Leo B. Marsh Memorial Award (1984). In 1964 she published her autobiography, *The Trumpet Sounds,* and in 1977 published a volume on civil rights, *The Gift of Chaos.*

REFERENCE

HEDGEMAN, ANNA ARNOLD. *The Trumpet Sounds.* New York, 1964.

JUALYNNE DODSON

Height, Dorothy (March 24, 1912–), clubwoman and activist. Dorothy Height's career as an activist and reformer has been dedicated to working for African Americans through women's organizations, ranging from girls' clubs and sororities to the YWCA and the NATIONAL COUNCIL OF NEGRO WOMEN (NCNW). Height was born in Richmond, Va.; her family moved to Rankin, Pa., when she was four. In this mining town, she and her family were active in the life of their church and community groups. As a young woman, Height participated in local girls' clubs and the YWCA, moving into leadership at a young age. This was the beginning of her successful combination of religious and community work, part of a long African-American tradition.

Height graduated from New York University in 1932. She was able to complete the degree in three years through her hard work and the support of an Elks scholarship. During this period she also took on a number of part-time jobs in restaurants, in a factory, in laundries, writing newspaper obituaries, and doing proofreading for Marcus GARVEY's paper, *Negro World.* Height then spent an additional year at the university to earn a master's degree in educational psychology. From here she took a position as assistant director of the Brownsville Community Center in Brooklyn and became involved with the United Christian Youth Movement. She traveled to England and Holland to represent her group at Christian youth conferences in 1937; she was also introduced to Eleanor Roosevelt, and helped Roosevelt to plan the 1938 World Youth Congress, held at Vassar College.

From 1935 until 1937, Height was a caseworker for the New York City Department of Welfare. In the wake of the 1935 Harlem riots, she became the first black personnel supervisor in her department. Seeking a position that would give her a broader range of work experience, she left the Department of Welfare in 1937 to work for the Harlem YWCA as the assistant director of its residence, the Emma Ransom House. In this position, Height gained expertise in issues facing many African-American women in domestic labor and learned to administer a community-

Dorothy Height. (© Oscar White)

based organization. She also became involved with the NCNW through her friendship with Mary McLeod BETHUNE.

In 1939, Height accepted the position of executive secretary of the Washington, D.C., Phillis Wheatley YWCA. She also began to work with the Delta Sigma Theta sorority, encouraging both organizations to improve the lives of working African-American women. Her outstanding efforts led Height to a position with the national board of the YWCA in 1944. She was involved in organizing the YWCA's watershed conference in 1946 at which the organization took a stand for the racial integration of its programs. From 1947 until 1956, Height served as president of Delta Sigma Theta, moving it to become an international organization in addition to expanding its work at home.

Height became president of the National Council of Negro Women in 1957. Under her leadership the NCNW, an umbrella group for a wide variety of black women's organizations, became an active participant in the civil rights struggles in the United States. She also involved the YWCA in civil rights issues through her position as secretary of the organization's Department of Racial Justice, a job she assumed in 1963.

Although she was moderate in her approach to the question of civil rights, Height has never ceased her activities in search of equality. Her commitment has been to a struggle carried on through the widest possible range of organizations, and so she has served as a consultant to many private foundations and government agencies. Height was a major force in moving the YWCA to be true to its 1946 declaration on interracial work. At the group's 1970 convention, she helped to write a new statement of purpose for the YWCA, declaring its one imperative to be the elimination of racism.

Through Dorothy Height's involvement, the YWCA has taken many steps forward in its attitudes and actions concerning African-American women. The organization's full commitment to integration and parity in its operation owes much to her work. She continues to guide the NCNW, and has made it an important voice in articulating the needs and aspirations of women of African descent around the world.

REFERENCES

GIDDINGS, PAULA. *In Search of Sisterhood.* New York, 1988.

HILL, RUTH EDMONDS, and PATRICIA MILLER KING, eds. *The Black Women Oral History Project.* Westport, Conn., 1991.

JUDITH WEISENFELD

Hemings, Sally (1773–1836), supposed mistress of Thomas Jefferson. Born a quadroon slave, Sally Hemings was the sixth child of John Wayles, of Bermuda Hundred, Va., and his slave concubine, Elizabeth Hemings. Wayles died the year Hemings was born, and she and her five brothers and sisters were inherited by her legitimate, white half-sister Martha Wayles Jefferson, wife of Thomas Jefferson, who would later become third president of the United States. Martha died in 1782, and two years later Thomas Jefferson left for France as ambassador, taking his oldest daughter, also named Martha. In 1787 he sent for his youngest daughter, Maria, and Hemings accompanied her as her nurse. During her stay in France, where she was legally free, Hemings allegedly became Jefferson's mistress. In 1789 she returned with him to Virginia, thereby re-enslaving herself. She remained at Monticello for the rest of her life and between 1790 and 1808 gave birth to seven children, all presumably Jefferson's: Thomas, Edy, Harriet I, Beverly, Harriet II, Madison, and Eston.

In 1802, the journalist James T. Callender, who had worked as a political muckraker, published the story in the *Richmond Recorder.* This article instigated an international political scandal that made Hemings famous and accused Jefferson of hypocrisy, immorality, and miscegenation—the last a crime punishable by fine and imprisonment. Jefferson never refuted this story and did not exile Hemings or her children from Monticello; they were allowed to run away and pass for white at twenty-one. In 1826 he died and freed Madison and Eston in his will, although he never freed Hemings. She was, however, subsequently freed by his legitimate, white daughter Martha.

Jeffersonians, such as Virginius Dabney, deny this story, and the bitter controversy over it persists to the present.

REFERENCES

BRODIE, FAWN F. "The Great Jefferson Taboo." *American Heritage* 23, no. 4 (June 1972): 48–47, 97–100.

———. *Jefferson: An Intimate Biography.* New York, 1974.

———. "Thomas Jefferson's Unknown Grandchildren." *American Heritage* 27, no. 6 (October 1976): 28–33, 94–99.

CHASE-RIBOUD, BARBARA. *Sally Hemings: A Novel.* New York, 1979.

DABNEY, VIRGINIUS. *The Jefferson Scandals: A Rebuttal.* New York, 1981.

GRAHAM, PEARL N. "Thomas Jefferson and Sally Hemings." *Journal of Negro History* 44 (1961): 89–103.

MOSS, SIDNEY P., and CAROLYN MOSS. "The Jefferson Miscegenation Legend in British Travel

Books." *Journal of the Early Republic* 7, no. 3 (Fall 1987): 253–274.

BARBARA CHASE-RIBOUD

Henderson, Fletcher Hamilton, Jr. (December 18, 1897–December 28, 1952), jazz band leader and composer. Born in Cuthbert, Ga., Henderson, whose first name is sometimes listed as James, began to play piano at age six. He studied chemistry and mathematics at Atlanta University and after graduating in 1920 moved to New York to continue his studies. In order to support himself, he worked as a music demonstrator with the black-owned Pace-Handy Music Co., and then as a recording manager for Harry PACE's Black Swan Records. When singer Ethel WATERS, whom Henderson had recorded, went on a national tour, she hired him as bandleader and tour director. Back in New York in 1922, Henderson recorded with his own ensemble for the first time, a session that included "Wang Wang Blues."

In 1924 Henderson began to lead the house band at New York's popular dance hall Roseland, an engagement that lasted on and off for ten years. In 1924 Henderson also hired trumpeter Louis ARMSTRONG, and began to integrate Armstrong's stunning solos into tightly arranged dance band compositions, a method that all but inaugurated the big band jazz era. Together, Henderson and Armstrong, who stayed with the band until 1925, made a string of recordings now considered crucial moments in early jazz ("Copenhagen," 1924; "Houston Blues," 1924; "Shanghai Shuffle," 1924). During this time Henderson established himself as the most important early architect of the big band sound, with compositions

The first great jazz big band, Fletcher Henderson's orchestra was already the talk of New York City in 1924 when Louis Armstrong joined the band for a year-long stint. Armstrong's nightly lessons in the art of swing transformed the sound of the band. Other key members of the ensemble included tenor saxophonist Coleman Hawkins and arranger Don Redman. In this 1924 photograph are (from left) Howard Scott, Coleman Hawkins, Louis Armstrong, Charlie Dixon, Fletcher Henderson, Kaiser Marshall, Buster Bailey, Elmer Chambers, Charlie Green, Bob Escudero, and Don Redman. (Frank Driggs Collection)

that established a model for structuring and balancing what would become the standard large jazz ensemble instrumentation of brass, wind, and rhythm sections. From 1924 until 1927, the chief arranger for Henderson was Don Redman, whose antiphonal, call-and-response style helped set the orchestra's early style ("The Stampede," 1926; "The Chant," 1926; "Hop Off," 1928). During this time the band's central soloist was Coleman HAWKINS, whose tenor saxophone improvisations on recordings from 1923 to 1934 not only remade the heretofore novelty voice of the tenor saxophone into a legitimate instrument with virtuoso potential, but helped invent the role of the solo voice in big band jazz. In the mid-to-late 1920s Henderson also performed as a sideman, most notably with Bessie SMITH ("Cake Walking Babies," 1925; "Alexander's Ragtime Band," 1927).

Although Henderson's bands achieved great musical and popular success in the 1920s and early 1930s, he was a diffident leader who could attract extraordinary solo talents, but could not keep them in the band for long. Among the many superlative musicians who spent time under Henderson's leadership were, in addition to Armstrong and Hawkins, Henry "Red" Allen, Chu BERRY, Sid CATLETT, Benny CARTER, Roy ELDRIDGE, Billie HOLIDAY, Benny Morton, Joe Smith, Ben WEBSTER, Dicky Wells, and Lester YOUNG.

Aside from a 1928 car accident that sidelined him briefly, the late 1920s and the early 1930s were periods of enormous productivity and popularity for Henderson ("Sugar Foot Stomp," 1931; "Queer Notions," 1933). During this time he began doing more arranging, though he also relied on his brother, Horace, for that task. By the mid-1930s Henderson was arranging for other orchestras, most notably that of Benny Goodman ("Down South Camp Meeting," 1934; "Wrappin' It Up," 1934; "King Porter Stomp," 1935; "Blue Skies," 1935). Henderson also kept his own orchestra together during the mid-1930s, performing at an extraordinary stay at Chicago's Grand Terrace in 1936. That year he also recorded "Jangled Nerves," "Shoe Shine Boy," "Stealin' Apples," "Sing, Sing, Sing," achieving his first big hit record with "Christopher Columbus."

By the mid-1930s, however, the band's strength and popularity had begun to decline. Many of the band's members departed, complaining about Henderson's failure to give them steady work and timely paychecks, and the orchestra's performances, along with its fame and influence, began to suffer. In the late 1930s Henderson continued working for Goodman as composer and arranger, as well as continuing to lead his own bands, but it was clear that his career had peaked. From 1941 to 1947 Henderson worked solely as a bandleader, touring on and off, especially in New York and Chicago. During this time one of his arrangers was Herman Blount, who was later an avant garde bandleader under the name SUN RA. From 1947 to 1948 Henderson again worked for Goodman, and in 1948–1949 he accompanied Ethel Waters. In 1949–1950 he briefly led a sextet. Henderson was paralyzed by a stroke in 1950, and he died two years later in New York.

REFERENCES

ALLEN, WALTER C. *Hendersonia: The Music of Fletcher Henderson.* Highland Park, N.J., 1973.
SCHULLER, GUNTHER. *Early Jazz.* New York, 1968, pp. 242–279.
———. *The Swing Era.* New York, 1988, pp. 323–325.
TAYLOR, J. R. "Fletcher Henderson: Developing an American Orchestra." LP liner notes, Smithsonian R9006, 1977.

MARTIN WILLIAMS

Henderson, Rickey Henley (December 25, 1958–), baseball player. Rickey Henderson was born in Chicago, but when his father left two months later, the family moved to Arkansas and then settled in Oakland, Calif. Henderson was a star running back at Oakland Technical High School and was vigorously recruited to play football by a number of colleges. Despite the promise of a football scholarship in a top college program, Henderson chose to sign with the hometown Oakland Athletics, who selected him in the fourth round of the 1976 baseball draft.

After two and a half seasons in the minor leagues, Henderson was brought up to the majors during the 1979 season and in only 89 games stole 33 bases. The following year, in his first full season, Henderson became an overnight superstar by stealing 100 bases, thereby breaking Ty Cobb's 65-year-old American League record of 96 thefts. In 1982, after the strike-shortened season of 1981, Henderson set his sights on Lou Brock's major-league record of 118 stolen bases and easily surpassed it with 130.

Besides his record-breaking accomplishments on the base paths, Henderson quickly established himself as one of the greatest players of the modern era. His .450-plus on-base percentage, coupled with his base-running abilities, makes him the best leadoff hitter of all time. Henderson has hit over .300 in several seasons and also hits for considerable power, a rarity among leadoff men. Henderson twice hit more than twenty home runs in a season, and holds a career record for the most home runs hit when leading off a game. On defense, Henderson has excelled as one of

the game's finest left fielders and in 1981 was awarded a Golden Glove.

In 1984 Henderson was traded to the New York Yankees for six players, and stayed with the Yankees until 1989, when he was traded back to the Athletics, where he remained until late summer 1993, when he was traded to the Toronto Blue Jays.

In 1991 Henderson became the all-time stolen base leader when he broke Lou Brock's mark of 938 career steals. As of the end of the 1993 season, he had 1,095 career stolen bases.

REFERENCE

PORTER, DAVID L. *Biographical Dictionary of American Sports: Baseball*. New York, 1987.

THADDEUS RUSSELL

Hendricks, Barkley (April 16, 1945–), painter and photographer. Barkley Hendricks was born in Philadelphia, Pa., and learned about art from various teachers in local public schools. A high school teacher encouraged Hendricks to study art in college, and he attended the Pennsylvania Academy of Fine Arts from 1963 to 1967. Hendricks then worked for three years as an art instructor for the Philadelphia Department of Recreation, and received both his B.F.A. and M.F.A. from the Yale University School of Art in 1972. In 1966 he purchased his first camera and began photographing JAZZ musicians such as Miles DAVIS, Cannonball ADDERLEY, and Dave Brubeck. At Yale, Hendricks studied photography with Walker Evans, and while Hendricks was primarily interested in painting, he adopted a photo-realist painting style that was influenced by Evans's documentary photography.

Hendricks is known for his life-sized portraits of urban African Americans, created with a crisp line and tight brush stroke that yields a photographic finish. Painting from memory or from his own photographs of individuals, Hendricks depicts people he sees on the street as well as his friends. His images are characterized by their use of clothing as a symbol for particular social types. Hendricks presents his subjects' expression, gesture, and accoutrements in stunning detail, but often locates them in a space without context, a backdrop of solid, flat color created by sponge rollers (*Little Old Man*, 1973; *Northern Lights*, 1975; *Pretty Peggy's Black Box*, 1976; *Tuff Tony*, 1978; *Sisters; Susan and Toni*, 1978). By forcing viewers to characterize people economically and socially through their style of dress, Hendricks makes his audience question the impulse to stereotype individuals based on the way they look (*Lamont on the Case*, 1976; *Sweet Thang*, 1976). Hendricks is also known for creating relationships between canvases, with the same

individual appearing in more than one painting (*Noir*, 1978; *Afro-Parisian Brothers*, 1978).

In the late 1970s, Hendricks began expanding his imagistic vocabulary, painting an image of two gay Latino men embracing (*Hasty-Tasty*, 1979), and creating a series of collages based on jazz themes (*Side Car Two* [Miles Davis], 1979; *Self Portrait in Three Colors* [Charles MINGUS], 1979). His best-known work of the 1980s is *American Anatomy* (1989), which includes five collages on black paper linked by the presence of a backbone created from sequins and lace. In the 1990s, Hendricks created a series of window installations using women's shoes and other everyday objects to explore the functional, decorative, and oppressive aspects of women's relationship to fashion (*Somebody's Gotta Do It*, 1993). He also created watercolors based on Jamaican themes. These paintings, known as *Lovers Leap*, feature wide expansive skies and a thin border of tropical landscape with a lighthouse perched on a cliff.

Hendricks's works have been featured in solo exhibitions at the ACA Galleries in New York (1976, 1978, 1982), the Studio Museum in Harlem (1980), Connecticut College (1973, 1984, 1993), the Pennsylvania Academy of Fine Arts, the Peale House Galleries in Philadelphia (1985), the Housatonic Museum of Art in Bridgeport, Conn. (1988), Norwalk Community-Technical College (1993), and at the Benjamin Mangel Gallery in Philadelphia (1993). Hendricks has taught art at Connecticut College since 1972. He also has been a disc jockey for a jazz program on Connecticut College's radio station, calling himself "Professor Dred" after the DRED SCOTT DECISION of 1857.

REFERENCES

Barkley L. Hendricks Presents Barkley L. Hendricks, 1967–1987. Bridgeport, Conn., 1988.

SCHMIDT CAMPBELL, MARY. *Barkley Hendricks: Oils, Watercolors, Collages, and Photographs*. New York, 1980.

RENEE NEWMAN

Hendricks, John Carl "Jon" (September 16, 1921–), jazz vocalist. Born in Newark, N.J., Jon Hendricks began singing at an early age, and received training in Ohio public schools before going on to further study at the University of Toledo. After service in World War II, Hendricks settled in New York and began singing at different spots in the local jazz scene. He was inspired to incorporate a vocal technique known as vocalese, which involves adding lyrics to existing instrumental solos, into his style after hearing singer Eddie Jefferson's version of "Moody's Mood."

Hendricks began working with singer Dave Lambert in 1955 and recorded *Four Brothers*. The duo added Annie Ross, a talented actress and singer, and, as Lambert, Hendricks, and Ross, gained the interest of Creed Taylor, a young record producer. The trio's first record, *Sing a Song of Basie* (1957), was one of the first to use extensive vocal overdubbing. The record was an enormous success and established them as one of the most sought-after singing acts in jazz until they disbanded in 1964. Hendricks continued to sing with various ensembles, and he performed in Africa and Europe for five years before settling in California in 1973.

Hendricks's rough, coarse timbre yet lyrical approach as a vocal technician made him the logical extension of the big-band sound, especially in his ability to emulate the timbral qualities of the saxophone, trombone, or growling trumpet. His style, including his scat singing and superb ability to imitate jazz instrumentalists, influenced a whole generation of singers who followed him, including Betty CARTER and Al JARREAU.

REFERENCES

WILSON, J. S. "Jazz: 'Tempo,' Reminiscence by Hendricks." *New York Times,* July 4, 1983, p. 13.
JOYCE, M., and K. JOYCE. "Jon Hendricks: Interview." *Cadence* 9, no. 1 (1983): 5.

WILLIAM C. BANFIELD

Hendrix, James Marshall "Jimi" (November 27, 1942–September 18, 1970), rock guitarist, singer, and songwriter. In a professional career that lasted less than a decade, Jimi Hendrix created music that would establish him as the most innovative and influential guitarist rock music produced.

Born in Seattle, Wash., Hendrix started to play the guitar at age eleven and was playing with local rock groups as a teenager. He left school at sixteen, and with his father's permission, joined the Army as a paratrooper a year later. While in the service he met bass player Billy Cox, with whom he would later join forces as a civilian. Hendrix's Army career ended when he was injured on a practice jump.

Once out of the Army, he hit the "chitlin" circuit as a backup guitarist for a host of popular rock and rhythm-and-blues artists including LITTLE RICHARD, the Isley Brothers, Curtis Knight, Wilson PICKETT, Ike and Tina TURNER, King Curtis, and James BROWN. During this period, from 1962 to 1964, he began incorporating his trademark crowd-pleasers—playing his guitar with his teeth, behind his back, and between his legs. Early in his career, Hendrix played ambidextrously before he eventually settled on using

a right-handed Fender Stratocaster, restrung upside down and played left-handed. He manipulated the tone and volume controls (which were now on top) to make unique effects and sounds. Hendrix's huge hands allowed him a phenomenal reach and range; his ability to play clean leads and distorted rhythm simultaneously remains a musical mystery.

In 1964 Hendrix came to New York, and using the name "Jimmy James," fronted his own band, called the Blue Flames. He became known in New York at the height of the folk music era in the mid-1960s. Holding forth as a solo act at the Cafe Wha?, a basement café on MacDougal Street in Greenwich Village, he also found time to play local venues as a sideman with a group called Curtis Knight and the Squires, and in Wilson Pickett's band, where he met young drummer Buddy Miles. In 1967, Chas Chan-

A charismatic performer on the electric guitar, Jimi Hendrix was the most influential rock instrumentalist of the late 1960s. Appreciation for his innovative solo techniques has grown in the years since his untimely death at the age of twenty-seven. Hendrix is accompanied here by Noel Redding, bass guitar. (Frank Driggs Collection)

dler (the bassist of the former Animals) convinced Hendrix to return with him to London. On the promise that he would meet Eric Clapton, Hendrix agreed. In just three weeks in England the Jimi Hendrix Experience was formed with Mitch Mitchell on drums and Noel Redding on bass. "Hey Joe," their first single, went all the way to number 6 on the British charts in 1967, and an appearance on the British television show "Ready, Steady, Go" attracted wide attention when Hendrix played their new single, "Purple Haze."

The same year, Paul McCartney persuaded the Monterey Pop Festival officials to book Hendrix, despite the fact that his first album had yet to be released. His riveting musical performance ended with his setting his guitar on fire. His action and his performance transformed the twenty-four-year-old into a rock superstar. Later that year (1967) his debut album *Are You Experienced?* was called by *Guitar Players'* Jas Obrecht "the most revolutionary debut album in rock guitar history."

In 1968 he released his second album, *Axis: Bold As Love,* which contained more of his distinctive sounds in such songs as "Little Wing," "If 6 was 9," and "Castles Made of Sand." His third album, a double set titled *Electric Ladyland,* was released just nine months later. Hendrix created a recording studio of the same name in Greenwich Village, a reflection of his belief that he was connected to a female spirit/muse of fire and electricity.

In 1969 Hendrix performed at the Woodstock Festival, the only black performer of his time to penetrate the largely white world of hard and psychedelic rock. He was pressured by black groups to take a more political stance, but Hendrix took no part in formal politics; his political statement was in his music. His electric version of the "Star-Spangled Banner," played at Woodstock, was in itself a political statement.

Later that year Hendrix formed the all-black Band of Gypsys with former Army friend Bill Cox on bass and Buddy Miles on drums. Although the group lasted only a few months, a live performance was captured on the album *Band of Gypsys.* Hendrix's management believed it was a mistake for him to forsake his white rock side, and he was pressured to make an adjustment. Hendrix finally settled on Mitch Mitchell on drums with Billy Cox on bass. They performed at the club Isle of Fehmarn in West Germany on September 6, 1970. Twelve days later Hendrix died in London after complications resulting from barbiturate use.

Though Hendrix's period as a headline performer lasted only three years, his influence on popular music has been considerable. In helping to establish the prime role of the electric guitar soloist, he was an inspiration for several generations of heavy metal musicians. His improvisatory style has inspired both jazz musicians and practitioners of avant-garde "new music."

REFERENCES

HENDERSON, DAVID. *Jimi Hendrix: Voodoo Chile'.* New York, 1978.

———. *'Scuse Me While I Kiss the Sky: The Life of Jimi Hendrix.* New York, 1981.

DAVID HENDERSON

Henson, Josiah (June 15, 1789–May 5, 1883), abolitionist clergyman. Josiah Henson was born a slave in Charles County, Md. He gained a reputation as a diligent worker with a capacity for leadership, and his role as a slave preacher was eventually recognized by the Methodist Episcopal church. Henson's last owner, Isaac Riley, made him a plantation manager and entrusted him on one occasion with the transportation of eighteen slaves to Kentucky. He remained a loyal slave until he was duped by his master in negotiations to purchase his freedom. In October 1830, he escaped with his wife, Charlotte, and their four children to Canada.

Once in Canada, Henson found work as a farm laborer and slowly established an itinerant ministry. He served as a captain in a company of the Essex Coloured Volunteers during the Canadian rebellion of 1837. Henson devoted much of his effort to assisting fugitive slaves. Working as a conductor on the UNDERGROUND RAILROAD, he brought fugitives from Kentucky to the Canadian haven. He envisioned racial progress under the protection of British law, and encouraged black settlement in Canada. With the financial backing of several New England philanthropists, he helped found a manual labor school, the British-American Institute, at the Dawn settlement, near Chatham, Canada West (present-day Ontario). The Dawn school and the settlement's sawmill provided educational and employment opportunities, respectively, for African Americans fleeing southern slavery and northern racial oppression.

Henson toured England in 1849 and 1851, lecturing on slavery, meeting with prominent reformers, and raising funds for the British-American Institute. He presented some of the Dawn settlement's products, including walnut lumber, at the Great Exhibition of 1851. His management of the school and fund-raising tours in England sparked criticism from some Canadian blacks, and upon his return he became embroiled in a decade-long struggle for control of the British-American Institute property. The school eventually closed in 1868.

Josiah Henson, a runaway slave, was the author of a slave narrative that has been much admired by Christian evangelicals. He was also a leader of the Dawn Institute, a community of slave fugitives in Canada. (Photographs and Prints Division, Schomburg Center for Research in Black Culture, The New York Public Library, Astor, Lenox and Tilden Foundations)

Henson's international notoriety increased dramatically with the publication of *Uncle Tom's Cabin* (*see* UNCLE TOM'S CABIN) in 1852. In her research for the novel, author Harriet Beecher Stowe interviewed Henson and read his biography, a seventy-six-page pamphlet published in 1849, *The Life of Josiah Henson, Formerly a Slave, Now an Inhabitant of Canada, as Narrated by Himself.* Despite some initial equivocations on the part of Henson and Stowe, he became identified in the public mind as the model for the fictional Uncle Tom, and he is best remembered for this connection with Stowe's widely read antislavery novel. Stowe wrote the introduction to his second narrative, *Truth Stranger than Fiction: Father Henson's Story of His Own Life,* in 1858. On his final tour of England, in 1876, he received an audience with Queen Victoria, and was celebrated as "Mrs. Stowe's Uncle Tom."

REFERENCES

BEATTIE, JESSIE LOUISE. *Black Moses: The Real Uncle Tom.* Toronto, 1957.
HARTGROVE, W. B. "The Story of Josiah Henson." *Journal of Negro History* 3 (1918): 1–21.

MICHAEL F. HEMBREE

Henson, Matthew Alexander (August 8, 1866 –March 9, 1955), explorer. Matthew Henson was born in rural Charles County, Md., the son of free-born sharecroppers. At the age of four, Henson and his family moved to Washington, D.C. When he was still a young child both of his parents died, and Henson and his siblings were put under the care of an uncle in Washington. At the age of twelve he left school, traveled to Baltimore, and started his career as a seaman when he was hired as a cabin boy on a ship sailing out of the port city. Henson spent the remainder of his adolescence traveling around the world as a merchant sailor and working menial jobs when back on the East Coast.

At the age of twenty, while working as a clerk in a Baltimore hat store, Henson was hired by U.S. Navy Lt. Robert E. Peary to be Peary's personal servant on a survey expedition for the building of a Central American canal. When the expedition returned to the U.S. in 1888, Henson followed Peary to the League Island Navy Yard, where he worked as a courier.

In 1891 Peary received a commission to explore northern Greenland and again hired Henson as a personal assistant, despite Peary's concern that a "son of the tropics" would not be able to withstand Arctic weather. While surveying Greenland, Henson grew close to the native Inuits, learned the Inuit language, became the expedition's most able dogsled driver, and acted as liaison with the Inuits, who were used as guides and porters by the survey team. Henson and Peary returned to the United States in the summer of 1892 and spent a year touring the country presenting lectures and reenactments of their Greenland expedition. On a second exploration of Greenland, from 1893 to 1895, Peary and Henson led an aborted attempt at reaching the North Pole. For the next eleven years, Peary, with Henson as his chief assistant, led five more unsuccessful attempts at the North Pole, each time succumbing to frostbite or Arctic storms.

In July of 1908, Peary, Henson, and a crew of twenty-seven aboard a specially made icebreaking ship left New York for a final attempt at the pole. In February of 1909, having arrived at Cape Sheridan, between the northern tip of Greenland and the frozen

REFERENCES

COUNTER, S. ALLEN. *North Pole Legacy: Black, White and Eskimo.* Amherst, Mass., 1991.
HENSON, MATTHEW A. *A Negro Explorer at the North Pole.* New York, 1912.
MILLER, FLOYD. *Ahdoolo! The Biography of Matthew A. Henson.* New York, 1963.
ROBINSON, BRADLEY. *Dark Companion.* New York, 1947.

THADDEUS RUSSELL

Explorer Matthew Henson, a key member of the 1909 Peary expedition, which was the first to reach the North Pole. (Prints and Photographs Division, Library of Congress)

edge of the Arctic Ocean, Peary led a team of twenty-two, with Henson as one of his chief lieutenants, across the polar ice cap. On April 6, 1909, Peary, Henson, and four Eskimos became the first people to reach the North Pole.

Upon returning to the mainland, Peary was confronted with the news that Frederick Cook had claimed to have reached the North Pole one year earlier. Thus began a protracted and bitter public controversy over the veracity of each man's claim. By the end of 1910, however, most scientific societies had rejected Cook's account and accepted Peary's.

Though celebrated by African-American leaders for many years, Henson was largely unrecognized by the white public as the codiscoverer of the North Pole. After the historic expedition of 1909, Henson spent the rest of his working life as a messenger in the U.S. Customs House and in the Post Office in New York City. In his later years he finally won some of the honors he deserved. The Explorers Club made Henson its first African-American member in 1937. In 1944 Congress awarded him a medal for his co-discovery of the North Pole. In 1948 he was given the Gold Medal of the Geographical Society of Chicago. In 1950 he was honored at the Pentagon, and in 1954, a year before his death, he was received at the White House by President Eisenhower. A U.S. postage stamp commemorating his achievement was issued in 1986.

Herndon, Angelo Braxton (May 6, 1913–), activist. Born in Wyoming, Ohio, Angelo Herndon lost his father early to miner's pneumonia. He traveled to work in Kentucky, then Birmingham, Ala., where in 1930 he joined the COMMUNIST PARTY. He became active in the Unemployment Council and was elected a delegate to the National Unemployment Council in Chicago. He was arrested after attempting to organize mine workers at the Tennessee Coal, Iron and Railroad Company, but was released. Critical of capitalist institutions, Herndon encouraged skepticism of the existing leadership within the African-American community. Sent to Atlanta, in 1932 he started to organize unemployment councils and agitated for unemployment insurance. That summer, in defiance of a Fulton County commissioner's statement that no want existed in the city, Herndon led a biracial hunger march. Shortly thereafter, he was arrested under an 1861 statute (originally meant to guard against slave revolts) punishing incitement to insurrection. The Communist-led International Labor Defense hired an African-American Atlanta attorney, Benjamin O. DAVIS, Jr., to defend him. During the trial, the prosecution introduced illegally obtained evidence of Communist party literature in Herndon's possession that called for a black state. Convicted by an all-white jury, Herndon was sentenced to twenty years on a chain gang.

The civil liberties issues raised by the Herndon trial quickly made it a *cause célèbre,* both for the left and for civil rights groups such as the NAACP. The first appeal—made on grounds of racial exclusion and bias by the judge—was made to the U.S. Supreme Court, which denied it 6–3 in 1935. However, in 1937, the same year Herndon's autobiography *Let Me Live* appeared (he had previously written another work, *You Cannot Kill the Working Class*), the Court ruled 5–4 that the insurrection law was unconstitutional and freed him.

During the next several years, Herndon continued his Communist party activities. He served on the board of the Negro Youth Conference and organized

the Frederick Douglass Cultural League. He moved to Harlem, where he briefly joined the Harlem Communist party. In 1941 he edited, with Ralph ELLISON, the short-lived journal *The Negro Quarterly*. During World War II he broke with the Communist party, and retired from public life. According to Ralph Ellison, Herndon became a salesman somewhere in the Midwest, and for many decades has refused to discuss his Communist past.

REFERENCES

HERNDON, ANGELO. *Let Me Live*. New York, 1969.
MARTIN, CHARLES H. *The Angelo Herndon Case and Southern Justice*. Baton Rouge, La., 1976.

EVAN A. SHORE

Herriman, George (August 22, 1880–April 24, 1944), cartoonist and creator of the comic strip *Krazy Kat*. Herriman was born in New Orleans, and while his birth certificate listed his racial identity as "Colored," his death certificate identified him as "Caucasian." Because of his Adonis-like appearance, during his lifetime friends suggested that he was perhaps of Greek or French derivation. The 1880 federal census for New Orleans listed his parents as "mulatto," and one unidentified friend has reported that Herriman once confided in him that he was "Creole" and probably had some "Negro blood." The likelihood, then, is that Herriman was an African American, his parents having passed for white after they had left Louisiana for California.

Herriman grew up in Los Angeles, demonstrated a talent for drawing early, and contributed sketches to local newspapers. After 1900 he moved to New York and published cartoons in *Life, Judge,* and other humor periodicals. William Randolph Hearst saw some of Herriman's first COMIC STRIPS and hired him for his staff. His first successful creation was *The Family Upstairs,* a domestic situation comedy about the Dingbats and their noisy neighbors in the flat above. A second narrative sequence began to appear at the bottom of the strip about a cat and an aggressive mouse—characters that would evolve into Krazy Kat and Ignatz Mouse and would, after 1911, have their own separate strip.

The daily gags and occasional story lines in *Krazy Kat* were based on a simple and classically arranged situation of unrequited love. Ignatz is the object of Krazy's love, but his response to the naively proffered passion is to hit the cat alongside the head with a brick, an act the cat accepts as a token of affection. The benevolent Offisa Pup attempts to thwart the mouse and is himself in love with Krazy, a feline of

"Self-portrait" by George Herriman from *Judge* magazine, October 21, 1922.

indeterminate gender. This story is acted out against a shifting background of abstract and surrealistic design and uses poetic dialogue unlike anything else in English outside James Joyce and e. e. cummings. Since Krazy is a black cat, perhaps one can read the figure as a symbol of the harsh experience of blacks in America, to which they have responded with a forgiving heart, but it is risky to interpret such an elusive piece of art as an ethnic statement. Herriman died in Los Angeles.

Several anthologies of *Krazy Kat* have been published, the first in 1946 with an appreciative introduction by e. e. cummings. At least two stage ballets have been based on the comic strip, writer Jay Cantor has used the characters in a novel, and numerous modern artists have testified to its influence or created works in homage to Herriman. Ishmael REED dedicated his 1972 novel *Mumbo Jumbo* to "George Herriman, Afro-American."

REFERENCES

HERRIMAN, GEORGE. *Krazy & Ignatz: The Complete Kat Comics*. Forestville, Calif., 1988–.
———. *Krazy Kat*. With an introduction by e. e. cummings. New York, 1946.
———. *Krazy Kat*. New York, 1969.
INGE, M. THOMAS. "*Krazy Kat* as American Dada Art." In *Comics as Culture*. Jackson, Miss., 1990, pp. 40–57.

McDonnell, Patrick, Karen O'Connell, and Georgia Riley de Havenon. *Krazy Kat: The Comic Art of George Herriman.* New York, 1986.

M. Thomas Inge

Herring, James Vernon

Herring, James Vernon (January 7, 1887–May 29, 1969), educator. Herring was born in Clio, S.C., and obtained his early education at the Academy at Howard University. He graduated from Syracuse University in 1918 and taught in several colleges in the South before joining Howard University's Department of Architecture as a teacher of art history. In 1921, Herring founded Howard's Department of Art. He soon became the department's chairman, a position he retained until his retirement in the 1950s.

Herring is best known for his work as an educator and for his staunch support of black artists. In 1930, he created the Howard University Art Gallery, the first gallery in the United States directed and controlled by African Americans and one of the first to highlight African and African-American art.

In 1943, Herring and Alonzo J. Aden opened the Barnett-Aden Gallery in Washington, D.C. The private gallery "welcomed artists of every race and creed. The only criterion was talent, based solely on the quality of one's work" (*The Barnett-Aden Collection,* 1974, p. 13). His health failing, Herring closed the gallery in 1968. He died in Washington, D.C., the following year.

REFERENCES

Driskell, David C. *Two Centuries of Black American Art.* New York, 1976.

Green, Samuel L. "James Vernon Herring, 1887–1969." *Art Journal* 29 (Fall 1969): 101.

Jane Lusaka

Higgins, Chester

Higgins, Chester (November 6, 1946–), photographer. Chester Higgins was born in Alabama and received a B.S. degree in business management from Tuskegee University in 1970. Higgins became interested in photography in 1966 and borrowed a camera, which he used to take pictures for the Tuskegee newspaper. He purchased his first camera in 1967 and began using photography as a way to document the CIVIL RIGHTS MOVEMENT and counter negative images of African Americans in the media. In the same year, Higgins began studying photography with P. H. Polk at Tuskegee. Higgins's early photographs include pictures of his friends, students at Tuskegee, and images of the South.

Higgins published his first photographs, a collection of images of the South, in *The Negro Digest* (*see* BLACK WORLD/NEGRO DIGEST) in the late 1960s. His first book, *Student Unrest at Tuskegee: A Chronology* (1968), documented political activity on the campus. In the early 1970s, his photos were included in two books by Nikki GIOVANNI, *Re-Creation* (1970) and *Gemini: An Extended Autobiographical Statement on My First Twenty-Five Years at Being a Black Poet* (1971).

Higgins became a staff photographer for the *New York Times* in 1975, a position he held into the 1990s. His best-known work for the *New York Times* included his coverage of David DINKINS's successful 1989 New York City mayoral campaign and his images of Nelson Mandela's visit to New York City in 1990. Higgins also photographed for publications including *Look, Life,* EBONY, *Encore, Black Enterprise, Essence,* and *Time.*

Higgins published several books of images, including *Black Woman* (1970), which focused on the experiences of African-American women in the 1960s; *Drums of Life* (1974), which documented the lives of African-American men during that period; and *Some Time Ago* (1980), which explored the experiences of blacks in the United States from 1850 to 1950.

Higgins's work has been shown at Acts of Art Gallery in New York City, Wellesley College in Wellesley, Mass., the National Portrait Gallery in Washington, D.C., the Studio Museum in Harlem and the International Center of Photography in New York City. His book *Feeling the Spirit: Searching the World For the People of Africa* (1994) is a collection of images that explores the daily rituals and experiences of people of Africa and the DIASPORA.

REFERENCES

Higgins, Chester. *Drums of Life: A Photographic Essay on the Black Man in America.* New York, 1974.

———. "Feeling The Spirit: Worshippers in New York Tap Ancestral Roots." *New York Times,* April 19, 1992.

Willis-Thomas, Deborah. *An Illustrated Bio-Bibliography of Black Photographers, 1940–1988.* New York, 1989, pp. 73–74.

Renee Newman

Highlander Citizenship School

Highlander Citizenship School. Myles Horton, the cofounder of the Highlander Folk School, described it as a place where "people can share their experience and learn from each other." This precursor of the Highlander Citizenship School, founded in Grundy County, Tenn., in 1932, to serve industrial and rural workers in southern Appalachia, quickly

became a regional center for worker education and labor organization. The racial dissension in the labor movement soon persuaded Highlander officials that racism was the primary obstacle to securing economic justice in the South. Uniquely situated to respond to racial developments in the 1950s, and anticipating the Supreme Court decision in BROWN v. BOARD OF EDUCATION, Highlander began to focus on desegregating public schools. A series of workshops, initiated in 1953, trained an interracial group of civic, labor, and church groups to lead the transition. Out of these workshops was born the Highlander Citizenship School.

Bernice Robinson and Septima Poinsette CLARK, the coordinators of the Citizenship Schools, developed their curriculums around the lived experiences and specific needs of the students in the communities from which they came. The Citizenship Schools provided instruction in areas ranging from adult literacy to voter registration, local voting requirements, political parties, social security, taxes, the functions of local school boards, and a host of other immediately relevant issues.

Citizenship Schools sprang up throughout the South. Among the hundreds who attended them were such people as Rosa PARKS, Ella BAKER, Dorothy Cotton, Ruby Doris Smith, and Diane Bevel NASH, all of whom became active in the civil rights movement of the 1950s and 1960s. In May 1961, Tennessee state officials, who for years had harassed Highlander, succeeded in revoking the school's charter and confiscating its property following a ruling by the Tennessee Supreme Court. Highlander transferred its programs to the SOUTHERN CHRISTIAN LEADERSHIP CONFERENCE and, under the direction of Clark and Robinson, continued to thrive. It was later reincorporated as the Highlander Research and Education Center, now located in New Market, Tenn.

REFERENCES

GLEN, JOHN M. *Highlander: No Ordinary School, 1932–1962*. Lexington, Ky., 1988.
LANGSTON, DONNA. "The Women of Highlander." In Vicki L. Crawford et al., eds. *Women in the Civil Rights Movement: Trailblazers and Torchbearers, 1941–1965*. Brooklyn, 1990, pp. 145–168.

CHRISTINE A. LUNARDINI

Hill, Henry Aaron

Hill, Henry Aaron (May 30, 1915–March 17, 1979), chemist. Henry Hill was born in St. Joseph, Mo. He attended college at Johnson C. Smith University in Charlotte, N.C. and received his B.A. degree in 1936. In 1942, he obtained a Ph.D. in CHEMISTRY from the Massachusetts Institute of Technology (MIT) in Cambridge, Mass. Hill took a position at Atlantic Research Corporation in Atlantic, Mass., that same year. He began as a research chemist and was promoted to director of research in 1943. In 1944, he became vice president in charge of research.

Hill left Atlantic in 1946 to accept a position at the Dewey & Almy Chemical Company as supervisor of research. He left Dewey in 1952 to become the assistant manager at National Polychemicals in Wilmington, Mass. In 1961, he founded the Riverside Research Laboratory, where he served as president. He conducted research on fluorocarbons and was an authority in the fields of polymer chemistry and fabric flammability.

In 1941, Hill became a member of the American Chemical Society, and in 1971, he was elected to the board of directors. In 1977, he became the first black president of the American Chemical Society in its ninety-nine-year history. Hill was a member of the American Association for the Advancement of Science and chair of its chemistry section in 1976. He also served on several government scientific groups including the National Commission on Product Safety, the National Bureau of Standards' Evaluation, and the Senate Commerce Committee's Subcommittee on Consumer Affairs. In 1979, Hill died in his office in Haverhill, Mass.

REFERENCES

Obituary. *The Washington Post*, March 20, 1979, p. C4.
SAMMONS, VIVIAN O. *Blacks in Science and Medicine*. New York, 1990.

SIRAJ AHMED

Hill, Leslie Pinckney

Hill, Leslie Pinckney (May 14, 1880–February 16, 1960), writer, educator. Leslie P. Hill was born in Lynchburg, Va., the son of a stationary engine operator. He grew up in Orange, N.J., where he attended public schools. In 1899 he entered Harvard University on a scholarship. He received a bachelor's degree (cum laude) in 1903 and a master's degree in 1904. Hill also became one of the university's first African-American members of Phi Beta Kappa.

After graduating from Harvard, Hill was named head of the Education Department at Tuskegee Institute (now TUSKEGEE UNIVERSITY) in Tuskegee, Ala. In 1907 he was named principal of Manassas Industrial Institute in Manassas, Va., and served for six years. In 1913 Hill was hired as principal of the Institute for Colored Youth (later Cheyney State College) in Cheyney, Pa. He remained school principal (and after 1933, also became president of the school, renamed Cheyney Training School for

Teachers), until his retirement in 1951. Hill also lectured at various colleges, including two summers as general education instructor at the University of California at Los Angeles. An inspiring educator and leader, Hill built Cheyney into a major state-supported teacher's college.

Hill was as renowned for his literary work as his educational efforts, although his philosophy was attacked as outmoded by the writers of the HARLEM RENAISSANCE. In 1921 he published *The Wings of Oppression,* a volume of sixty-nine poems. Many of his poems focused on what he considered the special mission of African Americans: to endure suffering as a harbinger of universal brotherhood and racial harmony. Other poems, such as a tribute to philosopher William James, Hill's former professor at Harvard, were nonracial in theme. Hill also published two plays, *Toussaint L'Ouverture: A Dramatic History* (1928), a five-part verse drama on the life of the Haitian revolutionary hero, and *Jethro* (1931), a biblical drama.

A moderate Republican, Hill was an active community leader and black spokesman, serving on such important commissions as the Hoover Commission on the Reorganization of the Federal Government (1948). He contributed an essay, "What the Negro Wants and How to Get It," to Rayford LOGAN's 1944 anthology, *What the Negro Wants;* in the essay Hill called for African Americans to push for freedom and equality by following leaders with "a unifying philosophy of life," but warned that blacks should support the American war effort in return for the fruits of democracy. He also praised Chinese nationalist president Chiang Kai-shek as a model of a nonwhite Christian leader who retained his faith despite great adversity.

In 1951 Hill retired from Cheyney, though he remained president emeritus until his death. From 1953 to 1956, he served as an administrator of Mercy-Douglass Hospital in Philadelphia, Pa. He died in Mercy-Douglass four years later.

REFERENCE

PERRY, PATSY B. "Leslie Pinckney Hill." *Dictionary of American Literary Biography,* Vol. 51, *Afro-American Writers From the Harlem Renaissance to 1940.* Detroit, 1987.

GREG ROBINSON

Hill, Peter (July 19, 1767–December 1820), clockmaker. He was born a slave in the household of Joseph Hollinshead, Jr., a clockmaker of Burlington Township, N.J. Trained by his master in his craft, Hill worked as his assistant until 1794. At the age of twenty-seven, he was manumitted by his master and became a free African American. His freedom was formally certified on May 1 of the following year. With Hollinshead's assistance and support, Hill established himself as a clock-and-watch maker in Burlington, the first African American in his trade. Four months after formalization of his manumission, he married a slave in the same household, Tina Lewis. A contemporary documents states, "By a Stipulation with the Master, wherein he engaged to Pay what was demanded for him for a limited time, Peter was enabled to set up his business and successively to accomplish his own purchase and that of his Wife whom he married whilst a Slave. . . . His stock in Trade is supposed to be worth at least . . . [£]300."

Hill continued to live in Burlington for the next twenty-three years, and by about 1814 he also maintained a clock shop in nearby Mount Holly. He prospered through the years, but eventually overextended his resources, for at the time of his death in late December 1820 his debts greatly exceeded his worth. He was buried in the Friends' Burial Ground adjacent to the Friends' Meeting House in Burlington. At least five tall case clocks made by Peter Hill are known, having eight-day brass striking movements with standard painted iron dials, housed in cases of mahogany and walnut matched veneer that were generally made for him by his next-door neighbor, a cabinetmaker named George Deacon.

REFERENCES

BEDINI, SILVIO A. "Peter Hill, the First African American Clockmaker." *Prospects, An Annual of American Cultural Studies* 17 (1992): 137–176.

DROST, WILLIAM E. *Clocks and Watches of New Jersey,* p. 123. Elizabeth, N. J., 1966.

DECOU, GEORGE. "Colonial Clockmakers of Burlington County." *Mount Holly Herald,* June 16, 1933, sec. 2, p. 4.

SILVIO A. BEDINI

Hill, T. Arnold (August 23, 1888–August 1947), civil rights leader. Born in Richmond, Va., T. Arnold Hill graduated from Virginia Union University in Richmond. He then studied sociology and economics at New York University before moving to Chicago. In about 1916 he became executive secretary of the recently formed (in 1915) Chicago Urban League (CUL) and witnessed the Chicago riots during the Red Summer of 1919. Hill is credited with helping to restore peace in the city. Under Hill, the CUL worked with migrants from the South as they adapted to city life.

The CUL also promoted equal industrial opportunity in the city, and in 1925 Hill was named direc-

tor of the NATIONAL URBAN LEAGUE's (NUL) new Department of Industrial Relations. His major task was to improve relations with the American Federation of Labor (AFL), and he tried to get the AFL to support integrated unions in nonsegregated states and black-only unions in Jim Crow states. The AFL refused to change its segregationist policies, and Hill became more sharply aware of the obstacles to black membership in craft unions. The NUL therefore concentrated its efforts on vocational training and studied the labor market in order to steer workers to needed occupations.

Hill also worked directly with large industrial plants to create more black opportunities for work and advancement. During the depression, Hill was critical of New Deal programs, which he felt fostered discrimination and segregation. In 1935, after being named acting executive secretary of the NUL, Hill dedicated the organization to a more aggressive, mass-movement role in identifying and describing blacks' grievances. He was particularly critical of President Franklin Roosevelt's failure to denounce racism and the AFL's anti-Negro policies and high unemployment among blacks, as well as his refusal to back antilynching laws.

When Executive Secretary Eugene K. Jones returned to the NUL in 1937 from a stint at the Commerce Department, he was jealous of Hill's good relations with local affiliates and felt that the NUL should operate within the white power structure to effect structural change. After several strained years, Hill resigned and began to work for the WORKS PROGRESS ADMINISTRATION and the National Youth Administration. Hill was part of the September 27, 1940, meeting with President Roosevelt which precipitated A. Philip RANDOLPH's planning a 1941 March on Washington and Roosevelt's issuing Executive Order 8802, which banned employment discrimination in war industries. Hill was active through 1946, making a speech urging the renovation of southwest Harlem. He died in 1947.

REFERENCES

MOORE, JESSE THOMAS, JR. *A Search for Equality: The National Urban League, 1910–1961*. University Park, Pa., 1981.
TUTTLE, WILLIAM M., JR. *Race Riot: Chicago in the Red Summer of 1919*. New York, 1970.

ALANA J. ERICKSON

Hill, Thelma (1924–November 21, 1977), dancer, teacher. As a young child growing up in New York City, Thelma Hill's first dance training was in TAP DANCE. She later studied BALLET at the Metropolitan Opera School of Ballet.

In the 1950s, Hill performed with many companies including those of Talley BEATTY, Jean-Leon DESTINE, and Geoffrey HOLDER. In 1954, she and Ward Flemyng founded the New York Negro Ballet Company. Hill served as dancer and later codirector for the company, which toured in Europe and the United States. In 1958, Hill and a group of top New York dancers, which included Alvin AILEY, formed a fledgling dance troupe that would eventually become the Alvin Ailey American Dance Theater in 1960.

Hill collaborated again with Ailey and other dancers, including Charles MOORE and James TRUITTE, to found a dance-training program at a New York City YWCA. In 1962, the program became the Clark Center for the Performing Arts. Besides studio and performance space, the center provided classes in a variety of techniques and choreographic approaches.

After an injury forced her off the stage in the 1960s, Hill's teaching career began to flourish. She was a proponent of the influential technique of Lester Horton. She taught at numerous institutions and was often known as "Mother Hill" by her students. These schools included the Davis Center for Performing Arts in New York City at City College of New York, the University of Cincinnati, and the American Dance Festival at Connecticut College in New London. She was also an active member of the Delacorte Dance Festival and Regional Ballet Association.

Hill died of smoke inhalation in 1977 during a fire in her New York City apartment. She was memorialized by the Thelma Hill Performing Arts Center (formerly the Arts Center) in New York City, which was renamed in her honor in 1977.

REFERENCES

Obituary. *Dance Magazine* (February 1978).
Obituary. *New York Times*, November 23, 1977, p. B2.

DERRY SWAN

Hill-Thomas Hearings. In September 1991, U.S. District Judge Clarence THOMAS, nominated to the U.S. Supreme Court by President George Bush, began his confirmation hearing by the Senate Judiciary Committee. On September 27, the committee, tied in its vote on the nomination, sent the nomination to the floor without a recommendation. Despite the committee's failure to issue a recommendation, most commentators believed the Senate would confirm Thomas. On October 6, 1991, National Public Radio and *New York Newsday* ran a story about Anita Faye Hill (b. 1956), a law professor at the University of Oklahoma. Hill, who had been a staff attorney under Thomas at the Department of Education and

the Equal Employment Opportunity Commission in the early 1980s, had told FBI investigators that Thomas had sexually harassed her during her tenure. The story was based on the leak of a confidential affidavit Hill had provided the committee on September 23. Her story made public, Hill openly repeated her accusations. In a comment later echoed by many women, Hill claimed the all-male Judiciary Committee had been insensitive to the importance of sexual harassment and had not questioned Thomas about it. Meanwhile, Thomas categorically denied any such conduct. On October 8, following a long debate in the Senate, the vote on Thomas's confirmation was delayed. Committee Chair Joseph R. Biden scheduled further hearings in order to provide Hill and Thomas an opportunity to testify publicly on the issue.

On October 11, 1991, before a nationwide television audience, the hearings on Thomas's conduct began. Hill described Thomas's repeated sexual over-

University of Oklahoma law professor Anita Hill is sworn in before the Senate Judiciary Committee in October 1991. Hill testified that U.S. Supreme Court nominee Clarence Thomas had harassed her sexually at the workplace by subjecting her to unwelcome explicit sexual remarks and innuendos. (AP/Wide World Photos)

tures to her, charging that he had boasted of his sexual prowess, frequently used prurient sexual innuendos, and had insisted on describing to her the plots of pornographic movies he had seen. When asked why, if Thomas had harassed her in such a fashion, Hill had accepted a position under him at the EEOC, she explained that the harassment had stopped for a period, and she feared she would be unable to find another job without his recommendation.

Thomas's testimony flatly contradicted that of Hill. While Thomas asserted he had not listened to Hill's testimony, which he angrily referred to as "lies," he denied any wrongdoing and repeatedly refused to discuss his private life. He denounced the committee's confirmation process as "un-American" and assailed it for staging what he called a "high-tech lynching" of him as an independent conservative black intellectual.

During the following days, as the Senate debated the hearings, Senate Republicans launched a furious assault on Hill's character and truthfulness in order to discredit her. Senators charged her with "fantasizing" about Thomas's interest in her. At the same time, many observers felt the Judiciary Committee had not investigated Thomas's veracity with equal zeal. Nationwide argument, which crossed ideological and gender lines, raged over whether Thomas or Hill was telling the truth, and whether Thomas's alleged sexual harassment was relevant to his confirmation.

Within the black community, debate was particularly pointed, although few, if any, blacks altered their position on Thomas's confirmation as a result of the revelations. Many, perhaps most, blacks saw the affair as an embarrassment, reviving stereotypes of blacks as sexually rapacious, vulgar, and mendacious, and the stigma of black males as rapists. Harvard sociologist Orlando Patterson assumed the essential truth of Hill's version, but thought Thomas's conduct was an example of "Rabelaisian humor," a harmless example of "down-home courting." Some suspected conspiracies, such as black conservative Arthur Fletcher, chair of the U.S. Civil Rights Commission, who claimed the hearings were a racist plot to pit blacks against each other. Yale law professor Stephen Carter called both parties victims of the confirmation process. Many black men and women considered Hill a traitor to the race for accusing Thomas publicly, and for trying to block a black man's ascension to the Supreme Court. Others defended Hill's courage. Jesse JACKSON called her the "Rosa Parks" of sexual harassment. Toni MORRISON asserted that black men such as Thomas wished to rise on the backs of black women, whose needs and feelings were ignored. Countless women, black and white, were inspired by the public discussion of sexual harassment to share their own feelings and stories of harassment.

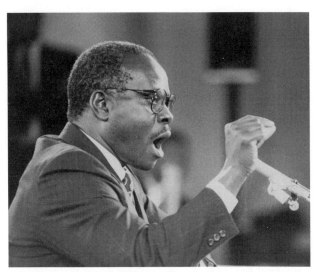

Clarence Thomas, appearing before the Senate Judiciary Committee, denied the accusations of Anita Hill and denounced the entire inquiry. (AP/ Wide World Photos)

On October 15, the Senate confirmed Thomas, 52–48, the second narrowest winning margin in history. Public opinion polls published at the time showed the majority of Americans believed Thomas and suspected Hill's allegations. Still, many women were politically energized by the hearings, and many women were elected to public office in 1992 with the support of their campaign contributions and activism. Within a year after the hearings, however, new opinion polls suggested that a majority of Americans now believed Anita Hill had told the truth. By that time, continuing public interest in the affair had been reflected in the publication of several books on the trials, including two notable anthologies of essays written by African Americans.

REFERENCES

BROCK, DAVID. *The Real Anita Hill*. New York, 1993.

CHRISMAN, ROBERT and ROBERT L. ALLEN, eds. *Court of Appeal: The Black Community Speaks Out on the Racial and Sexual Politics of Thomas v. Hill*. New York, 1992.

MORRISON, TONI, ed. *Race-ing Justice, Engendering Power*. New York, 1992.

GREG ROBINSON

Hilyer, Andrew Franklin (August 14, 1858– January 17, 1925), author, inventor, and civil rights leader. Andrew Hilyer was born a slave near Monroe, Ga. His maternal grandfather, who was freed before the Civil War and had moved to St. Louis, brought Hilyer, his siblings, his mother, and his uncle to St. Louis in 1866. In 1868 the family moved to Omaha, Neb. In 1872, following his mother's death, Hilyer moved to Minneapolis, Minn., and entered Minneapolis High School. Supporting himself as a barber, he graduated from Minneapolis High School in 1878. In 1882 he graduated from the University of Minnesota, one of the first African Americans to obtain a bachelor's degree there. Later that year he moved to Washington, D.C. and became an accountant. He worked as a clerk in the Treasury Department, and later became a member of the Interior Department's Division of the General Accounting Office. Hilyer was subsequently awarded two legal degrees, an LL.B. (1884) and an LL.M. (1885), from HOWARD UNIVERSITY, but he never practiced law. During this period Hilyer also became a real estate investor. In addition, he made several inventions relating to hot-air humidifying, including a hot-air register and a water evaporator attachment for it, for which he received a patent on August 26, 1890.

In 1892 Hilyer helped found the Union League of the District of Columbia, the first African-American business league in Washington (*see* UNION LEAGUE OF AMERICA). Under Hilyer, who was its first president, the league produced directories of African-American business leaders in 1892, 1894, and 1895. In 1901 Hilyer directed and coordinated the publication of *A Historical, Biographical and Statistical Study of Colored Washington*, which was the first census of African-American business published in book form. Hilyer was also the founder of the Correspondence Club, a secret organization of lobbyists that attempted to gain fair treatment of African Americans in the media and in public policy. In his public pronouncements, Hilyer endorsed many of Booker T. WASHINGTON's positions, but disagreed with Washington's view that industrial education should dominate the curricula of African-American schools.

Hilyer was a prominent member of America's black social elite. He was part of Washington, D.C.'s "Black 400," the exclusive social circle of blacks in the nation's capital. He was also an active member of the Bethel Literary and Historical Association, Epsilon Boule of Sigma Pi Phi (a black fraternity), and the NAACP. Hilyer was on Howard's board of trustees from 1913 until his death in 1925.

REFERENCES

GATEWOOD, WILLARD B. *Aristocrats of Color: The Black Elite, 1880–1920*. Bloomington, Ind., 1990.

JAMES, PORTIA P. *The Real McCoy: African-American Invention and Innovation, 1619–1930*. Washington, D.C., 1989.

SIRAJ AHMED

Himes, Chester (July 29, 1909–November 12, 1984), novelist and short story writer. Born in Jefferson City, Mo., the youngest of three sons, he spent his first fourteen years in the South. His mother, née Estelle Bomar, the daughter of former slaves who had achieved considerable success in the construction business, was educated at a black Presbyterian finishing school in North Carolina and taught music from time to time at African-American colleges and academies. Her husband, Joseph Himes, also born of former slaves, grew up in North Carolina poverty but acquired a diploma at Claflin College in Orangeburg, S.C. A skilled blacksmith and wheelwright, he taught mechanical arts at black institutions in Georgia, Missouri, Mississippi, and Arkansas. Both parents appear as thinly disguised characters whose conflicting social and racial views bewilder the protagonist in Himes's autobiographical novel *The Third Generation* (1954).

In 1923 a freak accident blinded Himes's older brother, causing the family to move from Pine Bluff, Ark., to St. Louis to seek specialized medical treatment. Two years later they moved to Cleveland, where Chester graduated from East High School in January 1926. Following graduation he worked as a busboy at a Cleveland hotel, where he suffered a traumatic fall that left him with permanent back and shoulder injuries. In September 1926 he enrolled as a liberal arts student at Ohio State University, but he was expelled the following February for failing grades and unseemly behavior. Thereafter he drifted into a life of crime in the black ghettos of Cleveland and Columbus. In December 1927, he was sentenced to serve twenty years in the Ohio State Penitentiary for armed robbery.

While in prison, Himes began a lifelong career writing fiction; his first stories were printed in African-American publications in early 1932. In 1934 he reached a national audience in *Esquire* for "To What Red Hell," describing the 1930 fire that swept through the Ohio penitentiary, killing more than 330 convicts. He was paroled in 1936, and in August 1937 he married Jean Lucinda Johnson, a longtime friend. From 1936 to 1940 he worked mainly at manual jobs and for the FEDERAL WRITERS' PROJECT, departing for California in the fall of 1940 in hopes of writing for Hollywood. Repeated rejections at the studios, however, required him to seek work at racially tense California shipyards. These experiences are reflected in several articles he wrote in the 1940s, as well as in two bitter novels, *If He Hollers Let Him Go* (1946) and *Lonely Crusade* (1947). The interethnic, economic, social, and sexual consequences of racism are treated at some length in these books.

From 1945 to 1953 Himes lived mainly in New York and New England; he sailed for France several months after the publication of his prison novel *Cast

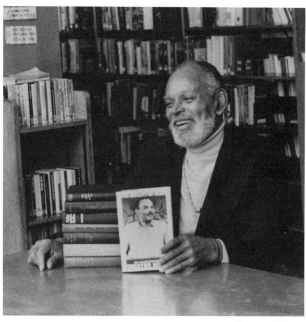

Chester Himes seated in a library with his published works, around 1970. (Photographs and Prints Division, Schomburg Center for Research in Black Culture, The New York Public Library, Astor, Lenox and Tilden Foundations)

the First Stone* (1952). For the rest of his life he lived mainly in France and Spain, making only occasional visits to the United States. Much of his subsequent fiction was published first in France before appearing elsewhere. Among his books written abroad were seven Harlem police thrillers involving Cotton Ed Johnson and Grave Digger Jones; one of these won a French literary award in 1958. Two incomplete novels, *Plan B,* dealing with a future race war, and *The Lunatic Fringe* have not yet been printed in the United States. Himes's own favorite among his works was *The Primitive* (1955), depicting an intense, troubled relationship between a black man and a white woman in post–World War II New York. Himes's only published novel with a non-American setting, *A Case of Rape* (1985), focuses on four black men being tried in Paris for the violation and death of a white woman. Because the fictional characters were modeled on well-known African Americans living in Europe, the book caused something of a stir in the expatriate community. Himes's other works written in Europe were *Pinktoes* (1961), an interracial sex comedy about the activities of a celebrated Harlem hostess, and *Run Man Run* (1966), a thriller telling of a black man's flight from a murderous New York policeman. In 1978, Himes obtained a divorce in absentia and married Lesley Packard, an English journalist.

While living in Spain, Himes wrote two volumes of an autobiography, *The Quality of Hurt* (1973) and *My Life of Absurdity* (1976). Toward the end of his life

he came to view his writings as being in the absurdist tradition. Racism, he said, made blacks and whites behave absurdly. He envisioned organized violence as the only means of ending racial oppression in America. Because his literary reputation was never as high in the United States as it was in Europe, Himes lived precariously for most of his authorial years, but a resurgence of interest in his writings in the 1970s brought him a measure of financial security. Upon his death in Alicante, Spain, he left a number of unfinished projects.

REFERENCES

LUNDQUIST, JAMES. *Chester Himes.* New York, 1976.
MILLIKEN, STEPHEN F. *Chester Himes: A Critical Appraisal.* Columbia, Mo., 1976.
MULLER, GILBERT H. *Chester Himes.* Boston, 1989.
SKINNER, ROBERT. *Two Guns from Harlem: The Detective Fiction of Chester Himes.* Bowling Green, Ohio, 1989.

EDWARD MARGOLIES

Hinderas, Natalie Leota Henderson (June 15, 1927–July 22, 1987), concert pianist. Natalie Hinderas Henderson was born into a musical family in Oberlin, Ohio. Her parents, Abram and Leota (Palmer) Henderson were both students at Oberlin College. Her father was a JAZZ pianist and her mother was a classical pianist who later taught at the Cleveland Institute of Music.

At the age of three, Hinderas began playing the piano. Her formal piano studies began at the age of six with her mother. She was a child prodigy and played a full length public recital at the age of eight. When she was twelve years old, she performed the Grieg Piano Concerto with the Cleveland Women's Symphony Orchestra. Hinderas received a Bachelor of Music degree in 1945 from Oberlin Conservatory as their youngest graduate. Assuming the name Natalie Hinderas, she did postgraduate work in piano at the Juilliard School of Music in New York City with Olga Samaroff, and later studied with Edward Steuermann at the Philadelphia Conservatory, where she also studied composition with Vincent Persichetti.

In 1954 Hinderas gave her New York debut at Town Hall. Thereafter, she began to tour widely as a solo pianist in the United States, Europe, Africa, the Caribbean, and Asia, often under sponsorship from the U.S. State Department. In the United States, she performed piano concertos with many of the nation's leading orchestras, including the Chicago Symphony Orchestra, the Philadelphia Orchestra, and the New York Philharmonic Orchestra.

Her concerto repertory included works by Alberto Ginastera, Sergei Rachmaninov, Edvard Grieg, Maurice Ravel, Robert Schumann, George Gershwin, and George Walker. Her recording debut came in 1971 with the album *Natalie Hinderas Plays Music by Black Composers* (DESTO); other recordings followed on the Orion and Columbia labels. Throughout her career she promoted and recorded works by African-American performers and composers, among them R. Nathaniel DETT, William Grant STILL, John W. WORK, and George Walker.

In 1968 she joined the faculty of Temple University in Philadelphia, where she was a full professor at the time of her death.

REFERENCES

SOUTHERN, EILEEN. *Biographical Dictionary of Afro-American and African Musicians.* Westport, Conn., 1982.
HINE, DARLENE CLARK, ed. *Black Women in America; An Historical Encyclopedia.* Brooklyn, N.Y., 1993.

OTHA DAY

Hines, Earl Kenneth "Fatha" (December 28, 1903–April 22, 1983), musician. Because of his influence on the styles of countless other jazz pianists, Earl "Fatha" Hines has often been called "the father of modern jazz piano." Working from a foundation of classical music, blues, novelty piano, and Harlem stride playing, Hines developed a style that combined a linear approach to melody with a stunning independence of the two hands. As a highly successful bandleader, he played an important role in the early careers of such notable jazz musicians as Charlie PARKER, Dizzy GILLESPIE, Billy ECKSTINE, and Sarah VAUGHAN. Hines was classically trained as a youngster, and his first major employment came as accompanist for Pittsburgh vocalist Lois Deppe, with whose group he recorded in 1923. He moved to Chicago in early 1925, and for the next four years he played with groups led by Carroll Dickerson, Erskine Tate, Jimmie NOONE, and others. The recordings made by Hines during this period, especially those with trumpeter Louis ARMSTRONG, are among the most celebrated in all of jazz.

In December 1928, Hines took his own band into Chicago's Grand Terrace Ballroom, where he appeared until 1940. He continued to lead his own band until 1947; then in 1948 he joined Louis Armstrong's All-Stars, touring extensively with this group until the autumn of 1951. During the 1950s, Hines worked in relative obscurity on the West Coast, where he played a long residency with a small group at San

Earl "Fatha" Hines at the piano. (Photographs and Prints Division, Schomburg Center for Research in Black Culture, The New York Public Library, Astor, Lenox and Tilden Foundations)

Francisco's Hangover Club. He moved to California permanently in 1960. In 1964, at the behest of his close friend Stanley Dance, Hines played a triumphant series of concerts at New York's Little Theater. During the 1960s and '70s, he toured Europe and recorded extensively. Playing mainly with a small group that featured vocalist Marva Josie, Hines continued performing regularly until the weekend before his death.

REFERENCES

RUSSELL, WILLIAM. "Boogie Woogie." In Frederick Ramsey, Jr., and Charles Edward Smith, eds. *Jazzmen*. New York, 1939.

SILVESTER, PETER J. *A Left Hand Like God: A Study of Boogie-Woogie*. New York, 1988.

JEFFREY TAYLOR

Hines, Gregory (February 14, 1946–), tap dancer. Born in New York City, Gregory Hines began dancing at age three and turned professional when he was five. For fifteen years he performed with his older brother Maurice as "The Hines Kids," garnering success in the dwindling world of vaudeville and in night clubs. His father, Maurice, Sr., joined his sons' act as a drummer in 1964, changing the act's name to "Hines, Hines & Dad." Although Broadway teacher and choreographer Henry LETANG created their first routines, they learned their technique from older tap masters, becoming the direct inheritors of the great black tap dance traditions. Hoofers like Howard "Sandman" SIMS would tutor

them between shows; these men became their heroes and mentors, their tap professors in the unofficial institutions that existed in theaters and clubs, as well as in such places as the alleyway of Harlem's APOLLO THEATER.

In the early 1970s, Hines decided to leave the family tap team, "retiring" (as he says) to Venice, Calif., where he turned his attention to guitar and formed the jazz-rock ensemble Severance in 1973. He released a record album of original songs, then returned to the New York stage and tap dance in the late 1970s. His Broadway debut in *Eubie* (1978), his performance in *Comin' Uptown* (1979), and his starring role in *Sophisticated Ladies* (1980–1981) earned him three Tony nominations. He has received two Emmy awards for his performances in television specials and has appeared in the movies *Wolfen* (1981), *The Cotton Club* (1984), *White Nights* (1985), *Running Scared* (1986), *Off Limits* (1988), *Tap* (1989), *A Rage in Harlem* (1991), and *Eve of Destruction* (1991). In 1988 Hines released a well-received solo debut album, *That Girl Wants to Dance with Me*. In 1989 he hosted the documentary *Tap: Dance in America* on public television and appeared in a production of *Twelfth Night* performed in Central Park by New York's Public Theater. In 1992, Hines earned a Tony Award as best actor in a Broadway musical for his leading role as Jelly Roll MORTON in *Jelly's Last Jam*.

Such fame has made Hines an especially important influence on the younger generation of male tap dancers. Like a jazz musician who ornaments a melody with improvisational riffs, Hines improvises within the frame of the dance. His "Improvography" demands the percussive phrasing of a composer, the rhythms of a drummer, and the lines of a dancer. Hines, like avant-garde jazz artists, purposely fractures normal tempos, breaking free of the regular rhythms of musical phrasing. He also updates tap by performing on a special acoustic stage where his taps are highly amplified. The leading tap dancer of his generation, Hines is a generous artist and teacher, conscious of his importance as a role model for the next generation of tap artists.

REFERENCE

SOMMER, SALLY. "Tap Happy: Hines on Tap." *Dance Magazine* (December 1988): 46–50.

CONSTANCE VALIS HILL

Hinkson, Mary (1930–), dancer. Born in Philadelphia, Mary Hinkson received her first dance training in a high school eurhythmics class that used techniques devised by Emile Jacques-Dalcroze to teach musical concepts through rhythmical body move-

ments. She attended the University of Wisconsin in Madison, where she studied dance with Margaret d'Houble and received both her B.S. and M.S. degrees in physical education.

After graduating, Hinkson moved to New York to study with Martha Graham, and by 1951 she joined the Martha Graham Dance Company, where she remained a principal dancer until her retirement. Hinkson was best known for her performances with the company in many works that Graham choreographed for her, including *Canticle for Innocent Comedians* (1952) and *Ardent Song* (1955). When the Graham company went on its Far East tour in 1955, Hinkson remained in New York. In 1956 she partnered Alvin AILEY in Harry BELAFONTE's touring revue "Sing Man Sing."

Her work outside the Graham company included Donald McKayle's *Rainbow 'Round My Shoulder* (1959) in which she created the female role, and with the New York City Ballet in George Balanchine's *Figure in the Carpet* (1960). During the 1960s Hinkson danced in *Circe* (1963), which Martha Graham choreographed for her; Hinkson also danced periodically with the New York City Opera Ballet in John Butler's staging of *Carmina Burana.*

Hinkson had a long career as a dance teacher, working throughout her career at the Martha Graham School, at the Juilliard School (1951–1968), and at the High School of Performing Arts (1955–1960). She has also periodically taught contemporary techniques to companies such as the Stuttgart Ballet, the Royal Danish Ballet, the Dance Theater of Harlem, and the Joffrey Ballet. In 1979 Hinkson and her husband, Julien Jackson, purchased D & G Bakery, an Italian bread bakery in New York City's Little Italy. Since Jackson's death in 1983, Hinkson has dedicated most of her time to managing the bakery with her daughter and her niece.

REFERENCES

BARNES, CLIVE. "The Dance: Part Real—Part Dream." *New York Times,* April 11, 1969.
EMERY, LYNNE FAULEY. *Black Dance from 1619 to Today.* Princeton, N.J., 1988, pp. 274, 316–317.
KISSELGOFF, ANNA. "Mary Hinkson Powerful in Graham's Medea Role." *New York Times,* May 10, 1973.
PROBST, BETHAMI. "A Shop That Makes Bread the Old-Fashioned Way." *New York Times,* December 9, 1987.

ZITA ALLEN

Hinton, Milton John "Milt" (June 23, 1910–) bassist. Hinton began taking piano lessons from his mother, a church organist, after the family moved to

Chicago. He received more formal training in violin, string bass, and tuba in high school, and first performed professionally in the late 1920s on bass, in groups led by saxophonist and violinist Boyd Atkins, and pianist Tiny Parham, and later at Chicago's Showboat Cabaret in bands led by trumpeter Jabbo Smith, and pianist Cassino Simpson. In the 1930s he played for violinist Eddie South (1931–1936), drummer Zutty SINGLETON (1936), and Cab CALLOWAY (1936–1951).

Hinton, who was nicknamed "The Judge" by his lifelong friend and former Calloway band member Ben WEBSTER, played a supporting role in the development of bebop, offering his impeccable, articulate accompaniment to jam sessions at Minton's Playhouse in Harlem in the late 1930s and early 1940s. After leaving Calloway in 1951, Hinton performed in New York City with Billie HOLIDAY, Joe Bushkin, and Jackie Gleason, and toured with Count BASIE (1953), Louis ARMSTRONG's All-Stars (1953–1954), Teddy Wilson (1954), and Benny Goodman (1955). In the 1960s Hinton continued to record and perform, most notably with Harry BELAFONTE (1965–1966) in support of the STUDENT NONVIOLENT COORDINATING COMMITTEE. Starting in the 1970s, Hinton began teaching music at Hunter College in New York, the City University of New York, and at Yale University. In the 1970s he also toured with Pearl BAILEY and Bing Crosby, and recorded as a leader *Here Swings the Judge* (1975). In the 1980s and 1990s Hinton remained active, performing with saxophonist Branford Marsalis, recording (*The Judge's Decision,* 1984), and exhibiting his photographs of JAZZ musicians. In 1988 Hinton, who has lived for many years in Queens, N.Y., published a volume of memoirs and photographs, *Bass Line: The Stories and Photographs of Milt Hinton.*

REFERENCES

HINTON, MILT and D. BERGER. *Bass Line: The Stories and Photographs of Milt Hinton.* Philadelphia, 1988.
SHAPIRO, NAT and NAT HENTOFF, eds. *Hear Me Talkin' to Ya: The Story of Jazz and the Men Who Made It.* 1955. Reprint. New York, 1966.
TRAVIS, DEMPSEY J. *An Autobiography of Black Jazz.* Chicago, 1983.

REUBEN JACKSON

Hinton, William Augustus (December 15, 1883–August 8, 1959), physician, educator, and author. William Hinton was born and raised in Chicago. He received a B.S. degree from Harvard in 1905, after studying for two years at Kansas Univer-

sity. Unable to afford medical school, Hinton taught for the next four years and studied medicine at the University of Chicago during the summer. He entered Harvard Medical School in 1909, where he won the Wigglesworth and the Hayden scholarships and graduated with honors after only three years.

Racial prejudice prevented Hinton from getting an internship in Boston. Consequently, he volunteered in the department of pathology at Massachusetts General Hospital, where he taught serological techniques. Hinton was hired at the Wasserman Laboratory, then associated with Harvard, and was made its director in 1915. He was appointed adjunct instructor in preventive medicine and hygiene at Harvard in 1918, named instructor in 1921, and was made lecturer in 1946. Hinton was promoted to clinical professor in 1949, becoming Harvard's first African-American full professor.

At Harvard, Hinton was well known for his vivid lectures and for his expertise on syphilis. He developed the famous Hinton test and, with J. A. V. Davies, the Davies-Hinton test, both widely used in the detection of syphilis. In 1936, Hinton wrote *Syphilis and Its Treatment,* which became a standard reference book in the field.

In 1948, Hinton was elected as a life member of the American Social Science Association to honor his accomplishments in science and public health. In ill health following retirement in 1952, Hinton died of diabetes in Canton, Mass., in 1959. Upon his death, $75,000 of his savings was bequeathed to establish the Eisenhower Scholarship Fund for graduate students at Harvard.

REFERENCES

COBB, W. MONTAGUE. "William Augustus Hinton, M.D." *Journal of the National Medical Association* (November 1957): 427–428.
GARRETT, ROMEO. *Famous First Facts About Negroes.* New York, 1972.
MORAIS, HERBERT M. *The History of the Negro in Medicine.* New York, 1967.

SIRAJ AHMED

Historians/Historiography. The writing of African-American history began as a quest to understand the status and condition of black people in the United States. The first works on the subject, James W. C. PENNINGTON's *A Textbook of the Origin and History of the Colored People* (Hartford, 1841), and Robert Benjamin Lewis's *Light and Truth: Collected from the Bible and Ancient and Modern History, Contain-*

ing the Universal History of the Colored Man and Indian Race, from the Creation of the World to the Present Time (Portland, 1836), sought to explain the enslavement of Africans in the western hemisphere. They recounted black achievement in ancient Africa, particularly Egypt and Ethiopia, to justify racial equality. These early black writers, similar to many of the first chroniclers of the United States, searched for the "hidden hand" of God in humane affairs. History for them was the revelation of divine providence in the activities of people and nations.

Although African Americans suffered from enslavement, prejudice, and discrimination, Pennington and Lewis considered their status and condition as temporary because of the biblical prophecy that "Ethiopia shall soon stretch forth her hands unto God" (Ps 68:31). For many African Americans, including black historians prior to the twentieth century, this prophecy was a promise of divine deliverance from the chains of slavery and the shackles of racial discrimination.

Histories written after Pennington and Lewis, such as William C. NELL, *The Colored Patriots of the American Revolution* (Boston, 1855), and William Wells BROWN, *The Black Man: His Antecedents, His Genius, and His Achievements* (Boston, 1863), were intended to convince black and white Americans that African Americans deserved freedom, justice, and equality. If given the opportunity, they argued and illustrated in their books, African Americans could excel in all areas of life and contribute to the country's development and progress. They wrote to inspire African Americans to lead exemplary lives and not to provide any excuse for racial prejudice and discrimination.

George Washington WILLIAMS, at different times a soldier, pastor, editor, columnist, lawyer, and legislator, was the first black historian to write a systematic study of the African-American past. He bridged the gap between early chroniclers of African-American history and the more scientific writers of the twentieth century. Although Williams employed methods of research similar to professional historians of his day in conducting interviews, examining newspapers, using statistics, and culling archives, he still wrote to discern the plans of God in studying the past. His impressive two-volume work, *History of the Negro Race in America from 1619 to 1880* (New York, 1883), was flawed by its often literal reproduction of documentation and lack of analysis and interpretation. The publication, however, was a remarkable achievement for its time and earned Williams recognition as a pioneer in modern African-American historiography.

Almost a decade after Williams's pathbreaking work, W. E. B. DU BOIS became the first African American to earn a doctorate in history, receiving the

degree in 1895 from Harvard University. A year later, his dissertation, "The Suppression of the African Slave Trade to the United States of America, 1638–1870," was the first volume published in the Harvard Historical Studies series. In his now classic *The Souls of Black Folk: Essays and Sketches* (Chicago, 1903), Du Bois was one of the first historians to explore the interior lives of African Americans and their distinctive culture. As was the case with much of his scholarship, Du Bois was ahead of his time. Because of the effort to achieve freedom, justice, and equality, black historians, in the main, paid greater attention to revising the errors, omissions, and distortions of white historians and to glorifying the contributions of African Americans to American life than to identifying and defining a distinctive African-American culture.

Carter G. WOODSON was the foremost proponent of the revisionist and contributionist school of African-American historiography. He earned the title "Father of Black History" for institutionalizing the revisionist and contributionist interpretation of the African-American past and for popularizing the study of black history. Woodson was the second African American to earn a doctorate in history, also from Harvard University, in 1912. He organized the Association for the Study of Negro Life and History (ASNLH) in 1915 to preserve the African-American heritage, promote interracial harmony, and inspire black youth to greater achievement. In 1916, Woodson launched the JOURNAL OF NEGRO HISTORY to publish scholarship about the African-American past. He established the ASSOCIATED PUBLISHERS in 1921 to publish books of black history and initiated Negro History Week in 1926 (expanded to BLACK HISTORY MONTH in 1976). To reach a more popular audience, Woodson started the *Negro History Bulletin* in 1937. Until his death in 1950, Woodson and his colleagues in the ASNLH (William M. Brewer, Lorenzo J. Greene, Luther Porter Jackson, James Hugo Johnston, Rayford W. LOGAN, W. Sherman Savage, Alrutheus A. Taylor, and Charles H. WESLEY) virtually dominated the field of African-American history.

Few historians wrote about the black experience before World War II. Gunnar Myrdal's two-volume study *An American Dilemma: The Negro Problem and Modern Democracy* (New York, 1944), and John Hope FRANKLIN's *From Slavery to Freedom: A History of American Negroes* (New York, 1947) sparked interest in the subject. Myrdal's report for the Carnegie Corporation on black life in the United States was completed with the assistance of several leading black and white scholars. The work was more sociological than historical, as it looked to resolve the problem of race and to avoid racial conflict similar to the riots that broke out in some twenty-five cities and towns after

World War I. Franklin's book was an example of meticulous research that demonstrated the central role African Americans played in the development of the United States. These two trailblazing works influenced scholars to take greater note of African-American history for understanding the American past. World War II, in large measure, destroyed the traditional ideology of white supremacy and with it the justification for excluding African Americans from full citizenship as well as from the story of the nation's past.

Although white scholars now paid greater attention to the African-American experience, they used more of a sociological or race relations approach to black history. Many historians, black and white, wrote in the abolitionist tradition of revealing injustices heaped on African Americans. Black people became victims more than shapers of history. The legacy of slavery, for example, supposedly explained all the problems that beset the black population, from underachievement to illegitimacy, family instability, crime, illiteracy, and self-hatred. African Americans allegedly internalized the oppression of slavery and were mired in a culture of poverty.

With the growth of the civil rights and black consciousness movements of the 1950s and 1960s, black historians in particular began to explore African-American resistance and the creation of a viable culture that sustained black people from the brutality of slavery, segregation, and subordination (*see* CIVIL RIGHTS MOVEMENT). If ordinary African Americans braved often violent assaults to desegregate buses, lunch counters, drinking fountains, swimming pools, restrooms, and voting booths, then how strong was the legacy of slavery? What were the real historical patterns of black behavior? Earl E. Thorpe, who wrote prolifically about African-American historiography, suggested that "It is because the past is a guide with roads pointing in many directions that each generation and epoch must make its own studies of history" (Thorpe 1957, p. 183). It therefore becomes necessary to go back in time, to understand what some writers referred to as the "Second Reconstruction," and to appreciate the origins of the struggle for civil rights and black power.

By the late 1960s, historians of the African-American experience largely abandoned the sociological or race relations interpretation. They adopted a more anthropological and psychological approach to the African-American past, a concern about black people as agents of history and not as helpless victims. They explored the interior lives of African Americans, their culture, and its antecedents in Africa. Ironically, it was the white anthropologist Melville J. Herskovits who insisted that African Americans had retained elements of African culture,

while the black sociologist E. Franklin FRAZIER argued that black people had been stripped of their past and started anew in the United States. The place of Africa loomed larger in the scholarship of the 1960s and 1970s, as historians studied emigration, black nationalism, religion, music, dance, folklore, and the family in the context of African persuasion.

In many respects, Benjamin QUARLES, a venerable black historian at Morgan State University, originated the new writing of African-American history with the publication of *Black Abolitionists* (1969). Quarles wrote that the African American was abolition's "different drummer," a participant in as well as a symbol of the movement, and one of its pioneers. John W. Blassingame's *The Slave Community: Plantation Life in the Antebellum South* (1972) soon followed with an original interpretation of slavery in which the slaves helped define the peculiar institution and possessed some discretion over the shape of their daily lives. The work of Barbara J. Fields, Eugene D. Genovese, Herbert G. Gutman, Vincent Harding, Nathan I. Huggins, Charles W. Joyner, Lawrence W. Levine, Daniel C. Littlefield, Albert J. Raboteau, Sterling Stuckey, Margaret Murray WASHINGTON, Thomas L. Webber, and Peter H. Wood has broadened and deepened our understanding of slave life and culture. Genovese's *Roll, Jordan, Roll: The World the Slaves Made* (1974), in particular, influenced study of the dialectical relationship between slave and master (and by extension blacks and whites) as one governed not by race relations but by reciprocal duties and obligations. This give-and-take in determining the status and condition of African Americans in slavery and freedom has been advanced in the work of Ira Berlin, Eric Foner, Gerald D. Jaynes, Leon F. Litwack, Nell I. Painter, James L. Roark, Willie Lee Rose, and Joel Williamson.

The new African-American historiography has been applied to themes of migration, urbanization, the working class, and protest. Historians have examined the causes and consequences of black migration from the rural South to urban areas of the North and South, finding them to be primarily the result of family decisions and kinship networks more than outside forces. They have studied both the physical and the institutional ghetto. Segregation produced the former, while African Americans created the latter to meet their own religious, economic, cultural, political, and social needs. The ghetto of the early twentieth century was not necessarily a slum. It was often a vibrant community in which African Americans carried out their daily lives.

A growing body of research on African Americans and European immigrants suggests that black workers enjoyed some advantages in education, skills, and language facility that eroded over time as immigrants

Dr. Henrick Clark. (Allford/Trotman Associates)

organized labor along ethnic and racial lines. Although the CONGRESS OF INDUSTRIAL ORGANIZATIONS' embrace of black workers during the late 1930s brought some absolute change for African Americans, there was little relative change in comparison with white workers. African Americans, moreover, experienced the Great Depression earlier and suffered longer than any other segment of the population. Historians such as John E. Bodnar, Dennis C. Dickerson, William H. Harris, August Meier and Elliott M. Rudwick, and Joe William Trotter, Jr., have illuminated the fate of the black working class.

Although they have faced great odds in racism, segregation, lynching, disfranchisement, and discrimination, African Americans have been resilient in not succumbing to oppression. As Herbert Aptheker, Lerone Bennett, Jr., Mary F. Berry, Richard J. M. Blackett, John H. Bracey, Jr., John Henrik Clarke, V. P. Franklin, Vincent Harding, Robert A. Hill, and August Meier and Elliott M. Rudwick have shown, the protest tradition among African Americans has endured. One of the strong tenets of recent African-American historiography is that black people retained their integrity as a people despite the potential of slavery and racism to break them. They resisted brutalization, although they could not always avoid brutality. They fashioned a distinctive and viable culture in opposition to oppression. Their culture was rooted

in Africa but given form and substance in the United States. Their tradition of resistance and protest burst forth in an unprecedented manner during the modern civil rights movement of the 1950s and 1960s. Taylor Branch, Clayborne Carson, William H. Chafe, David J. Garrow, Vincent Harding, Darlene Clark Hine, Steven F. Lawson, David L. Lewis, August Meier and Elliott M. Rudwick, Linda Reed, Harvard Sitkoff, and Robert Weisbrot have recorded the critical events, organizations, and personalities that constituted the "Second Reconstruction."

Although African-American historiography has broken away from explaining the past as divine providence, revising the errors, omissions, and distortions of racist white writers, celebrating the contributions of famous black men to the growth and development of the United States, depicting the endless horrors of racism and segregation, and analyzing race relations, it has until recently had a blind spot. The new African-American historiography has studied black people as agents rather than as victims of the past but has, for some time, ignored the issue of gender. The work of Elsa Barkley Brown, Paula Giddings, Sharon Harley, Evelyn Brooks Higginbotham, Darlene Clark Hine, Jacqueline Jones, Cynthia Neverdon-Morton, Jacqueline Rouse, Rosalyn Terborg-Penn, and Deborah Gray White has brought gender to the forefront of African-American historiography. As a result, we have gained fresh insight into the African-American past, the forebearers of black culture, and the builders of black progress.

From a field innovated by less than two dozen black historians prior to 1940, African-American historiography has grown to embrace a large corps of black and white scholars who have produced a new and exciting body of scholarship over the last two decades. The writing of African-American history has given voice and agency to a people for too long almost invisible, who were assumed to have no past worthy of study. African-American historiography has not only rescued the thought and action of black people over time and space in the United States, but it has also made the writing of United States history impossible without the voice and agency of African Americans.

REFERENCES

BLASSINGAME, JOHN W. "The Afro-Americans: From Mythology to Reality." In William H. Cartwright and Richard L. Watson, Jr., eds. *The Reinterpretation of American History and Culture*. Washington, D.C., 1973, pp. 53–79.

HARRIS, ROBERT L., JR. "Coming of Age: The Transformation of Afro-American Historiography." *Journal of Negro History* 67, no. 2 (Summer 1982): 107–121.

HINE, DARLENE CLARK, ed. *The State of Afro-American History: Past, Present, and Future*. Baton Rouge, La., 1986.

HOLT, THOMAS C. "African-American History." In Eric Foner, ed. *The New American History*. Philadelphia, 1990, pp. 211–231.

MEIER, AUGUST, and ELLIOTT M. RUDWICK. *Black History and the Historical Profession: 1915–1980*. Urbana, Ill., 1986.

QUARLES, BENJAMIN. "Black History's Antebellum Origins." *Proceedings of the American Antiquarian Society* 89 (1979): 89–122.

REDDING, JAY SAUNDERS. "The Negro in American History: As Scholar, as Subject." In Michael Kammen, ed. *The Past Before Us: Contemporary Historical Writing in the U.S.* Ithaca, N.Y., 1980, pp. 292–307.

THORPE, EARL E. *Black Historians: A Critique*. New York, 1969.

———. "Philosophy of History: Sources, Truths, and Limitations." *Quarterly Review of Higher Education Among Negroes* 25, no. 3 (July 1957): 172–185.

WOOD, PETER H. "I Did the Best I Could for My Day: The Study of Early Black History During the Second Reconstruction, 1960 to 1976." *William and Mary Quarterly* (3rd series) 35, no. 2 (April 1978): 185–225.

ROBERT L. HARRIS, JR.

Hodges, Johnny (Hodge, John Cornelius) (1907–1970), jazz saxophonist and clarinetist. Born in Cambridge, Mass., Johnny Hodges resisted the piano lessons offered by his parents, and started out on household drums before trying his hand at a real trap set. The family moved to Boston, where Hodges started playing the soprano saxophone. From the beginning he played in the broadtoned "singing" style that characterized the reed players of Boston—Howard Johnson, Harry CARNEY, Buster Toliver, George Matthews, Charlie Holmes—all of whom fell under the local influence of Jerome (Don) Pasquall, a New England Conservatory of Music saxophone student and JAZZ player. From the larger world of jazz, Hodges modeled his approach to music after that of Louis ARMSTRONG, jazz's first great soloist, and Sidney BECHET, the fluent clarinet and soprano sax player who, like Armstrong, was a master of the jazz styles associated with his home city, New Orleans. When Bechet came through Boston on tour, the thirteen-year-old Hodges met him and began an informal apprenticeship. During the 1920s, Hodges played sax and sometimes piano at house parties and public dances in Boston; he spent weekends in New York, where he played with

Bechet as well as with Lloyd Scott, Luckey ROBERTS, Willie (the Lion) SMITH, and Chick WEBB.

When one of Duke ELLINGTON's original reeds, Otto Hardwick, left the band temporarily, Ellington convinced Hodges to quit the Chick Webb Orchestra and join the Ellingtonians. Hodges's first recording sessions with Ellington, in 1928, show the young New Englander—still on soprano saxophone but now also on alto sax, as well as clarinet—playing with the big-toned authority and inventiveness that defined his permanent style. With apparent ease, Hodges covered the coolly mellifluous parts that Ellington had prepared for Hardwick; he also could execute snarls and growls in the Bechet style that jazz players of the day praised as "playing dirty." He could play fast and "hot"; he could shout the blues; he could present ballads with lyrical grace. Beginning in those early years, Ellington created melodies and special settings that complemented Hodges's panoply of skills, and by the early 1930s the sax player from Boston was widely regarded as Ellington's most eloquent soloist.

Aside from the hundreds of records Hodges made with the full band—blues, ballads, mood pieces, and longer works that frequently featured him as soloist—beginning in 1937 he also made a series of records with small ensembles drawn from the Ellington orchestra. These included such masterworks as "Jeep's Blues," "Hodge Podge," and "The Jeep Is Jumpin'," all composed by Hodges in collaboration with Ellington. In 1941, with small groups featuring Ellington, Hodges recorded "Passion Flower."

From 1951 to 1955, Hodges left Ellington to form his own small band. Along with Ellington alumni Lawrence Brown, Sonny Greer, and (briefly) Al Sears, Hodges produced a hit record, *Castle Rock* (1951), and dozens of other records that featured the Ellingtonians playing informally arranged ballads, blues, jump numbers, and blue-mood pieces, many of them associated with Duke.

The period after Hodges's return to Ellington was marked by soaring success. *Ellington at Newport 1956,* featuring a stunning remake of "Jeep's Blues," became a hit album. Back in the fold, Hodges continued to acquire from Ellington an ever-expanding circle of musical roles: Juliet in the Shakespearean suite *Such Sweet Thunder* (1957), in the ballet score *The River* (1970), a dancer in the Ellington–Billy STRAYHORN interpretation of Tchaikovsky's *Nutcracker Suite* (1960). Hodges stayed with Ellington for the rest of his life, and died only days before he was scheduled to play a piece Ellington had written especially for him: *Portrait of Sidney Bechet* (1970).

Along with Benny CARTER, whose work Hodges much admired, Johnny Hodges was one of the first great soloists on the alto saxophone. Some would argue that he was the music's very greatest alto. He strongly influenced the "Boston school" of saxophonists, of which he was the most accomplished member. His tone, with its expressive vibrato, and his elegant and yet soulfully economical phrasing, had a significant impact on the playing of Ellington saxophonists Harry Carney, Ben Webster, Russel Procope, Paul GONZALVES, and Norris Turney. By the mid-1930s, everyone playing saxophone seemed to owe something to Hodges. Charlie PARKER admired him, referring to him as "the Poet." John COLTRANE, who played in one of Hodges's bands in the 1950s, listed him as one of his favorites. In the 1980s and '90s, when jazz became more retrospective than ever, many young players showed the Hodges touch; some dedicated pieces and albums to his memory.

REFERENCES

DANCE, HELEN OAKLEY. "Impressions of Johnny Hodges." *Tempo* (November 1936): 10.
DANCE, STANLEY. *Johnny Hodges.* Alexandria, Va., 1979.
The World of Duke Ellington. New York, 1970.

ROBERT G. O'MEALLY

Hodges, Willis Augustus (February 12, 1815–September 24, 1890), abolitionist and newspaper editor. Willis Augustus Hodges was born in Blackwater, Princess Anne County, Va., to Charles Hodges and Julia Nelson Willis Hodges, prosperous free farmers. In his youth, Willis Hodges attended a predominantly white, segregated Baptist church, and obtained an education from a private tutor, Englishman Charles Blachford. After Nat Turner's failed slave rebellion in 1831 (*see* NAT TURNER CONTROVERSY), the Virginia legislature enacted a series of harsh laws designed to curb the liberties of free blacks. In this climate, in 1833, George Hodges took most of his family to New York, leaving Willis behind to tend to the farm. Once the family had been resettled, George and other members of the family made frequent trips between Virginia and New York.

In 1836, Willis himself moved to the New York area, settling in a black community in Williamsburgh, Kings County. There he was employed in a mercantile establishment. By 1840, he had saved enough money to open a grocery store with his older brother, William. Hodges also joined the Abyssinian Baptist Church and began to take an interest in local political affairs. In 1841 he successfully organized a protest against a free school in Williamsburgh which had refused to admit black children. He also served as a member of the New York Society for the Promo-

tion of Education Among Colored Children in 1847.

Hodges's interest in reform was not restricted to education, however. He also organized the Union Temperance Benevolent Society (1841), and supported black suffrage and antislavery advocates like Charles L. Reason and Thomas Van Renssalaer. With his brother William, he was a delegate to an 1840 convention in Albany that sought to remove the $250 property qualification for black suffrage in New York state.

In 1844, upon the death of his father, Hodges returned to Virginia. There he conducted private religious services for blacks which aroused suspicion among nearby plantation owners. He was accused of trying to foment a second Nat Turner–style revolt and was arrested. After being acquitted in two separate trials, Hodges returned to Williamsburgh and opened a stall in a local market, where he sold poultry and produce. He resumed his political activities and, with Renssalaer, began publishing the abolitionist newspaper the RAM'S HORN, beginning January 1, 1847. The weekly lasted about three years, although only one issue survives. It was through this newspaper that Hodges came into contact with John Brown (see JOHN BROWN'S RAID). Upon reading the paper, Brown purchased a subscription and donated money to the enterprise. He also became a contributor, writing an essay entitled "Sambo's Mistakes," which castigated northern free blacks for inactivity toward slavery.

In 1847 Hodges attended a convention of "colored people" held in Troy, N.Y. There, he and abolitionist Charles Ray coauthored a report extolling the virtues of an agricultural life. Hodges was convinced that such a life would encourage self-reliance and "moral, mental, and physical culture" among blacks. "An agricultural life," read the report, "is the life for a proscribed caste because it tends to break down proscriptions." In line with this philosophy, Hodges accepted abolitionist Gerrit Smith's invitation to lead the delegation of Kings County free blacks to settle small farms in upstate New York. At this new settlement, called Blacksville, Hodges found time to write an autobiography. (Although the manuscript was completed in 1849, it was not published until 1896, when it appeared in serialized form in the *Indianapolis Freeman*. In 1982 it was reissued as *Free Man of Color: The Autobiography of Willis Augustus Hodges*.)

By 1853 Hodges was back in Williamsburgh and had resumed political activities, including his efforts to abolish restrictions on black suffrage. In that year, he married Sarah Ann Corprew Gray, with whom he would have five children. He also resumed his acquaintance with John Brown. It is likely that Hodges knew of Brown's plan to take Harper's Ferry, and counseled him to wait, as civil war was imminent.

After Brown's failed raid in 1859, Hodges burned their correspondence.

Hodges's activities during the CIVIL WAR are obscure. He returned to Virginia and probably aided the Union Army as a scout. During RECONSTRUCTION he and his brothers, William, Charles, and John Q., participated in the making of what they called the "New Virginia." Hodges served as a delegate to Virginia's constitutional convention. He failed to be elected to the Virginia assembly but remained important in local politics, working for two years as a justice of the peace in Kempsville, Va. In 1876 southern conservatives forced him to resign under the charge of "malfeasance in office." From 1876 until his death, Hodges split his time between Virginia and New York City. In May 1887 he waged an unsuccessful campaign for magistrate of Tanner's Creek Township. He died in Virginia.

REFERENCES

GATEWOOD, WILLARD B., JR., ed. *Free Man of Color: The Autobiography of Willis Augustus Hodges*. Knoxville, Tenn., 1982.

PENN, I. GARLAND. *The Afro-American Press and Its Editors*. Springfield, Mass., 1891, pp. 61–65.

GRAHAM RUSSELL HODGES

Hogan, Ernest (Crowders, Reuben) (c. 1860– May 20, 1909), minstrel entertainer. Little is known about the early life of Ernest Hogan, who was born Reuben Crowders, also spelled Crowder or Crowdus, in Bowling Green, Ky., in 1860 or 1865. He first worked as an entertainer in traveling tent shows, and changed his name early in his career in order to capitalize on the popularity of Irish comedians. He came to prominence in the early 1890s as a member of Richard and Pringle's Georgia Minstrels, introducing the "Pasmala," a backward-hopping dance step. He then worked with Black Patti's Troubadours, billed as the "Unbleached American." In 1898 Hogan, who had gained renown for imitating fish and crabs, performed to great acclaim in *Clorindy, The Origin of the Cakewalk* in New York. His featured songs included Will Marion COOK's "Who Dat Say Chicken in Dis Crowd," and "Darktown Is Out Tonight." By this time Hogan had gained notoriety as the composer of "All Coons Look Alike But Me," a song that to his regret became the best known of the derogatory genre of "coon" songs.

By the turn of the century Hogan was one of the dominant figures in African-American popular entertainment, a position he held until his death a decade later. Not only was he a magnificent comic dancer,

but he also updated for the modern musical theater the traditional minstrel role of the end man. In 1899 Hogan went with the M. B. Curtis Afro-American Minstrels to Australia and Hawaii, performing with Billy McClain in the musical comedy *My Friend From Georgia* (which Hogan had helped write). Upon their return to the U.S., Hogan and McClain organized the Original Smart Set Company, and in 1900 Hogan brought *Uncle Eph's Christmas,* which was written by Paul Laurence DUNBAR and William Marion Cook, to the stage. He also performed in *The Military Man,* which included the singer Mattie Wilkes, to whom Hogan was briefly married.

In 1901 Hogan performed in *The Cannibal King,* the story of an African-American hotel waiter who becomes rich and attempts to improve the lives of other blacks. In the mid-1900s Hogan starred in *Rufus Rastus,* the story of an "unfortunate" who finds a fortune in a box of oats. During this time Hogan also starred in vaudeville performances by the Nashville Students, also known as the Memphis Students, the pioneering syncopated orchestra that later toured Europe as the Tennessee Students. In 1907 Hogan was assisted by Bert WILLIAMS in writing *The Oyster Man,* which opened in Lima, Ohio, with Hogan sharing the bill opposite John Rucker. As the show continued to travel in 1908, Hogan contracted tuberculosis and was forced to leave the troupe. He died the next year in Lakewood, N.J.

See also MINSTRELS/MINSTRELSY for an overview of the genre.

REFERENCES

RIIS, THOMAS. *Just Before Jazz: Black Musical Theater in New York, 1890–1915.* Washington, D.C., 1989.

SAMPSON, HENRY T. *Blacks in Blackface: A Source Book on Early Black Musical Shows.* Metuchen, N.J., 1980.

JONATHAN GILL

Holder, Geoffrey (August 20, 1930–), dancer, choreographer, and painter. Born in Port-of-Spain, Trinidad, Geoffrey Holder was one of four children in a middle-class family. He attended Queens Royal College, a secondary school in Port-of-Spain, and received lessons in painting and dancing from his older brother Boscoe.

When Holder was seven, he debuted with his brother's dance troupe, the Holder Dance Company. When Boscoe moved to London a decade later, Geoffrey Holder took over direction of the company. In 1952, Agnes de Mille saw the group perform on the island of St. Thomas, U.S. Virgin Islands, and invited Holder to audition for impresario Sol Hurok in New York City. Already an accomplished painter, Holder sold twenty of his paintings to pay for passage for the company to New York City in 1954. When Hurok decided not to sponsor a tour for the company, Holder taught classes at the Katherine DUNHAM School to support himself. His impressive height (6'6") and formal attire at a dance recital attracted the attention of producer Arnold Saint Subber who arranged for him to play Samedi, a Haitian conjurer, in Harold Arlen's 1954 Broadway musical *House of Flowers.* During the run, Holder met fellow dancer Carmen DE LAVALLADE, and the two married in 1955. During 1955 and 1956 Holder was a principal dancer with the Metropolitan Opera Ballet in New York. He also appeared with his troupe, Geoffrey Holder and Company, through 1960. The multitalented Holder continued to paint throughout this time, and in 1957 he was awarded a Guggenheim Fellowship in painting.

Geoffrey Holder in *Aida.* (Photographs and Prints Division, Schomburg Center for Research in Black Culture, The New York Public Library, Astor, Lenox and Tilden Foundations)

In 1957 Holder acted in an all-black production of *Waiting for Godot*. Although the show was short-lived, Holder continued to act, and in 1961 he had his first film role in the movie *All Night Long,* a modern retelling of *Othello.* His career as a character actor flourished with appearances in *Everything You Always Wanted to Know About Sex* (1972), *Live and Let Die* (1973), and as Punjab in *Annie* (1982).

Holder has also been an active director. His direction of the Broadway musical *The Wiz,* (1975) an all-black retelling of *The Wizard of Oz,* earned him Tony Awards for best director and best costume design. In 1978 he directed and choreographed the lavish Broadway musical *Timbuktu!.* He has choreographed pieces for many companies including the Alvin AILEY American Dance Theater, for which he choreographed *Prodigal Prince* (1967), a dance based on the life of a Haitian primitive painter. Dance Theater of Harlem has in its repertory Holder's 1957 piece *Bele,* which like most of his work combines African and European elements.

Holder cowrote (with Tom Harshman) and illustrated the book *Black Gods, Green Islands* (1959), a collection of Caribbean folklore; and *Geoffrey Holder's Caribbean Cookbook* was published in 1973. He also gained widespread recognition in the late 1970s and 1980s for his lively commercials. In 1992 Holder appeared in the film *Boomerang* with Eddie Murphy. He resides in New York, where he continues to paint, choreograph, and act.

REFERENCES

EMERY, LYNNE FAULEY. *Black Dance from 1619 to Today.* Princeton, N.J., 1988.
MOSS, ALLYN. "Who is Geoffrey Holder?" *Dance* (August 1958): 36–41.

ZITA ALLEN

Shown here in 1949, Billie Holiday was known for the fluttering timbre and rhythmic grace of her singing voice. (Prints and Photographs Division, Library of Congress)

Holiday, Billie (April 7, 1915–July 17, 1959), singer. Born Eleanora Fagan in Philadelphia, the daughter of Sadie Fagan and jazz guitarist Clarence Holiday, Billie Holiday grew up in Baltimore and endured a traumatic childhood of poverty and abuse. As a teenager, she changed her name (after screen star Billie Dove) and came to New York, where she began singing in speakeasies, influenced, she said, by Louis ARMSTRONG and Bessie SMITH. In 1933 she was spotted performing in Harlem by critic-producer John Hammond, who brought her to Columbia Records, where she recorded classic sessions with such jazz greats as pianist Teddy Wilson and tenor saxophonist Lester YOUNG.

Following grueling tours with the big bands of Count BASIE and Artie Shaw, Holiday became a solo act in 1938, achieving success with appearances at Cafe Society in Greenwich Village, and with her 1939 recording of the dramatic antilynching song "Strange Fruit." Performing regularly at intimate clubs along New York's Fifty-second Street, she gained a sizable income and a reputation as a peerless singer of torch songs. A heroin addict, she was arrested for narcotics possession in 1947 and spent ten months in prison, which subsequently made it illegal for her to work in New York clubs. Yet despite such hardships and her deteriorating health and voice, she continued to per-

form and make memorable, sometimes challenging recordings on Decca, Verve, and Columbia until her death in 1959.

Although riddled with inaccuracies, Holiday's 1956 autobiography, *Lady Sings the Blues,* remains a fascinating account of her mercurial personality. A 1972 film of the same title, starring pop singer Diana ROSS, further distorted her life but introduced her to a new generation of listeners. Holiday was one of America's finest and most influential jazz singers. Her voice was light, with a limited range, but her phrasing, in the manner of a jazz instrumentalist, places her among the most consummate of jazz musicians. She was distinguished by her impeccable timing, her ability to transform song melodies through improvisation, and her ability to render lyrics with absolute conviction. While she was not a blues singer, her performances were infused with the same stark depth of feeling that characterizes the blues.

REFERENCES

CHILTON, JOHN. *Billie's Blues.* New York, 1989.

KLIMENT, BUD. *Billie Holiday.* New York, 1990.

O'MEALLY, ROBERT. *Lady Day: The Many Faces of Billie Holiday.* New York, 1991.

BUD KLIMENT

Holiness Movement.

The Holiness movement is a significant religious movement in African-American religious history. The term *Holiness* can be confusing due to the multiplicity of its uses. Many publications use the term somewhat broadly to include PENTECOSTALISM and the APOSTOLIC MOVEMENT; however, properly used, it specifically describes that distinct Holiness movement that resulted in the founding of the Holiness church denomination.

The Holiness movement in the post–Civil War era was the result of an internal conflict within the METHODIST CHURCH. Eschewing the new, less austere standards of the postwar church, followers of the Holiness movement advocated a simple, antiworldly approach to life as well as adherence to a strict, moralistic code of behavior. The followers of the Holiness movement believed in the theological framework of John Wesley, but then went a step further in their interpretation of his writings. In addition to the first blessing of conversion which is justification by faith accepted by most Protestants, adherents of the movement declared that a second experience or blessing of complete sanctification was necessary in order to achieve complete emotional peace. The second blessing purified the believer of his inward sin (the

result of Adam's original sin), and would give the believer a perfect love toward God and man. A state of earthly holiness (or perfection) was seen as possible to achieve. This experience was attained through devout prayer, meditation, the taking of Holy Communion, and fellowship with other believers. Those who had received the second blessing were characterized by a deep inner feeling of joy and ecstasy, as well as by lives that reflected a moral and spiritual purity.

At first, the Methodist Church leaders welcomed the new movement as one which would instill more pious behavior in its members. By 1894, however, those who had experienced the "second blessing" began to press for changes to church doctrine, literature, even songs used in worship services. As a result, the followers of the new movement split from Methodism and founded their own churches throughout the South, North, and Midwest. In the early Holiness churches, racial lines were obscured. Many blacks and whites served together as officials, preachers, and church members. However, under pressure to conform to social norms of segregation, divisions along racial lines were well in place by the 1890s.

Black Holiness congregations, often calling themselves the Church of God, sprang up throughout the South after 1890. One of the largest and most influential was the CHURCH OF GOD IN CHRIST, founded by C. H. MASON and C. P. JONES, which was incorporated in Memphis in 1897. It was the first Holiness church of either race to be legally chartered. Mason and Jones had come out of a Baptist Church background, as had many other black converts to the Holiness movement (*see* BAPTISTS). Like their counterparts from the Methodist Church, they longed for a purer expression of their faith and a religion that was unfettered by the push toward worldly materialism. Because it was legally chartered, the Church of God in Christ could perform marriage ceremonies and ordinations. Many independent white Holiness ministers were ordained by Jones and Mason. It was also the denomination most receptive to musical experimentation, encouraging the use of instruments, RAGTIME, JAZZ, and the BLUES as a part of worship.

Both the black and white Holiness congregations were split after a black Holiness convert named William J. SEYMOUR organized a church in Los Angeles in 1906, where he espoused a third blessing—the Baptism of the Holy Ghost—which would be evidenced by the Pentecostal gift of speaking in tongues. Seymour taught that it was only after having received this third blessing that a believer was truly sanctified and perfected. Thousands of Holiness believers were converted to the new Pentecostal church. Pentecostalism has gone on to attract mil-

lions of converts and eventually overshadowed its founding Holiness faith.

In 1907, Mason was converted, which resulted in a schism between him and Jones over doctrinal differences. While Mason adhered to the tenet of a required third blessing in order to receive the Holy Spirit, Jones maintained that the gift of the Holy Spirit was given by God at the time of conversion. They split into two churches and Mason's new Church of God in Christ became the largest Pentecostal church in the United States. Jones founded the Church of Christ (Holiness) USA in 1907. By 1984 there were 170 congregations with approximately 10,000 members. One of the offshoot congregations that sprang from the Church of Christ (Holiness) USA is the Churches of God, Holiness. Founded in Atlanta in 1920, by 1967 there were forty-two churches with a reported membership total of about 25,000. There are several other, smaller Holiness churches, as well.

Besides serving as the birthplace of the Pentecostal church, the Holiness movement was very important and influential in the lives of those who believed in it. The movement was brought north during the Great Migration of the first two decades of the twentieth century and continued to thrive throughout the era of the Great Depression. Simplicity and continuity were stressed over consumption and liberalization of religious standards. The Holiness movement also stressed that anyone, regardless of race or gender, could participate in church hierarchy, including preaching, on an equal basis. The believers of the Holiness movement sought to undo the materialistic and divisive nature of American society by beginning with their own lives and their own hearts.

REFERENCES

AYERS, EDWARD L. *The Promise of the New South.* New York, 1992.

DUPREE, SHERRY SHERROD, ed. *Biographical Dictionary of African-American Holiness-Pentecostals: 1880–1990.* Washington, D.C., 1989.

MURPHY, LARRY G., J. GORDON MELTON, and GARY L. WARD, eds. *Encyclopedia of African American Religions.* New York, 1993.

PARIS, ARTHUR. *Black Pentecostalism.* Amherst, Mass., 1982.

PAYNE, WARDELL J., ed. *Directory of African-American Religious Bodies.* Washington, D.C., 1991.

SYNAN, VINSON. *The Holiness-Pentecostal Movement in the United States.* Grand Rapids, Mich., 1971.

DEBI BROOME

Holland, Jerome Heartwell (January 6, 1916–January 13, 1985), educator and diplomat. Born and raised in Auburn, N.Y., Jerome Holland was the first African-American to play football at Cornell University, in 1935, where he was twice selected as an All-American. Holland graduated with honors in 1939 and was granted a master's degree in sociology two years later. After subsequently teaching sociology and physical education at Lincoln University in Pennsylvania, Holland received his Ph.D. from the University of Pennsylvania in 1950. He served as president of Delaware State College in Dover, Del. (1953–1959) and of Hampton Institute in Hampton, Va. (1960–1970). Holland also authored a number of economic and sociological studies on African Americans, including *Black Opportunity* (1969), a treatise supporting the full integration of African Americans into the mainstream of the American economy.

In 1970, Holland was appointed U.S. ambassador to Sweden by President Richard M. Nixon, serving until 1972. He was a board member of nine major United States companies, including the Chrysler Corporation, American Telephone and Telegraph (AT&T), and General Foods, as well as a member of the board of directors of the NATIONAL URBAN

Jerome Holland, a former ambassador to Sweden, was the first African-American member of the Board of Directors of the New York Stock Exchange. (AP/Wide World Photos)

LEAGUE and the UNITED NEGRO COLLEGE FUND. In 1972, Holland became the first African American to sit on the board of directors of the New York Stock Exchange, a position he held until 1980. Holland was inducted into the National Football Foundation's College Hall of Fame in 1965, and he posthumously received the U.S. Presidential Medal of Freedom in 1985 for his contributions in education and public service.

REFERENCES

ASHE, ARTHUR R., JR. *A Hard Road to Glory: A History of the African-American Athlete 1619–1918.* New York, 1988.

YOUNG, A. S. "Doc." *Negro Firsts in Sports.* Chicago, 1963.

SASHA THOMAS

Holly, James Theodore (1829–March 13, 1911), emigrationist and missionary. James T. Holly was born to free parents in a free black settlement in Washington, D.C. At fourteen, the family moved to Brooklyn, N.Y., where Holly learned shoemaking under the direction of his father. In 1848, he began working as a clerk for Lewis Tappan, the renowned abolitionist, who furthered his interest in the anti-slavery movement.

In 1851, in reaction to the Fugitive Slave Act of 1850 (*see* FUGITIVE SLAVE LAWS), Holly and his wife, Charlotte, moved to Windsor, Canada. He became coeditor of Henry BIBB's newspaper, *The Voice of the Fugitive,* and began to encourage black emigration through his writing. Holly endorsed Bibb's controversial Refugee Home Society, a program designed by Bibb to train and rehabilitate fugitive slaves.

Holly became increasingly involved in the emigration movement. In 1854, the first National Emigration Convention was held in Cleveland, where Holly was named a delegate and represented the National Emigration Board as its commissioner; the following year he made his first trip to Haiti. During the 1850s, Holly also championed the American Colonization Society in its efforts to remove African Americans from the United States.

Holly was raised a Catholic, but in 1855 he converted from Roman Catholicism, becoming deacon in the Protestant Episcopal Church. The following year he became a priest and moved to New Haven, Conn., where he served at St. Luke's Church and continued to promote the idea of emigration to Haiti. During this period he wrote his major work, *Vindication of the Capacity of the Negro Race for Self-Government and Civilized Progress,* which was pub-

lished in 1857. Writing against the grain of American nationalism, Holly called the United States a "bastard democracy," and asserted that emigration to Haiti would provide far more personal liberty and general well-being for black men and women. Emigration would be a grand experiment in progress even in "monarchical" Haiti, Holly contended, and would demonstrate African-American capacities for political and social progress. Ironically, Holly also believed in English cultural supremacy. He was an anglophile who asserted that providence was directing black men and women in the New World in a vanguard struggle for independence and black pride that would promote European cultural ideals. His Christian expansionism and emigration plans were linked to a great respect for the developed arts and sciences of the "Anglo-American race."

In May 1861, Holly left the United States with 110 followers, made up of family and church members, and established a colony in Haiti. Yellow fever and malaria took their toll on the colony, however, and during the first year, the diseases killed his mother, his wife, their two children, and thirty-nine other members of the group. Others returned to the United States, leaving Holly with only a handful of followers. In 1862, Holly returned to the United States seeking financial assistance from the Episcopal Church to establish a mission. His request was granted.

In 1874, at Grace Church in New York City, Holly became the first African American to be consecrated bishop by the Episcopal Church. He served as head of the Orthodox Apostolic Church of Haiti, a church in communion with other Episcopal churches. He published a number of articles in the *AME Church Review*, and continued to believe, until his death in 1911, that black Americans should emigrate to Haiti.

REFERENCES

DEAN, DAVID M. *Defender of the Race.* Boston, 1979.

LOGAN, RAYFORD W., and MICHAEL R. WINSTON, eds. *Dictionary of American Negro Biography.* New York, 1982.

SUSAN MCINTOSH

Holman, Moses Carl (June 27, 1919–August 9, 1988), writer, scholar, and leader. M. Carl Holman was born to Moses and Mamie Durham Holman in Minter City, Miss. Shortly thereafter, his family moved to St. Louis. Holman attended Lincoln University in Missouri, graduating magna cum laude in 1942. Two years later he earned a master's degree in English from the University of Chicago. In 1948 Holman became a professor of English and the hu-

manities at Clark College in Atlanta, but continued his own education as well, receiving an M.F.A. from Yale University in 1954.

During his tenure at Clark, Holman continued a writing career he had begun as a boy in St. Louis, writing several plays and publishing his poetry, some of which was anthologized by Langston HUGHES and Arna BONTEMPS in *Poetry of the Negro.* In the mid-1950s, he became active in the civil rights movement, as cofounder of the Atlanta Committee for Cooperative Action and as a member of the NATIONAL ASSOCIATION FOR THE ADVANCEMENT OF COLORED PEOPLE. In 1960 Holman helped found the *Atlanta Inquirer,* and became editor of the all-black newspaper, which focused on civil rights and discrimination.

In 1962, Holman left Clark to join the staff of the United States Commission on Civil Rights, serving first as information officer and then as deputy staff director, beginning in 1966. In 1968 Holman joined the National Urban Coalition (NUC), serving as vice president of programs. Founded in 1967, in response to a wave of urban unrest, the NUC sought to address the needs of America's cities by fostering public discourse and community development. In 1971 Holman became the coalition's first black president. As president, Holman stressed the importance of public-private partnerships and worked to develop and maintain a constant dialogue between racial groups, civil rights and community organizations, government, labor, and business. He devoted much of his time to educational programs designed to improve the scientific and mathematical skills of American children, especially girls and those in the inner city. Holman died of cancer in Washington, D.C., in 1988.

REFERENCES

BOOKER, SIMEON. "Washington Notebook." *Ebony* (December 1974): 31.
Obituary. *New York Times,* August 10, 1988.
"Topics of the Times." *New York Times,* August 12, 1988.

BENJAMIN K. SCOTT

Holmes, Larry (November 3, 1949–), boxer. Larry Holmes, the seventh of twelve children born to sharecropper-steelworker John Holmes and his wife Flossie, was born in Cuthbert, Ga. but grew up in Easton, Pa. Holmes dropped out of school after the seventh grade and worked in a car wash to help support the family, which was otherwise dependent upon his mother's income from welfare.

Heavyweight Larry Holmes holding his championship belt, November 5, 1981. (AP/Wide World Photos)

Holmes began his professional career on March 21, 1973, with a fourth-round win over Rodell Dupree. On June 9, 1978, he won the World Boxing Council heavyweight title from Ken Norton. The six-foot three-inch 215-pound champion did not lose a match until Michael Spinks defeated him in September 1985. During this stretch he defeated Earnie Shavers, Leon SPINKS, Gerry Cooney, and an over-the-hill Muhammad ALI, among other opponents. Because of his lack of a spectacular knockout punch, however, the long-reigning champion never gained the respect and recognition that boxing fans showed other titleholders, such as Muhammad Ali and Mike Tyson.

After losing a second decision to Spinks in a rematch in 1986, Holmes retired. He tried to come back in February 1988, but was knocked out in four rounds by a much younger Mike TYSON. In 1992 he came out of retirement for a second time. He won several matches against unheralded rivals and then lost to the heavyweight champion Evander HOLYFIELD. The following year Holmes continued his comeback campaign by defeating a string of unknown fighters at a casino in Mississippi.

In 1987 Holmes, who has amassed a career record of 54–4, was named the sixth greatest heavyweight of all time by *Ring Magazine.* He has also successfully built a real estate and investment firm in Easton, Pa.

REFERENCES

HOFFER, RICHARD. "Cruisin' for a Bruisin'." *Sports Illustrated* (June 8, 1992).
PUTNAM, PAT. "I Had to Come Back." *Sports Illustrated* (January 18, 1988).

The Ring Record Book and Boxing Encyclopedia. New York, 1987.

THADDEUS RUSSELL

MALONE, DUMAS, ed. *Dictionary of American Biography.* Vol. 9. New York, 1932, pp. 176–177.

PETER SCHILLING

Holsey, Lucius Henry (July 3, 1842–August 3, 1920), bishop, C.M.E. Church. Lucius Henry Holsey was most likely born in 1842 (some documents suggest May 22, 1845) in Georgia, near the city of Columbus, the son of a slavewoman and her owner. Holsey received little formal education, though in 1857 he became the slave of a professor at the University of Georgia, and it was there that he taught himself to read and write. In 1858, Holsey joined the Methodist Episcopal Church South, and in 1862 he married Harriet Turner, a slave owned by Bishop Pierce.

In 1867, Holsey received his license to preach, and in 1870 he attended as a delegate the first General Conference of the Colored Methodist Church—the conference which established the denomination of African Americans who withdrew from the Methodist Episcopal Church South. Holsey was appointed pastor of Trinity CME Church in Augusta, Ga., from 1871–1873. In 1873 the CME church named him its fourth bishop and assigned him to the southwestern United States. During his long career with the church, Holsey spent fifteen years as the secretary of the CME College of Bishops, served as the denomination's corresponding secretary for over forty-two years, and was its commissioner of education. In 1904, he became the senior bishop of the Church—a position he held until his death in 1920.

Holsey initiated the founding of and raised the first money for Lane College in Jackson, Tenn., as well as for Paine College in Augusta, Ga. He also began Holsey Normal School and Industrial Academy in Cordele, Ga., and the Helena B. Cobb School for Girls in Barnesville, Ga. At Paine College, whose mission was to train young ministers, Holsey faced opposition and antagonism over his support for hiring white teachers.

In 1881, Holsey represented his church at the Ecumenical Conference in London, and when the Conference was held in Washington in 1891, Holsey again served as a delegate. Three years later, he wrote the *Manual of Discipline of the C.M.E. Church in America*, as well as the CME's hymnal. In 1900 Paine College and Morris Brown College both awarded Holsey honorary doctorates of divinity.

REFERENCES

CADE, JOHN B. *Holsey—The Incomparable.* New York, 1964.

Holyfield, Evander (October 19, 1962–), boxer. Evander Holyfield was born in Atmore, Ala., but his family moved to Atlanta soon after his birth. He began BOXING at age nine. Holyfield continued to box as an amateur through his adolescence, and in 1983 he defeated Ricky Womack for the National Sports Festival light heavyweight boxing title. Holyfield qualified for the 1984 U.S. Olympic boxing team as a light heavyweight and won the bronze medal at the Los Angeles Games.

In November 1984 Holyfield turned professional. He won his first five professional bouts as a light heavyweight, and in 1985 he moved up one weight class to the 190-pound cruiserweight level. Holyfield won his next six cruiserweight fights by knockout. In 1986 he captured the World Boxing Association (WBA) and International Boxing Federation (IBF) cruiserweight titles with a fifteen-round split decision over Dwight Muhammad Qawi.

After successfully defending his titles, Holyfield unified the cruiserweight championship in 1988 with an eight-round technical knockout of Carlos DeLeon, the World Boxing Council (WBC) champion. Holyfield then moved up to the heavyweight class and, despite being smaller and lighter than his opponents, won his next three bouts by knockout, including a tenth-round technical knockout of former heavyweight champion Michael Dokes.

On October 25, 1990, Holyfield easily knocked out a poorly trained Buster Douglas to capture the undisputed heavyweight championship. He successfully defended his new title three times, with decisions over George FOREMAN and Larry HOLMES and a knockout of Bert Cooper. But in 1992 Holyfield lost his title by unanimous decision to the much larger Riddick BOWE in a twelve-round fight marked by toe-to-toe ferocity. Immediately after the loss to Bowe, Holyfield announced his retirement.

Holyfield returned to the ring in June 1993, when he won by decision over Alex Stewart. He then accepted a rematch with Bowe in what came to be one of the strangest events in boxing history. The November title fight was stopped during the seventh round when a man flying a paraglider landed on the ring's ropes. During the fight Holyfield's hit-and-run strategy paid off, and he recaptured the heavyweight title with a majority decision.

In May 1994 Holyfield lost the championship to Michael Moorer in a twelve-round decision. One

month later Holyfield announced his retirement again, this time after a medical examination revealed two potentially life-threatening disorders in his heart.

REFERENCES

Current Biography Yearbook 1993. New York, 1993.
JUNOD, TOM. "Answered Prayers." *Sports Illustrated* 79 (November 22, 1993): 48–52.

THADDEUS RUSSELL

Homosexuality, Black. *See* Gay Men, Black; Lesbians, Black.

Hood, James Walker (May 30, 1831–October 30, 1918), minister. Born in Kennett Township, Chester County, Pa., Hood moved with his family to Wilmington, Del., in 1841. His father was a tenant farmer who helped found the local Methodist church. In 1852 Hood moved to New York City and was licensed to preach there in 1856 by the AFRICAN METHODIST EPISCOPAL ZION CHURCH (AMEZ). In 1857 he moved to New Haven, Conn., where he joined the local AMEZ church. Three years later he was ordained a deacon in that denomination and sent as a missionary to Nova Scotia. He returned to the United States in 1863, and served a congregation at Bridgeport, Conn. The following year he was sent to North Carolina to minister to freedmen within Union lines. He remained in North Carolina for the rest of his life, working in New Bern, Charlotte, and finally settling in Fayetteville.

Hood was a delegate to North Carolina's RECONSTRUCTION Constitutional Convention in 1868, and that same year was appointed assistant superintendent of public instruction in North Carolina, a position he held for three years. In 1872 he was ordained a bishop of the AMEZ church. In 1879 Hood was instrumental in the founding of Zion Wesley Institute (later Livingston College) in Salisbury, N.C. He served as chairman of the Institute's board of trustees until his retirement in 1916. He traveled to London as a delegate to the interdenominational 1881 Ecumenical Conference, and to Washington as the first black president of the 1891 conference. In 1884 a collection of his sermons appeared under the title *The Negro in the Christian Pulpit.* It was the first publication of its kind by an African-American clergyman. Hood's other published work includes *One Hundred Years of the African Methodist Episcopal Zion Church* (1895) and *The Plan of the Apocalypse* (1900). From 1901 to 1909 Hood was an informal advisor to Theodore Roo-

sevelt. Hood Theological Seminary, established in 1912 at Livingston College, was named in his honor.

REFERENCES

JOHNSON, ALLEN, ed. *Dictionary of American Biography,* Vol. 3. New York, 1929.
MURPHY, LARRY G., J. GORDON MALTON, and GARY L. WARD. *Encyclopedia of African-American Religions.* New York, 1993.
SIMMONS, WILLIAM J. *Men of Mark.* Cleveland, 1887.

LYDIA MCNEILL

Hoodoo. *See* Voodoo.

Hooker, John Lee (August 22, 1917–), blues singer and guitarist. John Lee Hooker learned the guitar from his stepfather and began playing blues in Memphis nightclubs. He moved to Detroit in the 1940s; there he worked in a factory, continued playing in clubs, and began recording for Modern Records in 1948, achieving great success there with "Boogie Chillun." Hooker recorded for different companies under a variety of pseudonyms on some seventy recordings between 1949 and 1953. He began to temper his sound in the 1950s by using a full band to back up his rhythmically driving guitar and deep voice, which yielded the commercially successful "Boom Boom" in 1961. A remake of the song by the Animals in 1964 introduced Hooker to a much broader audience. An active performer through the 1970s and '80s, he recorded for several labels, and his music was featured in the 1985 film *The Color Purple.* In 1991, Hooker was inducted into the Rock and Roll Hall of Fame.

REFERENCES

NEELY, KIM. "Rock and Roll Hall of Famers Tapped." *Rolling Stone* (November 29, 1990): 36.
OBRECHT, JAS. "John Lee Hooker." *Guitar Player* (November 1989): 50ff.

DANIEL THOM

Hooks, Benjamin Lawrence (January 31, 1925–), lawyer, minister, and civic leader. Benjamin Hooks was born in Memphis, Tenn., where he attended public schools. Upon graduation from Booker T. Washington High School, Hooks pursued prelaw studies at HOWARD UNIVERSITY, graduating with a bachelor of arts degree in 1944. In 1948 he

earned a Juris Doctor degree from De Paul University in Chicago and returned to Memphis to practice law, hoping to help end legal segregation.

In 1961 Hooks was appointed assistant public defender of Shelby County, Tenn. Four years later, he was appointed to fill a vacancy in the Shelby County Criminal Court (a position to which he was subsequently elected on the Republican ticket), becoming the first black criminal court judge in the state. In addition to practicing law, Hooks was active in the CIVIL RIGHTS MOVEMENT in the 1950s and 1960s, serving on the thirty-three-member board of directors of the SOUTHERN CHRISTIAN LEADERSHIP CONFERENCE (SCLC) from its inception in 1957 to 1977. Hooks also cofounded and sat on the board of the Mutual Federal Savings and Loan Association from 1955 to 1969. He was ordained a Baptist minister in 1956 and became pastor of the Middle Baptist Church in Memphis, a position he still held as of the mid-1990s. In 1972, nominated by Richard Nixon, Hooks became the first African American to serve on the Federal Communications Commission, where he actively sought to improve the employment and ownership opportunities of African Americans and worked for more positive depictions of blacks in the electronic media.

Hooks became executive director of the NATIONAL ASSOCIATION FOR THE ADVANCEMENT OF COLORED PEOPLE (NAACP) in 1977 at a difficult moment in the organization's history. Since the 1960s, militant organizations had begun to eclipse the prominence of the NAACP, which had come under increasing attack for being too conservative. Viewed by its critics as a stodgy bastion of the middle class, the NAACP suffered a decline in membership and financial contributions. When Hooks replaced Roy WILKINS, who had served as executive director for twenty-two years, the organization was $1 million in debt and controlled by a faction-ridden board of directors.

As executive director, Hooks sought to revitalize the finances and image of the NAACP, becoming more involved in such national issues as the environment, national health insurance, welfare, urban blight, and the criminal justice system. He announced his intention to forge new alliances with corporations, foundations, and businesses, in addition to strengthening the NAACP's traditional alliances with liberals, the government, and labor groups. Hooks led the fight for home rule in Washington, D.C., and was instrumental in securing votes for the passage of important legislation such as the Humphrey-Hawkins bill of 1978, which mandated a dramatic lowering of the unemployment rate through the use of federal fiscal and monetary policy. Under his direction the NAACP also encouraged the withdrawal of U.S. businesses from South Africa.

As executive secretary of the NAACP, Benjamin Hooks continued the historical commitment of his organization to fight racism in all forms. Here, in 1987, Hooks announces legal action and a boycott against Forsythe County, Ga., after officials there blatantly failed to protect civil rights marchers from an attack by the Ku Klux Klan. (UPI/Bettmann)

In 1980, Hooks became the first African American to address both the REPUBLICAN and DEMOCRATIC national conventions. As executive director, Hooks upheld the NAACP's tradition of focusing on political activity, but he also tried to steer the organization toward helping African Americans on an everyday level through programs like the Urban Assistance Relief Fund, which he founded in the wake of the MIAMI RIOT OF 1980. In conjunction with his position at the NAACP, Hooks also served as chairman of the LEADERSHIP COUNCIL ON CIVIL RIGHTS (LCCR), a coalition of organizations devoted to civil rights issues.

In 1992 Hooks stepped down as executive director of the NAACP amid disputes between his supporters and those of Chairman of the Board William F. Gibson over the leadership of the organization and its direction. Many in the association expressed the view that the NAACP had continued to lose its effectiveness, though Hooks and his supporters maintained

that the organization had upheld its heritage of civil rights activism. After leaving the NAACP, Hooks continued to serve as chairman of the LCCR until 1994. Upon his resignation from the LCCR, Hooks resumed his position as pastor of Middle Street Baptist Church on a full-time basis. In June 1992 Hooks was also chosen to serve as the president of the board of directors of the National Civil Rights Museum in Memphis.

REFERENCES

DELANEY, P. "Struggle to Rally Black America." *New York Times Magazine* (July 15, 1979): 20.

"New Voice of the NAACP." Interview. *Newsweek* (November 22, 1976): 46.

LOUISE P. MAXWELL

Hope, John (June 2, 1868–February 20, 1936), educator and civil rights activist. John Hope was born in Augusta, Ga., to Mary Frances (Fanny) and James Hope. His mother was the daughter of an emancipated slave, and his father was a native of Scotland. James Hope bequeathed a substantial estate to his family, but Fanny and her children were deprived of their inheritance.

John Hope completed the eighth grade in 1881; five years later he entered Worcester Academy (Mass.), where he graduated with honors in June 1890. That fall, he enrolled at Brown University in Rhode Island on a scholarship. It was at Brown that Hope began to hone his writing and speaking skills and to develop "race consciousness." (Although he could pass for white, he always identified himself as black.) He was the orator for his graduating class in 1894. Shortly afterward, he married Lugenia Burns, a Chicago social worker; they later had two sons.

Hope entered the field of education at a time when Booker T. WASHINGTON was advocating vocational training for African Americans. Hope rejected that philosophy, insisting that black people must acquire higher learning if they were to make a convincing case for social equality. Hope turned down an offer to teach at Washington's Tuskegee Institute. Instead, from 1894 to 1898 he taught Greek, Latin, and the natural sciences at Roger Williams College in Nashville, Tenn. He went on to teach classics at Atlanta Baptist College (which became Morehouse College in 1913). In 1906, Hope became the College's first black president.

Hope's views were shared by W. E. B. DU BOIS, with whom Hope nurtured a lifelong friendship. And, like Du Bois, Hope was willing to join with others to achieve common objectives. He was the only college president to participate in the Niagara movement in 1906, and the only one to attend the initial meeting that resulted in the formation of the NAACP three years later.

As president of Atlanta Baptist College, Hope faced obstacles to his goals. Just before school was set to begin in September 1906, an antiblack riot swept through Atlanta; Hope demonstrated his leadership by ensuring that classes went on as scheduled. He was also unable to obtain financial support from some white philanthropists until a colleague approached Booker T. Washington for help. Over the years, however, he proved extraordinarily successful in increasing enrollment, raising money, and attracting leading black scholars. His educational achievements culminated with his 1929 appointment as president of the "new" Atlanta University, a consortium including Atlanta University, Morehouse College, and Spelman College. In 1934, Hope convinced W. E. B. Du Bois to head the department of sociology.

Hope did not, however, restrict his activities to the university setting. He traveled to France during World War I, where he insisted that the Young Men's Christian Association (YMCA) adopt new policies to ensure equitable treatment for black soldiers; this effort initiated a lasting commitment to the YMCA's work. Hope served as president of the National Association of Teachers in Colored Schools, and he acted as honorary president of the Association for the Study of Negro Life and History. In addition, he was a member of both the NAACP's Advisory Board and the Urban League of New York's Executive Committee. In 1920, he joined the Commission on Interracial Cooperation, a moderate, liberal integrated group of Atlanta civic leaders; he was elected CIC president in 1932.

In the late 1920s and early 1930s, through his considerable organizational connections, Hope traveled widely in Europe, the Soviet Union, the Middle East, Latin America, and the Caribbean. His commitment to cooperation across national and racial boundaries reinforced his vision of education as a tool for gaining equality. Hope was a pioneer in developing outstanding graduate and professional programs for black people. At the same time, it was under his tutelage that Atlanta University's faculty offered training to public school teachers and established "citizenship schools" to encourage voter registration. Hope died in Atlanta in 1936.

REFERENCE

TORRENCE, RIDGELY. *The Story of John Hope.* New York, 1948.

SASHA THOMAS
TAMI J. FRIEDMAN

Hope, Lugenia Burns (February 19, 1871–August 14, 1947), reformer. Lugenia Burns Hope was one of the key members of a group of southern African-American activists in the late nineteenth and early twentieth centuries. Burns, born in St. Louis, Mo., came from a line of free black Mississippians on both sides. She grew up in Chicago and was educated in the public schools. She also studied art at the Chicago School of Design and the Chicago Art Institute. As a young woman, Burns bore the responsibility of supporting her family when her siblings were out of work. It was during this period that she became involved in reform work as a paid worker. She also became acquainted with the pioneering settlement work of Chicago's Hull House.

In 1897, Lugenia Burns married John HOPE, a college professor. Within a year, John Hope accepted a teaching position at his alma mater, Atlanta Baptist College (later Morehouse College). In Atlanta, Hope blossomed as an activist, focusing on the needs of black children in Atlanta. Her concern with children's issues became sharpened through the birth of the Hopes' two children, Edward and John.

In 1908 she was a driving force in the founding of the Neighborhood Union, with which she remained active until 1935. Hope was also active in the work of the YWCA in the South and was a vocal opponent of the segregationist policies of the organization in this period. She was also a prominent member of the National Association of Colored Women, the National Council of Negro Women, and the International Council of Women of the Darker Races.

After her husband's death in 1936, Hope moved to New York City, where she continued to be involved in reform organizations. During this period she worked as an assistant to Mary McLeod BETHUNE, then with the National Youth Administration. Hope was not able to continue with her demanding schedule through the 1940s as her health began to fail. Lugenia Burns Hope, dedicated activist for equality, died in 1947 after a long and influential career.

REFERENCE

ROUSE, JACQUELINE A. *Lugenia Burns Hope: A Black Southern Reformer.* Athens, Ga., 1989.

JUDITH WEISENFELD

Hopkins, Lightnin' (Sam) (March 15, 1912–January 30, 1982), blues guitarist and singer. Sam Hopkins was born in Centerville, Tex., and worked in cotton fields as a child. He also played guitar, inspired by a 1920 meeting with "Blind" Lemon JEF-FERSON. During the late 1920s and 1930s Hopkins lived near his birthplace, working on a farm and performing at parties, picnics, and clubs. After his marriage in 1942 to Antoinette Charles, he worked on a farm near Dallas. Hopkins had been playing guitar and singing BLUES for more than two decades before he became a professional musician in 1946. He then worked in clubs around Houston, and made his first recordings that year in Houston and Hollywood, Calif. with his cousin, the singer Texas Alexander, and the pianist "Thunder" Smith. It was in short-lived duos with Smith that Hopkins adopted the name Lightnin'. Over the next few years Hopkins made several hit recordings, including "Short-Haired Woman" (1947), "Big Mama Jump" (1947), and "Baby, Please Don't Go" (1948). During this time he made a precarious living, and reportedly spent time in the penitentiary at Big Brazos. In general Hopkins performed unaccompanied, on acoustic guitar, although he did occasionally record with electric ensembles.

In the 1950s and 1960s Hopkins gained a huge following as the last of the great country bluesmen. His harsh voice, accompanied by a piercing solo style and boogie-woogie rhythms made him one of the most frequently recorded bluesmen of the postwar era. Among his hundreds of recordings were "Coffee Blues" (1950), "Policy Game" (1953), "Lonesome in Your Home" (1964), and dozens of albums, including *Lightnin' in New York* (1960), *Goin' Away* (1963), and *Move On Out* (1965–1969). In the 1960s Hopkins was embraced by the FOLK MUSIC scene, and he played at numerous clubs, concert halls, and folk festivals. In 1968 he appeared in the documentary *The Blues According to Lightnin' Hopkins,* and he recorded the soundtracks for *Blue Like Showers of Rain* (1970) and *Sounder* (1972). In the 1970s Hopkins was in constant demand for concerts and recordings internationally. His last major appearance was at Carnegie Hall in 1979. Hopkins died three years later from cancer.

REFERENCES

BLANK, LES. "Lightnin' Hopkins, 1912–1982." *Living Blues* 53 (Summer-Autumn 1982): 15.

HOLT, JOHN, and PAUL OLIVER. *Lightnin' Hopkins Story and Discography.* London, 1965.

JONATHAN GILL

Hopkins, Pauline Elizabeth (1859–August 13, 1930), writer. Born in Portland, Me., in 1859, Pauline Hopkins and her family settled in Boston, Mass. At the age of fifteen, she won a contest with her essay

"Evils of Intemperance and Their Remedies." In 1879, she completed her first play, *Slaves' Escape, or The Underground Railroad*. This musical drama was produced the following year by the Hopkins' Colored Troubadours. Hopkins was an actress and singer in the production and became known as "Boston's favorite soprano."

During the early 1890s, Hopkins pursued a profession in stenography. She passed the civil service exam and was employed for four years at the Bureau of Statistics, where she worked on the Massachusetts Decennial Census of 1895. In May 1900 Hopkins's literary career was launched with the founding of *The Colored American* magazine by the Colored Cooperative Publishing Company (CCPC). The premiere issue published Hopkins's short story "The Mystery Within Us."

Throughout the life of *The Colored American* (1900–1909), Hopkins had six other short stories featured and three novels serialized. It was during *The Colored American*'s first year of publication that the CCPC also released her first and best remembered novel, *Contending Forces: A Romance Illustrative of Negro Life North and South*. Her writing, reflective of the historical conditions and cultural images of her day, advocated racial justice and the advancement of African-American women.

A frequent contributor to *The Colored American*, Hopkins was employed as an editor. She also helped increase circulation by creating the Colored American League in Boston. Twenty prominent African-American citizens were organized to generate subscriptions and business. During 1904, she raised additional support by lecturing throughout the country. By September, she left the magazine, apparently because of an affliction with neuritis. She continued writing, and her sociocultural survey series, "The Dark Races of the Twentieth Century," was featured in *Voice of the Negro* in 1905.

Hopkins's last published literary work, "Topsy Templeton," appeared in *New Era* magazine in 1916. Returning to stenography, she was employed at the Massachusetts Institute of Technology until August 1930. She died on August 13, 1930, when her bandages, worn to relieve her painful illness, accidentally caught fire.

REFERENCES

SHOCKLEY, ANN ALLEN. "Pauline Elizabeth Hopkins: A Biographical Excursion into Obscurity." *Phylon* 33 (1972): 22–26.

TATE, CLAUDIA. "Pauline Hopkins: Our Literary Foremother." In Marjorie Pryse and Hortense J. Spillers, eds. *Conjuring: Black Women, Fiction, and Literary Tradition*. Bloomington, Ind., 1985.

JANE SUNG-EE BAI

Horn, Rosa Artimus (1880–1976), minister. Affectionately called "Mother," Rosa Artimus Horn was best known for her radio program, the *You, Pray for Me Church of the Air*, which reached listeners as far as one thousand miles away from her Harlem-based congregation. Mother Horn began her ministry in Evanston, Ill., where she was also a clothing designer. She moved to New York City in 1926, believing that God had sent her there to "establish true holiness." She began her work in Brooklyn, holding revivals and faith-healing meetings, with many reports of conversions and miracles.

Her following was interracial and intercultural, attracting members of the Italian and Jewish communities as well as African Americans and people from the Caribbean. In 1929 she became the founder and first bishop of the Pentecostal Faith Church for All Nations, also known as the Mount Calvary Pentecostal Faith Church. The following year, after a summer-long preaching and healing crusade in Harlem, she established a church at 392-400 Lenox Avenue, fondly referred to by long-standing members as "Old 400."

In 1934, Horn began her radio broadcasting. The *You, Pray for Me Church of the Air* reached audiences as far away as Tennessee, Massachusetts, and the Caribbean. In the New York metropolitan area, many joined Mother Horn's church after having heard the broadcasts of her services from "Old 400." She did not confine her outreach to the masses of poor during the depression to radio messages. With personal funds, she leased a house at the corner of 132nd Street and Madison Avenue and had it renovated as a shelter and soup kitchen for the hungry and homeless. Called the Gleaners' Aid Home, Mother Horn's facility provided breakfast and dinner for thousands, and housed many women and children. She also took great interest in the adolescent and young-adult populations, offering them alternatives to street life through religion and hard work.

During World War II, Mother Horn's church, consistent with the majority of African-American Pentecostal groups of the time, encouraged young men to register as conscientious objectors. She went to local draft boards to ensure that her young ministers were not drafted. Burdened by their plight, she decided to create work for them that would be approved by the federal government as an alternative to military service. She secured farmland near her birthplace of Sumter, S.C., and there personally trained young men in farming. The produce was sold to local supermarkets and hospitals.

During the 1950s and 1960s, Mount Calvary sponsored a mission home for the poor in Los Angeles. Mother Horn's ministry also included foreign missions in the Dominican Republic and the Bahamas.

She expanded her youth work in 1962 when the church purchased a camp in the Catskills. Named the Bethel Sunshine Camp, the forty-acre facility provided summer recreation and religious instruction for youth from poor communities.

She was assisted in the development of these ministries by her natural daughter, Jessie Artimus Horn, who succeeded Mother Horn as presiding bishop upon her death in 1976, and by an adopted daughter, Gladys Brandhagen, who succeeded her adopted sister in 1981. Bishop Brandhagen, a woman of Norwegian ancestry, had become part of Mother Horn's movement in Evanston, after her father's conversion under Mother Horn's ministry. The Pentecostal Faith Church reports some twenty-two churches with an estimated membership of 1,200.

REFERENCES

FISHER, MILES MARK. "Organized Religion and the Cults." *Crisis* (January 1937): 8–10.

FRAZIER, E. FRANKLIN. *The Negro Church in America.* New York, 1964, 1973.

RASKY, FRANK. "Harlem's Religious Zealots." *Tomorrow* (November 1949): 11–17.

HAROLD DEAN TRULEAR

Horne, Frank Smith (August 18, 1899–September 7, 1974), poet, optometrist, and public servant. Frank Smith Horne was born and raised in Brooklyn, N.Y. He graduated from the City College of New York in 1921 and received his master's degree from the University of Southern California in Los Angeles. He later earned a doctor of optometry degree from the Northern Illinois College of Ophthalmology and Otology in 1923.

As a practicing optometrist in New York City, Horne wrote and published a book review in the journal OPPORTUNITY in 1924, and soon made his mark as a writer. His reputation as a poet was established by a sequence of prize-winning poems, "Letters Found Near a Suicide," published in CRISIS magazine (1925) under the pseudonym of Xavier I, which was awarded a prize in the Amy Spingarn Contest in Literature and Art. In 1929, Horne added seven other related poems; eventually the entire series appeared in *Haverstraw* (1963), a volume of his collected verse. Unlike most other HARLEM RENAISSANCE poets, his work focused less on racial identity and more on themes of death, illness, and the crisis of faith. In 1927, he gave up his practice in New York and moved to Georgia. At Fort Valley High and Industrial School, he taught, coached the track team, and later became dean and acting president.

In 1936, Horne began a new career in minority housing, an area in which he became an authority. For the next two years he worked under Mary McLeod BETHUNE as assistant director of Negro affairs at the National Youth Administration in Washington, D.C. In 1938, he began working at the U.S. Housing Authority, where he served in various positions in the Office of Race Relations. Through his work with the Housing Authority, Horne became a key member of President Franklin D. Roosevelt's "Black Cabinet," advising government officials on racism and inequities in public housing, project planning, labor employment in housing construction, management policies, and public relations. Horne advocated an open housing market and believed that the federal government should use its power to end racial and economic segregation in both public and private housing. In 1955, the Eisenhower administration attempted to reorganize the Housing Authority to bring the Office of Race Relations into closer political harmony with the White House, which opposed strong antidiscrimination policies. In the process, Horne's position was eliminated.

Horne was named executive director of the New York City Commission on Intergroup Relations in 1956, where he was instrumental in passing the country's first law prohibiting discrimination in the general housing market in 1957. Under the New York City Commission, Horne proposed an "Open City Housing Project" to develop integrated neighborhoods and end housing discrimination by government agencies, banks, mortgage brokers, and real-estate agents. Horne joined the New York City Housing Redevelopment Board in 1962 and was a founder of the National Committee Against Discrimination in Housing. He died in New York City in 1974.

REFERENCE

Dictionary of Literary Biography, Vol. 51. *Afro-American Writers From the Harlem Renaissance to 1940.* New York, 1987.

PAM NADASEN

Horne, Lena (June 30, 1917–), singer and actress. Born in New York, Lena Horne accompanied her mother on a tour of the Lafayette Stock Players as a child and appeared in a production of *Madame X* when she was six years old. She received her musical education in the preparatory school of Fort Valley College, Ga. and in the public schools of Brooklyn. Horne began her career at the age of sixteen as a dancer in the chorus line at the COTTON CLUB in Harlem. She also became a favorite at Harlem's

APOLLO THEATRE, and was among the first African-American entertainers to perform in "high-class" nightclubs. Appearing on stages and ballrooms from the Fairmont in San Francisco to the Empire Room at the Waldorf-Astoria in New York, Horne was among the group of black stars—including Sammy DAVIS, Jr., Eartha KITT, and Diahann CARROLL—who had musicals especially fashioned for them on Broadway.

Horne made her first recording in 1936 with Noble SISSLE and recorded extensively as a soloist and with others. She toured widely in the United States and Europe. In 1941 she became the first black performer to sign a contract with a major studio (MGM). Her first film role was in *Panama Hattie* (1942), which led to roles in *Cabin in the Sky* (1942), *Stormy Weather* (1943), *I Dood It* (1943), *Thousands Cheer* (1943), *Broadway Rhythm* (1944), *Two Girls and a Sailor* (1944), *Ziegfeld Follies of 1945* and *1946*, *The Duchess of Idaho* (1950), and *The Wiz* (1978). Horne was blacklisted during the McCarthy era of the early 1950s, when her friendship with Paul ROBESON, her interracial marriage, and her interest in African freedom movements made her politically suspect. Her

Lena Horne, whose career as an entertainer began at Harlem's Cotton Club in the early 1930s, in a 1981 publicity photograph for her successful one-woman Broadway show *Lena Horne: The Lady and Her Music*. (AP/Wide World Photos)

Broadway musicals include *Blackbirds of 1939*, *Jamaica* (1957), and the successful one-woman Broadway show *Lena Horne: The Lady and Her Music* (1981). The record album of the latter musical won her a Grammy Award as best female pop vocalist in 1981.

Horne's spectacular beauty and sultry voice helped to make her the first nationally celebrated black female vocalist. Her powerful and expressive voice is perhaps captured best in the title song of *Stormy Weather*. In 1984 she was a recipient of the Kennedy Center honors for lifetime achievement in the arts. She published two autobiographies: *In Person: Lena Horne* (1950) and *Lena* (1965).

REFERENCE

BUCKLEY, GAIL LUMET. *The Hornes: An American Family*. New York, 1986.

JAMES E. MUMFORD

Horse Racing. African Americans were significantly involved in professional horse racing from the sport's introduction into the United States in the mid-seventeenth century until the early twentieth century, when black jockeys and trainers were systematically driven out of the profession.

As the sport spread through the colonial South, where members of the gentry sought to emulate the pursuits of their English counterparts, slaves were most often used to train and race horses. In the colonial North racehorse owners usually imported English jockeys or hired local whites to tend the stables and ride in races. Horse racing was also popular in the United States among nonelites in the eighteenth and nineteenth centuries, with poor whites, free blacks, and even slaves participating in low-stakes races at rural social gatherings. Horse racing's increasingly black milieu contributed to its reputation as a sport of "the rabble." The Maryland General Assembly passed a law in 1747 "to prevent certain Evils and Inconveniences attending the sale of strong Liquors, and running of Horse-Races, near the yearly Meetings of the People called Quakers, and to prevent the tumultuous Concourse of Negroes and other Slaves during the said Meetings."

During the first half of the nineteenth century, however, black jockeys and trainers were increasingly hired by northern owners, and by the end of the CIVIL WAR, African Americans dominated the sport throughout the United States. In 1866, at the first Jerome Handicap at Jerome Park in what is now New York City, a black rider named Abe Hawkins won on a horse named Watson. Hawkins went on to win the third Travers Stakes at Saratoga Springs,

N.Y., in 1866 aboard a horse called Merritt. Oliver Lewis, a black jockey, rode Aristides to victory in the first Kentucky Derby, held in 1875 at Churchill Downs in Louisville. The predominance of African Americans in the sport was particularly evident that day; fourteen of the fifteen horses in the field were ridden by black jockeys. African Americans won fifteen of the first twenty-eight runnings of the Kentucky Derby.

Several black jockeys were among the sport's most prominent figures in the late nineteenth century. The leading jockey in the late 1870s was William "Billy" Walker, an African-American rider who, in 1877, won the Kentucky Derby and Dixie Handicap. Walker rode Ten Broeck—a Dutch name—to victory over Molly McCarthy in the famous 1878 Match Race in Louisville, which became the subject of the black folk song and later bluegrass standard "Molly and Ten Brooks." Isaac MURPHY, who was born a slave in Kentucky, won a remarkable 44 percent of his races, including three Kentucky Derby victories (1884, 1890, 1891), in a career that spanned the years 1878 to 1891. Murphy was widely considered the greatest jockey of his generation and was perhaps the most successful and best-known black athlete of the nineteenth century. Two other exceptional black jockeys in this period were Willie Simms and James "Soup" Perkins. Simms won the Kentucky Derby twice (1896, 1898), the Latonia Derby (1896), the Belmont Stakes twice (1893, 1894), and the Second Special four times (1892, 1894, 1895, 1897). Simms was the all-time money winner for black jockeys, with lifetime earnings of more than $300,000. Perkins, who rode five winners in one day at the age of thirteen, in one two-year period won the Kentucky Derby (1895), the Clark Handicap (1895), the Tennessee Oaks (1896), and the St. Louis Derby (1896).

Black trainers were also quite successful in the late nineteenth century. Black Kentucky Derby–winning trainers included Edward "Brown Dick" Brown with Baden-Baden in 1877, William Bird with Buchanan in 1884, and Alex Perry with Joe Cotton in 1885.

At elite horse racing venues, African Americans were generally excluded from owning racehorses, but a prominent exception to this rule was Robert James Harlan (1816–1897), the businessman, civil rights leader, and the mulatto half brother of U.S. Supreme Court Justice John Marshall Harlan. Robert Harlan owned a stable of racehorses in pre–Civil War Cincinnati and was said to be the only black owner allowed to enter horses in races in southern cities.

Jimmy Winkfield, who was among the last great African-American jockeys, left the United States for Europe when a racist backlash forced blacks from the

Isaac Murphy, the most successful jockey of his era, was a three-time winner of the Kentucky Derby. He won on more than 40 percent of his mounts during his career. (Prints and Photographs Division, Library of Congress)

sport in the first two decades of the twentieth century. Before he was driven from racing in the United States, however, Winkfield established himself as a top jockey, winning both the 1901 and 1902 Kentucky Derbies, the last to be won by a black jockey.

The wave of antiblack discrimination that profoundly altered the face of horse racing began in the 1890s, when white jockeys began to systematically harass and bully their successful black counterparts, often purposely fouling them during races and forcing their horses to stumble and even fall. The discrimination took an official form in 1894 with the establishment of the Jockey Club, which licensed riders but systematically denied the sanctioning of African Americans. By the 1920s only a few black jockeys were still eking out careers. Jess Conley was the last black jockey in the Kentucky Derby, finishing third aboard Colston in 1911. Among the remaining black jockeys in this period was Canada LEE, the actor and boxer, who raced on major tracks in New York State from 1921 to 1923 at the beginning

of his career. Black trainers also found the environment too hostile to continue and virtually vanished from the sport.

Many black jockeys and trainers turned to steeplechase racing, an obstacle-course event where the demand for competent professionals was such that discrimination was not as great as in traditional "flat track" racing. Through the 1920s and '30s several black jockeys rose to prominence as steeplechasers, including Charlie Smoot, who won several prestigious steeplechase races.

Since the early part of the twentieth century, only a handful of African Americans have maintained careers as jockeys and trainers and none have risen to prominence. In the 1940s, '50s, and '60s such riders as Hosea Lee Richardson, Robert McCurdy, and Al Brown managed to gain mounts at large tracks but never appeared in a major stakes race. Louis Durousseau, a Louisiana Cajun, was the most successful black jockey after World War II, winning more than $100,000 per year in the 1960s. Since the 1960s black jockeys have had a minimal presence in a profession dominated by whites and Latinos. In the 1980s and

'90s, however, a number of wealthy African Americans, including singer Barry White, record executive Berry GORDY, Jr., and the rapper Hammer have invested in racehorses.

REFERENCES

ASHE, ARTHUR R., JR. *A Hard Road to Glory: A History of the African-American Athlete, 1619–1918.* New York, 1988.

BETTS, JOHN RICKARDS. *America's Sporting Heritage: 1850–1950.* Reading, Mass., 1974.

PARMER, CHARLES. *For Gold and Glory.* New York, 1939.

THADDEUS RUSSELL

Jimmy Winkfield. (Photographs and Prints Division, Schomburg Center for Research in Black Culture, The New York Public Library, Astor, Lenox and Tilden Foundations)

Horton, George Moses (c. 1797–c. 1883), poet. George Moses Horton was born a slave on a farm in Northampton County, N.C. When he was six years old, his master moved to Chatham County, near the University of North Carolina. At an early age, Norton began to compose poems based on biblical themes. Although Horton taught himself to read, he did not learn to write until he was in his thirties. Horton probably made his initial contact with university students while peddling produce from his master's farm. Soon he was peddling dictated poems—acrostics and love poems written to order. By paying a regular fee to his master for the privilege, he was, eventually, permitted to work as a janitor at the university.

Horton's reading was augmented as university students provided him with books, and he received formal writing instruction from Caroline Lee Hentz, the Massachusetts-born wife of a literature professor and novelist, who was instrumental in his initial publication. Horton sought to purchase his freedom; his two antebellum collections were made specifically, though unsuccessfully, toward that end. With the help of southern friends, *Hope of Liberty* (1829) was published to raise "by subscription, a sum sufficient for his emancipation, upon the condition of his going in the vessel which shall first afterwards sail for Liberia." *Poetical Works of George Moses Horton, the Colored Bard of North Carolina* (1845) was underwritten by the president, faculty, and students of the University of North Carolina. His last and largest collection, *Naked Genius* (1865), was published with the assistance of Capt. Will Banks, whom Horton met when he fled to the Union Army in Raleigh (April 1865).

Horton is regarded as "the first professional black poet in America," and it is certainly the case that he wrote for money. His poetry clearly reveals a con-

scious craftsmanship. The heavy influence of his early exposure to Wesleyan hymnal stanzas and his fondness for Byron are evident, but Horton's work shows variety in stanzaic structure, tone, and theme. Although Horton's contemporary local reputation rested largely on his love poems, he addressed a wide variety of topics, including religion, nature, death, and poetry. Historical events and figures associated with the CIVIL WAR appear in the last volume, as do some rather misogynistic poems, seen as evidence of an unhappy marriage. Horton's dominant tone is sentimental, plaintive, or pious, but his work exhibits irony, satire, humor, bitterness, and anger as well.

In spite of the circumstances of his publication that discouraged direct abolitionist poems, some of Horton's most effective poems treat the devastating experience of slavery, e.g., "on Liberty and Slavery," "Slavery," "The Slave's Complaint."

Little is known about Horton's later years except that after Emancipation he moved to Philadelphia, where some sources report he wrote short stories for church magazines and where he is thought to have died.

REFERENCE

SHERMAN, JOAN. "George Moses Horton." *Invisible Poets: Afro-Americans of the Nineteenth Century,* 2nd ed. Urbana, Ill., 1989, pp. 5–20.

QUANDRA PRETTYMAN

Hosier, Harry "Black Harry" (c. 1750–1806), preacher. Harry Hosier, who in later years was frequently referred to as "Black Harry," was born in slavery around 1750 near Fayetteville, N.C. After being manumitted, he converted to METHODISM and became the first African-American Methodist preacher. For most of his career (1780s–1800s) he served as the traveling companion, servant, guide, and copreacher of the itinerant white Methodist Bishop Francis Asbury. Known to his colleagues for his lucid intelligence, remarkable recall, and, most importantly, his inspired preaching, Hosier halted his own education for fear that his growing ability to read and write interfered with the Lord speaking through him. Audiences from South Carolina to New England, Methodist and non-Methodist, applauded Hosier's gift for preaching. Prominent preachers of the day, such as Richard Whatcoat and Freeborn Garrettson, knew that if Hosier took the pulpit with them, they would draw a larger crowd.

In 1784 Hosier accompanied John Wesley's English representative, Bishop Thomas Coke, nominated by Wesley to be superintendent of the Meth-odist Church in North America, on an orientation tour of some 800 to 1,000 miles around Pennsylvania, Delaware, and Maryland. After their journey, Coke wrote in his journal that Hosier was one of the "best preachers in the world." Hosier was present at the historic 1784 Christmas Conference at Lovely Lane Chapel in Baltimore, and participated in the founding of the Methodist Episcopal Church in America.

From 1789 to 1790 Hosier traveled and preached north along the Hudson River with Garrettson. He then continued on to speak throughout New England (records indicate that when in Boston he stayed with Prince HALL, the founder of African-American masonry). In 1803 Asbury assigned Hosier to the Trenton Circuit. In his later years, Hosier had bouts with alcoholism, though this resulted in only a short leave from his preaching duties. He died of natural causes in Philadelphia in May 1806.

REFERENCES

ABBEY, MERRILL. *The Epic of United Methodist Preaching: A Profile in American Social History.* New York, 1984, pp. 30–31.
HARMON, NOLAN R., ed. *The Encyclopedia of World Methodism.* Vol. 1. 1974, pp. 1157–1158.

PETER SCHILLING

Hospitals, Black. Black hospitals have been of three broad types: segregated, black-controlled, and demographically determined. Segregated black hospitals included facilities established by whites to serve blacks exclusively, and they operated predominantly in the South. Black-controlled facilities were founded by black physicians, fraternal organizations, and churches. Changes in population led to the development of demographically determined hospitals. As was the case with Harlem Hospital, they gradually evolved into black institutions because of a rise in black populations surrounding the hospitals. Historically black hospitals—the previously segregated and the black-controlled hospitals—are the focus of this article.

Until the advent of the civil rights movement, racial customs and mores severely restricted black access to most hospitals. Hospitals—both in the South and in the North—either denied African Americans admission, or accommodated them, almost universally, in segregated wards, often placed in undesirable locations such as unheated attics and damp basements. The desire to provide at least some hospital care for black people prompted the establishment of the earliest segregated black hospitals. Geor-

gia Infirmary, established in Savannah in 1832, was the first such facility. By the end of the nineteenth century, several others had been founded, including Raleigh's St. Agnes Hospital in 1896 and Atlanta's MacVicar Infirmary in 1900. The motives behind their creation varied. Some white founders expressed a genuine, if paternalistic, interest in supplying health care to black people and offering training opportunities to black health professionals. However, white self-interest was also at work. The germ theory of disease, widely accepted by the end of the nineteenth century, acknowledged that "germs have no color line." Thus the theory mandated attention to the medical problems of African Americans, especially those whose proximity to whites threatened to spread disease.

Following the precedent set by other ethnic groups, African Americans themselves founded hospitals to meet the particular needs of their communities. Provident Hospital, the first black-controlled hospital, opened its doors in 1891. The racially discriminatory policies of Chicago nursing schools provided the primary impetus for the establishment of the institution. In addition, the hospital proved beneficial to black physicians, who were likewise barred from Chicago hospitals. Several other black-controlled hospitals opened during the last decade of the nineteenth century. These included Tuskegee Institute and Nurse Training School at Tuskegee Institute, Ala., in 1892; Provident Hospital at Baltimore, in 1894; and Frederick Douglass Memorial Hospital and Training School at Philadelphia, in 1895. The establishment of these institutions also represented, in part, the institutionalization of Booker T. WASHINGTON's political ideology. These hospitals would advance racial uplift by improving the health status of African Americans and by contributing to the development of a black professional class.

By 1919 approximately 118 segregated and black-controlled hospitals existed, 75 percent of them in the South. Most were small, ill-equipped facilities that lacked clinical training programs. Consequently, they were inadequately prepared to survive sweeping changes in scientific medicine, hospital technology, and hospital standardization that had begun to take place at the turn of the century.

The most crucial issue faced by the historically black hospitals between 1920 and 1945 was whether they could withstand the new developments in medicine. In the early 1920s, a group of physicians associated primarily with the National Medical Association (NMA), a black medical society, and the NATIONAL HOSPITAL ASSOCIATION (NHA), a black hospital organization, launched a reform movement to ensure the survival of at least a few quality black hospitals. The leaders of these organizations feared that the growing importance of accreditation and standardization would lead to the elimination of black hospitals and with it the demise of the black medical profession. For most African-American physicians, black hospitals offered the only places in which they could train and practice.

The NMA and NHA engaged in various activities to improve the quality of black hospitals, including the provision of technical assistance and the publication of educational materials. They also worked to raise funds for black hospitals. But funds were not readily forthcoming. Indeed, the depression forced all hospitals to grapple with the problem of financing. However, three philanthropies, the Julius Rosenwald Fund, the General Education Board, and the Duke Endowment, responded to the plight of black hospitals and provided crucial financial support.

The activities of the black hospital reformers and the dollars of white philanthropists produced some improvements in black hospitals by World War II. One prominent black physician hailed these changes as the "Negro Hospital Renaissance." This, however, was an overly optimistic assessment. The renaissance was limited to but a few hospitals. In 1923, approximately 200 historically black hospitals operated. Only six provided internships, and not one had a residency program. By 1944, the number of hospitals had decreased to 124. The AMA now approved nine of the facilities for internships and seven for residencies; the American College of Surgeons fully approved twenty-three, an undistinguished record at best. Moreover, the quality of some approved hospitals was suspect. Representatives of the American Medical Association freely admitted that a number of these hospitals would not have been approved except for the need to supply at least some internship opportunities for black physicians. This attitude reflected the then accepted practice of educating and treating black people in separate, and not necessarily equal, facilities.

The growth of the civil rights movement also played a key role in limiting the scope of black hospital reform. In the years after World War II, the energies of black medical organizations, even those that had previously supported separate black hospitals, shifted toward the dismantlement of the "Negro medical ghetto" of which black hospitals were a major component. Their protests between 1945 and 1965 posed new challenges for the historically black hospitals and called into question their very existence.

The NMA and the NAACP led the campaign for medical civil rights. They maintained that a segregated health care system resulted in the delivery of inferior medical care to black Americans. The organizations charged that the poorly financed facilities of the black medical ghetto could not adequately meet

(Top) Most black hospitals in the early twentieth century were relatively small, such as St. Luke's Colored Hospital in Marlin, Tex. (Bottom) Often underfunded and overcrowded, Harlem Hospital has been a vitally important provider of health care to its population for most of the twentieth century. (Photographs and Prints Division, Schomburg Center for Research in Black Culture, The New York Public Library, Astor, Lenox and Tilden Foundations)

Provident Hospital, opened in 1891, was the first hospital established by African Americans. It and other black voluntary hospitals have provided crucial medical services to a population frequently without adequate medical access. (Prints and Photographs Division, Library of Congress)

the health and professional needs of black people and rejected the establishment of additional ones to remedy the problem. Instead, the NMA and the NAACP called for the integration of existing hospitals and the building of interracial hospitals.

Legal action was a key weapon in the battle to desegregate hospitals. Armed with the precedent set by the Supreme Court ruling in BROWN V. BOARD OF EDUCATION OF TOPEKA, KANSAS, the medical civil rights activists began a judicial assault on hospital segregation. *Simkins* v. *Moses H. Cone Memorial Hospital* proved to be the pivotal case. The 1963 decision found the separate-but-equal clause of the Hill-Burton Act unconstitutional. The 1946 legislation provided federal monies for hospital construction. The Simkins decision represented a significant victory in the battle for hospital integration. It extended the principles of the Brown decision to hospitals, including those not publicly owned and operated. Its authority, however, was limited to those hospitals that received Hill-Burton funds. A 1964 federal court decision, *Eaton* v. *Grubbs,* broadened the prohibitions against racial discrimination to include voluntary hospitals that did not receive such funds.

The 1964 Civil Rights Act supplemented these judicial mandates and prohibited racial discrimination in any programs that received federal assistance. The 1965 passage of the Medicare and Medicaid legislation made most hospitals potential recipients of federal funds. Thus, they would be obligated to comply with federal civil rights legislation.

The predominant social role of the historically black hospitals before 1965 had been to provide medical care and professional training for black people within a segregated society. The adoption of integration as a societal goal has had an adverse effect on the institutions. Civil rights legislation increased the access of African Americans to previously white institutions. Consequently, black hospitals faced an ironic dilemma. They now competed with hospitals that had once discriminated against black patients and staff. In the years since the end of legally sanctioned racial segregation, the number of historically black hospitals has sharply declined. In 1944, 124 black hospitals operated. By 1990 the number had decreased to eight and for several of them the future looks grim.

Desegregation resulted in an exodus of physicians and patients from black hospitals. Where white physicians had once used these facilities to admit and treat their black patients, they abruptly cut their ties. Furthermore, since 1965, black physicians have gained access to the mainstream medical profession and black hospitals have become less crucial to their careers. This loss of physician support contributed to declines in both patient admissions and revenues at many black hospitals. As a result of changing physician referral practices and housing patterns, black hospitals have also lost many of their middle class patients. They have become facilities that treat, for the most part, poor people who are uninsured or on Medicaid. This pattern of decreased physician support, reduced patient occupancy, and diminished patient revenues forced many black hospitals to close after 1965. It also makes the few surviving institutions highly vulnerable.

The historically black hospitals have had a significant impact on the lives of African Americans. Originally created to provide health care and education within a segregated society, they evolved to become symbols of black pride and achievement. They supplied medical care, provided training opportunities, and contributed to the development of a black professional class. The hospitals were once crucial for the survival of African Americans. They have now become peripheral to the lives of most Americans and are on the brink of extinction.

REFERENCES

COBB, W. MONTAGUE. "Medical Care and the Plight of the Negro." *Crisis* 54 (1947): 201–211.

DOWNING, L. C. "Early Negro Hospitals." *Journal of the National Medical Association* 33 (1941): 13–18.

GAMBLE, VANESSA NORTHINGTON. *The Black Community Hospital: Contemporary Dilemmas in Historical Perspective.* New York, 1989.

———. "The Negro Hospital Renaissance: The Black Hospital Movement." In Diana E. Long and Janet Golden, eds., *The American General Hospital.* Ithaca, N.Y., 1989, pp. 182–205.

Julius Rosenwald Fund. *Negro Hospitals: A Compilation of Available Statistics.* Chicago, 1931.

KENNEY, JOHN A. "The Negro Hospital Renaissance." *Journal of the National Medical Association* 22 (1930): 109–112.

PAYNE, LARAH D. "Survival of Black Hospitals in the U.S. Health Care System: A Case Study." In Lennox S. Yearwood, ed. *Black Organizations: Issues on Survival Techniques.* Lanham, Md., 1980, pp. 205–211.

TARAVELLA, STEVE. "Black Hospitals Struggle to Survive." *Modern Healthcare* 20 (July 2, 1990): 20–26.

VANESSA NORTHINGTON GAMBLE

Hospital Workers Local 1199. See Local 1199: Drug, Hospital, and Health Care Employees Union.

House, Son (James, Eddie, Jr.) (March 21, 1902–October 18, 1988), blues singer and guitarist. Born in Lyon, Miss., Son House sang in church choirs as a child in Louisiana and began to preach at age fifteen. Returning to Mississippi in his mid-twenties, he became interested in the BLUES and took up the guitar. In 1930, House began a partnership with Charley Patton and Willie Brown, recording and working with them for the next decade. He was involved in a Library of Congress field-recording project in 1941, recording both solo and with a small string band. He retired from music in 1942 and moved to Rochester, N.Y.

House was rediscovered in the mid-1960s and began recording and performing again throughout the United States and Europe. Increasingly poor health forced his retirement in 1974 to Detroit, where he remained for the rest of his life. House supported his moaning, declamatory vocals with a guitar style that featured a driving bass rhythm underneath wailing bottleneck slide figures, representing the epitome of first-generation Delta blues.

REFERENCES

OBRECHT, JAS. "Requiem for Son House." *Guitar Player* 23, no. 1 (January 1989): 15.

OLIVER, PAUL. "Son House 1902–88." *Popular Music* 8, no. 2 (1989): 195–196.

DANIEL THOM

Housing Discrimination. The increasing urbanization of African Americans in the early twentieth century brought a dramatic increase in residential segregation. Initially regulated by social custom, residential segregation became increasingly institutional in nature as structural inequalities were built into local and federal housing policies and the housing market.

In response to black urbanization, southern cities, where blacks often migrated first, implemented a range of JIM CROW legislation to ensure racial separation. The first racial zoning ordinance was passed in Baltimore in 1910 in response to the movement of a black lawyer into an all-white neighborhood. Cities in Virginia, Georgia, and North Carolina, and South Carolina quickly followed suit. Zoning restrictions remained a predominantly southern and border state phenomenon, with Louisville, St. Louis, and New Orleans passing ordinances from 1913 to 1916, though Oklahoma City also passed a zoning ordinance during this period.

The NATIONAL ASSOCIATION FOR THE ADVANCEMENT OF COLORED PEOPLE (NAACP) led the legal battle against such residential restrictions, challenging a 1914 Louisville ordinance that prohibited blacks from residing in white sections of the city. This challenge culminated in the 1917 U.S. Supreme Court decision, *Buchanan* v. *Warley,* which ruled against racial zoning ordinances as violations of the Fourteenth Amendment. Subsequent attempts by cities, almost all of them southern, to resurrect these zoning restrictions were struck down by the courts. The Supreme Court's decision, however, did nothing to bar private acts of discrimination; property owners and real estate brokers simply turned to racially restrictive covenants made as private contractual agreements to prevent blacks and other racial and ethnic minorities from moving into all-white neighborhoods. In contrast to its earlier decision regarding zoning ordinances, the Supreme Court upheld the constitutionality of these restrictive covenants in *Corrigan* v. *Buckley* (1926).

Perhaps even more powerful than these legal restrictions in maintaining residential segregation were the informal, unspoken practices that operated alongside them. Local real estate boards acted as gatekeepers who restricted property ownership in certain neighborhoods to whites. In 1924, the president of the National Association of Real Estate Boards

(NAREB) drafted a model restrictive covenant for use by local boards. He also added to the NAREB code of ethics an amendment prohibiting the entry into a neighborhood of "members of any race or nationality" who would threaten property values. In addition, property owners often took it upon themselves to protect their neighborhoods from outsiders by forming their own associations and even by using violence. In Chicago, fifty-eight homes owned by blacks in "fringe areas" were bombed between 1917 and 1921.

Residential segregation by race accelerated rapidly as a result of depression-era legislation designed to stimulate the building and construction industries. In 1932, President Herbert Hoover passed two largely ineffective acts, the Federal Home Loan Bank Act and the Emergency Relief Construction Act, in an attempt to revitalize the building industry and to provide low-cost housing. It was not until 1933 and the formation of the Home Owners Loan Corporation (HOLC), signed into law by President Franklin D. Roosevelt, that substantial investment in the building industry was made. HOLC offered low-interest loans and refinanced thousands of mortgages in an effort to promote home ownership. It also provided home buyers with a system for paying their mortgages over an extended period of time and created the first formal, uniform system for appraising real estate.

To determine eligibility for federal assistance, HOLC established a rating system that placed neighborhoods in one of four categories—A, B, C, or D, each associated with a color code, ranging from green to red—based on the quality of existing housing in the area. Neighborhoods that had physically deteriorated were labeled as category D, and because HOLC considered physical deterioration to be both the cause and effect of a nonwhite residential population, black neighborhoods were automatically "redlined"—or assigned with a D status. Neighborhoods then were labeled, along with the appropriate color code, on residential security maps, which were placed in city survey files. Through this process, socioeconomic characteristics of the residents rather than the physical structure of the neighborhood became the primary determinant for the value of a neighborhood's housing stock.

HOLC, although responsible for establishing this system of appraisal, did not base its loan decisions strictly upon these guidelines, and it continued to make loans in declining and deteriorated neighborhoods. It was the Federal Housing Authority (FHA), established under the National Housing Act of 1934, that widely implemented HOLC's system of redlining, using HOLC's categories as the basis for loan eligibility. Also designed to encourage housing construction, the FHA was set up to insure long-term mortgage loans made by private lenders. Property appraisals were a mandatory first step in determining eligibility, and the FHA allowed for personal bias among its appraisers for all-white subdivisions. The FHA Underwriting Manual discouraged integrated housing and supported residential zoning as a means to stabilize property values in the areas where it had insured loans.

The housing shortage following World War II created an unprecedented demand for housing construction, and the FHA stepped in to fill the void. In its commitment to acquire low-risk loans, however, the FHA continued to support zoning restrictions that would ensure "neighborhood character," thus giving its support to racial and ethnic segregation. The FHA redlined huge sections of the urban landscape, inhabited primarily by African Americans, and either refused to guarantee mortgage loans or charged exorbitant interest rates and down payments in these areas. The majority of federal funds were directed into newly developed suburbs, where the FHA encouraged racially restrictive covenants to ensure residential homogeneity and prevent racial violence and declining property values. FHA lending practices essentially subsidized white flight from the city.

Led by the NAACP, blacks began to challenge the legality of racially restrictive covenants in the 1940s. The President's Committee on Civil Rights supported the NAACP's challenge, and the Justice Department filed an *amicus curiae* (friend of the court) brief on behalf of the NAACP. In *Shelley* v. *Kraemer* (1948), the U.S. Supreme Court ruled in favor of the NAACP, declaring restrictive covenants "unenforceable as law." This decision, however, did not outlaw covenants per se, and it did not rule against other forms of discrimination. Covenants thus were still used informally, and the FHA continued to advocate their use until 1950. Although the FHA eventually agreed after this date to oppose mortgages in neighborhoods with racially restrictive convenants, it continued to accept unwritten agreements until 1968. From 1946 to 1959, less than 2 percent of the housing constructed with FHA mortgages was made available to blacks.

While white Americans fled the city, encouraged and aided by generous government mortgage policies, black Americans were left to the increasingly abandoned inner cities. Recognizing the growing need for urban housing and the possibility for urban redevelopment in the postwar period, cities and states began their own programs of urban renewal and the construction of racially segregated public housing. The federal government followed the lead of state and local governments, passing the United States Housing Act (the Wagner-Steagall Act) in 1937. This act, representing the first government initiative to

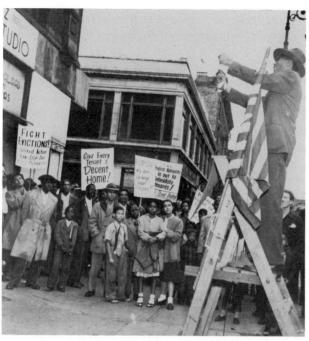

Though the 1930s and '40s public housing projects were at first seen as a solution to the rampant overcrowding and inadequate housing stock in black neighborhoods, all too often they soon became part of the problem. Depicted here is a demonstration against New York City's Housing Authority. (Photographs and Prints Division, Schomburg Center for Research in Black Culture, The New York Public Library, Astor, Lenox and Tilden Foundations)

accept permanent responsibility for constructing low-cost housing, supported public housing by providing federal funding for local housing agencies. The Housing Act of 1949 reinforced the local initiative for public housing by requiring communities to request federal assistance to receive funding. The Housing Act did not forbid discrimination in these projects, and it did not favor placing those displaced by its slum-clearance projects, thus accelerating the residential segregation begun in state and local public housing projects.

In addition, the federal projects rarely created adequate housing units for all of those removed from areas designated for redevelopment. Slum clearance was thus frequently used to free inner-city land for private development and raze black neighborhoods that threatened white propertied interests. When urban renewal projects did make provisions for additional housing units, they frequently resegregated tenants into high-rise buildings in densely populated sections of the inner city. The Federal Housing Act of 1954 reinforced these policies, using urban renewal as a means to control the city's racial geography and permit redevelopment only in certain sections of cities.

Carried by the momentum of the CIVIL RIGHTS MOVEMENT, fair-housing legislation began to attract national attention during the 1960 presidential campaign. After his election, President John F. Kennedy appointed Robert WEAVER as the first black director of the U.S. Housing Agency, and in 1962, Kennedy signed Executive Order 11603, requiring all federal agencies to take any necessary action to prevent discrimination in federally supported housing and in all institutions handling housing loans insured by the U.S. government. This order, however, was rarely enforced by federal housing officials, and the FHA refused to abide by its provisions when making loans.

While significant advances were made in other areas of civil rights legislation, neighborhood segregation proved to be extremely resistant to change. Civil rights groups renewed the battle for passage of a law prohibiting racial discrimination in housing, and in 1965, the establishment of the Department of Housing and Urban Development (HUD), designed to coordinate housing-subsidy programs, offer credit insurance, and provide public housing, placed housing issues at a cabinet-level position. Specific legislation concerning racial discrimination in the housing market, however, proved more difficult to pass. Whites who may have been willing to permit desegregation of the workplace and in public accommodations continued to resist the idea of integrated housing. However, after publication of the Kerner Commission's report in March 1968, which condemned residential segregation as a critical component in problems associated with urban racial violence, Congress finally adopted a compromise bill in February 1968.

The Fair Housing Act of 1968 made it unlawful to refuse to rent or sell a home to any person because of race; it prohibited racial discrimination in the terms of property rental or sale; it banned discrimination in real estate advertising, and it prevented agents from obstructing property purchase by blacks and from making statements about the predicted racial composition of a neighborhood to promote panic selling—a practice commonly referred to as "blockbusting." Although committed to a goal of open housing, the act suffered from its lack of enforcement provisions. HUD had no way to force compliance with the law, to assess damages, to grant a remedy, to penalize the violator, or to prevent discriminatory practices from recurring. In addition, HUD could investigate only the complaints brought to its attention by victims of discrimination, thus leaving the fight against this form of institutional racism to individual efforts.

The lack of a centralized system for making complaints about housing conditions made the restrictions outlined by the Fair Housing Act of 1968 difficult to enforce. Since housing remained primar-

ily in the hands of individuals, racial bias in the housing market persisted. The Fair Housing Act of 1968 had other shortcomings as well. Sections 235 and 236 removed the FHA's traditional role of supplementing conventional lending and charged the agency with subsidizing interest rates and maintaining low down payments. As a result, evidence of FHA activity assumed negative connotations: Its involvement in a neighborhood appeared as a signal to others that this was an unsound area in which to make loans.

During the 1970s, efforts were made to eliminate the racial bias in federal housing policies. In 1974, Congress passed the Equal Credit Opportunity Act to prohibit discrimination in home lending, and it required banks to compile information on the race of its applicants. As of 1976, however, the federal banking system still had not established a system for collecting racial data, and shortly after it finally was implemented, two of the three federal agencies covered under its provisions ceased operations. Two other pieces of legislation, the Home Mortgage Disclosure Act (1976) and the Community Reinvestment Act (1977) were passed during the 1970s to strengthen anti-redlining laws. Most of these federal provisions, however, remained largely unenforceable until 1979, when HUD implemented a program to monitor compliance with its regulations.

Other government legislation of the 1970s had a more clearly negative impact on minority neighborhoods. The Federal National Mortgage Association (Fannie Mae), established in 1970, and the Government National Mortgage Association (Ginnie Mae), created in 1968, were designed to facilitate the transfer of funds across the country to provide mortgage funds to the neighborhoods where they were most needed. In practice, however, they were used to channel funds into expanding middle-class suburbs in the South and West at the expense of inner-city neighborhoods in the Northeast. In addition, Section 8 of the Housing Act of 1974, signed into law by President Richard Nixon, redefined the federal role in public housing. The government moved from a builder of low-income housing to a facilitator, providing tax incentives and other mechanisms to the private sector to lower rents for low-income households. The government, in effect, retreated from the aggressive stance it had taken in the 1960s and placed increasing responsibility for housing upon private industry.

Problems with racial discrimination in the housing market remained obvious throughout the 1980s. Under President Ronald Reagan, HUD lost much of its already limited ability to detect housing discrimination, and local realtors were relieved of responsibility for enforcing the provisions of the Fair Housing Act. As a result, the number of cases prosecuted under the Fair Housing Act dropped dramatically during the Reagan administration. Amid mounting dissatisfaction over Reagan's housing record and increasing evidence of discrimination in federal lending policies, Congress passed the Fair Housing Amendments Act of 1988, which remedied the principal flaws of the 1968 Fair Housing Act. The responsibility for bringing complaints was shifted from individual victims, and HUD's powers of enforcement were significantly strengthened. As part of the Financial Institutions Reform, Recovery, and Enforcement Act of 1989 (FIRREA), an Affordable Housing Program was created within the Federal Home Loan Bank to provide funds to lenders helping to finance low-income housing projects.

Despite these improvements, problems with housing discrimination remained serious into the 1990s. A Federal Reserve Bank study released in 1991 showed that 34 percent of the blacks requesting loans were rejected; the comparable figure for whites was only 14 percent. And a study by the federal government found that large brokerage bankers, one of the largest group of home lenders in the 1990s, rejected black applicants twice as often as whites. Part of the problem is that mortgage banking, which rapidly expanded in the 1980s, was not covered by the same fair-lending regulations that the Community Reinvestment Act (CRA) applied to commercial banks and thrifts in the late 1970s. Steps have been taken to remedy these discrepancies, and by 1994, Congress had proposed to end the exemption of mortgage banks and credit unions from fair-lending legislation.

FHA loans continue to be the most widely available option to prospective African-American home owners, but these loans are often problematic. They have a high default rate due to careless lending and marginal borrowers, and an FHA property in foreclosure frequently sits vacant for years before it clears administrative red tape. These boarded-up homes erode property values in the neighborhood, perpetuating the housing crisis of the inner city.

African Americans have been responsible throughout the years for lodging complaints against racially discriminatory housing practices, but they have taken a renewed initiative in recent years to attract federal aid to their communities. Community-based action and civil rights groups have been crucial in fighting disinvestment by the private sector and discrimination within the real estate industry by initiating a program of community reinvestment.

National People's Action (NPA), established in 1972 by a coalition of community-based organizations from white, minority, and racially changing neighborhoods, has tried to focus national attention upon redlining policies by using direct-action techniques to single out discriminatory lenders and gov-

ernment agencies. NPA and similar groups such as the Association of Community Organizations for Reform Now (ACORN) have local chapters across the nation that are devoted to reinvestment in inner-city neighborhoods. These community-based organizations, assisted by legal and civil rights groups such as the NAACP and the National Urban League, attempt to form partnerships with the government and the private sector to eliminate discrimination in lending practices.

In recent years, these reinvestment groups have combined efforts with Community Development Corporations (CDCs). Originally funded through government support—until the Reagan administration cut funds in the 1980s—CDCs focus on new community development in low- and moderate-income housing projects. By working together, CDCs and reinvestment groups have been able to pool their resources and combine development with reinvestment, expanding into the areas of economic and job development in minority neighborhoods. In the absence of federal intervention in the housing market on their behalf, individual African Americans and, more recently, community-based action groups have had to carry the burden for acquiring and enforcing fair-housing legislation.

REFERENCES

HIRSCH, ARNOLD, ed. *Urban Policy in Twentieth Century America*. New Brunswick, N.J., 1993.

JACKSON, KENNETH. *Crabgrass Frontier: The Suburbanization of the United States*. New York, 1985.

KATZ, MICHAEL, ed. *The "Underclass" Debate: Views from History*. Princeton, N.J., 1993.

KING, RALPH T., JR. "Some Mortgage Firms Neglect Black Areas More Than Banks Do." *The Wall Street Journal*, August 9, 1994, pp. 1, 6.

MASSEY, DOUGLAS S. and NANCY A. DENTON. *American Apartheid: Segregation and the Making of the Underclass*. Cambridge, Mass., 1993.

LOUISE P. MAXWELL

Houston, Charles Hamilton (September 3, 1895–April 22, 1950), lawyer. Born in the District of Columbia the son of William L. Houston, a government worker who attended Howard University Law School and became a lawyer, and Mary Hamilton Houston, a teacher who later worked as a hairdresser, Charles Hamilton Houston attended Washington's M Street High School, and then went to Amherst College in Amherst, Mass. He graduated Phi Beta Kappa in 1915, then taught English for two years at Howard University. In 1917, Houston joined the Army and served as a second lieutenant in a segregated unit of the American Expeditionary Forces during World War I. Following his discharge, he decided on a career in law and entered Harvard Law School. Houston was the first African-American editor of the *Harvard Law Review*. He received an LL.B. degree cum laude (1922) and an S.J.D. degree (1923). He received the Sheldon Fellowship for further study in civil law at the University of Madrid (1923–1924).

In 1924, Houston was admitted to the Washington, D.C. bar, and he entered law practice with his father at Houston & Houston in Washington, D.C. (later Houston & Hastie, then Houston, Bryant, and Gardner), where he handled domestic relations, negligence, and personal injury cases, as well as criminal law cases involving civil rights matters. He remained with the firm until his death. Throughout his career, Houston served on numerous committees and organizations, including the Washington Board of Education, the National Bar Association, the National Lawyers Guild, and the American Council on Race Relations. He also wrote columns on racial and international issues for the CRISIS and the BALTIMORE AFRO-AMERICAN. In 1932, he was a delegate to the NAACP's second Amenia Conference.

In 1927 and 1928, after receiving a grant from the Rockefeller Foundation, Houston wrote an important report, "The Negro and His Contact with the Administration of Law." The next year, he was appointed vice dean at Howard University, where he served as professor of law and as head of the law school. He transformed the law program into a full-day curriculum that was approved by both the American Bar Association and the Association of American Law Schools. Houston mentored such students as Thurgood MARSHALL, William Bryant, and Oliver Hill. Under his direction, Howard Law School became a unique training ground for African-American lawyers to challenge segregation through the legal system.

In 1935, Houston took a leave of absence from Howard to become the first full-time, salaried special counsel of the NAACP. As special counsel, Houston argued civil rights cases and traveled to many different areas of the United States, sometimes under trying conditions, in order to defend blacks who stood accused of crimes. He won two important Supreme Court cases, *Hollins v. Oklahoma* (1935) and *Hale v. Kentucky* (1938), which overturned death sentences given by juries from which blacks had been excluded because of their race.

Houston persuaded the joint committee of the NAACP and the philanthropic American Fund for Public Service to support an unrelenting but incremental legal struggle against segregation, with public education as the main area of challenge. In 1896, the U.S. Supreme Court had ruled in PLESSY V. FER-

In 1935 Charles H. Houston, former dean of the Howard University Law School, became the first full-time counsel to the NAACP. There he began to implement the careful strategy of challenging legal segregation that culminated, twenty years later, in the 1954 decision in *Brown* v. *Board of Education of Topeka, Kansas.* (UPI/Bettmann)

GUSON that "separate but equal" segregated facilities were constitutional. Houston realized that a direct assault on the decision would fail, and he designed a strategy of litigation of test cases, and slow buildup of successful precedents based on inequality within segregation. He focused on combatting discrimination in graduate education, a less controversial area than discrimination in primary schools, as the first step in his battle in the courts. *University of Maryland* v. *Murray* was his first victory, and an important psychological triumph. The Maryland Supreme Court ordered Donald Murray, an African American, admitted to the University of Maryland Law School, since there were no law schools for blacks in the state. Two years later, Houston successfully argued *Missouri ex rel. Gaines* v. *Canada* in the Supreme Court. The Court ordered Lloyd Gaines admitted to the University of Missouri, which had no black graduate school, ruling that scholarships to out-of-state schools did not constitute equal admission. In 1938, suffering from tuberculosis and heart problems,

Houston resigned as chief counsel, and two years later he left the NAACP. However, he remained a prime adviser over the next decade through his membership on the NAACP Legal Committee. His position as special counsel was taken over by his former student and deputy Thurgood Marshall, who formed the NAACP Legal Defense and Education Fund, Inc. (LDF) to continue the struggle Houston had begun. Their endeavor culminated with the famous 1954 Supreme Court decision BROWN V. BOARD OF EDUCATION OF TOPEKA, KANSAS, which overturned school segregation. Houston remained active in the effort. Shortly before his death, he initiated *Bolling* v. *Sharpe* (1954), a school desegregation suit in Washington, D.C., which later became one of the school cases the Supreme Court decided in *Brown.*

In 1940, Houston became general counsel of the International Association of Railway Employees and of the Association of Colored Railway Trainmen and Locomotive Firemen. Houston and his co-counsel investigated complaints of unfair labor practices and litigated grievances. Houston successfully argued two cases, *Steele* v. *Louisville & Nashville Railroad* and *Tunstall* v. *Brotherhood of Locomotive Firemen and Enginemen,* involving racial discrimination in the selection of bargaining agents under the Railway Labor Act of 1934. Houston also worked as an attorney for hearings of the President's Fair Employment Practices Committee (FEPC). Appointed to the FEPC in 1944, he dramatically resigned in December 1945 in protest over President Truman's refusal to issue an order banning discrimination by Washington's Capital Transit Authority, and of the committee's imminent demise.

In the late 1940s, Houston led a group of civil rights lawyers in bringing suit against housing discrimination. He helped draft the brief for the LDF's Supreme Court case *Shelley* v. *Kramer,* and argued a companion case, *Hurd* v. *Hodge,* in which the Supreme Court barred enforcement of racially restrictive covenants in leases.

In 1948, Houston suffered a heart attack, and he died of a coronary occlusion two years later. He received the NAACP's SPINGARN MEDAL posthumously in 1950. In 1958, Howard University named its new main law school building in his honor.

REFERENCES

KLUGER, RICHARD. *Simple Justice.* New York, 1975.
McNEIL, GENNA RAE. " 'To Meet the Group Needs': The Transformation of Howard University School of Law, 1920–1935." In V. P. Franklin and James D. Anderson, eds. *New Perspectives on Black Educational History.* Boston, 1978, pp. 149–172.
———. *Groundwork: Charles Hamilton Houston and the Struggle for Civil Rights.* Philadelphia, Pa., 1983.

ROWAN, CARL. *Dream Makers, Dream Breakers: The World of Justice Thurgood Marshall.* Boston, 1993.

SEGAL, GERALDINE. *In Any Fight Some Fall.* Rockville, Md., 1975.

TUSHNET, MARK V. *The NAACP's Legal Strategy Against Segregated Education, 1925–1950.* Chapel Hill, N.C., 1987.

GENNA RAE MCNEIL

Houston, Texas. Houston, long a center of African-American life in Texas, boasts one of the nation's largest black populations. African Americans have been resident there from the city's very beginnings—slaves, with Mexican prisoners, cleared land for the settlement in 1836. Their numbers grew with the city, such that by 1860 the over 1,000 slaves and handful of free blacks composed 22 percent of Houston's population. Houston's early fortunes were based not on manufacture but on commerce—particularly the marketing of crops grown by African-American labor elsewhere in Texas—and slaves not employed in domestic service often worked as teamsters, dock workers, for merchants, or in road or railway building. Authorities imposed curfews and outlawed slaves hiring their own time or living apart from their masters, but contemporaries reported a relative laxity in the enforcement of such controls. SLAVERY survived in Houston until 1865, the city remaining in Confederate hands throughout the CIVIL WAR.

Following emancipation, rural freedpeople flocked to Houston, looking for nonagricultural employment, schools, and safety in numbers. The African-American population more than tripled between 1860 and 1870, peaking at nearly 40 percent of total population (3,691 out of 9,382). Black people resided in significant numbers in all the city's wards, though they often gathered in certain districts like the fourth ward's "Freedmantown," southwest of the business district. Black churches, such as Trinity Methodist Episcopal and Antioch Baptist, played a particularly important role in the early building of this free community.

An important coastal railroad hub, Houston thrived in the post–Civil War decades as a center of Texas's expanding cotton, timber, and grain trade. For the most part, however, African Americans were relegated to the least remunerative work—domestic and service positions or unskilled or semiskilled labor in commerce and transport. Nevertheless, freedpeople exercised considerable political leverage during RECONSTRUCTION. Aided by a mobilized black constituency, Republicans controlled the city through 1873. Black Houstonians served on the city council,

as city officials, and in the state legislature, the most prominent among them being businessman and former slave Richard ALLEN.

After Reconstruction ended, African Americans continued to vote and participate in politics, but the growing numbers and power of Democrats at the state and local levels, and the dispersal of the minority black population throughout the city, prevented them from winning office. The imposition of a state poll tax after the turn of the century, the barring of black voting in crucial Democratic primaries, at-large systems of representation, and the exclusion of blacks from Republican party leadership reduced their influence still further. At the same time, state, then local, segregation ordinances expanded and institutionalized the separation of the races. The 1903 segregation of Houston streetcars prompted a black boycott, but in 1907 the city authorized more extensive discrimination in public accommodations. JIM CROW in Houston bore bitter fruit in 1917, when black soldiers of the 24th Infantry, maddened by mistreatment at the hands of local police and citizens, rioted, murdering over a dozen whites (*see* HOUSTON, 1917).

As segregation hardened, the city itself was being transformed by the nearby discovery of oil in 1901 and by the completion, thirteen years later, of a ship channel making Houston a deep water port. Already a bustling entrepôt, Houston became a center for the refining and marketing of petroleum and related products. Its size and wealth would multiply steadily in the following decades. As total population boomed, African Americans became a smaller portion of the whole (e.g., slightly over 20 percent of city residents in 1930—63,377 out of 292,352). Yet blacks moved to Houston in great numbers, particularly from rural Texas and Louisiana, to work for the railroads, on the docks, in the oil and cotton trade, and in service occupations. Increasingly segregated black neighborhoods expanded in the fourth ward, near downtown, and in the third and fifth wards, to the southeast and northeast respectively. Many of them lacked paved streets, indoor plumbing, and other basic amenities, indicating not only neglect on the part of the city but also that the jobs a booming economy provided black workers were, typically, not well paid. In the newer industries, as in the old, African Americans in 1940 remained clustered in less skilled positions. In spite of such circumstances, though, Houston's African Americans built a distinctly vibrant urban community. They supported a large number of service and retail businesses, black newspapers such as Clifton Richardson and Carter Wesley's *Houston Informer,* a college, founded in 1927 which grew into Texas Southern University, and such legendary cultural figures as bluesman Lightnin' HOPKINS.

Houston's progress in civil rights paralleled that of the South as a whole. A local chapter of the NATIONAL ASSOCIATION FOR THE ADVANCEMENT OF COLORED PEOPLE had been formed as early as 1912, and black Houstonians had been active in the organization's litigation against the white primary and segregation in graduate education. By the 1950s, however, attention focused on public schools. Desegregation efforts mandated by federal courts began in the early 1960s, slowly and by no means thoroughly integrating schools over the course of the following twenty years (the growth of the white population in suburban districts and the continued concentration of black citizens within the city limits inevitably restricted this process). Though certain city facilities had been desegregated in the 1950s, lunch counter SIT-INS by local black college students in 1960 signaled a broader assault on discrimination in public accommodations. Black political participation had expanded after the Supreme Court's striking down of the white primary in 1944. Activists formed the Harris County Council of Organizations in 1949 to organize the black community politically as well as to challenge discrimination in its many forms. By 1958, a black woman, Hattie Mae White, had been elected to the city's school board. But only the 1965 VOTING RIGHTS ACT, the federally mandated end to the poll tax, redistricting, the creation of single-member legislative districts, and voter registration drives would allow black Houstonians, after a hiatus of nearly 100 years, to be elected to the state legislature in 1966 and to the city council in 1971. In 1972, Houston's Barbara JORDAN became the first Texan of African descent elected to the U.S. Congress. She would be succeeded there by Mickey Leland, then Craig Washington. In 1991, an African American, state representative Sylvester Turner, garnered 46 percent of the vote in a mayoral runoff, his loss attributed to his failure to win a majority of the steadily growing Hispanic vote.

In the same decades, the black population—beginning to grow more quickly than the city as a whole—multiplied several times over, reaching 458,000 (28.1 percent) in 1990. In the 1970s, no other city in the former Confederate states had a larger or faster growing African-American community. During these boom years, increasing numbers of black Houstonians found employ in white-collar and skilled professions. Yet substantive gains coexisted with lingering disparities. While faring better in terms of income and employment than black workers in many other southern cities, African Americans in 1980 were significantly less well paid and more likely to be jobless than "Anglo" Houstonians. They remained disproportionately concentrated in lower-paying service and blue-collar jobs and in impoverished, predominantly black, central city neighborhoods. The black community particularly suffered when the collapse of oil prices ravaged Houston's economy in the 1980s, unemployment far exceeding even the unusually high rates among whites. Preliminary 1990 figures suggested that black population growth had slowed as a result, though greater Houston remained among the nation's top ten metropolitan areas in numbers of African Americans.

REFERENCES

BEETH, HOWARD, and CARY WINTZ. *Black Dixie: Afro-Texan History and Culture in Houston*. College Station, Tex., 1992.

BULLARD, ROBERT. *Invisible Houston: The Black Experience in Boom and Bust*. College Station, Tex., 1987.

McCOMB, DAVID. *Houston: A History*. Austin, Tex., 1981.

WINTZ, CARY. "Blacks." In Fred R. von der Mehden, ed. *The Ethnic Groups of Houston*. Houston, 1984.

———. "The Emergence of a Black Neighborhood: Houston's Fourth Ward, 1865–1915." In Char Miller and Heywood Sanders, eds. *Urban Texas: Politics and Development*. College Station, Tex., 1990.

PATRICK G. WILLIAMS

Houston, 1917. In August 1917 about one hundred black soldiers of the Twenty-fourth Infantry retaliated against the racial discrimination they had faced in Houston, Tex. The result was the death of fifteen Texans and four soldiers and the eventual hanging of nineteen soldiers. The event shaped the Army's actions toward African-American soldiers for a decade.

The hostile racial climate in Houston in 1917 was a constant reminder to African Americans of their secondary status. When a battalion of the Twenty-fourth Infantry arrived in Houston in July 1917, the soldiers resented the racial epithets of whites working on a nearby National Guard camp, the segregation on the local streetcar lines, and the violence the police used against them. Many of the older black noncommissioned officers, who might have added steadiness in the tense situation, had left the battalion to perform other duties as the Army expanded to war strength. Among the battalion's white officers, there was little understanding of the tension that existed among their enlisted men, and their influence over the men's behavior was limited.

On August 23, 1917, an incident involving the police triggered off the pent-up anger of the soldiers.

After a violent confrontation between the black 24th Infantry and local Houston residents in August 1917, sixty-four soldiers were tried in a court-martial that resulted in the hanging of thirteen and lifetime imprisonment for forty others. (Photographs and Prints Division, Schomburg Center for Research in Black Culture, The New York Public Library, Astor, Lenox and Tilden Foundations)

When two black soldiers protested the beating of a black woman, they themselves were pistol-whipped and then arrested for interfering with the police. Tension ran high among the battalion. Attempts to prevent any retaliation, including getting the arrested soldiers away from the police and restricting the unit to the camp, were unsuccessful. About one hundred soldiers, including some of the black noncommissioned officers, armed themselves and headed into town to retaliate against any policeman they encountered. During the next two hours the soldiers shot and killed a number of individuals who looked like police officers, including a white National Guard officer. They attacked the police station where the two black soldiers had been taken. Four mutineers died, including one shot inadvertently by the soldiers themselves. Following the rampage, they returned to the camp.

The response of the Army was to move the troops to Columbus, N.M., and then begin a detailed investigation. Army officials were able to narrow their search down enough so that they could charge sixty-three soldiers with mutiny and premeditated murder. The first court-martial, held in San Antonio, Tex., in early December 1917, found fifty-four of the men guilty of both crimes. Most of them were sentenced to prison terms, but thirteen were ordered to be hanged.

Though normally such convictions would have included the opportunity to appeal the sentences, this did not occur. The records of the convictions reached the judge advocate general's office weeks after the hangings were carried out. African Americans were outraged and protested vehemently about the injustice of the proceedings.

During the next several months, two more courts-martial occurred against other members of the battalion. The second trial involved fifteen men who were accused of leaving their guard posts to participate in the mob action. Ten were sentenced to prison terms and five were ordered executed for desertion and murder. Several weeks later, in March 1918, forty more men were tried. Eleven were sentenced to be hanged, two were acquitted, and the remainder received prison terms. In the end, only six soldiers from the two later courts-martial were hanged.

The soldiers imprisoned as a result of the riot became a cause for the NAACP, which complained that the government had been discriminatory in their punishment. The Army slowly responded, reducing some sentences and granting releases to others. However, not until 1938 were the last of the Houston soldiers released from prison.

Many in the Army concluded that the incident made clear the problems caused by the presence of African Americans in the Army. Civil rights organizations and the black community, on the other hand, saw in the punishment meted out a glaring example of the double standard of justice in the military.

REFERENCES

HAYNES, ROBERT V. *A Night of Violence: The Houston Riot of 1917*. Baton Rogue, La., 1976.
NALTY, BERNARD C. *Strength for the Fight: A History of Black Americans in the Military*. New York, 1986.

MARVIN E. FLETCHER

Howard, Ethel. *See* Waters, Ethel.

Howard University. In December 1866, a group of Congregationalists in Washington, D.C., proposed establishing the Howard Normal and Theological Institute for the Education of Teachers and Preachers to train ministers and educators for work among newly freed slaves. After receiving some support and funding, Howard University was chartered on March 2, 1867, and given the mission of establishing a university "for the education of youth in the liberal arts and sciences."

Howard received its name from Gen. Oliver Otis Howard, head of the Freedmen's Bureau. Gen. Howard, along with several other Civil War generals and U.S. congressmen, was largely responsible for the organization of the university and its campaign to secure an annual appropriation for its maintenance from Congress. Despite substantial federal funding, Howard was governed by a privately selected board of trustees and has always maintained its independent status. In keeping with its religious mission, the board of the university decreed that anyone chosen for any position in the university "be a member of some Evangelical church."

In the first years of Howard University's operation, very few African Americans were involved in its administration or on the board of trustees. The first students enrolled at Howard, four or five young women, were also white; they graduated from the three-year Normal Department in 1870. George B. Vashon, the first black faculty member at Howard, taught in a short-lived evening school in 1867–1868. One of the first black female leaders at Howard was Martha B. Briggs (1873–1879, 1883–1889). At first an instructor in the Normal Department, Briggs would become principal of the department in 1883.

In 1868, the trustees created a Preparatory Department which served as preparation for entrance into undergraduate course work by ensuring a minimum level of achievement in basic subjects like reading and writing. They also added a collegiate department, which included a four-year curriculum; it would eventually become the mainstay of the university. In its inaugural year, the collegiate department only had one student and two professors. The first three graduates of the department received their degrees in 1872. One of the two blacks in this class, James Monroe Gregory, became a tutor in Latin and math; in 1876, he became a professor of Latin.

Several other departments rounded out the university in its early years. A medical department was established in 1868. Its first graduating class of five, in 1871, included two blacks. The nearby FREEDMEN'S HOSPITAL was invaluable for medical students and doctors who were often unable to secure medical privileges at other institutions. Charles Burleigh PURVIS, who worked virtually without compensation for

many years as a professor in the medical department, was largely responsible for guiding both the medical school and its students during his long career.

Under the tutelage of Dean John Mercer LANGSTON, a future congressman, the Law Department first enrolled students in the spring of 1869. It graduated its first class of ten in February 1871, including African-American John Cook, a future dean of the law school. An integral part of Howard from its founding, the theology department, opened officially in 1870, never used federal funds; instead, it relied upon contributions from the AMERICAN MISSIONARY ASSOCIATION, which was associated with the Congregational Church.

The university struggled financially for the first several years. Much of its original funding came from the Freedmen's Bureau, which provided capital for operation as well as money for the purchase of land and the construction of a campus. Before the bureau closed it channeled more than $500,000 to Howard, from 1867 until 1872. After the bureau's demise, the university received no additional federal funds until 1879, when Congress began granting Howard a small appropriation.

After several years, Howard's operations increased in scope. Between 1875 and 1889, more than 500 students received professional degrees in medicine, law, and theology, and almost 300 students received certificates from the normal, preparatory, and collegiate departments. The board of trustees also made efforts to expand and increase the African-American representation among its membership. In 1871, they appointed Frederick DOUGLASS to become a trustee; he served until his death in 1895. Several other blacks were named trustees in this period. Booker T. WASHINGTON became a trustee in 1907.

By 1900, Howard University had more than 700 students. Along with FISK and ATLANTA universities, Howard was one of the most prominent black academic colleges in the country. Under the administration of President Wilbur P. Thirkield (1906–1912), the university began to stress more industrial courses of study and the sciences. Howard established one of the first engineering programs at a predominantly black college; Howard's other science programs were also generally superior. The eminent biologist Ernest E. JUST (1907–1941), who taught at Howard for several decades, helped further develop Howard's reputation in the sciences.

Another leader at Howard—and one of the most important black educators in the early twentieth century—was Kelly MILLER. Miller, who served Howard in various capacities from 1890 to 1934, was dean of the College of Arts and Sciences from 1908 to 1919, fought for the introduction of courses on African-American life as early as the turn of the century.

Howard University. (Photographs and Prints Division, Schomburg Center for Research in Black Culture, The New York Public Library, Astor, Lenox and Tilden Foundations)

The 1920s was a decade of great growth and change. The high school that prepared students for entrance into Howard closed in 1920. Under the administration of President J. Stanley Durkee, the university budget grew from $121,937 in 1920 to $365,000, only five years later. Lucy Slowe Diggs (1922–1937) was the first dean of women at Howard; she helped to transform the role of female university officials to that of active administrators participating in shaping university policy. In 1925 students took part in a week-long strike for greater student participation in university policy-making and an end to mandatory chapel services. Another focus of student and intellectual agitation was the growing demand for the appointment of a black president to lead Howard. Mordecai W. JOHNSON, a Baptist minister, became Howard's first African-American president on September 1, 1926; he served until 1960.

In the 1920s and 1930s, Howard became a center of African-American intellectual life and attracted a brilliant faculty committed to finding new directions for black America. Many black scholars trained at Ivy League schools and other predominantly white institutions were unable to find employment other than in historically black colleges and universities (HBCUs). Howard attracted the cream of the crop.

One of the leading figures at Howard in the 1920s was philosopher Alain LOCKE (1912–1925, 1927–1954), popularizer of the NEW NEGRO movement. Several administration officials and faculty members urged the implementation of a curriculum that ex-

plicitly acknowledged the cultural accomplishments of African Americans. Kelly Miller had been doing so for years; William Leo Hansberry (1922–1959) became the first African-American scholar to offer comprehensive courses in the civilization and history of Africa in the 1920s.

The 1930s were a period of intellectual accomplishment at Howard, with a faculty that included the leading black scholars in the country. Led by political scientist Ralph J. BUNCHE (1928–1933), English professors Sterling BROWN (1929–1969) and Alphaeus HUNTON (1926–1943), sociologist E. Franklin FRAZIER (1934–1959), and economist Abram HARRIS, Jr. (1927–1945), the Howard faculty looked for ways to transcend the division between ACCOMMODATIONISM and BLACK NATIONALISM. While proud exponents of the distinctiveness of black culture, they often espoused industrial unionism and multiracial working class harmony, and were sensitive to the internal divisions and class differences within the black community. Historian Rayford LOGAN (1938–1982), largely responsible for strengthening the history department, wrote the most comprehensive history of Howard from its founding until its centennial. Logan also served the larger cause of African-American studies by producing the ground-breaking *Dictionary of American Negro Biography* (1982). The distinguished African-American pianist Hazel HARRISON (1936–1955) was one of the leading women faculty members of the period.

Charles H. HOUSTON (1929–1935), who helped to strengthen the curriculum at the law school and became one of the most important civil rights lawyers of the 1930s and 1940s, added to Howard's position as the best black law school in the country at the time. Under Houston's capable guidance, the law school strengthened its curriculum and received accreditation from the American Association of American Law Schools in late 1931. Graduates included Thurgood MARSHALL (1933), future justice of the U.S. Supreme Court.

The 1930s were also marked by administrative controversy. President Johnson came under harsh criticism from many who felt that his managerial style was heavy-handed and autocratic. Johnson had removed several administration officials and had fired several university employees. The alumni association criticized Johnson and the board of trustees as well, arguing that the alumni should have more of a voice in choosing trustees and constructing university policy.

Given their reliance on federal funds for operation, Howard officials were often held accountable by members of Congress for perceived ideological aberrations like socialism or communism. In the early 1940s, investigations into the activities of some fac-

The two most prominent leaders of the Student Non-violent Coordinating Committee (SNCC) during its militant nationalist period in the mid-1960s, Stokeley Carmichael (left) and H. Rap Brown (right), in conversation at Howard University, around 1967. (Moorland-Spingarn Research Center, Howard University)

ulty members, among them Alphaeus Hunton, by the House Committee on Un-American Activities (HUAC) brought unwanted attention to Howard. When another HUAC inquiry occurred in the early 1950s, President Mordecai Johnson did not attempt to derail the various investigations but declared his confidence that the faculty members being investigated would be vindicated; all were. The administration at Howard often urged moderation and discouraged university employees from making overtly political statements.

Several prominent black scholars taught at Howard during the 1940s and 1950s. Margaret Just

Butcher, daughter of biologist Ernest Just, taught English at Howard from 1945 until 1955; she collaborated with Alaine Locke on *The Negro in American Culture* (1956). Prominent civil rights leader Anna Arnold HEDGEMANN was dean of women from 1946 until 1948; she would later be instrumental in helping to plan the 1963 March on Washington. Mercer COOK (1927–1936, 1944–1960, 1966–1970), an influential translator of the Négritude poets, and the Afrocentrist Cheikh A. Diop, taught in the Department of Romance Languages for several generations.

While the 1950s was a time of relative quiet at Howard, the university experienced intellectual and political turmoil during the 1960s. In 1962, Vice President Lyndon B. Johnson spoke at the commencement; returning to Howard three years later, this time as president, Johnson renewed his pledge to struggle for equal rights for all and outlined the tenets of what would become his plans for the Great Society. Students vocally disrupted a 1967 speech by Gen. Lewis Hershey, director of the Selective Service System. They further disrupted campus operations in 1968 when students all over the country took part in demanding an end to the war in Vietnam. Howard students were also urging the implementation of a more radical curriculum. In 1969 Howard inaugurated its African-American Studies program.

President James M. NABRIT, Jr., one of the attorneys who crafted one of the briefs used to justify the decision by the U.S. Supreme Court to end segregation in the landmark 1954 BROWN V. BOARD OF EDUCATION OF TOPEKA, KANSAS, led Howard from 1960 until 1969, some of its most turbulent years. Notable faculty members included Patricia Roberts HARRIS (1961–1963, 1967–1969), who was an attorney, the first African-American woman to become an ambassador, and a professor in the Howard Law School for several years. Her tenure as the first black female dean of the law school, however, lasted only thirty days; outcry over student protests and conflicts with other university administrators compelled her to resign (1969).

In the mid-1980s, Howard was one of the first universities in the United States to initiate divestment from South Africa. Republican party chairman Lee Atwater resigned from the board of trustees in 1989 after protests by hundreds of students. Howard received more unfavorable publicity in early 1994 after the appearance on campus by former NATION OF ISLAM official Khalid Muhammad.

Howard has many notable facilities. The Moorland-Spingarn Center, one of the premier archival resources for studying African-American history and culture, had accumulated over 150,000 books and more than 400 manuscript collections. The center was a result of the donation of collections from

trustee Jesse MOORLAND in 1914 and NAACP official Arthur Spingarn in 1946; they included "books, pictures, and statuary on the Negro and on slavery." An art gallery includes an extensive African-American collection of painting, sculpture, and art. A university radio and television station sought to bring in revenue and offer a valuable educational service to the larger community of the District of Columbia. The Howard University Press has published more than 100 works since its inception in 1972. Howard University Hospital, a 500-bed teaching hospital, is responsible for, among other things, pioneering research by the Howard University Cancer Center and the Center for Sickle Cell Disease.

By the early 1990s the budget of the university was approximately $500 million, and the university employed more than 6,000 people. (In 1975 the budget was about $100 million.) Howard still receives more than 40 percent of its budget from the federal government. Its enrollment in 1993 stood at almost 12,000 students distributed among various colleges, programs, and institutes.

The future, however, holds uncertainty for Howard and other HBCUs. Howard has consistently dedicated itself to providing an intellectual haven for African Americans denied opportunities elsewhere. In 1963, the board of trustees promised that

> As a matter of history and tradition, Howard University accepts a special responsibility for the education of capable Negro students disadvantaged by the system of racial segregation and discrimination, and it will continue to do so as long as Negroes suffer these disabilities.

As bars against entry of blacks into primarily white universities have disappeared, a crisis has arisen for those schools which historically relied upon having the brightest African-American students and faculty. Partly to address this problem, Howard launched its Howard 2000 reorganization program in the early 1990s. Its goal was to help Howard remain fiscally and academically competitive into the next century.

REFERENCES

DYSON, WALTER. *Howard University, the Capstone of Negro Education: A History, 1867–1940.* Washington, D.C., 1941.

JANKEN, KENNETH ROBERT. *Rayford W. Logan and the Dilemma of the African-American Intellectual.* Amherst, Mass. 1993.

LEAVY, WALTER. "Howard University: A Unique Center of Excellence." *Ebony* 40 (September 1985): 140–142.

LOGAN, RAYFORD. *Howard University: The First Hundred Years, 1867–1967.* New York, 1969.

WOLTERS, RAYMOND. *The New Negro on Campus: Black College Rebellions in the 1920s.* Princeton, N.J., 1975.

ESME BHAN

Howlin' Wolf (Burnett, Chester Arthur)

(June 10, 1910–January 10, 1976), blues singer. Howlin' Chester Arthur Burnett was born in West Point, Miss. After moving to the Mississippi Delta, he began playing guitar as a teenager under the primary influence of Charley Patton, who lived on a nearby plantation. Burnett began performing in the late 1920s, traveling to various plantations throughout the South. In the 1930s he met Sonny Boy

Chicago bluesman Howlin' Wolf, who earned his nickname from his raw and feral singing showcased on recordings such as "Smokestack Lightning" and "Killin' Floor." (AP/Wide World Photos)

Williamson (Alex Miller), who taught him to play the harmonica. After serving in the Army during World War II, Howlin' Wolf relocated to West Memphis, Ark., where he worked as a disc jockey for WKEM radio and formed his first band, which began recording in 1951. Following the success of "Moanin' at Midnight" (Chess 1479), he was signed to an exclusive contract with Chess Records and relocated to Chicago, where he remained for the rest of his life. He continued to perform and record, touring the United States and Europe, helping to define the postwar Chicago blues style.

Throughout his career, Howlin' Wolf maintained the emotional directness and vitality of the country blues. Although originally a guitarist, he seldom recorded with the instrument; the guitar on his Chess recordings was handled primarily by Hubert Sumlin. Moans and high-pitched falsetto wails defined his vocal style, bringing an emotional urgency to his recordings. He died in Hines, Ill.

REFERENCE

OLIVER, PAUL. "Howlin' Wolf." *The New Grove Dictionary of American Music*. Vol. 2. New York, 1986, p. 436.

DANIEL THOM

Hubbard, William DeHart (November 25, 1903–June 23, 1976), athlete, public housing official. A native of Cincinnati, Ohio, William DeHart Hubbard enrolled at the University of Michigan in 1921. The following year he won the first of six consecutive Amateur Athletic Union (AAU) titles in the long jump. With his jump of 24'5⅛" at the 1924 Paris Olympiad, Hubbard became the first African American to win an Olympic gold medal. At the 1925 Intercollegiate American Amateur Athletic Association Championships in Chicago, his final competition as a Michigan undergraduate, he won the 100-yard dash with a time of 9.8 seconds, and set a world record in the long jump when he leaped 25'10⅞". After graduating from Michigan, Hubbard continued to compete, but because of injuries, he was unable to defend his Olympic title at the 1928 games in Amsterdam.

From 1926 to 1941, Hubbard worked for the Cincinnati Public Recreation Commission, supervising African-American athletic leagues. During those years he became involved with the Cincinnati Metropolitan Housing Authority. In 1942, he was named race-relations adviser to the Federal Public Housing Authority in Cleveland, Ohio, and beginning in 1947, he worked with the Federal Housing Authority

as a regional adviser on minority affairs. After an extended illness, he died on June 23, 1976. In 1979, Hubbard was elected to the National Track and Field Hall of Fame.

REFERENCES

Obituary. *New York Times*, June 25, 1976, p. A25.
PORTER, DAVID L., ed. *Biographical Dictionary of American Sports: Outdoor Sports*. Westport, Conn., 1988.

BENJAMIN K. SCOTT

Hudlin, Reginald (1963?–), screenwriter and director. Reginald Hudlin, who is reluctant to release information about his precise birthdate, was born and raised in East St. Louis, Ill. As a child, Hudlin attended Katherine DUNHAM's performance-arts training center in East St. Louis, where he received direct exposure to African artists, musicians, and dancers. This experience, according to Hudlin, was formative in focusing his attention upon cultural authenticity in his filmmaking.

Hudlin attended Harvard University and graduated with a B.A. in 1983. While at Harvard, Hudlin wrote a twenty-minute film, *House Party,* for his thesis film project. The film won the New England regional student Academy Award as best film and landed him a contract with Tri-Star Pictures for a feature-length production. With his brother, Warrington, as producer (*see also* Warrington HUDLIN), Reginald Hudlin released the full-length version of *House Party* in 1990. The film won the Filmmakers' Choice and the Cinematography awards that year at the Sundance United States Film Festival in Park City, Utah.

Hudlin is also known for two other half-hour films, *The Kold Waves,* a script he wrote in the summer of 1982 while attending Harvard, and *Reggie's World of Soul,* which he wrote and directed in 1985. In the late 1980s and 1990s he and his brother, Warrington, produced and directed a number of music videos for such hip-hop groups as Heavy D and the Boyz, and Guy and the Uptown Crew. In 1992 Hudlin directed *Boomerang,* starring Eddie MURPHY, a film produced by his brother and released by Paramount Pictures. That same year, he was the screenwriter and executive producer of *Bebe's Kids,* a full-length animated film featuring African-American characters.

Following these film successes, Hudlin signed a contract with Twentieth Century Fox to develop television pilots. In 1993 he wrote and directed two music videos for George CLINTON, *Paint the White*

House Black (nominated for an NAACP Image Award) and *Martial Law*.

REFERENCES

HUDLIN, REGINALD. "On 'Boomerang' and Issues of Black and White." *Los Angeles Times*, July 20, 1992, p. F3.

KANTOR, MICHAEL. "Tearing the Roof Off the Sucker: An Interview With Reginald and Warrington Hudlin." *Cineaste* 18 (1990): 22–23.

MILLS, DAVID. "Director Reginald Hudlin, Raising the Roof." *Washington Post*, March 9, 1990, p. D1, 3.

LOUISE P. MAXWELL

Hudlin, Warrington (1952?–), producer and director. Warrington Hudlin, who is reluctant to release information about his precise birthdate, was born and raised in East St. Louis, Ill. He attended the city's public schools, including an experimental high school that employed prominent African-American literary figures. In 1974 Hudlin graduated from Yale University with a B.A.

Hudlin's early inspiration for filmmaking came from a chance encounter with Gordon PARKS, Sr., whom he met in a theater lobby signing autographs after a screening of *Shaft* (1971), as well as from Melvin Van Peebles's *Sweet Sweetback's Baaaaadass Song* (1971). During his last year at Yale, Hudlin produced and directed a documentary entitled *Blacks at Yale*. In the late 1970s and 1980s Hudlin directed several independent films, including the acclaimed cinema verité, *Street Corner Stories* (1977).

After encountering difficulties finding a distributor for *Street Corner Stories*, Hudlin joined with two Yale classmates, George Cunningham and Alric Nembhard, to found a nonprofit organization, the Black Filmmakers Foundation, in 1978. Based in New York City, the organization provided administrative and networking support to black filmmakers and published a semiannual journal on black film, *Black Face*. The foundation distributed the early films of such notable black filmmakers as Spike LEE, Bill Duke, and John Singleton.

In 1986 Warrington and his brother, Reginald, became partners, forming the Hudlin Brothers, Inc. production company. Initially the company produced and directed music videos for such artists as Heavy D and the Boyz. In 1990 New Line Cinema released the popular feature length film, *House Party*, produced by Warrington, written and directed by Reginald, and starring the RAP performers Kid 'n' Play. The film, which also featured the music of LL Cool J. and Full Force, attempted to replicate the experiences of black teenagers growing up in urban America.

In July 1992, Paramount Pictures released *Boomerang*, produced and directed by the Hudlins and starring Eddie MURPHY. That year, the Hudlins also produced the cartoon feature, *Bebe's Kids*, for Paramount. This first full-length animated feature film centering on African-American characters was based on Toonz N the Hood, a seventy-minute musical comedy drawn from a routine by the comedian Robin Harris. After the release of these films, the Hudlin Brothers signed a television production deal with Twentieth Century Fox to develop television pilots for several networks.

REFERENCES

BATES, KAREN GRIGSBY. " 'They've Gotta Have Us': Hollywood's Black Directors." *New York Times Biographical Service* 22 (July 1991): 694–698.

NELSON, GEORGE. "The Hudlin Brothers." *Essence* (September 1987): 32.

PACHECO, PATRICK. "The Hudlin Brothers Set Out To Prove Black Is Beautiful." *New York Times*, July 26, 1992, pp. B9, 12–13.

LOUISE P. MAXWELL

Hudson, Hosea (1898–1988), union leader and communist activist. Born into an impoverished sharecropping family in Wilkes County in the eastern Georgia black belt, Hudson became a plowhand at ten, which sharply curtailed his schooling. The combination of a boll-weevil infestation and a violent altercation with his brother-in-law prompted Hudson in 1923 to move to Atlanta, where he worked as a common laborer in a railroad roundhouse. A year later he moved to Birmingham, Ala., and commenced his career as an iron molder.

Although he remained a faithful churchgoer, Hudson harbored persistent doubts about God's goodness and power, given the oppression of African Americans as workers and as Negroes. As a working-class black, however, he lacked a focus for his discontent until the COMMUNIST PARTY OF THE U.S.A. (CPUSA) began organizing in Birmingham in 1930. In the wake of the conviction of the Scottsboro boys and the Camp Hill massacre, both in Alabama in 1931, Hudson joined the CPUSA. Within a year he had lost his job at the Stockham foundry. Although he was able to earn irregular wages through odd jobs and iron molding under assumed names, much of the burden of family support in the 1930s fell on his wife, who never forgave him for putting the welfare of the Communist party before that of his wife and child.

During the GREAT DEPRESSION, Hudson was active with a series of organizations in and around the CPUSA. He helped the Unemployed Councils secure relief payments and fight evictions on behalf of the poor. In his first trip outside the South, he spent ten weeks in New York State at the CPUSA Party National Training School in 1934, during which he learned to read and write. As a party cadre in Atlanta from 1934 to 1936, he worked with neighborhood organizations and helped investigate the lynching of Lint Shaw. Returning to Birmingham in 1937, he worked on the WORKS PROJECT ADMINISTRATION PROJECT (WPA), served as vice president of the Birmingham and Jefferson County locals of the Workers Alliance, and founded the Right to Vote Club (which earned him a key to the city of Birmingham in 1980 as a pioneer in the struggle for black civil rights).

After the creation of the Congress of Industrial Organizations, Hudson joined the campaign to organize unorganized workers. As the demand for labor during World War II eased his way back into the foundries, he became recording secretary of Steel Local 1489, then organized United Steel Workers Local 2815. He remained president of that local from 1942 to 1947, when he was stripped of leadership and blacklisted for being a communist. He was underground in Atlanta and New York City from 1950 to 1956, during the height of the Cold War and McCarthyism. Imbued with a justified sense of the historical importance of his life, Hudson initiated two books on his experiences: *Black Worker in the Deep South* (New York, 1972) and *The Narrative of Hosea Hudson* (Cambridge, Mass., 1979). Active in the Coalition of Black Trades Unionists until his health failed in the mid-1980s, Hudson died in Gainesville, Fla., in 1988.

REFERENCE

PAINTER, NELL IRVIN. *The Narrative of Hosea Hudson: His Life as a Negro Communist in the South.* Cambridge, Mass., 1979.

NELL IRVIN PAINTER

Hughes, Langston (February 1, 1902–May 22, 1967), writer. James Langston Hughes was born in Joplin, Mo., and grew up in Lawrence, Kans., mainly with his grandmother, Mary Langston, whose first husband had died in John Brown's band at Harpers Ferry and whose second, Hughes's grandfather, had also been a radical abolitionist. Hughes's mother, Carrie Langston Hughes, occasionally wrote poetry and acted; his father, James Nathaniel Hughes, studied law, then emigrated to Mexico around 1903. After a year (1915–1916) in Lincoln, Ill., Hughes moved to Cleveland, where he attended high school (1916–1920). He then spent a year with his father in Mexico. In June 1921, he published a poem that was to become celebrated, "The Negro Speaks of Rivers," in the CRISIS magazine. Enrolling at Columbia University in New York in 1921, he withdrew after a year. He traveled down the west coast of Africa as a mess man on a ship (1923), washed dishes in a Paris nightclub (1924), and traveled in Italy and the Mediterranean before returning to spend a year (1925) in Washington, D.C.

Poems in journals such as the *Crisis* and OPPORTUNITY led to Hughes's recognition as perhaps the most striking new voice in African-American verse. Steeped in black American culture, his poems revealed his unswerving admiration for blacks, especially the poor. He was particularly inventive in fusing the rhythms of jazz and blues, as well as black speech, with traditional forms of poetry. In 1926 he published his first book of verse, *The Weary Blues,* followed by *Fine Clothes to the Jew* (1927), which was attacked in the black press for its emphasis on the blues culture. A major essay, "The Negro Artist and the Racial Mountain," expressed his determination to make black culture the foundation of his art. In 1926, he enrolled at historically black LINCOLN UNIVERSITY, and graduated in 1929. With the support of a wealthy but volatile patron, Mrs. Charlotte Osgood Mason (also known as "Godmother"), he wrote his first novel, *Not Without Laughter* (1930). The collapse of this relationship deeply disturbed Hughes, who evidently loved Mrs. Mason but resented her imperious demands on him. After several weeks in Haiti in 1931, he undertook a reading tour to mainly black audiences, starting in the South and ending in the West. He then spent a year (1932–1933) in the Soviet Union, where he wrote several poems influenced by radical socialism, including "Goodbye Christ," about religious hypocrisy. In Carmel, Calif. (1933–1934), he wrote most of the short stories in *The Ways of White Folks* (1934). After a few months in Mexico following the death of his father there, Hughes moved to Oberlin, Ohio.

In New York, his play *Mulatto,* about miscegenation in the South, opened on Broadway in 1935 to hostile reviews, but enjoyed a long run. Several other plays by Hughes were produced in the 1930s at the KARAMU PLAYHOUSE in Cleveland. He spent several months as a war correspondent in Spain during 1937. Returning to New York in 1938, he founded the Harlem Suitcase Theater, which staged his radical drama *Don't You Want to Be Free?* In 1939, desperately needing money, he worked on a Hollywood film, *Way Down South,* which was criticized for its

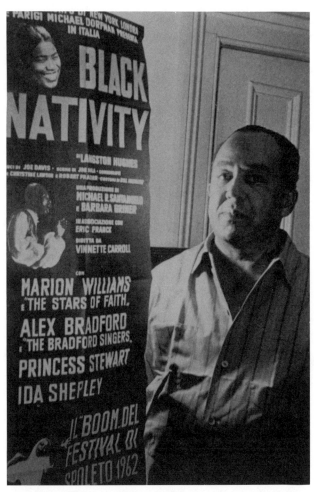

Langston Hughes. (Photographs and Prints Division, Schomburg Center for Research in Black Culture, The New York Public Library, Astor, Lenox and Tilden Foundations)

benign depiction of slavery. However, he was able to settle various debts and write an autobiography, *The Big Sea* (1940).

In 1940, when a religious group picketed one of his appearances, Hughes repudiated "Goodbye Christ" and his main ties to the left. In *Shakespeare in Harlem* (1942) he returned to writing poems about blacks and the blues. After two years in California, he returned to New York. Late in 1942, in the CHICAGO DEFENDER, he began a weekly newspaper column that ran for more than twenty years. In 1943 he introduced its most popular feature, a character called Jesse B. Semple, or Simple, an urban black Everyman of intense racial consciousness but also with a delightfully offbeat sense of humor. In 1947, his work as lyricist with Kurt Weill and Elmer Rice on the Broadway musical play *Street Scene* enabled him finally to buy a home and settle down in Harlem. Hughes, who never married, lived there with an old family friend, Toy Harper, and her husband, Emerson Harper, a musician.

As a writer, Hughes worked in virtually all genres, though he saw himself mainly as a poet. In *Fields of Wonder* (1947), *One-Way Ticket* (1949), and *Montage of a Dream Deferred* (1951), he used the new bebop jazz rhythms in his poetry to capture the mood of an increasingly troubled Harlem. With Mercer COOK, he translated the novel *Gouverneurs de la rosée* (*Masters of the Dew*, 1947) by Jacques Roumain of Haiti; he also translated poems by Nicolás Guillén of Cuba (*Cuba Libre*, 1948), Federico García Lorca of Spain (1951), and Gabriela Mistral of Chile (*Selected Poems*, 1957). The first of five collections of Simple sketches, *Simple Speaks His Mind*, appeared in 1950, and another collection of short stories, *Laughing to Keep from Crying*, came in 1952. Working first with composer William Grant STILL and then with Jan Meyerowitz, Hughes composed opera libretti and other texts to be set to music.

Right-wing groups, which were anti-Communist and probably also motivated by racism, steadily attacked Hughes—despite his denials—for his alleged membership in the Communist party. In 1953, forced to appear before Sen. Joseph McCarthy's investigating committee, he conceded that some of his radical writing had been misguided. Criticized by some socialists, he pressed on with his career, and later toured Africa and elsewhere for the State Department. He published about a dozen books for children on a variety of topics, including jazz, Africa, and the Caribbean. With the photographer Roy DECARAVA he published an acclaimed book of pictures accompanied by a narrative, *The Sweet Flypaper of Life* (1955). His second volume of autobiography, *I Wonder as I Wander*, came in 1956.

Perhaps the most innovative of Hughes's later work came in drama, especially his gospel plays such as *Black Nativity* (1961) and *Jericho–Jim Crow* (1964). He was also an important editor. He published (with Arna BONTEMPS) *Poetry of the Negro, 1746–1949* (1949), as well as *An African Treasury* (1960), *New Negro Poets: U.S.A.* (1964), and *The Book of Negro Humor* (1966). Hughes was widely recognized as the most representative African-American writer and perhaps the most original of black poets. In 1961, he was admitted to the National Institute of Arts and Letters. He died in New York City.

REFERENCES

BLOOM, HAROLD. *Langston Hughes.* New York, 1989.
MIKOLYAK, THOMAS A. *Langston Hughes: A Bio-Bibliography.* Westport, Conn., 1990.
RAMPERSAD, ARNOLD. *The Life of Langston Hughes.* New York, 1986–1988.

ARNOLD RAMPERSAD

Humes, Helen (June 23, 1913–September 13, 1981), jazz singer. Born in Louisville, Ky., Helen Humes learned to sing and play piano as a child, influenced both by classical music lessons and the music she heard in church. Humes became something of a local sensation when she recorded two risqué BLUES songs, "Do What You Did" and "Papa Has Outside Loving," in St. Louis at the age of thirteen. In 1929 she recorded "Race Track Blues" and "Black Cat Moan" with pianist James P. JOHNSON in New York. In the early 1930s Humes worked with Vernon Andrade's big band in New York, and in the mid-1930s she performed regularly at Cincinnati's Cotton Club. In 1937 Humes was singing in Cincinnati with Al Sears, whom she later married. Humes recorded with trumpeter Harry James that year, and in 1938 joined Count BASIE's band at the peak of its success. Humes stayed with Count Basie for four years, helping to define the mainstream big band vocal style. Her voice was powerful yet light-toned, and she gained a reputation as a forceful blues-style shouter. Among her recordings from this time are "Blues With Helen" (1938), "My Heart Belongs to Daddy" (1939), and "Between the Devil and the Deep Blue Sea" (1939).

Humes left the Basie band in 1942, and performed at New York's Village Vanguard before moving to California, where she performed often with Clarence Love's orchestra. During this time she sang in more popular genres, and recorded the soundtrack for the film *Panic in the Streets*. Her song "Be-baba-leba" (1945) was a RHYTHM AND BLUES hit. Humes appeared in a film of the same name during this time, and also appeared in the film *Jivin' in Bebop* in 1947. During the 1950s she continued to sing rhythm and blues, and pop music ("Million Dollar Secret," 1950, the soundtrack for *My Blue Heaven,* 1950) until 1957, when she toured Australia with vibraphonist Red Norvo. The next year she sang on *Red Norvo in Hi-fi,* and in 1961 she recorded as a leader on *Swingin' with Humes.* For the next decade she again sang in jazz bands, performing in tours of Europe, the U.S., and Australia. In 1967 she largely gave up singing in order to return home to Louisville to care for her aging parents. She returned to the stage in 1973, performing (with Count Basie) and recording (*Sneakin' Around* 1974, *Helen* 1981) in both Europe and the United States. She died of cancer in Santa Monica, Calif., in 1981.

REFERENCES

DAHL, LINDA. *Stormy Weather: The Music and Lives of a Century of Jazzwomen.* New York, 1984, pp. 225–233.

O'NEAL, J. "Helen Humes." *Living Blues* 52 (1982): 24.

JONATHAN GILL

Hunt, Henry Alexander (October 10, 1866–October 1, 1938), educator. Born near Sparta, Ga. in 1866, Henry Hunt was the son of a white father and an African-American mother. After his father abandoned the family, Hunt worked at various agricultural jobs to support his family. At the age of sixteen, he traveled to Atlanta University to receive technical training, and completed a technical course in 1876. After working for several years, he returned to school, receiving his B.A. from Atlanta University in 1890.

In 1891 Hunt was hired by Biddle University, now known as Johnson C. Smith University, in Charlotte, N.C. Working as proctor of boys and later as the superintendent of the Industrial Department, Hunt remained in Charlotte until 1904. In that year, he was lured away to become the first principal at Fort Valley High and Industrial School southwest of Macon, Ga. Hunt would remain there until his death thirty-four years later.

When he and his wife arrived at Fort Valley, they discovered a campus consisting of four wooden buildings and a community whose support was conditional at best. By offering extension programs, summer programs for teachers, and various other community services, and by securing outside means of financial support and increasing numbers of students, Hunt guaranteed the stability of what had been a precarious institution. At the time of his death in 1938, Fort Valley had over a dozen "well-designed, modern" buildings and more than 1,000 students. Only a year later, the school was absorbed into the state of Georgia's higher educational system, becoming Fort Valley State College.

An avid believer in both racial and economic empowerment, Hunt believed that only through the end of racial discrimination and increased economic opportunities could African Americans improve their position in the country. The NAACP presented Hunt with its SPINGARN MEDAL in 1930, for "twenty-five years of modest, faithful, unselfish, and devoted service in the education of Negroes of rural Georgia and to the teaching profession in that state." Known for his expertise on southern agricultural and educational issues, Hunt was tapped by the Roosevelt Administration in 1933 to be assistant to the governor of the Farm Credit Administration (FCA). While still acting as an agent of the FCA, he died in Washington, D.C., on October 1, 1938.

REFERENCE

BELLAMY, DONNIE D. "Henry Hunt and Black Agricultural Leadership in the South." *Journal of Negro History* 60, no. 4 (October 1975): 464–479.

JOHN C. STONER

Hunt, Richard (September 12, 1935–), sculptor, graphic artist, educator. Born and raised in Chicago, Richard Hunt saw his talent nurtured early in children's classes at the Art Institute of Chicago (AIC), which he attended from age thirteen. That institution was central to his development as a sculptor. There in 1953 he saw the work of Julio Gonzalez, a Spanish sculptor of welded metal whose technique differed radically from the traditional western methods of cast sculpture. Gonzalez' impact was so great that Hunt, still a high school student, built a studio in the basement of his father's barbershop to begin sculpting. He later taught himself to weld in two years. Also at the AIC, Hunt encountered the work of Richmond BARTHÉ, an African-American sculptor who had graduated from the School of the AIC in 1929. Although their styles differed—Barthé modeled naturalistic representations of the human figure, while Hunt was more abstract—Hunt found the older artist to be an inspiration. In 1953, Hunt enrolled in the School of the AIC on a scholarship from the Chicago Public School Art Society. Since the school had limited welding equipment, he taught himself by talking to professional metalworkers and by taking metalcraft classes where he made jewelry. He graduated four years later with a degree in art education and was awarded a travel grant to visit England, Spain, France, and Italy.

If the school taught him techniques, another institution prompted him with ideas that have informed his entire career. From 1951 to 1957, Hunt worked part-time in the zoological experimental laboratory at the University of Chicago. From his earliest work there is a propensity for images that are biomorphic, suggesting tentacles, bones, wings, thoraxes, antennae, and tendons. One of these early works, *Arachne,* was acquired for the permanent collection of the Museum of Modern Art (MoMA) in New York in 1957, while he was still a student. His first one-person show followed in the same city the next year. Exhibitions and purchases from major museums and universities in the years immediately following his graduation indicate his early aesthetic maturity.

This early work used discarded metal parts, which Hunt welded into small-scale zoomorphic and anthropomorphic shapes whose gestures paralleled the "drawing in space" that could be found among other sculptors of the period, including David Smith, another of his influences. The angular armatures and calligraphic forms echoed the gestures of Abstract Expressionist painting. Other sources for this style were the metal African sculpture he had seen with his mother on childhood visits to the Field Museum of Natural History, as well as Greek, Roman, and Renaissance sculpture. By the late 1960s, Hunt's reputation led to numerous commissions for public sculp-

Though abstract, Richard Hunt's sculptures often resemble trees, horns, and other animate objects. *Hybrid Form #3* in cast bronze dates from 1970. (The Studio Museum in Harlem)

ture. He resolved the resultant change to a larger scale by increasing the mass of his forms to give them a stronger visual presence in the out-of-doors (and to accommodate their being cast from bronze and brass as well as being welded from aluminum and cor-ten steel). Works appeared not as branch or limblike extensions, but as congealed extrusions from some geological source. The works are often designed to protrude from their own rectilinear bases as if they are being manipulated by some overwhelming force. Although different in style, this work maintains Hunt's interest in natural processes of growth and change presented, paradoxically, in the inert medium of metal. This second phase of Hunt's career has led to more than seventy commissions of public sculpture across the country in airports, schools and universities, plazas, hospitals, churches, and synagogues.

Hunt has been included in many national and international exhibitions since he began showing in 1955. Retrospectives of his career were held in 1967 at the Milwaukee Art Center and in 1971 at MoMA and at the AIC. His awards include a Guggenheim

Fellowship in the year 1962–1963 and a fellowship at the Tamarind Lithography Workshop in Los Angeles in 1965. In 1964 he was a visiting professor at Yale University. In 1966 he was included in the First World Festival of Negro Arts in Dakar, Senegal. His appointments include the Illinois Arts Council (1970–1975); the National Council on the Arts (1968–1974); board of trustees, Museum of Contemporary Art (Chicago, 1975–1979); board of governors, Skowhegan School of Painting and Sculpture (1979–1984); commissioner, National Museum of American Art, Smithsonian Institution (1980–1988); advisory committee, Getty Center for Education in the Arts (1984–1988); director, International Sculpture Center, (1984–); president, founder, Chicago Sculpture Society (1985–1989); and board of governors, School of the Art Institute of Chicago (1985–1989).

REFERENCES

Columbia College Art Gallery. *Outside In: Public Sculpture by Richard Hunt*. Chicago, 1986.

Landau/Traveling Exhibitions, and Samella Lewis. *Richmond Barthé/Richard Hunt: Two Sculptors, Two Eras*. Los Angeles, 1992.

Museum of Modern Art. *The Sculpture of Richard Hunt*. New York, 1971.

HELEN M. SHANNON

Hunter, Alberta (April 1, 1895–October 17, 1984), blues singer. Alberta Hunter was born in Memphis, Tenn., and left the city by the time she was twelve years old to seek a career on the stage in Chicago. She quickly adapted to the harsh life of the city and had earned a spot as a singer-dancer in a sporting club by the time she was fifteen. Hunter's style of blues singing was a mixture of torch song and sexy sophistication that propelled her into the spotlight at the clubs on Chicago's South Side. She recorded more than a hundred songs (including some of her own compositions) on several labels, under her own name and also used such pseudonyms as May Alix, Josephine Beatty, and Alberta Prime. Her song "Down Hearted Blues" (1922) became a blues classic. One of her last recordings was an album produced by Columbia Records' John Hammond in 1983.

Noted for her versatility, language fluency, beauty, and fashionable dressing, Hunter performed in film, on stage in both dramatic and singing roles, and on radio in the United States and Europe. She lived in Europe for several years, appearing on a regular radio show and recording. She abandoned her singing career when she returned from a stint enter-

Alberta Hunter, one of the best-known blues singers of the 1920s, was a popular cabaret and band singer through the World War II era. After she retired for twenty years from the music business, her career revived in the 1970s when she introduced a new generation to classic blues. (Photographs and Prints Division, Schomburg Center for Research in Black Culture, The New York Public Library, Astor, Lenox and Tilden Foundations)

taining World War II troops in the European theater; she took up nursing for three decades, and then was coaxed back to the nightclub circuit by Barney Josephson, owner of the Cookery, in 1977. She performed regularly in New York City until her death.

REFERENCE

HARRISON, DAPHNE DUVAL. *Black Pearls: Blues Queens of the 1920s*. New Brunswick, N.J., 1988.

DAPHNE DUVAL HARRISON

Hunter, Clementine Clemence Rubin (c. 1885–1988), painter and quilt artist. Born on Hidden Hill Plantation in northern Louisiana near Natchitoches, Hunter moved during her early teens to nearby Melrose Plantation, where she worked as a cotton picker and then for almost sixty years as a plantation cook. She produced her first painting in 1946 on a windowshade, using paints and brushes

that had been discarded by a New Orleans artist visiting Melrose. During the course of her career, Hunter completed more than 4,000 paintings. She worked in oils on cardboard and canvas panels, using a thick impasto technique.

Hunter's paintings usually depict scenes of the rural Cane River settlement on Isle Breville, La. Those subjects include cotton and pecan harvesting, cotton gins, weddings, funerals, birthday parties, revivals, still-lifes, and religious scenes. Her paintings possess the salient characteristics of folk art: flat bold primary colors, no attempts at modeling of form, and scale and perspective that defy logical interpretation. She painted the same subjects repeatedly, yet no two subjects are identical. Using her lap as an easel, she supported her panels in one hand while painting with the other. She did not date her paintings. They may be broadly classified, however, as early or late by the forward or reverse position of the "C" in the artist's signature.

Hunter's masterpiece is a series of nine four-by-ten-foot panels depicting a panorama of life in Cane River country that she painted in 1955. These murals are located on the second floor of the African House at Melrose Plantation, and represent the artist at the height of her creative powers. She also made quilts, both geometric and pictorial, that depict buildings at Melrose Plantation including the Big House, African House, and Yucca House. In 1956 Hunter and Francois Mignon (1899–1980), writer-in-residence at Melrose, published *Melrose Plantation Cookbook,* which recorded Hunter's legendary culinary talents. Mignon recorded the recipes, which were dictated to him by Hunter, including such original delicacies as Madame Gobar Game Soup, Calinda Cabbage, Parrain Pie, and Riz Isle Breville.

In 1955 Hunter was the first African-American artist to have a one-person exhibition at the Delgado Museum in New Orleans (now the New Orleans Museum of Art). In 1973 her works were included in a three-person exhibition at the Museum of American Folk Art in New York, and one of her paintings, *Threshing Pecans,* was used in 1976 as a UNICEF calendar selection. She is represented in numerous public and private collections, and had been the subject of many magazine and newspaper articles, two television documentaries, and a book published in 1988.

In 1985 Hunter was honored with numerous celebrations during the anniversary of her one hundredth birthday, and on May 16 of that year was awarded an honorary Doctor of Fine Arts degree by Northwestern University in Natchitoches, La. Unable to read or write, she never traveled more than fifty miles from her birthplace. Married twice, she was the mother of seven children, all but one of whom she outlived. At the time of her death on New Year's Day in 1988, Hunter was the most celebrated contemporary African-American folk artist.

REFERENCES

PERRY, REGENIA. *What It Is: Black American Folk Art from the Collection of Regenia Perry.* Richmond, 1982.

WILSON, JAMES L. *Clementine Hunter: American Folk Artist.* Gretna, La., 1988.

REGENIA A. PERRY

Hunter, Jane Edna (December 13, 1882–January 19, 1971), reformer. Born and raised in South Carolina, Jane Edna Hunter had a life that was typical for many southern black women of her time. She had a sporadic education, although she later earned a degree in nursing from the Hampton Institute in Virginia. She worked as a domestic servant and migrated to an urban center in search of a better future. In many ways, however, Hunter's life was extraordinary. Arriving in Cleveland in 1905, she experienced the difficulties and dangers of being a young, single working woman of color. Housing was scarce, as were jobs in her field. The YWCA and similar organizations in the city did not allow African-American women in their residences. Hunter took action to change this situation.

In 1911, Hunter and a group of black women gathered to form the Working Girls' Home Association. By 1913 the organization, now called the Phillis Wheatley Association, had gained the financial support of wealthy whites, and the grudging support of black leaders, who were uncertain about the prospect of an all-black home. Hunter prevailed with a gradual approach to race relations in Cleveland. The PWA provided lodging, a cafeteria, domestic training, and athletics, among other activities. In 1927, the PWA moved into a newly constructed building to accommodate the ever-growing numbers who desired its services.

Hunter also became important on the national scene in black women's club work. She served as an officer of the NATIONAL ASSOCIATION OF COLORED WOMEN, heading its Big Sister Department and creating a Phillis Wheatley Department to pass on her own success to other cities. Hunter resigned from the PWA in 1947, in conflict with the board of directors. She continued to be active in reform work, and when she died in 1971, her will provided scholarships for black women to attend college, a legacy in keeping with her life's work.

REFERENCES

HUNTER, JANE EDNA. *A Nickel and a Prayer: An Autobiography.* Cleveland, 1940.

JONES, ADRIENNE LASH. *Jane Edna Hunter: A Case Study of Black Leadership, 1910–1950.* Brooklyn, N.Y., 1990.

JUDITH WEISENFELD

Hunter-Gault, Charlayne (February 27, 1942–), journalist. As the creator and chief of the Harlem bureau of the *New York Times* in the late 1960s, Charlayne Hunter-Gault sought to move media coverage of African Americans away from stereotypes to in-depth, realistic, and accurate stories. Born in Due West, S.C., Hunter-Gault became the first black woman admitted to the University of Georgia. She graduated in 1963 with a degree in journalism. Her career has included work with the *New Yorker* magazine, NBC News in Washington, D.C., and PBS's *MacNeil/Lehrer Newshour.* Hunter-Gault has also taught at the Columbia University School of Journalism. Her distinguished career has brought her a number of important honors: She has won two Emmy awards, for national news and documentary film; was named the Journalist of the Year in 1986 by the National Association of Black Journalists; and was the 1986 recipient of the George Foster Peabody award. In 1992, she published her autobiography, *In My Place.*

REFERENCES

FRASER, C. GERALD. "Charlayne Hunter-Gault: From Frontline to Firing Line." *Essence* 17 (March 1987): 40–42, 110.

HUNTER-GAULT, CHARLAYNE. *In My Place.* New York, 1992.

LANKER, BRIAN. *I Dream a World: Portraits of Black Women Who Changed the World.* New York, 1989.

JUDITH WEISENFELD

Hunton, Addie Waites (June 11, 1875–June 21, 1943), activist. Addie Hunton, a worker for the rights of African Americans, pursued her goals through a wide range of organizations and activities. Born in Norfolk, Va., to a prominent and prosperous family, Addie Waites was educated in schools in the North. After teaching in a vocational school in Alabama, she married William Alphaeus HUNTON, Sr., a YMCA worker from Canada.

In 1906 the Huntons moved to Brooklyn, N.Y., where Addie became involved with the work of the YWCA. She was a field worker for the YWCA's National Board and was active with the Harlem YWCA. Following her husband's death in 1916, Hunton became involved with the YWCA's work abroad during WORLD WAR I. Stationed in France, she was one of three black women in service abroad during the war. From this experience she and her co-worker, Kathryn Johnson, wrote *Two Colored Women with the American Expeditionary Forces* (1920).

After the war, Hunton continued to work with the YWCA, the NAACP, and various black women's clubs. She became increasingly involved with international peace organizations as well as with the Pan-African Congress movement (*see* PAN-AFRICANISM). Hunton also wrote a biography of her husband, *William Alphaeus Hunton, a Pioneer Prophet of Young Men* (1938). Addie Waites Hunton was part of a circle of active women and men who never ceased to demand equality for African Americans, and she presented herself as a model and mentor for young women and men of her day. She passed on her commitment to her children, Eunice Hunton Carter and William Alphaeus Hunton, Jr., both of whom followed in her activist footsteps.

REFERENCE

HUNTON, ADDIE W. *William Alphaeus Hunton, a Pioneer Prophet of Young Men.* New York, 1938.

JUDITH WEISENFELD

Hunton, William Alphaeus, Jr. (September 18, 1903–January 13, 1970), political activist and educator. Alphaeus Hunton, Jr., was born in Atlanta, Ga. After the Atlanta race riot of 1906 (*see* ATLANTA RIOT [1906]) Hunton's parents, William HUNTON, Sr., and Addie Waites HUNTON, moved the family to Brooklyn. He received his B.A. from HOWARD UNIVERSITY in 1924. Two years later, Hunton graduated from Harvard University with an M.A. in English and accepted a position as an assistant professor in Howard's English department.

Hunton taught at Howard for over fifteen years, earning a Ph.D. from New York University in 1938 in the process. As a member of Howard's faculty, Hunton participated in the general intellectual activism prevalent at Howard during this period. He was a member of the national executive board of the NATIONAL NEGRO CONGRESS (NNC) and remained involved even after the moderates left the NNC and the organization was increasingly dominated by the COMMUNIST PARTY. Thereafter, Hunton was closely associated with the public positions of the party. In 1941, the House Committee on Un-American Activities (HUAC), a congressional committee investigating supposed subversive behavior, accused Hunton of Communist party membership. After leaving

Howard in 1943, Hunton moved to New York City, got married, and became the director of education for the COUNCIL ON AFRICAN AFFAIRS (CAA).

While with the council, Hunton prepared and wrote pamphlets, produced news releases, and lobbied international organizations on African issues. In the late 1940s, he was active in lobbying the United Nations to prohibit South Africa from annexing South-West Africa (now Namibia); he also protested the visit of South African Prime Minister Jan Smuts to the United States in 1946. Other South African campaigns included an attempt to improve conditions for black South African mineworkers.

In 1951, Hunton and other leftists formed the Civil Rights Bail Fund, which provided bail for those unwilling to give names to HUAC. After refusing himself to provide the names of contributors to the fund, Hunton was sentenced to six months in jail for contempt of court in July 1951. In 1953, the federal government, citing the CAA's aid to the African National Congress and its ongoing ties to the Communist party, ordered the council to register as a subversive organization. Continued harassment led Hunton to disband the CAA two years later.

Despite the closing of CAA, Hunton remained interested in African affairs, and in 1957 published *Decision in Africa: Sources of Current Conflict*. Late the following year, he attended the All African People's Conference in Ghana and did not return to the United States until August 1959, after extensive tours of Africa, Europe, and his first of many trips to the Soviet Union. In May 1960, Hunton and his wife moved to Conakry, Guinea, where he taught English in a lycée. After less than two years, the Huntons moved to Accra, Ghana at the behest of W. E. B. DU BOIS, who required Hunton's aid with the never completed *Encyclopedia Africana*. Hunton and his wife were deported after Kwamé Nkrumah's government fell during a military coup in 1966. After briefly returning to the United States, the Huntons settled in Lusaka, Zambia, in 1967. Alphaeus would remain there until his death from cancer in early 1970.

REFERENCES

HUNTON, DOROTHY. *Alphaeus Hunton: The Unsung Valiant*. 1986.

HUNTON, WILLIAM ALPHAEUS, JR. *Decision in Africa: Sources of Current Conflict*. New York, 1957.

JOHN C. STONER

Hunton, William Alphaeus, Sr. (October 31, 1863–November 26, 1916), YMCA executive. Born in Chatham, Canada West (now Ontario), in 1863, William Alphaeus Hunton was nicknamed "the Parson" in early childhood for his pious demeanor and religious devotion. Chatham and the surrounding region had long served as a haven for FUGITIVE SLAVES such as Stanton Hunton, William's father. Stanton Hunton was at least peripherally involved in planning the October 1859 attack on Harpers Ferry, Va. (now part of West Virginia), by John Brown and a group of his followers (*see* JOHN BROWN'S RAID). William Alphaeus had a much more sedate upbringing, however. After attending local schools and graduating from the Wilberforce Institute of Ontario in 1883, he became a schoolteacher for several years.

In 1885, Hunton went to work in a clerical position at the Department of Indian Affairs in Ottawa, Ontario. Three years later, he would become the first African-American secretary of a Young Men's Christian Association (YMCA) branch for blacks in Norfolk, Va. In 1891, the YMCA promoted Hunton to become the first black secretary of the international committee of the YMCA. Five years later, he assisted in the organization of the Colored Men's Department of the YMCA.

Traveling around the country to organize and speak to YMCA affiliates, Hunton was at the forefront of continuing the integration of the organization. Especially in the South and at colleges and universities, Hunton was responsible for setting up large numbers of YMCA branches and attracting African-American members. He also worked to break down barriers, especially in the South, that kept black YMCA members from participating in many of the benefits and opportunities enjoyed by their white peers.

At the turn of the century, the YMCA was one of the most important organizations for middle-class black men who would eventually assume prominent roles in the black community. Hunton was followed by Jesse MOORLAND, who became the second black secretary of the YMCA's international committee in 1898. Other prominent African-American leaders such as educator John W. DAVIS and civic leader Channing H. TOBIAS also began their careers working for the YMCA.

Hunton frequently traveled overseas to various conferences on behalf of the YMCA. Between the 1894 Golden Jubilee of the YMCA in London and the 1907 Tokyo World Student Christian Federation Conference, Hunton traveled throughout much of Europe and east Asia. He was also instrumental in planning the 1913 World Student Christian Federation Conference in Lake Mohonk, N.Y.

After contracting malaria on a tour of the South in 1904, Hunton never regained his health. As a result of his weakened condition, Hunton contracted tuberculosis in 1914 and died two years later in New York City.

REFERENCE

HUNTON, ADDIE WAITES. *William Alphaeus Hunton: A Pioneer Prophet of Young Men*. New York, 1938.

JOHN C. STONER

Hurley, Ruby (November 7, 1909–August 9, 1980), civil rights activist. Ruby Hurley was born in Washington, D.C., and attended public schools there. After studying at Miner Teachers College and Robert H. Terrell Law School, she worked for a Washington bank and the federal government. In 1939 she was part of a group that reorganized the Washington chapter of the NATIONAL ASSOCIATION FOR THE ADVANCEMENT OF COLORED PEOPLE (NAACP), and she developed its local youth council. In 1943 she was named the National Youth Secretary of the NAACP, and under her leadership the number of NAACP youth councils and local chapters grew from 86 to more than 280.

In 1951 the NAACP sent Hurley to Birmingham as the regional secretary of its newly organized Southeast Region. Her initial task was to coordinate NAACP campaigns for new branches in Alabama, Florida, Georgia, Mississippi, and Tennessee. By 1952 the NAACP had promoted her to regional director. She was asked to investigate violent racial crimes including the 1955 murders of the Rev. George W. Lee and Lamar Smith, who had been involved in black voter registration in Beloni and Brookhaven, Miss., respectively. In the same year, she also investigated, along with NAACP official Medgar EVERS, the LYNCHING of teenager Emmett TILL in Money, Miss. Hurley disguised herself as a laborer and traveled throughout the Mississippi countryside at great personal risk, attempting to locate witnesses. In 1956 she participated in the drive to register Autherine Lucy (*see* Autherine LUCY FOSTER) at the University of Alabama, which led to a court order to desegregate. The university, however, suspended Lucy and failed to integrate its student body until 1963.

Throughout this period, Hurley confronted physical danger on a daily basis: She was continually subjected to death threats, and bombs were thrown at her home. The constant physical and psychological demands of the movement took their toll on Hurley's health, and she suffered a nervous breakdown. On June 1, 1956, the Alabama legislature used an *ex parte* injunction to ban the NAACP within the state, on the grounds that the NAACP had not made its membership roles public. Forced to close the Birmingham office, Hurley moved to Atlanta, Ga., where the NAACP had relocated its Southeast Regional headquarters.

Hurley spent her years in Atlanta trying to work out differences between the NAACP and the more activist STUDENT NONVIOLENT COORDINATING COMMITTEE (SNCC). In 1961 she joined the Rev. Dr. Martin Luther KING, Jr. and other black leaders invited to Albany by SNCC to aid the organization's troubled Albany Campaign. In the same year, Hurley helped prepare the case that desegregated the University of Georgia. She remained Southeast Regional Director until her retirement on March 31, 1978, but after the late 1960s, maintained a lower profile. Hurley died in Atlanta at the age of seventy after a prolonged illness.

REFERENCE

DUNBAR, ERNEST. "Inside the NAACP: Ruby Hurley's South." *Look* (August 6, 1957): 58–64.

SIRAJ AHMED
LOUISE P. MAXWELL

Hurston, Zora Neale (c. 1891–January 28, 1960), folklorist. Zora Neale Hurston was born and grew up in Eatonville, Fla., the first black incorporated town in America. (Her exact date of birth is uncertain. She claimed to be born in either 1901 or 1910, but a brother thinks it was as early as 1891.) Her father, a carpenter and Baptist preacher and a signer of the town's charter, was elected mayor three terms in succession. Her mother, formerly a country schoolteacher, taught Sunday school but spent most of her time raising her eight children. In Eatonville, unlike most of the South at the turn of the century, African Americans were not demoralized by the constant bombardment of poverty and racial hatred, and Hurston grew up surrounded by a vibrant and creative secular and religious black culture. It was here she learned the dialect, songs, folktales, and superstitions that are at the center of her works. Her stories focus on the lives and relationships between black people within their communities.

The untimely death of Hurston's mother in 1904 disrupted her economically and emotionally stable home life, and a year later, at age fourteen, she left home for a job as a maid and wardrobe assistant in a traveling Gilbert and Sullivan company. She left the company in Baltimore, found other work, and attended high school there. In 1918 she graduated from Morgan Academy, the high school division of Morgan State University, and entered Howard University in Washington, D.C., where she took courses intermittently until 1924. She studied there

The novelist and anthropologist Zora Neale Hurston during her period of greatest productivity in the late 1930s and early '40s. During this time she wrote *Mules and Men, Their Eyes Were Watching God,* and *Dust Tracks on a Road.* (Prints and Photographs Division, Library of Congress)

thropological Society, the Ethnological Society, the New York Academy of Sciences, and the American Association for the Advancement of Science. From her extensive research Hurston published *Mules and Men* (1935), the first collection (seventy folktales) of black folklore to appear by a black American. *Tell My Horse* (1938), a second folklore volume, came after her travels to the Caribbean. Her most academic study, *The Florida Negro* (1938), written for the Florida Federal Workers Project, was never published.

While Franz Boas and Mrs. Mason stimulated Hurston's anthropological interests that gave her an analytical perspective on black culture that was unique among black writers of her time, she was fully vested in the creative life of the cultural movement as well. Her close friends included Carl Van Vechten, Alaine Locke, Langston HUGHES, and Wallace Thurman, with whom she coedited and published the only issue of the journal *Fire!!* Appearing in November 1926, its supporters saw it as a forum for younger writers who wanted to break with traditional black ideas. Ironically, *Fire!!* was destroyed by a fire in Thurman's apartment.

Hurston's first novel, *Jonah's Gourd Vine* (1934), reveals the lyric quality of her writing, her skillfulness with and mastery of dialect. The story is about a Baptist preacher with a personal weakness that leads him to an unfortunate end. But Hurston's protagonist, modeled on her father, is a gifted poet/philosopher with an enviable imagination and speech filled with the imagery of black folk culture. He is also a vulnerable person who lacks the self-awareness to comprehend his dilemma; thus, his tragedy.

For its beauty and richness of language, *Their Eyes Were Watching God* (1937), the first novel by a black woman to explore the inner life of a black woman, is Hurston's art at its best. Her most popular work, it traces the development of the heroine from innocence to her realization that she has the power to control her own life. An acknowledged classic since its recovery in the 1970s, it has been applauded by both black and white women scholars as the first black feminist novel. *Moses, Man of the Mountain* (1939), Hurston's third and most ambitious novel, makes of the biblical Israelite deliverance from Egypt an exploration of the black transition from slavery to freedom. Taking advantage of the pervasiveness of the Moses mythology in African and diaspora folklore and culture, Hurston removes Moses from Scripture, demystifies him, and relocates him in African-American culture, where he is a conjure man possessed with magical powers and folk wisdom. The novel tells the story of a people struggling to liberate themselves from the heritage of bondage. In *Seraph on the Suwanee* (1948), Hurston's last and least successful work, she turns away from black folk cul-

with poet Georgia Douglas JOHNSON and philosopher Alain LOCKE. Her first story, "John Redding Goes to Sea" (1921), appeared in *Stylus,* Howard's literary magazine.

Hurston arrived in New York in 1925, at the height of the HARLEM RENAISSANCE. She soon became active among the group of painters, musicians, sculptors, entertainers, and writers who came from across the country to be there. She also studied at Barnard College under the anthropologist Franz Boas and graduated with a B.A. in 1928. Between 1929 and 1931, with support from a wealthy white patron, Mrs. Osgood Mason, Hurston returned south and began collecting folklore in Florida and Alabama. In 1934 she received a Rosenwald fellowship and in 1936 and 1937 Guggenheim fellowships that enabled her to study folk religions in Haiti and Jamaica. She was a member of the American Folklore Society, the An-

ture to explore the lives of poor white Southerners. This story focuses on a husband and wife trapped in conventional sexual roles in a marriage that dooms to failure the wife's search for herself.

Dust Tracks on a Road (1942), Hurston's autobiography, is the most controversial of her books; some of her staunchest admirers consider it a failure. Critics who complain about this work focus on its lack of self-revelation, the inaccurate personal information Hurston gives about herself, and the significant roles that whites play in the text. Other critics praise it as Hurston's attempt to invent an alternative narrative self to the black identity inherited from the slave narrative tradition. Poised between the black and white worlds, not as victim of either but participant-observer in both, her narrative self in *Dust Tracks* presents positive and negative qualities of each. From this perspective, *Dust Tracks* is a revisionary text, a revolutionary alternative women's narrative inscribed into the discourse of black autobiography.

Reviews of Hurston's books in her time were mixed. White reviewers, often ignorant of black culture, praised the richness of her language but misunderstood the works and characterized them as simple and unpretentious. Black critics in the 1930s and 1940s, in journals like the CRISIS, objected most to her focus on black folk life. Their most frequent criticism was the absence from her works of racial terror, exploitation, and misery. Richard WRIGHT expressed anger at the "minstrel image" he claimed Hurston promoted in *Their Eyes Were Watching God*. None of her books sold well enough while she was alive to relieve her lifetime of financial stress.

Hurston and her writings disappeared from public view from the late 1940s until the early 1970s. Interest in her revived after writer Alice WALKER went to Florida "in search of Zora" in 1973, and reassembled the puzzle of Hurston's later life. Walker discovered that Hurston returned to the South in the 1950s and, still trying to write, supported herself with menial jobs. Without resources and suffering a stroke, in 1959 she entered a welfare home in Fort Pierce, Fla., where she died in 1960 and was buried in an unmarked grave. On her pilgrimage, Walker marked a site where Hurston might be buried with a headstone that pays tribute to "a genius of the South." Following her rediscovery, a once-neglected Hurston rose into literary prominence and enjoys acclaim as the essential forerunner of black women writers who came after her.

REFERENCES

HEMENWAY, ROBERT E. *Zora Neale Hurston: A Literary Biography*. Urbana, Ill., 1977.

WALL, CHERYL. "Zora Neale Hurston: Changing Her Own Words." In Fritz Fleischmann, ed. *American*

Novelists Revisited: Essays in Feminist Criticism. Boston, 1982, pp. 371–393.

NELLIE Y. MCKAY

Hutson, Jean Blackwell (September 7, 1914–), librarian. Curator and later chief of the Schomburg Center for Research in Black Culture of the New York Public Library for thirty-two years, Hutson was responsible from 1948 to 1980 for developing the world's largest collection of materials by and about people of African descent. She also publicized the poor physical condition of the building in which Schomburg's rare materials were stored. The result was a new climate-controlled building, quadruple the size of the old, which opened in September 1980.

Jean Blackwell was born on September 7, 1914, in Summerfield, Fla., to Paul and Sarah Blackwell. Her father was a farmer and produce merchant and her mother a teacher. From the age of four she lived in Baltimore, where she graduated from Douglass High School as valedictorian in 1931. After three years at the University of Michigan she transferred to Bar-

Jean Blackwell Hutson with Langston Hughes. (Photographs and Prints Division, Schomburg Center for Research in Black Culture, The New York Public Library, Astor, Lenox and Tilden Foundations)

nard College, graduating in 1935. She received a master's degree in library service from Columbia University the following year, and in 1941 a teacher's certificate, also from Columbia. After twelve years of working at various branches of the New York Public Library, Blackwell came to the Schomburg Collection on a six-month assignment in 1948. She was married to Andy Razaf, the song lyricist, from 1939 to 1947 and to John Hutson, a library colleague, from 1952 until his death in 1957. She stayed until 1980, when she was named assistant director of collection management and development for black culture for the research libraries. She retired in February of 1984.

Hutson lectured on black history at New York's City College from 1962 to 1971. Invited by Kwame Nkrumah, Ghana's president, she was at the University of Ghana from 1964 to 1965 to help build their African collection. She holds membership in the American Library Association, the NAACP, the Urban League, and Delta Sigma Theta sorority. She was a founder and first president of the Harlem Cultural Council. Among many awards, Hutson received an honorary doctorate from King Memorial College in Columbia, S.C., in 1977, and was one of the seventy-five women portrayed in the photographic exhibition "I Dream a World" in 1989. She was honored by Barnard College in 1990 and by Co-

lumbia University's School of Library Service in 1992.

REFERENCE

Schomburg Center for Research in Black Culture. *Jean Blackwell Hutson: An Appreciation.* New York, 1984.

BETTY KAPLAN GUBERT

Hyers Sisters, singing duo. Anna Madah Hyers (c. 1853–1920s) and her sister, Emma Louise Hyers (c. 1855–1890s), were born and raised in Sacramento, Calif., and studied piano and voice as children. Their father arranged their first public performance in 1867, with Anna singing soprano and Emma contralto, of selections from Verdi. Celebrated as prodigies, they continued to give local recitals. They sang Donizetti opera arias in Salt Lake City, Utah, in 1871, and performed to extraordinary acclaim that year in major concert halls in Cleveland, New York, and Boston. They became the first black women to gain national fame on the American concert stage, performing in both opera recitals and as the main attractions in minstrel-style sketches. In 1872 they performed in Boston's World Peace Jubilee. The

Concert and stage performers from the 1860s through the '90s, Anna Madah Hyers (left) and her sister Emma Louise Hyers (right) were among the first African-American women to have extensive success on stage. The Hyers Sisters performed a varied act consisting of light opera, popular songs, and dramatic entertainment. (Moorland-Spingarn Research Center, Howard University)

following year Emma married the band leader of Callendar's Minstrels.

In the mid-1870s the Hyers sisters were traveling with their own theater company, which included the singers Wallace King, John Luca, and Tom Fletcher, and began to confront issues of race directly in musical dramas and comedies. In 1875 they toured in a production of *Out of Bondage* and four years later appeared in *Urlina, the African Princess* in San Francisco. The Hyers sisters continued to tour America in the 1880s, performing *The Underground Railway* and *Princess Orelia of Madagascar*. In 1891 they performed together in the musical comedies *Blackville Twins* and *Colored Aristocracy*. In the 1890s the sisters began to appear separately more often. Emma, for example, appeared in an 1894 production of *Uncle Tom's Cabin*. However, the sisters did appear together again as the Hyers Sisters Colored Specialty Co. in Wisconsin, Illinois, and Philadelphia in 1896–1897. Emma is believed to have died in Sacramento by 1900. Anna appeared in *Octoroons* in 1896 in New York. The next year she appeared in Louisville, Ky., and in 1898 she was performing in Connecticut with John Isham's Tenderloin Coon Company. In 1899 she toured Canada, singing operatic selections. That same year she began a two-year tour of Australia, New Zealand, and Hawaii with Curtis's All-Star American Minstrels, and Hogan's Minstrels. Before retiring in 1902, Anna Madah sang again with Isham in his Oriental America show, and is believed to have died sometime during the 1920s in Sacramento.

REFERENCES

SAMPSON, HENRY. *Blacks in Blackface: A Source Book on Early Black Musical Shows*. Metuchen, N.J., 1980.
SOUTHERN, EILEEN. *The Music of Black Americans: A History*. New York, 1971.

JONATHAN GILL

Hyman, Flora "Flo" (July 29, 1954–January 24, 1986), volleyball player. Born in Inglewood, Calif., Flo Hyman graduated from Morningside High School in 1972. She enrolled at the University of Houston, where she studied mathematics and physical education and was a three-time VOLLEYBALL all-American. In 1976, she received recognition as America's top collegiate player. Hyman was named to the U.S. national volleyball team in 1975 and represented the United States at the 1977 World Cup. In 1978, the United States Volleyball Association opened a new facility in Colorado, and Hyman left school to train full-time. At six feet, five inches, she starred for the United States at the World Volleyball Championships in 1978 and 1982. At the 1981 World Cup in Tokyo, she was named to the six-member all World Cup team. Considered by many to be the best female volleyball player in the world, Hyman led the United States to a silver medal at the 1984 Olympic Games in Los Angeles.

Following the Los Angeles games, Hyman and three of her American teammates began playing professionally in Japan. On January 24, 1986, during a routine substitution in a Japanese league game, she collapsed and died. The cause was initially thought to be a heart attack. An autopsy later revealed that she suffered from Marfan's syndrome, a congenital heart disorder. In recognition of her accomplishments, Hyman was inducted into the Women's Sports Hall of Fame in 1986. The following year, the Women's Sports Foundation established the Flo Hyman Award, given annually as part of National Girls and Women in Sports Day to the female athlete who most exemplifies the "dignity, spirit, and commitment to excellence" with which Hyman played the game of volleyball.

REFERENCES

DEMAK, RICHARD. "Marfan's Syndrome: a Silent Killer." *Sports Illustrated* (February 17, 1986): 30–35.
Obituary. *New York Times*, January 25, 1986, p. 10.
WOOLUM, JANET. *Outstanding Women Athletes: Who They Were and How They Influenced Sports in America*. Phoenix, Ariz., 1992.

BENJAMIN K. SCOTT

Hyman, John Adams (July 23, 1840–September 14, 1891), congressman and state legislator. Born a slave in Warrenton, N.C., John Hyman learned to read from a white northern jeweler who was later forced to leave town for his attempts to teach African Americans. Although sold and removed to Alabama for a time, Hyman returned to Warrenton after the CIVIL WAR and became a successful farmer.

Hyman immediately entered into politics, first as a delegate to the state equal rights convention in September 1865, and then as one of fifteen African-American delegates to the state constitutional convention in 1868. Despite open intimidation by the KU KLUX KLAN, African-American voters turned out in large numbers, overwhelmingly ratified the progressive constitution, and swept Republican candidates, including Hyman, into many state and national offices. While Hyman would remain in the state Senate until 1874, the party's success was only temporary.

In the 1870 election Democrats regained many of the seats lost in 1868 and began to destroy many RECON-STRUCTION reforms.

In 1872, Hyman incurred severe financial obligations when he unsuccessfully attempted to win the nomination for Congress in the predominantly black district. In 1874, he tried again, this time securing the Republican endorsement. With local Democrats in disarray and unsure if they would even nominate a candidate, Hyman easily carried the election to become NORTH CAROLINA's first black Congressman. Hyman's tenure in the House showed that he was not the most dynamic of legislators. While he attended regularly, Hyman rarely addressed the Congress and the few bills he introduced never got out of committee. He publicly opposed a general amnesty for ex-Confederates but later voted to consider an amnesty measure.

The 1876 nomination was hotly contested. Hyman failed to obtain renomination and left Washington after Congress adjourned in 1877. Saddled with debt from his previous campaigns, he struggled to secure a patronage position from the federal government. Hyman remained a political aspirant, and was increasingly recognized as the head of a bloc in local politics which represented a moderate, pro-black agenda.

However, he never again managed to win nomination for any elected office. His financial problems forced him to leave North Carolina and seek employment in Washington, D.C., and Baltimore, Md.

Upon returning to North Carolina, Hyman again sought to win support for another political campaign. In 1888, he proposed a coalition of black Republicans and white Democrats to defeat the white Republicans who currently controlled the district. In a letter to a prominent local Democrat, Hyman guaranteed political results if he received financial support. His accommodationist attempts to construct such a coalition were politically desperate. Already marginalized, Hyman failed to win any support. In 1891, he died of a stroke in Washington, D.C., at the age of fifty-one.

REFERENCES

ANDERSON, ERIC. *Race and Politics in North Carolina, 1872–1901: The Black Second*. Baton Rouge, La., 1981.

CHRISTOPHER, MAURINE. *Black Americans in Congress*. New York, 1976, pp. 149–152.

MCFARLIN, ANNJENNETTE SOPHIE. *Black Congressional Reconstruction. Orators and Their Orations, 1869–1879*. Metuchen, N.J., 1976.

ALANA J. ERICKSON

I

Ice Hockey. Traditionally, blacks have been a minimal presence in ice hockey, until recently a predominantly Canadian sport, since African Canadians constitute a small minority of that country's population. The game has also remained relatively unpopular among African Americans because of the lack of black role models and the expensive equipment required to play the sport. Nonetheless black men have made their mark on the ice rinks. The first black to break the color line in the National Hockey League was William Eldon "Willie" O'Ree, born in 1936 in Fredericton, New Brunswick, Canada. Signed by the Boston Bruins, he played his first game for the Bruins on January 18, 1958. After the 1957–58 season he was sent to play for Boston's minor league team, but returned to the Bruins during the 1960–61 season in which he played forty-three games, scored four goals and had ten assists. O'Ree went on to play two decades in the minor leagues, with the Los Angeles Blades and the San Diego Gulls, before retiring in 1980. He played a total of forty-five games in the NHL.

O'Ree was not the first black to play organized professional hockey. Arthur Dorrington played with the Atlantic City Seagulls of the Eastern Amateur League from 1950 to 1951, while in the 1940s and '50s, centerman Herb Carnegie, along with his brother Ossie and another African Canadian, Mannie McIntyre, formed the famous Black Line, playing in various senior leagues in Ontario and Quebec.

Several African Canadians have played in the NHL since Willie O'Ree broke the color line. The most celebrated has been Grant Fuhr, the goaltender from Edmonton, Alberta, who led his team, the Edmonton Oilers, to five Stanley Cup victories (1984, '85, '87, '88, '90), and earned the Vezina trophy for the league's best goaltending in 1988.

It is likely that African-American players will become more common in the NHL as the league actively supports community programs aimed at inner city youth. Such a program is Ice Hockey in Harlem (IHIH), founded in 1987 by Dave Wilk. IHIH provides hockey equipment, coaching, and tutoring to disadvantaged children in New York City. It has also provided scholarships for its members to hockey camps and private schools.

REFERENCES

SELL, DAVE. "Blacks and Hockey: A Tenuous Relationship." *Washington Post,* March 29, 1990, pp. E1, E9.
SEXTON, JOE. "Rough Road for Blacks in the N.H.L." *New York Times,* February 25, 1990, Sec. 8, pp. 1, 9.

LYDIA McNEILL

Idaho. Although African Americans constitute only a small percentage of Idaho's population, their history is richly intertwined with the state's colorful past. The first blacks to enter the region were explorers and trappers. York, the servant of Lt. William

Clark, crossed the northern region of Idaho during the Lewis and Clark expedition of 1804–1806. During the next three decades, black trappers and guides traversed the region; in the 1820s one of them, James BECKWOURTH, lived for three years in the Snake River Valley in what is now southern Idaho.

The first black settlers, primarily gold miners, arrived in 1860, when Idaho was still part of the Washington Territory. Lured to the region by gold discoveries in the Clearwater River basin, they were among the 63,000 gold seekers who rushed into the region between 1860 and 1863. The Idaho goldfields also attracted a number of pro-Confederate Missourians who migrated west to avoid military conscription and guerrilla warfare. These miners used their political power to discourage black migration to the region. By 1863, soon after Idaho became a separate territory, white miners in Boise County passed a law excluding blacks and Chinese from prospecting there. Two years later, antiblack politicians made an unsuccessful attempt to enact legislation that would have banned black migration to the Idaho Territory altogether.

Despite such efforts, by 1870 sixty blacks, the vast majority of them miners, had arrived in Idaho, with the largest concentrations near Silver City in the southwest corner of the territory and the next largest group in Boise County. William Rhodes, a black miner, was one of the first gold seekers to reach the Clearwater country. Originally from Missouri, Rhodes moved to California during the gold rush of 1849 and joined the early rush to Idaho, arriving in 1860. Rhodes worked the mines until 1862 and reputedly left Idaho with $80,000. Despite the antiblack sentiment of many of the first Idaho miners, Rhodes Peak in the Bitterroot Mountains was named after this early African-American prospector. Another miner, George Washington, a former Missouri slave, prospected in the Sawtooth Mountains of central Idaho. The 1870 census listed Washington as owning $1,000 in real estate. At least three geographical formations in the Sawtooth Mountains—Washington Lake, Washington Peak, and Washington Basin—were named after him.

Idaho had few black homesteaders. Large-scale agricultural development in the territory evolved in the 1880s, after the gold-mining era, and eventually accounted for a much larger share of the territory's income. However, agricultural development was limited to the northern mountain valleys and to the Snake River Valley, which supported relatively expensive dryland farming. Nevertheless, some blacks homesteaded in northern Idaho. Joseph and Laura Wells, who arrived in the Boville-Deary area from Asheville, N.C., in 1889, were typical of such home-

steaders. The couple claimed more than 160 acres, part of which was cleared for wheat and barley and the remainder "logged" for timber. William King brought his family from North Carolina to northern Idaho in 1910 to homestead near the Coeur d'Alene Indian Reservation. The King family eventually purchased nearly five hundred acres, becoming the largest landowners in the valley that eventually bore the family name. Another black family, the descendants of Green Flake, the bodyguard of Mormon leader Brigham Young, settled in the Twin Falls area in the late nineteenth century.

Most nineteenth- and early twentieth-century black Idahoans, however, were urbanites, settling in the state's two largest cities, Boise and Pocatello. In 1910, Boise's 135 blacks made up about 1 percent of its residents, and the 127 Pocatello African Americans likewise represented 1 percent of that city's population. The vast majority of the early twentieth-century Idaho black population worked as barbers, waiters, servants, maids, railroad-maintenance workers, and common laborers. These limited employment opportunities—coupled with the increasingly hostile racial climate, as reflected in anti-intermarriage legislation and school segregation proposals—discouraged additional black migration to Idaho, and after 1920 prompted many black Idahoans to seek employment elsewhere. The black population in 1890, the year Idaho became a state, was 201. That population peaked at 920 in 1920, with Boise and Pocatello accounting for half of the state's black population. Pocatello, the second largest city in the state, emerged with the largest and most stable black population, primarily because its African-American labor force was composed almost entirely of employees in the railroad-repair shops located in the city.

Yet in the 1920s, a time when tens of thousands of African Americans were migrating from the rural South to northern industrial centers, Idaho's black population began a decline that continued until World War II. In 1940, the state's population of 595 blacks was only 64 percent of its previous peak in 1920.

World War II stimulated the Idaho economy and subsequently initiated a period of sustained, if moderate, black population growth. By 1950, the state's African-American population surpassed 1,000 for the first time, and by 1990, 3,370 blacks called Idaho home. Much of the post-1970 growth was concentrated in the Boise area, headquarters of major engineering and construction corporations, where some African Americans now held professional and managerial positions, as well as jobs in the rapidly growing service sector. The other major area of black concentration was Mountain Home, the site of Idaho's largest Air Force base. Black Idahoans achieved a po-

litical milestone in 1975 when T. Les Purce was elected mayor of Pocatello, becoming the first black mayor in the state's history.

REFERENCES

MERCIER, LAURIE, and CAROLE SIMON-SMOLINSKI. *Idaho's Ethnic Heritage.* Boise, Id., 1990.

PORTER, KENNETH W. *The Negro on the American Frontier.* New York, 1971.

SAVAGE, W. SHERMAN. *Blacks in the West.* Westport, Conn., 1976.

TAYLOR, QUINTARD. A History of Blacks in the Pacific Northwest: 1788–1970. Ph.D. diss., 1977.

———. "The Emergence of Afro-American Communities in the Pacific Northwest, 1865–1910." *Journal of Negro History* 64 (1979): 342–351.

QUINTARD TAYLOR

Ike, Reverend. *See* Reverend Ike.

Illinois. Illinois history is deeply interwoven with the African-American experience. A cultural and political cross-section of the United States in many ways, it has naturally mirrored the nation's ambivalent and troubled heritage on racial matters. Alternatively a haven of welcome and a bastion of prejudice, Illinois has been in many respects the "American Dilemma" writ small. Illinois history has featured all the major points of the African-American experience. It began as a land of slavery, and once slavery was abolished, it was transformed into a site of intense agitation between proslavery and antislavery political forces. In the early twentieth century, Illinois became a center of the Great Migration, and the black population of its urban areas swelled. By the second half of the century, the history of black CHICAGO had become largely the history of black Illinois. By 1990, the city and its suburbs contained some 85 percent of the state's blacks.

Black settlement antedated statehood by a century. In 1717, Philip Francis Renault brought 500 enslaved blacks from St. Domingue (later Haiti) to work in a mining operation in French Louisiana Territory's "Illinois Country." The mine eventually failed, and in 1744 Renault sold 300 of his slaves to local whites. By the time the British took over the area in 1763, there were some 600 slaves, mostly house servants and laborers on small farms. Free blacks also settled in the territory. In 1779, Jean Baptiste DU SABLE, a black trader, became Chicago's first settler. Both the French and the British considered slaves "personal property," regulated by the Louisiana slave code.

Interracial issues and tensions took root in Illinois as soon as blacks took residence, and African Americans grew to become both a substantial element in Illinois' social fabric and a chronic test of its democratic ideals. The Northwest Ordinance of 1787 banned slavery in the territory but failed to prohibit its surrogate, registered servitude. Thus began a charade of symbol versus substance that for two centuries has been an emblem of Illinois's race relations. In 1803, the Indiana Territory, which included Illinois, passed a "slave code" governing indentured servants. It provided for thirty-five-year terms of servitude for

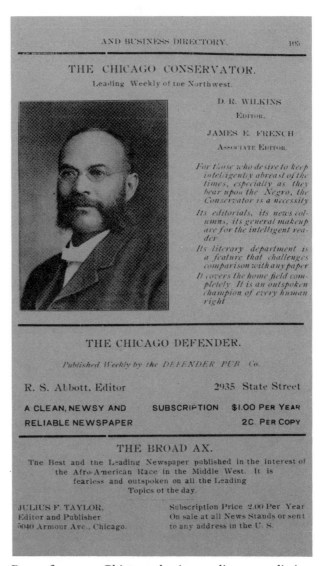

Page from a Chicago business directory listing African-American periodicals, published as part of *Colored People's Blue-Book,* 1905. (Illinois State Historical Library, Springfield)

black "apprentices" born in the territory and for slaves brought in from the South. Servants could be disciplined, sold, and inherited like southern slaves. Most worked as house servants and farmworkers on small holdings. Free blacks were required to post $1,000 bonds and carry passes and were denied the right to testify against whites in court. Because Illinois officials believed whites incapable of facing the harsh conditions in lead mines in the northwestern town of Galena and in salt wells around the southeast, an exception was made to permit slaves as "hired laborers" in the mines. Several thousand Kentucky and Tennessee slaves were leased to work the wells, and many slave owners held blacks on the pretext that they were connected with the salt trade. The state's first six governors had been slave owners, and several had registered black servants while in office. Illinois was forced to abolish slavery in order to be admitted to statehood. In 1818, after its admission to the union, Illinois passed a constitution that forbade slavery and provided for the end of slave labor in mines by 1825. However, it retained its indentured servitude system and passed a set of restrictive "black laws."

Intense proslavery views remained common among the white migrants who swarmed into southern and central Illinois in the early decades of the nineteenth century, notably those in the "Little Egypt" area surrounding Cairo. Evidence of their numbers and determination surfaced in a heated drive in 1824 to legalize slavery by amending the state constitution. The referendum found strong support, failing in the end because of courageous resistance by Gov. Edward Coles, a former Virginia slave owner who had grown to despise the institution.

As northern Illinois welcomed Yankee newcomers and as the national crisis over slavery grew, the state experienced sharp debate and even violence over racial issues. The ABOLITION movement grew. Pat Henderson's *The Statement*, begun around 1820, was probably the first antislavery journal published west of the Appalachians. The state also developed a thriving UNDERGROUND RAILROAD network, run under the guidance of its "Presidents," Peter Stewart of Wilmington and Dr. Charles Volney Dyer of Chicago. A few havens for escaped slaves were created, notably in the "Africa" section of Jacksonville, where runaways were sheltered at the Mount Emory Baptist Church (founded in 1837) and in the Jacksonville African Methodist Episcopal Church (founded 1846). However, in southern Illinois free blacks as well as runaway slaves were fair game for kidnappers. One fugitive reportedly surrendered because four days of fear and threat in Cairo were worse than four years of bondage. In 1837, shortly after the Illinois legislature passed a resolution attacking abolitionism and sup-

porting slavery in slave states, pioneering abolitionist Elijah P. Lovejoy, who used the pages of his Alton, Ill., newspaper to attack slavery, was murdered by an angry mob of southern sympathizers. Lovejoy's brother Owen espoused the cause during several terms in Congress.

In 1841 the sale of indentured servants was banned, and in 1845 the Illinois Supreme Court ruled that the apprenticeship system was unconstitutional. However, the state constitution and statutes continued to deny full citizenship to African Americans. Blacks found without proper papers were subject to fine and sometimes sale at auction for periods of slavery. A law was passed in 1848 barring freedmen from moving to Illinois, and an 1853 law imposed heavy fines on whites who brought blacks into the state. In November 1856, free black activists organized a large Repeal Convention in Alton to organize the community against legal harassment and to demand suffrage rights.

The ambivalence, complexity, and contradiction so characteristic of antebellum Illinois views on slavery and race found their supreme embodiment in the life and work of Abraham Lincoln, the state's most famous citizen. Lincoln's ambiguous and changing positions on slavery, abolition, racial difference, and the fate of freedmen are well documented. He despised slavery, but was willing to permit its survival as the price of union. No disciple of racial equality or social integration, he nevertheless foresaw the advent and justice of civil rights. His famous series of debates with Stephen Douglas during the senatorial campaign of 1858 made Illinois the main arena of the national dispute over slavery. During the campaign, and later as a presidential candidate and chief executive, he walked a racial tightrope that at times linked him with the racist sentiments common to southern Illinois and at other times resembled abolitionist and egalitarian views associated with Yankee residents farther north. Thus Lincoln epitomized the diversity of Illinois voices on racial matters, though he also demonstrated a capacity for progressive change.

Pro-South Copperhead sentiment remained a potent minority voice in Illinois before and during the CIVIL WAR, and a constitutional referendum in 1862 reaffirmed existing codes and revealed overwhelming popular resistance to black suffrage. Illinois blacks, organized into the 29th U.S. Colored Infantry in April 1864, fought bravely in the Civil War. The pressure generated by the Union victory and by black participation in the war effort eventually solidified the power of the REPUBLICAN PARTY. Harsh black codes were abolished in 1865.

In 1866, a State Convention of Colored Citizens was held at Galesburg. Members eloquently pre-

sented their demands for educational equality, civil rights, and suffrage, which were slowly conceded. In 1868 freedmen were granted the right to vote, and in 1872 the state's public schools were integrated. In 1876, John W. E. Thomas of Chicago was elected the state's first black state legislator. Under his leadership, in 1885 Illinois passed a comprehensive Civil Rights Act, covering transportation and public accommodations.

Illinois became an important destination in the post–Civil War black exodus to northern cities, a migration that continued through the late nineteenth and early twentieth century. The Illinois black population settled in growing manufacturing towns such as Chicago, Galesburg, Rockford, Carbondale, and East St. Louis. Convenient travel routes, the lure of new mining and factory jobs, and perhaps the image of Abraham Lincoln as the Great Emancipator combined to draw a disproportionate share of restless African Americans to the state.

The swelling ranks of black Illinoisans typically realized a marginal improvement in their economic prospects at the price of hostility and segregation in their social relations. Some outstanding figures emerged, such as Rockford surgeon Dr. Daniel Hale WILLIAMS, who performed the first successful open-heart surgery, and Fenton Johnson, a Chicago poet and writer. Editor/activist Ida B. Wells (*see* Ida B. WELLS-BARNETT) came to Illinois after being forced to flee Memphis in 1892 and married *Chicago Conservator* editor and assistant state's attorney Ferdinand Lee Barnett. Most blacks, however, faced low wages and poor living conditions. Fueling the existing interracial tension was a practice among mine and factory owners of recruiting unskilled southern blacks as strikebreakers.

It is emblematic of these growing racial tensions that three of the nation's worst, early urban race riots occurred in Illinois. Whites in Lincoln's hometown of Springfield erupted in a week of violence in the summer of 1908. So shocking was this outburst that it served as the catalyst for the founding of the NATIONAL ASSOCIATION FOR THE ADVANCEMENT OF COLORED PEOPLE (NAACP). Several lynchings, along with assaults and massive property destruction, left no doubt about the extent of racist feeling in Illinois. Nine years later, during the massive spurt of black migration that followed the beginning of World War I, East St. Louis, a steel and mining center dubbed "the Pittsburgh of the Midwest," experienced even bloodier mayhem. Rioting erupted in the aftermath of a failed labor strike, and dozens of blacks died and more were forced to flee from mob atrocities. During the notorious "Red Summer" of 1919, a lakefront incident in overcrowded Chicago ignited several days of violence by both whites and blacks. By the time order was restored, twenty-three African Americans were dead and hundreds were injured.

The Great Migration established Chicago as the center of black population in Illinois, and a primary locus of African-American life. The CHICAGO DEFENDER was a powerful national newspaper, and many black businesses, such as the Supreme Life Insurance Company and the Johnson Publishing Company, originated and prospered in the city. Beginning in 1928, when Chicago Alderman Oscar DEPRIEST became the first northern African American elected to the House of Representatives, Illinois has had the nation's longest run of black representatives in Congress. In 1934, Arthur MITCHELL became the first black Democrat elected to Congress.

The outbreak of World War II brought about an economic boom in Illinois industry and sparked renewed black immigration, especially to Chicago. The wave of migration continued for at least twenty-five years. In the years after the war, the struggle for black equality expanded, but progress was very slow. In 1951, when Harvey Clark, an African American, and his family bought a house in the Chicago suburb of Cicero and moved in, local whites rioted and tried unsuccessfully to pressure them into moving out. Not until 1962 did Illinois pass a Fair Employment Practices law. Civil rights laws were laxly enforced in Chicago and elsewhere. In 1966, the U.S. Civil Rights Commission held hearings in Cairo and uncovered widespread discrimination. During a second set of hearings in the town six years later, investigators discovered that African Americans, who made up approximately 50 percent of the town's population, faced chronic police harassment (only one of the town's police officers was black) and were often refused medical and dental care. The black unemployment rate was three times that of whites. To some African Americans, it seemed that the CIVIL RIGHTS MOVEMENT had completely passed by the region.

Generally mild forms of racial antagonism have prevailed in the modern era. Meanwhile, Illinois has built an impressive record of black achievement. In the 1980s, Chicago elected a black mayor, Harold WASHINGTON, and earned recognition as the national headquarters of OPERATION PUSH (People United to Save Humanity), led by the Rev. Jesse JACKSON. It was also the home of such prominent African Americans as poet Gwendolyn BROOKS, modern dance pioneer Katherine DUNHAM, and television personality Oprah WINFREY. By 1990, seventeen of the nation's 100 largest black corporations were located in Illinois. In 1991, Marjorie Judith Vincent, Miss Illinois, became the second black woman to be named Miss America. In 1992, Illinois state representative Carol

MOSELEY-BRAUN was elected the first African-American woman in the U.S. Senate.

However, poverty and discrimination continue to plague the state's African-American community. The city of East St. Louis, a black majority city as of the 1970s, suffered such powerful economic stress due to deindustrialization and white flight that the city went bankrupt and was forced to sell off city properties to mainly white investors. Contemporary evidence of the state's dissonance on racial matters is most conspicuous in Chicago. The same city that houses more than one million black citizens, including international celebrities in politics, commerce, and the arts, also displays extreme levels of segregation in housing and schools. Bitter racial divisions pervade municipal politics throughout the state. In 1987, black residents of Springfield sued to overturn a city government characterized by blatant discrimination. The double standard survives as a constant in Illinois race relations. Ironically, it was Illinois Gov. Otto Kerner who led the President's Advisory Commission on Civil Disorders in 1968. The commission's report described well the contemporary situation in Illinois when it concluded: "Our Nation is moving towards two societies, one black, one white—separate and unequal."

REFERENCES

BRIDGES, ROGER D. "Blacks in a White Society." In Roger D. Bridges and Rodney O. Davis, eds. *Illinois: Its History and Legacy*. St. Louis, 1984, pp. 90–99.

HARRIS, NORMAN DWIGHT. *The History of Negro Servitude in Illinois and of the Slavery Agitation in That State, 1719–1864*. 1904. Reprint. New York, 1969.

HODGES, CARL G. *Illinois Negro Historymakers*. Chicago, 1964.

HOWARD, ROBERT P. *Illinois: A History of the Prairie State*. Grand Rapids, Mich., 1992.

MUELDER, HERMANN R. *A Hero Home from the War: Among the Black Citizens of Galesburg, Illinois, 1860–1880*. Galesburg, Ill., 1987.

TINGLEY, DONALD E. *The Structuring of a State: The History of Illinois, 1899–1928*. Urbana, Ill., 1980.

VOGELI, V. JACQUE. *Free But Not Equal: The Midwest and the Negro During the Civil War*. Chicago, 1967.

CULLOM DAVIS

Imes, Elmer Samuel (October 12, 1883– September 11, 1941), physicist. With the completion of his PHYSICS dissertation in 1918 at the University of Michigan, Elmer Imes brought into existence a new field of research: the determination of molecular structure by means of high-resolution infrared spectroscopy. In particular, accurate measurements could be made for the first time of the distance between atoms in simple molecules. Imes's work also provided a change of view in the thinking of the general scientific community concerning quantum theory. His work clearly showed that the theory was not limited to electronic spectra, but could be applied to all phenomena at the molecular level.

Imes was born in Memphis, Tenn., on October 12, 1883, to Benjamin Albert Imes and Elizabeth Wallace, both of whom had received degrees from Oberlin College. He finished Fisk University in 1903 and for the next nine years taught physics and mathematics at Albany Normal Institute in Georgia. In 1913, Imes returned to Fisk, where he completed the requirements for the master of science degree. After graduation from the University of Michigan in 1918, he spent the next eleven years working in industry. In 1929, Imes returned to Fisk University as chair and professor of physics. He remained in this position until his death.

Imes was very successful as both a teacher and a researcher at Fisk. His enthusiasm and energy were contagious. In 1949, when Fisk started again to offer graduate degrees, Imes's research field of infrared spectroscopy became one of the most productive of these new programs. Since 1949, the Fisk University Molecular Spectroscopy Research Laboratory has trained over a thousand students, faculty, and professional researchers from other universities and from industry and government laboratories in the techniques of infrared and Raman spectroscopy. These activities have resulted in the publication in the scientific literature of a steady stream of research papers, numbering in the hundreds.

Imes married the novelist Nella LARSEN. Their marriage produced no children, and they eventually divorced. Imes died in New York of cancer in 1941.

REFERENCES

IMES, WILLIAM LLOYD. *The Black Pastures*. Nashville, Tenn., 1957.

MICKENS, RONALD E. "Bouchet and Imes: First Black Physicists." In *Proceedings of the 12th Annual Meeting and 16th Annual Day of Scientific Lectures of the National Society of Black Physicists*. Holmdel, N.J., 1989, pp. 1–14.

RONALD E. MICKENS

Immigration. For the most part, the study of African-American history and that of American immigration history have been viewed by scholars as completely separate entities. This division is misleading and arbitrary. With the exception of AMERICAN

INDIANS, the population of the United States is composed of migrants and their descendants. The study of African-American history has focused on the population created by the forced migrations of hundreds of thousands of Africans in the SLAVE TRADE lasting into the first decade of the nineteenth century. However, what is usually overlooked in the literature is the stream of voluntary migrants of persons of African descent to the United States from the late eighteenth century down to the present, a stream that has swollen significantly in the last third of the twentieth century.

The voluntary immigration from Africa and the Caribbean has produced considerable ethnic diversity within the African-American population. Among persons of African descent there are Haitians, Cape Verdeans, Jamaicans and numerous African ethnicities, among many others. (This article excludes black Latinos from detailed consideration. Given the extent of the integration of persons of African ancestry into the cultures of Cuba, Puerto Rico, and the Domini-

West Indian women at Ellis Island in New York Harbor in the early twentieth century. Between 1892 and 1924 more than 170,000 West Indian immigrants passed through Ellis Island before settling in the United States. (Photographs and Prints Division, Schomburg Center for Research in Black Culture, The New York Public Library, Astor, Lenox and Tilden Foundations)

can Republic, it would be difficult to separate blacks or the African dimensions of Latino culture from broader treatments of Latino culture and history which are outside the scope of this encyclopedia.)

Because blacks in this society are often seen solely in racial terms, their distinctive cultural identities go unrecognized. In the post-1960s era, the range of cultural and linguistic backgrounds that the migrants brought with them became increasingly more diverse. How they identified themselves was often constrained by how they were viewed by both whites and native-born blacks. Would they be recognized as members of an immigrant group or just simply as black? One may call oneself a Trinidadian, speak the *patois,* eat roti and curry goat, throw a weekly hand into the *susu* (rotating credit association), and play on a cricket team, but in the eyes of the members of the host society all such expressions of cultural difference are blotted out by the blinding force of racial STEREOTYPES.

The history of the relationship between native and foreign-born blacks in the United States has often been an uneasy one filled with ambivalence on both sides. Roy Simon Bryce-LaPorte (1993) has posed the provocative questions: "Who is or will be considered an African American?" and "When does a black person of foreign birth or ancestry become African American?" At times the realities of race have drawn the two populations together, particularly when outside discrimination has triggered a reactive solidarity. More often, however, cultural differences have superseded alliances based on color. Immigrants typically attempt to assert their cultural distinctiveness, foster ethnic solidarity, and resist identification with what has been the most subordinated sector of American society, while African Americans may exhibit resentment at the perceived preferential treatment accorded the foreigners, regarding them as a competitive threat in an economy where resources available to racial minorities are scarce.

As a by-product of a society that is organized on the basis of a rigid binary racial structure, official government records such as those compiled by the U.S. Census or the Bureau of Immigration are hopelessly deficient regarding black immigrant populations, further contributing to their sense of invisibility. For example, entrenched standards of "black" and "white" formed the basis of classification when the multiracial Cape Verdeans arrived during the latter part of the nineteenth and early twentieth centuries. Routinely grouped under other broader categories, those looking phenotypically most European or "white" were listed as "Portuguese" while the remainder were haphazardly labeled "African Portuguese," "Black Portuguese," and "Atlantic Islanders"—making any reasonable demographic estimates

from these sources impossible. Similarly, while British West Indians were distinguished from Puerto Ricans and Cubans, they were not distinguished from French or Dutch West Indians. Moreover, the U.S. Immigration and Naturalization Service collected demographic information only on those who were perceived to be mulatto under the designation "West Indian Race"; those appearing to be darker-skinned were simply lumped under the generalized label of "African Race," and no effort was made to gather data concerning the social characteristics of this group. Finally, information on Jamaicans was not compiled separately until 1953. Rather they were consolidated under "British West Indians" and then further subsumed under the classification of "Other Caribbean." As for arrivals from the continent of Africa, it was not until the 1960s that U.S. immigration records listed them separately by country of origin. From 1890 to 1980, totals of the foreign-born black population was tabulated in the decennial Census, but the figures were not broken down by place of birth (see Table 1). These limitations in conjunction with the sizable number of undocumented black aliens, especially among those who have entered since the 1970s, mean that official calculations of population data related to black immigrants contain serious shortcomings.

Scholarship that treats the black immigrant experience in America has been exceedingly sparse. The first and only book-length overview to date on the subject is Ira Reid's now classic monograph *The Negro Immigrant,* published in 1939. The vast majority of black immigrants to the United States at that time who established the most longstanding communities were Haitians, Cape Verdeans, or British West Indians. These continuing streams of immigration were joined in the post-1960s by increasing numbers of migrants from other countries in Africa and the Caribbean, as well as by people of African descent em-

igrating from nations where the dominant population is not black, e.g., Afro-Cuban newcomers. Furthermore, varying proportions of other Spanish-speaking multiracial societies in Latin America who migrate may be classified as black in the United States, further swelling the percentages of those of African descent.

Since the 1960s, several factors have converged to stimulate an upsurge in black immigration to the United States. The most significant development was the passage of the landmark Hart-Celler Immigration Reform Act of 1965, which established parity among independent nations in each of the hemispheres; this opened the doors to much more variegated groups in terms of race, ethnicity, religion, language, and national origin than any previous policy. Subsequent measures, most notably the liberal reforms of the Refugee Act of 1980, the Immigration and Reform Act of 1986, and the Immigration Act of 1990, reinforced this diversifying trend.

Political and policy changes during the 1960s in both the Caribbean region and in Britain roughly coincided with the implementation of Hart-Celler in this country, further contributing to the rise in black migrants. Many of the British West Indian islands with predominantly black populations moved toward independence from the British Commonwealth of Nations in this period and were thus able to circumvent the stringent visa quotas that had been allotted them as colonial possessions by the McCarran-Walter Act of 1952. In neighboring Haiti, François "Papa Doc" Duvalier's dictatorial rule caused many Haitians to relocate to the north. At about the same time, in 1962, the British Parliament enacted legislation that sharply curtailed the flow of West Indians to the United Kingdom. A final push factor was the rapid growth in population of many of the islands of the West Indies straining resources and triggering a serious unemployment crisis.

The post-1960s period also witnessed a dramatic increase in continental African blacks entering the United States from such sub-Saharan nations as Nigeria, Ghana, and Ethiopia. In the 1960s alone, the number of African-born blacks in this country increased sixfold. Most planned only a temporary stay, arriving to benefit from the higher education and technical skills training that are still unavailable to them in their native countries. Some, however, particularly those whose homelands are rife with political unrest or who hold asylum status, settled permanently. This "brain drain" of valued human resources has been cause for much concern to those acutely aware of the need for well-trained people to assist in pressing economic and social development in their countries of origin.

TABLE 1. The Foreign-Born Black Population of the United States

Year	Number
1890	19,979
1900	20,336
1910	40,339
1920	73,803
1930	98,620
1940	83,941
1950	113,842
1960	125,322
1970	253,458
1980	815,720

Source: U.S. Census of Population, 1890–1980.

Between 1972 and 1992, Jamaica, among non-Hispanic countries with overwhelmingly black populations accounted for 373,972 legal entrants into this country. This was followed by 249,953 from Haiti; 161,530 from Guyana; and 109,594 from Trinidad and Tobago—all Caribbean nations. The leading source of immigrants from Africa was Nigeria with 56,144; followed by 40,694 from Ethiopia; 25,046 from Ghana; and 14,954 from Cape Verde (see Table 2). While such figures usually represent severe undercounts, another indicator of the substantive presence of foreign-born blacks is contained in the *Report on the Foreign-Born Population in the United States* derived from the 1990 census: 435,000 listed themselves as having Jamaican ancestry; 290,000, Haitian; 82,000, Guyanese; 76,000, Trinidad-and-Tobagonian. Another 92,000 declared themselves of Nigerian ancestry.

Haitians

Within the history of black migration to the United States, Haitians are particularly noteworthy. They were the earliest voluntary settlers, starting in the second half of the eighteenth century and likewise they comprised, more than two centuries later, the first major group of black refugees to arrive here. Although their official status as political refugees has been contested, the desperation of their flight out of Haiti in the last decades of the twentieth century was often significantly motivated by direct experience with political persecution at home or fear of such reprisals, as well as by the desire to escape the dire

TABLE 2. **Top Eight Predominantly Black Immigrant Groups by Selected Country of Birth, 1972–1992**

	1972	1973	1974	1975	1976	1977	1978
Jamaica	13,427	9,963	12,408	11,076	11,100	11,501	19,265
Haiti	5,809	4,786	3,946	5,145	6,691	5,441	6,470
Guyana	2,826	2,969	3,241	3,169	4,497	5,718	7,614
Trinidad and Tobago	6,615	7,035	6,516	5,982	6,040	6,106	5,973
Nigeria	738	738	670	653	907	653	1,007
Ethiopia	192	149	276	206	332	354	539
Ghana	326	487	369	275	404	454	711
Cape Verde	248	214	122	196	1,110	964	941

	1979	1980	1981	1982	1983	1984	1985
Jamaica	19,714	18,970	23,569	18,711	19,535	19,822	18,923
Haiti	6,433	6,540	6,683	8,779	8,424	9,839	10,165
Guyana	7,001	8,381	6,743	10,059	8,990	8,412	8,531
Trinidad and Tobago	5,225	5,154	4,599	3,532	3,156	2,900	2,831
Nigeria	1,054	1,896	1,918	2,257	2,354	2,337	2,846
Ethiopia	726	977	1,749	1,810	2,643	2,461	3,362
Ghana	828	1,159	951	824	976	1,050	1,041
Cape Verde	765	788	849	852	594	591	627

	1986	1987	1988	1989	1990	1991	1992
Jamaica	19,595	23,148	20,966	24,523	25,013	23,828	18,915
Haiti	12,666	14,819	34,806	13,658	20,324	47,527	11,002
Guyana	10,367	11,384	8,747	10,789	11,362	11,666	9,064
Trinidad and Tobago	2,891	3,543	3,947	5,394	6,740	8,407	7,008
Nigeria	2,976	3,278	3,343	5,213	8,843	7,912	4,551
Ethiopia	2,737	2,156	2,571	3,389	4,336	5,127	4,602
Ghana	1,164	1,120	1,239	2,045	4,466	3,330	1,867
Cape Verde	760	657	921	1,118	907	973	757

Source: Compiled from the U.S. Department of Justice, Statistical Yearbooks of the Immigration and Naturalization Service.

economic conditions of the most impoverished country in the Western hemisphere.

The Republic of Haiti occupies one-third of the island of Hispaniola (the Dominican Republic occupies the remainder) situated in the Caribbean sea. The Haitian people are descended from African slaves who were brought to the island in the seventeenth and eighteenth centuries by French colonists to work on sugar plantations. The slaves initiated a successful revolution, overthrowing French rule in 1804 to become an independent nation—the second oldest republic in the New World after the United States.

Haitian migration to this country has occurred in three main waves: the years of the HAITIAN REVOLUTION, 1791–1803; the era of United States occupation, 1915–1934; and the period beginning with the long and repressive rule of the Duvaliers—François "Papa Doc," followed by his son, Jean-Claude "Baby Doc," 1957–1986—and continuing to the present, in late 1994, with no sign of abating. Even prior to the influx prompted by the Haitian Revolution, however, there had already been a Haitian presence in colonial America. One of the most notable émigrés was Jean Baptiste Point du Sable, who traded furs along the Mississippi River and founded with his Potawatami Indian wife Kittahaw the permanent settlement of Chicago in 1772. Later, in 1779, a battalion of 800 volunteers from Haiti fought valiantly to victory against the British in support of American independence at the Battle of Savannah.

Beginning in 1791, the number of arrivals began to increase, as the migrants sought to escape the turmoil of insurrection brewing in their homeland. The newcomers scattered along the coastal cities of New Orleans, Charleston, Philadelphia, and New York, and even as far as Boston. One such émigré, Joseph Savary, led the Second Battalion of Free Men of Color under Gen. Andrew Jackson in 1814–1815, distinguishing himself by becoming the first black to be ranked a major in the U.S. Army. Philadelphia was the cultural center of the émigré population in these years where settlers published a Haitian newspaper and ran a bookstore that served as a meeting place for compatriots.

Interestingly, the movement of blacks between Haiti and the United States has not always been one-way. At various times in the nineteenth century, African Americans left the United States for Haiti seeking a new homeland free of white domination. In the year 1824, some 13,000 black Americans emigrated to Haiti, and in 1861 another 12,000 made the journey, most departing from New Orleans. One of the first of these émigrés was a young man named Alexander Du Bois, the grandfather of W. E. B. DU BOIS, who sailed for Haiti in the early 1820s. He stayed only a few years, however, returning to the United States in 1831. Abraham Lincoln was the first American president to recognize Haiti's independence; under his administration a plan was also devised to resettle newly freed slaves to the island republic. Lincoln's policy toward Haiti, and perhaps even toward American blacks, was likely influenced by his personal barber and reputed confidant, the Haitian immigrant, William De Florville, known as "Billy the Barber."

More than a century after the Haitian revolution and in response to a succession of ineffectual presidents and continued political instability, the United States occupied the Republic of Haiti, triggering the outflow of hundreds, primarily from Port-au-Prince, to New York City. These newcomers were well educated and able to establish businesses, obtain professional employment, and assimilate fairly readily into existing urban communities. A significant proportion settled in Harlem, some joining other African Americans and West Indians in shaping the cultural movement of the HARLEM RENAISSANCE. After World War II, growing numbers of Haitian women made the journey, recruited initially as domestic workers in major cities throughout the United States. Like many immigrants these women viewed their relocation as a temporary measure, but also like so many, they ended up settling permanently in this country.

By far the largest outpouring of Haitians began as early as the late 1950s, when François Duvalier took office as president, inaugurating an era of dictatorship that lasted thirty years. Initially, the migrants from this last wave were primarily intellectuals, professionals, and political refugees of the middle and elite classes attempting to escape the brutal regime, but by the mid-1960s the high unemployment, shrinking opportunities, and oppressive rule in Haiti set in motion mass migration. This flow coincided with the liberalization of U.S. immigration policy, especially as regards provisions for family reunification.

The grim political and economic circumstances in Haiti made emigration a matter of life or death for many who found myriad ways, both legal and clandestine, of reaching U.S. shores, including much publicized, desperate attempts to make the crossing in leaky and overcrowded boats. Many sold everything they owned to book passage. Those who arrived by conventional means often came on tourist visas and simply overstayed their visit. By 1977 the volume of the exodus at sea escalated due to the confluence of several factors: deportation of Haitian workers from the Bahamas and a concurrent threat that they would also be expelled from the neighboring Dominican Republic; a shift in U.S. policy that made labor certification requirements more stringent

for prospective entrants; and finally, severe drought in Haiti in both 1975 and 1977, as well as stepped-up internal violence. This influx was predominantly male and largely illiterate—a flight from severe rural poverty.

For the most part the migrants were unwanted in this country, however, and their journey was filled with obstacles throughout. Some of the boats were simply intercepted en route by United States Coast Guard cutters and returned to Haiti. Those that did succeed in making the crossing faced a hostile reception by the authorities. Without proper documentation and often without knowledge of their legal rights, they were incarcerated in detention centers outside Miami such as the notorious Camp Krome, a miserable, overcrowded facility where large numbers of refugees languished for indefinite periods.

There was more trouble. Public health officials had already associated Haitians with the spread of tuberculosis, and in the early 1980s, the Center for Disease Control in Atlanta singled out the migrants as one of the high-risk groups for contracting the HIV virus. Although they were later officially removed from that list, the damage had already been done, further exacerbating negative sentiments toward the Haitian newcomers.

At this juncture, the charge of racial discrimination began to be made as explanation for the differential treatment accorded Haitians—the only black population seeking political asylum—as compared to the Cubans, the other major group of Caribbean refugees reaching South Florida. Cubans were classified as political refugees, and this enabled many to make an easier transition to the United States. By contrast, although most Haitians left their homeland in this period to escape political persecution, the vast majority did not hold refugee status but rather were categorized as economic migrants. Thus, even when they did actually succeed in relocation, and despite having experienced the violent disruptions and consequent liabilities of political repression, they could not take advantage of the resettlement services that come with refugee status in the United States.

When racial bias was raised as a major factor in the mistreatment of Haitian refugees, some in the African-American community made a concerted effort to persuade lawmakers to reassess their policies. The CONGRESSIONAL BLACK CAUCUS got involved as did such established black political figures as Jesse JACKSON and Shirley CHISHOLM lobbying on behalf of the Haitian cause during the early 1980s. Here then, was a situation where allegiances based on race overshadowed cultural differences.

After the 1991 ouster of the democratically elected President Jean-Bertrand Aristide, political reprisals against Aristide supporters in Haiti once again led

more than 50,000 to flee their homeland seeking refuge in the United States. While initially a few were screened and allowed entry, most were turned away or were intercepted at sea where they were then sent to detention centers in other parts of the Caribbean.

In the 1990s the largest concentration of Haitian immigrants was in New York City, where over half of those claiming Haitian ancestry in the United States lived. Within the metropolis, Haitians clustered in Brooklyn's low- and moderate-income neighborhoods while those who could afford it relocated to parts of Queens. Although the tendency was to reside among coethnics, these were also areas where black Americans and other Afro-Caribbeans lived. The Haitian influx into the city included migrants from a wide range of socioeconomic and educational backgrounds, but, for the most part, they worked in unskilled and semiskilled factory jobs and in service industries.

The sustained economic growth in Massachusetts during the 1980s attracted some of the Haitian population of the Northeast away from the established community in New York City, where many middle- and working-class families felt constrained by rising crime rates and congestion. The Boston area had a reputation for good schools, and its strong economy held out the promise of economic advancement and educational opportunity.

In the late 1970s and early '80s, while more than 60,000 Haitian "boat people" were arriving in South Florida, there was a secondary migration into Miami of primarily middle-class Haitians who had originally settled in New York. Together they have created a flourishing "Little Haiti" modeled after the successful ethnic economy of Miami's "Little Havana." While operating on a much smaller scale and with more obstacles than its Cuban counterpart, "Little Haiti" has grown to include enterprises from ethnic microbusinesses to more established ventures selling Caribbean and French-styled products, a well-developed community service sector, outlets for Haitian music and art, and a strong presence within the local educational system. When a new public school opened in the neighborhood, it was renamed Toussaint Louverture Elementary after the Haitian revolutionary leader. Low-cost housing is available to residents of the enclave, an area that is situated close to the garment factories and warehouses in Miami where many of the immigrants are employed. Others who fled to Florida in these years became migrant farmworkers, heading north to pick fruits and vegetables all along the southern Atlantic coast.

No matter where they ultimately settle, religious participation is high among the newcomers. While most Haitians are Catholic, increasing numbers are joining evangelical Protestant congregations, a legacy

of the Protestantism brought to Haiti by hundreds of American missions. Most of the immigrant Protestant worshipers are Baptists. Some churches serving the Haitian community offer services in Creole and some in French, while Haitian pastors are taking greater leadership roles. Many Haitian settlers have creatively combined their more institutionalized Christian practices with less formal, traditional vodoun religious beliefs (see VOODOO). A growing number of families send their children to parochial schools.

One of the defining features of the Haitian émigré community is the extended network of radio and television outlets that broadcast Haitian programming, usually in Creole. One can listen to Haitian music and news from the homeland at any hour of the day while educational, cultural and religious programs are offered on both radio and local cable stations. Typically, the Haitian migrants remain close to their relatives in Haiti. Family members already in the United States help the others to come in classic chain migration fashion. Although there are no statistics available on the subject, it is widely understood that the money sent by Haitians from this country to their families and relatives in Haiti is one of their most important sources of revenue. When travel is not risky, Haitian immigrants, when they can afford it, often make return visits. Similarly, the children of wealthy Haitians are more likely to fly to the United States, particularly Miami, than to travel out of the city of Port-au-Prince to another part of the country. It has also become more common for wealthy Haitian parents to send their children to American schools while English/French bilingual schools in Haiti have benefited from increasing popularity. Hence, at many differing levels, the back-and-forth movement and interpenetration of Haitian and American cultures permeate the Haitian-American immigrant experience.

Coming from a highly class-stratified society, Haitians must adjust to a situation in the United States where race predominates over both social class and ethnicity. Members of the first generation are much more likely to exhibit a strong national identity, continuing to speak Haitian Creole, which is not simply a dialect of French but a language of its own, and to associate primarily with coethnics. In general, they do not actively identify with African Americans. However, studies completed in New York, Miami, and Evanston, Ill., demonstrate that the immigrant children are much more likely to shed their traditional culture, speak English exclusively, and attempt to fit into black America. Haitians also view themselves as distinctive from other Afro-Caribbean migrants. They shun identifying themselves as West Indians especially because of the difference in language from their English-speaking Caribbean counterparts

and also because of their differing cultural background and their unique history of early self-rule. Faced with discrimination based on race as well as significant levels of anti-immigrant bias, Haitian Americans have had to juggle a complex mix of social, cultural, regional, and racial identifications in the process of adapting to their new communities.

Cape Verdeans

The first voluntary mass migration of a population of African descent to the United States began in the latter half of the nineteenth century when significant numbers of Cape Verdeans left their drought-stricken archipelago off the west coast of Africa, which had long been colonized by Portugal, to make southeastern New England their new home. Although little-known outside of the New England region, these Afro-Portuguese settlers are of particular significance as the only major group of Americans to have made the transatlantic voyage from Africa to the United States on their own initiative.

Most historians agree that the Cape Verde Islands were uninhabited until the mid-fifteenth century, when Portuguese explorers landed there. Almost from the very beginning of settlement, West African slaves were being brought to the Cape Verdes, initially to labor on sugar and cotton plantations, but the arid climate of these Sahelian islands prevented truly successful commercial cultivation of the land. What soon became more important to the Portuguese than agricultural production was the strategic location of the archipelago as a crossroads in the expanding slave trade. Situated near the Guinea coast and on the trade winds route to Brazil, the islands served as an entry point for the distribution of goods, for supplying foreign vessels with needed supplies and salt, and for transporting slaves to the New World.

As these exchanges were taking place, the sparse Portuguese population intermingled with the greater numbers of West Africans to produce a rich and distinctive society and culture. In this mesh of African ancestry, Catholicism, and Western presence, it has not always been possible to discern whether the European or the African influence predominates. Rather the interweaving has been so complete that it is most appropriate to speak of the evolution of a separate culture with its own distinctive customs, folklore, cuisine, music, literature and finally, language. Though based in Portuguese and several West African languages, the mother tongue of the Cape Verdean people is a full-fledged, creolized language of its own, called Crioulo. Although varying in dialect from one island to another, Crioulo has become a defining feature of the Cape Verdean cultural identity that has been transmitted to the United States and other parts of the world.

Cape Verdean immigrants in New England had a strong maritime background and many worked as sailors, often on Cape Verdean-owned packet boats and barks. In this picture from 1922, *Wanderer* prepares to sail, with its captain, Antone T. Edwards, in the foreground. (Old Dartmouth Historical Society—New Bedford Whaling Museum)

The effects of the dry climate in the Cape Verde Islands was exacerbated by colonial mismanagement of the land, so that by the end of the eighteenth century, the people of the islands were experiencing severe and recurrent drought with its resulting famine and high mortality. Unable to escape overland to more favorable conditions, young Cape Verdean men seized the chance to leave home in search of a better life as crew aboard the United States whaling ships that were beginning to arrive at the archipelago's protected harbors, particularly on the island of Brava.

The Cape Verdean seamen earned a reputation as disciplined and able crews. Despite their skill as whalers, however, they were routinely allotted the lowest rates in the division of profits and were frequently subject to harsh treatment in the mariners' hierarchy because of discrimination based on race and ethnicity. Their exploitation at sea foreshadowed a similar prejudice that they would face once the im-

migrants began to settle more permanently in this country.

By the late nineteenth century, with the advent of steamship travel and the decline of the whaling and sealing industries, the old sailing vessels had become obsolete and were available at a very low cost. Some of the early Cape Verdean migrants took advantage of this opportunity to buy up these old Essex-built "Gloucester Fishermen." They pooled their resources and converted them into cargo and passenger ships, used as packet boats that regularly plied between the Cape Verdes and the ports of New Bedford, Mass., and Providence, R.I. With the purchase of a sixty-four-ton fishing schooner, the *Nellie May*, Antonio Coelho became the first Cape Verdean-American packet owner. He hired a former whaleman as captain and set sail for Brava in 1892. Before long, Cape Verdean-American settlers came to own a fleet of these vessels. Thus, in a situation unlike that of most

immigrant groups, black or white, the Cape Verdeans had control over their own means of passage to this country.

During this same period, cheap sources of labor were being sought for the expanding textile mills, on the cranberry bogs and in the maritime-related occupations of southern coastal New England. Increasing numbers, including women and children, were arriving to fulfill the demand, fleeing their land of continuous hunger. The movement continued steadily until the enforcement of the restrictive immigration laws of the early 1920s, which curtailed the influx.

Like the records of other immigrants who do not fall readily within the dualistic confines of the United States system of racial classification, official population records have been completely inadequate in providing accurage demographic data on the Cape Verdeans. However, analysis of information recorded on the packet ship passenger lists has made it possible to calculate solid estimates of the numbers of Cape Verdean entrants as well as to construct a population profile on this group. In the years between 1820 and 1975 some 35,000 to 45,000 Cape Verdeans emigrated to the United States, with the islands of Brava and Fogo providing over 60 percent of the newcomers. In the years of the heaviest inflow, between 1880 and 1920, the overwhelming majority were male. After the islands became an independent nation in 1975, thanks to the continued liberal immigration policy of the United States, an average of 900 arrivals entered annually. Currently the estimated number of Cape Verdeans and their descendants living in the United States stands at 350,000, slightly more than the total population of the home country itself.

The Cape Verdean settlers brought with them a distinctive cultural identity, migrating freely to New England as Portuguese colonials, thereby initially defining themselves in terms of ethnicity. However, because of their mixed African and European ancestry, they were looked upon and treated as an inferior racial group. Although the Cape Verdeans sought recognition as Portuguese Americans, white society, including the other Portuguese immigrants, excluded them from their social and religious associations. They suffered similar discrimination in housing and employment. At the same time, the Cape Verdeans chose not to identify with American blacks. Their Catholicism tended to keep them apart from the primarily Protestant African-American population, but, more powerfully, they quickly perceived the adverse effects of racism on the upward mobility of anyone considered nonwhite in this country.

One noteworthy exception to this pattern is illustrated by the life of the flamboyant and charismatic evangelist leader "Sweet Daddy" GRACE, perhaps the most notorious Cape Verdean American immigrant.

Founder of the United House of Prayer for All People, by the late 1930s he had established hundreds of these Protestant congregations throughout the United States with an estimated half a million followers, primarily African Americans. In the process, he amassed hundreds of thousands of dollars, and by 1952, EBONY magazine called him "America's richest Negro minister." On the subject of race, Sweet Daddy declared, "I am a colorless man. I am a colorless bishop. Sometimes I am black, sometimes white. I preach to all races." Born Marceline Manoël de Graça in 1881, he sailed from his native island of Brava to New Bedford at the age of nine. Among the bishop's many teachings was the singular claim that along with his own migration, God, too, first arrived in America in the year 1900.

As in characteristic of other nonwhite immigrants to the United States, issues of identity among the Cape Verdeans are an ever-evolving and complex matter. The 1960s were watershed years for Cape Verdean Americans as the rise of black nationalism and its attendant emphasis on pride in one's African heritage had a transformative effect on many. The domestic social changes coincided with the struggles for liberation from Portuguese colonialism on the continent of Africa as well. At the time, the Cape Verde Islands, under the great revolutionary leader Amilcar Cabral, in collaboration with the Portuguese colony of Guinea-Bissau, were engaged in a protracted armed conflict to procure their independence. The process of rethinking racial identifications touched most Cape Verdean-American families in this period, often creating intergenerational rifts between the parents and grandparents, who were staunchly Portuguese, and their children, who were beginning to ally themselves with the African-American struggle not only in political thought but also in cultural expression.

Shortly after gaining its independence in 1975, the Republic of Cape Verde presented the United States with the gift of the schooner *Ernestina,* the last Cape Verdean packet boat in existence. In 1986, at the Tall Ships celebration of the Statue of Liberty centennial, the vessel took its place at the front of the flotilla, in recognition of its unique history as the only surviving ship in the parade that had actually carried immigrants to this country.

West Indians

The term *West Indian* refers here to the Anglophone Caribbean, a group of countries that were once British territories or are still formally associated with the British Commonwealth, including Jamaica, Trinidad and Tobago (which became one nation at the time of their independence in 1962), Barbados, the Bahamas, and Guyana (formerly British Guiana), as well as the

scattered smaller islands of St. Kitts and Nevis, Antigua, Montserrat, St. Vincent, St. Lucia, Dominica, and Grenada. Although Guyana, Panama, and Belize are located on the South American mainland, they are included under the British West Indian rubric because of their related history, Caribbean orientation, and substantial black population. Jamaica has always been the most populous, with roughly half of the region's inhabitants residing there. West Indians are English-speaking or speak an English-based Creole. Although their migration in large numbers did not begin until the early twentieth century, they make up the largest group of voluntary black settlers in the United States. West Indians constitute vibrant and growing ethnic communities, some of long-standing, especially in New York City and other cities of the northeast such as Boston and Hartford. They are also found along Florida's Gold Coast region, in the midwestern cities of Detroit and Chicago, and in southern California.

The English first settled the West Indies in the seventeenth century and shortly thereafter began to bring in large numbers of Africans as slaves for the enormously productive, labor-intensive sugar plantations. Before long, the black population had greatly outnumbered the white and continued to grow after slavery was abolished so that the West Indians by and large are descended from African ancestry. The only exceptions are in Trinidad and Guyana, where significant proportions of the inhabitants are Asian Indians, the legacy of labor recruitment in the nineteenth century.

Although a sprinkling of West Indians relocated to North America in the nineteenth century, the first sizable wave arrived in the early decades of the twentieth, with approximately 85,000 entering between 1900 and 1930. American investors in this period—in particular, the United Fruit Company—developed large tracts of agricultural land in the Caribbean, strengthening the connection between the two regions, while the steamship lines hauling the fruit established transportation routes, especially to the ports of the northeast. Other West Indians, chiefly from Barbados and the Bahamas, came to work as migrant laborers on farms and construction projects in the southern United States during World War I, with many choosing to stay on a permanent basis. Between 1910 and 1921, a series of damaging hurricanes hit the islands hard, heightening the level of out-migration. When passage of the restrictive U.S. immigration laws of 1921 and 1924 effectively cut off the influx from southern and eastern Europe, people from the West Indies, which were still British colonies, came in under the generous British quota.

The newcomers had considerable job skills and training upon their arrival as well as higher levels of literacy than most immigrant groups of this period. Early in the migration, the sex ratio was significantly skewed toward men, but by the 1920s more women than men were making the journey. By far, the largest concentration of West Indian settlers was in New York City. The consensus among scholars and contemporary observers has been that this wave of migrants made an extremely successful adjustment to their new society. West Indians opened small businesses as a route to upward mobility and, among the black population as a whole, were over-represented in the professions. They thus played prominent roles in the intellectual, political, and economic leadership of the community.

The success of West Indians, especially of those who settled in New York during the earlier part of the century, has been used invidiously to demonstrate the superiority of the foreigners over resident African Americans. West Indian business acumen has been related to cultural factors such as hard work, thrift, participation in coethnic revolving credit associations, and maintenance of a strong family economy—resources that the newcomers supposedly transplanted from their countries of origin and thus are unavailable to native-born blacks. More recent research, however, has led to a reexamination of the notion that West Indians outperform native-born blacks; it has been found that, at least among the post-1965 settlers, levels of self-employment and occupational mobility as compared to African Americans have been exaggerated.

West Indians arriving to New York at the beginning of the twentieth century brought with them a legacy of political sophistication derived from the experience of living in Commonwealth territories, where class distinctions formed the primary organizing structure of society. The most influential political leader in the early period was the Jamaican-born Marcus GARVEY, who had organized plantation laborers in the Caribbean and Central America before coming to the United States in 1916. Within a few short years, Garvey mobilized hundreds of thousands of both West Indians and African Americans throughout the country to active political participation through his UNIVERSAL NEGRO IMPROVEMENT ASSOCIATION (UNIA), an organization promoting black nationalism, entrepreneurship, and solidarity. While Garvey utilized his steamship company, the Black Star Line, to transport blacks between the United States, the West Indies, and even Africa, his central aim was not solely a back-to-Africa solution to racial strife, but rather a passionate commitment to the development of strong, self-reliant, capitalist, black communities in this country and around the world. By the mid-1920s, Garvey came under federal surveillance as a possible threat to national security and

was convicted of mail fraud. Because of his immigrant status—he never became a naturalized citizen of the United States—the government was able to deport him, and Garvey was expelled from the country in 1927.

During the 1920s and '30s, Caribbean intellectuals settled in Harlem, shaping leftist politics and making major contributions to the literary and artistic production of the Harlem Renaissance. Militant socialist thinkers, such as Richard B. MOORE, a native of Barbados; Cyril BRIGGS, born on the tiny island of Nevis; and Hubert H. HARRISON from the Virgin Islands, organized laborers and tenants, delivered public lectures, and published radical journals and Marxist treatises. With other West Indians, including Frank CROSSWAITH and the Rev. Ethelred Brown, they ran for political office on the Socialist or Communist tickets at the local, state, and even national level, though none ever succeeded in being elected. Another central figure to the Harlem Renaissance was the Jamaican-born writer and poet Claude MCKAY, whose lyrical but biting literary contributions served to define the movement. Some of the leadership actively promoted alliances between the foreign-born and native black populations based on class solidarity to jointly combat the forces of racism and capitalism.

Never large enough to constitute a separate ethnic enclave in New York, Boston and other cities, the British West Indian immigrants to the metropolis were scattered throughout African-American neighborhoods; typically, they held the same menial, unskilled, and low-paying jobs as the rest of the black population. The women almost all worked as domestics replacing the earlier Irish help and competing with native-born black women, as white employers increasingly showed a preference for hiring foreign-born blacks. In Boston, by the early 1980s, West Indians began to establish an ethnic niche for themselves within the expanding service economy, especially as health care paraprofessionals and hospital workers in the city's extensive network of medical facilities.

The primary adaptation strategy for the West Indian newcomers was to uphold their foreign-born identity as nationals of a particular colony and as British. There were community efforts to promote the celebration of the Commonwealth holidays of Empire and Coronation Day and to encourage participation in organized cricket matches; individuals expressed their differences by emphasizing their British accents. No matter how hard they tried to assert their foreignness, however, how they defined themselves was less significant ultimately than how they were defined by others. For the most part, the white majority did not differentiate West Indians from the larger black population. Yet, unlike their Haitian counterparts, those from the Anglophone West Indies have been much more likely to develop a Caribbean panethnicity in the United States, shedding strong identifications based on nationality—as Jamaican or Barbadian, for example—and manifesting instead a West Indian identity. Because the political climate in their home countries has been more stable than the situation in Haiti in the last decades, West Indians have been more free to move back and forth, maintaining strong ties and forging a transnational identity as well.

West Indian migration north to the United States skyrocketed in the post-1965 era. In New York City, the newcomers—unlike the early twentieth-century first generation of settlers who tended to disperse among the local African-American population—are establishing discrete West Indian neighborhoods with an unmistakable Caribbean flavor. The lively and elaborate carnivals celebrated at summer's end with the sounds of calypso music, the parades of flamboyant masqueraders, and the aromas of West Indian dishes are a declaration to the public that a distinctive *black* and *foreign* population makes its home in the United States.

Recent Trends

Since 1965 black immigration to the United States has expanded beyond its traditional sources in the Caribbean and Cape Verde Islands. Some European migrants are of African descent. Recent immigration from Great Britain has contained a high percentage of persons of African-Caribbean ancestry. In New York City, for example, many British newcomers have settled in neighborhoods such as Crown Heights and East Flatbush, areas with heavy recent Caribbean arrivals.

The most interesting recent trend has been the development of African immigration. There is a tradition of voluntary African immigration dating back to the mid-nineteenth century. Orishatukeh Faduma from west Africa, a nineteenth-century educator in North Carolina, was a member of the American Negro Academy in the early twentieth century and the author of a scalding critique on the lack of education evidenced among the black clergy. Chief Alfred Sam, from the Gold Coast (now Ghana), was a leader of a back-to-Africa movement in Oklahoma around 1913, where he tried to sell local black residents shares in his Akim Trading Company. Many Africans came to the United States seeking education, including John Chilembwe, leader of the revolt in Nyasaland in 1915 and Kwame Nkrumah, later the leader of Ghana. The historically black colleges and universities (HBCUs) have educated many African political and religious leaders.

In the 1940s, there were approximately 2,000 African immigrants living in Harlem, primarily work-

ing as seamen, laborers, and cocoa importers. Their places of origin ranged from Nigeria, Dahomey (now Benin), the Gold Coast (now Ghana), the Congo (now Zaire), Liberia, to Sierra Leone. As a result of the Italian-Ethiopian war, there was some emigration of Ethiopian refugees to the United States, including Malaku E. Bayen, the editor of the *Voice of Ethiopia* in the late 1930s.

However, it was in the 1970s that African emigration commenced in substantial numbers. Although only about 2 percent of immigrants to the United States during the 1980s were from Africa (less if one excludes North Africa), African newcomers have established flourishing subcommunities, and have become an important part of the cultural and political life in many black neighborhoods. The most populous country in Africa, Nigeria, has been the source of the largest numbers of arrivals. The political troubles in Ethiopia in the 1970s and '80s contributed to an exodus of refugees and immigrants; over 5,000 Ethiopians moved to the United States in 1991 alone. The struggle against apartheid was an important factor in the sizable outmigration from South Africa. Dennis Brutus, Abdullah Ibrahim (Dollar Brand), Miriam MAKEBA, and Lindewe Mabuza were some of the prominent refugees from South Africa during this time. Other countries with substantial outflows, many of them former British colonies with Anglophone traditions, include the Cameroons, Ethiopia, Ghana, Ivory Coast, Kenya, Liberia, Senegal, Sierra Leone, Somalia, Sudan, Tanzania, and Uganda. The influx of African immigrants has coincided with and helped catalyze a renewed interest among many African Americans in their African roots. These settlers have played a significant part in the burgeoning African handicraft and artwork markets within black urban communities.

Increasing immigration to the United States by persons of African descent has expanded and challenged conventional notions and assumptions about the nature of African-American identity. The mingling of cultures, languages, historical backgrounds, and lifestyles has fostered a sense of multicultural diversity within black America. The common benchmarks of African-American experience have been expanded to include the full range of cultures within the wide ambit of the African diaspora. For all of the tensions and problems cultural mixing and assimilation bring, the result has already replenished African-American cultural and political life.

REFERENCES

APRAKU, KOFI. *African Émigrés in the United States: A Missing Link in Africa's Social and Economic Development.* New York, 1991.

BRYCE-LAPORTE, ROY S. "Black Immigrants: The Experience of Invisibility and Inequality." *Journal of Black Studies* (September 1972): 29–56.

———. "Voluntary Immigration and the Continuing Encounters Between Blacks: The Post-Quincentenary Challenge." *Annals of the American Academy of Political and Social Science* 530 (November 1993): 28–41.

BRYCE-LAPORTE, ROY S., and DELORES M. MORTIMER, eds. *Caribbean Immigration to the United States.* Research Institute on Immigration and Ethnic Studies Occasional Papers No. 1. Washington, D.C., 1976.

FONER, NANCY. "The Jamaicans: Race and Ethnicity Among Migrants in New York City." In *New Immigrants in New York.* New York, 1987, pp. 195–219.

HALTER, MARILYN. *Between Race and Ethnicity: Cape Verdean American Immigrants.* Urbana, Ill., 1993.

———. " 'Staying Close to Haitian Culture': Ethnic Enterprise in the Immigrant Community." In Marilyn Halter, ed. *New Migrants in the Marketplace: Boston's Ethnic Entrepreneurs.* Amherst, Mass., 1995.

HO, CHRISTINE. *Salt-Water Trinnies: Afro-Trinidadian Immigrant Networks and Non-Assimilation in Los Angeles.* New York, 1991.

JOHNSON, VIOLET. "Culture, Economic Stability and Entrepreneurship: The Case of British West Indians in Boston." In Marilyn Halter, ed. *New Migrants in the Marketplace: Boston's Ethnic Entrepreneurs.* Amherst, Mass., 1995.

KASINITZ, PHILIP. *Caribbean New York: Black Immigrants and the Politics of Race.* Ithaca, N.Y., 1992.

LAGUERRE, MICHEL S. *American Odyssey: Haitians in New York City.* Ithaca, N. Y., 1984.

LAWLESS, ROBERT. "Haitian Migrants and Haitian-Americans: From Invisibility into the Spotlight." *Journal of Ethnic Studies* 14 (1986): 29–70.

MODEL, SUZANNE. "Caribbean Immigrants: A Black Success Story?" *International Migration Review* 25 (1991): 248–276.

PORTES, ALEJANDRO, and ALEX STEPICK. *City on the Edge: The Transformation of Miami.* Berkeley and Los Angeles, 1993.

REID, IRA DE AUGUSTINE. *The Negro Immigrant: His Background, Characteristics and Social Adjustment, 1899–1937.* New York, 1939.

REIMERS, DAVID M. *Still the Golden Door: The Third World Comes to America.* New York, 1992.

STAFFORD, SUSAN BUCHANAN. "The Haitians: The Cultural Meaning of Race and Ethnicity." In *New Immigrants in New York.* New York, 1987, pp. 131–159.

SUTTON, CONSTANCE R., and ELSA M. CHANEY. *Caribbean Life in New York City: Sociocultural Dimensions.* New York, 1992.

UEDA, REED. *Postwar Immigrant America: A Social History.* Boston, 1994.

WOLDENMIKAEL, TEKLE MARIAM. *Becoming Black American: Haitians and American Institutions in Evanston, Illinois.* New York, 1989.

MARILYN HALTER

Independence Federal Savings Bank. The first black-owned federally chartered savings institution in Washington, D.C., the Independence Federal Savings Bank opened on July 9, 1968, at 624 E Street, N.W. A top priority of the bank was to give African Americans better access to mortgage loans.

When Independence Federal was first established, it had $25 million in accounts from its 2,368 charter depositors. By 1977, the deposits of the Independence Federal Savings Bank had risen to more than $39 million; the total assets topped $43 million. However, it still lost money in part because rising interest rates led to problems with its outstanding mortgage portfolio. In 1985, the bank raised $3 million with a public stock offering and soon returned to financial health. By the end of 1993, it was the second largest black-owned financial institution in the nation. It had four branches, all located in Washington, D.C., assets of more than $236 million, and more than 7,000 account holders. Eighty percent of its loans were made within Washington, D.C., especially in inner-city neighborhoods that had been subject to discriminatory lending policies such as redlining. Independence Federal Savings Bank provides a variety of other financial services, including low-cost checking and a student-loan program targeted at historically black colleges and universities.

See also BANKING.

REFERENCE

INDEPENDENCE FEDERAL SAVINGS BANK. *Community Reinvestment Act*. Washington, D.C., 1993.

SIRAJ AHMED

Indiana. The African-American experience in Indiana is characterized by struggles to achieve autonomy and to realize self- and community improvement in spite of numerous obstacles. While the proportion of blacks residing in the state has historically been relatively small, the question of their status has been a primary political and social issue in Indiana history. African Americans provided an exception to the Hoosier idea that has prevailed throughout the state's history—the believe that people in Indiana were basically alike, shared a common respect for tradition, avoided extremes, and generally personified what was best and typical in the United States. Through the nineteenth and most of the twentieth centuries, most white Indianans accepted the doctrine that blacks were inherently inferior and consistently enforced those racial attitudes, legally and socially. African Americans just as consistently demonstrated the fallacy of that belief in their daily lives and through the institutions they created to enable them to survive and progress.

People of African descent first came to the area of Indiana as slaves of French colonists, and slavery persisted when the British took over the region in 1763, and through the area's transfer to the new United States. Throughout the territorial and antebellum years, white Hoosiers invariably tried to prohibit African-American settlement in Indiana. While the Northwest Ordinance of 1787 forbade slavery in Indiana, the Vincennes Convention of 1803 petitioned Congress to permit SLAVERY in Indiana. A law passed in 1803, the year after the Indiana Territory (including present-day Illinois) was created, limited free black entry into the state, and established a system of indentured servitude requiring full-time service and the service of male and female children to the ages of thirty and twenty-eight, respectively. By 1820, 190 African-American Indianans were officially enslaved under laws permitting the transport of slaves into the territory, and several hundred more under the guise of indentured servitude. Most worked as farm workers, growing grain or cotton.

In 1816 the framers of the state constitution, motivated by a desire to reserve the state for white settlement, opposed the extension of the slave system into Indiana. An 1820 Indiana Supreme Court ruling recognized the 1816 constitution's abolition of slavery, but exempted those indentures made prior to 1810. The following year, that court outlawed involuntary servitude, but the status of African Americans remained dubious at best throughout the antebellum era. As late as 1832, despite legal efforts by white Vermont settler Amory Kinner, thirty-two slaves were officially recorded in Vincennes.

White Indiana settlers wished to rid the state of African Americans, and the state funded colonization societies to send blacks to Africa. Free blacks in the state faced many obstacles. Black men were not allowed to vote, to serve on juries, to join a militia (a ban that stood until 1936), to testify in court against whites, to send their children to public schools, or to receive public welfare money. An 1831 law limited the right of settlement. In 1840 Indiana began to enforce vigorously both state and federal Fugitive Slave acts, and some white citizens guarded the banks of the Ohio River to turn back refugees from adjacent Kentucky. In 1851, one year after passage of the Fugitive Slave Act of 1850 (*see* FUGITIVE SLAVE LAWS), the Second Indiana Constitutional Convention, prompted by the fear of settlement by blacks traveling through Indiana on their way to freedom in Canada, adopted an article specifically prohibiting African-American settlement in the state.

Despite such hostile legislation, however, thousands of African Americans migrated to Indiana be-

fore 1850. Most were FUGITIVE SLAVES or freed slaves who moved there to avoid restrictive laws in the slaveholding states. They settled largely in towns, notably Madison, Indianapolis, and QUAKER-led Richmond, and in the years prior to the CIVIL WAR established more than twenty rural settlements in Indiana's southern counties and frontier areas. Throughout the antebellum period they built schools and churches and established newspapers, businesses, and other cultural institutions, some of which (e.g., the Prince Hall Masons, and the Bethel African Methodist Episcopal [AME] and Second Baptist churches) survive today. Under the leadership of AME bishop William Paul Quinn of Richmond, blacks not only flocked to the AME church in large numbers but also organized a convention movement in the state to resist the efforts of the colonization movement to remove them (*see* ANTEBELLUM CONVENTION MOVEMENT).

Indiana blacks also were involved in antislavery activities. In 1838 black and white abolitionists (*see* ABOLITION) formed the Indiana Antislavery Society. African Americans were active in assisting fugitive slaves who came to Indiana on the UNDERGROUND RAILROAD. Evansville and New Albany (opposite Louisville) were the most popular crossings. The most important "stations" were John W. Posey's coal mine in Petersburg, and the house of Levi Coffin (unofficial "president" of the railroad) at Fountain City, in the Quaker center of Wayne County. Abolitionist actions often resulted in attacks on blacks, for whom violence was already a fact of life.

In the years after the Civil War, large numbers of southern blacks moved to Indiana. The state's black population more than doubled from 1860 to 1870, though blacks still represented barely 1 percent of the total population. Many settled in the cities such as Indianapolis, which developed a vibrant black community, complete with churches and literary and social organizations. The city became home to a large upper class of "bon tons," black businessmen and professionals such as physicians Samuel and Henry W. Furniss (the latter also a diplomat, and minister to Haiti). The city gained special prominence due to the *Indianapolis Freeman* newspaper, edited by George Knox from 1884 to 1927. The *Freeman* was probably the first illustrated black newspaper, and had a large national readership. However, the southern region, notably Evansville, was easily accessible to southern migrants and became the state's major black population center in the late nineteenth century.

Several well-known African Americans were raised in Indiana in the late nineteenth century. Probably Evansville's best-known native of the period is writer, composer, and activist Shirley Graham DU BOIS, born on a farm near the city in 1896. Other famous natives from the period include concert pianist Hazel HARRISON of La Porte, as well as bicycle champion Marshall TAYLOR and songwriter and bandleader Noble SISSLE of Indianapolis.

Indiana grudgingly granted blacks a measure of equality. In 1865 the state repealed its black laws (though the term "white" was not expunged from the state constitution until 1926), and created a segregated school system. In 1869 Democratic state senators resigned en masse to prevent a special session of the legislature from ratifying the Fifteenth Amendment, and Indiana did not officially assent to black suffrage until 1881. A state civil rights act was passed in 1885. Nine years later, an African-American segregated during an instate journey on an interstate railroad in Indiana sued and won a notable court victory.

Nevertheless, as in most of the United States, segregation became pervasive in Indiana by the turn of the century, and racist practices severely limited African Americans in their pursuit of employment and educational opportunity. By the turn of the twentieth century, few black farmers remained, and by 1910, 80 percent of the state's blacks lived in urban areas, most holding menial jobs and living in poverty. Custom closed the entry of blacks into skilled trades, and though a small percentage managed to obtain formal education, there were no employment opportunities for them. White mobs lynched individuals and destroyed symbols of black achievement such as schools and churches (*see* LYNCHING). The largest outbreaks of racial violence came in Evansville in 1903 and in Greensburg in 1906. Violence against African-American Indianans continued through the 1930s, and the KU KLUX KLAN was extremely strong in the state. The town of Elwood even posted a sign warning blacks to keep out.

Blacks responded to white violence and exclusion by building their own separate institutions. Indianapolis blacks formed local chapters of the Daughters of the Eastern Star and the Knights of Pythias and other fraternal orders, the Anti-Lynching League, the National Association of Colored Women's Clubs, and the National Negro Business League. Within Indiana's larger towns and cities—Indianapolis, Evansville, and New Albany—a small middle class developed thriving business districts, where they managed their own businesses and provided community leadership. A handful of African-American businessmen and businesswomen amassed fortunes that allowed them to make philanthropic contributions to community institutions; Phillip Brookins of Richmond, E. G. Tidrington of Evansville, and Carl G. Fisher of Indianapolis all made financial contributions that supported the operation of local black hospitals.

The most famous entrepreneur was Madame C. J. WALKER, whose thriving beauty-care business made

her the first African-American woman millionaire. She set up operations in Indianapolis in 1910. Her factory employed many local residents, and with some of its proceeds she contributed heavily to the construction fund for the city's Senate Avenue Colored YMCA, to a local old-age home, and to local black schools.

In 1906 the U.S. Steel Company created a new company town, named Gary for its president, Judge Elbert Gary, in the Calumet region by Lake Erie. From its beginning, Gary had an important black population. Some two hundred African-American construction workers helped lay out the town. While many of them left, the town had four hundred black residents in shacks on the town's South Side by 1910. That year, the First Baptist Church was created, and social clubs such as the Workingman's Social and Political Club were founded.

During the Great Migration during and after WORLD WAR I, thousands of southern blacks entered Indiana, and others migrated from the southern part of the state to the northern half. While the populations of Indianapolis and other cities increased by large amounts, Gary's black population skyrocketed, jumping to 10 percent of the total, despite attacks on black workers during the giant steel strike of 1919. Organizations such as the NATIONAL URBAN LEAGUE were active in aiding the migrants.

By 1930, more than 90 percent of Indiana's 112,000 African-American citizens lived in urban areas, mostly in Indianapolis and Gary. Small businesses grew up, and both cities had significant black business and entertainment districts; Gary was dubbed "Sin City" for its extensive underworld gambling and nightlife. JAZZ was a popular pastime. Many musicians came to Indiana from nearby Chicago, and native musicians included such well-known artists as drummer Sidney Catlett and horn players Wilbur and Sidney De Paris. In addition, Indianapolis featured several black BASEBALL teams, including the popular Indianapolis Clowns of the Negro American League. The *Indianapolis Recorder* and the *Gary American* were prominent black newspapers.

During the GREAT DEPRESSION, as steel and other industries stalled, black workers, stuck in unskilled, low-paying jobs, were laid off in large numbers. Despite local and federal relief, many became destitute. During the late 1930s, blacks in Gary, previously largely excluded from unions, began to be absorbed into the member groups of the Congress of Industrial Organizations (*see* LABOR AND LABOR UNIONS).

Like African Americans throughout the nation, black Indianans valued education as the vehicle for racial progress. Schools, like churches, served as centers of black political activity. For example, in 1911 the Kappa Alpha Psi fraternity was created by students at Indiana University in Bloomington. The following year Indianapolis schoolteacher Mary Ellen Cable was responsible for the formation of the Indiana branch of the NATIONAL ASSOCIATION FOR THE ADVANCEMENT OF COLORED PEOPLE (NAACP), becoming the chapter's first president. In the period between 1920 and 1945, African Americans responded to hardening patterns of residential segregation, which resulted in stricter school segregation. In a blow against segregation in the 1930s, the NAACP sued local governments on behalf of local African-American citizens to halt the construction of Crispus Attucks High School in Indianapolis and Roosevelt High School in Gary. However, Indiana courts ruled against the NAACP, and schools remained segregated until passage of a desegregation law in 1949.

Many black community leaders, however, made the best of a bad situation, and used black schools as vehicles for community improvement and as forums to teach African-American culture, foster pride, and provide adult education classes for the communities. Black schools served as the focal points of the African-American community's fight against disease. Black women's clubs, medical practitioners, and church leaders, in concert with local health officials, used schools to disseminate helpful information about tuberculosis, smallpox, sanitation, and food preservation.

During World War II, many factory and skilled jobs previously closed to blacks opened in response to labor shortages caused by the war; however, during the postwar years, the job market for African Americans shrank once more. By 1960, postwar migration had doubled the state's black population in twenty years. Most of the new migrants were forced into overcrowded ghetto areas, where they faced poor city services. Despite the integration of city schools, residential segregation condemned many blacks to remain in separate schools. While African-American James Hunter was elected to the state legislature, black political power was limited. For example, while the migration pushed Gary's black population to a near majority by 1960, the city's corrupt, company-dominated electoral system worked against black political empowerment.

During the 1960s, the CIVIL RIGHTS MOVEMENT became a force in Indiana. The SOUTHERN CHRISTIAN LEADERSHIP CONFERENCE organized an Indiana chapter. Activists conducted demonstrations against segregated public facilities and worked to eliminate job discrimination. In Gary, NAACP attorney Richard HATCHER led demonstrations against Methodist Hospital's black exclusion policy and brought suit against de facto school segregation. Elected to the city council, he pushed through an open housing

ordinance. In 1967, despite opposition from the city's Democratic machine and allied black clergymen, Hatcher was narrowly elected mayor, becoming one of the first black mayors of a sizable American city. In tribute to the achievement of "Black Power" in Gary, the National Black Political Convention (*see* GARY CONVENTION) was held in the city in 1972.

Since the 1960s, Indiana blacks have achieved some impressive gains. Political empowerment has increased. In 1982 Katie Hall became the state's first African American in Congress, and in 1992 Pam Carter became Indiana's first black statewide-elected official, as well as the nation's first black woman state attorney general. Indianapolis has become a center for black conventions as well as such sporting events as the Circle City classic, an annual black college football game. The Indianapolis Black Expo (IBE), founded in 1970, is the largest annual African-American event. Many black Indianans have become prominent doctors, lawyers, and other professionals. Several members of the Jackson family, all Gary natives, achieved great prominence, and Michael JACKSON became one of the world's richest and most famous entertainers.

However, discrimination and economic troubles continue to plague black Indiana. In Gary, which was 80 percent black by 1990, the decline of the local steel industry has led to high unemployment among local blacks, and middle-class migration to nearby suburbs has cost the city one-third of its 1967 population. Black mayors and federal funding have been powerless against the decline of the city's tax base and infrastructure. In Indianapolis, which was about 22 percent black by 1990, one-fourth of the city's black population was under the poverty line. In 1993, widespread protests followed the firing of Shiri Gilbert, the city's first black school superintendent. In 1991, activist Mmoja Juba organized a Black Panther Militia, and threatened violence if the city did not grant more money to deal with the needs of poor blacks.

While the Indiana idea and traditional Hoosier attachment to self-help blocked African-American progress for more than one hundred years, these same qualities enabled African-American Indianans to create and support their own schools, hospitals, legal services, legal and medical organizations, libraries, social and philanthropic clubs, theaters, hotels, groceries, and other businesses. Despite the removal of some of these obstacles, the example of self-empowerment is an important inspiration for future efforts. The African-American experience in Indiana reflects the myriad ways in which an oppressed people confronted systematic denials of their rights as human beings, and how they created places for themselves to express their identity and talents.

REFERENCES

BINGHAM, DARREL E. *We Ask Only a Fair Trial: A History of the Black Community of Evansville, Indiana.* Bloomington, Ind., 1987.

BUNDLES, A'LELIA PERRY. *Madame C. J. Walker.* New York, 1991.

CRENSHAW, GWENDOLYNNE J. *Bury Me in a Free Land: The Abolitionist Movement in Indiana, 1816–1865.* Indianapolis, Ind., 1986.

FERGUSON, EARLINE RAE. "The Women's Improvement Club: Black Women Pioneers in Tuberculosis Work." *Indiana Magazine of History* 84: 237–261.

GIBBS, WILMA L., ed. *Indiana's African-American Heritage: Essays from Black History News and Notes.* Indianapolis, Ind., 1993.

LYDA, JOHN W. *The Negro in the History of Indiana.* Terre Haute, Ind., 1953.

MADISON, JAMES H. *Indiana Through Tradition and Change: A History of the Hoosier State and Its People, 1920–1945.* Indianapolis, Ind., 1982.

RAWLS, GEORGE H. *History of Black Physicians in Indianapolis, 1880–1980.* Indianapolis, Ind., 1984.

THORNBROUGH, EMMA LOU. *Since Emancipation: A Short History of Indiana Negroes, 1863–1963.* Indianapolis, Ind., 1963.

EARLINE RAE FERGUSON

Indians, American. *See* American Indians.

Indian Wars. African-American participation in the military efforts directed against Native Americans (*see* AMERICAN INDIANS) did not begin until after 1865, but it continued until the end of those campaigns in 1890. All four of the African-American regular Army regiments took part in duties of the Army, including garrisoning forts, patrolling the reservations, and fighting the occasional campaigns that took place in the Southwest and Northwest.

Until 1866 there were no African Americans in the regular United States Army. However, in that year, as a result of a need to garrison the South and fight the Native Americans, Congress expanded the Army and authorized the creation of six regiments staffed with African Americans. In 1869, as part of an economy move, the number of infantry regiments was reduced and the four African-American infantry regiments were consolidated into two, the Twenty-fourth and Twenty-fifth Infantry. They joined the Ninth and Tenth Cavalry. For most of this period almost every officer was white. The only exceptions occurred in the 1880s when Henry O. FLIPPER, John

Alexander, and Charles YOUNG graduated from West Point and were assigned to duty.

Organizing and training the new regiments proved to be quite difficult. Although some recruits had served in the United States Colored Troops in the Civil War, most had no experience with the military. Additionally, not many officers wanted to assume command of these regiments. George Custer was offered the colonelcy of a cavalry regiment but turned it down to assume the second-in-command of a white regiment. It also proved to be difficult to get good horses for the cavalry regiments. Post commanders sometimes treated the black troops with disdain. The commander of Fort Leavenworth, Kans., ordered the Tenth Cavalry to camp in an area that was filled with water, and then complained when the men got muddy.

In the years following their organization the regiments mainly served in the Southwest, especially in Texas, and the New Mexico and Arizona territories. Like much of the Army, the African-American regiments were assigned to isolated posts, often located near Indian reservations. Tension with white settlers was high, and several black soldiers were lynched (most for associating with white women). As soldiers involved in fighting the Indians, relations with the Native Americans were little better, for they were viewed as representatives of a hostile government. The Native Americans nicknamed the cavalrymen "Buffalo Soldiers," apparently because of the similarities between their hair and that of the buffalo; the term soon came to apply to all the African-American soldiers.

Despite these problems life in the Army was attractive to many African Americans. There was some glamour associated with taming the frontier. The pay was steady and life was not too difficult. As a result, the retention rate in the four regiments was quite high—higher than that for whites. Reenlistments were common, and many soldiers had twenty or more years of service.

The duties of the soldiers were similar to those of their white counterparts and involved long days of patrolling, fleeting contacts with Native Americans or outlaws, and traversing difficult terrain. One of the most arduous campaigns occurred in July 1877 in the Staked Plains region of western Texas. Capt. Nicholas Nolan and Troop A, Tenth Cavalry, were given the task of chasing some Mescalero Apache raiders who had attacked stagecoach stations. After a week of pursuit they had found few Native Americans and had very little water remaining. Their supplies began to run low so Nolan dispatched his civilian guide to find a supply of water; he never returned. The captain then sent eight of his men, loaded with canteens, to follow his trail and find some water.

They returned without supplies, and before the ordeal was finished some of the troops were reduced to drinking the blood of horses or their own urine. After four days without water, four men died before they reached a water supply.

For many soldiers, the Army provided basic education. Under a provision of the act that created the regiments, each was assigned a chaplain, who was given the task of educating their men, many of whom, white as well as black, were illiterate.

On several occasions soldiers received Congressional Medals of Honor for their bravery. In September 1879 Troop D, Ninth Cavalry, was on patrol near the Ute Reservation when they received a message that another Army unit was under attack. They charged to the rescue but soon came under attack from over 300 Native Americans. Sgt. Henry Johnson and his troopers quickly dug rifle pits and returned the fire. Johnson made the rounds of his men, keeping up their courage. After several days of fighting, supplies began to run low. Despite the intense fire of the Native Americans, Johnson went down to the nearby river and filled a number of canteens. Johnson was one of seventeen African Americans awarded the Medal of Honor for his service in the Indian Wars.

As wars against Native Americans waned in the 1880s, stationing assignments became more of an issue. There was some discussion of rotating regiments from the Plains to the more settled East; others suggested the officers should be rotated and the men left on the frontier. However, the vast majority of the Army remained in isolated posts in the Southwest, and after 1890, in the Northwest as well.

Another activity of the soldiers was as members of an experimental bicycle corps, created in the 1890s by James Moss, a lieutenant in the Twenty-fifth Infantry. Moss decided that this new method of transportation could provide an added element of mobility for his soldiers. During two summers he engaged in experimental cross-country rides; the second went 1,200 miles from Fort Missoula, Mont., to St. Louis, Mo.

The only African-American officer to see extended duty with the troops during this period was Henry O. Flipper. After his 1879 graduation from West Point, he was assigned to the Tenth Cavalry, then located in Texas. For several years he performed well and seemed to fit into the society of the white officers. However, conditions changed in 1882 when he and Lieutenant Charles Nordstrom vied for the attention of a white woman. Problems continued when his troop and Lieutenant Nordstrom were assigned to Fort Davis, Tex. They escalated when William Shafter became the commander of the post. Apparently Shafter and Nordstrom did not like Flipper or his relations with white women on the post. Shafter

G Company, 10th Calvary, near Tucson, Arizona Territory, in 1882, with Indian prisoners. African-American troops, so-called Buffalo soldiers, were active in the various campaigns against the Indians in the decades after the Civil War. (Arizona Historical Society/Tucson)

charged Flipper, the post commissary officer, with embezzling funds and conduct unbecoming an officer. During the ensuing court-martial it became very clear that Flipper did have the funds but that he had not stolen them. Although he was found not guilty on the embezzlement charges, he was found guilty of conduct unbecoming an officer and was dismissed from the service. For many years he continued to try to get the verdict reversed but to no avail. In 1979 the Army's Board for the Correction of Military Records posthumously accepted his position and directed that his discharge be revised to honorable.

The campaigns against the Native Americans came to an end in 1890 with the massacre at Wounded Knee, S.Dak. Although no African-American troopers were present that day, elements of the Ninth Cavalry arrived shortly afterward and helped the Seventh Cavalry subdue the Sioux.

The African-American troops were now called on to deal with other foes as well as Indians. In the 1890s there were a number of labor disputes where the Army was called upon to restore order. These included Coxey's Army and the railroad strike of 1894, and the miners strike in Coeur d'Alene in 1892.

REFERENCES

BILLINGTON, MONROE L. *New Mexico's Buffalo Soldiers, 1866–1900.* Niwot, Colo., 1991.

LECKIE, WILLIAM H. *The Buffalo Soldiers: A Narrative of the Negro Cavalry in the West.* Norman, Okla., 1967.

NALTY, BERNARD C. *Strength for the Fight: A History of Black Americans in the Military.* New York, 1986.

MARVIN E. FLETCHER

Industrial Arts. "Industrial arts" refers to skills employed by craftspeople and highly skilled workers incorporating tools and machinery, and employing a knowledge of industrial processes and design. Within the context of African-American history, the term is associated primarily with the period from the late 1860s to the early twentieth century, when it became an important part of the educational and political philosophy of Samuel Chapman Armstrong and Booker T. WASHINGTON. But African-American experience with the "arts" of industry actually begins with the skilled African-American craftsmen and women of the Colonial period.

From the time of the earliest settlements in the United States, when many Africans arrived as indentured servants and slaves, to the end of the Civil War, there had been large numbers of black "mechanicks" and artisans producing manufactures and erecting buildings. Black skilled slaves had a particular impact on the buildings, bridges, and edifices of the South, some of which still survive today. Among other skilled trades, blacks served as professional blacksmiths, silversmiths, cabinetmakers, coopers, stonemasons, wheelwrights, distillers, caulkers,

wagonmakers, brickmasons, carpenters, plasterers, shipwrights, painters, locksmiths, and shoemakers.

There were, however, significant constraints placed on black craftsmen. It was not easy for African Americans to obtain apprenticeships, particularly in those programs that provided training for highly paid crafts. Slave craftsmen were also severely limited by the prohibition on teaching slaves to read and write. Fears that slaves with highly developed skills would prove more difficult to manage and control also limited apprenticeship opportunities. Most slaveholding states had legislation that prohibited or limited the kinds of skilled jobs that African Americans. (both slave and free) could perform.

Both slaves and free black artisans suffered from the hostility of white skilled laborers. In some places, black and white artisans worked side by side, but in many places, threats and protests by white mechanics forced black skilled workers out of work. After the Civil War, with an increased pool of white (often European immigrant) craftsmen and skilled workers available, most employers began to restrict their hiring to white workers. As a result, black skilled laborers were driven out of the labor market.

After the war, pursuit of industrial training within the African-American community became closely identified with the philosophy of industrial education as propagated by Samuel Chapman Armstrong, and later by its most effective advocate, Booker T. Washington. In the context of the political, economic, and social turmoil of the postwar years, industrial education as advocated by Chapman met a number of needs: the demand by ex-slaves for education and training, the demand by northern capital for compliant black labor, and the need to maintain existing social relations between the races as much as possible, given the powerful impact of Emancipation and of Reconstruction.

With the advent of the twentieth century, the increasing division of labor had already begun to have an impact on the nature of traditional industrial arts. Skills became more specialized and began incorporating more complex and heavy machinery. The following letter by an African-American stationary-machinery engineer written at the turn of the century comments on what the writer sees as the degradation in craft skills and industrial arts:

> There are few, if any, of the carpenters of today who, if they had the hand tools, could get out the "stuff" and make one of those old style massive panel doors,—who could work out by hand the mouldings, the stiles, the mullions, etc., and build one of those windows, which are to be found today in many of the churches and public buildings of the South; all of which testify to the cleverness of the Negro's skill as artisan in the

broadest sense of the term. For the carpenter in those days was also the "cabinet maker," and wood turner, coffin maker, generally the pattern maker, and the maker of most things made of wood. The Negro blacksmith held almost absolute sway in his line, which included the many branches of forgery, and other trades which are now classified under different heads from that of the regular blacksmith . . . (Du Bois 1902, p. 35).

By 1910, according to Monroe Work, Director of Records and Research at Tuskegee Institute, industrial courses at Tuskegee had turned out approximately 12,000 students, three-fourths of whom were "directly or indirectly engaged in industrial pursuits" (Work 1911, p. 5). Opportunities for those trained in industrial arts, however, did not meet expectations. Southern employers and planters wanted to confine blacks largely to agriculture and unskilled labor, and often the industrial education curricula emphasized "the dignity of manual labor" to the detriment of professional skills and training.

By the time of the death of Booker T. Washington, in 1915, structural changes in industry which deemphasized craft skills in favor of the work of the semiskilled and unskilled undercut much of the value of training in the industrial arts. The term itself almost became archaic—indeed, by mid-century it was primarily used to refer to manual skills training classes offered to boys in elementary and secondary schools.

REFERENCES

Du Bois, W. E. B. *The Negro Artisan*. Atlanta, 1902.
Stavisky, Leonard. "The Origins of Negro Craftsmanship in Colonial America." *Journal of Negro History* 32 (1947): 417–429.
Work, Monroe. *Industrial Work of Tuskegee Graduates and Former Students*. Tuskegee Institute, Ala., 1911.

Portia P. James

Industrialization. Over the generations, the process of American industrial development has had a mixed impact on the status of African Americans as citizens and as workers. Southern extractive and food-processing industries exploited the labor of slaves and, after EMANCIPATION, confined black workers to physically arduous and hazardous jobs that were seasonal and ill paid. In contrast, heavy industry in the North offered to some black women and men a chance to enter the ranks of the stable working class and help build a progressive, biracial labor movement. By the late twentieth century, how-

ever, the decline of various "smokestack" industries signaled the demise of a vital labor-union movement, a development that had devastating consequences for the economic well-being of many African-American communities, families, and individuals.

The commercial-industrial establishments of the pre–Civil War South tended to be small businesses located in rural areas. Two major factors hindered industrial development in the region—the profitability of cotton as a staple crop, and the political identification of the South's elite with an agrarian way of life. Nevertheless, slaves predominated in virtually all of the South's industries during this period—grain, corn, rice, and sugar milling; hemp and textile production; naval stores; salt and coal mining; and lumbering. Moreover, slaves served as artisans and performed a wide variety of craft tasks and labored on public works projects and in the construction industry as unskilled workers. With the exception of plantation-based textile production, most of these enterprises employed slave men (and at times slave children) exclusively. The Tredegar Iron Works of Richmond, Va., was virtually the only heavy industry in the antebellum South, and its work force consisted primarily of enslaved men.

Wartime mobilization efforts in the Confederacy confirmed southern planters' and politicians' fears that intensive industrial development would ultimately prove subversive to the institution of SLAVERY. When slaveholders hired out their bondsmen and women, and when Confederate officials impressed slaves into service, the rigid system of plantation discipline eroded accordingly. The need to manufacture war supplies and to improve the South's transportation network necessitated that large numbers of slaves—again, most of them men—enter new work situations, under new kinds of supervision. In cities and in rural-industrial outposts, black wartime workers seized the opportunity to learn to read and write, to map out pathways (to new regions and jobs) that they would follow at slavery's end, and to abscond to freedom.

After the Civil War, the ranks of southern black craftsmen gradually declined in urban areas in the face of competition from skilled whites. In the countryside, sharecroppers labored in the fields during part of the year and worked in rural-industrial enterprises during the slack seasons of winter and late summer. As complements to the seasonal plantation system, these industries paid workers very little and employed them on an irregular basis only. Black men toiled in the lumber and turpentine camps, phosphate mines, cotton oil presses, and sugar mills. Black women and children found work in the tobacco and seafood-processing industries. Two counterexamples to this pattern include southern textiles, which re-

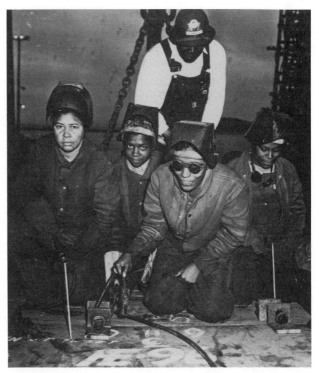

Women war workers played an important part in the construction of the Liberty Ship *SS George Washington Carver,* which was launched on May 7, 1943, at the Kaiser Shipyards in Richmond, Calif. Welders Alivia Scott, Hattie Carpenter, and Flossie Burtos (left to right) await an opportunity to weld their first piece of steel on the ship. (Photographs and Prints Division, Schomburg Center for Research in Black Culture, The New York Public Library, Astor, Lenox and Tilden Foundations)

served jobs at all levels for whites exclusively until the mid-1960s, and the coal mining industry in the Birmingham, Ala., district and southern West Virginia, where black men reached near-equality with their white co-workers, both in the mines and in the ranks of their union, the United Mine Workers (UMW) (*see* LABOR AND LABOR UNIONS).

After 1916, when northern manufacturing businesses began to recruit southerners for the first time, black people came to identify industrial jobs with the good wages and decent working conditions they had long been denied in the South. Gains made in industrial employment during WORLD WAR I proved ephemeral, especially for black women; but WORLD WAR II brought large numbers of African Americans into the manufacturing sector, especially in the upper Midwest and on the West coast.

With the exception of the egalitarian-minded UMW, labor unions had traditionally limited the job opportunities of black men and women. However, in the mid-1930s, the newly formed CONGRESS OF INDUSTRIAL ORGANIZATIONS, an industrial union,

launched an aggressive organizing campaign that appealed to workers of all races and ethnic groups. Black workers gained leadership positions in the United Automobile Workers and then pressed the major defense industries to abandon discriminatory hiring practices in the World War II mobilization effort.

Despite these gains, the inexorable workings of the American economy, combined with competition in the world marketplace, gradually diminished the size of the black industrial working class. In the 1950s, various forms of automation began to displace workers at the lowest levels of heavy manufacturing, and by the 1970s, competition from foreign imports led the automobile, steel, and rubber industries to restructure their work forces. In the 1980s, firm consolidations, plant closings, "runaway shops" (in search of cheap labor abroad), and the increased use of robotics and computers on the assembly line eliminated the need for many blue-collar workers, especially blacks, who remained at the lowest echelons of the work force. The steel industry, based in northwest Indiana, cut its labor demands by more than half in the 1970s and 1980s. Likewise, black Southerners finally gained a foothold in the textile industry in the 1960s, just when foreign imports were beginning to force individual businesses to mechanize their operations (and hence cut their work forces) or to close their doors forever.

In the increasingly credentials-conscious society of the late twentieth century, a large proportion of the African-American population—those persons living in distressed communities in the rural South and urban North—remained confined to areas with poor schools and few good jobs. These factors would continue to inhibit their employment in the lucrative high-technology industry, which was based in suburban areas and dependent on a relatively small number of highly educated employees. Under these conditions, black workers found themselves relying once again on service jobs that offered only part-time, minimum-wage work that recapitulated the second-class citizenship status of railroad porters and household domestics during the JIM CROW era in American history.

REFERENCES

COHEN, LIZABETH. *Making a New Deal: Industrial Workers in Chicago, 1919–1939.* New York, 1990.

HARRIS, WILLIAM H. *The Harder We Run: Black Workers since the Civil War.* New York, 1982.

JONES, JACQUELINE. *The Dispossessed: America's Underclasses from the Civil War to the Present.* New York, 1992.

LEWIS, RONALD L. *Coal, Iron, and Slaves: Industrial Slavery in Maryland and Virginia.* Westport, Conn., 1979.

JACQUELINE JONES

Ink Spots, The, vocal quartet. The Ink Spots were one of the earliest and most prominent vocal harmony groups, with a smooth but passionate sound that was characterized by the contrast of falsetto tenor with weighty bass voices. Their numerous hit records in the 1940s helped create the musical styles known as RHYTHM AND BLUES and doo-wop.

The Ink Spots were formed in 1934 by four porters at New York's Paramount Theater: tenors Charles Fuqua and Jerry Daniels (1915–), baritone Ivory Watson (?–1969), and bass Orville "Hoppy" Jones (1905–1944). Their gentle ballads supported Daniels's soaring lead voice with deep bass rhythm and wordless midrange accompaniment. They traveled to Europe in the mid-1930s, performing in England with Jack Hylton's orchestra. Transatlantic broadcasts of their European concerts helped build their following in the United States, but it wasn't until 1939, after Bill Kenny (1915–1978) replaced Daniels, that they achieved wide popularity with their recording of "If I Didn't Care."

In the 1940s the Ink Spots had several hugely successful records, including "Maybe," "Java Jive," "My Prayer," and "To Each His Own" (1946). They also made several recordings with Ella FITZGERALD, including "Into Each Life Some Rain Must Fall" (1944) and "I'm Beginning to See the Light" (1945) and appeared in two films, *The Great American Radio Broadcast* (1941) and *Pardon My Sarong* (1942). During this time the group also underwent some personnel changes. Watson was replaced by Billy Bowen (1909–1982). After Jones's death in 1944, Herb Kenny (1914–1992) joined the group, and in 1945 tenor Jim Nabbie (1920–1992) became a member.

In 1952 Fuqua and Kenny split. Each formed his own group called the Ink Spots—a move that resulted in numerous, protracted lawsuits. Yet another group, led by Stanley Morgan, also called itself the Ink Spots. Since the early 1950s all three groups have continued to perform and record, although solely as nostalgia acts, with numerous personnel changes and yet none of the commercial and artistic success of the early Ink Spots. In 1989 the Ink Spots were honored at the Rock and Roll Hall of Fame as early influences on rock music.

REFERENCES

JOYCE, MIKE. "Ink Spots Incarnate." *Washington Post,* December 29, 1989, p. 21.

WATSON, D. *The Story of the Ink Spots.* New York, 1967.

JONATHAN GILL

Innis, Roy (June 6, 1934–), civil rights activist. Roy Innis was born in St. Croix, U.S. Virgin Islands, and moved to New York City with his mother

in 1946. He served in the Army for two years during the Korean War and attended the City College of New York from 1952 to 1956, majoring in chemistry. He worked as a chemist at Montefiore Hospital in New York City. In 1963, he joined the Harlem chapter of the CONGRESS OF RACIAL EQUALITY (CORE), an interracial civil rights organization committed to nonviolent direct action. In 1964, Innis became chairman of the chapter's education committee. He advocated community control of public schools as an essential first step toward black self-determination. He was elected chapter chairman the following year and proposed an amendment to the New York State constitution that would provide an independent school board for Harlem. In 1967, he was one of the founders of the Harlem Commonwealth Council, an organization committed to supporting black-owned businesses in Harlem. He served as the organization's first executive director.

Innis became one of the leading advocates of black nationalism and Black Power within CORE, and in 1968, he was elected CORE's national director. He took control of the organization during a period in which its influence and vitality were declining. Under his leadership, which was characterized by tight centralization of organizational activities and vocal advocacy of black capitalism and separatism, CORE's mass base further declined. Despite this fact, Innis remained in the public eye.

Innis popularized his ideas as coeditor of the *Manhattan Tribune*—a weekly newspaper focusing on Harlem and the Upper West Side—which he founded with white journalist William Haddad in 1968. Later that year he promoted a Community Self-Determination bill, which was presented before Congress. He received national attention in 1973 when he debated Nobel Prize–winning physicist William Shockley on the issue of black genetic inferiority on NBC's late-night *Tomorrow Show*.

In 1980, after former CORE members, led by James FARMER, mounted an unsuccessful effort to wrest control of the organization from Innis, he consolidated his hold over the organization by becoming national chairman. By this time, Innis's polemical oratory, his argument that societal racism had largely abated, and his support of Republican candidates, placed him in the vanguard of black conservatism. In 1987, he received much notoriety for his support for Bernhard Goetz, a white man who shot black alleged muggers on a New York subway, and his championing of Robert Bork, a controversial U.S. Supreme Court nominee who had opposed the Civil Rights Act of 1965.

Innis entered the political arena in 1986, when he unsuccessfully ran for Congress from Brooklyn as a Democrat. In the 1993 Democratic primary, he unsuccessfully challenged David DINKINS, the first African-American mayor of New York City, and he then became a vocal supporter of Dinkins's Republican challenger, Rudolph Giuliani, who won the election. In 1994, Innis celebrated his twenty-fifth year of leadership of CORE.

REFERENCES

MEIER, AUGUST and ELLIOTT RUDWICK. *CORE: A Study in the Civil Rights Movement, 1948–1968.* Chicago, 1975.
VAN DEBURG, WILLIAM. *New Day in Babylon: The Black Power Movement and American Culture, 1965–1975.* Chicago, 1992.

ROBYN SPENCER

Institute of the Black World. A research institute in black studies, located in Atlanta, the Institute of the Black World was originally a project of the Martin Luther King, Jr., Center for Non-Violent Social Change. In 1969, the Institute of the Black World became an independent organization. Committed to scholarly engagement in social and political analysis and advocacy, the institute seeks to foster racial equality as well as African-American self-determination and self-understanding. It places particular emphasis on exploring the role of education in the African-American movement for social change. In the 1990s, under the leadership of historian Vincent Harding, the institute conducted research, trained scholars, organized conferences and lectures, and issued publications, as well as produced radio programs, a taped lecture series, and other audiovisual materials. It also encouraged black artists and developed teaching materials for black children. One of its projects is the Black Policy Studies Center. The Institute is located in a house where W. E. B. Du Bois once lived.

DANIEL SOYER

Institutions, Scientific. *See* Scientific Institutes.

Insurance Companies. Historically, African-American–owned insurance companies have their roots in the numerous FRATERNAL ORDERS AND MUTUAL AID SOCIETIES that existed in the early history of the United States. These societies were formed among free blacks to provide security during times of hardship. African Americans banded together to care

for the sick, widowed, and orphaned, and to administer burial rites. In 1780, free blacks formed the African Free Society in Newport, R.I., to care for indigent members of their community. Seven years later, Richard ALLEN and Absalom JONES formed the FREE AFRICAN SOCIETY OF PHILADELPHIA, which operated under a formal constitution. Members paid one shilling monthly. Mutual aid societies also existed in the South. In 1790, free mulattoes in Charleston, S.C., organized the BROWN FELLOWSHIP SOCIETY, which, aside from caring for widows and orphans, maintained a cemetery and credit union.

Often church-related, these mutual aid societies were the only place to which blacks could turn for financial protection. Evidence of the need for such security was given by the fact that over a hundred such societies existed in Philadelphia alone in 1849. Premiums ranged from about $.25 to $.35 and benefits from $1.50 to $3 per week for sickness, and $10 to $20 for death.

The late nineteenth and early twentieth centuries witnessed the transformation of mutual and fraternal aid societies into modern insurance companies—though fraternal societies such as the Masons, the Knights of Pythias, and the Oddfellows would remain an important source of insurance among the African-American community until the 1930s. One of the most important African-American reformers was William Washington Browne, who in 1881 founded the Grand United Order of the True Reformers in Richmond, Va. Browne, a former slave and preacher, formed the True Reformers to promote "happiness, peace, plenty, thrift, and protection." The society became quite popular, reaching a membership in the 1890s of 100,000 people in eighteen states. Browne's reforms included using mortality tables—though based on crude statistics—to set premium rates. Like other successful black entrepreneurs, he used the income from his organization to found other businesses, including a bank, a hotel, a department store, and a newspaper.

A great number of insurance associations founded in the upper South during the late nineteenth century can be traced to former associates and employees of Browne. These include Samuel Wilson Rutherford, who founded the National Benefit Insurance Company of Washington, D.C., in 1898; Booker Lawrence Jordan, who helped to create the Southern Aid Society of Richmond in 1893; and John Merrick, who founded what became the NORTH CAROLINA MUTUAL LIFE INSURANCE COMPANY in 1898. Newer insurance companies lost the fraternal and ritualistic side of the earlier societies; they were, for the most part, state-chartered insurance corporations.

Another entrepreneur, Thomas Walker, brought similar innovations to mutual aid associations in the lower South. Walker, also a former slave and preacher, organized the Union Central Relief Association of Birmingham in 1894 (it had previously been known as the Afro-American Benevolent Association). Walker tied benefits to premiums and selected policy holders with care; he sent a stream of African-American agents traveling throughout the South to secure insurees.

These enterprises were formed at least in part out of expediency. Many white-owned insurance companies refused to insure blacks, whom they regarded as too high a risk. The reluctance of white companies to insure black lives was based in part on the widespread poverty and the higher mortality rate among blacks. Those that did sell insurance to African Americans usually offered them inferior policies. In 1881, the white-owned Prudential Insurance Company calculated a mortality rate among blacks that was 50 percent in excess of that among whites. In turn, it offered policies to blacks that were worth only one-third that paid to whites for the same premiums. Despite these policies, most black-owned firms had trouble competing with their larger white-owned counterparts, even among black insurees. Calls for support of black-owned businesses had only limited appeal. National white-owned firms appeared to offer a stability and security that black firms could not match. In 1928, the white-owned Metropolitan of New York had twenty times more insurance on African-American lives than the largest black-owned insurance company.

The difficulties of black insurers were magnified by the fact that, due to the relative poverty of their policyholders, they were forced to compete almost exclusively in the field of industrial insurance—a type of insurance in which insurees paid a small weekly premium of only a few cents and received a small return. Industrial insurance had been introduced in the United States by the white-owned firms The Provident and John Hancock in the 1870s. It was popular among working class people who could not afford large annual premiums of term and whole life insurance; for blacks, industrial insurance was most often purchased to provide money for proper burial ceremonies. Industrial insurance incurred high operating costs, largely because agents had to make weekly trips to the homes of policyholders. This cost was made worse for black agents, who, at the turn of the century, were forced to travel on JIM CROW cars and stay in out-of-the-way, unsanitary hotels.

Industrial insurance also lent itself to fraud and abuse, one of the greatest of which was forfeiture, whereby customers who missed two or more consecutive payments would lose their entire policies. Complaints of the improprieties of insurance companies—both industrial and ordinary—led to a series of

investigations throughout the industry. The best-known were the 1905 Armstrong investigations, which revealed malpractice, fraud, and mismanagement in the workings of New York state's (and the nation's) largest life insurance companies. The trials led to stricter regulation in many states, such as larger cash reserve requirements, which many black-owned companies found difficult to meet.

Given these new requirements, the higher costs of selling industrial insurance, and the lack of reliable data on black mortality, many black-owned firms were unsuccessful. A small number of black-owned insurance companies, founded in the early twentieth century, proved more enduring. These included North Carolina Mutual (1898) and Atlanta Life (1905). The North Carolina Mutual Life Insurance Company was founded in Durham, N.C., by John Merrick. Its agents worked strictly on commission and sold industrial insurance almost exclusively. It formed offices in surrounding cities—Chapel Hill, Hilsboro, Raleigh, Greensboro—and after five years of business had over 40,000 policyholders. North Carolina Mutual also began the practice of reinsuring financially distressed black-owned societies. This became particularly true when stricter state regulation of mutual-assessment organizations came about in the early twentieth century. By 1907, it claimed, with some justification, to be the "Greatest Negro Insurance Company in the World."

One reason North Carolina Mutual was able to secure such business was the strength of its agency force. C[harles] C[linton] SPAULDING, who would later serve as president of North Carolina Mutual, was made general manager in charge of agents in 1900. He advised the company to publish a monthly newspaper to advertise and motivate agents. He also oversaw devotional meetings at which agents and other employees sang such songs as "Give Me That Good Ol' Mutual Spirit" to the tune of "Give Me That Old-Time Religion." These sales meetings, along with other trappings of modern business culture, straddled the line between the church-bound mutual aid societies of the past and the secularized business practices of the present. Because of its prominence, North Carolina Mutual was important in the black community—even outside of business circles. It established a savings bank and employment bureau, and erected a highly visible headquarters. In 1920, North Carolina Mutual had grown to the extent that it employed 1,100 people.

Another successful black-owned insurance company founded in the early twentieth century was the ATLANTA LIFE INSURANCE COMPANY. It was organized by Alonzo Herndon in 1905. Herndon had spent seven and a half years of his life as a slave; he was born in 1858 in Georgia. Like North Carolina

Mutual's founder, John Merrick, Herndon had made a fortune through the ownership of barbershops. Active in black intellectual movements, Herndon became friends with Booker T. WASHINGTON, and attended the first NIAGARA CONFERENCE in 1905 under the leadership of W. E. B. DU BOIS. In the company's first year, Atlanta Life secured 6,324 policyholders. Between 1922 and 1924, Atlanta Life entered a half-dozen new states, most in the lower South. Though the majority of its business was in industrial insurance, Atlanta Life opened an ordinary department in 1922. That same year, it became the first black company to create an educational department to teach agents salesmanship, and technical aspects of insurance and accounting.

Less successful in the long term than either of these was the Standard Life Insurance Company, founded in 1913 by Herman Perry. Standard Life was the first black company organized for the purpose of selling exclusively ordinary life insurance. It had an explosive beginning, with phenomenal sales which by 1922 had brought the company more than $22 million of insurance in force. Perry, however, expanded the operation to include a number of different businesses, including real estate, printing, pharmaceutical, and construction firms. This expansion proved ruinous to cash reserves, and Perry was forced to sell to the white-owned Southeastern Trust Company in 1924, despite the efforts of several black businessmen to retain ownership within the African-American community.

The migration of blacks to northern cities after World War I brought new opportunities for black-owned insurance companies. Several northern companies were founded: The Supreme Life Insurance Company (1921) and the Chicago Metropolitan Mutual Association (1927) were founded in Chicago; the United Mutual Life Insurance Company (1933) was founded in New York. Some southern-based companies, such as Atlanta Life, began selling policies in the North (in this case, in Ohio, and later, Michigan). In 1938, North Carolina Mutual, for the first time, sent agents north of Baltimore.

Black insurance enterprises suffered greater losses during the depression than did white enterprises, in part because they dealt almost exclusively in industrial insurance. A total of 63 percent of all insurance carried by Negro companies in 1930 was industrial, in contrast to only 17 percent for white companies. Black industrial policyholders generally had very little wealth, and were forced to give up policies at the onset of hard times. The major black firms of the 1930s experienced a lapse rate for industrial insurance nearly 350 percent higher than for ordinary insurance. Victory Life and National Benefit Life, which had been founded in 1898 by Samuel Rutherford both

failed, while Supreme Liberty Life switched from ordinary insurance to enter the industrial market. Throughout its relatively brief history as a business, insurance had largely been dominated by men. But women had held high positions in companies; and black-owned insurance companies seemed to offer more opportunities to women than did their white counterparts. In 1912, nearly one-fourth of agents for North Carolina Mutual were women; at the white-owned Metropolitan Life Insurance Company, only one woman was employed as an agent before the mid-1940s. At the start of World War II, as more and more men entered war-related industries or were drafted, opportunities for women agents increased. In Philadelphia, a woman, Essie Thomas, led all other agents in sales for North Carolina Mutual.

With improved prosperity at the end of World War II, black families became better prospects for insurance sales. More and more white-owned firms courted blacks and eliminated or reduced premium differentials. White firms began to hire agents away from black-owned firms to solicit the new black middle class. In 1940, the vast majority of white underwriters still refused to insure blacks at all, and of the fifty-five that did, only five did so at standard rates. By contrast, in 1957, over 100 white companies competed for black policyholders, often at standard rates. While the overall growth rate of black-owned insurance companies slowed after 1960, there was a corresponding rise in the number of black-owned companies from fifteen in 1930 to forty-six in 1960.

Some black-owned firms, such as North Carolina Mutual, began to lessen their appeals to black solidarity—to the annoyance of black separatists. In the 1960s, North Carolina Mutual was allowed to join the American Life Convention and Life Insurance Association. Black-owned companies also began selling other forms of insurance, such as group insurance offered to large employers. Although group insurance was first introduced early in the twentieth century, it did not become popular until the 1930s. The group insurance market proved a difficult one for minority-owned companies to enter. Few, if any, black enterprises employed a hundred or more workers, and white-owned companies were reluctant to sign on with a black-owned company. For this reason, many black-owned insurers had to remain outside the group market until the 1970s, when they were aided by affirmative action laws.

Golden State Mutual of Los Angeles became the second largest black insurance company in the United States, largely due to its success in group sales. Founded in 1925 by William Nickerson, Jr., Norman O. Houston, and George A. Beavers, Jr., Golden

State Mutual had remained fairly small for several decades, with operations in only six states. Between 1968 and 1970, its group business grew tremendously, expanding from $59 million to $202 million. North Carolina Mutual also recorded great increases in business due to group insurance; in 1971 it became the first black company with over $1 billion insurance in force.

The 1980s saw difficulties continue for black-owned insurance firms. Reduced federal aid to low-income families (the main policyholders of black insurers) made even industrial policies difficult to afford. The premium receipts dropped 0.92 percent between 1987 and 1988 for the insurance industry as a whole; for black-owned insurance companies, the drop in premium rates was 7.83 percent. Two strategies emerged among black-owned insurance firms for survival. The first, practiced by North Carolina Mutual and Atlanta Life, was to acquire new insurees through acquisition of smaller black-owned insurance companies. In 1985, Atlanta acquired Mammoth Life and Accident Insurance Company (founded in 1915 in Louisville, Ky.) and in 1989, Pilgrim Health and Life Insurance Company (founded in 1898 in Augusta, Ga.). In all, between 1977 and 1989, eleven black-owned insurance companies were merged or acquired. Golden State Mutual—operating in California, Hawaii, Florida, and Minnesota—followed another strategy. It attempted to sell term, whole life, and universal life to the middle-income market, rather than the low-income market, which was the mainstay of Atlanta Life and North Carolina Mutual. Golden State greatly reduced the size of its personnel (from 760 employees in 1984 to 410 in 1988, not including commissioned sales staff), and hired college-educated agents. It also began television advertising campaigns starring football star Herschel Walker.

With the onset of a recession, the early 1990s proved particularly hard for many black-owned insurance companies. At that time there were twenty-nine black-owned insurance companies operating in the United States; together, they held $23 billion of insurance in force. The largest were North Carolina Mutual, Atlanta Life Insurance, and Golden State Mutual Insurance. United Mutual Life, the eleventh largest black-owned insurance company in the country, was acquired by the white-owned Metropolitan Life Insurance Company of New York in 1992. It was the last black-owned insurance company in the Northeast.

REFERENCES

HENDERSON, ALEXA B. *Atlanta Life Insurance Company, Guardian of Black Economic Dignity*. Tuscaloosa, Ala., 1990.

WEARE, WALTER B. *Black Business in the New South: A Social History of the North Carolina Mutual Life Insurance Company.* Urbana, Ill., 1973.

WALTER FRIEDMAN

Intellectual Life. Whether cast as attempts to document African-American mind, worldview, racial philosophies, or cultural mythos, nearly all scholarly studies of black intellectual life have acknowledged—as this article will—the functional importance of formal and informal educational institutions and the central ideological role of the quest for freedom and equality. The diffusion of this latter complex of ideas through African-American communities, its crystallization in folk thought, in religion, in popular culture, and in social movements, plays as important a role in understanding African-American intellectual life as studying the history of black intellectuals as a social entity; and this article attempts to balance these approaches. It also recognizes that in African-American life and throughout the modern world, intellectuals themselves, as a professional category, employ, with relatively greater frequency and dexterity than most of their peers, symbol systems of broad scope and abstract reference concerning humanity, society, nature, and the cosmos. But because the social history of black Americans has severely restricted their formal practice of intellectual occupations, the performance of these roles has frequently been assumed by individuals practicing nonintellectual occupations. Accordingly, the deeply rooted human need to perceive, experience, and express value and meaning in particular events—through words, colors, shapes, or sounds—has manifested itself in black intellectual life only partially in professional works of science, scholarship, philosophy, theology, law, literature, and the arts. Without implying any absolute separation of literature, music, and the arts from African-American intellectual life, the task of delineating the fuller role of these expressive modes and their individual intellectual expositors will be left to the various specialized articles devoted to them particularly.

Despite contrary misconceptions, African Americans originated in Old World African societies with a wide spectrum of intellectual traditions, literate as well as oral, and in which even the most rudimentary and relatively undifferentiated communities created recognized institutional niches for the intellectual functions that are expressed in art and interpretive speculation. In the large, highly differentiated kingdoms of the Western Sudan and Central Africa, specialized intellectual leaders—ofttimes institutionalized in guilds or professional castes—defined the cosmologies in which the individual and group were conceptually located; they helped to identify and regulate the occurrence of evil; to legitimate the powers and responsibilities of authority; to preserve and explain society's past; to transmit analytical and expressive skills to the young; to guide and critique aesthetic and religious experiences; and to foster the control of nature.

The era of European New World colonization and the accompanying Atlantic slave trade dramatically disrupted the intellectual lives of Africans caught up in it (*see* SLAVERY); but throughout the history of the United States, African Americans have created syncretic intellectual lives often at the cutting edge of literary, artistic, and scientific creativity. Slavery notwithstanding, every era has produced individual representatives of what Benjamin BRAWLEY termed "the Negro genius," whose intellectual and moral capacities provided crucial armaments in the ongoing "literature of vindication" that reformers and abolitionists initially mounted to defend African Americans against persisting theories of their innate inferiority. Inevitably, developments in African-American intellectual life have continuously been shaped by the problems and possibilities affecting American intellectual life generally. These have included the modernizing, secularizing forces that have moved the life of the mind in America from a colonial intellectual setting dominated by Christian divines and isolated scientific prodigies to a twentieth-century context variously identified with communities of bohemians, exiles, government-service intellectuals, and university professors. African-American intellectual life has evidenced also the tendency before the mid-twentieth century for intellectuals to believe themselves to be agents of progress, whether in the form of millennialism, republicanism, high culture, or social science methodology. This Enlightenment legacy has persisted in contradistinction to the modern tendency for the earlier progressivist faith to be replaced by doubt, and the formerly unifying vision and influence of American thinkers to be diminished by fragmentation and narrow expertise. Not surprisingly, the phases of African-American intellectual life have been delimited by the shifting conditions and recurring crises in black social history as well as by such larger contrapuntal developments; though manifest social exigencies have lent the progessivist faith and the struggle for a unifying vision more than conventional staying power in the intellectual world of African-American communities.

Colonial and Revolutionary America

During the colonial and Revolutionary era, the circumstances of slavery shaped African-American intellectual life in specific ways. First, slavery rigorously suppressed African culture, its languages and institutions of intellectual discourse, and drove surviving oppositional intellectual forms underground. Second, the repudiation in the American colonies of the Greco-Roman tradition of the erudite slave and the corollary prohibitions against literacy, stultified the development of Western intellectual skills and opportunities for the vast majority of African Americans. Third, strict social control of even quasi-free black intellectuals was attempted through both de jure laws and de facto discrimination. Fourth, as a consequence, an African-American tradition of sacred and secular folk thought in sermons, tales, aphorisms, proverbs, narrative poems, sacred and secular songs, verbal games, and other linguistic forms became the primary matrix for historicizing, interpreting, and speculating about the nature and meaning of society and the cosmos. Toward the end of the colonial period, however, the emergence of the earliest professional black intellectual voices was fostered by two broad cultural developments in the British colonies—the Great Awakening (approximately 1735–1750) with its unifying religious fervor, millennial progressivism, and missionary appeal to African Americans and Native Americans; and then the revolutionary political ferment that accompanied the spreading Enlightenment doctrine of the Rights of Man: life, liberty, and equality. African Americans quickly grasped the relevance to their own circumstances of the democratic dogma and revolutionist rhetoric that transfixed colonial legislatures and the Continental Congress; and during the War of Independence, while weighing the loyalist appeals and promises of emancipation from British colonial governors, black men and women sponsored petitions to legislatures, court cases for individual freedom, and platform oratory calculated to convert the professed revolutionary faith of rebel American slaveholders into direct challenges to American slavery itself.

During the decades following the War of Independence, the growth of autonomous black churches, schools, and fraternal and burial societies in the free North (Philadelphia, New York, and Boston, especially) and in selected southern cities (New Orleans; Charleston S.C.; and Savannah) created the initial context for formal development of group intellectual life. In early African-American churches a vital intellectual tradition of intense striving for contact with the sacred focused on the mastery, interpretation, and exposition of biblical writings, with a distinctive strain of exegetical "Ethiopianism" apparent as early as the 1780s. Identifying Africans in American bondage with Israel in biblical Exodus became a controlling metaphor in secular as well as sacred African-American literature; and the Ethiopian prophecy of Psalms 68:31—"Princes shall come out of Egypt; Ethiopia shall yet stretch out her hands unto God"—became the dominant sermonic text offered to answer the omnipresent question of theodicy. This problem of explaining the divine purpose of black suffering—while simultaneously separating the slaveholders' religion from "true Christianity"—became the pivotal heuristic of antebellum black religious thought and the foundation of a distinctive African-American theology. Some of the initial virtuoso intellectual action by African Americans arose out of such religious preoccupations or out of conversion experiences fused with the political ferment of revolution: the neoclassicist verse of Phillis WHEATLEY; the sermons and letters of the Congregationalist minister Lemuel HAYNES; the antislavery autobiography of Olaudah EQUIANO, for example. Prior to the establishment of black secular education, the quest for literacy was fueled by religious impulses and facilitated by free black churches or by the "invisible church" in slave communities. And in NEW YORK CITY between 1787 and 1820, the AFRICAN FREE SCHOOL, with white missionary support, provided formal education for hundreds of students such as Ira ALDRIDGE, who went on to international fame as a Shakespearean actor.

But Free African societies and fraternal orders like the Prince Hall Masons also provided a counterconventional intellectual matrix—for mastering the secular and sacred freethought traditions of the Radical Enlightenment, in which the proselytizing mythographers of freemasonry and Renaissance hermeticism offered African-American free thinkers secret access to a "perennial philosophy" that hypothesized an unbroken continuity with, and a reverential attitude toward, the esoteric symbol systems and pagan wisdom literatures of ancient North Africa and the Orient. No less significant, the influence of Enlightenment science and technological innovation created a milieu in which perhaps the most variegated black intellectual career of the eighteenth century could evolve—that of Benjamin BANNEKER, mathematician, naturalist, astronomer, inventor, almanac compiler, surveyor, and essayist.

The Age of Abolition

In the nineteenth century the movement toward autonomous institutions in free black communities, North and South, continued. But the most significant developments for African-American intellectual life were the successive appearances of, first, wide-

spread protest between 1817 and 1830 against the mass black deportation schemes of the AMERICAN COLONIZATION SOCIETY; second, the opening phase of the National Negro Convention Movement, from 1830 to 1840; and third, the emergence of militant black abolitionism, from 1843 to the onset of the Civil War. Alongside the growth of stable, northern free black communities, these developments provided the broadest context to date for the fruition of African-American intellectual skills and activities. Besides spurring the general acquisition of forensic and oratorical prowess, the anticolonization movement helped forge a vital journalistic tradition with the development of the nation's first black newspaper, FREEDOM'S JOURNAL—cofounded in 1827 by the college-trained, Jamaica-born John RUSSWURM, and Samuel CORNISH, a Presbyterian minister. Anticolonization activities also provided the impetus for the strain of radical political exhortation that erupted in David WALKER's insurrectionist *Appeal in Four Articles* (1829), the nineteenth-century prototype for militant repudiation of white racism and black acquiescence.

The National Negro Convention Movement, which began with six annual aggregations between 1830 and 1835 (all save the fifth in Philadelphia), gave African-American intellectual life its first major coordinated organizational thrust—by providing linkages between the roughly fifty black antislavery societies then in existence; by creating a rationale for boycotts organized by newly established "Free Produce Societies" against the products of slave labor; and by founding temperance and moral reform societies and African missionary groups. With the revitalization of American abolitionism after the emancipation of slaves in the British West Indies in 1833, the ground was laid for a militant black ABOLITION struggle that, beginning with the Negro national convention of 1843, developed increasing intellectual autonomy from the antislavery program of William Lloyd Garrison. Over the next two decades, black abolitionism moved ideologically toward programmatic insurrectionism and nationalist emigrationism, as the Fugitive Slave Act of 1850 and the DRED SCOTT DECISION of 1857 made central in African-American philosophical debate the political issues surrounding the juridical denial of American citizenship rights and nationality to even native-born free black people (*see* FUGITIVE SLAVE LAWS).

The final three antebellum decades also witnessed an array of organized intellectual activities by newly formed African-American literary societies and lyceums in northern free black communities. The New York Philomathean Society, founded in 1830, the Philadelphia Library Company of Colored Persons, in 1833, as well as groups in midwestern and border

cities, like the Ohio Ladies Education Society, started private libraries and organized debating and elocution contests, poetry readings, and study classes variously devoted to promoting "a proper cultivation for literary pursuits and improvement of the faculties and powers" of the mind. As early as 1832 the African-American Female Intelligence Society of Boston provided a platform for pioneering moral reformer and black feminist lecturer Maria STEWART; and the Benjamin Banneker Society in Philadelphia sponsored regular lecture series on political, scientific, religious, and artistic issues.

These expanding institutional supports for black intellectual life facilitated the careers of the two most extensively educated figures of the antebellum era—Alexander CRUMMEL, Episcopal clergyman and Liberia mission leader; and James McCune SMITH, university-trained physician, abolitionist, editor, essayist, and ethnologist—both products of the African Free School and of advanced training outside restrictive American borders (*see* AFRICAN FREE SCHOOLS). The early pan-African scholarship of St. Thomas-born Edward Wilmot BLYDEN; the pioneering political essays and fiction of Martin DELANY; the voluminous racial uplift, moral reform, and women's rights lectures and belletristic works of Frances Ellen Watkins HARPER—all reflect the expanding audiences and material support for African-American intellectual actions and performances that accompanied the broader ferment in American culture during the era of romanticist and transcendentalist ascendancy. No less than their Euro-American counterparts, Jacksonian-era black intellectual leaders espoused a providential view of history that afforded them a special worldwide mission and destiny. Beginning with Robert Benjamin Lewis's *Light and Truth; Collected from the Bible and Ancient and Modern History* (1836, 1844) and James PENNINGTON's *Text Book of the Origin and History of the Colored People* (1841), a tradition evolved of popular messianic historiography by self-trained "scholars without portfolio," many of them Christian ministers, who drew eclectically on sacred and profane sources in ecclesiastical accounts, in the new romantic national histories, and in the archaeological and iconographic data vouchsafed by the rise of modern Egyptology during the early nineteenth century, following the discovery and decipherment of the Rosetta stone.

Although racial codes through the South greatly restricted black intellectual life, in Louisiana the language and intellectual traditions of French culture persisted during the antebellum era, with members of the African-American elite ofttimes acquiring an education in France itself and choosing expatriate status there over caste constraints in America. The career of New Orleans scientist-inventor Norbert

RILLIEUX, whose innovations in chemical engineering revolutionized the international sugar-refining industry, developed in this context, as did the dramaturgy of Victor Séjour, a leading figure in the black Creole literary enclave, LES CENELLES (The Hollyberries), which emerged in New Orleans during the 1840s. Although no specifically belletristic literary movement appeared in northern free black communities, literary traditions in poetry, autobiography, and the essay extended back into the eighteenth century; and the final antebellum decade witnessed the publication of the earliest extant African-American novels and stage plays. The northern free black community of New York City served as the site of Thomas Hamilton's pioneering *Anglo-African Magazine* (1859), an outgrowth of the publisher's lifelong ambition to provide an independent voice representing African Americans in "the fourth estate," and a vehicle for skilled historical essays, biographical sketches, fiction, critical reviews, scientific studies, and humor by such eminent antebellum black luminaries as Edward Wilmot Blyden, Martin Delany, Frances Harper, James Theodore HOLLY, George Vashon, Mary Ann Shadd CARY, and John Mercer LANGSTON.

The most influential product of African-American intellectual life during the era, however, was the twin stream of SLAVE NARRATIVES and spiritual AUTOBIOGRAPHIES that apotheosized the complementary ideologies of abolition and moral reform through biblical motifs of captivity and providential redemption related compellingly by such figures as William Wells BROWN, Frederick DOUGLASS, Harriet JACOBS, Jarena LEE, and Solomon NORTHRUP. In their assault on the legal and historical pretexts for slavery, self-authored slave narratives in particular (as opposed to those transcribed by white amanuenses) cultivated an assertive facticity about the horrors of bondage and a subjective ethos of faith, adaptability, and self-reliance that gave expressive mythic structure to an evolving African-American corporate identity. In the narratives by black abolitionist leaders like Douglass, Samuel Ringgold WARD, and Sojourner TRUTH, slave autobiographies revealed their close alliance also with oratory as a political instrument and a molder of group consciousness. Evidencing often distinctive uses of the "plain style" or the flamboyant rhetoric of the golden age in American platform oratory, formal public utterances by African Americans during the final antebellum decades lend greater credence to the claims of intellectual historians that the national consciousness was created and stabilized, policies for westward expansion formulated, the rights of women conceived, the slave power consolidated and then broken, all through the egalitarian processes of public address—ceremonial, hortatory,

deliberative (*see* ORATORY). Black Americans during the years leading to the Civil War heard, pondered, read aloud, and committed to memory their favorite orators. And passages learned from Wendell Phillips's thousandfold lectures on Toussaint Louverture, from annual West Indian Emancipation Day observances, from Frederick Douglass's Fourth of July oration, and from African School texts of classical rhetoric prepared African Americans intellectually to respond, with arms and labor, when Lincoln finally appealed for their support to help save the Union.

Reconstruction through the 1890s

The Civil War and Emancipation dramatically recast the contours of African-American intellectual life. The decade of RECONSTRUCTION optimism focused the thought of black communities largely on the equalitarian possibilities of the franchise, on education, on the acquisition of property and wealth, and on the cultivation of those qualities of character and conduct conducive to "elevating the race" within the body politic. Freedmen's Bureau professional occupations and the emerging constellation of black colleges and universities created new matrices for black intellectual life within corporate intellectual or practical institutions. During the following decade, one index to the shifting intellectual balance appeared with the publication of the *AME Church Review* (1884), which for the next quarter century, under the successive editorships of Benjamin Tucker TANNER, Levi COPPIN, and Hightower Kealing, would become the premier magazine published by and for African Americans and would be transformed from a church newspaper to a national scholarly journal of public affairs. It featured biblical criticism and theology, wide-ranging editorial opinions, articles on pan-African history and American civic issues, as well as black poetry and fiction and popular essays, all attuned to "the intellectual growth of our people" and carefully uniting sectarian and increasingly nonsectarian interests in the purpose of giving to the world "the best thoughts of the race, irrespective of religious persuasion or political opinion." Coterminously, a stream of articles and books on biblical interpretation by authors such as the Reverend James Theodore Holly, John Bryan Small, and Sterling Nelson Brown (father to the poet) confronted the hermeneutical practices and canonical assumptions of late nineteenth-century biblical higher criticism with allegorical, christological, typological, and historical challenges to traditionally anti-black exegeses of Jahwist traditions such as the so-called curse of Ham.

While black institutions like churches, fraternal societies, and conventions continued to foster intellectual activities, perhaps a better index of post-Reconstruction developments—and of the secular-

izing intellectual tendencies in particular—appeared with the formation in 1897 of the first major African-American learned society, the AMERICAN NEGRO ACADEMY, in Washington, D.C. It was constituted as "an organization of authors, scholars, artists, and those distinguished in other walks of life, men of African descent, for the promotion of Letters, Science, and Art." The Academy published twenty-two occasional papers over the next quarter century on subjects related to African-American culture, history, religion, civil and social rights. Its all-male membership spanned the fields of intellectual endeavor; and besides its first president, Alexander Crummel, it ultimately included such important intellectual leaders as Francis J. GRIMKÉ, a Princeton-trained Presbyterian clergyman; W. E. B. DU BOIS, professor of economics and history at ATLANTA UNIVERSITY; William H. Crogman, professor of classics at Clark University; William S. Scarborough, philologist and classicist at WILBERFORCE UNIVERSITY; John W. Cromwell, lawyer, politician, and newspaper editor; John HOPE, president of MOREHOUSE COLLEGE; Alain LOCKE, Harvard-trained philosopher, aesthetician, and Rhodes Scholar; Carter WOODSON, historian and Howard University dean; and James Weldon JOHNSON, poet, novelist, songwriter, and civil rights leader. Interrelated developments in institutionalized black intellectual life included the founding of the Atlanta University Studies of the Negro Problems in 1896, the American Negro Historical Society of Philadelphia in 1897, the Negro Society for Historical Research in 1912, and the ASSOCIATION FOR THE STUDY OF NEGRO LIFE AND HISTORY in 1915. Moreover, these institutions were frequently closely linked to the nationwide orbit of educational and reform activities sponsored by the more than one hundred local black women's clubs that had been founded by leaders such as Mary McLeod BETHUNE, Lucy LANEY, Charlotte Hawkins BROWN, Ida WELLS-BARNETT, and Nannie BURROUGHS and then federated in 1896 as the NATIONAL ASSOCIATION OF COLORED WOMEN. Nannie Burroughs, for instance, demonstrated the various intellectual intersections in her subsequent coterminous service as a life member of Woodson's Association for the Study of Negro Life and History.

No less important, the expanding literacy of the black audience during the educational fervor that followed Emancipation generated new opportunities for black intellectual entrepreneurs like the minister-pamphleteer-novelist Sutton GRIGGS and artist-intellectuals like dramatist-journalist-fictionist Pauline HOPKINS. They created intellectual products and performances devoted to racial solidarity and to a widening interracial marketplace of progressivist art and ideas. Following a decade of post-Reconstruction

struggle against reaction, in the 1890s a cluster of significant events coalesced that expressed in a variety of intellectual and artistic media the new dynamic of black independence and self-assertion: In 1895, Booker T. WASHINGTON galvanized national attention with his Atlanta Exposition speech. In 1895 also, "Harry" BURLEIGH was assisting Antonín Dvořák with the black folk themes of the *New World Symphony* and at the same time making his entry into the New York concert world. In 1896 Paul Laurence DUNBAR emerged as a leading poetic voice; and painter Henry Ossawa TANNER marked the beginning of his first substantial Paris recognition. In the same year a pioneering black musical comedy premiered on Broadway. In 1898 Will Marion COOK introduced "serious syncopated music" with *Clorindy;* and the Anglo-African composer, Samuel Coleridge Taylor, achieved maturity and fame with the first part of his *Hiawatha Trilogy*. And in 1898 and 1899 Charles CHESNUTT, the novelist, inaugurated the first fully professional career of a black fiction writer. The appearance in 1903 of W. E. B. Du Bois's *The Souls of Black Folk* became a synthesizing artistic event of this period and one that spurred, perhaps for the first time, an ascendancy to black national leadership on the basis of intellectual performance alone.

The era's famous Washington–Du Bois controversy highlighted not just the partisan intraracial ideological differences over political, educational, and economic strategies but the changing role and increasing prominence of secular intellectuals in black America generally—Washington's rise paralleling the emergence of an anti-intellectual, industrial-minded, managerial Euro-American elite and Du Bois's ascendancy paralleling that of a coterie of Arnoldian "elegant sages" who assumed the roles of national culture critics and prophets. Between African-American and Euro-American intellectuals of either orientation, however, the continuing predominance of conflict rather than the consensus over issues of racial justice also continued to parallel the still entrenched segregation of American intellectual and institutional life; and such conflict expressed itself through the continuing ideological and iconographical war over racial imagery in all the artistic and scholarly media of the period, a pattern that remained essentially unaltered until the intercession of WORLD WAR I.

Renaissance and War

The emergence after World War I of the first major African-American cultural movement gave evidence of a self-identified intellectual stratum of "New Negroes" (*see* NEW NEGRO). It was structured, first, by new sources of financial support and patronage for the performers of intellectual actions. Second, a cadre

of secular leaders had developed—university-trained philosophers and social scientists such as W. E. B. Du Bois, Alain Locke, and Charles S. JOHNSON and activist organizers like Marcus GARVEY—who superintended the intellectual performances from bases in corporate intellectual institutions (primarily black colleges and universities) or in practical institutions like the NAACP, the Urban League, and the UNIVERSAL NEGRO IMPROVEMENT ASSOCIATION (UNIA). These developments were reinforced by the less formal creation of salons like L'Alelia WALKER'S "Dark Tower," of the "NEGRO SANHEDRIN" at Howard University, and of coteries of artists in Philadelphia, Washington, D.C., and cities distant from the "Negro Mecca" in Harlem. Third, the movement responded to patterns of rising consumer demand from white and black audiences alike for black intellectual objects and intellectual-practical performances. Fourth, new relationships had emerged between tradition and creativity in the various fields of intellectual action—modernism in the arts, and the rise in academia of the social sciences, the "new history," and new paradigms in physical science.

The increasing urbanization and industrialization of the nation generally, and the country-to-city Great Migration of African Americans in particular, combined with the emergence of popular culture and the new media technologies (radio, cinema, phonograph, graphic arts, etc.) to provide the culturally nationalistic "Black Renaissance," as Langston Hughes termed it, an unprecedentedly "creativogenic" milieu with specific intellectual characteristics. The growth of mass audiences, and of new technical means for communicating with them, expanded the field of action for black intellectuals. The general reaction against standardization and conformity in American life, and the postwar openness to diverse cultural stimuli, which accompanied the further decline of prewar Victorianism, lowered the barriers to cross-cultural exchange. A modernist "cult of the new," which stressed *becoming* and not just being as a creative value, fostered experimental attitudes and improvisational styles for which jazz became an acknowledged exemplar. The growing shift of moral authority in vernacular culture from religious spirituals and parlor songs to secular blues and cabaret lyrics undergirded a pronounced generational rebellion against conventional sexual attitudes and gender roles in black communities and beyond. The freer access to cultural media for American citizens generally facilitated the emergence of independent African-American motion picture and recording companies. Among the cadre of Black Renaissance intellectuals, the conscious sense of greater freedom, following a legacy of severe oppression and near-absolute exclusion, had created a collective compensatory incentive

to creativity. A movement ethos that apotheosized youth, a self-conscious exposure to different and even contrasting cultural stimuli from black immigrants and ideas elsewhere in the African diaspora, and a now-fashionable tolerance for diverging views and intense debate helped make the Black Renaissance manifestly creativogenic, despite its manifold constraints.

A destabilizing facet of African-American intellectual life during the period, however, was the widening gulf between intellectuals and traditional patterns of authority and religious orthodoxy inside and outside black communities. As intellectual historians generally concur, at the end of Reconstruction the lives of most Americans were still dominated by the values of the village, by conventional nineteenth-century beliefs in individualism, laissez-faire, progress, and a divinely ordained social system. But in the closing decades of the century the spread of science and technology, industrialism, urbanization, immigration, and economic depression eroded this worldview. Black intellectuals experienced increasingly the same tension with ecclesiastical and temporal authority that modern intellectuals in general have felt—the intellectual urge to locate and acknowledge an *alternative* authority which is the bearer of the highest good, whether it be science, order, progress, or some other measure, and to resist or condemn *actual* authority as a betrayer of the highest values. Traditions for defining or seeking new "sacred" values that won stronger allegiance among African-American intellectuals included: (1) the tradition of scientism, that of the new social sciences in particular, because of their attention to the race problem and their role in public policy; (2) the romantic tradition, specifically the cults of "Negro genius," of an Herderian apotheosis of "the folk," of countercultural bohemianism and the "hip"; (3) the apocalyptic tradition of revolutionism, millenarianism, and radical Pan-Africanism adapted to the contours of American life; (4) the populist tradition with its themes of the moral and creative superiority of the uneducated and unintellectual and its critique of bourgeois/elite society by its disaffected offspring; (5) the feminist tradition, variously reformist or radical, with its revisionary assault on conventional gender roles and on the hegemony of an ostensibly patriarchal social matrix rooted in female subordination; and (6) the anti-intellectual tradition of order (dissensual political and religious sects built on charismatic models and revitalizationist discipline—Garveyism, FATHER DIVINE, the NATION OF ISLAM, etc.), which ofttimes deems pronounced intellectualism to be disruptive.

Among these traditions of alternative authority, scientism, despite the increasing popularization of scientific ideas in the mass media, had acquired the

broadest social prestige but the least democratized mechanisms of evaluation and reward. To the extent that its accomplishments were achieved through formal research in laboratory settings by research-degree holders, it retained the most uncertain footing in African-American intellectual life at the same time that it more and more supplanted achievement in the high arts as the greatest potential symbol of group capacities and progress. At the turn of the twentieth century, the most highly honored of all black scientists, the agricultural chemist, George Washington CARVER (1864–1943), symbolized the ambiguities that the issue of race introduced into scientific culture in America. The tensions between theoretical and applied science contributed to Carver's being derided by partisans of the former as more a concoctionist than a contributor to genuine scientific knowledge. The tensions between science and the Christian faith he espoused as a spur of his Tuskegee research placed him in conflict with the cult of scientific objectivity. And despite the revolutionary impact of that research on peanut and soybean derivatives for the economy of both the nation and the South, to many black proponents of nationalistic racial uplift, his characteristic humility and racial deference made problematic the role of such black scientists in group progress.

At the time, however, Carver's uncertain place in African-American intellectual life mirrored the uncertain place of scientists generally in American culture and progress, as revealed in the apparent "inferiority complex" of American scientific culture in the international intellectual community at the turn of the century. That sense of national deficiency crystallized in a widely discussed article from the *North American Review* in 1902; this article lamented the inferiority of American scholarship and science relative to the European and noted that none of the great scientific achievements of the preceding century—the theory of evolution, the atomic structure of matter, the principles of electromagnetic induction and electrolytic action, the discovery of microorganisms, and the concept of the conservation of energy—had been the work of Americans, whose successes instead were largely derivative in the major sciences or were located in minor fields such as astronomy, geology, and meteorology.

Perceived deficiencies in the life of the scientific mind—and the manifest need for greater achievement—functioned analogously at the levels of nation and race, then, in the early decades of the twentieth century. Among African Americans, despite the pioneering doctorate degree in physics awarded Edward BOUCHET at Yale University in 1876, a total of only thirteen physical or biological science doctorates had been earned prior to 1930. But in the next decade and a half a more than tenfold increase in earned science doctorates occurred, fueled primarily by doctors of medicine, among whom were pioneering research scientists such as Charles DREW (1904–1950; hematology) and Hildrus POINDEXTER (1901–1987; microbiology). An estimated 850 African Americans earned natural science doctorates by 1972; and at a fairly constant rate approximately one out of every one hundred American science doctorate holders would be African American into the 1990s. But because the social history of African-American scientists confined about 75 percent of them, as late as 1981, to employment at predominantly black institutions of higher learning—with limited laboratory facilities and research support and heavy instructional responsibilities—their primary role in African-American intellectual life has been to teach the sciences at those institutions, where the majority of black science doctorate holders have continued to receive their undergraduate training. Nevertheless, as recipients of scientific awards, as office holders or journal editors in scientific societies, as members of scientific advisory or research grant review committees, and as authors of textbooks, African-American scientists have achieved distinction in fields as diverse as aerospace science (NASA astronauts Drs. Ronald MCNAIR and Mae JEMISON, for example), organic chemistry, marine and cell biology. In the mathematical theory of games and statistical decisions, for instance, David H. BLACKWELL, the first black mathematician elected to the National Academy of Sciences, coauthored a pioneering textbook for the field in 1954, won the Von Neumann theory prize in 1979, and, for work as a Rand Corporation consultant, has been cited as one of the pioneers in the theory of "duels"—a two-person, zero-sum game involving the choice of the moment of time for firing in military conflict.

Besides the prestige and inherent intellectual attractions of the sciences and scientism, these fields, despite the persistence of racial discrimination within the world of professional researchers, offered African-American intellectuals careers in which the links between merit and acclaim were presumably established by "objective" standards of authority with "universal" provenience. The scientific tradition of rejecting tradition if it does not correspond with the "facts of verifiable experience" provided some black intellectuals the kind of "higher" authority that freed them to an increasing extent from the "priest-governed" black communities described by W. E. B. Du Bois. Such an outlook focused necessarily on the *methods* of science; but for natural scientists in particular, it failed to define concrete social objectives and social roles.

African-American intellectuals drawn to the social sciences, by contrast, found the then unquestioned

social utility of the new sciences of society a source of continuity with the pre–twentieth-century "gospel" of progress and with associated meliorist, progressivist, or millenialist philosophies of racial uplift. Unlike the natural sciences, the place of the social sciences in African-American intellectual life was firmly established early during the development of black post-Reconstruction practical and educational institutions; and a tradition of prominent African-American achievement in the fields of economics, political science, anthropology, sociology, and psychology developed almost coterminously with the emergence and professionalization of these fields within the modern academy.

During the 1890s the earliest formal departments of sociology appeared in America, as did the first contributions of African Americans to the new discipline—both emerging amid a climate of extreme racism in popular and academic thought. The half century between the appearance in 1899 of W. E. B. Du Bois's *The Philadelphia Negro* and of St. Clair DRAKE and Horace CAYTON's *Black Metropolis* in 1945 has been described as the golden age in the sociology of black America, with a series of path-breaking works by social scientists based at black colleges and universities. Du Bois's classic study of black Philadelphia was both the first scientific study of an African-American community—a precursor of the Atlanta University Publications series he later founded—and the pioneer work of American urban sociology. It spurred similar projects such as *The Negro at Work in New York City: A Study in Economic Progress* (1912), conducted by George Edmund HAYNES, one of the earliest black Ph.D. holders in sociology and an early proponent of black migration research. The period from World War I to the mid-1930s was dominated by the famous University of Chicago school of American sociology; and out of it a group of distinguished black sociologists and anthropologists—Charles S. Johnson, E. Franklin FRAZIER, Bertram Doyle, St. Clair Drake, and Horace Cayton—emerged with major research works on black family sociology, race relations, social stratification, community development, southern plantation systems, migration patterns, and related topics. At Atlanta University, Ira De A. Reid, a specialist on West Indian immigration and rural plantation studies, succeeded Du Bois in conducting studies on urban African-American life and in training new researchers. E. Franklin Frazier, at Howard University (where a sociology department had earlier been established by Kelly MILLER) and Charles Johnson at FISK UNIVERSITY commanded, like Reid, the resources necessary to develop strong sociology departments with graduate research programs. But at black institutions without resources for graduate study, strong undergraduate programs were built nonetheless by sociologists such as St. Clair Drake at Roosevelt College, Oliver COX at LINCOLN UNIVERSITY, W. S. M. Banks and Earl Pierro at Fort Valley State College, and Mozell Hill at Langston University.

Though sociologists have outnumbered black social scientists in other fields, the middle decades of the twentieth century witnessed an expanding representation of African-American scholars in economics, political science, psychology, and anthropology. During the period from the 1930s to the 1960s economists such as Booker T. McGraw, Frederick Jackson, Rodney G. Higgins, Frank G. Davis, and Winfred Bryson, Jr., developed careers as scholars and advisers to service organizations, businesses, and government, while Abram HARRIS, perhaps the most widely known black economist of the era, combined early service as an Urban League official with an academic career of research scholarship on the labor movement and black business development that culminated in his series of studies on social reform strategies in the economic philosophies of Thorstein Veblen, Werner Sombart, John Commons, Karl Marx, and John Stuart Mill. From the 1960s to the 1990s, as the sphere of black entrepreneurial activities and service opportunities expanded in the wake of the civil rights movement, African-American economists such as Bernard Anderson, Andrew BRIMMER, Samuel Myers, Thomas Sowell, Clifton WHARTON, and Walter Williams have played increasingly diverse roles in the academy, in private and public foundations, in conservative or liberal "think tanks," in political organizations such as the CONGRESSIONAL BLACK CAUCUS, and in a publishing industry eager for certified expertise in "the dismal science."

In economics, as in other social sciences like psychology and anthropology, however, black practitioners faced—with a difference—the dilemma that perplexed all fields of knowledge after the 1920s and 1930s, when scientism's leading edge—physics and mathematics—no longer epitomized the discovery of immutable natural laws but instead struggled with new uncertainties that undermined belief in fixed laws and principles. Albert Einstein's theory of relativity, Werner Heisenberg's "uncertainty principle," Kurt Gödel's demonstration that mathematical theories could not be verified without referring back to their own premises, all marked science, despite its spectacular technical achievements, as in some ways as metaphorical as the arts and incapable of vouchsafing ultimate principles for human action and judgment. Economic models that postulated rational patterns of buying and selling ignored irrational personal motivations such as race prejudice and circumvented

central issues such as the effects of racist institutions on individual behavior.

In psychology, psychometric measures, regarded at the turn of the century as empirical propositions of enormous accuracy, had become so interwoven with ideological nativism, elitism, social class bias, and racism that as early as 1927 Horace Mann BOND found it necessary to denounce as "invidious propaganda" the then widespread psychometric "game" of testing black children for standardized notions of intelligence, for "racial temperament," and for dubious "mulatto hypotheses." Between 1920 and 1950 the roughly thirty black doctorate holders in psychology, beginning with Francis Cecil Sumner and his work on the psychoanalytical theories of Sigmund Freud and Alfred Adler, were drawn to a variety of research modes, from G. Henry Alston's experimental neurological examination of the "psychophysics of the spatial conditions for the fusion of warmth and cold into heat" to May Pullins Claytor's construction of questionnaires for detecting symptoms of juvenile delinquency. The training of African-American psychologists during the era was strongly influenced by the urgent social need for black teachers and social service workers. Corresponding tendencies led black colleges and universities to deemphasize the ascendant German-derived laboratory science curriculum in psychology that, at white institutions, subordinated the practical and applied sphere. Throughout this period Howard University's program in psychology, under the leadership of Francis Sumner, was the only black school providing graduate and undergraduate training in laboratory-experimental psychology. In the course of preparing such outstanding scholars as Mamie Clark and Kenneth CLARK, it developed a strong curriculum based on the behaviorism of John Watson and the dynamic psychology of Freud and William McDougall. However, in psychology as in the other social science disciplines, the diminishing likelihood that any one theory could ultimately disprove any other made relatively arbitrary such procedural choices; and the growing uncertainty of the concept of race itself as an operative term made the incursions of relativism even more pronounced.

In stressing the "cultural significance" of psychology—its importance for understanding "literature, religion, philosophy, art, crime, genius, mental derangement, history, biography, and all creations of the human mind"—the Howard program implicitly aligned itself with developing traditions of anthropological and folkloric study in African-American life that embraced the new notions of "cultural relativism" promoted by social scientists such as Franz Boas. Boas believed that "the idea of a 'cultured' individual is merely relative" to the system of meanings in which that individual grows up and lives and that such a belief liberates us from the normative prejudice that Western civilization is absolutely superior to others. After World War I, Boas and his students (who included the writer-folklorist Zora Neale HURSTON) rejected genteel Victorian notions of culture that focused exclusively on the highest stratum of artistic expression by educated elites. They adopted instead a presumably detached viewpoint of culture as endemic to all human communities and perhaps better observed in everyday life and common emotions than in superordinate ideals or formalities.

The corresponding emphasis on folklore and folklife reinforced practices of cultural preservation that had become established in African-American intellectual life decades earlier. Groups of black scholars and students had been working actively to document and preserve African-American folk traditions since the 1880s and 1890s, when a black folklore group formed at HAMPTON INSTITUTE in Hampton, Va., to collect African-American sacred and secular songs, proverbs, tales, and wisdom lore. In the 1920s and '30s, in conjunction with a burst of interest in American folklore scholarship generally, a group of professionally trained black folklorists emerged who gave new regional and genre focuses to the enterprise. In 1922 Fisk professor Thomas Talley published a large collection of play songs, proverbs, and verbal art in his *Negro Folk Rhymes;* in 1925 an African musicologist and composer from Sierra Leone, Nicholas Ballanta-Taylor, who had come to the GULLAH communities of coastal Georgia and the Carolinas to study links between African and African-American music, published his transcriptions of religious songs in *St. Helena Island Spirituals.* Arthur Huff FAUSET, who earned a Ph.D. from the University of Pennsylvania, specialized in the folk narratives and riddles of the South and the West Indies and in the urban religious cults of Philadelphia. James Mason Brewer, a Texas-based folklorist who studied at Indiana University with folktale specialist Stith Thompson, published a ground-breaking slave tale collection, *Juneteenth,* and subsequent volumes of South Carolina humor, as well as preacher and ghost tales from the Texas Brazos region. And Zora Neale Hurston, trained in Boas's anthropology program at Columbia University, fused her ongoing folklore collecting and research with a developing career as a creative writer that led to a series of works on American hoodoo, Jamaican obeah, Haitian vodoun (*see* VOODOO) and to the southern songs, jokes, games, tales, and conjure lore of her classic *Mules and Men* in 1935. In the works of all these scholars the underlying premises of the new cultural relativism provided a scientistic source of authority for the pragmatic labors of doc-

umenting and preserving the communal traditions of African-American life.

In analogous ways the practice and study of law and politics in African-American intellectual life responded also to the influence of the new sciences of society. Early black lawyers like George B. Vashon (1824–1878) in pre–Civil War New York and his pupil, Oberlin graduate John Mercer LANGSTON, later the founder of the law school at Howard University, struggled for the rights of African Americans and for recognition as professionals in a nineteenth-century American culture in which the dignity, prosperity, formal cultivation, and pervasive influence of the legal profession were some of its most striking phenomena. Vashon had studied law in an age when jurisprudence, the liberal arts, and the sciences remained parts of a unified higher education, as testified to in his own multifaceted career as lawyer, mathematician, linguist (with fluency in Greek, Latin, Hebrew, German, French), and author of the masterful epic poem *Vincent Oge,* on the Haitian revolutionary hero. Powerful contrasts were emerging, however, between the scientific worldview affirmed in his *Anglo-African Magazine* essay on "The Successive Advances of Astronomy"—an encomium to the triumph of Laplacean mathematics and Newtonian physics—and the religious folk cosmology of unlettered preacher John JASPER's legendary 1880 sermon "The Sun Do Move," with its fervent experiential rejection of the counterintuitive postulates of Newtonian science. Modern legal science had embraced those postulates in the course of its rise to intellectual dominance; and more than their British or continental European counterparts, American lawyers dominated political life, and to a large extent, business. And as Alexis De Tocqueville had early noted, in America the language and ideas of judicial debate and the spirit of the law penetrated "into the bosom of society."

The pervasive influence of legal ideas and attitudes in American thought, however, was inherently a force for conservatism, a conservatism rooted in the "natural law" philosophy that laws, as in Newtonian science, are to be discovered, not made, that they are patterned in "the nature of things," not on changing human needs. Sanctified in the U.S. Constitution, perhaps no theory of law was better fitted, as Henry Steele Commager noted and as black litigants quickly discovered, to restrict government to negative functions, to put property rights on a par with human rights, to invest the prevailing practices of industrial capitalism with legal sanction, and to provide protection for slavery in the natural law limitations of the due process clause. The U.S. Supreme Court's DRED SCOTT DECISION of 1857, nullifying black citizenship rights, and the PLESSY V. FERGUSON decision

of 1896, sanctioning "separate but equal" facilities as amenable to the Fourteenth Amendment, reverberated throughout African-American intellectual life; but through their manifest justice, such decisions helped inculcate a pragmatic tradition of protestant legalism in black thought, which eschewed the cult of veneration for the law that, for many other Americans, "made constitutionalism a religion and the judiciary a religious order surrounded with an aura of piety."

At the turn of the twentieth century, as a conflict developed between fixed, Newtonian concepts of law and dynamic, progressive ideas in politics and science, African Americans, guided by their painful experience of law as a fixed system of predation and social control, aligned themselves understandably with the new "sociological jurisprudence" that Roscoe Pound inaugurated as "a process, an activity, not merely a body of knowledge or a fixed order of construction." In accord with the new jurisprudence, as they established practices in local areas and aided in the development of national organizations of racial uplift such as the NAACP, black lawyers like Frederick McGhee (1861–1912), who was admitted to the bar in Illinois and Minnesota and who helped initiate the NIAGARA MOVEMENT (1905), conceived law more and more as an evolving social science, even as a method of social engineering—one that was required to conform to the whole spectrum of social needs and was dependent on society and capable of improvement. W. Ashbie Hawkins (b. 1862) and Scipio Africanus Jones (1863–1943), counsels in World War I-era NAACP civil rights cases, helped establish patterns of case research grounded no less in social facts than in legal rules. Such patterns were intensified by a subsequent generation of constitutionally trained attorneys led by Charles Hamilton HOUSTON, William HASTIE, James NABRIT, Raymond Pace ALEXANDER, and Thurgood MARSHALL—whose collective work on classic civil rights cases spanned the 1930s, 1940s, and 1950s, culminating in the BROWN V. TOPEKA, KANSAS BOARD OF EDUCATION case of 1954, which ended legal segregation.

Houston, who had specialized in the study of constitutional law, absorbed the philosophy of "sociological jurisprudence" at Harvard Law School under Roscoe Pound's deanship; and on later becoming Dean of Law at Howard University, he promoted the philosophy of legal advocacy as a pragmatic tool available to groups unable to achieve their rightful place in society through direct action. Trained at Howard under Houston's mentoring dictum that "a lawyer's either a social engineer or . . . a parasite on society," Thurgood Marshall, whose nomination to the U.S. Supreme Court by President Lyndon Johnson in 1967 marked the high point of African-

American achievement in the judiciary, reaffirmed his own integral place in the new jurisprudential tradition by pointedly reminding celebrants of the 1987 bicentennial of the U.S. Constitution that the nation's founding fathers had held "a woefully incomplete conception of the people" and that their vision of the law, as reflected in the Constitution, had only been expanded through unceasing social struggle that had entailed a bloody civil war.

Because the law had retained its Newtonian character longer than any of the social sciences, the intellectual shift among African-American legal minds toward a pragmatic and evolutionary philosophy of the Constitution and the judiciary was part of a late phase in the broad scientist conversion of American social thought. Since the tradition of moral reform in black political thought had even deeper roots in the Newtonian worldview—faith that the very perfection of liberty and a just social order was possible if human beings were but reasonable enough to affirm those concepts and virtuous enough to conform to them—the rise of a new anti-Newtonian science of politics posed significant problems for African-American intellectuals. The history of abolitionism and moral reform movements had given black communities a rich tradition of extraofficial political practice anchored in ethical appeals to the "Newtonian" political theory—and the accompanying rhetoric of natural law, social compacts, inalienable rights, immutable laws, eternal principles of justice, and so forth—to which the founding fathers had subscribed. But the new science of politics had been jarred into being by the stark disharmony between those eighteenth-century abstractions and the undeniable late nineteenth-century reality of widespread governmental corruption and incompetence amidst profound changes in society, economy, and technology—changes beyond the ken of the founding fathers. Besides the failed logical legerdemain of the Constitution's three-fifths clause on slavery, the dissonance between eighteenth-century political theory and twentieth-century political reality was nowhere more apparent than in the original failure of the Constitution, and the corollary refusal of the law, to recognize the existence of the country's most important political institution—the political party.

The living realities of party politics—the spoils system, political pluralism, organizational inertia, mass and individual emotionalism or irrationality—therefore dominated the attentions of a statistically minded new political science that its practitioners addressed less to theory of any sort than to "the intimate study of the political process, dealing with interest groups and power relations, with skills and understandings, forms of communications, and personalities." Eschewing progressivist moral reformism as analytically bankrupt, the new science of politics aligned itself with Walter Lippmann's assertion in 1914 that "before you can begin to think about politics at all, you have to abandon the notion that there is a war between good men and bad men . . . [and that] politics is merely a guerilla war between the bribed and the unbribed." No less pertinent to a potential shift in black political strategies, Lippman's concept of the "stereotype" as an adaptive mechanism in mass psychology and public opinion underscored the new scientific orientation away from the Newtonian model of the "rational man" and toward the driven, irrational creature of Freud and the behaviorists.

Between the 1930s and the '60s, as a group of university-trained African-American political scientists emerged, which included Ralph BUNCHE, G. James Fleming, Robert E. Martin, Erroll Miller, Robert Gill, and Alexander J. Walker, this new orientation to political life became a complicating facet of the ongoing tactical debates in black communities—particularly as it implicated patterns of personal and organizational leadership. The problem of leadership had preoccupied African-American intellectual life from the era of nineteenth-century abolitionism and the National Negro Convention Movement to the Reconstruction era to the turn-of-the-century Washington-Du Bois controversy and the New Negro-Garveyite clashes of the 1920s. Beginning with the Washington-Du Bois controversy, so-called conservative and radical political traditions in African-American life became intensely polarized, though in the later view of scholars such as John Brown Childs, these categories reveal less about the various competing black strategies for social change than does a focus on their underlying materialist or idealist worldviews and related cooperative versus elitist conceptions of political leadership. As became evident in the wave of crusading black political journalism between World Wars I and II, African-American social and intellectual life had been transformed by northern migration and urbanization and by a rapidly diversifying array of organizations and ideologies advocating a wide spectrum of political strategies. Leading the journalistic upsurge was the NAACP magazine *The Crisis,* begun in 1910 under the editorship of W. E. B. Du Bois, through whom black social thinkers "talked to white America as America had never been addressed before." Other new journals and newspapers had expanded the ideological spectrum: the anarchist *Challenge,* edited by William Bridges, a former Black Nationalist Liberty Party member, in 1916; the socialist MESSENGER—the "Only Radical Magazine in America," edited by labor leaders A. Philip RANDOLPH and Chandler OWEN, in 1917; Marcus Garvey's *Negro World,* the organ of the Universal Negro Improvement Associ-

ation, in 1918; and OPPORTUNITY, from the Urban League, edited by the sociologist Charles S. Johnson, in 1923.

In this new communicative arena of proliferating print media, a cluster of competing but not mutually exclusive social philosophies in African-American life—several of them with antebellum antecedents—had now acquired formulaic structures and programmatic agendas: (1) liberal integrationism and "cultural pluralism"; (2) conservative bourgeois economic nationalism and black capitalism; (3) Pan-African cultural nationalism; (4) political separatism and emigrationist territorial nationalism; and (5) revolutionary nationalism. Alongside the official leadership of the rising black middle class's civil rights and racial uplift organizations, a popular tradition of millenarian cult heroes, religious revivalists, charismatic revolutionaries, and skilled confidence men had evolved. And parallel to and interpenetrating both of these from below, black folk beliefs, shifting and diversifying with migration, urbanization, and industrialization, articulated a vernacular pantheon of proto-political leadership in tales, toasts, blues, and ballads. Political manifestoes, essays, and fiction by literary intellectuals conversant with social science concepts, such as Richard WRIGHT ("Blueprint for Negro Writers," 1937, and *Native Son,* 1941), Langston Hughes ("The Need for Heroes," 1941), Zora Neale Hurston (*Moses, Man of the Mountain,* 1939), and Ralph ELLISON (*Invisible Man,* 1952), meditated metaphorically on the problems of leadership and helped reshape the political imaginations of a growing black audience.

But political scientists like Ralph Bunche, by his own admission, "cultivated a coolness of temper, and an attitude of objectivity" grounded in Darwinian concepts of social evolution, comparative analysis, pragmatism, and emphasis on economic and psychic factors. The first black holder of a political science doctorate, and the founder of Howard University's program in the field, Bunche symbolized a new political role for African-American intellectuals; and starting in 1935 he initiated a probing critique of black organizational leadership and programmatic policies that anatomized their limitations relative to (1) a society that was only "theoretically democratic," to (2) group antagonisms that capitalist economic competition made a "natural phenomenon in a modern industrial society," and to (3) "the stereotyped racial attitudes and beliefs of the masses of the dominant population." Characterizing the entire spectrum of racial advancement organizations—from the NAACP to Garvey's UNIA—as bound to anachronistic assumptions about the nature of the modern world, Bunche's assessment marked a new divide between academic analysts and political practitioners

that would become an enduring feature of African-American intellectual life, a divide made clear, for instance, in the contrast between Bunche's *A World View of Race* (1936), a model of economics-based evolutionary pragmatism, and *The Philosophy and Opinions of Marcus Garvey* (1925), with its Newtonian apotheosis of idealist nationalism and racial purity by the architect of urban black America's first mass movement. Ultimately, Bunche's worldview, elaborated through subsequent fieldwork on colonial policy in Africa, led him to play a pivotal role in the formation of the United Nations (drafting the trusteeship sections of the UN Charter in 1945) and to a Nobel Peace Prize for being the architect of the 1949 Near East accord between Jews and Arabs in Palestine.

The urban black world into which Ralph Bunche had been born, and to which Marcus Garvey had immigrated, experienced, during the years their political views were moving toward collision, a flowering of African-American architects on the most literal level (*see* ARCHITECTURE). Mass migration had spurred a rising nexus of formal black city-based institutions—businesses, political and educational organizations, churches, fraternal and sororal orders—and with them the New Negro "dream of a Black Metropolis." A paying clientele had evolved for the generation of professionally trained architects who had matriculated at the turn of the twentieth century in the self-help artisan curricula at Tuskegee and Hampton Institute, and later at Howard University. Before these schooled professionals a long history of antebellum slave artisans and free black "master builders" had produced a tradition of vernacular architecture in African-American intellectual life that had left traces of African spatial sense, ornamental motifs, and compositional utility on American buildings as disparate as the 1712 Dutch Jansen House on the Hudson River; various plantation mansions in Old South cities like Savannah, Charleston, and New Orleans; or the early nineteenth-century "African House" built in Louisiana for Isle Brevelle, a settlement of free people of color, by Louis Metoyer, a wealthy ex-slave who had studied architecture in Paris.

During the period from 1880 to 1900, as formal schools of architecture were being founded in America and as black institutions emerged in new southern and northern environments, the most significant American architectural achievements were not so much in monumental buildings as in railroads, grain elevators, bridges, powerhouses, dams, factories, and schools, where the focus on function helped American architects minimize the devitalizing influence of aesthetic imitation fostered by successive Eurocentric academic revivals of Greek, Romanesque, and Gothic styles. In 1892 Booker T. Washington recruited Rob-

ert R. Taylor, one of the earliest black graduates in architecture from the Massachusetts Institute of Technology, to develop (without formal accreditation at the time) mechanical industries at the school; and the group of architectural students he trained, including John LANKFORD, Wallace Rayfield, William PITTMAN, and Vertner TANDY, became leading designers of the new black religious, educational, and commercial architecture. Modernist style was not yet in the ascendancy in the academy or the public sphere; and African-American architects were caught like their professional peers in the prevailing cultural schism that permitted boldly expressive engineering in bridges or commercial buildings while limiting time-honored cultural institutions at the top of the social hierarchy—the church and the college—to conventional colonial, Romanesque, or Gothic molds. Working within these constraints, Lankford became national supervising architect for the AME Church, designing such landmarks as Atlanta's Big Bethel; Rayfield became supervising architect for the AME Zion Church; and Pittman designed the Negro Building for the 1907 Jamestown Tricentennial.

Some African-American architects who had been trained outside the black college orbit, like William Moses and Julian Abele, mastered the design ethos of public sphere architecture and achieved noteworthy successes outside the black institutional milieu. Moses, awarded a degree in architecture from Pennsylvania State in 1924, won, while on the faculty at Hampton Institute, the open competition to design the Virginia Pavillion at the 1939 New York World's Fair, though this winning design was not used once his racial identity was discovered. Abele, a graduate of the Pennsylvania School of Fine Arts and Architecture, turned his flair for the Gothic revival style into a prominent career as chief designer for the large white architectural firm Horace Trumbauer & Associates in Philadelphia, superintending such projects as Philadelphia's Free Library and Museum of Fine Arts, Harvard University's Widener Library, and the designs for Duke University and the Duke family mansions. Albert Cassell, a 1919 graduate of Cornell University, planned five trade buildings at Tuskegee Institute before assuming leadership of Howard University's Department of Architecture and, deploying a Georgian style, literally transformed the physical appearance of its entire campus.

Perhaps because of the institutional constraints within which most black architects have functioned, and because of the decline of the vernacular tradition, a distinctively African-American philosophy of architecture was slow to evolve, although by 1939 John Louis Wilson, the first black graduate (1928) of Columbia University's school of architecture, hinted at the possibility in his assertion that architecture is a

"lithic history of social conditions; [and] the monuments of a race—never the result of chance—survive as indices of the fundamental standards of a people, a locality, and an epoch." During the Harlem Renaissance, as a small black elite gained access to the expressive possibilities of "power architecture," the design choices made in domestic and recreational buildings by figures such as Madame C. J. WALKER took on broad symbolic significance. The "cosmopolitan ideal" current among fashionable New Negroes asserted itself in Vertner Tandy's Italianate design for Walker's Irvington-on-the-Hudson palazzo, Villa Lewaro; and a counterpointing "race ideal" manifested itself in the Egyptianizing art deco ornamental motifs created for the flatiron-shaped Walker theater and business center in Indianapolis by the white firm of Rubush & Hunter. In the decades during and after World War II, as black architectural, engineering, and construction firms such as McKissack & McKissack began to win government awards for design contracts, and as educational opportunities in architecture diversified, clusters of black architects and black-owned firms developed in the large urban centers of California, New York, and the District of Columbia, with periodic calls for an African-American style and "soul" in architecture echoing the cycles of cultural consciousness in the nation's increasingly black urban centers.

As secular sources of alternative intellectual authority, all the aforementioned fields of African-American scientistic activity have experienced these cycles of black cultural consciousness in tandem with the shifts in historicism and popular and professional historiography that have figured prominently in black intellectual life during the twentieth century (see HISTORIANS/HISTORIOGRAPHY). The nature and intellectual contexts of American history writing in general underwent dramatic changes at the end of the nineteenth century. African-American historians grappled, as did all their peers, both with the growing secularization of ideas that undermined the providential design of older, theologically based romantic historiography and with the rise of scientific methods and standards of research that accompanied the professionalization of history writing in modern universities. Self-trained George Washington WILLIAMS, whose *A History of the Negro Race in America from 1619 to 1880* (1882) constituted the first work of modern historical scholarship by an African American, bridged the old and the new worlds of historiography. His commitment to rigorous citation, to archival research, to cross-checked source materials, and to new primary sources such as newspapers and statistical and oral data placed him in the advance guard of historians. But his political partisanship, his missionary Christianity, and his optimistic faith in the

discernability of God's providential design in history set him against the intellectual tendencies that were teaching sociologists, economists, political scientists, and historians alike that they could no longer reveal God's and Newton's laws or construct grand systems. Unlike Harvard-trained W. E. B. Du Bois, whose pioneering monograph, *Suppression of the African Slave Trade* (1896), placed its dispassionate faith in "the empirical knowledge which, dispelling ignorance and misapprehension, would guide intelligent social policy," Williams attuned his work less to reasoned pragmatism than to the rhetoric of popular inspiration—"not as a blind panegyrist" to his race, he wrote, but to satisfy with "the truth, the whole truth, and nothing but the truth," his black readers' "keen sense of intellectual hunger."

Predicated on the need to combat the pejorative Anglo-Western practice that, from David Hume to Arnold Toynbee, denied historical significance to African peoples entirely, both the academic and popular strains of African-American historiography expanded their roles in black intellectual life at the onset of the twentieth century. Such expansion built on the growing black audiences fostered by the rise of public education and mass literacy, by the awakening interest in "race history" encouraged through spreading concepts of nation and nationality, and by the emergence of a group of historical writers based in black colleges and universities or at newspapers and the journals of racial uplift organizations. In Western society generally, the period following World War I saw an explicit ideal of popular history promoted on a mass scale, with an exploding market for sweeping, unflinchingly speculative accounts written in highly dramatic, nontechnical language made evident in the vast sales of H. G. Wells's *Outline of History* (1920), Hendrik Van Loon's *The Story of Mankind* (1921), and Oswald Spengler's *The Decline of the West* (1918–1922). Correspondingly, among nonacademic New Negro historians such as Hubert HARRISON, Drusilla Dunjee Houston, J. A. ROGERS, and Arthur SCHOMBURG, an inspirational philosophy of race history asserted itself in historical essays and books that were broad in scope and speculative appeal rather than narrowly monographic, that were assertively value-laden and judgmental, and that professed the social utility and moral edification appropriate to black renaissance. Appeals to racial solidarity helped modulate in African-American communities the schism that elsewhere led academic historians to confront the 1920s' and 1930s' vogue of nonprofessional historiography with perjorative contrasts between "popular writing" and "profound systematic treatment." But at mid-century, the contrasts between the works of black academic historians like John Hope FRANKLIN, Benjamin QUARLES, and Rayford LOGAN and those

of the "scholars without portfolio" clearly reflected the impact on the former group of the dispassionate ethos and limiting assumptions of authoritative social science methodologies, and the persisting influence on the latter of alternative intellectual authorities mentioned earlier in this article, whose "sacred values" often resided in the romantic, populist, and apocalyptic traditions of "Negro genius," "the folk," and Ethiopianist or Egyptianist revivalism.

In an attempt to characterize the evolution of historical scholarship in postbellum African-American life, John Hope Franklin has proposed the following four-generation typology: (1) a generation of largely nonprofessional historiography beginning with the publication in 1882 of Williams's *History of the Negro Race,* ending around 1909 with Booker T. Washington's *Story of the Negro,* and concerned primarily with explaining the process of adjustment African Americans made to American social conditions; (2) a second generation marked by the publication of Du Bois's *The Negro* in 1915 but dominated from that year forward by the books, organizational entities, periodical enterprises, and scholarly protégés of Carter G. Woodson, who produced a stream of monographs on labor, education, Reconstruction, art, music, and other topics before his death in 1950; (3) a third generation inaugurated by the appearance of Du Bois's *Black Reconstruction* in 1935, and impelled by the intellectual impact of the Great Depression and the World War II global crisis, to focus less on black achievements than on race relations and international contexts, authoring an impressive body of work on slavery and urban and intellectual history and closing the 1960s with a significant number of white historians in the field; and finally (4) the largest and best-trained generation, beginning around 1970, approaching comprehensiveness in their range of specializations, passionately revisionist regarding both conventional *and* black historiographical traditions, and buttressed conceptually and institutionally by the black studies movement and the nationwide integration of American colleges and universities.

Focused less on the developing cadre of professional historians and more on the various uses and diversifying clientele of black history, Benjamin Quarles suggests an alternative typology to describe the different publics that, by the 1970s, dictated the content and style of black history writing: (1) the black rank and file; (2) the black revolutionary nationalists; (3) the black academicians; and (4) the white world, lay and scholarly. First in this scheme, black history for the rank and file, was designed to create a sense of pride and personal worth; and it stressed victories and achievements in a "great man/woman" theory of history highlighted by heroic individuals from African antiquity to the present. Con-

veyed increasingly by such mass media vehicles as television and radio, magazines, newspapers, coloring books, postcards, games, and comic books, it has emphasized optimistic biographical sketches of black leaders in politics, business, athletics, and the lively arts, with special appeals to youth. By contrast, the black history espoused by revolutionary nationalists has constructed a core narrative of contrapuntal white oppression and black rebellion, has been apocalyptic and polemical in temper, and has compounded elements of Marxist, Pan-Africanist, and anticolonialist ideologies in a studiously historicized but partisan call to black liberation and nation building. Characterized more by radical interpretation than by original research, revolutionary nationalist historiography has eschewed the academic cult of objectivity as inherently conservative and typically selected topics of exploration consonant with its political objectives.

One issue in African-American intellectual life that the historiographical presence of black revolutionary nationalism crystallizes is the role of apocalyptic, millenarian, radical communitarian, socialist, Marxist, and neo-Marxist ideas and ideologies generally in the thought of black communities. Although still understudied as a facet of black intellectual life, the utopian antebellum communitarian movements in which American socialism originated—the Shaker villages, the Owenite communes such as New Harmony and Francis Wright's Nashoba, the Fourieristic phalanxes, and the like—ofttimes had black members (like Shaker elder Rebecca Cox JACKSON [1795–1871], for example), even if at the margins; and they characteristically proposed a combination of socialist and colonizationist schemes to end slavery and reconstruct society. The Communist Clubs of "scientific" or Marxian socialists took more radical abolitionist stances and as early as the 1850s were inviting African Americans to join as equal members in the "realization and unification of a world republic" that would recognize "no distinction as to nationality or race, caste or status, color or sex."

Equally important, indigenous African-American dreams of independent black communities or of a "black nation"—to be achieved through internal migration, insurrection, or emigration elsewhere—date back at least to the efforts of Paul CUFFE (1759–1817) to colonize Sierra Leone. In the postbellum era given imaginative expression in narratives such as Sutton Griggs's *Imperium in Imperio* (1899) and organizational form in pre-Garveyite "Back to Africa" schemes such as the Oklahoma exodus of Chief Alfred Sam, they became fused with various strains of programmatic socialism popularized by Edward Bellamy's utopian *Looking Backward* (1888) and *Equality* (1897). Reformist socialism and revolutionary Marxism gained broader appeal in early twentieth-century

black communities through the sermons of black socialist preachers such as George Washington Woodbey (b. 1854); through the radical journalism of Cyril BRIGGS's *The Crusader,* Philip Randolph and Chandler Owen's the *Messenger;* through Hubert Harrison's public oratory, newspaper columns, and Colored Unity League; and through an expanding body of Marxist polemics and historiography written by black members of socialist or communist organizations or by Marxian academics like W. E. B. Du Bois. During the interregnum between the two world wars, the pre-Stalinist "romance of communism," which influenced American liberal intellectuals generally after the 1917 Bolshevik Revolution, won the allegiance of performing artists such as Paul ROBESON and black literary intellectuals such as Claude MCKAY, Langston Hughes, and Richard Wright. And between 1928 and 1943, grounded in party member Harry HAYWOOD's subcommittee advocacy of a "national revolutionary" movement for black self-determination, the COMMUNIST PARTY OF THE U.S.A. based its mass appeal to African Americans on the proposal to establish an independent "Black Belt" nation in the South. Though the Stalinist era disillusioned many black radicals, as it did many of their nonblack colleagues, the apocalyptic ideological appeal of revolutionary Marxism has persisted in the post–World War II decades, revitalized in African-American intellectual life by the emergence of anticolonialist African socialism (an eclectic mixture primarily of African traditionalism, classical European Marxism, and Chinese socialism) and the Tanzanian socialism of Julius Nyerere in particular, whose *ujamaa* principles of family-centered communal enterprise and nationalized industries were assimilated into the KWANZA celebrations of contemporary African Americans during the apogee of Black Power era cultural nationalism. After the founding of the BLACK PANTHER PARTY FOR SELF DEFENSE in 1966 by Huey NEWTON (1942–1989) and Bobby SEALE (b. 1936), its paramilitary orchestration of ideas drawn from the Marxist-Leninist corpus, from black nationalist writings, and from anticolonial revolutionary movements in Asia and Africa became the most visible manifestation of black political militancy. Along with the evolving revolutionary nationalism of Malcolm X after his separation from Elijah MUHAMMAD's Nation of Islam, and with the cause célèbre of inmate George JACKSON and academically trained Angela DAVIS, the Black Panther phenomenon helped create a mystique of romantic revolutionism in African-American intellectual life that, among college and university students in particular, remained intense into the 1990s.

The intensity of that mystique is one of the forces that has frequently inclined African-American aca-

demic historians to differentiate their work conceptually from that of revolutionary nationalists. Black academicians, inclined by professional training to see history less as inspiration or ideological weapon than as a discipline, have been consistently impelled, by the demand for original and controlled research, away from the obvious and well known toward the study of processes more than persons and to the identification and solution of methodological and conceptual problems apparent in the African-American past. Considering emotionally charged, highly provocative discourse to be, by convention, more the province of the poet, the orator, and the charismatic leader than the professional historian, they have characteristically tried to subordinate their private wishes and values to social science imperatives presumed to be often counterintuitive and counterideological; and they have continued to seek, in the terms of their own understandings, "balanced" treatments of the past rather than the selectively self-gratifying or politically efficacious. Among academic historians, as the uses and clientele of African-American history have increasingly involved white and non-African-American communities, lay and academic, the dual objectives of demythologizing the American past and demonstrating the centrality of black Americans in the national experience have been complicated by the broadening conceptual challenges inherent in the newer historiography of social movements, feminism, and American cultural pluralism. One sign of the intellectual maturation of African-American historical studies in the 1980s and '90s has been their growing awareness of, first, the heuristic value of diversified uses and clienteles for history, and, second, the need for cross-fertilizing perspectives, multimedia modes of presentation, and multidisciplinary methods that recognize the changing character of historical evidence and the array of new techniques and technologies available to record the human journey through time and space.

Facing the Twenty-first Century

As suggested earlier, the emergence by the mid-twentieth century of a more stable black middle class fostered the development of an African-American intellectual stratum with functions analogous to those evident in varying degrees in modern societies around the world. Historian John Hope Franklin, himself a leading figure in the generation of professional black scholars who gained prominence during the first postwar decade, by 1979 could write that the years since 1925 had seen an increase, not only in the number of black artist-intellectuals that was unimaginable a half-century earlier, but also in the styles and forms by which they could communicate (see BLACK SCHOLAR). The increasing security, solidarity, and self-esteem of their work as intellectuals during "the most productive period in the history of Afro-American literature and culture" derived in large measure from their status as members of a professional intellectual class based increasingly at large, newly integrated white colleges and universities. And the foci of their intellectual activities, at least five of which seem manifest, increasingly paralleled those of intellectuals elsewhere—at the same time that conscious affirmations of difference figured more centrally in their worldview.

First, growing numbers of black intellectuals devoted themselves to creating and diffusing high culture—or a new synthesis of vernacular and high-culture traditions intended to supplant older artistic forms and mythologies. Creativity and originality in the arts and letters was increasingly perceived to be a primary intellectual obligation; and during the 1960s and '70s a "second Black Renaissance" or "BLACK ARTS MOVEMENT"—the "aesthetic sister of the Black Power Movement"—became the focus of a concerted effort to link African-American art and politics to the currents of Pan-African intellectual activism in the Third World. Following the opening of Leroi Jones/Imamu Amiri BARAKA's Black Arts Theatre in Newark, N.J., in 1965, shortly after the assassination of Malcolm X, self-proclaimed "New Breed" poets, dramatists, and fiction writers assertively manifested a self-conscious cultural nationalism, influenced partly by the poetics and varying anticolonial philosophies of Francophone black African and Caribbean artist-intellectuals such as Leopold Sedar Senghor of Senegal and Frantz Fanon of Martinique.

Larry NEAL, a coleader of the movement along with Amiri Baraka, described the new attitudes toward tradition as stemming from (1) "the historic struggle to obliterate racism in America"; (2) "the general dilemma of identity which haunts American cultural history"; and (3) "an overall crisis in modern intellectual thought in Western society, where values are being assaulted by a new generation of youth around the world as it searches for new standards and ideals." Blending the aesthetic postulates of Francophone "NÉGRITUDE," the rhythmic lyricism of contemporary blues-derived "soul" music, and the warrior ethos and scatological invective of urban street gangs, Black Arts intellectuals also developed cross-cultural analogies between their imperatives and those of turn-of-the-century radical Irish Renaissance poets and playwrights who had felt compelled to modulate the influence of English literature on their own works by plunging into Celtic mythology and folklore. Leading figures in the Black Arts Movement, dispersed nationwide in urban artists' collectives that communicated the black arts in new "little magazines" like the *Journal of Black Poetry* and *Black*

Dialogue, and through independent publishing houses like Dudley RANDALL's BROADSIDE PRESS in Detroit and Don L. Lee/Haki Madhubuti's THIRD WORLD PRESS in Chicago, helped sponsor a proliferation of black theaters and bookstores along with a self-consciously performative intellectual style that garnered unprecedentedly large audiences for spoken word recordings like those of *The Last Poets* and for a new wave of highly stylized urban-based black cinema presented by filmmakers such as Gordon PARKS, Melvin VAN PEEBLES, and Gordon PARKS, Jr.

A second forward-looking focus of African-American intellectual activity developed as global communications and rapid transport intensified the process by which black intellectuals provided national and cross-national models of development for aesthetically sensitive intellectuals all over the world. That process acquired new significance with the expanding power of the international mass media and the emotional appeal of the civil rights and Black Power movements as paradigms for social change among marginalized groups worldwide. A diversifying spectrum of ideologies and cultural modes, associated with groups ranging from the NAACP and CORE (the Congress of Racial Equality) to the Nation of Islam and the REPUBLIC OF NEW AFRICA, influenced youth and social protest movements in Britain and Eastern Europe; and as far away as India, a politico-artistic resistance movement among dark-skinned "untouchables"—the "Dahlit Panthers"—modeled itself on the feline iconography, Marxist-Leninist rhetoric, and community activism of the Black Panthers.

Third, black intellectuals assumed a programmatic commitment to developing common culture and a tradition of cultural criticism. As early as 1925 Alain Locke had described the New Negro movement as an effort to turn the common problem African Americans faced into a common consciousness and culture. William Stanley BRAITHWAITE, W. E. B. Du Bois, Benjamin Brawley, Sterling BROWN, Jessie FAUSET, Gwendolyn BENNETT, and Eric WALROND, among others, helped establish a magazine tradition of critical reviews of literature and the arts during the era; and Theophilus Lewis's columns in the *Messenger* offered pioneering critiques of African-American theater. Maude Cuney-Hare, trained at the New England Conservatory of Music, founded and directed the Allied Arts Centre in Boston in 1927, dedicating it to "discover and encourage musical, literary, and dramatic talent, and to arouse interest in the artistic capabilities of the Negro child." Superseding James Monroe TROTTER's *Music and Some Highly Musical People* (1878), her *Negro Musicians and Their Music* (1936) presented the first comprehensive critical history of the diasporic black creative tradition in a sin-

gle artistic medium, delineating African music from its earliest phases and explicating the New World influence of African instruments, rhythms, and dances on such forms as the Argentinian tango, the Cuban habañera, and the bamboula of Lousiana (*see* DANCE).

Alain Locke's own annual *Opportunity* magazine, defined as "retrospective reviews of the literature of the Negro," from 1928 to mid-century, composed the first sustained attempt at cross-disciplinary, cross-media black cultural criticism—and provided as well an intellectual-history-in-miniature of the era. During these and subsequent decades, the growth of the black population and its dispersion through mass migration and urbanization had created a subsociety too large to be united through kinship connection or first-hand experience. The development of common culture depended increasingly on "reproductive" intellectual institutions such as schools, churches, and newspapers—through which a sense of identity and symbolic group traditions were promoted by African-American teachers, clergy, and journalists. In contrast to the youth-conscious efforts of the New Negro era, during the Great Depression and World War II years a representative group of black intellectuals, including Alain Locke, W. E. B. Du Bois, Ira Reid, Sterling Brown, Ralph Bunche, and Eric Williams, founded an elaborate project of adult education and intergroup relations called the Associates in Negro Folk Education, which, in the course of combatting adult illiteracy, was intended "to bring within the reach of the average reader basic facts and progressive views about Negro life" by publishing a series of "Bronze Booklets" on black fiction, poetry and drama, the visual arts, music, social history, and so forth.

At mid-century, Locke's call for an introspective cultural criticism that would supply the missing "third dimension" of black intellectual life was first met by Margaret Just Butcher's posthumous synthesis, in *The Negro in American Culture* (1956), of Locke's own cumulative explorations of African-American contributions to American music, dance, folklore, poetry, polemics, fiction, drama, painting, sculpture, education, and regional nationalism. However, with the urban rebellions and cultural nationalism of the 1960s and '70s, the ensuing clash of ideas over the concept of racial integration magnified what Harold CRUSE called the "crisis of the Negro intellectual"—the problem of forging a cultural philosophy and a sense of tradition upon which a politics of liberation and a systematic criticism of the arts could be erected. The search for an irreducibly "black aesthetic" began in this context as a fragmentary critical movement grounded in separatist polemics and coalesced outside the academy under the Black Arts

leadership of Amiri Baraka, Larry Neal, Hoyt Fuller, Addison Gayle, Don L. Lee, and Ron Karenga. The "black aestheticians" came closest to discovering a viable indigenous sense of cultural tradition in Baraka's theoretical, ethnomusicologically focused social history, *Blues People* (1963), and his cultural essays. But the more comprehensive and systematic achievements in cultural criticism came after the eclipse of the Black Arts Movement, during the late 1970s and '80s, *within* the academy, as a generation of African-American scholars trained in the theoretical postulates and practices of structuralism, poststructuralism, deconstruction, hermeneutics, dialogics, feminism, and neo-Marxist criticism adapted these modes of analysis to African-American cultural texts and contexts. Academy-based critical theorists such as Houston Baker, Barbara Christian, and Henry Louis Gates became leading figures, as did "Hiphop" theorists and popular culture critics like Greg Tate, Michele Wallace, and Nelson George in avant-garde mass media newspapers and journals.

Besides the aforementioned emphases on creating art, on building cross-cultural alliances, and on developing a common African-American sense of tradition, a fourth intellectual impulse—to effect broad social change—has persisted in African-American intellectual life as a "sacred value." Continuing racial conflict has kept the degree of intellectual consensus in American society within strict limits; and the different social situations of the recipients of high culture, and the extreme discrepancies in educational preparation and receptive capacity, have fostered diverse paths of creativity and impelled a partial rejection of Western civilization's cultural values among African-American intellectuals. In the post–World War II decades, this rejection of prevailing intellectual traditions has included both "nihilistic" repudiation of popular or high-culture traditions tainted with ideological racism and the observance or development of an alternative stream of tradition, sometimes of suppressed or forgotten traditions of syncretized or authentic African origin. Guided by the philosophical anthropology of works such as Janheinz Jahn's *Muntu: The New African Culture* and Cheikh Anta Diop's *The African Origin of Civilization,* the theory of social change espoused in the mid-1980s by the proponents of AFROCENTRICITY is rooted in ideological advocacy of the original unity of African culture, and in the need for a revitalizing new ethnocultural consciousness among the peoples of the modern African DIASPORA, as a prerequisite for a unifying politics of liberation. Although the validity of Jahn's and Diop's views have been challenged by other specialists in African studies, and though debate about the "essentialist" postulates and racialist implications of Afrocentricity has intensified

among intellectuals inside and outside African-American communities, the growing pervasiveness of the concept and its texts and iconography cannot be dismissed.

Three other recent developments in African-American intellectual life merit attention with respect to concepts of social change—the growth of black liberation THEOLOGY, the emergence of African-American critical legal theory, and the consolidation of black neoconservative ideology. Regarding the first of these, under the leadership of James CONE, and in dialogue with other theologians such as James De Otis Roberts, Cain Felder, and philosopher Cornel West, black religious thinkers who matured in the Black Power era have moved beyond the black church tradition of Christian ecumenism, espoused by such earlier leaders as Benjamin MAYS (1894–1984) and Howard THURMAN (1900–1981), and beyond the synthesis with Gandhian nonviolence effected by Martin Luther KING, Jr. (1929–1968). As a forerunner to contemporary African-American theologians, Benjamin Mays, a Southern sharecropper's son who rose to because a Baptist minister and the president of Morehouse College, devoted part of his early career to scholarship for the Institute of Social and Religious Research and authored books such as *The Negro's Church* (1933) and *The Negro's God as Reflected in His Literature* (1938), which provided pioneering descriptions of African-American religious life "as scientifically exact as the nature of the material permits." In addition, as a religious teacher advocating Christian practice in race relations, he became one of the spiritual progenitors of the civil rights movement, urging students such as Andrew YOUNG and Julian BOND into public service and considering "his greatest honor [to be] having taught and inspired Martin Luther King, Jr." Howard Thurman, also an ordained Baptist minister, became dean of Rankin Chapel, professor of theology at Howard University, and one of the twelve "Great Preachers" of this century. But his unorthodox "inward journey" in quest of a spiritual liberation beyond race and ethnicity led him to develop a unique mystical ecumenism that drew on spiritual experiences in India (with Mahatma Gandhi), Sri Lanka, and Myanmar as well as on the cosmology of African-American spirituals and on Native American belief systems in his own ancestry. The most prolific of African-American religious writers, Thurman authored a long succession of richly metaphorical meditations on love, temptation, spiritual discipline, creative encounter, and the search for religious common ground, which influenced generations of black seminarians, among them Martin Luther King, Jr.

Because King has influenced African-American intellectual life perhaps more than any other religious

thinker, it is important to understand his theology of the "beloved community" as a complex fusion of African-American church traditions and advanced formal training in the philosophies of such diverse thinkers as Henry David Thoreau, Mahatma Gandhi, G. W. F. Hegel, Walter Rauschenbusch, and Reinhold Niebuhr. In James Cone's view, King's ministry of social transformation through creative, nonviolent confrontation embodied publicly the central ideas of black religious thought—love, justice, liberation, hope, and redemptive suffering—terms used in common with other Christian communities but given a distinctively black meaning by particular social and political realities. In Cone's own work, however, the preeminence King gave to love in this cluster of mutually dependent values was shifted to the concept of liberation; and in the wake of the Black Power era and under the influence of Malcolm X's nationalist, Islamicist critique of white Christian supremacism, Cone and other black liberation theologians have increasingly turned away from the texts of European Christian theology and toward African-American vernacular religion as a thematic locus. By drawing partly on the work of Latin American theologians of liberation, and by reformulating aspects of the African-American Ethiopianist tradition, they have posited a new Christocentric black theology, centered on a biblical witness of God's commitment to the poor and oppressed, which "places our *past* and *present* actions toward Black liberation in a theological context, seeking to create value-structures according to the God of black freedom." Cultivating a global worldview and sensitivities to other oppressed social groups, black liberation theologians have acknowledged the strengths and the weaknesses of traditional black theology: "For example, Africans showed the lack of knowledge black theologians had about African culture; Latin theologians revealed the lack of class analysis; Asia showed the importance of a knowledge of religions other than Christianity; feminist theology revealed the sexist orientation of black theology; and other minorities in the United States showed the necessity of a coalition in the struggle for justice in the nation and around the globe."

The import acknowledged herein of religions other than Christianity points to a related facet of African-American intellectual life—the long-lived and currently increasing role of non-Christian concepts of liberation, from Islamic, Judaic, Buddhist, Bahai, Rastafarian, traditional African beliefs, and occult traditions, among others. In developing a spectrum of relating thought that, as Cone recognizes, "is neither exclusively Christian . . . nor primarily African," African Americans have frequently chosen to profess other world religions or various nonconformist and free-thought beliefs ostensibly better suited to liber-

ate them from white Christian nationalism and the maladies of modern living. As early as Edward Wilmot Blyden's *Christianity, Islam, and the Negro Race* in 1887, selected black religious thinkers have lauded the elevating and unifying potential of Islam, the benefits of its world civilization, and its vaunted capacity for incorporating Africans without creating in them a sense of inferiority. The perceived historic continuity with West African Islam has been a contributing factor to its appeal, just as the antecedent historical tradition of Ethiopian "Falashas" has lent Judaism greater appeal to orthodox as well as heterodox African-American converts and believers.

By contrast, the reception of Bahaism, which treats religious truth as relative, not absolute, and as evolving through successive revelations provided by prophets from many different traditions, suggests the intellectual appeal of newer religious worldviews to African-American adherents. A much-persecuted, heretical nineteenth-century Persian offshoot of Islam, the Bahai faith developed a distinctly modern theology rooted in the professedly indivisible oneness of humankind, the necessary accord of religion with science and reason, the absolute equality of men and women, and the abolition of prejudice of all kinds. As it spread to America early in the twentieth century, Bahaism distinguished itself to African Americans by identifying the race problem as a major *spiritual* problem and by openly sponsoring "racial amity" conferences and unification through intermarriage at a time when American Christianity remained thoroughly segregated. The Bahai faith attracted African-American artist-intellectuals as different as the philosopher Alain Locke, the *Chicago Defender* publisher Robert ABBOTT, the jazz musician "Dizzy" GILLESPIE, and the poet Robert HAYDEN, offering a vision of progressive social change through priestless, "democratic theocracy" that by 1983 saw African Americans accounting for more than 30 percent of its U.S. membership.

At some remove from the religious worldview, in the decidedly secular thought of contemporary legal theorists such as Derrick Bell, Patricia Williams, and Stephen Carter, the importance of law as a locus for social change theories has been reemphasized; and the transformative powers *and* limits of the law have been reconceptualized in highly original mixtures of allegory, case law, social history, and autobiographical meditation that defy the positivist conventions of the older sociologist jurisprudence. A recurrent feature of this new legal discourse is a powerful intellectual skepticism that confronts the older African-American tradition of millenarian hope with the specter of racism as "an integral, permanent, and indestructible component of this society." Among black legal theorists on both the political left and right, the law itself

is seen less as an edifice of immutable truths or a blueprint for social engineering than as a chaotic mythological text; and the manifest contradictions of such legal remedies as affirmative action serve to underscore the narrowed possibilities for progressive social change through legal construction. The challenge such a perspective mounts to the activist traditions of African-American intellectual life are multiple, not the least of which is the very definition of the intellectual's proper function. Accordingly, as construed by constitutional lawyer Stephen Carter, "the defining characteristic of the intellectual is not (as some seem to think) a particular level of educational or cultural attainment, and certainly not a political stance," but rather "the drive to learn, to question, to understand, to criticize, not as a means to an end but as an end in itself."

In the wake of the civil rights and Black Power eras, the rise of a cohesive black neoconservative movement has given skeptical, iconoclastic criticism of African-American life high visibility, particularly through the scholarly writings of authors such as economist Thomas Sowell and cultural commentators Stanley Crouch and Shelby Steele. The movement has some historical precedent in early forms of black economic nationalism, capitalist and socialist, that have sought various degrees of economic and social autonomy from the larger society through (1) controlling the black segment of the marketplace through black businesses and "buy black campaigns"; (2) establishing a full-scale black capitalist economy parallel to that of the dominant society; or (3) forming black producer and consumer cooperatives or reviving preindustrial communalism. Such ideas have figured significantly in the outlooks of Booker T. Washington, W. E. B. Du Bois, Marcus Garvey, the Nation of Islam, and others; and they defy conventional "conservative" and "radical" categorization. But as early as 1903 sociologist Kelly Miller had highlighted the ideological warfare between black "radicals and conservatives" in order to interpret the Washington-Du Bois controversy over political, economic, and educational strategies for racial uplift. Acknowledging the ambiguities therein, Alain Locke in 1925 described the psychology of the "New Negro" in part by asserting that "for the present the Negro is radical on race matters, conservative on others, a 'forced radical,' a social protestant rather than a genuine radical." And giving these psychopolitical tensions the most emphatic personal configuration, *Pittsburgh Courier* journalist and satirist George SCHUYLER, having renounced his 1920s allegiances to leftist politics, ultimately embraced autobiographically a reformulated new public identity as *Black and Conservative* (1966), establishing further precedent for the phenomenon of the 1970s and 1980s

that saw growing numbers of African-American intellectuals joining the "neoconservative" flight from liberal-radical social philosophies and public policy.

Because conservatism has typically been identified—often wrongly—with Republican party politics, and because critics have often failed to distinguish properly conservatives from neoconservatives (the distinction is ideological more than chronological), African Americans have often chafed at the latter label. But whatever differentiates them from nominal neoconservatives, the writings of intellectuals like Sowell and Steele do share some pivotal neoconservative stances about social policy: (1) though less likely than conservatives to condemn governmental manipulation of the citizenry as fundamentally immoral regardless of the intended social improvements, they are more likely than liberals to be disillusioned by the failures of public policy and to insist that there is little public policy leverage for changing the relevant human behaviors and conditions of modern life; (2) they tend to agree with neoconservatives that the limitations of our knowledge about the consequence of any given policy, and the basic inefficiency of bureaucratic government in implementing policy, make the liberal agenda indefensible and unachievable.

Largely in accord with these stances, Thomas Sowell has elaborated the black neoconservative position in more than a dozen books that compare the economic performance of ethnic groups around the world and advocate laissez-faire economics, with minimal government regulation, as more amenable to black progress than the bureaucratic manipulations of the liberal welfare state. And in *A Conflict of Visions: Ideological Origins of Political Struggle* (1987), he has attempted to identify two perennial diametrically opposed visions of human nature and society, one "constrained" and the other "unconstrained," as the root of political turmoil in the modern era. The "constrained" vision with which Sowell has allied himself eschews "unconstrained" notions of human rationality and perfectibility for an emphasis on the limitations of human altruism and reason and on the pragmatic necessity for disciplined cultural traditions and a society ordered and stabilized by the free marketplace. Shelby Steele's corollary "new vision of race in America," articulated in *The Content of Our Character* (1990), lacks Sowell's theoretical sweep and supporting data but offers provocative speculations about the tangle of psychopathological guilt, fear, damaged self-esteem, and false ethnic pride that, in his view, has prevented African Americans from taking advantage of real opportunities for success and misdirected their energies away from meaningful social competition and into black nationalist fantasies, chauvinistic educational enterprises, and ineffective affirmative

action programs. However controversial, the arguments of Sowell, Steele, and other black neoconservatives have enhanced the sophistication of policy debates in African-American communities; and, capitalizing on the strategic and philosophical quandaries traditional liberal-radical civil rights organizations faced during the Reagan-Bush era, they have forced black thinkers across the political spectrum to consider anew the basic concepts and practical methods of social conservatism and social change.

Perhaps the most far-reaching recent developments in black intellectual life with respect to concepts of social change, however, have come through the flowering and dispersion of black feminist thought in the 1970s and '80s, building on a long tradition of African-American female leadership, creative activity, and political activism. The emergence of a cohesive and consummately skilled group of black female literary artists, in the wake of the Black Arts and women's liberation movements of the 1960s and '70s, helped galvanize the formation of black women's studies as an autonomous academic discipline in the middle 1970s, epitomized by the appearance in 1982 of Gloria Hull, Patricia Scott, and Barbara Smith's ground-breaking critical anthology *All the Women Are White, All the Blacks Are Men, But Some of Us Are Brave*. Organized as an interdisciplinary field of theoretical and practical study that is unified by black female perspectives on the conceptual triumvirate of "race, class, and gender," advocates of black women's studies have reconstructed an historical continuity of black feminist expression—from Maria STEWART's 1830s African-American Female Society addresses to Sojourner Truth's famous "Ain't I a Woman?" speech in 1851 to the 1890s manifestoes of Anna Julia COOPER and Victoria Earle MATTHEWS; and from Amy Jacques GARVEY's mid-1920s nationalist/feminist editorials and the depression-era fiction and folklore of Zora Neale Hurston to the contemporary "womanist" prose, poetry, and drama of Alice WALKER and her peers.

Walker's concept of the "womanist" as one who "acknowledges the particularistic experiences and cultural heritage of black women, resists systems of domination, and insists on the liberty and self-determination of all people" comes close to providing a consensual definition of the range of ideologies and praxis of black women's feminism. But the proliferation of black feminist ideas across the spectrum of lay and professional intellectual activities defies any narrow construction of its purposes and practices; and its versatility and growing popular appeal have become evident in the diverse audiences for such black feminist cultural critics as Hazel Carby, the writer bell hooks, and Michele Wallace, for popular and academic historians of black female experience

such as Paula Giddings and Darlene Clark Hine, for social scientists such as Joyce Ladner, Patricia Hill Collins, and MacArthur prize-winner Sara Lawrence Lightfoot, whose *Balm in Gilead: Journey of a Healer* (1988), an intergenerational biography of her mother, the pioneering child psychiatrist Margaret LAWRENCE, consummates the formal valorization of black female family traditions.

As a final focus of contemporary practical and theoretical activity, black intellectuals, spurred by an expanding African-American electorate and corollary concentrations of local and national political power, have increasingly found themselves playing explicitly political roles in grass-roots and electoral mobilization for city, state, and federal offices, for black third party conventions, and for presidential campaigns such as those of the Rev. Jesse JACKSON in 1984 and 1988 and Gov. Bill Clinton in 1992. However, inasmuch as the political elite needs the approbation and services of intellectuals but remains loath to share the highest authority with them, the separation of black intellectuals from the higher executive and legislative branches of government parallels more starkly the marginal situation of American intellectuals generally as it has evolved from the time of the Jacksonian revolution until the "New Liberalism" of Woodrow Wilson and afterward. Nonetheless, liberal and constitutional politics in modern states have to a large extent been "intellectuals' politics"—that is, politics vaguely impelled by ideals precipitated into programs. Racial exclusion has made even more pronounced for African Americans the intellectuals' major political vocation of enunciating and pursuing the ideal. And as part of the "crisis of the Negro intellectual" articulated by Harold Cruse at the height of the Black Power movement during the late 1960s, the vitiation of this political vocation among black intellectuals has been exacerbated by their problematic sense of continuity with their cultural, creative, and ideological antecedents.

Such a crisis notwithstanding, however, by no means have black intellectuals been uniformly attracted by ideological politics, even those of civil rights and Black Power. Moderation and devotion to the rules of civil polity, quiet and apolitical concentration on specialized intellectual tasks, cynical or antipolitical passivity, and faithful acceptance of, and service to, the existing order are all to be found in substantial proportions among modern black intellectuals, just as among their nonblack peers. Although their work in scientific and scholarly spheres remains subject to much stricter regulation than in the fields of expressive intellectual action, some black intellectuals have influenced realignments of the social structure, within the intellectual subsociety in particular, supplanting the incumbents of leadership

roles in professional intellectual associations and garnering previously unattainable allocations of intellectual awards and prizes—one of the most noteworthy being the award of the 1993 Nobel Prize for Literature to novelist Toni Morrison. And new fields of inquiry have been pioneered by black intellectuals such as Harry Edwards in the sociology of sport and the prolific critic Nathan Scott, Jr., in religious literary criticism. Nonetheless, in the closing decade of the twentieth century, the long-lived function of black intellectuals in supplying the doctrines and some of the leaders of protest and social change movements has remained one of their most widely accepted and effective roles. And from the evidence of the imaginative and theoretical roles played by contemporary writers such as Octavia BUTLER and Samuel R. DELANY in the immensely popular realm of fantasy and science-based "speculative fiction," black intellectuals in the closing years of the second millennium were poised also to help formulate and guide a global society's creative vision of its possible futures.

REFERENCES

BARKSDALE, RICHARD and KENNETH KINNAMON, eds. *Black Writers of America*. New York, 1972.

BUHLE, MARI JO, et al., eds. *Encyclopedia of the American Left*. New York, 1990.

BULLOCK, PENELOPE. *The Afro-American Periodical Press, 1838–1909*. Baton Rouge, La., 1981.

CHILDS, JOHN BROWN. *Leadership, Conflict, and Cooperation in Afro-American Social Thought*. Philadelphia, 1989.

COMMAGER, HENRY STEELE. *The American Mind: An Interpretation of American Thought and Character since the 1880s*. New Haven, Conn., 1950.

CONE, JAMES. "Black Religious Thought." In Charles Lippy and Peter Williams, eds., *Encyclopedia of the American Religious Experience*. Vol. 2. New York, 1988.

CRUSE, HAROLD. *The Crisis of the Negro Intellectual*. New York, 1967.

DOZIER, RICHARD. "Black Architecture." In Charles Wilson and William Ferris, eds., *Encyclopedia of Southern Culture*. Chapel Hill, N.C., 1989.

FONER, PHILIP S. *American Socialism and Black Americans, from the Age of Jackson to World War II*. Westport, Conn., 1977.

FRANKLIN, JOHN HOPE. *Race and History: Selected Essays 1938–1988*. Baton Rouge, La., 1989.

FULLINWIDER, S. P. *The Mind and Mood of Black America*. Homewood, Ill., 1969.

GUTHRIE, ROBERT V. *Even the Rat Was White: A Historical View of Psychology*. New York, 1976.

JACKSON, BLYDEN. *A History of Afro-American Literature*. Vol. 1, *The Long Beginning, 1746–1895*. Baton Rouge, La., 1989.

LOEWENBERG, BERT JAMES, and RUTH BOGIN, eds. *Black Women in Nineteenth-Century American Life*. University Park, Pa., 1976.

LOGAN, RAYFORD, and MICHAEL R. WINSTON, eds. *Dictionary of American Negro Biography*. New York, 1982.

LOGGINS, VERNON. *The Negro Author: His Development in America*. New York, 1931.

MEIER, AUGUST. *Negro Thought in America, 1880–1915*. Ann Arbor, Mich., 1963.

MILLER, PERRY. *The Life of the Mind in America, from the Revolution to the Civil War*. New York, 1965.

MOSES, WILSON. *The Wings of Ethiopia: Studies in African-American Life and Letters*. Ames, Iowa, 1990.

MOSS, ALFRED A. *The American Negro Academy: Voice of the Talented Tenth*. Baton Rouge, La., 1981.

PERRY, LEWIS. *Intellectual Life in America: A History*. New York, 1984.

PORTER, DOROTHY B. "The Organized Educational Activities of Negro Literary Societies, 1828–1846." *Journal of Negro Education* 5 (1936): 555–76.

QUARLES, BENJAMIN. *Black Mosaic: Essays in Afro-American History and Historiography*. Amherst, Mass., 1988.

ROBINSON, CEDRIC. *Black Marxism: The Making of the Black Radical Tradition*. London, 1983.

SAMMONS, VIVIAN OVELTON. *Blacks in Science and Medicine*. New York, 1990.

SHILS, EDWARD. "Intellectuals." In *International Encyclopedia of the Social Sciences*, 7: 399–415. New York, 1968.

SMITH, JESSE CARNIE, ed. *Notable Black American Women*. Detroit, 1992.

SMYTHE, MABEL, ed. *The Black American Reference Book*. Englewood Cliffs, N.J., 1976.

THORPE, EARL, *The Mind of the Negro*. Westport, Conn., 1961.

VINCENT, THEODORE, ed. *Voices of a Black Nation: Political Journalism in the Harlem Renaissance*. San Francisco, 1973.

WILMORE, GAYRAUD. *Black Religion and Black Radicalism*. 2nd ed. Maryknoll, N.Y., 1992.

JOHN S. WRIGHT

Interdenominational Theological Center.

The Interdenominational Theological Center (ITC) was founded in 1958 through the consolidation of four independent seminaries: the Gammon Theological Seminary (founded by the United Methodist Church at Clark University in 1869), Morehouse Theology Department (founded by the Baptist Church in 1867), Turner Theological Seminary (founded in 1885 by the African Methodist Church, department of Morris Brown College), and the Phillips School of Theology (founded by the Colored Methodist Church in 1944 in Jackson, Tenn.).

In 1956 a committee of prominent theologians and educators studied the possibility of developing a co-

operative element in theological education. They proposed the merger of the four institutions. Atlanta University deeded ten acres of land to the new school which was just east of the Atlanta University campus. The ITC became part of the AUC in 1958. Two other members were added in 1970: the Johnson C. Smith Theological Seminary (founded by the Presbyterian Church USA in North Carolina in 1967), and the Charles H. Mason Theological Seminary (founded by the Church of God in Christ in 1970).

Five degree programs are offered to prepare students for pastoral and other vocations in black churches. Each of the member seminaries also has retained its independent course and graduation requirements so that the graduate is able to meet the criteria of the specific denomination. The ITC is a fully accredited seminary. In 1992 the ITC had 350 students enrolled in its programs.

REFERENCES

BACOTE, CLARENCE A. *The Story of Atlanta University.* Atlanta, 1969.

ROEBUCK, JULIAN B., and KOMANDURI S. MURTY. *Historically Black Colleges and Universities.* Westport, Conn., 1993.

DEBI BROOME

International Sweethearts of Rhythm, all-female jazz band.

Originally the school orchestra of the Piney Woods, Miss., Country Life School, the International Sweethearts of Rhythm became a popular big band attraction throughout the United States in the late 1930s and 1940s. The founder and president of Piney Woods, Laurence C. Jones, was inspired to create the band by the success of the spate of white female jazz orchestras in the late 1930s. Jones selected from the school's 45-piece marching and concert band a smaller ensemble with 14 to 16 pieces, played by members whose ages ranged from 14 to 19. During the 1938–1939 school year the band, led by Piney Woods graduate Consuella Carter, performed during school fundraisers. They made their professional debut the next year, at the Howard Theater in Washington, D.C., and set off on a grand nationwide tour. The ensemble orginally included leader and vocalist Edna Armstead Williams, saxophonists Willie Mae Wong, Alma Cortez, and Helen Saine, trumpeter Nova Lee McGhee, trombonists Helen Jones and Ina Belle Byrd, pianist Johnnie Mae Rice, bassist Bernice Rothchild, and drummer Pauline Braddy.

During the tour the Sweethearts achieved great success, and brought two nonstudents, saxophonist Jennie Lee Morse and vocalist Evelyn McGhee, into the band, which was breaking attendance records across the country. It was so successful that the members quit school and became a full-time organization, based in Arlington, Va. Anna Mae Winburn fronted the band during this period, and arrangers included Eddie Durham, Jesse Stone, and Maurice King. In the early 1940s, as the band's popularity grew, white members were added, including trumpeters Toby Butler and Mim Polak, and saxophonist Rosalind Cron. In the mid-1940s the group performed in the country's largest theaters, including New York's Apollo Theater and Savoy Ballroom, and in 1945 they performed on a six-month tour of France and Germany for the United Service Organization (USO). They also made numerous recordings, including "Don't Get It Twisted" (1946). Eventually the band added a number of accomplished performers, including trumpeters Jean Starr and Ernestine Davis, saxophonists Marge Pettiford and Vi Burnside, bassists Edna Smith and Lucille Dixon, and guitarist Carline Ray. The group, which broke up in 1949, was the subject of a 1986 film, *International Sweethearts of Rhythm.*

REFERENCES

HANDY, D. ANTOINETTE. *Black Women in American Bands and Orchestras.* Metuchen, N.J., 1981.
———. *The International Sweethearts of Rhythm.* Metuchen, N.J., 1983.

D. ANTOINETTE HANDY

Interracial Council for Business Opportunity (ICBO).

Founded in 1963 in New York City by the NATIONAL URBAN LEAGUE and the American Jewish Congress, the ICBO aided people of color in starting, running, and expanding their own businesses. It assisted with business plans, financing, marketing, and management training. A nonprofit national organization functioning through local councils, the ICBO published annual reports and a monthly newsletter. Within ten years of its inception, the ICBO had helped more than 2,000 small businesses. In 1968, the ICBO began the New Enterprises Program to work with businesses worth at least $100,000 that were not confined to the inner city. In 1981, ICBO clients, under President Malcolm L. Corrin, obtained more than $136 million in assistance from various sources and developed new markets worth $135 million. The organization had the ICBO Fund to provide partial guarantees of loans to entrepreneurs. The ICBO did volunteer consulting, and many offices participated in the MBDA consulting program. In 1992, ICBO's headquarters remained in New York City.

REFERENCE

CASE, FREDERICK E. *Black Capitalism: Problems in Development.*

JOSEPH W. LOWNDES

Inventions. *See* Inventors and Inventions; Patents and Inventions.

Inventors and Inventions. Historians are just beginning to uncover some of the ways in which African Americans have contributed to the development of American technology. Seventeenth-century African-American inventors left no written records of their own. But many of them were skilled in crafts and created new devices and techniques in the course of their work. Africans brought a store of technological knowledge with them to the Americas. In the West, elements of African technology merged with European and Native American (*see* AMERICAN INDIANS) technology to create new American traditions in technology. This is particularly evident in the areas of boat building, rice culture, pharmacology (*see* PHARMACY), and musical instrument-making.

We know more about black inventors in the eighteenth and nineteenth centuries, particularly those who enjoyed some celebrity in their time, such as Norbert RILLIEUX, a Louisianan who invented the multiple-effect vacuum evaporation system for producing sugar from sugar cane. The Rillieux method revolutionized the sugar industry and came to be the accepted method of sugar cane juice evaporation. Though blacks contributed to the technological development that resulted, there was little public recognition of their achievements.

In the North, many African-American men turned to the maritime trades for employment, and from these ranks came several outstanding inventors such as James FORTEN, the wealthy Philadelphia black abolitionist whose fortune was built upon his invention around the turn of the nineteenth century of a sail handling device, and Lewis TEMPLE, who introduced the toggle harpoon to commercial whaling in Massachusetts in the 1840s.

Craftsmen who invented new devices discovered innovative techniques that improved the quality of their products or reduced the cost of producing them often went into business for themselves instead of hiring themselves out for wages. But these craftsmen-inventors still faced the problems of patenting the invention or protecting it somehow from competitors, financing its production, and marketing it.

Patented design for an "evaporating pan" by Norbert Rillieux, December 10, 1846. (Photographs and Prints Division, Schomburg Center for Research in Black Culture, The New York Public Library, Astor, Lenox and Tilden Foundations)

The enactment of the U.S. Patent Act in 1970 provided for some documentation of black inventors and their inventions, but this documentation is incomplete. Because the race of the inventor was not generally recorded by the U.S. Patent Office, it is not known for certain how many blacks received patents. Thoms L. Jennings, a New York abolitionist, is the earliest African-American patent holder to have been identified so far. He received a patent for a dry-cleaning process on March 3, 1821. Further research may uncover earlier black patent holders. Slaves were legally prohibited from receiving patents for their inventions, and there are few surviving accounts in which slave inventors are fully identified.

The slave inventor found himself in an unlikely position that must have strained the assumptions of slavery to the utmost. Nothing illustrates the slave inventor's dilemma more clearly than the situation of

two such inventors: "Ned" and Benjamin Montgomery. They were responsible for the federal government and the Confederate government formally taking up the "problem" of slave inventors.

Ned's owner, O. J. E. Stuart, wrote to the secretary of the interior requesting that he receive a patent for the invention of a cotton scraper that his slave mechanic, Ned, had invented. Although Stuart admitted that the concept for the invention came entirely from Ned, he reminded the secretary that "the master is the owner of the fruits of the labor of the slave both intillectual [sic], and manual." The U.S. attorney general rendered a final opinion on June 10, 1858, "that a machine invented by a slave, though it be new and useful, cannot, in the present state of the law, be patented." The attorney general also prohibited the masters of slaves from receiving patents for their slaves' inventions. The decision not to allow either slaves or their owners to receive patents for slave inventions meant that such inventions could not enjoy any legal protection or any formal recognition. The attorney general's opinion stood until the end of the Civil War and the passage of the THIRTEENTH AMENDMENT and fourteenth amendment. Further mention of Ned is absent from the historical record, and nothing is known of what became of him.

Benjamin Montgomery was also a slave inventor. He was the slave of Joseph Davis (brother of Jefferson Davis, later president of the Confederacy). Montgomery served as general manager and mechanic on Davis's plantation in Mississippi. In the late 1850s Montgomery invented a propeller for a river steamboat, specifically designed for the shallow waters around the plantation. Montgomery's biographers write that both Joseph and Jefferson Davis tried to have the propeller patented, but they were prevented from doing so by the attorney general's 1858 decision barring slave inventions from being patented. After he became president of the Confederate States, Jefferson Davis oversaw Confederate legislation that allowed a master to receive patents for his slaves' inventions. Many other slaves, lost to history, invented labor saving devices and innovative techniques.

After the Civil War, significant numbers of black inventors began to patent their inventions. The list of inventions patented by blacks reveals what kinds of occupations African Americans held and in which sectors of the labor force they were concentrated. Agricultural implements, devices for easing domestic chores, musical instruments, and devices related to the railroad industry were common subjects. These inventions served as a source of financial security, personal pride, achievement, and spiritual "uplift" for African Americans. Much of the struggle for black inventors of that era revolved around the battle

to assert themselves upon the national consciousness. On August 10, 1894, on the floor of the House of Representatives, Representative George Washington MURRAY from South Carolina rose to read the names and inventions of ninety-two black inventors into the Congressional Record. Rep. Murray hoped that it would serve as a testament to the technological achievement of a people so recently emancipated.

Many African Americans made contributions to the new technologies and industries developed in the nineteenth century. Jan MATZELIGER invented a shoe-lasting machine that made the skill of shoe lasting (i.e., shaping) by hand obsolete. Elijah MCCOY designed hydrostatic oil lubricators that were adopted by railroad and shipping companies. His standard of quality was so rigorous that the term "the real McCoy" came to be applied to his lubricators and to stand for the highest quality product available. Garrett A. MORGAN patented a safety hood (a precursor to the modern gas mask) and an automatic traffic signal. He once donned his safety hood himself to save the lives of men trapped in an underground explosion. Granville T. WOODS and Lewis H. LATIMER were pioneers in the newly emerging fields of electrical engineering. Woods patented many electrical and railway telegraphy systems; Latimer, with several patents to his credit, was one of the "Edison pioneers," the group of researchers who worked most closely with Thomas A. Edison.

The twentieth century brought many changes to industrial engineering and design. The rise of corporate enterprise led to more centralized research. Many of the most important inventions began to come from teams of researchers employed by large companies. As technology became more complicated, inventors in emerging fields began to have more formal education.

Today, advanced degrees in engineering and the sciences have become prerequisites for doing innovative work in some fields. Despite these changes, important inventions are still being patented by inventors who work alone—individuals who are suddenly struck by a solution to a daily encountered problem, or who laboriously work out a cheaper, quicker, or better means of producing something.

REFERENCES

BAKER, HENRY E. *The Colored Inventor: A Record of Fifty Years.* 1915. Reprint. New York, 1968.
CARTER-IVES, PATRICIA. *Creativity and Invention: The Genius of Afro-Americans and Women in the United States and Their Patents.* Arlington, Va., 1988.
GIBBS, CARROLL. *The Afro-American Inventor.* Washington, D.C., 1975.
HABER, LOUIS. *Black Pioneers of Science and Invention.* New York, 1970.

HAYDEN, ROBERT. *Eight Black American Inventors.* Boston, 1972.

HERMANN, JANET SHARP. *Pursuit of a Dream.* New York, 1981.

JAMES, PORTIA P. *The Real McCoy: African American Invention and Innovation, 1619–1930.* Washington, D.C., 1989.

KLEIN, AARON. *Hidden Contributors: Black Scientists and Inventors in America.* New York, 1971.

PORTIA P. JAMES

Investment Banking. Investment banks provide financing for corporations and municipalities through the underwriting of stock and bond issues. Securing issues are generally traded at stock markets. Although stock markets and investment banks have been active in the United States since the 1790s, African Americans had little role in the industry until the late 1940s. It was not until the mid-1960s and '70s that black firms began to enter the marketplace in substantial numbers.

African Americans have been investors in stocks and bonds since the early-twentieth century. Well-known black stock speculators in the early 1900s included brothers Edward and George Jones, who were number runners in New York City. They at one time owned more than $150,000 of stock in American Telephone and Telegraph. Like many other speculators, they were devastated by the stock-market crash of 1929.

After World War II, the New York Stock Exchange (NYSE), seeking untapped markets, began an aggressive campaign to lure black investors through such programs as the Monthly Investment Program. The NYSE also encouraged its firms to hire black stockbrokers. Among the first was Thorvald McGregeor, who began work as a sales manager in 1949 for the firm of Mercer Hicks. Although not a member firm of the NYSE, Special Markets, Inc., was nevertheless the first black-owned and -operated brokerage firm in the financial district. Founded in 1955, the firm was established to cater to black investors and invested primarily in mutual funds.

Phillip M. Jenkins, founder and president of Special Markets, began his career at Bache & Company as a stockbroker and then moved on to the mutual-fund department of B.G. Phillips & Company.

Although rare, African-American women were also involved in the securities industry in the 1950s. Wilhelmina B. Drake was vice president and director of women's activities at special markets. She graduated from Howard University and earned her master's degree from Columbia University. In the late 1950s, Lila St. John became the first black woman to pass the NYSE exam for financial advisers. June Middleton passed the exam in 1962 and, by May 1964, was selling securities for Hornblower & Weeks-Hemphill, Noyes.

By the time Clarence B. Jones, vice president of Carter, Berlind & Weil, Incorporated, became the first allied member of the NYSE in 1967, there were approximately one dozen African Americans employed as registered representatives (licensed stockbrokers) in NYSE member firms. Willie L. Daniels and Traves J. Bell, Jr., established Daniel & Bell Investment firm and, in 1971, purchased a seat on the NYSE, making it the first black firm to be admitted to the NYSE as a member. Four months later, a former branch of Shearson Hammill, First Harlem Securities, became independent and purchased an exchange membership. Headed by Russell L. Going, Jr. (a former professional football player), it became the second black-owned member organization and the first to have a Harlem office. Harold Doley in 1973 became the first African American to buy a personal seat on the NYSE. In 1976, Doley founded Doley Securities Incorporated, a New Orleans investment bank. In 1972, Jerome Holland became the first African American on the New York Stock Exchange's board of directors. As these pioneers became established, the field of investment banking became increasingly integrated.

The rise of black big-city politics facilitated the growth of black investment banks. Minority set-asides and affirmative action programs have permitted minority firms to succeed in a field that has been historically closed to ethnic minorities with little capital. In 1977, Atlanta Mayor Maynard JACKSON declared that his administration would favor investment banks that provided blacks with equal training and opportunity. After his final term, Jackson went on to open his own investment banking firm, Jackson Securities, in Atlanta. With the growth of minority set-aside requirements for municipal underwriting, a number of black-owned investment firms were established to meet this new demand.

One of the great successes in the history of black investment banking involved Reginald F. LEWIS. In 1983, Lewis established and became CEO of TLC (The Lewis Company), an investment firm in New York City. In 1987, with financing help from Michael Milken at Drexel, Burnham, & Lambert, TLC bought Beatrice International Foods, a collection of sixty-four companies located throughout thirty-one countries. This was the largest leveraged purchase of a non-American company in the United States, and it made TLC the largest black-owned company—a position it held well into the 1990s. As a result, Lewis became one of six executives inducted into the National Sales Hall of Fame in New York City. At the time of his death from a brain tumor in

1993, Lewis's personal wealth was estimated at $400 million.

As African Americans have become more prominent in investment banking, there have been failures and scandals as well as successes. Joseph Jett, a trader at Kidder, Peabody & Company, was accused of orchestrating a $350 million fraud in May 1994. The same month, W. R. Lazard, founder and CEO of W. R. Lazard & Company, died of an accidental drug and alcohol overdose in a Pittsburgh hotel. The firm, which replaced him with two executives, was the largest black-owned money manager in 1994, with $2.8 billion under management.

Black investment bankers have founded their own professional organizations. The National Association of Securities Professionals (NASP) in New York City seeks to enhance minority participation in the securities industry. The National Association of Investment Companies (NAIC) was founded in 1971 in Washington, D.C. The Council on Minority Affairs (COMA), founded by Gordon Brown, was established in November 1981 by minority employees of the NYSE to promote the causes of minorities within the exchange.

By 1993, there were more than fifteen black-owned investment banks. Four black firms—Pryor, McClendon, Counts & Company (PMC); M. R. Beal & Company; Grigsby, Bradford; and W. R. Lazard—were among the top seventy investment banks in the United States. Together, they led or comanaged seventy-nine issues worth $4.38 billion. However, this totaled less than one percent of the business conducted by white-owned firms in the United States during the same year.

Pryor, McClendon, Counts & Company (PMC) was established in 1981 in Philadelphia. By 1993, the firm had offices in New York, Philadelphia, and Atlanta and was ranked first of all minority-owned investment firms on BLACK ENTERPRISE's "Top 15 Investment Firms" list. It was fifteenth among the nation's long-term municipal new-issue underwriters, participating in 270 transactions totaling $36.3 billion.

As black investment banks expand, they face a number of challenges. One problem that faces many firms is to grow beyond their base in municipal finance and compete for corporate underwriting and asset management. San Francisco-based Grigsby, Bradford & Company has taken important steps in that direction. Another problem concerns the minority set-asides that many of the firms used to establish a base in municipal finance. In 1993 and 1994, there were accusations that some black-owned investment firms were being bankrolled by mainstream investment firms to benefit from the set-asides. Whatever the truth of these charges, many observers noted that black investment firms were proving their ability to compete head to head with larger firms. The logic and choices of the marketplace would thus determine the future of black investment banking.

REFERENCES

BATES, TIMOTHY, and WILLIAM BRADFORD. *Financing Black Economic Development*. New York, 1979.

GREEN, SHELLEY, and PAUL PRYDE. *Black Entrepreneurship in America*. New Brunswick, N.J., 1990.

IRONS, EDWARD D. "A Positive View of Black Capitalism." *The Bankers Magazine* 153 (Spring 1970): 43–47.

McCOY, FRANK. "Going Head to Head." *Black Enterprise* (June 1994): 164–173.

———. "Investment Firms Show What They Can Do." *Black Enterprise* (June 1993): 173–174, 176–179.

THIEBLOT, ARMAND J., JR. *The Negro in the Banking Industry*. Philadelphia, 1970.

WILLIAMS, TERRY. "They've Got the Capital." *Black Enterprise* (October 1991): 69–72.

KAREN REARDON

Iowa. The story of African Americans in Iowa is one of reluctant accommodation. A seeming "promised land," Iowa appeared to African Americans as a safe haven, a place without the malevolent history of the antebellum, postbellum, and JIM CROW South. Nonetheless, there was no "welcome mat" greeting nor any clarion call beckoning African Americans there. Acceptance of African Americans occurred slowly in the Hawkeye State.

Congress approved Iowa's settlement in 1838. The territory and future twenty-ninth Union state was slave-free. Iowa gained statehood on December 28, 1846. The Missouri Compromise legally precluded SLAVERY in any land north of Missouri's border, which encompassed Iowa. Yet slaves did exist in antebellum Iowa. The 1840 federal census showed that sixteen slaves lived there. Some appeared before 1838 in the company of white explorers. Others arrived in the parties of a few white homesteaders. Territorial Gov. John Chambers, Iowa's chief executive, duty-bound to obey its laws, arrived in 1841 accompanied by his "elegant black body servant, 'Uncle Cassius.'" Visiting slavers were permitted to stay temporarily in Iowa with their bondsmen, using a legal loophole known as the "sojourners' provision." Iowa's prohibition against slavery did not signal that many white Iowans considered African Americans their equals. This point became clear when the antebellum legislatures of 1838 and 1851 enacted a set of

insidious so-called BLACK CODES. Ostensibly, these codes sought to prevent Iowa from becoming a refuge to free blacks and runaway slaves. "Negroes" who entered Iowa after April 1, 1839, were required to have a "certificate of freedom" and to post a $500 bond as "proof that they would not become a public charge." Accordingly, one legislative measure permitted captured fugitive slaves to be returned to slavery.

Viewing Iowa's black codes as anathema to God's law, Quaker, Congregational, and Presbyterian communities worked assiduously to aid and abet runaway slaves in their flight to freedom in Canada. The communities, located in southeast Iowa's Washington, Henry, Des Moines, and Lee counties, served also as stations of the UNDERGROUND RAILROAD. Individually and collectively, they constituted the state's first antislavery societies and led in the repeal of its black codes. Religious ideologies aside, they believed that "the law of love requires us to protect and aid the fugitive in his escape from slavery." One testimonial to the Quakers stated that "no fugitive who reached Salem was ever returned to bondage."

Nineteen years before the landmark 1857 U.S. Supreme Court DRED SCOTT DECISION, Iowa's Territorial Supreme Court decided a similar case: *In Re Ralph,* which involved a Missouri slave named Ralph who received permission from his owner to work in a Dubuque, Iowa, lead mine to earn the $550 his master had set for his manumission. After the debt went unpaid for five years, Ralph's master declared him a fugitive and had him captured to be returned to servitude in Missouri. Thanks to friends who outwitted his captors, Ralph never reached Missouri, and his fate was left for Iowa's highest court to decide. In its first official decision, the court reasoned that "Ralph, having reached free soil, was not a fugitive since his Missouri owner had given him permission to move to Iowa" (Hill, p. 291).

Iowa's sons served gallantly in the CIVIL WAR. Among them was the First Regiment Iowa African Infantry, organized July 27, 1863, which became the Sixtieth Regiment on March 11, 1864. The Sixtieth Regiment fought one battle and was mostly used for garrison duty at Helena, Ark. It was one of 222 such African-American volunteer Union units.

When the Civil War ended, Iowa's African-American population increased many times, so that by 1870 there were 5,762 African-American Iowans. This figure nearly doubled by 1890. African Americans "concentrated in the agricultural counties on the southern border, the Mississippi River counties in the east, and two Missouri River counties" (*Des Moines Register,* December 1, 1991). They sought employment in railroading, mining, and shipping. Most unique of Iowa towns was Buxton, a coal-mining company town with a majority African-American population. Buxton existed from 1900 to 1922, after which mining operations moved elsewhere. Buxton offered African Americans salaries competitive with those of whites, and neighborhoods where African Americans and whites lived together harmoniously. The Buxton YMCA was the social hub for African Americans. Boasting a well-equipped library, it established a Literary Society in 1906.

The 1900s saw continued progress for African Americans in Iowa. In 1901, Des Moines attorney George H. Woodson organized the Iowa Negro Bar Association; it was the predecessor of the National Negro Bar Association, formed in 1925. This professional association of mostly African-American attorneys is now the National Bar Association. In 1917, the first military officers' training facility for African-American men was approved. The Fort Des Moines Training Camp for Colored Officers, located in Des Moines, was established through the efforts of African-American leaders, including members of African-American college fraternities, educators, and the NAACP. Among its charter 329 first lieutenants was Charles Hamilton Houston, subsequent dean of Howard University's Law School and "The First Mr. Civil Rights."

Before the late 1800s, white Iowans vehemently opposed public education as it concerned blacks. Politicians suggested separate schools, but this measure was too costly for communities with small African-American populations. Frugality prevailed over racism and it became financially prudent to provide African-American Iowans with a "common share of education." The great impact of this commitment was felt in the state's colleges. In 1891, George Washington CARVER became the first African American admitted to Iowa State University. When he graduated four years later, he became its first African-American professor. In 1941, Lulu Merle Johnson received from the University of Iowa the first doctorate in history awarded in the United States to an African-American woman.

JIM CROW racial subjugation in Iowa was not enforced with South-like directness; there was a certain subterfuge to the practice. No posted signs delineated racial privilege; consequently, segregation seemed not to exist. According to one lifelong African-American Des Moines resident, before World War II "you grew up knowing what restaurants would not serve you" (*Des Moines Register,* December 1, 1991).

African Americans were also a part of Iowa's "field of dreams" as there were several early twentieth-century "Negro" or "Colored" baseball teams. Buxton had the Wonders and Waterloo, Des Moines, and Cedar Rapids had the Colored Giants. In 1903, the Algona Brownies were the "Colored Champions of the West."

REFERENCES

BERGMANN, LEOLA NELSON. *The Negro in Iowa.* Iowa City, Iowa, 1969.

CHASE, HAL S. "Struggle for Equality: Fort Des Moines Training Camp for Colored Officers, 1917." *Phylon* 39 (1968): 297–310.

DYKSTRA, ROBERT R. *Bright Radical Star: Black Freedom and White Supremacy on the Hawkeye Frontier.* Cambridge, Mass., 1993.

HILL, JAMES L. "Migration of Blacks to Iowa, 1820–1960." *Journal of Negro History* 66 (1981–1982): 289–303.

SCHWIEDER, DOROTHY. *Buxton: Work and Racial Equality in a Coal Mining Community.* Ames, Iowa, 1987.

DERRYN E. MOTEN

Irvin, Monte (February 25, 1919–), baseball player. Known as a power hitter, Monte Irvin played in the Negro Leagues and, for eight years, in the major leagues with the New York Giants (1949–1955) and the Chicago Cubs (1956). Many players thought that he would be the first African-American player admitted into the major leagues, but his chances were diminished when he went into the Army and was unable to maintain his top form.

In 1949, Irvin and Hank Thompson were the first black players to sign with the New York Giants, just two years after Jackie ROBINSON entered the league. The left fielder for the 1951 championship New York Giants team, Irvin had a .312 average that year and a league-leading 121 RBIs. After his retirement, he became a special assistant to the commissioner of baseball. He was inducted into the Hall of Fame in 1973 on the basis of his performance in the Negro Leagues.

REFERENCE

RUST, ART, JR. *"Get That Nigger off the Field!" A Sparkling, Informal History of the Black Man in Baseball.* New York, 1976.

LINDA SALZMAN

Islam. Originating as a religion in the seventh century A.D. through the revelations, visions, and messages received by the prophet Muhammad in Arabia, Islam spread rapidly throughout North Africa. Black African converts to Islam were called "Moors," and not only helped conquer southern Spain but also gained a reputation as skilled navigators and sailors. The Moors who accompanied the Spanish explorers in the fifteenth and sixteenth centuries were among the first to introduce the Islamic religion to the Amer-

Monte Irvin was a Negro National League star for the Newark Eagles before joining the New York Giants in 1949. Here Irvin gets ready for a preseason game in 1951. He was elected to the Baseball Hall of Fame in 1973. (AP/Wide World Photos)

icas. However, the greater impact of Islam in British North America occurred with the arrival of African Muslims (adherents of Islam) from the Islamized parts of West Africa who had been captured in warfare and sold to the European traders of the Atlantic slave trade.

The presence of Muslim slaves has been ignored by most historians, who have tended to focus on the conversion of Africans to Christianity or on the attempts to preserve aspects of traditional African religions. Yet their presence has been attested to by narrative and documentary accounts, some of which were written in Arabic. Yarrow Mamout, Job Ben Solomon, and Lamine Jay arrived in colonial Maryland in the 1730s. Abdul Rahaman, Mohammed Kaba, Bilali, Salih Bilali, and "Benjamin Cochrane" were enslaved in the late eighteenth century. Omar Ibn Said, Kebe, and Abu Bakr were brought to southern plantations in the early 1800s; two others, Mahommah Baquaqua and Mohammed Ali ben Said,

came to the United States as freemen about 1850 (Austin 1984, p. 9). Abdul Rahaman, a Muslim prince of the Fula people in Timbo, Fouta Djallon, became a slave for close to twenty years in Natchez, Miss., before he was freed; he eventually returned to Africa through the aid of abolitionist groups.

Court records in South Carolina described African slaves who prayed to Allah and refused to eat pork. Missionaries in Georgia and South Carolina observed that some Muslim slaves attempted to blend Islam and Christianity by identifying God with Allah and Muhammad with Jesus. A conservative estimate is that there were close to 30,000 Muslim slaves who came from Islamic-dominated ethnic groups such as the Mandingo, Fula, Gambians, Senegambians, Senegalese, Cape Verdians, and Sierra Leoneans in West Africa (Austin 1984, p. 38). However, in spite of the much larger presence of African Muslims in North America than previously thought, the Islamic influence did not survive the impact of the slave period. Except for the documents left by the Muslims named above, only scattered traces and family memories of Islam remained among African Americans, such as Alex HALEY's ancestral Muslim character, Kunta Kinte of the Senegambia, in his novel *Roots*.

By the late nineteenth century, black Christian churches had become so dominant in the religious and social life of black communities that only a few African-American leaders who had traveled to Africa knew anything about Islam. Contacts between immigrant Arab groups and African Americans were almost nonexistent at this time. After touring Liberia and South Africa, Bishop Henry McNeal TURNER of the African Methodist Episcopal church recognized the "dignity, majesty, and consciousness of [the] worth of Muslims" (Austin 1984, p. 24; Hill and Kilson 1971, p. 63). But it was Edward Wilmot BLYDEN, the West Indian educator, Christian missionary, and minister for the government of Liberia, who became the most enthusiastic supporter of Islam for African Americans. Blyden, who began teaching Arabic in Liberia in 1867, wrote a book, *Christianity, Islam and the Negro Race* (1888), in which he concluded that Islam had a much better record of racial equality than Christianity did—a conclusion that struck him especially after he compared the racial attitudes of Christian and Muslim missionaries whom he had encountered in Africa. Islam, he felt, could also be a positive force in improving life conditions for African Americans in the United States. Though he lectured extensively, Blyden did not become a leader of a social movement that could establish Islam effectively in America. That task awaited the prophets and forceful personalities of the next century.

The massive rural-to-urban migrations by more than four million African Americans during the first decades of the twentieth century provided the conditions for the rise of a number of black militant and separatist movements, including a few that had a tangential relationship to Islam. These "proto-Islamic" movements combined the religious trappings of Islam—a few rituals, symbols, or items of dress—with a core message of black nationalism.

In 1913 Timothy Drew, a black deliveryman and street-corner preacher from North Carolina, founded the first Moorish Holy Temple of Science in Newark, N.J. Rejecting Christianity as the white man's religion, Drew took advantage of the widespread discontent among the newly arrived black migrants and rapidly established temples in Detroit, Harlem, Chicago, Pittsburgh, and cities across the South. Calling himself Prophet NOBLE DREW ALI, he constructed a message aimed at the confusion about names, national origins, and self-identity among black people. He declared that they were not "Negroes" but "Asiatics," or "Moors," or "Moorish Americans" whose true home was Morocco, and their true religion was Moorish Science, whose doctrines were elaborated in a sixty-page book, written by Ali, called the *Holy Koran* (which should not be confused with the Qur'an of orthodox Islam).

Prophet Ali issued "Nationality and Identification Cards" stamped with the Islamic symbol of the star and crescent. There was a belief that these identity cards would prevent harm from the white man, or European, who was in any case soon to be destroyed, with "Asiatics" then in control. As the movement spread from the East Coast to the Midwest, Ali's

Elijah Muhammad, 1960. (Photographs and Prints Division, Schomburg Center for Research in Black Culture, The New York Public Library, Astor, Lenox and Tilden Foundations)

followers in Chicago practiced "bumping days," on which aggressive male members would accost whites on the sidewalks and surreptitiously bump them out of the way—a practice that reversed the Jim Crow custom of southern whites forcing blacks off the sidewalks. After numerous complaints to the police, Noble Drew Ali ordered a halt to the disorders and urged his followers to exercise restraint. "Stop flashing your cards before Europeans," he said, "as this only causes confusion. We did not come to cause confusion; our work is to uplift the nation" (Lincoln 1961, p. 54). The headquarters of the movement was moved to Chicago in 1925.

The growth of the Moorish Science movement was accelerated during the post–World War I years by the recruitment of better-educated but less dedicated members who quickly assumed leadership positions. These new leaders began to grow rich by exploiting the less educated membership of the movement and selling them herbs, magical charms, potions, and literature. When Ali intervened to prevent further exploitation, he was pushed aside, and this interference eventually led to his mysterious death in 1929. Noble Drew Ali died of a beating; whether it was done by the police when he was in their custody or by dissident members of the movement is not known. After his death, the movement split into numerous smaller factions with rival leaders who claimed to be "reincarnations" of Noble Drew Ali.

The Moorish Science Temple movement has survived, with active temples in Chicago, Detroit, New York, and a few other cities. In present-day Moorish temples, membership is restricted to "Asiatics," or non-Caucasians, who have rejected their former identities as "colored" or "Negro." The term *el* or *bey* is attached to the name of each member as a sign of his or her Asiatic status and inward transformation. Friday is the Sabbath for the Moors, and they have adopted a mixture of Islamic and Christian rituals in worship. They face Mecca when they pray, three times a day, but they have also incorporated Jesus and the singing of transposed hymns into their services. The Moorish Science Temple movement was the first proto-Islamic group of African Americans, and helped to pave the way for more orthodox Islamic practices and beliefs. Many Moors were among the earliest converts to the NATION OF ISLAM, or Black Muslim movement.

While the Moors were introducing aspects of Islam to black communities, sometime around 1920 the Ahmadiyyah movement sent missionaries to the United States, who began to proselytize among African Americans. Founded in India in 1889 by Mizra Ghulam Ahmad, a self-proclaimed Madhi, or Muslim messiah, the Ahmadiyyahs were a heterodox sect of Islam that was concerned with interpretations of the Christian gospel, including the Second Coming. The Ahmadiyyahs also emphasized some of the subtle criticisms of Christianity that were found in the Qur'an such as the view that Jesus did not really die on the cross (Surah 4:157–159).

As an energetic missionary movement, the Ahmadiyyah first sent missionaries to West Africa, then later to the diaspora in the United States. Sheik Deen of the Ahmadiyyah mission was influential in converting Walter Gregg, who became one of the first African-American converts to Islam and changed his name to Wali Akram. After a period of studying the Qur'an and Arabic with the sheik, Akram founded the First Cleveland Mosque in 1933. He taught Islam to several generations of Midwesterners, including many African Americans. He also worked as a missionary in India. Although it was relatively unknown and unnoticed, the Ahmadiyyah mission movement is significant in that it provided one of the first contacts for African Americans with a worldwide sectarian Islamic group, whose traditions were more orthodox than the proto-Islamic black-nationalist movements.

About the same time that the Ahmadiyyah movement began its missionary work in the United States, another small group of orthodox Muslims, led by a West Indian named Sheik Dawud Hamed Faisal, established the Islamic Mission to America in 1923 on State Street in Brooklyn. At the State Street Mosque, Sheik Dawud taught a more authentic version of Islam than the Ahmadiyyahs because he followed the Sunna (practices) of the Prophet Muhammad; where the Ahmadiyyahs believed in the tradition of the Mahdi, or Islamic messianism, Dawud belonged to the tradition of Sunni orthodoxy. The sheik welcomed black Americans to mingle with immigrant Muslims. He taught Arabic, the Qur'an, the Sunna-Hadith tradition, and Sharia, or Islamic law, emphasizing the five "pillars" of Islam: the credo (*shahadah*) of Islam that emphasizes belief in one God and Muhammad as the messenger of Allah; prayer (*salat*) five times a day facing Mecca; charity tax (*zakat*); fasting (*saum*) during the month of Ramadan; pilgrimage to Mecca (*hajj*) if it is possible. Sheik Dawud's work was concentrated mainly in New York and New England. He became responsible for converting a number of African-American Muslims.

A smaller group and third source of African-American Sunni Muslims was the community in Buffalo, N.Y., that was taught orthodox Islam and Arabic by an immigrant Muslim, Prof. Muhammad EzalDeen, in 1933. EzalDeen formed several organizations, including a national one called Uniting Islamic Societies of America in the early 1940s.

The work of the Ahmadiyyah movement, Sheik Dawud's Islamic Mission to America and the State

Noble Drew Ali (standing in first row, fifth from left), with officers and other leaders of the Moorish Science Temple of America. (Photographs and Prints Division, Schomburg Center for Research in Black Culture, The New York Public Library, Astor, Lenox and Tilden Foundations)

Street Mosque, Imam Wali Akram's First Cleveland Mosque, and Professor EzalDeen's Islamic Societies of America was important in establishing a beachhead for a more orthodox and universal Sunni Islam in African-American communities.

During the turmoil of the 1960s, young African Americans traveled abroad and made contact with international Muslim movements such as the Tablighi Jamaat. The Darul Islam movement began in 1968 among dissatisfied African-American members of Sheik Dawud's State Street Mosque in Brooklyn, and was led by a charismatic black leader, Imam Yahya Abdul Karim. Sensing the disenchantment with the lack of leadership, organization, and community programs in Sheik Dawud's movement, Imam Karim instituted the Darul Islam, the call to establish the kingdom of Allah. The movement spread to Cleveland, Baltimore, Philadelphia, and Washington, D.C. A network of over forty mosques was developed between 1968 and 1982. After a schism in 1982, the Darul Islam movement declined in influence, but it is since being revived under the charismatic leadership of Imam Jamin Al-Amin of Atlanta (the former H. Rap BROWN of the STUDENT NONVIOLENT COORDINATING COMMITTEE). Other

smaller Sunni organizations also came into existence during the 1960s, such as the Islamic Party and the Mosque of the Islamic Brotherhood. It is ironic, however, that the greatest impact and influence of Islam among black people were exerted by another proto-Islamic movement called the Nation of Islam.

In 1930 a mysterious peddler of sundry goods, who called himself Wali Fard Muhammad (see Wallace D. FARD), began to spread the word of a new religion, designed for the "Asiatic black man." He soon developed a following of several hundred people and established Temple No. 1 of the Nation of Islam. Focusing on knowledge of self as the path to individual and collective salvation, Master Fard explained that black people were members of the lost-found tribe of Shabazz and owed no allegiance to a white-dominated country, which had enslaved and continuously persecuted them. When Fard mysteriously disappeared in 1934, his chief lieutenant—the former Robert Poole, now called Elijah MUHAMMAD—led a segment of followers to Chicago, where he established Muhammad's Temple No. 2 as the headquarters for the fledgling movement.

Elijah Muhammad deified Master Fard as Allah, or God incarnated in a black man, and called himself the

Prophet or Apostle of Allah, frequently using the title "the Honorable" as a designation of his special status. Although the basic credo of the Nation of Islam stood in direct contradiction to the tenets of orthodox Islam, the movement's main interests were to spread the message of black nationalism and to develop a separate black nation. The Honorable Elijah Muhammad emphasized two basic principles: to know oneself, a development of true self-knowledge based on the teachings of the Nation of Islam; to do for self, an encouragement to become economically independent. He also advocated a strict ascetic lifestyle, which included one meal per day and a ban on tobacco, alcohol, drugs, and pork. From 1934 until his death in 1975, Muhammad and his followers established more than 100 temples and Clara Muhammad schools, and innumerable grocery stores, restaurants, bakeries, and other small businesses. During this period the Nation owned farms in several states, a bank, a fleet of trailer trucks for its fish and grocery businesses, and an ultramodern printing plant. Muhammad's empire was estimated to be worth more than $80 million.

Elijah Muhammad's message of a radical black nationalism, which included the belief that whites were devils, was brought to the American public by a charismatic young minister who had converted to the Nation of Islam after his incarceration in a Boston prison in 1946 for armed robbery. Upon his release from prison in 1952 and until his assassination in 1965, Minister MALCOLM X, the former Malcolm Little, had an enormous impact on the growth of the movement.

Extremely intelligent and articulate, Malcolm was an indefatigable proselytizer for the Nation, founding temples throughout the country and establishing the newspaper *Muhammad Speaks*. For his efforts, he was rewarded with the prestigious post of minister of Temple No. 7 in Harlem and appointed as the national representative by Elijah Muhammad. Malcolm led the Nation of Islam's attack on the use of the word *Negro* as depicting a slave mentality, and successfully laid the ideological basis for the emergence of the Black Consciousness and Black Power movements of the late 1960s. However, an internal dispute with Elijah Muhammad about future directions and personal moral conduct led Malcolm to leave the Nation in 1964. On his *hajj* to Mecca, Malcolm became convinced that orthodox Sunni Islam was a solution to the racism and discrimination that plagued American society. On February 21, 1965, the renamed El Hajj Malik El Shabazz was assassinated in the Audubon Ballroom in Harlem while delivering a lecture for his newly formed Organization for Afro-American Unity. Minister Louis FARRAKHAN, another charismatic speaker, replaced Malcolm as the national representative and head minister of Temple No. 7.

When Elijah Muhammad died a decade later, in February 1975, the fifth of his six sons, Wallace Deen Muhammad, was chosen as his father's successor as supreme minister of the Nation. In April 1975, Wallace shocked the movement by announcing an end to its racial doctrines and black-nationalist teachings. He disbanded the Fruit of Islam and the Muslim Girls Training, the elite internal organizations, and gradually moved his followers toward orthodox Sunni Islam. Wallace's moves led to a number of schisms, which produced several competing black-nationalist groups: Louis Farrakhan's resurrected Nation of Islam in Chicago, the largest and most well known of the groups; Silas Muhammad's Nation of Islam in Atlanta; and a Nation of Islam led by John Muhammad, brother of Elijah Muhammed, in Detroit.

In the evolution of his movement, Wallace took the Muslim title and name Imam Warith Deen Muhammad (in 1991 the spelling of his surname was changed to the British *Mohammed*). The movement's name and the name of its newspaper also changed several times: from the World Community of Al-Islam in the West (*Bilalian News*) in 1976 to the American Muslim Mission (*American Muslim Mission Journal*) in 1980; then in 1985 Warith decentralized the movement into independent masjids (*Muslim Journal*). With several hundred thousand followers—predominantly African Americans—who identify with his teachings, Mohammed has continued to deepen their knowledge of the Arabic language, the Qur'an, and the Sunna, or practices of the Prophet. Immigrant Muslims from Africa, Pakistan, and Middle Eastern countries also participate in the Friday Jumuah prayer services.

Although it adheres to the basic tenets of orthodox Sunni Islam, the movement has not yet settled on a particular school of theological thought to follow. Since every significant culture in Islamic history has produced its own school of thought, it is Mohammed's conviction that eventually an American school of Islamic thought will emerge in the United States, comprising the views of African-American and immigrant Muslims. Imam Warith Deen Mohammed has been accepted by the World Muslim Council as a representative of Muslims in the United States, and has been given the responsibility of certifying Americans who desire to make the pilgrimage to Mecca.

In its varying forms, Islam has had a much longer history in the United States, particularly among African Americans, than is commonly known. In the last decade of the twentieth century, about one million African Americans belong to proto-Islamic and orthodox Islamic groups. It has become the fourth major religious tradition in American society, along-

side Protestantism, Catholicism, and Judaism. In black communities, Islam has reemerged as the dominant religious alternative to Christianity.

REFERENCES

AUSTIN, ALLEN. *African Muslim Slaves in Ante-Bellum America*. New York, 1984.

BLYDEN, EDWARD WILMOT. *Christianity, Islam and the Negro Race*. 1888. Reprint. Edinburgh, 1967.

ESSIEN-UDOM, E. U. *Black Nationalism: A Search for Identity in America*. Chicago, 1962.

FARRAKHAN, LOUIS. *Seven Speeches*. Chicago, 1974.

FAUSET, ARTHUR HUFF. *Black Gods of the Metropolis*. 1944. Reprint. Philadelphia, 1971.

HADDAD, YVONNE, ed. *The Muslims of America*. New York, 1991.

HILL, ADELAIDE C. and MARTIN KILSON. *Apropos of Africa: Afro-American Leaders and the Romance of Africa*. Garden City, N.Y., 1971.

HILL, ROBERT A., ed. *The Marcus Garvey and The Universal Improvement Association Papers*. 3 vols. Los Angeles, 1983–1984.

LINCOLN, C. ERIC. *The Black Muslims in America*. Boston, 1960.

MALCOLM X and ALEX HALEY. *The Autobiography of Malcolm X*. New York, 1965.

MAMIYA, LAWRENCE H. "From Black Muslim to Bilalian: The Evolution of a Movement." *Journal for the Scientific Study of Religion* 21, no. 2 (June 1982): 138–152.

MUHAMMAD, ELIJAH. *Message to the Black Man in America*. Chicago, 1965.

MUHAMMAD, WARITH DEEN. *As the Light Shineth from the East*. Chicago, 1980.

PERRY, BRUCE. *Malcolm: The Life of a Man Who Changed Black America*. Barrytown, N.Y., 1991.

TURNER, RICHARD B. Islam in the United States in the 1920's: The Quest for a New Vision in Afro-American Religion. Ph.D. diss., Princeton University, 1986.

WAUGH, EARLE H., BAHA ABU-LABAN, and REGULA B. QURESHI, eds. *The Muslim Community in North America*. Edmonton, Alberta, 1983.

LAWRENCE H. MAMIYA

Islam, Nation of. *See* Nation of Islam.

J

Jack, Beau (April 1, 1921–), boxer. Born Sidney Walker in Augusta, Ga., Beau Jack gained much of his early boxing experience in battle royals, degrading free-for-alls in which a group of black youths battled until a winner was left standing. He moved north when still a teenager to pursue a boxing career. His first professional fight took place in Holyoke, Mass., in 1940. In 1943, he won the New York Commission's version of the world lightweight championship, joining Joe LOUIS as only one of two African-American champions at that time. He then lost, regained, and lost the title in three fights with Bob Montgomery in 1943 and 1944. Jack was the most popular fighter at New York's Madison Square Garden in the early 1940s, grossing $481,415 for six fights in 1943. Jack finished his career in 1955 with a record of 83 wins, 24 defeats, and 5 draws. After his boxing days were finished, he worked as a bootblack in the Fontainebleau Hotel in Miami, Fla., and also worked as a boxing trainer, barbecue entrepreneur, farmer, and wrestling referee.

REFERENCES

FLEISCHER, NAT. "Fame Comes to Jack." *Ring* (March 1943): 6–7.

HENDERSON, EDWIN BANCROFT. *The Negro in Sports*. Rev. ed. Washington, D.C., 1949.

ODD, GILBERT. *The Encyclopedia of Boxing*. Secaucus, N.J., 1989.

WAYNE WILSON

Jack, Hulan Edwin (December 29, 1906–December 19, 1986), politician. Born in St. Lucia, British West Indies, Hulan Jack came to New York in 1923 at the age of seventeen with a grammar-school education and work experience in a printer's shop. He found a job cutting paper boxes at the Peerless Paper Box Company, where thirty years later he became vice president. Following his boss's advice, Jack enrolled in night school, and after graduation entered New York University, where he majored in business administration. Soon after graduation, he became involved in hands-on politics; by the age of twenty-five, in 1931, Jack was actively canvassing and campaigning for candidates he supported.

He quickly gained recognition in the Manhattan Democratic organization, which resulted in his selection in 1940 to run on the Democratic ticket for State Assembly. With little opposition, Jack easily won and went on to represent the seventeenth district in Harlem for the next thirteen years. During his tenure, he sponsored legislation for human rights and against racial discrimination. Although many bills he sponsored did not pass, some important ones became law, including two designed to eliminate discrimination in housing and liability insurance.

In 1953, in the middle of his seventh term in the State Assembly, Jack was elected Manhattan borough president. He was the first black to hold this office, which was, indeed, the highest post held by a black at the time, controlling one of the wealthiest and most densely populated areas in the country and paying $25,000, compared with the congressional salary of

$22,000. During Jack's administration, Manhattan launched many public-works projects, and in 1957 he published a report, *Manhattan Civic Center Development*. In 1957, he won reelection, only to be forced out in 1960 after his trial and conviction on conflict-of-interest charges. Jack received a suspended sentence for accepting a $4,500 renovation of his apartment from a real estate operator. However, he retained his position as Democratic district leader of the fourteenth Assembly district, and in 1968 he returned to the State Assembly. In 1970, Jack was indicted for conspiracy and another conflict-of-interest charge; he and four others were accused of having pressured Harlem stores to sell certain brand-name products. Although he retained his office, he lost in the 1972 Democratic primary. In the meantime, he was convicted of the 1970 charges and received a $5,000 fine and a prison sentence of three months.

REFERENCES

CLAYTON, EDWARD T. *The Negro Politician: His Success and Failure*. Chicago, 1964.

JACK, HULAN E. *Fifty Years a Democrat: The Autobiography of Hulan E. Jack*. New York, 1982.

JEFFREY L. KLEIN

Jack and Jill of America, nonprofit philanthropic organization. Jack and Jill of America was founded in 1938 in Philadelphia by Marion T. Stubbs Thomas, with the primary aim of serving African-American children from the ages of two to nineteen. The group grew out of volunteer community work by African-American women during the Great Depression. Along with several other women of the Philadelphia black elite, Thomas agreed that most of the women who associated socially and professionally had children who did not know one another, so the women sponsored cultural events and created a network for parents and children. In 1939, Jack and Jill of America expanded to New York, and by 1988, its fiftieth anniversary, it had expanded to 187 chapters across the nation.

Through the 1940s and 1950s, Jack and Jill of America raised funds for a variety of charities, including those concerned with children's health. The leaders of Jack and Jill, without representation on the boards of charities that they supported, decided to form their own Jack and Jill of America Foundation. It began in 1968 and is involved in a variety of efforts in areas such as health, education, science, and culture. It works with local chapters of Jack and Jill and other groups in most of the United States and in the District of Columbia.

REFERENCES

HINE, DARLENE CLARK. *Black Women in America: An Historical Encyclopedia*. Brooklyn, N.Y., 1993.

ROULHE, NELLIE C. *Work, Play, and Commitment: A History of the First Fifty Years, Jack and Jill of America, Incorporated*. 1989.

THOMAS PITONIAK

Jackson, Angela (July 25, 1951–), poet, playwright, and fiction writer. Born in Greenville, Miss., Angela Jackson grew up in Chicago, the fifth of nine children. She first gained prominence as the leading poetic voice of the OBAC WRITERS WORKSHOP (Organization of Black American Culture, pronounced "*o-bah-see*") in the 1970s. She grew up in Chicago, developing a sense of language that was deeply southern but tempered by urban, midwestern rhythms. Her work has been especially admired for its exquisite language, which combines a distinctly African-American conversational style with a highly refined literary discipline.

Her poetry books include *Voo Doo/Love Magic* (1974), *The Greenville Club* (1977), *Solo in the Boxcar Third Floor E* (1985), and *And All These Roads Be Luminous* (1992), her collected poems. Most of her published fiction, appearing in magazines such as the *Chicago Review* and *TriQuarterly*, has been excerpts from her novel *Tremont Stone*, a project that was over a decade in the making. Jackson's best-known play, *Shango Diaspora*, was first staged in Chicago in 1980. It was subsequently staged by Woodie King's New Federal Theater in New York and by Chicago's Ebony Talent Theater. Writing with Sandra Jackson-Opoku (no relation) under the pen name Lia Sanders, Jackson coauthored *The Tender Memory*, the first black Candlelight Romance.

In addition to her work as the sustaining presence in the OBAC Workshop after its founder, Hoyt Fuller, departed in 1976, Jackson also served as the chair of the Coordinating Council of Literary Magazines (1984). She received numerous literary awards, including an Academy of American Poets Prize, the Conrad Kent Rivers Memorial Prize, and fellowships from the Illinois State Arts Council and the National Endowment for the Arts. She taught at Stephens College and Columbia College of Chicago, where she continues to reside.

REFERENCE

SMITH, DAVID LIONEL. "Angela Jackson." In *Afro-American Poets Since 1955*, Vol. 41, *Dictionary of Literary Biography*. Detroit, 1985.

DAVID LIONEL SMITH

Jackson, George Lester (September 23, 1941–August 21, 1971), activist. George Jackson was born in Chicago and moved to Los Angeles with his family when he was fourteen. One year later, he was convicted of attempted robbery and sent to California's Youth Authority Corrections facility in Paso Robles. After his release, Jackson was again arrested and convicted for attempted robbery, and at age sixteen he was incarcerated in a California county jail. In 1960, Jackson was accused of stealing $71 from a gas station and received an indeterminate sentence of one year to life. After he served the statutory minimum of one year, his case was reconsidered yearly. Jackson was never granted parole, and he spent the rest of his life in prison.

Jackson was incarcerated in Soledad State Prison in Salinas, Calif. He was politicized by his experiences in prison and began to study the theories of Third World communists Mao Zedong, Frantz Fanon, and Fidel Castro. He became a strong supporter of communist ideas, viewing capitalism as the source of the oppression of people of color. Jackson soon became a leader in the politicization of black and Chicano prisoners in Soledad Prison. In part as the result of his prison activities, he was placed in solitary confinement for extended periods of time.

On January 16, 1970, in response to the death of three black inmates in Soledad Prison, a white guard—John Mills—was killed. George Jackson, John Clutchette, and Fleeta Drumgo were accused of the murder. All three were regarded as black militants by prison authorities. The extent of their involvement in the murder has never been clarified.

The fate of the "Soledad Brothers" became an international *cause célèbre* that focused investigative attention and publicity on the treatment of black inmates. Jackson's eloquence and dignity made him a symbol of militant pride and defiance. Massive grassroots rallies and protests popularized the plight of the Soledad Brothers.

The publication in 1970 of *Soledad Brother: The Prison Letters of George Jackson* greatly contributed to Jackson's visibility. The book traced his personal and political evolution and articulated the fundamental relation he saw between the condition of black people inside prison walls and those outside. Jackson believed that the building of a revolutionary consciousness among imprisoned people was the first step in the overall development of an anticapitalist revolutionary cadre in the United States.

For many of Jackson's supporters in the Black Power movement and the New Left, the guilt or innocence of the Soledad Brothers was not the issue. They perceived the Soledad Brothers as political prisoners who were victims of a conspiracy by prison authorities. Angela DAVIS, spokesperson for the Soledad Brothers Defense Committee, argued that the Soledad Brothers were being persecuted solely because they had helped create an antiestablishment consciousness among black and Chicano inmates.

On August 7, 1970, Jackson's teenage brother, Jonathan, entered the Marin County Courthouse in San Rafael, held the courtroom at gunpoint, distributed weapons to three prisoners present, and attempted to take the judge, assistant district attorney, and three jurors as hostages to bargain for his brother's freedom. In the ensuing struggle, Jonathan Jackson was killed, along with two of the prisoners and the judge. Angela Davis was accused of providing him with the four weapons and was arrested on October 13, 1971. Davis's trial gained international attention, and after spending sixteen months in jail, she was acquitted in 1972.

During 1970, the Soledad Brothers had been transferred to San Quentin Prison. On August 21, 1971, three days before his case was due to go to trial, Jackson was killed by prison guards. The official report said that Jackson was armed; that he had participated in a prison revolt earlier in the day, which had left two white prisoners and three guards dead; and that he was killed in an apparent escape attempt. However, accounts of this incident are conflicting, and many argue that Jackson was set up for assassination and had nothing to do with the earlier melee.

Jackson was eulogized by many in the Black Power movement and the New Left as a martyr and a hero. After his death, *Soledad Brother* was published in England, France, Germany, and Sweden. In March 1972, the remaining two Soledad Brothers were acquitted of the original charges.

REFERENCES

DURDEN-SMITH, JO. *Who Killed George Jackson? Fantasies, Paranoia, and the Revolution.* New York, 1976.

SZULC, TAD. "George Jackson Radicalizes the Brothers in Soledad and San Quentin." *New York Times Magazine*, August 1, 1971.

ROBYN SPENCER

Jackson, Henry, Jr. *See* Armstrong, Henry.

Jackson, Jesse Louis (October 8, 1941–), minister, politician, civil rights activist. Jesse Jackson was born Jesse Burns in Greenville, S.C., to Helen Burns and Noah Robinson, a married man who lived next door. In 1943, his mother married Charles Henry

Jackson, who adopted Jesse in 1957. Jesse Jackson has recognized both men as his fathers. In 1959, Jackson graduated from Greenville's Sterling High School. A gifted athlete, Jackson was offered a professional baseball contract; instead, he accepted a scholarship to play football at the University of Illinois, at Champaign-Urbana. When he discovered, however, that African Americans were not allowed to play quarterback, he enrolled at North Carolina Agricultural and Technical College in Greensboro. There, besides being a star athlete, Jackson began his activist career as a participant in the student sit-in movement to integrate Greensboro's public facilities.

Jackson's leadership abilities and charisma earned him a considerable reputation by the time he graduated with a B.S. in sociology in 1964. After graduation he married Jacqueline Brown, whom he had met at the sit-in protests. During his senior year, he worked briefly with the CONGRESS OF RACIAL EQUALITY (CORE), quickly being elevated to the position of director of southeastern operations. Jackson then moved north, eschewing law school at Duke University in order to attend the Chicago Theological Seminary in 1964. He was later ordained to the ministry by two renowned figures: gospel music star and pastor, Clay Evans, and legendary revivalist and pulpit orator, C. L. FRANKLIN. Jackson left the seminary in 1965 and returned to the South to become a member of the Rev. Dr. Martin Luther KING, Jr.'s staff of the SOUTHERN CHRISTIAN LEADERSHIP CONFERENCE (SCLC).

Jackson initially became acquainted with SCLC during the famous march on Selma, Ala. in 1965. In 1966, King appointed him to head the Chicago branch of SCLC's OPERATION BREADBASKET, which was formed in 1962 to force various businesses to employ more African Americans. In 1967, only a year after his first appointment, King made Jackson the national director of Operation Breadbasket. Jackson concentrated on businesses heavily patronized by blacks, including bakeries, milk companies, soft-drink bottlers, and soup companies. He arranged a number of boycotts of businesses refusing to comply with SCLC demands of fair employment practices, and successfully negotiated compromises that soon gained national attention.

Jackson was in King's entourage when King was assassinated in Memphis in 1968. After King's death, however, Jackson's relationship with SCLC became increasingly strained over disagreements about his independence and his penchant for taking what was considered to be undue initiative in both public relations and organizational planning. He was also criticized for the direction in which he was leading Operation Breadbasket. Finally, in 1971, Jackson left SCLC and founded Operation PUSH (see PEOPLE

UNITED TO SAVE HUMANITY), which he would lead for thirteen years. As head of PUSH, he continued an aggressive program of negotiating black employment agreements with white businesses, as well as promoting black educational excellence and self-esteem.

In 1980, Jackson had demanded that an African American step forward as a presidential candidate in the 1984 election. On October 30, 1983, after carefully weighing the chances and need for a candidate, he dramatically announced, on the television program, "60 Minutes," his own candidacy to capture the White House. Many African-American politicians and community leaders, such as Andrew YOUNG, felt that Jackson's candidacy would only divide the Democrats and chose instead to support Walter Mondale, the favorite for the nomination. Jackson, waging a campaign stressing voter registration, carried a hopeful message of empowerment to African Americans, poor people, and other minorities. This constituency of the "voiceless and downtrodden" became the foundation for what Jackson termed a "Rainbow Coalition" of Americans—the poor, struggling farmers, feminists, gays, lesbians, and others who historically, according to Jackson, had lacked representation. Jackson, offering himself as an alternative to the mainstream Democratic party, called for, among other things, a defense budget freeze, programs to stimulate full employment, self-determination for the Palestinians, and political empowerment of African Americans through voter registration.

Jackson's campaign in 1984 was characterized by dramatic successes and equally serious political gaffes. In late 1983, U.S. military flyer Robert Goodman was shot down over Syrian-held territory in Lebanon, while conducting an assault. In a daring political gamble, Jackson made Goodman's release a personal mission, arguing that if the flyer had been white, the U.S. government would have worked more diligently towards his release. Traveling to Syria, Jackson managed to meet with President Hafez al-Assad and Goodman was released shortly afterwards; Jackson gained great political capital by appearing at the flyer's side as he made his way back to the United States.

The 1984 campaign, however, was plagued by political missteps. Jackson's offhand dubbing of New York as "Hymietown" while eating lunch with two reporters cost him much of his potential Jewish support and raised serious questions about his commitment to justice for all Americans. Though Jackson eventually apologized, the characterization continued to haunt him, and remains a symbol of strained relations between African Americans and Jews. Another issue galling to many Jews and others was Jackson's relationship with Louis FARRAKHAN, head of

Jesse Jackson during his 1988 presidential campaign. (© Dennis Brack/Black Star)

the NATION OF ISLAM. Farrakhan had appeared with Jackson and stumped for him early in the campaign. Jackson, despite advice to the contrary, refused to repudiate Farrakhan; it was only after one speech, in which Farrakhan labeled Judaism a "dirty" religion, that the Jackson campaign issued a statement condemning both the speech and the minister. Another controversy, and a source of special concern to Jews, was Jackson's previous meetings with Yasir Arafat, head of the Palestine Liberation Organization (PLO), and his advocacy of self-determination for the Palestinians.

Jackson ended his historic first run with an eloquent speech before the Democratic National Convention in San Francisco, reminding black America that "our time has come." In a strong showing in a relatively weak primary field, Jackson garnered almost 3.3 million votes out of the approximately 18 million cast.

Even more impressive than Jackson's first bid for the presidency was his second run in 1988. Jackson espoused a political vision built upon the themes he first advocated in 1984. His campaign once again touted voter registration drives and the Rainbow Coalition, which by this time had become a structured organization closely overseen by Jackson. His new platform, which included many of the planks from 1984, included the validity of "comparable worth" as a viable means of eradicating pay inequities based on gender, the restoration of a higher maximum tax rate, and the implementation of national health care. Jackson also urged policies to combat "factory flight" in the Sun Belt and to provide aid to farm workers in their fight to erode the negative effect of corporate agri-business on family farms. Further, he railed against the exploitative practices of U.S. and transnational corporations, urging the redirection of their profits from various foreign ventures to the development of local economies.

While he failed to secure the Democratic nomination, Jackson finished with a surprisingly large number of convention delegates and a strong finish in the primaries. In thirty-one of thirty-six primaries, Jackson won either first or second place, earning almost seven million votes out of the approximately 23 million cast. In 1988, Jackson won over many of the black leaders who had refused to support him during his first campaign. His performance also indicated a growing national respect for his oratorical skills and his willingness to remain faithful to politically progressive ideals.

In the 1992 presidential campaign, Jackson, who was not a candidate, was critical of Democratic frontrunners Bill Clinton and Al Gore, and did not endorse them until the final weeks of the campaign. Since his last full-time political campaign in 1988, Jackson has remained highly visible in American public life. He has crusaded for various causes, including the institution of a democratic polity in South Africa, statehood for the District of Columbia, and the banishment of illegal drugs from American society.

Jackson has also been an outspoken critic of professional athletics, arguing that more African Americans need to be involved in the management and ownership of professional sports teams and that discrimination remains a large problem for many black athletes. Further, on the college level, the institution of the NCAA's Proposition 42 and Proposition 48 have earned criticism from Jackson as being discriminatory against young black athletes. Through the medium of a short-lived 1991 television talk show, Jackson sought to widen his audience, addressing pressing concerns faced by African Americans.

Jackson's various crusades against illegal drugs and racism, while often specifically targeted towards black teenagers, have exposed millions of Americans to his message. His powerful oratorical style—pulpit oratory which emphasizes repetition of key phrases like "I am somebody"—often impresses and challenges audiences regardless of their political beliefs. In late 1988, Jackson became president of the National Rainbow Coalition, Inc.; he remains involved in the activities of numerous other organizations.

Jackson has been the most prominent civil rights leader and African-American national figure since the death of Martin Luther King, Jr. The history of national black politics in the 1970s and 1980s was largely his story. He has shown a great ability for making alliances, as well as a talent for defining issues and generating controversy. The essential dilemma of Jackson's career, as with many of his peers, has been the search for a way to advance and further the agenda of the civil rights movement as a national movement

at a time when the political temper of the country has been increasingly conservative.

REFERENCES

FAW, BOB, and NANCY SKELTON. *Thunder in America.* Austin, Tex., 1986.

GIBBONS, ARNOLD. *Race, Politics, and the White Media: The Jesse Jackson Campaigns.* Lanham, Md., 1993.

HATCH, ROGER D., and FRANK E. WATKINS, eds. *Reverend Jesse L. Jackson: Straight From the Heart.* Philadelphia, 1987.

REYNOLDS, BARBARA. *Jesse Jackson: The Man, the Movement, the Myth.* Chicago, 1975.

MICHAEL ERIC DYSON

Jackson, Jimmy Lee (1939–February 26, 1965), activist. Jimmy Lee Jackson was the first black person to die during the violence surrounding the SOUTHERN CHRISTIAN LEADERSHIP CONFERENCE's (SCLC) 1965 Alabama Project for voting rights. Little is known about Jackson's background.

Jackson was a twenty-six-year-old woodcutter when, on February 18, 1965, he traveled with his mother and grandfather to Marion, Ala., a small town outside Selma, to participate in a rally and march in support of James Orange, an SCLC leader jailed during a voting rights drive. Shortly after the march began, the marchers were attacked by Alabama state troopers, and Jackson's grandfather was injured during the confrontation. Attempting to help his grandfather and protect his mother, Jackson was shot in the stomach at close range by a state trooper. The wounded Jackson was forced to run a gauntlet of troopers swinging their nightsticks before he was taken to the Negro Good Samaritan Hospital in Selma.

On February 26, Jackson died of his wounds. The Rev. Dr. Martin Luther KING, Jr., preached at his funeral on March 3 and led a procession of one thousand marchers to Jackson's grave. At the funeral, an activist (accounts differ as to whom) suggested a march from Selma to Montgomery, the state capital, to demand an explanation for Jackson's death from Gov. George Wallace.

While not widely publicized at the time, Jackson's death galvanized activists to undertake the march from Selma to Montgomery on March 7, 1965. Known as "Bloody Sunday" for the way it was violently broken up by Selma police, the march was a turning point in alerting the national consciousness to the black struggle for equal rights.

REFERENCE

GARROW, DAVID J. *Bearing the Cross: Martin Luther King, Jr. and the Southern Christian Leadership Conference.* New York, 1986.

MICHAEL PALLER

Jackson, Joseph Harrison (September 11, 1900–August 18, 1990), minister. Born in Jamestown, Miss., Joseph H. Jackson received a B.A. from Jackson College (Jackson, Miss.), and a bachelor of divinity degree from Colgate-Rochester Divinity School. (He later received an honorary doctor of divinity degree from Jackson College.) From 1922 to 1941, Johnson served as a minister in churches in Mississippi, Nebraska, and Pennsylvania. In 1934, he became corresponding secretary of the Foreign Mission Board of the National Baptist Convention (NBC), USA, and vice president of the World Baptist Alliance. In 1941, he became pastor of the Olivet Baptist Church in Chicago, perhaps the largest Baptist church in the country.

In 1953, Jackson was elected president of the National Baptist Convention, USA, Inc. the country's largest black religious group, with five million members. He campaigned as a reformer, pledging to eliminate presidential self-succession. Ironically, Jackson remained president for twenty-nine years, a tenure marked by controversy over his conservative opposition to civil rights activism and autocratic leadership.

While Johnson supported legal efforts in support of civil rights, he strongly believed that blacks should concentrate on "self-development" through advancing economic opportunity, and that civil disobedience would inflame racial differences. In January 1961, he denounced the sit-in movement, and referred to the Rev. Dr. Martin Luther King, Jr., as a "hoodlum." In 1963, Jackson denounced the planned March on Washington as "dangerous and unwarranted." Attempting to speak at an NAACP rally that year, he was booed off the stage. In contrast, Jackson actively pursued an African uplift program. In 1961, he developed a land investment program through which Baptists used 100,000 acres in Liberia to encourage settlement and raise money for missionaries. For his efforts, Jackson was made a Royal Knight of the Republic of Liberia, and received an honorary degree from Bishop College in Monrovia. He also led the Baptists to create Freedom Farm, a model farming community in Somerville, Tenn.

Jackson faced several challenges to his leadership of the NBC. In 1957, despite his repeated promises to

Joseph H. Jackson was president of the National Baptist Convention, U.S.A., Inc., the largest African-American organization in the United States, for twenty-nine years, from 1953 to 1982. He is perhaps best remembered for his animosity toward the civil rights efforts of the Rev. Dr. Martin Luther King, Jr. Here Jackson denounces the 1966 open housing demonstrations in Chicago as a "conspiracy aimed at the destruction of the American way of life." (AP/Wide World Photos)

resign, he had his supporters suspend the convention's rules, and was reelected by a voice vote. Angered opponents brought suit against the NBC Board, but to no avail.

In 1960, at the NBC Convention in Philadelphia, civil rights advocates led by Dr. King supported the Rev. Gardner Taylor for president. When Jackson's supporters attempted to reelect him by means of a voice vote, pandemonium broke out and Jackson left the hall. Taylor won a roll call vote, and the two factions brought injunctions against each other. Jackson retained the support of the NBC Board, and retained his presidency. At the 1961 NBC Convention in Kansas City, Mo., Jackson was reelected in a disputed vote that resulted in a riot. Banished from the NBC, King and Taylor formed the Progressive National Baptist Convention, a group committed to social action.

As president of the NBC, Jackson toured widely, visiting Africa, the Middle East, Asia, and Russia. In 1962, he attended the Second Vatican Council in Rome, and had a private meeting with Pope John XXIII. He wrote several books, including *Stars in the Night* (1950), *The Eternal Flame* (1956), *Many But One: The Ecumenics of Charity* (1964), and *Unholy Shadows and Freedom's Holy Light* (1967), as well as *A Story of Christian Activism: The History of the National Baptist Convention, U.S.A., Inc.* (1980). In 1973, the NBC's library in Chicago was named for him. In 1982, Jackson retired, and in 1989, he established a $100,000 scholarship fund at Howard University.

REFERENCES

BRANCH, TAYLOR. *Parting the Waters: America in the King Years, 1954–1963.* New York, 1988.
PARIS, PETER J. *Black Religious Leaders: Conflict in Unity.* 2nd ed. Louisville, Ky., 1991.

GREG ROBINSON

Jackson, Laurence Donald "Baby Laurence" (1921–1974), tap dancer. "Baby Laurence" was born Laurence Donald Jackson in Baltimore, Md. He first performed at age eleven as a boy soprano with McKinney's Cotton Pickers, a leading big band at the time. After the death of his parents in Baltimore, Jackson ran away to New York, where he found a job at the Harlem nightclub owned by former dancer and Count BASIE trombonist Dickie Wells, who nicknamed him "Baby." He soon turned to dancing, picking up advice at the Hoofers Club from Harold Mablin and absorbing ideas and techniques from such tap dancing performers as Eddie RECTOR, Pete NUGENT, Toots Davis, and Teddy Hale. In the mid-1930s, Jackson sang and danced with "The Four Buds." After some personnel changes, the group became "The Harlem Highlanders," six performers who dressed in kilts and sang Jimmie LUNCEFORD arrangements.

In the 1940s, Jackson expanded his technique in jazz dancing. Sometimes working with Art TATUM, he would duplicate with his feet what Tatum played on the piano, creating his sound—a succession of explosions, machine-gun rattles, and jarring thumps. Increasingly his dancing was influenced by the complex rhythms of bebop. A 1959 recording of his tapping, *Baby Laurence—Dance Master,* highlights his distinctive-sounding tap. He joined Charles MINGUS at the Showplace in 1960 for a long-term engagement. In 1961 he played an engagement with Count Basic at the APOLLO THEATER in New York; the next

year he appeared at the Newport Jazz Festival with Duke ELLINGTON. In the 1970s, with his home base in Baltimore, Baby Laurence headed the Sunday afternoon tap sessions at the Jazz Museum. He died in 1974.

REFERENCES

BALLIETT, WHITNEY. *New York Notes: A Journal of Jazz 1972–1975*. Boston, 1976.

HENTOFF, NAT. Liner notes. *Baby Laurence—Dance Master* (Classic Jazz CJ30). Recorded 1959, released 1977.

STEARNS, MARSHALL, and JEAN STEARNS. *Jazz Dance: The Story of American Vernacular Dance*. New York, 1968.

CONSTANCE VALIS HILL

Jackson, Lillie Mae Carroll (May 25, 1889–July 6, 1975), civil rights leader. Born in Baltimore, Md., Lillie Mae Carroll was the daughter of former slave Charles Carroll, who was an eponymous descendant of one of the signers of the Declaration of Independence. In 1903, the Carrolls bought a house in the prosperous Druid Hill section of Baltimore, where much of that city's black middle class resided. Lillie Mae Carroll graduated from the Colored High and Training School in 1908 and began teaching. She married Kieffer Jackson, a traveling salesman, in 1910, and the two spent the next eight years on the road throughout the South. They returned to Baltimore in 1918 to raise their four children.

Jackson's involvement in civil rights activism began in 1931, when her daughter Juanita returned from college in Pennsylvania and organized the Baltimore Young People's Forum. Lillie Jackson formed an adults' advisory board for the group. They sponsored a successful "Buy Where You Can Work" campaign against businesses that refused to employ African Americans. Shortly thereafter, following a series of lynchings in the area, the national NAACP named Jackson to revive the floundering Baltimore branch. She then began a thirty-five-year career with the NATIONAL ASSOCIATION FOR THE ADVANCEMENT OF COLORED PEOPLE (NAACP) that resulted in many landmark civil rights victories. One of the Baltimore branch's first actions was a lawsuit to desegregate the University of Maryland law school, which was argued by Thurgood MARSHALL in his first case. Under Jackson, the NAACP also brought lawsuits throughout the 1940s and 1950s that resulted in the desegregation of public schools, parks, beaches, and swimming pools.

Under "Fearless Lil," the 1940s saw enormous growth in the Baltimore NAACP membership, which rose to 18,000 in 1946. Jackson organized and was elected president of the Maryland NAACP state conference in 1942. She helped organize demonstrations against police brutality in Annapolis that year. In response, the governor appointed her to the newly formed Interracial Commission, but she resigned shortly afterward, explaining that the commission was an ineffectual body that censored her opinions. She organized and participated in the Maryland Congress Against Discrimination in Baltimore in 1946. An extensive voter registration drive throughout the 1940s doubled the number of black voters and made registration more accessible. In 1956, Jackson received an honorary doctorate from Morgan State College (now Morgan State University) in Baltimore. During the 1950s, she also worked to make Baltimore the first city to comply with the 1954 BROWN V. BOARD OF EDUCATION Supreme Court decision. When the CIVIL RIGHTS MOVEMENT accelerated in the late 1950s, Jackson often contributed her own money to bail out arrested activists when the NAACP's funds were depleted.

Jackson was a devout Christian and a lifelong member of Baltimore's Stark Street United Methodist Church, as well as the first woman to serve on its board of trustees. She believed that the NAACP was "God's workshop" and was instrumental in uniting different congregations and denominations for civil rights activism. After she retired from the NAACP in 1970 at age eighty, she formed Freedom House, a network of inner-city community activists. She died in Baltimore in 1975.

REFERENCES

"Dr. Lillie M. Jackson: Lifelong Freedom Fighter." *Crisis* 82 (1975): 279–300.

GREENE, SUSAN ELLERY. *Baltimore: An Illustrated History*. Woodland Hills, Calif., 1980.

ALLISON X. MILLER

Jackson, Luther Porter (1892–April 20, 1950), educator, civic leader, and historian. Luther Porter Jackson was born to former slaves Edward and Delilah Jackson in Lexington, Ky., sometime in 1892. He graduated from high school at the Chandler Normal School in 1910, and attended Fisk University where he received his B.A. in 1914 and his M.A. in 1916. Years later, in 1937, he received a Ph.D. in history from the University of Chicago.

Jackson's teaching career began in South Carolina where he taught at the Voorhees Industrial School from 1915 to 1918. He then taught at the Topeka Industrial Institute until 1920. In 1922 he joined the

staff of the Virginia Normal and Industrial Institute in Petersburg (renamed Virginia State College in 1930), and was named associate professor of history in 1925. In 1929 he was promoted to full professor and chair of the history and social science department, a position he held for the rest of his life.

Jackson became an expert on blacks in Virginia, scrupulously studying courthouse documents. In 1942 he published *Free Negro Labor and Property Holding in Virginia, 1830–1860*. He went on to publish numerous scholarly works, including *Virginia Negro Soldiers and Seamen in the Revolutionary War* (1944) and *Negro Office Holders in Virginia, 1860–1895,* (1945).

Jackson was a vocal advocate for black suffrage, and beginning in 1942 he published *The Voting Status of Negroes in Virginia,* a pamphlet intended to encourage African Americans to vote. He also founded the Petersburg League of Negro Voters, which later became the Virginia Voters League. In 1947 the Southern Regional Council commissioned Jackson to study black voting in the South, the results of which were published in a pamphlet, *Race and Suffrage in the South Since 1940* (1948).

Jackson was very involved with the Petersburg Negro Business Association, which eventually became the Virginia Trade Association. He also was an accomplished musician—he played the cornet—and founded the Petersburg Community Chorus, which he directed in yearly concerts from 1933 to 1941.

Jackson was an active participant in Carter G. WOODSON's Association for the Study of Negro Life and History. He was also very active in fund-raising for the NAACP. In 1948 his efforts resulted in an award from the Virginia NAACP "for unselfish and devoted services in enhancing the voting status of Negroes." Jackson was a driven man who, in addition to his other activities, served on numerous boards and councils and often worked late into the night. He died of a heart attack in 1950. Luther Jackson High School was dedicated in his memory on April 17, 1955, in Merrifield, Va.

REFERENCE

LOGAN, RAYFORD W., and MICHAEL R. WINSTON, eds. *Dictionary of American Negro Biography.* New York, 1982.

DEBI BROOME

Jackson, Mahalia (October 26, 1911–January 27, 1972), gospel singer. When sixteen-year-old Mahala Jackson (as she was named at birth) arrived in Chicago in 1927, she had already developed the vocal style that was to win her the title of "world's greatest

gospel singer" (*see* GOSPEL MUSIC). Though born into an extremely religious New Orleans family, she spent hours listening to the recordings of blues singers Bessie SMITH and Ma RAINEY, and could be found at every parade that passed her neighborhood of Pinching Town in New Orleans.

In later life she would admit that though she was a thoroughgoing Baptist, the Sanctified church next door to her house had had a powerful influence on her singing, for though the members had neither choir nor organ, they sang accompanied by a drum, tambourine, and steel triangle. They clapped and stomped their feet and sang with their whole bodies. She recalled that they had a powerful beat she believed was retained from slavery, and once stated, "I believe blues and jazz and even rock 'n' roll stuff got their beat from the Sanctified church."

Jackson's style was set early on: From Bessie Smith and Ma Rainey she borrowed a deep and dark resonance that complemented her own timbre; from the Baptist church she inherited the moaning and bending of final notes in phrases; and from the Sanctified church she adopted a full-throated tone, delivered with a holy beat. Surprisingly, though gospel in its early stages was being sung in New Orleans, none of her vocal influences came from gospel singers.

Upon arriving in Chicago with her Aunt Hannah, Jackson joined the Johnson Singers, an a cappella quartet. The group quickly established a reputation as one of Chicago's better gospel groups, appearing

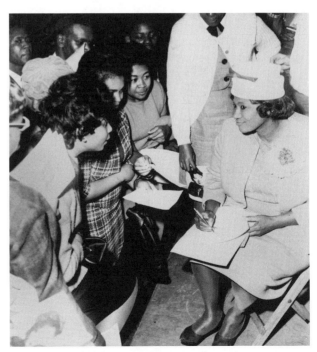

Mahalia Jackson (seated), signing autographs at Hunter College in New York City, 1965. (© George West)

regularly in concerts and gospel-song plays with Jackson in the lead. In time, Mahalia, as she now chose to call herself, became exclusively a soloist. In 1935 Thomas A. DORSEY persuaded her to become his official song demonstrator, a position she held until 1945. Dorsey later stated that Jackson "had a lot of soul in her singing: she meant what she sang."

Though she made her first recordings in 1937 for Decca, it was not until 1946, when she switched to the small Apollo label, that Jackson established a national reputation in the African-American community. Her 1947 recording of "Move On Up a Little Higher" catapulted her to the rank of superstar and won her one of the first two Gold Records for record sales in gospel music. (Clara Ward won the other.) Accompanied on this recording by her longtime pianist, Mildred Falls, Jackson demonstrated her wide range and ability to improvise on melody and rhythm. As a result of this recording, she became the official soloist for the National Baptist Convention and began touring throughout the United States. She was the first gospel singer to be given a network radio show when, in 1954, CBS signed her for a weekly show on which she was the host and star. In the same year she moved to the Columbia label, becoming a crossover gospel singer through her first recording on that label, "Rusty Old Halo." Several triumphs followed in rapid succession. She appeared on the Ed Sullivan and Dinah Shore television shows, at Carnegie Hall, and in 1958 for the first time at the Newport Jazz Festival. Tours throughout the world began, with Jackson garnering accolades in France, Germany, and Italy.

A crowning achievement of Jackson's was the invitation to sing at one of the inaugural parties of President John F. Kennedy in 1961. In 1963 she was asked to sing just before Rev. Dr. Martin Luther King, Jr. was to deliver his famous "I Have a Dream" speech at the March on Washington. Her rendition of "I've Been Buked and I've Been Scorned" contributed to the success of King's speech. During her career, she appeared in such films as *Imitation of Life* (1959) and *Jazz on a Summer's Day* (1958), sang "Precious Lord, Take My Hand" at the funeral of Dr. King, and recorded with Duke Ellington. Toward the end of her life, she suffered from heart trouble but continued to sing. She died in Chicago on January 27, 1972.

REFERENCES

HEILBUT, TONY. *The Gospel Sound: Good News and Bad Times.* 1971. Revised. New York, 1985.
JACKSON, MAHALIA, and E. M. WYLIE. *Movin' On Up.* New York, 1966.

HORACE CLARENCE BOYER

Jackson, May Howard (May 12, 1877–July 12, 1931), artist. May Howard Jackson is best remembered for her sculpture portraits of prominent African Americans of her day. Jackson was born in Philadelphia and attended the city's public schools. She became the first African-American woman to win a scholarship to the Pennsylvania Academy of Fine Arts, from which she graduated in 1899. Unlike most young and successful artists of her day, Jackson did not continue her studies in Europe but settled in Washington, D.C., after her marriage to high school principal William T. S. Jackson in 1902.

In Washington, Jackson established a studio and produced portrait busts of W. E. B. DU BOIS, Francis GRIMKÉ, Kelly MILLER, Paul Laurence DUNBAR, and others. Her portraits, as well as such thematic works as *Mulatto Mother and Child* and *Head of a Child*, broke ground with their realistic representations of African Americans. Jackson eschewed stereotypes of African Americans in art and refused to Europeanize African-American features in her work.

Jackson received critical acclaim, and her sculptures were exhibited at such prestigious sites as the Corcoran Art Gallery, the National Academy of Design, the National Academy of Art, and the 1913 Emancipation Exhibit. In 1928, her portrait of Kelly Miller was recognized with a bronze medal from the HARMON FOUNDATION. She also dedicated time to teaching young black artists and to passing on her ideals and commitments to the possibilities that art holds for uplifting a community. Jackson's fidelity to these ideals sometimes hindered the commercial success of her work, but she remained steadfast in her resolve until her death, leaving a concrete and lasting legacy in her sculptures.

REFERENCE

BONTEMPS, JACQUELINE F. *Forever Free: Art by African American Women, 1862–1980.* Alexandria, Va., 1980.

JUDITH WEISENFELD

Jackson, Maynard Holbrook, Jr. (March 23, 1938–), lawyer, politician. Maynard Jackson was born in Dallas, Tex., and at the age of seven moved with his family to Atlanta, Ga., where the elder Jackson served as pastor of Friendship Baptist Church until his death in 1953. As a Ford Foundation Early Admissions scholar, Jackson graduated from Morehouse College in Atlanta in 1956 with a B.A. in political science and history.

After graduation, Jackson worked for one year in Cleveland, Ohio, as a claims examiner for the Ohio

State Bureau of Unemployment Compensation, then as an encyclopedia salesman, and later as assistant district sales manager for the P.F. Collier Company in Buffalo, Boston, and Cleveland. In 1964, he received an LL.B. from North Carolina College at Durham and returned to Atlanta to practice law with the U.S. National Labor Relations Board (NLRB), where he handled representation cases and unfair labor practice cases. In 1967, Jackson left the NLRB to work for the Community Legal Services Center of Emory University. Specializing in housing litigation and providing free legal services to the poor in Atlanta's Bedford-Pine neighborhood, he developed a reputation as a civil rights activist.

In 1968, Jackson made a bid for a seat in the U.S. Senate against Senator Herman Talmadge, trying to appeal to those whom Talmadge had traditionally neglected, namely blacks and white liberals. Jackson lost the election but succeeded in out-polling Talmadge in Atlanta. Despite Jackson's defeat, this election provided him political exposure and helped him build a base of support among blacks and white liberals, a following that contributed to his later electoral victories.

In 1969, Jackson ran for vice mayor of Atlanta against Milton Farris, a white alderman, on a "coalition" campaign that built upon his previous support from black and white liberal voters. In the 1969 campaign both Jackson and the mayoral winner, Sam Massell, received crucial support from the city's growing number of black voters. While Jackson recognized the importance of his support from blacks, he avoided any direct appeals to race consciousness for fear of alienating the city's white voters. Jackson won the election and was sworn in as Atlanta's first black vice mayor in 1970, and in conjunction with this position, as the first black president of the board of aldermen. In the same year, he cofounded the law firm of Jackson, Patterson, and Parks. As vice mayor, Jackson was a strong supporter of grassroots organizations, urging the formation of neighborhood coalitions.

In 1973, Jackson entered the mayoral race against eleven candidates, including incumbent Mayor Sam Massell and the powerful black state senator and favorite of the old guard black leadership, Leroy Johnson. Jackson defeated Massell in the runoff election in which Massell, a liberal Democrat and traditionally a moderate on racial issues, ran a racially divisive campaign. Jackson, however, continued to build upon the support he had received from blacks and white liberals in earlier elections and campaigned on a "people-oriented" platform. The major issues he addressed were crime, law enforcement, housing, and a jobs training and placement program. Jackson pledged to end racism in the city's hiring policies but stated his opposition to any program that favored blacks as racially or legally superior.

Jackson was inaugurated as Atlanta's first black mayor in January 1974. At the age of thirty-four, he was also the city's youngest mayor. He served two consecutive terms, holding the mayoral office from 1974 to 1982, and serving the maximum number of consecutive terms allowed by the city's charter.

Jackson entered office in 1974 under a new city charter, the first in one hundred years, which replaced the former weak mayor-council form of government with one that gave the mayor increased administrative powers. The charter required all agencies and departments to report to the mayor and abolished the position of vice mayor. The charter also augmented Jackson's power by providing him the opportunity to reorganize the city government.

As mayor, Jackson worked to break down discriminatory barriers in the city's hiring policies and in securing city contracts. He created the city's first minority business program, ensuring opportunities for minorities and women in major city contracts and in administrative posts in the city government while at the same time maintaining links to the city's traditional white business elite. Jackson also opened the lines of communication between his office and Atlanta's neighborhoods, creating a monthly "People's

Maynard Jackson, mayor of Atlanta, Ga., at the Democratic National Convention in New York, July 1976. (© Lawrence Frank/Black Star)

Day," in which he traveled to various neighborhoods to listen to residents' concerns and complaints.

After leaving office, Jackson became a managing partner of Chapman and Cutler, a Chicago-based municipal law firm, building a lucrative bond practice and founding Jackson Securities Inc., an investment banking firm, in 1987. In 1989, Jackson reentered Atlanta politics, winning a landslide election to serve his third term as mayor. During this period he guided the city through the initial steps of preparation for the summer centennial Olympic Games in 1996. At the close of his term at the end of 1993, Jackson returned to Jackson Securities, Inc. as full-time chairman of the board and majority stockholder.

REFERENCES

Bass, Jack. *The Transformation of Southern Politics.* New York, 1976.

Jamieson, Duncan R. "Maynard Jackson's 1973 Election as Mayor of Atlanta." *Midwest Quarterly* 18 (October 1976): 7–26.

Derek M. Alphran

"The Jackson Five" (clockwise from the front), Randy, Michael, Marlon, Jackie, and Tito. (Photographs and Prints Division, Schomburg Center for Research in Black Culture, The New York Public Library, Astor, Lenox and Tilden Foundations)

Jackson, Michael, and the Jackson Family,

pop singers and performers. A dominant influence on American popular music since the 1960s, the Jackson family consists of the nine children of Joseph and Katherine Jackson. The couple's first five sons, Sigmund "Jackie" (May 4, 1951–), Toriano "Tito" (October 15, 1953–), Jermaine (December 11, 1954–), Marlon (March 12, 1957–) and Michael (August 29, 1958–), began singing in 1962. Their other children, Maureen "Rebbie" (May 29, 1950–), LaToya (May 29, 1956–), Steven "Randy" (October 29, 1962–), and Janet (May 16, 1966–) began entertaining publicly with their siblings in the 1970s. By the 1980s, the Jackson family was generating a nonstop stream of recordings, music videos, movies, television shows, and concerts, that were hugely popular among both African-American and white audiences. In the 1990s, however, public attention increasingly turned to squabbles within the family, and focused on their public airing of grievances.

All of the Jackson children were born and raised in the midwestern industrial city of Gary, Ind., where they led a sheltered existence in a working-class neighborhood. The five oldest sons were driven by their father, a steel mill crane operator and one-time RHYTHM AND BLUES guitarist, to practice music three hours a day. They began to perform in local talent contests in 1963, and rapidly advanced to amateur contests in Chicago. In 1967, Michael's lead soprano

and irresistible dance moves, borrowed from James BROWN, helped the brothers win the famed amateur night contest at Harlem's APOLLO THEATER. The next year, after two single records released on the Steeltown label failed to create a stir, the Jacksons signed with MOTOWN, the black-owned Detroit recording company. Motown's owner Berry Gordy took complete control over the group, even concocting the story that the group had been discovered by Motown singer Diana ROSS. Gordy chose their songs, managed their performances, and gained the rights to their name, then "The Jackson Five." The group's first singles, including "I Want You Back" (1969) and "ABC" (1970), were popular, layering Michael's vocals over funky, stutter-step bass lines.

In 1970 the family moved to Los Angeles, and in the years that followed the Jacksons made numerous television appearances, including a cartoon series and a feature special, "Goin' Back to Indiana." Although their recordings from this time suffered from a sense of forced cuteness, their popularity never flagged,

and the brothers continued to distinguish themselves by insisting on performing much of the instrumental backing themselves. Their recordings from this time include *Lookin' Through The Windows* (1972) and *Get It Together* (1973). Michael recorded his first solo album, *Got To Be There*, in 1971. His second solo recording, *Ben* (1972), a soundtrack single, went to number one and received an Academy Award nomination. In 1974 the Jacksons broke with the formulaic routine of Motown recordings and produced "Dancing Machine," a frenetic dance hit that presaged the disco era. The next year, Michael recorded another solo album, *Forever, Michael*. In 1975 the group broke with Motown, and signed with Epic, which offered them five times as much in royalties as Motown. Since Motown owned the name "The Jackson Five," they changed their name to "The Jacksons." However, Jermaine remained with Motown to pursue a solo career, having married Hazel Gordy, the daughter of Motown's founder.

Like Motown, Epic at first refused to let the Jacksons, who had replaced Jermaine with Randy, write or produce their own material. Instead, their densely layered pop hits, bridging the gap between soul and disco, were written by the Philadelphia-based team of Kenny Gamble and Leon Huff. It was only in 1977 that the Jacksons were finally allowed to fully control their own recordings. The resulting album, *Destiny*, mixed Michael's intense, gospel-style vocals with streamlined rhythms, and yielded the hit single "Shake Your Body (Down to the Ground)," written by Michael and Randy. In 1976 and 1977 Randy joined Michael, Jackie, Tito, and Marlon in a television variety show, "The Jacksons." Rebbie, LaToya, and Janet also joined the cast, performing in both musical and comedy sketches. In 1978 Michael appeared as the Scarecrow in the film *The Wiz*.

In 1979 Michael appeared resplendent in a tuxedo and glowing white socks in a photograph on the cover of *Off The Wall*, an album that announced his emergence as an adult entertainer. A collaboration with Quincy JONES, the album yielded four Top Ten singles, including scorching dance cuts such as "Don't Stop 'Til You Get Enough," as well as lush ballads, and sold eleven million copies. The next year Michael reunited with his brothers on *Triumph*, but by this time it was clear that his superstar status virtually relegated his brothers to a backing role. In 1982 Michael again teamed up with Jones to make *Thriller*, a rock-oriented album that yielded seven Top Ten singles, including "Wanna Be Startin' Somethin' "; a duet with Paul McCartney, "The Girl is Mine;" "Beat It"; "Billie Jean"; and the title track, with a witty rap by actor Vincent Price. *Thriller* sold more than 40 million copies, making it the best-selling album of all time. The music videos for *Thriller*'s sin-gles brought an end to MTV's refusal to feature African-American music. The "Beat It" video brought special acclaim, with its choreographed gang fight evoking the production numbers of a Broadway musical scored for rock and roll, and was called "Michael's *West Side Story*."

During this time Michael, who had always been a witty and talented stage performer, began to attract attention as a dancer. In a 1983 television special celebrating Motown's twenty-fifth anniversary, Michael electrified a huge broadcast audience with his rendition of the African-American vernacular dance step known as "the creep." Michael's version, known as "the moonwalk," combined the traditional forward-stepping, back-sliding routine with James Brown's signature spins, which Michael had copied as a child, and the robotic "locking" motions long popular among street performers.

After recording *Triumph* in 1980, the Jacksons brought Michael back for the enormously successful *Victory* album and tour. Since then the Jacksons as a group have been less active, concentrating on solo careers, although Jackie, Marlon, Tito, and Randy did record *2300 Jackson Street* (1989). After Michael, Jermaine Jackson has been the most successful male singer in the family. He released *Jermaine* in 1972 and recorded almost a dozen more solo albums over the next decade. In recent years he has recorded *Precious Moments* (1986), *Be the One* (1989), and *Don't Take It Personal* (1990). In 1991 he recorded "You Said, You Said" and "Word to the Badd," a scalding attack on Michael. Marlon Jackson's solo album, *Baby Tonight*, was released in 1987. Randy Jackson, who was badly injured in a 1980 auto accident, recovered in time for the Jacksons' reunion in 1984. He released his first solo album in 1989.

The Jackson daughters have also had solo careers. The oldest, Rebbie, continued performing after the 1970s, but without the popularity of her two younger sisters. LaToya Jackson released four undistinguished solo albums, including *LaToya Jackson*, *My Special Love*, *Heart Don't Lie*, and *LaToya* before bringing on the censure of her family and many members of the African-American community by posing nude in *Playboy* in 1989. Since then she has continued to record and perform, notably in a Paris revue. In 1991 she countered her mother's 1990 memoirs, *The Jacksons: My Family*, by publishing *LaToya: Growing Up in the Jackson Family*, which portrayed a childhood dominated by fear and abuse.

Janet Jackson appeared on several television shows and recorded two albums, *Janet Jackson* and *Dream Street*, before her graduation from high school in 1984. Her 1986 album *Control*, presenting a persona of steely independence against spare, mechanical rhythms, sold more than six million copies and

yielded the hit single "What Have You Done For Me Lately?" In 1989 she released *Janet Jackson's Rhythm Nation 1814*. The album's plea for racial unity sits somewhat uneasily over its pulsating rhythms, but it sold eight million copies, won a Grammy Award, and led to a world tour in which Janet showed off her precisely choreographed ensemble dancing. In 1993 she starred in the film *Poetic Justice* and released *janet.*, an album that traded in the bitter, independent stance of her previous albums for more themes involving romantic and sexual love.

Since the mid-1980s, Michael Jackson has become less a pop superstar than an icon of American popular culture. He helped write and perform the charity song "We Are the World" in 1985. His 1987 album *Bad* and his 1991 album *Dangerous* sold well, but broke no new musical ground. Increasingly, he has been noted more for his eccentricity than for his music. At first his flamboyant wardrobe combined martial elegance with street toughness, and he became famous for wearing a single, sequined glove. Extensive plastic surgery on his nose, chin, eyes, and cheeks, and chemical skin peels, as well as heavy makeup, have led to accusations that he is attempting to erase his identity as an African American. Michael has answered by claiming that he has a rare skin disease that causes discoloration. His increasingly androgynous appearance has caused frequent speculation in the media regarding his sexual identity, but Michael, who aside from his 1988 autobiography *Moonwalker* and infrequent television interviews, has guarded his privacy, long proclaimed his celibacy. He lived with his mother until he was twenty-nine, and he subsequently moved to "Neverland," a fantasy estate that includes a ferris wheel and a zoo. He has long publicly befriended children, and has worked on behalf of children's charities. In 1993 Michael was accused of having sexual relations with a minor. Jackson vigorously denied the accusation, but reached a monetary settlement with the boy's family in January 1994. Later that year he announced his marriage to Lisa Marie Presley, the daughter of white superstar Elvis Presley. In June 1995, just before the release of Michael's album *HIStory*, he and Lisa Marie were interviewed on television, and insisted on his innocence of any sexual misconduct with minors. *HIStory* reached number 1 on the charts shortly after its release.

Despite internal family conflicts, the Jacksons remain, collectively and individually, the most prominent and productive family in African-American popular music.

REFERENCES

GEORGE, NELSON. *The Michael Jackson Story*. New York, 1984.

JACKSON, MICHAEL. "Michael Jackson Speaks." *Jet* 85, no. 10 (January 10, 1994): 60.

MARSH, DAVE. *Trapped: Michael Jackson and the Crossover Dream*. New York, 1985.

ORTH, MAUREEN. "Nightmare in Neverland." *Vanity Fair* 57, no. 1 (January 1994): 70.

TARABORRELLI, RANDY. *Michael Jackson: The Magic and the Madness*. New York, 1991.

HARRIS FRIEDBERG

Jackson, Milton "Bags" (January 1, 1923–), jazz vibraphonist. Born into a musical family in Detroit, Mi. Milt Jackson began teaching himself piano and guitar at age seven and began formal piano lessons at age eleven. He performed regularly for church and local groups and sang tenor with a gospel quartet, experiences that were influential in shaping his personal musical style. He switched to vibraphone and xylophone in high school and eventually became the first to play the bebop style on these instruments. He is considered by many to be one of the best improvisers in jazz, combining the fluid melodic inventions of bebop with an aggressive blues and gospel feel.

Jackson was discovered by Dizzy GILLESPIE in 1945, while playing in a Detroit-based band. He played and recorded in various Gillespie groups over the next few years and also did freelance work. In

Premier bebop vibraphonist Milt Jackson has a unique, shimmering sound that has been an integral part of jazz ensembles from his days with Dizzy Gillespie to his over forty years as a member of the Modern Jazz Quartet. (Photographs and Prints Division, Schomburg Center for Research in Black Culture, The New York Public Library, Astor, Lenox and Tilden Foundations)

1952, he recorded with his own group, the Milt Jackson Quintet. He remained with the group, renamed the Modern Jazz Quartet (MJQ), until it disbanded in 1974. He served on the faculty of the annual three-week School of Jazz workshop in Lenox, Mass., in 1957. After 1974, he pursued a solo career, making recordings, touring, and giving periodic reunion performances with the MJQ.

REFERENCE

PALMER, R. "Milt Jackson Revisited." *Jazz Journal International* 39, no. 5 (1986): 8; and 39, no. 7 (1986): 14.

GUTHRIE P. RAMSEY, JR.

Jackson, Oliver Lee (June 23, 1935–), painter, sculptor. Born and raised in St. Louis, Mo., Oliver Jackson studied art at Illinois Wesleyan University in Bloomington, Ill., where he received his B.F.A. in 1958. Five years later, in 1963, he received his M.F.A. from the University of Iowa. Jackson then returned to St. Louis and began teaching art at local colleges, including St. Louis Community College and Washington University. In 1968, Jackson became a member of the St. Louis Black Artists Group (BAG), a grass-roots organization created by black artists to promote the arts in black communities around St. Louis. Members of BAG included painter Emilio CRUZ, dancer Georgia Collins, poet Bruce Rutlin, and musicians Julius Hemphill and Oliver LAKE.

Since the 1960s, Jackson has developed a style influenced by sources ranging from the drip paintings of Jackson Pollock to the late figural works of Phillip Guston, and the avant-garde jazz compositions of his friend Julius Hemphill. In his paintings, Jackson has utilized an abstract organization of space but has represented the human figure, with an emphasis upon physical gestures, to communicate spiritual or psychological states of being. He has created a luminous, vibrantly colored environment, often comprised of pinks, greens, and silvers, in which weightless forms float toward a magnetic center, actively drawing the viewer into the image (*Untitled [11/30/80],* 1980; *Sharpeville* series, 1968–77; *Alchemy* series, 1975–77). Jackson's largest paintings, often ten by fifteen feet, were created on the floor by stepping into the painting from various angles to see the piece from different perspectives.

Jackson began to focus on sculpture after 1978, and has continued to develop his interest in using gesture to represent psychological states. Utilizing a wide range of materials, from sheet metal and flattened marble to cloth, glass beads, and metal pieces, Jack-son has drawn upon traditions in European and African art to create works that reveal themselves as constructed objects (*Iron People,* 1978; *Untitled No. 4,* 1983). One of his best-known sculptures, *Untitled No. 3* (1983), is a figure shaped from bolted sheets of flat marble with a heart made from the rags that were used to clean the marble.

Jackson's paintings have been exhibited at the Allan Stone Gallery in New York (1980), the Seattle Art Museum (1982), the University Art Museum in Berkeley (1983, 1985), and the Ianetti-Lanzone Gallery in San Francisco. He received a National Endowment for the Arts Award in Painting in 1980–1981, and has served as artist-in-residence at schools across the United States. Jackson has been a professor of art at California State University in Sacramento since 1971.

REFERENCES

ALBRIGHT, THOMAS, and JAN BUTTERFIELD. *Oliver Jackson.* Seattle, 1982.
HACKETT, REGINA. "Oliver Lee Jackson: Forms that Feeling Takes." *Artforum* (Summer 1979).

ELIZABETH WRIGHT MILLARD

Jackson, Peter (July 3, 1861–July 13, 1901), boxer. Peter Jackson was born in St. Croix, in the British Virgin Islands. At age six he moved with his parents to Australia, one of the world's BOXING centers at the time. Jackson competed both in sculling and swimming before turning to boxing in 1878, when he began taking lessons from a professional trainer. At 6′ 1″ and 190 pounds, Jackson began prizefighting in 1882. Four years later, he won the Australian heavyweight title from Tom Leeds, becoming the first black man to win a national boxing title.

Jackson sailed for the United States in 1888 to continue his boxing career. That year, he soundly defeated George Godfrey, one of the major black contenders at the time, in nineteen rounds. While his boxing career was limited primarily to black opponents, Jackson was able to get matches with such prominent white boxers as Joe McAuliffe, Patsy Cardiff, and Frank Slavin, all of whom he defeated. Nevertheless, Jackson was never able to fight the heavyweight champion, John L. Sullivan, because of Sullivan's refusal to box with blacks. Jackson left for England around 1890 to fight the former bare-knuckle champion, Jem Smith.

In 1891 Jackson returned to the United States to fight James Corbett in San Francisco. The match, one of the first in which the boxers wore gloves, ended in a draw after sixty-one rounds. But Jackson never had

the opportunity to meet Corbett in a rematch or to contend for the championship title since Corbett refused to fight black boxers after he captured the heavyweight title in 1892.

Due to the racist attitudes of his white opponents, Jackson's boxing opportunities were limited. He had a career record of 35 wins, 3 losses, and 1 draw, and was noted more for his defensive than his offensive technique. Denied the opportunity to compete for the U.S. heavyweight title, Jackson fought in some minor exhibition bouts after 1891. He followed his boxing career with several unsuccessful business ventures, including a short-lived vaudeville company in 1893 and a boxing school in London in 1897. After the boxing school's almost immediate failure, Jackson returned to Queensland, Australia, where he died of tuberculosis in 1901.

REFERENCES

ASHE, ARTHUR R., JR. *A Hard Road to Glory: A Story of the African-American Athlete Since 1946*. New York, 1988.

ISENBERG, MICHAEL T. *John L. Sullivan and his America*. Urbana, Ill., 1988.

LOUISE P. MAXWELL

Jackson, Rebecca Cox (February 15, 1795–May 24, 1871), preacher. Rebecca Cox Jackson was born into a free family in Horntown, Pa., and lived at different times with her maternal grandmother and with her mother, Jane Cox (who died when Rebecca was thirteen). In 1830, when her religious autobiography begins, she was living in the household of her older brother, Joseph Cox, a tanner and local preacher of the Bethel African Methodist Episcopal (AME) Church in Philadelphia. Married to Samuel S. Jackson, and childless herself, Jackson cared for her brother's four children while earning her own living as a seamstress.

As the result of a powerful religious awakening during a thunderstorm, Jackson became active in the early HOLINESS MOVEMENT. She moved from leadership of praying bands to public preaching, stirring up controversy within AME circles not only as a woman preacher but also because she had received the revelation that celibacy was necessary for a holy life, and she criticized the churches roundly for "carnality." Jackson's insistence on being guided entirely by the dictates of an inner voice ultimately led to her separation from husband, brother, and church.

After a period of itinerant preaching in the late 1830s and early 1840s, Jackson joined the United Society of Believers in Christ's Second Appearance (SHAKERS), at Watervliet, N.Y., attracted by their religious celibacy, emphasis on spiritualistic experience, and dual-gender concept of deity. With her younger disciple and lifelong companion, Rebecca Perot, Rebecca Jackson lived there from June 1847 until July 1851.

Disappointed in the predominantly white Shaker community's failure to take the gospel of their founder, Ann Lee, to the African-American community, Jackson left Watervliet in 1851, on an unauthorized mission to Philadelphia. In 1857 she and Perot returned to Watervliet, and after a brief second residence Jackson won the right from Shaker leadership to found and head a new Shaker "outfamily" in Philadelphia. This predominantly African-American and female Shaker family survived her death in 1871 by at least a quarter of a century.

Rebecca Jackson's major legacy is her remarkable spiritual autobiography, *Gifts of Power*. Here Jackson records her receipt of a wide variety of visionary experiences, dreams, and supernatural gifts, and her spiritual journey as a woman with a divine calling. Her visionary writing has received growing recognition both as source material for African-American history and theology and as spiritual literature of great power. Alice WALKER has described Jackson's autobiography as "an extraordinary document" that "tells us much about the spirituality of human beings, especially of the interior spiritual resources of our mothers" (Walker 1983, p. 78).

REFERENCES

HUMEZ, JEAN MCMAHON. *Gifts of Power: The Writings of Rebecca Cox Jackson, Black Visionary, Shaker Eldress*. Amherst, Mass., 1981.

WALKER, ALICE. "Gifts of Power: The Writings of Rebecca Cox Jackson." In *In Search of Our Mothers' Gardens*. New York, 1983, pp. 71–82.

JEAN MCMAHON HUMEZ

Jackson, Reginald Martinez, "Reggie" (May 18, 1946–), baseball player. Born in Wyncote, Pa., Reggie Jackson attended Arizona State University on a football scholarship, but switched to baseball after one year. He began his twenty-one-year major league career in baseball in 1967, when he joined the Kansas City Athletics. He moved with the team to Oakland in 1968 and the following year established his batting prowess, hitting 47 home runs in 1969. He left Oakland in 1976 to play with the Baltimore Orioles, and then joined the New York Yankees in 1977 for five tumultuous seasons. Jackson, nicknamed "Mr. October" by Yankee catcher Thurman Munson, earned

his greatest fame for his extraordinary post-season play. His single most famous exploit was in the sixth game of the 1977 World Series against the Los Angeles Dodgers, when he hit three consecutive home runs thrown by three different pitchers, all on the first pitch.

Between 1982 and 1986 Jackson was a member of the California Angels, and he ended his career in 1987 with the Oakland Athletics. Although he generally played in the outfield, in about a fifth of his games he was used as a designated hitter. Jackson hit 563 home runs during his career, but also set a career record for strikeouts by a hitter (2,597). Jackson played in eleven All-Star Games, and played for the American League pennant for eleven seasons, and in five World Series. He was voted the American League's Most Valuable Player in 1973.

Jackson was a brash, exciting player who did not mind challenging managers or owners when he thought them wrong. He also excelled in the art of self-promotion (he even had a candy bar named after him, the "Reggie"), especially after he went to play in New York.

Reggie Jackson's late-season heroics under pressure earned him the sobriquet "Mr. October." Protected from the rush of fans by a policeman, he returns to the dugout after a victory that clinched the 1980 Eastern Division title for the New York Yankees. (UPI/Bettmann)

Jackson was elected to the Baseball Hall of Fame in 1993. In recent years he has been involved with the Big Brothers and Big Sisters program, has served as National Chairman for Amyotrophic Lateral Sclerosis, and has owned several automobile dealerships in the Oakland, Calif., area. In 1993 he became a special adviser to the General Partners of the New York Yankees.

REFERENCE

ASHE, ARTHUR R., JR. *A Hard Road to Glory: A History of the African American Athlete Since 1946.* New York, 1988.

PETER EISENSTADT

Jackson, Shirley Ann (August 5, 1946–), theoretical physicist. Born, raised, and educated in Washington, D.C., Shirley Jackson was one of only thirty or so women who entered MIT in 1964. She was awarded a B.S. in physics in 1968 and a Ph.D. in 1973 for her work in elementary particle physics. Jackson's was the first female African-American doctorate from M.I.T. After earning her degree, she was a research associate (1973–1974, 1975–1976) at the Fermi National Accelerator Laboratory in Batavia, Ill., and a visiting scientist (1974–1975) at the European Center for Nuclear Research (CERN), where she worked on theories of strongly interacting elementary particles.

In 1975 Jackson moved to the Stanford Linear Accelerator Center and Aspen Center for Physics before leaving the following year to work for the Bell Laboratories of American Telephone and Telegraph in Murray Hill, N.J. During her early years at Bell Laboratories, Jackson's research was in the areas of theoretical physics, scattered- and low-energy physics, and solid-state quantum physics. She studied the electrical and optical properties of semiconductors.

Jackson was elected in 1975 as a member of the Massachusetts Institute of Technology Corporation, the institute's board of trustees. She was made a lifetime trustee in 1992. In 1985, New Jersey Governor Thomas Kean appointed her to the state's Commission on Science and Technology. Specializing in optical physics research, she was named a distinguished member of the technical staff of Bell Laboratories in 1990. In 1991 she received an appointment as professor of physics at Rutgers University. Jackson's achievements in science have been recognized by other scientists through her election as a fellow of the American Physical Society and the American Academy of Arts and Sciences.

A theoretical physicist with a research interest in semiconductors, Shirley Jackson taught at the Massachusetts Institute of Technology for many years and was later a trustee there. (Photographs and Prints Division, Schomburg Center for Research in Black Culture, The New York Public Library, Astor, Lenox and Tilden Foundations)

REFERENCES

HAYDEN, ROBERT C. "Dr. Shirley A. Jackson: From Bumblebees to Elementary Particles." *Seven African-American Scientists.* Frederick, Md., 1992.
"Nuclear Physicist at Fermi Lab," *Ebony* (November 1974): 113–122.

ROBERT C. HAYDEN

Jackson, Vincent Edward "Bo" (November 30, 1962–), athlete. Bo Jackson was born in Bessemer, Ala. He received his nickname as a youth because he was said to be as wild as a "Boar Hog," which was subsequently shortened to "Bo." He excelled in BASEBALL, FOOTBALL, and TRACK AND FIELD (he was a two-time state decathalon champion at McAdory High School) and became perhaps the most successful modern two-sport professional athlete.

After attending high school in McCalla, Ala., Bo turned down a $250,000 bonus from the New York Yankees to attend Auburn University in Alabama. From 1982 to 1985 Bo rushed for 4,303 yards for Auburn's football team. He hit .335, with 28 home runs and 70 RBIs in baseball, and also ran in the 55- and 100-meter races for the track team. In 1985 he received the Heisman Trophy, awarded annually to the best college football player in the country.

In 1986 Jackson surprised the sports world by choosing to sign a baseball contract with the Kansas City Royals rather than with the Tampa Bay Buccaneers professional football team. With the Royals from 1986 to 1990, he hit .250, with 109 home runs and 313 RBIs. He was named Most Valuable Player of the 1989 All-Star Game, hitting a first-inning home run on his first swing.

In 1987 Jackson announced that he would join the Los Angeles Raiders football team after baseball season was over. With the Raiders from 1987 to 1990, he rushed for 2,782 yards and scored 16 touchdowns, two of which were runs of over 90 yards. He is the only player in National Football League history to do so more than once. In 1990 he was selected to the NFL Pro Bowl, thereby becoming the first player to be selected to All-Star games in two professional sports.

On January 13, 1991, Jackson suffered a severe hip injury during an NFL playoff game. Subsequently, he missed the 1991 and 1992 baseball and football seasons. The *National,* a daily sports paper, called it "the $100 Million Injury." Jackson had been one of the best-known product endorsers from the world of sports in 1989. His catchphrase, "Bo Knows . . .", calling attention to his multisport prowess, was part of a product endorsement campaign that brought Bo's image to people all across the nation.

On April 4, 1992, Jackson underwent surgery to receive an artificial hip. He returned to major league baseball with the Chicago White Sox baseball club for the 1993 baseball season and continued to play for them during the strike-shortened 1994 campaign.

REFERENCE

JACKSON, BO, with Dick Schaap. *Bo Knows Bo.* New York, 1990.

DAVID J. ROSENBLATT

Jackson State Incident. On May 14, 1970, members of the Mississippi Highway Patrol and the Jackson, Miss., Police Department fired on students at a predominantly black institution, Jackson State College (now Jackson State University), killing two and wounding twelve. The tragedy was one of a

number of instances in which, during the turbulent Vietnam era, armed force brought campus unrest to a violent end.

Just two weeks earlier, on April 30, President Richard M. Nixon announced plans to invade Cambodia, and universities across the United States exploded in protest. On May 4, four Kent State University students were killed and nine wounded by Ohio National Guard troops. More turmoil followed the bloodshed as students went on strike nationwide and campus-based military facilities went up in flames.

Jackson State was not known as a bastion of organized political activity; in the past, school administrators, dependent on state support, had threatened to expel students active in civil rights. Still, the escalation of the war in Vietnam, the expansion of the military draft, and the Kent State slayings, together with an atmosphere of racial hostility in Mississippi, added fuel to student discontent. On May 7, some 500 students attended a peaceful rally at Jackson State about the war. By May 13, two days after six black people were murdered amid racial disturbances in Augusta, Ga., tensions on campus had noticeably risen.

The college, located about one mile from downtown Jackson, was frequently traversed by white motorists, and black students resented the intrusion. Since the mid-1960s, some had taken to tossing rocks and bottles at white drivers passing by. On the night of May 13, 100 to 150 students gathered near the dormitories and student union, some throwing rocks at passing cars. The crowd chanted antiwar slogans, and several participants set park benches, tires, and trash on fire. Campus security and local police were called in, while Mississippi Gov. John Bell Williams sent the state highway patrol and placed the National Guard on alert. By the early morning hours, the tumult had died down.

The next night, May 14, the scene was repeated, with National Guard troops stationed on the outskirts of the campus. One person set a dump truck on fire, and some students jeered and threw rocks from behind a chain-link fence. Shortly after midnight, highway patrol and police officers opened fire on the crowd and into Alexander Hall, a women's dormitory. After a twenty-eight-second fusillade, twelve students were wounded and two killed—Phillip Lafayette Gibbs, a twenty-one-year-old college junior, and James Earl Green, a seventeen-year-old high school student. Alexander Hall was riddled with hundreds of bullets, and the college closed down for the rest of the term.

Following the attack, a number of Mississippi politicians and law enforcement officials—many with long histories of animosity toward African Americans—were quick to fix blame on the students. When members of the highway patrol refused to cooperate with the Federal Bureau of Investigation (FBI), Governor Williams threw his support behind them. While the highway patrol acknowledged discharging their weapons, the city police insisted they had not done so; their claims were later proved false. Moreover, officers' reports of sniper fire from a dormitory window were never substantiated. A federal grand jury convened in June 1970 issued no indictments for the killings; a county grand jury not only vindicated the officers but tried to indict a black youth for inciting them. In September of that year, the President's Commission on Campus Unrest called the shootings at both Kent and Jackson State "unjustified," but the commission's findings carried no legal weight.

The Jackson State survivors, together with victims' families, filed suit in U.S. District Court in February 1972 against members of the highway patrol and police, the city of Jackson, and the state of Mississippi. An all-white jury found for the defendants, and the plaintiffs filed an appeal. In October 1974, the U.S. Court of Appeals ruled that the use of force had been excessive but exonerated the city and state from the suit on grounds of "sovereign immunity." In January 1982, the U.S. Supreme Court rejected a further appeal to hear the case by a vote of 7–2.

Over the years, events at Kent State (where the students who died were white) have received far more attention that those at Jackson State. The shootings at Jackson State, however, were an equally devastating consequence of the "war at home"—exacerbated in this case by racial antagonism—that continued to rage even after the decade of the 1960s drew to a close.

REFERENCES

The Report of the President's Commission on Campus Unrest. New York, 1970.
RHODES, LELIA GASTON. *Jackson State University: The First Hundred Years, 1877–1977.* Jackson, Miss., 1979.
SPOFFORD, TIM. *Lynch Street: The May 1970 Slayings at Jackson State College.* Kent, Ohio, 1988.

JEANNE THEOHARIS

Jacobs, Harriet Ann (1813–March 7, 1897), slave narrator and reformer. She was born a slave in Edenton, N.C. Jacobs's major contribution is her narrative, *Incidents in the Life of a Slave Girl: Written by Herself* (1861). The most comprehensive antebellum autobiography by an African-American woman, *Incidents* is the first-person account of Jacobs's pseudonymous narrator "Linda Brent," who writes of her sexual oppression and her struggle for freedom. After publishing her book, Jacobs devoted her life to

providing relief for black Civil War refugees in Alexandria, Va.; Savannah, Ga.; and Washington, D.C.

Writing as "Linda Brent," Jacobs tells the story of her life in the South as slave and as fugitive, and of her life as a fugitive slave in the North. Breaking the taboos forbidding women to discuss their sexuality, she writes of the abuse she suffered from her licentious master, Dr. James Norcom, whom she calls "Dr. Flint." She confesses that to prevent him from making her his concubine, at sixteen she became sexually involved with a white neighbor. Their alliance produced two children, Joseph (c. 1829–?), whom she calls "Benny," and Louisa Matilda (1833–1917), called "Ellen." Jacobs describes her 1835 flight from Norcom and the almost seven years she spent in hiding, in a tiny crawl space above a porch in her grandmother's Edenton home.

She further recounts her 1842 escape to New York City; her reunion with her children, who had been sent north; and her subsequent move to Rochester, N.Y., where she became part of the circle of abolitionists around Frederick DOUGLASS's newspaper the *North Star*. Condemning the compliance of the North in the slave system, she describes her North Carolina master's attempts to catch her in New York after passage of the 1850 FUGITIVE SLAVE LAW. Jacobs explains that despite her principled decision not to bow to the slave system by being purchased, in 1853 her New York employer, Nathaniel Parker Willis (called "Mr. Bruce"), bought her from Norcom's family. Like other slave narrators, she ends her book with her freedom and the freedom of her children.

Most of the extraordinary events that "Linda Brent" narrates have been documented as having occurred in Jacobs's life. In addition, a group of letters that Jacobs wrote while composing her book present a unique glimpse of its inception, composition, and publication, and recount her complex relationships with black abolitionist William C. NELL and white abolitionists Amy Post and Lydia Maria Child. They also make an interesting commentary on Jacobs's northern employer, the litterateur Nathaniel Parker Willis, and on Harriet Beecher Stowe, the author of UNCLE TOM'S CABIN, whom Jacobs tried to interest in her narrative.

Although *Incidents* was published anonymously, Jacobs's name was connected with her book from the first; only in the twentieth century were its authorship and its autobiographical status disputed. *Incidents* made Jacobs known to the northern abolitionists, and with the outbreak of the Civil War she used this newfound celebrity to establish a new career for herself. She collected money and supplies for the "contrabands"—black refugees crowding behind the lines of the Union Army in Washington, D.C., and in occupied Alexandria, Va.—and returned south.

Supported by Quaker groups and the newly formed New England Freedmen's Aid Society, in 1863 Jacobs and her daughter moved to Alexandria, where they provided emergency relief supplies, organized primary medical care, and established the Jacobs Free School—a black-led institution providing black teachers for the refugees. In 1865, mother and daughter moved to Savannah, where they continued their relief work. Throughout the war years, Harriet and Louisa Jacobs reported on their southern relief efforts in the northern press and in newspapers in England, where Jacobs's book had appeared as *The Deeper Wrong: Incidents in the Life of a Slave Girl: Written by Herself* (1862). In 1868, they sailed to England, and successfully raised money for Savannah's black orphans and aged.

But in the face of increasing violence in the South, Jacobs and her daughter then retreated to Massachusetts. At Boston, they were connected with the newly formed New England Women's Club, then moved to Cambridge, where for several years Jacobs ran a boardinghouse for Harvard faculty and students. She and Louisa later moved to Washington, D.C., where the mother continued to work among the destitute freedpeople and the daughter was employed in the new "colored schools" and at HOWARD UNIVERSITY. In 1896, when the NATIONAL ASSOCIATION OF COLORED WOMEN held its organizing meetings in Washington, Harriet Jacobs was confined to a wheelchair, but it seems likely that Louisa was in attendance. The following spring, Harriet Jacobs died at her Washington home. She is buried in Mount Auburn Cemetery, Cambridge, Mass.

REFERENCES

CARBY, HAZEL. *Reconstructing Womanhood: The Emergence of the Afro-American Woman Novelist.* New York, 1987.

YELLIN, JEAN FAGAN. "Text and Contexts of Harriet Jacobs's *Incidents in the Life of a Slave Girl: Written by Herself.*" In Charles T. Davis and Henry Louis Gates, Jr., eds. *The Slave's Narrative.* New York, 1985, pp. 262–282.

———. Introduction to *Incidents in the Life of a Slave Girl: Written by Herself* by Harriet Jacobs. Cambridge, Mass., 1987, pp. xiii–xxxiv.

JEAN FAGAN YELLIN

Jacobs, Marion Walter "Little Walter" (May 1, 1930–February 15, 1968), blues harmonica player. Born in Alexandra, La., Marion Jacobs earned the nickname "Little Walter" because of his precocious harmonica talent. By the age of eight he supported himself by performing on the streets of New Or-

leans, Monroe, and Alexandria, La., and he often spent nights sleeping on pool tables. At the age of fourteen he moved to Helena, Ark., then an important center for BLUES, and he soon had a regular job performing on radio station KFFA. In 1947 he moved to Chicago and recorded "Ora Nelle Blues" for a local record label. Around this time he also joined the bands of Chicago bluesmen Jimmy Rogers and Muddy WATERS. It was as a member of the latter's ensemble that Little Walter made his best-known recordings—including "Louisiana Blues" (1950), "Long Distance Call" (1951), and "All Night Long" (1952)—and became one of the most popular and influential musicians in blues music.

Along with his model, John Lee "Sonny Boy" WILLIAMSON, Little Walter developed tongue and hand-cupping techniques to lend a warbling sound to the raw, emotional style known as Chicago blues. Little Walter, however, was the first to use an amplifier to exploit the hornlike potential of the harmonica, and his impact on the Chicago blues scene in the late 1940s and early 1950s was equal to that of Muddy Waters himself. In 1951 Little Walter played guitar on several more Muddy Waters recordings, including "Honey Bee" and "Still a Fool," and in 1952 Little Walter, backed by Muddy Waters's group, recorded "Juke," which became a hit and enabled him to tour with his own bands. For the rest of the 1950s Little Walter was one of the most important representatives of the Chicago blues, leading ensembles whose loud, raucous sound quickly overcame the popularity of milder country blues and JAZZ acts. His recordings from this time include "Mean Old World" (1952), "Mellow Down Easy" (1954), "Blue Light" (1954), "Blue and Lonesome" (1955), and "Key to the Highway" (1959). In the 1960s he toured Europe to enormous acclaim, but rock and roll began to eclipse his popularity. Little Walter's temper and excessive drinking were the source of problems, and he died in 1968 after a fight in a Chicago alley.

REFERENCES

LINDEMANN, W., and B. IGLAUER. "Little Walter and Louis Myers." *Living Blues* 6 (1971): 17.

ROWE, MIKE. *Chicago Breakdown*. London, 1973. Reprinted as *Chicago Blues: The City and the Music.* New York, 1981.

JONATHAN GILL

James, Cyril Lionel Richard (January 4, 1901–May 31, 1989), political activist. Born in Tunapuna, Trinidad, C. L. R. James attended Queen's Royal College in Trinidad, where he later taught English and history. He started to write fiction while he was teaching. In 1929, his controversial story about women in a slum, "Triumph," appeared in the short-lived magazine *Trinidad,* which James coedited. In the early 1930s, James moved to England, where he supported himself by writing articles on cricket, a sport in which he was skilled. In England he became politically active as an anti-Stalinist Marxist, and joined the Trotskyite faction of the International Labour Party. His first political book, *The Life of Captain Cipriani* (1932), treated questions of colonialism. In it, James called for West Indian independence.

In the mid-1930s, James turned his attention to PAN-AFRICANISM, joining forces with the theorist and orator George Padmore. After the Italian invasion of Ethiopia in 1935, James became editor of *International African Opinion,* and chaired the International Friends of Abyssinia. His Pan-African thought was further developed in his historical work *The Black Jacobins* (1938), in which he analyzed the 1791 Haitian slave revolt led by Toussaint L'Ouverture as a model of revolutionary struggle.

James, an internationally known figure, came to the United States on a Trotskyist lecture tour in 1938. He decided to stay and work in America's small anti-Stalinist Marxist circle. While he admired Trotsky, James associated himself with the independent Socialist Worker's Party (SWP). In 1940, he broke with the SWP to join the new Worker's Party. Using the party pseudonym "J. P. Johnson," James formed the Johnson-Forest Tendency with Raya Dunayevskaya. Within the group, he organized sharecroppers and workers, and wrote theoretical articles.

During the 1940s, James formed his mature ideas. Some he circulated in mimeographed form and in *The New Internationalist* (and published later as *Notes on Dialectics*). Others appear in *State Capitalism and World Revolution* (1950). James attacked the theory that state property equaled SOCIALISM. Refuting the principle of a vanguard party, he warned that bureaucracy, even if communist in name, was an obstacle to change in social relations of production. He argued that people of color were the lever for successful social change, because of their numerical superiority and the communitarian nature of African institutions. James, who considered socialism a vehicle for Pan-Africanism, felt American blacks would serve to unite workers in the West and the Third World.

In 1950, the Johnsonites left the Worker's Party, and returned to the Socialist Worker's Party. In 1952, James was labeled an undesirable alien by the U.S. State Department and interned on Ellis Island. In 1953, the same year he published his study of Herman Melville, *Mariners, Renegades, and Castaways,* James was expelled from the United States. He re-

turned to Trinidad to become secretary of the Federation Labour party and to work for West Indian independence. His later books include *Modern Politics* and *Party Politics in the West Indies*. James left Trinidad in 1962 after falling out with the West Indies Federation. He spent his last years in England, where he lectured and wrote historical articles and essays on Caribbean politics and culture.

REFERENCES

BUHLE, PAUL. *C. L. R. James: The Artist as Revolutionary*. New York, 1988.
WORCESTER, KENT. *C. L. R. James and the American Century, 1938–1953*. San Juan, P.R., 1980.

NANCY GAGNIER

James, Daniel "Chappie," Jr. (February 11, 1920–February 25, 1978), the first black four-star general. In 1937 James joined Tuskegee's pioneer black Army Air Corps unit. He served in World War

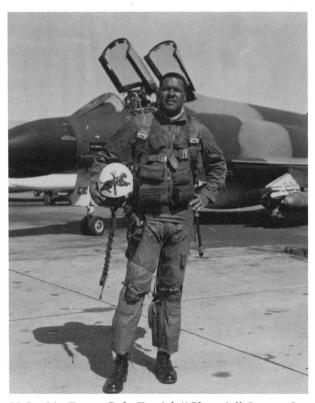

U.S. Air Force Col. Daniel "Chappie" James, Jr., stands in front of his F-4C "Phantom" in Southeast Asia. Col. James was a wing deputy commander for operations for a Phantom wing flying strike missions in North Vietnam. (Photographs and Prints Division, Schomburg Center for Research in Black Culture, The New York Public Library, Astor, Lenox and Tilden Foundations)

II and led a fighter group in Korea, inventing air tactics to support ground forces and receiving the Distinguished Service Medal. In Vietnam he was vice commander of the Eighth Tactical Fighter Wing, earning the Legion of Merit award. National attention accompanied his speeches supporting the war and black soldiers' reasons to fight.

Afterward he commanded Wheelus Air Force Base in Libya, then became Defense Department public affairs officer and a popular speaker. He received his fourth star with command of the crucial North American Air Defense, monitoring possible air and missile attacks.

Skills and overwhelming personality smoothed James's unprecedented ascent. Generally opposed to mass movements to improve blacks' situation, he cited his mother's dictum that personal excellence could overcome all barriers. He applauded peaceful demonstrations, however; indeed, the violence at Selma, Ala., made him consider resigning. He brushed off personal experiences with racism, though seldom wearing civilian clothes so his uniform might shield him. Blacks sometimes criticized him, but many Americans liked his support of the VIETNAM WAR and his view of race relations that emphasized individualism.

REFERENCES

McGOVERN, JAMES R. *Black Eagle: General Daniel "Chappie" James, Jr.* University, Ala., 1985.
PHELPS, J. ALFRED. *Chappie: America's First Black Four-Star General: The Life and Times of Daniel James, Jr.* Novato, Calif., 1991.

ELIZABETH FORTSON ARROYO

James, Elmore (January 27, 1918–May 24, 1963), blues guitarist and singer. Elmore James was born near Richland, Miss., and as a child learned about music in church. He taught himself to play guitar by plucking broom wires which he had strung on the walls of the sharecropper cabin in which his family lived. In his teens James knew the BLUES singer and guitarist Robert JOHNSON, who showed him some of the essential phrases and techniques of the Mississippi Delta slide guitar style. By the age of twenty-one James was performing with a blues band at local clubs and dances. He served in the Navy starting in 1943, and after a tour of duty that included the invasion of Guam, returned to work as an itinerant musician in Mississippi and Arkansas with the harmonica player and guitarist Rice Miller (also known as Sonny Boy WILLIAMSON II), and the guitarist Arthur "Big Boy" Crudup.

In 1952 James's recording of Johnson's "Dust My Broom" was a Top Ten hit on the rhythm and blues charts. Buoyed by his success, he recorded again, in Los Angeles, and then moved to Chicago, where he began working with the Mississippi pianist Johnny JONES, and recorded "I Believe" and another version of "Dust My Broom," both of which became hits. Their group, which became known as James and his Broomdusters, performed together throughout the rest of the 1950s and had a central place in the postwar Chicago blues scene.

Despite being blacklisted by the local musicians union for failing to pay his dues, from 1960 to 1963 James recorded several performances that stand as masterpieces of Chicago-style blues. "Something Inside of Me," "The Sky Is Crying," "Shake Your Money Maker," "Done Somebody Wrong," and "It Hurts Me Too" display James's extraordinary adaptation of the slide leads of Robert Johnson to the electric blues. In addition to his piercing, super-amplified guitar solos, he was also a moving singer, capable of agonized, shrill vocals. James, who was a heavy drinker, struggled against asthma and heart disease for his last decade. He died of a heart attack in Chicago. After his death James's fame and influence spread, and he was idolized and imitated by generations of both black and white musicians. James was inducted into the Rock and Roll Hall of Fame in 1992.

REFERENCES

PALMER, ROBERT. *Deep Blues*. New York, 1981.
ROWE, M. *Chicago Breakdown*. London, 1973.

JONATHAN GILL

James, Etta (January 5, 1938–), rhythm and blues singer. Etta James, born Jamesetta Hawkins in Los Angeles, sang during her childhood in the choir of Saint Paul's Baptist Church. She began to sing professionally at the age of fourteen, when she worked with a RHYTHM AND BLUES ensemble led by Johnny Otis. Her first recording, "Roll With Me Henry" (1954), was originally banned by radio stations because of its salacious content. However, the record became a hit, and it was rereleased in 1955 under the title "Wallflower."

In the mid-to-late 1950s, James was one of the most popular singers in rhythm and blues, behind only Dinah WASHINGTON and Ruth BROWN in her number of hit rhythm and blues records. Nominally a blues shouter, her gospel-influenced voice was also by turns sweet, pouting, or gruff. Among her hit records, many of which were recorded for Chicago's Chess Records, were "Good Rockin' Daddy" (1955), "W-O-M-A-N" (1955), "How Big a Fool" (1958), "All I Could Do Was Cry" (1960), "Stop the Wedding" (1962), "Pushover" (1963), and "Something's Got a Hold On Me" (1964). James toured with LITTLE RICHARD, James BROWN, Little Willie John, and Johnny "Guitar" Watson.

Heroin addiction forced James to quit recording in the mid-to-late 1960s. She eventually entered a rehabilitation program that culminated in her return to the music industry in 1973 with the album *Etta James*, which won a Grammy award. James then recorded numerous albums, including *Come a Little Closer* (1974), *Etta is Betta than Evvah* (1976), *Deep in the Night* (1978), *Blues in the Night* with Eddie "Cleanhead" Vinson (1986), *Seven Year Itch* (1988), and *Stickin' to My Guns* (1990). Nonetheless, her pioneering role as a rhythm and blues singer was often overlooked until the 1990s. In 1990 she won an NAACP Image Award, and in 1993 she was inducted into the Rock and Roll Hall of Fame.

REFERENCE

HESS, NORBERT. "Living Blues Interview: Etta James." *Living Blues* 54 (1982): 12.

ROBERT W. STEPHENS

James, Leon Edgehill (1913–1970), and **Minns, Albert David** (1920–May 1, 1985), jazz dancers. Leon James and Al Minns worked as a team of jazz dancers from the mid-1940s through 1970. James was born in New York City and by the early 1930s was a regular at the Alhambra Ballroom, where he developed a reputation for extraordinary leg movements. Minns, a native of Newport News, Va., moved to Harlem at the age of five, and showed his dancing talent early. Both were regular Lindy Hoppers at the SAVOY BALLROOM in the mid-1930s and both, James dancing with Edith Mathews; and Minns dancing with Mildred Pollard; in 1935 and 1938 respectively, won the Lindy Hop competition of the *New York Daily News* Harvest Moon Ball.

After 1938 James and Minns joined the Savoy's top dancers, Whitey's Lindy Hoppers, and toured until the beginning of World War II; they also had roles in Broadway musicals such as *Knickerbocker Holiday* (1938), *Hellzapoppin'* (1938), *Hot Mikado* (1939), and *Blackbirds of 1939*. Their work is also featured in a film made with their long-time collaborator, Mura Dehn, *The Spirit Moves*. Their careers were revived in 1958 when they appeared with dance historian Marshall Stearns in a lecture at the 1958 Newport

Jazz Festival, and traveled extensively with Stearns in the late 1950s and early '60s.

With the death of James in 1970, Minns retired from dancing until 1982, when he became active in a number of ensembles such as the Harlem Jazz and Blues Band, Cab CALLOWAY's COTTON CLUB Revue, and served as artistic director of the Original Jazz Dancers. Minns died in New York City in 1985.

REFERENCES

CREASE, ROBERT. "Laying Down Some Leather." *New Yorker* (February 15, 1969): 29–31.
———. "Swing Story." *Atlantic* (February 1986): 77–82.

JACKIE MALONE

James, Rick (Johnson, James Ambrose) (February 1, 1952–), singer.

Rick James was born and spent his formative years in Buffalo, N.Y., before he enlisted in the U.S. Naval Reserve at age fifteen. After deserting the navy, he formed the Mynah Birds with Neil Young in Toronto in the mid-1960s. Following a sentence for his desertion charge, James began to work at Motown as a staff writer-producer. He began recording as a solo artist for Gordy/Motown in 1979, achieving popularity with his energetic, riff-based dance songs and suggestive, streetwise lyrics.

Known as the King of Funk in the 1980s, James had his greatest commercial success with 1981's *Street Songs,* which sold more than one million copies. His crossover recordings dominated the black and pop charts, and he began producing other successful acts for Motown. He left Motown in the late 1980s and recorded a single album for Warner Bros. James's 1981 hit "Super Freak" provided the musical motif for rapper M. C. Hammer's "U Can't Touch This," which was named best rhythm and blues song of 1990, earning James a Grammy Award as a cowriter.

REFERENCES

GOLDBERG, MICHAEL. "Rick James' Perfectionism." *Musician* 61 (November 1983): 82–86.
GREIN, PAUL. "Rick James Taking Care of Business." *Billboard* 97 (August 10, 1985): 35.

DANIEL THOM

James, Willis Laurence (September 18, 1900–December 27, 1966), music folklorist.

Willis James was born in Montgomery, Ala., and moved with his family to Jacksonville, Fla., as a child. His mother nurtured his musical talent and influenced his early interest in African-American folk music. He attended MOREHOUSE COLLEGE in Atlanta, Ga., where he was the protégé of Kemper Harreld, a concert violinist and music educator. He studied at the University Extension Conservatory in Chicago, and privately with Edwin Gershefski and Oswald Blake. He spent his early teaching career at Leland College and Alabama State Teachers College. From 1933 to his death in 1966, he taught at SPELMAN COLLEGE.

James made significant contributions to folklore research as a pioneer folklorist and self-trained ethnomusicologist. He began collecting folk songs in Louisiana in 1923, and later collected in much of the deep South. He did extensive fieldwork in the mining areas of Alabama and Georgia Sea Islands on a 1939 research fellowship. He cofounded the Fort Valley College Folk Music Festivals in 1941 with John WORK III, with whom he also recorded the 1942 festival as a field recorder for the Library of Congress. James lectured on the college and folk-music circuits in the United States and Canada, at the Newport Jazz and Folk Music festivals, and at the Center for Negro Arts in Lagos, Nigeria, in 1961. His theory of the folk cry as a basic element in African-American folk song, and in much American music, received wide attention and response following its publication. "Stars in the Elements," his unpublished study of African-American folk music, contains collected folk songs with texts, and his theories on African-American folk music.

James believed that folk music was preserved through use. He arranged his collected songs for performance by voice students and college choral ensembles. He is highly regarded as a master of choral forms; his music is especially beloved for its authentic folk style and rich harmonic texture. His published arrangements include "The Negro Bell Carol," "O, Po' Little Jesus," "Around the Glory Manger," "Here's a Pretty Little Baby," and "Reign, King Jesus" for mixed voices; and "Cabin Boy Call" for solo voice. Unpublished manuscripts include arrangements of sacred and secular folk songs for women's, men's, and mixed voices; folk songs and art songs for solo voice; and compositions for solo violin, for piano, and for violin and piano.

REFERENCES

CUREAU, REBECCA T. "Black Folklore, Musicology, and Willis Laurence James." *Negro History Bulletin* 43 (1980): 16–20.
———. "Willis Laurence James and the Preservation of Black Religious Folk Music." *Journal of Black Sacred Music* 4, no. 2 (1990): 1–13.
JAMES, WILLIS L. "The Romance of the Negro Folk Cry in America." *Phylon* 16 (1955): 15–31. Also

reprinted in Alan Dundes, ed. *Mother Wit from the Laughing Barrel*. New York, 1973, pp. 490–498.

REBECCA T. CUREAU

Jamison, Judith (May 10, 1943–), dancer. Born the younger of two children in Philadelphia, Pa., Jamison studied piano and violin as a child. Tall by the age of six, Jamison was enrolled in dance classes by her parents in an effort to complement her exceptional height with grace. She received most of her early dance training in classical ballet with master teachers Marion Cuyjet, Delores Brown, and John Jones at the Judimar School of Dance. Jamison decided on a career in dance only after three semesters of coursework in psychology at Fisk University, and she completed her education at the Philadelphia Dance Academy. In 1964 she was spotted by choreographer Agnes de Mille and invited to appear in de Mille's *The Four Marys* at the New York–based American Ballet Theatre. Jamison moved to New York in 1965 and that same year joined the Alvin AILEY American Dance Theater (AAADT).

Jamison performed with AAADT on tours of Europe and Africa in 1966. When financial pressures forced Ailey to briefly disband his company later that

Judith Jamison in 1988. A former member of the Alvin Ailey American Dance Theater, she rejoined the company and became its director in 1989 upon the death of Alvin Ailey. (AP/Wide World Photos)

year, Jamison joined the Harkness Ballet for several months and then returned to the re-formed AAADT in 1967. She quickly became a principal dancer with that company, dancing a variety of roles that showcased her pliant technique, stunning beauty, and exceptional stature of five feet, ten inches. Jamison excelled as the goddess Erzulie in Geoffrey Holder's *The Prodigal Prince* (1967), as the Mother in a revised version of Ailey's *Knoxville: Summer of 1915* (1968), and as the Sun in the 1968 AAADT revival of Lucas Hoving's *Icarus*. These larger-than-life roles fit neatly with Jamison's regal bearing and highly responsive emotional center, and critics praised her finely drawn dance interpretations that were imbued with power and grace. Jamison's and Ailey's collaboration deepened, and she created a brilliant solo in his *Masekela Language* (1969). Set to music of South African trumpeter Hugh Masekela, Jamison portrayed a frustrated and solitary woman dancing in a seedy saloon. Her electrifying performances of Ailey's fifteen-minute solo *Cry* (1971) propelled her to an international stardom unprecedented among modern dance artists. Dedicated by Ailey "to all black women everywhere—especially our mothers," the three sections of *Cry* successfully captured a broad range of movements, emotions, and images associated with black womanhood as mother, sister, lover, goddess, supplicant, confessor, and dancer.

In 1976 Jamison danced with ballet star Mikhail Baryshnikov in Ailey's *Pas de Duke* set to music by Duke ELLINGTON. This duet emphasized the classical line behind Jamison's compelling modern dance technique and garnered her scores of new fans. Jamison's celebrity advanced, and she appeared as a guest artist with the San Francisco Ballet, the Swedish Royal Ballet, the Cullberg Ballet, and the Vienna State Ballet. In 1977 she created the role of Potiphar's Wife in John Neumeier's *Josephslegende* for the Vienna State Opera, and in 1978 she appeared in Maurice Béjart's updated version of *Le Spectre de la Rose* with the Ballet of the Twentieth Century. Several choreographers sought to work with Jamison as a solo artist, and important collaborations included John Parks's *Nubian Lady* (1972), John Butler's *Facets* (1976), and Ulysses DOVE's *Inside* (1980).

In 1980 Jamison left the Ailey company to star in the Broadway musical *Sophisticated Ladies,* set to the music of Duke Ellington. She later turned her formidable talent to choreography, where her work has been marked by a detached sensuality and intensive responses to rhythm. Jamison founded her own dance company, the Jamison Project, "to explore the opportunities of getting a group of dancers together, for both my choreography [and] to commission works from others." Alvin Ailey's failing health caused Jamison to rejoin the AAADT as artistic associate for

the 1988–1989 season. In December 1989 Ailey died, and Jamison was named artistic director of the company. She has continued to choreograph, and her ballets include *Divining* (1984), *Forgotten Time* (1989), and *Hymn* (1993), all performed by the AAADT.

Jamison has received numerous awards and honors, including a Presidential Appointment to the National Council of the Arts, the 1972 Dance Magazine Award, and the Candace Award from the National Coalition of One Hundred Black Women. Her greatest achievement as a dancer was an inspiring ability to seem supremely human and emotive within an elastic and powerful dance technique.

REFERENCES

"Jamison, Judith." *Current Biography Yearbook.* New York, 1973, pp. 202–205.

JAMISON, JUDITH, with Howard Kaplan. *Dancing Spirit: An Autobiography.* New York, 1993.

JOWITT, DEBORAH. " 'Call Me a Dancer': (Judith Jamison)." *New York Times,* December 5, 1976, Sec. 6, pp. 40–41, 136–148.

MAYNARD, OLGA. *Judith Jamison: Aspects of a Dancer.* New York, 1982.

THOMAS F. DeFRANTZ

Jarreau, Alwyn Lopez "Al" (1940–), jazz and pop singer. Al Jarreau was born in Milwaukee, Wis., in 1940. He received B.S. and M.S. degrees in psychology from Ripon College in 1962 and the University of Iowa in 1965 and worked in San Francisco as a rehabilitation counselor at the Presidio army base until 1968. After some success singing part-time in local clubs, Jarreau turned professional with a band named the Indigos. He next worked with George Duke's trio, playing the club circuit in San Francisco, where he appeared both at the Jazz Workshop and the Half Note (*see* NIGHTCLUBS). Jazz standards formed the major part of his repertoire. He released his first album, *We Got By,* in 1975; the following year he toured Europe, where he acquired considerable popularity. Jarreau cites Nat "King" COLE, Billy ECKSTINE, Sarah VAUGHAN, Ella FITZGERALD, and Johnny MATHIS as among his major influences. His singing represents a refinement of the bebop style of "Jon" HENDRICKS and Dave Lambert. Jarreau's intonation and range are impressive; his vocal "library" is versatile and virtuosic, characterized by groans, tongue clicks, gasps, and unique "Oriental"-sounding nonsense syllables. He has received many awards for his work, including Grammy Awards for Best Jazz Vocalist in 1978 and 1979 and for vocals on the albums *Look to the Rainbow* (1977) and *Breakin' Away* (1981). He is generally considered to be one of

Possessing a remarkable vocal range, Al Jarreau has been one of the most distinctive pop performers since the 1970s, combining jazz, scat singing, soul, and gospel musical styles. (Photographs and Prints Division, Schomburg Center for Research in Black Culture, The New York Public Library, Astor, Lenox and Tilden Foundations)

the foremost jazz and scat singers of his generation (*see* JAZZ).

REFERENCE

KERNFELD, BARRY, ed. *The New Grove Dictionary of Jazz.* Vol. 1. London, 1988.

MICHAEL D. SCOTT

Jasper, John (July 4, 1812–March 30, 1901), minister. John Jasper was born a slave on a plantation in Fluvanna County, Va., the last of twenty-four children. His father, Philip, a slave preacher, died two months before Jasper was born. His mother, Nina, supervised the other female slaves until the death of the plantation owner, a man named Peachy. She and some of her children were then sold to a Richmond family, where she became the chief servant in the house. Jasper was sold to Samuel Hargrove, who owned a Richmond tobacco factory, where Jasper

worked until the end of the Civil War as a "stemmer," pulling cured leaves from stems.

In 1837, Jasper experienced a religious awakening and joined the First Baptist Church in Richmond. Following his conversion, he learned to read and studied the Bible with another slave, William Jackson. Self-taught, in 1839 Jasper became a preacher.

As a slave preacher, he could preach only with Hargrove's permission and under the supervision of a white minister or committee of ministers, who attended his services to monitor his conduct as a preacher and the content of his sermons. His style was highly theatrical. He was known for circling the pulpit as he talked, and for laughing, singing, and shouting. William E. Hatcher, a white minister who saw Jasper preach, wrote later, "He was the preacher; likewise the church and the choir and the deacons and the congregation." He delivered his sermons with such a fiery passion and deep sincerity that despite an obviously limited vocabulary, he quickly became a favorite of white Baptist churchgoers as well as black. Hargrove, a deeply religious man, encouraged Jasper in his pastoral work (while retaining his services as a slave in the tobacco factory), and allowed him to preach often in Richmond and Petersburg.

During the Civil War, Jasper continued to preach. He also read the Bible to sick and wounded Confederate soldiers. In 1866, he founded the Sixth Mount Zion Church of Richmond.

Jasper is best known for his sermon "De Sun Do Move," which he first delivered around 1880. In it, he argued that the earth is flat and the sun moves around it. He based his twin theories on the seventh chapter of Revelation, which refers to four angels standing on the four corners of the earth, and on Joshua 15:3, in which Joshua commands the sun to stand still. Although the sermon infuriated many of Richmond's other black ministers, it was unfailingly popular among churchgoers, who perhaps were more moved by Jasper's indisputable sincerity and commitment than by the sermon's persuasiveness or its basis in fact. Jasper repeated the sermon in churches in Washington, D.C., Baltimore, Philadelphia, and New Jersey, as well as before the Virginia state legislature. All told, he was said to have delivered "De Sun Do Move" about 250 times (many of those at the Sixth Mount Zion Baptist Church, where he regularly repeated sermons). He and the sermon failed conspicuously, however, on the popular lecture circuit when a commercial syndicate sent him on a tour of the North (which was aborted early, in Philadelphia).

Jasper's personal life was also controversial. He had a reputation as a ladies' man, which his four marriages apparently did little to deflect. His first marriage was to a slave named Elvy Weadon. In 1837,

after his conversion, he left Weadon and married Candus Jordan, with whom he had nine children. After the Civil War, Jasper divorced her and married Mary Ann Cole, who died in 1874. Jasper married once more, to a woman who survived him when he died on March 30, 1901. At the time of his death, he was still a beloved figure among many blacks and whites in Richmond, where both *The Richmond Dispatch* and *The Richmond Times* provided detailed coverage of his funeral.

REFERENCES

BRAWLEY, BENJAMIN G. *Negro Builders and Heroes.* Chapel Hill, N.C., 1965.

HATCHER, WILLIAM E. *John Jasper, The Unmatched Negro Philosopher and Preacher.* Richmond, 1908. Reprinted, New York, 1969.

SABRINA FUCHS
MICHAEL PALLER

Jazz. Despite complex origins, the status of jazz as a distinctively African-American music is beyond question. Nonetheless, in its development from folk and popular sources in turn-of-the-century America, jazz has transcended boundaries of ethnicity and genre. Played in every country of the globe, it is perhaps twentieth-century America's most influential cultural creation, and its worldwide impact, on both popular and art music, has been enormous. Jazz has proved to be immensely protean, and has existed in a number of diverse though related styles, from New Orleans– and Chicago-style Dixieland jazz, big band or swing, bebop, funky cool jazz, hard bop, modal jazz, free jazz, and jazz rock. One reason for the variety in jazz is that it is basically a way of performing music rather than a particular repertory. It originated in blends of the folk music, popular music, and light classical music being created just prior to 1900, and now embraces a variety of popular musical styles from Latin America, the Caribbean, Asia, and Africa, as well as diverse modern, classical, and avant-garde performance traditions.

Jazz also has an inescapable political thrust. It originated during a time of enormous oppression and violence in the South against African Americans. The early African-American practitioners of jazz found racial discrimination in virtually every aspect of their lives, from segregated dance halls, cafes, and saloons to exploitative record companies. Like blackface minstrelsy, early jazz was popular with whites, in part because it reinforced "darkie" stereotypes of African Americans as happy-go-lucky and irrepressibly

rhythmic. Nonetheless, many black jazz musicians used jazz as a vehicle for cultural, artistic, and economic advancement, and were able to shape their own destinies in an often hostile environment. African-American jazz was, from its earliest days, often performed for or by whites, and it was assimilated into the overall fabric of popular music, to the uneasiness of some on both sides of the racial divide. It has continued to mirror and exemplify the complexities and ironies of the changing status of African Americans within the broader culture and polity of the United States.

Early Jazz

Although its origins are obscure, early forms of jazz began to flourish around the turn of the century in cities such as New Orleans, Chicago, and Memphis. The long prehistory of jazz begins with the rhythmic music slaves brought to America in the sixteenth and seventeenth centuries and developed on southern plantations. Since the traditional drums, flutes, and horns of West Africa were largely forbidden, call-and-response singing and chanting, field hollers, foot stomping, and handclapping were common, especially in the context of fieldwork and church worship. Under those restrictions, among the earliest African-American instruments adopted were European string instruments such as the violin and guitar. The African-derived banjo was also a popular instrument. Eventually the publicly performed music that Reconstruction-era city-dwellers made an essential part of urban life demanded brass and woodwind instruments, not only for their volume, but to accompany the Spanish American War–era military marches, popular songs, and light classics that were so popular among all classes and races in the late nineteenth century.

While it is difficult to draw a precise line between jazz and its precursors, its immediate predecessors were two forms of African-American folk and popular music known as BLUES and RAGTIME. Ragtime is primarily piano music that integrates complex African-derived rhythmic practices with the harmonies of light classics, parlor music, show tunes, and popular songs. The virtuosic practice of "ragging"—altering rhythms to, in effect, "tease" variety and humor out of formal, strict patterns—was widespread by the 1880s, especially in towns along the Mississippi River like St. Louis and (eventually) New Orleans. Ragtime was also being played before the turn of the century in eastern cities such as New York and Baltimore. The greatest ragtime players, Scott JOPLIN, Eubie BLAKE, Tony Jackson, and Jelly Roll MORTON, also composed, and sheet music became a central feature of home entertainments among families, black and white, who could afford pianos. Rag-

Trumpeter, vocalist, bandleader, and conductor Valaida Snow lived abroad for much of the 1930s. She is shown here as she appeared in the London production of *The Blackbirds of 1935*. (Photographs and Prints Division, Schomburg Center for Research in Black Culture, The New York Public Library, Astor, Lenox and Tilden Foundations)

time was also played by instrumental ensembles; the syncopated orchestras led in New York City by James Reese EUROPE and Will Marion COOK during the first two decades of the century owed much to the precise, contrapuntal style of piano rags. The ragtime-derived piano style proved influential on later jazz styles, especially since many of the best bandleaders of the swing era, including Duke ELLINGTON, Earl "Fatha" HINES, and Count BASIE, were heavily influenced by Harlem stride pianists such as James P. JOHNSON, Fats WALLER, Willie "the Lion" SMITH, and Luckey ROBERTS. Also deeply indebted to stride were later pianists such as Teddy Wilson, Art TATUM, and Thelonious MONK.

The blues similarly began along the Mississippi River in the 1880s and 1890s. Among the first pub-

lished blues, "Memphis Blues" (1912), by W. C. HANDY, was broadly derived from black rural folk music. The sexual frankness and suggestiveness, its recognition of suffering and hardship of all kinds, and the slow, insinuating melodies soon had an impact on popular music. The 1920s saw the rise of such blues singers as Ma RAINEY, Bessie SMITH, and Mamie SMITH, but long before that the blues had a palpable influence on the music of early New Orleans jazz.

It was New Orleans that gave its name to the earliest and most enduring form of jazz, and bred its first masters. That Buddy BOLDEN, Bunk Johnson, Kid ORY, Jelly Roll Morton, King OLIVER, Sidney BECHET, and Freddy Keppard all came from New Orleans attests to the extraordinary fertility of musical life in what was then the largest southern city. In New Orleans, blacks, whites, and the culturally distinct light-skinned African Americans known as creoles supported various kinds of musical ensembles by the mid-nineteenth century. Other influences included traveling cabaret and minstrel shows, funeral, carnival, and parade bands. A more or less direct African influence on New Orleans was also perva-sive, no more so than in Congo Square, a onetime site of slave auctions that later became an important meeting place and open-air music hall for New Orleans blacks.

The various layers of French, Spanish, Haitian, creole, Indian, and African-American culture in New Orleans created a mixed social environment, and not only in Storyville, the legendary red-light district whose role in the birth of jazz has probably been overemphasized. Nonetheless, it was in Storyville that legalized prostitution encouraged a proliferation of brothels, gambling houses, and saloons where many of the early New Orleans jazz musicians first performed. Though many of the early New Orleans jazz bands and performers, including Sidney Bechet and Jelly Roll Morton, were creoles, very soon non-creoles such as King Oliver and Louis ARMSTRONG were integrated into creole ensembles.

By the end of the first decade of the twentieth century, these diverse musical styles had evolved into the style of music that was almost exclusively associated with New Orleans. Although there are no recordings of jazz from this period, what the music

Louis Armstrong performing as a member of King Oliver's Creole Jazz Band, around 1923. (Photographs and Prints Division, Schomburg Center for Research in Black Culture, The New York Public Library, Astor, Lenox and Tilden Foundation)

The unique gathering of five of the major figures in bebop for a concert in Toronto's Massey Hall in May 1953 has led some aficionados to dub this event "the greatest jazz concert ever." In this photograph are (from left) Max Roach, drums; Dizzy Gillespie, trumpet; and Charlie Parker, alto saxophone. Not pictured are Bud Powell, piano, and Charles Mingus, bass. Mingus recorded the concert and preserved it for posterity. (Frank Driggs Collection)

sounded like can be inferred from photographs of the period, later reminiscences, and later recordings. A typical early New Orleans jazz ensemble might include one or more cornets, trombone, clarinet, and a rhythm section of string or brass bass, piano, and guitar or banjo. The cornets, which were eventually replaced by the trumpets, took the melodic lead, while an elaborate countermelody was contributed by the clarinet, and the trombone provided a melodic bass line. The rhythm section filled in the harmonies and provided the beat. The typical repertory of these ensembles consisted largely of blues-based songs.

The two main types of improvisation in early jazz were solo and collective improvisation. Solo improvisation takes place when one musician at a time performs solo. In collective improvisation, which was the key feature of the New Orleans early jazz sound and later Chicago-related Dixieland style, more than one musician improvises simultaneously. This style

can be heard in the early recordings of Kid Ory, King Oliver, and Jelly Roll Morton, as well as music made by whites such as the Original Dixieland Jazz Band, the New Orleans Rhythm Kings, the Wolverines, and Chicago's Austin High School Gang.

Jazz no doubt existed in some recognizable form from about 1905—the heyday of the legendary and never-recorded New Orleans cornetist Buddy Bolden —but the first recording by a group calling itself a "jazz" band was made in 1917, in New York, by the white, New Orleans–based ensemble the Original Dixieland Jazz Band. Though as early as 1913 James Reese Europe had recorded with his black syncopated orchestra, and by the early 1920s Johnny Dunn and Kid Ory had recorded, it was not until 1923 that the first representative and widely influential New Orleans–style jazz recordings by African Americans were made in the Midwest, by King Oliver and Jelly Roll Morton.

The movement of the best New Orleans musicians to Chicago is often linked to the closing of Storyville in 1917. Much more important was the Great Migration of southern blacks to northern cities during the World War I years. In Chicago, jazz found a receptive audience, and jazz musicians were able to develop profitable solo careers while enjoying a more hospitable racial climate than in the South.

Big Band Jazz

Jazz underwent significant changes on being transplanted to the North. By the early 1920s, when the New York–based band of Fletcher HENDERSON made its first recordings, jazz was being presented in a manner akin to the refined dance band orchestras of the time, with larger ensembles of ten pieces or more, working within carefully written arrangements. Whereas the early jazz repertory consisted largely of original blues, in the 1920s, jazz musicians began performing waltzes and popular songs. The style of playing changed as well. In place of the thrilling but often unwieldy polyphony of New Orleans jazz came the antiphonal big-band style, in which whole sections traded off unison or close-harmony riffs, often in a call-and-response format with a single soloist. In contrast to the instrumentation of the typical New Orleans early jazz ensemble of three horns and a rhythm section, big bands generally had a brass section consisting of three trumpets and one trombone, and three or four reeds (a variety of saxophones and clarinets). In the 1930s the size of big bands often grew to fifteen or more musicians. Providing the pulse for the swing big bands was a rhythm section, usually containing a piano, string bass and drums, and often an acoustic guitar.

If the big bands regimented and reined in the sounds of New Orleans jazz, it also permitted the emergence of the soloist, particularly on the saxophone and trumpet, probably the most important development of the era. Though featured soloists were not unknown in the New Orleans jazz style, big band jazz arrangements often used themes as mere preludes to extended solo improvisations, with both the rhythm section and the orchestra as a whole often served as accompanists to whoever was soloing. No figure exemplified this change better than Louis Armstrong. Although bred in New Orleans, his stay in Chicago taught him much about the theatrical possibilities of a well-constructed solo. During 1924 and 1925 he performed with the Henderson band in New York, where his majestic tone and unfailingly fresh phrasing almost singlehandedly turned that ensemble from a straightlaced dance band toward a New Orleans–influenced style that would eventually become known as swing. Armstrong's recordings with

Sidney Bechet's piercing and utterly distinctive style on the saxophone and clarinet is one of the great sounds of jazz. The only New Orleans jazz musician to rival Louis Armstrong as a solo performer, Bechet moved in 1951 to France where he finally achieved the celebrity that had previously eluded him in the United States. (Photographs and Prints Division, Schomburg Center for Research in Black Culture, The New York Public Library, Astor, Lenox and Tilden Foundations)

his own ensembles in the 1920s feature not only his brilliant trumpet, but his voice. By singing the same way that he played the trumpet, Armstrong became the model for superb jazz phrasing and popularized scat singing—using nonsense syllables instead of words. In the 1930s, his recordings of such emerging standards as "Body and Soul" and "Stardust" proved that jazz could redefine pop tunes.

In 1929 Armstrong fronted a big band in New York, a move that signaled the decline of both Chicago and Chicago-style jazz in favor of Harlem as the new capital, and swing big bands as the dominant sound. By the mid-1930s, Harlem was the undisputed center of the jazz world, and the swing era coincided with the rise of Harlem as the focal point for African-American culture. The largest black com-

munity in the world made its home along 125th Street in Manhattan, attending elegant and inexpensive dance palaces, and buying recordings also made in New York. However, it would be a mistake to focus exclusively on New York or Chicago. Many of the greatest swing big bands, known as territory bands, came from elsewhere. The Southwest, in particular Kansas City, an important railroad switching station as well as host to an extensive collection of mob-owned after-hours nightclubs, was the most important center for territory bands. In the early 1920s Bennie MOTEN's group had already inaugurated a Kansas City style, in its mature phase marked by looser, four-to-the-bar rhythms and freer styles of soloing. The pianist in the band, a student of Harlem stride named Count Basie, brought the core of that band to New York in 1936, and brought to prominence a whole new generation of hard-swinging soloists such as Lester YOUNG, Herschel Evans and Buck Clayton, as well as vocalist Jimmy RUSHING.

The big band era was the only time jazz was truly America's popular music. Starting in the late 1920s, the dance bands of Ellington, Henderson, Basie, Jimmie LUNCEFORD, Andy Kirk, Teddy Hill, Earl "Fatha" Hines, as well as those of Chick WEBB, Cab CALLOWAY, and Lionel HAMPTON competed with white bands led by Benny Goodman, Paul Whiteman, Tommy Dorsey, and Artie Shaw. The prominence of the soloist during the swing era marks the emergence of celebrity jazz musicians like Louis Armstrong, who became "stars" almost on a par with the most popular white entertainers of the day, such as Bing Crosby, in both white and black communities, in Europe as well as in America. The big band era also marks the emergence of tenor saxophonist stars such as Coleman HAWKINS and Ben WEBSTER, as well as vocalists such as Billie HOLIDAY and Ella FITZGERALD.

Jazz in the swing era gave numerous African-American performers a largely unprecedented degree of acceptance, fame, and financial success. Still, these achievements occurred within a society that was uncomfortable at best with both public and private racial interaction in any but the most controlled settings. Although some dance halls and nightclubs were integrated, many others, including the most famous ones, such as the COTTON CLUB, were not. Musicians often appeared there in less than flattering contexts, and audiences clamored for Duke Ellington's "exotic" side, known as jungle music, and for the comic, minstrel side of performers such as Louis Armstrong and Fats Waller. Through the end of the 1930s almost all jazz bands were segregated, with white bands such as those led by the Dorsey brothers, Paul Whiteman, Benny Goodman, Glenn Miller, Woody Herman, and Artie Shaw making consider-

ably more money than their African-American counterparts.

Goodman's ensemble was the first intergrated jazz band. He hired Fletcher Henderson as an arranger and in 1936 hired Teddy Wilson as pianist and Lionel Hampton on vibes for his quartet. Goodman, the most popular bandleader of the late 1930s, played in a style quite similar to the best of the black bands, and was unfairly crowned the "King of Swing" by critics. This raised the ire of many black musicians. Although Armstrong, Ellington, Basie, and Waller became genuine celebrities, the white musicians who played in a "black" style often captured a market unavailable to blacks. This would be a persistent grievance among black jazz musicians.

Bebop

In the early 1940s, one of the last major bands from the Southwest to reach prominence in New York was led by Jay McShann, whose band contained the seeds of the next development in jazz (primarily through the innovations of its own saxophonist, Charlie PARKER). Although the emergence of the frenetic and rarified style of jazz that became known as "bebop"—so named because of the final, two-note phrase that often ended bebop solos—is frequently seen as a revolt against big band swing, all of the early bebop giants drew upon their experiences playing with swing musicians, often in big bands. Earl Hines, Billy ECKSTINE, Coleman Hawkins, and Cootie WILLIAMS nurtured many beboppers, and one of the first great bebop groups was a big band led by Dizzy GILLESPIE in 1945 and 1946. After Parker left Jay McShann, he worked with Gillespie in bands led by Hines and Eckstine. Thelonious Monk worked with Cootie Williams, as did Bud POWELL.

The very first stirrings of bebop had come in the late 1930s, when drummer Kenny CLARKE, who had worked in big bands led by Teddy Hill and Roy ELDRIDGE, began keeping time on the high-hat cymbal, rather than on the bass drum, which was reserved for rhythmic accents, a style adopted by young drummers such as Max ROACH and Art BLAKEY. Just as timekeepers were experimenting with the rhythmical palate of the drum kit, so too were soloists extending the limits of the harmonies of standard popular songs and blues, and aspiring to a new and recondite tonal vocabulary. Inspired by the virtuosic playing and harmonic sophistication of pianist Art Tatum and tenor saxophonist Lester Young, in the early 1940s Gillespie and Parker were creating a music for musicians, noted for its complexity, with a whole new, difficult repertory. Trumpeter Fats NA-VARRO, bassist Charles MINGUS, and pianists Thelonious Monk and Bud Powell were also prime archi-

Billy Eckstine. (Photographs and Prints Division, Schomburg Center for Research in Black Culture, The New York Public Library, Astor, Lenox and Tilden Foundations)

tects of bebop, as were such white musicians as pianists Lennie Tristano and Al Haig, and alto saxophonist Lee Konitz.

Disgruntled swing musicians complained that bebop was an elitist style that robbed jazz of its place as America's popular music. Certainly, the refusal of bebop musicians to adhere to a four-to-bar bass drum rhythm meant that the music was no longer suitable for dancing. As bebop lost its function as dance music, tempos quickened even more, and solos became more rhythmically adventurous. Bebop's quirky, sophisticated compositions and fleet, witty improvisations demanded the serious and more or less undivided attention that concert music requires. Bebop came of age and reached its height of popularity not in "high-toned" Harlem dance halls, but in the nightclubs and after-hours clubs of Harlem and 52nd Street, and often the audience consisted of a small coterie of white and black jazz fans and sympathetic jazz musicians. In retrospect, however, it was not bebop that dealt the death blow to jazz as a popular music. The big bands were struggling to survive long before the bebop era began, and by the 1950s, not even Count Basie and Duke Ellington's bands could keep up with the dance rhythms of rhythm and blues and early rock and roll.

Just as New Orleans–style jazz established the basic language for what is generally considered "classic jazz," so too did the beboppers define what is still considered modern jazz. Bebop was inherently music for small ensembles, which usually included a rhythm section of piano, bass, and drums, and two or three horns, playing a new repertory of jazz standards often derived from the chord changes of Ray Noble's "Cherokee" or George Gershwin's "I Got Rhythm." In the standard bebop ensemble, after the initial statement of the theme in unison, each soloist was given several choruses to improvise on that theme. The beboppers, ever restless innovators, also experimented with Latin music, string accompaniments, and the sonorities of twentieth-century European concert music.

The latter influenced pianist John LEWIS and trumpeter Miles DAVIS, bebop pioneers who forged a new style known as "cool jazz." In the late 1940s, Davis began listening to and playing with white musicians, especially arranger Gil Evans, associated with Claude Thornhill's band. Davis formed an unusual nine-piece band, including "non-jazz" instruments such as tuba and French horn for club and record sessions later known as *Cool Jazz*. The ensemble's elegant, relaxed rhythms, complex and progressive harmonies, and intimate solo styles proved enormously influential to white musicians such as Gerry Mulligan, Chet Baker, Lennie Tristano, Dave Brubeck, George Shearing, and Stan Getz, as well as to Lewis's Modern Jazz Quartet.

Davis, a prodigious creator of jazz styles, helped launch the other major trend of the 1950s, "hard bop." Inaugurated by "Walkin' " (1954), hard bop was marked by longer, more emotional solos reminiscent of 1930s cutting contests, and reaffirmation of the gospel and blues. Charles Mingus, Sonny ROLLINS, Clifford BROWN, Horace SILVER, Art Blakey, and Thelonious Monk were all major exponents of hard bop, as were Cannonball ADDERLEY, Eric DOLPHY, Mal Waldron, Jackie MCLEAN, and Wes MONTGOMERY later. During the late 1950s Davis led an ensemble that included some of the finest and most influential of all hard bop players, including John COLTRANE, Cannonball Adderley, and white pianist Bill Evans. Davis's landmark *Kind of Blue* (1959) introduced a popular and influential style of playing known as modal, in which modes or scales, rather than chord changes, generate improvisation. Davis also never gave up his interest in large-ensemble, arranged music, and he experimented in the late 1950s, collaborating with Gil Evans, with orchestrations derived from modern European concert music. This music, which white composer Gunther Schuller dubbed as "Third Stream," was never popular among jazz audiences, although black jazz composers

such as John Lewis and George Russell embraced its concepts.

Bebop, cool jazz, hard bop, Third Stream music, and "soul" or "funk" jazz, pioneered by Horace Silver, dominated jazz in the late 1950s. However, the giants of the previous decades, playing what was to be called "mainstream" jazz, had some of their greatest popular, if not musical, successes. During that decade Louis Armstrong toured regularly in small and large ensembles, and had several enormously popular records. Basie organized a new orchestra, and also had several hit records. Ellington, who had triumphantly introduced new extended works annually in the 1940s, continued to compose for his orchestra, and also had several hits.

Avant-Garde Jazz

By the early 1960s, jazz had reached a crucial turning point. Many of the jazz masters of the swing era, such as Lester Young and Billie Holiday, were dead. Many of the most important musicians, including Charlie Parker, Bud Powell, and Clifford Brown, had died tragically young or had been devastated by heroin addiction, mental illness, or accidents. Musicians had pushed the rhythmic and harmonic conventions that had been established during the swing era to their breaking point. During the 1960s, Coltrane, Ornette COLEMAN, and Cecil TAYLOR led the way in beginning to abandon the swinging rhythms and

Horace Silver, a jazz pianist of Cape Verdian ancestry, was a pioneer in hard bop and "soul jazz" in the 1950s. Here he is photographed in 1980. (Photographs and Prints Division, Schomburg Center for Research in Black Culture, The New York Public Library, Astor, Lenox and Tilden Foundations)

The avant-garde jazz of tenor saxophonist Ornette Coleman, a pioneer of "free jazz" in the late 1950s and early '60s, challenged almost all conventional assumptions about the sound of jazz. A restless innovator, Coleman expanded the vocabulary of jazz for more than thirty years. (Photographs and Prints Division, Schomburg Center for Research in Black Culture, The New York Public Library, Astor, Lenox and Tilden Foundations)

melodies of traditional jazz in favor of implied tempos and harmonies, drawing on the largely unexplored reaches of their instruments, often in epic-length solos. By the mid-1960s, a whole new generation of avant-garde or free jazz musicians, including Albert Ayler, Archie SHEPP, Marion Brown, Bill Dixon, SUN RA, and Don CHERRY began to abandon even the bedrock jazz convention of theme and improvisation in favor of dissonant collective improvisations related to the energetic polyphony of New Orleans–style jazz. These musicians, inspired by the civil rights movement, also began to address politics, especially race problems and black nationalism, in their music. They were often joined by musicians from the previous generation, such as Max Roach and Charles Mingus. Also in the 1960s, many jazz musicians visited Africa, and some converted to Is-

lam, although some musicians—for example, Sadik Hakim—had converted as early as the 1940s. Many figures in the BLACK ARTS MOVEMENT, such as Amiri Baraka, hailed the extended solos of musicians such as John Coltrane as an authentic African-American art form. Ironically, at the same time, almost any connection to a large black audience in America was sundered.

The "further out" jazz became, the more harshly it was attacked by traditional musicians and listeners alike. In response, by the late 1960s many free jazz musicians were searching for ways to recapture a mass black audience. Once again, it was Miles Davis who led the way. Starting in the late 1960s, Davis began using electric instruments in his bands, and incorporating funk, rhythm and blues, and rock rhythms into his albums. Members of Davis's electric ensembles, such as Herbie HANCOCK, Wayne SHORTER, and Chick Corea, later enjoyed tremendous popular success.

Trumpeter Wynton Marsalis, a central figure in jazz as its first century draws to a close, is an articulate defender of the need to preserve and reinvigorate jazz traditions. Marsalis has also made several award-winning recordings of classical trumpet concertos. (AP/Wide World Photos)

One of the most popular jazz singers of the 1960s, Nina Simone was a versatile performer whose repertory included rhythm and blues, popular material, and songs from the musical theater. She recorded a number of songs about the civil rights movement, including "Mississippi Goddamn." (Photographs and Prints Division, Schomburg Center for Research in Black Culture, The New York Public Library, Astor, Lenox and Tilden Foundations)

If the electric music Davis created, known as "fusion" or "jazz rock," inspired accusations that he was selling out, in the 1970s, the purist mantle would be carried by a group of musicians who had been playing in Chicago since the early 1960s. Striving toward the implicit racial pride and artistic and economic independence preached by Sun Ra, Mingus, and Taylor, the ASSOCIATION FOR THE ADVANCEMENT OF CREATIVE MUSICIANS (AACM) was founded in 1965. The AACM, and its offshoot, the St. Louis–based Black Artists Group, have been responsible for many of the most important developments in jazz since the mid-1970s. The ART ENSEMBLE OF CHICAGO, pianist Muhal Richard ABRAMS, and saxophonist Anthony BRAXTON and Henry THREADGILL have all been important exponents of what they term "creative music," which idiosyncratically and unpredictably draws upon everything from ragtime to free jazz.

Jazz in the 1990s

In the 1980s, the institutionalization of jazz accompanied the more general interest of universities, symphonies, and museums in many areas of African-American culture. Since the 1970s, many jazz

musicians, including Mary Lou WILLIAMS, Archie Shepp, Jackie McLean, Bill Dixon, and Anthony Braxton have held university positions. Although there is a long history of formally trained jazz musicians, from Will Marion Cook to Miles Davis, a large proportion of the best young jazz musicians now come from conservatories. Such training has resulted not only in avant-gardists like Anthony DAVIS and David Murray, who have a healthy appreciation for the roots of jazz, but bebop-derived traditionalists like Wynton MARSALIS, who have brought mainstream jazz to the public prominence it has lacked for forty years. Further, although independent scholars compiled discographies and wrote biographies as early as the 1930s, since the1980s there has been a burst of institutional scholarly activity, accompanied by the integration of jazz into traditional symphony repertories, as well as the creation of jazz orchestras dedicated to preserving the repertory, and developing new compositions, at the Smithsonian Institution and Lincoln Center. Jazz, as perhaps the greatest of all African-American cultural contributions, always captured the imagination of great African-American writers like Langston HUGHES and Ralph ELLISON, and it continues to suffuse the work of contemporary writers like Ishmael REED, Toni MORRISON, Albert MURRAY, and Stanley Crouch.

As jazz approaches its second century, a new generation of musicians, including pianist Geri Allen and tenor saxophonist Joshua Redman, continue to improvise on the history of jazz to further address and define issues central to this particular African-American experience.

REFERENCES

BERENDT, JOACHIM E. *The Jazz Book: From Ragtime to Fusion and Beyond.* Westport, Conn., 1982.

BLESH, RUDI. *Shining Trumpets: A History of Jazz.* 4th ed. London, 1958.

CHARTERS, SAMUEL B., and LEONARD KUNSTADT. *Jazz: A History of the New York Scene.* Garden City, N.Y., 1962.

DAHL, LINDA. *Stormy Weather: The Music and Lives of a Century of Jazz Women.* New York, 1984.

DRIGGS, FRANK, and HARRIS LEWINE. *Black Beauty, White Heat: A Pictorial History of Classic Jazz.* New York, 1982.

FEATHER, LEONARD. *Encyclopedia of Jazz.* Revised edition. New York, 1970.

GITLER, IRA. *Jazz Masters of the Forties.* New York, 1966.

GOLDBERG, JOE. *Jazz Masters of the Fifties.* New York, 1966.

HADLOCK, RICHARD. *Jazz Masters of the Twenties.* New York, 1965.

HODEIR, ANDRE. Translated by David Noakes. *Jazz: Its Evolution and Essence.* New York, 1956.

JOST, EKKEHARD. *Free Jazz.* New York, 1981.

LEONARD, NEIL. *Jazz and White Americans: The Acceptance of a New Art Form.* Chicago, 1962.

RUSSELL, ROSS. *Jazz Style in Kansas City and the Southwest.* Berkeley, Calif., 1971.

SCHULLER, GUNTHER. *Early Jazz: Its Roots and Musical Development.* New York, 1968.

———. *The Swing Era: The Development of Jazz, 1930–1945.* New York, 1989.

STEARNS, MARSHALL. *The Story of Jazz.* New York, 1970.

STEWART, REX. *Jazz Masters of the Thirties.* New York, 1972.

WEINSTEIN, NORMAN C. *A Night in Tunisia: Imaginings of Jazz in Africa.* Metuchen, N.J., 1992.

WILLIAMS, MARTIN. *Jazz Masters of New Orleans.* New York, 1967.

———, ed. *The Art of Jazz: Ragtime to Bebop.* New York, 1981.

———, ed. *Jazz Panorama.* New York, 1964.

LEONARD GOINES

Jefferson, "Blind" Lemon (July 1897–December 1929), blues guitarist and singer. Although the circumstances of his birth are obscure, Lemon Jefferson's birthplace is often given as Couchman, Tex. He is thought to have been born blind, but several of his songs indicate that he lost his sight in childhood. Jefferson learned to play guitar as a teen, and was soon performing on the streets of nearby Wortham, as well as at barber shops and parties. He also sang spirituals at the family's church, Shiloh Baptist Church in Kirvin.

Jefferson moved to Dallas permanently in 1912. He weighed almost 250 pounds at the time, and for a brief time earned money as a novelty wrestler in theaters. He met Huddie "Leadbelly" LEDBETTER in Dallas's Deep Ellum neighborhood, and they played and traveled together throughout East Texas, until Leadbelly was jailed for murder in 1918. Jefferson also performed for spare change on Dallas streets, at times assisted by T-Bone Walker and Josh WHITE, and Jefferson was noted for his ability to hear pennies by the sound they made in his tin cup, reject them. In the early 1920s Jefferson married and had a son.

Jefferson's first recordings were spirituals, including "All I Want Is That Pure Religion" and "I Want to be Like Jesus in my Heart," made under the name Deacon L. J. Bates. "Long Lonesome Blues" (1926), his first popular success, displayed his clear, high-pitched voice, accentuated by hums and moans. His guitar playing was marked by a subtle, almost contrapuntal use of hammered bass and treble lines. Like many East Texas and Delta bluesmen, Jefferson sang

of day-to-day life ("Corinna Blues" [1926], "Jack of Diamonds" [1926], "Rising High Water Blues" [1927], "Piney Woods Money Mama" [1928], "See That My Grave Is Kept Clean" [1928], "Pneumonia Blues" [1929]) as well as travel ("Sunshine Special" [1927], "Rambler Blues" [1927], "Matchbox Blues" [1927]). He sang lyrics filled with sexual innuendo ("That Black Snake Moan" [1926], "Oil Well Blues" [1929], "Baker Shop Blues" [1929]). Many of Jefferson's songs were about jail ("Blind Lemon's Penitentiary Blues" [1928], "Hangman's Blues" [1928]), although he himself was never incarcerated. In the late 1920s Jefferson's recordings made him a wealthy, nationally recognized figure. He traveled throughout the South and Midwest, and even kept an apartment in Chicago. However, his popularity lasted only briefly, and by 1929 he was no longer performing and recording as frequently. In December 1929, on a date that has never been verified, Jefferson froze to death in a Chicago blizzard.

REFERENCES

GOVENAR, ALAN. "That Black Snake Moan: The Music and Mystery of Blind Lemon Jefferson." In Peter Welding and Toby Byron, eds. *Bluesland*. New York, 1991.

GROOM, BOB. *Blind Lemon Jefferson*. London, 1970.

JONATHAN GILL

Jefferson, Isaac (c. 1775–1853), writer and former slave. Isaac Jefferson was born a slave to Thomas Jefferson in Monticello, Va. His mother, Ursula, was a house servant nicknamed "Queen" whose husband was a slave known as "King" George. In 1779 Thomas Jefferson took his slaves with him to Richmond, where the new seat of government was located. During the Revolutionary War, Isaac Jefferson learned to beat a drum to signal the approach of the British. When the British captured Richmond, Isaac Jefferson was taken to Yorktown until the end of the war.

In 1790 Jefferson went back to Monticello, where he remained for nine years with Thomas Jefferson's son-in-law, Thomas Mann Randolph. He later joined Thomas Jefferson in Philadelphia, where he learned the tinner's trade in the shop of Whiteman Bringhouse. He returned to Monticello where he worked in the nail business for seven years. From 1822 until 1847 Isaac Jefferson took up the blacksmith trade in a shop in Petersburg, Va. (During this time he helped nurse the ailing Thomas Jefferson, who died in 1826.) Isaac Jefferson remained in Petersburg until his death in 1853. The story of his life is recorded in *Memoirs of a Monticello Slave, As Dictated to Charles Campbell in the 1840s by Isaac, One of Thomas Jefferson's Slaves*.

REFERENCE

LOGAN, RAYFORD W., and MICHAEL R. WINSTON, eds. *Dictionary of American Negro Biography*. New York, 1982.

SABRINA FUCHS

Jefferson, Mildred Fay (1927–), physician and politician. Born in Pittsburgh, Tex., Mildred Jefferson received a B.A. degree from Texas College in Tyler and studied at Tufts University in Medford, Mass., before becoming the first black woman to graduate from Harvard Medical School in 1951. (The medical school admitted women beginning only in 1945.) Jefferson attended the school on a scholarship from a synagogue in Boston. She continued her medical career as general surgeon and assistant clinical professor of surgery at Boston University Medical Center.

The 1973 U.S. Supreme Court decision legalizing abortion (*Roe* v. *Wade*) spurred Jefferson into political action. She became president of the National Right to Life Committee (NRTLC), a predominantly white organization that opposed abortion under any circumstances. Jefferson was one of the witnesses for the prosecution in the controversial abortion-related manslaughter trial of Dr. Kenneth Edelin in Boston. She has repeatedly called for the overturning of the *Roe* v. *Wade* decision and has voiced her disagreement with feminists. In a 1978 interview, she said, "There isn't anything they talk about that I can support in any way." In 1984, when U.S. Sen. Paul Tsongas retired, Jefferson ran unsuccessfully as a candidate for his seat.

REFERENCES

Crisis (August–September 1951): 444.
Ebony (May 1948): 16.
Ebony (April 1978): 78–94.

LYDIA MCNEILL

Jehovah's Witnesses. The New World Society of the Witnesses of Jehovah, a fundamentalist, indigenous North American religious group under the corporate behest of the Watchtower Bible and Tract Society of New York and Pennsylvania, known commonly as the Jehovah's Witnesses, has throughout much of its history consisted of some 20–30 percent African Americans. Although it has at various times and places endorsed racist and segregationist policies

and practices, it has often led white society as a whole in its race-blind recruitment of members. In addition, several of the civil liberties suits argued by the Jehovah's Witnesses in the United States set important precedents for later civil rights litigation.

Founded near Pittsburgh, Pa., in 1872 by Charles Taze Russel, it relocated its headquarters to the Lighttower in Brooklyn, N.Y., in 1909. Fundamental to the Witnesses is their belief in the imminence of Har-Magedon (Armageddon)—so imminent that their second president, Judge Joseph Franklin Rutherford, declared that "many [of the Witnesses] now living will never die." For this reason, the Society requires total commitment from its members and does not permit involvement in any other organization—such as the NAACP or a political party.

The strong, supportive, and largely self-sufficient community resulting from this commitment has appealed to groups and individuals distinct or somehow excluded from dominant social groups, and to African Americans in particular. Throughout the twentieth century, the Society's aggressive recruitment activities have made Jehovah's Witnesses one of the fastest-growing religious groups in the United States, and African Americans have joined at a higher percentage rate than any other group. The Society counts some 4,289,737 members worldwide, with a year's average increase of 866,362 (peak: 904,963) in the United States.

Throughout its history, the Society has had conflicting policies towards African Americans. *The Watchtower*, one of the Society's official biweekly publications, stated in 1952 that racial divisions have no place among Witnesses. Indeed, the Witnesses have long accepted minority members more openly than most other groups. On the other hand, *Awake*, the other official biweekly publication, has counseled members against interracial marriages (April 4, 1953), and supported the policy of apartheid in South Africa (October 8, 1953). In November 1935, *The Watchtower* quoted Rutherford's decree that because blacks have less education than whites, "reading matter distributed to colored congregations would be more than half wasted. . . ." Until 1956, African Americans were not asked to attend the Jehovah's Witnesses' national conventions, though they were encouraged to conduct their own. Through the early 1960s, local assemblies, especially in the South, remained segregated.

A small group of the Church's officers and their aids appoint all supervisors, local congregational leaders, and elders. Although the Society keeps meticulous statistics, it neither responds to nor encourages inquiries about its members. Still, few African Americans have ever held important positions within the Society's hierarchy. In 1952 the NAACP's *Crisis* reported that of the 400 members on the staff of the national headquarters of the Jehovah's Witnesses, only two were African American—a mail clerk and a linotypist. In the ensuing years, more blacks worked at the Lighttower, though the upper echelons continued to exclude them.

REFERENCES

COOPER, LEE R. " 'Publish' or Perish: Negro Jehovah's Witness Adaptation in the Ghetto." In Irving Zaretsky, ed. *Religious Movements in Contemporary America*. Princeton, N.J., 1974.
1993 Yearbook of Jehovah's Witnesses. New York, 1993.
STROUP, HERBERT HEWITT. *The Jehovah's Witnesses*. New York, 1945.
WHALEN, WILLIAM. *Armageddon Around the Corner: A Report on Jehovah's Witnesses*. New York, 1962.

PETER SCHILLING

Jemison, Mae Carol (October 17, 1956–), astronaut. Mae C. Jemison was born in Decatur, Ala., but grew up in Chicago, Ill. In 1977, she graduated from Stanford University with a B.S. in Chemical Engineering and a B.A. in African and Afro-American Studies. She received an M.D. from Cornell University Medical College in 1981. After interning at the University of Southern California Medical Center in Los Angeles, she worked in private practice until January 1983, when she joined the Peace Corps. She served in Sierra Leone and Liberia as a Peace Corps medical officer for two and a half years, returning in 1985 to Los Angeles to work as a general practitioner.

In 1987, Jemison's application to NASA's astronaut training program was accepted, and she was named the first African-American woman astronaut. After completing the one-year program, she worked as an astronaut officer representative at the Kennedy Space Center in Florida. In September 1992, Jemison became the first black woman in space when she flew as a payload specialist aboard the space shuttle *Endeavor*. During the seven-day flight, Jemison conducted experiments to determine the effects of zero gravity on humans and animals.

In March 1993, Jemison resigned from NASA in order to form her own company, the Jemison Group, which specializes in adapting technology for use in underdeveloped nations. Her historic spaceflight brought her much adulation. In Detroit a school was named after her. And in the spring of 1993, a PBS special, *The New Explorers*, focused on her life story, while *People* named her one of the year's "50 Most Beautiful People in the World." Also in 1993, Jemi-

son made a guest appearance as a transport operator named Lieutenant Palmer on the television series *Star Trek: The Next Generation*. This was fitting, as Jemison claimed that she was inspired to become an astronaut by the actress Nichelle Nichols, who portrayed the black Lieutenant Uhura on the original *Star Trek*.

Jemison received the CIBA Award for Student Involvement in 1979, the Essence Award in 1988, the Gamma Sigma Gamma Woman of the Year Award in 1989, and the Makeda Award for community contributions in 1993.

REFERENCES

"Coalition Luncheon." *Houston Chronicle,* June 30, 1993, p. 4.
GIOVANNI, NIKKI. "Shooting for the Moon." *Essence* (April 1993): 58–60.
HAWTHORNE, DOUGLAS B. *Men and Women of Space.* San Diego, Calif., 1992.

LYDIA McNEILL

Jenkins, Edmund Thornton (April 9, 1894– 1926), composer. Edmund Thornton Jenkins, composer, conductor, and music publisher, was born in Charleston, S.C. As a young member of the well-known Jenkins Orphanage Band of Charleston and the son of its founder-director, Rev. Daniel Jenkins, he began his music education at an early age. In 1908, he continued his training at MOREHOUSE COLLEGE, where he met and established lasting relationships with Kemper Harreld and Benjamin BRAWLEY. In 1914, he enrolled at the Royal Academy of Music in London and studied composition with Frederick Corder. Jenkins distinguished himself at the Royal Academy by receiving several prizes, including the Bronze Medal (sightsinging), the Oliveria Prescott Gift (composition), the Charles Lucas Prize (merit), and the Battison Hayne Prize (composition). He became an associate of the Royal Academy of Music in 1921. In 1923, he returned to the United States with plans to establish a music academy, a music publishing company, and an orchestra of African-American musicians. Unable to find financial support and the proper social climate for these ventures, Jenkins returned to Paris in 1924, where he remained until his death, due to causes unknown, in 1926.

Jenkins's compositions, now housed at the Center for Black Music Research at Columbia College, Chicago, were written in the European classical tradition. However, in keeping with his political activism in African and African-American affairs, several of his compositions contain black folk melodies and have such African-inspired titles as *Folk Rhapsody* (1919) and *African War Dances* (late 1925). Twenty-five of his titled compositions have been discovered, along with several incomplete, untitled scores. His list of compositions includes songs for voice and piano, violin sonatas, songs for piano solo, works for full orchestra, works for cello, a clarinet concerto, a prelude for organ and orchestra, and a work for saxophone and piano. A cello sonata in A minor (late 1925), for which he received the Holstein Prize, was lost and has not been recovered.

REFERENCE

GREENE, JEFFREY P. *Edmund Thornton Jenkins: The Life and Times of An American Black Composer, 1894– 1926.* Westport, Conn., 1982.

BETTY HILLMON

Jenkins, Esau (July 3, 1910–October 30, 1972), grassroots organizer. Esau Jenkins was a farmer born on Johns Island, S.C., in 1910. At fourteen, with only a fourth-grade education, he returned to school and was instructed and heavily influenced by civil rights activist Septima Clark. Jenkins became a local activist and a community leader. In the 1940s he supplemented his income by working as a bus driver, and he used the bus as a forum to spread his political and educational message. In 1948, he organized the Johns Island Progressive Club, which initiated community centers and cooperative grocery stores, and provided legal aid to blacks on the island. In the early 1950s, Jenkins organized and headed the Civic Club, which worked to register African-American voters, but with little success.

In 1954, at the urging of Clark, Jenkins attended the Highlander Folk School in Monteagle, Tenn. The school provided a gathering place for black and white community activists and taught them how to develop strategies and tools for achieving social change. At Highlander, Jenkins honed community leadership skills which he utilized for the betterment of Johns Island. In 1954, he ran for a position on the school board and became the first African American in ninety years to seek office on Johns Island. Despite having received the votes of all 203 registered blacks, Jenkins lost. It was clear to him that illiteracy kept African Americans from registering to vote.

In 1956, Jenkins requested funding from the Highlander Folk School to set up literacy classes to teach black adults basic reading skills. He was allotted $1500 and Highlander's first Citizenship School was born. The process of setting up the school involved grassroots mobilization, community leadership con-

ferences, and informal meetings between Johns Island residents and white activists at Highlander. These interracial contacts, structured on a plane of equality and mediated by Jenkins, moved Johns Island residents away from their sense of isolation and empowered them to address their own problems. The school, which was held in the back of Jenkins's cooperative store and taught by Bernice Robinson, Septima Clark's niece, became a successful prototype for citizenship schools throughout the South. From 1956 to 1960, the percentage of African Americans registered to vote on Johns Island increased by 300 percent.

Jenkins became a member of Highlander's executive council in 1957, and was involved in developing programs designed to help new voters take what he called "the second step" and create political action groups and develop strategies for tackling problems that faced their communities. In June 1963 he was appointed project director of the Southwide Voter Education Project established through Highlander. Three years later, he organized the Community Organization Federal Credit Union, which made capital available for car, house, education, and hospital loans for the residents of Johns Island. Jenkins was appointed to the Johns Island School Board shortly before his death in 1972.

REFERENCES

BLEDSOE, THOMAS. *Or We'll All Hang Separately: The Highlander Idea.* Boston, 1969.
GLENN, JOHN. *Highlander: No Ordinary School 1932–1962.* 1988.

JEANNE THEOHARIS

Jenkins, Leroy (March 11, 1932–), jazz violinist and composer. Born in Chicago, Jenkins was educated in the public schools there. He received a bachelor of music degree in 1961 from Florida A&M University and taught public school in Mobile, Ala. (1961–1965), and Chicago (1965–1969). While in Chicago, he played with the ASSOCIATION FOR THE ADVANCEMENT OF CREATIVE MUSICIANS. In 1967, Jenkins helped found the Creative Construction company with Anthony BRAXTON and Leo Smith. He was also a founding member of the Revolutionary Ensemble (1971). By the late 1960s, he was considered the leading violinist in free jazz style.

Jenkins has composed in many genres. He began expanding his horizons in the 1980s to include more traditional classical forms. In 1983, he premiered his *Concerto for Improvised Violin and Chamber Orchestra* with the Brooklyn Philharmonic under conductor

Lukas Foss. This was followed by *Mixed Quintet* (1984, based on a 1979 work), and *Winnie and Nelson* (1985). The Kronos String Quartet premiered *Themes and Improvisations on the Blues,* which was commissioned by the Composers' Forum (1985). His opera *Mother of Three Sons,* which incorporates dance as an integral part of the performance, was highly successful and was performed in both Europe and the United States. Jenkins's rap opera, *Fresh-Faust* (libretto by Greg Tate), is based on the life of Edmund Perry, a youth killed by a New York City police officer.

Jenkins has been awarded commissions by the Rockefeller Foundation, the Brooklyn Philharmonic, the New York State Council of the Arts, the Cleveland Chamber Symphony, and the Composers' Forum. He has toured extensively throughout the United States and Europe and has led his own groups, including a trio with Anthony DAVIS and Andrew Cyrille. Jenkins is most noted for his virtuosic technique and improvisations. He has introduced various traditional technical devices into the jazz idiom—trill, harmonics, spiccato, bariolage, and Jenkins's own technique, "vicato."

REFERENCES

BLUMENTHAL, BOB. "Leroy Jenkins: For the Records." *Down Beat* 49, no. 3 (1982): 20.
GANN, KYLE. "*Three Sons* Debuts: Leroy Jenkins at City Opera." *Village Voice,* November 5, 1991.

LYNN KANE

Jennings, Wilmer Angier (November 13, 1910– June 25, 1990), artist. Wilmer Jennings was born in 1910 in Atlanta, Ga., to Levi and Matilde Angier Jennings. He graduated from Morehouse College in 1933, then studied with Hale WOODRUFF, painting in oils and experimenting with wood and steel engraving and learning other techniques of printmaking. Jennings was also a student of sculptor Nancy Elizabeth PROPHET. He worked on the federal WORKS PROJECT ADMINISTRATION in Atlanta and painted a mural for Booker T. Washington High School there. Jennings's work was well received and exhibited often during the 1930s in New Jersey, Texas, Chicago, Baltimore, and New York. In the 1940s he moved to Providence, R.I.

Art historians James Porter and David Driskell have written about the rich textures and vigorous designs of Jennings's wood engravings and linocuts, noting their bold contrasts of velvety blacks and sharp whites. Jennings won the National Silversmith Award for designing jewelry and an honorary doctorate in 1978 from Rhode Island College. Works by

Jennings were shown at the Newark Museum's exhibition "Against the Odds" in 1990, and *Sanctuary* was part of the exhibition "Bridges and Boundaries" at the Jewish Museum in New York in 1992. His paintings and engravings are held by the Smithsonian Institution, the Newark Museum, the National Center for Afro-American Artists (Boston), and the Rhode Island School of Design.

REFERENCES

REYNOLDS, GARY A., and BERYL J. WRIGHT. *Against the Odds: African-American Artists and the Harmon Foundation.* Newark, N.J., 1989.

"Wilmer A. Jennings, 79; Providence Artist Noted for Woodcuts, Engravings." *Providence Journal-Bulletin*, June 29, 1990, p. C4.

BETTY KAPLAN GUBERT

Jernagin, William Henry (October 13, 1869–February 1958), clergyman. William Jernagin was born in Mashulaville, Miss. He attended Meridian Academy in Meridian, Miss., and taught in Mississippi public schools for five years. Converted at thirteen, Jernagin was licensed to preach by the Bush Fork Baptist Church in 1890 and was ordained in 1892 as pastor of the New Prospect Baptist Church near Meridian. In 1896, he received a B.A. degree from Jackson College (now Jackson State University) and became pastor at Oktibbeha Baptist Church in Oktibbeha, Miss. After a brief stay there, Jernagin served as pastor at several churches in the state and as president of the Young People's Christian Educational Congress of Oklahoma, before leaving in 1906 for the Tabernacle Baptist Church in Oklahoma City, where he served until 1912. While there, he was president of the Oklahoma General Baptist Convention.

From Oklahoma, Jernagin was invited to be pastor of Mount Carmel Baptist Church in Washington, D.C., where he served the rest of his career, expanding the membership of his church and its appeal to young people. He was also instrumental in involving the church in social service and civil rights activities; in the process, he became nationally known as an African-American church leader.

In 1916, Jernagin was elected the first president of the National Race Congress, a short-lived, exclusively black organization formed in Washington, D.C., to rival the NATIONAL ASSOCIATION FOR THE ADVANCEMENT OF COLORED PEOPLE (NAACP). He was its representative to the 1919 Paris Pan-African Conference (*see* PAN-AFRICANISM), which Jernagin attended as a correspondent for the *Washington Bee*, because he was originally denied a passport. He also attended the 1921 follow-up conference in London.

In 1926, he was elected president of the Congress of Christian Education, a position he held until the end of his career. In 1928, he was voted president of the Consolidated National Equal Rights League and Race Congress. In 1932, he was a delegate to the Republican national convention. During President Herbert Hoover's administration, Jernagin became the first black clergyman to be invited to tea at the White House. In 1937, he was elected president of the National Fraternal Council of Negro Churches, the first important African-American ecumenical organization. As its head during the 1940s and 1950s, Jernagin was a leader in establishing a position of the black church on social, political, and civil rights issues.

During World War I, Jernagin preached to black soldiers in France. In World War II, he again volunteered his services as an army chaplain and served in the Pacific. Active in youth and church affairs until the end of his life, William Jernagin died of a gallbladder obstruction in Miami in 1958.

REFERENCES

JACKSON, JOSEPH H. *The Story of Church Activism.* Nashville, Tenn., 1980.

JERNAGIN, WILLIAM H. *Christ at the Battlefront: Servicemen Accept the Challenge.* Washington, 1946.

Our World (July 1954): 28–32.

SCHWARZ, JOE. *Religious Leaders of America.* New York, 1942.

LYDIA MCNEILL

Jessye, Eva Alberta (January 20, 1895–February 21, 1992), composer and choral director. Eva Alberta Jessye was born in Coffeyville, Kans., the only child of former slaves. She earned a baccalaureate degree in 1914 from Western University in Kansas, and did graduate work at Langston University, in Langston, Okla. In the early 1920s she studied with composer Will Marion COOK, became music director at Baltimore's Morgan College, and went on to become a leader in African-American choral music. She organized her Original Dixie Jubilee Singers (later renamed the Eva Jessye Choir), which appeared regularly from 1926 to 1929 on syndicated radio programs, including the Major Bowes Family Radio Hour, and the General Motors Hour. She published a book of music, *My Spirituals,* in 1927. During this time she also conducted her choir in performances between shows at New York's Capitol and Rivoli theaters. In 1929 she was named choral director of the MGM film *Hallelujah,* one of the first talking films with an African-American theme and cast.

In 1934 Jessye worked as choral director of *Four Saints in Three Acts,* an opera by Virgil Thomson, with a libretto by Gertrude Stein. The next year George Gershwin chose her as choral director for his folk opera *Porgy and Bess.* Jessye also composed her own music, including an oratorio, *Paradise Lost and Regained* (1934), which was broadcast on NBC Radio, and *The Chronicle of Job* (1936), a folk drama. Jessye was the first black woman to win international distinction as a director of a professional choir.

In the 1940s and '50s Jessye had an established reputation as one of the most prominent choral conductors in the United States, the first African-American woman to do so. She worked on a 1958 television production of *Kiss Me Kate,* and the next year appeared at a festival of spirituals at the Antioch Baptist Church in New York City.

In 1974 Jessye donated her papers and memorabilia to the University of Michigan African American Music Collection, in Ann Arbor. In 1979 she became an artist-in-residence at Pittsburg State University, in Pittsburg, Kans., and published her *Selected Poems.* This university also houses a collection of some of her papers, photographs, and memorabilia. Jessye was the subject of a special session at the 1981 Afro-American Music Workshop at Morehouse College in Atlanta, and in 1985 she appeared at a symposium on her work in Los Angeles. Jessye spent the last ten years of her life in Ann Arbor where she died in 1992.

REFERENCES

ALBERT, HOLLIS. *The Life and Times of Porgy and Bess.* New York, 1990.

BLACK, DONALD. The Life Work of Eva Jessye and Her Contributions to American Music. Ph.D. diss., University of Michigan, 1986.

JAMES STANDIFER

Jet. The magazine *Jet,* founded by John H. JOHNSON in November 1951, is the leading African-American newsweekly. In 1990 its weekly readership was over 8.7 million. Among the publications of the Johnson Publishing Company, it ranks second in circulation to *Ebony,* the popular large-format monthly magazine it was designed to complement.

Jet, whose title carries the connotation both of dark skin color and of speedy airplanes, was meant as a quick, pocket-sized review of black news. Founded on the model of *Life* magazine's unsuccessful pocket-sized feature magazine *Quick, Jet* was originally only $5\frac{3}{4}'' \times 4''$. Within six issues of its founding, it had a weekly circulation of 300,000. By the 1990s, circulation was 900,000 per week, and the magazine had grown to a $7\frac{3}{8}'' \times 5\frac{1}{4}''$ format.

By the early 1990s, *Jet* was distributed throughout the United States and in forty foreign countries, including many African nations. Its appeal stems from its coverage of important issues in the African-American community and from its concise style. *Jet*'s articles are meant to cover important issues in readable form, for people who neither have the time nor wish to read deeply on current events but want to stay informed. Its reputation for news and commentary on social events was best expressed by a character in a play by writer Maya ANGELOU, who claimed, "If it didn't happen in *Jet,* it didn't happen anywhere."

REFERENCE

JOHNSON, JOHN H. and LERONE BENNETT. *Succeeding Against the Odds.* New York, 1989.

KAREN BENNETT HARMON

Jim Crow. As a way of portraying African Americans, "Jim Crow" first appeared in the context of minstrelsy in the early nineteenth century (*see* MINSTRELS AND MINSTRELSY). Thomas "Daddy" Rice, a white minstrel, popularized the term. Using burnt cork to blacken his face, attired in the ill-fitting, tattered garment of a beggar, and grinning broadly, Rice imitated the dancing, singing, and demeanor generally ascribed to Negro character. Calling it "Jump Jim Crow," he based the number on a routine he had seen performed in 1828 by an elderly and crippled Louisville stableman belonging to a Mr. Crow. "Weel about, and turn about / And do jis so; / Eb'ry time I weel about, / I jump Jim Crow." The public responded with enthusiasm to Rice's caricature of black life. By the 1830s, minstrelsy had become one of the most popular forms of mass entertainment, "Jim Crow" had entered the American vocabulary, and many whites, north and south, came away from minstrel shows reinforced in their distorted images of black life, character, and aspirations.

Less clear is how a dance created by a black stableman and imitated by a white man for the amusement of white audiences would become synonymous with a system designed by whites to segregate the races. The term "Jim Crow" as applied to separate accommodations for whites and blacks appears to have had its origins not in the South but in Massachusetts before the Civil War. Abolitionist newspapers (*see* ABOLITION) employed the term in the 1840s to describe separate railroad cars for blacks and whites. Throughout the North, blacks, though legally free, found

themselves largely the objects of scorn, ridicule, and discrimination. Most northern whites shared with southern whites the conviction that blacks, as an inferior race, were incapable of assimilation as equals into American society. Racial integrity demanded that blacks, regardless of class, be segregated in public transportation—that they be excluded from the regular cabins and dining rooms on steamboats, compelled to ride on the outside of stagecoaches, and forced to travel in special Jim Crow coaches on the railroads. Only in New England, prior to the Civil War, did blacks manage to integrate transportation facilities, but only after prolonged agitation, during which blacks and white abolitionists deliberately violated Jim Crow rules and often had to be dragged from the trains.

Before the Civil War, enslavement determined the status of most black men and women in the South, and there was little need for legal segregation. During RECONSTRUCTION, the Radical state governments, though several of them outlawed segregation in the new constitutions, did not try to force integration on unwilling whites. Custom, habit, and etiquette defined the social relations between the races and enforced separation. The determination of blacks to improve their position revolved largely around efforts to secure accommodations that equaled those provided the whites.

But in the 1890s, even as segregation became less rigid and pervasive in the North, the term "Jim Crow" took on additional force and meaning in the South. It came to represent an expanded apparatus of segregation sanctioned by law. Economic and social changes had multiplied the places and situations in which blacks and whites might come into contact, and whites had become alarmed over a new generation of blacks undisciplined by slavery, unschooled in racial etiquette, less fearful of whites, and more inclined to assert their rights as citizens.

Jim Crow, then, came to the South in an expanded and more rigid form in the 1890s and the early twentieth century, in response to white perceptions of a new generation of blacks and to growing doubts that this generation could be trusted to stay in its place without legal force. Some whites, caught up in the age of Progressive reform, preferred to view legal

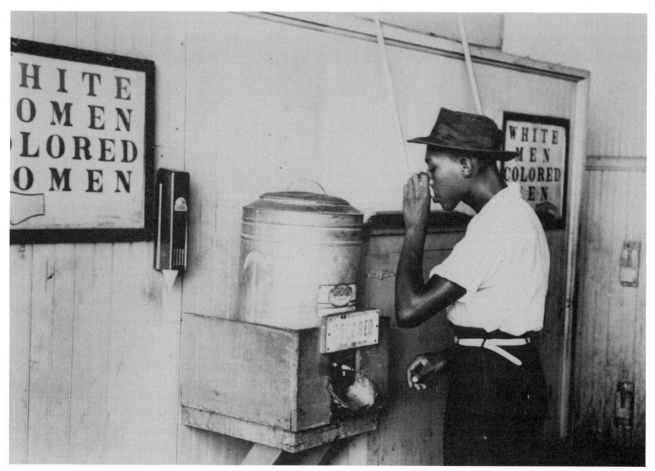

Signs about race hung wherever blacks and whites were likely to meet. In Oklahoma City, July 1939, a man drinks from a Jim Crow water fountain. (Prints and Photographs Division, Library of Congress)

A black patron makes his way to the colored balcony of a movie theater in Belzoni, Miss., in October 1939. In even the most mundane aspects of public life in the South, Jim Crow restrictions reminded blacks of their legal inferiority. (Prints and Photographs Division, Library of Congress)

segregation as reform rather than repression, as a way to resolve racial tensions and maintain the peace. For most whites, however, it was nothing less than racial self-preservation, deeply rooted in the white psyche. "If anything would make me kill my children," a white woman told a northern visitor, "it would be the possibility that niggers might sometime eat at the same table and associate with them as equals. That's the way we feel about it, and you might as well root up that big tree in front of the house and stand it the other way up and expect it to grow as to think we can feel any different."

Between 1890 and 1915, the racial creed of the white South manifested itself in the systematic disfranchisement of black men, in rigid patterns of racial segregation, in unprecedented racial violence and brutality, and in the dissemination of racial caricatures that reinforced and comforted whites in their racial beliefs and practices. The white South moved to segregate the races by law in practically every conceivable situation in which they might come into social contact. The signs "White Only" and "Colored"

would henceforth punctuate the southern scenery: from public transportation to public parks and cemeteries, from the work place to hospitals, asylums, orphanages, and prisons, from the entrances and exits at theaters, movie houses, and boardinghouses to toilets and water fountains. Oftentimes, Jim Crow demanded exclusion rather than separation, as with municipal libraries and many sports and recreational facilities. Jim Crow legislation tended to be thorough, far-reaching, even imaginative: from separate public school textbooks for black and white children to Jim Crow Bibles for black witnesses in court, from separate telephone booths to Jim Crow elevators. New Orleans adopted an ordinance segregating black and white prostitutes.

In PLESSY V. FERGUSON (1896) the United States Supreme Court employed the "separate-but-equal" principle to affirm the constitutionality of Jim Crow, confirming what most black southerners already knew from personal experience—that the quality of their life and freedom depended on the whims and will of a majority of whites in their locality or state.

The court decision, along with the elaborate structure of Jim Crow, remained in force for more than half a century. In the 1950s and 1960s, a new climate of political necessity and a new generation of black Americans helped to restructure race relations. With an emboldened and enlarged civil rights movement in the vanguard, the federal government and the courts struck down the legal barriers of racial segregation and ended Jim Crow. But a far more intractable and elusive kind of racism, reflected in dreary economic statistics and a pervasive poverty, lay beyond the reach of the law and the growing civil rights movement.

REFERENCES

CELL, JOHN W. *The Highest Stage of White Supremacy: The Origins of Segregation in South America and the American South.* Cambridge, Mass., 1982.

McMILLAN, NEIL R. *Dark Journey: Black Mississippians in the Age of Crow.* Urbana, Ill., 1989.

RABINOWITZ, HOWARD. *Race Relations in the Urban South, 1865–1890.* New York, 1978.

TOLL, ROBERT C. *Blacking Up: The Minstrel Show in Nineteenth-Century America.* New York, 1974.

WILLIAMSON, JOEL. *The Crucible of Race: Black-White Relations in the American South Since Emancipation.* New York, 1984.

WOODWARD, C. VANN. "The Strange Career of a Historical Controversy." In *American Counterpoint: Slavery and Racism in the North-South Dialogue.* New York, 1971.

———. *The Strange Career of Jim Crow.* 3rd revised ed. New York, 1974.

LEON F. LITWACK

Joans, Ted (July 4, 1928–), poet, surrealist painter, and jazz musician. Ted Joans was born in Cairo, Ill. Joans's father was a riverboat entertainer, and Joans played the trumpet from an early age, developing a lifelong interest in jazz. In 1951 he received a B.A. in fine arts from Indiana University. Shortly afterward, he moved to New York City to study art at the New School for Social Research and Brooklyn College. Joans quickly became a part of the arts community of Greenwich Village and set up a studio at Astor Place. Over the next few years he became acquainted with a number of notable jazz musicians and with many Beat poets. In 1958 Joans began giving public readings of his poetry, which integrated JAZZ rhythms, social protest, surrealistic imagery, and satire. He soon became well known as a central figure of the Beat movement and a pioneer performer of jazz poetry; in 1959 he published his first volume of poetry, *Jazz Poems.*

Ted Joans, 1993. (© Leandre Jackson)

Joans soon became dissatisfied with the commercialism that he felt had taken over the Beat scene. In 1961, after publishing two more collections of poems, the satirical *The Hipsters* and *All of Ted Joans and No More* (intended as a farewell to the United States and to Beat culture), he moved to Paris. After brief residences there and in Africa, Joans settled into a migratory lifestyle, spending most of the year in Timbuktu, Mali, with long seasonal visits to Europe and the United States. His later work, beginning with *Black Pow-Wow: Jazz Poems* (1969), shows the influence of Joans's immersion in African culture while maintaining ties to both jazz and surrealism.

Joans has published over thirty collections of poems, including *Afrodisia: New Poems* (1970), *A Black Manifesto in Jazz Poetry and Prose* (1971), and *Double Trouble* (1992). Although best known for his poetry, Joans has also worked as an essayist and critic. In 1981, Joans was invited to read his work at UNESCO in Paris, where in the 1990s he established a full-time residence.

REFERENCES

FABRE, MICHEL. *From Harlem to Paris: Black American Writers in France, 1840–1980.* Chicago, 1991.

WILENTZ, ELIAS, ed. *The Beat Scene*. New York, 1960.

JON WOODSON

John Brown's Raid at Harpers Ferry, Virginia. On his way to the gallows in 1859, John Brown handed a note to one of his attendants avowing that SLAVERY "*will* never be purged *away*; but with Blood." The Connecticut-born abolitionist (*see* ABOLITION) and Christian zealot held that the South would never voluntarily abandon slavery. Nearly three decades of abolitionist agitation had not, Brown maintained, moved the nation any closer to ending that "wicked" institution. His war against proslavery forces in the Kansas Territory and Missouri during the 1850s convinced him that only a direct attack on the South offered hope of destroying slavery.

Beginning in 1857, Brown used his extensive contacts in the antislavery community to raise funds for an astonishing scheme. Although he contacted scores of black and white abolitionists, he offered them few details and gave most only the broadest outline of his plan to invade Virginia. Blacks pledged their support, but some of his closest friends in the African-American community, such as Frederick DOUGLASS, had no idea that Brown aimed to seize the federal arsenal at Harpers Ferry, Va. (now part of West Virginia), arm local slaves, and commence a war against the slaveholding South. Although northern blacks eagerly promised money and assistance, most feared retribution against their families and refused to join his small band. Others, with far more militant ideas than Brown's, simply did not trust the plans of whites.

Despite a disappointing response from blacks, Brown proceeded with his scheme and in May 1858 presented a draft constitution, an outline for a provisional government, and details of the plan to an interracial meeting of forty-six abolitionists in Chatham, Ontario. Many of his supporters doubted the advisability of launching a race war in the South, but nevertheless supported the charismatic figure. By July 1859, Brown had raised sufficient funds to purchase arms and supplies, and rented a farmhouse in Maryland, seven miles from Harpers Ferry, to serve

In this contemporary illustration from *Frank Leslie's Illustrated News* in 1859, John Brown and his party are in the engine-house of the Harpers Ferry Armory just prior to its storming by the U.S. Army. (Prints and Photographs Division, Library of Congress)

as a staging ground. Frederick Douglass again met with him from August 19 to 21 in Chambersburg, Pa., but upon learning the details of the raid refused to join the venture. By October 15, 1859, however, twenty-one others—including five blacks, Osborne P. ANDERSON, Dangerfield Newby, Shields Green, John A. Copeland, Jr., and Lewis Leary—had pledged their lives to Brown and his cause. If he had exercised more patience and better organization, Brown might have been joined by black militia units from Ohio and Canada, but he believed that divine inspiration dictated action. On October 16 at 8:00 P.M., he assembled his small force and announced: "Men, get on your weapons; we will proceed to the ferry."

After quickly seizing the armory and engine house, Brown stalled and waited. He expected that word of the uprising would attract slaves eager for the opportunity to throw off their shackles and slay their oppressors. Instead, his inaction allowed militia forces to organize and the state to alert President James Buchanan, who promptly dispatched a detachment of marines under the command of Robert E. Lee and J. E. B. Stuart. After only thirty-six hours, Brown found himself cornered in the armory's engine house; ten of his men, including two of his own sons, lay dead; and nearly the entire western part of the state had been incited against him. Federal troops stormed the building, easily capturing Brown and his surviving comrades.

The outcome of Brown's trial, beginning on October 27, was never in doubt. Although some of his northern supporters prepared to free him, Brown rejected such schemes. He now sought the martyrdom that was assured him and turned the trial into a forum for his antislavery views. Newspapers across the country reported his speeches, winning him the admiration of thousands. Even his bitterest enemies could not deny Brown's courage and devotion to his principles. By the time of his execution for murder and treason against the state of Virginia on December 2, 1859, he had captured the attention of the entire North. The transcendentalist poet and author Ralph Waldo Emerson proclaimed that Brown "will make the gallows glorious like the cross." Brown's raid also radicalized northern blacks. "I believe in insurrections," the Boston black abolitionist John S. ROCK exclaimed after Harpers Ferry, and most northern blacks hailed Brown and his men as martyrs in the cause of liberty. The attack became a watershed event in African-American history, convincing blacks that only violence would end slavery; more important, it convinced most Americans that compromise on the issue of slavery was impossible. Although the raid failed dismally in its immediate goals, Brown succeeded in riveting the nation's attention upon the issue of slavery and firmly put the country on the road to civil war.

REFERENCES

OATES, STEPHEN B. *To Purge This Land with Blood: A Biography of John Brown.* New York, 1970.
QUARLES, BENJAMIN. *Allies for Freedom: Blacks and John Brown.* New York, 1974.
ROSSBACH, JEFFERY. *Ambivalent Conspirators: John Brown, the Secret Six, and a Theory of Slave Violence.* Philadelphia, 1982.

DONALD YACOVONE

John Henry. One of the towering legendary American working-class folk heroes, John Henry represents not only the nineteenth-century struggle of the human spirit against the coming industrial era, but African-American resistance to white labor domination. It is not clear how the legend represents actual events surrounding the construction of the Big Bend tunnel of the Chesapeake & Ohio railroad in Summers County, W.Va., in the 1870s. In the legend, John Henry, an enormously strong black steel driver, pits himself in a contest against a steam drill intended to replace workers. Wielding only a hammer, John Henry wins by drilling holes along fourteen feet of granite, compared to the machine's nine feet, but the effort kills him.

The story exists in many different musical versions, often with different melodies. The text, which was first printed around the turn of the century, also exists in different versions, but all combine thematic aspects of the African-American work song with the narrative structure of British folk ballads. It is one of the most popular American folk songs, and has been recorded hundreds of times, most often by blues singers. The first recording was by country music pioneer Fiddlin' John Carson in 1924. The first recording by black musicians was by the Francis and Sowell duo in 1927. Since then, versions have been released by LEADBELLY, Brownie MCGHEE and Sonny TERRY, Fred McDowell, Memphis Slim, ODETTA, Mississippi John Hurt, Big Bill BROONZY, and Harry BELAFONTE.

REFERENCES

CHAPPELL, LOUIS W. *John Henry: A Folk-Lore Study.* Port Washington, N.Y., 1968.
COHEN, NORM. *Long Steel Rail.* Urbana, Ill., 1981.

ANDREW BIENEN
GREG ROBINSON

John Reed Clubs. John Reed clubs were left-wing cultural institutions named after the progressive American journalist who died in the Soviet Union. They were set up in a dozen cities on the initiative of the COMMUNIST PARTY around 1932 and lasted throughout much of the decade, often becoming the cradle of black artistic and literary talent while discrimination was rampant, and before the Federal Artists Project and Federal Writers Project were established under the WPA. At the Chicago club, Richard WRIGHT discussed serious literature with white friends. He was elected secretary of the club and edited the magazine *Left Front,* which published his early revolutionary poetry. *Midland Left,* the elusive organ of the Minneapolis club, also ran two of his poems.

The New York John Reed club published a little magazine which later became *Partisan Review.* Langston HUGHES often read and lectured for the clubs, notably in Chicago and the Midwest. It rapidly appeared, however, that the clubs were really geared to serve political purposes, at times to the detriment of artistic or literary endeavor. They were dissolved around 1937 on orders from Communist party leaders, although several black (and white) writers fought to save these channels of expression which favored their creativity.

REFERENCES

AARON, DANIEL. *Writers on the Left.* New York, 1961.
MOMBERGER, ERIC. *American Writers and Radical Politics, 1900–39: Equivocal Commitments.* New York, 1986.

MICHEL FABRE

Johns, Vernon (1892–June 11, 1964), minister. Vernon Johns was born and raised on a small farm in rural Prince Edward County, Va. After completing secondary school he enrolled at Virginia Seminary in Lynchburg, but was soon expelled for insubordinate behavior. Johns then ran away from home and traveled to Oberlin Seminary in Ohio, where he talked his way into the graduate program despite not having a bachelor's degree. He completed his master's degree in theology in 1918. After graduating from Oberlin, Johns enrolled in the Graduate School of Theology at the University of Chicago, which was then the center of the "Social Gospel" movement of which Johns became an important proponent.

Johns left Chicago in the early 1920s and took a series of positions as minister in black Baptist churches throughout the Midwest and South. Toward the end of the decade he returned to the family farm and limited his theological work to occasional lectures in black schools and churches along the East Coast. Johns became one of the most important African-American members of the school of liberal theology that rejected fundamentalist interpretations of the Bible and encouraged Christians to work for social reform. He published several articles in theology journals in which he argued for the need to tie the inspiration of religious leaders to the experience of the masses. But Johns's fame came primarily from his pulpit oratory, and he was less well published than most of his colleagues. In the 1930s Johns toured the South as an itinerant preacher. During World War II he returned to the more lucrative academic lecture circuit, where he furthered his reputation as a broadly knowledgeable scholar and eccentric, dramatic orator.

In 1940 Johns was recruited to be the minister of the Dexter Avenue Baptist Church in Montgomery, Ala. At Dexter, Johns quickly turned the pulpit into a vehicle for his politically engaged theology. His sermons often interpreted passages from the Bible as condemnations of segregation. Johns soon became a controversial figure within the Dexter congregation for his frequent denunciations of whites as anti-Christian and of black ministers as elitist opportunists. He helped local victims of racist violence press charges in court and carried out one-man protests against segregation in buses and restaurants. Johns embarrassed and alienated a large part of the Dexter membership by selling farm produce in front of the church. By selling food he hoped to demonstrate to the membership that ministers had a duty to live like the common people and that black emancipation could only be won through earnest, independent labor.

Johns's political radicalism, iconoclastic behavior, and confrontational tactics created a rift within the church over his tenure as minister, and Johns finally resigned in 1952. He returned again to the family farm in Virginia. One year later Dexter hired as minister the Rev. Dr. Martin Luther KING, Jr., who considered himself an intellectual disciple of his predecessor. While staying outside political activity, Johns remained an important intellectual figure within the clerical leadership of the civil rights movement.

After leaving Dexter, Johns spent the rest of his life alternately tending to his farm near Petersburg, Va. and touring as a preacher and lecturer. He died on June 11, 1964, in Washington, D.C., shortly after delivering a lecture at HOWARD UNIVERSITY. In 1994, James Earl JONES portrayed Johns in the television film, "The Vernon Johns Story."

REFERENCES

BODDIE, CHARLES EMERSON. *God's "Bad Boys."* Valley Forge, Penn., 1972.

BRANCH, TAYLOR. *Parting the Waters: America in the King Years, 1954–63.* New York, 1988.

GANDY, SAMUEL LUCIUS. *Human Possibilities: A Vernon Johns Reader.* Washington, D.C., 1977.

THADDEUS RUSSELL

Johnson, Alonzo "Lonnie" (February 8, 1899–June 16, 1970), blues singer and guitarist. Alonzo Johnson was born in New Orleans, probably in February 1899. As a child he played violin, guitar, bass, and piano in an ensemble led by his father. As a teenager, Johnson appeared at New Orleans cafes, performing ragtime songs, operetta selections, waltzes, and blues. In 1917 he traveled to London with a musical revue. He returned to the United States the next year and began working on Mississippi riverboats, playing violin and piano in the bands of Charlie Creath and Fate Marable. During this time Johnson, who had settled in St. Louis, also worked in a steel foundry.

By 1925, Johnson was singing as well as playing guitar, and he won first prize in a St. Louis BLUES contest. He recorded "Mr. Johnson's Blues" and "Falling Rain Blues" for Okeh Records, and for the next seven years he was a staff musician at the company. During the 1920s, Johnson's elegant singing and extraordinary virtuosity on guitar made him a favorite on both JAZZ and blues theater circuits; he was one of the few musicians to succeed in both styles. Credited with "inventing" the single-note, improvised guitar "solo," he also wrote hundreds of songs and made numerous recordings, often backing singers such as Clara Smith, Spencer Williams, and Victoria Spivey. In the late 1920s, Johnson recorded both as a leader ("Low Land Moan," 1927) and with some of the country's leading jazz musicians, including Louis ARMSTRONG ("I'm Not Rough") and Duke ELLINGTON ("Hot and Bothered," "The Mooche"). Johnson also played with the white guitarist Eddie Lang in one of the earliest integrated recording sessions ("A Handful of Riffs," 1929). In 1932, Johnson moved to Cleveland, where he performed with Putney Dandridge's orchestra. He also worked in a tire factory and in a steel mill to support himself. In 1937, he moved to Chicago, where he performed with Johnny Dodds and led his own quartet. In 1939, Johnson ended a seven-year recording hiatus with "He's a Jelly Roll Baker," which became a rhythm-and-blues hit.

During the 1940s, Johnson took advantage of a resurgence of interest in traditional jazz and performed in many nostalgia events with elderly New Orleans musicians. However, he also continued recording, on electric guitar, in popular and rhythm and blues idioms ("Tomorrow Night," 1947). In 1952, he traveled to London and attracted enormous attention working in New Orleans–style jazz bands. However, during most of the 1950s, Johnson, who had moved to Philadelphia, worked as a hotel janitor.

Johnson had another comeback in 1960, when he was recognized by the growing folk-music audience. He performed at concerts in Chicago, recorded *Blues by Lonnie Johnson,* and reunited with Ellington for a concert in New York. During the 1960s, Johnson worked prolifically in the United States and in Europe. In his final years he moved to Toronto, Canada, where he performed regularly until 1969, when he was injured after being struck by a car. Johnson performed in one last concert in Toronto in 1970, and died later that year.

REFERENCES

ALBERTSON, CHRIS. "Lonnie Johnson: Chased by the Blues." In Pete Welding and Toby Byron, eds. *Bluesland.* New York, 1991, pp. 38–49.

GROOM, R. "Lonnie Johnson." *Blues World* 35 (1970): 3.

JONATHAN GILL

Johnson, "Blind" Willie (c. 1902–1947), singer and guitarist. Born near Waco, Tex., probably in Temple, Tex., on a date that remains in dispute, Willie Johnson was blinded at the age of seven, apparently when his enraged stepmother threw lye in his face. Growing up in Marlin, Tex., he learned to sing religious songs and play guitar as a child. By adolescence, he was supporting himself as a street-corner evangelist and musician. In the 1920s Johnson was a member of the Marlin Church of God in Christ, a Pentecostal church, and performed regularly there. He also played at rural churches and Baptist Association conventions, and played and preached on the street in Waco and Dallas.

Johnson's first recordings, including "Jesus Make Up My Dying Bed" (1927), "Motherless Children" (1927), and "If I Had My Way I'd Tear the Building Down" (1927), were huge commercial successes in the race record market, and made him the most popular African-American religious singer of the late 1920s. These dramatic performances are marked by a low, gritty voice, and tender, plaintive solos on slide guitar, which he played with a pocket knife. Johnson was also capable of haunting effects, including a falsetto, and sinuous guitar lines that suggested the moaning, "sanctified" sounds of rural churches ("Dark Was the Night, Cold Was the Ground"

[1927]). Johnson's brief recording career also included "Praise God I'm Satisfied" (1929), and "God Moves on the Water" (1929). Many of his thirty recordings are duets, probably with Willie B. Harris, his girlfriend or first wife, or with Angeline Johnson, whom he married in 1930. Although Johnson is thought to have performed only religious material, his music influenced secular BLUES performers, such as the East Texas blues guitarists "Blind" Lemon JEFFERSON and Lightnin' HOPKINS, to whom Johnson is often compared.

The Great Depression decimated the recording industry, and after 1930 Johnson never again recorded. He preached, performed, and begged for small change on the streets of Waco. The exact circumstances and date of Johnson's death are uncertain. According to Angeline Johnson, after their house in Beaumont, Tex., burned down in the late 1940s, she and her husband continued to sleep in the wet ashes, which led to Willie Johnson contracting a fatal case of pneumonia.

REFERENCES

"Blind Willie Johnson." *Blues Magazine* 3, no. 5 (October 1977): 35–47.

CHARTERS, SAM. Liner notes to *The Complete Blind Willie Johnson*. Columbia C2K/C2T 52835 (1993).

OLIVER, PAUL. *Songsters and Saints: Vocal Traditions on Race Records*. Cambridge, Eng., 1984.

JONATHAN GILL

Johnson, Caryn. *See* Goldberg, Whoopi.

Johnson, Charles Richard (April 23, 1948–), novelist. Charles Johnson was born in Evanston, Ill., and studied at Southern Illinois University and SUNY at Stony Brook in New York, majoring in philosophy. As he writes in the essay "Where Philosophy and Fiction Meet" (1988), he was inspired by a campus appearance of LeRoi Jones (Amiri BARAKA) to turn toward literary expression (after some work as a cartoonist). Johnson's flirtation with cultural nationalism was intense but brief: He came to recognize that its built-in danger "is the very tendency toward the provincialism, separatism, and essentialist modes of thought that characterize the Anglophilia it opposes." If the utopianism and the mix of social hope and colorful individual expression of the 1960s inspired him to become a writer, he was attracted to the tradition of the philosophical novel, in which he began to write at the postmodern mo-

ment when parody, comedy, and tongue-in-cheek improvisation in the face of disaster came together. He worked under the supervision of novelist John Gardner and remained closely associated with him for many years. Johnson draws freely on Indian and Japanese Buddhist sources, Western philosophy, and literary precursors from Cervantes to SLAVE NARRATIVES and from Saint Augustine to Hermann Hesse's *Siddhartha*. He has also been deeply influenced by the ways in which the African-American writers W. E. B. DU BOIS, Jean TOOMER, Richard WRIGHT, and Ralph ELLISON approached fundamental questions of culture and consciousness. Johnson traced their legacy in the essay "Being & Race: Black Writing Since 1970" (1988), a subtly yet firmly argued survey of the contemporary literary scene, for the title of which Martin Heidegger served as an inspiration.

After writing a number of increasingly accomplished short stories that were collected in *The Sorcerer's Apprentice* (1986) and publishing a first novel, *Faith and the Good Thing,* in 1974 (several others exist in manuscript but were never published), Johnson achieved an artistic breakthrough with his novel *Ox-*

Charles Johnson at the National Book Awards in New York City in 1990, after winning the fiction award for his novel *Middle Passage*. (AP/Wide World Photos)

herding Tale (1982). A meditation on the representation of the eighth of the "Oxherding Pictures" by Zen artist Kakuan-Shien (in which both the ox and herdsman are gone), the novel also continues the tradition of autobiographical fiction as embodied in James Weldon JOHNSON's *Autobiography of an Ex-Colored Man. Oxherding Tale* represents the education of Andrew Hawkins, who is raised by a transcendentalist tutor on a southern plantation—a plantation that is visited by Karl Marx in the novel. As Andrew (like Saint Augustine before him) learns to free himself from dualism, another figure, that of the Soulcatcher, grows in importance. Johnson draws the philosophical issues out of love, education, or enslavement. It is a stylistically brilliant novel, both comic and profound, picaresque and self-reflexive. It parodies the eighteenth-century novel and the genre of the slave narrative yet manages to remain faithful to both these inspirations. Johnson received the Governor's Award for Literature from the state of Washington for *Oxherding Tale* in 1983.

Johnson's novel *Middle Passage* (1990) continued the exploration of a nineteenth-century setting for unusual purposes. It is the tale of Rutherford, who eludes collectors of gambling debts and the offer of redemption by marriage in New Orleans when he takes the place of a sailor, only to find himself aboard a slave ship headed for Africa. Johnson manages to revitalize what have become fixtures in imagining the nineteenth century by concerning himself with the human issues he locates in particular spaces. The enslaved Almuseri add some elements of magical realism to the text, which may be the most imaginative modern thematization of the experience that the title refers to, free from the clichéd ways in which this historical period has sometimes been fictionalized. *Middle Passage* was awarded the National Book Award in 1990.

REFERENCES

JOHNSON, CHARLES. "Where Philosophy and Fiction Meet." *American Visions* 36 (June 1988): 47–48.

KUTZINSKI, VERA. "Johnson Revises Johnson: *Oxherding Tale* and *The Autobiography of an Ex-Colored Man*." *Pacific Philology* (Spring 1989): 39–46.

WERNER SOLLORS

Johnson, Charles Spurgeon (July 24, 1893–October 27, 1956), sociologist and editor. Born in Bristol, Va., in 1893, Charles S. Johnson was given a classical education by his father, Rev. Charles Henry Johnson, a Baptist minister who had been taught to read English, Latin, Greek, and Hebrew by his former slave master. In 1916 the younger Johnson earned a B.A. from Virginia Union University in Richmond.

In 1917, Johnson moved to Chicago to pursue his graduate study of sociology at the University of Chicago, where he became associated with a group of influential scholars who made up the Chicago School of Sociology, including Robert E. Park and W. I. Thomas. Johnson had a profound regard in particular for Park, his lifelong mentor who specialized in race relations and urban sociology. He received a Ph.B. in 1918, while serving as a director of research and records for the Chicago Urban League, of which Park was the president.

After the race riot of 1919, Johnson was appointed to the interracial Chicago Commission on Race Relations, coauthoring the committee report, *The Negro in Chicago: A Study in Race Relations and a Race Riot* (1922). Written under the supervision of Park, this was Johnson's first major research project. It was one of the first significant sociological studies that indicated the persistence of racial segregation and discrimination within Northern cities, and warned that the pervasive barriers to black economic and social equality might provoke other riots.

In 1921 Johnson moved to New York City to become director of research for NATIONAL URBAN LEAGUE. Two years later, he founded the league's magazine, *Opportunity: A Journal of Negro Life,* which he edited from 1923 to 1928. This journal proved to be an important cultural force in the HARLEM RENAISSANCE, publishing many of the black poets and writers of the time, and organizing literary contests and awards ceremonies to gain recognition for these authors and encourage white publishers to support them. Moreover, as an editor Johnson was concerned with bringing social science research to a general readership among blacks.

The bulk of Johnson's sociological contribution was made from 1927 to 1947, the period during which he served as chairman of the department of social sciences at FISK UNIVERSITY. In various publications, Johnson made a major contribution to the understanding of the South as a region, the economic foundation of race relations, and contemporary debate on racial problems. One of his most important books is *Shadow of the Plantation* (1934), in which Johnson demonstrated that racial discrimination was compounded by the economic exploitation that existed in the South during the GREAT DEPRESSION in the 1930s. In this study of the collapse of cotton tenancy in the South, Johnson argued that sharecropping created an ongoing economic basis for racial discrimination, and demonstrated how powerful agrarian and industrial interests shaped the "human

Charles S. Johnson, photographed in 1948, was one of the leading sociologists of his generation and the first black president of Fisk University. (Prints and Photographs Division, Library of Congress)

ancy, and was a U.S. delegate to UNESCO in 1946. Johnson died suddenly on October 27, 1956.

REFERENCES

BLACKWELL, JAMES and MORRIS JANOWITZ, eds. *Black Sociologists, Historical and Contemporary Perspectives*. Chicago, 1974.

KELLER, BRUCE. *The Harlem Renaissance: A Historical Dictionary for the Era*. Westport, Conn., 1984.

RAUSCHENBUSH, WINFRED. *Robert E. Park: Biography of a Sociologist*. Durham, N.C., 1979.

JO H. KIM

Johnson, Earvin, Jr., "Magic" (August 14, 1959–), basketball player. "Magic" Johnson was born and raised in Lansing, Mich., where he soon demonstrated an unusual aptitude for BASKETBALL. Despite the flair suggested by his nickname (which was given to him in 1974 by Fred Stabley, Jr., a reporter for the *Lansing State Journal*), Johnson's playing style was crafted out of devotion to basketball fundamentals and endless hours of practice. After leading his high school team to the state championship in his senior year, Johnson chose to attend college at nearby Michigan State University. He electrified crowds with his dazzling playmaking and the enthusiasm he displayed on the court while leading the Spartans to a national collegiate championship as a sophomore in 1979. At 6'9", he was perhaps the most agile ball-handler for anyone of his size in the history of the game, and his combination of height, athletic skills, and passing ability brought a new dimension to the position of guard.

Johnson left Michigan State after his sophomore year, and at the age of twenty he joined the professional ranks, leading the Los Angeles Lakers to the National Basketball Association (NBA) Championship in 1980—a feat they achieved four more times during the decade (in 1982, 1985, 1987, and 1988). Though Johnson holds the NBA record for assists (9,921) and was named the league's MVP three times (1987, 1989, 1990), Playoff MVP three times (1980, 1982, 1987), and All-Star Game MVP twice (1990, 1992), his desire to win translated into an unselfish style of play that elevated passing to an art form and stressed teamwork over individual accolades. His charisma and court savvy helped to revive interest in the NBA, while his versatility transformed the game to one dominated by multitalented guards and forwards. Johnson's contributions on the court have been matched by his efforts and leadership away from it: He has worked for numerous charitable organiza-

relations" of race and racism. In *The Negro College Graduate* (1938), he described in great detail how difficult it was for blacks to gain entrance to college, and to advance professionally after graduation, and the economic and psychological problems this caused. *Growing Up in the Black Belt* (1941) showed black adolescence to be at once a product of the omnipresent "color system" and of the socialization process as it works out in any complex society where there are differences among young people in age, sex, class, and urban or rural background.

In 1947 Johnson became the first black president of Fisk University. Over the years, he was a consultant on race relations to U.S. Presidents Franklin D. Roosevelt, Herbert Hoover, and Dwight D. Eisenhower. In 1930 Johnson was a member of the League of Nations Commission whose mission was to investigate human rights violations in Liberia, and he served on the Tennessee Valley Authority in 1934. From 1936 to 1937 he was a consultant to the U.S. Department of Agriculture on the issue of farm ten-

Earvin "Magic" Johnson shoots in warmups before an NBA exhibition match in Chapel Hill, N.C., November 3, 1992, a few days after announcing his second retirement. (AP/Wide World Photos)

tions and has raised several million dollars for the UNITED NEGRO COLLEGE FUND over the course of his career. With an engaging personality and smile, Johnson became one of the most famous and recognizable Americans in the 1980s.

He retired from professional basketball in November 1991 when he revealed that he had tested positive for the virus that causes AIDS (acquired immune deficiency syndrome). Following his announcement, Johnson assumed a leadership role once again in working to raise research funds for, and awareness of, the disease. In 1992 he was appointed to the President's National Commission on AIDS, but he resigned soon thereafter when he became disillusioned with the government's efforts on behalf of AIDS research. Johnson kept AIDS in the public eye when he resumed his career shortly after guiding the United States basketball team to a gold medal at the 1992 Olympics. He attempted a comeback with the Lakers in the fall of 1992, but after some players in the league expressed reservations about playing with him because of his infection, he retired again. In that same year, Johnson authored *What You Can Do to Avoid AIDS,* the net profits from which went to the Magic Johnson Foundation, which Johnson established for prevention, education, research, and care in the battle against AIDS.

REFERENCES

JOHNSON, EARVIN "MAGIC," and ROY S. JOHNSON. *Magic's Touch.* Reading, Mass., 1989.
PASCARELLI, PETER F. *The Courage of Magic Johnson: From Boyhood Dreams to Superstar to His Toughest Challenge.* New York, 1992.

JILL DUPONT

Johnson, Fenton (May 7, 1888–September 17, 1958), writer. Born in Chicago to a middle-class African-American family, Fenton Johnson attended the University of Chicago and Northwestern University. During his student days, he became interested in poetry and playwriting, and at the age of nineteen had a play produced at Chicago's Pekin Theater. In 1913, following a short stint as an English teacher at State University in Louisville, Ky., Johnson privately printed *A Little Dreaming,* a book of poems. Around the same time, Johnson moved to New York City, where he attended Columbia University's Pulitzer School of Journalism, leaving in 1917 without a degree. During this time he supported himself by working as a writer for the mainstream Eastern Press Association and as acting dramatic critic for the *New York News.* In 1915 and 1916 he wrote two more volumes of poetry, *Visions of the Dusk* and *Songs of the Soil.* Unable to find a publisher, Johnson complained that gaining recognition was as difficult for him as "walking in the Atlantic Ocean." With the aid of several patrons, he printed the works privately. During these years, he published three of his short stories in *The Crisis,* the magazine of the NAACP. Most of Johnson's early poems were written either in conventional Victorian style, or were dialect poems that showed the influence of Paul Laurence DUNBAR. Johnson was also strongly influenced, as he would remain throughout his career, by the New Chicago School of Edgar Lee Masters and Vachel Lindsay.

In 1916 Johnson moved back to Chicago. Interested in various literary forms, he became the editor of the *Champion Magazine* and wrote all its articles. After it folded in 1918, he founded and edited another review, *Favorite Magazine. Favorite* was a costly failure, and Johnson was hard-pressed to continue it. In 1920 he published *Tales of Darkest America,* a collection of short stories from *Favorite,* and *For the Highest Good,* a book of essays written for the review. While

Johnson kept *Favorite* going through spring 1921, it bankrupted him.

Little is known about Johnson's life after 1920. While in New York City, in 1919–1920, he created the Reconciliation Movement, a group which sponsored racial cooperation through disseminating information and through educational efforts by white and black social workers. He remained largely silent through the 1920s, though his poems were anthologized in several collections. During the 1930s Johnson was hired as a poet by the Federal Writers Project of the WORKS PROGRESS ADMINISTRATION (WPA). His collection of poems written for the WPA, which he entitled "The Daily Grind: 42 WPA Poems," is very different in style from his earlier works. Most of these later poems are written in free verse, using ordinary speech. Deeply pessimistic in style, they deal with the difficulties of African-American life in the face of poverty and racism. One of Johnson's later poems, "Tired," contains the well-known line "I am tired of civilization." Johnson was unable to find a publisher for the WPA collection, as well as for another collection of poems, called *African Nights,* but several of the works were anthologized in such notable collections as Langston HUGHES and Arna BONTEMPS's *Poetry of the Negro* (1949). Johnson seems not to have written any poems after the mid-1930s. He died in obscurity in 1958.

REFERENCE

LUMPKIN, SHIRLEY. "Fenton Johnson." *Dictionary of Literary Biography.* Vol. 45. New York, 1984.

GREG ROBINSON

Johnson, Frank (1792–1844), bandleader and composer. Frank Johnson wrote more than two hundred compositions, including marches, cotillions, quadrilles, waltzes, and other social dance music of the early nineteenth century. His bands and orchestras, which comprised between four and ten instruments over the years, traveled from his base in Philadelphia as far south as St. Louis and as far north as Toronto, as well as to England. Johnson was a virtuoso on the Kent bugle and also played the violin. Among his most popular works were "Johnson's Celebrated Voice Quadrilles," "Princeton Grand March," and "Philadelphia Gray's Quickstep." His quadrilles and cotillions were based upon imported French country dance music. The "Voice Quadrilles," an example of his well-known musical innovations, include vocal parts in addition to the instrumental music. In 1980, Johnson, in spite of having suffered discrimination in his lifetime, was named an honorary member of the Artillery Corps Washington Grays at Philadelphia.

REFERENCES

CROMWELL, JOHN W. "Frank Johnson's Military Band." *Southern Workman* 29 (1900): 532–535.
SOUTHERN, EILEEN. "Frank Johnson and His Promenade Concerts." *Black Perspective in Music* 5, no. 1 (1977): 3–29.

SAMUEL A. FLOYD, JR.

Johnson, Georgia Douglas (September 10, 1877–May 14, 1966), poet and playwright. Georgia Douglas Johnson was the foremost woman poet and one of the most prolific and versatile woman playwrights of the HARLEM RENAISSANCE. Her literary reputation has traditionally been based on three poetry volumes published between 1918 and 1928 and on her role as hostess of a salon for black artists and intellectuals in her Washington, D.C., home. Since the 1970s, her plays have also received critical attention and her importance in the African-American women's dramatic tradition has been affirmed. Her literary contributions, along with those of her female contemporaries in the New Negro movement, are currently being reassessed.

Writing in the manner of the Genteel School, Johnson composed short romantic lyrics in order to demonstrate literary accomplishment and challenge racist propaganda. In *The Heart of a Woman* (1918), *Bronze: A Book of Verse* (1922), *An Autumn Love Cycle* (1928), and *Share My World* (1965), she portrays

Although poet and playwright Georgia Douglas Johnson is primarily remembered for her work during the Harlem Renaissance, she maintained an active literary career into the 1960s. (Photographs and Prints Division, Schomburg Center for Research in Black Culture, The New York Public Library, Astor, Lenox and Tilden Foundations)

the richness and complexity of her inner world and social situation as a woman of English, Native American, and African-American ancestry.

As a dramatist, she wrote both protest and folk plays. Several of her dramas, including *A Sunday Morning in the South* (c. 1925), protested lynching. Her tragicomedy *Blue Blood* won honorable mention in the 1926 *Opportunity* play competition and was produced that fall by the Krigwa Players. Her folk drama *Plumes* won first prize the following year and was produced by the Harlem Experimental Theater. Many of her thirty plays—along with much other writing—have been lost. In 1965, shortly before her death, she received an honorary doctorate of letters from Atlanta University.

REFERENCE

HULL, GLORIA T. *Color, Sex, and Poetry: Three Women Writers of the Harlem Renaissance*. Bloomington, Ind., 1987.

ANN TRAPASSO

Johnson, Hall (March 12, 1888–April 30, 1970), composer. Hall Johnson was born in Athens, Ga., into the educated family of the Rev. William Decker Johnson and Alice Virginia Sansom. He studied piano with his oldest sister, Mary, and was inspired to play the violin after hearing Joseph Douglass (the grandson of Frederick Douglass) in concert. In 1903 he graduated from Knox Institute and entered Atlanta University. The following year he transferred to Allen University in South Carolina (where his father was president), graduating in 1908. He then entered Hahn School of Music (known today as the Philadelphia Musical Academy), where he studied violin with Frederick Hahn. In 1909 he entered the University of Pennsylvania (B.A., 1910) and studied composition under Hugh A. Clarke. He won the Senior Simon Haessler Prize for the best composition for chorus and orchestra.

In 1914, Johnson moved to New York, where he joined James Reese EUROPE's instrumental group and toured with Irene and Vernon Castle. Four years later he played with the New York Syncopated Orchestra (a.k.a. the Southern Syncopated Orchestra), under the direction of Will Marion COOK. He traveled extensively with this group, though he did not go abroad. In 1921 he joined the orchestra of Sissle and Blake's revue *Shuffle Along,* and, three years later, its sequel *Runnin' Wild.* During 1923, Johnson became a member of the NEGRO STRING QUARTET, playing viola with Felix Weir (first violinist), Arthur Boyd (second violinist), and Marion Cumbo (cello).

In 1925, Johnson established the critically acclaimed Hall Johnson Choir, which was to preserve and present traditional African-American music. The choir staged concerts in Carnegie Hall and Town Hall, among other places. It performed on radio, sang with major orchestras, and performed on Broadway in Marc Connolly's play *Green Pastures* (1930), for which Johnson was the musical director. The choir also sang in the film version of *Green Pastures* (1935) and in the films *Lost Horizon* (1937) and *Cabin in the Sky* (1943). RCA Victor began recording songs of the Hall Johnson Choir in 1930. In 1933, Johnson produced *Run, Little Chillun,* which played on Broadway for four months despite the Great Depression. It was also produced in California (1935–1937) as part of the Federal Theater Project, and again in New York in 1943.

More than one hundred arrangements of black spirituals were published by Johnson, including such favorites as "Ain't Got Time to Die," "Elijah Rock," and "Honor, Honor." He also organized several large festival choruses on the West and East coasts. The Festival Negro Chorus presented his *Son of Man* cantata at New York's City Center (1946) and at Carnegie Hall (1948). The State Department sent Johnson's choir to represent the United States at the International Festival of Fine Arts in Berlin in 1951.

During Johnson's lifetime, he received many honors and awards for his achievements, including two Hostein Prizes for composition (1925, 1927), the Harmon Award (1931), a citation from the City of New York (1954), an honorary doctorate from the Philadelphia Musical Academy (1934), and the Handel Award, one of New York City's highest and most coveted general-achievement awards (1970).

REFERENCES

CARTER, MARVA GRIFFIN. *Hall Johnson: Preserver of the Old Negro Spiritual*. M.A. thesis, Boston University, 1975.

SOUTHERN, EILEEN. *Biographical Dictionary of Afro-American and African Musicians*. Westport, Conn., 1982.

MARVA GRIFFIN CARTER

Johnson, Helen V. "Helene" (c. 1907–), poet. Born in Boston, Mass., Johnson was named Helen, but nicknamed Helene by an aunt. She grew up in Brookline, Mass., and Martha's Vineyard, where her grandfather, a former slave, owned property. Johnson studied piano, and also wrote poetry as a member of the Saturday Evening Quill Club of Boston. She also studied at Boston University before moving to New York. In 1925–1926 several of her

poems, including "Trees At Night," "My Race," "Metamorphism," "Fulfillment," "Manalu," and "The Road," appeared in *Opportunity*, a periodical dedicated to promoting the work of young African-American writers. During this time Johnson also published poems in William Stanley BRAITHWAITE's *Anthology of Magazine Verse*, as well as in *Messenger*, *Fire!*, and an issue of *Palms* edited by Countee CULLEN, who in 1927 also included eight of her poems in *Caroling Dusk: An Anthology of Negro Poets*. That year Johnson studied journalism at Columbia University, and published her poem "Bottled" in *Vanity Fair*. Her poems "Summer Matures" and "Sonnet to a Negro in Harlem" won awards in *Opportunity*'s 1927 literary contest.

In the late 1920s Johnson became a fixture in the group of artists and writers identified with the HARLEM RENAISSANCE. Her poetry was praised for its use of African-American slang in addressing issues of race. During this time Johnson also became politically active. In 1927 she joined the Fellowship of Reconciliation, an international organization promoting interracial harmony and passive resistance to war and violence. She continued to write poetry, and during the next two years published poems in *Harlem* magazine, *The Saturday Evening Quill*, and James Weldon JOHNSON's *The Book of American Negro Poetry*.

In the 1930s Johnson's literary output slowed. In 1934 her writing appeared in Dorothy WEST's first issue of *Challenge: A Literary Quarterly*. The next year Johnson married William Warner Hubbell, a railroad motorman, and published "Let Me Sing My Song" in the May 1935 issue of *Challenge*. The couple raised one child before separating. Afterward, Johnson retreated into private life, and effectively ended her career as a published poet. She has subsequently lived in Massachusetts and New York City.

REFERENCES

"Helene Johnson." *Michigan Chronicle*, March 11, 1992, p. 1C.
REDMOND, EUGENE B. *Drumvoices: The Mission of Afro-American Poetry*. Garden City, N.Y., 1976.
WAGNER, JEAN. *Black Poets of the United States*. Urbana, Ill., 1973.

JANE SUNG-EE BAI

Johnson, James Ambrose. *See* James, Rick.

Johnson, James Louis "J. J." (January 22, 1924–) jazz trombonist and composer. A native of Indianapolis, J. J. Johnson studied piano and took up the trombone upon the encouragement of friends at Crispus Attucks High School. During the war years he worked with the orchestras of Snookum Russell (1942) and Benny CARTER (1942–1945). From 1945 to 1946 he played with Count BASIE and thereafter worked primarily in small bebop combos in the flourishing 52nd Street jazz scene, though he also toured with Illinois Jacquet and Oscar PETTIFORD. Lean times led him to leave music for a factory job in 1952. When he resumed his musical career in 1954, he teamed with Danish trombonist Kai Winding in an unusual two-trombone ensemble billed as J. J. and Kai. They disbanded in 1956, and Johnson continued to lead a variety of ensembles through the late 1960s. A lack of engagements prompted a move to California, where he worked as a composer for films and television. He continued to work as a studio musician, though he occasionally brought out small groups on concert tours. Johnson was the most important bebop trombonist of the era, and was a performer of great tonal clarity and surefooted articulation. He has been a significant composer and arranger for large jazz ensembles. His best-known compositions include "In Walked Horace," for pianist Horace SILVER, "Mohawk," and "Lament."

REFERENCE

BOURGOIS, L. G. III. *Jazz Trombonist J. J. Johnson: A Comprehensive Discography and Study of the Early Evolution of his Style*. Ph.D. diss., Ohio State University, 1986.

RON WELBURN

Johnson, James Price (February 1, 1894–November 17, 1955), pianist and composer. Though James P. Johnson had a prolific career as a recording artist and composer of songs, piano solos, musical comedies, and extended instrumental works, his reticence and modesty limited his reputation with the public. Yet he was widely recognized and honored by contemporaries and students alike as the dean of Harlem stride pianists. Together with Luckey ROBERTS, he was among the first pianists responsible for the transformation of RAGTIME into stride. The left hand, which in ragtime was bound to a strict and predictable pattern, became in Johnson's playing more swinging, more rhythmically free. In some recordings, he disrupts the expected alternation in the left hand between an octave in the bass and a midrange chord by striking a second bass note before playing the chord, thus displacing the pattern, syncopating it, and creating a quasi-polyrhythmic effect (which he probably invented) against the right hand.

This effect was admired and imitated by many stride players in competitive situations (rent parties, cutting contests), as in Fats WALLER's May 13, 1941, recording of Johnson's "Carolina Shout." Johnson also brought to his playing a delicacy of touch, a facility for elegant decoration, the use of call and response (rooted in African-American sacred music), an affinity for blues structures and melodic gestures, an improvisatory approach to repeated sections, and—often overlooked by critics—a wide range of subtle dynamic effects. These elements, some of which were alien to ragtime, became characteristic of stride.

His greatest creative energies, however, seem to have been reserved for composition. The songs document his ability to fashion a well-constructed and captivating melodic line. (Fats Waller once commented that in all composing, ". . . you got to have melody. Jimmie Johnson taught me that.") Surviving scores of the large-scale works, on the other hand, provide evidence of his attempts to incorporate elements of African-American folk music into the fabric of extended musical structures: *Yamekraw: Negro Rhapsody* (1927); *Harlem Symphony* (1932), and his opera *The Organizer* (c. 1939), to a libretto by Langston HUGHES adapted from Theodore Brown's play *Natural Man*.

REFERENCES

BROWN, SCOTT E. *James P. Johnson: A Case of Mistaken Identity*. Metuchen, N.J., 1986.

DAVIN, TOM. "Conversations with James P. Johnson." Reprinted in John Edward Hasse, ed. *Ragtime: Its History, Composers, and Music*. New York, 1985.

PAUL S. MACHLIN

Johnson, James Weldon (July 17, 1871–June 17, 1938), writer and political leader. James William Johnson, who changed his middle name to Weldon in 1913, was born in Jacksonville, Fla. James, Sr., his father, the headwaiter at a local hotel, accumulated substantial real estate holdings and maintained a private library. Helen Dillet Johnson, his mother, a native of Nassau in the Bahamas, was the only African-American woman teaching in Jacksonville's public schools. Through his parents' example, the opportunity to travel, and his reading, Johnson developed the urbanity and the personal magnetism that characterized his later political and literary career.

Johnson graduated in 1894 from Atlanta University, an all-black institution that he credited with instilling in him the importance of striving to better the lives of his people. Returning to Jacksonville, he traveled many different roads to fulfill that sense of racial responsibility. Appointed principal of the largest school for African Americans in Florida, he developed a high-school curriculum. At the same time, he founded a short-lived newspaper, the *Daily American* (1895–1896); studied law; passed the bar examination; and wrote lyrics for the music of his brother, J. Rosamond JOHNSON. In 1900 the brothers collaborated on "Lift Ev'ry Voice and Sing," a song that is regarded as the NEGRO NATIONAL ANTHEM.

Johnson moved to New York in 1902 to work with his brother and his brother's partner on the vaudeville circuit, Robert COLE. Called by one critic the "ebony Offenbachs," the songwriting team of Cole, Johnson, and Johnson was one of the most successful in the country. (The 1902 song "Under the Bamboo Tree" was their greatest success.) The team tried to avoid stereotypical representations of blacks and tried to invest their songs with some dignity and humanity, as well as humor.

While his brother toured with Cole, James Weldon Johnson studied literature at Columbia University and became active in New York City politics. In 1904, in a political association dominated by Booker

James Weldon Johnson. (Photographs and Prints Division, Schomburg Center for Research in Black Culture, The New York Public Library, Astor, Lenox and Tilden Foundations)

T. WASHINGTON, Johnson became the treasurer of the city's Colored Republican Club. The Republican party rewarded his service with an appointment to the United States Consular Service in 1906, and Johnson served first as United States consul at Porto Cabello, Venezuela, and then, from 1908 to 1913, in Corinto, Nicaragua.

In Venezuela he completed his first and only novel, *The Autobiography of an Ex-Coloured Man* (1913). Published anonymously, it was taken by many readers for a true autobiography. That realism marks an important transition from the nineteenth- to the twentieth-century African-American novel. Johnson brought modern literary techniques to his retelling of the popular nineteenth-century "tragic mulatto" theme.

The election of Woodrow Wilson, a Democrat, to the presidency blocked Johnson's advancement in the consular service. He returned to New York, where, in 1914, he joined the *New York Age* as an editorial writer. While he was associated with the politics of Booker T. Washington, Johnson's instincts were more radical and he gravitated toward the NAACP. In 1916, the NAACP hired him as a field secretary, charged with organizing or reviving local branches. In that post, he greatly expanded and solidified the still-fledgling organization's branch operations and helped to increase its membership, influence, and revenue. He also took an active role organizing protests against racial discrimination, including the racial violence of the "RED SUMMER" of 1919, a phrase he coined.

Shortly after he joined the staff of the NAACP, Johnson published his first collection of poetry, *Fifty Years and Other Poems* (1917). Like the work of Paul Laurence Dunbar, Johnson's poetry falls into two broad categories: poems in standard English and poems in a conventionalized African-American dialect. While he used dialect, he also argued that dialect verse possessed a limited range for racial expression. His poems in standard English include some of his most important early contributions to African-American letters. Poems like "Brothers" and "White Witch" are bitter protests against lynching that anticipate the poetry of Claude MCKAY in the 1920s and the fiction of Richard WRIGHT in the 1930s and 1940s.

During the 1920s, Johnson's political and artistic activities came together. He was appointed secretary of the NAACP's national office in 1920. His tenure brought coherence and consistency to the day-to-day operations of the association and to his general political philosophy. He led the organization in its lobbying for the passage of the Dyer Anti-Lynching Bill and in its role in several legal cases; his report on the conditions of the American occupation of Haiti prompted a Senate investigation. Johnson's leadership helped to establish the association as a major national civil rights organization committed to accomplishing its goals through lobbying for legislation and seeking legal remedies through the courts. In 1927–1928 and again in 1929, he took a leave of absence from the NAACP. During the latter period he helped organize the consortium of Atlanta University and Spelman and Morehouse colleges.

Also in the 1920s, Johnson, with such colleagues at the NAACP as W. E. B. DU BOIS, Walter WHITE, and Jessie FAUSET, maintained that the promotion of the artistic and literary creativity of African Americans went hand in hand with political activism, that the recognition of blacks in the arts broke down racial barriers. Their advocacy of black artists in the pages of *Crisis,* and with white writers, publishers, and critics, established an audience for the flourishing of African-American literature during the HARLEM RENAISSANCE. Johnson himself published an anthology of African-American poetry, *The Book of Negro Poetry* (1922, rev. 1931), and he and his brother edited two volumes of *The Book of American Negro Spirituals* (1925 and 1926). In his introductions to these anthologies and in critical essays, he argued for a distinct African-American creative voice that was expressed by both professional artists and the anonymous composers of the spirituals. *Black Manhattan* (1930) was a pioneering "cultural history" that promoted HARLEM as the cultural capital of black America.

Johnson was not in the conventional sense either a pious or a religious man, but he consistently drew on African-American religious expressions for poetic inspiration. In early poems like "Lift Ev'ry Voice and Sing," "O Black and Unknown Bards," and "100 Years," he formulated a secular version of the vision of hope embodied in spirituals and gospel songs. His second volume of poetry, *God's Trombones* (1927), drew on the African-American vernacular sermon. Using the rhythms, syntax, and figurative language of the African-American preacher, Johnson devised a poetic expression that reproduced the richness of African-American language without succumbing to the stereotypes that limited his dialect verse.

In 1930, Johnson resigned as secretary of the NAACP to take up a teaching post at Fisk University and pursue his literary career. His autobiography, *Along This Way,* was published in 1933; his vision of racial politics, *Negro American, What Now?,* was published in 1934; and his third major collection of poetry, *St. Peter Relates an Incident,* was published in 1935. He was killed in an automobile accident on June 17, 1938.

REFERENCES

FLEMING, ROBERT E., ed. *James Weldon Johnson and Arna Wendell Bontemps: A Reference Guide.* Boston, 1978.

FLEMING, ROBERT E. *James Weldon Johnson*. Boston, 1987.

LEVY, EUGENE. *James Weldon Johnson: Black Leader, Black Voice*. Chicago, 1973.

GEORGE P. CUNNINGHAM

John Arthur "Jack" Johnson. (Prints and Photographs Division, Library of Congress)

Johnson, John Arthur "Jack" (March 31, 1878–June 10, 1946), boxer. The third of six surviving children, Jack Johnson was born in Galveston, Tex., to Henry Johnson, a laborer and ex-slave, and Tiny Johnson. He attended school for about five years, then worked as a stevedore, janitor, and cotton picker. He gained his initial fighting experience in battle royals, brutal competitions in which a group of African-American boys engaged in no-holds-barred brawls, with a few coins going to the last fighter standing. He turned professional in 1897. In his early years Johnson mainly fought other African-American men. His first big win was a sixth-round decision on January 17, 1902, over Frank Childs, one of the best black heavyweights of the day. The six-foot, 200-pound Johnson developed into a powerful defensive boxer who emphasized quickness, rhythm, style, and grace.

In 1903, Johnson defeated Denver Ed Martin in a twenty-round decision, thus capturing the championship of the unofficial Negro heavyweight division, which was created by West coast sportswriters to compensate for the prohibition on blacks fighting for the real crown. Johnson, who was then the de facto leading heavyweight challenger, sought a contest with champion Jim Jeffries but was rebuffed because of the color line. Racial barriers largely limited Johnson's opponents to black fighters like Joe Jeanette, whom he fought ten times. Johnson's first big fight against a white contender was in 1905, against Marvin Hart, which he lost by the referee's decision, despite having demonstrated his superior talent and ring mastery. Hart became champion three months later, knocking out Jack Root to win Jeffries's vacated title. Johnson's bid to get a title fight improved in 1906, when he hired Sam Fitzpatrick as his manager. Fitzpatrick knew the major promoters and could arrange fights that Johnson could not when he managed himself. Johnson enhanced his reputation with victories in Australia, a second-round knockout of forty-four-year-old ex-champion Bob Fitzsimmons in Philadelphia, and two wins in England.

In 1908 Canadian Tommy Burns became champion, and Johnson stalked him to Australia, looking for a title bout. Promoter Hugh McIntosh signed Burns to a match in Sydney on December 26 for a $30,000 guarantee with $5,000 for Johnson. Burns was knocked down in the first round by Johnson, who thereafter verbally and physically punished Burns until the police stopped the fight in the fourteenth round. White reaction was extremely negative, with journalists describing Johnson as a "huge primordial ape." A search began for a "white hope" who would regain the title to restore to whites their sense of superiority and to punish Johnson's arrogant public behavior. To many whites, Johnson was a "bad nigger" who refused to accept restrictions placed upon him by white society. A proud, willful man, Johnson recklessly violated the taboos against the "proper place" for blacks, most notoriously in his relationships with white women. Though much of the black middle class viewed his lifestyle with some disquiet, he became a great hero to lower-class African Americans through his flouting of conventional social standards and his seeming lack of fear of white disapproval.

Johnson defended his title five times in 1909, most memorably against middleweight champion Stanley Ketchell, a tenacious 160-pound fighter. Johnson toyed with Ketchell for several rounds, rarely attacking. Ketchell struck the champion behind the ear in the twelfth round with a roundhouse right, knocking him to the canvas. An irate Johnson arose, caught the attacking challenger with a right uppercut, and knocked him out. Johnson's only defense in 1910 was against Jim Jeffries, who was encouraged to come out of retirement by an offer of a $101,000 guarantee, split 3:1 for the winner, plus profits from film rights. When moral reformers refused to allow the match to be held in San Francisco, it was moved to Reno, Nev. The former champion, well past his prime, was overmatched. Johnson taunted and humiliated him, ending the fight with a fifteenth-round knockout. Fears that a Johnson victory would unleash racial hostilities were quickly realized as gangs of whites ran-

domly attacked blacks in cities across the country. Some states and most cities barred the fight film for fear of further exacerbating racial tensions. Overnight the national press raised an uproar over the "viciousness" of boxing and clamored for its prohibition. Even Theodore Roosevelt, himself an avid boxer, publicly hoped "that this is the last prizefight to take place in the United States." The reaction to Johnson's victory over a white champion proved a significant event in the history of American racism, as white fears of black male sexuality and power were manifested in a wave of repression and violence.

In l910, Johnson settled in Chicago, where he enjoyed a fast lifestyle; he toured with vaudeville shows, drove racing cars, and in 1912 opened a short-lived nightclub, the Cafe de Champion. Johnson defended his title once during the two years following the Jeffries fight, beating "Fireman" Jim Flynn in nine rounds in a filmed fight in Las Vegas, N.M. Subsequently, in response to anti-Johnson and antiboxing sentiment and concern about films showing a black man pummeling a white, the federal government banned the interstate transport of fight films.

In 1911, Johnson married white divorcee Etta Terry Duryea, but their life was turbulent and she committed suicide a year later. Johnson later married two other white women. His well-publicized love life caused much talk of expanding state antimiscegenation statutes. More important, the federal government pursued Johnson for violation of the Mann Act (1910), the so-called "white slavery act," which forbade the transportation of women across state lines for "immoral purposes." The law was seldom enforced, but the federal government chose to prosecute Johnson, even though he was not involved in procuring. Johnson was guilty only of flaunting his relationships with white women. He was convicted and sentenced to one year in the penitentiary, but fled the country to Europe through Canada. He spent several troubled years abroad, defending his title twice in Paris and once in Buenos Aires, and struggled to earn a living.

In 1915 a match was arranged with Jess Willard (6'6" and 250 pounds) in Havana. By then Johnson was old for a boxer and had not trained adequately for the fight; he tired and was knocked out in the twenty-sixth round. The result was gleefully received in the United States, and thereafter no African American was given a chance to fight for the heavyweight title until Joe LOUIS. Johnson had hoped to make a deal with the government to reduce his penalty, and four years later claimed that he threw the fight. Most boxing experts now discount Johnson's claim and believe it was an honest fight. Johnson returned to the United States in 1920 and served a year in Leavenworth Penitentiary in Kansas. He subsequently fought a few bouts, gave exhibitions, trained and managed fighters, appeared on stage, and lectured. His autobiography, *Jack Johnson: In the Ring and Out*, appeared in 1927; a new edition was published, with additional material, in 1969. Johnson died in 1946 when he drove his car off the road in North Carolina.

Johnson's life was memorialized by Howard Sackler's play *The Great White Hope* (1969), which was made into a motion picture in 1971. Johnson finished with a record of 78 wins (including 45 by knockout), 8 defeats, 12 draws, and 14 no-decisions in 112 bouts. He was elected to the Boxing Hall of Fame in 1954. In 1987 *Ring* magazine rated him the second greatest heavyweight of all time, behind Muhammad ALI.

REFERENCES

GILMORE, AL-TONY. *Bad Nigger! The National Impact of Jack Johnson*. Port Washington, N.Y., 1978.

JOHNSON, JACK. *Jack Johnson: In the Ring and Out*. 1927. Revised. Chicago, 1969.

———. *Jack Johnson Is a Dandy: An Autobiography*, ed. Dick Schaap. New York, 1969.

ROBERTS, RANDY. *Papa Jack: Jack Johnson and the Era of White Hopes*. New York, 1983.

WIGGINS, WILLIAM H. "Jack Johnson as Bad Nigger: The Folklore of His Life." *Black Scholar* 2 (January 1971): 4–19.

STEVEN A. RIESS

Johnson, John Harold (January 19, 1918–), publisher. John H. Johnson rose from humble origins to found the country's largest African-American publishing empire and become one of the wealthiest men in the United States. Johnson was the only child of Leroy Johnson and Gertrude Jenkins Johnson and was reared in the Mississippi River town of Arkansas City. His father was killed in a sawmill accident when young Johnny (the name with which he was christened) was eight years old. The following year, 1927, his mother married James Williams, who worked as a bakery shop deliveryman.

Because the public school curriculum for blacks in Arkansas City terminated at the eighth grade and because Johnson and his mother had heard of greater opportunities in Chicago, they became part of the African-American migration to that city in 1933. Johnson enrolled in DuSable High School and proved himself an able student. Perhaps the crucial event in his life occurred when he delivered an honors convocation speech heard by Harry H. Pace, president of the Supreme Liberty Life Insurance Company.

Pace, who often helped talented black youths (among them Paul ROBESON), encouraged Johnson to attend college. Pace gave Johnson a part-time job

at the insurance company that enabled his protégé to attend the University of Chicago. But Johnson's interest focused on the impressive operations of the black-owned insurance firm, and he eventually dropped his university studies, married Eunice Walker in 1941, and assumed full-time work at Supreme Liberty Life.

Among Johnson's duties at Supreme Liberty Life was to collect news and information about black Americans and prepare a weekly digest for Pace. Johnson thought that such a "Negro digest" could be marketed and sold. In 1942 he parlayed a $500 loan using his mother's furniture as collateral to publish the first issue of Negro Digest, a magazine patterned after Reader's Digest. Although there were format similarities between the two publications, Johnson noted in his 1989 autobiography, Succeeding Against the Odds, that Reader's Digest tended to be upbeat whereas Negro Digest spoke to an audience that was "angry, disillusioned and disappointed" with social inequalities in the United States. Within eight months Negro Digest reached $50,000 a month in sales.

In 1945 Johnson launched his second publication, Ebony, using the format made popular by the major picture magazine Life. Central to his philosophy was the concept that African Americans craved a publication that would focus on black achievement and portray them in a positive manner. Six years later he created Jet, a pocket-sized weekly carrying news, society, entertainment, and political information pertinent to African Americans. In ensuing years Johnson added other enterprises to his lucrative empire, in-cluding new magazine ventures, book publishing, Fashion Fair cosmetics, several radio stations, and majority ownership of Supreme Liberty Life Insurance Company.

Despite the wide range and diversity of his business holdings, Johnson admitted his management style to be hands-on and direct, with every detail of operations requiring his personal approval. While tasks may be delegated, Johnson believes that his staff requires daily monitoring and oversight to ensure performance. Although he named his daughter, Linda Johnson Rice, president and chief operating officer in the late 1980s, he clearly remained in charge but asked "her opinion on decisions I plan to make."

By 1990 Johnson's personal wealth was estimated at $150 million. He has been a confidant of several U.S. presidents of both political parties and served as a goodwill ambassador to various nations throughout the world, including Eastern Europe and Africa.

REFERENCES

EMERY, EDWIN, and MICHAEL EMERY. *The Press and America*. Englewood Cliffs, N.J., 1978.

JOHNSON, JOHN H. *Succeeding Against the Odds*. New York, 1989.

WILSON, CLINT C. II. *Black Journalists in Paradox*. Westport, Conn., 1991.

CLINT C. WILSON II

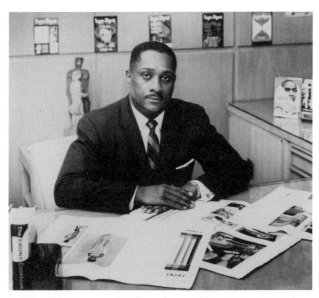

John H. Johnson, the founder and longtime president of Johnson Publishing Co., in his office in Chicago in 1964. For many decades Johnson Publishing Co. has been one of the largest black-owned businesses in the United States. (AP/Wide World Photos)

Johnson, John Rosamond (August 11, 1873– November 11, 1954), composer. J. Rosamond Johnson was born in Jacksonville, Fla. He was taught by his mother to play the piano at age four, and he studied music at the New England Conservatory and privately in London. In the summer of 1899, Rosamond and his brother, James Weldon JOHNSON, traveled to New York, where they met the famed vaudevillian Robert "Bob" COLE. The musical collaboration between Rosamond and Cole, often assisted by James Weldon, resulted in the composition of more than 150 songs between 1900 and 1910. Many of these songs were interpolated into Broadway shows, including *Sleeping Beauty and the Beast* (1901) and *Humpty Dumpty* (1904). Among their most popular songs were "Under the Bamboo Tree," "The Congo Love Song," and "Nobody's Lookin' but the Owl and the Moon." Their songs were popularized by Marie Cahill, Anna Held, George Primrose, and Lillian Russell. Johnson and Cole produced several musical comedies, including *The Shoo-Fly Regiment* (1906) and *The Red Moon* (1908), which were performed on Broadway by all-black casts.

Johnson collaborated with Bert WILLIAMS for the musical *Mr. Lode of Koal* (1909), and with J. Leubrie

John Rosamond Johnson, the composer of "Lift Ev'ry Voice and Sing," was equally adept at writing light, popular songs, such as "Under the Bamboo Tree." (Prints and Photographs Division, Library of Congress)

Hill for the musical *Hello, Paris* (1911). Johnson and Cole formed a vaudeville act that toured the United States and abroad until Cole's death in 1911. In 1912, Johnson performed in the London revue *Come Over Here,* and became the musical director of the Hammerstein Opera House there. From 1914 to 1919 he was director of the Music School Settlement for Colored in New York. He later toured, presenting concerts featuring spirituals. Johnson became musical director of *Blackbirds of 1936* and he appeared in *Porgy and Bess* (1935), *Mamba's Daughter* (1939) and *Cabin in the Sky* (1940). He is best known for "Lift Ev'ry Voice and Sing" (a.k.a. the NEGRO NATIONAL ANTHEM; 1900), for which he wrote the music and his brother, James Weldon, the lyrics. The Johnson brothers also published two books of African-American spirituals (1925, 1926). Johnson was a leading songwriter who was instrumental in elevating the musical stage from the stereotypes of minstrelsy. He died in New York City.

REFERENCE

RIIS, THOMAS L. *Just before Jazz: Black Musical Theatre in New York, 1890–1915.* Washington, D.C., 1989.

MARVA GRIFFIN CARTER

Johnson, Joshua (c. 1765–c. 1830), portrait painter. Almost nothing is known about the early life of the African-American portraitist Joshua Johnson, whose name is often spelled "Johnston." Scholars have suggested that he was a Caribbean immigrant who settled in Baltimore, or that he was a freed slave, possibly once owned by the Peale family of painters. The most reliable information about Johnson's life comes from Baltimore city records, where his name first appears in the 1790s. During the late eighteenth and early nineteenth centuries, Baltimore was home to a vibrant community of free blacks and aristocratic abolitionists, a situation that surely favored Johnson's early career. Nonetheless, in a 1798 advertisement in the *Baltimore Intelligencer,* Johnson claimed that as a self-taught artist he had "experienced many insuperable obstacles in the pursuit of his studies."

Whether or not Johnson was once owned by members of the Peale family, he was stylistically allied with them throughout his career, which lasted into the 1820s, with the oil-on-canvas portrait tradition in which the Peales worked. Johnson described himself as a "limner," an early American term for a nonacademic, itinerant portrait painter in a "naive" style.

Johnson's portrait subjects included members of the working and middle classes, but he is best known for his delightful depictions of well-to-do Baltimore families and children, arranged along the length of gracefully curved and tack-studded Federal-style sofas and chairs, often complemented by domestic objects such as containers of strawberries, branches of cherries, pet dogs, red shoes, coral jewelry, and white Empire-style dresses.

Among Johnson's finest family portraits are the *Portrait of Mr. and Mrs. James McCormick and Their Children, William Lux McCormick, Sophia Pleasants McCormick, and John Pleasants McCormick* (1804–1805); *Portrait of Mrs. Thomas Everette and Her Children, Mary Augusta Everette, Rebecca Everette, John Everette, Thomas Everette, Jr., and Joseph Myring Everette* (1818); and *Mrs. Hugh McCurdy and Her Daughters Mary Jane McCurdy and Letitia Grace McCurdy* (1806–1807). Johnson's best-known portraits of children include *The Westwood Children* (1807); *Portrait of Edward Pennington Rutter and Sarah Ann Rutter* (1804); and *Charles John Stricker Wilmans* (1803–1805).

Only two Johnson paintings of African-American sitters have been identified. One of these, *Portrait of Daniel Coker* (1805–1810, in the collection of the American Museum in Bath, England), is considered Johnson's most important work, a rendering of the prominent early black Methodist and advocate of African emigration.

Johnson's painting style is characterized by a restrained palette with a silvery quality that evokes the reflected light of Baltimore's seaport. Johnson was also noted for his capturing an elegance of pose and for

composition that accentuated a stiff but gentle modeling of the human form. He applied paint thinly, focusing with a fine line on details of costume, facial features, hair, and props. In his later works, Johnson was especially attentive to individual characteristics of his sitters, becoming adept at expressing their relationships through their poses and gestures. Those scholars who claim that Johnson had a West Indian or French Caribbean background—possibly coming from Saint Dominique, now known as Haiti—point to elements of French influence in those details, particularly in his representations of hair styles and costumes.

Johnson is presumed to have died sometime after 1824, since that is the last year he appears in Baltimore municipal records. No date of death or burial records have been found for Johnson, although records indicate that his second wife, Clara (or Clarissa), whom he had wed before 1803, probably survived him. Johnson's first marriage, to Sarah, sometime before 1798, resulted in two daughters, both of whom died in childhood, and two sons, who grew up in Baltimore.

Although Johnson clearly earned a living as a "limner," and even gained some local fame, his achievements came to wider public attention only during the 1940s, with the publication of a series of articles by Jacob Hall Pleasants, a genealogist and historian who had collected various accounts about the artist from the owners of a remarkable group of unsigned portraits of Baltimoreans from the late eighteenth and early nineteenth centuries. In attempting to reconcile these conflicting accounts, Pleasants drew from various Baltimore housing, tax, professional, and church directories—as well as newspaper advertisements from 1798 and 1802—to identify twenty-one portraits by Johnson.

By the 1990s, more than eighty paintings had been credited to Johnson, most of which have been acquired by major museums and private collections. Since Johnson rarely signed his paintings—his only signed work is *Portrait of Sarah Ogden Gustin* (1798–1802)—scholars and historians have continued to discover additional works. Johnson's paintings have also been featured in exhibitions at the Municipal Museum of the City of Baltimore in 1948 and at the Abby Aldrich Rockefeller Folk Art Center with the Maryland Historical Society in 1987.

REFERENCES

"Early Black Painter." *Colonial Homes* 8, no. 5 (September–October 1982): 124–127, 164–165.

HARTIGAN, LINDA ROSCOE. *Sharing Traditions: Five Black Artists in Nineteenth-Century America.* Washington, D.C., 1985.

HUNTER, WILBUR HARVEY, JR. "Joshua Johnston: 18th Century Negro Artist." *American Collector* 17 (February 1948): 6–8.

PLEASANTS, J. HALL. "Joshua Johnston, the First American Negro Portrait Painter." *Maryland Historical Magazine* 37, no. 2 (June 1942): 121–149.

LINDA CROCKER SIMMONS

Johnson, Louis (March 19, 1931–), dancer and choreographer. Louis Johnson was born in Statesville, N.C., and spent most of his childhood in Washington, D.C. After initial study at the Doris Jones–Clara Haywood School of Dance he moved to New York in 1950 to accept a scholarship at the School of American Ballet. In 1952 Johnson performed with the New York City Ballet in the premiere of Jerome Robbins's *Ballade.* Throughout the 1950s Johnson danced on Broadway in several shows including *My Darlin' Aida, House of Flowers, Hallelujah Baby!* and both the stage and screen versions of Bob Fosse's *Damn Yankees.*

Johnson began making dances in 1953 and achieved his greatest fame as a choreographer who comically combines a continuum of movement styles including social dances to popular music, classical ballet technique, Katherine DUNHAM–inspired modern dance, spiritual dancing, and acrobatics. His two most popular ballets are *Forces of Rhythm* (1972), created for the Dance Theatre of Harlem, and *Fontessa and Friends* (1981), first performed by the Alvin Ailey American Dance Theater. In 1970 Johnson was nominated for a Tony Award for his choreography of *Purlie,* a musical version of Ossie Davis's *Purlie Victorious.* He also choreographed the films *Cotton Comes to Harlem* (1970) and *The Wiz* (1978). Johnson staged the Houston Grand Opera's 1975 revival of the Scott JOPLIN opera *Treemonisha,* which included a reconstruction of the "slow drag," a nineteenth-century African-American social dance. Active as an arts educator and teacher since the 1970s, Johnson has conducted black arts symposiums at Howard, Yale, Virginia State, Hampton Institute, and Morehouse College, and in 1986 was appointed as the director of the dance division of the Henry Street Settlement on the Lower East Side of Manhattan.

REFERENCES

DUNNING, JENNIFER. "Louis Johnson: 'I Love Dance—Any Kind of Dance'." *New York Times,* September 28, 1975, Sec. 2, p. 6.

GOODMAN, SAUL. "Brief Biographies: Louis Johnson." *Dance Magazine* (August 1956).

THOMAS F. DEFRANTZ

Johnson, Malvin Gray (January 28, 1896–October 4, 1934), painter. Malvin Gray Johnson was born in Greensboro, N.C. He moved to New York

in the 1920s where he trained at the National Academy of Design under Francis Coates Jones. Johnson supported himself by working at menial jobs and as a commercial artist. He began to exhibit his oils and watercolors with the Harmon Foundation in the late twenties, winning the Foundation's Otto Kahn Prize in 1929 for his painting *Swing Low, Sweet Chariot*. In New York, Johnson also exhibited with the Society of Independent Artists and the Salons of America.

Though trained in the academic style, Johnson soon became known as a bold experimentalist with light, color, and form. Paintings such as *African Masks* (1932) and *Convict Labor* (1928) display a Cubist influence with their planar style and geometric forms. Johnson's appropriation of the abstract, unfinished style of Modernist painting is best seen in still lifes and landscapes like *Arrangement–Still Life* (1933) and *The Old Mill* (1934). Fauvist colors infuse much of his work as well.

Johnson painted scenes of everyday, African-American life in both urban and rural settings. Paintings like *Picking Beans* (1930) and *Thinnin' Corn* (1930) depict rural black laborers from the South of Johnson's youth. New York City comes to life in such Harlem street scenes as *Orphan Band* (1934) and *Come up Sometime* (1930). Johnson also frequently explored black Christian themes drawn from Negro Spirituals;

a sense of powerful communal emotion animates his paintings *Swing Low, Sweet Chariot* and *Roll, Jordan, Roll* (1933).

Johnson was an unusually gifted and expressive portraitist. His portraits present seated black men and women gazing uninhibitedly into the space of the viewer. In *Meditation* (1932), an elegantly attired woman stares into the far distance, the dreamy quality of her thought enhanced by Johnson's use of round shapes and soft lines. Johnson's *Postman* (1934) reveals the thoughtful and relaxed individual behind the government uniform. The proud but suffering aspect of his *Negro Soldier* (1934) is enhanced by sharp body angles and uneasy yellow-and-brown coloring. Johnson's *Self-Portrait* (1934) gives us the artist in his studio, with a fragment of his earlier *African Masks* in the background. The weight of Johnson's presence is conveyed through the use of heavy textures, Cubist forms, and a direct, probing stare. Johnson participated in the Federal Arts Project in New York from 1933 to 1934. He then traveled to rural Brightwood, Va., in 1934 to paint scenes of southern black life. Upon his return to New York, he died suddenly and unexpectedly of unknown causes at age thirty-eight. In recognition of Johnson's work, the Harmon Foundation held a posthumous exhibit of fifty-three of his oils and watercolors in 1935 at the Delphic Studios which attracted enthusiastic notice. His work has been acquired by the Smithsonian Institution and the Schomburg Center.

REFERENCES

PORTER, JAMES A. "Malvin Gray Johnson, Artist." *Opportunity* (April 1935): 117–118.
REYNOLDS, GARY A., and BERYL J. WRIGHT, eds. *Against the Odds: African-American Artists and the Harmon Foundation.* Newark, N.J., 1989.

FRANCES A. ROSENFELD

Malvin Gray Johnson's searching demeanor dominates his "Self-Portrait" (1934), painted in the last year of his short life. (National Archives)

Johnson, Mordecai Wyatt (January 12, 1890–1976), educator. Born in Paris, Tenn., Mordecai Johnson received his first bachelor of arts degree from Morehouse College in 1911. A second B.A. came from the University of Chicago in 1913, followed by a bachelor of divinity degree from Rochester Theological Seminary in 1916 and graduate degrees from Harvard University, HOWARD UNIVERSITY, and Gammon Theological Seminary. Johnson began his career teaching English at Morehouse College in Atlanta.

After leaving Morehouse, Johnson served as a Baptist minister in New York and in West Virginia, where he organized Charleston's first NAACP branch. Never one to back down from an injustice,

Mordecai Wyatt Johnson was the first African-American president of Howard University. (Photographs and Prints Division, Schomburg Center for Research in Black Culture, The New York Public Library, Astor, Lenox and Tilden Foundations)

he was merciless in his attacks on what he called the "Jim Crow churches" of America and worked to integrate all denominations. A gifted speaker, Johnson traveled throughout the Southwest with the YMCA, making detailed studies of many black schools and colleges.

In 1926, Johnson was unanimously recommended by Howard University's board of trustees to serve as the school's first African-American president. Three years later, he was honored as the fifteenth recipient of the NAACP SPINGARN MEDAL. A fighter for equal rights, Johnson promoted a policy of academic freedom at Howard for both students and faculty. While president, he could be heard quoting the principles of Mohandas K. Gandhi to his students in the 1930s and rallying for African independence in the 1940s. In 1952, Johnson called for a nonviolent solution to the Cold War that culminated in a peace mission to Moscow in 1959. On June 30, 1960, he retired as president of Howard. Thirteen years later, the university honored him with a building in his name. Johnson died in 1976 at the age of eighty-six.

REFERENCES

Low, W. Augustus, and Virgil A. Clift. *Encyclopedia of Black America*. New York, 1981.

Thompson, Charles H. "Howard University Changes Leadership." *Journal of Negro Education* 29, no. 4 (Fall 1960): 409–411.

Michael A. Lord

Johnson, Noble M. (April 1881–c. 1957), and **Johnson, George Perry** (February 1885–1977), filmmakers. Little is known about the early lives or later years of Noble and George Johnson, two brothers who in 1916 founded Lincoln Motion Pictures, the second black American FILM company. The brothers were born and raised in Colorado Springs, Colo., but Noble Johnson first worked as an actor in Philadelphia. George Johnson attended HAMPTON INSTITUTE, in Hampton, Va., before moving to Oklahoma, where he worked at one of the region's early black newspapers in 1906. After moving to Tulsa, he produced the *Tulsa Guide*, another early black regional newspaper, and then became the first black clerk at the Tulsa post office.

At the time that they founded Lincoln Motion Pictures, George Johnson was working as a mailman in Omaha, Nebr., and his brother was playing bit parts in Universal Studios films. They formed the studio, which was among the earliest Hollywood film companies, in order to avoid the financial domination of whites in the film industry and to protest the racist attitudes embodied in D. W. Griffith's BIRTH OF A NATION (1915). Noble Johnson ran Lincoln's studio in Los Angeles, while George Johnson continued to work as a postman in Lincoln, Nebr., and directed the company's booking office there.

The company was one of the first independent film companies to make black films with black financing for black audiences, offering black actors and actresses some of the era's few opportunities to play characters other than servile domestics or heartless villains. Lincoln made about one film per year between 1915 and 1922, including *The Realization of a Negro's Ambition* (1916), *The Trooper of Troop K* (1916), and *A Man's Duty* (1921), all of which starred Noble Johnson. Despite large turnouts and excited responses in some cities, the company never gained a big enough audience for its films and lacked a national distribution system. This, combined with a depression that followed World War I, led to the company's failure in 1922.

Even before Lincoln Motion Pictures closed, George Johnson had started an informal news service devoted to black films and filmmakers. Eventually he moved to Hollywood, changed his name to George Perry, and turned what had been at first a simple collection of newspaper clippings into the Pacific

Coast Bureau, which documented production and financial activities and spread gossip about dozens of black film companies. George Johnson gave his archive to the University of California and completed an oral history there before his death in 1977.

After the demise of Lincoln Motion Pictures Noble Johnson continued to work in film. He acted in many prominent films of the 1920s and 1930s, including *Four Horsemen of the Apocalypse* (1921), *Ben Hur* (1925), and *King Kong* (1933), but almost always in the "exotic" roles, such as that of the Native American, African, Latino, or Asian "primitive." He also appeared in *Tropic Fury* (1939), *The Desert Song* (1943), and *North of the Great Divide* (1950) before retiring in 1950. He died in 1957.

REFERENCES

CRIPPS, THOMAS. *Slow Fade to Black: The Negro in American Film.* New York, 1977.
LEAB, DANIEL J. *From Sambo to Superspade: The Black Experience in Motion Pictures.* Boston, 1975.

MICHAEL PALLER

Johnson, Robert Leroy (May 8, 1911?—August 16, 1938), blues guitarist and singer. The year of Robert Johnson's birth in Hazelhurst, Miss., is subject to dispute, with biographers often listing 1912 or 1914, or even 1891. Johnson grew up in the upper Mississippi Delta, mostly in Memphis, Tenn., and Robinsonville, Miss. As a child he played the Jew's harp and harmonica, and in the mid-1920s he studied guitar with Willie Brown in the Robinsonville area. He also learned about music from Charley PATTON and Son HOUSE. In 1929 Johnson married Virginia Travis. She died the next year, and in 1931 Johnson married Calletta Craft.

By the early 1930s Johnson was performing professionally at parties, juke joints, and nightclubs, and occasionally on the streets of Delta towns and cities. He spent most of the rest of his life traveling, often with Johnny Shines, performing throughout the South and Midwest, and apparently visiting New York and New Jersey, and possibly Canada. During visits to Texas in 1936 and 1937 he made his only recordings—twenty-nine songs in all—only one of which, "Terraplane Blues," had any success. During his lifetime, Johnson's career was surrounded by a mystique of danger and hedonism. His virtuosity as a singer and guitarist, combined with powerful appetites for alcohol, sex, and fighting, caused a story to circulate that one night at a lonely Delta crossroads he had sold his soul to the devil. That myth was fueled by the mysterious circumstances surrounding his demise. It is not certain how Johnson died, but his biographers have generally confirmed the account that he was poisoned by the jealous husband of a woman he had met at a party near Greenwood, Miss.

After his death Johnson came to be called "King of the Delta Blues." Although the title may be somewhat misleading, Johnson's impact in the years before World War II was enormous. In his own lifetime, Johnson's influence came about largely through his encounters with the musicians who heard him during his travels. These musicians adopted Johnson's dominant seventh "turnaround" chord and his boogie woogie–style "walking" bass lines, both of which became standard aspects of every blues guitarist's style. After his death, Johnson's reputation came to rest as much on his recordings as on his myth. His piercing, high-pitched voice often came close to a moaning whine, while his songwriting encompassed simple but detailed and dramatic observations about life and travel in the Mississippi Delta ("Ramblin' on My Mind," "Love in Vain," "Terraplane Blues") and haunting visions of loneliness and almost supernatural psychological torment ("Hell Hound on My Trail," "Crossroads Blues," "Stones in My Passway"). As a guitarist, Johnson coupled a powerful rhythmic drive with stinging slide guitar solos.

Johnson was "rediscovered" in the 1960s, when FOLK and BLUES music became popular among white audiences, and his songs became staples of 1960s rock and roll. In the 1980s and '90s scholars uncovered many details of Johnson's life, including the only two existing photographs of him. A 1990 release of all of his recordings, *Robert Johnson: The Complete Recordings,* including forty-one sides, many never before commercially released, was a huge success. In addition, he inspired Alan Greenberg's screenplay *Love in Vain* (1983), the documentary *The Search for Robert Johnson* (1992), and Bill Harris's play *Robert Johnson: Trick the Devil* (1993).

REFERENCES

GURALNICK, PETER. "Searching For Robert Johnson." *Living Blues* 53 (1982): 27–41.
PALMER, ROBERT. *Deep Blues.* New York, 1981.

JONATHAN GILL

Johnson, Sargent (1887–1967), sculptor. Born in Boston of a Swedish father and an African-American mother, Johnson was orphaned as a child; for several years afterward he lived in Washington, D.C., with the sculptor May Howard JACKSON, a maternal aunt. After moving to San Francisco in 1915, Johnson studied at the A. W. Best School of Art and the California

School of Fine Arts, where he worked with the sculptors Robert Stackpole and Beniamino Bufano; Bufano is often cited as his mentor.

Johnson's reputation first spread beyond local bounds when he won the Harmon Foundation's Otto Kahn prize for *Sammy,* a terra-cotta head, in 1927; after that he exhibited frequently with the foundation and in 1929 won its bronze award for fine arts. Critics praised his technical skill and the sensitivity and grace that marked his portrayals of blacks. In the mid-1930s Johnson executed a number of large-scale works commissioned by the WORKS PROJECT ADMINISTRATION, including statues for the Golden Gate International Exposition in San Francisco and carvings and a mosaic mural for the city's Maritime Museum; the best known of his large-scale decorative works, however, is a cast-stone frieze made for the George Washington High School Athletic Field in 1942.

In the late 1940s Johnson made his first trip to Mexico; the ancient art of the country became a powerful influence on his work, as did the art of Asia and Africa in later years. In addition to sculpting, Johnson was also an accomplished graphic artist, ceramicist, and potter. He died in San Francisco in 1967 after an extended illness.

REFERENCE

REYNOLDS, GARY A. and BERYL J. WRIGHT. *Against the Odds. African-American Artists and the Harmon Foundation.* Newark, N.J., 1989.

DOROTHY DESIR-DAVIS

Johnson, Virginia Alma Fairfax (January 25, 1950–), dancer. Born in Washington, D.C., to Madeline Johnson, a physical education instructor at Howard University, and James Lee Johnson, a physicist with the Department of the Navy, Virginia Johnson began studying ballet with Therrell Smith when she was three years old and became a scholarship student at the Washington School of Ballet when she was thirteen. After graduating from the Washington School of Ballet high school division, Johnson received a scholarship to New York University, where she majored in dance.

While at NYU she continued to study ballet outside the university with Karel Shook at the Katherine Dunham School and Arthur Mitchell, who founded the DANCE THEATER OF HARLEM (DTH) in 1969 to show that African Americans could perform classical repertory as well as whites. Mitchell convinced Johnson to commit herself to a professional dance career, and she premiered with DTH at the company's debut in 1971.

Since 1974, when Johnson began performing as a soloist with DTH, she has been able to draw upon her broad training to develop a wide spectrum of dance roles from historical classical to contemporary experimental ballets. Her most famous roles have included Mitchell's staging of *Giselle,* a revival of Valerie Bettis's *A Streetcar Named Desire* (1952), Lester Horton's *Don Quixote,* a revival of Agnes de Mille's *Fall River Legend* (1948), and Frederic Franklin's *Swan Lake.* Johnson is most often praised as a lyrical dancer and noted for the dramatic effect of her superb extensions as a dancer standing at five feet, eight inches tall. Aside from her work as prima ballerina with DTH, Johnson has had guest engagements with the Washington Ballet, Capitol Ballet, and Stars of the World Ballet, and has performed in a one-woman show at Marymount College in 1978. In 1985 she was awarded a Young Achiever Award by the National Council of Women of the United States.

BIBLIOGRAPHY

ASANTE, KARIAMU WELSH. "Virginia Johnson." In Darlene Clark Hine, ed. *Black Women in America: An Historical Encyclopedia.* Brooklyn, N.Y., 1993, p. 646.
HERRIDGE, FRANCES. "Yes, Virginia, The Dance Dream Can Come True." *New York Post,* January 2, 1981.
HOFFMAN, MARILYN. "Ballerina Shares Her Art with Young People." *Christian Science Monitor,* July 19, 1985.
HUNT, MARILYN. "Offstage View: Virginia Johnson." *Dance Magazine* (October 1990): 38–45.
"Virginia Johnson, Starring in New York." *Daily News,* June 16, 1985.

ZITA ALLEN

Johnson, William Henry (March 18, 1901– April 13, 1970), painter. For most African Americans, life in a small southern town after Reconstruction hardly promised more than a succession of menial jobs, a world of hard labor, and an insular, often fearful existence. As an artistically inclined but poverty-stricken black youth growing up in Florence, S.C., during the first two decades of the twentieth century, William H. Johnson followed this all-too-familiar pattern. There were very few options in his life other than running errands for his parents at the local YMCA and train depot, or working at the local steam laundry.

With the encouragement of a few teachers and his Pullman porter uncle, however, Johnson left South

Carolina around 1918 in search of a better life and migrated to New York City. From 1921 until 1926, Johnson attended the School of the National Academy of Design, where he quickly became one of the school's most outstanding students. Johnson also worked for three summers (1924–1926) with artist and teacher Charles Webster Hawthorne at his Cape Cod School of Art in Provincetown, Mass.

After failing to win the Pulitzer Traveling Scholarship in his final year at the School of the National Academy of Design, Johnson (with the financial backing of Charles Webster Hawthorne and painter George B. Luks) traveled to Paris, where he continued his art studies and experienced a sense of personal freedom for the first time. After about a year in Paris, Johnson moved to Cagnes-sur-Mer on the French Riviera, where he inaugurated an expressive and rhythmic painting style, best seen in works like *Village Houses* or *Cagnes-sur-Mer* (c. 1928–1929), *Young Pastry Cook* (c. 1928–1930), and *Jacobia Hotel* (1930).

These French-inspired paintings earned Johnson the William E. Harmon gold medal for distinguished achievements in the field of Fine Arts (1929–1930). Although his European sojourn was interrupted by a brief (and, as a result of the Harmon gold medal, widely celebrated) return to the United States in

"Self-Portrait" by William H. Johnson. (William H. Johnson papers, Archives of American Art, Smithsonian Institution)

1929, Johnson again returned to Europe—specifically, Denmark—in 1930, and maintained this Scandinavian base until 1938. During this time, Johnson married a Danish textile artist, Holcha Krake, traveled throughout Europe and North Africa, and exhibited his bold, expressionistic paintings (e.g., *Old Salt, Denmark*, c. 1931–1932; *Bazaars Behind Church, Oslo*, c. 1935; and *Midnight Sun, Lofoten*, 1937) in galleries in Denmark, Norway, and Sweden.

With the rise of the National Socialist Party in Germany and the expansion of Adolf Hitler's political dominion throughout Europe, Johnson and his wife fled Denmark in 1938 and settled in New York City. Johnson embarked on a new career in New York, based not on his European-inspired portraits and landscapes, but rather on African-American subjects and themes, all painted in a highly chromatic two-dimensional patchwork quilt–like technique.

Although he lived for much of this time (c. 1938–1946) in a humble manner (in poorly heated lofts in Greenwich Village), Johnson exhibited regularly in New York galleries as well as in all of the major "all-Negro" exhibitions that were organized around the country during this time. Johnson's paintings of rural life in the South (*Going to Church*, c. 1940–1941), Harlem's fashionable nightclubs and urban lifestyles (*Cafe*, c. 1939–1940), the black soldier during World War II (*K.P.*, c. 1942), and religious themes based on Negro spirituals (*Swing Low Sweet Chariot*, c. 1944) all reaped positive but limited critical notice in their day, and remain classic examples of an authentic African-American painting tradition during the war years.

In spite of Johnson's critical successes and personal satisfaction with his work, he sold very little during his lifetime and experienced numerous personal tragedies. In 1942, a fire broke out in his studio/loft, destroying many of his paintings and personal belongings, and forcing him and his wife to seek temporary housing in the middle of winter. In 1943, his wife was diagnosed as suffering from breast cancer, from which she died shortly thereafter, leaving Johnson profoundly bereft.

Works produced by Johnson from 1944 onward exhibit a strange, almost untutored look, stemming no doubt from these trials in his personal life and, moreover, from an encroaching paresis, brought on by a then undiagnosed case of advanced syphilis. Still, these late paintings, which examined black history (*Nat Turner*, c. 1945), the breaking down of colonial rule in the world (*Nehru and Gandhi*, c. 1945), and the major political conferences which led to the conclusion of World War II (*Three Allies in Cairo*, c. 1945), demonstrate a heightened political consciousness on Johnson's part, as well as his desire to connect the world's mid-century quest for political and economic

independence with the African American's ongoing struggle for freedom.

Johnson's art career halted in 1947, when he suffered a mental breakdown and was committed to a New York State mental hospital in Central Islip, Long Island. While Johnson languished in the hospital, never to paint or lead a normal life again, his personal estate of more than a thousand paintings, drawings, and prints lay in a wooden storage bin in lower Manhattan, neglected and essentially forgotten for almost a decade. In 1956, the Harmon Foundation, a philanthropic organization that had supported Johnson earlier in his career, agreed to take possession of Johnson's estate just as it was about to be disposed of by Johnson's court-appointed lawyers.

After several years of organizing, conserving, and exhibiting Johnson's art, the Harmon Foundation ceased operation in 1966, and soon thereafter turned over the entire collection (still in need of further research and conservation) to the Smithsonian Institution's National Museum of American Art (then known as the National Collection of Fine Arts). On the eve of the opening of Johnson's first major retrospective at the Smithsonian Institution in November 1971, the exhibition organizers learned that Johnson had died at Central Islip Psychiatric Center in 1970, totally unaware that his work and extraordinary career were finally receiving the recognition and acclaim that he had sought so fervently during his active years.

The art and life of William H. Johnson, the subject of several retrospective exhibitions, numerous publications, and a film documentary, intrigue audiences who have an interest in American art produced between the Great Depression and the end of World War II, the issue of primitivism in modern art and intellectual thought, and the various modes and methods of representing African-American culture during the twentieth century.

REFERENCE

POWELL, RICHARD J. *Homecoming: The Art and Life of William H. Johnson.* New York, 1991.

RICHARD J. POWELL

Johnson, William Julius "Judy" (October 26, 1899–June 15, 1989), baseball player. The son of a seaman who became athletic director of the Negro Settlement House in Wilmington, Del., Judy Johnson, also known as "Jing," starred for three Negro League (*see* BASEBALL) teams during his eighteen-season career.

"If Judy Johnson were white," Connie Mack once said, "he could write his own price." Instead, Johnson barnstormed his way across the United States, encountering the lower pay, long rides, and segregated accommodations that the career of a black ballplayer involved. His forte was defense, where his steady hands, rifle-like arm, and heady play won him acclaim in the Negro Leagues and in Cuba. Considered black baseball's best third baseman, Johnson hit over .300 in the games for which there are records.

A key component of the great Hilldale club of the 1920s, Johnson was player/manager of the 1930 Homestead Grays and then field captain of the Pittsburgh Crawfords, perhaps the greatest Negro League club ever. Johnson, who later scouted for three major league teams, was inducted into the Baseball Hall of Fame in 1975.

REFERENCES

HOLWAY, JOHN. *Blackball Stars: Negro League Pioneers.* Westport, Conn., 1988.

PETERSON, ROBERT. *Only The Ball Was White.* New York, 1984.

ROB RUCK

Johnson-Brown, Hazel Winifred (October 10, 1927–), military nurse. Born in West Chester, Pa., Hazel Johnson received a nursing diploma from Harlem Hospital in 1950. After working for five years as a nurse, she entered the Army in 1955 seeking greater opportunities for travel, education, and career advancement. She received a B.S. (1959) from Villanova University, an M.S. (1963) in nursing education from Columbia University Teacher's College, and a Ph.D. (1977) in education administration from Catholic University, Washington, D.C. Commissioned as a first lieutenant in the U.S. Army Nursing Corps in 1960, she was named a full colonel in 1977, becoming the highest-ranking black woman in the U.S. military. In 1979 she became the first African-American woman to ever achieve the rank of brigadier general. That year Johnson also became the first black Chief of the Army Nurse Corps.

In 1983 Johnson retired from the Army and worked as the director of the government affairs division of the American Nursing Association (ANA) and as adjunct professor at the Georgetown University School of Nursing. Three years later Johnson-Brown, who had changed her name upon her marriage to David B. Brown, left her post at the ANA and was named a professor of nursing at George Mason University in Fairfax, Va. She has been awarded the Army Commendation Medal (1966), the Legion of Merit (1973), and the Meritorious Service Medal (1979).

See NURSING for an overview of blacks in the nursing profession.

REFERENCES

CLOYD, IRIS. *Who's Who Among Black Americans.* Detroit, Mich., 1990.

HAWKINS, WALTER L. *African American Generals and Flag Officers: Biographies of Over 120 Blacks in the United States Military.* Jefferson, N.C., 1993, pp. 141–143.

LYDIA MCNEILL

Johnson Products.

Johnson Products Co. was founded in Chicago in 1954 by George (1927–) and Joan B. Johnson (1929–). George Johnson, then a twenty-seven-year-old laboratory worker in a cosmetics company, decided to experiment to find an African-American men's hair relaxant. Lye, which was used by blacks to straighten their hair, was painful and often damaged the hair and scalps of those who used it. Johnson discovered a safe formula that mixed lye and petroleum, and borrowed $250 to develop the product, which he named Ultra Wave Hair Culture. Johnson became a traveling salesman, peddling his formula to hairdressers throughout the country. Meanwhile, his wife Joan B. Johnson controlled finances and bookkeeping. Johnson's brother mixed and packaged the product. In 1961, the company developed a women's version. By 1965, despite competition from cheaper, inferior products, the company was grossing $2 million annually.

In 1965, the company improved its product, removing the petroleum base. Sales quickly soared, and Johnson became a symbol of black economic success. In 1969, the firm sold its first stock offering, for $10.2 million. In 1971, Johnson Products Co. became the first black-owned firm to trade on the American Stock Exchange. By 1975, the firm was grossing $37.2 million annually, selling hair straighteners and other products to hairdressers (the company controlled 85 percent of the market) and in stores.

Johnson Products became famous for serving the community. It promoted its products, notably Ultra Sheen, using black advertising firms and models. Its ads aided the growth of *Essence* magazine, and its television commercials were a fixture on the program *Soul Train.*

By the mid-1970s, however, Johnson Products began to lose sales, as white-owned hair-care companies moved into the market, hired black sales staff, and sold hair relaxants. Problems with the Federal Trade Commission and competition from white-owned firms cut sharply into business. By the mid-1980s, the company was losing money.

In 1988, the Johnsons filed for divorce. George Johnson gave up his operating interest, and Joan B. Johnson became the new chair and controlling shareholder. Although the company had a financial turnaround under their son, Eric Johnson, Joan Johnson fired her son in March 1992 and aroused family and staff resentment by promoting Thomas P. Polke and Corey Meyer, two white men, to president and director of operations. In 1993, she brought on further controversy by selling Johnson Products for some $67 million to Ivax Corp., a white-owned Miami firm. Ivax promised to continue the black hiring and community activism for which Johnson Products was known. Some blacks hailed the sale as symbolizing the expansion of black-owned business into the American mainstream, while others feared the demise of independent black business.

REFERENCE

PULLEY, BRETT. "A Crown Jewel: The Johnson Family Splits on What Is Best for Black-Owned Firm." *Wall St. Journal*, July 29, 1993.

GREG ROBINSON

Johnson Publishing Company.

One of the largest black-owned businesses in the United States in the 1990s, the Johnson Publishing Company is a family-owned conglomerate of media and beauty companies based in Chicago and founded by John H. JOHNSON in 1945. In 1942, Johnson saw the possibilities for a monthly review of articles about blacks, whom the white media largely ignored. Borrowing $500 with his mother's furniture as security, he started *Negro Digest*. The success of the periodical led him to create *Ebony*. As *Negro Digest* used the format of *Reader's Digest*, *Ebony*'s glossy picture layout was based on that of *Life*. *Ebony* was an immediate success and its popularity and circulation grew steadily, making the magazine the keystone of the Johnson publishing empire and a staple in black homes. Despite its large circulation, *Ebony*'s production costs in its first years almost bankrupted the company until Johnson was able to secure advertising contracts from white-controlled corporations. *Negro Digest* remained small, with a circulation of about 60,000. In 1951, Johnson discontinued it and started the vastly successful pocket-sized news magazine, *Jet*. (*Negro Digest* was revived in 1965 and renamed *Black World* in 1970. It folded not long thereafter.)

Over the decades, Johnson has launched or acquired many enterprises, including *Copper Romance* and *Hue*, short-lived publications of the mid-1950s; *Tan Confessions*, which became the fan magazine

Black Stars; Ebony Africa (1965), a brief attempt at developing an Africa-centered magazine, and such businesses as the Supreme Life Insurance Company. He has thus augmented the scope of his company. In the early 1990s, his holdings included *Ebony, Jet, Ebony, Jr.* (1973–), and *EM: Ebony Man* (1985–) magazines; Fashion Fair Cosmetics; Supreme Beauty Products; the syndicated television program *Ebony/Jet Showcase;* three radio stations, and the annual Ebony Fashion Fair traveling fashion show.

The Johnson Publishing Company remains entirely family owned and operated. In the early 1990s, it employed more than 2,300 people worldwide, had a total magazine circulation of more than three million, and had increased its sales from $72 million in 1980 to $274.2 million in 1992. Some black journalists and readers are critical of Johnson's refusal to print negative or analytical pieces about African-American life in his magazines, and blacks have questioned his contention that black entrepreneurs can start businesses without bank loans and credit. Still, Johnson is one of a handful of African Americans featured on *Forbes* magazine's list of 400 wealthiest Americans, and he is a man whose rise from poverty has interwoven itself into the company's mystique.

REFERENCES

COHEN, ROGER. "Black Media Giant's Fire Still Burns." *New York Times,* November 19, 1990.

JOHNSON, JOHN H., and LERONE BENNETT, JR. *Succeeding Against the Odds.* New York, 1989.

PETRA E. LEWIS

Joint Center for Political and Economic Studies–Public Policy Institute.

Growing out of two conferences for black elected officials—one in Chicago in 1967 and the other in Washington, D.C., in 1969—the Joint Center for Political Studies opened its door on July 1, 1970, under the sponsorship of Howard University and the Metropolitan Applied Research Center (MARC). It has become one of the nation's foremost authorities on black political behavior. Funded by a grant from the Ford Foundation, the Joint Center set about to provide direct technical assistance for the new cadre of black elected officials. Under the leadership of Eddie N. Williams, president since 1972 (the original president was Frank Reeves), the Joint Center later began to provide management and budget seminars to newly elected officials. The Joint Center also began publishing studies, reports, books, it own monthly magazine, *Focus,* and an annual roster of all black elected officials across the country in all levels of government. In the early

1980s, the Center became involved in national policy issues and began the process of restructuring itself towards becoming a national public institution. In 1989, it changed its name to the Joint Center of Political and Economic Studies to reflect its growing involvement in economic policy issues.

REFERENCE

CULP, JUDITH. "Joint Center: Think Tank Translates Black Agenda," *The Washington Times,* December 13, 1990, pp. E1–E3.

BILL OLSEN

Jones, Absalom

Jones, Absalom (1746–1818), minister and community leader. Among the enslaved African Americans who gained their freedom in the era of the American Revolution, Absalom Jones made some of the most important contributions to black community building at a time when the first urban free black communities of the United States were taking form. Enslaved from his birth in Sussex County, Del., Jones served on the estate of the merchant-planter Benjamin Wynkoop. Taken from the fields into his master's house as a young boy, he gained an opportunity for learning. When his master moved to Philadelphia in 1762, Jones, at age sixteen, worked in his master's store but continued his education in a night school for blacks. In 1770 he married, and through unstinting labor he was able to buy his wife's freedom in about 1778 and his own in 1784.

After gaining his freedom, Jones rapidly became one of the main leaders of the growing free black community in Philadelphia—the largest urban gathering of emancipated slaves in the post-Revolutionary period. Worshiping at Saint George's Methodist Episcopal Church, Jones soon began to discuss a separate black religious society with other black Methodists such as Richard ALLEN and William WHITE. From these tentative steps toward community-based institutions came the Free African Society of Philadelphia, probably the first independent black organization in the United States. Although mutual aid was its purported goal, the Free African Society was quasi-religious in character; beyond that, it was an organization where people emerging from the house of bondage could gather strength, develop their own leaders, and explore independent strategies for hammering out a postslavery existence that went beyond formal legal release from thralldom.

Once established, the Free African Society became a vehicle for Jones to establish the African Church of Philadelphia, the first independent black church in North America. Planned in conjunction with Rich-

A towering figure in the early history of the black church, Absalom Jones was a cofounder of the Free African Society of Philadelphia in 1789; in 1804 he became the first African American ordained as an Episcopal priest in the United States. This dignified portrait of Jones by Raphaelle Peale dates from about 1810. (Delaware Art Museum; gift of the Absalom Jones School)

ard Allen and launched with the assistance of Benjamin Rush and several Philadelphia Quakers, the African Church of Philadelphia was designed as a racially separate, nondenominational, and socially oriented church. But in order to gain state recognition of its corporate status, it affiliated with the Protestant Episcopal Church of North America and later took the name Saint Thomas's African Episcopal Church. Jones became its minister when it opened in 1794, and served in that capacity until his death in 1818. For decades, Saint Thomas's was emblematic of the striving for dignity, self-improvement, and autonomy of a generation of African Americans released or self-released from bondage, mostly in the North. In his first sermon at the African Church of Philadelphia, Jones put out the call to his fellow African Americans to "arise out of the dust and shake ourselves, and throw off that servile fear, that the habit of oppression and bondage trained us up in." Jones's church, like many others that emerged in the early nineteenth century, became a center of social and political as well as religious activities, and a fortress from which to struggle against white racial hostility.

From his position as the spiritual leader at Saint Thomas's, Jones became a leading educator and re-

former in the black community. Although even-tempered and known for his ability to quiet controversy and reconcile differences, he did not shrink from the work of promoting the rights of African Americans. He coauthored, with Richard Allen, *A Narrative of the Proceedings of the Black People, During the Late Awful Calamity in Philadelphia, in the year 1793,* a resounding defense of black contributions in the yellow fever epidemic of 1793—Jones himself assisted Benjamin Rush in ministering to the sick and dying in the ghastly three-month epidemic—and a powerful attack on slavery and white racial hostility. In 1797, he helped organize the first petition of African Americans against slavery, the slave trade, and the federal Fugitive Slave Law of 1793. Three years later, he organized another petition to President Jefferson and the Congress deploring slavery and the slave trade. From his pulpit he orated against slavery, and he was responsible in 1808 for informally establishing January 1 (the date on which the slave trade ended) as a day of thanksgiving and celebration, in effect an alternative holiday to the Fourth of July for black Americans.

Typical of black clergymen of the nineteenth century, Jones functioned far beyond his pulpit. Teaching in schools established by the Pennsylvania Abolition Society and by his church, he helped train a generation of black youth in Philadelphia. As Grand Master of Philadelphia's Black Masons, one of the founders of the Society for the Suppression of Vice and Immorality (1809), and a founder of the literary Augustine Society (1817), he struggled to advance the self-respect and enhance the skills of the North's largest free African-American community. By the end of Jones's career, Saint Thomas's was beginning to acquire a reputation as the church of the emerging black middle class in Philadelphia. But he would long be remembered for his ministry among the generation emerging from slavery.

REFERENCE

NASH, GARY B. " 'To Arise Out of the Dust': Absalom Jones and the African Church of Philadelphia, 1785–95." In Nash, ed. *Race, Class, and Politics: Essays on American Colonial and Revolutionary Society.* Urbana and Chicago, 1986, pp. 323–355.

GARY B. NASH

Jones, Bill T. (February 15, 1952–), dancer, choreographer. Bill Jones was born and raised in rural Steuben County in upstate New York. He began his dance training as a student at the State University of

New York at Binghamton where, as a theater major on an athletic scholarship, he enrolled in dance classes with Percival BORDE.

After living briefly in Amsterdam, Jones returned to SUNY in 1973 and joined with Lois Welk in forming the American Dance Asylum. Two years earlier, Jones met his long-time partner and companion Arnie Zane. The two choreographed and performed innovative solos and duos in the 1970s, often employing openly gay choreography. In 1982 they founded Bill T. Jones/Arnie Zane and Company, which provided a vehicle for the development of their choreography. Their works increasingly took on evening-length dimensions.

Jones, a tall, powerful dancer, was an outstanding soloist who often mixed video, text, and autobiographical material with his choreography, as he did in *Blauvelt Mountain* (1980) and *Valley Cottage* (1981), part of the trilogy that began with *Monkey Run Road* (1979). Jones and Zane gained recognition as "new wave" or "post modern" choreographers whose large-scale, abstract collaborations, such as *Secret Pastures, Freedom of Information,* and *Social Intercourse,* were visually and spatially altered by contemporary sets, costumes, and body paintings. They danced in costumes by clothing designer Willi SMITH and had sets created by pop artist Keith Haring. These collaborative works were performed in prestigious venues such as the Brooklyn Academy of Music and New York's City Center theater.

In 1983, Jones was commissioned to create the fast-paced, all-male *Fever Swamp* for the Alvin AILEY American Dance Theater, followed by *How to Walk an Elephant,* in 1985. After Zane's death in 1988 from AIDS, Jones continued to choreograph and perform. His works expanded to the field of opera and musical theater. He choreographed British composer Sir Michael Tippett's *New Year* (1990), choreographed and directed Leroy Jenkins's *Mother of Three Sons* (1991) at the New York City Opera, and directed Kurt Weill's *Lost in the Stars* in 1992. Jones's work has been commissioned by companies throughout the U.S. and Europe. In 1986 Jones and Zane received a Bessie Award, and in 1991 Jones was recognized as an "innovative master" with the Dorothy B. Chandler Performing Arts Award. In June of 1994, Jones was awarded a MacArthur fellowship.

REFERENCES

EMERY, LYNNE FAULEY. *Black Dance from 1619 to Today.* 2nd rev. ed. Princeton, N.J., 1988.
LEWIS, JULINDA. "Making Dances From the Soul: The Warm and Startling Images of Bill T. Jones." *Dance Magazine* (November 1981): 70–71.
THORPE, EDWARD. *Black Dance.* Woodstock, N.Y., 1990.
ZIMMER, ELIZABETH. "Solid Citizens of Post-Modernism: Bill T. Jones and Arnie Zane." *Dance Magazine* (October 1984): 56–60.

JULINDA LEWIS-FERGUSON

Jones, Charles Price (December 9, 1865–January 19, 1949), religious leader. Born near Rome, Ga., Charles Price Jones was raised in the Baptist faith by his mother, Mary Jones, a former slave. When she died in 1882, he wandered aimlessly for a few years, supporting himself by picking cotton and doing railroad construction work. In 1885 he was baptized and joined the Locust Grove Baptist Church in Arkansas, where he taught Sunday school. He was ordained in 1888 and elected pastor of Pope Creek Church in Grant County, Ark. That year he enrolled in the Arkansas Baptist College at Little Rock. While studying, Jones continued to preach at Little Rock, and upon graduation from the seminary he moved to Selma, Ala., in 1892, accepting the pastorate of the Tabernacle Baptist Church.

In Alabama in the 1890s, Jones first encountered the Holiness movement, which maintained that sanctification was a necessary act of grace after conversion. He himself had this experience in 1894. The next year, preaching at the Mt. Helm Baptist Church near Little Rock, Jones challenged the doctrines of his fellow Baptists and began to preach the necessity of sanctification from his pulpit. He founded the Church of God (later the Church of God in Christ) with Charles H. MASON in 1895. The following year Jones founded *Truth,* an organ of the Holiness movement, which he edited for more than twenty years. (He was also a talented poet and hymnwriter and was most responsible for the church's particular tradition of praising God in song. His many books of poetry and hymns include *Jesus Only* (1901) and *His Fullness* (1906).) Jones continued to move further from his Baptist peers even while nominally remaining in the fold. In 1897 he organized the first African-American Holiness Convention. Here he and other likeminded clergy realized that disputes between themselves and the rest of the Baptists were irreconcilable. They formed Christ's Association of Mississippi of Baptized Believers in 1900. Jones even tried to strike the word "Baptist" from the name of the church in which he preached. Finally in 1902, he and his followers were ousted from the Mt. Helm Church, and they then established Christ Temple Church, affiliating with Mason's Church of God in Christ.

A dispute developed in 1907 after Mason returned from the Azusa Street Revival in Los Angeles, the birthplace of modern Pentecostalism, where he had

encountered baptism in the Holy Spirit, evidenced by speaking in tongues. Mason preached the Pentecostal doctrine that this additional experience of grace was needed for salvation. Jones did not agree, and the two factions split, the one following Jones renamed the Church of Christ (Holiness) U.S.A. The Christ's Missionary and Industrial College was established under church auspices and moved to a large estate in Jackson in 1907.

In 1917 Jones moved to Los Angeles, becoming pastor of the Christ Temple Church and continuing to serve as bishop of the church. A church-wide convention in 1926 agreed that the Church of Christ had begun to lose its evangelical fervor as organizational strain and lax discipline became evident. Attempts at reform did not preclude a crisis in 1938, when internal feuding threatened to destroy the church. Many questioned whether Jones, then in his seventies, was physically well enough to lead the church. In 1942 he stepped down as head bishop and moved back to Jackson to reorganize the southern diocese. Infirmities required that he leave his leadership duties in 1944 and return to Los Angeles, where he died in 1949.

REFERENCES

AYERS, EDWARD L. *The Promise of the New South.* New York, 1992.

COBBINS, OTHO B. *History of the Church of Christ (Holiness) U.S.A., 1895–1965.* Chicago, 1966.

MELTON, J. GORDON. "Charles Price Jones." In *Biographical Dictionary of American Cult and Sect Leaders.* New York, 1986.

LYDIA MCNEILL
ALLISON X. MILLER

Jones, Claudia (February 21, 1915–December 25, 1964), Communist party leader. Claudia Jones was born in Port of Spain, Trinidad, and moved with her family to Harlem in New York in 1924. When she was still a teenager, her mother died. Jones was forced to leave school and work in a factory. In the early 1930s, Jones became involved in the campaign to free the nine "Scottsboro boys," led by the Communist-dominated International Labor Defense, and she was recruited into the Harlem branch of the Young Communist League (YCL). Shortly afterward, Jones became editor of the YCL *Weekly Review* and the *Spotlight*. In 1940, she was elected chair of the YCL national council.

During the 1930s and 1940s, Jones was active in the party's civil rights campaigns and supported the NATIONAL NEGRO CONGRESS (NNC), a civil rights organization that increasingly came under the control of the COMMUNIST PARTY. She was also a leading voice within the party for women's rights and, after World War II, was appointed to the National Executive Committee's Commission on Women, briefly serving as its secretary.

In 1948, Jones and several other party leaders were arrested on charges of sedition and nearly deported before a protest campaign compelled the federal government to free her on bail. Two years later, Jones was rearrested under the Smith Act, along with fifteen other New York City party leaders, for "teaching and advocating Marxism." In 1951, she was convicted and imprisoned in a federal penitentiary for one year.

In 1955, Jones was deported from the United States. She settled in London, where she renewed her work with the Communist party. During the late 1950s and early 1960s, she also served as the editor of the left-wing *West Indian Gazette* and worked for the Caribbean Labour Congress. Jones died in London in 1964.

REFERENCES

JOHNSON, BUZZ. *"I Think of My Mother": Notes on the Life and Times of Claudia Jones.* London, 1985.

THOMAS, ELEAN. "Remembering Claudia Jones." *World Marxist Review* (March 1987).

THADDEUS RUSSELL

Jones, Edward (c. 1808–1865), missionary and educator. Edward Jones was freeborn in 1807 or 1808 in Charleston, S.C., where his father, John Jones, Sr., a wealthy free black, ran an inn. In 1822, Jones was sent north by his father to begin his education. He entered Amherst College in Massachusetts, the first African American admitted to the school. Amherst, which was devoted mainly to training ministers, promoted colonization as the appropriate solution to the race problem. It was a position that Jones came to accept.

On August 23, 1826, Jones graduated from Amherst, probably becoming the first African American to graduate from college. (He received his degree two weeks before John Brown Russwurm graduated from Bowdoin College in Maine on September 6, 1826.)

Upon graduation, Jones was prevented from returning to South Carolina by a law that prohibited free blacks from entering the state. Jones traveled for several months before accepting a job as an assistant editor of FREEDOM'S JOURNAL, the first black newspaper, in 1827. The following year, he enrolled at An-

JONES, EUGENE KINCKLE 1477

dover Theological Seminary in Massachusetts, where he prepared for missionary work at the African Mission School. Jones was admitted as a deacon in the Protestant Episcopal Church in August 1830, and in September, he was ordained in Connecticut for missionary work in Africa. That same year, he was awarded an honorary master of arts degree from Trinity College in Connecticut.

In October 1831, Jones arrived in Sierra Leone and was employed as a schoolmaster in the offshore Banana Islands. He spent the next ten years in that position. In 1841, Jones joined the Anglican Church Missionary Society (CMS) in Sierra Leone as a missionary educator. As part of his service to CMS, Jones worked as a pastor and principal of the Fourah Bay Christian Institution, a school founded by CMS in 1827 that trained Africans for the ministry.

In 1845, Jones traveled to Great Britain to secure citizenship for himself in Sierra Leone, a privilege that would enable him to own property there. Three years later, he returned to England to raise money for the Fourah Bay school. During his stay, he appeared before the Select Committee on the Slave Trade for the House of Commons, where he spoke out against the SLAVE TRADE and discussed the harmful effects of SLAVERY upon Africans. He also discussed Africans' receptivity to Christianity and the high rate of attendance at his own church in Sierra Leone.

However, attendance at the Fourah Bay institution declined steadily during the late 1850s, and the school was closed by the school's parent committee in England in 1858. Jones assumed pastoral duties at Kissy Road Church, an Anglican church in Freetown, Sierra Leone. He also worked as an assistant editor (1859) of the *African and Sierra Leone Weekly Advertiser* and, in 1861, became the editor of *The Sierra Leone Weekly Times and West African Record*. During the thirty-one years he spent in Sierra Leone, Jones remained a strong supporter of colonization and worked to modernize African society. Jones left Sierra Leone in 1864 for health reasons and settled in England, where he died the following year.

REFERENCE

CONTEE, CLARENCE G. "Missionary-Educator to Sierra Leone and 'First' Afro-American College Graduate—1808? to 1865." *Negro History Bulletin* 38 (February–March 1975): 356–357.

SUSAN MCINTOSH
LOUISE P. MAXWELL

Jones, Elvin Ray (September 9, 1927–), jazz drummer. Born in Pontiac, Mich., Jones grew up in a musical family. He learned jazz as a child along with his brothers, Thad and Hank, who also went on to become jazz musicians. Jones began playing professionally in Pontiac and Detroit before serving in the Army and playing in military bands from 1946 to 1949. After returning to the Detroit area, he recorded with his brother Thad (*Thad Jones–Billy Mitchell Quintet,* 1953) before taking Art Mardigan's chair full-time in Billy Mitchell's quintet. Jones played with that band, which performed nightly at Detroit's Bluebird Club, until 1956, when he moved to New York. There he worked with many of the most prominent names in jazz, including Charles MINGUS, Bud POWELL, Donald Byrd, J. J. JOHNSON, Harry Edison, and Stan Getz. He also recorded with Sonny ROLLINS (*A Night at the Village Vanguard,* 1957) and Miles DAVIS and Gil Evans (*Sketches of Spain,* 1959–1960).

In 1960, Jones joined John COLTRANE's band, and it was there that the drummer perfected an influential drum sound characterized by a complex polyrhythmic foundation matched with shifting foreground patterns and figures. Jones contributed to Coltrane's searching, powerful solos passionate, commanding accompaniments that virtually defined jazz drumming in the mid-1960s as a voice equal to the other instruments (*Africa/Brass,* 1961; *Impressions,* 1961; *A Love Supreme,* 1954; *Ascension,* 1965). After leaving Coltrane in early 1966, Jones toured Europe briefly with the Duke ELLINGTON Orchestra. He later performed in trios with former Coltrane bassist Jimmy Garrison. He also co-led recordings with bassist Richard Davis (*Heavy Sounds,* 1968). A commanding presence behind and in front of the drum set, Jones appeared in the film *Zachariah* (1970) and was the focus of the documentary *Different Drummer* (1979). In the early 1990s he continued to lead his own sextet, featuring Coltrane's son Ravi on saxophone, touring and recording frequently.

REFERENCES

"Elvin Jones Interview." *Cadence* 7, no. 2 (1981): 9.
TAYLOR, ARTHUR. "Learn How to Make the Perfect Roll." In *Notes and Tones.* 1977. Rev. ed. Liege, Belgium, 1982.

ANTHONY BROWN

Jones, Eugene Kinckle (July 30, 1885–January 11, 1954), administrator. Eugene Kinckle Jones was born in Richmond, Va., the son of Joseph Endon Jones (a former slave whose college education was financed by a sympathetic northerner) and freeborn Rosa Daniel Kinckle Jones. Both parents were college professors. After attending a preparatory acad-

emy, Jones went on to Virginia Union University and graduated in 1906. He then pursued graduate studies at Cornell University, where he was instrumental in organizing Alpha Phi Alpha, the first black fraternity. After completing a masters degree in 1908, Jones taught college and high school in Louisville, Ky., for several years.

In April 1911, Jones was named field secretary of the Committee on Urban Conditions Among Negroes in New York, which later became the NATIONAL URBAN LEAGUE (NUL). At first working under the direction of founder George E. HAYNES, and then assuming a greater share of responsibility, Jones became the NUL's executive secretary in 1917.

Jones's leadership of the NUL over the years was shaped by enormous changes taking place in the black community. With the massive World War I–era migration of African Americans from the South to the North, the NUL expanded its network of local affiliates and established social service programs to assist in providing job training and placement, housing, and youth recreation. In this period, Jones promoted trade unionism among black workers and urged the American Federation of Labor to abandon its policy of racial exclusion. During the GREAT DEPRESSION, he strengthened the NUL's vocational education efforts and pressured the federal government to ensure fairness in relief programs.

In 1933 Jones took a leave from the NUL to serve as adviser on African-American concerns with the U.S. Department of Commerce in Washington, D.C. During his absence, T. Arnold HILL, then director of industrial relations, oversaw the NUL's programs. Jones, unwilling to relinquish authority, returned frequently to New York in order to monitor operations. By spring 1936 he had cut back significantly on his government duties in order to more effectively assert control; in 1937 he returned to the NUL on a permanent basis.

Stricken with tuberculosis in the spring of 1939, Jones worked intermittently for several years. By late 1941 it had become impossible for him to carry on his duties, and he was granted an official one-year leave from the NUL, which was extended indefinitely. Lester B. Granger was selected as the new executive secretary, and Jones held the title of general secretary, at half-salary, until 1950. He died in New York on January 11, 1954.

Among the NUL's achievements during Jones's tenure was the launching of the magazine OPPORTU-NITY: *Journal of Negro Life,* which published the work of leading black writers and artists. In 1926 Jones orchestrated the New York Public Library's acquisition of Arthur SCHOMBURG's massive collection of African-American historical and cultural materials. Today the Schomburg Center for Research in Black Culture remains one of the outstanding repositories of its kind.

REFERENCES

MOORE, JESSE THOMAS, JR. *A Search for Equality: The National Urban League, 1910–1961.* University Park, Pa., 1981.

PARRIS, GUICHARD and LESTER BROOKS. *Blacks in the City: A History of the National Urban League.* Boston, 1971.

WEISS, NANCY J. *The National Urban League, 1910–1940.* New York, 1974.

TAMI J. FRIEDMAN

Jones, Gayl (November 23, 1949–), novelist, poet, and critic. Born in Lexington, Ky., Gayl Jones grew up listening to the African-American oral tradition that is prominent in her narratives. Storytelling, both oral and written, was a part of her family experience. Her grandmother wrote religious dramas, and her mother composed stories to entertain the children. Jones herself began writing fiction when she was seven or eight. She received several prizes for poetry while an English major at Connecticut College. She then studied creative writing at Brown University under William Meredith and Michael HARPER. She published her first novel while still a graduate student. She taught creative writing and African-American literature at the University of Michigan until 1983; since then, she has lived primarily in Paris.

Her narratives focus on women driven to or over the edge of madness by the abuses they endure. The originality of her work lies in allowing these women to speak for themselves. *Corregidora* (1975), *Eva's Man* (1976), and the stories in *White Rat* (1977) are narrated by characters whose racial and sexual experiences are rendered in voices that are simultaneously obsessive in their concerns and ordinary in their idiom. Her later narratives are poems that present the history of blacks in the New World, including Brazil. *Song for Anninho* (1981), *The Hermit-Woman* (1983), and *Xarque and Other Poems* (1985) continue the focus on the suffering of black women, but without the obsessive voices. Her work of criticism, *Liberating Voices: Oral Tradition in African American Literature* (1991), explores folk traditions in the major writers of poetry and fiction.

REFERENCES

BYERMAN, KEITH E. "Beyond Realism: The Fictions of Gayl Jones and Toni Morrison." In *Fingering the*

Jagged Grain: Tradition and Form in Recent Black Fiction. Athens, Ga., 1986, pp. 171–184.
WARD, JERRY W. "Escape from Trublem: The Fiction of Gayl Jones." *Callaloo* 5 (1982): 95–104.

KEITH E. BYERMAN

Jones, James Earl (January 17, 1931–), actor. James Earl Jones, an actor renowned for his broad, powerful voice and acting range, was born in Arkabutla, Miss., the son of actor Robert Earl JONES. He was raised by his grandparents, who moved to Michigan when Jones was five. Soon afterwards, Jones developed a bad stutter, and remained largely speechless for the following eight years. When he was fourteen, a high school English teacher had him read aloud a poem he had written, and Jones gradually regained the use of his voice. He subsequently starred on the school's debating team. In 1949 Jones entered the University of Michigan as a premedical student, but soon switched to acting, and received his bachelor's degree in 1953. Two years later, he moved to New York City and studied at the American Theater Wing. He made his professional debut in 1957.

Jones first became well known in the early 1960s. His first leading role was in Lionel Abel's *The Pretender* in 1960. That same year he became a member of Joseph Papp's New York Shakespeare Festival; he remained with the company until 1967, performing on and off Broadway in numerous theatrical productions. He also played several small parts on Broadway. Between 1961 and 1963 he appeared in eighteen different plays Off-Broadway. His most notable performances came in Shakespeare Festival productions, as well as in an all-black production of Jean Genet's *The Blacks,* in Josh Greenfield's *Clandestine on the Morning Line* and in Jack Gelber's *The Apple.* In 1962 Jones won an Obie Award for best actor of the season based on his performances in the latter two productions and in Errol John's *Moon on a Rainbow Shawl.* He subsequently won both a Drama Desk Award (1964) and a second Obie (1965) for his performance in the title role of *Othello* at the New York Shakespeare Festival. Jones also made his screen debut at this time, in a small role in Stanley Kubrick's *Dr. Strangelove* (1964).

In 1967 Jones received his first widespread critical and public recognition when he was cast as the boxer Jack Jefferson (a fictionalized version of heavyweight champion Jack JOHNSON) in a Washington, D.C. production of Howard Sackler's play *The Great White Hope.* In 1968 the play moved to Broadway. The following year, it won a Pulitzer Prize and Jones received a Tony Award. He also starred in the 1970

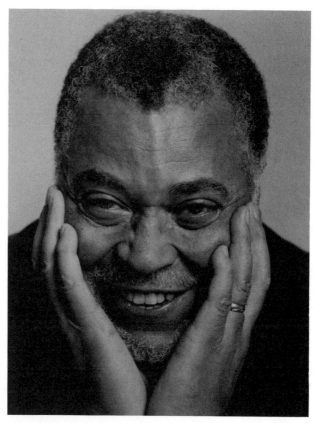

The distinguished actor James Earl Jones, best known for his serious dramatic roles, was photographed here in 1990 with an uncharacteristic grin. (AP/Wide World Photos)

film based on the play and was nominated that year for an Oscar.

During the 1970s Jones appeared in a variety of stage and screen roles, including such movies as *The Man* (1972), *Claudine* (1974)—for which he was nominated for a Golden Globe Award—*The River Niger* (1975), *The Bingo Long Travelling All-Stars and Motor Kings* (1976), and *A Piece of the Action* (1977); he also provided the voice of Darth Vader in *Star Wars* (1977) and its sequels. On stage, Jones starred in Lorraine Hansberry's *Les Blancs* (1970), in Athol Fugard's *Boesman and Lena* (1970), in an adaptation of John Steinbeck's *Of Mice and Men* (1974), and in various Shakespearean roles.

In 1977 Jones appeared on Broadway in a one-man show in which he portrayed singer/activist Paul ROBESON. The show (which opened soon after Robeson's death) was denounced as a distortion of Robeson's life by Paul Robeson, Jr., and was picketed by a committee of black artists and intellectuals who complained that the play had soft-pedalled Robeson's political radicalism. Jones countered that the committee was engaged in censorship. The play's Broadway run and subsequent appearance on public tele-

vision served to revive public interest in Robeson's life and career.

During the 1980s and early '90s, Jones continued to act in various media. On stage, he starred on Broadway in 1981–82 in a highly acclaimed production of *Othello* with Christopher Plummer as Iago and Cecilia Hart (Jones's wife) as Desdemona, in Athol Fugard's *A Lesson From Aloes* (1980) and *Master Harold . . . and the Boys* (1982), and in August WILSON's *Fences,* for which he received a second Tony award in 1987. He also appeared in more than thirty films during this period, including such movies as *Matewan* (1984), *Soul Man* (1985), *Gardens of Stone* (1985), *Coming to America* (1988), *Field of Dreams* (1989), *The Hunt for Red October* (1990), *Sommersby* (1993), and the animated feature *The Lion King* (1994).

Jones also has had considerable experience in television. He appeared in several episodes of such dramatic series as *East Side, West Side* in the early 1960s. In 1965 his role on *As the World Turns* made him one of the first African Americans to regularly appear in a daytime drama. In 1973 he hosted the variety series *Black Omnibus.* In 1978 Jones played author Alex Haley in the television miniseries *Roots: The Next Generations.* He also has starred in two short-lived dramatic series, *Paris* (1979–80) and *Gabriel's Fire* (1990–1992), and has made many television movies, including *The Cay* (1974), *The Atlanta Child Murders* (1984), and *The Vernon Johns Story* (1994). In 1993 Jones published a memoir, *Voices and Silences.*

REFERENCES

BOGLE, DONALD. *Blacks in American Film and Television: An Illustrated Encyclopedia.* Westport, Conn., 1988.

JONES, JAMES EARL and PENELOPE NIVEN. *Voices and Silences.* New York, 1993.

SABRINA FUCHS

Jones, Jonathan "Papa Jo" (October 7, 1911–September 3, 1985), jazz drummer. Born in Chicago, Jones was raised in Alabama, where he studied music in the public schools, and took private drum lessons with Wilson Driver. His first professional experience was as a dancer and musician with touring carnival shows. In the late 1920s and early '30s Jones played with a variety of bands performing in the Southwest, including Walter Page's Blue Devils and Benny MOTEN's ensemble. From 1931–1933 he performed and made his first recordings with the Omaha-based Lloyd Hunter's Serenaders. In 1933 he settled in Kansas City, and the next year he began working with Count BASIE. After briefly rejoining Page in the St. Louis-based Jeter-Pillars Orchestra in 1936, Jones performed with Basie's band until 1944, when he entered the army.

As the pulse of the quartet comprising Basie's "All-American rhythm section," Jones enjoyed popular success with what was one of the finest swing orchestras in the country. During the 1930s Jones epitomized Kansas City-style dance band drumming, and his records with the Count Basie Orchestra during that time ("One O'Clock Jump," 1937; "Jumping at the Woodside," 1938) won him international acclaim as a paragon of elegance and taste. Jones changed the timbral quality of jazz percussion accompaniment and lightened the sound by partially transferring the basic pulse from the bass drum to the hi-hat cymbals. This shimmering effect created a legato, flowing style of swing which became a trademark of Basie's orchestra. He also helped elevate the playing of wire brushes from a novelty effect into a refined part of the modern drummer's arsenal.

From 1944–5 Jones served in the army. Following his discharge he returned to play for Basie for two years. In 1947 he began a long association with Norman Granz's Jazz at the Philharmonic (JATP), a traveling jam session that toured throughout the U.S. and Europe in the late 1940s and 1950s. During this time Jones also performed with the leading artists in jazz, including Illinois Jacquet (1948–1950), and Lester YOUNG (1950), as well as with Billie HOLIDAY, Duke ELLINGTON, Art TATUM, Teddy Wilson, Lionel HAMPTON, and Benny Goodman.

Jones became known as "Papa Jo" later in life because of his position as one of the greatest swing-era drummers, and his abiding devotion to the art form of big band dance drumming, which he helped to perfect. In 1973 he recorded an album of musical and spoken reminiscences, *The Drums,* in which he acknowledged the precursors who inspired him, including Manzie Campbell, Jimmy Bertrand and A. G. Godley. Also in 1973 Jones, who had appeared in film on the Academy Award-winning *Jammin' the Blues* (1944), and *The Unsuspected* (1947), appeared in the film *Born to Swing.* In 1976 he recorded as a leader on *The Main Man.* He died in New York, where he had lived for several decades.

REFERENCES

DANCE, STANLEY. *The World of Count Basie.* New York, 1980.

MCMILLAN, L. K., JR. "Jo Jones: Percussion Patriarch." *Down Beat* 37, no. 6 (1971): 16.

ANTHONY BROWN

Jones, Joseph Rudolph "Philly Joe" (July 15, 1923–August 30, 1985), jazz drummer. Born in Philadelphia, Joe Jones learned piano from his mother, and started on drums at age four. He received his musical education in public schools in Philadelphia and studied for three years with Cozy COLE. He started his professional career in high school, playing with local groups which occasionally accompanied jazz musicians visiting Philadelphia. After serving in the army as a military policeman (1941–1945), he returned to his hometown and worked at a variety of jobs before moving to New York in 1947. He worked as the house drummer at the Cafe Society and other clubs, where he accompanied Charlie PARKER, Dizzy GILLESPIE, Fats NAVARRO, and Dexter GORDON, and worked with groups led by Tadd DAMERON, Gil Evans, and Tony Scott. In the late 1940s, he toured and made his first recording with Joe Morris's rhythm-and-blues group, and worked with Johnny Griffin, Lionel HAMPTON, Elmo Hope, and Tiny Grimes. In 1952, he played at the Downbeat Club in New York with Miles DAVIS, Lee Konitz, and Zoot Sims, and the next year he performed and recorded with Tadd Dameron (*A Study in Dameronia*, 1953).

Although Jones had established a reputation in the late 1940s as a bebop drummer, it was as a member of Miles Davis's quintet from 1955 to 1958 that he became famous. Jones's trademark brush work, and his typical accompaniment pattern, accenting the fourth beat of each bar with a reverse stick rim shot (*Round About Midnight,* 1955–1956, *Milestones,* 1958), became a part of the standard repertory in modern jazz drumming. As a soloist, Jones was particularly attentive to musical structure.

By the end of the 1950s, Jones had left Davis, and began to lead and record with his own groups (*Blues for Dracula,* 1958), as well as work for other musicians (*Blue Train,* with John Coltrane, 1957; *Dexter Calling,* with Dexter Gordon, 1961). In 1967 he moved to London, where he conducted a music studio, and in 1969 he settled in Paris, where he performed regularly and taught with Kenny CLARKE. That year he also recorded with avant-garde saxophonist Archie SHEPP.

Jones returned to Philadelphia in 1972 and formed various bands, including a jazz-rock group, Le Grand Prix. During the late 1970s he worked frequently in piano trios, most notably those led by Bill Evans and Red Garland. He also recorded with his own ensemble (*Philly Mignon,* 1977). In 1981 Jones assumed leadership of the nine-piece ensemble Dameronia, dedicated to performing the music of his early musical mentor, Tadd Dameron (*To Tadd With Love,* 1982). Although he was most closely associated with the music of the hard bop era, Jones performed in the 1980s in experimental contexts, working with SUN RA, Archie Shepp, and Amiri BARAKA, and in the quartet of percussionists Pieces of Time. He died in 1985.

REFERENCES

TAYLOR, ARTHUR. "Philly Joe Jones." In *Notes and Tones.* Liege, Belgium, 1979.
WILMER, VALERIE. "Ode to Philly Joe," *Melody Maker* (January 1968) 6.

ANTHONY BROWN

Jones, John Raymond (November 19, 1899–June 9, 1991), politician. J. Raymond Jones was born on the island of St. Thomas, Danish West Indies (now the U.S. Virgin Islands). An only child, Jones was the son of St. Thomas native Ansedella Perdereaux and Barbados native Alfred Percival Jones. In 1915 he graduated from Lincoln Junior High School in St. Thomas. Two years later Jones moved to Harlem, New York, where he finished his high school education; met his first wife, Christophina Bastian; and became a Pullman porter for the remainder of World War I.

Jones returned to Harlem in 1919. In 1920, he was attracted to the GARVEY movement and joined the UNIVERSAL NEGRO IMPROVEMENT ASSOCIATION (UNIA). He soon became the assistant to U. S. Poston, the UNIA's minister of labor and industry. In 1921 Jones became an election inspector for UNITED COLORED DEMOCRACY, the black section of the Manhattan Democratic organization. During the 1920s Jones and several fellow Caribbean Democrats began forming their own Democratic clubs, organized separately from Tammany's United Colored Democracy.

In 1933 Jones became a lieutenant of John Kelley, the white leader of Harlem's Twenty-second Assembly District. Throughout the decade, Jones expanded his influence in Tammany by supporting Kelley and other powerful white Tammany leaders in Harlem. In 1943 he formed his own club, the Carver Democratic Club, increased his popularity with Tammany leaders, and through his political savvy earned the nickname of "the Fox." When Harlem's districts were redrawn in 1944, Jones won the leadership of the eastern portion of Harlem's new Thirteenth District.

After William O'Dwyer was elected the first Democratic mayor in thirteen years in 1946, the new mayor made Jones his personal assistant, and Jones later served as deputy commissioner of housing and buildings. Jones left Democratic party politics in 1953

and took a patronage position as secretary to a judge.

When the Tammany Democratic machine tried to defeat Harlem Rep. Adam Clayton POWELL, JR. in 1958 (for supporting Dwight Eisenhower in 1956), Jones came out of retirement to defend Powell. The following year, Jones returned to the leadership of the eastern Thirteenth District in Harlem. In 1960 he agreed to support Lyndon Johnson for the presidency in return for Powell's selection as chairman of the House Committee on Education and Labor. Despite Johnson's defeat for the nomination, his efforts won Jones's second wife, Ruth Holloway Jones, a position as collector of customs for the U.S. Virgin Islands.

During the 1961 New York mayoral election, Jones supported Democratic Mayor Robert F. Wagner. Jones himself won election to the City Council the following year. In 1964 Wagner rewarded Jones by making him the first black leader of the New York County Democratic organization, the traditional seat of Tammany Hall. As county leader, Jones sought to reestablish Tammany's greatly eroded influence. He also helped to mediate escalating tensions between regular and reform Democrats. Jones's tenure was brief, but he continued to further the careers of other black officeholders, such as Constance Baker MOTLEY, Percy SUTTON, Basil A. PATTERSON, Charles B. RANGEL, and David N. DINKINS.

Jones resigned from both the Tammany leadership and the District leadership in 1967. His last influential act was to support Republican Mayor John Lindsay in 1969 against Democratic candidate Mario Procaccino, who he thought was race baiting. Jones retired to St. Thomas with his wife later that year. In 1989 his autobiographical memoir, *The Harlem Fox*, written by John C. Walter, was published. In May 1990 he entered the Greater Harlem Nursing Home. He died in New York City on June 9, 1991, at the age of ninety-one.

REFERENCES

FRASER, C. GERALD. "J. Raymond Jones, Harlem Kingmaker, Dies at 91." *New York Times*, June 11, 1991, p. B7.

HAMILTON, CHARLES V. *Adam Clayton Powell, Jr.: The Political Biography of an American Dilemma.* New York, 1991.

WALTER, JOHN C. *The Harlem Fox: J. Raymond Jones and Tammany, 1920–1970.* Albany, N.Y., 1989.

DURAHN TAYLOR

Jones, K. C. (May 25, 1932–), professional basketball player and coach. Born in Taylor, Tex., K. C. Jones (whose given name consists only of initials) spent his early childhood in a number of small Texas towns before moving with his mother and four siblings to San Francisco at the age of ten. An excellent athlete in high school, Jones was named to the All-Northern California All-Star teams in both BASKETBALL and FOOTBALL. He attended the University of San Francisco (USF) on a basketball scholarship. A 6′ 1″ guard who specialized in defense, Jones, with teammate Bill RUSSELL, led USF to two consecutive National Collegiate Athletic Association (NCAA) titles in 1955 and 1956. In 1956, Jones was selected by the Boston Celtics in the second round of the National Basketball Association (NBA) draft. That same year he won a gold medal as a member of the U.S. Olympic basketball team. Following two years' service in the Army, and a brief stint with the Los Angeles Rams football team, Jones joined the Celtics for the 1958–1959 season; the Celtics would win eight consecutive NBA championships from 1959 to 1966.

After nine seasons with Boston, Jones began a coaching career as an assistant basketball coach at Harvard University (1967–68) and was head coach of Brandeis University from 1968 to 1971. Following an assistant coaching position in the NBA and one year as head coach of the American Basketball Association's San Diego Conquistadores (1972–73), Jones was offered a three-year contract as head coach of the Capital (Washington, D.C.) Bullets of the NBA. Although he coached the team to three successful seasons, including an appearance in the 1975 NBA finals, Jones was unable to win a championship and was fired at the end of the 1975–1976 season.

In 1977 Jones got a job as an assistant coach with his old team, the Boston Celtics. After serving as an assistant to three head coaches, Jones himself was offered the position in 1983. Under his tutelage, the Celtics won the Eastern Conference Championship four times (1983–1984 to 1986–1987) and the NBA championship twice (1984 and 1986). In 1988 Jones left coaching to work in the front office of the Celtics. The following year, he joined the Seattle Supersonics, first as an assistant (1989–1990) and then as head coach (1990–91 to 1991–92). *Rebound,* his autobiography written with Jack Warner, was published in 1986.

REFERENCES

JONES, K. C., and JACK WARNER. *Rebound.* Boston, 1986.

PORTER, DAVID L., ed. *Biographical Dictionary of American Sports: Basketball and Other Indoor Sports.* New York, 1989.

BENJAMIN K. SCOTT

Jones, LeRoi. *See* Baraka, Amiri.

Jones, Lillie Mae. *See* Carter, Betty.

Jones, Lois Mailou (November 3, 1905–), painter, textile designer, and illustrator. Born and raised in Boston, Lois Jones studied art from childhood, receiving her training at the School of the Museum of Fine Arts and other local institutions. Named professor of design and watercolor in the Howard University art department in 1930, she taught several generations of artists, including Elizabeth CATLETT and David DRISKELL, until her retirement in 1977.

Simultaneous to her teaching, Jones was a prolific artist. She was initially trained as a textile designer, and her patterns were produced by leading manufacturers. Wishing to receive further recognition, she studied painting in Paris in 1937–1938, creating landscapes that showed the influence of impressionism, and postimpressionism. While she continued in this vein upon her return, the next decade also saw scenes of black life, both mundane and traumatic. In the 1950s, visits to her husband's homeland of Haiti provoked the use of vibrant colors and abstract shapes. Although African themes had appeared in the 1930s, after a trip to that continent in the late 1960s, Jones

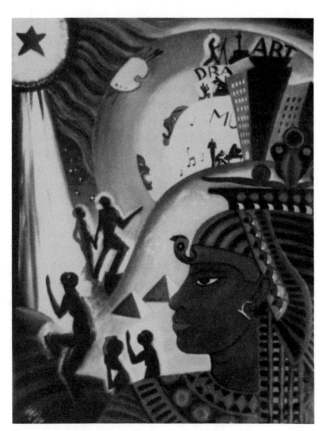

"Ascent of Ethiopia" by Lois Mailou Jones. (National Archives)

developed a distinctive style that melded her strong sense of design with images of African people, art, and culture. Over a career that spanned dramatic historical flux, Lois Mailou Jones's work reveals her innate responsiveness to changing times and places.

Jones has shown in numerous exhibitions in the United States, France, and Haiti, including several retrospectives. Her work is represented in collections in all three countries. She has been decorated by the government of Haiti and received honorary doctorates from the Massachusetts College of Art and Howard University.

REFERENCE

Meridian House International. *The World of Lois Mailou Jones.* Washington, D.C., 1990.

HELEN M. SHANNON

Jones, M. Sissieretta "Black Patti" (January 5, 1869–June 24, 1933), dramatic concert soprano. Born in Portsmouth, Va., she moved around 1876 with her family to Providence, R.I., where she began formal music training. She studied voice at the Providence Academy of Music and the New England Conservatory of Music, and privately with Louisa Capianni and Mme. Scongia. Her public debut occurred on April 5, 1888, at Steinway Hall, New York. That July she embarked on a six-month tour of the West Indies with the Tennessee Jubilee Singers. On that tour she acquired the sobriquet "Black Patti" (derived from the name of Spanish soprano Adelina Patti), which she retained for the rest of her career.

Jones sang widely as a soloist from 1890 to 1895 in the United States, Canada, the West Indies, and Europe. She attracted considerable national attention from well-publicized performances at the Grand Negro Jubilee at Madison Square Garden and the White House in 1892 and the Pittsburgh Exposition and World's Columbian Exposition in Chicago in 1893. Her career as a soloist ended abruptly in 1896, when she became the leading soprano of Black Patti's Troubadours, a newly organized company managed by Rudolf Voelckel and James Nolan. This company attracted such established entertainers as Robert ("Bob") COLE, the De Wolfe Sisters, Ernest Hogan, and Aida Overton WALKER. The show combined elements of vaudeville, minstrelsy, skits, and popular songs, and featured a special classical finale, called an "operatic kaleidoscope," which starred Jones with a supporting cast of soloists, chorus, and orchestra performing staged scenes from operas and musical comedies.

M. Sissieretta Jones, also known as "Black Patti." (Photographs and Prints Division, Schomburg Center for Research in Black Culture, The New York Public Library, Astor, Lenox and Tilden Foundations)

Jones emerged as a singer during the short-lived vogue of black prima donnas that flourished between 1870 and about 1895. She enjoyed celebrity status when most blacks with classical training found professional opportunities limited in American music because of racial prejudices. Endowed with a natural voice of phenomenal range and power, she brought musicality, artistry, and dramatic flair to the stage. Her repertory included classical songs, sentimental ballads, popular tunes, and roles in such operas as *Carmen, Lucia di Lammermoor, La Traviata,* and *Il Trovatore.*

REFERENCES

MAJORS, M. A. *Noted Negro Women: Their Triumphs and Activities.* Chicago, 1893.

SOUTHERN, EILEEN. *Biographical Dictionary of Afro-American and African Musicians.* Westport, Conn., 1982.

WRIGHT, JOSEPHINE. "Black Women and Classical Music." *Women's Studies Quarterly* 12, no. 3 (Fall 1984): 18–21.

JOSEPHINE WRIGHT

Jones, Quincy Delight, Jr. (March 14, 1933–), music producer and composer. Born in Chicago, Quincy Jones learned to play trumpet in the public schools in the Seattle, Wash., area, where his family moved in 1945. Jones sang in church groups from an early age, and wrote his first composition at the age of sixteen. While in high school he played trumpet in RHYTHM AND BLUES groups with his friend Ray CHARLES. After graduating from high school, Jones attended Seattle University, and then Berklee School of Music in Boston. He traveled with Jay McShann's band before being hired by Lionel HAMPTON in 1951. Jones toured Europe with Hampton, and soloed on the band's recording of his own composition, "Kingfish" (1951).

After leaving Hampton in 1953, Jones, who had an undistinguished solo style on trumpet, turned to studio composing and arranging, working with Ray Anthony, Tommy DORSEY, and Hampton. During the 1950s Jones also led his own big bands on albums such as *This Is How I Feel About Jazz* (1956). In 1956 Jones helped Dizzy GILLESPIE organize his first state department big band. From 1956 to 1960 he worked as the music director for Barclay Records in Paris, and while there he studied arranging with Nadia Boulanger. He also worked with Count BASIE, Charles Aznavour, Billy ECKSTINE, Sarah VAUGHAN, Dinah WASHINGTON, and Horace SILVER, and led a big band for recording sessions such as *The Birth of a Band* (1959). Jones served as music director for Harold Arlen's blues opera *Free and Easy* on its European tour. Back in the U.S. in the early 1960s, Jones devoted his time to studio work, attaining an almost ubiquitous presence in the Los Angeles and New York music scenes.

Jones began working as a producer at Mercury Records in 1961. After producing Leslie Gore's hit record "It's My Party" (1963), he became Mercury's first African-American vice president in 1964. He increasingly made use of popular dance rhythms and electric instruments. In 1964 he also scored and conducted an album for Frank Sinatra and Count Basie, *It Might As Well Be Swing.* He recorded with his own ensembles, often in a rhythm and blues or pop jazz idiom, on albums such as *The Quintessence* (1961),

Composer and producer Quincy Jones at work in his studio, 1974. Some of his twenty Grammy awards adorn the wall. (AP/Wide World Photos)

Golden Boy (1964), *Walking in Space* (1969), and *Smackwater Jack* (1971). Jones also branched into concert music with his *Black Requiem,* a work for orchestra (1971). Jones was the first African-American film composer to be widely accepted in Hollywood, and he scored dozens of films, including *The Pawnbroker* (1963), *Walk, Don't Run* (1966), and *In Cold Blood* (1967).

In 1974, shortly after recording *Body Heat,* Jones suffered a cerebral stroke. He underwent brain surgery, and after recovering he formed his own record company, Qwest Productions. Throughout the 1970s Jones remained in demand as an arranger and composer. He also wrote or arranged music for television shows (*Ironside, The Bill Cosby Show,* the miniseries *Roots,* and *Sanford and Son*), and for films (*The Wiz,* 1978). During the 1980s Jones expanded his role in the film business. In 1985 he coproduced and wrote the music for the film *The Color Purple,* and served as executive music producer for Sidney Poitier's film *Fast Forward* (1985).

Jones's eclectic approach to music, and his ability to combine gritty rhythms with elegant urban textures is perhaps best exemplified by his long association with Michael JACKSON. Their collaborations on *Off The Wall* (1979) and *Thriller* (1984) resulted in two of the most popular recordings of all time. Jones also produced Jackson's 1987 *Bad.* During this time, Jones epitomized the crossover phenomenon by maintaining connections with many types of music. His eclectic 1982 album *The Dude* won a Grammy award, and in 1983 he conducted a big band as part of a tribute to Miles DAVIS at Radio City Music Hall. The

next year he produced and conducted on Frank Sinatra's *L.A. Is My Lady.* He conceived of USA for Africa, a famine relief organization that produced the album and video *We Are The World* (1985). In 1991 Jones appeared with Davis at one of the trumpeter's last major concerts, in Montreux, Switzerland, a performance that was released on album and video in 1993 as *Miles and Quincy Live at Montreux.* During this time Jones also continued to work with classical music, and in 1992 he released *Handel's Messiah: A Soulful Celebration.*

By 1994, with twenty-two Grammy awards to his credit, Jones was the most honored popular musician in the history of the awards. He also wielded enormous artistic and financial power and influence in the entertainment industry, and was a masterful discoverer of new talent. In 1990 his album *Back on the Block,* which included Miles Davis and Ella FITZGERALD in addition to younger African-American musicians such as Ice-T and Kool Moe Dee, won six Grammy awards. He continued to expand his activities into the print media, including the magazine *Vibe,* aimed primarily at a youthful African-American readership. He also produced the hit television series "Fresh Prince of Bel Air," which began in 1990. That same year Jones was the subject of a video biography, *Listen Up: The Lives of Quincy Jones* (1990).

REFERENCES

HORRICKS, RAYMOND. *Quincy Jones.* Tunbridge Wells, U.K., 1985.
SANDERS, CHARLES LEONARD. "Interview with Quincy Jones." *Ebony* (October 1985): 33–36.
SHAH, DIANE K. "On Q." *New York Times Magazine,* November 18, 1990, p. 6.

JONATHAN GILL

Jones, Robert Earl (February 3, 1900–), actor. Robert Earl Jones, born in Coldwater, Miss., received his first dramatic roles in U.S. Army training films boxing opposite Joe LOUIS. He made his Broadway debut as Blossom in *The Hasty Heart* (1945), originated the role of Henry in *Strange Fruit* (1945), and appeared with his son, James Earl JONES, in *Moon on a Rainbow Shawl* (1962). He also had roles in *The Iceman Cometh* (1974), *All God's Chillun Got Wings* (1975), and *Mule Bone* (1991).

Film credits include *Lying Lips* (1939), *The Notorious Elinor Lee* (1940), and *One Potato, Two Potato* (1964). In 1975 Jones was inducted into the Black Filmmakers Hall of Fame.

REFERENCE

MAPP, EDWARD. "Jones, Robert Earl." In *Directory of Blacks in the Performing Arts*. Metuchen, N.J., 1990.

SARAH M. KEISLING

Jones, Ruth Lee. *See* Washington, Dinah.

Joplin, Scott (c. 1867/68–April 1, 1917), RAGTIME composer. Born in eastern Texas, some 35 miles south of present-day Texarkana, to an ex-slave father and a freeborn mother, Joplin rose from humble circumstances to be widely regarded as the "King of Ragtime Composers." (Formerly thought to have been born on November 24, 1868, he is now known to have been born in late 1867 or early 1868.) In the early years of his career he worked with minstrel companies and vocal quartets, in bands as a cornetist, and as a pianist. His earliest published compositions (1895–1896) were conventional songs and marches. In 1894 he settled in Sedalia, Mo., where he attended the George R. Smith College. His "Maple Leaf Rag" (1899), which memorializes a black social club in Sedalia, became the most popular piano rag of the era. By 1901 he was famous and moved to St. Louis, where he worked primarily as a composer. Despite his success in ragtime, he wanted to compose for the theater. In 1903 he formed a company to stage his first opera, *A Guest of Honor* (now lost). He spent all his money on the unsuccessful opera tour and then returned to composing piano rags. In 1907 he moved to New York, where major music publishers were eager to issue his rags, but he still aspired to be a "serious" composer. In 1911 he completed and self-published his second opera, *Treemonisha,* in which he expressed the view that his race's problems were exacerbated by ignorance and superstition and could be overcome by education. He never succeeded in mounting a full production of this work.

Despite his efforts with larger musical forms, Scott Joplin is today revered for his piano rags, these being the most sophisticated examples of the genre. His published output includes fifty-two piano pieces, of which forty-two are rags (including seven collaborations with younger colleagues); twelve songs; one instructional piece; and one opera. Several songs, rags, a symphony, and several stage works—his first opera, a musical, and a vaudeville—were never published and are lost.

A Scott Joplin revival began in late 1970 when Nonesuch Records, a classical music label, issued a

Scott Joplin, one of the primary creators of ragtime, composer of "The Maple Leaf Rag" and "The Entertainer." This photograph dates from around 1911, about the time Joplin was composing his opera *Treemonisha,* a symbolic account of the progress of African Americans. (Photographs and Prints Division, Schomburg Center for Research in Black Culture, The New York Public Library, Astor, Lenox and Tilden Foundations)

recording of Joplin rags played by Joshua Rifkin. For the record industry, this recording gave Joplin the status of a classical composer. This status was enhanced a year later when the New York Public Library issued the two-volume *Collected Works of Scott Joplin.* Thereafter, classical concert artists began including Joplin's music in their recitals. In 1972, his opera *Treemonisha* received its first full performance, staged in Atlanta in conjunction with an Afro-American Music Workshop at Morehouse College, and in 1975 the opera reached Broadway. (There have been three orchestrations of the work—by T. J. ANDERSON, William Bolcom, and Gunther Schuller.) In 1974, the award-winning movie *The Sting* used several Joplin rags in its musical score, bringing Joplin to the attention of an even wider public. "The Entertainer" (1902), the film's main theme, became one of the most popular pieces of the mid-1970s. Further recognition of Joplin as an artist came in 1976 with a special Pulitzer Prize, and in 1983 with a U.S. postage stamp bearing his image.

REFERENCES

BERLIN, EDWARD A., *King of Ragtime: Scott Joplin and His Era*. New York, 1994.

HASKINS, JAMES, and KATHLEEN BENSON. *Scott Joplin.* Garden City, N.Y., 1978.

EDWARD A. BERLIN

Jordan, Barbara Charline (February 21, 1936–), congresswoman and professor. Barbara Jordan was born in Houston, Tex., the daughter of Arlyne Jordan and Benjamin M. Jordan, a Baptist minister. She spent her childhood in Houston, and graduated from Texas Southern University in Houston in 1956. Jordan received a law degree from Boston University in 1959. She was engaged briefly in private practice in Houston before becoming the administrative assistant for the county judge of Harris County, Tex., a post she held until 1966.

In 1962, and again in 1964, Jordan ran unsuccessfully for the Texas State Senate. In 1966, helped by the marked increase in African-American registered voters, she became the first black since 1883 elected to the Texas State Senate. The following year she became the first woman president of the Texas Senate. That year, redistricting opened a new district in Houston with a black majority. Jordan ran a strong campaign, and in 1972 she was elected to the House of Representatives from the district, becoming the first African-American woman elected to Congress from the South.

Jordan's short career as a high-profile congresswoman took her to a leadership role on the national level. In her first term, she received an appointment

Barbara Jordan. (© Carol Bernson/Black Star)

to the House Judiciary Committee, where she achieved national recognition during the Watergate scandal, when in 1974 she voted for articles of impeachment against President Richard M. Nixon. A powerful public speaker, Jordan eloquently conveyed to the country the serious constitutional nature of the charges and the gravity with which the Judiciary Committee was duty-bound to address the issues. "My faith in the Constitution is whole, it is complete, it is total," she declared. "I am not going to sit here and be an idle spectator to the diminution, the subversion, the destruction of the Constitution."

Jordan spent six years in Congress, where she spoke out against the Vietnam War and high military expenditures, particularly those earmarked for support of the war. She supported environmental reform as well as measures to aid blacks, the poor, the elderly, and other groups on the margins of society. Jordan was a passionate campaigner for the Equal Rights Amendment, and for grassroots citizen political action. Central to all of her concerns was a commitment to realizing the ideals of the Constitution.

Public recognition of her integrity, her legislative ability, and her oratorical excellence came from several quarters. Beginning in 1974, and for ten consecutive years, the *World Almanac* named her one of the twenty-five most influential women in America. *Time* magazine named Jordan one of the Women of the Year in 1976. Her electrifying keynote address at the Democratic National Convention that year helped to solidify her stature as a national figure.

In 1978, feeling she needed a wider forum for her views than her congressional district, Jordan chose not to seek reelection. Returning to her native Texas, Jordan accepted a professorship in the School of Public Affairs at the University of Texas at Austin in 1979, and since 1982 she has held the Lyndon B. Johnson Centennial Chair in Public Policy. Reflecting her interest in minority rights, in 1985 Jordan was appointed by the secretary-general of the United Nations to serve on an eleven-member commission charged with investigating the role of transnational corporations in South Africa and Namibia. In 1991, Texas Gov. Ann Richards appointed her "ethics guru," charged with monitoring ethics in the state's government. In 1992, although confined to a wheelchair by a degenerative disease, Jordan gave a keynote speech at the Democratic National Convention, again displaying the passion, eloquence, and integrity that had first brought her to public attention nearly two decades earlier.

REFERENCE

HASKINS, JAMES. *Barbara Jordan.* New York, 1977.

CHRISTINE A. LUNARDINI

Jordan, Clifford Laconia, Jr. (September 2, 1931–), jazz tenor saxophonist. Born in Chicago, Clifford Jordan studied piano at an early age and began playing tenor saxophone at fourteen. His musical studies at DuSable High School under Capt. Walter Dyett were undertaken in the company of fellow saxophonists Johnny Griffin and John Gilmore. During the mid-1950s, Jordan worked at rhythm-and-blues jobs in the Chicago area, as well as performing with many of the bands that passed through the city at the time.

Moving to New York in 1957, Jordan played with Max ROACH briefly before spending a year with Horace SILVER, both on the West Coast and in New York. From 1959 to 1960 he was a member of J. J. JOHNSON's group in New York, before leading a quintet with Kenny Dorham from 1961 to 1962. Jordan toured the United States, Japan, and Europe with Max Roach during the 1960s and worked with Charles MINGUS on a tour of Europe in 1964. He worked frequently in Europe during the 1960s and '70s. In the summer of 1991, he toured Europe again with his own large band.

Jordan is a creative and technically able saxophonist with a warm, round tone and a style related to Lester YOUNG's. He has the skill and flexibility to work in a variety of settings and circumstances as leader, soloist, composer, and arranger.

REFERENCE

GARDNER, MARK. "Clifford Jordan." In *The New Grove Dictionary of Jazz*. New York, 1988.

BILL DIXON

Jordan, June (July 9, 1936–), writer. Born in Harlem to Jamaican immigrants Granville and Mildred Jordan, June Jordan grew up in Brooklyn's Bedford Stuyvesant, where poverty and racism were rampant. She absorbed quite early, as she records in the introduction to her first collection of essays, *Civil Wars* (1981), her community's belief in the power of the word. In her family, literature was important, so that by age seven she was writing poetry. She attended an exclusive New England white high school and went to Barnard College in 1953, both of which she found alienating experiences.

In college she met Michael Meyer, a student at Columbia, whom she married in 1955. They had a son, Christopher David, in 1958 and were divorced by 1965, experiences she explores in later essays. In the 1960s, Jordan, now a single working mother, actively participated in and wrote about African-American political movements in New York City.

Her first book-length publication, *Who Look at Me* (1969); her poems collected in *Some Changes* (1971); and her essays in *Civil Wars* exemplify her illumination of the political as intimate, the personal as political change, poetry as action—concepts central to all Jordan's work.

Jordan's writing workshop for Brooklyn children in 1965 resulted in the anthology *Voice of the Children* (1970), and anticipated her many books for children: *His Own Where* (1971), written in black English; *Dry Victories* (1972); *Fannie Lou Hamer* (1972); *New Life: New Room;* and *Kimako's Story* (1981), while her organizing of poets in the 1960s resulted in the anthology *SoulScript* Poetry. Her collaboration with Buckminster Fuller in 1964 to create an architectural design for Harlem indicates her concern with black urban environments, a theme evident in *His Own Where* and *New Life: New Room*. Her work as an architect won Jordan a Prix de Rome in 1970, a year she spent in Rome and Greece, geographical points for many poems in *New Days: Poems of Exile & Return* (1974).

Jordan's teaching at City College, New York City, and the State University of New York at Stony Brook is a starting point for theoretical essays on black English, of which she is a major analyst. Her reflections on her mother's suicide in 1966 are the genesis for black feminist poems such as "Getting Down to Get Over," in *Things That I Do in the Dark: Selected Poems* (1977). In the 1970s, Jordan contrib-

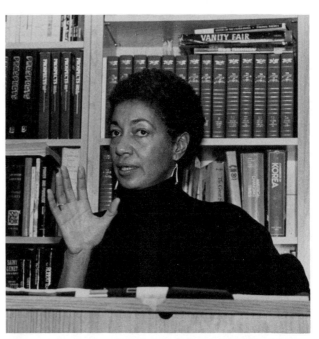

The novelist, poet, and anthologist June Jordan has written extensively for children and young adults. She is photographed here in the Center for American Culture Studies, Columbia University, N.Y. (© Mel Rosenthal, Impact Visuals)

uted to black feminism with major essays and poems. Her "Poem about My Rights" in *Passion: New Poems, 1977–80* also indicates her growing internationalism, as she relates the rape of women to the rape of Third World countries by developed nations.

In the 1980s, through poetry in *Living Room* (1985) and *Naming Our Destiny* (1989), as well as in *On Call: Political Essays,* Jordan writes about oppression in South Africa, Lebanon, Palestine, and Nicaragua as she widens her personal vision as an African-American woman to include more of the struggling world. The growth of her international audience is indicated by the translation of her work into many languages (including Arabic and Japanese), by British publications of *Lyrical Campaigns: Poems* (1985) and *Moving towards Home: Political Essays* (1989), and by recordings of her poems as sung by Sweet Honey in the Rock.

In 1978 and 1980, Jordan recorded her own poems, and in the 1980s she began writing plays, a genre she calls "a living forum." Her play *The Issue* was produced in 1981; *Bang Bang über Alles,* in 1986, and *All These Blessings,* in 1990, had staged readings. Jordan has also widened her audience by being a regular columnist for the *Progressive* magazine. In her poetry, prose, and plays, Jordan continues to dramatize how life seems to be an increasing revelation of the "intimate face of universal struggle," a truth she offers to those who would hear her.

REFERENCES

ERICKSON, PETER. "June Jordan." In Thadius Davis and Trudier Harris, eds. *Dictionary of Literary Biography,* Vol. 38, Detroit, 1985.

FRECCERO, CARLA. "June Jordan." In Lea Baechler and A. Walton Litz, eds. *African American Writers.* New York, 1991.

BARBARA T. CHRISTIAN

Jordan, Lewis Garnet (c. June 2, 1853–March 4, 1939), minister and prohibitionist. Lewis Jordan was born a slave near the town of Meridian, Miss. Though Jordan was unsure of the exact date of his birth, he chose June 2, 1853. He claimed in his autobiography to have adopted his name from two soldiers who freed his family, and he chose his middle name from abolitionist Henry Highland GARNET.

Jordan became a Baptist preacher at an early age and attended the Baptist Institute in Nashville (later Roger Williams University), from 1875 to 1878. He thereafter became pastor of a congregation in Yazoo City, Miss. In 1881 Jordan moved to Texas, and served as minister for congregations in Waco, San Antonio, and Hearne between 1881 and 1891. During this period he became noted as a temperance lecturer and was dubbed "the Texas Cyclone." In 1888 he was a delegate to the National Prohibition Convention in Indianapolis, Ind., and remained an active prohibitionist for the remainder of his life.

In 1891 Jordan moved to Philadelphia and became pastor of the Union Baptist Church. He played an important role in increasing the visibility of Baptists in Philadelphia. In 1894 he received the nomination of the Pennsylvania Prohibition party for congressman-at-large. At a meeting of the Foreign Mission Board of the National Baptist Convention, held on February 13, 1896, he was elected as its corresponding secretary, serving in that capacity for the next twenty-six years. Under his leadership the board achieved financial stability and increased its number of foreign missionaries from seven to more than forty. Jordan visited West Africa several times as a missionary. In 1900 Baptist schools in Mississippi and Texas collaborated to confer upon Jordan the degree of doctor of divinity. In 1904 he organized delegates to attend the first World Baptist Alliance in London and the World Missionary Conference in Edinburgh in 1910.

In 1930 Jordan published one of the first important histories of African-American Baptists in the United States, *Negro Baptist History U.S.A., 1750–1930.* He also wrote various other books and pamphlets that chronicled Baptist history and his missionary work in Africa, including *Up the Ladder in Foreign Missions* (1901), *The Prince of Africa* (1911), *In Our Stead* (1913), and *Pebbles from an African Beach* (1917). His autobiography, *On Two Hemispheres,* appeared in 1937. He died in Philadelphia two years later.

REFERENCES

JORDAN, LEWIS GARNET. *On Two Hemispheres: Bits from the Life Story of Lewis G. Jordan.* Nashville, Tenn, 1937.

THORPE, EARL. *The Black Historians: A Critique.* New York, 1971.

KEVIN PARKER
SASHA THOMAS

Jordan, Louis (July 8, 1908–February 4, 1975), saxophonist and bandleader. Louis Jordan was born in Brinkley, Ark. He received early musical instruction from his father, and spent time touring with the Rabbit Foot Minstrels while he was still in high school. He also studied music at Arkansas Baptist College.

Jordan arrived in New York in 1929 and soon made his first recordings. During the 1930s, he worked with groups led by Charlie Gaines, Leroy Smith, and Chick Webb. In 1938, he left Webb and formed the group whose name would eventually become (and remain) the Tympany Five, despite there often being more than five musicians.

From the early 1940s until the early '50s, Jordan and his Tympany Five were one of the most influential and popular musical groups performing "jump blues" that did well on both the R&B and pop charts. Many of Jordan's lyrics were delivered in the "hep-cat" slang popular during his time and appealed to many African Americans living in America's urban areas. Some of his best-known hits include "Choo Choo Ch'boogie" (1946), "Let the Good Times Roll" (1946), and "Saturday Night Fish Fry" (1949). Jordan and his group also appeared in films such as *Beware* (1946) and *Reet, Petite, and Gone* (1949). Although his popularity declined in the early 1950s, he continued to work into the 1970s. He died in Los Angeles in 1975.

Interest in his life and work was revived in the early 1990s by the success of the stage revue *Five Guys Named Moe* and a host of reissued recordings.

REFERENCES

GEORGE, NELSON. *The Death of Rhythm and Blues.* New York, 1987.

TOSCHES, NICK. "The Hep Cosmogony: Louis Jordan, Forefather of Rock 'N' Roll." *Village Voice,* August 18, 1992, pp. 65, 68.

TRAVIS JACKSON

Jordan, Michael Jeffrey (February 17, 1963–), basketball player. Widely acknowledged as the most exciting player ever to pick up a basketball, Michael Jordan was born in Brooklyn, N.Y., the fourth of James and Deloris Jordan's five children and the last of their three boys. He grew up in North Carolina, first in rural Wallace and later in Wilmington.

A late bloomer in athletic terms, Jordan was released from the Laney High School varsity basketball team in his sophomore year. Even after an impressive junior season, he received only modest attention from major college basketball programs and chose to attend the University of North Carolina.

On March 29, 1982, the nineteen-year-old freshman sank the shot that gave his school a 63–62 victory

An ebullient master of the up-tempo humorous song, Louis Jordan was one of the most popular recording artists of the 1940s and a pioneer of rhythm and blues. In this photograph of Jordan and his Tympany Five from his first full-length film, *Beware* (1946), members of the group are (from left) Josh Jackson, tenor sax; Bill Davis, piano; Louis Jordan, alto sax; Jess Simpkins, bass; Aaron Izenhall, trumpet; and Eddie Byrd, drums. (Frank Driggs Collection)

over Georgetown and its first NCAA men's basketball championship in twenty-five years. Jordan followed that by winning the college Player of the Year award from the *Sporting News* in each of the next two seasons. After announcing that he would enter the NBA draft after his junior season, he capped his amateur career by captaining the U.S. men's basketball team to a gold medal at the 1984 Olympic Games in Los Angeles.

Jordan was the third pick in the 1984 NBA draft, chosen by the woeful Chicago Bulls. The six-foot-six-inch guard immediately set about reversing their fortunes and was named the NBA Rookie of the Year after leading the team in scoring, rebounding, and assists.

After sitting out most of his second season with a broken foot, Jordan put on one of the greatest individual performances in postseason history, scoring 63 points in a playoff loss to the Boston Celtics in 1986. The following season he scored 3,041 points—the most ever by a guard—and won the first of his six successive scoring titles with a 37.1 average. In 1987–1988 he became the first player ever to win the Most Valuable Player and Defensive Player of the Year awards in the same season.

Jordan's brilliance on the basketball court, however, was almost eclipsed by his success as a commercial spokesperson. Before his rookie season he signed with the Nike sneaker company to promote a signature shoe—the Air Jordan. The shoe was an instant smash, establishing Jordan as a viable spokesperson. The commercials in which he starred with filmmaker Spike LEE helped make him a pop icon as well.

Basketball purists have criticized Jordan for indulging his individual brilliance at the expense of his teammates. But he and the Bulls shook the one-man-team tag in 1990–1991 by defeating Earvin "Magic" JOHNSON and the Los Angeles Lakers in five games to win the franchise's first NBA championship. The following season, they defeated the Portland Trailblazers in six games to clinch another title, and in 1993 they again won the championship when they defeated the Phoenix Suns in six games.

Jordan was named the NBA's Most Valuable Player three times between 1988 and 1992. During that period he became the most successfully marketed player in the history of team sports, earning roughly sixteen million dollars in commercial endorsements in 1992 alone from such corporations as Nike, McDonald's, Quaker Oats (Gatorade), and General Mills (Wheaties). Even when controversy surrounded Jordan, as it did during the 1992 Olympic Games when he refused to wear a competing sponsor's uniform, or when he incurred sizable debts gambling on golf and poker, he regularly registered as one of the nation's most admired men and one of young peoples' most revered role models. Jordan's basketball career came to a sudden halt in October 1993 when he announced his retirement in a nationally televised news conference. He said a diminishing love for the game, the pressures of celebrity, and the murder of his father three months earlier contributed to his decision. In February 1994 he signed with the Chicago White Sox of the American League, hoping to work his way up through the White Sox farm system to major league baseball. Unhappy with the progress he was making, Jordan subsequently elected to drop out of the White Sox organization, and in the spring of 1995, he resumed his basketball career by returning to the Bulls.

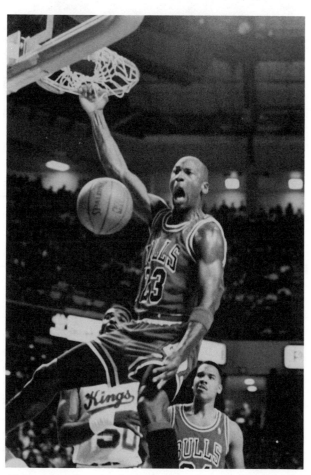

Chicago Bulls guard Michael Jordan slam-dunks the ball while forward Stacey King (right) and Sacramento Kings center Ralph Sampson (left) look on, February 1991. (AP/Wide World Photos)

REFERENCE

NAUGHTON, JIM. *Talking to the Air: The Rise of Michael Jordan.* New York, 1992.

JIM NAUGHTON

Jordan, Stanley (July 21, 1959–), jazz guitarist. Stanley Jordan began playing piano at age six and switched to guitar at eleven. He graduated in 1981 from Princeton, where he studied electronic music, theory, and composition. His self-produced first album, *Touch Sensitive* (1982), combined with frequent live appearances, brought him recognition as an unaccompanied soloist. His second album, *Magic Touch* (1985), achieved success with both jazz and pop audiences and remained on *Billboard*'s jazz charts for fifty-one weeks. His subsequent recordings have continued to be successful, featuring him both in a group context and as an unaccompanied soloist. His repertory includes jazz standards and interpretations of contemporary popular songs. Jordan is most acclaimed for his pianistic "touch technique," in which he taps the strings on the fingerboard of the guitar with four fingers of both hands, allowing him to accompany himself and, simultaneously, play solos. His unique chord voicings, not usually attainable on the guitar, are achieved by abandoning the standard guitar timing in favor of one based on fourths.

REFERENCES

MOON, TOM. "Has Stanley Jordan Lost the Magic Touch?" *Musician* 143 (September 1990): 88–94.
STEIN, STEPHANIE. "Stanley Jordan: Guitar Wizard." *Downbeat* 4, no. 11 (November 1988): 23–25.

DANIEL THOM

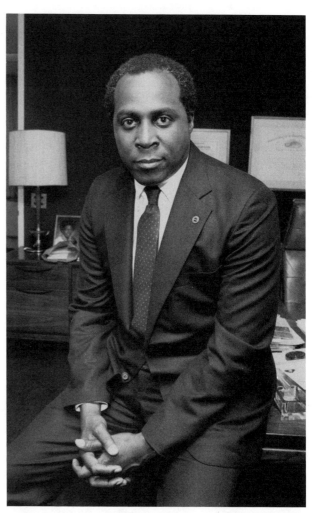

Vernon Jordan, in 1979, as president of the National Urban League, worked hard to improve the relations between African Americans and the business community. Since leaving the Urban League, as a successful Washington lawyer, he has continued to work for the same goal. In 1992 he was a leading adviser in Bill Clinton's successful campaign for the presidency. (UPI/Bettmann)

Jordan, Vernon Eulion, Jr. (August 8, 1935–), lawyer, civil rights leader. Born and raised in Atlanta, Vernon E. Jordan, Jr. lived until the age of thirteen in the University Homes Project, the first federally funded housing project in the country. He majored in political science at DePauw University in Indiana. After graduating in 1957 as the only African American in his class, Jordan attended Howard University for his law degree (1960). In 1960 his home state of Georgia admitted him to the bar and he began work as a law clerk in the office of the eminent black civil rights attorney, Donald L. Hollowell. Jordan worked with Hollowell on the landmark 1961 desegregation suit which forced the University of Georgia to admit its first black students. The Georgia branch of the NATIONAL ASSOCIATION FOR THE ADVANCEMENT OF COLORED PEOPLE hired Jordan as its field secretary from 1961 to 1963. Beginning in 1965, Jordan headed the Voter Education Project (VEP) of the Southern Regional Council, which succeeded in registering approximately two million black voters.

In 1969, Jordan was appointed a fellow of the Institute of Politics at Harvard University's Kennedy School of Government, and the next year was named Executive Director of the UNITED NEGRO COLLEGE FUND, where he continued to hone his fund-raising skills. In 1972, he became executive director of the NATIONAL URBAN LEAGUE. With monies raised from the corporate sector as well as federal grants, Jordan doubled the size of the League's operating budget and undertook programs in housing, health, education, and job training. He also inaugurated League programs in the areas of energy and the environment. In 1975, Jordan began a policy review journal, *The Urban League Review,* and the next year instituted an annual report, *The State of Black America.*

On May 29, 1980, while returning to his hotel in Fort Wayne, Ind., following a speech, Jordan was

shot in the back by a sniper. He spent more than ninety days in the hospital, but despite his near-fatal wounds, he recovered fully. In August 1982, Joseph Paul Franklin was brought to trial in federal court on charges of violating Jordan's civil rights (Indiana authorities did not file attempted murder charges). Franklin, an avowed racist, had been convicted earlier in 1982 of the murder of two black joggers, for which he was serving four consecutive life sentences, but was nevertheless acquitted of violating Jordan's civil rights.

On December 31, 1981, Jordan resigned his position at the Urban League. While Jordan claimed that he had only planned to serve for ten years, his resignation was widely seen as having been influenced by his attempted assassination. Soon thereafter, he accepted a position as partner in the powerful Washington, D.C. law firm of Akin, Gump, Strauss, Hauer & Feld. He also served on a number of corporate and foundation boards throughout the 1980s and early 1990s. His lucrative corporate and lobbying activities have been controversial among civil rights activists, who have accused him of forsaking the black struggle for personal advantage. Jordan's defenders have responded by pointing to his private lobbying of business and government, notably for the 1991 Civil Rights Act. A close advisor of President Bill Clinton, Jordan headed the president-elect's transition team in 1993, though he refused the office of U.S. attorney general.

REFERENCES

"Jordan, Vernon." *Current Biography,* August 1993, pp. 25–29.
PERTMAN, ADAM. "Vernon Jordan: No. 1 FOB on Martha's Vineyard." *The Boston Globe,* August 25, 1993, p. 53.
WILLIAMS, MARJORIE. "Clinton's Mr. Inside." *Vanity Fair* 56 (March 1993): 172–175.

PETER SCHILLING

Jordan, Wings Over. *See* Wings Over Jordan.

Joseph, Ronald (1910–1992), painter. Born on St. Kitts, Ronald Joseph lived in Dominica with his foster parents, Theophilus and Henrietta Joseph, until 1920, when they emigrated to New York. Recognized early for his artistic ability, Joseph attended special classes organized by Henry E. Fritz at Stuyvesant High School. His work was included in a student exhibition at the Metropolitan Museum of Art

in 1929. Graduating from the Fieldston School in 1929 and Pratt Institute during the depression (c. 1932), Joseph ran a printing press and operated an elevator. He spent "half my life . . . [in the art section] at the New York Public Library." Joseph was a muralist on the WORKS PROJECT ADMINISTRATION (WPA) and was influenced mainly by Goya, Da Vinci, Gris, and Chinese artists. His interest was always in "painting forms and effects rather than people," which led James Porter in 1943 to call Joseph the "foremost Negro abstractionist painter." Joseph exhibited two paintings, *Mood* and *Backstage,* in the Downtown Gallery's 1941–1942 show "American Negro Art."

After serving in the ground crew in the Army Air Corps at Tuskegee, Ala., Joseph received a Rosenwald Fellowship for the years 1945–1947, which enabled him to go to Peru. He then studied at the Grande Chaumière in Paris, on the G.I. Bill, for two years. Ronald Joseph left the United States in 1956 and moved to Brussels with his wife, Claire, where he lived until his death.

REFERENCES

GIBSON, ANN. "Interview with Ronald Joseph." Hatch-Billops Collection. *Artist and Influence 1989: The Cornucopia,* Vol. 8, pp. 58–73.
WILSON, LOUISA. "Negro Boy's Ability to Portray Action in Art Amazes Critics." *New York World,* June 9, 1929.

BETTY KAPLAN GUBERT

Journalism. Faced with the challenge of seeking just treatment in a society that systematically restricted the lives of freed blacks as well as slaves, African Americans began publishing their own periodicals long before the Civil War, using words as weapons in their protracted struggle for equality. The crusading editors of early black newspapers constituted an intellectual vanguard with a five-pronged mission: (1) to define the identity of a people who had been stripped of their own culture in a hostile environment; (2) to create a sense of unity by establishing a network of communication among literate blacks and their white supporters throughout the country; (3) to examine issues from a black perspective; (4) to chronicle black achievements that were ignored by the American mainstream; and (5) to further the cause of black liberation.

These objectives, set forth by founders of one of the oldest black institutions in the United States, underscored the activities of African-American journalists for nearly 150 years. When blacks began to

move into the mainstream during the latter part of the twentieth century, assuming positions on general-circulation newspapers and in the broadcast media, most still retained a sense of being somehow involved with a larger racial cause. Yet these modern practitioners often were torn by conflicting loyalties: Were they blacks first or journalists first? Should they strive for respect in the mainstream by avoiding stories dealing with black topics, or fill in the gaps of coverage that might be left by white reporters? Should they follow the journalistic rule that calls for objectivity and report even events that might be damaging to blacks, or be ever mindful of the effects their stories might have on attitudes toward African Americans? It was a measure of social change that no such questions would have entered the minds of their predecessors.

Origins

The first African-American newspaper, FREEDOM'S JOURNAL, was founded in New York City on March 16, 1827, in response to the persistent attacks on blacks by a proslavery white paper, the New York *Enquirer*. The purpose of this pioneering publication was to encourage enlightenment and to enable blacks in the various states to exchange ideas. Thus it provided a forum for debate on issues that swirled around the institution of slavery. Among these was the question of whether blacks should strive for full citizenship and assimilation in America—a view favored by most blacks at that time—or whether they should follow a course of separation and opt for resettlement in Africa, a position then held mostly by whites who saw this as a way to rid the country of troublesome free blacks.

The two founding editors of *Freedom's Journal* were accomplished freemen who stood on opposite sides of the colonization question. Samuel E. CORNISH, an ordained minister who had organized the first African Presbyterian church in the United States, thought blacks should fight for integration in America, while the Jamaican-born John B. RUSSWURM, who was the nation's second black college graduate (from Bowdoin College), supported repatriation in a part of West Africa that became Liberia. However, they were united in their opposition to slavery and stood as one in their appetite for discussion. They set forth their mission clearly in the first issue of *Freedom's Journal*, stating: "We wish to plead our own cause. Too long have others spoken for us. . . . From the press and the pulpit we have suffered much by being incorrectly represented."

Six months later, when their differences over the colonization issue proved insurmountable, Cornish left. Russwurm continued publishing the paper until March 28, 1829. He then settled in Liberia, where he

John B. Russwurm, along with Samuel Cornish, founded the first black newspaper in the United States, *Freedom's Journal,* in New York City in 1827. (Photographs and Prints Division, Schomburg Center for Research in Black Culture, The New York Public Library, Astor, Lenox and Tilden Foundations)

remained until his death in 1851. There he worked as a school administrator, government official, and editor of a newspaper called the *Liberia Herald*.

Two months after Russwurm's departure, Cornish resurrected *Freedom's Journal,* on May 29, 1829, changing its name to *The Rights of All* and infusing it with a more militant tone; publication was suspended on October 9 of the same year. Cornish remained active in both the antislavery and black convention movements, but returned to journalism in 1837, serving as editor of Philip A. BELL's newspaper, the WEEKLY ADVOCATE. Two months after its debut, the paper was renamed the *Colored American;* it was published until 1842. Although the paper was based in New York, there is evidence that a Philadelphia edition also was produced, making it possibly the first African-American publication to serve more than one city with different editions. Scholars of the early black press have noted the quality and originality of the

Colored American, which was uncompromising in its call for black unity and full citizenship rights for all.

After the first steps were taken, others began using journalism to establish communication links in a largely illiterate nation and to generate support in the struggle against slavery. While most of these newspapers were based in New York, the *Alienated American* was launched in Cleveland on April 9, 1853. Martin R. DELANY, the first black graduate of Harvard, published his own newspaper, *Mystery,* in Pittsburgh before he became assistant editor of Frederick DOUGLASS's *North Star.* Other outstanding early publications were Stephen Myer's *Elevator* (Albany, 1842), Thomas Hamilton's *Anglo-African* (New York, 1843), and William Wells BROWN's *Rising Sun* (New York, 1847).

The first black newspaper to be published in the South before the Civil War was the *Daily Creole,* which surfaced in New Orleans in 1856 but bowed to white pressure in assuming an anti-abolitionist stance. It was followed, near the end of the Civil War, by the *New Orleans Tribune,* which appeared in July 1864 and is considered the first daily black newspaper. Published three times a week in both English and French, it was an official organ of Louisiana's Republican party, then the nation's progressive political wing. The *Tribune* called for bold measures to redress the grievances of bondage, including universal suffrage and payment of weekly wages to ex-slaves.

Most of these newspapers depended on the personal resources of their publishers along with contributions from white sympathizers to supplement their meager income from subscriptions, but prosperous blacks also lent their support. A notable "angel" of the period was James FORTEN, a Philadelphia veteran of the American Revolution who had amassed a fortune as a sail manufacturer. Forten was a major backer of William Lloyd GARRISON, a white journalist who became one of the leading voices in the abolitionist movement through his newspaper the LIBERATOR, first published on January 1, 1831.

Of the forty or so black newspapers published before the Civil War, the most influential was the *North Star,* founded and edited by Frederick Douglass in Rochester, New York, beginning on November 1, 1847. The name was that of the most brilliant star in the night sky, Polaris, a reference point for escaping slaves as they picked their way northward to freedom. Since Douglass is a figure of major historical importance he is not regarded primarily as a journalist, but he, like the black leaders who would follow him, knew how to use the press as a weapon. In the prospectus announcing his new publication, he wrote: "The object of the *North Star* will be to attack slavery in all its forms and aspects; advocate Universal Emancipation; exact the standard of public morality; promote the moral and intellectual improvement of the colored people; and to hasten the day of freedom to our three million enslaved fellow countrymen." Thus he defined the thrust of the early black press.

A Period of Transition

The number of black newspapers increased dramatically after the end of the Civil War in 1865, as the newly emancipated struggled to survive with no resources and few guaranteed rights. Publications sprang up in states where none had previously existed. Armistead S. Pride, the leading scholar on the black press, determined in the mid–twentieth century that African Americans had published 575 newspapers or periodicals by 1890, the end of the Reconstruction period. Although most were short-lived and many were religious or political publications rather than regular newspapers, some survived—notably the *Philadelphia Tribune,* which was founded in 1884 and continues to be published. It is considered the oldest continuously produced black newspaper in

Philip A. Bell was an important newspaper publisher and editor on both the East and West coasts. He co-founded *The Colored American,* the second African-American newspaper in the United States, in New York City in 1837. (*Pittsburgh Courier* Photographic Archives)

the United States. This period also marks the beginning of the AFRO-AMERICAN, which originated as a four-page Baptist church publication in Baltimore on August 13, 1892. After several metamorphoses, it became the highly respected anchor of a nationally distributed newspaper chain.

This heightened journalistic activity was due to many factors, among them an increase in literacy and greater mobility on the part of blacks, though their position in society as a whole was hardly satisfactory. When federal troops were withdrawn from the South in 1877 as a matter of political expediency, African Americans were left to the mercy of bitter whites who had fought to deny them freedom. Slavery was replaced by the economic bondage of sharecropping. White dominance was sustained through a system of rigidly enforced segregation and terrorism, including lynching, or the random torture and hanging of blacks. When southern blacks fled to northern cities in the first wave of black migration, they found themselves entrapped in squalid ghettos with few opportunities for work except in the most menial of jobs. For these reasons, the black press was still fueled by the spirit of protest, but that spark often had to be carefully veiled.

The pattern for race relations in America had been set in 1895 when Booker T. WASHINGTON, a former slave who had founded Tuskegee Institute, a school providing vocational education for blacks, went before the Cotton States' Exposition in Atlanta and proclaimed that it was folly for blacks to seek equal rights: they should pull themselves up by their own bootstraps and make the best of things as they were,

getting along with whites by being patient, hardworking, subservient, and unresentful. In one of the most infamous metaphors of American history, Washington raised his hand and declared, "In all things that are purely social, we can be as separate as the fingers, yet one as the hand in all things essential to mutual progress." Such rhetoric, calling for a separate but not necessarily equal society, condoned the conservative mood of the era. Ordained by whites to speak for blacks, due to his "Atlanta compromise," Washington came to wield extraordinary power. It extended to the press, as black publishers struggled to keep their papers alive. Most had a small subscription base and advertising was hard to come by; therefore, they were inordinately dependent on contributions. Washington's critics said that he exercised undue influence over the black press by controlling loans, advertisements, and political subsidies, making certain that his doctrine prevailed.

The journalist most commonly associated with Washington is T. Thomas FORTUNE, who was editor of the *New York Age* during a period when Washington controlled it financially and used the paper as a conduit for presentation of his views, though Fortune did not share them. But Fortune had an identity in his own right. Respected as an accomplished and aggressive writer with a sharply satiric style, he stood out as a true professional. He had learned the business by working as a typesetter and later became one of the first of his race to hold an editorial position on a white daily, writing for the New York *Sun* and the *Evening Sun,* leading turn-of-the-century newspapers. Before assuming control of the *Age,* Fortune

Founded by T. Thomas Fortune in 1887, the *New York Age* was one of the leading black newspapers in New York City during the first half of the twentieth century. (Photographs and Prints Division, Schomburg Center for Research in Black Culture, The New York Public Library, Astor, Lenox and Tilden Foundations)

had published two newspapers of his own, the *Globe* and the *Freeman,* which were considered the best of their type. The *Age* had grown out of a tabloid called the *Rumor,* established in 1890.

Firmly committed to the struggle for racial equality, Fortune was an activist and organizer who used the *Age* to promulgate his own ideas. He extolled black pride before the turn of the century, urging that the term *Afro-American* be used instead of *negro,* then usually spelled with a lowercase *n.* Disdaining political patronage and declaring himself an independent, he was unable to attract the political advertising that was the main source of income for black newspapers. As a result, Fortune relied increasingly on contributions from Booker T. Washington, who eventually purchased the *Age.* Obligated to write editorials espousing Washington's accommodationist views, Fortune responded by presenting his own beliefs in opposing editorials in the same edition. Researchers credit Fortune with having written or edited all of Washington's books and many of his speeches, but Washington never acknowledged him. Torn by the compromises he was forced to make, Fortune succumbed to mental illness and poverty during the latter part of his career, but he has been called the dean of black journalism.

A few intrepid journalists refused to accept a state of such uneasy compromise. One stood out from all others. While several women contributed to journalism during the formative years of the black press, Ida B. WELLS transcended gender by risking her life to expose racially motivated crimes. She taught in rural schools before migrating to Shelby County, Tennessee, where she began writing for a black newspaper called the *Living War* under the name "Iola." As a teacher in Memphis, she was fired for writing exposés about injustices in the education system. Turning to journalism on a full-time basis, she became part-owner and editor of the *Memphis Free Speech.* In May 1892, when three black Memphis businessmen were lynched after a white mob attacked their grocery store, Wells charged in her paper that the murders had been instigated by the white business community. She called for a boycott of those white businesses and urged blacks to migrate to the new Oklahoma territory, where they might find freedom from oppression. She also wrote that she had purchased a pistol and would use it to defend herself. In her last column for that paper, Wells said that the white women who accused black men of rape often were their lovers.

When Wells left town to attend a convention in Philadelphia, her newspaper office was destroyed and the building burned. Relocating to New York, she continued her crusade in Fortune's *New York Age,* of which she became a part-owner. Lecturing through-

Ida B. Wells, also known as "Queen Ida." (Photographs and Prints Division, Schomburg Center for Research in Black Culture, The New York Public Library, Astor, Lenox and Tilden Foundations)

out the United States and abroad, she later published documentation of lynchings in *Redbook* magazine and helped found the Negro women's club movement. One of the most outspoken black journalists of all time, Ida B. Wells became the only woman of her profession to be commemorated by the issuance of a stamp in 1990 as part of the U.S. Postal Service's Black Heritage series.

As some blacks continued to resist Booker T. Washington's accommodationist doctrine, a militant tone was set for the twentieth century when William Monroe TROTTER founded the Boston *Guardian* in 1901 with George Forbes. Both had graduated from college in 1895, Trotter from Harvard and Forbes from Amherst. Trotter quickly became the dominant force on the paper. The product of an interracial marriage, he had grown up comfortably in a Boston suburb. At Harvard, he had become the first African American inducted into the honor society Phi Beta Kappa and went on to earn his M.A. degree there in 1896. Unwilling to accept any sort of compromise,

he demanded absolute equality for blacks and used his paper to consolidate the first organized opposition to Washington and his ideas. Trotter joined with another son of Massachusetts, W. E. B. DU BOIS—who is considered by many to be the greatest intellectual produced by black America—in laying groundwork for the NIAGARA MOVEMENT, the forerunner of the NATIONAL ASSOCIATION FOR THE ADVANCEMENT OF COLORED PEOPLE (NAACP). Trotter then disdained the NAACP for being too little, too late, and too white. He carried the fight for black rights to the international arena, going before the League of Nations and the World Peace Conference in Paris, to no avail. Disillusioned and ill, Trotter either jumped or fell to his death from the roof of his Boston home in 1934, when he was sixty-two years old. But he had sounded a defiant note that set the tone for further development of the black press throughout the twentieth century.

Early black newspapers bore little resemblance to their modern counterparts. From the beginning, they had not been intended as instruments of mass communication. They were aimed at a small educated elite and emphasized commentary over news coverage. Editors exchanged copies of their publications by mail and engaged in debates over issues, with the responses appearing in their next editions. It was assumed that subscribers also read white publications and thus were informed on major national events. Yet these papers filled a void by interpreting the news from a black perspective and noting developments of particular interest to African Americans, providing information that was not available elsewhere. This included local coverage of religious and social events, a mainstay of black newspapers.

Growth and Power

The modern black press did not come into being until 1905, when Robert S. ABBOTT founded the CHICAGO DEFENDER, the first African-American newspaper designed to appeal to the masses and, consequently, the first commercially successful black journalistic enterprise. Although Abbott's sole objective was to improve the plight of blacks in America, he realized that he would have to communicate with the common people if he were to help them. In this respect, Abbott followed the imperatives that have shaped the daily newspapers of the twentieth century, when it has been assumed that a publication first must capture the attention of the largest number of potential readers by playing up stories that generate immediate interest. Abbott took particular note of the practices of William Randolph Hearst, who had built the largest journalistic empire of the early twentieth century by engaging in sensationalism to boost sales. But in spite of the screaming red headlines and excited tone that came to mark the *Defender's* style, the paper, at its core, held to the same precepts that have informed black journalism since its inception.

A small, very black man who suffered the indignities imposed on those of his color during a period when dark skin was considered a major social liability even among African Americans, Abbott was a Georgian who settled in Chicago, where he decided to publish his own newspaper, although three other black papers already were being distributed there. According to Roi Ottley, Abbott's biographer, the publisher started out in a rented room with nothing but a card table, a borrowed chair, and twenty-five cents in capital, intent on producing his newspaper. Abbott, who had a law degree, called it the *Defender* because he intended to fight for the rights of black people. At that time, the black population of Chicago was concentrated in so few blocks on the South Side that Abbott could gather the news, sell advertising, and distribute his newspaper on foot by himself. That was a situation he was to change with his paper.

At first, Abbott avoided politics and other contentious topics, featuring neighborhood news and personals, but he hit his stride when he began to concentrate on muckraking, publishing exposés of prostitution and other criminal activities in the black community. Adopting the scarlet headlines favored by his white counterparts, Abbott developed a publication so popular that copies were posted in churches and barbershops where blacks congregated, so that the latest stories could be read aloud.

One of the factors that contributed to Abbott's early success was increasing literacy among blacks. By 1910, seven out of ten blacks over the age of ten could read and Chicago's black population had grown to 44,103, though still concentrated in a small area. In 1910 Abbott hired his first paid employee, J. Hockley Smiley, an editor who moved the paper more decidedly toward sensationalism and encouraged the publisher to press for national circulation. White distributors refused to carry black newspapers, but Chicago was a major railroad center, so Smiley suggested that railroad porters and waiters be used to carry bundles of papers to their destinations, smuggling them into the South, where they could be turned over to local black agents. In turn, the railroad workers brought back news, enabling the *Defender* to become the first black publication with a truly national scope. To shore up this thrust, Abbott employed Roscoe Conkling Simmons, a leading orator, to tour the country, promoting the paper. Since the stance of the *Defender* was militant, with detailed accounts of injustices committed against blacks, participants in this underground distribution system courted danger. Two agents were killed and others

were driven from their homes because of their involvement with the *Defender*. Yet Abbott did not back down, engaging the redoubtable Ida B. Wells to report on riots, lynchings, and other racial wrongs.

Abbott found his place in history in 1917, during World War I, when he began to publish front-page stories with blazing headlines urging southern blacks to migrate to the North, where they could escape from the indignities of Dixie and acquire higher-paying jobs in industry. The paper offered group railroad rates to migrants and encouraged them to seek personal advice on how to adjust to the big city by following the *Defender*'s regular features. Scholars credit the *Defender* with being a major force in stimulating the tide of northern migration after the war, when blacks realized that the rights U.S. soldiers had fought for abroad were not being extended to them at home. More than 300,000 African Americans migrated to the great industrial cities of the North between 1916 and 1918, with 110,000 moving to Chicago alone, tripling the city's black population.

By 1920, the *Defender* claimed its peak circulation of 283,571, with an additional high pass-along rate. Unlike those struggling earlier black publishers, Abbott became a millionaire, moving into his own fully

World War I correspondent bound for the front. (Photographs and Prints Division, Schomburg Center for Research in Black Culture, The New York Public Library, Astor, Lenox and Tilden Foundations)

paid-for half-million-dollar plant on Chicago's South Side. With a broad-based national circulation, the *Defender* offered hope and inspiration to poor southern blacks like the young Johnny Johnson, who read the paper as a youth in his native Arkansas during the early 1930s and soon moved north with his family to Chicago, where he would build his own publishing empire (*see* John H. JOHNSON). Though the paper eventually declined in popularity, due to its failure to keep up with the growing sophistication of blacks, it is still being published. When Abbott died in 1940, one of his nephews, John H. Sengstacke, assumed leadership. In 1956, he converted the *Defender* into a daily; it appeared four times a week with an additional weekend edition.

While Abbott carved out his empire from Chicago, publishers in other parts of the country also built journalistic enterprises that cumulatively developed into one of the most powerful institutions in black America.

At least a dozen black newspapers had come and gone in Pittsburgh by 1910, when the lawyer Robert L. VANN drew up incorporation papers for the PITTSBURGH COURIER, a publication he edited and eventually came to own. Born impoverished in 1879 in Ahoskie, N.C., Vann struggled for years to acquire an education, finally earning both baccalaureate and law degrees from the Western University of Pennsylvania, later renamed the University of Pittsburgh. A relatively small man, like Abbott, he was encouraged by friends to pass for an East Indian because he had straight hair and keen features, but Vann remained staunchly black. Though the *Courier* managed to survive, it did not gain much momentum until 1914, when Ira F. Lewis joined the staff as a sportswriter. He turned out to be a gifted salesman who built advertising and circulation, going on to become business manager of the paper and transforming it into a national institution.

In its editorial tone, the *Pittsburgh Courier* tended to be somewhat less sensational than the *Defender*, commanding attention with its distinctive peach-colored cover page. In front-page editorials, Vann led his crusades, demanding that the huge industrial firms hire African Americans as well as the European immigrants who were surging into the labor market, and criticizing unions for denying blacks membership. He called for better education and housing for blacks and urged them to boycott movie houses and stores that overcharged them or treated them disrespectfully.

A local publication during its early years, the *Courier* began to make national inroads during the 1920s, when Vann improved its quality by retaining some of the most talented black journalists of the period. George S. SCHUYLER, a figure of the HARLEM REN-

AISSANCE who was called the black H. L. Mencken due to his bitingly satiric prose, began contributing a weekly column and became chief editorial writer, a position he held for several decades. Schuyler also toured the nation to produce extensive series on the socioeconomic status of black America.

Vann sent Joel A. ROGERS, a self-taught historian, to Europe and Africa, where he documented black contributions to Western civilization. Rogers later produced a column called "Your History" and collaborated with an artist on a weekly illustrated feature that stimulated pride among blacks, who had been denied evidence of prior achievements by their race. When Italy invaded Ethiopia in 1935, Rogers became one of the first black war correspondents by covering the conflict from the front. His colorful dispatches captured the attention of African Americans throughout the United States, and this boosted circulation.

Sparkling entertainment and social news were staples, but the *Courier*'s forte was its sports coverage. Excellent reportage was provided by W. Rollo Wilson, William G. Nunn, Sr., Wendell SMITH, and Chester "Ches" Washington, a championship speed typist who went on in the 1970s to become the successful publisher of a chain of newspapers in California. The *Courier* secured its national stature during the 1930s by recognizing the potential of a young pugilist named Joe LOUIS and maintaining a virtual monopoly on coverage of his activities until long after Louis had become the most popular heavyweight champion in history. As a result, circulation reached 250,000 by 1937, according to figures of the Audit Bureau of Circulation, and the *Courier* supplanted the *Defender* as the nation's leading black weekly.

It was a role of the nation's top black newspapers to bridge the gap separating artists and intellectuals from the masses. The *Defender* published the early poems of the Chicagoan Gwendolyn BROOKS, who would become the first African American to win a Pulitzer Prize, and employed Willard MOTLEY as a youth editor long before he became a bestselling novelist. The poet and humorist Langston HUGHES introduced his character Jesse B. Semple (Simple) in its pages. Similarly, the *Courier* featured commentary and reviews by James Weldon JOHNSON, while W. E. B. Du Bois wrote a column for the paper after he stepped down as editor of the *Crisis*, the official magazine of the NAACP.

Unlike Abbott, who relished his ties to the man in the street and especially fellow migrants from the South, Vann was an aloof, politically driven man who used his paper to promote his own career as a lawyer and to seek control of black patronage. He is perhaps best known for his defection from the Republican party, which had claimed the loyalties of

Cover from *The Messenger* dated December 1921. (Photographs and Prints Division, Schomburg Center for Research in Black Culture, The New York Public Library, Astor, Lenox and Tilden Foundations)

black voters since the time of Abraham Lincoln. Democrats were strongly identified with their party's southern segregationist faction. By 1932, the country was in the throes of an economic depression and the yet untried Franklin D. Roosevelt was the Democratic presidential candidate. Vann, who thought that the Republicans had taken the black vote for granted for too long without responding to the needs of that constituency, delivered a speech that projected him to national prominence. Calling for the black vote to remain "liquid" rather than allied to a single party, he said, "I see millions of Negroes turning the picture of Lincoln to the wall." The line became a catchphrase in the successful Democratic campaign to get black votes and win the election.

As a result, Vann was given a position as a special assistant to the attorney general, but he found only disillusionment in Washington, where he was generally ignored. As patterns of patronage shifted toward a younger group of blacks, Vann switched back to the Republican party, failing to take the black vote

with him. He died in 1940, seven months after Robert S. Abbott. Yet he had established so firm a foundation for the *Courier* that it retained its popularity for several more years under the management of Ira Lewis, with the publisher's widow, Jesse L. Vann, at the helm. Under editors P. L. Prattis and William G. Nunn, Sr., the crusades continued, with calls for integration of the armed forces during World War II and a "double V" campaign for victory abroad and against discrimination at home. In 1946 the *Courier* published fourteen editions, including local and national editions, with branch offices in twelve cities, and was the most popular black publication even in several cities with their own black newspapers. It attained a circulation of 357,212 in May 1947, a record for audited black newspapers.

Some of the paper's crusades had tangible results. *Courier* sportswriter Wendell Smith, who had been using his column to press for integration of major-league baseball since the 1920s, served as the liaison between Jackie ROBINSON and Branch Rickey, general manager of the Brooklyn Dodgers, resulting in Robinson's joining that team in 1947.

After the death of Ira Lewis in 1948, the *Courier* lapsed into a general decline, due to mismanagement and numerous other factors that affected the black press in the 1950s and '60s. On the brink of financial collapse in 1965, it was purchased by John Sengstacke, owner of the *Defender* chain. Thus the similar but separate missions of Robert S. Abbott and Robert L. Vann converged in a final irony. Continuing publication as the *New Pittsburgh Courier,* the paper was but a shadow of its old self. Sengstacke Publications, which included the *Courier* and other acquisitions, became the largest African-American newspaper chain in the country as the black press struggled for its very survival.

The third member of what could be called a triumvirate of great black national newspapers was the *Afro-American,* which evolved from its beginnings as a Baltimore church publication to become one of the most widely circulated black newspapers in the South and East, with branch offices in Washington, Philadelphia, Richmond, and Newark, N.J. Its founder was John H. Murphy, Sr., a former slave and a whitewasher by trade, who created it by merging his own Sunday-school sheet with two similar church publications, and going on to expand its coverage to include issues and events of interest to the general black population.

When Murphy died in 1922, his five sons took over the operation, with one of them, Carl MURPHY, assuming control. Under his leadership, the *Afro-American* grew into a national publication with multiple editions that emphasized solid reportage and took moderate editorial positions. It became the dominant black publication in the Washington-Baltimore-Richmond triangle, focusing on political matters in a part of the country with a heavy concentration of African Americans. Though firmly pa-

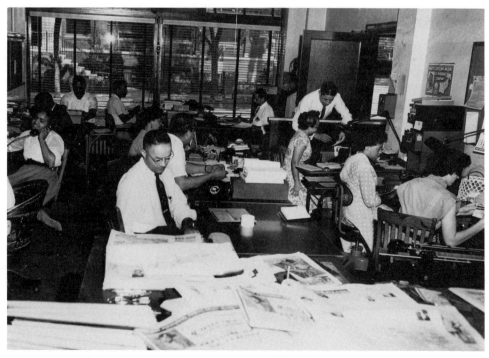

Newsroom of the *Pittsburgh Courier* around 1950. (Tennie Harris/*Pittsburgh Courier* Photographic Archives)

triotic in most of its views, the *Afro,* as it was known, demonstrated courage by standing up for the singer/actor Paul ROBESON and the scholar/editor W. E. B. Du Bois when both were accused of being Communists during the McCarthy era. The publisher also ignored official pressure and sent the journalist William Worthy to Communist China on assignment after the U.S. State Department had denied him a visa. From 1961 through the 1980s, the founder's grandson, John Murphy III, played a major role in the paper's fortunes, especially after the death of Carl Murphy in 1967. Over the years, successive generations of Murphys have stepped forward to assume leadership.

While these were the titans in the era of the popular black press, other newspapers distinguished themselves by serving the needs of their own urban communities. The AMSTERDAM NEWS was established in 1909 in New York City when James H. Anderson began publishing a local sheet with $10 and a dream, giving it the name of the street on which he lived. It gained prominence and commercial success after 1936, when it was purchased by two Harlem physicians, one of whom, C. B. Powell, assumed control and developed the paper to the point where it had a circulation of more than 100,000 after World War II. The Norfolk *Journal and Guide* achieved a high level of respectability after 1910, when P. B. Young, a twenty-six-year-old North Carolinian, purchased its original entity, a fraternal organ, and transformed it into a general-circulation black newspaper. Avoiding sensationalism and maintaining a relatively conservative stance, the *Journal and Guide* was singled out for praise by mainstream scholars of the press, who considered it the most objective of black newspapers. Yet it responded readily to the needs of its readers, launching campaigns that resulted in better housing for black residents and pay scales for black teachers that equaled those of whites. W. O. Walker built the Cleveland *Call and Post* into a "bread-and-butter" paper that focused firmly on local news, while the Scott family, beginning in 1932, built the *Atlanta Daily World* into the nation's oldest black daily, one of only three that survived into the 1990s. Across the nation, from the early to mid-twentieth century, it was difficult to find a major city that was not served by a black newspaper.

The reasons for their existence were obvious. Until the late 1950s, African Americans were mostly ignored by mainstream publications, and when they did appear it was as perpetrators of crimes. If news of interest to the black population was included at all, it was in tiny, segregated columns dubbed "Afro-American," or some similar name, placed inconspicuously in back pages. Even reportage on African-American sports or entertainment figures was designed to reinforce prevailing stereotypes. Thus the black press served the palpable needs of a neglected and maligned people. Editors of black newspapers said that they hoped to change society to such an extent that they would put themselves out of business. But when this change began to take place, they were not prepared to cope with the consequences.

The Tides of Change

When the struggle for racial equality blossomed into the modern CIVIL RIGHTS MOVEMENT, beginning with the Montgomery, Ala., bus boycott in 1955, mainstream publications took steps toward covering events in which African Americans were the major players. As the movement spread from Montgomery to Birmingham to Little Rock and beyond, white newspaper editors began to realize that they were witnessing one of the biggest stories of the century. Furthermore, they were being challenged, for the first time, by television, a news medium that could provide more immediate coverage, enhanced by dramatic visual images that captured the action as it happened. This was most forcefully demonstrated on August 28, 1963, when television provided extended live coverage of the historic MARCH ON WASHINGTON and the Rev. Dr. Martin Luther KING, Jr.'s "I Have a Dream" speech. Since each day brought new developments, most black newspapers, limited to weekly publication, were unable to compete. Furthermore, few of them possessed or were willing to commit the resources that would have enabled them to deploy correspondents to the various hot spots throughout the country. Reporters who worked for the black press during that time recalled their frustration at having to cover the movement by telephone or by rewriting accounts that appeared in the leading white-owned papers.

Although the coverage provided by mainstream print and broadcast media was from a white perspective, inroads were made into a territory that had been the exclusive property of the black press. Yet black journalists were rarely employed by the white media. Even in New York City, the nation's media capital, no African Americans held full-time jobs on white newspapers until Lester A. Walton was hired by the *World* in the 1920s. No further advances were made until the late 1940s, when three veterans of the black press were hired by New York daily papers: George Streator by the *Times,* Edgar T. Rozeau by the *Herald Tribune,* and Ted Poston by the *Post.* In 1955, a year after the Supreme Court school-desegregation decision, *Ebony* magazine found only thirty-one blacks working on white newspapers throughout the country. Black journalists were so rare in the developing medium of TELEVISION that they were not even counted before 1962, when Mal Goode, a radio news-

caster and former advertising salesman for the *Pittsburgh Courier,* was hired by ABC to become the first network correspondent of his race.

No major changes were to occur until the late 1960s, when the nation's black communities went up in flames, from Watts in Los Angeles to Harlem in New York. The 1968 *Report of the National Advisory Commission on Civil Disorders,* better known as the Kerner Commission Report, analyzed the causes of those upheavals. In a section implicating the media, the report said:

> They have not communicated to the majority of their audience—which is white—a sense of the degradation, misery, and hopelessness of living in the ghetto. They have not communicated to whites a feeling for the difficulties and frustrations of being a Negro in the United States. They have not shown understanding or appreciation of—and thus have not communicated—a sense of Negro culture, thought or history.
>
> Equally important, most newspaper articles and most television programming ignored the fact that an appreciable part of their audience was black. The world that television and newspapers offered to their black audience was almost totally white, in both appearances and attitude. As we have said, our evidence shows that the so-called "white press" is at best mistrusted and at worst held in contempt by many black Americans. Far too often, the press acts and talks about Negroes as if Negroes do not read the newspapers or watch television, give birth, marry, die and go to PTA meetings.

The riots, as they were transpiring, had driven home a message to white news managers, who realized that their reporters were ill-equipped to enter the alien world of black neighborhoods and to gain the confidence of residents to the point where they might discover what was really going on. As the flames of rage spread from the ghettos to central commercial areas, some realized that the destiny of white America was irrevocably linked to that of black America. As a result, some black reporters were hired literally in the heat of the moment. With the strong indictment of the Kerner Commission finding its mark, black reporters were recruited by the mainstream for the first time, most commonly from the black press. By the mid-1970s, nearly a hundred African-American journalists were employed by mainstream publications.

Another response to the report was the development of training programs to increase the limited supply of black journalists. The largest of these was a concentrated summer program established at Columbia University in 1968 through a $250,000 grant from the Ford Foundation. Directed by Fred Friendly,

former head of CBS News and a professor at Columbia's Graduate School of Journalism, the program trained members of various minority groups, then placed from twenty to forty of them each year in both print and broadcast jobs. When one of its black graduates, Michele Clark, died in an airplane crash after working her way up to become co-anchor of the *CBS Morning News,* the minority-training program was renamed in her honor. In 1974, after substantial increases in the number of African Americans earning degrees from journalism schools, including Columbia's, this program was discontinued. The following year, it was revived through the efforts of Earl Caldwell, a leading African-American journalist and columnist for the New York *Daily News.* Relocated to the University of California at Berkeley and operated by the Institute for Journalism Education (IJE), the program continued to train and place members of minorities on mainstream newspapers into the early 1990s. Under the guidance of nationally known African-American journalists, among them Nancy Hicks, Robert Maynard, and Dorothy Gilliam, the IJE broadened its scope to include programs in editing and management training, designed to facilitate movement of black journalists into the upper echelons of the print media.

All of these changes had a devastating effect on black newspapers. Their circulations plummeted as television and mainstream newspapers encroached on their readership by providing more immediate, though often superficial and insensitive, coverage of major events affecting the African-American community. By 1977 the audited circulation of the *Chicago Defender* had shrunk to 34,000 daily and 38,000 for the weekend edition; the *New Pittsburgh Courier* dipped to 30,000 weekly; the Baltimore *Afro-American* averaged 34,000 for two weekday editions and 18,500 for a weekend national edition. A few publications fared somewhat better, but others teetered on the brink of bankruptcy or had disappeared altogether. While more than 300 black newspapers were being published in the early 1960s, only 170 remained by the late 1980s. Their overall quality also declined as most of the top talent defected to the mainstream, where the rewards included salaries that were several times larger, far better benefits, and greater prestige. Television offered not only large salaries, but high visibility and glamour, a heady kind of stardom. After 1970, few aspiring journalists entered the field with the intention of working for the black press.

Exceptions to this grim pattern were two radical newspapers that surfaced during the 1960s in the furor of the Black Revolution. *Muhammad Speaks,* the official organ of the NATION OF ISLAM, otherwise known as the Black Muslims, stemmed from a col-

umn called "Mr. Muhammad Speaks" that its leader, Elijah MUHAMMAD, had written for the *Pittsburgh Courier* during the 1950s. When Christian ministers, valuable links in the black press circulation chain, objected to Muhammad's anti-Christian rhetoric, the column was discontinued. Since Muslim followers had employed aggressive tactics to sell the paper on the streets, they took with them a huge chunk of the paper's circulation. The column resurfaced in the *Amsterdam News* during the 1960s, when MALCOLM X was galvanizing the black masses not only in Harlem but throughout the nation. By the early 1970s, the Black Muslims were publishing a popular weekly newspaper of their own called *Muhammad Speaks,* producing it in Chicago, where a staff of experienced journalists (who were not necessarily Muslims) worked out of a well-equipped plant. Featuring African-American news with a militant slant, along with dogma, and distributed through the same street-selling techniques, *Muhammad Speaks* achieved an un-audited weekly circulation of 400,000 to 600,000, an all-time record for a black newspaper. Circulation dropped sharply after the assassination of Malcolm X, the death of Elijah Muhammad, power struggles within the Muslim sect, and a general shift away from overt militance in the African-American population, but the paper continued publication under other names, including the *Bilalian News* and later the *Final Call,* in the late 1980s and early 1990s.

A shorter-lived but significant effort was the *Black Panther,* which achieved an unaudited circulation of 100,000 during the 1970s, when it was edited by Eldridge CLEAVER, author of the autobiographical militant manifesto *Soul on Ice.* Politically radical in its tone, condemning police brutality at home and America's foreign policy abroad, the paper ceased publication after the credibility of Panther leaders was undermined.

While the movement toward integration all but obliterated the power previously held by black newspapers, one genre of African-American publications flourished. These were the black magazines that had been conceived as commercial enterprises rather than instruments of protest. They were better able to adjust to the demands of an increasingly competitive marketplace.

Black Magazines and John H. Johnson

Early black newspapers so resembled magazines in tone and content that differentiation between the two often was based primarily on frequency of publication. The first black magazines seem to have been subsidized organs that originated in the black church during the early 1840s. The first general-circulation magazine owned independently by African Americans and directed to them was the *Mirror of Liberty,*

published by David RUGGLES, a New Yorker who was a key figure in the Underground Railroad. Forwarding the cause of abolition, it was published from 1847 to 1849. Other magazines followed. Frederick Douglass, after publishing a series of newspapers, lent his name to an abolitionist magazine, *Douglass' Monthly,* that was aimed primarily at British readers and was issued from 1860 to 1862. A forerunner of popular modern periodicals was *Alexander's Magazine,* a national publication produced in Boston from 1905 to 1909. It emphasized the positive aspects of African-American life, featuring stories about outstanding individuals with commentary on cultural, educational, and political events.

The first African-American magazine to have a lasting impact was the CRISIS, which was the brainchild of W. E. B. Du Bois. It first appeared in 1910, a year that resonates with significance due to the number of African-American organizations, institutions, and publications spawned at that time. Du Bois, who was one of the original incorporators of the NAACP, assumed the position of director of publications and research for that organization after several previous excursions into journalism. He used the *Crisis*—which remains the official organ of the NAACP—to criticize national policies that impeded the progress of blacks and to educate African Americans in the techniques of protest. After Du Bois resigned his post in 1934 following squabbles with the NAACP leadership, he launched other magazines, the most notable being *Phylon,* a scholarly journal published by Atlanta University, where he spent portions of his career as a professor and head of the sociology department.

Following Du Bois's inspired lead, the NATIONAL URBAN LEAGUE published OPPORTUNITY, a journal that documented the literary and artistic accomplishments of the Harlem Renaissance and lasted until 1949. Another notable periodical of the post–World War I period was the MESSENGER, a militantly socialist journal edited by Chandler OWEN and A. Philip RANDOLPH, the latter of whom was to become the voice of black labor as head of the Brotherhood of Sleeping Car Porters. All of these publications depended on subsidies. Commercial black magazines—meaning those that were fully self-sustaining through advertising as well as subscriptions—did not surface until the 1940s, a period when general-circulation magazines were one of the main forms of home entertainment. The engaging combination of pictures and words had made *Life* a popular chronicle of the American Dream, while *Time* provided snappily written coverage of weekly events and the *Saturday Evening Post* reinforced mainstream values in fiction and nonfiction. The *Reader's Digest* offered encapsulated extracts from the era's leading publications, in-

cluding periodicals like the *Ladies' Home Journal,* which catered to the traditional interests of women. Yet African Americans remained invisible in the pages of these magazines, as they had been in mainstream newspapers.

A veritable revolution in black magazines began in 1942 when John H. Johnson began publishing *Negro Digest,* a monthly periodical roughly the size of the *Reader's Digest,* featuring stories about black accomplishments, news items of interest to African Americans, and provocative original articles by prominent whites addressing black issues. He used it as the cornerstone for the development of the most successful black publishing firm in history. Although other quality mass-circulation black magazines originated in the post–World War II period, Johnson outmaneuvered his competition and thus eliminated it by developing brilliant marketing strategies. His climb from poverty to inclusion in *Forbes* magazine's list of the four hundred richest Americans was a real-life Horatio Alger story.

Johnson was born poor in 1918 in Arkansas City, Ark., a tiny town on the banks of the Mississippi River. His father was killed in a sawmill accident when he was eight and his mother remarried a year later. Since the town offered no opportunities for a black child to be educated beyond the eighth grade, his mother, Gertrude Johnson Williams, moved the family north to Chicago in 1933 and worked as a domestic to educate her son. When he graduated from the city's DuSable High School as the most outstanding student in the class of 1936, Johnson was offered a scholarship to the University of Chicago but opted to attend part-time while working at Supreme Liberty Life Insurance Company, one of the nation's leading black businesses. Among his tasks was to produce the company's monthly newspaper. Another was to provide digests of news about blacks for the company's president, Harry Pace, who was Johnson's mentor.

When friends were fascinated by the nuggets of black-oriented news Johnson shared with them, he conceived the idea of publishing a monthly magazine based on this kind of information. Having no money, he used his mother's new furniture as collateral to borrow $500. With this sum, he paid for the mailing of an introductory subscription letter sent to Supreme's twenty thousand customers. The resultant magazine, *Negro Digest,* was so popular that Johnson was able to launch a second magazine, EBONY, in 1945. Stressing the positive aspects of African-American life and employing ample pictures in a storytelling fashion, *Ebony* eventually became the all-time leader among black magazines.

Along the way, Johnson outstripped his most promising competitor, *Our World,* which was pub-lished by John P. DAVIS, a Harvard Law School graduate. It was launched in 1946, just after *Ebony,* and also was a quality picture magazine printed on slick paper. *Our World* amassed a circulation of 251,599 by 1952, but went bankrupt in 1955 because it could not attract major advertising accounts, the lifeblood of commercial publications. Meanwhile, Johnson used every ounce of ingenuity he could muster to break down the barriers that led white manufacturers to dismiss black magazines as advertising venues. By Johnson's own admission, he triumphed not so much because he had a better magazine, but because he was a more inventive businessman.

Johnson also was adept at changing his tactics as the times demanded. He discontinued *Negro Digest* in 1951 when *Ebony* had usurped its audience, replacing his first publication with JET, a pocket-size weekly newsmagazine. In 1965, when black militance was in vogue, he revived *Negro Digest,* changing its name to BLACK WORLD. Under the editor Hoyt Fuller, it became a prestigious outlet for African-American literature and thought, documenting the developments of what some have called the second black Renaissance. By 1970, when the movement subsided and subscriptions dropped, Johnson again discontinued the magazine.

Responding to what he read to be public taste, Johnson published *Tan Confessions* during the 1950s and 1960s, later transforming it into *Black Stars,* a fan magazine; *Hue,* a pocket-size picture magazine of the late fifties; *Ebony, Jr.,* an educational magazine for children, produced during the late sixties; and *Ebony Africa,* which reflected the African independence movement but was discontinued after a few issues in 1965 when it foundered on differing national, linguistic, and political realities. By 1992, Johnson was publishing *Ebony,* with a monthly circulation of 1.9 million; *Jet,* with a weekly circulation of nearly 1 million; and *EM: Ebony Man,* a lifestyle magazine for the African-American man that was established in 1985 and had a monthly circulation base of 225,000.

Some criticized Johnson's publications for concentrating too heavily on entertainment and light features while paying too little attention to major issues. But *Ebony* also had its serious side, and provided a nurturing environment for the development of talented black writers. Foremost among these was Lerone BENNETT, Jr., who joined the staff in 1953. A scholar as well as a journalist, Bennett produced several series of articles that interpreted and dramatized black history in a literary style accessible to the general reader. Most of these articles evolved into popular books, published by Johnson, that became a mainstay of the BLACK STUDIES programs instituted by American colleges and universities during the 1970s.

Johnson maintained his leadership in the field and accumulated an estimated net worth of $200 million by expanding into the areas of radio broadcasting, television production, and cosmetics manufacturing. Although he never earned a college degree, he was granted several honorary doctorates. He also became the chief stockholder of Supreme Life, where he had started his career, and served on the boards of several major corporations.

The legislative gains of the 1960s led to improvements in the overall educational and economic status of African Americans, providing fertile ground for the cultivation of magazines aimed at newly affluent black consumers. A dozen new magazines surfaced in 1970 alone, and two of them went on to become major publications: *Essence* and *Black Enterprise*.

Essence: The Magazine for Today's Black Woman was conceived when a Wall Street brokerage firm invited a group of young black businessmen to come up with ideas for business ventures. As a result, Johnathan Blount, Cecil Hollingsworth, Ed Lewis, and Clarence Smith developed a proposal for a black women's magazine. The idea was sold to financial backers and a staff was assembled. *Essence* attracted an audience from its very first issue, which appeared in April 1970, but was hampered by numerous organizational and editorial changes during its early years. By the 1980s, it had achieved stability and enormous popularity by offering fashions, fiction, self-help, and other articles addressing the interests of African-American women, especially those under forty. By 1992, *Essence* had a circulation of 900,000.

Black Enterprise reflected the improved national climate and positive mood of the post-movement period by encouraging black participation in the economic mainstream. First published by Earl GRAVES in August 1970, the magazine was nearly two years in the planning, with input from a board of advisers that included Whitney YOUNG, Jr., head of the National Urban League. A major objective was to stimulate black entrepreneurship, but the concept was broader than that of a simple black business magazine. *Black Enterprise* interpreted national economic and political trends from a black perspective and provided advice on career planning and money management. Its annual listing of the one hundred biggest black businesses provided a ready reference for determining the progress of African-American entrepreneurs. Like *Essence*, *Black Enterprise* was able to establish a substantial advertising base and had a circulation of 250,500 in 1992.

With the expansion of the black middle class, a variety of magazines were developed to address specific tastes. By 1990, at least twenty-five black-oriented magazines were being published in the United States. Promising newcomers included *Vi-sions*, a Washington-based quarterly focusing on the arts, history, and culture, founded in 1985; *Emerge*, a New York–based monthly newsmagazine targeting the upscale, which first appeared in 1989; and *YSB* (short for "Young Sisters and Brothers"), which was aimed at the youth market and was launched in 1991 in conjunction with the Black Entertainment Television cable network.

The boom in black magazines also provided increased opportunities for African-American photographers to have their work displayed to greater advantage. Photojournalists had contributed to black newspapers throughout the twentieth century, but under circumstances in which graphics were not stressed. Magazines, with their slick paper and more attractive layouts, offered a far better showcase, but the mainstream had been all but closed to African Americans. The only one to achieve distinction there was Gordon PARKS, SR., who had taught himself photography while working as a railroad waiter. After honing his craft on a Rosenwald Fellowship, Parks joined the staff of *Life* magazine in 1949 and acquired a national reputation for his riveting photographs of the disadvantaged. *Ebony*, in particular, with its physical similarity to *Life*, became a showcase for the work of Moneta SLEET, Jr., who previously had been on the staff of *Our World*. He joined *Ebony* in 1955, covering major stories throughout the world, from the civil rights movement to the evolution of an independent Africa. In 1969, he became the first African-American photographer to win a Pulitzer Prize, for his picture of Mrs. Martin Luther King, Jr., with her daughter, Bernice, at the funeral of the slain leader. One of Sleet's younger colleagues at *Ebony* was Ozier Muhammad, who went on to win a Pulitzer Prize in 1969 as a staff photographer for the New York daily *Newsday*.

Mainstreaming

The last decades of the twentieth century brought a dramatic shift toward the mainstreaming of African-American journalists. Beginning in the 1970s, general-circulation daily newspapers and television stations recruited black journalists as they never had before. By 1990, nearly four thousand blacks were employed by daily newspapers; a few established national reputations. Possibly the best known of these was Carl T. ROWAN, who also appeared regularly as a commentator on televised public-affairs programs. Rowan built his entire career within the mainstream. He started out in 1948 on the staff of the *Minneapolis Tribune*, where he won several awards for reporting. A distinguished author, Rowan held some high government posts in the 1960s during the Kennedy and Johnson administrations. He became a syndicated columnist for the *Chicago Daily News* in 1965, later

expanding on that base. William Raspberry of the *Washington Post* also gained broad recognition through a syndicated column published in general-market newspapers throughout the country. Other African-American journalists became well known through columns in major metropolitan newspapers, among them Earl Caldwell and Bob Herbert of the New York *Daily News*, Les Payne of *Newsday*, Dorothy Gilliam of the *Washington Post*, Chuck Stone of the *Philadelphia Daily News*, and Clarence Page of the *Chicago Tribune*.

Most major newspapers had at least a few African-American reporters on their staffs by 1990, while the *Washington Post* and *New York Times* each had more than fifty. However, the *Post* responded more readily to the need for change and offered more opportunities for these journalists to move into high-level positions as editors and managers. They also were better able to establish a public identity through the prominent display of their work in the *Post*.

The Gannett Corporation, which was the nation's largest newspaper chain, publishing eighty-seven dailies throughout the country as well as the national *USA Today*, outstripped others in the field by implementing a strong affirmative-action policy. Under chairman Allen Neuharth, Gannett enforced strict rules ensuring that minorities were included in the coverage of news and that they were consulted as sources for stories that did not necessarily pertain to race. Through the Gannett chain, Robert MAYNARD, who had spent ten years at the *Washington Post* as a national correspondent, ombudsman, and editorial writer, became the first African-American publisher of a general-market daily in 1979, at the *Oakland Tribune*. Maynard went on to purchase the paper in 1983, another first. Also under the Gannett system, Pam Johnson, who held a Ph.D. in communications, was named publisher of the *Ithaca Journal* in upstate New York in 1981, becoming the first African-American woman to control the affairs of a mainstream daily newspaper. And Barbara Reynolds, who had been an *Ebony* editor and an urban-affairs writer for the *Chicago Tribune*, was featured as a columnist in *USA Today*.

Similar changes took place in television, though they did not extend to the higher levels of management. The first black journalist on television was Louis Lomax, a newspaperman and college teacher who entered the relatively new medium in 1958 at WNTA-TV in New York. The author of five books, Lomax contributed to mainstream magazines like *Harper's* and produced television documentaries before his death in an automobile accident in 1970.

Due to the visual nature of television, it often appeared that blacks were making more progress there than in print journalism. Some shifted easily from one medium to the other. In 1963, a year after Mal Goode integrated network television news, Bill Matney moved from the *Detroit News*, a general-circulation daily newspaper, to NBC, where he covered the White House for the network from 1970 to 1972. Yet no African American held a major position in television until 1978, when Max Robinson became the first of his race to become a regular co-anchor for a prime-time network newscast, heading the national desk in Chicago for the ABC nightly news. Robinson left the network five years later after being demoted, and died of AIDS in 1988, but he served as a role model for young blacks aspiring to careers in television news.

One of the most durable of network television newscasters was Ed BRADLEY, who joined CBS as a stringer in its Paris bureau in 1971, then became a White House correspondent in 1976. He later anchored the CBS *Sunday Night News*, was one of the chief correspondents for the top-rated *60 Minutes*, and hosted his own weekly newsmagazine program, *Street Stories*. Perhaps the most ubiquitous was Bryant GUMBEL, a former sportswriter, who straddled the fence between journalism and entertainment when he became co-anchor of NBC's popular *Today* show in 1981, piloting that program into the 1990s while also hosting major network specials. Bernard Shaw carved out an important niche in the alternative outlet of cable television. After serving as a network correspondent for both ABC and CBS, he joined the Cable News Network at its inception in 1980 and became its anchor, gaining distinction as a hard-hitting interviewer on national and international issues.

Progress was uneven for women. By the late 1980s, it was common for local stations to feature African-American women as anchors, but only a few were able to break into the networks as correspondents, among them Lee Thornton, Norma Quarles, and Jacqueline Adams. Charlayne HUNTER-GAULT became one of the most visible woman journalists on television in 1978 when she became New York correspondent for the *McNeil-Lehrer Report*, the Public Broadcasting System's nightly news hour. Carole Simpson took the next major step in 1989, when she became the first African-American woman to anchor a network evening newscast, for ABC.

Some of these gains, in both print and broadcast journalism, were illusory, more cosmetic than substantive. While African Americans were involved in gathering and presenting the news, they seldom participated in the important decision-making process that determined what stories were to be covered and how they were to be played. A survey conducted by the American Society of Newspaper Editors in 1985 revealed that almost 95 percent of the journalists on

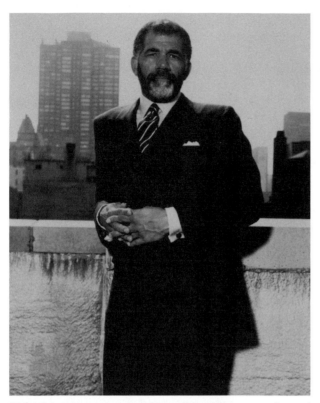

Television newscaster Ed Bradley. (Photographs and Prints Division, Schomburg Center for Research in Black Culture, The New York Public Library, Astor, Lenox and Tilden Foundations)

daily newspapers were white and that 92 percent of the nation's newspapers did not have a single minority person in a news executive position. Fifty-four percent of the newspapers had no minority employees at all. While African Americans accounted for more than 11 percent of the population, only about 4 percent of newsroom employees were black.

Affairs were no better in broadcasting, where assignment editors, producers, and associate producers shape the news and the real power is held by executive producers and other top managers. In a 1982 survey of the nation's three networks, Michael Massing of the *Columbia Journalism Review* found that no blacks held high-level management positions. The highest-level job held by an African American at ABC was as an assignment editor on a nightly news show, while at CBS and NBC the top posts were held by bureau chiefs. At all the networks, about 5 percent of the producers and associate producers were black, many in lower-level jobs.

The efforts of black reporters often were overshadowed by general policies that resulted in a predominance of negative portrayals of African Americans in the media. While only 15 percent of the poor people in the United States in 1990 were black, newspaper and television coverage, in particular, perpetuated the impression that most criminals, prostitutes, drug addicts, welfare mothers, illiterates, and homeless persons were black. On the other hand, hardworking African Americans and those who constituted a large middle class were glossed over. For many mainstream viewers, the most astounding offshoot of the televised 1992 congressional hearings on the nomination of Clarence THOMAS to the U.S. Supreme Court was not the sensational nature of Anita Hill's accusations of sexual harassment by Thomas, but the fact that the American audience had a chance to observe several highly educated, well-spoken, and impeccably dressed witnesses who happened to be black (*see also* HILL-THOMAS HEARINGS).

There also were rumblings within the profession. Black reporters frequently complained about racist attitudes in newsrooms and sluggishness in promotions. The result was a series of lawsuits in the 1980s charging discrimination. The most notable outcome was in a case brought by four black reporters against the New York *Daily News*. In 1987, a federal court ruled on their behalf, charging that the newspaper had given them fewer promotions, worse assignments, and lower salaries than their white counterparts; they were granted sizable financial settlements.

Subtler problems also prevailed. Black journalists who had struggled to establish their credibility shuddered in 1981 when Janet Cooke, a black reporter for the *Washington Post,* admitted that she had fabricated a story about an eight-year-old drug addict that had won her a Pulitzer Prize. Cooke returned the prize, but the incident haunted black journalists, who feared that all of them subsequently would be suspect, which would not have been the case had a white journalist engaged in a similar breach of ethics.

There also were points where conflicting loyalties came into play. When the Rev. Jesse JACKSON sought the Democratic presidential nomination in 1984, his quest for broad-based support crumbled when the *Washington Post* reported that Jackson had referred to Jews as "hymies" and New York City as "Hymietown." The effect of this disclosure was all the more profound because it had been made by a black reporter, Milton Coleman. The incident, more than any other, caused many black journalists to consider whether there might be times when they should disobey the rule of objectivity in reporting the news without regard to the effect it might have on their own people. This question was addressed by Juan Williams of the *Washington Post* in the paper's July 16, 1989, edition, when he railed at criticism from black readers who accused him of being a traitor because he wrote articles that were critical of blacks, including the city's mayor, Marion BARRY. Williams contended that black journalists were obligated to ask hard questions of black politicians, holding them to an absolute standard.

Beyond the problems of professional ethics, black journalists frequently found themselves isolated in the newsrooms where they worked. In the old days of the black press, most journalists had known each other, or at least had been aware of each other through a tightly woven network. They also had been devoted to a common cause: to improve the situation of their people. But modern professionals were scattered, often building careers as specialists in areas far removed from racial topics.

Fragmentation and a collective sense of isolation, along with concern for their overall effectiveness within the mainstream, led to the formation of the National Association of Black Journalists (NABJ) in Washington, D.C., on December 12, 1975. While black journalists' groups had sprung up and often withered away in various cities, this became the largest and most successful national organization, especially in terms of developing local affiliates. By 1992, the NABJ had a membership of more than two thousand, of whom 60 percent were in print and 40 percent in broadcasting. Unlike other journalism organizations, it limited membership to those involved in gathering and disseminating the news, excluding those in public relations.

Yet certain fundamental questions prevailed. Black journalists in the mainstream realized that they were merely employees, for the most part, having little power in the institutions where they worked. Meanwhile, a tide of conservatism had swept over the nation in the 1980s during the Reagan and Bush administrations, undermining affirmative-action policies and threatening to cancel out previous gains. As African Americans in general were revisited by old woes of economic instability, family deterioration, and escalating prejudice, it seemed that the clock had been turned back to an earlier time. Furthermore, black communities were beset with violent crime, drug abuse, teen pregnancy, and social disorganization. Some of these problems could not be remedied by the government and had to be addressed by blacks themselves. In earlier periods, the black press had provided a forum for honest discussion of black-on-black problems, but these publications no longer had a broad enough circulation base to be effective. The popular black magazines sometimes addressed these issues, but their major thrust was elsewhere. The challenge facing committed African-American journalists, as the twentieth century neared its end, was how they could attain greater power within the mainstream while, perhaps, beginning to build institutions of their own.

REFERENCES

BENNETT, LERONE, JR. *Before the Mayflower: A History of Black America.* 5th ed. Chicago, 1982.

BERGER, WARREN. "One Year and Counting: Wilmer Ames and 'Emerge.' " *Folio* (December 1, 1990): 35.

Black Press Handbook 1977: Sesquicentennial 1827–1977. Washington, D.C., 1977.

BRITT, DONNA. "The Relentlessly Upbeat Woman behind Spirit of Essence." *Los Angeles Times,* June 3, 1990, p. E14.

BUNI, ANDREW. *Robert L. Vann of the Pittsburgh Courier: Politics and Black Journalism.* Pittsburgh, 1974.

CARMODY, DEIDRE. "Black Magazines See Sales in Unity." *New York Times,* May 4, 1992, p. D9.

COHEN, ROGER. "Black Media Giant's Fire Still Burns." *New York Times,* November 19, 1990, p. D8.

DANN, MARTIN E., ed. *The Black Press 1827–1890.* New York, 1971.

DATES, JANNETTE, L., and WILLIAM BARLOW, eds. *Split Image: African Americans in the Mass Media.* Washington, D.C., 1990.

Ebony. "Negroes on White Newspapers." November 1955.

GILLIAM, DOROTHY. "What Do Black Journalists Want?" *Columbia Journalism Review* (May/June 1972): 47.

HICKS, JONATHAN P. "More New Magazines, and These Beckon to Black Readers." *New York Times,* August 5, 1990, p. 20.

HOGAN, LAWRENCE D. *A Black News Service: The Associated Negro Press and Claude Barnett, 1919–1945.* Cranberry, N.J., 1984.

JOHNSON, JOHN H., with Lerone Bennett, Jr. *Succeeding against the Odds.* New York, 1989.

JONES, ALEX S. "Oakland Publisher in Uphill Struggle." *New York Times,* June 5, 1985, p. A16.

———. "Sense of Muscle for Black Journalists." *New York Times,* August 21, 1989, p. D1.

LaBRIE, HENRY III. *Perspectives of the Black Press: 1974.* Kennebunkport, Maine, 1974.

MICHAELSON, JUDITH. "Black Journalists Remember Robinson as Role Model." *Los Angeles Times,* December 23, 1988, pt. 6, p. 36.

The Negro Handbook. Chicago, 1966.

NOBLE, GIL. *Black Is the Color of My TV Tube.* New York, 1981.

OTTLEY, ROI. *The Lonely Warrior: The Life and Times of Robert S. Abbott.* Chicago, 1955.

POLSKI, HARRY A., and JAMES WILLIAMS, eds. *The Negro Almanac: A Reference Work on the Afro-American,* 5th ed. New York, 1987.

QUINTANILLA, MICHAEL. "Blacks Seek Changes in Newsrooms." *Los Angeles Times,* August 3, 1990, p. E1.

Report of the National Advisory Commission on Civil Disorders. New York, 1968.

SCARDINO, ALBERT. "Black Papers Retain a Local Role." *New York Times,* July 24, 1989, p. D1.

SHAW, DAVID. "Critics Cite a Need to Lead in Hiring Minorities." *Los Angeles Times,* December 13, 1990, p. A1.

———. "Negative News and Little Else." *Los Angeles Times,* December 11, 1990, p. A1.

———. "Newspapers Struggling to Raise Minority Coverage." *Los Angeles Times,* December 12, 1990, p. A1.

SMITH, ROGER W. "Black Journalists Deplore Pace of New Media Hires." *Newsday,* March 19, 1988, p. 11.

SMYTHE, MABEL, ed. *The Black American Reference Book.* New York, 1976.

STRADER, JIM. "Black on Black." *Washington Journalism Review* (March 1992): 33–36.

WELLS, IDA B. *Crusade for Justice: The Autobiography of Ida B. Wells.* Edited by Alfreda M. Duster. Chicago, 1970.

WILLIAMS, JUAN. "Being Black, Being Fair; Journalists Have to 'Do the Right Thing,' Too." *Washington Post,* July 16, 1989, p. B1.

WOLSELEY, ROLAND E. *The Black Press, U.S.A.* Ames, Iowa, 1971.

PHYL GARLAND

Journal of Negro History, The. As soon as he founded the ASSOCIATION FOR THE STUDY OF AFRO-AMERICAN [originally *Negro*] LIFE AND HISTORY, African-American historian Carter G. WOODSON hoped to begin publishing a "Quarterly Journal of Negro History." Prior to Woodson's establishment of this publication, white historians controlled the production and distribution of scholarship in black history through the editorial policies they formulated for scholarly journals. In January 1916, just four months after the association was founded, the first issue of the *Journal of Negro History* was published. Several members of Woodson's executive council believed that publishing the *Journal* was too risky, and maintained that he should have obtained greater financial support before launching the new publication. Woodson, however, would not delay publication of the *Journal,* for he believed that fundraising would be easier if potential subscribers and contributors could see the product of his labors. Yet throughout his long career as editor, Woodson had to devote an inordinate amount of his time to fundraising for the *Journal,* as it was a continual drain on his financial resources. He managed to keep it going and never missed an issue during his thirty-five-year career as editor.

The *Journal* was the centerpiece of Woodson's research program and provided black scholars with an outlet for the publication of their research. Without it, far fewer black scholars would have been able to publish their work. It also served as an outlet for the publication of articles written by white scholars whose interpretations differed from the mainstream of the historical profession.

Through the *Journal* Woodson promoted black history, combated racist historiography written by white scholars, and provided a vehicle for the publication of articles on the black experience in Africa and the Americas. Woodson formulated an editorial policy that was very inclusive. Topically, the *Journal* provided coverage on all aspects of the black experience: slavery, the slave trade, black culture, the family, religion, the treatment of slaves, resistance to slavery, antislavery and abolitionism, and biographical articles on prominent African Americans. Chronologically, articles covered the sixteenth through the twentieth centuries. Interested amateurs, as well as scholars, published important historical articles in the *Journal,* and Woodson took care to keep this balance between contributors. Most of the early contributors were his black colleagues and associates from the Washington, D.C., public schools, Howard University, and the organizations with which he was affiliated. When he lacked enough articles, Woodson may have written articles and signed his friends' names. He also wrote the majority of book reviews in early issues, sometimes leaving them unsigned or using pseudonyms.

The authors who published in the *Journal* pioneered in their interpretations and methods in black history. They used many of the techniques that were later adopted by social historians beginning in the 1960s. Authors pointed to the positive achievements and contributions of African Americans during slavery, emphasized black struggles against it, uncovered the rich cultural traditions blacks maintained in bondage, and challenged the widely held belief in black inferiority. Many scholars published significant articles in the *Journal* that interpreted slavery from the slaves' point of view, rather than from the masters'. This interpretation facilitated a shift in historiography in the mainstream of the historical profession, which would begin to adopt this perspective only in the late 1950s. Among the pathbreaking articles published in the *Journal* were those of Herbert Aptheker, Melville Herskovits, Arthur Link, Kenneth Stampp, and, most notably, Richard Hofstader, whose critique of historian U. B. Phillips appeared in 1944. Also notable was black historians' emphasis on black culture created during slavery. While recognizing the harshness of slavery, these scholars argued that blacks had enough autonomy to create distinctive institutions. They also took note of the African background and the influence of African culture on African-American culture.

Among many black scholars who published in the *Journal* were John Hope FRANKLIN, Lorenzo Johnson Greene, Rayford LOGAN, Benjamin QUARLES,

Charles WESLEY, and Eric Williams. Woodson also published more articles by and about women than any of the other major historical journals. He highlighted the publication of documentary source materials that he and his associates had uncovered while doing research; by 1925, at least one-quarter of the *Journal*'s space was devoted to the publication of transcripts of primary source materials, which thereby encouraged their use by scholars who otherwise would not have known about them.

Without Woodson's efforts, contemporary scholars would have fewer resources for studying African-American history. Woodson retired as editor in 1950. He was succeeded by Rayford W. Logan (1950–1951), William M. Brewer (1952–1970), W. Augustus Low (1971–1974), Lorraine A. Williams (1975–1976), and Arthur Hornsby, Jr., who assumed the editorship in 1977.

REFERENCES

GOGGIN, JACQUELINE. *Carter G. Woodson: A Life in Black History*. Baton Rouge, La., 1993.
———. "Countering White Racist Scholarship: Carter G. Woodson and the *Journal of Negro History*." *Journal of Negro History* 68 (1983): 355–375.

JACQUELINE GOGGIN

Joyner, Mattilda S. *See* Jones, M. Sissieretta.

Joyner-Kersee, Jacqueline (March 3, 1962–), track and field athlete. Born and raised in East St. Louis, Ill. Jacqueline Joyner entered her first TRACK AND FIELD competition at age nine. Five years later, she won the first four Amateur Athletic Union Junior Pentathlon championships. At Lincoln High School, she received All-American selections in BASKETBALL and track. Joyner graduated in the top 10 ten percent of her high school class and accepted a basketball scholarship to the University of California at Los Angeles (UCLA). A four-year starter for the Lady Bruins basketball team, she continued her track and field career, winning the National Collegiate Athletic Association (NCAA) heptathlon title in 1982 and 1983. After winning the heptathlon at the 1984 U.S. Olympic Trials, Joyner won a silver medal at the Olympic Games in Los Angeles.

In 1986, Joyner married her coach, Bob Kersee. Later that year, at the Goodwill Games in Moscow, she set a world record in the heptathlon when she led all competitors with 7,148 points. Breaking the old mark by 200 points, Joyner-Kersee became the first American woman since 1936 to establish a multi-event world record. That same year, she broke her own world record at the U.S. Olympic Sports Festival in Houston and won the Sullivan Memorial Trophy, awarded to America's top amateur athlete. At the 1987 World Track and Field Championships in Rome, Joyner-Kersee won the gold medal in both the long jump and heptathlon competitions and became the first woman to win gold medals in multi-sport and individual events at the same Olympic-level competition. She repeated this feat at the 1988 Olympics in Seoul, winning the long jump with an Olympic record leap of 24′ 3½″ and the heptathlon with a new world record of 7,291 points.

Joyner-Kersee continued to dominate the heptathlon into the 1990s; she won at the 1990 Goodwill Games, the 1992 Olympics in Barcelona (where she also earned a bronze medal in the long jump), the 1993 World Championships, and, once again, at the Goodwill Games in 1994. At the 1994 USA/Mobil Outdoor Track and Field Championships, she won gold medals in the long jump and the 100-meter hurdles. Eager to provide inspiration and support for young people and women interested in athletics, she established the Jackie Joyner-Kersee Community Foundation in her home town of East St. Louis. In 1992, she was named Amateur Sports Woman of the Year by the Women's Sports Foundation.

REFERENCES

DAVIS, MICHAEL D. *Black American Women in Olympic Track and Field*. Jefferson, N.C., 1992.
PORTER, DAVID L., ed. *Biographical Dictionary of American Sports: Outdoor Sports*. Westport, Conn., 1988.

BENJAMIN K. SCOTT

Judaism. Estimates of the number of black people in the United States who consider themselves Jews or Hebrews range from 40,000 to 500,000. These people can be divided into three groups: individuals, such as Sammy Davis, Jr., and Julius Lester, who convert to Judaism and join predominantly white congregations—often as a result of intermarriage; African Americans who trace their Jewish heritage back to slavery and who worship in either black or white synagogues; and blacks whose attraction to Judaism is based on a racial identification with the biblical Hebrews.

The third group is by far the largest, but it is made up of many independent denominations that have a wide variety of beliefs and practices. The best known are the Black Jews of Harlem, the Temple Beth-El congregations, the Nation of Yahweh, the Original Hebrew Israelite Nation, the Israeli School of Uni-

versal Practical Knowledge, the Church of God, and the Nubian Islamic Hebrews. Reconstructionist Black Jews and Rastafarians are two groups whose relationship to Judaism or Hebrewism is so limited that they are best thought of as movements basically rooted in Christianity that have an affinity to the Old Testament and Jewish symbols.

Each of the major groups is unique and will be discussed separately. However, they generally have the following characteristics in common: They believe that the ancient Hebrews were black people, that they are their descendants, and that their immediate ancestors were forcibly converted from Judaism to Christianity during slavery. In addition, they believe that they are not converts to Judaism but have discovered or returned to their true religion. On the other hand, they believe that white Jews are either converts to their way of life, descendants of one of the biblical people whom they believe started the white race (Edomites, Canaanites, Japhites, or lepers), or that they are imposters altogether. This is the principle reason why some groups consider the term "Jew" anathema and insist on the biblical terms Hebrew or Israelite, or more commonly, Hebrew Israelite. They believe that the enslavement of and discrimination against African Americans were predicted in the Bible and are therefore a combination of divine punishment upon the children of Israel for their sins and the result of the blatant aggression of white people. Hebrew Israelites are messianic and believe that when the messiah comes, retribution will be handed down upon all sinners—but particularly upon white people for their oppression of people of color. Beyond these similarities—which a few Hebrew Israelites strongly oppose—the groups can differ widely according to the degree to which they follow rabbinic traditions, use Hebrew, conduct services, follow dress codes, and incorporate Christian or Islamic beliefs into their theology.

There have been three main phases in the use of elements of the Jewish religion in African-American worship. From exposure to evangelical Protestantism in the early nineteenth century, many African Americans identified with the enslavement, emancipation, and nation-building of the Hebrews as depicted in the Bible. Old Testament imagery was a staple of sermons and spirituals. The best-known of the latter is undoubtedly "Go Down, Moses," in which the release of the Hebrews from Egyptian captivity is seen as a sign of the redemption of blacks from slavery. This connection to the Jewish people, often strengthened by connections to Pan-African movements such as the one led by Marcus GARVEY, provided the impetus for more formal identification as Jews, often outside of a Christian context, in the late nineteenth and early twentieth centuries. Since the 1960s, another period of active black nationalism, there has been renewed identification with elements of the Jewish religion by a number of African-American religious groups. Many of these groups are quite eclectic in their theology and religious borrowings, and are often hostile to mainstream Judaism.

The Black Jews of Harlem is one of the oldest, largest, and best-known Hebrew Israelite groups in the United States. The denomination was founded in New York City by Rabbi Arnold J. Ford (1877–1935) and Rabbi Wentworth Arthur Matthew (1892–1973). Ford was the musical director of Garvey's UNIVERSAL NEGRO IMPROVEMENT ASSOCIATION (UNIA). The Black Jews based their nationalism of Ethiopianism on the belief that biblical prophecies about Ethiopia, notably Psalm 68:31 "Ethiopia shall soon stretch out her hands," referred to Ethiopia in connection with the regathering of the Children of Israel as applied specifically to black people. To achieve this Ford tried to create a Black Jewish denomination based on beliefs and customs he learned from European Jews. During the early period the group used the term Ethiopian Hebrew rather than Hebrew Israelite. Also, whereas Ford and Matthew emphatically believed that the ancient Hebrews were black, they were less certain about the origins of white Jews and would sometimes refer to them as "our fairer brothers."

In 1923 Ford opened a congregation called Beth B'nai Abraham (House of the Children of Abraham) for black people in Harlem. Rabbi Matthew, who had founded The Commandment Keepers Congregation in Harlem four years earlier, became Ford's student. In 1933, Ford ordained Matthew before leaving for Ethiopia where he lived the remainder of his life. Matthew quickly instituted the Jewish knowledge he gained from Ford into his services. In the late 1940s he created the Ethiopian Hebrew Rabbinical College in New York City where he trained and ordained twenty-two other rabbis who carried their blend of black nationalist and orthodox European Judaism to black communities throughout the United States and the Caribbean. By the 1990s, this community was being led by two students of Matthew: Rabbi Levi Ben Levy, who is the chief rabbi of the Israelite Board of Rabbis, and Rabbi Yhoshua Ben Yahonatan, who is the president of the Israelite Council. The rabbis and congregation affiliated with these bodies have limited but cordial relations with mainstream white Jewish congregations in New York. The Black Jews generally conduct their services in both Hebrew and English, observe Jewish holidays such as Hanukkah and Purim, the high holy days, and ceremonies such as Bar and Bat Mitzvah. By the early 1990s, the size of the group was probably less than five thousand, though higher estimates are sometimes given.

The Temple Beth-El congregations, also known as the Church of God and Saints of Christ (CGSC), were founded by William Saunders CROWDY (1847–1908). Crowdy was born a slave and fought in the Civil War. In 1893 he had a prophetic vision on his farm in Guthrie, Okla. that told him to start a new church that had no affiliation with any religious denomination. The specific doctrines of the church evolved over time and were based on Crowdy's revelations which he called the "Seven Keys." Crowdy taught that black people were part of the "lost tribes of Israel" and that the Hebraic Laws of the Old Testament, such as Passover, were to be obeyed. Unlike the Black Jews of Harlem, Crowdy did not abandon the use of the New Testament or a belief in Jesus Christ, and he continued practices such as baptism and ritual foot washing. In 1896 he founded his first church in Lawrence, Kans. Two years later the first CGSC general assembly was held. By 1900 the church had 5,000 members. After his death in 1908 the church suffered a split. As a whole, the church was at its height in 1936 when there were over 213 tabernacles in the United States. By the 1990s the number of tabernacles had declined to fifty-three with seven branches in South Africa. Over the years the Christian component of the Beth-El tabernacle has diminished and the Jewish elements have been augmented. The Temple's national headquarters is in Philadelphia, Pa. and its international headquarters is on a 500-acre farm in Suffolk, Va. It has an estimated membership of 38,000.

The Church of God was founded by Prophet F.S. CHERRY. The anthropologist Arthur Huff Fauset describes this group in *Black Gods of the Metropolis* (1944). Fauset reports that this group was located at 2132 Nicholas Street in Philadelphia, Pa. The church had less than 300 members at its founding, and there was no mention of affiliate congregations. All that is known about Prophet Cherry is that he was born in the South and worked as a seaman and on the railroads, which allowed him to travel throughout the United States and to many parts of the world. He was self-educated and taught his followers that they were the original Hebrews. They believed that Jesus was the messiah and used the Old and New Testaments in their services. Hebrew and Yiddish were taught in the church's schools, but white Jews were generally thought to be imposters. Saturday was considered to be the Sabbath Day, but services were also held on Sundays. The group celebrated Passover and did not recognize either Christmas or Easter. The eating of pork was prohibited among members of the group as was the taking of pictures. Prophet Cherry predicted that the new millennium would take place in the year 2000. Whether the denomination still exists is unknown.

The Nation of Yahweh, also known as the Temple of Love, was founded by Hulon Mitchell (1935–) who calls himself Yahweh Ben Yahweh ("God the Son of God"). Yahweh Ben Yahweh was raised in a Pentecostal church; in the 1960s he joined the Nation of Islam before leaving it to start his congregation of Hebrew Israelites in the 1970s. Members of this group believe that the black people of America are the "lost sheep of the House of Israel." They teach that white people are "real devils" and will be destroyed when God restores black people to power. Members of this group are encouraged to wear long white robes and they use the Star of David—though they also believe in Jesus. They believe that black people should not participate in political processes and that there is a government-sponsored plan to commit genocide against African people. By the 1990s the Nation of Yahweh had congregations located in thirty-five cities in the United States. Its headquarters is in the Miami area where members own many businesses, housing units, a printing press, a fleet of buses, and a school. The Nation of Yahweh has been indicted on a number of state and federal charges ranging from extortion to child abuse. In 1992, its leader, Yahweh Ben Yahweh, was convicted of murder and racketeering. His followers saw the conviction as a case of political oppression, and most have remained loyal to the group.

The Original Hebrew Israelite Nation was founded by Ben Ammi Carter in Chicago during the 1960s. They attempt to follow what they conceive of as an ancient form of Judaism that includes polygamy. They have developed a unique garb that resembles African and Middle Eastern attire, which includes colorful robes, and knitted skull caps, or turbans. Members of this group are strict vegetarians and believe that they are witnessing the "end of the Gentile age," which is taken to mean the end of a period of white rule. This is the only group of Hebrew Israelites which is Zionist and has attempted to immigrate to Israel. In 1969, the first of 1,500 Hebrew Israelites left Liberia, where they had established a temporary settlement, to found a permanent settlement in Dimona, Israel. Since their identity as Jews was questioned by Israeli authorities, they have not been granted Israeli citizenship under the Law of Return which guarantees citizenship to persons who are regarded as Jews under rabbinic law. However, some members of this group are allowed to work and own businesses in various cities around the country, and perform in a popular musical group at Israeli festivals. As a whole, members of this group have very little contact with either Israelis, Arabs, or Ethiopians—though they still have followers in the United States.

The Nubian Islamic Hebrew Mission, also known as the Ansaaru Allah Community, traces its origin to

Mohammed Ahmed Ibn Adulla (1845–1885), the leader of a revolt against British occupation of the Sudan in the 1880s. Mohammed Ahmed was hailed by his followers as the Mahdi, the predicted Khaliyfah (successor) to the Prophet Mohammed. In 1993 the group was lead by As Sayyid Al Imaan Isa Al Haadi Al Hadhi, the alleged great-grandson of the founder. The group organized in the United States in the late 1960s. They believe that they are both Hebrew and Muslim because both nationalities trace their lineage to Abraham, who they believe was a black man. They profess to observe all the laws and holidays of the Torah and the Koran—though Arabic and Islamic beliefs seem to be more prominent. The group's emblem is the Star of David and the inverted crescent. Their headquarters is in Brooklyn, N.Y., and they have followers in many cities throughout the United States. Members of this group do not recognize Orthodox Muslims as true followers of Islam, nor do they recognize white Jews as Hebrews. They repudiate the Nation of Islam, Malcolm X, and Wallace D. Mohammed as spreading a false Islam to black people. They teach that Abraham is the father of their nation, Jesus was the Messiah, and Mohammed was the last prophet. Members of this group wear white robes and have many vendors on the streets of New York where they sell incense, idols, and books, and recruit new members.

The Israeli School of Universal Practical Knowledge was founded in Harlem during the 1960s and claims to have branches throughout the United States. Two of their leaders are Ta-Har, who describes himself as a high priest, and Peter Sherrod, who runs the school. Like most of the other Black Jewish groups, they believe that black people are the only true Hebrew Israelites. White people are generally thought to be evil according to the teachings of this group. They are a paramilitary organization, and their mostly male followers dress in flamboyant garb that is either African in design or altered military fatigues. Their dress is often adorned with big belt buckles, emblems of different kinds, turbans, and combat boots. They also carry large staffs or wear swords or daggers. They propagate their message from street corners in New York and by means of a public access cable TV program called "It's Time to Wake Up," which began in the early 1990s. They teach that the Twelve Tribes of Israel correspond to "Negroes (African Americans), West Indians, Haitians, Dominicans, Panamanians, Puerto Ricans, Cubans, North American Indians, Seminole Indians, Brazilians, Argentineans, and Mexicans." They believe that the scriptures predict a violent confrontation between black and white people in which black people will be victorious, and the ancient nation of Israel will be restored.

RASTAFARIANS are sometimes considered a sect of Hebrew Israelites because they believe that Haile Selassie was the messiah and a descendant of King Solomon and the Queen of Sheba. They place particular emphasis on the Old Testament laws concerning the Nazzerites who were not allowed to cut their hair. This practice has developed into the wearing of "dred locks" that have been popularized by Reggae musicians since the 1970s. There are also references to the Lion of Judah and the Star of David in their music.

There are a number of other small religious groups not discussed here that have more in common with Pentecostal "holiness" churches or purely political organizations, which make use of some Jewish elements in their worship. However, with many of these other groups, Judaism or Hebraisms are a minor part of their doctrine and ritual.

REFERENCES

BERGER, GRAENUM. *Black Jews in America: A Documentary with Commentary*. New York, 1978.

BROTZ, HOWARD M. *The Black Jews of Harlem: Negro Nationalism and the Dilemmas of Negro Leadership*. New York, 1964.

FAUSET, ARTHUR HUFF. *Black Gods of the Metropolis: Negro Religious Cults of the Urban North*. Philadelphia, 1971.

SHOLOMO BEN LEVY

Julian, Hubert Fauntleroy (September 20, 1897–February 19, 1983), pilot. One of the earliest black aviators, Hubert Julian obtained his pilot's license in Canada when he was nineteen. Through risks, stunts, charm, and self-generated publicity he became known as the Black Eagle of Harlem. Hundreds of newspaper articles in the black and the white press recorded his parachute jumps over Harlem rooftops (playing the saxophone on the way down), his training the Ethiopian Air Force for Emperor Haile Selassie's coronation in 1930, his elegant clothing and Rolls Royce, and his travels around the world. Julian was born in Port of Spain, Trinidad, to Henry and Silvina (Lily) Hilaire Julian. His father owned a cocoa plantation and a shoe factory and was able to provide the best education for their only child, whom they wanted to be a doctor. At the age of fourteen Julian was sent to England, but he left at the outbreak of WORLD WAR I for Canada.

Julian, who had aviation on his mind as early as 1909, learned to fly here, taught by the famous aviator Billy Bishop. He also learned that dressing well and publicity, good or bad, would bring fame and wealth. Julian invented an air-safety device for which

Doreen Thompson. There were children from both marriages.

REFERENCE

JULIAN, HUBERT, as told to John Bulloch. *Black Eagle*. London, 1964.

BETTY KAPLAN GUBERT

Hubert Julian, "the Black Eagle," was somewhat more proficient in self-promotion than in aviation. Though his attempt to fly across the Atlantic ended in Long Island Sound, he remained a popular figure in Harlem. Active in Marcus Garvey's Universal Negro Improvement Association, Julian worked for the Ethiopian Air Force during the 1930s. (Photographs and Prints Division, Schomburg Center for Research in Black Culture, The New York Public Library, Astor, Lenox and Tilden Foundations)

he received a Canadian patent on May 24, 1921. It was later patented in the United States. In the 1920s Julian engaged in stunt flying and made unsuccessful attempts to fly to Africa. He came to Ethiopia's attention because his plane was so named, and he was invited to help prepare for the emperor's coronation and later to train the army in Ethiopia's war with Italy. Julian served in the United States Army, was an administrator at the Ford Motor plant in Detroit, and then became a registered arms dealer. He always insisted that his deeds were for the betterment of his race. In 1974 he offered Ethiopia's new government more than a million dollars to free Haile Selassie from military custody. Julian was first married to Essie Marie Gittens, who died in January 1975, and then to

Julian, Percy Lavon (April 11, 1899–April 21, 1975), chemist. The grandson of a former slave, Percy L. Julian was born in Montgomery, Ala. His father, James Sumner Julian, a railway mail clerk, and his mother, Elizabeth Adams Julian, stressed academic achievement. His two brothers earned M.D.'s. while his three sisters all received master's degrees.

Julian began his formal education in a public elementary school in Montgomery. Because the state of Alabama had only one public high school for African Americans, he was sent to a private school, the State Normal School for Negroes, in Montgomery. Upon graduating from high school in 1916, Julian was admitted to DePauw University in Greencastle, Ind. Because of the poor quality of his secondary education, he was admitted on a conditional basis, as a subfreshman. As a result, he was required to take, simultaneously, both high school and college courses during his first two years of college. In 1920, he graduated as valedictorian of his class, earning membership in both the Phi Beta Kappa and Sigma Xi honorary societies.

It was the tradition at DePauw for the head of the CHEMISTRY department to find fellowships for students planning to pursue the Ph.D. degree. Julian was the top student; therefore, his classmates assumed he would get the award to attend Harvard. After all of his classmates received graduate fellowships, Julian became concerned that he not been informed of his fellowship. He approached the department head, who informed him that because of his race no graduate school had granted him a fellowship. In fact, graduate advisers at some of the country's leading departments had advised DePauw's department head to encourage Julian to forget about a Ph.D. and to pursue a teaching career at one of the predominantly black colleges. Left with few options, Julian took a position as a chemistry teacher at Fisk University in Nashville.

After two years at Fisk, Julian received an Austin Fellowship to attend Harvard, where he earned a M.A. in 1923. He returned to teach at West Virginia State College for Negroes. The following year, he took a position at Howard University, where he

Percy L. Julian. (Photographs and Prints Division, Schomburg Center for Research in Black Culture, The New York Public Library, Astor, Lenox and Tilden Foundations)

taught chemistry for two years. While at Howard, he received a General Education Board Fellowship to pursue his Ph.D. at the University of Vienna. After earning his doctorate in 1931, Julian resumed his teaching duties at Howard. He left Howard in 1932 to teach organic chemistry at his alma mater, De Pauw. It was at DePauw that he became internationally known for his research on the structure and synthesis of physostigmine, a drug that was effective in the treatment of glaucoma.

Julian's research success at DePauw led to employment opportunities in private industry. He was offered a research position at the Institute of Paper Chemistry in Appleton, Wis., until company officials allegedly discovered that the city had an old statute on the books prohibiting the housing of an African American overnight. Fortunately, W. J. O'Brien, a vice president of the Glidden Company, was president at the institute and heard of the incident. He offered Julian the position of chief chemist and director of research at the company; and Julian joined the staff of Glidden in 1936. His appointment is considered the turning point in the hiring of African-American scientists in industry in the United States; it opened opportunities for other talented African-American scientists who had been denied industrial employment because of their race.

At Glidden, Julian directed the company's study of soybeans. The study involved developing a new process for isolating and commercially preparing soybean protein to be used in coating and sizing paper, in cold-water paints, and in textile sizing. This new process was cheaper than the existing one, and of equal quality. It was a huge commercial success for Glidden. The soybean protein was also used to develop a product for extinguishing gasoline and oil fires, which was credited with saving the lives of numerous sailors and airmen during World War II.

In 1953, Julian founded his own companies—Julian Laboratories, Inc., in Chicago and Julian Laboratorios de Mexico in Mexico City. These firms grew to be among the world's largest producers of drugs processed from wild yams. By the early 1960s, Julian had sold his laboratories for a considerable profit. At the time of his retirement, he held more than 130 chemical patents.

Julian was also a prominent civil rights leader. In 1967, he and Asa T. Spaulding, president of the black-owned NORTH CAROLINA MUTUAL LIFE INSURANCE COMPANY, cochaired a group of influential African Americans recruited by the NAACP's Legal Defense and Education Fund to raise a million dollars to finance lawsuits to enforce civil rights legislation. He was the recipient of numerous awards, including honorary degrees from twelve colleges and universities, the NAACP's prestigious SPINGARN MEDAL, and Sigma Xi's Proctor Prize. Julian was a fellow of the National Academy of Science, American Chemical Society, American Institute of Chemists, Chemical Society of London, and New York Academy of Science.

REFERENCES

HARBER, LOUIS. *Black Pioneers of Science and Invention.* New York, 1970.

JULIAN, PERCY L. "On Being Scientist, Humanist, and Negro." In Stanton L. Wormley and Lewis H. Fenderson, eds. *Many Shades of Black.* New York, 1969.

MELNICK, VIJAYA L., and FRANKLIN D. HAMILTON, eds. *Minorities in Science: The Challenge for Change in Biomedicine.* New York, 1977.

Obituary. *New York Times.* April 20, 1975.

WILLIE J. PEARSON, JR.

Just, Ernest Everett (August 14, 1883–October 27, 1941), zoologist and educator. Ernest Just was born in Charleston, S.C., the son of Charles Fraser Just, a carpenter and wharf-builder, and his wife, Mary Mathews Cooper Just, a teacher and civic leader. His early education was received at a school

run by his mother, the Frederick Deming, Jr. Industrial School. In 1896, he entered the teacher-training program of the Colored Normal, Industrial, Agricultural and Mechanical College (South Carolina State College) in Orangeburg, S.C. After graduating in 1899, he attended Kimball Union Academy in Meriden, N.H. (1900–1903), before proceeding to Dartmouth College. At Dartmouth he majored in biology and minored in Greek and history. He received an A.B., graduating magna cum laude, in 1907.

Essentially, there were two career options available to an African American with Just's academic background: teaching in a black institution or preaching in a black church. Just chose the former, beginning his career in the fall of 1907 as an instructor in English and rhetoric at Howard University. In 1909, he taught English and biology, and a year later assumed a permanent full-time commitment in zoology as part of a general revitalization of the science curriculum at Howard. He also taught physiology in the medical school. A devoted teacher, he served as faculty adviser to a group that was trying to establish a nationwide fraternity of black students. The Alpha

Ernest Just. (Photographs and Prints Division, Schomburg Center for Research in Black Culture, The New York Public Library, Astor, Lenox and Tilden Foundations)

chapter of Omega Psi Phi was organized at Howard in 1911, and Just became its first honorary member. In 1912, he married a fellow Howard faculty member, Ethel Highwarden. They had three children—Margaret, Highwarden, and Maribel.

Meanwhile, Just laid plans to pursue scientific research. In 1909, he started studying at the Marine Biological Laboratory (MBL) in Woods Hole, Mass., under the eminent scientist Frank Rattray Lillie, MBL director and head of the zoology department at the University of Chicago. He also served as Lillie's research assistant. Their relationship quickly blossomed into a full and equal scientific collaboration. By the time Just earned a Ph.D. in zoology at the University of Chicago in 1916, he had already coauthored a paper with Lillie and written several on his own.

The two worked on fertilization in marine animals. Just's first paper, "The Relation of the First Cleavage Plane to the Entrance Point of the Sperm," appeared in *Biological Bulletin* in 1912, and was cited frequently as a classic and authoritative study. He went on to champion a theory—the fertilizin theory—first proposed by Lillie, who postulated the existence of a substance called "fertilizin" as the essential biochemical catalyst in the fertilization of the egg by the sperm. In 1915, Just was awarded the NAACP's first Spingarn Medal in recognition of his scientific contributions and "foremost service to his race."

Science was for Just a deeply felt avocation, an activity he looked forward to doing each summer at the MBL as a welcome respite from his heavy teaching and administrative responsibilities at Howard. Under the circumstances, his productivity was extraordinary. Within ten years (1919–1928), he published thirty-five articles, mostly relating to his studies on fertilization. Though proud of his output, he yearned for a position or environment in which he could pursue his research full-time.

In 1928, Just received a substantial grant from the Julius Rosenwald Fund that allowed him a change of environment and longer stretches of time for his research. His first excursion, in 1929, took him to Italy, where he worked for seven months at the Stazione Zoologica in Naples. He traveled to Europe ten times over the course of the next decade, staying for periods ranging from three weeks to two years. He worked primarily at the Stazione Zoologica; the Kaiser-Wilhelm Institut für Biologie in Berlin; and the Station Biologique in Roscoff, France.

In Europe, Just wrote a book synthesizing many of the scientific theories, philosophical ideas, and experimental results of his career. The book was published under the title *Biology of the Cell Surface* in 1939. Its thesis, that the ectoplasm or cell surface has a funda-

mental role in development, did not receive much attention at the time but later became a major focus of scientific investigation. Also in 1939, he published a compendium of experimental advice under the title *Basic Methods for Experiments on Eggs of Marine Animals*. In 1940, Just was interned briefly in France following the German invasion and then released to return to America, where he died a year later.

REFERENCES

GOULD, STEPHEN JAY. "Just in the Middle: A Solution to the Mechanist-Vitalist Controversy." *Natural History* (January 1984): 24–33.
MANNING, KENNETH R. *Black Apollo of Science: The Life of Ernest Everett Just*. New York, 1983.

KENNETH R. MANNING

K

Kaiser, Ernest Daniel (December 5, 1915–), editor and bibliographer. The publication in 1992 of the five-volume *Kaiser Index to Selected Black Resources, 1948–1986* crowned the career of Ernest D. Kaiser at the Schomburg Center for Research in Black Culture at the New York Public Library. The index consists of nearly 200,000 entries about African Americans, primarily in black periodicals, compiled by Kaiser during his forty-year tenure at the library.

Kaiser was born in Petersburg, Va., to Ernest Bascom, a railroad worker, and Elnora Ellis Kaiser. He attended City College of New York from 1935 to 1938, and worked as a redcap from then until 1942. His literary and political interests led him to work at the *Negro Quarterly* and for the political action committee of the Congress of Industrial Organizations (CIO). When he became a staff member at the SCHOMBURG COLLECTION (now the Schomburg Center) in 1945, he was able to combine his interests in writing and political activism. In fact, Kaiser stated, "I consider writing an important arm of the black liberation movement and of the struggles of all peoples for liberation."

Besides compiling the *Index*, Kaiser wrote numerous articles and bibliographic essays, and served as a consultant to many scholars and publishers. He has been a coeditor and contributing editor to *The Negro Almanac*. Some of the titles to which he contributed are: *Black Titan: W. E. B. Du Bois; In Defense of the People's Black and White History and Culture; No Crystal Stair: A Bibliography of Black Literature; Harlem: A History of Broken Dreams; William Styron's "Nat Turner": Ten Black Writers Respond;* and *Paul Robeson: The Great Forerunner.* In 1961 he founded the important journal *Freedomways: A Quarterly Review of the Freedom Movement,* which lasted until 1985. In 1985, Kaiser received the Humanitarian Award from the Harlem School of the Arts. His wife, Mary Orford, died in 1990.

REFERENCE

Contemporary Authors. New Revised Series, Vol. 1. Detroit, 1981.

BETTY KAPLAN GUBERT

Kansas. For African Americans, the state of Kansas has functioned on two levels, one symbolic and romanticized, the other harshly real. As the place where John Brown waged guerilla warfare against chattel slavery, Kansas represented the "promised land" of freedom and equality to African Americans. Yet in Kansas, too, African Americans encountered the unrelenting force of the color line. "I kem [*sic*] to Kansas to live in a free state," explained a free-soil clergyman in 1856, "and I don't want niggers a-tramping over my grave."

The first documented African Americans in Kansas arrived in the 1820s. Some were free and others purchased their freedom, but most were enslaved and in the service of Army officers, fur traders, missionaries, and Native Americans. With the passage of the

Kansas-Nebraska Act in 1854, the territory became "Bleeding Kansas," the nation's battleground over slavery. While violence erupted between proslavery and antislavery forces, increasing numbers of African Americans sought refuge in Kansas from bondage. It was "not at all strange," wrote a local abolitionist, "that hardly a week passed that some way-worn bondsman did not find his way into Lawrence, the best-advertised anti-slavery town in the world. . . ." In 1860, when Kansas adopted a constitution that prohibited slavery, African Americans in neighboring slave states immediately fled to Kansas to work as free people. "I didn't worry," explained Robert Skeggs, a blacksmith. "I knew if I could make a living for myself and him [the slaveholder], too, I could get along some way with him left off." The census reflected this influx; the African-American free population jumped from 192 in 1855 to 625 in 1860. In 1861 Kansas entered the union as a free state; it had been a turbulent era. "Kansas was born in a struggle for liberty and freedom," historian Richard B. Sheridan writes, "a struggle that raised the curtain on the Civil War and sounded the death knell of slavery."

Kansas remained a major destination of African-American migration for the next two decades. During the CIVIL WAR, several thousand reached the state by braving the Missouri River; some came on skiffs, some swam, and still others walked across the ice in winter. By 1865, Kansas's black population had increased to 12,527. Many newcomers found work as farm laborers while others became domestic servants, but in Lawrence and other towns the leading occupation for African Americans was soldiering. Indeed, during the war, about one of every six African Americans in Kansas was serving in the Union Army. In 1862 in Missouri, black troops from Kansas were the first African-American soldiers to engage the enemy in military action, as members of the First Regiment of Kansas Colored Volunteers.

African Americans continued to come to Kansas after the Civil War, and in 1877 a second great wave of black migration began. Over the next four years, between 40,000 and 70,000 African Americans migrated to the state. Some moved on, but most stayed. Various factors coalesced to trigger the exodus: Reconstruction had ended and, with it, all hope for racial equality in the South. Both political repression and poverty were widespread, and with white supremacy entrenched in the South, blacks feared that slavery might be reestablished. They needed to act, and Kansas stood in the mind of EXODUSTERS in Mississippi, Louisiana, and Tennessee as both a beacon of freedom and a place where they could own their farms. A few hundred migrants came in 1877 and established several all-black communities, the best known of which was Nicodemus in western Kansas, but what started

slowly in 1877 became a mass movement in 1879. Railroads and speculators advertised Kansas as peaceful and idyllic, filled with free land. "Kansas Exodus Fever" spread, and thousands of families decided to make the move; by 1880 Kansas's African-American population exceeded 48,000.

With the end of the exodus, Kansas's black population grew slowly. It stood at 52,000 in 1900; 58,000 in 1920; and 65,000 in 1940. These were years of community building. From the beginning African Americans had established their own institutions. Excluded from white churches, blacks in 1859 established their own churches in Kansas City, Leavenworth, and other towns. They also founded mutual aid and benevolent societies (see FRATERNAL ORDERS AND MUTUAL AID ASSOCIATIONS), such as the Ladies' Refugee Aid Society, established in Lawrence in 1864, and they asserted their political rights. The first of the annual Kansas State Colored Conventions, for example, met in 1863 to demand political equality and an end to racial discrimination. African Americans established not only more churches in the coming years, but also masonic lodges, women's clubs, and schools. Furthermore, to provide needed professional training and services in Kansas City, blacks founded both a college (Western University in 1881) and a hospital (Douglass Hospital in 1899). Blacks in Topeka established the Kansas Industrial and Educational Institute, which aspired to become the "Tuskegee of the Midwest" in 1895. During these years, too, the all-black cavalry units, popularly known as the Buffalo soldiers, were stationed in the state. In various ways African Americans in the state made productive economic lives for themselves; in addition to farming, some blacks became teachers, coal miners, and police officers, while others worked on the railroads and in the meat-packing houses.

African Americans in Kansas established their own newspapers and engaged in electoral politics. Whereas three black newspapers were established in the 1870s, thirteen new papers appeared in the 1880s, twenty-eight in the 1890s, and ten more between 1900 and 1920. Some of these newspapers were DEMOCRATIC and some Populist, but most were REPUBLICAN. Indeed, black voters, who were courted by the other parties, were very important to the Republicans. Kansas's first African-American state legislator, Alfred Fairfax, a Republican, was elected in 1889, and three years later, Edward P. McCabe, a Republican lawyer and landowner in Nicodemus, was elected to statewide office as the state auditor.

African Americans established a variety of businesses in Kansas, partly in recognition of the racial segregation or outright exclusion practiced, for example, by hotels and restaurants in the state. Racial discrimination was also widespread in the schools.

While many Kansas communities, especially in rural areas, had mixed schools, others did not. In 1879 the Kansas Legislature gave "first-class cities" with populations above 10,000 the authority to establish racially separate grade schools, and Leavenworth and Topeka did so. High schools in Kansas were generally mixed until 1905, when the legislature granted Kansas City, Kans., the authority to establish a separate secondary school, Sumner High School, a first-rate institution which graduated several generations of college-bound men and women until its close in 1978. Indeed, African-American children generally received good educations in Kansas whether in integrated or all-black schools. Access to quality schools was a primary motivation for southern migration to Kansas, and the illiteracy rate for African Americans in the state dropped from 32.8 percent in 1890 to 8.8 percent in 1920.

African Americans in Kansas could matriculate in the state's public colleges and universities; and since neighboring state universities, such as those in Missouri and Oklahoma, excluded African Americans, black high school graduates from these states also enrolled at the University of Kansas and other colleges in the state. Still, admission to these institutions did not mean that black students would share equally in the benefits of campus life. At the University of Kansas in the 1920s, the union cafeteria was segregated, as were cultural events and even some classrooms, with blacks seated alphabetically in the back row. The university waived its swimming requirement for black students in order to keep them out of the pool. Therefore, while black students at all levels took advantage of educational opportunities in Kansas, they usually did so as second-class citizens.

Economic opportunities for blacks in white-collar jobs and the professions were sorely limited in Kansas. As a result, many of the state's best and brightest left the state upon graduation from high school or college. George Washington CARVER, whose research into the uses of the peanut earned worldwide acclaim, was a graduate of high school in Minneapolis, Kans. George Nash Walker left Lawrence for vaudeville and achieved success as a comedian with his partner, Bert WILLIAMS. Oscar DE PRIEST, a young man from Salina, moved to Chicago and, in 1928, became the first African American elected to Congress in the twentieth century. Raised in Lawrence, Langston HUGHES, the poet, gained fame in Harlem in the 1920s (see also HARLEM RENAISSANCE). Throughout the twentieth century, Kansas has been an exporter of black minds and talent, and blacks from Kansas have made distinguished contributions to American life. In art, the African-inspired drawings of Aaron DOUGLAS from Topeka decorated Alain LOCKE's *The New Negro* (1925); Douglas became a professor at FISK UNIVER-

SITY in Tennessee. In music, Eva JESSYE, a native of Coffeyville, composed oratorios and was the original choral director of George Gershwin's *Porgy and Bess* (1935). More recently, one Gordon Parks from Fort Scott—not the Gordon PARKS, SR. or JR., discussed in other articles—has become famous not only for his photographs, but also for his writings, compositions, and films. John Slaughter from Topeka helped shape federal policy as the director of the National Science Foundation and has served as the president of Occidental College. Also from Topeka, Franklin E. Peterson, a pilot who, during the Vietnam War, was the first African American to command a squadron in the U.S. Navy or Marine Corps, became the first black marine general. Another distinguished Kansan is Delano Lewis. Born in Arkansas City, Kans., Lewis became the president of National Public Radio in 1994.

Since 1940, a substantial number of blacks have migrated to Kansas. Indeed, the third great wave of African-American migration began in that year. Stimulated by job opportunities in the state's defense industries, Kansas's black population has more than doubled, from 65,138 in 1940 to 143,076 in 1990. With population growth came renewed civil rights activism, particularly in towns with branches of the NATIONAL ASSOCIATION FOR THE ADVANCEMENT OF COLORED PEOPLE (NAACP). A case against the segregated schools of Topeka brought on behalf of Linda Brown, an elementary school student in that city, reached the U.S. Supreme Court as BROWN V. BOARD OF EDUCATION OF TOPEKA (1954). The Court's landmark decision found that segregated education is unconstitutional. The first post-*Brown* SIT-IN occurred in Wichita in 1958, when eight black high school and college students took their places at the lunch counter of the Dockum Drug Store and asked for service. They were spat upon and verbally abused, but the eight returned every day for the next week, at the end of which the drugstore capitulated and racial barriers tumbled throughout the city.

Beginning in the 1960s, black political representation increased substantially in Kansas. Augmenting the burgeoning black population in Kansas cities and towns was legislative reapportionment, which had been ordered by the Supreme Court in 1962. This decision (*Baker* v. *Carr*) effectively shifted legislative seats from rural to urban areas. In 1956, for example, one African American sat in the Kansas legislature; twenty years later, six blacks were serving in the House and Senate. Moreover, in the 1980s African Americans were elected mayors of a number of smaller cities, including Abilene, Coffeyville, and Leavenworth. Meanwhile, the civil rights and black power movements have produced lasting institutions, such as the University of Kansas's Department of African and African-American Studies, established

in 1970 and recognized by the federal government as a national resource center in 1994. In recent years, too, the black middle class has swelled in Kansas. In 1950, only 4 percent of African Americans in Kansas earned their living in professional jobs; by 1970, however, that figure had risen to 9 percent, and by 1990 it reached 16 percent.

Despite such political and economic progress, equality has remained elusive in other areas, such as education. The road from *Brown* to meaningful school desegregation has been strewn with obstacles, including gerrymandered school districts. The struggle for equality has continued, however. In 1979 black parents in Topeka showed that the city's schools were still segregated and revived the *Brown* case. And in 1994, a full forty years after the *Brown* decision, a federal judge began hearing plans to eliminate all vestiges of school segregation in Topeka.

Much has changed for African Americans in Kansas; but much remains the same. For this reason, the long-ago uttered words of a Kansas black newspaper seem surprisingly up-to-date. Over one hundred years ago—on August 21, 1891—the Kansas City *American Citizen* called for the day:

When Negroes' rights are granted,
When all the Race is free.
When blacks and whites are all alike
And no differences we see. . . .

REFERENCES

CORNISH, DUDLEY T. *The Sable Arm: Negro Troops in the Union Army, 1861–1865.* New York, 1966.

COX, THOMAS C. *Blacks in Topeka, Kansas, 1865–1915.* Baton Rouge, La., 1982.

CROCKETT, NORMAN L. *The Black Towns.* Lawrence, Kans., 1979.

HAMILTON, KENNETH MARVIN. *Black Towns and Profit: Promotion and Development in the Trans-Mississippi West.* Urbana, Ill., 1991.

KANSAS STATE HISTORICAL SOCIETY. *In Search of the American Dream: The Experiences of Blacks in Kansas, A Resource Booklet for Teachers.* Topeka, Kans., 1984.

KLUGER, RICHARD. *Simple Justice: The History of Brown v. Board of Education: Black America's Struggle for Equality.* New York, 1976.

PAINTER, NELL IRVIN. *Exodusters: Black Migration to Kansas after Reconstruction.* New York, 1977.

RAWLEY, JAMES A. *Race and Politics: Bleeding Kansas and the Coming of the Civil War.* Philadelphia, 1969.

SCHWENDEMANN, GLEN. "Nicodemus: Negro Haven on the Solomon." *Kansas Historical Quarterly* 34 (1968): 10–31.

SHERIDAN, RICHARD B. "From Slavery in Missouri to Freedom in Kansas: The Influx of Black Fugitives and Contrabands into Kansas, 1854–1865." *Kansas History* 12 (1989): 28–47.

TUTTLE, WILLIAM M., JR., and SURENDRA BHANA. "Black Newspapers in Kansas." *American Studies* 13 (1972): 117–124.

DEBORAH L. DANDRIDGE
WILLIAM M. TUTTLE, JR.

Kansas City. The metropolis of Kansas City, Mo., has its origins in a fur trading post established by François Chouteau on the Missouri River in 1821. The adjacent town of Westport was founded in 1833. Westport and nearby Independence became population centers during the California Gold Rush of 1849 as the eastern end of the Santa Fe Trail. The riverside village was incorporated as the City of Kansas in 1853. During the next three years, the region was plunged into the undeclared civil war spilling over from "bleeding Kansas," as Southerners fought antislavery Northerners over extending slavery. Violence continued through the CIVIL WAR period; the 1863 Battle of Westport was later called "the Gettysburg of the West."

African Americans were present in the region throughout this early period. As the western edge of Missouri's strip of fertile alluvial soil, Jackson County was well suited to large-scale agriculture, and was an outpost of slavery. Other slaves worked on the river traffic, and in 1857 an eastern reporter described the "busy crowd of whites, Indians, half-breeds, Negroes, and Mexicans" laboring in the port.

In 1865 the first railroad came to the City of Kansas, and the first stockyards opened in 1870. Kansas City swiftly became a meat-packing and trade center, and soon after, a central depot for the grain trade. Blacks settled in houses and shanties in the North End and in the West Bottom areas of town. In 1879 the city's black population temporarily swelled with the migration of stranded EXODUSTERS fleeing the South for Kansas. With aid from the mayor and city officials, Kansas City blacks contributed funds to help support the refugees.

By the turn of the century, Kansas City (its name was changed in 1889) had established itself as a population and cultural center. The black population rose quickly, as blacks from the Southwest and other feeder areas migrated in search of work. Churches sprang up, with the Vine Street Baptist Church being the largest. To these immigrants the city owes its distinctive culinary, linguistic, and musical heritage. The advent of RAGTIME music around the turn of the century began Kansas City's preeminence in black popular music. Scott JOPLIN published some of his first compositions in Kansas City, and ragtime composer James Scott (1886–1938) lived and worked there.

However, segregation and discrimination remained entrenched in the city. Other than streetcars, most public facilities, including the city's famous park system, were closed to blacks by the turn of the century. Few African Americans owned their homes, and almost all were confined to dilapidated tenements in "the Bowery," where poverty and mortality rates were so high that by 1910 more residents were dying than being born. While black school attendance was actually higher than that of whites during the period, school funds for black schools were pitifully low. Seventy-five percent of businesses would not hire blacks. Those who did secure employment worked at menial labor in some of the stockyards and meat-packing plants, or in domestic labor. A few African Americans rose to prominence. In 1890 E. L. Hamlin, a rich contractor, ran unsuccessfully for the city council on the Republican ticket. Eight years later, Nelson Crews, an influential community leader, successfully organized the black vote in favor of city home rule and control of the city police force. Since hospitals were closed to black patients, African-American doctor J. Edward PERRY set up a system of health care in converted private homes. In 1910 he founded the Perry Sanitarium, the city's first hospital for African Americans. It was expanded and renamed the Wheatly-Provident Hospital in 1916.

In 1910 "Boss" Tom Pendergast and his political machine took over power in Kansas City, and the city soon became an "open town," with relatively unrestrained gambling and prostitution. The Pendergast machine long enjoyed the electoral support of the black community, due to its policy of curbing police abuses, and the black vote became an integral part of the Pendergast coalition. Some critics, noting that no blacks were appointed to offices or given patronage positions, complained that the main benefit Pendergast offered the black community in exchange for its support was toleration of black vice lords. Nevertheless, the machine did provide small favors and social welfare aid, though on a minor basis compared to its white patronage efforts. For example, in 1930 the city opened a black public hospital, the first such institution west of the Mississippi River.

Under the Pendergast regime, Kansas City's black community experienced a cultural flowering. The black area, comprising the area between 9th and 28th Streets, and Troot Street East and Indiana Street, and centered around the intersection of 18th and Vine Streets, became the hub of a vice and entertainment district, where liquor flowed freely in defiance of Prohibition and music clubs and theaters proliferated. Reuben Street's Hotel, considered the best black hotel west of Chicago, became a major stopping place for black musicians and other celebrities in the Midwest. During the halcyon years of the Pendergast era,

hundreds of bars, speakeasies, dance halls, nightclubs, and cabarets sprang up. There were at least fifty in the six-block stretch from 12th to 18th Streets, immortalized in Euday L. Bowman's "12th Street Rag" (1914). The most famous were the Subway Club, owned by African Americans Piney Brown and Felix Payne; the Sunset Club, owned by Brown; and, most famous of all, the Reno Club. These clubs attracted not only local JAZZ musicians, but those who passed through the city, which then was a major railroad junction. By the late 1920s, boogie-woogie pianists such as Pete Johnson and Sammy PRICE, and BLUES singers such as Big Joe TURNER had become major attractions. In the 1930s and early 1940s some of the finest jazz bands in the country were based in Kansas City. Orchestras led by Bennie MOTEN, Andy Kirk, Harlan Leonard, and Count BASIE played a distinctive style of big band jazz whose four-to-the-bar rhythms and lean, vigorous arrangements featured some of the most important soloists of the big band era, including Buck Clayton, Herschel Evans, Budd Johnson, Ben WEBSTER, Mary Lou WILLIAMS, Lester YOUNG, and singers such as Jimmy RUSHING. Charlie PARKER, the founder of bebop, was born and raised in Kansas City, where he became an active member of the local jazz scene in his early teens. A major focus of civic pride during the 1920s and 1930s was the Kansas City Monarchs BASEBALL team. The Monarchs were founded in 1919 by J. K. Wilkinson, a white man, out of his interracial All Nations barnstorming team. When the National Negro League was organized in 1920, as a tribute to the strength and popularity of Kansas City baseball its formative meetings were held in Street's Hotel and the Paseo YMCA in Kansas City. Despite hesitation due to the Monarchs' white ownership, the team was so popular that it was invited to join the new league. The Monarchs remained in the league until its demise in 1931. It then returned to barnstorming, using portable electric lights for night games, before joining the new Negro American League in 1937. Baseball games were one of the few areas of interracial mixing—for several years the majority of Monarchs customers were white—and the team's booster club included most of the city's black elite, members of exclusive societies such as the Twilight City League and the Young Men's Progressive Club (whose businesses expanded on the patronage of fans). Although the Monarchs dissolved in 1964, killed by the integration of major league baseball and the coming of major league teams to Kansas City, their feats are commemorated in the city's Negro League Baseball Museum, opened in 1990.

Despite the crusading journalism of editor Chester A. Franklin's *Kansas City Call,* founded in 1919, the struggle for black equality in Kansas City was slow

and bitter. Discrimination remained rampant throughout the first half of the century. When Samuel R. Hopkins, a successful black realtor, attempted to move into a formerly all-white area in 1925, his house was bombed. During the GREAT DEPRESSION, the situation worsened as whites competed with blacks for menial labor. Unemployed blacks who went to the National Reemployment Service in Kansas City, whatever their previous training and qualifications, were put in domestic and personal service jobs. Government projects also discriminated. Although Dr. William J. Thompkins, a prominent local African-American physician, was appointed Recorder of Deeds in Washington, D.C., in 1934, the Kansas City Civil Works Administration excluded black laborers, despite high Depression-era black unemployment, until the federal government threatened to cut off aid to Missouri if blacks were not hired. A well-organized Kansas City chapter of the NATIONAL ASSOCIATION FOR THE ADVANCEMENT OF COLORED PEOPLE (NAACP) developed under the leadership of Kansas City Call editor Roy WILKINS. Wilkins later became the NAACP's national director. In 1939, following the fall of the Pendergast regime, a citizen's movement sponsored by the NAACP succeeded in forcing municipal golf courses to open for use by blacks, but was otherwise ineffective. The same year, following the precedent set by the U.S. Supreme Court's Missouri ex rel. Gaines v. Canada decision, by which Lloyd Gaines was admitted to the University of Missouri Law School, editor Lucille Bluford of the Kansas City Call applied for admission to the University's School of Journalism, which refused her. Rather than integrate, the state created a minuscule, separate School of Journalism at Lincoln University.

The coming of WORLD WAR II brought significant change to Kansas City. Blacks were originally excluded from defense work, and the African-American unemployment rate remained constant throughout 1941 while the white rate fell. That year, five hundred people marched against the exclusionary policy, but it was not until after March 1942, when thirteen thousand blacks met in the Municipal Auditorium to demand an end to discrimination, that the Fair Employment Practices Committee was able to force black hiring. During the war years, Fellowship House, an interracial living center sponsored by liberal whites of the Fellowship of Reconciliation (FOR) came to the city. FOR members began a small chapter of the CONGRESS OF RACIAL EQUALITY (CORE), and organized a few successful protests against segregated facilities. In 1945 the city's blacks united to elect an African-American state representative, Democrat James McKinley Neal, who served several terms.

The first small victories against discrimination came in 1951, when the city council admitted blacks to public parks and buildings, and organized a Commission on Human Relations. The same year, however, a judge refused to admit black students to a superior white school on the grounds that differences in physical plant did not negate "substantial equality." Many black parents kept their children at home (a practice tolerated by truant officers) rather than send them to overcrowded black schools. Integration finally began in 1954, after the U.S. Supreme Court's BROWN V. BOARD OF EDUCATION OF TOPEKA, KANSAS decision.

In 1960 sit-ins began in Kansas City, sponsored by an intergroup Public Accommodations Movement. While most downtown restaurants agreed to serve African Americans by the end of the year, the city council refused to pass an ordinance until 1963, and protests continued through passage of the Civil Rights Act of 1964. Throughout the decade, race relations remained tense in the face of white intransigence. Radical black groups such as the BLACK PANTHERS organized in the city, offering free school breakfast programs. In April 1968, following the assassination of the Rev. Dr. Martin Luther King, Jr., city authorities refused to close schools for a day of remembrance, although schools in nearby Kansas City, Kans., were closed. Three hundred black students marched on City Hall and were met by police with tear gas. That night, rioting broke out in black areas. Nervous white officials responded to the violence by sending in almost three thousand state troopers and members of the National Guard to augment the police force. By the end of the evening, fifty-seven people had been wounded and 275 people arrested.

Since the 1960s, African Americans in Kansas City have made significant political gains. Freedom, Inc., a political organization founded in 1962 by businessmen Leon Jordan and Bruce Watkins, organized the black vote over the following years and helped elect city council members, state legislators, judges, and others. Watkins ran unsuccessfully for mayor in 1979, but his strong finish demonstrated black community political power. In 1982 the city's district elected its first black U.S. representative, Alan Wheat. In 1991 Kansas City elected Emanuel Cleaver, a Methodist minister and onetime black radical, as the city's first African American mayor. In tribute to the city's historical role as regional political and cultural center, civil rights activist Horace Peterson III opened an archive/museum, the Black Archives of Mid-America, in 1974.

Despite these accomplishments, blacks in Kansas City continue to face many difficulties. Unemploy-

ment remains high, despite the efforts of organizations such as the Black Economic Union, founded in 1967, to stimulate investment in black business, and the city's economic base has been damaged by white flight and deindustrialization. School segregation has been a continuing problem. In 1984 a desegregation plan was implemented which created a system of magnet schools to induce whites to attend predominantly black schools, and the city council increased taxes to pay for them. Still, studies in the 1990s indicated that the magnet schools were not increasing the educational opportunities of most black students, who were doing worse, not better. In 1990 the U.S. Supreme Court, upholding a Federal Appeals court ruling, ordered Missouri to pay for the education of one-fourth of Kansas City's black students at predominantly white suburban schools. However, it will be many years before the full effects of the decision are clear.

REFERENCES

BROWN, A. THEODORE and LYLE W. DORSETT. K.C.: A History of Kansas City, Missouri. Boulder, Colo., 1978.

BRUCE, JANET. The Kansas City Monarchs: Champions of Black Baseball. Lawrence, Kans., 1983.

GREENE, LORENZO, GARY F. KREMER, and ANTONIO F. HOLLAND. Missouri's Black Heritage. Rev. ed., Columbia, Mo., 1992.

MARTIN, ASA EARL. Our Negro Population: A Sociological Study of the Negroes of Kansas City, Missouri. Kansas City, 1913. Reprint. New York, 1969.

RUSSELL, ROSS. Jazz Style in Kansas City and the Southwest. Berkeley, Calif., 1971.

THOMAS, TRACY and WALT BODINE. Right Here in River City: A Portrait of Kansas City. Garden City, N.Y., 1976.

GREG ROBINSON

Karamu House. Founded in Cleveland as the Playhouse Settlement in 1915 by two white Oberlin College graduates, Russell and Rowena Jelliffe, Karamu House became internationally known as an interracial center for theater and the arts. Playhouse Settlement was originally designed to help smooth the transition of blacks migrating from the rural South. Initially, the Jelliffes worked with neighborhood children, providing them with a variety of recreational services. While Playhouse has continued these activities to the present and its members have also been involved in civil rights work, its primary focus since the 1920s has been cultural, especially the theater. In 1927, when the playhouse acquired its own building, its name was changed to Karamu, Swahili for "a place of joyful meeting."

The first dramatic production was Cinderella in 1917 with a racially integrated cast. In the 1920s drama at Karamu House evolved from the activities of an informal theater group into a serious and thriving production company that explored the expressive and dramatic capabilities of African-American actors and playwrights. In the course of this evolution, the group changed its name many times: Known initially as the Dumas Dramatic Club, in 1922 it was renamed the Gilpin Players, after the great African-American actor Charles GILPIN, who encouraged the troupe; it became the Karamu Players in 1927. The first black play the group produced was Ridgely Torrence's Granny Maumee in 1924; the next year it staged Willis Richardson's Compromise. By 1930 THE CRISIS magazine would call Karamu the "most successful Negro Little Theatre in the United States."

The best known black playwright associated with Karamu was Langston HUGHES, who grew up in Cleveland and got to know the Jelliffes when in high school. Hughes, who stayed near Karamu House when he visited Cleveland in the 1930s, would often drop by to encourage the members. Between 1936 and 1939 the theater premiered five plays by Hughes, as well as the original version of Mulatto. During the 1930s Karamu received federal funding from the Works Project Administration (WPA) and became known for its visual arts programs. Artists such as Charles Sallee, Fred Carlo, Hughie LEE-SMITH, and Elmer Brown worked at Karamu House.

In 1939 Karamu House was destroyed by fire, and efforts to rebuild had to wait until after World War II. In 1949 contributions from Cleveland residents as well as big donors such as the Rockefeller Foundation enabled a new complex to be built. This had two theaters, a visual arts studio, a dance studio, clubrooms, and offices. Karamu House flourished in the 1950s, presenting not only new and experimental black theater but dance and music performances as well as exhibitions of art and sculpture.

Karamu changed direction in the 1970s following the rise of black nationalism, promoting black theater aimed exclusively at black audiences. Several critically acclaimed plays were produced in this period, but in 1982 Karamu went back to its interracial roots, though with a strong African-American emphasis.

In the 1990s, Karamu House maintained its original function of being available for those with nonarts interests and conducted diverse lessons for Cleveland natives, from jewelry making to wood carving. But Karamu House continues to be primarily known for its performing arts theater.

REFERENCES

ABOOKIRE, NOERENA. *Children's Theatre Activities at Karamu House*. Ann Arbor, Mich., 1981.

BARNHILL, ALIYA. "The Heart and Soul of Ohio." *American Visions* (June 1990): 50–52.

MILAM, KATHRYN. "Arts for All." *Horizon* (December 1986): 12–13.

SELBY, JOHN. *Beyond Civil Rights*. Cleveland, 1966.

SILVER, REUBEN. *A History of the Karamu Theatre*. Ann Arbor, Mich., 1981.

ELIZABETH MUTHER

Karenga, Maulana (Everett, Ronald McKinley) (1941–), activist and educator. Ronald Everett was born in Parsonburg, Md., the youngest of fourteen children of a Baptist minister. He moved to Los Angeles in 1959 and received his B.A. (1963) and M.A. (1964) in political science from the University of California at Los Angeles. He became active in local civil rights battles, and in 1965 he worked to help rebuild the Watts community following the riots earlier that year. At that time he embraced cultural nationalism and adopted the African name Maulana (master teacher) Karenga (keeper of the tradition). In 1966 Karenga founded US (indicating "us" as opposed to "them"), a nationalist organization that believed that a black cultural renaissance was the first step in the revolutionary struggle for black power.

Karenga was deeply influenced by Pan-Africanists such as Ghana's Kwame Nkrumah, Kenya's Jomo Kenyatta, and W. E. B. DU BOIS. He argued that to experience true liberation, African Americans needed to embrace a culture that reflected their African heritage. Karenga termed this ideology KAWAIDA. Kawaida stressed that black liberation could not be achieved unless black people rejected the cultural values of the dominant society. Under his leadership US's guiding principle became "back to black." Members wore traditional African garb, promoted the teaching of Swahili, and sponsored Afrocentric community art events. Although consisting of fewer than one hundred members, US played an important role in building independent schools, BLACK STUDIES departments, and black student unions.

Karenga believed that African Americans should base their lives around seven African values: Umoja (unity), Kujichagulia (self-determination), Ujima (collective work and responsibility), Ujamaa (cooperative economics), Nia (purpose), Kuumba (creativity), and Imani (faith). In 1966 he founded the holiday of KWANZA, a seven-day celebration based on these principles. Karenga coplanned and convened black power conferences in Washington, D.C.

(1966), Newark, N.J. (1967), and Philadelphia (1968) —*see* BLACK POWER CONFERENCE OF NEWARK.

His popularity declined, however, in the late 1960s and early '70s due to the struggles with the BLACK PANTHER PARTY over the control and direction of the West Coast black nationalist movement. The Black Panther party viewed social and economic struggle, not cultural reaffirmation, as the key to black liberation. Confrontations often escalated into violence because of both groups' reliance on arms. In 1968, following a bitter debate and violent confrontation over the appointment of a director of the Afro-American Studies Center at UCLA, three US members were convicted of the shooting deaths of two Black Panthers. (In 1976 the FBI admitted abetting the warfare between US and the Black Panther party in the hope that it would result in mutual destruction.)

In 1971 Karenga was charged and later convicted of the aggravated assault of two female US members. He received an indeterminate sentence of one to ten years. Upon his release from prison in 1975, he embraced socialism and called for black people to struggle against class, as well as racial, oppression. One year later he received a doctorate in leadership and human behavior from U.S. International University in San Diego.

In the mid-1990s Karenga remains a vocal supporter of Afrocentrism. He serves as the director of the African-American Cultural Center in Los Angeles as well as chairman of the black studies department at California State University at Long Beach. In 1993 Karenga earned a second doctorate in social ethics from the University of Southern California. He is the author of three books, *The Quotable Karenga* (1967), *Introduction to Black Studies* (1982), and *Kemet, the African World View: Research and Restoration* (1986).

REFERENCES

ALEXANDER, VICTOR S. "Interview: Dr. Maulana Ron Karenga." *African Commentary* 1, no. 1 (October 1989): 61–64.

VAN DEBURG, WILLIAM L. *New Day in Babylon: The Black Power Movement and American Culture, 1965–1975*. Chicago, 1992.

WALDO E. MARTIN

Kaufman, Bob (April 18, 1925–January 12, 1986), poet. Raised in New Orleans by a black mother from Martinique and a father who was an Orthodox Jew from Germany, Bob Kaufman reflected a complex blend of cultural influences. He attended Catholic

masses with his mother and synagogue with his father, and learned about VOODOO from his maternal grandmother, whose own mother came from the Gold Coast of Africa in a slave ship. At thirteen, Kaufman joined the merchant marine and circled the earth nine times, experiencing four shipwrecks. Literature became a concern due to the influence of a first mate who introduced him to Federico García Lorca, Hart Crane, T. S. Eliot, and Walt Whitman. He also read works by Marx and Lenin, and in 1948 became a union organizer working with miners and farmers in West Virginia, Tennessee, and Kentucky. He later organized seamen in the West Coast ports of Spokane, Seattle, San Francisco, and San Diego.

Kaufman's interest in radical thought led him to attend New York's New School for Social Research in the 1940s. While in New York in the 1950s, he met the Beat writers Allen Ginsberg and William S. Burroughs. He also became friends with bebop musicians Charlie PARKER and Miles DAVIS and action painters Franz Kline, Larry Rivers, and Jackson Pollock. The influence of music and painting based on spontaneity propelled him in the direction of poetry produced through the technique of automatic writing. Another important influence on Kaufman's poetry was the psychological effect of undergoing electric-shock treatments at Bellevue Hospital after an argument with a policeman.

In the late 1950s, Kaufman arrived in the North Beach section of San Francisco, where he became associated with the emerging Beat poetry renaissance. His chief contribution was to become the only black writer to contribute substantially to the growth of Beat poetry on the West Coast by joining Ginsberg, William Margolis, and John Kelly in founding *Beatitude,* a mimeographed poetry miscellany that was to appear weekly. City Lights Books made Kaufman into a cult figure by publishing three broadsides: *Abomunist Manifesto* (1959), *Second April* (1959), and *Does the Secret Mind Whisper?* (1960). He also published three books of poetry: *Solitudes Crowded with Loneliness* (1965), *The Golden Sardine* (1967), and *The Ancient Rain* (1981).

Writing a poetry that is more socially committed and oriented toward activism than is typical for Beat writers, Kaufman is also remarkable for his ability to rapidly shift moods from rage to comedy. Something of a legend has been made of him, for it is widely believed he took a vow of silence that he maintained from 1963 to 1973 and again after 1978; it is also believed that his wife assembled his books from poems scribbled on scraps of paper that he left behind wherever he went. Although he has a small audience in the United States, the prophetic and engaged nature of his poetry provided him with a large following in France, where French translations of his works have earned him the title the American Rimbaud. There have been translations of Kaufman's work into six European languages, and there is a Bob Kaufman archive in the library of the Sorbonne in Paris.

REFERENCES

CLAY, MEL. *Jazz—Jail and God: Bob Kaufman: An Impressionistic Biography.* San Francisco, 1987.
FOYE, RAYMOND. "Editor's Note." In Bob Kaufman, *The Ancient Rain: Poems 1956–1978.* New York, 1981.
KAUFMAN, EILEEN. "Laughter Sounds Orange at Night." In Arthur and Kit Knight, eds. *Beat Angels.* California, Pa., 1982.

JON WOODSON

Kawaida, cultural nationalist theory and movement. The philosophy of Kawaida (a Swahili word meaning "tradition" or "reason," pronounced "ka-wa-EE-da") is a synthesis of nationalist, Pan-Africanist, and socialist ideologies (*see* PAN-AFRICANISM and SOCIALISM). It was created and defined by Maulana KARENGA during the height of black pride and self-awareness that characterized the Black Power movement in 1966. Karenga believed that black people needed a change of consciousness before they could mount a political struggle to empower themselves. He argued that the reclamation of an African value system based on the *Nguzo Saba* (Seven Principles) of *umoja* (unity), *kujichagulia* (self-determination), *ujima* (collective work and responsibility), *ujamaa* (cooperative economics), *nia* (purpose), *kuumba* (creativity), and *imani* (faith) would serve as a catalyst to motivate, intensify, and sustain the black struggle against racism. This value system, which served as the basis of Kawaida, would provide the foundation for a new African-American culture defined in terms of mythology (religion); history; social, economic, and political organization; creative production; and ethos.

Kawaida, the guiding philosophy behind Karenga's California-based cultural nationalist organization "US," was introduced to a wider audience of African Americans at the National Conference on Black Power in Newark, N.J., in 1967. Although some African Americans criticized the ideology for not mounting a revolutionary challenge to the economic status quo, the search for connections to an African past and the ideal of unifying the black nation had widespread appeal.

Amiri BARAKA, writer and militant activist, became the chief spokesperson for the ideology in the late

1960s and was key to its popularization. Baraka believed that Kawaida was an instrument that could be used to politicize the black masses, and he supported the creation of community theaters and schools that focused on African cultural values. In the late 1960s, he became head of the Temple of Kawaida in Newark, N.J., which taught African religions and he played a key role in the creation of Kawaida Towers, a low- and middle-income housing project in Newark, during the early 1970s. Baraka sought to bridge the gaps between culture, politics, and economics, and by 1974 he had reinterpreted Kawaida to include a socialist critique of capitalism.

Kawaida's influence in black America has continued to grow, and the ideology provided a basis for the development of theories of "Afrocentricity" in the late 1970s and 1980s. In the late 1980s, the National Association of Kawaida Organizations (NAKO) was founded under the direction of Maulana Karenga. NAKO sponsors workshops, forums, and symposia to promote awareness and appreciation for Africa in the black community. The most influential expression of Kawaida is KWANZA, an African-American holiday, based on the *Nguzo Saba,* created by Karenga in 1966.

REFERENCES

HUBER, PALMER. Three Black Nationalist Organizations and Their Impact Upon Their Times. Ph.D. diss. Clavemont Graduate School, 1973.

KARENGA, MAULANA. *Kawaida Theory: An Introductory Outline.* Inglewood, Calif., 1980.

VAN DEBURG, WILLIAM L. *New Day in Babylon: The Black Power Movement and American Culture, 1965–1975.* Chicago, 1992.

MANSUR M. NURUDDIN
ROBYN SPENCER

Kay, Ulysses Simpson (January 7, 1917–May 20, 1995), composer. Born in Tucson, Ariz., Ulysses Kay is one of the twentieth century's leading African-American composers, a self-described traditionalist whose neoclassical style draws on romantic and expressionist movements as well as African-American musical idioms. A nephew of the pioneering jazz trumpeter Joe "King" OLIVER, Kay has composed in a variety of genres, ranging from solo instrument and voice, and pieces for children, to band and chamber music, opera, and works for orchestra and chorus. He has also written extensively for film and television. Kay received his earliest training at home, and in the Tucson public schools. He earned a Bachelor of Music degree from the University of Arizona in 1938, and a Master of Music degree in 1940 from the Eastman School of Music in Rochester, N.Y., where he studied with Howard Hanson and Bernard Rogers. He studied with Paul Hindemith at Yale from 1941 to 1942 before serving four years in the United States Navy, where he played flute, saxophone, piccolo, and piano in Navy bands or jazz ensembles.

After the war, Kay studied with Otto Luening at Columbia in 1946 and 1947, during which time his overture *Of New Horizons* (1944) won the 1946 American Broadcasting Company prize. Other prize-winning works from this period include *Suite for Orchestra* (1945), *A Short Overture* (1946), and *Portrait Suite* (1948), all for orchestra. In 1948 Kay composed and arranged the score for the film *The Quiet One.* From 1949 to 1953 Kay studied at the American Academy in Rome, composing *Pietà* (1950), for English horn and strings.

In 1953 Kay began working as a consultant for Broadcast Music Inc. Continuing his compositional activity, he wrote *The Juggler of Our Lady* (1956), an opera; *Fantasy Variations* (1963) for orchestra; and *Markings* (1966) for orchestra. After leaving BMI in 1968, Kay began teaching at Lehman College of the City University of New York. His later compositions include *Epigrams and Hymn* (1975) for voice and organ; *Chariots* (1978), an orchestral rhapsody; *Festival Palms* (1983), for voice and piano; the opera *Frederick Douglass* (1986); and *String Triptych* (1988) for string orchestra. Kay retired from teaching in 1988.

REFERENCES

HADLEY, RICHARD T. "The Life and Music of Ulysses Simpson Kay." *Negro Educational Review* 26 (January 1975): 42–51.

HOBSON, CONSTANCE T., and DEBORRA A. RICHARDSON, comps. *Ulysses Kay: A Bio-Bibliography.* Westport, Conn., 1994.

DEBORRA A. RICHARDSON

Kearse, Amalya Lyle (June 11, 1937–), judge and bridge player. Born and raised in Vauxhall, N.J., Amalya L. Kearse graduated from Wellesley College in Massachusetts in 1959 and received her law degree from the University of Michigan in 1962. Upon graduating, she went to work for the law firm of Hughes, Hubbard & Reed in New York City, where, in 1969, she became the firm's first African-American partner.

In 1979, Kearse was appointed by President Jimmy Carter to serve as a judge on the United States Court of Appeals, Second District, in New York City. She became the first woman and the second African

American to sit on the federal appeals court in Manhattan. Among her notable decisions was her 1981 ruling that Banco Para el Comercio Exterior, the Cuban state bank, could not be held liable on a United States bank's claim for losses resulting from the Cuban government's expropriation of the U.S. bank's assets. The Cuban bank, she held, had a status independent from the government. Her decision, however, was later overturned by the U.S. Supreme Court. In 1987, Kearse wrote an opinion upholding a lower court ruling against the city of Yonkers, in which she ruled that Yonkers had intentionally segregated schools for decades by creating segregated public housing projects.

During the 1991 Senate Judiciary Committee hearings on the nomination of Clarence THOMAS to the U.S. Supreme Court (*see also* HILL-THOMAS HEARINGS), Kearse was named a possible alternative choice to Thomas in an article in the *American Lawyer,* which listed her among fifteen "first-rate centrists." She was considered as a serious candidate by the Clinton administration in 1992 for the position of U.S. Attorney General and, later in the year, as a candidate for another opening on the U.S. Supreme Court. In 1994, Kearse ruled in a Second Circuit decision that the Bush administration's 1990 census had vastly undercounted African Americans and Latinos in major cities in a way that diminished the flow of federal monies and the distribution of congressional seats.

Generally considered a social liberal and fiscal conservative, Kearse is highly respected by her peers for having a keen intellect, for being well prepared for each case that has come before her, and for being evenhanded and thoughtful. Her written opinions are regarded as both scholarly and thorough.

Kearse is also an avid BRIDGE player. In 1972, she won the National Women's Pairs Bridge Championship in the American Contract Bridge League. She wrote a book on the subject in 1980, *Bridge at Your Fingertips.* She won her first world-class championship in contract bridge in 1986.

REFERENCES

PEREZ-PEÑA, RICHARD. "Big Cities Win Appeals Ruling on '90 Census." *New York Times,* August 9, 1994, p. A1.
"Ruling is Upheld in Yonkers Bias." *New York Times,* December 29, 1987, p. 1.

JOSEPH W. LOWNDES

Keckley, Elizabeth (1818–May 26, 1907), dressmaker. Elizabeth Keckley was born Elizabeth Hobbs to a slave family in Dinwiddie Court House, Va. While in her teens she was sold to a North Carolina slaveowner. In North Carolina she was raped, probably by her owner, and gave birth to a son. At the age of eighteen she was repurchased, along with her son, by the daughter of her original owner and taken to St. Louis. There she began her career as a dressmaker, supporting her owners and their five children as well as her own son. In St. Louis she married James Keckley—a slave who convinced her to marry him by claiming to be free—but soon separated from him.

In 1855 Elizabeth Keckley was loaned $1,200 by her dressmaking customers to purchase her own freedom. She then established a successful dressmaking business. In 1860 she moved first to Baltimore and then to Washington, D.C., where she established herself as one of the capital's elite dressmakers. One of her customers was the wife of Jefferson Davis.

Mary Todd Lincoln, the wife of Abraham Lincoln, became one of Keckley's most loyal customers. Keckley soon made all of the First Lady's clothes, and the two struck up a close friendship. From 1861 to 1865 Keckley worked in the White House as Mary Todd Lincoln's dressmaker and personal maid.

During the Civil War Keckley became active in the abolitionist movement, helping to found an organization of black women to assist former slaves seeking refuge in Washington, D.C. The Contraband Relief Association received a $200 donation from Mary Todd Lincoln, and Keckley successfully solicited several prominent abolitionists for financial support, including Wendell Phillips and Frederick DOUGLASS.

After the assassination of President Lincoln, Mary Todd Lincoln and Keckley remained close friends until 1868, when Keckley's diaries were published as a book, *Behind the Scenes; or, Thirty Years a Slave, and Four Years in the White House.* Mary Todd Lincoln considered the book a betrayal and broke off her relationship with Keckley. Even several noted African Americans criticized Keckley for what they believed to be a dishonorable attack on "the Great Emancipator." Nonetheless, the book has long been considered an invaluable resource for scholars of the Lincoln presidency. It reveals much about the personalities of Abraham and Mary Todd Lincoln, their family life, and their opinions about government officials. The memoir also offers an intimate depiction of Keckley's life in slavery, particularly of the sexual violence she endured as a teenager. While its accuracy has not been questioned, the book's true authorship has been the subject of considerable debate, since its polished prose seems to be at odds with Keckley's lack of formal education.

Keckley's dressmaking business declined as a result of the controversy surrounding the book. In the 1890s she was briefly a teacher of domestic science, but for most of her later years lived in obscurity, supported by a pension paid to her because her son

Elizabeth Keckley, a dressmaker and confidante of Mary Todd Lincoln during her years as First Lady, later published a memoir, *Behind the Scenes,* a controversial account of the Lincoln White House. A former slave, Keckley was active in raising funds for freedpeople during the Civil War and remained active in African-American philanthropies in Washington, D.C., for many years. (Moorland-Spingarn Research Center, Howard University)

had been killed fighting for the Union Army. Keckley died on May 26, 1907, in a Washington rest home she had helped found.

REFERENCES

HINE, DARLENE CLARK. *Black Women in America: An Historical Encyclopedia.* Brooklyn, N.Y., 1993.

KECKLEY, ELIZABETH. *Behind the Scenes; or, Thirty Years a Slave, and Four Years in the White House.* 1868. Reprint. New York, 1988.

WASHINGTON, JOHN E. *They Knew Lincoln.* New York, 1942.

THADDEUS RUSSELL

Keith, Damon Jerome (July 4, 1922–), federal judge. Damon Keith was born and raised in Detroit, Mich. He earned an A.B. in 1943 from West Virginia State College, then served as a staff sergeant in the U.S. Army from 1943 to 1946. In 1949 Keith received an LL.B. from HOWARD UNIVERSITY. He returned to Detroit and from 1951 to 1955 worked as an attorney at the Office of the Friend of the Court. In 1956 he received an LL.M. from Wayne State University. Keith was a founding member of the Detroit law firm of Keith, Conyers, Anderson, Brown & Whals, where he was a full partner from 1964 to 1967. During his years in private practice, Keith was active politically in civil rights work as president of the Detroit Housing Commission (1958–1967), chairman of the Michigan Civil Rights Commission (1964–1967), and in other organizations, as well as being an active member in both the Detroit Area Council of the Boy Scouts of America and the Tabernacle Baptist Church.

In 1967 President Lyndon B. Johnson appointed him to the U.S. Federal District Court for Michigan. Among his most important decisions, often referred to by legal scholars as "The Keith Decision," was the case of the *United States* v. *U.S. District Court* (1971), in which he ruled that warrantless wiretaps, even those ordered by the president, are unconstitutional.

In 1974 Keith was awarded the NAACP's SPINGARN MEDAL. Three years later President Jimmy Carter appointed Keith to the Sixth Circuit, comprising Tennessee, Kentucky, Ohio, and Michigan. In 1979, in a widely noticed opinion, Keith, who has a reputation as a liberal Democrat, ruled in favor of the Detroit Police Department's affirmative action hiring program.

Keith has served as the First Vice President of the Detroit Chapter of the NAACP. In 1987 Chief Justice William Rehnquist appointed Keith as the National Chair of the Judicial Conference Committee on the Bicentennial of the Constitution. In 1993 Wayne State University established, in Keith's honor, the Damon J. Keith Law Collection, the first archival collection devoted entirely to African-American lawyers and judges.

REFERENCE

"Federal Judge Damon Keith Honored by Michigan Governor for Twenty Years on Bench." *Jet* (December 21, 1987): 14.

LOUISE P. MAXWELL

Kelley, William Melvin (November 1, 1937–), novelist. Born in New York City, William Melvin Kelley was raised in an Italian-American neighborhood in the north Bronx. He was educated at the Fieldston School in New York and at Harvard University (1957–1961), where he studied under poet

Archibald MacLeish and novelist John Hawkes. Kelley received the Dana Reed Literary Prize from Harvard in 1960 and was named Bread Loaf Scholar in 1962. His fiction, written primarily during the turbulent years of the civil rights era, is experimental in form and style. Particularly influenced by the writings of William Faulkner and James Joyce, Kelley applied postmodern literary strategies to a highly critical examination of contemporary American society.

His interrelated novels and stories are a deliberate attempt to create an American epic that would pertain to the individual experiences of blacks in this country. His first novel, *A Different Drummer* (1962), received both the John Hay Whitney Foundation Award and the Rosenthal Foundation Award in 1963. The novel treats the mass exodus of blacks from a southern state and examines the reasons for migration and its effects on both black and white citizens. Kelley's second book, *Dancers on the Shore* (1964), is a collection of short stories that examine the experiences of middle- and lower-class African-American families. The volume received the Transatlantic Review Award in the year of its publication.

The novel *A Drop of Patience* followed in 1965. It concerns the painful experiences of a blind African-American jazz musician who has an affair with a white woman. Kelley was a writer-in-residence at the State University of New York at Geneseo in 1965, then taught at the New School for Social Research in Manhattan. In 1967, he published the novel *dem,* a satire of middle-class white mores and values that focuses on a white New York City woman who gives birth to twins, one white and one black. The novel is an embittered critique of the violence and moral vacuity of America's racist institutions, culture, and psyche in the Vietnam era.

After finishing the final draft of *dem* in the spring of 1967, Kelley moved to Paris, where he lectured at Nanterre University and began writing *Dunfords Travels Everywheres* (1970), an experimental novel that critics have called the black equivalent of Joyce's *Finnegan's Wake.* The novel, which received an award from the Black Academy of Arts and Letters in 1970, is noted for its linguistic experimentation and for its use of a "double protagonist" to explore African-American identity and cultural heritage. The surrealistic narrative focuses on Chig Dunford, a Harvard-educated African American who first appeared in some of the stories in *Dancers on the Shore.* Dunford's search for self-actualization is developed through his identification with Carlyle Bedlow, a Harlem-raised trickster who fully understands the implications of his racial identity.

Kelley moved to Jamaica in the fall of 1968 and taught at the University of the West Indies, Mona, from 1969 to 1970. His essays and stories appeared in

Novelist and essayist William Melvin Kelley, the author of *A Different Drummer* and *Dunfords Travels Everywheres.* (Prints and Photographs Division, Library of Congress)

numerous periodicals and anthologies in the years following the publication of *Dunfords Travels Everywheres.* A freelance photographer, he also made a video entitled *Excavating Harlem* that was produced by Manhattan Cable Channel D in 1988.

REFERENCE

FABRE, MICHEL. "William Melvin Kelley and Melvin Dixon: Change of Territory." In *From Harlem to Paris: Black American Writers in France, 1840–1980.* Urbana, Ill., 1991.

WEYANT, JILL. "The Kelley Saga: Violence in America." *CLA Journal* 19 (1975): 210–220.

CAMERON BARDRICK

Kelly, Leontine Turpeau Current (March 5, 1920–), bishop and minister. Leontine Turpeau was born in Washington, D.C., and attended public

schools in Cincinnati, where her family moved in the late 1920s. In 1938, Turpeau entered West Virginia State College (later renamed West Virginia State University), but withdrew in 1941 to marry Goster Bryant Current.

The Currents divorced in the early 1950s, and Leontine Turpeau Current remarried in 1956. In 1958, she moved with her second husband, James David Kelly, a United Methodist minister, to Richmond. Leontine Kelly enrolled at Virginia Union University in Richmond and received her bachelor of arts degree in 1960. That same year, Kelly took a job teaching social studies and became a certified lay speaker in the Methodist Church. In 1966, Leontine Kelly quit her teaching job after her husband accepted the pastorship at Galilee United Methodist Church in Edwardsville, Va.

When James Kelly died in 1969, Galilee Church asked his wife to assume responsibility for running the church. Leontine Kelly accepted and began her theological studies shortly thereafter. In 1975, she left Galilee to accept a two-year position as director of the programs of social ministry at the Virginia Conference Council of Ministries. In 1976, Kelly received a master's of divinity from Union Theological Seminary in Richmond, and one year later, she was ordained an elder in the Methodist church.

In 1977, Kelly became pastor at Asbury United Methodist Church in Richmond. In 1983, she moved to Nashville, to accept an executive position on the board of discipleship of the national staff of the United Methodist Church. During this time, Kelly was active in the clergywomen's movement, struggling for greater opportunities for women in the ministry. In July 1984, Kelly was elected bishop of the Western Jurisdiction of the Methodist Church, becoming the second woman and the first African-American woman ever to hold this position.

Kelly moved to San Francisco to assume her duties, supervising close to four hundred churches in the California and Nevada conferences. As bishop, Kelly focused on improving the positions of women and ethnic groups within the church and on increasing church involvement in the social and economic development of black communities. During her term, Kelly served on the executive committee of the Council of Bishops and as president of the six-member Western Jurisdictional College of Bishops. In 1988, Kelly retired as bishop and accepted a part-time teaching position at the Pacific School of Religion in Berkeley, Calif. Since her retirement, she has remained active in the religious community, devoting her attention to church involvement in the country's health care crisis. In 1988, she accepted a one-year term as president of the board of directors of the AIDS National Interfaith Network. In January 1992, Kelly was elected to serve as president of the Washington, D.C.–based Interreligious Health Care Access Campaign, an organization devoted to achieving universal access to health care benefits.

REFERENCES

LANKER, BRIAN. *I Dream a World: Portraits of Black Women Who Changed America.* New York, 1989.

MARSHALL, MARILYN. "First Black Woman Bishop." *Ebony* 40 (November 1984): 164–170.

SMITH, JESSIE CARNEY, ed. *Epic Lives: One Hundred Black Women Who Made a Difference.* Detroit, 1993.

LOUISE P. MAXWELL

Kennedy, Adrienne (September 13, 1931–), playwright. Adrienne Kennedy was born Adrienne Lita Hawkins in Pittsburgh, Pa., and grew up in Cleveland, Ohio, where she went to public school. She received her bachelor of arts in education from Ohio State University in 1952 and shortly thereafter moved to New York City with her husband and child. Over the following ten years, she studied creative writing at various schools, including Columbia University (1954–1956), the New School for Social Research (1957), and the American Theater Wing (1958). The first of Kennedy's plays to be produced, *Funnyhouse of a Negro* (1963), was written while she was attending Edward Albee's workshop at the Circle in the Square. *Funnyhouse,* a one-act play about a young mulatto woman's efforts to come to terms with her mixed-race heritage, opened off-Broadway in 1964. Kennedy wrote two other one-act plays, *A Rat's Mass* and *The Owl Answers,* in 1963 and received the Stanley Drama Award for *Funnyhouse* and *The Owl Answers* that same year. She won an Obie for *Funnyhouse* in 1964.

Kennedy, an avant-garde dramatist, has considered the one-act play to be the most congenial form for exploring conflicts of race, gender, and identity. Her plays tend to be surrealistic and symbolic, rather than naturalistic, and she frequently uses masks or divides a single character's story among several characters or actors, to convey a sense of racial and psychic disorientation. Kennedy's fourth one-act play, *A Lesson in Dead Language,* was written in 1964. The following year, *A Beast's Story* appeared; it was performed in Westport, Conn., but did not open off-Broadway until 1969, when it was billed with *The Owl Answers* under the title *Cities in Bezique.*

Between the years 1967 and 1969, Kennedy was awarded a Guggenheim Memorial Fellowship as well as several writing grants from the Rockefeller Foundation. Her first full-length play, *In His Own Write,*

an adaptation of John Lennon's stories and poems, was written in 1967 and produced in London by the National Theatre Company. In 1971, Kennedy joined with five other women playwrights in founding the Women's Theater Council, a cooperative designed to promote the works of women playwrights and provide opportunities for women in other aspects of theater. *An Evening with Dead Essex,* her one-act memorial to Mark Essex, a black New Orleans youth who was murdered by the police, was written two years later.

During the 1970s and early '80s, Kennedy taught creative writing at Yale, Princeton, and Brown universities and received grants from the National Endowment for the Arts and the Creative Artists Public Service. Her second full-length play, *A Movie Star Has to Star in Black and White,* opened off-off-Broadway in 1976. In 1980, Kennedy was commissioned by the Empire State Youth Theatre Institute in Albany, N.Y., to write a children's musical, *A Lancashire Lad,* about the boyhood of Charlie Chaplin. That year, she wrote another children's play, *Black Children's Day,* based on the black experience in Rhode Island. In 1981, she was commissioned by the Juilliard School to write a full-length adaptation of *Orestes and Electra.* The year 1987 marked the appearance of another full-length play, *Diary of Lights,* and the publication of her memoirs, *People Who Led to My Plays.* In 1994, Kennedy was the recipient of the Lila Wallace–Reader's Digest Fund's Writer's Award, which she used to establish an arts and culture program for minority children in Cleveland's inner-city schools.

REFERENCES

BETSKO, KATHLEEN, and RACHEL KOENIG, eds. *Interviews with Contemporary Women Playwrights.* New York, 1987.
BRASMER, WILLIAM, and DOMINICK CONSOLO, eds. *Black Drama: An Anthology.* Columbus, Ohio, 1970.
COHN, RUBY. *New American Dramatists: 1960–1980.* New York, 1982.

PAMELA WILKINSON

Kenney, John Andrew (June 11, 1874–January 29, 1950), surgeon and editor. John Kenney was born in Albemarle County, Va., the son of John A. and Caroline Kenney. After early schooling in Charlottesville, Va., he attended Hampton Institute and graduated (in 1897) as class valedictorian. He earned an M.D. degree in 1901 at Leonard Medical School, Shaw University, and proceeded to Freedmen's Hospital in Washington, D.C., for his internship (1901–1902).

In 1902, Kenney accepted Booker T.WASHINGTON's offer of a position as school physician at the Tuskegee Institute. He became medical director and chief surgeon of Tuskegee's health-care facility, the John A. Andrew Memorial Hospital. An energetic administrator, he organized a school of nursing attached to the hospital and, in 1912, founded an annual postgraduate course—the John A. Andrew Clinic—that for years provided one of the few outlets in the country for African-American medical practitioners seeking to acquire new knowledge in their field. When he advocated the hiring of black staff for a new Veterans Administration hospital planned for Tuskegee in the early 1920s, the Ku Klux Klan burned a cross on his lawn and threatened his life. This incident prompted his departure for Newark, N.J., in 1924. There he established the Kenney Memorial Hospital (in memory of his parents) and worked in private practice. In 1939, he returned to Tuskegee as medical director of the John A. Andrew Memorial Hospital. He retired to Montclair, N.J., in 1944.

Kenney served as secretary of the National Medical Association from 1904 to 1912 and became its fourteenth president in 1912. In 1908 he proposed that the association publish a journal as a forum for medical and scientific dialogue among black professionals. He served as the journal's associate editor (1909–1916) and editor (1916–1948). In 1912, Kenney published one of the first monographs on the history of blacks in medicine, *The Negro in Medicine.*

REFERENCES

COBB, W. MONTAGUE. "John Andrew Kenney, M.D., 1874–1950." *Journal of the National Medical Association* 42 (May 1950): 175–177.
KENNEY, JOHN A. *The Negro in Medicine.* Tuskegee, Ala., 1912.

PHILIP N. ALEXANDER

Kentucky. African Americans were among the first settlers in Kentucky. Their numbers grew rapidly during the pioneer period, and in 1777 blacks made up about 10 percent of the inhabitants. The black population peaked at 25 percent of Kentuckians in 1830 before declining to 20 percent in 1860.

Most African Americans were slaves, and the main areas of SLAVERY were the central Bluegrass region, the counties along the Ohio River, and southwestern Kentucky. Eastern Kentucky's black population remained small, and urban slavery was unimportant outside of Lexington and Louisville.

A land of small farms, Kentucky was not particularly suitable for large-scale slavery. Only 28 percent of whites owned slaves, with the average owner possessing only five; 25 percent of slave holders owned just one. During settlement, African Americans labored alongside their owners clearing forests and building cabins. Later, most slaves toiled in agriculture but some more highly skilled served as artisans or factory laborers. In addition to domestic work, women wove cloth, sewed, and cared for children. Slave holders sometimes hired out skilled bondsmen. Increasingly popular as a practice, slave hiring occasionally provided bondsmen opportunities to purchase their freedom.

Family, home, and church were the centers of slave culture. Marriages were illegal, but family institutions remained strong. Despite a 20 percent chance of being sold at least once in their life, many slaves maintained fairly happy family relationships. The typical family of five lived in a 100-square-foot log cabin with crude furniture and no privacy. Clothing for many provided inadequate protection during winter. African Americans supplemented limited diets by gardening, hunting, and fishing. Recreational singing and dancing softened slavery's harshness. Treated as second-class members of white churches, slaves preferred separate, all-black services. African-American churches became the protectors of black rights, initiators of self-help programs, and training grounds for leadership.

The patrol system failed to eliminate black mobility, but those caught breaking regulations received harsh punishments. The legal protections for blacks were largely unenforced. Harassment of blacks was easy and on occasion the legal system condoned heinous crimes by whites against African Americans. Typically, slaves protested their condition with passive resistance, but some ran away to free soil north of the Ohio River. Those who fled usually did so without assistance from the UNDERGROUND RAILROAD. Perhaps the best-known runaway slave from Kentucky was Josiah HENSON, who escaped from Kentucky in 1830 and later became one of the prototypes for the character of Uncle Tom in Harriet Beecher Stowe's UNCLE TOM'S CABIN.

Kentucky's small free-black population—about 4 percent of blacks and totaling 10,684 in 1860—gravitated toward cities where greater numbers made surveillance difficult. Whites applied the same inaccurate stereotypes to both free and enslaved blacks, labeling them as lazy and worthless. In reality, free blacks provided many skilled laborers for Kentucky's economy; a few achieved enough success as entrepreneurs to purchase the freedom of loved ones.

The CIVIL WAR offered the first viable opportunity for Kentucky bondsmen to express openly their opposition to slavery. They increasingly refused to obey orders, fled to Union lines, and joined the federal army when black recruiting began. About 24,000 Kentucky blacks served in the Union army. Kentucky, which did not secede from the Union, was not covered by the EMANCIPATION PROCLAMATION and state officials refused to accept the end of slavery until ratification of the THIRTEENTH AMENDMENT on December 18, 1865.

At the Civil War's end, Kentucky's African Americans possessed few of life's necessities, and the state legislature fastened inequality upon them by law. Only family solidarity and meager support from the Freedmen's Bureau kept many from starving. Blacks usually found jobs at the bottom rung of the economic ladder. From that disadvantaged position, they provided their own social services while living in a segregated society. Churches remained cultural centers from which ministers rallied their people to agitate for public education, civil, and political rights. After years of protest, African Americans won voting rights in 1870, the right to testify against whites in state courts in 1872, a system of public education in 1874, and full jury participation in 1882. These gains, unfortunately, came as Kentucky blacks saw federal protections under the Civil Rights Acts of 1866 and 1875 overturned by the Supreme Court in 1883. By the mid-1890s segregation in Kentucky intensified as blacks were driven from white-owned restaurants, hotels, and theaters, and in 1892 the legislature's attempt to segregate railway travel failed only because of the concerted statewide opposition of blacks, led by Professor C. C. Monroe of the State Normal School in Frankfort and Rev. Charles H. Parrish, Sr., of Louisville.

By the 1890s, however, a small but energetic middle class prospered in Kentucky. Dr. Henry Fitzbutler, a graduate of the University of Michigan, opened a thriving medical practice and in 1888 founded the National Medical School in Louisville. James A. Chiles began practicing law in Lexington, and Robert Lander opened a law office in Hopkinsville. W. H. Steward's *American Baptist,* headquartered in Louisville, the official organ of black Baptists, was one of more than a dozen black newspapers in the state. William J. SIMMONS was author of the pioneering African-American biographical dictionary *Men of Mark* (1887). He was also president of State University, Kentucky's Baptist educational institution which opened in 1879, known as the Baptist Normal and Theological Institute until 1883. In addition, Simmons launched *Our Women and Children,* a popular magazine.

The twentieth century brought new opportunities as well as new divisions within the black community. After acquiring the right to vote with the passage of the FIFTEENTH AMENDMENT in 1870, Kentucky blacks

became the linchpin of the state Republican Party. By the late nineteenth century, however, the failure of white Republicans to share patronage erupted into a division within the black community which continued throughout the twentieth century. This split reflected a basic dichotomy within the black community—accommodationists (*see* ACCOMMODATIONISM) versus activists. The first challenge to accommodationist leadership provided by figures such as W. H. STEWARD, came from I. Willis Cole, founder in 1917 of the *Louisville Leader,* Kentucky's dominant black newspaper until the appearance of the *Louisville Defender* in the 1930s, and William Warley. Cole and Warley, both crusading journalists, challenged accommodationist leadership, taking a militant stand against discrimination. In 1921, convinced that African Americans could anticipate no rewards for their steadfast loyalty to the REPUBLICAN PARTY, Warley formed the Lincoln Independent Party, which represented a new generation of black leaders no longer moved by calls to support the "party of emancipation." Though opposed by moderate blacks, the Lincoln Independent Party set a new course for those determined to oppose demands for JIM CROW streetcars and to challenge the white majority for jobs, education, and political positions. Though denounced by accommodationist blacks and beaten at the polls by Republican money, the Lincoln Independent Party demonstrated to Republican leaders that they must make concessions to African Americans, without whose votes the Republican Party could not win. As a result, Republican administrations during the 1920s began hiring blacks for the first time for clerical jobs and as policemen and firemen.

The NEW NEGRO leadership of the twentieth century also struggled against conservative control of the NATIONAL ASSOCIATION FOR THE ADVANCEMENT OF COLORED PEOPLE (NAACP) in Kentucky. From the first chapter formed in Louisville in 1914, the NAACP spread to ten Kentucky cities and towns by 1930 and about thirty branches existed by World War II. Victory over older conservatives for the new, more militant black NAACP leaders, such as Warley and Cole, came in 1920 when antiaccommodationists defeated a bond issue for the University of Louisville which did not admit black students. Through the 1920s and 1930s, the NAACP successfully challenged segregation ordinances and fought against the activities of Kentucky's KU KLUX KLAN.

Two interracial organizations also assisted Kentucky's black community. The local chapter of the NATIONAL URBAN LEAGUE, which worked to improve housing and economic opportunities, organized a chapter in Louisville in 1920; unfortunately, no other branch opened until 1966 when a chapter was organized in Lexington. From 1920 to 1929,

James Bond, a graduate of Berea College and Oberlin Seminary, directed the Kentucky Interracial Commission, another conservative organization. Though controlled by a white agenda and dominated by black conservatives, Bond's leadership skills made Kentucky's Interracial Commission the best led in the nation.

In spite of exhaustive efforts to advance economically, at the turn of the century blacks were still barred from most jobs in Kentucky. The best jobs available to blacks were service jobs such as messengers, barbers, and postmen. In 1910 more than 60 percent of black men worked in agriculture, as laborers, or as servants, while fewer than 10 percent held semi-skilled, skilled, or professional jobs. Employment conditions for women were even worse; about 80 percent of black women worked as domestics.

The first great economic successes within the black community came during the second decade of the twentieth century. In 1915 Louisville businessmen William Wright and Henry Hall founded Mammoth Life and Accident Insurance Company. Mammoth Life soon had offices throughout the commonwealth, and rapidly became the most successful black-owned firm in Kentucky, writing 80,000 policies in just five years. In 1922 Mammoth Life opened the American Mutual Saving Bank. Mammoth survived the GREAT DEPRESSION and by the 1970s had offices in eight states. A second group of businessmen formed Domestic Life and Accident Insurance Company in Louisville in 1921, and shortly thereafter, organized First Standard Bank, also a quick success.

At the outbreak of World War II, positions for blacks in defense industries in Kentucky were few and progress remained slow. When A. Philip RANDOLPH, president of the BROTHERHOOD OF SLEEPING CAR PORTERS, organized a march on Washington, D.C., to protest employment discrimination, the president issued an executive order mandating fair employment opportunities for blacks. Unfortunately, discrimination in federal jobs, including the military, did not end in Kentucky. At mid-century, Kentucky employers continued to advertise available jobs as "white" and "black" positions, with lower pay for blacks.

The Great Depression affected a political revolution for Kentucky blacks. New Deal programs led to a mass exodus of blacks from the Republican Party, and from the 1930s through the 1950s a new generation of African-American lawyers, editors, and educators provided community leadership. In the 1930s the *Louisville Defender,* under award-winning editor Frank Stanley, Sr., became Kentucky's leading black newspaper.

Despite or perhaps because of the Republican Party's steady loss of black voters, in 1936 Kentucky's Republicans successfully ran Charles ANDER-

SON for the legislature, the first black elected to the state house. Well-educated, outspoken, and determined to rid Kentucky of all forms of racism and segregation, Anderson, with the backing of Stanley's paper, challenged JIM CROW on every front. Together he and Stanley worked tirelessly to secure better education, acquire equal pay for black teachers, end school segregation, and integrate the Universities of Louisville and Kentucky. In 1946 Anderson became Assistant Commonwealth Attorney for Jefferson County, the first black to hold that position.

Education for blacks immediately after the Civil War largely reflected their own efforts and meager support from northern philanthropists. Several urban school districts began assisting private black schools by 1870, but Kentucky did not fashion a public system of education for blacks until 1874. Black public schools were segregated and unequally funded until 1882. Even after equalization of school financing, school officials found ways to deprive black schools of their share of funding. African-American demands for a teacher training institution forced the legislature to establish Kentucky State Normal School in Frankfort in 1886. Plagued by a lack of funds and an excess of politics, Kentucky State Normal School consisted of little more than a high school well into the twentieth century. Other opportunities for higher education for blacks in Kentucky existed at State University and Berea College in central Kentucky. Berea, begun by white Kentucky abolitionists in 1855 as an experiment in integrated education, provided quality education for blacks and whites until 1904 when passage of the Day Law prohibited integrated education in Kentucky, even in private schools.

Before the 1930s, public school terms remained woefully short, programs emphasized industrial skills designed to keep African Americans "in their place," few opportunities for higher education existed, and 15 percent of Kentucky's blacks remained illiterate. During the 1930s, Charles Anderson and a band of dedicated citizens began efforts that eventually desegregated public education at all levels. Anderson's first success came in a 1948 amendment to the Day Law which allowed integrated programs for nurses and postgraduate courses for physicians. In 1949, following a court battle, Lyman T. Johnson, a civil rights leader and a Louisville teacher, won admission to the University of Kentucky, but five years passed before black students were accepted as undergraduates. The University of Louisville admitted black students in 1950, but more than five years elapsed before all state universities admitted blacks.

The integration of public schools began with promise in the fall of 1955, but patterns of desegregation soon revealed a deep racial division within Kentucky society. While governors and white liberals gave positive support to African-American demands, rural school districts maintained the status quo. By the mid-1960s, the NAACP had instituted integration suits in thirteen school districts, achieving token integration but at a grossly unfair displacement of black teachers and with an 80 percent decline in black school administrators by 1970. Attempts in the mid-1970s to correct these problems by busing students led to violence and white flight to the suburbs, forcing the federal courts to require a new desegregation plan. However, by the late 1980s, largely because of further desegregation of Jefferson County schools, Kentucky achieved the highest level of school integration of any state.

During the 1960s, Kentucky's blacks finally won access to public accommodations, largely because of the work of leaders such as Georgia Davis POWERS, the first black woman elected to the Kentucky state senate, and the activities of the Kentucky Commission on Human Rights. In 1966, a commission-advocated public accommodations bill which guaranteed equal access to public accommodations and prohibited employment discrimination finally became law. Buoyed by Bardstown's model 1966 fair housing law—and those of Covington, Lexington, and Louisville—in 1968 Senator Georgia Davis Powers and Representative Mae Street Kidd pushed Kentucky's Fair Housing Act through the legislature. Antisegregation suits initiated in the early 1970s against public housing authorities slowly yielded results by the 1980s. In instances where housing authorities adopted long-range, affirmative-action desegregation plans, integration moved in a timely fashion, but in several areas where large units of public housing existed, such as Bowling Green, Louisville, and Lexington, desegregation marched at a snail's pace, making the overall rate of desegregation minimal.

In 1982 protection for minority rights received a tremendous boost when the Kentucky Supreme Court upheld a 1974 law which made victims of discrimination eligible for financial compensation for embarrassment and/or humiliation. Nevertheless, the condition of blacks in the 1990s seemed sadly familiar. Despite significant contributions, blacks did not share fully and proportionally in Kentucky's prosperity. In 1994, blacks held 7 percent of state positions, a percentage equal to their proportion of the population, but most remained concentrated in lower-paying jobs. One noticeable trend, however, was the movement of African Americans into high-profile positions at the city, county, and state levels. Blacks made significant gains as school administrators, as paraprofessionals, in management, and in technical services positions, and in 1994 more than 100 African Americans held elective or appointive office. Joe W. Denning sat on the Bowling Green School Board

from 1975 until 1992 when he won a seat on the City Commission, and since 1983 Darrell T. Owens has served as Jefferson County Commissioner. In 1989 Gary Payne was chosen district judge in Lexington, a position Janice Martin attained in 1993. Two African Americans have served on the governor's cabinet: George W. Wilson was appointed Corrections Cabinet Secretary in 1981, and since 1992 Kim M. Burse has held the position of Revenue Cabinet Secretary. Much improvement, however, remains to be made in employment before African Americans can realize in Kentucky the promise of American life.

In the 1990s, black Kentuckians also won national recognition in the arts. The design of Louisville-born sculptor Ed Hamilton was selected as the centerpiece for a Civil War Memorial for African-American soldiers to be erected in Washington, D.C. In 1993 writer-director George C. Wolfe of Frankfort, Ky., creator of *Jelly's Last Jam* and winner of Tony and Drama Desk awards for best director for *Angels in America: Millennium Approaches,* was chosen producer of the New York Shakespeare Festival.

REFERENCES

COMMISSION ON HUMAN RIGHTS. *Kentucky's Black Heritage.* Frankfort, Ky., 1971.

DUNNIGAN, ALICE ALLISON. *The Fascinating Story of Black Kentuckians: Their Heritage and Traditions.* Washington, D.C., 1982.

HARRISON, LOWELL H. *The Antislavery Movement in Kentucky.* Lexington, Ky., 1978.

LUCAS, MARION B. *A History of Blacks in Kentucky: From Slavery to Segregation, 1760–1891.* Frankfort, Ky., 1992.

WRIGHT, GEORGE C. *A History of Blacks in Kentucky: In Pursuit of Equality, 1890–1980.* Frankfort, Ky., 1992.

WRIGHT, GEORGE G. *Life Behind a Veil: Blacks in Louisville, Kentucky, 1865–1930.* Baton Rouge, La., 1985.

MARION B. LUCAS

Kerner Report. The Kerner Report was the result of a seven-month study by the National Commission on Civil Disorders to pinpoint the cause of racial violence in American cities during the late 1960s. The eleven-member panel was better known as the Kerner Commission, after its chairman, Gov. Otto Kerner of Illinois.

President Lyndon Johnson appointed the commission on July 28, 1967, in the wake of large-scale urban rioting in the United States between 1965 and 1967 (*see* URBAN RIOTS AND REBELLIONS), which resulted in several deaths and injuries as well as wide-spread property damage. The commission was charged with tracing the specific events that led up to the violence, finding general reasons for the worsening racial atmosphere in the country, and suggesting solutions to prevent future disorders.

The Kerner Report was submitted to Johnson in February 1968. It concluded, in part, that the violence had its roots in the frustration and anger of poor urban blacks concerning such problems as high unemployment, discrimination, poor schools and health care, and police bias.

Stating that discrimination and segregation were deeply embedded in American society, the report warned that America was "moving toward two societies, one black, one white—separate and unequal." The report recommended a massive national commitment to sweeping reforms to improve education, housing, employment opportunities, and city services in poor black urban areas.

The Rev. Dr. Martin Luther KING, Jr., called the report "a physician's warning of approaching death, with a prescription for life." The prescription was, however, largely ignored. Many whites thought the report placed too much blame for the riots on societal problems and white racism, and not enough on the lawlessness of black rioters. Johnson accepted the report but did not support its conclusions. Few of the report's recommendations were ever implemented.

REFERENCES

CARSON, CLAYBORNE, ed. *Eyes on the Prize: America's Civil Rights Years.* New York, 1989.

O'REILLY, KENNETH. *Racial Matters: The FBI's Secret File on Black Americans, 1960–1972.* New York, 1989.

RENE SKELTON

Killens, John Oliver (January 14, 1916–October 27, 1987), novelist. Born in Macon, Ga., to Charles Myles, Sr., and Willie Lee (Coleman) Killens, John Killens credits his relatives with fostering in him cultural pride and literary values: his father had him read a weekly column by Langston HUGHES; his mother, president of the Dunbar Literary Club, introduced him to poetry; and his great-grandmother filled his boyhood with the hardships and tales of slavery. Such early exposure to criticism, art, and folklore is evident in his fiction, which is noted for its accurate depictions of social classes, its engaging narratives, and its successful layering of African-American history, legends, songs, and jokes.

Killens originally planned to be a lawyer. After attending Edward Waters College in Jacksonville,

Fla. (1934–1935) and Morris Brown College in Atlanta, Ga. (c. 1935–1936), he moved to Washington, D.C., became a staff member of the National Labor Relations Board, and completed his B.A. through evening classes at HOWARD UNIVERSITY. He studied at the Robert Terrel Law School from 1939 until 1942, when he abandoned his pursuit of a degree and joined the army. His second novel, *And Then We Heard the Thunder* (1963), concerning racism in the military, was based on his service in the South Pacific. It was nominated for the Pulitzer Prize.

In 1946 Killens returned briefly to his office job at the National Labor Relations Board. In 1947–1948, he organized black and white workers for the Congress of Industrial Organizations (CIO) and was an active member of the Progressive Party. But he soon became convinced that leading intellectuals, the white working class, and the U.S. government were not truly committed to creating a more inclusive society.

Killens moved to New York in 1948, attended writing classes at Columbia University and New York University, and met such influential figures as Langston HUGHES, Paul ROBESON, and W. E. B. DU BOIS. While working on his fiction, he wrote regularly for the leftist newspaper *Freedom* (1951–1955). His views at the time, closely aligned to the COMMUNIST PARTY, were evident in his 1952 review of Ralph ELLISON's *Invisible Man*. He attacked the novel as a "decadent mixture . . . a vicious distortion of Negro life." Killens believed that literature should be judged on its potential for improving society: "Art is functional. A Black work of art helps the liberation or hinders it."

Fortunately, Killens had already found some young writers, many with close ties to left-wing or black nationalist organizations, committed to the idea of writing as a vehicle of social protest. With Rosa GUY, John Henrik Clarke, and Walter Christmas, he founded a workshop that became known as the HARLEM WRITERS GUILD in the early 1950s.

Killens's *Youngblood* (1954), the first novel published by a guild member, treats the struggles of a southern black family in early twentieth-century Georgia. Following the critical praise of this book, Killens toured the country to speak on subjects concerning African Americans. In 1955 he went to Alabama to research a screenplay on the MONTGOMERY BUS BOYCOTT and to visit with the Rev. Dr. Martin Luther KING, Jr. Killens also became close friends with MALCOLM X, and with him founded the Organization for Afro-American Unity in 1964. *Black Man's Burden,* a 1965 collection of political essays, documents his shift from a socialist philosophy to one that promotes black nationalism.

Killens's major subject is the violence and racism of American society, how it hinders black manhood and family. *'Sippi* (1967) is a protest novel about struggle over voting rights in the 1960s. *The Cotillion; or, One Good Bull Is Half the Herd,* published in 1971 and nominated for the Pulitzer Prize, satirizes middle-class African-American values, and was the basis for *Cotillion,* a play produced in New York City in 1975. Killens's other plays include *Ballad of the Winter Soldiers* (1964, with Loften MITCHELL) and *Lower Than the Angels* (1965). He wrote two screenplays, *Odds Against Tomorrow* (1959, with Nelson Gidding) and *Slaves* (1969, with Herbert J. Biberman and Alida Sherman). He also edited *The Trial Record of Denmark Vesey* (1970) and authored two juvenile novels, *Great Gittin' Up Morning: A Biography of Denmark Vesey* (1972) and *A Man Ain't Nothin' but a Man: The Adventures of John Henry* (1975).

By the mid-1960s, Killens had already started a string of positions as a writer-in-residence: at Fisk University (1965–1968), Columbia University (1970–1973), Howard University (1971–1972), Bronx Community College (1979–1981), and

John O. Killens, a leading African-American novelist of the twentieth century, saw his literary efforts as part of the black struggle for equality. Standing is the poet and critic Sterling Brown. (Moorland-Spingarn Research Center, Howard University)

Medgar Evers College in the City University of New York (1981–1987). Other awards included a fellowship from the National Endowment for the Arts (1980) and a Lifetime Achievement Award from the Before Columbus Foundation (1986). Until his death, Killens continued to contribute articles to leading magazines such as EBONY, *Black World, The Black Aesthetic,* and *African Forum. The Great Black Russian: a Novel on the Life and Times of Alexander Pushkin* was published posthumously in 1988.

REFERENCES

CRUSE, HAROLD. *The Crisis of the Negro Intellectual.* New York, 1967.

GAYLE, ADDISON, JR. *The Way of the New World: The Black Novel in America.* Garden City, N.Y., 1975, pp. 261–277.

MALINOWSKI, SHARON. *Contemporary Authors: New Revision Series.* Vol. 26. New York, 1991, pp. 213–216.

Obituary. *American Visions* 3 (February 1988): 10.

Obituary. *New York Times,* October 30, 1987, sec. IV, p. 22.

WIGGINS, WILLIAM H., JR. "John Oliver Killens." *Dictionary of Literary Biography.* Vol. 33, *Afro-American Fiction Writers After 1955.* Detroit, 1984, pp. 144–152.

DEREK SCHEIPS

Kincaid, Jamaica (May 25, 1949–), author. Born Elaine Potter Richardson in St. Johns, Antigua, Jamaica Kincaid moved to New York at the age of sixteen, ostensibly to become a nurse. Working first as an au pair and then at other odd jobs, she spent brief periods studying photography at New York's School for Social Research and at Franconia College in New Hampshire. She began her career as a writer by conducting a series of interviews for *Ingénue.* Between 1974 and 1976 she contributed vignettes about African-American and Caribbean life to the *New Yorker.* In 1976 she became a staff writer for the *New Yorker,* which two years later published "Girl," her first piece of fiction. Most of Kincaid's fiction has first appeared in the magazine, for which she also began to write a gardening column in 1992.

Kincaid's first volume of stories, *At the Bottom of the River* (1983), has a dreamlike, poetic character. Her early interest in photography, evident here, also undergirds the rest of her work with its emphasis on condensed images. The choice of the short-story form allows her to isolate moments of heightened emotion. Published separately, the stories that make up the novel *Annie John* (1985) string such brief glimpses together to explore a defiant Annie's growing up in Antigua and especially her relationship to her mother. Themes of mother-daughter conflict are central to Kincaid's work and can be extended into metaphorical relations, such as that between the Caribbean island and those who leave it. For those who visit it, *A Small Place* (1988) is an extended essay on contemporary Antigua, an essay directed toward the tourist. Its tone is alternately cynical and wise, its information painful to accept, but its characteristically careful wording entices the reader as much as any poster of island beauty. *Lucy* (1990) combines the vigor of this Antiguan commentary and the embryonic artistic sensibility of *Annie John* into an extended allegory of the colonial relation set in the contemporary period. Lucy Josephine Potter, a young woman from the Caribbean entrusted with caring for four blond children, brazenly charges through her new world until the blank page confronts her with the fragility of her own identity.

Kincaid's colorful personality and life history, perhaps best exemplified in the selection of her assumed name, propel critical interest in her biography. Like many black writers, especially women, she is burdened both with the expectation that she will represent not merely herself but her community and with the assumption that her stories will be true and factual. The insistent presence of the first person in Kincaid's work is a challenge to that combined requirement. Filtering every perception through an individual, even selfish, lens, her stories are not autobiography; only the depth of feeling is. Kincaid has maintained that she is uninterested in literary realism. Borne by her plain-speaking prose, her audacious girl/woman protagonists gain an audience they might never have gotten in life.

REFERENCES

CUDJOE, SELWYN R. "Jamaica Kincaid and the Modernist Project: An Interview." In *Caribbean Women Writers: Essays from the First International Conference.* Wellesley, Mass., 1990, pp. 215–232.

MURDOCH, H. ADLAI. "Severing the (M)other Connection: The Representation of Cultural Identity in Jamaica Kincaid's *Annie John.*" *Callaloo* 13, no. 2 (Spring 1990): 325–340.

GINA DENT

King, Albert (c. April 25, 1923–December 21, 1992), blues singer and guitarist. Albert King was born Albert Nelson near Indianola, Miss., in the Mississippi Delta, on a date that remains in dispute. As a child he sang in churches, and after 1931, when his family moved to Osceola, Ark., he began to sing blues and play a homemade guitar, learning from

such local musicians as Elmore JAMES, HOWLIN' WOLF, and Robert Nighthawk. In the 1940s and '50s he supported himself by field and factory work, and by driving bulldozers and tractors. However, he also played music professionally, living in St. Louis, Chicago, and Gary, Ind. In the late 1940s King, as he began to be called, performed with In the Groove, a RHYTHM AND BLUES jump band. During this time he also performed with the Harmony Kings, a gospel vocal quartet. King played drums with Jimmy Reed in the early 1950s. He had his first breakthrough in 1953, when he took up guitar again and recorded "Bad Luck Blues."

King returned to St. Louis in 1956 and began to make a name for himself as a formidable guitarist and singer. His recordings from this time include "I Walked All Night Long" (1959) and "Blues at Sunrise" (1960). In 1962 King had a hit record with "Don't Throw Your Love on Me So Strong," which featured his gruff, shouting voice and brusque solos on guitar, which he played left-handed and upsidedown. In 1966 he began to record with Stax Records, an association that resulted in several rhythm and blues hits, including "Crosscut Saw" (1966), "Laundromat Blues" (1966), "The Hunter" (1967), and "Born Under a Bad Sign" (1967).

King's music strongly influenced ROCK AND ROLL musicians, and in the late 1960s his audience grew. He often performed in large concert halls, and in 1968 recorded *Live Wire/Blues Power* at the Fillmore West in San Francisco. In 1969 he performed with the St. Louis Symphony Orchestra. By the 1970s King's reputation as a blues guitarist equalled that of MUDDY WATERS and B. B. KING, and he performed at clubs and festivals in both the United States and Europe. Although he never produced any hits after the 1960s, King continued to record prolifically. His albums included *Lovejoy* (1971), *The Pinch* (1976), *New Orleans Heat* (1978), *Blues for Elvis* (1983), *I'm in a Phone Booth Baby* (1984), and *Red House* (1991). King, who was inducted into the Blues Foundation's Hall of Fame in 1983, died at the age of sixty-nine of a heart attack in Memphis, Tenn.

REFERENCES

ALDIN, MARY KATHERINE. "Albert King Interview." *Blues and Rhythm* 1 (July 1984): 4–10.
GURALNICK, PETER. *Lost Highway*. New York, 1982.

JONATHAN GILL

King, Coretta Scott (April 27, 1927–), civil rights activist. Born in Marion, Ala., a rural farming community, Coretta Scott attended Lincoln High School, a local private school for black students run by the AMERICAN MISSIONARY ASSOCIATION. After graduating in 1945, she received a scholarship to study music and education at Antioch College in Yellow Springs, Ohio. Trained in voice and piano, she made her concert debut in 1948 in Springfield, Ohio, as a soloist at the Second Baptist Church. Scott officially withdrew from Antioch in 1952 after entering the New England Conservatory of Music in 1951 to continue her music studies.

During her first year at the conservatory, she met the Rev. Dr. Martin Luther KING, Jr., who was a doctoral candidate at Boston University's school of theology. The two were married on June 18, 1953, despite Martin Luther King, Sr.'s opposition to the match because of his disapproval of the Scott family's rural background and his hope that his son would marry into one of Atlanta's elite black families. The couple returned to Boston to continue their studies. The following year, Coretta Scott King received a bachelor's degree in music (Mus.B.) from the New England Conservatory of Music, and in September the two moved to Montgomery, Ala., despite Coretta King's misgivings about returning to the racial hostility of Alabama.

Although Coretta King aspired to become a professional singer, she devoted most of her time to raising her children and working closely with her husband after he had assumed the presidency of the MONTGOMERY IMPROVEMENT ASSOCIATION in 1955. She participated in many major events of the CIVIL RIGHTS MOVEMENT along with her husband, both in the United States and overseas, as well as having to endure the hardships resulting from her husband's position, including his frequent arrests and the bombing of their Montgomery home in 1956.

Early in 1960, the King family moved to Atlanta when King became copastor of Ebenezer Baptist Church with his father. Later that year, Coretta King aided in her husband's release from a Georgia prison by appealing to presidential candidate John F. Kennedy to intervene on his behalf. In 1962, Coretta King became a voice instructor at Morris Brown College in Atlanta, but she remained primarily involved in sharing the helm of the civil rights struggle with her husband. She led marches, directed fund raising for the SOUTHERN CHRISTIAN LEADERSHIP CONFERENCE and gave a series of "freedom concerts" that combined singing, lecturing, and poetry reading. A strong proponent of disarmament, King served as a delegate to the Disarmament Conference in Geneva, Switzerland, in 1962, and in 1966 and 1967 was a cosponsor of the Mobilization to End the War in Vietnam (*see* VIETNAM WAR). In 1967, after an extended leave of absence, she received her bachelor of arts degree in music and elementary education from Antioch College.

Coretta Scott King speaking at a rally during the Peace March on Washington, D.C., 1963. (© Dennis Brack/Black Star)

On April 8, 1968, only four days after the Rev. Dr. Martin Luther King, Jr., was assassinated in Memphis, Coretta King substituted for her deceased husband in a march on behalf of sanitation workers that he had been scheduled to lead. Focusing her energies on preserving her husband's memory and continuing his struggle, Coretta King also took part in the POOR PEOPLE'S WASHINGTON CAMPAIGN in the nation's capital during June 1968, serving as the keynote speaker at the main rally at the Lincoln Memorial. In 1969 she helped found and served as president of the Atlanta-based Martin Luther King, Jr. Center for Nonviolent Social Change, a center devoted to teaching young people the importance of nonviolence and to preserving the memory of her husband. In 1969 she also published her autobiography, *My Life with Martin Luther King, Jr.,* and in 1971 she received an honorary doctorate in music from the New England Conservatory.

In 1983 Coretta King led the twentieth-anniversary march on Washington and the following year was elected chairperson of the commission to declare King's birthday a national holiday, which was observed for the first time in 1986. She was active in the struggle to end apartheid, touring South Africa and meeting with Winnie Mandela in 1986 and returning

there in 1990 to meet the recently released African National Congress leader, Nelson Mandela.

Coretta King has received numerous awards for her participation in the struggle for civil rights, including the outstanding citizenship award from the Montgomery Improvement Association in 1959 and the Distinguished Achievement Award from the National Organization of Colored Women's Clubs in 1962. As of 1993, she retained her position as chief executive officer of the Martin Luther King, Jr. Center for Nonviolent Change, having resigned the presidency to her son, Dexter Scott King, in 1989. As she has done for many years, Coretta Scott King continues to press for the worldwide recognition of civil rights and human rights.

REFERENCES

BRANCH, TAYLOR. *Parting the Waters: America in the King Years, 1954–63.* New York, 1988.
KING, CORETTA SCOTT. *My Life with Martin Luther King, Jr.* New York, 1969.

LOUISE P. MAXWELL

King, Don (August 20, 1931–), boxing promoter. Don King was born and raised in Cleveland, Ohio. As a young adult King was involved in organized crime in Cleveland, running an illegal lottery. King also owned a nightclub, and in 1966 was convicted of manslaughter for killing a former employee during a street fight. He spent four and a half years in an Ohio penitentiary and was paroled in 1971. King was pardoned by the governor of Ohio in 1983.

Soon after his release King began a career as a BOXING promoter. By 1972 he was promoting and unofficially managing local fighters, including Earnie Shavers, who went on to become a challenger for the heavyweight championship. In 1973, immediately after George FOREMAN knocked out Joe FRAZIER to become heavyweight champion, King talked himself into Foreman's camp and was hired as the new champion's promoter. With his newly established Don King Productions company, King set up Foreman's first defense of the championship, a successful two-round knockout of Ken NORTON in Caracas, Venezuela. In 1974 King arranged a match between Foreman and former champion Muhammad ALI in Kinshasa, Zaire. The "Rumble in the Jungle" ended when Foreman was knocked out in the eighth round, but the fight provided Foreman with $5 million and established King as the sport's most successful promoter.

Based in New York, King went on to promote fights for a number of the greatest boxers of the

Boxing promoter Don King has been instrumental in the careers of many important fighters, among them heavyweight champion Mike Tyson, seen here in front of King after an Atlantic City bout in 1988. (AP/Wide World Photos)

1970s, '80s, and '90s, including Muhammad Ali, Larry HOLMES, Roberto Duran, Mike TYSON, and Julio Cesar Chavez. King copromoted the famous 1975 "Thrilla in Manila" heavyweight championship match between Muhammad Ali and Joe Frazier. King's rise to fame was aided by his flamboyant, often volatile personality and trademark vertical shock of salt-and-pepper hair. In 1984 King branched out from boxing by promoting the multimillion-dollar world tour of the Jacksons, the singing group consisting of Michael JACKSON and his brothers.

King's business practices have been the focus of significant controversy. In 1984 King and his long-time secretary Constance Harper were indicted by a federal grand jury, but ultimately acquitted, on twenty-three counts of income tax evasion and con-spiracy. In the late 1980s King was investigated, but never indicted, by the Federal Bureau of Investiga-tion and the U.S. Attorney's office for alleged rack-eteering in the boxing industry.

From the late 1970s through the early 1990s, King held a virtual monopoly on promotions for major boxing matches, and boxing reformers often pointed to his powerful hold over the industry as an example of the sport's corrupt centralization. King was often criticized for acting as *de facto* manager for many of the boxers whose fights he promoted. (International boxing bylaws prohibit one person serving as a box-er's promoter and manager because of potential con-flicts of interest.) In the most famous instance, King

came under intense scrutiny for "advising" both Mike Tyson and Buster Douglas, whose 1990 heavy-weight championship fight King promoted. King also was accused by many of his former clients of misappropriating funds from boxing matches. In 1993 he proposed his own seven-point plan to reform boxing, including round-by-round displayed scor-ing, the elimination of draws, and a prohibition on promoters paying the expenses of judges and ref-erees. King's reform plan, while often mocked as hypocritical, was lauded by many in boxing as a constructive proposal.

REFERENCES

LUPICA, MIKE. "Donfire of the Vanities." *Esquire* (March 1991): 52.
ZIEGEL, VIC. "The King of Boxing." *Rolling Stone* (January 19, 1984): 13–14.

THADDEUS RUSSELL

King, Martin Luther, Jr. (January 15, 1929– April 4, 1968), minister and civil rights leader.

This entry consists of two articles. The first, by Clay-borne Carson, deals with King's life and work; the second, by David J. Garrow, evaluates King's legacy and influence on a later generation.

Life

Born Michael King, Jr., in Atlanta on January 15, 1929, he was the first son of a Baptist minister and the grandson of a Baptist minister, and his forebears exemplified the African-American social gospel tra-dition that would shape his career as a reformer. King's maternal grandfather, the Rev. A. D. Williams, had transformed Ebenezer Baptist Church, a block down the street from his grandson's child-hood home, into one of Atlanta's most prominent black churches. In 1906, Williams had joined such figures as Atlanta University scholar W. E. B. DU BOIS and African Methodist Episcopal (AME) bishop Henry McNeal TURNER to form the Georgia Equal Rights League, an organization that condemned lynching, segregation in public transportation, and the exclusion of black men from juries and state mi-litia. In 1917, Williams helped found the Atlanta branch of the NAACP, later serving as the chapter's president. Williams's subsequent campaign to regis-ter and mobilize black voters prodded white leaders to agree to construct new public schools for black children.

After Williams's death in 1931, his son-in-law, Michael King, Sr., also combined religious and po-litical leadership. He became president of Atlanta's

Martin Luther King, Jr., with schoolchildren in Grenada, Miss., fall 1966. (© Bob Fitch/Black Star)

NAACP, led voter-registration marches during the 1930s, and spearheaded a movement to equalize the salaries of black public school teachers with those of their white counterparts. In 1934, King, Sr.—perhaps inspired by a visit to the birthplace of Protestantism in Germany—changed his name and that of his son to Martin Luther King.

Despite the younger King's admiration for his father's politically active ministry, he was initially reluctant to accept his inherited calling. Experiencing religious doubts during his early teenage years, he decided to become a minister only after he came into contact with religious leaders who combined theological sophistication with social gospel advocacy. At Morehouse College, which King attended from 1944 to 1948, the college's president, Benjamin E. MAYS, encouraged him to believe that Christianity should become a force for progressive social change. A course on the Bible taught by Morehouse professor George Kelsey exposed King to theological scholarship. After deciding to become a minister, King increased his understanding of liberal Christian thought while attending Crozer Theological Seminary in Pennsylvania. Compiling an outstanding academic record at Crozer, he deepened his understanding of modern religious scholarship and eventually identified himself with theological personalism. King later wrote that this philosophical position strengthened his belief in a personal God and provided him with a "metaphysical basis for the dignity and worth of all human personality."

At Boston University, where King began doctoral studies in systematic theology in 1951, his exploration of theological scholarship was combined with extensive interactions with the Boston African-American community. He met regularly with other black students in an informal group called the Dialectical Society. Often invited to give sermons in Boston-area churches, he acquired a reputation as a powerful preacher, drawing ideas from African-American Baptist traditions as well as theological and philosophical writings. The academic papers he wrote at Boston displayed little originality, but King's scholarly training provided him with a talent that would prove useful in his future leadership activities: an exceptional ability to draw upon a wide range of theological and philosophical texts to express his views with force and precision. During his stay in Boston, King also met and began dating Coretta Scott, then a student at the New England Conservatory of Music (see Coretta Scott KING). On June 18, 1953, the two students were married in Marion, Ala., where Scott's family lived. During the following academic year, King began work on his dissertation, which was completed during the spring of 1955.

Soon after King accepted his first pastorate at Dexter Avenue Baptist Church in Montgomery, Ala., he had an unexpected opportunity to utilize the insights he had gained from his childhood experiences and academic training. After NAACP official Rosa PARKS was jailed for refusing to give up her bus seat to a white passenger, King accepted the post of president of the MONTGOMERY IMPROVEMENT ASSOCIATION, which was formed to coordinate a boycott of Montgomery's buses (see MONTGOMERY BUS BOYCOTT). In his role as the primary spokesman of the boycott, King gradually forged a distinctive protest strategy that involved the mobilization of black churches, utilization of Gandhian methods of nonviolent protest, and skillful appeals for white support (see CIVIL RIGHTS MOVEMENT).

After the U. S. Supreme Court outlawed Alabama bus segregation laws in late 1956, King quickly rose to national prominence as a result of his leadership role in a successful boycott movement. In 1957, he became the founding president of the SOUTHERN CHRISTIAN LEADERSHIP CONFERENCE (SCLC),

formed to coordinate civil rights activities throughout the South. Publication of King's *Stride Toward Freedom: The Montgomery Story* (1958) further contributed to his rapid emergence as a nationally known civil rights leader. Seeking to forestall the fears of NAACP leaders that his organization might draw away followers and financial support, King acted cautiously during the late 1950s. Instead of immediately seeking to stimulate mass desegregation protests in the South, he stressed the goal of achieving black voting rights when he addressed an audience at the 1957 Prayer Pilgrimage for Freedom. During 1959, he increased his understanding of Gandhian ideas during a month-long visit to India as a guest of Prime Minister Jawaharlal Nehru. Early in 1960, King moved his family—which now included two children, Yolanda Denise (born 1955) and Martin Luther III (born 1957)—to Atlanta in order to be nearer SCLC's headquarters in that city and to become co-pastor, with his father, of Ebenezer Baptist Church. The Kings' third child, Dexter Scott, was born in 1961; their fourth, Bernice Albertine, was born in 1963.

Soon after King's arrival in Atlanta, the lunch counter sit-in movement, led by students, spread throughout the South and brought into existence a new organization, the STUDENT NONVIOLENT COORDINATING COMMITTEE (SNCC). SNCC activists admired King but also pushed him toward greater militancy. In October 1960, his arrest during a student-initiated protest in Atlanta became an issue in the national presidential campaign when Democratic candidate John F. Kennedy intervened to secure his release from jail. Kennedy's action contributed to his narrow victory in the November election. During 1961 and 1962, King's differences with SNCC activists widened during a sustained protest movement in Albany, Georgia. King was arrested twice during demonstrations organized by the Albany Movement, but when he left jail and ultimately left Albany without achieving a victory, his standing among activists declined.

King reasserted his preeminence within the African-American freedom struggle through his leadership of the BIRMINGHAM, ALABAMA campaign of 1963. Initiated by the SCLC in January, the Birmingham demonstrations were the most massive civil rights protests that had occurred up to that time. With the assistance of Fred SHUTTLESWORTH and other local black leaders, and without much competition from SNCC or other civil rights groups, SCLC officials were able to orchestrate the Birmingham protests to achieve maximum national impact. During May, televised pictures of police using dogs and fire hoses against demonstrators aroused a national outcry. This vivid evidence of the obstinacy of Bir-

mingham officials, combined with Alabama Governor George C. Wallace's attempt to block the entry of black students at the University of Alabama, prompted President John F. Kennedy to introduce major new civil rights legislation. King's unique ability to appropriate ideas from the Bible, the Constitution, and other canonical texts manifested itself when he defended the black protests in a widely quoted letter, written while he was jailed in Birmingham.

King's speech at the August 28, 1963, March on Washington, attended by over 200,000 people, provides another powerful demonstration of his singular ability to draw on widely accepted American ideals in order to promote black objectives. At the end of his prepared remarks, which announced that African Americans wished to cash the "promissory note" signified in the words of the Constitution and the Declaration of Independence, King began his most quoted oration: "So I say to you, my friends, that even though we must face the difficulties of today and tomorrow, I still have a dream. It is a dream deeply rooted in the American dream that one day this nation will rise up and live out the true meaning of its creed—we hold these truths to be self-evident, that all men are created equal." He appropriated the familiar words of the song "My Country 'Tis of Thee" before concluding: "And when we allow freedom to ring, when we let it ring from every village and hamlet, from every state and city, we will be able to speed up that day when all of God's children—black men and white men, Jews and Gentiles, Catholics and Protestants—will be able to join hands and to sing in the words of the old Negro spiritual, 'Free at last, free at last, thank God Almighty, we are free at last.' "

After the march on Washington, King's fame and popularity were at their height. Named *Time* magazine's Man of the Year at the end of 1963, he was awarded the Nobel Peace Prize in December 1964. The acclaim he received prompted FBI director J. Edgar Hoover to step up his effort to damage King's reputation by leaking information gained through surreptitious means about King's ties with former communists and his extramarital affairs.

King's last successful civil rights campaign was a series of demonstrations in Alabama that were intended to dramatize the denial of black voting rights in the deep South. Demonstrations began in Selma, Ala., early in 1965 and reached a turning point on March 7, when a group of demonstrators began a march from Selma to the state capitol in Montgomery. King was in Atlanta when state policemen, carrying out Governor Wallace's order to stop the march, attacked with tear gas and clubs soon after the procession crossed the Edmund Pettus Bridge on

the outskirts of Selma. The police assault on the marchers quickly increased national support for the voting rights campaign. King arrived in Selma to join several thousand movement sympathizers, black and white. President Lyndon B. Johnson reacted to the Alabama protests by introducing new voting rights legislation, which would become the VOTING RIGHTS ACT of 1965. Demonstrators were finally able to obtain a court order allowing the march to take place, and on March 25 King addressed the arriving protestors from the steps of the capitol in Montgomery.

After the successful voting rights campaign, King was unable to garner similar support for his effort to confront the problems of northern urban blacks. Early in 1966 he launched a major campaign in Chicago, moving into an apartment in the black ghetto. As he shifted the focus of his activities north, however, he discovered that the tactics used in the South were not as effective elsewhere. He encountered formidable opposition from Mayor Richard Daley, and was unable to mobilize Chicago's economically and ideologically diverse black populace. He was stoned by angry whites in the suburb of Cicero when he led a march against racial discrimination in housing. Despite numerous well-publicized protests, the Chicago campaign resulted in no significant gains and undermined King's reputation as an effective leader.

His status was further damaged when his strategy of nonviolence came under renewed attack from blacks following a major outbreak of urban racial violence in Los Angeles during August 1965. When civil rights activists reacted to the shooting of James MEREDITH by organizing a March against Fear through Mississippi, King was forced on the defensive as Stokely CARMICHAEL and other militants put forward the Black Power slogan. Although King refused to condemn the militants who opposed him, he criticized the new slogan as vague and divisive. As his influence among blacks lessened, he also alienated many white moderate supporters by publicly opposing United States intervention in the Vietnam War. After he delivered a major antiwar speech at New York's Riverside Church on April 4, 1967, many of the northern newspapers that had once supported his civil rights efforts condemned his attempt to link civil rights to the war issue.

In November 1967, King announced the formation of a POOR PEOPLE'S CAMPAIGN designed to prod the nation's leaders to deal with the problem of poverty. Early in 1968, he and other SCLC workers began to recruit poor people and antipoverty activists to come to Washington, D.C., to lobby on behalf of improved antipoverty programs. This effort was in its early stages when King became involved in a sanitation workers' strike in Memphis. On March 28, as he led thousands of sanitation workers and sympa-thizers on a march through downtown Memphis, violence broke out and black youngsters looted stores. The violent outbreak led to more criticisms of King's entire antipoverty strategy. He returned to Memphis for the last time early in April. Addressing an audience at Bishop Charles H. Mason Temple on April 3, he sought to revive his flagging movement by acknowledging: "We've got some difficult days ahead. But it doesn't matter with me now. Because I've been to the mountaintop. . . . And I've seen the promised land. I may not get there with you. But I want you to know tonight that we, as a people, will get to the promised land."

The following evening, King was assassinated as he stood on a balcony of the Lorraine Motel in Memphis. A white segregationist, James Earl Ray, was later convicted of the crime. The Poor People's Campaign continued for a few months but did not achieve its objectives. King became an increasingly revered figure after his death, however, and many of his critics ultimately acknowledged his considerable accomplishments. In 1969 his widow, Coretta Scott King, established the Martin Luther King, Jr., Center for Nonviolent Social Change, in Atlanta, to carry on his work. In 1986, a national holiday was established to honor his birth.

REFERENCES

BALDWIN, LEWIS V. *There is a Balm in Gilead: The Cultural Roots of Martin Luther King, Jr.* Minneapolis, 1991.

BRANCH, TAYLOR. *Parting the Waters: America in the King Years, 1954–63.* New York, 1988.

GARROW, DAVID J. *Bearing the Cross: Martin Luther King and the Southern Christian Leadership Conference.* New York, 1986.

KING, CORETTA SCOTT. *My Life with Martin Luther King, Jr.* New York, 1969.

KING, MARTIN LUTHER, SR., and CLAYTON RILEY. *Daddy King: An Autobiography.* New York, 1980.

LEWIS, DAVID LEVERING. *King: A Biography.* Urbana, Ill., 1978.

OATES, STEVEN B. *Let the Trumpet Sound: The Life of Martin Luther King, Jr.* New York, 1982.

REDDICK, L. D. *Crusader Without Violence: A Biography of Martin Luther King, Jr.* New York, 1959.

CLAYBORNE CARSON

Legacy

More than twenty-five years after his assassination, the militant political legacy of the Rev. Dr. Martin Luther King, Jr., is in eclipse. Simultaneously, King's historical reputation is frequently distorted by the popular misconception that he was primarily a philosophical "dreamer," rather than a realistic and often courageous dissident.

King's true legacy is not the 1963 March on Washington (*see* CIVIL RIGHTS MOVEMENT; WASHINGTON. D.C.) and his grandly optimistic "I Have a Dream" speech; it is instead his 1968 plan for a massively disruptive but resolutely nonviolent "POOR PEOPLE'S CAMPAIGN" aimed at the nation's capital, a protest campaign that came to pass only in a muted and disjointed form after his death.

Some of the distortion of King's popular image is a direct result of how disproportionately he nowadays is presented as a gifted and sanguine speechmaker whose life ought to be viewed through the prism of his "dream." King had used the "I Have a Dream" phrase several times before his justly famous oration, but on numerous occasions in later years King invoked the famous phrase only to emphasize how the "dream" he had had in Washington in 1963 had "turned into a nightmare."

Both the dilution of King's legacy and the misrepresentation of his image are also in part due to the stature accorded his birthday, now a national holiday. Making King an object of official celebration

Coretta Scott King leading the Garbage Workers Parade on April 8, 1967, four days after Martin Luther King, Jr.'s murder in Memphis, Tenn. (© Dennis Brack/Black Star)

inescapably leads to at least some smoothing of edges and tempering of substance that otherwise would irritate and challenge those Americans who are just as eager to endorse "I Have a Dream" as they are to reject any "Poor People's Campaign."

But another facet of King's erroneous present-day image as a milquetoast moderate, particularly among young people, is directly tied to the greatly increased prominence of MALCOLM X. Even before the media boomlet that accompanied Spike LEE's 1992 movie, *X*, popular appreciation of Malcolm X had expanded well beyond anything that had existed in the first two decades following his 1965 death. Even if young people's substantive understanding of Malcolm X's message is oftentimes faulty or nonexistent, among youthful Americans of all races the rise of Malcolm X has vastly magnified the mistaken stereotype that "Malcolm and Martin" were polar opposites.

Far too many people assume that if Malcolm personified unyielding tenacity and determination, King, as his supposed opposite, was no doubt some sort of vainglorious compromiser who spent more time socializing with the Kennedys than fighting for social change. Hardly anything could be further from the truth, for while Malcolm's courageous self-transformation is deserving of far more serious attention and study than it has yet received, King was as selflessly dedicated and utterly principled a public figure as the United States has seen in this century.

Perhaps King's most remarkable characteristic was how he became a nationally and then internationally famous figure without ever having any egotistical desire to promote himself onto the public stage, as is otherwise the case with virtually every luminary in contemporary America. Drafted by his colleagues in Montgomery, Ala., in 1955 to serve as the principal spokesperson for the black community's boycott of municipal buses, King was far from eager to be any sort of "leader," and only a deeply spiritual sense of obligation convinced him that he could not refuse this call.

King's resolutely selfless orientation gave his leadership both a public integrity and a private humility that are rare, if not wholly unique, in recent U.S. history. Perhaps the greatest irony generated by the hundreds upon hundreds of King's ostensibly private telephone conversations that were preserved for history by the FBI's indecently intrusive electronic surveillance—and released thanks to the Freedom of Information Act—is that one comes away from a review of King's most unguarded moments with a distinctly heightened, rather than diminished, regard for the man. Time and again, those transcripts show King as exceptionally demanding of himself and as an overly harsh judge of his own actions. How many other public figures, lacking only an FBI director like

J. Edgar Hoover to preserve their off-the-cuff comments for posterity, could hope to pass such an ultimate test of civic character?

King's remarkable political courage and integrity were just as dramatically visible on the public stage, however, as in his self-critical private conversations. Unlike almost every other public figure in the country both then and now, King had no interest in assessing which position on which issue would be the most popular or the most remunerative for organizational fund-raising before he decided how and when to speak his mind.

Nowhere was this more starkly apparent than in King's early decision to speak out against U.S. involvement in Vietnam (*see* VIETNAM WAR) at a time when President Lyndon B. Johnson's war still had the support of most progressive Democrats. Many liberal newspapers—and even several "mainstream" civil rights organizations—harshly attacked King for devoting his attention to an issue that did not fall within the "black" bailiwick, and while in private King was deeply hurt by such criticism, he had decided to confront the Vietnam issue knowing full well that just such a reaction would ensue.

"Leadership" to King did not mean tailoring one's comments to fit the most recent public opinion poll or shifting one's positions to win greater acclaim or support. King realized, too, that real leadership did not simply comprise issuing press releases and staging news conferences, and he was acutely aware that most real "leaders" of the southern civil rights struggle—unheralded people who performed the crucial task of encouraging others to stand up and take an active part in advancing their own lives and communities—got none of the public attention and awards that flowed to King and a very few others.

King understood that in our culture of publicity, the recognition of an individual symbolic figure such as he was inevitable and essential to the movement's popular success, but he always sought to emphasize, as in his Nobel Peace Prize lecture, that he accepted such applause and honors only as a "trustee" on behalf of the thousands of unsung people whose contributions and aspirations he sought to represent. King realized, better than many people at the time, and far better than some subsequent disciples, that the real essence of the movement was indeed the local activists in scores of generally unpublicized locales. In private, King could be extremely self-conscious about how he personally deserved only a very modest portion of all the praise and trophies that came his way.

King would very much welcome the newfound appreciation of Malcolm X, but King likewise would be intensely discomfited by a national holiday that in some hands seems to encourage celebration of King's own persona rather than the movement he came to symbolize. King also would rue how our culture of celebrity has become more and more a culture of violence, and how economic inequality in America is even more pronounced in the 1990s than it was at the time of his death in 1968.

King likewise would rue his legacy being too often shorn of his post-1965 nonviolent radicalism, and the celebration of his image by people who proffered him and the movement no support when he was alive. But King would not worry about any decline in his own reputation or fame, for he would greatly welcome increased credit and appreciation for those whom the media and history habitually overlook. If in the next several decades Martin Luther King, Jr.'s individual image continues gradually to recede, King himself would be happy rather than sad, for personal fame and credit were not something that he sought or welcomed either in 1955 or in 1968.

REFERENCES

ALBERT, PETER J., and RONALD HOFFMAN. *We Shall Overcome: Martin Luther King, Jr., and the Black Freedom Struggle.* New York, 1990.

CONE, JAMES H. *Malcolm & Martin & America: A Dream or a Nightmare.* Maryknoll, N.Y., 1991.

GARROW, DAVID J. *Bearing the Cross: Martin Luther King, Jr., and the Southern Christian Leadership Conference.* New York, 1986.

MILLER, KEITH D. *Voice of Deliverance: The Language of Martin Luther King, Jr., and Its Sources.* New York, 1992.

DAVID J. GARROW

King, Riley B. "B. B." (September 16, 1925–), blues singer and guitarist. Born Riley B. King in Itta Bena, Miss., B. B. King grew up on a plantation, working as a farmhand. He sang in choirs at school and church before teaching himself to play the guitar. He moved to Memphis in 1947 and began singing blues in bars. Following a radio appearance with Sonny Boy Williamson (Alex Miller), King began working on Memphis radio station WDIA as "the Pepticon Boy," advertising Pepticon tonic. He later became a disc jockey for WDIA, being billed as "the Blues Boy from Beale Street," gradually becoming "B. B." He began recording in 1949 and had a few local hits. His recording of "Three O'Clock Blues" (1952) was a national hit and allowed him to begin touring the country as a blues singer. By the mid-1960s he had become known as one of the country's greatest blues performers and a leading figure in the urban blues scene, thanks to the praise of many "British invasion" rock musicians, including Eric Clapton

and Mick Jagger, who cited his influence. He has continued to record and perform, earning many industry awards, including a Grammy for his 1981 album *There Must Be a Better World Somewhere* and induction into the Rock and Roll Hall of Fame in 1987.

The focus of King's music remains his powerful, commanding voice and guitar playing, through which he maintains an emotional urgency while supporting his performance with a full band. Traditional blues arrangements form the backbone of his songs, featuring prominent call-and-response sequences between the guitar and vocals. His guitar playing is characterized by warm, clear tone and lyrical phrases punctuated by a quick, stinging vibrato.

REFERENCES

GEORGE, NELSON. *The Death of Rhythm and Blues.* New York, 1988, pp. 49–50.

SAWYER, CHARLES. *The Arrival of B. B. King: The Authorized Biography.* Garden City, N.Y., 1980.

DANIEL THOM

King, Woodie, Jr. (July 27, 1937–) actor, director, writer, and producer. Born in Baldwin Springs, Ala., Woodie King, Jr., spent his early years in Mobile, Ala. The son of Woodie King, Sr., a truck driver, and Ruby King, Woodie King, Jr., moved to Detroit with his mother when his parents separated. King's mother supported the family by working as a domestic. He attended Cass Technical High School in Detroit, where he became interested in theater. King won a scholarship to the Will-O-Way Apprentice Theatre School, which awarded him a bachelor of arts degree in 1961. In 1959, while attending Will-O-Way, King became a drama critic for the *Detroit Tribune,* an African-American newspaper, a position he held through 1962.

King began postgraduate work in drama at Wayne State University in Detroit in 1961. Frustrated by the lack of roles for African Americans, King and several other students remade an abandoned bar into the Concept-East Theatre, where he directed and acted in plays by such writers as Le Roi Jones (later known as Amiri BARAKA) and Edward Albee.

King left Wayne State in 1962 and in 1964 went to New York with the touring production of *Study in Color,* which played at Union Theological Seminary there. He remained in New York and began a John Hay Whitney Fellowship at the American Place Theater, where he studied with directors Lloyd Richards and Wyn Handman.

In 1965 King became cultural arts director of Mobilization for Youth, an antipoverty program that

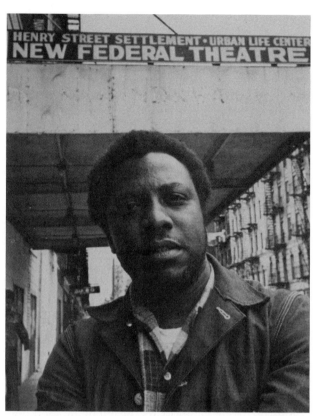

Producer, writer, actor, and director Woodie King, Jr., standing in front of the Henry Street Settlement in New York City, 1973. (Reprinted from *In the Shadow of the Great White Way: Images from the Black Theatre,* Thunder's Mouth Press, © 1957–1989 by Bert Andrews. Reprinted by permission of the Estate of Bert Andrews)

helped provide arts training to black and Puerto Rican children. In 1970, when the program became part of the Henry Street Settlement, King became director of the Arts for Living Program and founded the New Federal Theatre, a multiethnic theater, also housed at Henry Street, where he has continued to work through the early 1990s.

In keeping with his belief that theater should be financially and culturally accessible to all communities, in the late 1970s King began planning the National Black Touring Circuit, a program to cultivate an international audience for black theater. Its premier was a production of Ntozake SHANGE's *Boogie Woogie Landscapes,* directed by Avery Brooks at the Kennedy Center for Performing Arts in Washington, D.C., on June 16, 1980. Laurence Holder's *Zora Neale Hurston* premiered in 1990 at the American Place Theater in New York City with Wyn Handman as director; it then traveled to Winston-Salem, N.C., and St. Louis. King also produced *Shades of Harlem,* a musical revue by Jeree Palmer Wade that traveled to Tokyo in 1994.

In 1968 King began producing documentary films. His first, *The Game* (1968), won an award at the Venice Film Festival. *Right On!* (1970), in which the Last Poets perform on a New York rooftop, won an International Film Critics Award. *The Black Theatre Movement: "A Raisin in the Sun" to the Present* (1978) is probably his most ambitious and widely seen film. It traces the history of black theater through changing political and social climates.

In addition to directing and producing, King is a prolific writer and has written plays, essays, short stories, and one book, *Black Theater, Present Condition* (1980). He is also the editor of six collections of work by black authors, among them *Black Drama Anthology* (1986) and *Voices of Color* (1994).

REFERENCE

DAVIS, THADIOUS M., and TRUDIER HARRIS. "Woodie King." In *Dictionary of Literary Biography*, vol. 38: *Afro-American Writers After 1955: Dramatists and Prose Writers*. Detroit, 1985.

KENYA DILDAY

Kitt, Eartha Mae (January 26, 1928–), singer and actress. Born on a farm in the town of North, S.C., Eartha Kitt and her sister Pearl were abandoned as small children by their mother. They were raised in a foster family until 1936, when Eartha moved to New York City to live with her aunt.

In New York, Kitt attended the Metropolitan High School (which later became the High School of Performing Arts), and at sixteen she met Katherine DUNHAM, who granted her a scholarship with Dunham's dance troupe. Kitt toured Europe and Mexico with the troupe, developing a sexually provocative stage presence and a throaty, sensual singing style. When the troupe arrived in Paris, Kitt was offered a job singing at a top nightclub. Orson Welles saw her perform and cast her as "Girl Number Three" in his 1951 stage production of Marlowe's *Doctor Faustus*. After touring Germany with the production and a brief singing engagement in Turkey, Kitt returned to New York. She performed at La Vie en Rose and at the Village Vanguard, where Leonard Sillman saw her and decided to cast her in his Broadway show *New Faces of 1952*. Kitt also appeared in the 1954 film version of *New Faces*. In both versions she sang "C'est Si Bon," "Monotonous," and "Uska Dara," which were recorded for her 1955 album *The Bad Eartha*.

Kitt performed from the mid-1950s through the '60s in theaters, nightclubs, and cabarets in the United States and abroad, honing her reputation as a "sex kitten." Her stage appearances included *Mrs. Patterson* (1954), a musical produced by Sillman, for which she received a Tony Award nomination, and *Shinbone Alley* (1957). Kitt also appeared in the films *St. Louis Blues* (1958), *The Accused* (1957), and *Anna Lucasta* (1959), which earned her an Oscar nomination. During this period she recorded two notable albums, *Bad but Beautiful* in 1961 and *At the Plaza* in 1965. Kitt also made numerous television appearances, including a stint on the 1960s *Batman* series, in which she played "Catwoman."

In 1968 Kitt's career took a dramatic turn when she criticized the war in Vietnam at a White House luncheon hosted by the First Lady, Lady Bird Johnson. As a result she lost bookings and was vilified by conservatives and much of the mainstream press and was investigated by the Central Intelligence Agency and the Federal Bureau of Investigation. Although Kitt's subsequent appearances in Europe were commonly believed to be the result of her being blacklisted in the United States, in fact she maintained a significant presence in American clubs, film, and television. In 1972 her political reputation took a sharp turn when she performed in South Africa and publicly complimented her white hosts for their hospitality.

In the late 1970s and '80s Kitt continued her career as a cabaret singer and occasional actor. Her return to Broadway in the 1978 show *Timbuktu* earned her a second Tony nomination. She recorded the album *I Love Men* in 1984 and published two autobiographies during this period, *I'm Still Here* in 1989 and *Confessions of a Sex Kitten* in 1991. Kitt also appeared in a variety of marginal Hollywood films, including *Erik the Viking* in 1989, *Ernest Scared Stupid* in 1991, *Boomerang* in 1992, and *Fatal Instinct* in 1993. A five-compact disc retrospective of her work, entitled *Eartha Quake,* was released in 1993.

REFERENCES

HINE, DARLENE CLARK, ed. *Black Women in America*. New York, 1993.
KITT, EARTHA. *Alone with Me*. New York, 1976.
———. *Thursday's Child*. New York, 1956.
SMITH, JESSIE CARNEY, ed. *Notable Black American Women*. Detroit, 1992.

SUSAN MCINTOSH
THADDEUS RUSSELL

Kittrell, Flemmie Pansy (December 25, 1904– October 1, 1980), nutritionist and home economist. Born in Henderson, N.C., Flemmie Kittrell attended local public schools and then Hampton Institute in Hampton, Va., from which she graduated in 1929. At Cornell University she received a master's degree (1930) and a doctorate in nutrition (1935). Kittrell's

research interests included protein levels in adults, the nutritional requirements of black infants, and the education of preschool children. She taught nutrition and home economics at a number of colleges and universities including Benton College in Greensboro, N.C. (1928–1940) and Hampton Institute (1940–1944). She later served as Head Nutritionist at HOWARD UNIVERSITY (1944–1973), where she developed both master's and doctoral programs in the field of nutrition.

Kittrell began promoting international cooperation in home economics in 1950 when she received a Fulbright Award to help Baroda University in India establish a College of Home Economics. She returned to India in 1953 and again in 1960 to help complete the organization of the college and to assist with a nutritional survey of India and Thailand for the Food and Agriculture Organization of the United Nations. Kittrell also promoted cooperation in Africa, where in 1957 she researched nutritional practices in Liberia, Nigeria, and French West Africa for the U.S. State Department, and participated in cultural tours of West and Central Africa (1959) and Guinea (1961).

Kittrell was the recipient of numerous citations and awards, including the Scroll of Honor from the NATIONAL COUNCIL OF NEGRO WOMEN for special services rendered to the U.S. government. She died in Washington, D.C., in 1980.

REFERENCES

LOGAN, RAYFORD. *Howard University: The First Hundred Years.* New York, 1969.

SAMMONS, VIVIAN. *Blacks in Science and Medicine.* New York, 1990.

SASHA THOMAS

KKK. *See* Ku Klux Klan.

Knight, Etheridge (April 19, 1931–March 10, 1991), poet. Born to Etheridge "Bushie" Knight and Belzora Cozart Knight in Corinth, Miss., Etheridge Knight was raised with his six siblings in Paducah, Ky. A troubled, restless youth, Knight ran away from home, quit high school after two years, and enlisted in the Army at the age of sixteen. He served as a medical technician in Korea, Guam, and Hawaii, and he returned home with a narcotics addiction. Knight became a drug dealer to support his habit and in 1960 was sentenced in Indiana to a ten- to twenty-five-year sentence for a robbery he committed. Knight began to educate himself in prison, and discovered poetry. He later said, "I died in Korea of a shrapnel wound and narcotics resurrected me. I died in 1960 from a prison sentence and poetry brought me back to life." Broadside Press editor Dudley RANDALL discovered Knight's work and showed it to poet Gwendolyn BROOKS, who served as Knight's mentor.

Knight's first book of poetry, *Poems from Prison,* with an introduction by Brooks, was written during Knight's sentence in the penitentiary in Michigan City, Ind. The book was published by Broadside in 1968, the year in which Knight was released from prison. Along with Haki MADHUBUTI (then Don L. Lee), Sonia SANCHEZ (to whom Knight was briefly married), and Nikki GIOVANNI, Knight became one of the revolutionary young African-American poets whose work, disseminated by Broadside, had a powerful impact on the BLACK ARTS MOVEMENT of the late 1960s and early 1970s. Knight was particularly popular with prison audiences and spoke for nonviolence wherever he read. Knight "professed" at the Library of Congress and at Leavenworth Prison and served as writer-in-residence at the University of Pittsburgh, the University of Hartford, Lincoln University (Missouri), and Temple University. He also set up "free people's workshops" in Boston and other places. Knight received numerous awards for his work, including a Guggenheim Fellowship (1974), fellowships from the National Endowment for the Arts (1972, 1980, and 1987), and the Shelley Memorial Award (1985). His volume *Belly Song and Other Poems* (1973) was nominated for a National Book Award and a Pulitzer Prize. He won the American Book Award (1987) for *The Essential Etheridge Knight* (1986). Knight published five books, and his poetry appeared in several collections, most notably *The Norton Anthology of American Poets.*

Knight's early poetry, written explicitly for a black audience, deals with the private demons of substance abuse, the tensions of urban life, the experience of imprisonment, oppression, and loneliness, and the difficulty (and necessity) of gaining freedom, while his later work shows the influence of blues lyrics. Knight came to write poetry through composing and performing "toasts," long narratives of rhymed couplets recited or improvised in front of an audience; the performer generally uses slang and stock characters to relate stories of life on the street. Knight's debt to traditional African-American oral forms can be seen in the way he emphasizes rhythm and sound, using repetition, word spacing, slash marks, and punctuation to achieve the effect of speech.

In 1988, Knight returned to drinking and relapsed into drug addiction. He ran out of money and eventually became a homeless person on the streets of New York. Suffering from phlebitis and lung cancer, he died in Indianapolis in 1991.

REFERENCES

BERNSTEIN, DENNIS. "Etheridge Knight: Soldier, Thief, Junkie, Poet—Hard Time." *Village Voice,* March 28, 1989, pp. 37–38.

KNIGHT, ETHERIDGE. *Born of a Woman: New and Selected Poems.* Boston, 1980.

TRACY, STEVEN C. "A MELUS Interview: Etheridge Knight," *Melus* 12, no. 2 (Summer 1985): 7–23.

LILY PHILLIPS
GREG ROBINSON

Knight, Gladys (May 28, 1944–). Gladys Knight, who was born and raised in Atlanta, Ga., made her public singing debut at the age of four at Mount Mariah Baptist Church, where her parents were members of the choir. By the time she was five, Knight had performed in numerous Atlanta churches and toured through Florida and Alabama with the Morris Brown Choir. At the age of seven Knight won the Grand Prize on Ted Mack's nationally televised *Original Amateur Hour.*

In 1952 Knight formed a quartet with her brother Merald "Bubba" Williams and cousins William Guest and Edward Patten. The group, named "The Pips" after James "Pip" Woods, another cousin and the group's first manager, quickly established itself in Atlanta night clubs. By the late 1950s the group was a popular fixture on the national RHYTHM AND BLUES circuit. The first recording came in 1961, when Vee Jay Records released the single "Every Beat of My Heart," which became a Top Ten pop and number-one R&B hit. The following year Fury Records signed the group, changed its name to Gladys Knight and the Pips, and released their Top Ten R&B single "Letter Full of Tears."

Though well known in R&B circles, Gladys Knight and the Pips did not become a major crossover act until 1965, when they signed with Motown Records and were featured on the label's touring reviews. Their 1967 Motown single, "I Heard It Through the Grapevine," reached number two on the *Billboard* pop chart. The late 1960s brought the group mass acclaim for its polished, call-and-response singing style and slick, synchronized dance routines. The next big hit came in 1970 with the top-selling single, "You Need Love Like I Do." Six of the group's albums made the R&B charts: *Nitty Gritty* (1970); *Greatest Hits* (1970); *If I Were Your Woman* (1971); *Standing Ovation* (1972); *Neither One of Us*; and *All I Need is Time* (1972).

In 1972 Gladys Knight and the Pips had another big hit with "Neither One of Us (Wants to Be the First to Say Goodbye)." In 1973 the group switched to the Buddah label for its Top-Forty album, *Imagination,* which included two of the group's most enduring successes, "Midnight Train to Georgia," a number one pop single in 1973, and "I've Got to Use My Imagination." The group won two 1974 Grammy Awards for "Neither One of Us" and "Midnight Train to Georgia."

In the late 1970s the group's popularity began to wane. Legal conflicts with Motown forced Knight to record separately for a brief period in the late 1970s. The group reunited in 1980 and continued touring, but was not able to record another chart-topping record until 1988, when "Love Overboard" reached the Top Twenty on the *Billboard* pop chart. The following year Knight once again left the group, this time voluntarily, to establish a solo career. The following year she released *Good Woman,* a solo LP that was moderately successful on black radio.

REFERENCES

BLOOM, STEVE. "Gladys Knight in No Man's Land." *Rolling Stone* (June 30, 1988): 23.

WHITAKER, CHARLES. "Hotter Than Ever: Gladys Knight and the Pips Mark 36 Years of Making Music." *Ebony* (September 1988): 72.

THADDEUS RUSSELL

Knight, Gwendolyn (May 26, 1913–), painter. Gwendolyn Knight was born in Barbados and came to the United States at the age of seven. She lived in St. Louis, Mo., until she was thirteen when her family relocated to Harlem. As a child, Knight did portraits of her friends and relatives, and she took art classes in public school, but did not receive formal art education until she attended Howard University's School of Fine Arts from 1931 to 1933. She left Howard during the Great Depression and returned to Harlem, where she became part of the community of artists working in sculptor Augusta SAVAGE's studio. While studying with Savage, Knight met painter Jacob LAWRENCE. She married him in 1941.

For several decades Knight pursued her career with little public attention. Beginning in the 1960s, Knight decided to focus intently on art and she returned to school, studying at the New School for Social Research in New York (1960–1966) and at Skowhegan School of Painting and Sculpture in Skowhegan, Me. (1968–1970). Primarily a figurative painter of portraits and still lifes, Knight used oil, charcoal, ink, and brush in her works. Her portraits were made from loose brush strokes, and while they did not present details of an individual's face, they conveyed the sitter's personality through gesture and facial ex-

pression. Some of Knight's works include *New Orleans, Scene I and II* (1941), a series of brush-and-ink images called *Flutist* (1981), *Portrait of the Artist* (1991), and *Dancers II* (1992).

Knight spent much of her career in the shadow of her husband's artistic success, and her work was not displayed in solo exhibitions until the 1970s. Since then, her work has been shown at the Seattle Art Museum (1976), at the Francine Seders Gallery (1977, 1987, and 1994), and at a retrospective at the Virginia Lacy Jones Gallery in Atlanta, Ga., in 1988. Her work frequently has been displayed in group exhibitions tracing the history of African-American art. Knight's paintings were included in the exhibit *Significant Others: Artist Wives of Artists* at the Kraushaar Gallery in New York City in 1993.

REFERENCES

Fox, CATHERINE. "Gwendolyn Knight Stands on Her Own with Retrospective." *Atlanta Journal,* January 19, 1988.

"Gwendolyn Knight: A Portfolio and Conversation." *Callaloo* 2, no. 4. 1988.

VIRGINIA LACY JONES GALLERY. *Gwendolyn Knight: Paintings.* Atlanta, 1988.

SUSAN MCINTOSH
RENEE NEWMAN

Knights of the White Camellia. The Knights of the White Camellia was one of the largest terrorist organizations in the Reconstruction South and may have had more members than any other. Founded in St. Mary's Parish, La., in May 1867 by Alcibiad DeBlanc, the knights took their name from a fragrant white flower common in the South. They rapidly spread through Arkansas and into Alabama and East Texas. The knights rode during the night, sent threatening letters to black and Republican officials, disrupted political meetings, and intimidated voters. Their constitution stated that their duty was to assure "the supremacy of the Caucasian race, and restrain the black or African race to that condition of social and political inferiority for which God has destined it." Supposedly unaffiliated with any party, the knights were often led by local Democratic party officials.

The knights were often confused with other similar secret terrorist societies, notably the Ku Klux Klan. However, the knights seldom wore costumes and were generally more open about their organization's existence and objectives. Local chapters in New Orleans and Houston even advertised their meetings in newspapers. Also, knights tended to be socially more prominent than Klansmen. Leaders claimed that the knights' actions were legal and that the organization did not condone violence except in self-defense. Blame for atrocities was fixed on imitative nonmembers.

In 1868, through widespread election fraud and intimidation of Louisiana's African-American electoral majority, the knights helped transform the state in a few months from a heavily Republican to a Democratic one. However, once white dominance was restored, the organization lapsed into insignificance. In spring 1869 Arkansas and other states banned the knights as a front for the Ku Klux Klan, and a Republican newspaper revealed the knights' passwords and ceremonies. The Knights of the White Camellia, after a few meetings and a state convention, evidently disbanded after summer 1869.

REFERENCE

TRELEASE, ALLEN. *White Terror: The Ku Klux Klan Conspiracy and Southern Reconstruction.* Westport, Conn., 1971.

ELIZABETH FORTSON ARROYO

Komunyakaa, Yusef (April 29, 1947–), poet. The son of a carpenter, Yusef Komunyakaa was born and grew up in the Louisiana mill town of Bogalusa. His father taught him the tools of the trade, but Komunyakaa turned to writing after reading James BALDWIN's *Nobody Knows My Name* at the age of sixteen. In 1969 Komunyakaa joined the Army and went to Vietnam, where he served as an "information specialist" for a military newspaper and won a Bronze Star. Upon his return to the United States, he attended college at the University of Colorado, where he received a bachelor of arts in 1975. Komunyakaa went to earn a master of arts degree from Colorado State University (1979) and a master of fine arts from the University of California at Irvine (1980). His first volume of poems, *Dedications & Other Darkhorses,* was published in 1977; two years later, *Lost in the Bonewheel Factory* appeared.

Komunyakaa's dense, autobiographical poems depict a childhood fraught with violence as well as an intense love for the Louisiana lowlands where he was raised. After teaching at various schools in New England, he returned to New Orleans in 1984 to take up the position of poet-in-the-schools; his third volume, *Copacetic,* was published that year. It was in New Orleans that Komunyakaa finally began to write about his Vietnam experiences, and these were the subject of *Toys in a Field,* which appeared, along with *I Apologize for the Eyes in My Head,* in 1986. The same

year, Komunyakaa received the San Francisco Poetry Center Award for *I Apologize* and became professor of English at the University of Indiana in Bloomington. In 1988 he published another set of Vietnam poems called *Dien Cai Dau;* these were followed by a collection titled *February in Sydney,* published the following year. Komunyakaa was the Holloway Lecturer at the University of California at Berkeley in 1992. *Neon Vernacular,* a collection of new and selected poems, appeared in 1993. This volume won Komunyakaa the Pulitzer Prize for poetry in 1994.

REFERENCE

WEBER, BRUCE. "A Poet's Values: It's the Words over the Man." Interview. *New York Times,* May 2, 1994, pp. C11, C18.

PAMELA WILKINSON

Korean War. When North Korea invaded South Korea on June 25, 1950, the second anniversary of President Harry S. Truman's executive order integrating the races in the armed forces was fast approaching. In the order of July 26, 1948, Truman established the President's Committee on Equal Treatment and Opportunity in the Armed Services, headed by Charles T. Fahy, an attorney and future federal judge, which reviewed and approved the integration plans of the armed forces. Once the Fahy Committee granted approval, the President let each service carry out its program with a minimum of interference.

The Korean War, which ended on July 27, 1953, did not require a mobilization of manpower, industry, and resources on the scale of World War II. Limited though it was, the Korean conflict demonstrated that racial segregation resulted in the wasteful misassignment of men and women and undermined the efficient conduct of the war. The armed services discovered that they could no longer delay compliance with the two-year-old order calling for equal treatment and opportunity regardless of race.

The impact of the war on race relations in civil society proved less decisive, because a civil rights movement, which for the present used the courtroom as a battlefield, was gathering momentum. As a consequence of the Civil Rights Movement, the Supreme Court in 1954 decided *Brown* v. *Board of Education of Topeka* and overturned the principle of separate-but-equal, the legal foundation upon which racial segregation rested.

The Air Force

When the Air Force became independent of the Army in September 1947, Lieut. Gen. Idwal W. Edwards, a member of the Air Staff, became concerned that, in the event of wartime expansion, poorly educated blacks, products of a segregated and second-rate educational system, would not fit easily into a service heavily dependent on advanced technology. Yet Lieut. Col. Jack Marr, investigating race relations for Edwards, discovered a cadre of African-American pilots, technicians, and administrators just as competent as their white counterparts. To promote efficiency, Edwards proposed that the Air Force abolish segregation and let blacks and whites compete for all assignments, so that only the best would survive, regardless of race. Before President Truman issued his order, Edwards sold this idea to Gen. Carl Spaatz, the first Air Force Chief of Staff, and his successor, Gen. Hoyt S. Vandenberg. Secretary of the Air Force Stuart Symington agreed and placed Assistant Secretary Eugene M. Zuckert in charge of integrating the races.

Despite the authority of the Commander in Chief and endorsement by the Secretary of the Air Force and two successive Chiefs of Staff, a number of influential Air Force officers opposed racial integration. One of them, Gen. George C. Kenney, whose airmen had supported Gen. of the Army Douglas MacArthur's advance from Australia to Japan, argued that blacks would embarrass themselves in a racially mixed Air Force, while others predicted a decline in white enlistments, if not large-scale desertions. Moreover, blacks serving in segregated units worried that integration merely provided an excuse for purging them from the service. Edwards, in fact, did not expect many African Americans to compete successfully, estimating that their presence in integrated units would stabilize at about 1 percent.

In May 1949, the Air Force adopted a personnel policy that ended racial segregation and prohibited the assignment of airmen outside their specialties—employing black mechanics as laborers, for example—so as to subvert integration. The fears of African-American airmen proved groundless, as the Air Force broke up the segregated units and reassigned the officers and men in accordance with their skills. The predicted exodus of whites did not occur.

The Air Force began integrating the races some thirteen months before the Korean fighting began in June 1950. By the end of 1949, roughly 60 percent of all African-American airmen either served in or were about to join racially mixed units. The Korean War confirmed the new policy, demonstrating that the needs of the service, and not race, should determine assignments. The last all-black unit disbanded in June 1952, two years after the North Korean invasion.

Edwards may well have been surprised by the ability of blacks to compete with whites, when opportunities were more or less equal. The proportion of

African Americans in the Air Force, far from shrinking, increased in the course of the conflict from 6.4 percent to 7.2 percent. The representation of blacks in the officer corps (including pilots and navigators) remained minuscule, however, increasing during the war from 0.6 percent to 1.0 percent.

The Navy and Marine Corps

Although the other services had submitted integration plans that the Fahy Committee approved, none had progressed as far as the Air Force when the Korean War began. The Navy, for example, formulated a policy that theoretically opened every specialty without regard to race, but 65 percent of the African Americans in the service—more than 10,000 sailors—served in the Steward's Branch. In an attempt to make this duty more attractive, the Navy in 1949 directed that chief stewards have all the privileges of chief petty officers in the general service, and in August 1953 decreed that all senior stewards assume the status of petty officers, effective January 1.

The African-American community resented the recruitment of blacks to function essentially as cooks, servants, and waiters—in the words of Rep. Adam Clayton Powell, "fighting communism with a frying pan or shoe polish." The continued existence of a large body of black stewards raised doubts about the sincerity of the Navy's commitment to racial integration and made it difficult to recruit African Americans during the Korean War expansion. Lester Granger, formerly an adviser to the Navy Department on racial matters and a member of the Fahy Committee, warned that the Steward's Branch remained a "constant irritant" to his fellow African Americans and recommended recruiting whites for this specialty. The fighting in Korea ended, however, before the Navy in 1954 stopped recruiting expressly for the Steward's Branch and allowed any sailor to volunteer. This decision opened the branch to whites, without preventing veteran African-American stewards from reenlisting.

Despite the tardiness in accepting white stewards, the number of blacks in that specialty declined during the Korean conflict until more than half of the African-American sailors performed other duty. A policy recommended by Anna M. Rosenberg, the Assistant Secretary of Defense for Manpower and Personnel, and adopted in April 1951 by Secretary of Defense George C. Marshall, opened a wider spectrum of assignments to African Americans in the armed forces. The new policy required that the Army, Navy, Marine Corps, and Air Force accept a share from each of four categories of recruits, groupings based on scores on the standardized qualification test then in use. Assistant Secretary Rosenberg hoped to divert into the Army a greater proportion of recruits from Categories I through III, especially those in the highest two, who formerly would have gravitated into the Air Force and Navy, and divide more equitably the members of Category IV, many of them African Americans taught in segregated schools. The Navy had no choice but to assign the resulting tide of blacks to a wide variety of occupations.

Although the Navy did provide greater opportunity for blacks during the Korean War, the specter of the Steward's Branch deterred many African Americans from enlisting. The proportion of blacks in the Navy declined by about 0.2 percent between 1950 and the end of the fighting in 1953. Not until 1960 did black Americans account for even 4.9 percent of naval personnel, a lesser proportion than the Air Force had a decade earlier. In spite of the admission of blacks to the Naval Academy—which graduated its first African American, Ensign Wesley A. Brown, in 1949—and the efforts of Lieut. Dennis D. Nelson, a graduate of the World War II officer candidate course for blacks, to stir up interest in officer training, the proportion of African-American naval officers did not exceed 1 percent when the Korean War ended.

The wartime demand for manpower forced the Marine Corps, a part of the Naval Establishment, to abandon the practice of racial segregation and conform to the Truman directive by carrying out the plan approved by the Fahy Committee. When the Korean War began in June 1950, racial integration in the Marine Corps remained confined mostly to athletic teams. With 1,605 African Americans on active duty—just 1.6 percent of the enlisted strength, and no officers—the Marine Corps easily maintained segregated units or specialties to accommodate them. A rapid wartime mobilization and a hurried deployment to the Far East resulted in the merging of blacks and whites in units being expanded to wartime strength. As the war continued—especially after the Chinese intervened, beginning in October 1950—greater reliance on the draft, together with Assistant Secretary Rosenberg's program for the qualitative distribution of manpower, increased the number of black Marines more than ninefold to 15,729, 6 percent of total strength. The number of African-American officers remained small, however, with only thirteen on active duty when the Korean conflict ended. This group included Franklin E. PETERSEN, Jr., the first African American to become a pilot in the Marine Corps and ultimately a four-star general. In short, the Korean struggle compelled the Marine Corps to accept large numbers of blacks, assign them where they could best help fight the war, and aban-

don the prewar practice of concentrating them in security and service units or employing them as stewards.

The Army

Like the Navy and Marine Corps, the Army complied slowly with President Truman's integration order. Not until April 1950, some twenty-one months after the Truman directive and within three months of the outbreak of war, did the Army abolish racial quotas for recruiting. Black males continued, nevertheless, to train in racially separate units, even though African-American women trained alongside their white counterparts. Segregated training for black males became an early casualty of the Korean War, however. The increase in white recruits forced the commanders of training divisions to assign some whites to regiments or battalions reserved for blacks. By March 1951, the sheer number of trainees defeated efforts to segregate the races in all of the Army's nine training divisions.

The largest African-American combat unit, the 24th Infantry, which traced its regimental lineage to the post–Civil War reorganization of the Army, went to war in July 1950. Like the other understrength American units trying to stop the North Korean onslaught, the 24th Infantry proved ill prepared for war, both physically and mentally. Some 62 percent of the enlisted men had general classification test scores in Categories IV and V, and this challenged the leadership and instructional skills of noncommissioned officers. Moreover, the regiment depended upon a replacement pool determined exclusively by race; it could not accept whites—except for officers, especially in command positions—even though suitably trained blacks, noncommissioned officers in particular, proved scarce. These problems ensured that the regiment would amass a mixed record of success and failure.

Racism, whether reflexive or calculated, may have magnified the flaws of the 24th Infantry and obscured its accomplishments. Prejudice against African Americans existed in American society and in the Army that fought the early battles in Korea. Alarmed by the number of courts-martial of members of the regiment, the NAACP sent Thurgood MARSHALL to investigate the administration of justice in the Army's Far East Command. He discovered that blacks, compared to whites, tended to be charged with more serious offenses, convicted more readily, and given harsher punishment.

One of the regiments sent to Korea in the summer of 1950, the 9th Infantry, had two battalions of whites and one made up of black soldiers transferred from the segregated 25th Infantry, disbanded as part of the Army's retrenchment after World War II. When casualties mounted among his white soldiers, one of the battalion commanders demanded replacements and in August accepted more than 200 African Americans, some of them also former members of the 25th Infantry, whom he assigned throughout his unit.

As the experience of the 9th Infantry indicated, race could not determine assignments; black soldiers had to serve wherever the Army needed them, not in a particular regiment or battalion. In a limited conflict requiring only a partial mobilization, the Army could not maintain two separate channels of recruitment, training, and assignment—one for whites, the other for blacks, and each with its own overhead for administration.

Gen. Matthew B. Ridgway understood the inherent inefficiency and leveled the crumbling ramparts of racial segregation throughout the Far East. Upon taking over the Far East Command from Gen. MacArthur, Ridgway abolished segregation, which he later described as "wholly inefficient, not to say improper," and "both un-American and un-Christian." As part of his integration program, he disbanded the 24th Infantry on July 1, 1951, and reassigned the African-American soldiers to formerly all-white units.

The Army could have integrated swiftly and smoothly, if it had reassigned its African Americans, about 12 percent of aggregate strength, uniformly throughout the service. Unfortunately, not every senior commander shared Ridgway's belief in racial integration, and because he integrated first, they sent their unwanted blacks to the Far East, increasing the proportion there to 17.6 percent. The Far East Command absorbed the newcomers, however, and Ridgway's success became a source of pride to the Truman administration and the Army.

The European Command began integrating the races in 1951 but bogged down amid fears of unrest in the ranks and friction with local civilians. The Army prodded the command into acting, however, and the last all-black unit in Europe—indeed, in the entire service—integrated in November 1954. Meanwhile, the Korean fighting ended, draft calls declined, and the proportion of African Americans in the Army leveled off at about 12 percent, essentially the same as when the war began.

By the time President Dwight D. Eisenhower took office in January 1953, the armed forces had made an irrevocable commitment to integrating the races. In April, four months before the Korean armistice went into effect, the new administration undertook the racial integration of the schools operated by the Department of Defense for the children of servicemen.

When the 1953 school year began, all the schools located on federal land and sustained by federal funds had integrated. Those operating off-base, or locally funded, eventually followed suit, for in May 1954 the Supreme Court, in Brown v. *Board of Education of Topeka,* declared segregated schools unconstitutional.

Civil Society

The mobilization for the Korean War, and the maintenance of powerful armed forces for the continuing Cold War, boosted the American economy as a whole, creating jobs, some of which went to African Americans. As President Roosevelt had done during World War II, Truman issued a series of executive orders during 1951 that barred discrimination on the part of firms under contract to the government. In December of that year, the President established the Committee of Government Contract Compliance, a faint shadow of Roosevelt's Fair Employment Practice Committee. The new organization could do no more than publicize instances of racial discrimination and advise the contracting agencies, which alone had the authority to cancel agreements with firms that violated government policy. The Korean War did not alter the fact that the racial attitudes of a community determined employment opportunities for blacks.

Nor did the pressures of war slow the shift of the black populace from southern farms to northern cities or end the exclusion of African Americans from the new suburbs springing up around America's urban centers. About 1.5 million blacks from the rural South migrated to the cities during the 1950s, as 3.5 million nonwhites moved into the inner portions of the nation's twelve largest cities and 4.5 million whites moved out, most of them to the suburbs. Although 5 percent of African Americans lived in the suburbs, they dwelt either in segregated communities or on rural tracts counted as suburban only for purposes of the census. The Supreme Court, in *Shelley* v. *Kraemer* (1948), had declared racial covenants designed to enforce segregated housing unenforceable at law, but one of the new model suburbs, Levittown in Pennsylvania, actually had no black resident until 1957.

REFERENCES

DALFIUME, RICHARD M. *Desegregation of the U.S. Armed Forces: Fighting on Two Fronts, 1939–1953.* Columbia, Mo., 1969.

GROPMAN, ALAN L. *The Air Force Integrates, 1945–1964.* Washington, D.C., 1978.

MCCOY, DONALD R., and RICHARD T. RUETTON. *Quest and Response: Minority Rights and the Truman Administration.* Lawrence, Kans., 1973.

MACGREGOR, MORRIS J. *Defense Studies: The Integration of the Armed Forces, 1940–1965.* Washington, D.C., 1981.

NICHOLS, LEE. *Breakthrough on the Color Front.* New York, 1954.

POLENBERG, RICHARD. *One Nation Divisible: Class, Race, and Ethnicity in the United States Since 1938.* New York, 1980.

BERNARD C. NALTY

Ku Klux Klan. To most people the words *Ku Klux Klan* mean a southern terrorist movement organized after the Civil War, with active chapters still in existence, that seeks forcibly to deny African Americans their rights. Such a perception mistakes the Klan as a monolithic movement with a continuous history. Similarities in name, costume, and ritual have hidden from view the Ku Klux Klan's separate incarnations. In four distinct movements differing in geographical base, tactics, targets, and purpose, Klansmen have organized their resources to claim power.

Confederate army veterans formed the first Klan movement in 1866 in Pulaski, Tenn. Manipulating the Greek word for circle, *kuklos,* they alliteratively created "Ku Klux Klan" as the name of what was initially designed to be only a fraternal body. Members, however, quickly became aware of the social-control power of a secret organization of armed white men. The Klan, under former Confederate General and now Imperial Wizard Nathan Bedford Forrest, soon spread throughout the South, emerging as a vehicle to combat Reconstruction and subordinate recently emancipated blacks and their white Republican allies. Masked and robed Klansmen threatened, flogged, and killed those who sought black rights and a more just distribution of wealth and power. Congress, with the support of President Ulysses S. Grant, responded to these outrages in 1870–1871 with laws protecting black voters and outlawing Klan activities. In 1871, under these laws, Grant suspended habeas corpus in parts of Klan-dominated South Carolina and ordered mass arrests and prosecutions of Klansmen. White Southerners, with the Klan's usefulness at an end, resorted to political activism and the more subtle and "acceptable" means of economic coercion inherent in their control of credit, land, and jobs to reassert influence.

Nearly half a century later, the second Ku Klux Klan appeared. On Thanksgiving Day in 1915, William Joseph Simmons, a former Methodist circuit rider and fraternal organizer and the son of a Reconstruction Klansman, convinced fifteen of his friends to follow him to the summit of Stone Mountain in

Georgia. There, under an American flag and a burning cross, the men knelt and dedicated themselves to the revival of the Knights of the Ku Klux Klan. As early as 1898, Simmons had planned to re-create the Klan to honor the men of the first hooded order and to pioneer a new fraternal group. The interest generated by the fiftieth anniversary in 1915 of the end of the Civil War, and the premiere in Atlanta of the motion-picture masterpiece BIRTH OF A NATION, enticed Simmons to reify his dream.

The second Klan grew slowly. By 1920, it counted only four or five thousand members in scattered chapters in Georgia and Alabama. To revitalize his dream, Simmons turned for help in promoting the Klan to E. Y. Clarke and Elizabeth Tyler of the Southern Publicity Association. They signed a contract with Simmons stipulating that the Association, henceforth the Propagation Department of the Invisible Empire, would promote and enlarge the Klan in exchange for eight dollars of every ten-dollar membership fee, or klectoken. Clarke and Tyler enlisted more than 200 organizers, known as kleagles, and directed them to exploit any issue or prejudice that could be useful in recruiting men for the movement. The kleagles fanned out across the United States. Working on a commission basis, they sought to secure as many new members for the Klan as they possibly could. The sharp rise in the secret order's membership reflected their success, for between June 1920 and October 1921, 85,000 men joined.

Directed from Atlanta by the new imperial wizard, Hiram Wesley Evans, but tuned to the local environment, the kleagles preached a multifaceted program. They portrayed the Klan as a patriotic movement determined to safeguard endangered American institutions and values. The Klan posed as the champion of the "old-time religion" and promised to unite all Protestants under a single banner. Law and order was another rallying cry. A sharp upsurge in crime in the postwar years, primarily fueled by Prohibition law violations, alarmed Americans. Many of those impatient with the police and courts turned to the Klan to enforce the laws and restore order to their communities.

The message of Americanism, Protestantism, and law enforcement was not aimed at all Americans. The Klan accused Catholics of placing their allegiance to the pope above their loyalty to the United States. Vowing to eliminate "papist power," the Klan boycotted Catholic businesses, burned crosses before churches, fired Catholic public school teachers, and defeated Catholic candidates for public office. Anti-Semitism was also a plank in the Klan program. The Jews, declared the kleagles, dominated the American economy and led those who sought to commercialize the Sabbath and exclude the Bible from the public schools. White supremacy was another tenet: Klan leaders exploited white fears of change and offered the movement as a means to maintain the racial status quo. Finally, the Klan beckoned lodge joiners by providing the fellowship, festivity, and mystery that these men craved. Simmons's creation of rituals and his titles for movement officers—kleagle, kludd, exalted cyclops—were intended to appeal to these men's imaginations.

The Klan advanced quickly in the early 1920s. In Texas, 200,000 men joined, and a Klansman was elected to the United States Senate. California's 50,000 Klansmen helped capture the statehouse for their candidate. Colorado Klan organizers counted 35,000 recruits, and elected members as governor and U.S. senator. Twenty local chapters were organized for Chicago's 50,000 Klansmen, while 35,000 wore the hood and robe in Detroit. The Klan citadel of Indiana claimed 240,000 knights, who succeeded in electing two governors and two United States senators. New York added 200,000 more Klansmen, and Pennsylvania 225,000. Only 16 percent of the membership lived in the South. The Klan population was higher in New Jersey than in Alabama; Indianapolis Klan membership was nearly double that in South Carolina and Mississippi combined. At its height in 1924, the national movement drew an estimated 3 million to 6 million men from throughout the United States.

The impact of the Ku Klux Klan on the 1924 presidential election is difficult to judge. Klan leaders' unyielding opposition at the Democratic National Convention to the presidential ambitions of New York governor Al Smith, a Catholic and antiprohibitionist, and to a platform plank specifically condemning their organization deepened divisions that the party would not bridge for years.

The Klan's response to community problems was usually political. By electing trusted officials, Klansmen would be assured that crime would be suppressed, minorities regulated, and community improvements initiated. In many cities and towns across America, Klan and government merged. Mayors, city councilmen, and police officials consulted with Klan leaders about policy, legislative agendas, and appointments. Such relationships also existed on the state level in Indiana, Oregon and Colorado. Violence, which occurred in isolated instances, was mainly perpetrated by independent bands of radicals, usually in the early days of Klan building.

The second Klan's fall was as rapid as its rise. The reasons for decline were varied: the movement's inability to fulfill its promises; members' demoralization in the face of their leaders' financial or moral corruption; and a failure to respond as the salience of past issues faded and new concerns came to the fore.

The Ku Klux Klan parading along Pennsylvania Avenue in Washington, D.C., 1926. (Photographs and Prints Division, Schomburg Center for Research in Black Culture, The New York Public Library, Astor, Lenox and Tilden Foundations)

By the end of the 1920s the Klan was discredited and without influence. Anti–New Deal rhetoric and a flirtation with the pro-Nazi American Bund in the 1930s did not revive the movement. In 1944, the Internal Revenue Service revoked its designation of the Klan as a charitable organization and forced William Simmons's Invisible Empire out of business with a demand for $685,000 in back taxes.

Burning crosses of the third Klan movement appeared in 1946; by 1949 over 200 chapters, holding 20,000 Klansmen, had been organized. Additional growth spurts followed the Supreme Court's BROWN V. TOPEKA, KANSAS, BOARD OF EDUCATION decision in 1954 and school desegregation in LITTLE ROCK in 1957, for this was a southern campaign, focused upon African Americans' quest for racial and economic equality. Splintering early into more than a dozen separate groups, the secret order resorted to bombing, arson, and murder to stop the black challenge. The Klans competed unsuccessfully with the more respectable urban and middle-class WHITE CITIZENS COUNCILS for members and funds, and re-

mained a secondary impulse in the 1950s and 1960s. Still, the organization became the center of national attention. In 1961, Klansmen assaulted freedom riders. In 1963, members bombed a Birmingham church, killing four black children. The following year, Klansmen murdered three civil rights workers in Mississippi.

In response, the Federal Bureau of Investigation (FBI) targeted seventeen Klan groups in 1964. Agents infiltrated chapters and paid Klansmen to disrupt activities by sowing discord among fellow members. By the early 1970s, one of every six Klansmen was on the FBI payroll. Repression was effective. Klan membership, which had grown to 50,000 in the mid-1960s, declined to 6,500 by 1975.

New Ku Klux Klans emerged in the late 1970s. College-educated leaders, proficient in their use of the media, offered a "modern" movement that rejected terrorism. Welcoming Catholics for the first time and accepting women as equal partners, the Klans opposed busing to remedy school segregation, affirmative action programs, and illegal immigration

The activity of the Ku Klux Klan intensified after World War II with the growing strength of the civil rights movement. Pictured here is a cross burning in suburban Jacksonville, Fla., in June 1950. (AP/Wide World Photos)

from Mexico. Klansmen spread north and west, aligning with neo-Nazi groups such as Aryan Nations and the White Aryan Resistance in a United Racist Front. Adopting the slogans of the Christian Identity movement that proclaimed white Christians as the true chosen people of God, Klansmen assailed blacks, Asians, and Hispanics as "mud people" under the rule of Satan's offspring, the Jews. Leaders, predicting a coming race war, established military training camps in the West and Midwest and organized a computer network linking members throughout the United States.

By the late 1980s, the Klan was again in retreat. Federal prosecutors brought Klansmen and their leaders to trial for violent acts, sedition, and conspiracy to overthrow the government. Groups such as the NATIONAL ASSOCIATION FOR THE ADVANCEMENT OF COLORED PEOPLE (NAACP), the Anti-Defamation League, and the SOUTHERN POVERTY LAW CENTER monitored hooded activities and filed civil lawsuits on behalf of Klan victims to collect damages and drain the movement of funds. Within the decade, the Klans had lost over half of their members, leaving approximately 5,000 men and women beneath hood and robe.

Yet the Klan's hold on America's mind has not loosened. The history of the Ku Klux Klan is a history of resurrection, and the observant search for the spark that will ignite another revival. Thus Louisiana state legislator David Duke, a former member of the American Nazi party and sometime imperial wizard of a Klan splinter group, drew the national spotlight when he ran for governor in 1991. His defeat did not ease concern, for he captured a majority of white votes. America's long history of racial and religious conflict, the eerie sight of the flaming cross, and the menacing imagery of hooded and robed men ensure that the Invisible Empire of the Ku Klux Klan will

retain its powerful symbolism for friend and foe alike into the next century.

REFERENCES

ALEXANDER, CHARLES. *The Ku Klux Klan in the Southwest*. Lexington, Ky., 1966.

CHALMERS, DAVID. *Hooded Americanism: The History of the Ku Klux Klan*. New York, 1981.

COBEN, STANLEY. *Rebellion against Victorianism: The Impetus for Cultural Change in 1920s America*. New York, 1991.

GOLDBERG, ROBERT A. *Hooded Empire: The Ku Klux Klan in Colorado*. Urbana, Ill. 1981.

JACKSON, KENNETH. *The Ku Klux Klan in the City*. New York, 1967.

WADE, WYN CRAIG. *The Fiery Cross: The Ku Klux Klan in America*. New York, 1987.

ROBERT ALAN GOLDBERG

Kwanza. In 1966, at the height of the black self-awareness and pride that characterized the Black Power movement, cultural nationalist Maulana KARENGA created the holiday of Kwanza. Kwanza, meaning "first fruits" in Swahili, is derived from the harvest time festival of East African agriculturalists. Karenga believed that black people in the diaspora should set aside time to celebrate their African cultural heritage and affirm their commitment to black liberation. His philosophy, called KAWAIDA, formed the ideological basis of Kwanza. The holiday was intended to provide a nonmaterialistic alternative to Christmas, and is celebrated from December 26 through January 1. Each day is devoted to one of the seven principles on which kawaida is based: *umoja* (unity), *kujichagulia* (self-determination), *ujima* (collective work and responsibility), *ujamaa* (cooperative economics), *nia* (purpose), *kuumba* (creativity), and *imani* (faith).

The attempt to honor communal heritage through ceremony is central to Kwanza. On each evening of the celebration, family and friends gather to share food and drink. The hosts adorn the table with the various symbols of Kwanza, and explain their significance to their guests. First a mkeka (straw mat) representing the African-American heritage in traditional African culture is laid down. Upon the mat, a kinara (candleholder) is lit with seven candles in memory of African ancestors. Each of the seven candles represents one of the seven values being celebrated. A kikomba (cup) is placed on the mat to symbolize the unity of all African peoples, and finally, tropical fruits and nuts are laid out to represent the yield of the first harvest.

Although Kwanza was at first limited in practice to cultural nationalists, as more African Americans

One of the ceremonies of the Kwanza, a holiday honoring the cultural and spiritual vitality of African peoples, is the lighting of the kinara, a seven-pronged candelabrum. Since its founding in 1966, Kwanza has been a cherished time of the year for millions of people. (C. Fournier)

came to heightened awareness and appreciation of their African heritage, the holiday gained wider and more mainstream acceptance. In the 1990s, Kwanza is celebrated internationally, but has gained its widest acceptance and popularity among African Americans.

REFERENCES

KARENGA, MAULANA. *Kawaida Theory: An Introductory Outline.* Inglewood, Calif., 1980.

MAGUBANE, BERNARD. *The Ties That Bind: African American Consciousness of Africa.* Trenton, N.J., 1987.

WEUSI-PURYEAR, OMONIKI. "How I Came to Celebrate Kwanza." *Essence* (December 1979): 112, 115, 117.

NANCY YOUSEF
ROBYN SPENCER

L

LaBelle, Patti (Holt, Patricia Louise) (October 4, 1944–), singer. Born and raised in Philadelphia, Pa., Patti LaBelle grew up singing in the choir of the Beaulah Baptist Church. She was sixteen years old when she joined a vocal group called the Ordettes; a year later, LaBelle, Cindy Birdsong (who joined the SUPREMES as Florence Ballard's replacement in 1967), Nona Hendrix, and Sarah Dash signed on with Newton Records, and named their group the BlueBelles after Newton's subsidiary label, Bluebelle records. After their song "I Sold My Heart to the Junkman" reached the Top Twenty in 1962, the group was rechristened Patti LaBelle and the BlueBelles.

LaBelle, who is known for her fiery stage presence and outrageous attire—a mixture of leather, feathers, glitter, and enormous fanlike coiffures—received her first big break in 1968, when she and the BlueBelles opened for the Who during their U.S. tour. The following year, she married Armstead Edwards, an educator who enrolled in business courses in order to become her personal manager. In 1971, LaBelle and the BlueBelles became known as simply "LaBelle." Their album *Nightbirds,* with its number one single "Lady Marmalade," made the Top Ten in 1973. In 1974, LaBelle became the first black band to perform in New York's Metropolitan Opera House; as the lead singer, Patti LaBelle caused a sensation when she began the show by descending from the ceiling, where she hung suspended, to the stage.

LaBelle went solo in 1977, after personal and artistic differences between the singers caused the band's dissolution the previous year. By the end of the 1970s, she had recorded two LPs for Epic Records, and she continued to appear live and record albums throughout the '80s and early '90s. In 1985, LaBelle appeared in Pennsylvania to perform in the Live Aid Benefit Rock Concert; her album *Burnin'* earned her a Grammy Award for best RHYTHM AND BLUES performance by a female vocalist in 1991.

LaBelle is well known for her support of numerous charitable and social organizations, including Big Sisters and the UNITED NEGRO COLLEGE FUND, as well as various urban renewal and homelessness projects in Philadelphia, where she lives. In addition to giving concert performances, she costarred with singer Al GREEN in a revival of *Your Arms Too Short to Box with God* on Broadway in 1982, and appeared in the films *A Soldier's Story* and *Beverly Hills Cop,* in her own television special, and in the television series *A Different World* and *Out All Night.*

REFERENCES

EBERT, ALAN. "Girlfriend: A Down Home Diva!" *Essence* 21 (March 1991): 68–70.

HINE, DARLENE CLARK, ed. *Black Women in America: An Historical Encyclopedia,* Vol. 1. Brooklyn, N.Y., 1993.

PAMELA WILKINSON

Labor and Labor Unions. African-American workers' relationship to the organized labor movement has undergone tremendous, if uneven, shifts

since the CIVIL WAR. Concentrated in southern agriculture or in unskilled occupations before World War I, most black workers simply did not compete directly with whites in the economic sphere. Trade unions were dominated by white workers, whose skills and racial solidarity often enabled them to bar blacks from membership in their associations and employment in certain sectors of the economy. By World War I, however, the efforts of an ever-growing number of urban industrial black workers to advance economically undermined the success of white labor's exclusionary strategy. With the triumph of industrial unionism represented by the rise of the CONGRESS OF INDUSTRIAL ORGANIZATIONS during the Great Depression of the 1930s, an important branch of the labor movement committed itself to interracial organizing. The modern American labor movement has both reflected and contributed to the nation's changing race relations. While never free of racial tensions or inequality, and while possessing a wide range of unions with different racial policies, practices, and degrees of commitment to racial equality, the labor movement has served as one more arena of black workers' larger struggle for racial equality in the economy.

Agriculture

In the aftermath of the Civil War, the overwhelming number of black workers made their living in southern agriculture as landless sharecroppers and tenant farmers, concentrated at the bottom of the South's economic hierarchy where they exercised little political or economic power. Black agricultural workers launched periodic collective challenges to white planters' authority in the political realm during RECONSTRUCTION and the Populist Era in the late 1880s and early 1890s, and in the economic arena in the form of strikes by rural Knights of Labor in the mid-1880s and by various sharecroppers' movements in the 1930s. But their movements and uprisings were quickly crushed. The 1887 strike by some 10,000 Knights of Labor (most of whom were black) working in the Louisiana sugar fields met with fierce state repression, as did the efforts of the black Alabama Share Croppers' Union in the 1930s. Trade unions and other movements found the rural South infertile soil in which to take root and flourish, for many reasons, including the South's racial ideology, black workers' economic weakness arising from their landlessness, the power of the planter class, the commitment of the state to repressing rural labor, and the organized labor movement's lack of interest in agricultural and black workers. The most successful black response to economic and political oppression was short-range mobility within the South and ultimately migration out of the South. Engaged overwhelm-

ingly in rural southern agriculture at the end of the Civil War, African Americans have, by the late twentieth century, become a largely urban people, engaged in manufacturing, transportation, and service trades in the North, South, and West.

Nineteenth- and Early Twentieth-Century Trade Unions

Before and after the Civil War, trade unions of white workers in the North and South viewed skilled and unskilled urban black workers as a threat to their own economic security. Skill, independence, manliness, and a sense of racial superiority defined the contours of these skilled whites' beliefs. In white workers' thinking, black workers (slave or free) might demean a craft by working more cheaply and without regard to union work rules or customs. Accordingly, whites excluded blacks from membership in their organizations, denied blacks access to apprenticeship programs, and occasionally resorted to force to drive blacks out of employment.

Immediately after the Civil War, a new, loosely organized, and short-lived national federation of white trade unions, the National Labor Union (1866–1872), eventually admitted black delegates representing black workers to its conventions but went no further. At the same time, most of its constituent members barred blacks from their unions, urging them to organize separately into their own unions. While white workers excluded blacks from white associations, their acceptance, sometimes reluctant, sometimes not, of all-black associations was as far as most white union members were willing to go. The alternative, which was more widely practiced, was white exclusion, nonrecognition, and outright hostility toward blacks. Until the 1930s, exclusion and biracial unionism represented the white labor movement's two dominant tendencies toward African Americans.

In response to their exclusion from white organizations, black workers built upon their communities' larger institutional networks to create all-black unions that championed their members' class and racial interests. Black labor leader Isaac Myers, a Baltimore ship caulker, was a founder of another short-lived association in 1869, the black National Labor Union which brought together representatives of newly formed black unions, community leaders, and black political (Republican) officials. More enduring, if less recognized, were the dozens of smaller associations that emerged during and after Reconstruction in such southern urban centers as Richmond, Galveston, New Orleans, Mobile, and Savannah.

During the 1880s, the Knights of Labor emerged from obscurity to become the nation's most powerful labor federation. The Knights' ideology was co-

(Top) Though black labor organizations, such as this carpenters' union in Jacksonville, Fla., in 1903, worked hard to improve the working conditions of their members, their efforts were frequently hampered by the bitter opposition of both employers and white union members. (Bottom) African-American laundry workers and washerwomen organized unions as early as 1866; in Atlanta, in 1881, three thousand washerwomen went on strike. Labor organizing in large commercial laundries began before World War I. In the late 1920s the heavily female work force in commercial laundries earned, on average, less than fifteen dollars a week. (Prints and Photographs Division, Library of Congress)

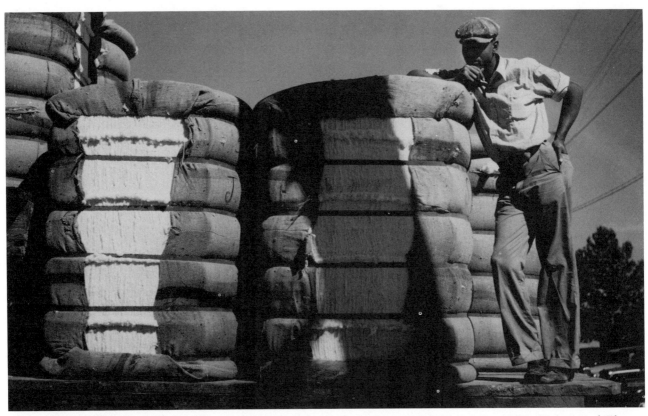

Cotton gin worker on the back of a truck with cotton bales near Smithfield, N.C., 1936. (Prints and Photographs Division, Library of Congress)

Union appeal in favor of integration. (Photographs and Prints Division, Schomburg Center for Research in Black Culture, The New York Public Library, Astor, Lenox and Tilden Foundations)

operative, inclusive, and egalitarian. The organization embraced all wage earners across lines of skill, gender, religion, ethnicity, and race (with the exception of Asian immigrants). Although there are no precise figures, one contemporary estimated that blacks constituted about 10 percent (roughly 60,000) of the Knights' membership in 1886. Yet the formation of Knights' locals largely followed strict racial lines. The Order, particularly in the South, absorbed already existing black and white locals, and new locals formed along racially distinct lines. This biracial character did not prevent black and white delegates from meeting together or formulating joint strategies, but it did perpetuate existing differences and made expressions of solidarity more difficult. By 1886, the Knights' racial policies came under fierce attack from conservative southern editors, politicians, and employers as well as some white Knights. Playing upon white workers' racial fears, employers "race-baited" the Order, which, for many reasons, went into decline in the late 1880s.

The American Federation of Labor (founded in 1881) succeeded the Knights as the nation's dominant labor organization by the early 1890s. In contrast to the inclusiveness of the Knights, the social bases of the AFL rested on white craft workers who sought to protect their skills and jobs from all newcomers. Craft unions were exclusive, barring workers from membership on the basis of their lack of skills, their sex, race, and in some cases ethnicity. The AFL was formally opposed to racial discrimination in its ranks; in 1892, its New Orleans members participated in an (unsuccessful) interracial general strike on behalf of unskilled black and white workers. But by the turn of the century, AFL leaders tolerated widespread discrimination by its constituent members, explaining that the all-important principle of craft autonomy—which granted considerable power to individual unions—made it impossible for them to intervene in member unions' internal affairs. AFL officials adhered to that principle only selectively, however, for on other issues they did sometimes intervene.

The majority of union internationals in the AFL, as well as the independent, powerful railroad brotherhoods, remained all white, and a minority of union internationals admitted blacks into segregated, second-class unions. Several large internationals defied these trends. The International Longshoremen's Association and the United Mine Workers of America, while embracing biracial unions (all-black and all-white locals), espoused somewhat more egalitarian views and policies. The existence of large numbers of black workers, many of whom were organized, compelled white trade unionists in these fields to reach accommodations with African-American workers. That is, these unions' success and very existence required a coming-to-grips with racial divisions; they could little afford to exclude or ignore black workers.

During the Progressive Era, only the Industrial Workers of the World (IWW) adopted a principled stand against racial discrimination. Far to the left of the AFL, the IWW advocated the formation of industrial unions (all workers in a factory, regardless of craft, would be members of the same union) and the overthrow of capitalism, championing a working-class solidarity that transcended all lines of division. While it gained adherents among black and white southern timber workers and Philadelphia longshoremen before World War I, the IWW confronted massive government and employer repression and declined rapidly during the war.

In the late nineteenth and early twentieth century, maintaining all-white workplaces sometimes brought white workers into sharp conflict with employers and blacks. Employers used white workers' racial beliefs and practices to their own advantage by turning to black workers to break strikes or otherwise undermine union wages and work rules. Black workers, who were barred from certain sectors of employment and union membership, found strikebreaking to be one method of cracking the economic color line and securing new jobs. In this period, there were dozens of instances of small- and large-scale riots and other violence as whites in all-white unions battled black workers imported by employers to undercut union authority and power.

White workers often coexisted easily or uneasily with black workers in their trades, but upon other occasions they sought to drive blacks completely out of those jobs. For instance, the 1894–1895 strikes by white New Orleans dock workers and the 1909 strike by white Georgia railroad firemen each sought as its goal the elimination of black workers. During the World War I era, massive labor shortages in the North contributed to an unprecedented migration of African Americans out of the South. Securing a wide foothold in mass-production industries for the first time, black workers confronted often-hostile whites, especially during the postwar economic downturn. Competition for jobs was only one of the many causes of the race riots that exploded in 1919, and black workers suffered discrimination not only at the hands of unions but by employers as well.

Despite the AFL's racial practices and black leaders' condemnation of those practices, numerous black workers formed all-black unions and joined the federation. Generally representing unskilled workers (in such trades as longshoring and mining), these unions were often smaller and weaker than their white counterparts. Nonetheless, they participated in the labor upheavals of the World War I era. The years 1918 and

1919, for instance, witnessed strikes by black female domestic workers and laundry workers in Mobile and Newport News, black male longshoremen in New Orleans, Galveston, Savannah, and Key West, and black (and white) coal miners in West Virginia, Tennessee, Kentucky, Arkansas, and Alabama. These strikes failed less because of white workers' opposition (in some cases, whites and blacks struck together) than because of violent opposition by employers and government. Yet the rare union effort to bridge the racial gap in northern industry, such as the wartime drive by Chicago's multiracial and multiethnic packinghouse workers, failed not only because of the employers' hostility; in the Chicago packinghouses, racial and skill divisions proved too deep for organizers to overcome, dooming the unions' efforts.

Immediately after the war, black unionists demanded that the AFL abolish its color line and actively organize black workers. While the AFL passed lofty resolutions, the behavior of its white affiliates changed little, if at all. Although the AFL eventually did offer organizational backing to the largest all-black union in the United States, the BROTHERHOOD OF SLEEPING CAR PORTERS, founded in 1925 and led by A. Philip RANDOLPH, it did little to challenge the racism of its other railroad unions, which remained virtually lily-white until the 1960s.

African Americans, like their white native-born and immigrant counterparts, were of many minds on the subject of organized labor. Until the mid-twentieth century, most blacks worked in sectors of the economy (agriculture, domestic service, and common labor) that were not conducive to sustaining trade unions, regardless of the race of the labor force. If no one could deny the institutional racism of organized white labor, African Americans disagreed on such issues as the possibilities of positive institutional change, the relationship between black workers and white industrialists, the union movement's tactics, and the like. Conservative leader Booker T. WASHINGTON, along with many business-oriented black newspaper editors and clergymen, were extremely harsh in their evaluation of the AFL, counseling black workers to ally with the industrial leaders in the New South and in the North. Some black workers, excluded from white unions and hence certain job categories, reluctantly or enthusiastically became strikebreakers as the only way to gain access to better jobs. Other black leaders were ideologically flexible, praising organized labor when it opened its doors to blacks, condemning it when it kept those doors closed. Black proponents of black union organizing, like miner Richard L. Davis and longshoreman James PORTER, worked within their respective union internationals, attempting to enlist black workers in the labor movement's ranks at the same time they sought to modify white labor's racism. Given white workers' often abusive treatment, a relative lack of skills, and economic subordination, a majority of black workers remained outside of the labor movement (as did a majority of white workers). Black workers who joined trade unions did so for many of the same reasons white workers did: to improve wages and working conditions, to eliminate or reduce abuses, to win a degree of job security and control over the conditions of their labor, and to secure a measure of dignity in their work lives. Black trade unions waged a continual struggle to carve out a place for themselves in an often reluctant labor movement dominated by whites. Until the rise of the Congress of Industrial Organizations in the 1930s, their successes were relatively few and far between.

Industrial Unionism and Unions in Modern America

The formation of the Congress of Industrial Organizations in 1935 heralded a gradual transformation in the relationship between organized labor and African-American workers. Breaking away from the AFL, CIO unions advocated industrial unionism and campaigned vigorously to organize basic industry (auto, steel, meat packing, electric, rubber). Committed to organizing all workers, regardless of skill, sex, or race, the CIO both ideologically and practically had to secure the support of black workers, whose presence in basic industry in the North had increased dramatically since the great migration of the World War I era brought hundreds of southern blacks into the northern economy. There was no single CIO perspective or practice on racial issues, for CIO unions' record on racial issues and behavior toward black workers varied by industry and region. During World War II, thousands of white workers (many of whom were themselves newcomers to industry and the labor movement) conducted unofficial, unsanctioned hate strikes against the presence or advancement of black workers in their factories, strikes that were opposed by the federal government and top union leaders. Before and after World War II, left-wing CIO unions maintained the strongest record on civil rights issues and the treatment of black members. Influenced by communist leaders and an active black rank and file, the United Packinghouse Workers, the Farm Equipment Workers, the Food, Tobacco, Agricultural, and Allied Workers, the Mine, Mill, and Smelter Workers, and, by the 1950s and 1960s, the Hospital Workers Union stood at the forefront of those in the labor movement advancing a civil rights agenda (see COMMUNIST PARTY OF THE U.S.A.; CIVIL RIGHTS MOVEMENT). The more cen-

trist United Automobile Workers Union, especially in Detroit, worked in close alliance with black political leaders in the 1940s.

Since 1950, the labor movement's record on issues of black equality has remained checkered. Participating in the anti-communism of the post–World War II era, the CIO purged its left wing, firing communist organizers and expelling unions most active in the struggle for racial equality. The CIO's failed Operation Dixie in 1946–1947 left organized labor far weaker and economic segregation far stronger in the South. The merger of the AFL and the CIO in 1955 sealed the labor movement's primary organizational fault line, but on terms that left substantively untouched much of the racial conservatism of the AFL craft unions. Over the next several decades, black trade unionists founded a number of all-black organizations (the NATIONAL NEGRO LABOR COUNCIL, the NEGRO AMERICAN LABOR COUNCIL, the League of Revolutionary Black Workers, and the Coalition of Black Trade Unionists) as well as caucuses within various international unions (affecting unions in steel, the garment trade, the postal service, and education), all of which aimed at advancing African Americans' civil rights by pressuring AFL-CIO officials and employers alike. Since the 1960s, many white AFL unions have continued to discriminate against blacks and have opposed affirmative action strongly, and, in the 1980s, many white unionists participated in the "white backlash" and defected from the Democratic party, becoming "Reagan Democrats" who voted

Republican in presidential elections (*see* AFFIRMATIVE ACTION). Yet the united AFL-CIO did create a civil rights department, and some union internationals and locals contributed money and organizers to the civil rights movement of the late 1950s and 1960s. The percentage of blacks in the AFL-CIO continued to rise, reaching roughly 10 percent of the federation's declining membership by 1970. African Americans in unionized jobs earned about 25 percent more than blacks in nonunionized jobs by 1979. By the 1990s, unions containing a large African-American membership include the United Auto Workers, the Service Employees International Union, the American Federation of State, County, and Municipal Employees, and the Hospital Workers Local 1199. During the 1980s, unions with large numbers of black members were active in supporting South Africa's anti-apartheid movement and in lobbying for progressive legislation in health care; a number of unions endorsed Jesse JACKSON's 1988 bid for the presidency.

Since the 1960s, deindustrialization and capital flight, the expansion of dead-end and poorly paid jobs in the new "service" economy, an increasingly hostile political environment, and the revival of strong anti-union sentiment in the business community have contributed to the steady and dramatic decline of organized labor. Fighting an uphill battle for its own survival, the labor movement has devoted relatively little attention to making inroads in the economy's fast-growing, low-wage, unskilled sector, which is increasingly dominated by black and other nonwhite workers. Because of its current weakness, its narrow vision, and its adherence to traditional strategies that center primarily on its members' needs, the labor movement has contributed little to addressing the larger issues of economic decline and postindustrial poverty, which have had tremendously negative effects on the African-American urban working class.

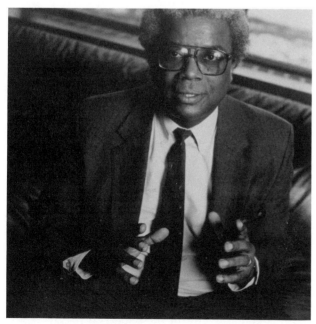

Stanley Hill, head of Municipal Employees Union, New York City. (Allford/Trotman Associates)

REFERENCES

ANDERSON, JERVIS. *A. Philip Randolph: A Biographical Portrait*. New York, 1972.

ARNESEN, ERIC. *Waterfront Workers of New Orleans: Race, Class, and Politics, 1863–1923*. New York, 1991.

CAYTON, HORACE R., and GEORGE S. MITCHELL. *Black Workers and the New Unions*. Chapel Hill, N.C., 1939.

HARRIS, WILLIAM H. *The Harder We Run: Black Workers since the Civil War*. New York, 1982.

JACOBSON, JULIUS, ed. *The Negro and the American Labor Movement*. New York, 1968.

KORSTAD, ROBERT, and NELSON LICHTENSTEIN. "Opportunities Found and Lost: Labor, Radicals, and the Early Civil Rights Movement." *Journal of American History* 75 (1988): 786–811.

LEWIS, RONALD L. *Black Coal Miners in America: Race, Class, and Community Conflict, 1780–1980.* Lexington, Ky., 1987.

MEIER, AUGUST, and ELLIOTT RUDWICK. *Black Detroit and the Rise of the UAW.* New York, 1979.

RACHLEFF, PETER J. *Black Labor in Richmond, 1865–1890.* 1984. Reprint. Urbana, Ill., 1988.

ROEDIGER, DAVID R. *The Wages of Whiteness: Race and the Making of the American Working Class.* New York, 1991.

SPERO, STERLING D., and ABRAM L. HARRIS. *The Black Worker: The Negro and the Labor Movement.* 1931. Reprint. New York, 1969.

ZIEGER, ROBERT H., ed. *Organized Labor in the Twentieth-Century South.* Knoxville, Tenn., 1991.

ERIC ARNESEN

Lacrosse. Lacrosse, a sport that was, until recent years, almost exclusively confined to northeastern intercollegiate competition, had no African-American participation until near the middle of the twentieth century.

The first African American to play organized lacrosse was Simeon F. Moss, who played for Rutgers University in 1939. Two years later, Lucien Alexis, Jr., a black player for Harvard, was involved in a racial controversy when the team from the U.S. Naval Academy refused to play against him. Harvard's athletic director capitulated and benched Alexis for the game. Students and several civil rights groups, including the NAACP, protested the university's decision. Verneda Thomas was a member of the U.S. Women's Lacrosse Association team in the 1950s and later became an official of the National Lacrosse Association.

Jim BROWN, whose fame was gained as a star in the National Football League, was the greatest black lacrosse player of all time. Some have argued that he was simply the greatest lacrosse player ever. Brown played the midfield position for Syracuse University in 1955 and 1956 and became the first African American to play in the North-South Game, the annual national all-star contest. His speed and power overwhelmed defenses and altered many of the game's strategies.

After Brown's unprecedented rise to dominance in lacrosse, several other black players achieved considerable success in the sport generally associated with elite northeastern universities. From 1971 through 1974, Wendell Thomas of Towson State in Baltimore starred in the sport. In 1974, Thomas was named the NCAA Division II Player of the Year. Other black lacrosse All-Americans were John Sheffield, who played for the University of Pennsylvania from 1972 through 1974; Ed Howard, a defenseman for Hobart College from 1976 through 1979; James Ford of Rutgers University, who played the attack position from 1977 through 1980; and Albert Ray, an All-American for Rutgers in 1982.

Morgan State University in Baltimore is the only historically black university to have a major lacrosse team. The school began intercollegiate competition in the sport in 1969 and, by 1975, achieved a number-ten ranking in the College Division. Morgan State's star players included Wayne Jackson, a player in the 1973 North-South Game; Dave Raymond, a College Division Honorable Mention All-American in 1974; and Joe Faulks, who in 1978 became the first player from a black university selected as an NCAA Division I All-American.

Tina Sloan Green was perhaps the greatest woman player in modern lacrosse, leading Temple University in Philadelphia to three NCAA championships in the 1980s.

REFERENCE

ASHE, ARTHUR R., JR. *A Hard Road to Glory: A History of the African-American Athlete.* 3 vols. New York, 1988.

THADDEUS RUSSELL
BENJAMIN K. SCOTT

Lacy, Sam (October 23, 1903–), sports journalist. Born in Mystic, Conn., Sam Lacy was raised in Washington, D.C. As a youth, Lacy regularly attended the Washington Senators' BASEBALL games. He eventually became a vendor at the Senators' Griffith Stadium, also filling in as a fielder during batting practice, going on to play in semipro Negro Leagues in the Washington, D.C., area. He enrolled at Howard University, where he earned a B.A. in education with the thought of becoming a coach. However, in 1930, Lacy turned his part-time job as a sports journalist with the *Washington Tribune* into his full-time career.

Lacy wrote for numerous newspapers, including the *Chicago Defender* and the *Chicago Sun,* but achieved greatest fame during his more than fifty years at the *Baltimore Afro-American.* Beginning there in 1943 as a writer and sports editor, Lacy strongly advocated the integration of major league baseball. In 1946 he covered Jackie ROBINSON's first season with the Dodgers' farm team the Montreal Royals. Lacy often faced discrimination in covering Robinson's career. In 1948 Lacy became the first African-American member of the Baseball Writers' Association.

Lacy covered the fights of Joe LOUIS and Sugar Ray ROBINSON (*see also* BOXING), the Olympics from 1960 to 1984, as well as the major events of baseball and FOOTBALL. In 1985 he was inducted into the Black Athletes Hall of Fame, and in 1991 the National Association of Black Journalists awarded him its Lifetime Achievement Award. Lacy has served on the President's Council for Physical Fitness, and the Baseball Hall of Fame's selection committee for the Negro Leagues.

REFERENCES

FIMRITE, RON. "Sam Lacy: Black Crusader." *Sports Illustrated* (October 29, 1990): 90–94.

WILSON, CLINT C., JR. *Black Journalist in Paradox: Historical Perspectives and Current Dilemmas.* New York, 1991, p. 69.

PETER SCHILLING

Lake, Oliver (September 14, 1942–), saxophonist and composer. Born in Marianna, Ark., Oliver Lake grew up in St. Louis, playing percussion in a drum-and-bugle band. He took up the alto saxophone while still in his teens, and played at first in a style influenced by Paul Desmond and Jackie MCLEAN. By the time he graduated from Lincoln University in Jefferson City, Mo., in 1968, he had moved from a strict hard-bop vocabulary toward the experimental style of the ASSOCIATION FOR THE ADVANCEMENT OF CREATIVE MUSICIANS (AACM), whose members he had met on a 1967 visit to Chicago. The next year, inspired by the AACM, Lake joined with Abdullah Yakub, Julius Hemphill, Floyd LeFlore, and Charles Bobo Shaw to form the Black Artists Group (BAG) in St. Louis. Like the AACM, BAG sponsored performances, classes, and even cooperative living arrangements. During this period, Lake made his first recording, *NTU: Point from Which Creation Begins* (1971).

Upon the dissolution of BAG in 1972, Lake moved to Paris, where many midwestern free jazz musicians had also settled in order to work under more hospitable conditions. Upon his return to the United States in 1974, he moved to New York and began playing with his own quintet. *Passin' Thru* (1974) and *Shine!* (1978) feature Lake's spry tone and mischievous improvisations on alto saxophone. In 1976, Lake, along with Hamiet Bluiett, Hemphill, and David Murray, formed the WORLD SAXOPHONE QUARTET, a tuxedoed chamber group that draws inspiration from traditional jazz, and rhythm and blues, all the while playing in an unpredictable style that ranges from highly disciplined and tightly interwoven ensemble harmonies to unstructured free improvisations (*Point of No Return*, 1977; and *Revue*, 1980). In the late 1970s, Lake also taught at Karl Berger's Creative Music Studio in Woodstock, N.Y.

In the 1980s and 1990s, Lake continued to record and perform with the World Saxophone Quartet (*World Saxophone Quartet Plays Duke Ellington*, 1986) and his own small groups (*Expandable Language*, 1984, and *Gallery*, 1986), as well as with larger ensembles (*Otherside*, 1988). Lake, who lives in New Jersey, has also composed for string quartet and for the theater and performs with Jump Up, a reggae group he formed in 1981.

REFERENCE

LITWEILER, JOHN. *The Freedom Principle: Jazz After 1958.* New York, 1984.

JONATHAN GILL

La Menthe, Ferdinand Joseph. *See* Morton, Ferdinand "Jelly Roll."

Lampkin, Daisy Elizabeth Adams (March 1884–March 10, 1965), civil rights leader. The date and place of Daisy Elizabeth Adams Lampkin's birth is not certain. Some records list her as being born in March 1884 in the District of Columbia (the stepdaughter of John and Rosa Temple), while others list her as born on August 9, 1888, in Reading, Penn., to George and Rosa Anne (Proctor) Adams. Records become more reliable for her late adolescent years: She finished high school in Reading, moved to Pittsburgh in 1909, and married William Lampkin in 1912.

Daisy Lampkin met PITTSBURGH COURIER publisher Robert L. VANN in 1913, after she had won a cash prize for selling the most copies of the newspaper; with the prize, she purchased stock in the *Courier* corporation. She continued to invest in the *Courier* corporation until 1929, when she began a lifelong tenure as the corporation's vice president.

In 1915 Lampkin became president of the Negro Women's Franchise League, and became involved in the National Suffrage League and the women's division of the REPUBLICAN PARTY. In July 1924, as president of the National Negro Republican Convention in Atlantic City, she helped pass a strong resolution against lynching. She also took part that year in a black delegation to the White House, led by James Weldon JOHNSON, to vindicate black soldiers in-

volved in the HOUSTON RIOT OF 1917. She also became a delegate-at-large to the 1924 Republican National Convention in Cleveland, Ohio.

In 1929 NATIONAL ASSOCIATION FOR THE ADVANCEMENT OF COLORED PEOPLE (NAACP) acting executive secretary Walter WHITE had Lampkin appointed regional field secretary for the organization. She used her positions in the NAACP and the powerful *Courier* corporation to attract new funds and members to both organizations. In 1930 her grassroots political influence helped defeat Roscoe McCullough's reelection bid as senator from Ohio. McCullough had supported the nomination of Judge John J. Parker (who had once opposed black suffrage) to the U.S. Supreme Court.

In 1935 Lampkin was named national field secretary of the NAACP, a post she held until 1947. In this capacity, Lampkin displayed a great skill for raising funds while keeping operating expenses to a minimum. She and White campaigned strongly, although unsuccessfully, for the passage of the 1935 Costigan-Wagner federal antilynching bill. During Franklin Roosevelt's Administration, she encouraged blacks to change their voting preferences from the Republican party to the Democratic party. However, she supported the Democrats selectively. Under Roosevelt, she supported the party despite the NAACP directives against partisan activity; under Truman, she cited those same directives as a reason to withhold her official support.

Although physical fatigue forced her to resign as national field secretary in 1947, Lampkin continued her fundraising activities as a member of the NAACP board of directors. She continued to challenge any symbolic or substantive threats to African-American progress, but at the increasing cost of her physical stamina. She supported the Republicans in 1952 when the Democrats ran a segregationist vice presidential candidate, Alabama's John J. Sparkman. She also led a major fundraising effort for the Delta Sigma Theta sorority's purchase of a $50,000 building that year.

Lampkin remained active in NAACP activities through the early 1960s, receiving the NATIONAL COUNCIL OF NEGRO WOMEN's first Eleanor Roosevelt–Mary McLeod Bethune award in December 1964. Lampkin died at her home in Pittsburgh on March 10, 1965. In 1983 she became the first black woman honored by the state of Pennsylvania with a historical marker, located at the site of her Webster Avenue home.

REFERENCES

GIDDINGS, PAULA. *In Search of Sisterhood: Delta Sigma Theta and the Challenge of the Black Sorority Movement*. New York, 1988.

———. *When and Where I Enter: The Impact of Black Women on Race and Sex in America*. New York, 1985.

MCKENZIE, EDNA B. "Daisy Lampkin: A Life of Love and Service." *Pennsylvania Heritage* (Summer 1983): 9–12.

DURAHN TAYLOR

Lane, Isaac (March 3, 1834–December 6, 1937), bishop, college founder. Isaac Lane was born a slave in Jackson, Tenn., the illegitimate son of Cullen Lane, his master. Although Lane found life as a slave laborer difficult, he was granted a few privileges denied other slaves on his father's plantation. He was permitted to learn how to read and write, to marry and to cohabit with his wife. In 1854, Lane was converted, joined Jackson's Salem Methodist Church, and received his "call to preach." He petitioned church elders for a license to preach. Refused a license on racial grounds, Lane was offered an exhorter's license, and he began public speaking. After the Civil War, in 1866, Lane was named a deacon.

In 1870, Lane helped form the Colored Methodist Episcopal Church (C.M.E.), now called the CHRISTIAN METHODIST EPISCOPAL CHURCH, a black offshoot of the Methodist Episcopal Church, South. Named a bishop of the church in 1873, he established congregations in the South and Southwest, as well as in major cities of the Midwest, and became active in the fight to establish church day schools, against the opposition of most of the church's hierarchy.

In 1882, Lane demonstrated his commitment to education when he bought four acres of land in Jackson, Tenn. for $240. The school he established, originally called the C.M.E. High School, was one of the state's few secondary schools for African Americans. After 1883 it was known as Lane Institute. Lane raised money to support and expand its college department. After this department was instituted in 1896, the school became known as Lane College. In 1907, Lane's son, James Lane, a mathematics professor, became president. Lane retired from his bishopric in 1914, and lived in Jackson until his death in 1937.

REFERENCE

SAVAGE, HORACE C. *The Life and Times of Bishop Isaac Lane*. Nashville, 1958.

GREG ROBINSON

Lane, William Henry (c. 1825–c. 1852), tap dancer. This early African-American tap dancer pioneer, also known as Master Juba, was the most influential single performer in nineteenth-century American TAP DANCE. Born a free man in Rhode Island, he grew up around the Five Points district in Manhattan (now the South Street Seaport area), learning to dance from "Uncle" Jim Lowe, a black

jig and reel dancer of exceptional skill. Performing in dance establishments, he was "adopted" by the fraternity of white minstrel players (*see* MINSTRELS/ MINSTRELSY). By 1844, after beating reigning minstrel dancer John "Master" Diamond in a series of challenge dances, he was hailed as "the very greatest of all dancers," becoming the champion minstrel dancer of the American Northeast. His skill earned him the dancing name Master Juba (stemming from the African *Gioube,* a step dance with elaborate variations), a name often given to slaves who were dancers and musicians. Praised for his execution of steps, unsurpassed in grace and endurance, and popular for his skillful imitations of well-known minstrel dancers and their specialty steps—after which he would perform his own specialties, which no one could copy—he was also a first-rate singer and tambourine virtuoso. In 1845 he had the unprecedented distinction of touring with the all-white Ethiopian Minstrels, while he also prospered as a solo variety performer and was a regular attraction at White's Melodeon. In London with Pell's Ethiopian Serenaders in 1848, he enthralled English audiences and critics, who were discerning judges of traditional jigs and clogs. "Far above the common performances of the mountebanks who give imitations of American and Negro character, there is an ideality in what he does that makes his efforts . . . poetical, without losing sight of the reality of representation," wrote the *Theatrical Times* in 1848. Juba's enormous popularity influenced both the English clown tradition and the blackface clown tradition in European circuses as performer's added splits, jumps, and cabrioles to their entrees, as well as donning blackface makeup. In America his influence kept the minstrel show in touch with its African-American sources at a time when the stage was dominated by white performers offering theatrical derivatives. Juba's grafting of African rhythms and loose-body styling onto the exacting techniques of jig and clog dancing fused a new rhythmic blend, the hybrid that was the true American tap dance.

REFERENCES

EMERY, LYNN FAULEY. "Jim Crow and Juba." In *Black Dance from 1619 to Today.* 2nd ed. Princeton, N.J., 1988.

WINTER, MARIAN HANNAH. "Juba and American Minstrelsy." In Paul Magriel, ed. *Chronicles of the American Dance. Dance Index* 6, no. 2 (February 1947): 39–64.

CONSTANCE VALIS HILL

Laney, Lucy Craft (April 13, 1854–October 24, 1933), educator. Lucy Laney was a pioneer in the area of black secondary education, setting a standard that many African-American educators of the early twentieth century strove to meet. Laney was born in Macon, Ga., to parents who had purchased their freedom from slavery. Her mother took charge of her early education, and she went on to do preparatory work at an American Missionary Association school. At the age of fifteen, Laney entered Atlanta University, graduating in 1873 with the university's first class of Higher Normal Department students.

With her training as a teacher, Laney spent the next ten years teaching in the Georgia public schools. In 1883 she opened her own small, poor school in a Presbyterian church in Augusta, Ga. The school grew rapidly and, three years later, received a Georgia charter as a normal and industrial school. Seeing the great need for education for African-American youth, Laney was not content to stop at this point. She began to solicit contributions to expand the school. The task was difficult, but she found an ally in Francine E. H. Haines of the Women's Executive Committee of Home Missions of the Presbyterian church. Haines encouraged her friends and associates to contribute to

The cofounder of the Haines Normal and Industrial School in Augusta, Ga., 1886, Lucy Laney was one of the most important African-American educators in the South for half a century. (Photographs and Prints Division, Schomburg Center for Research in Black Culture, The New York Public Library, Astor, Lenox and Tilden Foundations)

the school, and Laney in turn named it the Haines Normal and Industrial Institute.

Although the school aimed to prepare students to become teachers or to equip them with other types of vocational skills, Laney insisted on a liberal arts curriculum with a rigorous academic focus. Among her students was John HOPE, who would become president of Morehouse College and Atlanta University. Mary McLeod BETHUNE began her teaching career at the Haines Institute. Laney never ceased her own education, taking the opportunity to study at the University of Chicago during the summers.

The depression caused great financial difficulties for the Haines Institute, which at its peak had more than nine hundred students. Operations ceased in 1949, sixteen years after Laney's death. On the site of the old Haines Institute now stands the Lucy C. Laney High School, in tribute to her contributions to American education.

REFERENCES

BRAWLEY, BENJAMIN. *Negro Builders and Heroes.* Chapel Hill, N.C., 1937.
DANIEL, SADIE IOLA. *Women Builders.* Washington, D.C., 1931.

JUDITH WEISENFELD

Langford, Samuel E. (March 4, 1883–January 12, 1956), boxer. Sam Langford, the son of a farmer, was born in Weymouth, Nova Scotia. He migrated to Boston and fought his first professional BOXING match in 1902, picking up the nickname, the "Boston Tarbaby." Although he had his most important fights in the heavyweight division, Langford's relatively slight build—approximately 5′ 8″ and ranging, at various times, from 139 to 204 pounds—enabled him to box in a number of weight divisions, including lightweight, welterweight, middleweight, light heavyweight, and heavyweight. In 1906 Langford fought soon-to-be heavyweight champion Jack JOHNSON, losing in a decision after fifteen rounds.

Although most of the leading white contenders refused to meet Langford, he amassed an impressive record against first-rate competition. In 1909 Langford knocked out the English heavyweight champion, Ian Hagne, in four rounds. And in 1911 he defeated the reigning American light heavyweight champion, Jack O'Brien. Langford later won the Mexican heavyweight title in 1923. During an era when boxers fought as often as three times a month and had matches that could go on for up to twenty rounds, Langford accumulated 116 knockouts (the fourth highest in boxing history) in a career 291 fights.

Langford's deteriorating eyesight forced him to retire from the professional boxing circuit in 1924. Unprepared for life after boxing, Langford struggled to earn a living. During the 1930s he traveled in Canada as part of a sideshow, offering to box people for small sums of money. When he returned to the United States, Langford took odd jobs in New York and the Boston area to support himself. In 1953 he was briefly confined to a mental institution. Upon his release, he lived with his sister until her death in 1954, when he moved to a Boston rest home. Although blind and impoverished, Langford was not forgotten by the boxing world and was elected to *The Ring* magazine's Boxing Hall of Fame in 1955, shortly before his death in 1956.

REFERENCES

PORTER, DAVID L., ed. *Biographical Dictionary of American Sports: Basketball and Other Indoor Sports.* Westport, Conn., 1988.
The Ring Record Book and Boxing Encyclopedia. New York, 1987.

KENYA DILDAY

Langston, Charles Henry (1817–December 14, 1892), abolitionist. Born in Louisa County, Va., Charles H. Langston was one of three sons of Ralph Quarles, a planter, and his manumitted slave, Lucy Langston. The Langston children were resettled in Ohio after the death of their parents in 1834. Charles Langston studied at the preparatory department of Oberlin College, then found employment as a teacher at black schools in Chillicothe and Columbus, Ohio.

Charles and his brothers, John Mercer LANGSTON and Gideon Langston, made the family name synonymous with black abolitionism and civil rights in Ohio. He served as an officer and agent of the Ohio Anti-Slavery Society in the early 1850s, and helped revive the society in 1858 as a black organization— the Ohio State Anti-Slavery Society. Langston presided at black state conventions and represented Ohio at black national conventions in 1848 and 1853. His involvement with the UNDERGROUND RAILROAD culminated in the dramatic rescue of the fugitive slave John Price in 1858. For his part in the Oberlin-Wellington rescue, he received a fine and a brief prison sentence.

During the Civil War, Langston worked as a recruiter in Ohio, Illinois, and Indiana for the Union army's black regiments. He settled in Kansas and opened a school for freedmen at Leavenworth. After the war, he became active in Republican politics, but ran for state auditor in 1886 as a Prohibition party

candidate. In 1869 he married Mary S. Leary, widow of Lewis S. Leary, one of the participants in the Harpers Ferry raid. He spent his last years in Lawrence, Kans., as a grocer and as editor of a local journal, *Historic Times.*

REFERENCES

CHEEK, WILLIAM, and AIMEE LEE CHEEK. *John Mercer Langston and the Fight for Black Freedom, 1829–1865.* Urbana, Ill., 1989.

RIPLEY, C. PETER, et al., eds. *The Black Abolitionist Papers, Volume 5: The United States, 1859–1865.* Chapel Hill, N.C., 1992.

MICHAEL F. HEMBREE

Langston, John Mercer (December 14, 1829–November 15, 1897), politician. John Mercer Langston was born in Louisa County, Va., the youngest of four children born to Ralph Quarles, a white planter, and Quarles's manumitted slave, Lucy Langston. After the death of their parents in 1834, the Langston children were settled in Ohio. John Mercer began his studies in theology at Oberlin College in 1844, and received bachelor's and master's degrees. He later read law under Philemon Bliss, a judge from Elyria, Ohio, and passed the state bar examination in 1854.

Langston established a successful law practice in Brownhelm, Ohio, and participated in local politics. His election as town clerk in 1855 made him the first African American elected by popular vote to a public office. Together with his brothers, Gideon Langston and Charles H. LANGSTON, he made the family name synonymous with black abolitionism in Ohio. He participated in a variety of community activities, from organizing antislavery and reform societies to presiding at local and state black conventions. He was involved in the protests against state black laws (*see* BLACK CODES), and worked with the Ohio branch of the UNDERGROUND RAILROAD to assist escaping slaves. Langston's commitment to social reform included women's rights, temperance, and racial progress through self-reliance. He worked to improve black education in Ohio and supported the black press. His correspondence on current issues appeared frequently in *Frederick Douglass' Paper,* and he also contributed some articles to the *Anglo-African Magazine.*

Langston became disheartened by the deterioration in American race relations in the early 1850s. He began advocating black separatism and emigration, but at the 1854 national emigration convention in Cleveland he surprised delegates with a vigorous de-

Before the Civil War, John Mercer Langston was one of the first African Americans elected to public office. After the war he went on to become the first dean of the Howard University School of Law and later served in the U.S. Congress. (Prints and Photographs Division, Library of Congress)

fense of integration and an optimistic assessment of the prospects for racial progress and equality in the United States. In the late 1850s, he grew increasingly militant and predicted that the issue of slavery would lead to a national conflict. He was among several blacks who conspired with John Brown in the plan to incite a slave insurrection, but declined to participate directly in the Harpers Ferry raid (*see* JOHN BROWN'S RAID).

During the Civil War, Langston directed his efforts to the Union cause. His work as the chief recruiting agent in the western states helped fill the

ranks of the Union Army's black regiments. He also encouraged the charity of the soldiers'-aid societies. The black national convention held in Syracuse, N.Y., selected him as president of the newly founded National Equal Rights League in 1864.

Contemporaries described Langston as an intelligent, persuasive orator with an "aristocratic style and a democratic temperament." Given these qualities and an impressive career of public service, he established a national reputation. Beginning in 1867, he toured the South as an inspector for the Freedmen's Bureau. His message to southern blacks emphasized educational opportunity, political equality, and economic justice. He organized the law department at HOWARD UNIVERSITY in 1868 and later became the university's acting president. In 1877, he received an appointment as the American consul general to Haiti. After returning to the United States in 1885, he became president of Virginia Normal and Collegiate Institute. As the Democratic party regained control of Virginia, Langston faced a growing challenge to his civic and political leadership, but he remained in the state that he always had considered his home. In 1888, he ran as an independent in a bitterly contested campaign for a seat in the U.S. House of Representatives. The House adjudicated in Langston's favor in September 1890, and he held his seat until March 1891. Langston surveyed his distinguished public career in an autobiography, *From the Virginia Plantation to the Nation's Capitol* (1894).

REFERENCES

CHEEK, WILLIAM, and AIMEE LEE CHEEK. *John Mercer Langston and the Fight for Black Freedom, 1829–1865.* Urbana, Ill., 1989.

RIPLEY, C. PETER, et al., eds. *The Black Abolitonist Papers, Volume 4: The United States, 1847–1858.* Chapel Hill, N.C., 1991.

MICHAEL F. HEMBREE

Lankford, John Anderson (December 4, 1874–July 1946), architect, engineer. John Lankford (sometimes known as John Langford) was born in Potosi, Mo., in 1874. In the 1880s and '90s, he attended several schools and colleges, including Lincoln Institute in Jefferson City, Mo.; Tuskegee Normal and Industrial Institute in Alabama; Architectural College in Scranton, Pa., and Shaw University in Holly Springs, Miss., where he received his B.S. degree in 1898. He went on to obtain an M.S. degree from Wilberforce University in 1902. However, even before the completion of his baccalaureate degree, Lankford opened the nation's first African-American professional architectural office in Washington, D.C., in 1897. In 1901, Lankford designed the Pythian Building in Washington, D.C., the first large office building designed by an African American.

Chiefly known for his church designs, Lankford's style reflected an appreciation for classical and European forms. His designs included the White Presbyterian Church of Potosi, Mo. (an English neo-Gothic structure with castellated towers); the neo-Romanesque St. John's Church in Norfolk, Va.; St. Phillips Church in Savannah, Ga. (another Romanesque structure featuring Corinthian columns); the Allen Chapel African Methodist Episcopal (AME) Church in Franktown, Va.; and the Haven Methodist Episcopal Church in Washington, D.C.—the latter two in Gothic revival style.

In 1908, the AME Church made Lankford its worldwide supervising architect. He went on to design additional churches in South America and in West and South Africa, such as the AME Church of Cape Town, South Africa. In 1916, Lankford published a pamphlet entitled *Christian Art,* which explained his approach to designing churches.

Lankford also designed a number of nonecclesiastical buildings. One was Palmer Hall at the State Agricultural and Mechanical College for Negroes (now Alabama A & M University) in Normal, Ala.; another was Allen University's English colonial–style Chappelle Administration Building, built in Columbia, S.C.

Lankford served as a vice president of the National Negro Business League, as president of the National Technical Association, and as director general of the 1907 Jamestown Exposition for the District of Columbia. Lankford, an active member of the NAACP, was a strong advocate of equal opportunity for African Americans in prominent government and corporate positions. Lankford supervised defense construction projects for the United States government during World War I, then returned to civilian architectural practice in Washington, D.C., where he died in 1946.

REFERENCES

DOZIER, RICHARD K. "Black Architects and Craftsmen." *Black World* (May 1974): 10.

FERRIS, WILLIAM H. "John A. Lankford . . . Pioneer Architect." *The Spokesman* (February 1925): 17.

Who's Who of the Colored Race. (1915): 172.

DURAHN TAYLOR

Lanusse, Armand (1812–March 16, 1868), writer and educator. Armand Lanusse was born in New Orleans, the son of a French father and a free colored

mother. Although sources disagree on whether he was educated in France (or in fact whether he ever visited France at all), he was clearly well educated. Lanusse soon formed a circle of educated francophone black writers and artists. In 1843, Lanusse helped edit *l'Album littéraire,* a short-lived magazine, which was the first to publish African-American literature in French. Lanusse contributed a story, "Une Mariage de conscience," a melodramatic tale of a quadroon seduced and abandoned by a white man. Inspired by the example of *L'Album littéraire,* in 1845 Lanusse published LES CENELLES, a collection of poetry written by members of his group (including Numa Lanusse, his younger brother). The collection included six of Lanusse's own poems.

During the 1840s, Lanusse began his journalistic career. He contributed articles to *La Tribune de la Nouvelle-Orléans,* and later *L'Union* and the *Daily Crusader.* Although light skinned, he denounced racism. Lanusse also campaigned for better education for people of color, and he was largely responsible for the opening of the Catholic School for Indigent Orphans (or the COUVENT INSTITUTE) in 1848. In 1852, Lanusse became the Institute's first principal, a post he held until 1866.

Despite his antiracist activism, Lanusse was a southern patriot. When Union forces took New Orleans, Lanusse refused to fly the Stars and Stripes from the roof of Couvent Institute, an action he later regretted. He soon began a campaign urging freedom for slaves. After the end of the war, he spoke out in favor of civil rights and suffrage, although for a time he advocated mass black emigration to Mexico, and championed black-mulatto unity. Lanusse died in New Orleans; he was survived by a wife and four children.

REFERENCE

DESDUNES, RODOLPHE. *Our People and Our History.* Translated by Dorothea Olga McCants. New York, 1911.

MICHEL FABRE

Larsen, Nella (April 13, 1891–c. March 30, 1964), novelist. Born in Chicago, Nella Larsen was the mixed-race child of immigrant parents. Reared in a visibly "white" family, she was a lonely child whose racial identity separated her from both parents and sibling. She compensated for her difference by becoming an avid reader of novels and travelogues and a keen observer of life around her. Although she later claimed her Danish or her West Indian heritages, she became part of an African-American world when she

Photograph of Nella Larsen by James Latimer Allen, c. 1928. (Photographs and Prints Division, Schomburg Center for Research in Black Culture, The New York Public Library, Astor, Lenox and Tilden Foundations)

entered the Fisk University Normal High School. She left after a year and without receiving either a diploma or a teaching degree. She moved to New York where, in 1915, she completed nurse's training at the Lincoln Hospital School of Nursing. Her career choice enabled her to become self-supporting, working initially for her alma mater, and briefly for Tuskegee Institute's John Andrew Memorial Hospital, and subsequently for New York City's Board of Health.

In 1919 she married a research physicist, Dr. Elmer S. IMES, and became part of the upwardly mobile African-American middle class. Disillusioned with the opportunities for African-American females in nursing, she capitalized on her love of books by working for the New York Public Library, a job that enabled her to enter the New York Public Library School in 1922 and introduced her to the emerging coterie of writers in Harlem. Her first publication, a 1923 book review in the MESSENGER, was the result of her work for the Library School.

Throughout the 1920s, Larsen was active in the HARLEM RENAISSANCE. Two of her early stories, "The Wrong Man" and "Freedom," appeared under a pseudonym in 1926. Shortly thereafter, she published two novels, *Quicksand* (1928) and *Passing* (1929), which earned her a considerable reputation as a writer of powerful explorations of female psychology and modern consciousness. *Quicksand* follows the exploits of an educated mulatto, Helga Crane, as she searches for self-definition, social recognition, and sexual expression. *Passing* presents two light-skinned women as antagonists and psychological doubles in a drama of racial passing, class and social mobility, and female desire. Larsen received the Harmon Foundation's Bronze Medal for achievement in literature in 1929, and a Guggenheim Fellowship in creative writing in 1930. She spent her fellowship year in Spain and France researching a novel on racial freedom and writing a novel about her husband's infidelity.

Larsen's literary promise, however, did not achieve a full maturity. She ceased publishing during the 1930s, after several public humiliations undermined her confidence in her ability. She was accused in *Forum* magazine of plagiarizing *Sanctuary* (1930), and she was sensationalized in the African-American press during her divorce proceedings (1933). By the 1940s after several efforts at collaborative novels had failed, she gave up all efforts to write and returned to the nursing profession. She continued to work as a nurse in New York hospitals until March 1964 when she was found dead in her apartment. Although nearly forgotten as a writer at the time of her death, Larsen has subsequently achieved renewed visibility as a major, modern African-American novelist whose complex representations of gender and race intrigue postmodern readers and resist reductive readings.

REFERENCES

DAVIS, THADIOUS M. *Nella Larsen: Novelist of the Harlem Renaissance*. Baton Rouge, La., 1944.
McDOWELL, DEBORAH. "Introduction." In Nella Larsen, *Quicksand and Passing*. New Brunswick, N.J., 1986.
WASHINGTON, MARY HELEN. "Nella Larsen." In *Invented Lives: Narratives of Black Women, 1860–1960*. New York, 1987.

THADIOUS M. DAVIS

Last Poets, radical writers' and musicians' group. The Last Poets grew out of the BLACK ARTS MOVEMENT in the late 1960s, performing and recording politically and rhythmically charged messages that prefigured the RAP MUSIC of the 1980s and '90s. The Last Poets were formed at a May 1968 gathering in Harlem's Mount Morris Park to commemorate MALCOLM X. The members of that group—Gylan Kain, Abiodun Oyewole, and David Nelson—went on to sell more than 300,000 copies of their first album, *The Last Poets*. This contained such songs as "New York, New York," "Niggers Are Scared of Revolution," and "When the Revolution Comes." These were heated denunciations of racial oppression in the United States set to stripped-down African, Afro-Cuban, and African-American drumming. Nelson soon left the group, to be replaced by Felipe Luciano.

The Last Poets appeared in the film *Right On!* (1969) before an ideological disagreement between Oyewole and Kain caused the members to split into two groups. Kain, Luciano, and Nelson continued to work under the name of the "Last Poets," as did Oyewole and such new members as Umar Bin Hassan, Suliaman El-Hadi, and Alafia Pudim (later known as Jalaludin Mansur Nuriddin). Albums by the two groups attacked both whites and blacks who compromised on militant positions of black power and social justice, and their comments were often intensified through the use of profanity and offensive language. Despite their initial success, the Last Poets never received a major recording contract and failed to gain a large following. Aside from occasional performances in the United States and Europe, the members of the Last Poets remained cult figures who constantly fought and bickered over the rights to the name.

The rediscovery of the Last Poets by rap musicians in the 1980s helped the members of both ensembles become more active. In 1985, Nuriddin and El-Hadi released *Oh My People*, followed the next year by a book of poems, *Vibes of the Scribes*, and the album *Freedom Express*. In 1990, believing that the success of rap music had paved the way for a comeback, Kain, Nelson, and Oyewole reunited and made a tour of the United States. However, the group failed to recapture its initial popularity. Two albums from Last Poets members, *Holy Terror* and *Be Bop or Be Dead*, were released the next year. Since then the groups calling themselves the Last Poets—a new figure, Don Babatunde Eton, plays with Oyewole and Bin Hassan—have continued to perform at concerts, often along with 1970s groups such as the Ohio Players and George Clinton's P-Funk All Stars. The Last Poets' spoken word and drums format continued on the 1994 release *Scatterap/Home*.

REFERENCES

JAMES, CURTIA. "Political Snoozers Beware: The Last Poets are Back." *Essence* 17 (June 1986): 32.
MILLS, DAVID. "The Last Poets: Their Radical Past, Their Hopeful Future, Their Broken Voice." *Washington Post*, December 12, 1993, pp. G1, G4.

RULE, SHEILA. "Generation Rap: Interview with A. Oyewole and Ice Cube." *New York Times Magazine* (April 3, 1994): 40–45.

JONATHAN GILL

Lateef, Yusef (October 9, 1920–), tenor saxophonist, flutist, and composer. Born William Evans in Chattanooga, Tenn., Lateef combined the developments of swing and bebop with the instruments and performance traditions of Africa, the Middle East, and Asia to become a mainstay of postbop jazz, both as a sideman and as a leader of his own small groups. Lateef studied alto and tenor saxophone while growing up in Detroit, eventually playing in New York with Roy Eldridge, Lucky Millinder, and Hot Lips Page in the mid-to-late forties. In 1949 he converted to Islam, adopting the name "Yusef Lateef," and toured with Dizzy GILLESPIE. He returned to Detroit in 1950 to study composition at Wayne State University, mastering flute, oboe, and bassoon as well as double-reed instruments from Asia and Africa and also homemade instruments. In 1955 he resumed performing and recording, both as leader (*Eastern Sounds,* 1961) and sideman, playing with Charles Mingus from 1959 to 1961, Babatundi Olatunji from 1961 to 1962, and Cannonball Adderley. During the 1960s he continued performing and recording (*A flat G flat and C,* 1966) and also received bachelor's and master's degrees from the Manhattan School of Music.

From 1971 to 1975, when he received a Ph.D. in education from the University of Massachusetts at Amherst, Lateef taught music at the Borough of Manhattan Community College. Since the mid-1970s he has continued to perform, teach, and record in the United States, Europe, and Africa—in particular, Nigeria—gaining recognition for his virtuosity on the tenor saxophone as well as for such compositions as *Suite* (1970), *Yusef Lateef's Little Symphony* (1987), *Concerto for Yusef Lateef* (1988), and *Nocturnes* (1988), all of which allow improvisation within nominally classical forms.

REFERENCES

GOLD, D. "Yusef Lateef." *Down Beat* 25, no. 9 (1958): 18.

WELDING, P. "Music as Color: Yusef Lateef." *Down Beat* 32, no. 11 (1965): 20.

WHALEN, J. "Yusef Lateef: Interview." *Cadence* 8, no. 10 (1982): 9.

ERNEST BROWN

Latimer, Lewis Howard (September 4, 1848–December 11, 1928), inventor. Lewis Latimer was born in Chelsea, Mass., the son of runaway slaves from Virginia. In his youth Latimer worked at a variety of odd jobs, including selling copies of William Lloyd Garrison's *Liberator,* sweeping up in his father's barbershop, hanging paper, and waiting tables. In 1863 he joined the Union Navy and worked as a cabin boy aboard the U.S.S. *Massasoit.* He served on the James River in Virginia until the end of the war in 1865.

After the war Latimer returned to Boston where, in 1871, he was hired by patent lawyers Crosby and Gould. Although hired as an office boy, he became an expert mechanical drafter. He also tried his hand at inventing, and on February 10, 1874, he patented a pivot bottom for a water closet for railroad cars. The inventor of the telephone, Alexander Graham Bell, retained Crosby and Gould to handle his patent ap-

A pioneer in the development of electric power, Lewis Latimer worked with Thomas Alva Edison in developing and improving electric incandescent lighting. (Photographs and Prints Division, Schomburg Center for Research in Black Culture, The New York Public Library, Astor, Lenox and Tilden Foundations)

plication, and Latimer helped sketch the drawings for Bell's 1876 patent.

In 1880 Latimer was hired by inventor Hiram Maxim's United States Electric Lighting Company in Bridgeport, Conn. Maxim was a competitor of Thomas A. Edison, who had patented the incandescent light bulb in 1879. In 1881 Latimer and his colleague Joseph V. Nichols shared a patent for an electric lamp. Latimer's most important invention, patented in 1882, was a carbon filament that increased the brightness and longevity of the light bulb. Because of its decreased costs, the resulting product made electric lighting more accessible. Latimer also invented a locking rack for hats, coats, and umbrellas in 1896.

From 1880 to 1882, Latimer oversaw the establishment of factories for U.S. Electric's production of the filaments and the installation of electric-light systems in New York City and Philadelphia and later in London. After his return from Britain, he worked for firms in the New York area until he joined the Edison Electric Light Company in 1884. (Edison Electric soon bought out other companies to form General Electric.) There he served as engineer, chief draftsman, and an expert witness for Edison in patent infringement lawsuits. Latimer was author of *Incandescent Electric Lighting* (1896), one of the first textbooks on electric lighting. When General Electric and Westinghouse decided that year to pool patents, they created the Board of Patent Control to monitor patent disputes and appointed Latimer to the board. He used his drafting techniques and knowledge of patent law in this capacity until 1911, when the board was disbanded. He then did patent law consulting with the New York firm of Hammer & Schwarz.

Latimer moved to Flushing, N.Y., in the late nineteenth century and was active in New York City politics and civil rights issues. In 1902 he circulated a petition to New York City Mayor Seth Low, expressing concern about the lack of African-American representation on the school board. He also taught English and mechanical drawing to immigrants at the Henry Street Settlement in 1906. In 1918 Latimer became a charter member of the Edison Pioneers, an honorary group of scientists who had worked for Thomas Edison's laboratories. Latimer's booklet, *Poems of Love and Life,* was privately published by his friends on his seventy-fifth birthday in 1925. Latimer died in Flushing in 1928. On May 10, 1968, a public school in Brooklyn was named in his honor.

REFERENCES

BRODIE, JAMES MICHAEL. *Created Equal: The Lives and Ideas of Black American Inventors.* New York, 1993.
HABER, LOUIS. *Black Pioneers of Science and Invention.* New York, 1970.
HAYDEN, ROBERT C. *Eight Black American Inventors.* Reading, Mass., 1972.
TURNER, GLENNETTE TILLEY. *Lewis Howard Latimer.* Englewood Cliffs, N.J., 1991.

ALLISON X. MILLER

KEVIN PARKER

Latter-Day Saints. *See* Mormons.

Laurie, Eunice Verdell Rivers (November 12, 1899–August 28, 1986), nurse. Eunice Verdell Rivers was born in Early County, Ga., the oldest of the three children of Albert and Henrietta Rivers. Graduating as a nurse from the Tuskegee Institute in 1922, she did some private nursing and worked with Tuskegee's Moveable School, educating African-American women about health and sanitation, in Tuskegee's Andrews' Hospital, and for the state vital-statistics unit.

Beginning in 1932, she was part of the TUSKEGEE SYPHILIS EXPERIMENT in Macon County, Ala., a 1932–1972 "study" by the U.S. Public Health Service of untreated syphillis in four hundred African-American men, who thought they were being treated for what was colloquially called "bad blood." Rivers helped to find men for the study, followed up on their conditions, assisted in their examinations, and gained familial support for autopsies, receiving the coveted Oveta Culp Hobby Award in 1958 from the U.S. Department of Health, Education and Welfare for this work.

"Nurse Rivers" remains a complicated figure in the Tuskegee story. She has been interpreted as morally conflicted, as someone who sold out her own people, as a nurse who just followed orders. Rivers and others stressed the importance of her efforts for patients who could not get health care, her ability to temper the physicians' racism and ignorance of black mores, and her service to church and community. In 1952, Rivers married Julius Laurie. She died in Tuskegee, Ala.

REFERENCES

HILL, RUTH, ed. "Interview with Eunice Rivers Laurie, October 10, 1977." In *Black Women Oral History Project; From the Arthur and Elizabeth Schlesinger Library on the History of Women in America, Radcliffe College,* vol. 7, pp. 218–242. Westport, Conn., 1991.

JONES, JAMES. *Bad Blood: The Tuskegee Syphilis Experiment.* New York, 1981.

<div align="right">SUSAN M. REVERBY</div>

Laveau, Marie, two religious practitioners. Two women named Marie Laveau, mother and daughter, were key figures in the practice of VOODOO in NEW ORLEANS from approximately 1830 until the 1880s. The first Marie Laveau (b. 1783) built a reputation as a powerful leader in the particular form of West African Dahomean religion that developed in New Orleans. There, voodoo practice centered on several Dahomean deities (*vodun*) and on healing, herbalism, and divination. In the Louisiana context, elements of Roman Catholicism were blended with the Dahomean tradition as well.

The first Marie Laveau oversaw large ritual gatherings in Congo Square and on the banks of Lake

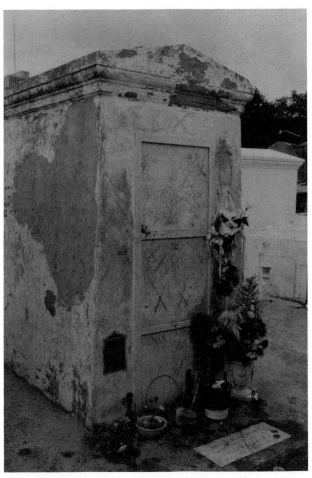

The tomb of Marie Laveau, the legendary "voodoo queen" of nineteenth-century New Orleans. Note the offerings on the perimeter of the tomb. (© Keith Calhoun)

Ponchatrain. She also saw clients in her home who came with health problems, domestic difficulties, and other troubles. Clearly, Laveau was successful in her practice, and black and white residents of the city knew of her skills and solicited them. She was also widely known for visiting and caring for death row prisoners.

Around 1875 Marie Laveau's health began to fail, and her daughter (b. 1827) assumed the public role of Marie Laveau. By the time the first Marie died in 1881, the reputation of her daughter had been solidified. The second Marie continued the craft developed by her mother and other practitioners of voodoo, particularly healing, divining, and providing protective charms for white and black clients. By the last decade of the century, Marie Laveau's practice had declined significantly, as other figures assumed prominence in the city. The legend of Marie Laveau was kept alive by twentieth-century conjurers who claimed to use Laveau techniques, and it is kept alive through the continuing practice of commercialized voodoo in New Orleans.

REFERENCES

RABOTEAU, ALBERT J. *Slave Religion: The "Invisible Institution" in the Antebellum South.* New York, 1978.

TALLANT, ROBERT. *Voodoo in New Orleans.* New York, 1946.

<div align="right">JUDITH WEISENFELD</div>

Lawless, Theodore K. (December 6, 1892–1971), dermatologist. Born in Thibodeaux, La., Theodore Lawless was educated at Talladega College and received his M.D. degree in 1919 from Northwestern University School of Medicine (Chicago). After postgraduate research and teaching at Columbia University's Vanderbilt Clinic and the Massachusetts General Hospital, he conducted research in skin disease at leading European hospitals in France, Germany, and Austria between 1921 and 1924. Returning to Chicago in 1924, he established a large and thriving dermatology practice in the growing African-American community on Chicago's South Side. His patients were from all ethnic and racial groups. Along with his practice and teaching at Northwestern, he served as senior attending physician at Provident Hospital, where he donated a clinical laboratory for experimental medicine. From 1924 to 1941, he served as an instructor in dermatology at Northwestern University School of Medicine. Between 1921 and 1941 he published nine scientific articles on dermatological subjects dealing primarily with syphilis. `

His philanthropy extended to Dillard University and several other historically black colleges, but his financial assistance to education and medical advancement was not restricted to African-American institutions. In Israel, the Lawless Department of Dermatology at Beilinson Hospital in Tel Aviv and the Lawless Clinical and Research Laboratory in Dermatology of the Hebrew Medical School in Jerusalem were initiated with his help.

Lawless's achievements in medicine were honored with the Harmon Award in Science in 1929, the prestigious Spingarn Medal from the National Association for the Advancement of Colored People (NAACP) in 1954 for contributions as "physician, educator and philanthropist," and a distinguished citation from the City of Chicago in 1963.

REFERENCES

COBB, W. MONTAGUE. "Theodore Kenneth Lawless." *Journal of the National Medical Association.* Vol. 62 (July 1970), pp. 310–312.

MORAIS, HERBERT, M. *History of the Negro in Medicine.* New York, 1967, pp. 109–110.

ROBERT C. HAYDEN

Lawrence, Jacob Armstead (September 7, 1917–), painter and draftsman. Born in Atlantic City, N.J., Lawrence grew up in Harlem during the Great Depression, and his career owes much to that heritage. Soon after the births of his sister, Geraldine, and brother, William, in Pennsylvania, his parents separated. Seeking domestic work, Lawrence's mother brought her three children to Harlem around 1930. She enrolled them in a day-care program at Utopia House, a settlement house offering children hot lunches and after-school arts and crafts activities at nominal cost. The arts program was run by painter Charles ALSTON, who encouraged the young Jacob Lawrence, recognizing his talent.

Lawrence's mother was often on welfare, so Jake, as he was called, took on several jobs as a young teenager to help support the family: he had a paper route, and he worked in a printer's shop and in a laundry. But in the evenings he continued to attend art classes, and he committed himself to painting.

Between 1932 and 1937, Lawrence received training in the Harlem Art Workshops, which were supported first by the College Art Association and then by the government under the Federal Art Project of the WORKS PROJECT ADMINISTRATION. He attended the American Artists School in New York City on scholarship between 1937 and 1939. He was still a student when he had his first one-person exhibition

at the Harlem YMCA in February 1938. At twenty-one and twenty-two years of age, he served as an easel painter on "the Project" in Harlem. Swept up in the vigorous social and cultural milieu of the era following the HARLEM RENAISSANCE, Lawrence drew upon Harlem scenes and black history for his subjects, portraying the lives and aspirations of African Americans.

By 1936, Lawrence had established work space in the studio of Charles Alston at 306 West 141st Street—the renowned "306" studio that was a gathering place for people in the arts. There Lawrence worked for several years, meeting and learning from such African-American intellectuals as philosopher Alain LOCKE, writers Langston HUGHES and Claude MCKAY, and painter Aaron DOUGLAS.

Lawrence's first paintings assumed the character of Social Realism, a popular style of the 1930s. His earliest works date from around 1936, and are typically interior scenes or outdoor views of Harlem activity (e.g., *Street Orator*, 1936; *Interior*, 1937). He was primarily influenced by the other community artists, such as Alston, sculptor Augusta SAVAGE, and sculptor Henry Bannarn, who believed in him and inspired him by their interest in themes of ethnic origin and social injustice.

Lawrence's general awareness of art came from his teachers as well as from books, local exhibitions, and frequent trips to the Metropolitan Museum. When he was a youth, he met painter Gwendolyn KNIGHT, originally from Barbados, and their friendship led to marriage in 1941. Their long relationship has been a vital factor in Lawrence's career.

Lawrence's art has remained remarkably consistent throughout the decades. His content is presented through either genre (scenes of everyday life) or historical narrative, and always by means of simplified, representational forms. He uses water-based media applied in vivid color. Lawrence is an expressionist: he tries to convey the feeling he gets from his subject through the use of expressionistic distortion and color choice, and often through cubist treatment of form and space.

A distinctive feature of Lawrence's work is his frequent use of the series format to render narrative content. Stimulated by the Harlem community's interest in the stories of legendary black leaders, he created several historical series about these heroic figures, including *Toussaint L'Ouverture* (1937–1938), *Frederick Douglass* (1938–1939), and *Harriet Tubman* (1939–1940). Some of his fifteen series are based on nonhistorical themes, such as *Theater* (1951–1952).

Jacob Lawrence received almost overnight acclaim when his *Migration of the Negro* series was shown at New York's prestigious Downtown Gallery in November 1941. With this exhibition, he became the

Multitalented artist Jacob Lawrence. (Simon & Schuster)

first African-American artist to be represented by a major New York gallery. By the time he was thirty, he had become widely known as the foremost African-American artist in the country. In 1960, the Brooklyn Museum mounted his first retrospective exhibition, and it traveled throughout the country. In 1974, the Whitney Museum of American Art in New York held a major retrospective of Lawrence's work, which toured nationally. In December 1983, he was elected to the American Academy of Arts and Letters. His third retrospective exhibition, originated by the Seattle Art Museum in 1986, drew record-breaking crowds when it toured the country. For more than forty years, Lawrence also distinguished himself as a teacher of drawing, painting, and design, first at Black Mountain College, North Carolina, in the summer of 1946, then at schools such as Pratt Institute in Saragota Springs, N.Y. (1955–1970), Brandeis University (spring 1965), and the New School for Social Research, New York (1966–1969).

During World War II, Lawrence served in the U.S. Coast Guard (then part of the Navy), first as a steward's mate and then as a combat artist. On coming out of the service, he received a Guggenheim Fellowship to paint a series about his war experiences (*War,* 1946–1947).

Lawrence and his wife spent eight months in Nigeria in 1964, an experience that resulted in his *Nigerian* series (1964). Also in the 1960s, he produced powerfully strident works in response to the civil rights conflicts in America (e.g., *Wounded Man,* 1968). When he was appointed professor of art at the

University of Washington in 1971, he and his wife moved to Seattle. He retired from teaching in 1987. Since around 1968, Lawrence has concentrated on works with a *Builders* theme, which place a symbolic emphasis on humanity's aspirations and constructive potential. In 1979, he created the first of his several murals, *Games,* for the Kingdome Stadium in Seattle.

Lawrence's work is full of humor, compassion, and pictorial intensity. His central theme is human struggle. Always a social observer with a critical sensibility, he approaches his subjects with a quiet didacticism. Although his work is always emotionally autobiographical, his imagery has universal appeal. Lawrence's greatest contribution to the history of art may be his reassertion of painting's narrative function. In his art's ability to speak to us through time of the often neglected episodes of African-American history and the black experience, Lawrence offers a significant link in the traditions of American history painting, American scene painting, and American figural art.

REFERENCES

BEARDEN, ROMARE, and HARRY HENDERSON. *Six Black Masters of American Art.* Garden City, N.Y., 1972.

BROWN, MILTON W. *Jacob Lawrence.* New York, 1974.

WHEAT, ELLEN HARKINS. *Jacob Lawrence, American Painter.* Seattle, 1986.

———. "Jacob Lawrence and the Legacy of Harlem." *Archives of American Art Journal* 26, no. 1 (1986): 18–25.

———. *Jacob Lawrence: The Frederick Douglass and Harriet Tubman Series of 1938–40.* Hampton, Va., and Seattle, 1991.

ELLEN HARKINS WHEAT

Lawrence, Margaret Cornelia Morgan (August 19, 1914–), physician. Margaret Morgan was born in New York City because her mother, Mary Elizabeth Morgan, a teacher, had traveled there in search of the better medical care available to black people in the North. Margaret's father, Sandy Alonzo Morgan, was an Episcopal minister, and the family followed him as he answered calls to minister in Portsmouth, Va., New Bern, N.C., Widewater, Va., and MOUND BAYOU, Miss., before settling in Vicksburg, Miss., when Margaret was seven. Certain at a young age that she wanted to be a doctor, Morgan persuaded her parents to allow her live with relatives in New York City to take advantage of the better educational opportunities there. She attended Wadleigh High School for Girls in New York City, and entered Cornell University with a full scholar-

ship in 1932. She was the only African-American undergraduate studying there at the time. Barred from the Cornell dormitories because of her race, she boarded as a live-in maid to a white family. Although her grades and entrance examinations were more than satisfactory, Cornell Medical School refused her admission because she was black. She enrolled in Columbia University, where she earned her M.D. in 1940, and served her medical internship and residency at Harlem Hospital. In 1943, she received an M.S. in Public Health from Columbia. That year she moved with her husband, sociologist Charles Radford Lawrence II, and their baby son to Nashville, where she became a professor at Meharry Medical College. While in Nashville, she gave birth to two daughters eighteen months apart, created a Well-Baby Clinic in East Nashville, and maintained a private pediatric practice at home. In 1947, the Lawrence family returned to New York, and Lawrence attended Columbia University's Psychiatric Institute. She was the first African-American trainee at the Columbia Psychoanalytic Clinic for Training and Research, from which she received a Certificate in Psychoanalysis in 1951. That year she moved with her family to Rockland County, N.Y., where she organized the Community Mental Health Center and had a private psychiatric practice. From 1963 until her retirement in 1984, Lawrence served as a child psychiatrist at Harlem Hospital, directing its Developmental Psychiatry Clinic, and an associate clinical professor of psychiatry at Columbia's College of Physicians and Surgeons.

Lawrence, one of the first black women psychiatrists in the nation, published two books on child psychiatry, *The Mental Health Team in Schools* (1971) and *Young Inner City Families* (1975). She was a Julius Rosenwald Fellow (1942–1943) and a National Institute of Mental Health Fellow (1948–1950). In 1991 her pioneering work developing the "ego-strength" of disadvantaged children was recognized as she received the Camille Cosby World of Children Award. In 1988, Lawrence's achievements were celebrated in an award-winning biography, *Balm in Gilead: Journey of a Healer,* written by her daughter, Sara Lawrence Lightfoot, a professor of education at Harvard University.

REFERENCES

CHRISTY, MARIAN. "Dr. Margaret Lawrence: Overcoming All Odds." *Boston Globe,* October 23, 1991, p. 71.
LIGHTFOOT, SARA LAWRENCE. *Balm in Gilead: Journey of a Healer.* Reading, Mass., 1988.

SABRINA FUCHS
LYDIA MCNEILL

Lawrence, Robert Henry, Jr. (October 2, 1935–December 8, 1967), test pilot and astronaut trainee. Born and raised in Chicago, Ill., Robert Lawrence was a chess enthusiast and airplane model builder as a child. In 1956, he earned a B.S. in chemistry from Bradley University in Peoria, Ill., where he was enrolled in the Air Force Reserve Officer's Training Corps (ROTC). That same year he joined the Air Force as a second lieutenant and was sent to pilot instruction school at Craig Air Force Base in Alabama. He subsequently served as a fighter pilot and instructor of pilot trainees in Fürstenfeldbruck, West Germany, as part of the Military Assistance Advisory Group (MAAG). Lawrence returned to the United States in 1965 and studied simultaneously at the Air Force Institute of Technology at Wright-Patterson Air Force Base (AFB) in Ohio and at Ohio State University. After completing a dissertation entitled *The Mechanism of the Tritium Beta-Ray Induced Exchange Reactions of Deuterium with Methane and Ethane in the Gas Phase,* he received a Ph.D. in nuclear chemistry from Ohio State University in 1965.

Next Lawrence was a nuclear research officer at the Air Force Weapons Laboratory at Kirtland AFB in New Mexico. In 1967, he completed a one-year course at the Aerospace Research Pilot School at Edwards AFB in California. On June 30, 1967 he was named to the Air Force's Manned Orbiting Laboratory (MOL) program, and enrolled in a six-month astronaut training program at Edwards. Though not the first black to receive training at the Aerospace Research Pilot School, Lawrence was the first black actually named to a manned space program. His efforts to be the first African American in space were tragically ended on December 8, 1967. On that day he was killed at Edwards AFB during a proficiency training flight when the modified F-104 Starfighter he was piloting crashed on the runway. He was the ninth U.S. astronaut fatality. In his career as an Air Force pilot he had logged more than 2,500 hours of flying time, and had received the Air Force Commendation medal and the Air Force Outstanding Unit Award.

REFERENCES

ATKINSON, JOSEPH D., JR., and JAY W. SHAFRITZ. *The Real Stuff: A History of NASA's Astronaut Recruitment Program.* New York, 1985.
HAWTHORNE, DOUGLAS B. *Men and Women of Space.* San Diego, Calif., 1992.

LYDIA MCNEILL

Lawson, James Morris (September 22, 1928–), minister, civil rights leader. Born in Ohio in 1928, James Lawson graduated from Baldwin Wal-

lace College and studied at Oberlin Theological Seminary. Before he sought admission to Vanderbilt University Divinity School in 1958 to study for a Bachelor of Divinity degree, he had already become involved in issues of conscience and the fight for social change. Lawson had refused to enter the armed forces during the Korean War, which resulted in his imprisonment for three years. His early parole in 1951, however, permitted his church to send him as an ordained minister to India, where he became familiar with Gandhian methods of civil disobedience.

At Vanderbilt, Lawson used his knowledge of nonviolent direct action to train students to challenge segregation. The university, however, ordered him to end his participation in the Nashville sit-in movement. When he refused, the university dismissed him. Later, faculty pressure forced Vanderbilt to provide a means for Lawson to receive his degree, but he remained at Boston University, where he had gone following his dismissal.

Lawson forced Vanderbilt and many white Americans to wrestle with the ethical issues of nonviolence. He played an activist role in the CIVIL RIGHTS MOVEMENT following his student years, thus helping to refine the protest technique of nonviolent direct action that led to an end to legalized Jim Crow in the United States.

REFERENCES

CONKLIN, PAUL. *Gone with the Ivy: A Biography of Vanderbilt University.* Knoxville, Tenn. 1985.

GARROW, DAVID J. *Bearing the Cross: Martin Luther King, Jr., and the Southern Christian Leadership Conference.* New York, 1966.

JIMMIE LEWIS FRANKLIN

Lawyers. The first African American to serve on the U.S. Supreme Court, Justice Thurgood MAR-SHALL is the most famous black lawyer of the twentieth century. Together with his mentor, Charles Hamilton HOUSTON, Marshall was the chief architect of the strategy of the NAACP Legal Defense and Educational Fund (LDF), which led to the 1954 U.S. Supreme Court decision BROWN V. BOARD OF EDUCATION OF TOPEKA, KANSAS. Long before Marshall and Houston were born, however, earlier black lawyers had sown the seeds of liberty and equality to try and advance the social and political status of black citizens.

African Americans had great difficulty entering the legal profession during the nation's early history. Although a number of blacks entered such learned professions as medicine and the clergy, they had much less success establishing themselves as lawyers. Given the restrictions on black suffrage and the questions regarding black citizenship raised by the DRED SCOTT DECISION of 1857 and previous cases, it is not surprising that so few blacks entered the legal profession before the CIVIL WAR. Requirements regarding entry to the bar varied from state to state, but most required that an individual study law as an apprentice with a practicing lawyer for a prescribed period of time. This restriction placed blacks at a disadvantage, because many white lawyers objected to the presence of blacks in the profession. Although some northern states abandoned this requirement by the mid-nineteenth century, the decentralized system of admission still left decisions regarding entry to the bar to local lawyers, who were frequently hostile to black applicants.

Even when African Americans could find a lawyer or judge willing to accept them as apprentices, other requirements prevented them from pursuing a career in the law. In the 1830s, William Cooper NELL's refusal to take an oath in support of the Constitution in keeping with his strict Garrisonian principles kept him from becoming a lawyer. Black lawyers also had difficulty finding clients—a problem exacerbated by the lack of black judges in the legal system. Black citizens seeking legal services were hesitant to hire African-American lawyers because they feared economic reprisal from the white community and because they believed that with a black lawyer, they would have little chance of winning a case in an all-white court room. Blacks thus were deterred from entering the legal profession both by racial discrimination and by the inability to support themselves as lawyers.

Early Black Lawyers

Driven by the desire to improve the position of African Americans, several free blacks, some of whom were active in the abolitionist movement, overcame the obstacles to their entry into the legal profession in the nineteenth century. The first black lawyers appeared in New England, where the growing free black population provided sufficient demand for legal assistance. In 1844, Macon Bolling ALLEN was admitted to the bar in the state of Maine, although he never practiced law there. In 1845, he was admitted to practice law in the Commonwealth of Massachusetts. In 1847, Allen was appointed as justice of the peace by the Massachusetts governor, becoming the first African-American lawyer in the nation's history to hold a judicial post. Allen, like many lawyers who followed him, studied law as an apprentice under the supervision of another lawyer or a judge. It was not until the 1860s, with the graduation of George Lewis Ruffin

(1834–1887) from Harvard Law School in 1869, that blacks first attended formal law schools.

Other black lawyers in the New England states followed Allen to the bar. Robert Morris, Sr. (1823–1882), who became the nation's second black lawyer in 1847, was also admitted to the bar in Massachusetts. A leading abolitionist, he was the first black lawyer both to try and win a lawsuit in an American courtroom. In addition, in 1848, Morris became the first black lawyer in the nation to file a civil rights lawsuit, challenging Boston's segregated public school system. In 1865, another Boston lawyer, John Sweat ROCK, with the support of Massachusetts Sen. Charles Sumner, became the first black lawyer admitted to practice before the U.S. Supreme Court. Rock never actually argued before the high court, however. The first argument by a black lawyer occurred twenty-five years later, when Everett J. Waring, the first black lawyer in the state of Maryland, argued a case in 1890. In 1890, the first year that the census provided listings by occupation, there were only 431 African-American lawyers reported in the country.

According to the census reports, all the black lawyers in the United States were male; however, several African-American women had become lawyers by 1890. Faced with the double burden of being black and female, African-American women had even more difficulty entering the legal profession than black males. It was not until 1872 that the first black woman, Charlotte E. RAY, received a law degree from Howard University, becoming the first black woman to graduate from law school. After she received her degree from the Howard University School of Law, Ray became the first black woman admitted to the bar in Washington, D.C., and one of the first women admitted to any bar in the nation. In 1872, she opened her own law firm in the District of Columbia, specializing in business law, but she was forced to close it shortly thereafter due to financial difficulties.

The difficulty that African-American women had in entering the male-dominated legal community is demonstrated by the fact that few others followed Ray to the bar in the nineteenth century. African-American women who did succeed in becoming lawyers broke new ground, proving that black women could succeed in all aspects of the legal profession. In 1926, Violette Neatly Anderson (1882–1937) became the first black woman admitted to practice before the U.S. Supreme Court. One year later, Sadie T. M. ALEXANDER became the first black woman graduate of the University of Pennsylvania Law School and the first African-American woman to enter the bar and practice law in Pennsylvania. These pioneer black women lawyers worked both to emancipate black women and to emancipate African Americans from the legacy of slavery.

Black Lawyers in Politics

Lawyers, both black and white, have often pursued political careers. Black lawyers, for example, played a significant role in Congress after the CIVIL WAR. Robert Brown ELLIOT, elected in 1870, and Thomas Ezekiel MILLER, elected in 1888, both represented South Carolina in the House of Representatives. John Mercer LANGSTON, who in 1854 was the first black lawyer in the state of Ohio and in 1869, the first black lawyer to head a law school (Howard University School of Law), was elected to Congress from Virginia in 1890. James Edward O'HARA and George H. WHITE, Sr., were elected to Congress from North Carolina in the 1880s. Hiram Rhodes REVELS, who had been admitted to the bar in the state of Indiana, was elected to the United States Senate from the state of Mississippi in 1870. The first African American elected to Congress in the North, William Levi DAWSON—who served three terms from a Chicago district starting in 1929—was a 1920 graduate of the Northwestern University School of Law.

Black women lawyers did not share in this representation in Congress until the late twentieth century. In 1972, Yvonne Braithwaite BURKE became the first black woman from California to serve in the U.S. House of Representatives. That same year, Barbara JORDAN, a 1959 graduate of Boston University Law School, was elected to Congress from a Texas district. In 1990, Eleanor Holmes NORTON, a graduate of Yale Law School, was elected as a representative from the District of Columbia. Carol Moseley Braun (1947–), a graduate of the University of Chicago Law School and a native of Illinois, was the first black woman elected to the Senate in 1992.

With few exceptions, prior to the election of Franklin D. Roosevelt in 1932, most of the nation's black lawyers were Republicans. Many, such as Henry Lincoln Johnson, Sr., and Perry W. Howard (1877–1961), who were powerful Republican committee members in Georgia and Mississippi in the early twentieth century and controlled significant political patronage, held important posts in the REPUBLICAN PARTY. There were few black Democrats in the early twentieth century, but some black lawyers, such as Earl Burris Dickerson (1891–1986), identified themselves as supporters of the DEMOCRATIC PARTY. Dickerson served as an assistant attorney general for Illinois (1933–1939) under a Democratic administration, and in 1938, he was elected to the Chicago City Council as its first black Democratic alderman. In 1934, Chicago lawyer Arthur W. MITCHELL was

elected as the first black Democrat to Congress, signaling a notable shift in African-American party alliance.

Judges

Within ten years of the abolition of slavery, at least two black lawyers had become judges in the South. In 1870, Jonathan Jasper Wright (1840–1887) was elected as justice of the Supreme Court of South Carolina, serving in that post until 1877. (It was not until 1994 that another African American, Justice Ernest Finney [1931–], was elected as chief justice to the Supreme Court of South Carolina.) In 1873, Mifflin Wistar GIBBS (1823–1915) was elected to the Office of City Judge in Little Rock, Ark.

Black lawyers also served in important judgeships outside of the South. In 1883, George Ruffin was appointed by Benjamin Butler, the Democratic governor of Massachusetts, to the bench of the municipal court in Charlestown. In 1910, President Taft nominated Robert Herberton Terrell (1857–1925), over vehement protest in the Senate, as judge of the municipal court of the District of Columbia. Jane M. BOLIN (1908–), who in 1931 was the first black woman to graduate from Yale law school, became the nation's first black woman judge when Mayor Fiorello H. La-

Jonathan Jasper Wright (1840–1887), a South Carolina jurist, was the only African American to serve on a state supreme court during Reconstruction. (Prints and Photographs Division, Library of Congress)

Guardia appointed her to the domestic relations court in New York City. In some cases, African-American lawyers served outside of the United States altogether. In 1906, for example, T. McCants STEWART, a black lawyer from South Carolina, was appointed associate justice of the Supreme Court of Liberia.

In 1937, William Henry HASTIE became the first African-American federal judge when he was appointed to the U.S. District Court of the Virgin Islands. When President Harry S. Truman appointed him to the Third Circuit Court in Pennsylvania in 1949, Hastie also was the first African American to serve as a federal circuit court judge. However, it was not until the Kennedy administration that another African American received an appointment to a district or circuit court in the continental United States. In 1961, John F. Kennedy appointed James B. Parsons and Wade Hampton McCree, Sr. to district courts in Illinois and Michigan, respectively, making them the first African-American federal district court judges to serve in the continental United States. Kennedy also appointed Thurgood Marshall to the Second Circuit Court in New York in 1961, making him the second African American to sit on the bench of a federal circuit court in the continental United States.

Constance Baker MOTLEY, who assisted Thurgood Marshall in many successful civil rights cases, was the first black woman to try a case in the state of Mississippi and in 1966 she was appointed to the U.S. District Court of the Southern District of New York, becoming the nation's first black woman federal judge. In 1979, Amalya L. KEARSE became the first African-American woman appointed to a circuit court. From 1937 to 1976, only twenty-seven African Americans, and only one of them female, had been appointed as federal judges. Between 1976 and 1992, the number of black federal judges increased substantially, particularly under the Carter administration, when thirty-three African Americans were appointed to the federal courts.

There were no African Americans appointed as justices to the Supreme Court until the 1960s. Nominated by President Lyndon B. Johnson in 1967, Thurgood Marshall became the first African American to serve as a justice on the U.S. Supreme Court. Marshall served in this position until he retired on June 28, 1991. On July 1, 1991, President George W. Bush announced his nomination of Clarence THOMAS, a graduate of Yale Law School and chairman of the U.S. Equal Employment Opportunity Commission, to the Court. In October of that year, Thomas was confirmed, becoming the second African American to sit on the Court. (*See also* HILL-THOMAS CONTROVERSY.) William T. Coleman,

(Left to right) George E. C. Hayes, Thurgood Marshall, and James M. Nabrit led the fight before the U.S. Supreme Court for abolition of segregation in public schools. They are seen here leaving the court following the announcement of the court's decision declaring segregation unconstitutional, May 17, 1954. (AP/Wide World Photos)

who clerked for Supreme Court Justice Felix Frankfurter from 1948 to 1949, was the first black law clerk at the Supreme Court.

Lawyers in the Federal Government

Black lawyers have also received important Justice Department appointments. In 1911, William Henry LEWIS, an 1895 graduate of Harvard University School of Law, was appointed as the first black assistant attorney general of the United States. This appointment made Lewis the first black American lawyer ever nominated and confirmed by the U.S. Senate to a post at the U.S. Department of Justice. In 1937, H. Elsie Austin of Ohio became the first black woman appointed as an assistant state attorney general in the nation. In 1992, Pamela F. Carter (1949–) became the first African-American woman in the nation to serve in the statewide post of attorney general when she was elected to that position in Indiana. Three black lawyers have served as solicitor general of the United States: Thurgood MARSHALL (1965–1967), Wade Hampton McCree (1977–1981), and Drew S. Days III (1994–).

Ambassadors

One of the areas in which black lawyers have been particularly successful has been in foreign ambassadorial posts. In 1873, John F. Quarles (c. 1847–1885) was appointed by President Ulysses Grant to the U.S. Consulate at the port of Mahon in Menorca, Spain; in 1898, James Robert Spurgeon (1868–?) was appointed by President William McKinley as secretary to the U.S. Legation in Monrovia, Liberia; and in 1901, writer James Weldon JOHNSON was appointed as consul to Puerto Cabello, Venezuela, and in 1908, to Corinto, Nicaragua, by President Theodore Roosevelt. In more recent times, several black lawyers have served as ambassadors or in high foreign policy positions in the national government. For example, Clarence Clyde Ferguson, Jr., a former dean of the Howard University School of Law, served as ambassador-at-large and as special coordinator for relief to the civilian victims of the Nigerian civil war during the Nixon administration. Walter CARRINGTON, appointed ambassador to Nigeria in 1993, was a 1955 graduate of Harvard Law School.

Black women lawyers have also played vital roles as representatives and political operatives of the United States in foreign-policy affairs. In 1947, President Harry S. Truman appointed Edith S. Sampson (1901–1979) as an alternate to the United Nations, making her the first black U.S. delegate to that organization. In 1965, Patricia Roberts HARRIS, a former Howard University law professor, became the first African-American woman to hold the rank of ambassador, when President Lyndon B. Johnson appointed her as ambassador to Luxemburg. In 1971, Goler Teal Butcher (1925–1993) became a consultant to the House Foreign Affairs Committee and counsel to the subcommittee on Africa. Butcher was the first black woman in the nation's history to serve as counsel to a congressional committee.

Civil Rights

In the twentieth century, black lawyers continued to be motivated by the desire to win political and social rights for African Americans. As early as 1915, the NAACP submitted an amicus, or "friend of the court," brief in *Guinn* v. *U.S.* that overturned Oklahoma's grandfather clause (*see also* GRANDFATHER CLAUSES). In 1932, Benjamin J. DAVIS, Jr., a graduate of Harvard Law School, defended Angelo Herndon, a young black communist charged with violating an 1861 law prohibiting "insurrections." This case catapulted Davis into the national spotlight, and he became active in the COMMUNIST PARTY and in New York politics, fighting against racial discrimination.

During the 1930s and 1940s, Charles Hamilton Houston and Thurgood Marshall were involved in

many of the legal battles for civil rights. Houston, whom many consider the architect of the modern CIVIL RIGHTS MOVEMENT, won two Supreme Court cases in 1935 and 1938, establishing legal precedents against the exclusion of blacks from juries. With the assistance of Marshall and William I. Gosnell, he also won a major decision before the Maryland Court of Appeals, which forced the University of Maryland School of Law to open its doors to black students (1936).

The NAACP Legal Defense and Educational Fund Inc. (LDF), founded in 1940 and originally headed by Thurgood Marshall, played an instrumental role in the legal assault on segregation in public education and other areas of public life. Through the courtroom efforts of Marshall and William Henry Hastie, the U.S. Supreme Court held in *Smith* v. *Allwright* (1944) that the all-white primary was unconstitutional. In addition, the efforts of the LDF in *McLaurin* v. *Oklahoma State Regents for Higher Education* (1950) and SWEATT V. PAINTER (1950) were critical in establishing legal precedents for the 1954 case of *Brown* v. *Board of Education of Topeka,* Robert L. Carter, Thurgood Marshall, James Madison NABRIT, Jr., and Herbert Ordré Reid, Sr., were some of the most prominent leaders in the fight to repudiate statutory segregation. Lawyers such as Charles and John Scott, both graduates of the Washburn University School of Law in Topeka, who filed the original lawsuit in that city, also played important roles.

Under subsequent directors, Jack Greenberg (who served 1961–1984), Julius LeVonne Chambers (1984–1992), and Elaine Ruth Jones (1993–), the first black woman chosen as the counsel-director, the LDF has continued to play an important role in the fight against segregation and discrimination. It also has served as a vital training ground for black and white lawyers and has provided invaluable economic assistance to African Americans interested in attending law schools.

Law Schools

Historically, black law schools, especially the Howard University School of Law, founded in 1869, have played a critical role in the progress made by black lawyers in America. Approximately twenty-five other black law schools operated between 1869 and the 1990s. Many of these schools, opened in an effort to avoid forced integration at all-white state schools, were poorly funded and soon closed. Howard University's law school is the only one of the nineteenth- and early twentieth-century black law schools that has survived into the 1990s. Three other southern black law schools founded in the late 1940s continue to graduate black lawyers: the Thurgood Marshall Law School at Texas Southern University in Houston,

Tex.; North Carolina Central University School of Law in Durham, N.C.; and Southern University School of Law in Baton Rouge, La.

John Mercer Langston was the first black to head a law school, serving as dean of Howard University Law School from 1869 to 1875. Among other notable deans of Howard Law School have been Richard T. Greener (who served in 1878–1880), Charles Hamilton Houston (1930–1935), William H. Hastie (1939–1946), James Madison Nabrit, Jr. (1958–1960), and Spottswood William Robinson, III (1960–1963). In 1969, Patricia Roberts Harris was appointed as the first and only woman to serve as dean. J. Clay Smith, Jr. (1986–1988) and Henry Ramsey, Jr. (1990–) have served as the most recent deans of Howard Law School.

Black women lawyers have made great strides in the legal profession and have received prestigious faculty appointments at other law schools. In 1896, Lutie A. Lytle became the first woman law professor in the nation when she accepted a position on the faculty at Central Tennessee Law School, a black law school. Sharon Pratt Dixon, later mayor of Washington, D.C., taught at Antioch School of Law in Yellow Springs, Ohio, from 1972 to 1976, and Pauli Murray (1910–1985), who in 1945 was the first black woman to publish a lead article in a major law review, was appointed to the faculty at Brandeis University in Waltham, Mass., in 1973. In 1987, Marilyn V. Yarbrough became the first black woman law dean (University of Tennessee), and in 1992, Emma Coleman Jordan became the first black professor to head the Association of American Law Schools.

Derrick A. Bell, Jr., a graduate of Pittsburgh Law School, has been one of the most prominent and controversial law school teachers in recent years. In 1969, Bell became the first African American to serve on the faculty at Harvard University Law School. He left Harvard in 1981 to accept a position as dean of the University of Oregon Law School, but returned to Harvard in 1986. In 1990, Bell requested a leave of absence without pay to protest the lack of a black female tenured law professor at Harvard and he accepted a visiting professorship at New York University Law School. After filing a complaint against Harvard's hiring practices with the federal Education Department's Office of Civil Rights in 1992, Bell requested an extension of his leave from Harvard. Harvard denied the request, stating that it considered Bell to have resigned from the faculty as of 1992.

Black Bar Associations

Black bar groups have also played a vital role in the achievements of African-American lawyers. The de-

In the late twentieth century the number of black women judges increased considerably. Judge Glenda Hachett-Johnson is a nationally respected judge in Atlanta's juvenile courts. (Allford/Trotman Associates)

velopment of black bar groups emanated at the state level and influenced the formation of national bar groups. Black lawyer associations were founded because black lawyers were barred from joining white bar groups, including the American Bar Association, which barred black lawyers from membership affiliation until 1943.

Around 1890, black lawyers in the city of Greenville, Miss., formed the first Colored Bar Association in the city of Greenville, and other associations followed in regions throughout the country. It was probably Josiah Thomas Settle, the first president of the Mississippi Colored Bar Association, who persuaded Booker T. WASHINGTON to support the formation of a national bar group under the umbrella of the NATIONAL NEGRO BUSINESS LEAGUE. Founded in 1909, the bar group was called the National Negro Bar Association.

Many of the lawyers in the state Colored Bar Association were members of the National Negro Business League and, therefore, it was convenient for them to gather during the annual meeting to exchange ideas and formulate strategies to fight Jim Crow laws, which they did until 1922 when the lawyers broke away from the National Negro Business League. After a series of delays, the black lawyers formed a new national bar group, the National Bar Association (NBA), in 1925. The National Bar Association, a group that remains a powerful organization among black lawyers today, has grown from a handful of members to more than 20,000, with 82 affiliate chapters.

Like its predecessor's, the NBA's support comes from several local affiliates constituted in states across the nation. For seventy years, the NBA has been the center of black lawyer meetings to develop theories of law and continuing legal-education programs, and to work at cooperative efforts to fight against all forms of discrimination, and for the appointment of judges on the local and national levels, as well as other federal posts.

Black women have made great strides in their roles in the black bar associations and the NBA. In 1921, Gertrude E. D. Rush (1880–1918) was elected president of the Iowa Colored Bar Association, and in 1931, Louise J. Pridgeon was a founder and elected president of the Harlan Law Club in Ohio. At the national level, Georgia Jones Ellis of Illinois became the first woman elected as a national officer (secretary) in 1928; she was elected vice president in 1929. In 1981, Arnette R. Hubbard became the first woman president of the NBA; she had been followed by four others: Arthenia L. Joyner (1984), Algenita Scott Davis (1990), Sharon McPhail (1991), and Paulette Brown (1993). In 1983, Mahalia A. Dickerson, the first black woman admitted to the bar in the state of Alaska, became the first black woman to head the National Association of Women Lawyers.

Black Lawyers in Recent Years

Under adverse circumstances, blacks have fought persistently to overcome the barriers to their entry into the legal profession. During the 1960s and through the 1990s, the number of black lawyers continued to increase, as did their influence both at the national and local levels. While there were more than 600,000 white lawyers in the nation in the early 1990s, black lawyers represent slightly more than 30,000 of that figure, and black women represent about 10,000 of the total number of black lawyers—and both numbers continue to increase.

Black lawyers have made notable efforts in recent years to expand their practices from domestic, civil rights, and criminal law—the areas to which they historically have been confined. With the help of a growing network of influential black business executives and politicians, black lawyers have begun to enter the

field of corporate law. African-American lawyers have come a long way since Charles Berrian and D. Macon Webster practiced corporate law on Wall Street early in the twentieth century. While many African-American lawyers, such as Yvonne B. Burke, who is a partner in the Los Angeles corporate law firm Jones, Day, Reavis, and Pogue, have joined successful, predominantly white law firms, others have established their own firms. In 1970, Reginald F. Lewis (1942–1993) helped establish Murphy, Thorpe, and Lewis as the first major black firm on Wall Street—a firm in which he was a partner from 1970 to 1973. (Lewis later went on to an extraordinarily successful career as an investment banker and entrepreneur.) In 1984, *The Wall Street Journal* estimated that there were several dozen black corporate firms in the country, located primarily in predominantly black urban centers such as Atlanta, Detroit, and Washington, D.C. That number continues to expand as corporate affirmative-action programs and the awarding of municipal contracts to minority law firms provide important sources of employment for African-American corporate lawyers.

REFERENCES

BELL, DERRICK A., JR. *Race, Racism and American Law.* Boston, 1973.

BROWN, CHARLES SUMNER. "The Genesis of the Negro Lawyer in New England." Parts 1 and 2. *Negro History Bulletin* (April 1959): 147–152; (May 1959): 171–177.

GREENBERG, JACK. *Crusaders in the Courts.* New York, 1994.

HIGGINBOTHAM, A. LEON, JR. *In the Matter of Color: Race and the American Legal Process—The Colonial Period.* New York, 1978.

KLUGER, RICHARD. *Simple Justice: The History of Brown v. Board of Education and Black America's Struggle for Equality.* New York, 1975.

LEONARD, WALTER J. *Black Lawyers: Training and Results, Then and Now.* Boston, 1977.

McNEIL, GENNA RAE. *Groundwork: Charles Hamilton Houston and the Struggle for Civil Rights.* Philadelphia, 1983.

MILLER, LOREN. *The Petitioners: The Story of the Supreme Court of the United States and the Negro.* New York, 1967.

SMITH, J. CLAY, JR. *Emancipation: The Making of the Black Lawyer, 1844–1944.* Philadelphia, 1993.

———. *Justice and Jurisprudence and the Black Lawyer.* Notre Dame Law Review 69 (1994): 313.

———. "Thurgood Marshall: An Heir of Charles Hamilton Houston." *Hastings Constitutional Law Quarterly* 20 (1993): 503.

SMITH, JESSIE CARNEY. *Notable Black American Women.* Detroit, 1992.

TUSHNET, MARK V. *Making Civil Rights: Thurgood Marshall and the Supreme Court, 1956–1961.* New York, 1994.

WARE, GILBERT. *William Hastie: Grace Under Pressure.* New York, 1984.

J. CLAY SMITH, JR.

Leadership Conference on Civil Rights.

The Leadership Conference on Civil Rights (LCCR) has been the most important lobbying group for civil rights legislation over the last half of the twentieth century. It grew out of an unsuccessful campaign by NAACP staffers Roy WILKINS and Clarence MITCHELL and labor leader A. Philip RANDOLPH to revive the wartime FAIR EMPLOYMENT PRACTICES COMMITTEE (FEPC), which had been terminated in 1946. Randolph organized a unique interracial group, the seventy-group National Council for a Permanent FEPC, to coordinate lobbying efforts. Arnold Aronson served as the committee's secretary. In 1949, after the NAACP launched failed lobbying campaigns for the FEPC and for civil rights measures, Wilkins and Aronson called for a National Emergency Civil Rights Mobilization.

On January 15, 1950, more than four thousand representatives of one hundred black and white religious, political, and civil rights groups met in Washington, D.C., for the mobilization, a three-day conference, and agreed to found a coalition and information clearinghouse for the sole purpose of passing civil rights laws. In order to join, groups had to be nonpartisan and have a significant, identifiable constituency. Money was raised by membership dues. NAACP leader Walter White was named the director, although Roy Wilkins actually exercised that function. Mitchell was named legislative chair, the most powerful lobbying position, and Aronson was secretary. Americans for Democratic Action (ADA) attorney Joseph L. Rauh was named as counsel. Randolph, wishing to concentrate on securing an FEPC, declined to join. The group was officially named the Leadership Conference on Civil Rights in 1951, following a subsequent conference.

The LCCR led the fight for civil rights legislation through lobbying and drafting of bills, and was responsible in part for the Civil Rights Bills of 1957, 1960, and 1964—including lobbying for the Equal Employment Opportunity Commission to act as an FEPC. LCCR efforts were especially crucial to passage of the Civil Rights Act of 1968, as well as the 1965 VOTING RIGHTS ACT and its extension in 1975. Wilkins (director as of 1955) coordinated relations within the group. Mitchell was chief strategist and lobbyist. He became such a ubiquitous figure on Capitol Hill that he was dubbed the "101st senator." The LCCR was housed in Aronson's New York law office until 1963, when it moved to Washington, D.C.

The LCCR expanded its activities in the 1960s and 1970s, as other groups, such as Latinos, Asian-Americans, women, and gays and lesbians began fighting for civil rights legislation. In 1965, a Committee on Compliance and Enforcement was begun to assure effective use of legislation. The LCCR also began the practice of screening judicial candidates, and in 1969 and 1970 led the successful struggles against the confirmation of Clement Haynesworth and Harold Carswell for the U.S. Supreme Court.

By the end of the 1970s, the organization had undergone several changes. Roy Wilkins and Clarence Mitchell retired. In 1981, the Rev. Benjamin HOOKS, leader of the NAACP, became the chairperson, and Ralph G. Neas became the first white executive director of the LCCR. The LCCR also inaugurated an annual Hubert H. Humphrey Civil Rights Award dinner to honor outstanding civil rights figures and as a fundraiser, and in 1985 began publishing the bimonthly *Civil Rights Monitor,* which contained organizational news and notices of hearings and meetings.

Under Neas, who described himself as "facilitator" of civil rights lobbying, the organization grew to include at least 185 groups by the early 1990s. Neas gained prominence by his leadership in the successful struggle against the confirmation of Robert Bork to the U.S. Supreme Court in 1987, and he helped design and pass the 1988 Civil Rights Restoration Act and the 1991 Civil Rights Act. Neas was strongly critical of the Reagan administration's civil rights record, and in 1991, he unleashed a storm of controversy when he accused President George Bush of "sabotaging" talks between the group and business leaders organized to design legislation to prevent job discrimination. In 1993 the LCCR pledged support for Washington, D.C., statehood on civil rights grounds.

REFERENCE

WATSON, DENTON. *Lion in the Lobby: Clarence Mitchell, Jr.'s Struggle For the Passage of Civil Rights Laws.* New York, 1990.

GREG ROBINSON

League of Revolutionary Black Workers.

Growing out of the merger of the Dodge Revolutionary Union Movement (DRUM) and other Revolutionary Union Movement (RUM) organizations, the League of Revolutionary Black Workers was formed in the aftermath of a wildcat strike by about four thousand workers at the main Dodge automobile plant in Hamtramck, Mich., on May 2, 1968. Automobile production had increased during the pre-

vious five years, and many young African Americans had been hired. However, almost all black workers were placed under older white men, many of whom expressed racist views. There were struggles about safety rules and promotion of blacks into positions of authority in the workplace and in the United Auto Workers (UAW) union. The DRUM, organized barely a year after the massive Detroit riot of 1967, was formed to respond to these problems.

The DRUM started a newsletter, *drum,* organized several rallies and strikes, and led the organization of RUMs at different Detroit factories. In early 1969, DRUM merged with several auto RUMs in Detroit and Mahwah, N.J., including FRUM (Ford), CA-DRUM (Cadillac), and ELRUM (Chrysler Eldon Avenue Plant), as well as such nonautomotive groups as Birmingham steelworkers, to form the League of Revolutionary Black Workers. The league remained a small operation, with never more than a few hundred members. Its leaders combined socialist theory and civil rights organization. In mid–1969, the league associated itself with James FORMAN, who used funds raised by the Black Economic Development Conference to fund a league staff. Leaders came from the Detroit activist community, notably the African-American lawyers Mike Hamlin and Ken Cockrel, and the revolutionaries General Gordon Baker and John Watson, who had turned the Wayne State University daily *South End* into a radical organ and printed their journal *Inner City Voice* on its presses. They also joined with Forman's publishing house, Black Star Press, to print league pamphlets. Members formed a film collective, which put out a feature-length documentary, *Finally Got the News* (1970).

By 1970, however, the entire movement was disintegrating. The car industry slumped after 1969, and many of the young workers who were core league supporters were laid off. The league became more a discussion group than a union and never devised a consistent program. Its members alienated many black workers with their Marxist rhetoric. In 1970, there was a schism. One faction, mostly plant organizers, tried to solidify unionization efforts, and ran union slates in 1970 and 1971 in an unsuccessful attempt to unseat the white UAW leadership. This earned the movement the enmity of union leaders. Meanwhile, the "outside" radicals formed a Black Workers Congress, in hopes that the league would be a central unit and sponsor the organization of RUMs on a Maoist model. The league did not affiliate, and the the Black Workers Congress was "taken over" by the Stalinist Communist Labor party. By May 1973, the league and the RUMs were gone; members returned to the UAW or joined more radical organizations. The league did leave a legacy of African-American political awareness, and it increased the

number of black foremen and UAW leaders in Detroit.

REFERENCES

BUHLE, JARI JO, PAUL BUHLE, and DANIEL GEORGA-HAS. *Encyclopedia of the American Left*. New York, 1990.

FINE, SIDNEY. *Violence in the Model City: The Cavanagh Administration, Race Relations, and the Detroit Riot of 1967*. Detroit, 1989.

GESCHWENDER, JAMES. *Class, Race, and Worker Insurgency: The League of Revolutionary Black Workers*. Detroit, 1977.

ALANA J. ERICKSON

Ledbetter, Hudson William "Leadbelly"

(c. January 15, 1888–December 6, 1949), blues singer and guitarist. Born Hudson William Ledbetter and raised near Mooringsport, La., on a date that is subject to dispute (January 21, 1885, and January 29, 1889, are also often given), Leadbelly, as he was known later in life, was still a child when he began to work in the cotton fields of his sharecropper parents. Later, they bought land across the border in Leigh, Tex. and "Huddie," as he was called, learned to read and write at a local school. During this time he also began to play the windjammer, a Cajun accordion. He also danced and performed music for pay at parties. Ledbetter learned to play twelve-string guitar as well as shoot a revolver in his early teens, and he began to frequent the red-light district of Fannin Street in Shreveport, La., where he performed for both black and white audiences. By the time he left home for good in 1906, Ledbetter had a reputation for hard work, womanizing, violence and musical talent. In 1908 Ledbetter, who had already fathered two children with Margaret Coleman, married Aletta Henderson, and settled down in Harrison County, Tex., where he worked on farms and became a song leader in the local Baptist church. Ledbetter also claimed to have attended Bishop College, in Marshall, Tex., during this time. In 1910 Ledbetter and his family moved to Dallas, and Ledbetter began to frequent the Deep Ellum neighborhood, where he began playing professionally with Blind Lemon JEFFERSON. The two were inseparable for five years.

In 1915 Ledbetter was jailed and sentenced to a chain gang for possessing a weapon. He escaped, and for several years lived under the pseudonym Walter Boyd. In 1917 he shot and killed a man in a fight, and the next year was sentenced to up to thirty years for murder and assault with intent to kill. He served at the Shaw State Farm Prison, in Huntsville, Tex., from 1918 to 1925. That year, when Texas Gov. Pat

Huddie Ledbetter, or "Leadbelly," with his second wife, Martha Promise Ledbetter, in Connecticut in 1935. Leadbelly, an accomplished musician with an enormous repertory of songs, was a central figure in the folk music revival of the 1930s and '40s. (Prints and Photographs Division, Library of Congress)

Neff visited the prison, Leadbelly made up a song on the spot asking to be released and convinced Neff to set him free. By this time Ledbetter was known as "Leadbelly," a corruption of his last name that also referred to his physical toughness. In the late 1920s Leadbelly supported himself by working as a driver and maintenance worker in Houston and around Shreveport. He also continued to perform professionally. In 1930 Leadbelly was again jailed, this time for attempted homicide in Mooringsport. He had served three years when John Lomax came to the notorious Louisiana State Penitentiary at Angola to record music by the prisoners. Lomax, impressed by Leadbelly's musicianship, lobbied for his release, which came in 1934. Lomax hired him as a driver and set him on a career as a musician. In 1935 Leadbelly married Martha Promise.

Leadbelly made his first commercial recordings in 1935, performing "C.C. Rider," "Bull Cow," "Roberta Parts I and II," and "New Black Snake Moan." Thereafter, aside from another prison term in 1939–1940 for assault, Leadbelly enjoyed enormous success as a professional musician, performing and recording to consistent acclaim. In the late 1930s and throughout the 1940s he appeared at universities and political rallies on both the East and West coasts, as well as on radio and film, and was a key element and influence in the growth of American folk and blues music. He became a fixture of the folk music scene in Greenwich Village, near his home on New York's Lower East Side, and was often associated with left-wing politics.

Leadbelly was best known for his songs about prison and rural life in the South. However, his repertory was huge and included blues, children's tunes, cowboy and work songs, ballads, religious songs, and popular songs. Although his audiences were generally white, and Leadbelly made only a few recordings for the "race" market of African-American record buyers, he addressed matters of race in songs such as "Scottsboro Boys" (1938) and "Bourgeois Blues" (1938). His powerful voice was capable of considerable sensitivity and nuance, and his twelve-string guitar playing was simple, yet vigorous and percussive. Among his most popular and enduring songs, some of which were recorded by Lomax for the Library of Congress, are "Goodnight Irene" (1934), "The Midnight Special" (1934), "Rock Island Line" (1937), "Good Morning Blues" (1940), and "Take This Hammer" (1940). He recorded in 1940 with the Golden Gate Quartet, a gospel vocal group. From 1941 to 1943 Leadbelly performed regularly on the U.S. Office of War Information's radio programs, and in 1945 he appeared in Pete Seeger's short documentary film *Leadbelly*. He made a trip to Paris shortly before his death in New York City at the age of sixty-one from amyotrophic lateral sclerosis (Lou Gehrig's disease). The 1976 film *Leadbelly* was based on his life story. In 1988 Leadbelly was inducted into the Rock and Roll Hall of Fame.

REFERENCES

ADDEO, EDWARD, and RICHARD GARVIN. *The Midnight Special: The Legend of Leadbelly.* New York, 1971.

WOLFE, CHARLES, and KIP LORNELL. *The Life and Legend of Leadbelly.* New York, 1992.

JONATHAN GILL

Lee, Archy. *See* Archy Lee Incident.

Lee, Canada (May 3, 1907–May 9, 1952), athlete and actor. Born Leonard Lionel Cornelius Canegata in New York City, Canada Lee began studying violin with the composer J. Rosamond JOHNSON at age seven and made his first concert appearance four years later. At age fourteen, he ran away from home and went to Saratoga, N.Y., where he became a horse-race jockey. Opportunities for African-American jockeys were few (*see* HORSE RACING), and he returned home to New York after two years. He soon turned to BOXING, and won 90 of 100 amateur bouts. Within two years, he won the Metropolitan Inner-

City and Junior National Championships, and by the time he was 18 he had won three National Amateur Lightweight championships. In 1926, he turned professional, and adopted the name Canada Lee. He also became a welterweight, and soon was a leading contender for the welterweight championship. However, in 1933, an eye injury ended his career in the ring.

Lee returned to Harlem and tried to make a career as a dance bandleader, supporting himself in the meantime by working on New York's docks. He won an acting role in a WORKS PROJECT ADMINISTRATION (WPA) musical, *Brother Mose* (1934), and two years later was cast as Banquo in Orson Welles's famous "voodoo" production of *Macbeth*, set in Haiti, for the Negro Federal Theater Project of the WPA. He subsequently played roles in *Haiti* (1937), and in *Mamba's Daughters* (1939).

In 1941, Lee gained fame for his performance in the lead role in Orson Welles's production of Richard Wright's *Native Son*. He subsequently played lead roles in *Across the Board Tomorrow Morning* (1942); Harry Rigsby and Dorothy Heyward's play *South*

Actor Canada Lee was never afraid to lend his support to political causes. Here, in 1945, he speaks in favor of extending the life of the Fair Employment Practices Commission (FEPC). Lee paid for his involvement in left-wing causes during the early 1950s when he was blacklisted from work in Hollywood. The stress this caused likely contributed to his early death. (AP/Wide World Photos)

Pacific (1943); *On Whitman Avenue* (1944), which he also produced; *The Dutchess of Malfi* (1946), which he played in whiteface; and *Anna Lucasta* (1944). In 1945, director Margaret Webster invited him to play Caliban in Shakespeare's *The Tempest*. Lee also had a radio show, *New World A-Coming*.

Lee also made three films during the 1940s: Alfred Hitchcock's *Lifeboat* (1944), Robert Rosen's *Body and Soul* (1947), and Alfred Werker's *Lost Boundaries* (1949).

However, by the late 1940s, Lee's career was stalled by accusations that he was a communist. He was fired from his radio show in 1948 and was allegedly banned from forty shows. Although he was outspoken about racial matters and participated in demonstrations for civil rights causes, Lee denied he was a communist. Nevertheless, under the pressure of ostracism and unemployment, his health began to fail. In 1951, English director Alexander Korda cast Lee in the antiapartheid drama *Cry, the Beloved Country*, which was filmed in South Africa. After completing the film, Lee returned to the United States, but he was unable to find work. He traveled to England, where he collapsed and died shortly thereafter of a heart attack. Lee remains a tragic figure, a victim of the blacklist. While his career was cut too short for his fame to last, the Canada Lee Foundation, which he set up and which provides scholarships to black DRAMA students, remains a lasting legacy.

REFERENCE

GILL, GLANDA E. "Canada Lee: Black Actor in Nontraditional Roles." *Journal of Popular Culture* 25 (Winter 1991): 79–89.

GREG ROBINSON

Lee, Don L. *See* Madhubuti, Haki R.

Lee, Everett (1919–), orchestra conductor. Born in Wheeling, W. Va., Everett Lee studied violin at the Cleveland Institute of Music and received his B. Mus. there in 1940. He studied conducting with Dmitri Mitropoulos, Max Rudolf, and Bruno Walter; in 1944 he received critical acclaim as a conductor when he substituted in the Broadway musical *Carmen Jones*, becoming the first African American to conduct a leading Broadway show that was not a black production (though it did have a black cast). In that year Lee and the conductor Dean DIXON founded the American Youth Orchestra in New York. Lee, who married the pianist Sylvia Olden (*see* Sylvia Olden LEE),

studied with Boris Goldovsky at the Berkshire Music School in Lenox, Mass., in 1946. From 1947 to 1948 he studied at Juilliard. In 1948 he founded the Cosmopolitan Little Symphony, which made its debut at New York's Town Hall in 1948. Two years later Lee directed Columbia University's Opera Repertory summer session, and in 1952 he headed the school's opera department. Thereafter Lee toured widely, conducting leading orchestras in Europe and South America. He also conducted frequently in the United States, becoming the first African American to conduct an established symphony orchestra below the Mason-Dixon line (the Louisville Orchestra).

From 1955 to 1958 Lee was a staff member of the New York City Opera. In his first year he conducted Verdi's *La Traviata*, becoming the first African American to conduct an opera there in full performance. From 1962 to 1972 Lee was musical director of Sweden's Norrköping Symphony Orchestra. Lee returned to the United States to conduct the New York–based Symphony of the New World from 1973 to 1976. He made his conducting debut with the New York Philharmonic in 1976 and became director of the Bogotá Symphony in Colombia in 1979.

REFERENCE

ABDUL, RAOUL. "Everett Lee's Philharmonic Debut." In *Blacks in Classical Music*. New York, 1977.

RAE LINDA BROWN

Lee, Gaby. *See* Lincoln, Abbey.

Lee, Jarena (February 11, 1783–c. 1850s), preacher. Through her career as an itinerant preacher and as an author, Jarena Lee exemplified the work of black women in African Methodist Churches who struggled for official recognition of their talents. Born in Cape May, N.J., in 1783, Lee became a member of Philadelphia's Bethel AFRICAN METHODIST EPISCOPAL (AME) Church at the age of twenty-one. Around 1811, the same year she married the Rev. Joseph Lee, she felt called by God to preach. The Rev. Richard ALLEN, the founder of Bethel, emphasized to Lee that he could not recognize her as an official preacher because he felt that ordaining women contradicted Methodist doctrine. After Joseph Lee's death in 1817, Jarena Lee became an itinerant preacher, with Richard Allen's blessing, but still without official acknowledgement. Lee traveled widely across the country and preached at churches and camp meetings. She was also

involved with the work of the AMERICAN ANTI-SLAVERY SOCIETY.

In 1836 Lee published and distributed her spiritual autobiography, *The Life and Religious Experience of Jarena Lee, a Coloured Lady, Giving an Account of Her Call to Preach the Gospel*. The narrative describes Lee's conversion, religious development, travels, and trials in her work. The book is a theological study as well. Lee and other AME preaching women were concerned with broad theological issues and their implications for both men and women in the church, and her arguments for the right of women to preach were never put forth in isolation from theology. Although Lee was never able to obtain a formal position within the hierarchy of the AME Church, she was a prominent figure in black women's struggles for access to ordination and an inspiration to the women who came after her.

REFERENCES

ANDREWS, WILLIAM, ed. *Sisters of the Spirit: Three Black Women's Autobiographies of the Nineteenth Century*. Bloomington, Ind., 1986.

DODSON, JUALYNNE. "AME Preaching Women in the Nineteenth Century: Cutting Edge of Women's Inclusion in Church Polity." In Hilah Thomas and Rosemary Keller, eds., *Women in New Worlds*. Nashville, Tenn., 1981.

JUDITH WEISENFELD

Lee, Rebecca (1833–?), physician. Rebecca Lee was born in Richmond, Va., but grew up in Pennsylvania where she lived with her aunt, who worked as a health care provider. From 1852 to 1860 Lee was a nurse in Massachusetts. In 1860 she decided to go to medical school and was accepted by the New England Female Medical College in Boston. When she received her M.D. in 1864, she became the first black female physician in the United States, as well as the first and only black woman to graduate from the New England Female Medical College. For many years Lee maintained a private practice in Richmond, Va., catering to the needs of freed black people. In 1883, after having moved back to Boston, she published *A Book of Medical Discourses in Two Parts*. The book focused primarily on the health care concerns of women and children. Little is known about her life after this point; the year of her death also is unknown.

REFERENCES

Bulletin: Medico-Chirugical Society of the District of Columbia, Inc. 6, no. 1 (January 1949).

HINE, DARLENE CLARK. "Co-Laborers in the Work of the Lord: Nineteenth-Century Black Women Physicians." In *"Send Us a Lady Physician": Women Doctors in America; 1835–1920*. New York, 1985.

HINE, DARLENE CLARK, ed. *Black Women in America*. Brooklyn, N.Y., 1993.

SAMMONS, VIVIAN OVELTON. *Blacks in Science and Medicine*. New York, 1990.

WAITE, FREDERICK C. *History of the New England Female Medical College: 1848–1874*. Boston, Mass., 1950.

LYDIA MCNEILL

Lee, Shelton Jackson "Spike" (March 20, 1957–), filmmaker. Spike Lee was born in Atlanta, Ga., to William Lee, a jazz musician and composer, and Jacqueline Shelton Lee, a teacher of art and literature. The oldest of five children, Lee grew up in Brooklyn, N.Y., with brothers David, Chris, and Cinque, and sister Joie. Lee's family environment was imbued with a strong sense of black history. Like his father and grandfather, Lee attended MOREHOUSE COLLEGE, and graduated with a B.A. in 1979. Upon graduating, Lee enrolled in New York University's Tisch School of the Arts, where he received an M.F.A. in film production in 1983. While at New York University Lee produced several student films: *The Answer* (1980), *Sarah* (1981), and *Joe's Bed-Stuy Barbershop: We Cut Heads* (1982). *Joe's Bed-Stuy Barbershop*, his M.F.A. thesis film, was awarded a Student Academy Award by the Academy of Motion Picture Arts and Sciences in 1982, was broadcast by some public television stations, and received critical notice in *Variety* and the *New York Times*.

Lee has produced six feature films. In all of the films he has been director, writer, actor, and producer. Lee's first feature-length film was the highly acclaimed comedy *She's Gotta Have It* (1986), which he shot in twelve days on location in Brooklyn at a cost of $175,000. The film eventually grossed $8 million. The action of the film centers on a sexually liberated young black woman who is having affairs simultaneously with three men. Interspersed with these scenes, she and the film's characters debate her conduct from ideological perspectives then current in the black community; such topics as hip-hop, color differences, sexual codes, and interracial relationships are raised. This debate spilled over into the national media. Controversy was to become a hallmark of Lee's work.

She's Gotta Have It is characterized by disjointed narrative syntax, mock–cinéma vérité technique, active camera movement, and disregard for autonomy of text. Lee has often employed the same actors and

Film director Spike Lee at the Cannes Film Festival in France in 1991, at the time of the premiere of his film *Jungle Fever*. Since the 1980s, Lee has directed and scripted a number of films with African-American subject matter that explore the complexities of black-white relations. (AP/Wide World Photos)

film technicians in many films, giving them a repertory effect.

Lee's second film, *School Daze* (1988), was financed by Columbia Pictures for $6.5 million and grossed more than $15 million. It also dealt with a controversial topic, the conflict at a southern black college between light-skinned students who seek assimilation into mainstream America and dark-skinned students who identify with Africa.

In 1989 Lee produced *Do the Right Thing,* which was set in Brooklyn. The film was produced for $6 million and grossed $30 million. *Do the Right Thing* focused on the relationship between an Italian-American family that operates a pizzeria in the Bedford-Stuyvesant neighborhood and the depressed black community that patronizes it. The film chronicles the racial tensions and events over a period of one day, climaxes in a riot in which one black youth is killed, and ends with the complete destruction of the pizzeria.

This highly successful film was followed by *Mo' Better Blues* (1990), the story of the love affairs, personal growth, and development of a jazz musician in New York City. *Jungle Fever* (1991), also set in New York, was Lee's treatment of interracial relationships, centering on an affair between a married black architect and his Italian-American secretary.

Lee's most ambitious film to date has been *Malcolm X,* which was released in November 1992. In this film Lee departed from his earlier technique and employed the traditional style and approach of the Hollywood epic biography. Produced by Warner Brothers, *Malcolm X* was three hours long and cost $34 million, though it had originally been budgeted for $28 million. By the end of 1994 it had grossed $48.1 million. In a highly publicized initiative Lee raised part of the additional funds needed from black celebrities Bill COSBY, Oprah WINFREY, Earvin "Magic" JOHNSON, Michael JORDAN, Janet Jackson, and PRINCE, among others. Denzel WASHINGTON, who portrayed MALCOLM X, was nominated for an Academy Award as best actor. Lee based his film on an original screenplay, written by James BALDWIN and Arnold Perl in 1968, that was based on *The Autobiography of Malcolm X* as told to Alex HALEY.

In 1994 Lee collaborated with his siblings Joie and Cinque Lee in the production of *Crooklyn,* the story of a large, working-class black family growing up in Brooklyn.

Spike Lee's film career has generated a film company, Forty Acres and a Mule; a chain of retail outlets that sell paraphernalia from his films; and a series of television commercials, ten of them with basketball star Michael Jordan.

REFERENCES

LEE, SPIKE. *By Any Means Necessary: The Trials and Tribulations of the Making of Malcolm X.* New York, 1992.

————. *Spike Lee's Gotta Have It: Inside Guerilla Filmmaking.* New York, 1987.

————. *Uplift the Race: The Construction of School Daze.* New York, 1988.

LEE, SPIKE, with Lisa Jones. *Do the Right Thing: A Spike Lee Joint.* New York, 1989.

ROBERT CHRISMAN

Lee, Sylvia Olden (1919–), concert pianist and accompanist. Born Sylvia Olden in Washington, D.C., she studied piano as a youth and performed at the White House for the first convention of the NATIONAL COUNCIL OF NEGRO WOMEN in 1935. She studied at Howard University in Washington, D.C., before obtaining a bachelor of music degree at the Oberlin Conservatory of Music in 1938. She then taught for two years at Talladega College in Alabama and from 1942 to 1943 at Dillard University in New Orleans.

Lee, who married the conductor Everett Lee, performed with the Cosmopolitan Symphony and in a duet with Thomas Kerr, but she was best known in the 1940s and early '50s as a vocal coach. She prepared students for the New York City Center and Metropolitan Opera and in 1946 served as technical adviser for the American premiere of Benjamin Britten's *Peter Grimes* at Tanglewood, in Lenox, Mass. She also worked with Boris Goldovsky as a coach at Tanglewood. Lee was appointed the first black coach of the Metropolitan Opera in 1953. During this time Lee also gained a reputation as an accompanist. She performed with Carol Brice and Paul ROBESON in the 1940s, as well as for students of Todd Duncan. She also accompanied many lieder recitals in Munich, Stuttgart, and West Berlin. Beginning in the late 1960s, Lee concentrated on an academic career. From 1967 to 1969 she taught at the University of Cincinnati. Since 1970 she has taught at Curtis Institute of Music in Philadelphia. In 1985 Lee returned to the Metropolitan Opera to serve as consultant for the company's first performance of *Porgy and Bess.*

REFERENCE

"Met Opera Coach." *Ebony* (May 1955): 4.

RAE LINDA BROWN

Lee-Smith, Hughie (September 20, 1915–), artist. Hughie Lee-Smith was born in Eustis, Fla., and spent his early years in Atlanta, Ga. When he was ten years old his family moved to Cleveland, where he finished high school. In 1935 he won a scholarship to the Art School of the Detroit Society of Arts and Crafts. The following year he returned to Cleveland, where he taught part-time at KARAMU HOUSE and studied art at the Cleveland Institute of Art. Lee-Smith worked for the Ohio branch of the WORKS PROJECT ADMINISTRATION (WPA) from 1938 to 1940 and produced a series of lithographic prints that were exhibited widely. While serving in the Navy (1943–1945), he produced mural-sized paintings on the history of African Americans in the Navy. He relocated to Detroit during the 1940s, received a B.S. in Art Education from Wayne State University in 1953, and moved to New York City in 1958.

Lee-Smith was part of the generation of African-American artists that included Margaret BURROUGHS, Clarence Lawson, Eldzier CORTOR, Rex GORLEIGH, and the poet Gwendolyn BROOKS, who came to maturity in the Midwest in the 1940s. Lee-Smith's style has been described as both a surrealist and social realist, and his influences have included classicism, romanticism, academic, and *plein air* painting. He often used children as surrogates for the adult world, enabling him to explore social issues through allegory (*Girl with Balloon,* 1949–1950; *Boy with Tire,* 1952; *Girl with Portfolio,* 1987). He used a realistic style to create a feeling of otherworldliness, placing men and women of all races and ages in landscapes which metaphorically evoked the sense of loneliness and emptiness he found in his psychological investigation of the American experience. Set on desolate beaches or vacant lots, with backdrops of pitted walls, urban rooftops, or classical architecture, Lee-Smith's men and women encountered each other in the midst of flapping balloons and streamers, a windswept world striking in its serenity and quietude (*Impedimenta,* 1958; *Man with Balloons,* 1960; *The Scientist,* 1949). While Lee-Smith's work did not carry an explicit political message, he believed in the ability of art to unify people in the struggle for political and economic goals. Toward this end Lee-Smith believed that the artist's style had to be understood and approved by the majority of people.

Lee-Smith exhibited predominantly in the Midwest during the early years of his career, and had shows at the South Side Community Arts Center and Snowden Gallery in Chicago (1945), numerous small galleries in Detroit during the 1950s, and the Forsythe Gallery in Ann Arbor (1954). He had solo exhibitions at Howard University (1958), Grand Central Art Galleries in New York City (1960, 1962), the University of Chicago's Bergman Galleries (1969), Summit Art Gallery in New York City (1982), and the Evans-Tibbs Collection in Washing-

ton, D.C. (1983). The New Jersey State Museum in Trenton held a retrospective of Lee-Smith's work in 1988.

Lee-Smith has taught at Claflin College in Orangeburg, S.C., the Studio on the Canal in Princeton, N.J., Howard University, Trenton State College, and the Art Student's League in New York City (from 1972 through the early 1990s). He was elected to the National Academy of Design in 1976 and is also a member of the Century Association and the National Curatorial Council of the Studio Museum in Harlem.

Hughie Lee-Smith's work represents an important contribution to the tradition of American romantic-realist painting, imbuing everyday objects with a sense of magic while depicting the haunting loneliness of American social life.

REFERENCES

Hughie Lee-Smith Retrospective Exhibition. Exhibition catalog. New Jersey State Museum, Trenton, N.J., 1989.

Three Masters: Eldzier Cortor, Hughie Lee-Smith, Archibald John Motley, Jr. Exhibition catalog. Kenkeleba Gallery, New York, 1988.

LOWERY STOKES SIMS

Leidesdorff, William Alexander (1810–May 1848), merchant, California pioneer. Born in Concordia (St. Croix) in the Danish West Indies (now the U.S. Virgin Islands), William A. Leidesdorff was the son of a Danish planter and a black mother. No record of his education exists, but he became fluent in several languages, including French and German. From boyhood he worked in his father's cotton business, sailing vessels to such ports as New York City and New Orleans. In 1841 he sailed the 160-ton schooner *Julia Ann* to California, then under Mexican rule. He soon became established in trade between San Francisco and Hawaii. In 1843 he purchased two lots at the corner of Kearney and Clay Streets. He later built the Big City Hotel on the lot. In 1844 he became a Mexican citizen in order to buy the 35,000-acre Rio de Los Americanos Ranch, near Sutter's Mill on the American River. His beef and leather business prospered, and by 1846 he had 4,500 cattle and 250 horses on the ranch. In 1846 he was granted a lot at the foot of California Street (on what is today called Leidesdorff Street in his memory), where he erected a warehouse. In 1847 he acquired property at California and Montgomery Streets and built a house.

During this period Leidesdorff also became a leader of the community. In 1845 U.S. Consul Thomas Lar-

kin appointed him vice-consul, though he remained a Mexican citizen. In 1847 he was an active participant in the American takeover of the region; he was named to the city council, and he chaired the school committee. In 1848, when San Francisco's first public schools opened, Leidesdorff was a member of the school board.

Leidesdorff is perhaps best known as the "Robert Fulton of the West." In 1847 he bought a thirty-seven-foot steamboat, the first ever seen in San Francisco Bay. He bet a friend a side of bacon that he could sail it to Sacramento in less time than the friend could walk, but mechanical difficulties ensued and Leidesdorff lost the bet.

In May 1848, Leidesdorff died of typhus during an epidemic. His estate was deeply in debt. However, months after his death, gold was discovered on his ranch, and the property became quite valuable. His estate was eventually awarded to white Army Captain Joseph Folsom, who became wealthy on its proceeds.

REFERENCE

WHEELER, B. GORDON. *Black California: The History of African Americans in the Golden State.* New York, 1993.

GREG ROBINSON

Lendwood, John. *See* McLean, Jackie.

LeNoire, Rosetta Olive Burton (August 8, 1911–), performer, theater executive. Rosetta Olive Burton LeNoire was born in New York City, to Harold Burton and Marie Jacques, who had recently emigrated from Dominica, British West Indies. Her father was the first black licensed plumber in New York State and for fifty years was a district leader for the REPUBLICAN PARTY in New York City. Her mother was a housewife. Although her parents wished her to become a nurse, LeNoire's godfather, the dancer Bill "Bojangles" ROBINSON, encouraged her interest in dancing and the theater. (He also gave her the nickname "Bubblin' Brown Sugar in a Crystal Ball.")

After studying at Hunter College, the American Theatre Wing, and the Betty Cashman Dramatic School, LeNoire made her professional New York debut in 1936 as the First Witch in the historic Haitian *Macbeth,* directed by Orson Welles for the Federal Theatre Project. In 1939 she made her Broadway de-

Rosetta LeNoire. (Reprinted from *In the Shadow of the Great White Way: Images from the Black Theatre,* Thunder's Mouth Press, © 1957–1989 by Bert Andrews. Reprinted by permission of the Estate of Bert Andrews)

but opposite Bill Robinson in *The Hot Mikado.* In the course of a lengthy acting career, she was often called upon to play domestics, and brought dignity and self-worth to these often demeaning roles.

LeNoire was active in the development of the Negro Actors Guild and helped organize the Coordinating Council for Negro Performers. In 1955, the council led a boycott of sponsors to protest television's discriminatory hiring practices and the distorted view that television presented of black life.

In 1969, with Mara Kim and Greta Grunen, LeNoire founded the Amas Repertory Theatre in New York City. Amas was dedicated to bringing together people of all races and creeds through the performing arts—specifically, through musical theater. Its most successful production bore LeNoire's own nickname: *Bubblin' Brown Sugar,* a musical revue of Harlem nightlife from 1910 through 1940, which was produced off-Broadway in 1975, and moved to Broadway the following year, where it became a hit. Amas also produced theater for children and senior citizens, held workshops for adults, and sponsored many outreach programs designed to take theater into communities where it was rarely seen previously.

REFERENCES

NORFLETT, LINDA KERR. "Rosetta LeNoire: The Lady and Her Theater." *Black American Literature Forum* 17, no. 2 (Summer 1983): 69–72.

"Rosetta LeNoire: In the Sun." *New Yorker* 65 (February 27, 1989): 24–25.

MICHAEL PALLER
EVAN SHORE

Leonard, Ray Charles "Sugar Ray" (May 17, 1956–), boxer. Named after the musician Ray CHARLES, Ray Leonard was born in Wilmington, N.C., and spent his childhood in Palmer Park, Md., just outside Washington, D.C. Leonard took his nickname from "Sugar Ray" ROBINSON, the former middleweight champion. By the time he was twenty years old, Leonard had completed one of the most successful amateur boxing careers in modern history. During a tour of Moscow in 1974 with the U.S. National Boxing Team, judges awarded the decision to Leonard's Soviet opponent, who then spontaneously turned around, marched across the canvas, and handed the award to Leonard. Leonard's 145–5 amateur record culminated with his winning the light-welterweight gold medal at the Montreal Olympics in 1976. His lightning-quick punches and charismatic style made Leonard an instant television and crowd favorite.

The following year Leonard turned professional. With Janks Morton as coach and Mike Trainor as promoter, Leonard rose rapidly in the professional ranks by defeating such top-rank fighters as Rafael Rodriguez, Floyd Mayweather, Armando Muniz, and Adolfo Viruet. In 1979, Leonard won both the North American Boxing Federation and World Boxing Council's welterweight championships by knocking out Pete Ranzany and Wilfred Benitez.

Leonard's two most famous fights as a welterweight were in 1980. In June, he lost his WBC crown by decision to Roberto Duran in Montreal. In November, he won it back in New Orleans, in what came to be called the "no mas" (no more) fight, a reference to Duran's cryptic announcement to Leonard when he abruptly quit in the middle of the eighth round for no apparent reason. A year later, Leonard took on Tommy HEARNS, the undefeated welterweight champion of the World Boxing Association, and knocked him out in fourteen rounds, thereby became the undisputed welterweight champion. Leonard was named "Sportsman of the Year" by *Sports Illustrated* in 1981.

After a three-year retirement due to an eye injury sustained in 1984, Leonard returned to the ring in

1987 as a middleweight, dethroning Marvin HAGLER as WBC champion in a controversial twelve-round split decision in Las Vegas. The victory over Hagler increased his career earnings to $53 million. In 1988, Leonard knocked out Canadian Don Lalonde, the WBC light heavyweight champion, which earned him both the WBC light heavyweight and super middleweight titles, making him the first boxer ever to win at least a share of titles in five different weight classes. His 37 professional bouts over fourteen years included 35 wins, 25 by knockout. Since his retirement in 1991, Leonard has worked as a commentator on boxing broadcasts and has appeared in several television commercials.

REFERENCES

PORTER, DAVID L., ed. *Biographical Dictionary of American Sports: Basketball and Other Indoor Sports.* Westport, Conn., 1989.

"Sportsman of the Year." *Sports Illustrated* (December 28, 1981): 34–41.

NANCY YOUSEF
THADDEUS RUSSELL

Leonard, Walter Fenner "Buck" (September 9, 1907–), baseball player. Although Buck Leonard did not begin playing Negro League BASEBALL until he was twenty-five, the hard-hitting first baseman for the Negro and Caribbean leagues, who was called "the black Lou Gehrig," stayed with the black leagues until they disbanded in 1950.

The son of a railroad fireman, born in Rocky Mount, N.C., Leonard played semipro ball until signing with the Baltimore Stars in 1933. A year later, he joined the Homestead Grays. Along with Josh GIBSON, Leonard led the Grays to nine consecutive pennants, a feat rivaled only by the Tokyo Giants. A fine defensive player, he hit for power and average.

Leonard was a twelve-time Negro League all-star who led the league in batting average and in home runs in 1939 and 1948. For over twenty years, he also played winter ball in Cuba, Puerto Rico, and Venezuela. He was elected to the Baseball Hall of Fame in 1972.

ROB RUCK

Lesbians. The existence of lesbians as a diverse and vibrant segment of the black community is often overlooked or even denied in most literature concerning African Americans. This neglect is rooted historically in the long-standing negative perceptions and hostile treatment of lesbians and gay men within American society as a whole, by blacks as well as whites. The black church has often been hostile to homosexuality, viewing it as a sin or a form of mental illness. Perhaps because of the prominence of the black church, much of the discussion of sexual preference by prominent black leaders has been caustically homophobic. Some elements in the black nationalist movement, in an effort to assert patriarchal social relations and to equate the advancement of black people with the achievement of "black manhood," have issued harsh denunciations of homosexuality. Some black scholars and activists have argued that homosexuality is a manifestation of internalized racism, or have claimed that the identity is exclusively European, reflecting white cultural values. Still others have attacked the lesbian and gay rights movement, fearing that its claims would undercut demands for racial equality and diminish the legitimacy of civil rights activism.

At the same time, some observers have suggested that the black community, historically diverse because of the confines of segregation, may have displayed greater tolerance for homosexuality than society at large. Black lesbian writers and critics, including Ann Shockley, Barbara Smith, and Jewelle Gomez, have pointed to an unspoken acknowledgement of lesbianism in black life, in spite of public disavowal and disdain. Prominent black lesbian activists have connected their efforts to a long tradition of struggle for liberation among African Americans, and some black ministers and civil rights leaders, such as the Rev. Jesse JACKSON, have lent wholehearted support to the lesbian and gay movement's quest for equality and justice.

Until recently, lesbians have been marginalized in black discourse and have rarely been viewed outside of stereotypes. However, black lesbians are making themselves more visible and embracing their sexuality as a positive aspect of their identities. At the same time, they are openly challenging widespread prejudices that distort their lives, asserting their contributions to the history of African Americans and continuing to play an integral role in their communities.

The history of lesbians in the United States can best be characterized as an "emergence of visibility." Lesbianism has been difficult to document historically, largely because of the silence and hostility surrounding lesbian existence (and women's sexuality more generally). Women who loved women did not always wish to claim an explicitly lesbian identity, nor were they necessarily able to do so. Moreover, disagreement persists over the very definition of lesbian identity. Some argue that only women's sexual

and romantic involvement with other women can be properly considered as lesbianism. Others insist that platonic intimacy between close women friends—particularly in historical periods, such as the Victorian era, in which women lacked a language to openly describe these relationships—may have constituted lesbianism as well.

Black women's own lifestyle choices, frequently shaped by their lack of economic options, have also obscured the existence of lesbianism. Many black lesbians—including prominent figures whose histories of involvement with women are well-known, such as blues singer Ma RAINEY—were married, perhaps as a means to achieve economic well-being or as a "cover" to thwart suspicions of their same-sex relationships. Others were "passing" women who lived and worked as men for many years precisely in order to attain economic independence, courting and even marrying other women. Some of these women were eventually "discovered." Annie Lee Grant, for example, was exposed as a woman in Mississippi in 1954 after having lived as a man for fifteen years; at the time, she was engaged to another woman. Certainly many others lived out their lives without detection.

In many cases, we can only speculate about women whose personal histories are noticeably silent on the subject of their sexuality. Women who were "unconventional" may or may not have been explicitly "lesbian" in the contemporary understanding of the term. For example, Mary FIELDS, born a slave in Tennessee in the 1830s, dressed as a man and worked as a stagecoach driver and in other traditionally male-dominated employment. Whether or not she was a lesbian is not clear.

With the formation of an organized and self-identified black lesbian community, it is possible to determine more explicitly the nature and meaning of black lesbian existence. For black lesbians, such a form of community has only been traced as far back as the 1920s. That traces emerge in this period is indicative of the transformations black communities underwent as a result of the Great Migration, for the movement of single black women to northern urban centers—particularly Chicago, Detroit, and New York City—forced them to create and sustain support systems for their survival. At the same time, it enabled them to escape the intense scrutiny and regulation to which they were subjected in small southern towns and cities.

These circumstances were particularly conducive and crucial to the development of a black lesbian community, for the ability to make connections demanded some level of autonomy economically and socially. Thus, in communities such as Harlem, a number of social settings—bars, clubs, "buffet flat" gatherings, and rent parties—were lesbian-oriented.

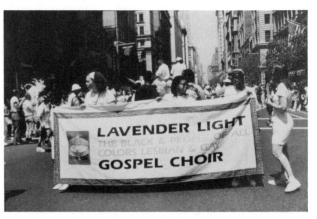

The Lavender Light Gospel Choir marching in the Lesbian and Gay Pride Parade, New York City. (© Martha Cooper/City Lore)

At the same time, some social spaces frequented by straight people also tolerated, if not welcomed, the presence of lesbians and gay men. Black women in Harlem socialized with each other, worked with each other, and even married each other in large public ceremonies, either with one woman "passing" and using a male name, or with a gay male friend acting as a surrogate.

The flourishing of literary and cultural expression in 1920s Harlem also added to the visibility and viability of lesbian life. Many of the literati of the so-called HARLEM RENAISSANCE were lesbians, among them poet and playwright Angelina Weld GRIMKÉ and writer Alice Moore DUNBAR-NELSON. The women blues singers and other entertainers who rose to fame during the same period also participated, often quite openly, in sexual relationships with other women; Bessie SMITH, Ma Rainey, Ethel WATERS, and Alberta HUNTER, among many others, all had lesbian relationships at some point in their lives.

These Harlem sophisticates frequented the lavish gatherings hosted by A'Lelia WALKER (heiress daughter of washerwoman-turned-millionaire Madame C. J. WALKER), who surrounded herself with prominent lesbian and gay artists and performers. And they flocked to the Clam House to see the performances of entertainer Gladys Bentley, a male impersonator who publicly married another woman. (In later years, Bentley underwent hormone treatments, married a man, and renounced her past life.) Some whites also traveled to Harlem to participate in the lesbian and gay scene, participating in what they perceived as a looser and more tolerant atmosphere.

If the personal lives of Harlem's luminaries gave visibility and legitimacy to lesbian existence within their own circles, their influence was extended to the wider community through their work. Black lesbians were portrayed in some Renaissance-era fiction,

including Wallace THURMAN's *The Blacker the Berry* (1929) and white author Blair Niles' *Strange Brother* (1931). Blues songs also contained lyrics that explicitly recognized and asserted lesbian sexuality, particularly Bessie Jackson's "BD Women's Blues" and Ma Rainey's "Prove It On Me Blues." While lesbian and gay male identity was not always presented in a positive light—often the depiction drew on prevalent stereotypes or reflected ambivalent attitudes within the community—the themes introduced by blueswomen clearly legitimized women's quest for economic and sexual independence from men.

The emergence of visibility was further influenced by the changes wrought by the entry of the United States into World War II, when women flooded the job market to replace men who went off to war. Despite continuing discrimination against black women, those black women who were able to participate in either civilian or military workplaces attained a greater measure of economic and sexual independence and were able to meet and socialize with each other. For lesbians the urgency of mobilization

Participants at a rally in New York's Central Park marking the beginning of Lesbian and Gay Pride Weekend, June 24, 1989. It was estimated that five thousand people turned out for the rally, which commemorated the start of the lesbian and gay rights movement twenty years earlier. (AP/Wide World Photos)

served as protection from, in historian John D'Emilio's words, "the taint of deviance." While little scholarly research has been done to illuminate the experience of black lesbians specifically during World War II, given the preponderance of lesbians in the military at that time, it is certain that, among the 4,000 black women who served in the Women's Army Corps—separated from men and from white women—a good number were probably lesbians.

By the end of the war, lesbians and gay men in general had expanded their social networks. In urban communities such as New York's Greenwich Village and Harlem, black lesbians participated in an active, though clandestine, social milieu (often interracial) that centered around house parties. Bars catered to a lesbian crowd as well, but were often notorious for their discriminatory treatment of black women patrons. Lesbians who were part of the "gay girls" scene have pointed to the significance of these early efforts by lesbians to come together, as friends as well as lovers, across racial lines.

At the same time, some lesbians and gay men began to identify and critique their oppression in a political way. The 1950s was marked by both political and sexual repression, in which a virulent anticommunism was explicitly linked to fears about racial equality and "deviant" sexual behavior. Still, by mid-decade two organizations—the Mattachine Society and the Daughters of Bilitis (DOB)—had formed to address the civil rights of gay men and lesbian women, respectively. Although these two groups were an important precursor to the lesbian and gay liberation movement that was forged in the late 1960s, their memberships were small and they zealously protected the confidentiality of those they reached. Their activities touched few blacks, but several anonymous letters to DOB's publication *The Ladder*, expressing support for the group's efforts, have been traced to playwright Lorraine HANSBERRY, acclaimed author of *A Raisin in the Sun*.

It was through the civil rights, BLACK POWER, and women's and gay liberation movements of the 1960s that many black lesbians first gained the experience of collective identity and action that was pivotal for the emergence of a politicized and organized black lesbian community. For the most part, the civil rights and Black Power movements posed no fundamental challenge to patriarchal gender relations. While black women played a significant role in the black liberation struggle, both in leadership and at the grassroots level, they often faced sexist discrimination and were excluded from decisionmaking. Thus, while many black women were empowered by their experience of activism, at the same time they were limited and constrained. Those who hoped to redefine the meaning of liberation in ways that would challenge

traditional gender norms were often isolated and attacked as a divisive force detracting from the struggle against racism. Although critical of the black liberation movement, many black women continued to identify with it.

By the late 1960s, activist white women were also developing a critique of the oppression and exploitation of women based on their work in civil rights and the New Left, and they were beginning to organize on their own. But white women began to define their struggle as a distinctive women's liberation movement, largely autonomous from other movements in which they had participated. At the same time, they sought unity among women through universalizing women's experiences. However, many black women felt alienated by the affirmation of inclusiveness that did not necessarily speak to their experiences or interests. To the extent that the women's movement began to respond to the racism within its own ranks, it was due to the courageous initiative of black women.

By the early 1970s black women were developing a broader conception of feminism that spoke to their specific concerns and took into account the intersections of race, sex, and class. As black feminist discourse began to take shape, and as a visible gay liberation movement began to emerge, the way was opened for the development of an identifiable and organized black lesbian community.

Black lesbians have become a more visible force in American culture than ever, creating the basis for black lesbian organizing and establishing links with other lesbians to color in the search for common ground. In 1974, black women in Boston formed the Combahee River Collective and issued a classic statement of commitment to struggle against "racial, sexual, heterosexual, and class oppression." Other groups, including Salsa Soul Sisters of New York City, and the Sapphire Sapphos of Washington, D.C., have also carried out political and educational work. The National Coalition of Black Gays (now the National Coalition of Black Lesbians and Gays) sponsored the first National Third World Lesbian and Gay Conference in 1979; a year later, the first Black Lesbian Conference was held. Black lesbians have also been at the forefront in initiating a number of political and literary publications, including *Azalea, Moja: Black and Gay,* and the *Third World Women's Gay-zette.*

Also since the 1970s, black lesbians—including Cheryl Clarke, Anita Cornwell, Jewelle Gomez, Gloria Hull, Audre LORDE, Pat Parker, Ann Shockley, Barbara Smith, and many others—have pioneered work in black feminist theory, literary criticism, poetry, and fiction. They have increased the visibility of black lesbians not only through their own public

presence but also through their writing, some of which was showcased in several important collections of black women's writing: *Conditions Five: The Black Women's Issue* (1979) and *Home Girls: A Black Feminist Anthology* (1983). Love relationships between women have been depicted in such widely acclaimed works as Gloria NAYLOR's *Women of Brewster Place* (1982) and Alice WALKER's *The Color Purple* (1982).

That much of this cultural outpouring both celebrates black lesbian existence and portrays the tragic dimensions of persistent oppression reflects the reality of black lesbians' lives. Visibility can heighten society's level of tolerance, but it often carries an increased threat of violence as well, and "coming out" is not always an option among black lesbians whose survival and livelihood are at stake. Many black lesbians continue to struggle both inside their relationships and within their communities for the right to live and love as they choose.

In recent years, the devastating effects of the AIDS epidemic on gays and blacks—and the consequent homophobic response throughout the country—have intensified black lesbians' organizing efforts and so have increased their visibility as well. They are not only affirming their lives, but also are ensuring that they will be recognized as a valuable sector of the black community and of U.S. society as a whole.

REFERENCES

BENTLEY, GLADYS. "I Am a Woman Again." *Ebony* (August 1952): 92–98.

COOPER, GARY. "Stagecoach Mary." *Ebony* (October 1977): 96–98ff.

CORNWELL, ANITA. *Black Lesbian in White America.* Tallahassee, Fla., 1983.

D'EMILIO, JOHN, and ESTELLE B. FREEDMAN. *Intimate Matters: A History of Sexuality in America.* New York, 1988.

FADERMAN, LILLIAN. *Odd Girls and Twilight Lovers: A History of Lesbian Life in Twentieth-Century America.* New York, 1991.

GARBER, ERIC. "A Spectacle in Color: The Lesbian and Gay Subculture of Jazz Age Harlem." In Martin B. Duberman, Martha Vicinus, and George Chauncey, Jr., eds. *Hidden from History: Reclaiming the Gay and Lesbian Past.* New York, 1989.

GOMEZ, JEWELLE, and BARBARA SMITH. "Talking About It: Homophobia in the Black Community: A Dialogue." *Feminist Review* (Spring 1990): 47–55.

LORDE, AUDRE. *Zami: A New Spelling of My Name.* Trumansburg, N.Y., 1982.

———. *I Am Your Sister: Black Women Organizing Across Sexualities.* Freedom Organizing Series #3. New York, 1985.

MAYS, VICKIE M., SUSAN D. COCHRAN, and SYLVIA RHUE. "The Impact of Perceived Discrimination

on the Intimate Relationships of Black Lesbians." *Journal of Homosexuality* 25, no. 4 (1993): 1–14.

OMOSUPE, EKUA. "Black/Lesbian/Bulldogger." *Differences: A Journal of Feminist Cultural Studies* 3, no. 2 (Summer 1991): 101–111.

SMITH, BARBARA, ed. *Home Girls: A Black Feminist Anthology.* New York, 1983.

"The Woman Who Lived as a Man for 15 Years." *Ebony* (November 1954): 93–98.

ALYCEE JEANNETTE LANE

Les Cenelles. A collection of verse written in French by free men of color, *Les Cenelles* was published in New Orleans in 1845. It was one of the first anthologies of literary works by African Americans. Edited by Armand LANUSSE, the 209-page book contained poems written by a circle of seventeen francophone colored poets. Some of them we know little about. Among the more famous are Lanusse; Victor Séjour, who later enjoyed a career as a playwright, and had twenty-one plays produced in Paris; and Camille Thierry, who later moved to France and published *Les Vagabondes, poésies américaines* (1874). The other contributors were Jean Bloise, Louis Bloise, Pierre Dalcour, Désormes Dauphin, Nelson Desbrosses, Joanni Questy, Numa Lanusse, Auguste Populus, Nicol Riquet, Manuel Sylva, M. F. Liotau, B. Valcour, and Michel St. Pierre.

After the publication in 1843 of the literary revue *L'Album littéraire* by the white French educator J. L. Marciacq, who with Lanusse's assistance solicited and published work by the African-American writers, Lanusse was inspired to publish a book of verse in order to show off the talent and civilization of his black peers. "Les Cenelles," which literally means "holly berries" but in Louisiana was used to describe the hawthorn bush, was selected as the title. Since the hawthorn is a tough, knobby bush which puts out both white and colored flowers, the title likely refers to the difficulty of expression under the oppressive conditions in which people of color lived in New Orleans. Also, like the native berries, this was indigenous "creole" poetry. The work was dedicated to "the fair sex of Louisiana."

The poems in the anthology, all written in excellent French, borrow heavily in form, style, and subject matter from French Romantic poets such as Lamartine and Victor Hugo. Many of the poems deal with sustaining kindred intellects and male friendship, and feature Romantic flourishes of spleen, sorrow over death, and thoughts of suicide. Racial discrimination is absent as a theme of verse, but Lanusse states in his preface, "We begin to understand that, in such a position as we are placed, a good education is a shield against [the charges] launched against us by disdain or calumny. It is thus with a feeling of pride that we see growing every day the number of those among us who travel surefootedly the difficult road of arts and sciences." Although it contains much derivative poetry, *Les Cenelles* was a landmark in the African-American literary tradition.

REFERENCE

LANUSSE, ARMAND, ed. *Les Cenelles.* Translated and introduced by Regine Latortue and Gleason A. Adams. Boston, 1978.

MICHEL FABRE

Lester, Julius (January 27, 1939–), writer, professor. The son of a Methodist minister, Julius Lester was born in St. Louis, Mo. In 1960 he received his bachelor's degree from Fisk University, and from 1966 to 1968 he was director of the Newport Folk Festival in Newport, R.I. For seven years, 1968–1975, he was the host and producer of a live talk show on WBAI-FM in New York. During 1968–1970, Lester was a lecturer at the New School for Social Research in New York City. From 1971 to 1973, he was also host of a live television show, *Free Time,* on WNET-TV in New York. Lester has been a professor at the University of Massachusetts at Amherst in the Department of Afro-American Studies (1971–1988) and then in the Departments of Comparative Literature and Near Eastern and Judaic Studies. During 1982 to 1984, Lester also served at the University of Massachusetts as the acting director and associate director of the Institute for Advanced Studies in the Humanities. In 1985, he was writer-in-residence at Vanderbilt University.

Lester's serious scholarly side is well evidenced in the long introduction he wrote as editor of the two-volume anthology *The Seventh Son: The Thoughts and Writings of W. E. B. Du Bois* (1971). *To Be a Slave* (1969) was nominated for the Newbery Award, and *The Long Journey Home: Stories from Black History* (1972) was a National Book Award finalist. Other works written and edited by Lester, which make clear the diversity of his interests, include (with Pete Seeger) *The 12-String Guitar as Played With by Leadbelly* (1965), *Look Out Whitey! Black Power's Gon' Get Your Mama!* (1968), *Black Folktales* (1969), *Search for the New Land: History as a Subjective Experience* (1969), *Revolutionary Notes* (1969), *The Knee-High Man and Other Tales* (1972), *Two Love Stories* (1972), *Who I Am* (1974), *All is Well: An Autobiography* (1976), *This*

Author Julius Lester. (© Rick Friedman/Black Star)

Strange New Feeling (1982), *The Lord Remember Me* (1984), and *The Tales of Uncle Remus,* 4 vols. (in progress since 1987).

Lester's work basically falls into two categories, one encompassing African-American history and the other recreating tales and legends from African-American folklore. In both cases, Lester deals with white oppression and the historical basis for the current relationship between the African-American community and the mainstream white community. While his early work was sometimes criticized as "antiwhite," Lester has in recent years stressed the broader implications of the civil rights era for *all* Americans.

Lester has had a long record of being embroiled in controversies and of dramatic turns in his search for moral verities. This is perhaps best exemplified by the events following the publication in 1988 of *Lovesong: Becoming a Jew. Lovesong* is, among other things, Lester's account of how a hesitant early fascination with Judaism in the late 1970s led finally to an official conversion in 1983. In *Lovesong,* however, Lester accuses the late James BALDWIN of making anti-Semitic remarks in a 1984 University of Massachusetts class

discussion. The accusation led to furious conflicts on the campus and eventually to his estrangement from the University of Massachusetts' Department of Afro-American Studies.

Deeply concerned about the tensions between African Americans and American Jews, Lester seems to have contrived a way, as one critic put it, "to internalize the conflict between blacks and Jews by being able to experience the rival claims of both sides." As the twentieth century draws to an end, he remains the most prominent African-American Jew in contemporary America.

REFERENCES
LEHMAN, DAVID. "A Conversion." *Partisan Review* (Spring 1990): 321–325.
LESTER, JULIUS. "Black and White—Together." *Salgamundi* (Winter 1989): 174–181.

AMRITJIT SINGH

LeTang, Henry (c. 1915–), tap dancer and choreographer. A native of New York City, Henry LeTang began his dancing career at the age of seven. After polishing his technique, he decided to open his own studio near Broadway when he was seventeen. Betty Hutton was one of the first of his students who would later emerge as a star. He worked with Lena HORNE when she was an up-and-coming talent, as well as with Billie HOLIDAY, and later choreographed routines for the young brothers Gregory and Maurice HINES. LeTang is known for his simple rhythmic lines, the repetition of flashy steps, and choreographic structures that make the sounds clearly accessible to audiences. Emphasizing the importance of choreography for nightclub performers, he soon became one of the country's foremost stylists, creating specialty dances for many stars. Hinton Battle, Debbie ALLEN, Peter Gennaro, and Chita Rivera have all been coached by him. In *Eubie* (1978), his choreography captured the spirit of 1920s' TAP DANCE. As one of three choreographers who shaped the dancing in *Sophisticated Ladies* (1981), LeTang received two Tony Award nominations, a Drama Critics Circle Award, and an Outer Circle Award. His other Broadway credits include the Tin Woodman's dance in the musical *The Wiz* (1975) and the rousing Act 1 finale "The Rhythm Man" in *Black and Blue* (1989). LeTang choreographed the films *The Cotton Club* (1984) and *Tap* (1989). He also choreographed and directed the musical *Stardust,* which opened at the Wilshire Theatre in West Hollywood in 1992. The Henry LeTang School of Dance has branches on both coasts.

CONSTANCE VALIS HILL

Lewis, Carl (July 1, 1961–), track-and-field athlete. Born in Birmingham, Ala., and raised in Willingboro, N.J., Lewis was reared in a family with a rich athletic tradition. His parents, both former athletes, founded and coached the Willingboro Track Club, where the young Lewis's athletic achievements were frequently overshadowed by the accomplishments of his older, multitalented brothers and precocious younger sister. It was not until high school that Lewis came into his own, displaying both the speed and long-jumping ability that enabled him to dominate TRACK AND FIELD throughout the 1980s and early 1990s. As a collegian at the University of Houston, Lewis became the first athlete in the twentieth century to win both the long jump and 100-meter dash at consecutive national championships. Lewis drew comparisons to Jesse OWENS at the 1984 Olympic Games when he equaled the latter's feats of 1936 by winning gold medals in the long jump, 100-meter dash, 200-meter dash, and 4 × 100-meter relay. He repeated as long-jump champion at the 1988 Games and was awarded the gold medal in the 100 when Canadian Ben Johnson, the apparent victor, was disqualified after testing positive for steroid use. Lewis won the long jump again at the 1992 Olympics in Barcelona and captured his eighth career gold medal by anchoring the United States 4 × 100 relay team to a world record time of 37.40.

In a sport defined by youth and specialization, Lewis achieved an unusual blend of versatility and longevity while maintaining a standard of excellence. In 1991, at the age of thirty, he established a world record of 9.86 in the 100, and it took a world-record long jump by Mike Powell at that same meet to halt Lewis's string of 65 victories—a streak dating back to 1981.

Despite his consistently superior performances of the 1980s, Lewis seldom received public acclaim equal to his accomplishments. His businesslike approach to competition, perceived aloofness or arrogance, and outspokenness on certain controversial issues—ranging from the use of performance-enhancing drugs by Ben Johnson and others to the compensation of athletes in a sport reluctant to make the transition from amateur to professional standing—sometimes overshadowed his athletic achievements and meant that Lewis himself often met with an ambivalent response from the American public. That track and field is largely invisible—made accessible and meaningful to a large audience in the United States only with the Olympic Games every four years—also contributed to Lewis's difficulty in gaining the widespread popular appeal granted other athletic figures.

Interestingly, Lewis did begin to receive the appreciation and recognition merited by his lengthy, remarkable career only when he no longer appeared unbeatable. For while Lewis sustained his overall level of performance into the 1990s, his competition grew stronger and sometimes overtook him. The most dramatic example of this came at the United States Olympic Trials in 1992, when he failed to qualify in the event he had dominated perennially: the 100-meter dash. In defeat, Lewis became a more "human" figure—occasionally vulnerable to younger, talented challengers—and his achievements appeared all the more extraordinary.

REFERENCES

GERINGER, DAN. "A Better Deal This Time?" *Sports Illustrated* (September 14, 1988): 23–29.

LEWIS, CARL, and JEFFREY MARX. *Inside Track: My Professional Life in Amateur Track and Field.* New York, 1992.

SMITH, GARY. " 'The Best Ever.' " *Sports Illustrated* (August 17, 1992): 40–43.

JILL DUPONT

Lewis, Edmonia (1844–c. 1909), sculptor. Information on Edmonia Lewis's life is sparse and difficult to verify. She was often inconsistent in her own accounts of her early days. Born in upstate New York in 1844, the daughter of a Chippewa mother and a black father, Lewis, who was given the Indian name Wildfire, and her older brother, Sunrise, were orphaned when she was five years old. Raised by maternal aunts, she described her youth as something of an idyll in which she lived in the wild, fished for food, and made moccasins to sell. She was able, as well, to study at a school near Albany.

With financial help from her older brother, Lewis attended Oberlin College, where her studies included drawing and painting. In a dramatic incident, she was accused of the attempted murder, by poisoning, of two classmates who were stricken shortly after enjoying a hot drink she had prepared. While the young women lay ill, Lewis was abducted by a mob and severely beaten. After her recovery and subsequent vindication in the courts, she ended her studies and moved to Boston, Mass., in order to pursue a career in the arts.

There, she found encouragement and support from William Lloyd Garrison, Lydia Maria Child, the sculptor Edward Brackett, with whom she studied, and a community of friends and patrons of the arts, many of whom were active in the ABOLITIONIST MOVEMENT. Her *Bust of Robert Gould Shaw* (1864), the Boston Brahmin and Civil War hero who died leading black troops into battle, was a great success.

Sales of copies of that work enabled her to finance a trip to Europe, where, following travels in England, France, and Italy, she settled in a studio once occupied by Antonio Canova on the Via Della Frezza in Rome.

A friend of sculptors Anne Whitney and Harriet Hosmer, and the actress Charlotte Cushman, Lewis was a member of the group of British and American expatriate women artists dubbed by Henry James the "white, marmorean flock." About Lewis, he wrote: "One of the sisterhood . . . was a Negress, whose color, picturesquely contrasting with that of her plastic material, was the pleading agent of her fame."

James's opinion notwithstanding, Lewis's work was much in demand during the heyday of the "literary" sculptors. Her studio, listed in the best guide-

Only fierce determination enabled Edmonia Lewis to realize her ambition to become a professional sculptor. Finding her reception as a black woman artist to be hostile and uncomprehending, Lewis left the United States for Rome, where she spent much of her adult life. (Photographs and Prints Division, Schomburg Center for Research in Black Culture, The New York Public Library, Astor, Lenox and Tilden Foundations)

books, was a fashionable stop for Americans and others on the grand tour, many of whom ordered busts of family members or of literary and historical figures to adorn their mantels and front parlors.

The first African American to gain an international reputation as a sculptor, Lewis was a prolific artist. The catalog of her work runs to over sixty items, not all of which have been located. Her early work in Boston included portrait medallions and busts of major abolitionists such as John Brown, Maria Weston Chapman, and Garrison. There was also a small statue, now lost, showing the black hero Sgt. William H. Carney holding aloft the flag at the battle of Fort Wagner.

In Rome, she executed such major works as *Forever Free* (1867), a depiction of a slave couple hearing the news of emancipation, and *Hagar* (1868–1875) about which she said, "I have a strong feeling for all women who have struggled and suffered." Henry Wadsworth Longfellow's poem *Song of Hiawatha* made him a literary folk hero and inspired numerous artists. Lewis drew on that familiar resource with groups such as *The Marriage of Hiawatha* (1867) and *The Old Arrow-Maker and His Daughter* (1867). These works seemed to patrons all the more authentic coming from the hand of a young woman, part Indian, reputed to have grown up in the wild.

Lewis's considerable celebrity reached its height with the unveiling of her *Death of Cleopatra* (1876) at the Philadelphia Centennial Exhibition. That monumental work, a life-sized depiction of Cleopatra on her throne, was praised for the horrifying verisimilitude of the moment when the snake's poison takes hold, and for Lewis's attempt to depict the "authentic" Egyptian queen from the study of historic coins, medals, and other records.

In the 1880s, as the vogue for late neoclassical sculpture declined, references to Lewis dwindled as well. While it is known that she was living in Rome as late as 1909, it is not certain where and when she died.

REFERENCES

BLODGET, GEOFFREY. "John Mercer Langston and the Case of Edmonia Lewis: Oberlin 1862." *Journal of Negro History* 53, no. 3 (July 1968): 201–218.
RICHARDSON, MARILYN. "Vita: Edmonia Lewis." *Harvard Magazine* 88, no. 4 (March–April 1986): 40–41.

 MARILYN RICHARDSON

Lewis, John (February 21, 1940–), civil rights activist, politician. John Lewis was born near the town of Troy, in Pike County, Ala. Growing up on

a small farm, Lewis was one of ten children in a poor sharecropping family. Lewis had been drawn to the ministry since he was a child, and in fulfillment of his lifelong dream, he entered the American Baptist Theological Seminary in Nashville, Tenn., in 1957. He received his B.A. four years later. As a seminary student Lewis participated in nonviolence workshops and programs taught by James LAWSON—a member of the Fellowship of Reconciliation (FOR), a pacifist civil rights organization. Lewis became a field secretary for FOR and attended Highlander Folk School, an interracial adult education center in Tennessee committed to social change, where he was deeply influenced by Septima CLARK, the director of education at Highlander.

Lewis became an active participant in the growing CIVIL RIGHTS MOVEMENT. He became a member of the Nashville Student Movement, and along with Diane Nash BEVEL, James BEVEL, and other African-American students he participated in the Nashville desegregation campaigns of 1960. Lewis was one of the founding members of the STUDENT NONVIOLENT COORDINATING COMMITTEE (SNCC) in 1960 and played a leading role in organizing SNCC participation in the CONGRESS OF RACIAL EQUALITY's (CORE) freedom rides. He led freedom rides in South Carolina and Alabama, where he and the other protesters were violently attacked by southern whites.

Lewis rose to a leadership position within SNCC, serving as national chairman from 1963 to 1966. During the 1963 march on Washington, Lewis—representing SNCC—delivered a highly controversial speech that criticized the federal government's consistent failure to protect civil rights workers, condemned the civil rights bill as "too little, too late," and called on African Americans to participate actively in civil rights protests until "the unfinished revolution of 1776 is complete." Despite the fact that he had acceded to the march organizers and other participants and allowed his speech to be severely edited to tone down its militant rhetoric, it was still considered by most in attendance to be the most radical speech of the day.

In March 1965 Lewis marched with Rev. Dr. Martin Luther KING, Jr., in Selma, Ala., to agitate for a voting rights act that would safeguard African Americans' access to the franchise. He was one of the many participants severely beaten by state troopers on what became known as Bloody Sunday. By 1966 Lewis's continued advocacy of nonviolence had made him an anachronism in the increasingly militant SNCC. He resigned from the organization in June of that year, to be succeeded by Stokely CARMICHAEL as SNCC's chairperson. Lewis continued his civil rights activities as part of the Field Foundation from 1966 to 1967

and worked as director of community organization projects for the Southern Regional Council. In 1970 he was appointed director of the Voter Education Project, which promoted black empowerment through greater participation in electoral politics.

Lewis became more directly involved in the political arena six years later when he was appointed by President Carter to serve on the staff of ACTION—a government agency that coordinated volunteer activities. From 1981 to 1986, he served on the Atlanta City Council. In 1986, in a bitter race, he challenged and defeated Julian BOND—another civil rights veteran—for the seat in Congress from an Atlanta district. In Congress Lewis became an influential member of the House Ways and Means Committee. He was an advocate of civil rights and drew much praise from political observers for his political acumen. In 1992 he was reelected from Georgia's Fifth Congressional District for a fourth term.

REFERENCES

CARSON, CLAYBORNE. *In Struggle: SNCC and the Black Awakening of the 1960s.* Boston, 1981.

GARROW, DAVID. *Bearing the Cross: Martin Luther King, Jr. and the Southern Christian Leadership Conference.* New York, 1986.

MARSHALL HYATT

Lewis, Julian Herman (May 26, 1891–1989), physician and educator. Lewis was born in Shawneetown, Ill., the son of John C. and Cordelia O. (Scott) Lewis, both public-school teachers. With a B.A. (1911) and M.A. (1912) from the University of Illinois, he earned a doctorate in pathology and physiology at the University of Chicago in 1915. In 1917, he graduated from Rush Medical College with an M.D.

Lewis was the first African American to hold a regular academic appointment at the University of Chicago. After serving as a teaching fellow from 1912 to 1915, he was appointed instructor in pathology in 1917 and assistant professor in 1922. At the time of his retirement from the university in 1943, he held the rank of associate professor. Lewis carried a simultaneous appointment as investigator at the Sprague Memorial Institute for Medical Research, where he pursued, among other things, his interest in the racial pathology of disease. He served as pathologist of PROVIDENT HOSPITAL, and later as director of pathology at Our Lady of Mercy Hospital in Dyer, Ind.

Between 1924 and 1934, Lewis published over twenty articles in American and European scientific

journals. In his major work, *The Biology of the Negro*, (1942), he sought to present a thorough, objective treatment of a subject that white anthropologists, biologists, and others had often used to buttress prevailing theories of black racial inferiority. His balance and expertise were held in high regard, as suggested by the invitations he received from the *Journal of the American Medical Association* to publish responses to write-in queries about race mixing, race discrimination by blood banks, and other topics.

REFERENCES

LEWIS, JULIAN HERMAN. *The Biology of the Negro*. Chicago, 1942.

"Negro Higher Education in 1921–22." *Crisis* 24 (July 1922): 108, 110.

PHILIP N. ALEXANDER

Lewis, Meade "Lux" (September 4, 1905–June 7, 1964), pianist. Along with Albert AMMONS and Pete Johnson, Meade Lewis was an important figure in the development of boogie-woogie BLUES playing, a style that featured repetitive and hard-driving figures in the left hand. Born in Chicago on September 4, 1905, Lewis studied violin as a child. But after meeting fellow Chicagoan Albert Ammons, Lewis began to perform exclusively on piano. As a youth he was influenced by the styles of James Edwards "Jimmy" YANCEY, also a Chicago native, and Harlem pianist and organist Thomas "Fats" WALLER. After playing in Chicago clubs during the 1920s, in 1927 Lewis recorded his most famous piece, "Honky-Tonk Train Blues," a virtuoso blues composition that combined a percussive ostinato of left-hand chords and a series of right-hand figurations to evoke the sound of the trains that frequently passed by his home. Lewis's style, which featured exceptional technique and a talent for creating polyrhythms between the two hands, made him a major figure in the boogie-woogie craze of the 1930s and '40s; he was in constant demand both as soloist and as a member of a piano trio with Ammons and Johnson. In 1941 Lewis settled in California, where he worked in clubs and on radio and television. He died in an auto accident in Minneapolis on June 7, 1964.

REFERENCES

HILL, D. "Meade Lux Lewis" (interview). *Cadence* 13, no. 10 (1987): 16.

SILVESTER, PETER J. *A Left Hand Like God: A Study of Boogie-Woogie*. London and New York, 1988.

JEFFREY TAYLOR

Lewis, Norman Wilfred (July 23, 1909–August 27, 1979), painter. Born and raised in Harlem, Norman Lewis attended New York Vocational High School, where he studied commercial design. He toiled at odd jobs before discovering sculptor Augusta SAVAGE's studio in 1933, which inspired him to become an artist. From 1933 to 1935, Lewis studied with Raphael Soyer at the John Reed Club Art School and at Columbia University.

During the 1930s, Lewis became part of the "306 Group" (named for its Harlem address). The studios at "306" became a meeting place for artists, writers, and musicians. His first public recognition was in 1934, at a group exhibition at the Metropolitan Museum of Art. His paintings during this period were influenced by Diego Rivera and reflected the plight of blacks during the depression (*The Wanderer*, or *Johnny*, 1933).

Lewis organized and taught in art schools for the WORKS PROJECT ADMINISTRATION (WPA) from 1935 to 1938. He was a founding member of the Harlem Artists Guild, which organized the federally funded Harlem Community Art Center that opened in 1937. In the 1940s, he utilized abstract imagery to depict subject matter common to social realists (*Dishwasher*, 1944). From 1943 to 1949 he taught at two alternative schools: George Washington Carver

"Bonfire" by Norman Lewis, oil on canvas, 1962. (The Studio Museum in Harlem)

School, and Thomas Jefferson School of Social Science. In the 1940s, Lewis moved between Harlem and lower Manhattan, where he became associated with abstract artists such as Ad Reinhardt, Willem de Kooning, and Robert Motherwell. In 1946, Lewis was the only African-American artist accepted by the prestigious Willard Gallery. It was a pivotal period in his life; he had his first solo exhibition at the Willard Gallery and eight more from 1949 to 1964. Through the Willard, his work was exhibited in 1954 in segregated Richmond at the Virginia Museum of Fine Art along with the work of Willem de Kooning and others, but he did not attend the exhibit. Lewis wrote on his invitation, "P.S. If I had gone, I would never have gotten in the door." Lewis also exhibited at the Museum of Modern Art (1951) and at the Whitney Museum (1958) in group shows.

By the 1950s, Lewis was painting small faceless stick figures which paraded across the canvas (*Boccio*, 1957). In the 1960s, he continued to organize space rhythmically, but he used a colorful mélange of brush strokes (*Players Four*, 1966). By the 1970s, Lewis's work had evolved to linked ovals highlighted in the center of the canvas (the "Seachange" series, 1976).

In the late 1960s and through the 1970s, Lewis's work continued to be exhibited, even though he concentrated on teaching during this period. He was included in the 1967 City College of New York exhibit "Evolution of African-American Artists, 1800–1950." In 1969, he and Ernest Crichlow and Romare Bearden founded the Cinque Gallery, a showcase for minority artists. A retrospective of Lewis's work was held at the Graduate School and University Center of the City University in New York (1976). From 1965 to 1971 he taught for HARYOU-ACT (Harlem Youth in Action, Inc.), and from 1972 to 1979 he taught at the Art Students League. He died in New York City in 1979.

The most important African-American abstract expressionist, Lewis joined with other artists in arguing that "abstraction" allowed artists to address more fundamental issues than could be addressed with figurative painting. His work has been exhibited around the world and he is represented in major collections. However, Lewis has never received the success of Willem de Kooning or Jackson Pollock. A prolific artist, he vastly expanded the range of subjects and techniques available to artists of his generation.

REFERENCES

Kenkeleba Gallery. *Norman Lewis: From the Harlem Renaissance to Abstraction*. Exhibition catalog. New York, 1989.

LEWIS, NORMAN. Taped interview with Vivial Browne, August 23, 1973, Hatch-Billops Collection, Inc. Schomburg Center for Research in Black Culture, New York Public Library.

LEWIS, OUIDA (MRS. NORMAN). Unpublished interview with the author. March 3, 1993.

LAUREL TUCKER DUPLESSIS

Lewis, Reginald F. (December 7, 1942–January 19, 1993), attorney and financier. Born in Baltimore, Md., Reginald F. Lewis received a B.A. in 1965 from Virginia State College, and an L.L.B. in 1968 from Harvard Law School. After graduating, he accepted a position at the law firm of Paul Weiss Rifkind Wharton & Garrison in New York. In 1973, he founded the first black law firm on Wall Street, Lewis & Clarkson, concentrating on corporate law and venture capital business.

During the early 1980s, Lewis served on the board of New York's Offtrack Betting Corporation. In 1983, he established and became CEO of a successful investment firm, the TLC Group. TLC (The Lewis Company) made headlines in 1984 when it bought the 117-year-old McCall Pattern Company, revitalized it, and sold it three years later at an eighty-to-one return on its investment. In 1987, with financing help from Michael Milken at Drexel Burnham Lambert, TLC bought Beatrice International Foods, a collection of sixty-four companies in thirty-one countries. This was the largest leveraged purchase ever of a non-American company, and it made TLC the largest black-owned company in the United States.

In 1992, Lewis was one of six executives inducted into the National Sales Hall of Fame by the Sales and Marketing Executives of Greater New York. In that same year, the was named by New York City Mayor David N. DINKINS to the nine-member Municipal Assistance Corporation.

At the time of his death from brain cancer on January 19, 1993, his personal fortune was estimated at $400 million. Through his philanthropic organization, The Lewis Foundation, Lewis donated approximately $10 million in four years to various institutions, charities, and artistic organizations, including the Abyssinian Baptist Church in Harlem, Howard University, and Virginia State University. His $3 million donation to his alma mater, Harvard Law School, establishing the Reginald F. Lewis Fund for International Study and Research, was the largest the school ever received from a single donor. The Lewis Center at Harvard was the first such facility there named in honor of an African American.

REFERENCES

BOJAS DON, and HERB BOYD. "Reginald Lewis Dies of Brain Cancer at a New York Hospital." *The

New York Amsterdam News, January 23, 1993, pp. 1, 8.

"Buying Into the Big Time." *Time* (August 24, 1987): 42.

The *New York Times Biographical Service.* Vol. 19, March 1988, pp. 324–327.

LYDIA MCNEILL

Lewis, William Henry (November 30, 1868–January 1, 1949), football player and lawyer. Born to former slaves in Berkeley, Va., William Lewis worked to pay for his education at the Virginia Normal and Industrial Institute (now Virginia State University). He later matriculated at Amherst College in Massachusetts, where he became an accomplished orator. Also excelling in athletics, Lewis was one of the first African Americans to play collegiate football. He served as team captain from 1890 to 1891, probably also a first for a black collegian. It was at his graduation that Lewis met his future wife, Elizabeth Baker. After graduating from Amherst, Lewis entered Harvard Law School; since graduate students were not barred from participation in varsity sports at that time, Lewis was able to continue to play football. His play earned him consecutive annual selections to Walter Camp's newly created All-American team in 1892 and 1893.

While at Harvard, Lewis worked to combat racism and discrimination. After being refused a haircut at a local barbershop patronized by students, Lewis strove to ensure that such treatment would not occur in the future. Eventually pressing his case to a state legislator, Lewis's advocacy resulted in the passage of an amendment to a state law broadening the prohibition of discrimination in public businesses. After his graduation from Harvard in 1895, Lewis worked as an attorney in Boston. He participated in local politics, being elected for three consecutive years to the Cambridge Common Council and serving one term in the Massachusetts House of Representatives. In 1903 Theodore Roosevelt, after obtaining approval from Booker T. WASHINGTON, appointed Lewis to the post of assistant district attorney for Boston.

While earlier Lewis had vocally denounced Washington as an accommodationist, he himself became increasingly conservative. By 1903 Lewis had reconciled with Washington and had become one of the most prominent Bookerites in Boston. In July 1903, Washington and other luminaries from the Tuskegee Institute (*see* TUSKEGEE UNIVERSITY) travelled to Boston to address the local branch of the NATIONAL NEGRO BUSINESS LEAGUE; Lewis was chosen to introduce T. Thomas FORTUNE, prominent newspaper editor and adviser to Washington.

A Renaissance man of the early twentieth century, William Henry Lewis was an Ivy League football star, a graduate of Harvard Law School, and an assistant attorney general under President William Howard Taft, the highest-ranking African American in the federal government up to that time. (Prints and Photographs Division, Library of Congress)

As Lewis spoke to the multiracial audience, he was interrupted by hecklers in the rear of the hall. As Fortune began to speak, the meeting was disrupted further by several African Americans hostile to Washington and his conservative upliftment strategies. A melee ensued, and several people, including African-American activist William Monroe TROTTER and his sister, were arrested. When Lewis testified against the protesters at Trotter's trial for inciting the so-called Boston Riot, he further alienated liberal African Americans opposed to Washington's ideals.

Nevertheless, Lewis continued to enjoy national recognition for his abilities. In October 1910, President Taft announced Lewis's appointment as an assistant attorney general, the first African American to be appointed to a sub-cabinet position. In 1911 he was one of the first three black men accepted into the

American Bar Association (ABA); only private pressure by the U.S. Attorney General, however, coerced the ABA to admit the men once it was discovered that they were black. In 1915 Lewis was one of many prominent African Americans who denounced D. W. Griffith's paean to the KU KLUX KLAN, the 1915 film BIRTH OF A NATION. During the 1920s, Lewis was active in national Republican politics. For the next several decades, he returned to practicing law, often defending unpopular clients in cases ranging from alleged bootlegging and corruption to racial discrimination. After his wife's death in 1943, Lewis moved back to Boston, where he died in 1949.

REFERENCES

Fox, Stephen R. *The Guardian of Boston: William Monroe Trotter.* New York, 1970.
Harlan, Louis R. *Booker T. Washington: The Wizard of Tuskegee, 1901–1915.* New York, 1983.
Lewis, David Levering. *W. E. B. Du Bois: Biography of a Race, 1868–1919.* New York, 1993.

JOHN C. STONER

Liberation Theology. The term "liberation theology" was first used by Latin American priests/theologians (mainly Catholic) and U.S. African-American clergy/theologians (mainly Protestant) during the latter part of the 1960s. It refers to an interpretation of the Bible and the Christian faith from the standpoint of the poor and their struggles for justice in society. Without knowledge of the political activities and theological reflections of each other, Latin-American priests working among the masses and U.S. African-American ministers working with exploited blacks began to claim that God was involved in the history of oppressed people, empowering them to fight against poverty and racism.

Latin Americans focused their concern primarily on economic exploitation, the great gap between large poor majorities and rich landowners. African Americans focused their concern primarily on racial oppression, the extreme dehumanization of black people arising from 244 years of slavery and more than a hundred years of segregation. Both Latin Americans and U.S. African Americans, however, emphasized that the world should not be the way it is and that it is therefore the task of Christians to change it.

A key moment in the development of Latin American liberation theology was the conference in Chimbote, Peru, in July 1968. A Peruvian priest and theologian, Gustavo Gutierrez, made the first statement on liberation theology, delivering a paper entitled "Toward a Theology of Liberation." He outlined the methodology for which liberation theology has become famous. "Theology is a reflection—that is, . . . a second act . . . that comes after action. Theology is not first; the commitment is first." Theology, therefore, does not tell us what to do; rather, it arises out of what we do. The truth of the gospel of Jesus is discovered only in practice.

One month after the Chimbote meeting, the well-known Second General Conference of Latin American Bishops was held at Medellín, Colombia, from August 26 to September 6, 1968. The Medellín conference marked a turning point in the history of the Church in Latin American analogous to the impact of the Second Vatican Council on the Roman Catholic Church worldwide. At Medellín, the Latin American Bishops, with much encouragement from Gutierrez and other theological advisers, discovered the world of the poor, the exploited masses who "hunger and thirst after justice." This discovery inspired a continent-wide preferential option for the poor.

While the Medellín conference is often cited as the beginning of liberation theology, Gustavo Gutierrez's *A Theology of Liberation* is regarded as its most influential text. Published in Spanish in 1971 and translated into English in 1973, the continuing and worldwide influence of this book is the major reason Gutierrez has been called the "father of liberation theology." This book is an extended interpretation of his Chimbote paper on liberation theology. He emphasized that liberation theology is not a reflection on the abstract and timeless truths about God; rather, it is chiefly a new way of doing theology, a "critical reflection on historical praxis." Liberation theology "does not stop with reflecting on the world, but tries to be part of the process through which the world is transformed."

The key moment in the development of black liberation theology was the publication of the Black Power statement in the *New York Times* on July 31, 1966, by an ad hoc committee of radical black clergy who later organized themselves as the National Conference of Black Christians (NCBC). In this statement, they opposed the white church's rejection of Black Power as unchristian and instead expressed their solidarity with the urban black poor in their communities, affirming the need for black self-determination and empowerment. Two years later, responding to the widespread Black Power movement in the black communities throughout the United States (*see* BLACK POWER CONFERENCE OF NEWARK, 1967), James Cone published an essay entitled "Christianity and Black Power." He defined the liberating message of Black Power as the message of Christ. He deepened the theological meaning of Black Power in the book *Black Theology and Black*

Power (1969). During the same year, using Cone's book as the main source of their deliberations, the Theological Commission of the NCBC issued an official statement on "Black Theology," defining it as a "theology of black liberation." One year later, Cone's *A Black Theology of Liberation* (1970) was published, making liberation the organizing principle of his theological perspective.

Like Latin American liberation theology, black theology also emphasized praxis. It was defined as a specific kind of obedience that organizes itself around a social theory of reality in order to implement in society the freedom inherent in faith. If faith is the belief that God created all for freedom, then praxis is the social theory used to analyze what must be done for the historical realization of freedom. To sing about freedom and to pray for its coming is not enough. Freedom must be actualized in history by oppressed peoples who accept the intellectual challenge to analyze the world for the purpose of changing it.

Soon after the appearance of liberation theology in Latin America and in African-American communities in the United States, other expressions of it appeared in Africa, in Asia, and among women in all groups. Black and contextual theologies of liberation were created by Christian communities struggling against apartheid in South Africa, with Desmond

James Cone, author of *Black Theology and Black Power,* was a pioneer in applying liberation theology to the situation of American blacks. (Burke Library of the Union Theological Seminary in the City of New York)

Tutu and Alan Boesak as prominent leaders. African theology appeared in other parts of Africa with an emphasis on indigenization and Africanization. John Mbiti of Kenya and Engelbert Mveng of Cameroon were prominent interpreters. An Asian liberation theology emerged out of Christian communities encountering the overwhelming poverty and the multifaceted religiousness of the continent. Aloysius Pieris of Sri Lanka and Samuel Rayan of India were important representatives.

Responding to their struggles against sexism, women on all continents began to develop theologies of liberation out of their experience. In the United States, Mary Daly and Rosemary Ruether were among the leading voices in initiating the development of feminist theology; Delores Williams and Jacquelyn Grant helped to create a womanist theology out of black women's experience; and Ada Marie Isasi-Diaz made a similar contribution to the development of a feminist theology among Hispanics. Mercy Amba Oduyoye of Ghana, Chung Hyun-Kyung of South Korea, and Elsa Tamez of Mexico reflected on the liberating presence of God in the struggles of third-world women against patriarchal mechanisms of domination in the global context of the Church and the society.

Recognizing the commonality of their concerns, theologians of liberation in Latin American, Africa, Asia, and among U.S. minorities met in Dar es Salaam, Tanzania, in August 1976 and created the Ecumenical Association of Third World Theologians. Their concern was to break with "theological models inherited from the West" and to develop a new way of doing theology that would "interpret the gospel in a more meaningful way to peoples of the Third World and promote their struggles of liberation." In more than fifteen years of dialogue, visiting each others' places of struggle, liberation theologians debated one another about the most important starting point for doing Christian theology. Latin Americans emphasized their struggle to overcome economic structures of domination, the wide gap between the rich and poor among nations and within nations, stressing the need for theology to make use of the social sciences in analyzing the world of the poor. Africans talked about their struggle against "anthropological poverty," the "despoiling of human beings not only of what they have but of everything that constitutes their essence—their identity, history, language, and dignity." Africans stressed the need to liberate theology from the cultural captivity of the West. Asians emphasized the need to develop a theological method that combined the analyses of religion, culture, politics, and economics. U.S. minorities, the smallest group in the association, reminded all of the importance of race analysis in the doing of theology.

In their dialogues, which have often been intense, liberation theologians have learned much from each other. They have published eight volumes, including *The Emergent Gospel: Theology From the Underside of History* (1978), *Irruption of the Third World: Challenge to Theology* (1983), *Doing Theology in a Divided World* (1985), *With Passion and Compassion: Third World Women Doing Theology* (1988), and *Third World Theologies: Commonalities and Divergences* (1990).

All liberation theologians agree that the Christian gospel can best be understood and interpreted in the context of one's participation in the struggles of the poor for justice. Faith is not primarily intellectual assent to truths about God. It is a commitment to God and to human beings, especially the poor. Theology, therefore, is a reflection on the commitment that Christians make in their effort to put into practice the demands of faith.

The contrast between liberation theologies and the dominant theologies of Europe and North America is quite revealing. The identity of the dominant theologies has been strongly influenced by the Enlightenment and secularism, creating the problem of the unbeliever. The central task of theology, therefore, is to make the Christian faith intelligible in a world that can be explained without God.

The identity of liberation theologies has been defined by oppression—poverty, racism, colonialism, and sexism—creating the problem of the nonperson. In this context, theology asks, what is the relationship between salvation and the struggle for justice in society? Faith demands not only that it be understood, but that salvation be realized in the social, economic, and political lives of people.

REFERENCES

BOFF, LEONARDO, and CLODOVIS BOFF. *Introducing Liberation Theology*. Maryknoll, N.Y., 1987.

CONE, JAMES H. *For My People: Black Theology and the Black Church*. Maryknoll, N.Y., 1984.

HENNELLY, ALFRED T., ed. *Liberation Theology: A Documentary History*. Maryknoll, N.Y., 1990.

WILMORE, GAYRAUD S., and JAMES H. CONE. *Black Theology: A Documentary History, 1966–1979*. Maryknoll, N.Y., 1979.

JAMES H. CONE

Liberator, The, abolitionist newspaper. The *Liberator* was begun in 1831 by William Lloyd Garrison (1805–1879) and Isaac Knapp (1804–1843) in Boston. Garrison used the *Liberator* for over thirty years to voice his scathing indictments of the slave system and of the country which allowed it to flourish. It complemented his work in the New England Anti-

Slavery Society and the AMERICAN ANTI-SLAVERY SOCIETY, which he founded in 1832 and 1833, respectively. From the start, the *Liberator*, which was published weekly, received substantial African-American support. Of its 450 initial subscribers, roughly 400 were black. One was Philadelphian James FORTEN, who urged Garrison to "plead our cause," and expose "the odious system of slavery." A deeply religious Baptist and pacifist, Garrison aimed at bringing people to the cause or ABOLITION through "moral suasion." He therefore avoided politics and called for immediate, rather than gradual, abolition. "I am in earnest—I will not equivocate—I will not excuse—I will not retreat a single inch—AND I WILL BE HEARD," pledged Garrison in the first issue. In the early years of the paper, this was a radical stance, even among antislavery advocates.

The publication of the *Liberator* brought furious reaction from southern politicians, who passed legislation banning its circulation. Columbia, S.C., offered a reward of $5,000 for the arrest and conviction of Garrison or Knapp. In October 1831, the corporation of Georgetown, D.C., forbade any free black to take the *Liberator* out of the post office. Offenders would be punished by fine and imprisonment, and if they did not pay, were to be sold into slavery for four months. Despite its inflammatory appeal, the *Liberator*'s circulation remained relatively small, particularly among the white population. In its fourth year, nearly three-quarters of the 2,000 subscribers were African Americans. Knapp, whose contributions to the paper were more in terms of publishing and trying (unsuccessfully) to keep the paper financially afloat, left in 1839. Wanting to try his hand at writing editorials, he published his own abolitionist paper, *Knapp's Liberator*, in January 1842, but this proved unsuccessful.

The *Liberator* contained some of the most important writings on the abolitionist cause. Aside from Garrison's fiery editorials, it published the writings of John Rankin, Oliver Johnson, Wendell Phillips, and English abolitionist George Thompson. With these writers, the *Liberator* continued its fight: opposing colonization (which Garrison perceived as a plot to strengthen slavery by removing free blacks from the country) and rallying boycotts against the products of slavery. In 1842, Garrison called for a "Repeal of the Union." The US. Constitution, he wrote, was "a Convenant with Death and an Agreement with Hell." This quickly became the *Liberator*'s motto. When secession became a reality in 1861, however, it was the slave holders who wanted to leave the Union. At first, Garrison celebrated their departure. But as the Civil War progressed, he shifted his position and used the *Liberator* to pressure President Abraham Lincoln for abolition. Significantly, the new motto of

THE LIBERATOR.

VOL. I.] WILLIAM LLOYD GARRISON AND ISAAC KNAPP, PUBLISHERS. [NO. 1.

BOSTON, MASSACHUSETTS.] OUR COUNTRY IS THE WORLD—OUR COUNTRYMEN ARE MANKIND. [SATURDAY, JANUARY 1, 1831.

William Lloyd Garrison promised in the initial issue of the *Liberator* in January 1831 that he would not compromise his militant abolitionism and that his voice would be heard. He proved as good as his word. For more than three decades, Garrison, unrelenting in his attacks on slave holders and their northern appeasers, was at the forefront of the crusade against slavery. (Prints and Photographs Division, Library of Congress)

the paper became, "Proclaim liberty throughout the land, to all the inhabitants thereof." Garrison cheered the issuance of the Emancipation Proclamation, writing "Glory Hallelujah!," but he kept working, hoping to secure the freedom of slaves in border states. With the passing of the Thirteenth Amendment, Garrison believed the mission of the paper accomplished. "Great and marvelous are thy works, Lord God Almighty!" he wrote in one of the last issues. On December 29, 1865, the *Liberator,* the most influential and important abolitionist newspaper, ceased publication.

REFERENCES

GRIMKÉ, ARCHIBALD HENRY. *William Lloyd Garrison the Abolitionist*. 1891. Reprint. New York, 1969.

MERRIL, WALTER MCINTOSH. *Against Wind and Tide, a Biography of William Lloyd Garrison*. Cambridge, Mass., 1963.

MOTT, FRANK LUTHER. *A History of American Magazines*. Cambridge, Mass., 1967.

WALTER FRIEDMAN

Licensing and Accreditation. In the context of professions such as law and medicine, licensing and accreditation denote the granting of privileges to practice or perform a function. The tradition evolved out of controls exercised by guilds in medieval Europe. Its theoretical aims are (1) to regulate entry, thereby protecting a profession from oversupply likely to increase competition and reduce income; and (2) to promote the quality, integrity, and proficiency of personnel and institutions. Licensing and accreditation provide a critical interface with the public that a profession exists to serve. In no area are these functions more important, or more complex, than in medicine and other health fields, where the monitoring of standards may be literally a life-or-death matter. While early attempts to establish a regulatory system in America met with widespread resistance,

medical reformers of the late nineteenth century viewed it as an essential ingredient in any struggle to improve professional standards.

As regulatory bodies multiplied after 1875, their impact on African-American professionals varied. State boards charged with licensing physicians dealt fairly for the most part; examiners often graded written tests without knowledge of candidates' names, origins, or medical colleges, thus reducing the likelihood that bias would creep into their appraisal. For the period 1903 to 1910, the two major black schools—Howard University Medical School and Meharry Medical College—had average state board pass rates of 70.6 percent and 57.1 percent respectively, which were neither the best nor the worst showings among American medical schools (their rates improved to 89.8 percent and 93.9 percent respectively for the period 1930 to 1939). But even though examination results appear to have been race-blind, the motivations of state boards were not always nonracial. Many white physicians refused to practice among blacks, so black physicians were needed to keep the black population healthy—at least to the point where blacks did not pose a health hazard to whites in the community. In 1921, for example, the Mississippi board was anxious to recruit blacks who might qualify for a license and to dispel rumors that blacks were being excluded from consideration. "Colored physicians," the board's secretary asserted, "are always given a perfectly square deal . . . and . . . the sentiment, if any is indulged at all, is always much in favor of the colored doctors."

Thus, racial segregation ironically opened opportunities for professional licensing that otherwise might have been closed. After 1915, when the National Board of Medical Examiners established a more rigorous standard of licensing, blacks encountered new obstacles. One of the board's requirements—a one-year internship—posed a special problem, since blacks were excluded from most hospitals. In the late 1920s, only three nonblack hospitals admitted black interns (Cook County Hospital in Chi-

cago and Harlem Hospital and Bellevue Hospital in New York), while only twelve black hospitals were accredited for internships. The resulting shortfall in available slots meant that a third of all black medical graduates were unable to meet basic requirements for licensing. Although the internship supply for blacks rose from 68 to 168 slots in less than a decade, the problem of clinical experience was exacerbated in other ways. In the 1930s and 1940s, for example, some white medical schools reduced or eliminated their (already small) black enrollment in order to avoid the conflicts that might arise should blacks, as part of their required training, be assigned to treat whites.

Nowhere in the broad spectrum of medical-licensing bodies was race more of a factor than in the specialty colleges. The American College of Surgeons, chartered in 1913, elected only two blacks to its ranks through 1945. Daniel H. WILLIAMS and Louis T. WRIGHT became "fellows" in 1913 and 1934, respectively. A third applicant, George D. Thorne, was informed in 1945 that "fellowship . . . is not being conferred on members of the Negro race at the present time." The ensuing public outcry prompted the college to induct fifteen blacks between 1945 and 1947. Algernon B. Jackson was the first African American elected to the American College of Physicians, and J. Edmond Bryant the first to the American College of Chest Physicians.

Specialty boards were less racially exclusive. Unlike the "colleges," which served a social as well as a professional function, the boards came into existence for the sole purpose of certifying competence. The first board-certified black specialist was W. Harry Barnes of the American Board of Otolaryngology, in 1927. Other firsts in their respective fields were Henry A. Callis, American Board of Internal Medicine, 1940; Roscoe C. GILES, American Board of Surgery, 1938; Chester W. Chinn, American Board of Ophthalmology, 1936; R. Frank Jones, American Board of Urology, 1936; Alonzo deG. Smith, American Board of Pediatrics, 1936; Theodore K. LAWLESS, American Board of Dermatology, 1935; and William S. QUINLAND, American Board of Pathology, 1937.

REFERENCES

COBB, W. MONTAGUE. *Medical Care and the Plight of the Negro.* New York, 1947.

". . . Medical Registration in Mississippi." *Journal of the National Medical Association* 13 (July–September 1921): 207–208.

SHRYOCK, RICHARD HARRISON. *Medical Licensing in America, 1650–1965.* Baltimore, 1967.

PHILIP N. ALEXANDER

Liele, George (ca. 1750–1820), Baptist minister. Born into slavery in Virginia, George Liele was taken by his owner, Henry Sharp, to Burke County, Ga., in 1773. Sharp, a Baptist deacon, supported Liele's conversion the following year, and Buckhead Creek Baptist Church certified him to minister to slaves on surrounding plantations. Thus, Liele became one of the first licensed black preachers in North America. He was emancipated on the eve of the American Revolution. When Sharp, a Tory, was killed in the war, his heirs attempted to reenslave Liele, but British officers whom Liele had served protected him. In 1777 Liele gathered one of the first black Baptist churches in America at Yama Craw, near Savannah. Among those who heard him preach were the influential black Baptists David GEORGE and Andrew BRYAN.

When the British evacuated Savannah in 1782, Liele indentured himself in exchange for passage to Jamaica. Upon working out his indenture, he was given his free papers in 1784 and began to preach, first in a private home, and then publicly, after obtaining a grant of toleration from the Jamaican Assembly. In Jamaica, Liele faced strong opposition from Anglican authorities. He was tried and acquitted on a charge of sedition, and was also imprisoned for debts he acquired while building a church in Kingston. Nevertheless, his congregation grew. By 1791 Liele estimated that he had baptized four hundred people in Jamaica, including a few whites. In addition to his ministry, Liele established and promoted a free school, and earned his living as a farmer and transporter of goods. A founding father of the African Baptist faith in two countries, he died in Jamaica in 1820.

REFERENCES

KAPLAN, SIDNEY, and EMMA NOGRADY KAPLAN. *The Black Presence in the Era of the American Revolution.* Amherst, Mass., 1989.

LOGAN, RAYFORD W., and MICHAEL R. WINSTON, eds. *Dictionary of American Negro Biography.* New York, 1982.

SOBEL, MECHAL. *Trabelin' On: The Slave Journey to an Afro-Baptist Faith.* Westport, Conn., 1979.

BENJAMIN K. SCOTT

Lincoln, Abbey (August 6, 1930–), actress and jazz singer. Abbey Lincoln was born Anne Marie Woolridge in Chicago, Ill. In high school she toured Michigan with a dance band; in 1951 she moved to California and sang in nightclubs as Gaby Lee. After a club residency in Hawaii (1952–1954) she returned

to California and began singing in nightclubs in Hollywood. In 1956 she made her recording debut with Benny CARTER's orchestra and changed her name to Abbey Lincoln. During the 1950s and '60s she sang with the jazz group led by Max ROACH (to whom she was married until 1971) and helped to popularize his *Freedom Now Suite* (1960), one of the musical hallmarks of the civil rights movement.

During the 1970s Lincoln toured Europe, Asia, and Africa as a soloist. As an actress she appeared in *Nothing but a Man* (1964), which won the top film award at the First World Festival of Negro Arts in Dakar, Senegal. She also made appearances in Jean Genet's play *The Blacks* and was a member of the road company of the musical *Jamaica*. Lincoln was also active in television and radio. In 1975 she adopted the name Aminata Moseka and in her lyrics expressed political positions devoted to the advancement of the culture and arts of African Americans. In 1991, in a comeback as a jazz diva, she recorded the album *You Gotta Pay the Band*, for which she penned five of the songs. Critics considered it one of the best examples of her work.

REFERENCE

JONES, LISA. " 'Late Bloomer' in her Prime." *New York Times*, August 4, 1991, Sec. Z, p. 22.

JAMES E. MUMFORD

Lincoln Theatre. Located on 135th Street just off Lenox Avenue in New York City, the Lincoln Theatre was Harlem's premier center of popular entertainment from the turn of the century until the Great Depression. Its predecessor was the Nickelette, a storefront nickelodeon presenting fifteen-minute segments of live entertainment on a makeshift stage. One early performer, around 1903, was "Baby Florence," the child singer and dancer who grew up to be Florence MILLS, the Broadway and London star. The Nickelette was purchased in 1909 by Maria C. Downs, who doubled the seating to three hundred and named the theater after Abraham Lincoln. Harlem was becoming increasingly black, but most theaters segregated or refused admission to African Americans. Downs turned the Lincoln into a headquarters for black shows and audiences, a policy so successful that she constructed the present building with a seating capacity of 850 in 1915.

While there was some emphasis on serious drama—with the Anita Bush Stock Company, for example, before it moved to the rival Lafayette—the Lincoln during the 1910s and '20s became the focal point for down-home, even raucous, vernacular entertainment that particularly appealed to recent working-class immigrants from the South. As the New York showcase of TOBA, the Theatre Owners Booking Association, it drew all the big names of black vaudeville: Bessie SMITH, Bert WILLIAMS, Alberta HUNTER, Ethel WATERS, and Butterbeans and Susie. The Lincoln was the only place in New York where Ma RAINEY ever sang. Mamie SMITH was appearing there in Perry Bradford's *Maid of Harlem* when she made the first commercial recording of vocal blues by a black singer.

Because it housed a live orchestra, the Lincoln also became a venue for jazz musicians. Don Redman performed there in 1923 with Billy Paige's Broadway Syncopators. Lucille Hegamin and her Sunny Land Cotton Pickers featured a young Russell Procope on clarinet in 1926, the same year Fletcher HENDERSON with his Roseland Orchestra played there. Perhaps the name most closely identified with the Lincoln was the composer and stride pianist Thomas "Fats" WALLER, who imitated the theater's piano and organ player while still a child and was hired for twenty-three dollars a week in 1919 to replace her; he was then fifteen years old. When he failed to find financial backing to produce his opera *Treemonisha*, Scott JOPLIN paid for a single performance at the Lincoln. Unable to afford an orchestra, he provided the only accompaniment himself on the piano.

A steady stream of white show-business writers and composers, including George Gershwin and Irving Berlin, joined the black audiences at the Lincoln, not only to be entertained but to find new ideas and new tunes. More than one melody, dance step, or comedy routine that originated with a black vaudeville act wound up in a white Broadway musical. The Lincoln did not survive the economic disaster of the Great Depression and the changing tastes of the Harlem community, where more sophisticated people began to refer to it as "the Temple of Ignorance." Downs sold the theater in 1929 to Frank Shiffman, who turned it into a straight movie house. When that fell on hard times, he sold the building to a church. Now the only early building left on the block, a renovated Lincoln Theatre houses the Metropolitan AME Church.

REFERENCE

NEWMAN, RICHARD. "The Lincoln Theatre." *American Visions* 6, no. 4 (August 1991): 29–32.

RICHARD NEWMAN

Lincoln University. Lincoln University is located in Southern Chester county, four miles north of Oxford, Pa. Founded in 1854, the university is the oldest extant black institution of higher learning in

the United States. The university was founded by John Miller Dickey, a white senior pastor of the Oxford Presbyterian Church. Before founding Lincoln University, Dickey had shown concern for the welfare of African Americans. In 1850, he contributed decisively to the liberation of two sisters, Rachel and Elizabeth Parker, who had been kidnapped in Oxford for sale into slavery. Dickey also supported the American Colonization Society and felt that emancipated Africans should return to the African continent as missionaries. In 1852 Dickey made unsuccessful attempts to place James Ralston Amos, an African American and the treasurer of the fund for "Negro Church" building established by Richard Allen in 1794, into Princeton University Seminary and also at a religious academy managed by the Presbyterian Synod of Philadelphia. Frustrated by a failed effort to secure admission for a "colored" student in a "white" institution, Dickey sought a solution in establishing an institution for "colored" men.

The institution Dickey established was originally chartered by the state of Pennsylvania as Ashmun Institute, named in honor of Jehudi Ashmun, the first governor of Liberia. After the Civil War and in recognition of the role that President Abraham Lincoln played in the emancipation of the enslaved, Ashmun Institute was renamed Lincoln University. The educational curriculum was originally conceived to include not only all aspects of liberal arts, but also law, medicine, and theology. Financial problems and declining enrollment, however, necessitated the closing of the seminary as well as the schools of law and medicine. The university's charters of 1854 and 1866 restricted admission to male students. However, in 1953 the university amended its charter to permit coeducation. In 1972, Lincoln University became a state-related institution within Pennsylvania's Commonwealth System of Higher Education and was placed on the same basis for state aid as Temple University and the University of Pittsburgh as well as Pennsylvania State University.

Lincoln University has played a vital role in the training of leaders, not only among African Americans but also among Africans. In the first hundred years of its existence, Lincoln University graduated 20 percent of the African-American doctors, and more than 10 percent of the African-American attorneys in the United States. In the words of Dr. Niara Sudarkasa, the eleventh president of Lincoln University, "Lincoln University's alumni roster reads like a section of Who's Who of the Twentieth Century." Its distinguished alumni include Thurgood MARSHALL, who not only argued successfully the historic school desegregation case before the Supreme Court in 1954 but also became the first African-American appointed to the Supreme Court, and the poet Lang-

ston HUGHES, who was in Lincoln University's class of 1929. Two former heads of state in Africa were educated at Lincoln University: Kwame Nkrumah, Ghana's first prime minister, graduated in 1939, and Nnamdi Azikiwe, Nigeria's first president, was in Lincoln University's class of 1930. Lincoln's alumni have been presidents of thirty-six colleges and universities.

Lincoln's positive impact has particularly been felt in the Commonwealth of Pennsylvania, where many of its graduates have distinguished themselves as educators, physicians, judges, lawyers, and scientists. Harry W. Bass, Pennsylvania's first African-American legislator; Robert N. C. Nix, the state's first African-American congressman; Herbert Millen, the state's first African-American judge; and Roy C. Nichols, the first African-American Bishop of the United Methodist Church, were graduates of Lincoln University.

Lincoln University has continued the tradition of educating students from Africa who return to their continent to assume leadership positions. Namibia's first independence government cabinet had at least six Lincoln University graduates. This impressive record of Lincoln's national and international alumni in various fields of human endeavor testifies to the value of a preparation solidly rooted in an education for freedom.

Since the 1960s, Lincoln University has intensified its tradition of international involvement. In 1961, the U.S. State Department sponsored the African Languages and Area Studies Program at the university. From 1963 to 1971, the United States Peace Corps Training Program prepared volunteers on Lincoln University's campus and sent them to places in Africa and the Caribbean. Dr. Niara Sudarkasa, an internationally recognized anthropologist and the first African-American female to be appointed as Lincoln's president, has since her inauguration in 1987 highlighted the international focus of Lincoln University. Under her leadership Lincoln has established the Center for Public Policy and Diplomacy, the Center for the Study of Critical Languages, and the Center for the Comparative Study of the Humanities. These centers have become focal points for international studies at the university. Also, in addition to the European languages that are traditionally taught in colleges, Lincoln also teaches Chinese, Japanese, Russian, and Arabic languages.

Dr. Horace Mann BOND, a graduate of Lincoln University, was the institution's first African-American president. He served from 1945 to 1957. Dr. Bond was succeeded by Dr. Marvin Wachman, who was white. After Dr. Wachman, the succeeding presidents—Dr. Herman Branson (1970–1985) and Dr. Sudarkasa (1987–present)—have been black.

Lincoln University's student population has traditionally numbered about 1,400. Students are recruited from various social, economic, and national backgrounds. The university has continued to expand its physical facilities on its 400 acres of land.

REFERENCES

BOND, HORACE MANN. *Education for Freedom: A History of Lincoln University, Pa.* Lincoln University, Pa., 1976.

CARR, GEORGE B. *John Miller Dickey.* Philadelphia, 1929.

LEWIS, THOMAS E. "Lincoln University—The World's First Negro School of Higher Learning." *Philadelphia Bulletin,* August 26, 1951, p. 3.

SUDARKASA, NIARA. "Lincoln University's International Dimension." In Andrew Dinniman and Burkard Holzner, eds. *Education for International Competence in Pennsylvania.* Harrisburg, Pa., 1988.

LEVI A. NWACHUKU

Lindsey, Richard William (1904–), painter and graphic artist. Born in North Carolina, Richard William Lindsey moved to New York City to train at the National Academy of Design under Augusta SAVAGE. Lindsey's early work won him several awards including the Art Association Prize from the Herron Institute in Indianapolis in 1924. During the 1920s and '30s, he exhibited with the Harmon Foundation (1928–1933), at the Baltimore Museum (1939), and the American Negro Exposition in Chicago (1940), among others. Lindsey supported himself in New York by working as a part-time postal clerk and by teaching painting, soap carving, and model-airplane building to children at the Harlem Art Center. In the mid-1930s, Lindsey also taught art at the 135th Street branch of the YMCA and also at the Community Boys' Club.

Lindsey's strong eye for urban landscapes can be seen in paintings like *Boat and Bridge* (c. 1928) and *Lower Manhattan* (c. 1931) and in the lithograph *Colonial Park* (c. 1940). The print depicts an urban park where mothers are pushing their children on swings; the dramatic swinging motion is reinforced by the repeated use of diagonal lines throughout the image. Other paintings like *Swing, Birth of Jazz,* and *A Daughter of Africa* (no dates) portray dynamic scenes of contemporary African-American life. Although Lindsey enjoyed critical recognition into the early 1940s, little is known about either his life or work thereafter. The Schomburg Center in New York and the National Archives in Washington, D.C., have acquired his work.

REFERENCES

CEDERHOLM, THERESA DICKASON, ed. *Afro-American Artists: A Bibliographical Directory.* Boston, 1973, p. 181.

Lehman College Art Gallery. *Black Printmakers and the W.P.A.: The Lehman College Art Gallery February 23–June 6, 1989.* Exhibition Catalogue. New York, 1989.

SHIRLEY SOLOMON

Lion, Jules (1810–January 10, 1866), photographer. Jules Lion was born in Paris in 1810. He studied art there and in 1831 he was one of the youngest artists to exhibit in the Salon. He also exhibited his paintings and lithographs at the 1833 Paris Exposition, where he was awarded an honorable mention for his lithograph, *Affut aux Canards* (The Blind Duck).

In 1836, Lion moved to New Orleans as a free man of color, where he lived and worked the rest of his life. Lion holds the distinction of exhibiting the first successful daguerreotype of views of New Orleans in March 1840. The exhibition was held in the hall of the Saint Charles Museum, opposite the Saint Charles Hotel, a popular Sunday gathering place in the American district. Lion was active as a daguerreotypist from 1840 to the mid-1860s. He advertised in the local newspapers during the early years that he offered his clients daguerreotypes for rings and brooches as well as hand-colored daguerreotypes. Lion photographed such well-known figures as John J. Audubon and Jefferson Davis; he also took portraits of sick and deceased people, as well as the streets, buildings, and monuments in New Orleans. In an advertisement in the *New Orleans Bee* dated November 25, 1843, Lion's work is cited as follows: "As a Lithographist, he has perhaps, not any equal in the country. His portraits are distinguished for their fidelity, correct drawing, and good taste. His daguerreotype impressions are likewise very fine, and he possesses the art of coloring them—a process by which that faintness of outline which has been considered the chief objection to the daguerreotype, is made to give place to a strong bold and durable impression. Mr. Lion is deserving of public patronage."

Lion also taught art and in 1848 he founded an art school with another artist, Dominique Canova, on Exchange Alley. From 1852 to 1865, he was listed as a professor of drawing at Louisiana College. Jules Lion died in New Orleans on January 10 the following year.

REFERENCE

WILLIS-THOMAS, DEBORAH. *Black Photographers, 1840–1940: An Illustrated Bio-Bibliography*. New York, 1985.

DEBORAH WILLIS-THOMAS

Liston, Charles "Sonny"

(May 8, 1932–December 30, 1970), boxer. Sonny Liston was the tenth of eleven children of Helen (Baskin) Liston and impoverished Arkansas cotton farmer Tobe Liston, who already had fourteen offspring by his first wife. Sonny moved with his mother to St. Louis in 1945; there the illiterate youth became a juvenile delinquent, and later an armed robber and goon. He was convicted in 1950 of robbing a gas station and served nineteen months. A priest in prison directed him into BOXING, and in 1953 he won the national Golden Gloves championship. Liston turned professional, achieving a 14–1 record, but assaulted a policeman and returned to prison in 1956. After his release, he won his next nineteen bouts, becoming number-one contender in 1960. He won the championship from Floyd PATTERSON on September 25, 1962, with a first-round knockout. However, the New York State Boxing Commission refused to license him because of reputed underworld connections. His aura of invincibility was strengthened by a first-round knockout in a rematch with Patterson in July 1963.

Liston had an awesome physical presence, delivered a crushing left hook, and had a remarkable ability to take punches. He fought Cassius Clay, a rank underdog, on February 25, 1964, losing on a TKO when unable to answer the bell for the seventh round because of a shoulder injury. The rematch on May 25, 1965, was equally shocking as Clay (who by then had changed his name to Muhammad ALI) gained a first-round knockout (1:52) with a phantom right. Most experts felt that Ali had landed a blow on a physically and mentally washed-up Liston. Liston had a career record of 50–4 (with 39 knockouts). He died in 1970 of natural causes, six months after his last fight.

REFERENCE

New York Times, January 7, 1971, sec. 1, p. 38.

STEVEN A. RIESS

Liston, Melba Doretta

(January 13, 1926–), trombonist. Born in Kansas City, Mo., Melba Liston moved with her family to Los Angeles in 1937 and by World War II was playing trombone in the Lincoln Theater's pit orchestra. This established her foundation in big-band jazz, and in 1944 she joined Gerald Wilson's modern big band, contributing arrangements to its repertory and appearing on its mid-1940 recordings. She also developed soloist skills, influenced by Tommy Dorsey and the new trombone language offered by J. J. JOHNSON.

Liston's abilities earned her the opportunity to record on a session for Dial Records led by tenor saxophonist Dexter GORDON. These 1947 recordings confirmed her as a trombonist in the new idiom, and as the first nonpianist woman instrumental musician in bebop. In 1949 she toured with Billie HOLIDAY, then went to New York with Wilson's aggregation. Her reputation had preceded her, and Dizzy GILLESPIE immediately hired her to play and coarrange for his reconstituted orchestra. At the orchestra's breakup in 1950, she performed sporadically while working for the New York City Board of Education and writing for Count Basie's small and large ensembles.

Respect for Liston's musicianship grew when in 1956 Gillespie hired her to coarrange for his U.S. State Department tour of Europe and the Middle East. As a woman in all-male bands prior to the feminist movement, she experienced numerous insults, but Gillespie challenged many of his bandsmen's attitudes and actions meant to make her uncomfortable. In 1958 she again toured Europe with arranger and big-band leader Quincy JONES.

In 1960 Liston wrote for large jazz ensembles, recorded for Riverside Records, and composed in particular for pianist Randy Weston, saxophonist Johnny Griffin, and vibraphonist Milt JACKSON. Returning to California for the rest of the decade, she wrote arrangements for Motown's touring artists and through Etoile Productions for Tony Bennett, Jon Lucien, and Solomon Burke. She co-led an orchestra with flügelhornist Clark TERRY in the late 1960s, and also contributed scores for the Buffalo Symphony Orchestra. Liston began teaching jazz education in urban programs in the late 1960s, first through Pratt Institute in Brooklyn (1967) and later, organizations in Harlem (1968) and Watts (early 1970s).

In 1973, Liston accepted a faculty position at the University of the West Indies in Jamaica. The revitalized jazz scene of the 1980s caused her to divide her time between performing and arranging, while teaching and administering music education for youth.

REFERENCES

PAGANI, D. "Melba Liston: Interview." *Cadence* 11, no. 9 (1985): 5.
WOOLLEY, S. "Melba Liston." *Jazz Journal International,* no. 112 (1987): 20.

RON WELBURN

Literary Criticism. *See* Criticism, Literary.

Literary Magazines. Literary magazines and journals occupy a position of great importance in the development of African-American literature. Since their appearance in the nineteenth century, such magazines have served as outlets for writers who would otherwise have had few opportunities to publish their work. They have been important forums for discussion of the literary aesthetics of black literature and catalysts of change in black culture and politics. The influence of black literary journals is especially notable given their small numbers and the difficult conditions in which they were generally produced. With scarce financial support and limited readership, most black literary journals rarely survived long enough to publish more than a few issues. Magazines and journals that concentrated on literary work while maintaining a more general focus on society and politics occasionally offered more stable platforms for literary publication, but literature was often the first thing to be eliminated from such publications during times of financial distress.

Another important factor in the difficulty of sustaining African-American literary magazines has been the often factional and highly politicized nature of black intellectual and literary debate. Politics has always been integral to African-American literature. Many of the most important literary magazines were considered by their creators to be primarily political publications; their contents often contained much that would not conventionally be considered literature, in the sense of poetry, drama, and narrative fiction. The abolitionist journalism of the early nineteenth century (*see* ABOLITION), the political editorials of W. E. B. DU BOIS, and the ongoing debates over the proper role of the arts in black culture are all significant contributions to black literature and important examples of the varied and often apparently extraliterary writing that has appeared in black literary magazines. One theme that frequently recurs in the history of black literary magazines is the ongoing debate over the relationship between literary aesthetics and cultural politics, a debate that often led to attempts to avoid or transcend the apparent dichotomy between "art as propaganda" and "art for art's sake." More important, it can be seen as a sustained effort to develop a literature that can bridge the gap between the two.

The earliest African-American journals were published in the northern centers of the free black population in the 1820s. Avowedly abolitionist and opposed to racial discrimination, they established the foundation on which later black protest journalism was built. The first black periodical was FREEDOM'S JOURNAL (1827), followed by the *National Reformer* (1833), the *Mirror of Liberty* (1837), an early incarnation of the *Colored American Magazine* (1837–1841), and *Douglass' Monthly* (1858–1861). These early journals had a strong political focus and usually served as mouthpieces for their publishers. A notable exception to this practice was the ANGLO-AFRICAN MAGAZINE (1859–1862). The *Anglo-African* and the associated *Weekly Anglo-African* newspaper (1859–1865) were more diversified in approach, and their inclusion of contending political perspectives and literary efforts made them the most influential African-American journals of their day. The *Anglo-African* magazine was also the first African-American journal to include substantial works of literary prose, initiating the early development of a black literary aesthetic. Because of the difficulty African Americans encountered in finding publishing opportunities, these magazines afforded one of the only venues for black authors. Martin DELANY's novel *Blake; or, The Huts of America,* for example, was serialized in the *Anglo-African* magazine in 1859–1860 but was not published in book form until 1970. Other notable contributors to *Anglo-African* magazine included Frederick DOUGLASS, John LANGSTON, Daniel PAYNE, Frances Ellen Watkins HARPER, and William Wells BROWN.

After the CIVIL WAR and the failure of radical RECONSTRUCTION, the optimism of the abolitionists was eroded. Although African-American newspapers flourished during the last quarter of the nineteenth century, literary magazines virtually vanished during this period. As the century approached its close, Booker T. WASHINGTON emerged as the preeminent leader of African Americans. He made substantial efforts to gain control of the African-American journals and thus to eliminate opposition within the African-American community to his accommodationist position. By the first decade of the twentieth century, Washington's views were endorsed by most of the notable journals of the time, including *Southern Workmen* (1872–1910), *Colored Citizen* (1900), *Age* (1900), and most notably, *Colored American* magazine (1900–1909). *Colored American* magazine, edited in its opening years by Pauline HOPKINS, was the first significant African-American literary journal of the twentieth century, publishing such notable writers as William Stanley BRAITHWAITE, Benjamin BRAWLEY, James Corrothers, Angelina Weld GRIMKÉ, and Paul Laurence DUNBAR. Until 1904, when Washington succeeded in having Hopkins dismissed from her post, its varied contents—politics, business, religion, history, and fiction—reflected strong opposition to his views.

Despite Washington's takeover of *Colored American,* the opposition was at this time gaining strength

under the leadership of W. E. B. Du Bois. A number of new journals reflecting Du Bois's ideas were established, the most important of which were *Voice of the Negro* (1904–1907), *Moon Illustrated Weekly* (1905–1906), and *Horizon* (1907–1910). *Voice of the Negro,* edited by J. Max BARBER, was the first African-American magazine edited in the South, and *Moon* and *Horizon* were Du Bois's first journalistic platforms. While none of these journals was able to survive for long (because opposition to Washington virtually eliminated any possibility of substantial financial support), they served an important role in developing a radical aesthetic of explicit and energetic political protest.

All the journals, whether influenced by Washington or Du Bois, included literary pieces in addition to social and political commentary, and debate over the appropriate aesthetic for African-American literature intensified in this decade. Hopkins and Du Bois, recalling the energetic protest journalism of the abolitionists, attempted to develop a direct and audacious style of writing that would reinforce the radically confrontational political themes of their literary work. The pro-Washington magazines, such as *Alexander's* and *Colored American* magazine, after 1904 wished to avoid such provocative positions. They placed less emphasis on explicitly political themes and favored instead light poetry and popular fiction written with conventional restraint and intended to provide entertainment or to describe some exemplary achievement.

By Washington's death in 1915 the sort of conventional literature favored by those magazines under his influence was rapidly losing ground to the energetically and provocatively modern style fostered by Du Bois and such journals as the CRISIS (1910–) and OPPORTUNITY (1923–1949), published by the NATIONAL ASSOCIATION FOR THE ADVANCEMENT OF COLORED PEOPLE and the NATIONAL URBAN LEAGUE, respectively. These journals, financially supported by social and political organizations involved in race relations, provided for the first time not only a stable forum for black literary work and critical discussion but also a substantial, national black readership. As a result of this support and wide exposure, a remarkable number of young writers, including Arna BONTEMPS, Countee CULLEN, Langston HUGHES, Zora Neale HURSTON, and Claude MCKAY gained national recognition. This new generation of writers moved beyond traditional concerns with countering white prejudices and opposing related political views to address themselves to issues of African-American self-definition.

Over the next two decades, black literature experienced an unprecedented degree of aesthetic experimentation and development as African-American writers turned their attention to articulating the identity of the NEW NEGRO, the term chosen by Alain LOCKE as the title of his landmark 1925 anthology of the period's poetry and prose. As Locke observed in 1928, "Yesterday it was the rhetorical flush of partisanship, challenged and on the defensive. . . . Nothing is more of a spiritual gain in the life of the Negro than the quieter assumption of his group identity and heritage; and contemporary Negro poetry registers this incalculable artistic and social gain" (Locke 1928, p. 11). The organizational journals and a host of little literary magazines were the primary vehicles for this development and the ensuing controversy.

The first and in many ways the most influential of the organizational journals was the *Crisis*. Du Bois's sponsorship of young writers and his own development of an energetic, modern style of writing made him the most important single figure in the early growth of the modern black literary aesthetic that would reach maturity in the HARLEM RENAISSANCE. Along with Jessie FAUSET, the literary editor of the *Crisis* from 1919 to 1926, Du Bois provided critical early support and exposure for the unprecedented numbers of young, educated black writers. The quick national success of the *Crisis* was encouraging, and its example was followed by the launching of *Stylus* (1916–1941) and *New Era* (1916), both smaller literary magazines. *Stylus* was established at HOWARD UNIVERSITY by Locke and Montgomery Gregory, and *New Era* was a short-lived attempt by Pauline Hopkins to revive the early form of *Colored American* magazine.

Despite Du Bois's central role in the early development of the Harlem Renaissance, his increasingly emphatic insistence that literature concern itself with political and moral issues had distanced him by the mid-1920s from many of the younger generation. As Du Bois lost influence, dominance of the expanding literary scene shifted to Charles Spurgeon JOHNSON, the editor of *Opportunity* from 1923 to 1928. Unlike Du Bois and, to some extent, Fauset, Charles Johnson did not insist that literary aesthetics be tied to the political and moral values of the prosperous, educated, black middle class—the Talented Tenth. Instead, he asserted that self-expression and artistic freedom were the paramount concerns for the new literature, and *Opportunity*'s support of more radical young writers of the time marked the maturation of the Harlem Renaissance.

The more general cultural vitality of the Harlem Renaissance brought further attention to black literary development through a number of special issues of essentially white periodicals, including *Palms* (1926), *Carolina* magazine (1927–1929), and *Survey Graphic* (1925), much of which was reprinted in Locke's anthology *The New Negro* (1925).

With the success of the organizational magazines and the attention garnered by the special numbers of white periodicals, the African-American literary community had become optimistic enough to launch a number of independent little literary magazines. *New Era* and *Stylus* were followed in the mid-1920s by numerous other independent journals, including *Harlem* (1926) and the more conservative *Black Opals* (1927–1928) and *Saturday Evening Quill* (1926–1930). However, in many ways the most notable of the little magazines of this era was *Fire!!* (1926), the first exclusively literary, independent black magazine. Edited by Wallace THURMAN, the first and only issue of *Fire!!* caused substantial controversy upon publication because of its energetically antipuritanical position. Rather than presenting conventional portraits of exemplary, middle-class African Americans, the magazine attempted to put forward a new radical aesthetic that concerned itself with many of the aspects of African-American life considered to be disreputable, such as prostitution and homosexuality.

The radical themes of *Fire!!* were more than a simply aesthetic rejection of the practices of the Talented Tenth: Focus on lower-class black life also reflected the growing influence of socialist political theory among the black writers of the 1920s. In 1926 Thurman had served a brief term as editor of the era's third influential organizational journal, the MESSENGER (1917–1928), which had begun as a radical socialist magazine (*see* SOCIALISM) and eventually became allied with the mainstream labor movement. (In 1925 it became the official organ of the BROTHERHOOD OF SLEEPING CAR PORTERS.) Despite its early rejection of the importance of black literary efforts, the *Messenger* became a significant supporter of many of the more radical Harlem Renaissance writers after it came under the editorial control of George SCHUYLER and Theophilus Lewis in 1923. With the exception of Thurman's brief stint as editor, Schuyler and Lewis maintained control of the magazine until its demise five years later, and under their leadership, the *Messenger* provided support for literature that reflected the growing interest in the life of the black lower class.

The literary renaissance of the 1920s turned out to be unexpectedly short-lived. With the onset of the next decade, economic hardship made financial survival difficult for journals, and their numbers decreased sharply. While *The Crisis* and *Opportunity* were able to survive, both experienced such financial difficulties that they sharply curtailed their support of literature. The depressed economic situation also had its impact on literary aesthetics; both the primarily middle-class aesthetic of the organizational journals and the radical aesthetic style of some of the little magazines seemed increasingly out of touch with the

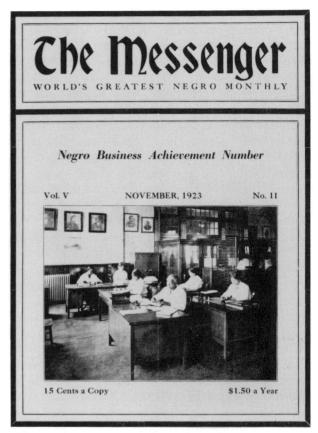

Although in its early years the editorial policy of the *Messenger* was one of militant socialism, by 1923 the journal was taking a more favorable view of the accomplishments of the black middle class. (Photographs and Prints Division, Schomburg Center for Research in Black Culture, The New York Public Library, Astor, Lenox and Tilden Foundations)

problems of the GREAT DEPRESSION. The radical writers' focus on the life of the lower classes, however, now came to the fore as the foundation for much of the black literature of the 1930s. In *Challenge* (1934–1937), edited by Dorothy WEST, and *New Challenge* (1937), edited by West, Marion Minus, and Richard WRIGHT, a new generation of black writers (including Wright and Ralph ELLISON) developed a literary aesthetic that linked radical socialism to folklore and to the experience of the working class. While such work foregrounded politics to a degree that had not been seen since the early writing of Du Bois and Pauline Hopkins, the socialist orientation of the new literature focused on class tensions as much as it did on race.

With the onset of WORLD WAR II, the political position of most African-American journals shifted to liberal anticommunism, and the journals focused their attentions on the legal struggle to achieve integration, an emphasis that would remain dominant throughout the 1940s and most of the 1950s. At the

same time, many black authors found it increasingly easy to publish in mainstream literary journals. For instance, James BALDWIN's famous attack on Richard Wright and the black protest tradition, "Many Thousands Gone" (1949), appeared not in an African-American literary magazine but in *Partisan Review*. The diversity and unity of human experience became the primary thematic concerns, and notions of an independent or oppositional black literary aesthetic were minimized. Many mainstream publications were opened to black writers for the first time, although such interest was limited to formulaic entertainment pieces. Only two small journals, *Negro Quarterly* (1942–1944) and *Negro Story* (1944–1946), existed during the war, and *Crisis* and *Opportunity* continued to serve as important outlets for serious literary work. However, both experienced further financial strain and erosion of circulation during wartime, and neither journal was able to maintain a sig-

Opportunity, sponsored by the National Urban League, provided a stable venue for literary work and critical discussion. (Photographs and Prints Division, Schomburg Center for Research in Black Culture, The New York Public Library, Astor, Lenox and Tilden Foundations)

nificant role in literary development after the war. *Opportunity* had reached particularly desperate straits, and it ceased publication in 1949. *Phylon* (1940–), a journal published by Atlanta University and started by W. E. B. Du Bois, took over the position left open by *Crisis* and *Opportunity* in the late 1940s and maintained its influence through the next decade.

The era's aesthetic trend toward the white mainstream was not conducive to independent little black magazines, and their scarcity during this period eventually became a cause for concern among black writers. By the end of the 1940s, the predominant aesthetic emphasis on the universality of human experience began to be perceived by some as a potentially negative influence on African-American culture, drawing it into the mainstream while diluting its identity. *Harlem Quarterly* (1949–1950) and *Voices* (1950) were short-lived efforts to counteract this trend; they attempted to answer the need for a journal of black fiction about African-American life in particular. *Free Lance* (1953–1976) and *Yugen* (1958–1963), the earliest platforms for Le Roi Jones (later known as Imamu Amiri BARAKA), addressed the same problem in the next decade, though neither of these journals was exclusively concerned with African-American interests and literature.

By the middle of the 1960s, the BLACK ARTS MOVEMENT and black political militance created a climate in which the rejection of Western cultural norms and values in favor of an independent African-American cultural identity became the basis for a new black literature. The return to a literary aesthetic of opposition and protest was carried out through a new renaissance of independent small journals, including *Liberator* (1961–1971), *Soulbook* (1964–1976), *Black Dialogue* (1964–1970), the *Journal of Black Poetry* (1966–1973), and the more moderate *Umbra* (1963–1975). *Negro Digest* (1942–1970) also lent support to this position after a shift in its editorial position in the middle of the decade (*see* BLACK WORLD/NEGRO DIGEST). The aesthetic position that developed in the small journals of this decade was part of the larger attempt by the Black Arts Movement to disengage African-American artistic culture from the Western tradition and to form a new black cultural consciousness. Fundamentally political, the black aesthetic combined language and form indigenous to the African-American experience with revolutionary, nationalistic political critique.

The Black Arts Movement peaked at the end of the 1960s, just as *Negro Digest* adopted its new title, *Black World* (1970–1976). The decline of the Black Arts movement, and of the Black Power movement in general, was gradual and not immediately noticeable. In the early years of the 1970s, a number of new magazines and journals were established as part of the

movement, including *Nommo* (1969–1970), *Black Creation* (1970–1975), *Black Review* (1971–1972), *Kitaba Cha Jua* (1974–1976), and *First World* (1977–1980). However, as the general political climate cooled and the movement splintered and slowed, financial support for such journals became scarce. Few survived.

By the middle of the 1970s, the pendulum had swung away from radical oppositional politics, and the new emphasis became the necessity of establishing a strong and consistent critical and theoretical base for a separate black literary aesthetic. A number of university publications, such as *Hambone* (1974–), *Callaloo* (1976–), and *Black American Literature Forum* (1967, 1976–), played a central role in the development of this new aesthetic, providing academic critics (such as Henry Louis Gates and Houston Baker) with an unprecedented degree of influence in the African-American literary community. Other literary magazines and journals that contributed to this development include *Obsidian/Obsidian II* (1975–), *Y'Bird* (1977–1978), *Quilt* (1980–1984), *Sage: A Scholarly Journal on Black Women* (1984–), *Catalyst* (1986–), *Shooting Star Review* (1986–), and *Konch* (1990).

At the same time that recent literary journals have reflected an increasingly academic orientation, they have also displayed a significant shift toward greater diversity of focus and opinion. Unlike the literary debates of earlier periods, that of the 1980s and early 1990s does not reveal any particular dominant concern so much as it begins to confront the internal heterogeneity of the African-American literary community. This heterogeneity accounts in part for the relatively large number of literary journals in recent years.

REFERENCES

BONTEMPS, ARNA, ed. *The Harlem Renaissance Remembered.* New York, 1972.

BULLOCK, PENELOPE. *The Afro-American Free Press, 1838–1909.* Baton Rouge, La., 1981.

HUTTON, FRANKIE. *The Early Black Press in America, 1827–1860.* Westport, Conn., 1993.

JOHNSON, ABBEY ARTHUR, and RONALD MAYBERRY JOHNSON. *Propaganda and Aesthetics: The Literary Politics of African-American Magazines in the Twentieth Century.* Amherst, Mass., 1979.

KORNWEIBEL, THEODORE, JR. *No Crystal Stair: Black Life and The Messenger, 1917–1928.* Westport, Conn., 1975.

LEWIS, DAVID LEVERING. *When Harlem Was in Vogue.* New York, 1979.

LOCKE, ALAIN. "The Message of the Negro Poets." *Carolina* 28 (May 1928).

WOLSELEY, ROLAND E. *The Black Press, U.S.A.* 2nd ed. Ames, Iowa, 1990.

MATTHEW BUCKLEY

Literature. African-American literature, like African-American culture in general, was born out of the harsh realities of black life in North America. Although the African presence in the Americas preceded both slavery and its predecessor, indentured service (which began for blacks in North America with the landing of nineteen Africans from a Dutch ship at Jamestown, Va., in 1619), blacks lived virtually from the start under severe pressures that tended to erode their African identity, although many important features of African culture and personality unquestionably persisted. These pressures also prevented the easy acquisition by blacks of the more complex aspects of European civilization. Except in rare circumstances, literacy among blacks was discouraged or forbidden on pain of punishment by the law courts, by slave owners, or by vigilante force. On the other hand, because the determination of blacks to become free and to acquire power (essentially one and the same idea) is as old as their presence in North America, the ability to read and write became quickly established as essential to the political and economic future of the group.

The earliest black writing reveals a combination of factors and influences that set African-American literature on its way. The desire for freedom and power was shaped at the start by religious rather than secular rhetoric, so that the Bible was the most important text in founding the new literature. Gradually, religious arguments and images gave way in the nineteenth century to political and social protest that eschewed appeals to scriptural authority. As blacks, increasingly estranged from their African cultural identities, sought to understand and represent themselves in the New World, they drew more and more on the wide range of European literatures to find the models and characters which they would adapt to tell their own stories. Rich forms of culture developed in folktales and other works of the imagination, as well as in music, dance, and the other arts. A major aspect of African-American literature, broadly defined, is the persisting influence of oral traditions rooted in the African cultural heritage; these traditions have probably affected virtually all significant artistic meditations by African Americans on their social and political realities and aspirations.

The first significant black American writing emerged toward the end of the eighteenth century with the poet Phillis WHEATLEY. Born in Africa but reared as a slave in Boston, Wheatley was anomalous in that she was encouraged by her white owners not only to read and write but also to compose literature. Like the other black poet of note writing about the same time, Jupiter HAMMON, Wheatley was strongly influenced by Methodism. Unlike Hammon, however, she responded to secular themes as, for exam-

ple, in celebrating George Washington and the American struggle for independence. Her volume *Poems on Various Subjects, Religious and Moral* (London, 1773) was the first book published by a black American and only the second volume of poetry published by any American woman.

One consequence of the religious emphasis in early black American writing was a tendency to deny, in the face of God's omnipotence, the authenticity of the individual self and the importance of earthly freedom and economic power. In AUTOBIOGRAPHY, the first literary assertion of the emerging African-American identity came in the eighteenth century from a writer ultimately committed to religion—Olaudah EQUIANO, born in Africa and sold into slavery in the West Indies, North America, and Great Britain. His volume *The Interesting Narrative of the Life of Olaudah Equiano, or Gustavus Vassa, the African* (London, 1789) became the model for what would emerge as the most important single kind of African-American writing: the slave narrative (*see* SLAVE NARRATIVES).

Also in the eighteenth century appeared the first of another significant strain—the essay devoted primarily to the exposition of the wrongs visited on blacks in the New World and to the demand for an end to slavery and racial discrimination. In 1791, the gifted astronomer and almanac maker Benjamin BANNEKER addressed an elegant letter of protest to Thomas Jefferson, then secretary of state and later president of the United States. Banneker appealed to Jefferson, as a man of genius who had opposed slavery (even as he continued to own slaves) and as a signer of the Declaration of Independence, to acknowledge the claims of blacks to equal status with white Americans.

Although the United States formally abolished the importation of slaves in 1807, the first half of the nineteenth century paradoxically saw the deepening of the hold of slavery on American life, primarily because the invention of the cotton gin revived slavery as an economic force in the South. In response, African-American writers increasingly made the quest for social justice their principal theme. In 1829, George Moses HORTON of North Carolina, who enjoyed unusual freedom for a slave, became the first black American to protest against slavery in verse when he published his volume *The Hope of Liberty*. Far more significant, however, was *David Walker's Appeal, in Four Articles* (1829), in which David WALKER aggressively expounded arguments against slavery and racism and attacked white claims to civilization even as that civilization upheld slavery. Walker's writing may have encouraged the most famous of all slave insurrections, led by Nat Turner in Virginia the following year, when some sixty whites were killed (*see* NAT TURNER'S REBELLION).

The founding by the white radical William Lloyd Garrison of the antislavery newspaper the *Liberator* in 1831 helped to galvanize abolitionism as a force among both whites and blacks. In particular, abolitionism stimulated the growth in popularity of slave narratives. A major early example was *A Narrative of the Adventures and Escape of Moses Roper* (1837), but the most powerful and effective was undoubtedly *Narrative of the Life of Frederick Douglass, an American Slave* (1845), which enjoyed international success and made Frederick DOUGLASS a leader in the antislavery crusade. One New England observer, Ephraim Peabody, hailed the narratives as representing a "new department" in literature; another, Theodore Parker, declared that they were the only native American form of writing and that "all the original romance of Americans is in them, not in the white man's novel." Slave narratives were certainly a major source of material and inspiration for the white writer Harriet Beecher Stowe when she published, in the wake of the Fugitive Slave Act of 1850, her epochal novel UNCLE TOM'S CABIN (1852). This novel, which offered the most expansive treatment of black character and culture seen to that point in American literature, would itself have a profound effect on black writing.

One autobiography largely ignored in its time, but later hailed as a major work, was Harriet JACOBS's *Incidents in the Life of a Slave Girl* (1861), published under the pseudonym Linda Brent. In its concern for the fate of black women during and after slavery, and its emphasis on personal relationships rather than on the acquisition of power, *Incidents in the Life* anticipated many of the concerns that would distinguish the subsequent writing of African-American women.

Other important writers of the antebellum period who sounded notes of protest against social injustice were escaped slaves such as William Wells BROWN and Henry Highland GARNET, as well as the freeborn John Brown RUSSWURM (from Jamaica, West Indies) and Martin R. DELANY. Of these writers, the most versatile was certainly Brown, who published as a poet, fugitive slave narrator, essayist, travel writer, dramatist, historian, and novelist. Responding to the implicit challenge of *Uncle Tom's Cabin*, Brown published the first novel by an African American, *Clotel; or, The President's Daughter* (London, 1853), in which he drew on the rumor of a long-standing affair between Thomas Jefferson and a slave. *Uncle Tom's Cabin* and *Clotel* helped to establish the main features of the black novel in the nineteenth century. These include an emphasis on the question of social justice for African Americans, on light-skinned heroes and heroines, and on plots marked by melodrama and sentimentality rather than realism.

Almost as versatile as Brown, and in some respects the representative African-American writer of the

second half of the nineteenth century, was the social reformer Frances Ellen Watkins HARPER. As with the vast majority of black writers before and after the Civil War and the heyday of the abolitionist movement, Harper maintained her career by printing and distributing her own texts, almost entirely without the opportunities and rewards that came from white publishers. Her major source of her fame was her poetry, although she depended technically on the lead of traditional American poets of the age, such as Longfellow and Whittier. Antislavery sentiment formed the core of her first book, *Poems on Miscellaneous Subjects* (1854), which went through almost two dozen editions in twenty years. Harper also published the first short story by an African American, "The Two Offers," in 1859; the biblical narrative *Moses, a Story of the Nile* (1869); and a novel about an octoroon heroine, *Iola Leroy, or Shadows Uplifted* (1892). Although Harper's limitations as a novelist are clear, *Iola Leroy* raises significant questions about the place of women in African-American culture.

While opposition to slavery was an enormous stimulus to African-American writing of the time, the Civil War itself went largely unreflected in black poetry, fiction, or drama. William Wells Brown published *The Negro in the American Rebellion: His Heroism and His Fidelity* (1867), and a generation later the historian George Washington WILLIAMS offered his *History of the Negro Troops in the War of Rebellion* (1888). In some respects, however, the most powerful document to emerge from that watershed event in African-American history is the *Journal of Charlotte Forten* [1854–1892] (published in abridged form in 1953) by Charlotte Forten GRIMKÉ. The journal records events in Forten's life from her school days in Salem, Mass. (she was born in Philadelphia, the granddaughter of a wealthy black sail-maker active in the abolitionist cause), through her two years as a volunteer teacher in the Sea Islands off South Carolina during the war. Also illuminating is the autobiography of Elizabeth Keckley, *Behind the Scenes; or Thirty Years a Slave, and Four Years in the White House* (1868), which culminates in an account of her service as a seamstress to Mary Todd Lincoln, when Keckley strove to use her insider's position to assist other blacks and the war effort in general.

Although it is possible to see black literature of the 1850s as constituting a flowering or even a renaissance of writing, the two decades after the Civil War saw no rich development of the field. Reconstruction was a period of promise but also of disillusionment for blacks. It was followed by a dramatic worsening in their social, economic, and political status, culminating in the U.S. Supreme Court decisions *Williams* v. *Mississippi* (1895) and *Plessy* v. *Ferguson* (1896). These and other decisions effectively nullified the Fif-

teenth Amendment to the U.S. Constitution, which gave black freedmen the right to vote. Soon, black Americans had also essentially lost the right to associate freely with whites in virtually the entire public sphere.

The rise of segregation and of vigilante repression after Reconstruction diminished, but did not destroy, black American literature. With the rise of black newspapers and journals (as exemplified at the turn of the century by *The Voice of the Negro* and *The Colored American*), formed in response to the barriers to integration, there was another upsurge in literary creativity. In 1884, the poet Albery A. Whitman published probably his finest work, *Rape of Florida,* a long narrative poem in Spenserian stanzas that showed off his considerable lyrical gift. In 1899, Sutton GRIGGS published *Imperium in Imperio,* the first of five privately printed novels that gave expression to Griggs's startlingly nationalistic ideas about the future of black America. Another important figure was Pauline HOPKINS, who served as editor of *The Colored American*. However, the major new talents of the age were the fiction writer Charles W. CHESNUTT and the poet and novelist Paul Laurence DUNBAR.

Between 1887 and 1900, Chesnutt kept his racial identity a secret from his readers while he built his reputation as a gifted writer of poems, articles, and short stories in magazines (including the prestigious *Atlantic Monthly*) and newspapers that served mainly whites. Several of his short stories, including "The Goophered Grapevine," drew on the black folklore of the antebellum South, which Chesnutt treated with imagination and sympathy but also with a shrewd awareness of the harsh realities of slavery. In 1900 came the first of his three novels, *The House Behind the Cedars,* followed by *The Marrow of Tradition* (1901) and *The Colonel's Dream* (1905). Folklore dominated his collection of stories *The Conjure Woman* (1899), but Chesnutt also boldly explored in realist fashion the racial tensions of his day, as in his use of the infamous Wilmington, N.C., riot of 1898 in *The Marrow of Tradition*.

Dunbar, on the other hand, published from the start as an African-American writer. Starting out with the collection *Majors and Minors* (1895), he achieved national fame as a poet—the first black American to do so—with his volume *Lyrics of Lowly Life* (1896). This volume sported a glowing introduction by William Dean Howells, the distinguished white novelist, critic, and editor. In 1899 came another collection, *Lyrics from the Hearthside*. Drawing on the stereotypes of black life formed by the black minstrel tradition, as well as on the so-called plantation tradition, which sought to glorify the antebellum culture of the South, Dunbar was an acknowledged master of dialect verse (*see* DIALECT

The 75th Jubilee Anniversary, Jackson State College, Jackson, Miss., October 1952. (Front row, left to right) Sterling Brown, Zora Neale Hurston, Margaret Walker, Langston Hughes; (back row, left to right) Arna Bontemps, Melvin B. Tolson, college president Jacob Redick, Owen Dodson, Robert Hayden. (Photographs and Prints Division, Schomburg Center for Research in Black Culture, The New York Public Library, Astor, Lenox and Tilden Foundations)

POETRY). Such poems found a ready audience among whites and, perhaps more uneasily, among blacks. Unwittingly, Howells had pointed to the essential lack of authenticity of black dialect verse. He praised Dunbar for writing poetry that explored the range of African-American character, which Howells saw as being "between appetite and emotion, with certain lifts far beyond and above it." Eventually Dunbar regretted Howells's endorsement. In his brief poem "The Poet," he seemed to deplore the fact that for all his valiant attempts to compose dignified poems in standard English, the world had "turned to praise / A jingle in a broken tongue."

Nevertheless, dialect poems became a staple of black literature, especially in the hands of writers such as John Wesley Holloway and James D. Corrothers; Dunbar's verse, in both dialect and standard English, became enshrined within African-American culture as beloved recitation pieces. He also published four volumes of short stories and four novels, few of which are memorable. Genial collections of stories such as *Folks from Dixie* (1898) and *In Old Plantation Days* mainly gave comfort to those Americans who would remember the "good old days" of slavery. His novels, too, were rather weakly constructed—except for the last, *The Sport of the Gods* (1902). Here Dunbar, emphasizing black characters in his novels for the first time, helped to break new ground in black fiction by dwelling on the subject of urban blight in the North.

Dunbar was admired and imitated by many black poets of the age, but his misgivings about dialect verse came to be widely shared. One of his most gifted admirers, James Weldon JOHNSON, himself later an influential poet, anthologist, novelist, and autobiographer, credited a reading of Whitman's *Leaves of Grass* around 1900 with alerting him to the limitations of dialect verse. However, by far the most influential publication for the future of African-American literature to appear in Dunbar's day was W. E. B. DU BOIS's epochal *The Souls of Black Folk* (1903). With essays on black history and culture, as

well as a short story and a prose elegy on the death of his young son, Du Bois virtually revolutionized Afro-American self-portrayal in literature.

Du Bois directly challenged the most popular recent book by a black American, Booker T. WASHINGTON's autobiography, *Up from Slavery* (1901). Washington's story tells of his rise from slavery to his acknowledged position as a powerful black American (he was the major consultant on black public opinion for most of the leading whites of his day). The autobiography comforted whites, especially white Southerners, by urging blacks to concede the right to vote and to associate freely with whites. Criticizing Washington, *The Souls of Black Folk* offered a far more complex definition of black American history, culture, and character. In elegant prose, it fused a denunciation of slavery and racism with equally detailed descriptions of the heroism of blacks in facing the vicissitudes of American life. The most striking passage of Du Bois's book was probably his identification of an essential "double consciousness" in the African American—"an American, a Negro; two souls, two thoughts, two unreconciled strivings; two warring ideals in one dark body, whose dogged strength alone keeps it from being torn asunder."

Along with his other books of history, sociology, biography, and fiction between 1897 and 1920, Du Bois's work as editor of the CRISIS (founded in 1910), the official magazine of the newly formed NAACP, unquestionably helped to pave the way for the flowering of African-American writing in the 1920s. Influenced by *The Souls of Black Folk,* James Weldon Johnson explored the question of "double consciousness" in his novel *The Autobiography of an Ex-Coloured Man* (1912), which has been described as the first significantly psychological novel in African-American fiction. He also published an influential volume of verse, *Fifty Years and Other Poems* (1917, celebrating the anniversary of the Emancipation Proclamation in 1913), and an even more significant anthology, *Book of American Negro Poetry* (1922), which included dialect verse but consciously set new standards for younger writers. Another important anticipatory figure was the poet Fenton Johnson of Chicago, with his modernist compositions that deplored the pieties and hypocrisy of western civilization. The Jamaican-born Claude MCKAY, in a body of poetry highlighted by his *Spring in New Hampshire* (1920) and *Harlem Shadows* (1922), combined conventional lyricism with racial assertiveness. His best-known poem, the 1919 sonnet "If We Must Die," was widely read by blacks as a brave call to strike back at white brutality, especially at the bloody antiblack riots that year in Chicago and elsewhere. Jean TOOMER's *Cane* (1923), an avant-garde pastiche of fiction, poetry, and drama, captivated the younger writers and intellectuals with its intensely lyrical dramatization of the psychology of blacks at a major turning point in their American history.

The *Crisis,* the *Messenger* (founded in 1917 by the socialists A. Philip RANDOLPH and Chandler OWEN), and OPPORTUNITY (founded in 1923 by Charles S. JOHNSON for the National Urban League) consciously sought to stimulate literature as an adjunct to a more aggressive political and cultural sense among blacks. Marcus GARVEY's *Negro World,* with its "back-to-Africa" slogan, also added to the sense of excitement among black Americans at the coming of a new day, especially with the mass migration to the North from the segregated South. In some respects, the culmination of these efforts was Alain LOCKE's *The New Negro* (1925). A revised version of a special Harlem number of the national magazine *Survey Graphic* (March 1925), this collection of essays, verse, and fiction by a variety of writers announced the arrival of a new generation and a new spirit within black America.

Among writers born in the twentieth century, the poets Countee CULLEN, starting with *Color* (1925), and Langston HUGHES, with *The Weary Blues* (1926) and *Fine Clothes to the Jew* (1927), set new standards in verse. Cullen offered highly polished poems that combined his reverence for traditional forms (he was influenced by the English poets John Keats and A. E. Housman, in particular) with his deep resentment of racism. Less reverential about literary tradition, and guided by the American examples of Whitman and Carl Sandburg, Hughes experimented with fusions of traditional verse and blues and jazz forms native to black culture. Also during what is often called the HARLEM RENAISSANCE (although the literary movement was certainly felt elsewhere) came the work of poets such as Georgia Douglas JOHNSON, Anne SPENCER, Gwendolyn BENNETT, and Arna BONTEMPS, as well as Sterling A. BROWN, who also rooted his poetry in the lives of the southern black folk and in the blues idiom. Several of these writers were reticent about race as a subject in verse, let alone forms influenced by blues and jazz. For the others, however, the new spirit was perhaps captured best by Hughes in his essay "The Negro Artist and the Racial Mountain" (*Nation,* 1926). Dismissing the reservations of both blacks and whites, Hughes declared that "we younger Negro artists who create now intend to express our individual dark-skinned selves without fear or shame. . . . We know we are beautiful. And ugly too."

Later in the 1920s and in the early 1930s, fiction supplanted poetry as the most powerful genre among black writers. In 1924, Jessie FAUSET, the literary editor of the *Crisis* and ultimately the most prolific black novelist of the period, published her first book, *There*

Is Confusion, set in the refined, educated black middle class from which she had come. The same year also saw Walter WHITE's *The Fire in Flint,* on the subject of lynching. In 1928, Claude McKay published *Home to Harlem,* which antagonized some older blacks by emphasizing what they saw as hedonism. Nella LARSEN's *Quicksand* (1928) and *Passing* (1929) sensitively treated the consciousness of African-American women teased and taxed by conflicts about color, class, and gender. Du Bois's *Dark Princess* (1928) sought to examine some of the global political implications of contemporary black culture. Wallace THURMAN's *The Blacker the Berry* (1929) probed color consciousness within the black world, and in *Infants of the Spring* (1932) he satirized aspects of the new movement. Langston Hughes's *Not without Laughter* (1930) told of a young black boy growing up with his grandmother and her daughters in the Midwest. Other noteworthy novels include Bontemps's *God Sends Sunday* (1931), George SCHUYLER's *Black No More* (1931), and Cullen's *One Way to Heaven* (1932).

A major feature of the New York flowering had been the close dependence of the younger black writers on personal relationships with whites—not only editors but wealthy patrons. If the role of white patronage in the movement would remain a much-debated matter, the financial collapse of Wall Street in 1929 and the onset of the Great Depression certainly helped to end the renaissance. Many black writers, like their white counterparts, began to find radical socialism and the Communist party appealing. Setting aside the blues, Langston Hughes, who lived in the Soviet Union for a year (1932–1933), wrote a series of propaganda poems for the radical cause; and even Countee Cullen found the Communist party attractive.

On the other hand, probably the greatest single work of this decade—Zora Neale HURSTON's second novel, *Their Eyes Were Watching God* (1937)—went against the grain of radical socialism or the overt assertion of racial pride. A lover of black folk culture as well as a trained ethnographer, Hurston set in the rural South her highly poetic story of a black woman's search for an independent sense of identity and self-fulfillment; the narrative abounds in examples of folk sayings, humor, and wisdom. Ignored in its day, her novel would eventually be hailed as a masterpiece.

In poetry, both Margaret WALKER's *For My People* (1942) and Melvin B. TOLSON's *Rendezvous with America* (1944) reflected the radical populism and socialist influence of the 1930s, when both began to write seriously. Again, however, the outstanding work came in fiction. In Chicago, Richard WRIGHT, not long from Mississippi and Tennessee, had started out as a propaganda poet for the Communist party,

then turned to fiction. In 1938, his first collection of short stories, *Uncle Tom's Children,* set in the South, showed great promise that was realized two years later, when *Native Son* appeared. A Book-of-the-Month Club main selection, the novel became a national bestseller (the first by an African-American writer). *Native Son* was unprecedented in American literature. Its bleak picture of black life in an urban setting—Chicago—and the brutishness and violence of its central character, Bigger Thomas, who kills two young women, drew on extreme realism and naturalism to express Wright's sense of a crisis in American—and African-American—culture. His brilliant autobiography, *Black Boy* (1945), also a bestseller, set his individual determination to be an artist against the backdrop of almost unrelieved hostility from both whites and blacks in the South; it confirmed Wright's status as the most renowned black American writer.

In 1947, Wright emigrated with his family to Paris, where he lived until his death in 1960. However, *Native Son,* with its emphasis on black fear, rage, and violence in an urban, northern setting, left its mark on the next generation of African-American novelists. William ATTAWAY's *Blood on the Forge* (1941), Chester HIMES's *If He Hollers Let Him Go* (1945), Anne PETRY's *The Street* (1946), and Willard MOTLEY's *Knock on Any Door* (1947) all showed Wright's influence. On the other hand, the most successful (at least in terms of book sales) of African-American writers, the novelist Frank YERBY, also started his career in the 1940s, but on a completely different footing. Eschewing black culture and the idea of racial protest as sources of inspiration, Yerby established his reputation mainly with romances of the South, starting with his enormously popular *The Foxes of Harrow* (1946).

In a sense, Wright and his admirers, on the one hand, and Yerby, on the other, were enacting the latest stage of the essential political and aesthetic debate among African-American intellectuals, which pitted the merits of racial awareness and protest against the allure of integration within white America as the major goal. Yerby represented one extreme response to this question; the career of the gifted poet Gwendolyn BROOKS illustrated a more moderate position. She won the Pulitzer Prize in 1950 for her volume *Annie Allen* (1949), which appeared to confirm not only the unprecedented degree of acceptability of black literature by whites but also Brooks's wisdom and insight in mixing, as she did, "high" or learned modernist technique with a commitment to African-American subject matter. Her first volume, *A Street in Bronzeville* (1945), in which she drew on the same Chicago setting on which *Native Son* is based, exemplifies this strategy.

In fiction, an even more acclaimed fusion of modernism and black material came with Ralph ELLISON's novel *Invisible Man* (1952), which won the prestigious National Book Award for fiction. Ellison had attended Tuskegee Institute for two years. There he had been drawn to modernist literature, especially as epitomized by T. S. Eliot's epochal poem *The Waste Land* and James Joyce's *Ulysses*. In New York, he had become friends with Richard Wright. In the following years, Ellison schooled himself in virtually all aspects of modernist literary criticism and technique, including advanced uses of folk material, and deepened his understanding of his relationship to the mainstream American literary tradition going back to Emerson, Melville, and Whitman. In *Invisible Man,* his unnamed hero struggles with fundamental questions of identity as a naive young black man making his way in the American world. At times baffled and confused, hurt and alienated, Ellison's hero nevertheless is sustained by a recognizably American vivaciousness and optimism. This last quality perhaps accounted in part for the success of the book among many white critics, as well as with many blacks, when it appeared.

Another pivotal figure in the late 1940s and the early 1950s was James BALDWIN, who more clearly than Brooks or Ellison defined himself in opposition to earlier writers, and in particular to the master figure of Wright. Deploring what he saw as the commitment of black writing to forms of protest, Baldwin attacked *Native Son* in the celebrated essay "Everybody's Protest Novel" (*Partisan Review,* 1949), which is ostensibly concerned mainly with Harriet Beecher Stowe's *Uncle Tom's Cabin.* According to Baldwin, both novels dehumanize their black characters; art must rise, he argued, above questions of race and politics if it is to be successful. In his own first novel, *Go Tell It on the Mountain* (1953), set almost entirely within a black American community, a troubled adolescent struggles against a repressive background of storefront Pentecostal religion to assert himself in the face of his brutal, insensitive father and passive, victimized mother. Baldwin's second novel, *Giovanni's Room* (1956), on the individual's search for identity in the face of homophobia, included no black characters at all.

In 1954, the U.S. Supreme Court decision *Brown* v. *Board of Education* appeared to signal the end of segregation across the United States. Instead, it set in motion sharpening conflicts over the standing questions concerning race, identity, and art as the civil rights movement carried the struggle to the strongholds of segregation in the South. These conflicts in the 1950s and the early 1960s (in the era before the distinctive rise of Black Power as a philosophy, with its attendant BLACK ARTS MOVEMENT) certainly stimulated the growth of African-American literature. Some older black writers, such as Hughes, Wright, Tolson, and Brooks, published effectively in this period. Hughes brought out five collections of stories based on his popular character "Simple," drawn from his columns in the weekly Chicago *Defender,* as well as several other books, including his second volume of autobiography, *I Wonder as I Wander* (1956). Ellison's collection of essays, *Shadow and Act* (1964), on the interplay between race and culture, consolidated his reputation as a leading intellectual. Baldwin became celebrated as an essayist with dazzling collections such as *Notes of a Native Son* (1956) and *Nobody Knows My Name* (1961). His novel *Another Country* (1962), with its exploration of the themes of miscegenation and bisexuality among blacks and whites, was a bestseller. In focusing primarily on whites, however, *Another Country* perhaps epitomized the integrationist impulse that was soon to pass from African-American writing.

In the theater (*see* DRAMA), Lorraine HANSBERRY's *A Raisin in the Sun* (1959) dramatized in timely fashion the conflicts of integration within a black family rising in the world. This play became the longest-running drama by an African American in the history of Broadway, as well as an acclaimed motion picture. When Hansberry won the New York Drama Critics Circle Award, she became the first black American and the youngest woman to do so. Other playwrights of the 1950s included the indefatigable Langston Hughes, who broke ground with gospel plays such as *Black Nativity* and *Jericho-Jim Crow,* as well as younger writers such as Alice CHILDRESS (*Mojo, a Black Love Story;* 1971), William BRANCH (*In Splendid Error;* 1953), Loften MITCHELL (*A Land beyond the River;* 1957), and the actor-dramatist Ossie DAVIS, whose *Purlie Victorious* (1961) was a solid commercial success.

Although the civil rights struggle was being waged mainly in the South, a major disquieting voice boldly challenging racism in the United States was that of MALCOLM X. *The Autobiography of Malcolm X,* cowritten with Alex HALEY and published in the year of Malcolm's assassination (1965), was hailed almost at once as a classic work that combined spiritual autobiography with racial and political polemic. The work tells of Malcolm's rise from a life of crime and sin to deliverance through his conversion to the Nation of Islam, then his repudiation of that sect in favor of a more inclusive vision of world and racial unity. Malcolm's work appeared to stimulate a series of highly significant autobiographies that demonstrated once again the centrality of this genre to black culture. Claude BROWN's *Manchild in the Promised Land* (1965) is an often harrowing account of its author's determination to climb from a life of juvenile

Judges for the Amy E. Spingarn prizes for literature and art. (Moorland-Spingarn Research Center, Howard University)

delinquency in Harlem. Anne MOODY's autobiography, *Coming of Age in Mississippi* (1969), chronicles her troubled evolution from a small-town southern girlhood into a life as a militant worker in the tumultuous civil rights movement; it illuminates both her individual growth and some of the weaknesses of the movement as it affected many idealistic young blacks. Maya ANGELOU's *I Know Why the Caged Bird Sings* (1970) is a lyrical but also realistic autobiography of a woman whose indomitable human spirit triumphs over adversity, including her rape as a child.

Although Malcolm's *Autobiography* appeared finally to repudiate racial separation, it had a major impact on the separatist ideal that informed the next major stage in the evolution of African-American culture. In 1965, in a break with the integrationist ideal of all the major civil rights organizations, younger black leaders began to rally around the cry of Black Power. In this move, they were supported brilliantly by certain writers and artists. In 1964, LeRoi Jones, soon to be known as Amiri BARAKA, had staged *Dutchman* and *The Slave,* two plays that anticipated this turnabout. A graduate of Howard University, Jones had begun his career as a bohemian poet in Greenwich Village, where he had edited the magazine *Yugen* and helped to edit *The Floating Bear* and *Kulchur.* All of these journals featured the work of avant-garde poets, almost all of them white. Exploring the sensibility of a bohemian poet, his first volume of verse, *Preface to a Twenty-Volume Suicide Note* (1961), touched only lightly on the theme of race. *Dutchman* and *The Slave,* however, laid bare Jones's deepening hatred of white culture and of African-American artists and intellectuals who resisted the evidence of white villainy. He soon left Greenwich Village for Harlem, where he founded the Black Arts Repertory Theatre School. Barring whites, he transformed himself into an ultraradical black artist, an extreme cultural nationalist whose art would be determined almost entirely by the conflicts of race and by the connection between blacks and Africa.

Vividly expounded by Baraka and by other theorists (several of them poets) such as Ron KARENGA and Larry NEAL, radical cultural nationalism became the dominant aesthetic among younger blacks. Baraka's collection of new poems, *Black Magic* (1969), defined the artistic temper of the movement. These and other poems of the age voiced their radical opinions in blunt, often profane and even obscene language inspired by an easy familiarity with black street idioms and jazz rhythms, conveyed through typographic and other stylistic innovations. A spurning of all persons and things white and a romantic questing for kinship with Africa—the proclaimed fountainhead of all genuine spirituality—characterized the writing of these cultural nationalists. Addison Gayle,

Jr.'s *The Black Aesthetic* (1971), an edited collection of essays on literature and the other arts by black writers, gave another name and another degree of focus to the movement, even though several of the essays did not readily endorse the new radical nationalist position. Undoubtedly the most respected journal sympathetic to the new movement, imaginatively edited by Hoyt Fuller, was the monthly BLACK WORLD (formerly called *Negro Digest,* and published by the parent company of *Ebony* magazine).

Baraka's attempt to form a theater committed to the politically purposeful expression of African-American values encouraged black playwrights to be bolder than ever. However, the existence Off-Broadway of the NEGRO ENSEMBLE COMPANY, led by Douglas Turner WARD, with a vision often in conflict with Baraka's, ensured variety among the writers. The result was probably the most prolific period in the history of African-American theater. Baldwin's *Blues for Mister Charlie* (1964) and *The Amen Corner* (staged on Broadway in 1965) reflected the new militancy and cynicism of black artists as they viewed the American landscape. Hansberry's *The Sign in Sidney Brustein's Window* (first staged in 1964) explored the minds and reactions of white liberals in contemporary New York. Adrienne KENNEDY's *Funnyhouse of a Negro* (1964–1969) revealed her interest in expressionism and violence as she pursued questions of identity and personality. Charles Gordone's realist *No Place to Be Somebody* (1969) won a Pulitzer Prize for drama, the first by a black American. Other playwrights included Ted SHINE, Douglas Turner Ward, Ed BULLINS, Philip Hayes Dean, Ron MILNER, and Richard Wesley. Lonnie ELDER III wrote the acclaimed *Ceremonies in Dark Old Men* (1969), and Charles FULLER later enjoyed a commercial hit with *A Soldier's Play* (1981) about blacks in the military. In 1975, Ntozake SHANGE's brilliant staging of her "choreopoem" *For Colored Girls Who Have Considered Suicide / When the Rainbow Is Enuf* captivated audiences as it anticipated a theme of rising importance, the feminist revaluation by women of their role in American and African-American culture.

In spite of successes on stage and in fiction, poetry became the most popular genre of the new black writers of the late 1960s. One encouraging development was the rise of small black-owned publishing houses (*see* PUBLISHERS), especially Dudley RANDALL's Broadside Press and Naomi Long Madgett's Lotus Press, which brought out the work of several poets in cheap editions that reached a wide audience among blacks. In this way, Sonia SANCHEZ, Nikki GIOVANNI, Don L. Lee (later known as Haki MADHUBUTI), Mari EVANS, Lucille CLIFTON, Jayne CORTEZ, Etheridge KNIGHT, Conrad Kent Rivers, Samuel

Allen, June JORDAN, Carolyn RODGERS, Ted JOANS, Audre LORDE, and other writers acquired relatively large followings. Indeed, the relationship of poets to the black population in general had virtually no counterpart in the white world, where poetry had long passed almost entirely into the hands of academics. Among black poets less committed to populist and nationalist expression, the most outstanding were probably Jay WRIGHT and Robert HAYDEN. Hayden's first volume had appeared in 1940; his *Selected Poems* (1966) showed his commitment to an allusive poetry of reflection and painstaking art, even as he probed subjects as disparate as the African slave trade, the Holocaust, and the landscapes of Mexico. Somewhere between the populist poets and the gravely meditative Hayden was Michael S. HARPER, in whose several books of verse, such as *Dear John, Dear Coltrane* (1970) and *Nightmare Becomes Responsibility* (1975), one finds a lively interest in contemporary black culture, including jazz, as well as a deeply humane cosmopolitanism in the face of personal tragedy and the brutalities of racism.

With the exception of the work of a few poets, however, fiction by black writers exhibited a more sophisticated impulse than did poetry. Novelists such as Ishmael REED and William Melvin KELLEY broke relatively new ground in black fiction with work that often satirized whites and their culture, aspirations, and pretensions. Reed's *Yellow Back Radio Broke-Down* (1969) and *Mumbo Jumbo* (1972) are rich in diverse forms of parody, as are Kelley's *dem* (1967) and *Dunfords Travels Everywheres* (1970). Novelists such as William DEMBY, Jane Phillips, Charlene H. POLITE, and Clarence MAJOR also represented the commitment to narrative experimentalism that coexisted, sometimes uneasily, with the realist tradition in black American literature. More traditional in technique but equally rooted in an affection for black American culture is the fiction of Ernest GAINES, notably *The Autobiography of Miss Jane Pittman* (1971).

John A. WILLIAMS, with ten novels (as well as other books) published so far, was the most prolific black novelist of the era. Emphasizing the travails of blacks in white America but often with reference to international conspiracy, espionage, and genocide, his books include *The Man Who Cried I Am* (1967), *Sons of Darkness, Sons of Light* (1969), and *!Click Song* (1982). Another major figure, but one with different concerns, was Paule MARSHALL, whose publishing career spanned more than three decades. Born in Brooklyn but keenly aware of her Caribbean ancestry, she has explored her experience between these worlds in *Brown Girl, Brownstones* (1959), *The Chosen Place, the Timeless People* (1969), and *Praisesong for the Widow* (1983). The poet Margaret WALKER's historical novel *Jubilee* (1966) was probably the single most

popular work of fiction published by a black woman in the 1960s. Other fiction writers of the age include John Oliver KILLENS, Al YOUNG, and Cecil BROWN. Gayl JONES's novel *Corregidora* (1975) was praised for its lyrical examination of sexual fear and rage, and Toni Cade BAMBARA's collection of stories *Gorilla, My Love* (1972) richly reflected the wide range of personalities and styles within black America. Writers who established themselves as urban realists included Nathan Heard, Robert D. Pharr, Louise MERIWETHER, and George Cain.

By the late 1970s, the high point of the Black Power, Black Arts, and Black Aesthetic movements had clearly passed. However, all had left an indelible mark on the consciousness of the African-American writer. Virtually no significant black writer in any major form now defined him- or herself without explicit, extensive reference in some form to race and the history of race relations in the United States. On the other hand, gender began to rival race as a rallying point for an increasing number of women writers, most of whom addressed their concern for the black woman as a figure doubly imperiled on the American scene. Zora Neale Hurston's *Their Eyes Were Watching God* and, to a lesser extent, Harriet Jacobs's *Incidents in the Life of a Slave Girl* became recognized as fountainhead texts for black women, who were finally seen as having their own distinct line within the greater tradition of American writing.

The most influential black feminist fiction writer of this period was Alice WALKER, who gained critical attention with her poetry and with her novels *The Third Life of Grange Copeland* (1970) and *Meridian* (1976). However, *The Color Purple* (1981), with its exploration of the role of incest, male brutality against women, black "womanist" feeling (Walker's chosen term, in contrast to "feminist"), and lesbianism as a liberating force, against a backdrop covering both the United States and Africa, became an international success. The novel, which won Walker the Pulitzer Prize for fiction, appealed to black and white women alike, as well as to many men, although its critical portraiture of black men led some to see it as divisive. Gloria NAYLOR's *The Women of Brewster Place* (1982), the interrelated stories of seven black women living in a decaying urban housing project, was also hailed as a striking work of fiction; her *Linden Hills* (1985) and *Mama Day* (1988) brought her further recognition. Audre Lorde also contributed to black feminist literature, and expanded her considerable reputation as a poet with her autobiography, or "biomythography," *Zami: A New Spelling of My Name* (1982), which dealt frankly with her commitment to lesbianism as well as to black culture. With poetry, literary criticism, and her widely admired historical novel *Dessa Rose* (1986), Sherley Anne WILLIAMS established herself as a ver-

satile literary artist. Earlier fiction writers, such as Toni Cade Bambara and Paule Marshall, also published with distinction in a new climate of interest in women's writing. Bambara's *The Salt Eaters* (1980) and Marshall's *Daughters* (1991) found receptive audiences.

The most critically acclaimed black American writer of the 1980s, however, was Toni MORRISON. Without being drawn personally into the increasingly acrimonious debate over feminism, she nevertheless produced perhaps the most accomplished body of fiction yet produced by an African-American woman. Starting with *The Bluest Eye* (1970), then with *Sula* (1973), *Song of Solomon* (1977), *Tar Baby* (1981), and—garnering enormous praise—*Beloved* (1987), Morrison's works consistently find their emotional and artistic center in the consciousness of black women. *Beloved,* based on an incident in the nineteenth century in which a black mother killed her child rather than allow her to grow up as a slave, won Morrison the Pulitzer Prize for fiction in 1988. Her sixth novel, *Jazz,* appeared in 1992. In 1993 Morrison became the first black woman to be awarded the Nobel Prize for literature.

In some respects, the existence of a chasm between black female and male novelists was more illusion than reality. Certainly they were all participants in a maturing of the African-American tradition in fiction, marked by versatility and range, in the 1980s. In SCIENCE FICTION, for example, Samuel R. DELANY, Octavia BUTLER, and Steven Barnes produced notable work, as did Virginia HAMILTON in the area of CHILDREN'S LITERATURE. David BRADLEY in the vivid historical novel *The Chaneysville Incident* (1981), and John Edgar WIDEMAN in a succession of novels and stories set in the black Homewood section of Pittsburgh where he grew up, rivaled the women novelists in critical acclaim. Charles JOHNSON's novels *Oxherding Tale* (1982) and *Middle Passage* (1990; winner of the National Book Award) exuberantly challenged the more restrictive forms of cultural nationalism. Without didacticism, and with comic brilliance, Johnson's work reflects his abiding interests in Hindu and Buddhist religious and philosophical forms as well as in the full American literary tradition, including the slave narrative and the works of mid-nineteenth-century American writers.

The shift away from fundamental black cultural nationalism to more complex forms of expression was strongly reflected in the waning popularity of poetry. Most of the black-owned presses either went out of business or were forced by a worsening economic climate to cut back severely on their lists. The work of the most acclaimed new poet of the 1980s, Rita DOVE, showed virtually no debt to the cultural-nationalist poets of the previous generation. While Dove's verse indicated her interest in and even commitment to the exploration of aspects of black culture, it also indicated a conscious desire to explore more cosmopolitan themes; from the start, her art acknowledged formalist standards and her sense of kinship with the broad tradition of American and European poetry. In 1987, she won the Pulitzer Prize for poetry (the first African American to do so since Gwendolyn Brooks in 1950) with *Thomas and Beulah,* a volume that drew much of its inspiration from her family history in Ohio. She was named U.S. poet laureate in 1993.

Sealing the wide prestige enjoyed by African-American writers late in the twentieth century, a major playwright appeared in the 1980s to match the recognition gained by writers such as Morrison and Walker. August WILSON, with *Fences* (1986), *Ma Rainey's Black Bottom* (1988), *The Piano Lesson* (Pulitzer Prize, 1990), and *Two Trains Running* (1992), was hailed for the power and richness of his dramas of black life. George C. WOLFE, especially with *The Colored Museum* and *Jelly's Last Jam* (1992), also enjoyed significant critical success as a dramatist.

By the last decade of the twentieth century, the study of African-American literature had become established across the United States as an important part of the curriculum in English departments and programs of African-American studies. This place had been created in part by the merit of the literature, but more clearly in response to demands by black students starting in the 1960s. Still later, the prestige of black literature was reinforced in the academic community through widespread acceptance of the idea that race, class, and gender played a far greater role in the production of culture than had been acknowledged. The academic study and criticism of African-American writing also flourished. In addition to the work of anthologists, who had helped to popularize black writers since the 1920s, certain essays and books had helped to chart the way for later critics. Notable among these had been the work of the poet-scholar Sterling Brown in the 1920s and '30s, especially his ground-breaking analysis of the stereotypes of black character in American literature. More comprehensively, a white scholar, Vernon Loggins, had brought out a study of remarkable astuteness and sympathy, *The Negro Author: His Development in America to 1900* (1931).

In 1939, J. Saunders REDDING, himself a novelist and autobiographer of note, published a landmark critical study, *To Make a Poet Black;* with Arthur P. Davis, he also edited *Cavalcade,* one of the more important of African-American anthologies. Later, Robert Bone's *The Negro Novel in America* (1958; revised edition, 1965) laid the foundation for the future study of African-American fiction. In the 1960s and

Novelist Toni Morrison (left) receives the Nobel Prize for Literature from Swedish King Carl XVI Gustaf in the Concert Hall, Stockholm, Sweden, December 10, 1993. Morrison was the first black woman to receive this literature prize. (AP/Wide World Photos)

1970s, academics such as Darwin Turner, Addison Gayle, Jr., Houston A. Baker, Jr., Mary Helen Washington, George Kent, Stephen Henderson, and Richard Barksdale led the reevaluation of black American literature in the context of the more radical nationalist movement. In biography, the French scholar Michel Fabre and Robert Hemenway contributed outstanding studies of Richard Wright and Zora Neale Hurston, respectively. Another French scholar, Jean Wagner, published the most ambitious study of black verse, *Black Poets of the United States* (1973). Still later, other academics such as Barbara Christian, Hortense Spillers, Frances Smith Foster, Donald Gibson, Thadious Davis, Trudier Harris, Robert B. Stepto, Robert G. O'Meally, Richard Yarborough, Deborah McDowell, Hazel V. Carby, William L. Andrews, Nellie Y. McKay, Gloria Hull, and Henry Louis Gates, Jr., provided an often rich and imaginative counterpart in criticism and scholarship to the achievement of African-American creative writers of the past and present. Gates's *The Signifying Monkey* (1988), which explores the relationship between the African and African-American vernacular traditions and literature, became perhaps the most frequently cited text in African-American literary criticism. In 1991, Houston A. Baker, Jr., became the first African American to serve as president of the Modern Language Association, the most important organization of scholars and critics of literature and language in the United States.

REFERENCES

ANDERSON, JERVIS. *This Was Harlem: 1900–1950.* New York, 1981.

BONE, ROBERT. *The Negro Novel in America.* New Haven, 1965.

BONTEMPS, ARNA, ed. *The Harlem Renaissance Remembered.* New York, 1972.

CULLEN, COUNTEE, ed. *Caroling Dusk: An Anthology of Verse by Negro Poets.* New York, 1929.

DAVIS, ARTHUR P. *From the Dark Tower: Afro-American Writers 1900–1960.* Washington, D.C., 1981.

HONEY, MAUREEN, ed. *Shadowed Dreams: Women's Poetry of the Harlem Renaissance.* New Brunswick, N.J., 1989.

HUGGINS, NATHAN I. *Harlem Renaissance.* New York, 1971.

———, ed. *Voices from the Harlem Renaissance.* New York, 1976.

HUGHES, LANGSTON, and ARNA BONTEMPS, eds. *Poetry of the Negro, 1746–1970.* Garden City, N.Y., 1970.

HUGHES, LANGSTON. *The Big Sea.* New York, 1940.

IKONNE, CHIDI. *From Du Bois to Van Vechten: The Early Negro Literature, 1903–1926.* Westport, Conn., 1981.

JOHNSON, JAMES WELDON. *Along This Way.* New York, 1990.

KELLNER, BRUCE, ed. *The Harlem Renaissance: A Historical Dictionary for the Era.* New York, 1987.

KNOPF, MARCY. *The Sleeper Wakes: Harlem Renaissance Stories by Women.* New Brunswick, N.J., 1993.

LEWIS, DAVID LEVERING. *When Harlem Was in Vogue.* New York, 1989.

LOCKE, ALAIN, ed. *The New Negro.* New York, 1968.

McKAY, CLAUDE. *A Long Way from Home.* New York, 1970.

OSOFSKY, GILBERT. *Harlem: The Making of a Ghetto.* New York, 1963.

PERRY, MARGARET. *Silence to the Drums: A Survey of the Literature of the Harlem Renaissance.* Bloomington, Ind., 1985.

RAMPERSAD, ARNOLD. *The Life of Langston Hughes: Vol. 1, 1902–1941: I Too Sing America.* New York, 1986.

Studio Museum in Harlem. *Harlem Renaissance Art of Black America.* New York, 1987.

WAGNER, JEAN. *Black Poets of the United States.* Translated by Kenneth Douglas. Urbana, Ill., 1973.

WINTZ, CARY D. *Black Culture and the Harlem Renaissance.* Houston, 1988.

ARNOLD RAMPERSAD

Little, Malcolm. *See* Malcolm X.

Little Richard (Penniman, Richard) (December 25, 1935–), singer. Born to a devout Seventh-Day Adventist family, Richard Penniman began singing and playing piano in the church. He left home at thirteen to start a musical career. In 1951 he made some recordings with various jump-blues bands but with little success. Shortly thereafter, however, he began recording for Specialty Records, where he was to have six hits, beginning with "Tutti Frutti" (1954), that outlined the style that became rock and roll. In 1957 he left his music career behind and enrolled at Oakwood College in Huntsville, Ala., following an "apocalyptic vision." He received a B.A. and became a minister in the Seventh-Day Adventist church. Inspired by the "British invasion," he returned to rock and roll in 1964, but he was unable to recapture his early success. During the 1970s he brought his flamboyant act to the Las Vegas showroom circuit, billing himself as the "bronze Liberace." He returned to the church in the early 1980s,

but his influence on rock and roll was not forgotten. In 1986 he was among the first artists inducted into the newly established Rock and Roll Hall of Fame, an honor that helped restore his celebrity status in the late 1980s.

Little Richard's style, defined by his Specialty recordings, featured frenetic, shrieking vocals, suggestive lyrics, and boogie-woogie-style piano performed at a remarkably fast tempo. His flamboyant stage persona and extravagant costumes also became a significant part of his act.

REFERENCES

MORTHLAND, JOHN. "Little Richard." In the *New Grove Dictionary of American Music,* vol. 3. New York, 1986.

"Rock's Top Ten: Little Richard." *Rolling Stone* 467 (February 13, 1986): 37.

WHITE, CHARLES. *The Life and Times of Little Richard.* New York, 1984.

DANIEL THOM

Llewellyn, James Bruce (July 16, 1927–), businessman. Born in Harlem to Jamaican immigrants, J. Bruce Llewellyn attended New York City public schools. Llewellyn joined the U.S. Army at the age of sixteen and served in the Army Corps of Engineers from 1944 until 1948. He graduated from the City College of New York (CCNY) with a B.S. in 1955, and received a J.D. from New York Law School in 1960.

Llewellyn ran his first business, a retail liquor store in Harlem, while still in college. From 1958 to 1960, he was a student assistant in the New York County District Attorney's Office. From 1962 until 1965, after graduating from law school, Llewellyn was a partner in the small law firm of Evans, Berger, and Llewellyn. In 1965 he became the executive director of the Upper Manhattan office of the Small Business Development Corporation (SBDC), a federally funded city agency with several offices in New York City. After a brief tenure in 1965 as regional director of the federal Small Business Administration (SBA), Llewellyn returned to the SBDC between 1965 and 1968, serving as a program officer, director of its management training program, and eventually executive director. From 1968 to 1969, he was the deputy commissioner of the New York City Housing and Development Administration. Later government service included acting from 1977 to 1981 as the first African-American president of the Overseas Private Investment Corporation (OPIC), a federal agency which facilitates private business investment in developing countries, during the Carter administration.

In 1969 Llewellyn decided to seek greater entrepreneurial opportunities. Symbolic of his philosophy that "you have to be willing to take chances" to succeed, Llewellyn bought Fedco Food Stores, a supermarket chain in the Bronx, after mortgaging his house and securing loans from other sources. Despite its location in one of the poorest areas of New York City, Llewellyn built the chain into a successful business. By 1975 Fedco had sales of over $30 million, had 500 employees, and was the fourth largest black-owned firm in the country. By 1983 the chain had twenty-nine stores and sales of almost $100 million. In the same year, Llewellyn broke up the company, selling each store to independent minority grocers.

With his earnings from the sale of Fedco, Llewellyn and several partners—including basketball great Julius ERVING and comedian Bill COSBY—bought a stake in the New York Coca-Cola Bottling Company in 1983. Two years later, the same group purchased the Philadelphia Coca-Cola Bottling Company, becoming the first African-American owners of a Coca-Cola bottling franchise. By 1992 the company, with Llewellyn as chairman of the board and CEO, was the third largest black-owned industrial/service business in the United States, with $266 million in sales and more than 800 employees. Llewellyn has also served as the chief executive officer of the Coca-Cola Bottling Company of Wilmington, Inc.; Garden State Cablevision, Inc.; and Queen City Broadcasting, Inc., of Buffalo, N.Y.

Llewellyn has endeavored to make greater economic opportunities available to minorities. His purchase of Fedco was explicitly aimed towards increased opportunities for black and Hispanic workers. He was president of One Hundred Black Men, a service organization of African-American professionals, during much of the 1970s. During the 1980s, Llewellyn criticized the Reagan administration for "going backwards" in race relations and making them more antagonistic. As an adviser to various state and national organizations, Llewellyn has campaigned for maintaining affirmative action, as long as professional standards are not sacrificed.

REFERENCES

BERNS, DAVID L. "Ahead on the Fast Track; Entrepreneur Capitalizes on Wits, Glitz." *USA Today,* March 14, 1989, p. 1B.

HERBST, LAURA. "J. Bruce Llewellyn; Helping Blacks Get Ahead." *New York Times,* June 26, 1988, Sec. 12, p. 2.

TAYLOR, B. KIMBERLY. "What Do These Millionaires Have in Common? They All Found Work with Equal Opportunity Employers Themselves." *New York Newsday,* February 1, 1994, p. 44.

ALANA J. ERICKSON

Lloyd, Ruth Smith (January 25, 1917–), anatomist. Ruth Smith Lloyd was born in Washington, D.C., the daughter of Bradley Donald and Mary Elizabeth Morris Smith. A 1933 graduate of Dunbar High School, she attended Mount Holyoke College, where she earned an A.B. in zoology (magna cum laude) in 1937. On the urging of her zoology professors, she went on for graduate work at Howard University under the eminent black zoologist Ernest Everett JUST. In 1938, she earned an M.S. in zoology, and Just motivated her to pursue doctoral studies. With the support of a Rosenwald Fellowship, she earned a Ph.D. in anatomy at Western Reserve University in 1941. Her thesis focused on adolescent development in macaques, a type of monkey. She was the first African-American woman to receive a doctorate in anatomy.

Lloyd began her professional career in physiology at Howard (1940–1941, 1942) and in zoology at Hampton Institute (1941–1942). In 1942, she was appointed instructor in anatomy at Howard's college of medicine. She became assistant professor of anatomy in 1947 and associate professor in 1955, the position she held until her retirement in 1977. Lloyd's primary research interest was ovarian anatomy. She also assisted William Montague COBB, head of the anatomy department at Howard, on a bibliography of physical anthropology, published in the December 1944 issue of *American Journal of Physical Anthropology.* Among her numerous educational activities, she was a director of Howard's academic reinforcement program for medical students during the mid-1970s.

Lloyd was a member of the American Association of Anatomists, American Association of Medical Colleges, and New York Academy of Sciences. Her husband, Sterling Morrison Lloyd (whom she married in 1939), was a physician. The couple had three children.

REFERENCE

Who's Who of American Women. Chicago, 1975, p. 532.

KENNETH R. MANNING

Local 1199: Drug, Hospital, and Health Care Employees Union. Since the late 1950s, Local 1199, the hospital workers' union based in New York City, has been one of the largest and most effective minority-dominated unions in the United States. The union organized tens of thousands of the most exploited and disempowered black workers and was an important component of LABOR support for

the CIVIL RIGHTS MOVEMENT. Local 1199 was also rare within the labor movement in the United States for its commitment to interracial working-class organizing and a broader social vision of economic justice and ethnic pluralism.

In 1932 the union was founded as Local 1199 of the Retail Drug Employees Union through the merger of two COMMUNIST PARTY–led drugstore unions in New York City. Over the next twenty-five years, the membership of the local remained mostly white, but in 1957 it began organizing in New York City hospitals, whose janitors, orderlies, nurse's aides, laundry workers, and food employees were predominantly black and Latino, mostly women, and nearly all poor. With successful organizing drives at several hospitals in the late 1950s and early '60s, Local 1199 added tens of thousands of these workers to its ranks and almost overnight was reborn as one of the most important minority-dominated unions in the United States. Despite its growing identification as a "black" union, however, 1199's leadership, headed by Russian immigrant Leon Davis (1906–1992), remained largely white, mostly Jewish ex-communists from the drugstore union.

Though its ties to the American Communist party were effectively severed during the McCarthy era, the union vigorously promoted a wider political agenda than simple economic concerns and actively participated in the civil rights movement of the 1950s and '60s. During a series of pivotal organizing strikes in 1959, Local 1199 gained the public support of several civil rights leaders, including the Rev. Dr. Martin Luther KING, Jr., and A. Philip RANDOLPH. In the 1960s King was a frequent visitor at the union's demonstrations and often referred to Local 1199 as "my favorite union." The union, whose official motto came to be "union power, soul power," regularly sponsored cultural programs with African-American and political themes and donated the proceeds to the SOUTHERN CHRISTIAN LEADERSHIP CONFERENCE (SCLC) and other civil rights organizations.

In the 1960s Local 1199 enjoyed rapid and extensive growth, successfully organizing nearly every major hospital in the New York City area. Many of the black workers organized by 1199 in this period declared their struggle to be a northern, urban extension of the civil rights movement. The civil rights slogan of "Freedom Now!" became 1199's motto as well. A 1963 campaign on behalf of collective-bargaining legislation for hospital employees was called "Operation First-Class Citizenship," and several organizing efforts carried the slogan "Freedom and Decent Jobs." The union's greatest economic achievement came in 1968 with the attainment of a $100-per-week minimum salary from the League of Voluntary Hospitals and Homes of New York, a co-

alition of fifteen hospitals that employed a majority of 1199's membership. During the 1960s Local 1199 tripled the wages of its rank and file, built a large cooperative-housing development in East Harlem, and distinguished itself in the labor movement for its wide-ranging and sophisticated cultural programs.

In 1969 Local 1199's reputation as a civil rights union was cemented when staff members joined leaders of the SCLC in assisting a strike of 510 hospital workers in Charleston, S.C. All the striking workers were black, and 498 were women. For four months Charleston's newly formed Local 1199B waged one of the South's fiercest labor battles since the 1930s. Nearly a thousand strikers and supporters were arrested. The National Guard was called out to contain the union's protests. Though the workers won some gains in wages, benefits, and working conditions, they failed to achieve union recognition. Nonetheless, as a result of the Charleston strike, 1199's mission came to be seen within and outside the union as an inextricable part of the broader black struggle for political and economic power.

Despite its limited success, the Charleston campaign encouraged Davis and the 1199 leadership to expand organizing efforts beyond New York City. In the early 1970s the union scored several certifications in eastern cities and was most successful in areas with large black hospital workforces, notably in Baltimore and Philadelphia, where roughly half of the health-care service workers were African American. By 1973 the union counted nearly eighty thousand members in twenty regional affiliates in fourteen states and the District of Columbia, though at least three-quarters of the membership was in the New York area. To consolidate its new victories, Local 1199 hosted a convention in New York in 1973, at which it founded the National Union of Hospital and Health Care Employees, the central coordinating organization for its various regional districts. The national hospital union remained an affiliate of its original parent union, renamed the Retail, Wholesale, Department Store Union (RWDSU). Davis was elected national president in addition to his position as president of the New York district. The national union continued to grow throughout the 1970s, reaching a peak of 150,000 members by the end of the decade.

In the 1970s and early '80s, a cadre of African-American leaders emerged from the rank and file to take the place of the aging white hierarchy. Davis, nearing retirement in 1981, instructed an informal black caucus of the union's executive council to nominate an African American as his successor in the national office. The caucus unanimously selected Henry Nicholas, a former nursing attendant, who had built the Philadelphia union into 1199's second-largest district organization. Nicholas was formally elected at

the union convention in December 1981. Five months later, Doris Turner (1930–), a former diet clerk who had become vice president of the New York hospital division, was chosen to succeed Davis as president of the New York district, which was still the union's center of power.

The end of Davis's fifty-year reign initiated an intense power struggle within 1199's black leadership—with charges of racism suddenly rampant in a union that had long prided itself on interracial solidarity. Under Turner, New York Local 1199 experienced seven years of internal strife as the new president purged the staff of the former leadership, isolated the local from the national union, and accused her enemies of practicing paternalistic racism. In 1984 a dissident faction developed in New York after an unsuccessful forty-six-day strike and allegations of corruption and embezzlement were leveled against the Turner leadership. Antagonisms within the local become so intense that activists on both sides carried guns for self-defense; Turner herself traveled with a phalanx of armed bodyguards.

A slate of rebels, headed by Georgianna Johnson (1930–), a black social-work assistant, defeated Turner at the union's 1986 officer elections. But Johnson's brief tenure as president of New York Local 1199 was similarly plagued by mismanagement and ineffectual contract negotiations. In 1989 Dennis Rivera (1950–), a Puerto Rican immigrant, was nominated by the executive council to replace Johnson, and he won by a nine-to-one ratio in a virtually uncontested election. Shortly thereafter the national union changed its name to the Drug, Hospital and Health Care Employees Union.

Soon after his election Rivera gained national prominence by winning several key contracts from New York hospitals and by reinvigorating 1199's political activism. The union helped lead the Rev. Jesse JACKSON's New York campaign in the 1988 Democratic presidential primary and served as a crucial base of support for David DINKINS's successful New York mayoral bid in 1989. In the early 1990s Rivera and the 1199 leadership broke with the local Democratic party to help establish the New Coalition party, an alliance of New York labor, civil rights, and various grassroots groups that pressured Mayor Dinkins and the city council from the left during the 1993 municipal elections.

REFERENCES

FINK, LEON, and BRIAN GREENBERG. *Upheaval in the Quiet Zone: A History of Hospital Workers' Union, Local 1199.* Urbana, Ill., 1989.

RASKIN, A. H. "Profiles: Getting Things Done." *New Yorker* (December 10, 1990): 54–85.

THADDEUS RUSSELL

Locke, Alain Leroy (September 13, 1885–June 9, 1954), philosopher. Best known for his literary promotion of the HARLEM RENAISSANCE of the 1920s, Alain Locke was a leading spokesman for African-American humanist values during the second quarter of the twentieth century. Born into what he called the "smug gentility" and "frantic respectability" of Philadelphia's black middle class, Locke found himself propelled toward a "mandatory" professional career that led to his becoming the first African-American Rhodes scholar, a Howard University professor for over forty years, a self-confessed "philosophical midwife" to a generation of black artists and writers between the world wars, and the author of a multifaceted array of books, essays, and reviews.

Locke was descended from formally educated free black ancestors on both maternal and paternal sides. Mary and Pliny Locke provided their only child with an extraordinarily cultivated environment, partly to provide "compensatory satisfactions" for the permanently limiting effects that a childhood bout with rheumatic fever imposed. His mother's attraction to the ideas of Felix Adler brought about Locke's entry into one of the early Ethical Culture schools; his early study of the piano and violin complemented the brilliant scholarship that won him entry to Harvard College in 1904 and a magna cum laude citation and election to Phi Beta Kappa upon graduation three years later.

Dr. Alain Locke on the *Town Hall Show*. (McNeill Photo)

Locke's undergraduate years, during Harvard's "golden age of philosophy," culminated with his being selected a Rhodes scholar from Pennsylvania (the only African American so honored during his lifetime) and studying philosophy, Greek, and humane letters at Oxford and Berlin from 1907 to 1911. There Locke developed his lasting "modernist" interests in the creative and performing arts, and close relationships with African and West Indian students that gave him an international perspective on racial issues. Locke's singular distinction as a black Rhodes scholar kept a national focus on his progress when he returned to the United States in 1912 to begin his long professional career at Howard University. His novitiate there as a teacher of English and philosophy was coupled with an early dedication to fostering Howard's development as an "incubator of Negro intellectuals" and as a center for research on worldwide racial and cultural contacts and colonialism. He managed simultaneously to complete a philosophy dissertation in the field of axiology on "The Problem of Classification in Theory of Value," which brought him a Ph.D. from Harvard in 1918. In 1924, he spent a sabbatical year in Egypt collaborating with the French Oriental Archeological Society for the opening at Luxor of the tomb of Tutankhamen.

On his return in 1925, Locke encountered the cycle of student protests then convulsing African-American colleges and universities, including Hampton, Fisk, and Lincoln, as well as Howard. Subsequently dismissed from Howard because of his allegiances with the protestors, he took advantage of the three-year hiatus in his Howard career to assume a leadership role in the emerging Harlem Renaissance by first editing the March 1925 special "Harlem number" of *Survey Graphic* magazine. Its immediate success led him to expand it into book form later that year in the stunning anthology THE NEW NEGRO, which—with its cornucopia of literature, the arts, and social commentary—gave coherent shape to the New Negro movement and gave Locke the role of a primary interpreter.

More than just an interpreter, mediator, or "liaison officer" of the New Negro movement, however, Locke became its leading theoretician and strategist. Over the following fifteen years, and from a staggering diversity of sources in traditional and contemporary philosophy, literature, art, religion, and social thought, he synthesized an optimistic, idealistic cultural credo, a "New Negro formulation" of racial values and imperatives that he insisted was neither a formula nor a program, but that confronted the paradoxes of African-American culture, charting what he thought was a unifying strategy for achieving freedom in art and in American life.

Locke's formulation was rooted, like the complex and sometimes competing ideological stances of W. E. B. DU BOIS, in the drive to apply the methods of philosophy to the problems of race. It fused Locke's increasingly sophisticated "cultural racialism" with the new cultural pluralism advocated by Jewish-American philosopher Horace Kallen (a colleague during Locke's Harvard and Oxford years) and by Anglo-American literary radicals such as Randolph Bourne and V. F. Calverton. Locke adapted Van Wyck Brooks's and H. L. Mencken's genteel critical revolt against Puritanism and Philistinism to analogous problems facing the emergent but precarious African-American elite; and he incorporated into his outlook the Whitmanesque folk ideology of the 1930s and 1940s "new regionalism." Finally, Locke's credo attempted to turn the primitivist fascination with the art and culture of Africa to aesthetic and political advantage, by discovering in it a "useable past" or "ancestral legacy" that was both classical and modern, and by urging an African-American cultural mission "apropos of Africa" that would combine the strengths of both Garveyism and Du Bois's Pan-African congresses.

In the course of doing so, Alain Locke became a leading American collector and critic of African art, clarifying both its dramatic influence on modernist aesthetics in the West and its import as "perhaps the ultimate key for the interpretation of the African mind." In conjunction with the Harmon Foundation, he organized a series of African-American art exhibitions; in conjunction with Montgomery Gregory and Marie Moore-Forrest, he played a pioneering role in the developing national black theater movement by promoting the Howard University Players, and by coediting with Gregory the 1927 watershed volume *Plays of Negro Life: A Source-Book of Native American Drama.* From the late 1920s to mid-century, Locke published annual *Opportunity* magazine reviews of scholarship and creative expression that constitute in microcosm an intellectual history of the New Negro era.

With the onset of the worldwide depression in 1929 and the end of the 1920s "vogue for things Negro," Locke viewed the New Negro movement to be shifting, in lockstep, from a "Renaissance" phase to a "Reformation." His commitment to adult-education programs led him to publish, for the Associates in Negro Folk Education, *The Negro and His Music* and *Negro Art: Past and Present* in 1936 and a lavish art-history volume, *The Negro in Art: A Pictorial Record of the Negro Artists and the Negro Theme in Art,* in 1940. A return to formal work in philosophy found him producing a series of essays in the 1930s and 1940s on cultural pluralism. And his early interest in the scientific study of global race relations was revived in his coediting with Bernhard Stern of *When Peoples Meet: A Study in Race and Culture Contacts* (1942).

During a year as an exchange professor in Haiti, Locke had begun a potential magnum opus on the cultural contributions of African Americans, which occupied the last decade of his life, when his preeminence as a scholar and the lessening of segregation in American higher education kept him in demand as a visiting professor and lecturer within the United States and abroad. The effects of his lifelong heart ailments led to Locke's death in June 1954. His uncompleted opus, *The Negro in American Culture,* was completed and published posthumously by Margaret Just Butcher, daughter of a Howard colleague.

REFERENCES

HARRIS, LEONARD. *The Philosophy of Alain Locke: Harlem Renaissance and Beyond.* Philadelphia, 1989.

LINNEMANN, RUSSELL J. *Alain Locke: Reflections on a Modern Renaissance Man.* Baton Rouge, La., 1982.

TIDWELL, J. EDGAR, and WRIGHT, JOHN S. "Alain Locke: A Comprehensive Bibliography of His Published Writings." *Callaloo* 4 (February–October 1981).

JOHN S. WRIGHT

treated demonstrators who were camped in "Resurrection City" during the POOR PEOPLE'S WASHINGTON CAMPAIGN.) He was also the friend and personal physician of the Rev. Dr. Martin Luther KING, Jr., Jackie ROBINSON, Whitney YOUNG, and Duke ELLINGTON, one of whose compositions *UMMG* (1956), was dedicated to Logan.

Logan fell to his death in 1973 while inspecting the site of a proposed expansion of the Knickerbocker Hospital in Harlem, a project that consumed much of his time during the last five years of his life. His funeral service was attended by more than two thousand mourners. In 1977, the City University of New York School of Community Health and Social Medicine endowed a chair in his name.

REFERENCES

HASSE, JOHN EDWARD. *Beyond Category: The Life and Genius of Duke Ellington.* New York, 1993.

HAYDEN, ROBERT, C., and JACQUELINE HARRIS. *Nine Black American Doctors.* Reading, Mass., 1976.

Obituary. *New York Times,* November 26, 1973.

JOSEPH W. LOWNDES

LYDIA MCNEILL

Logan, Arthur Courtney (September 8, 1909–November 25, 1973), surgeon and civil rights activist. Arthur C. Logan was born in Tuskegee, Ala., where his father worked as treasurer for the Tuskegee Institute (*see* TUSKEGEE UNIVERSITY). At age nine he went to live with his sister Ruth Logan Roberts and her husband Eugene Percy Roberts in New York City, both of whom were health care professionals. He received his B.S. from Williams College in 1928, and then became one of the first African Americans to earn an M.D. from the College of Physicians and Surgeons at Columbia University. Logan did his internship at Harlem Hospital from 1934 to 1936 where he was trained by the well-known black medical researcher and surgeon Louis T. WRIGHT. In 1948, Logan founded the Upper Manhattan Medical Group (UMMG), an early health maintenance organization. Logan was a surgeon at Harlem Hospital until he left in 1962 to become chief of surgery at Sydenham Hospital, also in Harlem.

In 1965, Logan was appointed by New York City Mayor Robert Wagner to head the city's Council Against Poverty. He was also deeply involved in civil rights struggles, and was active in both the SOUTHERN CHRISTIAN LEADERSHIP CONFERENCE (SCLC) and the NATIONAL URBAN LEAGUE. Often referred to as the "house physician to the civil rights movement," Logan saw to the medical needs of protestors. (In 1968, for example, he organized the medical team that

Logan, Myra Adele (1908–January 13, 1977), physician and surgeon. Myra Logan was born in Tuskegee, Ala., where her father was treasurer of the Tuskegee Institute (*see* TUSKEGEE UNIVERSITY). She attended Tuskegee's laboratory school, the Children's House. A 1923 honors graduate of Tuskegee High School, she was the valedictorian of her graduating class at Atlanta University in 1927. She then moved to New York City where her sister, Ruth Logan Roberts, a nurse involved in public health issues, was already living. Logan received an M.S. in psychology from Columbia University in New York, and an M.D. from New York Medical College in 1933. (She went to medical school on a $10,000 four-year scholarship established by Walter Gray Crump, a white surgeon committed to helping blacks advance in the medical profession.)

Logan did her internship at Harlem Hospital, and continued to practice there as a surgeon. She is generally regarded as the first woman to successfully operate on the heart, and was the first black woman elected a Fellow of the American College of Surgeons. She did extensive research on the use of aureomycin and other antibiotics, publishing many articles on the subject in such medical journals as *The Archives of Surgery* and *The Journal of American Medical Surgery.* Along with her brother, the physician Arthur C. LOGAN, she was a founding member of an early health

maintenance organization, the Upper Manhattan Medical Group of the Health Insurance Plan. She left the group in 1970 to join the Physical Disability Program of the New York State Workmen's Compensation Board. Logan was a member of many organizations, including the Planned Parenthood Association and the National Medical Association of the NAACP. She had been a member of the New York State Committee on Discrimination, but resigned in 1944 to protest Gov. Thomas E. Dewey's disregard of the antidiscrimination legislation the committee had proposed.

She died in New York City in 1977.

REFERENCES

HABER, LOUIS. *Women Pioneers in Science.* San Diego, Calif., 1979.
Obituary. *New York Times,* January 15, 1977.

LYDIA MCNEILL

Logan, Rayford Whittingham (January 7, 1897–November 4, 1982), historian. Born to Arthur C. and Martha Logan, Rayford Logan was born and raised in Washington, D.C. Although his family was poor, it had social status and connections owing to Arthur's position as butler to the Republican senator from Connecticut. Logan was educated at the prestigious but segregated M Street (later Dunbar) High School, whose faculty included Carter G. WOODSON and Jessie FAUSET, and whose alumni included Charles HOUSTON, William HASTIE, and Charles DREW; his secondary education was conscious preparation not only for college but also for race leadership. He attended Williams College (graduating Phi Beta Kappa in 1917) and then joined the Army, rose to lieutenant, and was injured in combat.

World War I was a turning point for Logan. Like most African Americans, he had expected that participation in the conflict would lead to full citizenship rights for him. But the extreme racism of Army life angered him. After the armistice, he demobilized in France, remaining there for five years. Because he avoided white American tourists, he experienced the freedom of a society that appeared to harbor little animus toward people of color. While an expatriate, he began a lifelong association with W. E. B. DU BOIS and became a leading advocate of PAN-AFRICANISM, helping to articulate a program for racial equality in the United States and the protection and development of Africans.

In 1924 Logan returned to the United States with a desire to pursue an academic career and merge it with civil rights activism. While working toward an A.M. at Williams (1927) and a Ph.D. from Harvard (1936), Logan taught at Virginia Union University (1925–1930) where he was the first to introduce courses on imperialism and black history, and at Atlanta University (1933–1938). Both were elite, historically black colleges. He also spent two years as Woodson's assistant at the ASSOCIATION FOR THE STUDY OF NEGRO LIFE AND HISTORY. (Along with Du Bois, Woodson was a seminal influence on Logan's scholarship.) In the 1930s he worked closely with Du Bois on the *Encyclopedia of the Negro* project. In 1938 he moved to Howard University, where he remained until he retired in 1974. Logan developed a strong scholarly and political interest in Haiti and the European powers' administration of their African colonies. His dissertation on Haiti and the United States broke new scholarly ground on the issue of race and diplomacy (*see* HAITIAN REVOLUTION). He witnessed firsthand the 1934 end of the American occupation of the island republic, and in 1941 the Haitian government awarded him the Order of Honor and Merit with rank of commander for his scholarship and advocacy. In the same year, his study *The Diplomatic Relations of the United States with Haiti, 1776–1891* was published. His articles on colonial abuses in Africa and the African DIASPORA appeared in the *Journal of Negro History,* the *Journal of Negro Education,* and the *Pittsburgh Courier.*

The thrust of Logan's scholarship and activism was to promote the dignity and equality of black people around the world and to expose the racial hypocrisy of American democracy. He organized voter registration drives in Richmond and Atlanta in the 1920s and 1930s, campaigned against the segregated military in the 1940s, and was a leader in A. Philip RANDOLPH's March on Washington Movement (participating in the final negotiations that led to Executive Order 8802). In 1944 he edited *What the Negro Wants,* a collection of essays by fourteen prominent African Americans that helped to put squarely before a national, interracial audience the demand for a total end to segregation. He championed, in close association with Du Bois, the cause of African and Third World decolonization in the post–World War II era; between 1948 and 1950 he was the NAACP's principal adviser on international affairs. His most renowned work, *The Negro in American Life and Thought: The Nadir, 1877–1901* (1954), established an analytical framework that historians continue to find useful. Logan spent his last decade compiling and editing, with Michael R. Winston, the *Dictionary of American Negro Biography* (1982), an important reference work that was inspired by Du Bois's unfinished *Encyclopedia of the Negro.*

An intellectual of considerable talent, Logan also hoped to be a major civil rights figure. But in part because of his abrasive personality and aversion to accepting the organizational discipline of others and in part because his views were at times more strident than those of the mainstream advancement organizations, he could more often be found on the margins, in the role of the prophet who received little recognition. This conundrum allowed Logan the luxury of being an incisive critic but prevented him from consistently implementing his often farsighted plans and from accumulating the recognition he felt he deserved from both African Americans and white Americans. Nevertheless, he was awarded the SPINGARN MEDAL by the NAACP in 1980. He died in Washington, D.C., in 1982.

REFERENCES

JANKEN, KENNETH ROBERT. *Rayford W. Logan and the Dilemma of the African-American Intellectual.* Amherst, Mass.: University of Massachusetts Press, 1993.

MEIER, AUGUST, and ELLIOTT RUDWICK. *Black History and the Historical Profession, 1915–1980.* Urbana, Ill., 1986.

KENNETH ROBERT JANKEN

Loguen, Jermain Wesley (Logue, Jarm)

(c. 1813–September 30, 1872), minister and abolitionist. Jermain Wesley Loguen was born Jarm Logue on a plantation sixteen miles outside of Nashville. His mother, Jane, lived as a freeperson in Ohio until she was kidnapped as a young girl and sold into slavery to David Logue, who, with his two brothers, owned a small plantation. Logue changed Jane's name to Cherry and was probably Jarm's father. The brutality of plantation life—Jarm saw his mother whipped repeatedly, and witnessed the murder of another slave by a white planter—fueled his fierce determination to escape.

Jarm Logue's first attempt to escape failed. But the sale of his sister made him determined to try again. In about 1834 or 1835, Logue, aided by Quakers, succeeded in escaping, first to Detroit and then to Fort Hamilton, Upper Canada (now Ontario) where a white family hired him as a farm laborer. They taught him to read and urged him to take up religion, which he eagerly did.

Logue came back to the United States in the late 1830s, working first as a porter in a Rochester hotel. He attended the Oneida Institute in Whitesboro, N.Y. (the only formal schooling he had) for three years, and then opened a school for black children in Utica. In 1840, he married Caroline Stirum. Shortly afterward, the couple moved to Syracuse, where Loguen opened another school. He also operated Syracuse's UNDERGROUND RAILROAD station and became so vital a part of the Railroad's activities that he was referred to in Central New York as the "Underground Railroad King."

Logue was ordained a minister in the AFRICAN METHODIST EPISCOPAL ZION CHURCH in 1843, and by 1850 he had established six churches around central New York (the most important of which was the Abolition Church in Syracuse). During this period he changed his name: "Jarm" became Jermain, "Logue" became Loguen, and he added the middle name Wesley to honor John Wesley, the founder of Methodism.

Loguen campaigned against the FUGITIVE SLAVE LAW in 1850, but a year later he became one of its victims, when he was indicted for participating in the rescue of Jerry McHenry, a fugitive slave. Because Loguen was himself a fugitive slave, he was liable to be returned to the Logues, and so he fled to Canada. He returned to Syracuse by the end of 1851, however, and resumed his work with the Underground Railroad. All told, he is said to have aided some 1,500 African Americans escape slavery by 1860. During this period he was also active in the abolitionist Liberty Party and in 1853 served on several committees with his friend Frederick DOUGLASS at the party's state convention. In 1859 he published his autobiography, *The Rev. J. W. Loguen as a Slave and as a Freeman: A Narrative of Real Life.*

Loguen was elected the thirteenth Bishop of the American Methodist Episcopal Zion Church in 1864. He declined his assignment to the church's southern district, however, fearing that it was too soon for a fugitive slave—especially one who was also a well-known abolitionist—to return to the South. He was re-elected in 1868 and served in districts that included Kentucky, Baltimore, and Philadelphia. Loguen was elected bishop a third time in 1972 and placed in charge of missionary work on the Pacific Coast. However, he died September 30, 1872, in Saratoga Springs, N.Y., before he could take up those duties.

REFERENCES

PEASE, JANE H., and WILLIAM H. PEASE. *They Who Would Be Free: Blacks' Search for Freedom, 1830–1861.* New York, 1974.

RICHARDSON, HARRY V. *Dark Salvation: The Story of Methodism as It Developed Among Blacks in America.* New York, 1976.

MICHAEL PALLER

LILY PHILLIPS

Long, Jefferson Franklin (March 3, 1836–February 5, 1900), congressman. Born into slavery near Knoxville, Crawford County, Ga., Jefferson Long was the son of a white father and slave mother. By the end of the Civil War, the self-educated Long was running a successful tailoring business in Macon, Ga. Soon afterward, he joined an increasing number of black Georgians in organizing the state REPUBLICAN PARTY.

Georgia was one of the southern states that most bitterly resisted RECONSTRUCTION reforms. The state's continuing unwillingness to accept Reconstruction and ratify the FOURTEENTH and FIFTEENTH AMENDMENT caused Congress to refuse to seat any Congressmen elected from Georgia. When they were finally admitted in late 1870, Long was the first Georgian seated and the second African American ever to serve in the House. (He would remain the only black legislator elected from Georgia until 1972, when Andrew YOUNG was elected to Congress.) Having run a campaign espousing an end to violence and lynching, Long prevailed by only 900 votes. Since the Georgians were not admitted until December 1870, he had only three months to make his mark upon Congress.

On February 1, 1871, Jefferson Long became the first African American to address the House. Speaking about an imminent vote on a bill to modify the test-oath taken by former Confederates, Long counseled caution. Pessimistic about the future for African Americans if their former masters gained control, Long strongly opposed the issue. "If this House removes the disabilities of disloyal men by modifying the test-oath," he warned, "I venture to prophesy you will again have trouble from the very same men who gave you trouble before." The measure passed, although without the signature of President Grant.

Disillusioned by events in Georgia where racist politicians and the KU KLUX KLAN were busily neutralizing the African-American electorate, Long decided not to seek nomination for a second term—a nomination he would not likely have gained. Returning to his tailoring business, which had suffered defections from white customers unhappy with his politics, Long continued to dabble in national Republican politics and continued efforts to call for an end to violence and discrimination in the South. In 1880, his disillusionment with the Republican party complete, Long supported a Democrat for the gubernatorial campaign. He died in Macon in 1900.

REFERENCES

CHRISTOPHER, MAURINE. *Black Americans in Congress.* New York, 1976.
DRAGO, EDMUND. *Black Politicians and Reconstruction in Georgia: A Splendid Failure.* Baton Rouge, La., 1982.
MCFARLIN, ANNJENNETTE SOPHIE. *Black Congressional Reconstruction Orators and their Orations, 1869–1879.* Metuchen, N.J., 1976.

ALANA J. ERICKSON

Longhair, Professor. *See* Professor Longhair.

Longview, Texas, Riot of 1919. Longview, Tex., was the site of a small but brutal riot on July 11, 1919, one of several incidents of violence during the notorious RED SUMMER. Longview's population of 5,000, about 30 percent African American, was mostly cotton farmers. One major cause of the riot was the economic tension caused by the formation of the Negro Business Men's League, an organization of black cotton-growers led by Dr. C. P. Davis. The group decided to seek higher prices for their cotton by sending their products straight to Galveston for processing, thus bypassing local white middlemen. The League also established a cooperative grocery story, where members could buy products more cheaply than at local stores. Economic tension was compounded by a new black assertiveness, fanned by the CHICAGO DEFENDER. The newspaper, a fixture in black homes in Longview, angered whites by its advocacy of black migration to the North. On July 4, the *Defender* carried an article describing a black man who had been lynched in the Longview area for raping a white woman. The newspaper maintained that the two had had a prior relationship, and that the woman mourned her black lover.

Whites angered by the newspaper article claimed it had been written by Samuel L. Jones, a leader of the Negro Business Men's League, and sought him out. Jones took refuge in Davis's house, and Negro Business Men's League members defended him with rifles. The black community, hearing of the threats, organized armed resistance and drove the white mob from their neighborhood. Before fleeing, the whites, finding the black community deserted, set fire to Jones's and other houses as well as to Davis's office and the League's lodge hall.

The next day, Texas Ranger troops arrived to restore order. The Rangers arrested twenty-three men on charges of arson and attempted murder, but all were acquitted. Twenty black men, all members of the Negro Business Men's League, were arrested for inciting a riot. Eventually, following intervention by the NATIONAL ASSOCIATION FOR THE ADVANCEMENT OF COLORED PEOPLE (NAACP), half of the black prisoners were allowed to return to Longview.

The other half, who had fired on the white mob entering the black community, were freed on the condition they leave town. Officials ordered copies of the *Chicago Defender* burned.

REFERENCE

TUTTLE, WILLIAM M., JR. "Violence in a 'Heathen' Land: The Longview Race Riot of 1919." *Phylon* 33 (1972): 324–333.

GAYLE T. TATE

Lorde, Audre Geraldine (February 18, 1934–November 17, 1992), poet, novelist, and teacher. Born in Harlem to West Indian parents, Audre Lorde described herself as "a black lesbian feminist mother lover poet." The exploration of pain, rage, and love in personal and political realms pervades her writing. Perhaps because Lorde did not speak until she was nearly five years old and also suffered from impaired vision, her passions were equally divided between a love of words and imagery and a devotion to speaking the truth, no matter how painful. Her objective, she stated, was to empower and encourage toward speech and action those in society who are often silenced and disfranchised.

Lorde published her first poem while in high school, in *Seventeen* magazine. She studied for a year (1954) at the National University of Mexico, before returning to the United States to earn a bachelor of arts degree in literature and philosophy from Hunter College in 1959. She went on to receive a master's degree from the Columbia School of Library Science in 1960. During this time she married attorney Edward Ashley Rollins and had two children, Elizabeth and Jonathan. Lorde and Rollins divorced in 1970. Juggling her roles as black woman, lesbian, mother, and poet, she was actively involved in causes for social justice. Throughout this period she was a member of the HARLEM WRITERS GUILD.

An important juncture in Lorde's life occurred in 1968. She published her first collection of poetry, *The First Cities,* and also received a National Endowment for the Arts Residency Grant, which took her to Tougaloo College in Mississippi. This appointment represented the beginning of Lorde's career as a full-time writer and teacher. Returning to New York, she continued to teach and publish. In 1973, her third book, *From a Land Where Other People Live,* was nominated for the National Book Award for Poetry. It was praised for its attention to racial oppression and injustice around the world. She spent ten years on the faculty of John Jay College of Criminal Justice and then became professor of English at her alma mater, Hunter College, in 1980. She wrote three more books of poetry before the appearance of *The Black Unicorn* (1978), for which she received the widest acclaim and recognition. It fuses themes of motherhood and feminism while placing African spiritual awakening and black pride at its center.

Lorde's devotion to honesty and outspokenness is evident in the works she produced in the 1980s. She published her first nonpoetry work, *The Cancer Journals* (1980), so she could share the experience of her cancer diagnosis, partial mastectomy, and apparent triumph over the disease with as wide an audience as possible. *Zami: A New Spelling of My Name* (1982) was enthusiastically received as her first prose fiction work. Self-described as a "biomythography," it is considered a lyrical and evocative autobiographical novel. She was a founding member of Women of Color Press and Sisters in Support of Sisters in South Africa.

Sister Outsider (1984), a collection of speeches and essays spanning the years 1976 to 1984, details Lorde's evolution as a black feminist thinker and writer. In 1986, she returned to poetry with *Our Dead behind Us. Burst of Light* (1988), which won an American Book Award, chronicles the spread of Lorde's cancer to her liver, and presents a less hopeful vision of the future than *The Cancer Journals.* Lorde's work appeared regularly in magazines and journals and has been widely anthologized. In 1991 she became the poet laureate of New York State. She died in St. Croix, U.S. Virgin Islands.

REFERENCES

CHRISTIAN, BARBARA. "Dynamics of Difference." *Women's Review of Books* 1, no. 11 (August 1984): 6–7.
DRAPER, JAMES P., ed. "Audre Lorde." In *Black Literature Criticism.* Detroit, 1992, pp. 1275–1289.
New York Times, November 20, 1992, p. A23.
STEPTO, R. B. "Audre Lorde: The Severed Daughter." In *American Women Poets.* New York, 1986, pp. 289–294.

NICOLE R. KING

Los Angeles, California. The experiences of African Americans in Los Angeles have differed from those of black people in most other large American cities. Los Angeles has always been characterized by cultural diversity. This diversity has shaped the history of African Americans in Los Angeles: African Americans have frequently compared themselves to Latinos and Asian Americans, and patterns of cooperation and competition among these groups have left indelible marks on the city's politics and culture.

The first black people in Los Angeles spoke Spanish. Twenty-nine of the 46 people who established the pueblo in September 1781 could trace some ancestors to Africa. Throughout the Spanish (1781–1821) and Mexican (1821–1848) eras, black residents participated in social, cultural, and political activities. Several black men or mulattoes held positions in the pueblo's government.

The U.S. conquest of northern Mexico and the Gold Rush of 1848–1849 scarcely affected Los Angeles, which remained a small, largely Mexican town. In the 1850s and '60s, Southern California's remoteness attracted some FUGITIVE SLAVES. Biddy Mason, for example, came to Los Angeles in the 1850s. She acquired a fortune through shrewd investments in real estate, and she used some of her money to establish and support the first black community organizations. Reports of Mason's success helped Southern California to develop a reputation as a land of economic opportunity for African Americans.

The completion of railroad lines and harbor improvements in the 1870s and '80s sparked explosive growth in Southern California. Los Angeles' population grew from 11,000 in 1880 to nearly 320,000 in 1910 and to more than 1.2 million in 1930. Among the new residents were small but significant numbers of African Americans. The black population grew from under 100 in 1870 to 7,500 in 1910 and to nearly 50,000 by 1930. In 1940, the census counted 75,000 African Americans in the area.

New black residents moved into a segregated city. The first black neighborhood, labeled "Nigger Alley" by white residents, developed in the 1870s on Alameda Street, near Chinatown. By 1910 a ghetto had formed around the Central Avenue Hotel in downtown Los Angeles. This ghetto expanded south along Central Avenue toward Watts, a community that attracted African Americans from the rural South. By 1930, some 70 percent of the city's black residents lived in the Central Avenue neighborhood. Significant numbers of African Americans also settled in the West Adams district, west of downtown.

The Central Avenue district became the center of African-American culture. Businesses, entertainment houses, restaurants, and churches served the expanding community. Notable musicians such as tenor saxophonist Dexter GORDON emerged from the jazz clubs of Central Avenue. The district's theaters regularly drew celebrated black performers such as Nat King COLE, Duke ELLINGTON, and Paul ROBESON to Los Angeles in the 1930s and '40s.

Prior to World War II, black residents were routinely denied access to public swimming pools and parks. They were also excluded from many theaters and restaurants. Employers refused to hire black people for clerical or white-collar jobs, and skilled black workers found few openings in the city's small industrial sector. Most black men worked as manual laborers, and most black women worked as domestic servants.

Despite the pervasive housing and employment discrimination, the city's African Americans were able to exercise some political power. Frederick Roberts, a black Republican, represented the "East Side" in the State Assembly from 1919 until 1933. Democrat Augustus Hawkins defeated Roberts in the 1932 election and served in the Assembly from 1933 until his election to Congress in 1962.

The growth of the Mexican-American and Asian-American communities in the 1910s and '20s led African-American leaders to conclude that black residents might achieve greater political and economic power through cooperation with other minority groups. The black "East Side" abutted "Little Tokyo" and the Mexican-American barrio of East Los Angeles, and all of these communities confronted racial prejudice and discrimination.

WORLD WAR II offered African-American leaders the opportunity to test their theories about multicultural cooperation. Federal propaganda fueled the desire of African and Mexican Americans to destroy racial discrimination in the United States. The federal government's decision to incarcerate Japanese Americans also haunted minority community leaders. Thousands of African Americans moved into the vacant houses and storefronts of Little Tokyo.

During the war years, black and Mexican-American civil rights organizations cooperated in their efforts to combat discrimination. Peaceful demonstrations and formal complaints to the President's FAIR EMPLOYMENT PRACTICES COMMITTEE (FEPC), which Franklin Roosevelt had created in 1941, succeeded in placing many black and Mexican-American workers in high-paying jobs in war industries. By 1945 black workers held 14 percent of the shipyard jobs in Los Angeles, even though African Americans comprised only 6.5 percent of the city's population.

The "Zoot-Suit Riots" further encouraged cooperation among African Americans and Mexican Americans. In response to rumors that gangs of young Mexican Americans had initiated a war against military men, hundreds of sailors and soldiers converged on downtown and east Los Angeles in early June 1943. Although the soldiers and sailors ostensibly sought gang members dressed in "zoot suits"—flashy outfits comprised of long, broad-shouldered jackets and pants that were baggy at the hips but tight around the ankle—their victims also included young Mexican-American and black men who were not wearing zoot suits. The sailors and soldiers dragged these young men from theaters and stores, stripped them of their clothing, beat them, and left them na-

ked in the streets. After four nights of violence, military authorities ordered soldiers and sailors not to go downtown, and the rioting dissipated. In the wake of the riots, concerned activists and elected officials created several organizations which, along with the NATIONAL ASSOCIATION FOR THE ADVANCEMENT OF COLORED PEOPLE (NAACP) and the NATIONAL URBAN LEAGUE, were the backbone of an emerging multiracial civil rights coalition.

This coalition's strength peaked in 1945 and 1946, when Japanese Americans returned to the city. The War Relocation Authority (WRA), which operated the concentration camps during the war, later worked to reestablish the Japanese-American community in Los Angeles. In this process, WRA employees recognized the similarities between discrimination against Japanese Americans and discrimination against African Americans and Mexican Americans. WRA employees then began to combat all forms of racial discrimination. The War Relocation Authority lent strong governmental support to the civil rights coalition, which mounted successful legal challenges to housing and school segregation.

After the war ended, however, civil rights activists found it difficult to reform local institutions. Many African Americans lost their jobs, and financial support for the NAACP and other organizations diminished. Politicians and newspaper publishers attached the "communist" label on all civil rights activism. The fears of white residents dominated the 1946 election: two-thirds of Los Angeles's voters rejected an initiative that would have outlawed employment discrimination in California.

Southern California's mild climate and its image as a land of opportunity continued to attract black people from the East and the South after World War II. The area's African-American population grew from 75,000 in 1940 to 200,000 in 1950 and to approximately 650,000 by 1965. The population growth promised greater political power. Tom BRADLEY, a retired police officer, put together a coalition of African Americans and liberal white voters—many of them Jews—and won a seat on the City Council in 1963.

Bradley's election lifted the hopes of many of Los Angeles's black residents, but conditions in the ghetto did not improve in the 1950s and '60s. Unemployment was higher in African-American districts than in the rest of the city, and police officers routinely harassed black people, often using excessive force in arresting black suspects.

An arrest on August 11, 1965, turned into a confrontation between police and Watts residents and ignited a six-day rebellion. As many as 30,000 African Americans looted and burned hundreds of businesses. State officials mobilized more than 15,000 National Guard troops and police officers to quell the rebellion. The violence left thirty-four people—thirty-one of whom were black—dead and hundreds injured. The police arrested more than 4,000 people.

After the rebellion, government officials and community leaders called for sweeping reforms, including programs to train and employ the thousands of unemployed African Americans in south central Los Angeles. Local, state, and federal agencies, however, never fully implemented these reforms.

While unemployment and other social problems continued to fester in the ghetto, changes within U.S society helped to open new opportunities for some African Americans. Access to good schools and colleges led to the emergence of a new black middle class in Los Angeles. Pressure from the NAACP and other civil rights organizations created new opportunities for black performers in film and television. Black superstars such as Eddie MURPHY and Michael JACKSON began to wield power within the entertainment industry in the 1980s. The wealth and power of these stars, however, put them out of touch with the hundreds of thousands of people trapped by poverty and discrimination in South Central Los Angeles.

Although African Americans were divided economically, they were able to unite politically. Bradley's electoral coalition expanded in the late 1960s and came to power in 1973, when Bradley was elected mayor. Bradley eliminated racial discrimination in municipal employment and encouraged interracial cooperation. Despite Bradley's popularity—he was reelected four times—he was unable to end police brutality or to improve conditions in the ghetto. By the 1980s, black unemployment reached 40 percent in some areas, more than three times the white jobless rate. Poor schools, inadequate health care, AIDS, crime, and drug abuse plagued South Central Los Angeles. These conditions threatened intercultural cooperation: African Americans increasingly blamed the community's problems on outsiders.

In the mid- to late 1980s, some young African Americans began to address ghetto conditions in their art and music. South Central Los Angeles and the surrounding black suburbs produced a number of influential filmmakers and musical artists. Motion picture director John Singleton received an Oscar nomination for *Boyz N the Hood* (1991), which explored life in the ghetto. Musicians such as NWA and Ice Cube sold millions of copies of their releases. Many of these artists succeeded in appealing to a large, diverse audience while retaining their base in Los Angeles's black community.

Race relations in Los Angeles reached a critical point in the early 1990s. On March 3, 1991, police officers stopped a car driven by an African American named Rodney King. Before the police handcuffed

King, four officers kicked him and beat him with clubs, fracturing his skull and one of his legs. A witness recorded King's beating on videotape. When the news media broadcast the tape, there was a national uproar. Less than two weeks after the beating, the police officers were indicted on charges that included assault with a deadly weapon.

More than a year after the beating, the police officers stood trial. On April 29, 1992, a mostly white jury acquitted the defendants on all but one of the charges. Within hours of the verdict's announcement, South Central Los Angeles exploded in violence. Angry people pelted cars with rocks and bottles and set fire to hundreds of buildings. African Americans and Latinos—many of them Central American refugees who had moved into South Central Los Angeles in the late 1980s—looted many of the stores in the area. Looters and arsonists spared some businesses belonging to African Americans. Stores owned by recent Asian immigrants, especially Koreans, were frequent targets.

Local, state, and federal officials responded rapidly to the riot. Within three days of the verdict's announcement, nearly 20,000 armed soldiers and peace officers patrolled the city's streets. Despite the quick response, 51 people were killed in the violence, and more than 2,000 were injured. The police arrested approximately 10,000 people.

The 1992 rebellion transformed racial politics in Los Angeles. Police Chief Daryl Gates resigned shortly after the rebellion. Mayor Bradley chose not to run for a sixth term. Before Bradley left office, however, he did succeed in convincing the voters to give the mayor greater power over the police department, a move that signaled a commitment to effect a decrease in police brutality toward African Americans. In the mayoral election of 1993, voters rejected Bradley's multicultural coalition, represented by City Council member Michael Woo, in favor of Richard Riordan, a white multimillionaire who promised to unite the divided city.

The bleak conditions in the ghetto in the late 1980s and the rebellion of 1992 changed black perceptions of Los Angeles. To most African Americans the city no longer symbolized hope and opportunity. Los Angeles's black population stopped growing in the 1980s; some black residents turned to the South. The stable number of black and white people in Los Angeles presages more change as the growing Latino and Asian-American communities demand greater political representation. In these political struggles, African Americans may lose some of the power they enjoyed between the 1960s and the early '90s.

Los Angeles was one of the first cities to experience the demographic changes that will continue to shape U.S society in the twenty-first century. Most cities will attract greater numbers of Latinos and Asian Americans. The lessons that other cities' officials can learn from Los Angeles are not clear, but the history of Southern California suggests that governments and community leaders must be committed to equality and intolerant of discrimination if cities are to escape bloodshed and fulfill the promise of multiethnic cooperation.

REFERENCES

COLLINS, KEITH E. *Black Los Angeles: The Maturing of the Ghetto, 1940–1950.* Saratoga, Calif., 1980.

CONOT, ROBERT. *Rivers of Blood, Years of Darkness.* New York, 1967.

DAVIS, MIKE. *City of Quartz: Excavating the Future in Los Angeles.* London, 1990.

DE GRAAF, LAWRENCE BROOKS. *Negro Migration to Los Angeles, 1930 to 1950.* San Francisco, 1974.

GEORGE, LYNELL. *No Crystal Stair: African Americans in the City of Angels.* New York, 1992.

GOODE, KENNETH G. *California's Black Pioneers: A Brief Historical Survey.* Santa Barbara, Calif., 1974.

HIMES, CHESTER. *If He Hollers, Let Him Go.* Garden City, N.Y., 1945.

PAYNE, J. GREGORY, and SCOTT RATZAN. *Tom Bradley: The Impossible Dream.* Santa Monica, Calif., 1986.

SONENSHEIN, RAPHAEL J. *Politics in Black and White: Race and Power in Los Angeles.* Princeton, N.J., 1993.

WHEELER, B. GORDON. *Black California: The History of African Americans in the Golden State.* New York, 1992.

KEVIN ALLEN LEONARD

Los Angeles Watts Riot of 1965. The Watts ghetto, part of the sprawling area of South Central Los Angeles, erupted in the summer of 1965. Tension and rage had long existed among Los Angeles' growing inner-city black population, which faced the same problems of unemployment, inadequate housing, and discrimination as blacks in other cities, with the added insult of living in a city known for prosperity and luxury. The Los Angeles Police Department was notorious for racism and police brutality.

On August 11, 1965, during a heat wave, police chased and arrested a black motorist on a drunk-driving charge. The motorist's family and other onlookers jeered and spat at the police. When the police retaliated physically, stories that police had beat pregnant women spread through the neighborhood. Soon Watts residents took to the street and began to loot and burn local stores. Most stores owned by African-Americans were spared damage, but hundreds of white-owned stores were targeted by fire and loot-

ing. Rioters stoned windows and attacked the cars of passing white motorists. Mayor Sam Yorty imposed a curfew and called out National Guard troops and police officers to put down the riot. By morning, calm was restored, but the area was too large to cover effectively. The rioting continued for four nights.

By the time the disturbances ended on August 16, 15,000 National Guard troops, county sheriff's deputies, and police had been called out. Thirty-four people, all but a few black, had been killed, hundreds had been injured, the police had arrested over 4,000 people, and large sections of Watts lay in ruins. City officials blamed the riots on recent immigrants and outside agitators, but sociological studies of rioters later indicated that many were Los Angeles-born, and slightly more affluent and educated than nonparticipants. The riot, coming shortly after the signing of the 1965 VOTING RIGHTS ACT, signalled to many Americans the limits of civil rights protest. Black militants pointed to the riot to illustrated the anger of urban African Americans at the persistence of prejudice. Conservatives claimed change had gone too fast, and claimed the riot was an example of the disorder that the CIVIL RIGHTS MOVEMENT bred. The Watts uprising discredited liberal California Gov. Edmund G. "Pat" Brown and helped assure the election of Republican Ronald Reagan and his subsequent rise to the presidency. However, as the first of the major urban rebellions of the 1960s, it also shocked white leaders into increased attention to African-American problems. Even so, in the 1990s, much of Watts remained burned out and uninhabitable.

See also URBAN RIOTS AND REBELLIONS.

REFERENCES

BULLOCK, PAUL. *Watts; The Aftermath; an Inside View of the Ghetto.* New York, 1969.
GENTRY, CURT. *The Last Days of the Late, Great State of California.* New York, 1968.

GAYLE T. TATE

Louis, Joe (Barrow, Joe Louis)

Louis, Joe (Barrow, Joe Louis) (May 13, 1914–April 12, 1981), boxer. Joe Louis Barrow was born to a sharecropping couple in Chambers County, Ala., the seventh of eight children. Louis's father, Munroe Barrow, was placed in a mental institution when Louis was two, apparently unable to cope with the strain of the dirt farming life. (It has been suggested by a few observers that Louis's mental and emotional problems in later life may have resulted from congenital causes rather than blows in the prize ring.) Louis's father died in Searcy State Hospital for the Colored Insane nearly twenty years later, never having learned that his son had become a famous athlete.

Lillie Barrow, Louis's mother, remarried a widower with a large family of his own named Pat Brooks who, in 1920, moved the family to Mt. Sinai, Ala. In 1926 Brooks migrated north to Detroit to work for the Ford Motor Company. The family, like many other African-American families of this period of the Great Migration, followed suit soon after, settling in Detroit's burgeoning black ghetto.

At the time of the move to Detroit, Louis was twelve years old. He was big for his age, but because of his inadequate education in the South and his lack of interest in and affinity for school, he was placed in a lower grade than his age would have dictated. Consequently, he continued to be an indifferent student and eventually went to work when his stepfather was laid off by Ford at the beginning of the depression.

Like many poor, unskilled, undereducated, ethnic urban boys of the period, Louis drifted into BOXING largely as an opportunity to make money and to release his aggression in an organized, socially acceptable way. Although his stepfather was opposed to his entry into athletics, his mother supported and encouraged him.

Competing as a light heavyweight, Louis started his amateur career in 1932 but lost badly in his first fight and did not return to the ring until the following year. Following this brief hiatus, however, Louis quickly rose to prominence in boxing and African-American or "race" circles. By 1933 he compiled an amateur record of 50 wins, 43 by knockout, and only 4 losses. In 1934, shortly after winning the light heavyweight championship of the Amateur Athletic Union, Louis turned professional and moved up to the heavyweight division. His managers were two black numbers runners, John Roxborough and Julian Black. Louis's trainer was a white man, the former lightweight fighter Jack Blackburn.

Thanks to generous coverage by the black press, Louis was already a familiar figure in the black neighborhoods of northern cities by 1934. At a time when color bars prohibited blacks from competing with whites in every major professional sport other than boxing, Louis became a symbol of black aspirations in white America. Through the prime of his career, Louis's fights were major social events for African Americans, and spontaneous celebrations would erupt in urban ghettos after his victories.

At the start of his professional career, Louis faced a number of obstacles in trying to obtain the heavyweight title. First, under a "gentlemen's agreement," no black fighter had been permitted to fight for that title since Jack JOHNSON, the first black heavyweight champion. Johnson lost the title in Havana, Cuba, to Jess Willard in 1915. Second, Louis had an entirely

black support and management team, making it difficult for him to break into the big market for the fight game in New York City and to get a crack at the name fighters against whom he had to compete if he were to make a name for himself.

Louis's managers overcame the first problem by making sure that Louis did not in any way act like or remind his white audience or white sportswriters of Johnson, who scandalized white public opinion with his marriages to white women and other breaches of prevailing racial mores. Louis was not permitted to be seen in the company of white women, never gloated over his opponents, was quiet and respectful, and generally was made to project an image of cleanliness and high moral character. The second problem was solved when Mike Jacobs, a fight promoter in New York City, decided to take on Madison Square Garden's monopoly on boxing with his 20th Century Sporting Club and formed a partnership with Louis's managers to promote him with the intention of guiding him to the championship.

UNCROWNED
CHAMPION

Even before Joe Louis made it official on June 22, 1937, by knocking out James J. Braddock and capturing the heavyweight title, Louis had dominated the division like few before him. (Prints and Photographs Division, Library of Congress)

Louis, 6'1", with a fighting weight around 200 pounds, soon amassed a glittering record. Starting in his first professional bout, a first-round knockout of Jack Kracken on July 4, 1934, to his winning the heavyweight title, in an eighth-round knockout of Jim Braddock on June 22, 1937, Louis recorded a record of 30 wins, 25 by knockout, and 1 loss. The most memorable of his fights during this period included the easy knockouts of former heavyweight champions Max Baer and Primo Carnera in 1935. Louis's one loss during this period was critically important in his career and in American cultural history. On June 19, 1936, the German Max Schmeling knocked out Louis, then a world-class challenger to the heavyweight crown, in twelve rounds, giving the highly touted black fighter his first severe beating as a professional. This loss greatly reduced Louis's standing with white sportswriters, who had previously built him up almost to the point of invincibility. (The writers had given him a string of alliterative nicknames, including the "Tan Tornado" and the "Dark Destroyer," but it was the "Brown Bomber" that stuck.) However, Louis's loss was also a watershed as it marked a slow change on the part of white sportswriters, who began to stop patronizing him and slowly grew to treat him more fully as a human being.

The loss also set up a rematch with Schmeling on June 22, 1938, after Louis had become champion by defeating Braddock the previous year. The second bout with Schmeling was to become one of the most important fights in American history. It was not Louis's first fight with political overtones. He had fought the Italian heavyweight Primo Carnera (beating him easily) as Italy was beginning its invasion of Ethiopia, and both fighters became emblems of their respective ethnicities; Louis, oddly enough, became both a nationalistic hero for blacks while being a kind of crossover hero for non-Italian, antifascist whites. By 1938, Hitler was rapidly taking over Europe and Nazism had clearly become a threat to both the United States and the world generally. Schmeling was seen as the symbol of Nazism, an identification against which he did not fight very hard. Indeed, Schmeling seemed eager to exploit the racial overtones of the fight as a way of getting a psychological edge on Louis. Louis became an emblem not simply of black America, but, like Jesse OWENS in Berlin a few years earlier, a symbol of antitotalitarian America itself, of its ideology of opportunity and freedom. Perhaps in some sense no one could better bear the burden of America's utopian vision of itself as an egalitarian paradise than a champion black prizefighter, combining both the myths of class mobility with racial uplift. Under the scrutiny of both their countries and most of the rest of the world,

Louis knocked out Schmeling in two minutes of the first round.

Following the second Schmeling bout, Louis embarked on a remarkable string of title defenses, winning seventeen fights over four years, fifteen by knockout. Because of the general lack of talent in the heavyweight division at the time and the ease of Louis's victories, his opponents were popularly referred to as "The Bum of the Month Club." The only serious challenge came from Billy Conn in 1941, who outboxed the champion for twelve rounds before succumbing to Louis's knockout punch in the thirteenth.

During World War II, Louis in some ways matured deeply as a man and came into his own as an American icon and hero. When the war began, he was twenty-seven and at his prime as a fighter. When it ended, he was thirty-one, beginning to slip as a champion athlete, and, probably, was not as interested in boxing as he had been. However, he had become something of an elder statesman among blacks who were also prominent in popular culture. Younger black athletes such as Jackie ROBINSON and Sugar Ray ROBINSON looked up to and respected him. Both men had served in the segregated armed forces with him, and he helped them bear with dignity the hostilities and humiliations that were often visited upon them as black soldiers. Louis became self-consciously political at that time; he campaigned for Republican presidential candidate Wendell Wilkie in 1940.

Louis was drafted January 12, 1942, but remained active as a boxer, continuing to fight professionally during the war. He contributed his earnings to both the Army and the Navy Relief Funds. While this was a wise move politically, it was disastrous for Louis financially. (In fact, even before he joined the service, he contributed the purse from his Buddy Baer fight on January 9, 1942, to the Navy Relief Fund.)

"We're going to do our part, and we will win," Louis intoned at a Navy Relief Society dinner on March 10, 1942, "because we are on God's side." This moment, perhaps more than any other in Louis's career, signaled the complete transformation of the image of the man in the mind of the white public. Louis rose from being the sullen, uneasy "colored boy" from black Detroit who was considered in 1935 the *wunderkind* of boxing, to become in seven years, the mature, patriotic American who could speak both to and for his country. Louis could now not simply address his audience but command it. He could, as one pundit put it, "name the war." Louis's phrase, "We're on God's side," became one of the most famous phrases in American oratory during the Second World War. Ironically, however, Louis had misremembered his lines. He was supposed to say the more

commonplace, "God's on our side," yet it is this cunning combination of the inadvertent and the opportunistic, the serendipitous and the intentional, that marks Louis's career in its later phase.

After the war, Louis's abilities as a fighter diminished as his earnings evaporated in a mist of high living and alleged tax evasion. After winning a rematch against Jersey Joe WALCOTT on June 25, 1948—only the second black fighter against whom Louis defended his title, indicating how much of a presence white fighters were in the sport well into the twentieth century—on the heels of winning an earlier controversial match on December 5, 1947, that most observers felt he had lost, Louis retired from the ring in 1949. At that time he made a deal with the unsavory Jim Norris and the International Boxing Club, which resulted in the removal of an old, sick Mike Jacobs from the professional boxing scene. Louis's deal with Norris created an entity called Joe Louis Enterprises that would sign up all the leading contenders for the heavyweight championship and have them exclusively promoted by Norris's International Boxing Club. Louis received $150,000 and became a stockholder in the IBC. He was paid $15,000 annually to promote boxing generally and the IBC bout specifically. In effect, Louis sold his title to a gangster-controlled outfit that wanted and eventually obtained for a period in the 1950s virtual control over both the management and promotion of all notable professional fighters in the United States. By 1950, however, an aged Louis, reflexes shot and legs gimpy, was forced back into the ring because of money problems. He lost to Ezzard CHARLES in a fifteen-round decision on September 27. On October 26, 1951, his career ended for good when he was knocked out in eight rounds by the up-and-coming Rocky Marciano.

In 66 professional bouts, Louis lost only 3 times (twice in the last two years of his career) and knocked out 49 of his opponents. He was elected to the Boxing Hall of Fame in 1954.

After his career, Louis, like many famous athletes who followed him, lived off of his reputation. He certainly never considered the idea of returning to the ordinary work world he left in the early 1930s when he became a fighter. He was hounded by the IRS for back taxes, began taking drugs, particularly cocaine, suffered a number of nervous breakdowns, and seemed often at loose ends, despite a third marriage to a woman of considerable maturity and substance, Martha Jefferson. Eventually, in part as a result of his second marriage (his second wife Marva Trotter was a lawyer for Teamster boss Jimmy Hoffa), Louis wound up working in Las Vegas as a casino greeter, playing golf with high-rolling customers, and serv-

ing as a companion for men who remembered him in his glory years.

On April 12, 1981, the day after he attended a heavyweight championship match between Larry Holmes and Trevor Berbick, Louis collapsed at his home in Las Vegas and died of a massive heart attack. He was, without question, one of the most popular sports figures of this century. In 1993 Louis appeared on a U.S. postage stamp.

REFERENCES

ANDERSON, JERVIS. "Black Heavies." *American Scholar* 47 (1978): 387–395.

EDMONDS, A. O. *Joe Louis.* Grand Rapids, Mich., 1973.

GROMBACH, JOHN V. *The Saga of Sock.* New York, 1949.

LOUIS, JOE, with Edna and Art Rust. *Joe Louis: My Life.* New York, 1981.

MEAD, CHRIS. *Champion: Joe Louis, Black Hero in White America.* New York, 1985.

NAGLER, BARNEY. *Brown Bomber: The Pilgrimage of Joe Louis.* New York, 1972.

WRIGHT, RICHARD. "High Tide in Harlem: Joe Louis as a Symbol of Freedom." *New Masses* (July 5, 1938): 18–20.

GERALD EARLY

Louisiana. The first two blacks came to the French colony of Louisiana in 1709, as slaves of the governor, Jean Baptiste, Sieur de Bienville. In 1712, when there were ten blacks in the colony, King Louis XIV granted Anthony Crozat the privilege of sending one ship to Africa to bring blacks to the Louisiana colony, and the next year twenty slaves were imported. The increase of slaves led Bienville to establish rules governing the SLAVE TRADE. Between 1719 and 1731, twenty-seven slave ships arrived from Africa, most from Senegal, but then only one further ship in the thirty-two years that followed. Many slaves worked in NEW ORLEANS, where they worked for the colonial government or private masters to build the city, or were trained in skilled trades such as ironwork. Other slaves were forced into agricultural work in swampy rural areas, where they grew indigo and taught their masters to cultivate rice, as they had in their African homeland. Poorly fed, they sustained themselves by hunting and fishing.

In 1724, the colony's *code noir* (Black Code) was published, based on the codes enacted to regulate slavery in France's Caribbean islands, and to specify the legal status of free blacks. The codes, often evaded, gave exact rules of conduct and punishment for offenses. They stipulated that slaves receive Ro-

man Catholic instruction and baptism, permitted slaves to own property and marry, forbade owners to sell couples apart, and outlawed Sunday labor. These provisions offer a marked contrast to Anglo-American slave codes, which did not recognize marriage, and which were often indifferent or hostile to slave religion (*see* BLACK CODES, NORTH AND SOUTH). Like the others, the *code noir* forbade marriage or concubinage of slaves to whites or free blacks, and deprived slaves of the right to hold office or to sue and be sued in court. Although the codes forbade the shackling of slaves and outlawed the whipping of female slaves, they prescribed the death penalty for slaves striking their masters.

During the French period, the culture of Creole Louisiana grew up out of the interaction between Europeans, Indians, and Africans. Creoles, native-born white and black francophone Louisianians, developed common styles of speech, dress, cooking, and music with discernible African components. Louisiana remained a frontier society. The treatment of enslaved blacks was made less harsh by the presence of Indians in the colony, although whites worked to prevent potential alliances between Africans and Indians (some of whom kept slaves) which would threaten white rule. Many African males married Indian women, particularly as few African women entered the colony, and slaves who escaped with Indian aid formed maroon colonies (*see* MAROONAGE). In 1736, authorities discovered a planned revolt by the maroons, who were allegedly preparing to overthrow the colonial government with Chickasaw Indian help, and massacre the white settlers. Other slaves were enlisted into military units, under the command of free blacks, to exterminate the Chickasaw in return for their freedom. After Indian opposition had been crushed, more slaves were enrolled in militia. In 1739 there were 270 black soldiers, fifty of them free.

In 1763 Louisiana was ceded to Spain, although it remained French in culture. The Spanish slave code differed from the French code by making the slave completely subordinate to the will of his owner, without whose consent the slave could not marry. However, Spain eased manumission laws in order to build up a free mulatto class which would serve as a buffer between enslaved blacks and whites. In 1780, after Spain declared war on England, a company of free black soldiers aided in the capture of British forts at Baton Rouge and Natchez.

In 1782 Spain eliminated the duty on slave imports in order to encourage trading. Soon after, colonial authorities began a military campaign to wipe out maroon colonies, which challenged the slave system. In June 1784, after prolonged resistance, military units finally captured the African-American St.

Malo, leader of some thirty-seven escaped slaves and chief of the largest maroon colony. In the early 1790s, Louisiana welcomed a few refugees, black and white from the slave revolt in St. Domingue (later Haiti). Spanish authorities tightened security lest slaves be inspired by the events to revolt. In April 1795, Spanish authorities at Pointe Coupée uncovered an interracial plan for a slave revolt, to be coordinated with an invasion of the French, who would retake Louisiana and end slavery. The black plotters were hanged, though the whites were merely banished. For decades the plot was used to discredit antislavery and humanitarian efforts in Louisiana.

Between 1801 and 1803, Louisiana passed from Spain back to France. Under the Louisiana Purchase of 1803, President Thomas Jefferson bought the vast territory for the United States. The state of Louisiana, comprising only a small fraction of the purchase, was created nine years later. By 1810, African Americans represented a majority of the state's population. In 1811, a reported 500 slaves from St. John the Baptist Parish marched on New Orleans, burning plantations on the way, before being put down by a garrison at Fort St. Charles.

Under American rule, the condition of blacks deteriorated. Proponents of slavery increased their efforts at justifying the hypothesis of blacks' innate inferiority. The slave had no claim to his family and could be sold as the master desired. Louisiana planter Bennett H. Barrow recorded in the diary he kept from 1836 to 1846 the punishment he gave to slaves: "whipped every hand in the field this evening." Officially previous slave laws remained in effect, and the effort to deny blacks legal protection took on a subtle and evasive nature. In the state constitutions of 1812, 1845, and 1852, there were no explicit provisions for slavery as an institution, although they restricted membership in the legislature and the right to bear arms to "free white men" of the state.

Slavery in Louisiana was harsh, especially in the southeastern part of the state, where sugarcane was introduced on a large scale. Planting and harvesting sugar was labor-intensive work. The sugar plantations were among the largest in the South. By 1844 there were 464 plantations of 200 acres or more. By 1849, four years after the industry was revolutionized by the invention of the vacuum refining process by the creole Norbert RILLIEUX, there were 1,536 sugar mills in Louisiana, and the state was producing 95 percent of the sugar in the United States. By 1860, there were 400,000 slaves in the state, clustered in the Southeast and near the Mississippi and Red rivers.

Antebellum Louisiana was notable for the presence of a large free black population, especially in the capital of New Orleans. The free colored population of Louisiana, already large under Spanish rule, swelled with the entry of 4000 *gens de couleur libres* from Haiti, who arrived from exile in Havana in 1809, and was further augmented in the following years by black migrants profiting from the state's easy manumission policy and job opportunities. Many of the skilled tradesmen of New Orleans were people of color, and mulatto children often inherited property from their white fathers. By 1860, creoles owned $15,000,000 worth of property in New Orleans, including enslaved blacks.

During the Battle of New Orleans, the last battle of the WAR OF 1812, the free colored population supplied two battalions for U.S. Gen. Andrew Jackson, who promised them the same bounty as white soldiers and called on them to defend America's "mild and equitable government." Batteries III and IV distinguished themselves for valor. During the 1840s, free colored soldiers served in the MEXICAN WAR.

There were legal and social distinctions between the rights of mulattoes and free blacks, and colored society was divided into classes by skin color with "octoroons" and "quadroons" forming the colored elite, mulattoes (half white, half black) in the middle, and "briques" and "griffes" (light- and dark-brown-skinned blacks) at the bottom. Free people of color enjoyed more privileges in Louisiana society than they did in other states, but they were still required by the Black Codes to show deference to whites and were relegated to an inferior status. They could not vote or "presume to conceive themselves equal to the white." After 1840, as Anglo-American whites increased their dominance in the state and Louisianians became more Southern in sentiment, the numbers and status of free people of color began to decline. The *code noir* was officially abrogated in the early 1850s. In 1857, Gov. Robert C. Wicliffe recommended to the state legislature that free blacks be expelled from the state. In 1860 the state Supreme Court proclaimed in *African Methodist Episcopal Church* v. *City of New Orleans:* "The African race are strangers to our constitution and are the subjects of special and exceptional legislation."

In spring 1862, during the CIVIL WAR, Union troops occupied New Orleans. Slaves in the city were freed, and others in the surrounding countryside fled to freedom behind Union lines. Still, most Louisiana slaves were in Union-held territory in 1863 and thus exempt from the EMANCIPATION PROCLAMATION. Both free colored people and freedmen united to agitate for emancipation and black suffrage. Blacks willingly fought to end bondage. Louisiana provided more black troops for the Union cause—over 24,000—than any other Southern state, and in 1863, blacks fought bravely under fire at the battle for Port Hudson, a Confederate fortress north of Baton Rouge on the Mississippi River.

During Reconstruction African Americans gained leadership positions in state government. (Photographs and Prints Division, Schomburg Center for Research in Black Culture, The New York Public Library, Astor, Lenox and Tilden Foundations)

When the Civil War ended, Louisiana was under the control of a Southern Unionist government, which limited suffrage to whites, despite pressure from the influential creole community. After a group of black marchers supporting a suffrage convention was attacked in the New Orleans Riot of 1866, Congress dissolved the Louisiana government, and an interim government enfranchised the state's black majority, who enthusiastically registered and received voting papers. Blacks comprised 84,436 out of 129,654 registered voters. They elected local and state officials, as well as delegates to the 1868 "Black and Tan" constitutional convention, half of whose members were people of color.

The constitution of 1868, largely the work of African Americans, was the first in Louisiana's history to contain a Bill of Rights. It recognized public education, civil rights, and black citizenship, and extended black enfranchisement while disenfranchising many ex-Confederates. After ratification, state officials were elected. Several of those elected were black, including Lieut. Gov. Oscar James Dunn. Throughout RECONSTRUCTION in Louisiana, blacks generally comprised approximately one-third of the state legislature. In 1871 P. B. S. PINCHBACK replaced Dunn as lieutenant governor. The following year, after Gov. Henry C. Warmoth, a white man, was impeached, Pinchback briefly became the nation's first black governor. He later was named a U.S. senator.

On the local level, there were more black than white officials only in parishes with a black population of eighty-five percent or higher. The policies advocated by black officials included state-supported public education, civil rights laws, support for charitable institutions, protection for laborers on plantations, legalizing common-law marriages, and constructing internal improvements. By 1873, the Louisiana legislature, according to Paul Kunkel, "had written into its enactments racial equality in the state, for which the constitution of 1868 had carefully provided."

Opposition by whites to Reconstruction was widespread. Violent activities by the KU KLUX KLAN, the KNIGHTS OF THE WHITE CAMELLIA, and others were rampant. Whites charged black officials with corruption, although government corruption was not due merely to the presence of blacks. In September 1868, whites in St. Landry Parish assaulted a Republican newspaper editor, Emerson Bently, broke up his press, and murdered a group of blacks who had rushed to his defense. In 1874, after a disputed gubernatorial election, white and black factions fought for control of the government, riots and armed confrontations broke out at Liberty Place in New Orleans, at the Conshattau Massacre in Red River parish, and at Colfax in Grant Parish.

As the election of 1876 approached, one antiblack politician, John McEnery, observed, "We shall carry the next election if we have to ride saddle-deep in blood to do it." Louisiana's disputed votes in the presidential election were traded for a Republican promise to end Reconstruction. Soon after, "white supremacy" reestablished, a new state constitution was enacted. Intimidation, violence, and economic coercion were used to threaten black voters. One authority asserted, "For all the talk of white suffering during the Reconstruction era, it was the black man who experienced the greatest deprivation and mistreatment first and last." The "Kansas Fever" exodus of 1879 was a reaction to the harsh new conditions. Throughout the state, the black press, especially the *New Orleans Weekly Pelican,* reported such incidents as black schools and churches being burned down, and phantom riders inflicting violence and committing murder. Few culprits were punished. By 1890, the state had a white majority.

By the 1890s, whites had begun institutionalized antiblack efforts. In 1890, state legislators passed a railroad segregation law. A creole, Homer Plessy, challenged the decision, but the U.S. Supreme Court, in the notorious decision PLESSY V. FERGUSON (1896), sanctioned the policy of "separate but equal," and segregation was introduced on a large scale in Louisiana. Legislators also passed restrictive voting registration laws, and in 1898 inserted a "grandfather clause" in the state constitution which effectively removed over ninety-five percent of black voters. After the U.S. Supreme Court outlawed GRANDFATHER CLAUSES in the Oklahoma case *Guinn* v. *United States* (1915), the Louisiana constitution of 1921 adopted poll taxes and an "understanding clause." Blacks were forced to convince white registrars they understood the state constitution. As a result of these measures, the number of blacks registered to vote in the entire state in 1940 was 897.

Life for black Louisianians continued to be dismal into the early decades of the twentieth century. Of the 3,211 blacks lynched in the United States from 1889 through 1918, Louisiana ranked fourth with 313. When boxer Jack Dempsey came to Baton Rouge in September 1920, his black sparring partner was prohibited from working with him while in the city. Most blacks continued to live in the area of their slave residence, while some moved to the larger cities of Shreveport, Baton Rouge, and New Orleans. Many were agricultural laborers or Mississippi River dockworkers, but among urban dwellers were craftsmen, carpenters, masons, mechanics, blacksmiths, butchers, tailors, cooks, entrepreneurs, educators, barbers, clerks, and grocers. Louisiana had a thriving African-American culture. Several black newspapers were established, including the bilingual *New Orleans*

Crusader, the *Concordia Eagle* (Vidalia), *The Grand Era* (Baton Rouge), *Lafouche Times* and *News Pioneer* (Iberville) and the *Pointe Coupee Republican.* Perhaps the most famous element of Louisiana African-American life was JAZZ, invented and developed in New Orleans, and carried up the Mississippi to the rest of the state. Later, ZYDECO music was born out of the efforts of black creoles and with some influence from cajuns, French-speaking white farmers.

Public education was poor or nonexistent. Charitable agencies actually provided more funds for black education than did state government for the first four decades of the twentieth century. Blacks raised money privately and by voluntarily paying an extra school tax to support black schools. Many black civic, social, and FRATERNAL ORDERS helped the schools. The Masons, Odd Fellows, Knights of Pythias, and other societies, churches, and FRATERNITIES AND SORORITIES, as well as local Baton Rouge men's clubs such as the Purple Circle and Bonanza, and the Women's Matrons Club all provided funds. As a result, many one-room schools were set up.

Several institutions of higher learning for blacks were set up during this period, most of them in New Orleans. Leland University, a private college, eventually moved to Baker, La., before closing in 1960. Straight University, chartered by the Louisiana legislature in 1869, was originally financed by the Freedmen's Bureau. Taken over by the American Missionary Association in 1870, Straight merged with New Orleans University, a state-run school founded in 1873, to form Dillard University in 1935.

Southern University, a state-supported institution of higher learning, was authorized by the constitutional convention of 1879. It was chartered by the state legislature in 1880 and qualified as a land grant college under the Morrill Act in 1892. It moved to Baton Rouge in 1914, and has two branch campuses, one in New Orleans and one in Shreveport. With a total enrollment of over fifteen thousand students, it is the largest predominantly African-American school in the country. Xavier University, opened in New Orleans in 1915, is the only Roman Catholic black college in the United States. Grambling State University, renowned for its football team, was established from the Colored Industrial and Agricultural School in Lincoln Parish; it inaugurated a four-year college program in 1940 and a graduate program in 1974. In 1992, a federal judge ordered Louisiana's black and white state college systems merged.

While New Orleans blacks successfully fought streetcar segregation in the 1920s, and formed a powerful NAACP branch, the first government efforts to improve black life came in the 1930s under the semi-dictatorial regime of Huey Long. While Long never indulged in public race-baiting, he supported the ra-cial status quo. However, he made quiet efforts to include black citizens in his "Share-the-Wealth" efforts, offering free school textbooks and homestead tax exemptions on a nonracial basis.

The 1944 U.S. Supreme Court decision in *Smith* v. *Allwright* and the Louisiana case of *Hall* v. *Nagel* voided the white primary and discriminatory application of state registration laws. Although the state legislature instituted other devices to dilute black voting strength, newly enfranchised African Americans participated in the struggle for change. When white soldiers, but not black, were allowed to vote by absentee ballot, Zelma Wyce, a future political leader in Madison Parish, later explained that "I said to myself right then that when I get back to Talullah [in Madison Parish] I was gonna start laying the groundwork for black people to get the right to vote." Throughout the 1950s and '60s, blacks throughout Louisiana launched voter education and registration drives, and in the 1960s began to vote in large numbers. State officials resisted change in the racial status quo through a strategy of "legislate and litigate," which included segregation laws, White Citizens Councils, blocks to voter registration, and economic coercion.

Louisiana was a major battleground in the CIVIL RIGHTS MOVEMENT. The first major efforts came in May 1960, when Southern University students commenced a two-year campaign of sit-ins in Baton Rouge, assisted by the CONGRESS OF RACIAL EQUALITY (CORE). Arrests in 1961 led to protest demonstrations which were repressed by tear gas and attack dogs. Students charged with disturbing the peace were expelled from Southern University and jailed. Bail was set at extravagantly high levels. Despite widespread condemnation of city authorities, media coverage of the events was minimal, and desegregation of the downtown Baton Rouge area did not occur until mid-1962.

CORE devoted major resources to Louisiana Summer Projects in 1963 and 1964. Volunteers built community organizations, marched against segregated facilities, and promoted voter education, in the face of white intimidation and terrorism. The largest effort was the ongoing voter registration campaign based in the small town of Plaquemine, begun in 1962. Blacks attempting to register continued to face obstacles, and in August 1963 CORE leader James FARMER inaugurated daily downtown marches, which were met with tear gas.

The pressure proved insufficient to force large-scale change or voter registration until the Civil Rights Act of 1964 and the VOTING RIGHTS ACT OF 1965, which forever changed the political landscape of the state (see also CIVIL RIGHTS AND THE LAW). Since then, major political gains have been made, largely through the work of grassroots organizers and

groups which sprung from the civil rights movement. These groups include the Black Organization for Leadership Development (BOLD), Louisiana Independent Federation of Electors (LIFE), Gus Young Civic Association, South Baton Rouge Advisory Committee, and Scotlandville Area Advisory Committee (SAAC). The 1980s saw a record number of blacks elected to state and local offices, and by the 1990s, the state legislature was 16 percent black, the second highest percentage in the United States, and had the highest number of black members since Reconstruction. Despite these gains, blacks, who make up about one-third of the state's population, are underrepresented in local, state, and national offices. In fall 1990, State Sen. William Jefferson was elected to the U.S. House of Representatives, the first black Louisianian in Congress since the 1870s. A second black representative, Cleo Fields, was elected in 1992.

Despite these triumphs, black life in Louisiana remains difficult. Education, health, and housing standards remain among the nation's worst, and unemployment remains high. Black Louisianians have also been faced with a white backlash against black equality. In 1986, David Duke, a former leader of the KU KLUX KLAN, was elected to the Louisiana legislature. In 1990, Duke lost a U.S. Senate race, and a year later ran for governor. Duke ran a race-baiting campaign in which he stigmatized blacks as lazy and welfare-dependent. Duke won a majority of the white vote, but a record 80 percent turnout of black voters handed the election to Edwin Edwards, Duke's opponent. The narrow victory underlined the precariousness of civil rights gains in Louisiana.

REFERENCES

FISCHER, ROGER A. The Segregation Struggle in Louisiana, 1862–1877. Urbana, Ill., 1974.

HALL, GWENDOLYN. Africans in Colonial Louisiana: The Formation of an Afro-Creole Culture in the Eighteenth Century. Baton Rouge, La., 1992.

MEIER, AUGUST and ELLIOTT RUDWICK. CORE: A Study in the Civil Rights Movement, 1942–1968. Urbana, Ill., 1973.

PERKINS, A. E. Who's Who in Colored Louisiana. Baton Rouge, La., 1930.

ROUSSEVE, CHARLES B. The Negro in Louisiana: Aspects of His History and Culture. New Orleans, 1937.

Statistical Abstract of Louisiana, 8th ed. New Orleans, 1990.

STERKX, H. E. The Free Negro in Antebellum Louisiana. Rutherford, N.J., 1972.

VINCENT, CHARLES. Black Legislators in Louisiana During Reconstruction. Baton Rouge, La., 1976.

———. A Centennial History of Southern University and A&M College. Baton Rouge, La., 1981.

CHARLES VINCENT

Louisville, Kentucky. African Americans have been an important part of Louisville since the first settlers arrived in 1778. The city's black population initially grew slowly, but by 1860 its 6,820 blacks were the largest urban concentration in Kentucky and 10 percent of the city's residents.

Despite their second-class status, antebellum Kentucky blacks—slave or free—had their best opportunities for progress in Louisville. Racism in Louisville proved slightly less harsh than throughout Kentucky, and better work opportunities existed, probably because of the size of the black population and the city's proximity to free soil.

African Americans provided much of the labor in antebellum Louisville. As slaves, men worked on the docks as stevedores, on the streets as draymen, and in woolen and cotton mills. Women toiled as cooks, housekeepers, washers, and ironers. By the 1830s, perhaps 20 percent of Louisville's black labor force consisted of hired-out slaves. Typically, owners hired out their more skilled slaves to the service industries—hotels and entertainment—the building trades, and factories. Hired women generally worked as domestics, often living in shacks in alleys behind their employers' homes. Free blacks, relegated by law to an inferior position, demonstrated a remarkable resilience within Louisville's economy. Many achieved success as teachers, ministers, barbers, tailors, carpenters, plasterers, and stewards.

The size of Louisville's African-American population enabled blacks to create a viable community with a sense of self-identity and even independence. The strong ministers of the independent black churches provided leadership and created a feeling of community. Louisville African Americans displayed an extraordinary determination to protect the few rights they possessed. Leaders advocated strong family relationships, opened schools for their children, and inaugurated social programs to assist the poor and the sick.

At the end of the CIVIL WAR, Louisville's African Americans faced four pressing problems: employment, housing, education, and civil rights. Those who possessed a skill fared best, but physical strength remained a prime necessity for employment. Within a few years African Americans became important laborers in the building trades and dominated Louisville's service industry and carrying trade. A few entrepreneurs enjoyed success in furniture and grocery stores, as barbers, and as undertakers.

Chafing at discrimination in the marketplace, Louisville businessmen William Wright and Henry Hall founded Mammoth Life and Accident Insurance Company in 1915, and other African-American businessmen in Louisville founded the Domestic Life and Accident Insurance Company in 1921. Mammoth Life

eventually opened offices in eight midwestern states and employed hundreds of agents.

Economic progress, however, moved slowly through the GREAT DEPRESSION. New Deal programs assisted a handful of high school and college students, but the greatest gains in employment for African Americans came during World War II when wages and opportunities increased. Samuel Plato's construction company won several sizeable federal contracts for building projects, and the city school board equalized black and white teachers' salaries; however, only a federal executive order banning discrimination brought gains in war industries jobs. Black protests in the 1950s forced the city government and several large businesses to hire African Americans for clerical and skilled positions, but as late as 1970 the median income of blacks remained 30 percent below that of whites, and in a city where blacks were 20 percent of the population they owned just 5 percent of the businesses.

African Americans flocked into Louisville from the countryside after the Civil War, crowding into shacks and shanties, many on poorly drained streets and alleys. Over the years, blacks were pushed into two large ghettos, "Smoketown" and "Brownstown." Determined to acquire better housing, Louisville blacks formed several self-help organizations designed to improve living conditions, but low-paying jobs and frequent economic panics prevented success for most. Despite arduous efforts, blacks remained poorly housed during the early twentieth century, and a 1950s housing study revealed that African Americans occupied most of Louisville's substandard housing. The greatest gains in acquiring upscale housing by blacks occurred in the 1980s and '90s, but some real estate agencies, unfortunately, continue making arbitrary decisions about where less affluent African Americans can rent or purchase homes.

Believing education to be the key to progress, Louisville African Americans quickly expanded their church schools after the Civil War and began demanding a system of public education for blacks. Pressure forced Louisville whites in 1870 to allocate funds for black public schools, four years before the creation of a state system. In 1879 Kentucky black Baptists founded the Baptist Normal and Theological Institute, which became the State University in Louisville in 1883, the first college in Kentucky for African Americans. (More recently its name was changed to Simmons University and then to Simmons Bible College, as it is known today.)

Louisville African Americans also took the lead in fighting for basic human and civil rights. In 1870–1871 a committee representative of the black community began a city-wide protest that forced an end to segregation and harassment on local streetcar lines. By 1875, however, Louisville blacks were divided over community responses to encroaching JIM CROW laws. William H. Steward, editor of the *American Baptist,* and Nathaniel P. Harper, the city's leading black lawyer, representing the conservative old guard, urged that blacks not test the federal Civil Right Act. Dr. Henry Fitzbutler, representing more militant civil rights activists, urged Louisville blacks to demand their legal rights. In 1883 the U.S. Supreme Court overturned the 1875 Civil Rights Act, leading to increasing discrimination and a growth in Jim Crow policies in Louisville, but the division between accommodationists and militants remained. In 1892, when the Louisville and Nashville Railroad Company segregated passenger cars, Louisville's African Americans led the "Anti-Separate Coach Movement," which blocked segregated railroad cars.

In the early twentieth century, the Louisville chapter of the NATIONAL ASSOCIATION FOR THE ADVANCEMENT OF COLORED PEOPLE (NAACP) made its reputation fighting for equal public accommodations, antilynching legislation, and an end to Jim Crow housing. Accommodationist leaders, such as William H. STEWARD, who controlled the Louisville chapter of the NAACP, working through powerful white friends, blocked three efforts to segregate public transportation between 1910 and 1918, but could not prevent Louisville's 1914 Residential Segregation Ordinance which the U.S. Supreme Court struck down in 1917.

After 1920, militant journalists I. Willis Cole and William Warley challenged the conservative African-American leadership. First under the banner of the Lincoln Independent Party, and later upon gaining control of the NAACP, they pulled back the veil of racism that dominated city services and government, forcing concessions. In the 1930s a new generation of antiaccommodationists, led by Frank Stanley, Sr., editor of the *Louisville Defender,* and Charles W. ANDERSON assumed leadership in Louisville. Stanley and Anderson spearheaded the fight to integrate the University of Louisville and won for blacks the right to enjoy city parks.

The hard work of Stanley and Anderson seemed to reach fruition when desegregation of public schools began during the mid-1950s; by the mid-1960s one-half of Louisville's schools had integrated. A 1963 executive order by the governor essentially ended legal discrimination, but anti-integration attitudes among whites remained largely unchanged. The home of a black couple who had purchased a house in the all-white Shively subdivision was bombed, and an angry mood gripped the black community as harassment and discrimination continued at lunch counters, at the Churchill Downs race track, and in employment. Economic boycotts and picketing of white-owned businesses turned into rock throwing and name-

calling incidents. Louisville blacks watched with increasing anger as the U.S. government and the boxing establishment persecuted Louisville-born heavyweight boxing champion Muhammad ALI, and complained that no amount of effort seemed to change their status as second-class citizens. The inevitable blow-up came in May 1968 when violence erupted in Louisville's West End, leaving two black teenagers dead, ten persons injured, 472 under arrest, and $200,000 in property damage.

During the 1970s and '80s slow but permanent progress occurred in interracial relations in Louisville, even though the racial attitudes of a significant portion of whites lagged behind progressive changes. Schools were the key. In spite of desegregation efforts, early 1970s Kentucky Human Rights Commission reports indicated that 74 percent of Louisville's schools had remained largely segregated because of white flight to the suburbs, and that 15 percent of Louisville's formerly all-black schools retained a "racial identity."

The breakthrough came in 1975 when, to stop white flight to the suburbs, Louisville and Jefferson County school systems merged and inaugurated court-ordered, county-wide busing to achieve integration. Massive busing resulted in ugly protests and wanton violence, but busing permanently altered Louisville over the next decade, largely because of its effect on team sports. The addition of blacks to previously all-white basketball and football teams probably accomplished more toward bringing black and white Louisvillians together than any other development. By 1984–85, Jefferson County schools were the third-most desegregated system in the nation and race relations significantly improved.

In the early 1990s Louisville's African Americans enjoyed a richer, fuller life, if not one of total equality. Blacks were honored guests at the Kentucky Derby, enjoyed the city's rich cultural traditions, dominated team sports at all levels, and resided in some of the city's most fashionable subdivisions. Much progress remains to be made, but progressive Louisvillians, black and white, believe their city has at last taken a major step toward deserving the "liberal" designation they have so long proclaimed.

REFERENCES

Kentucky Commission on Human Rights. *30th Anniversary Commemoration of the Kentucky Commission on Human Rights.* Louisville, Ky., 1990.

LITWACK, LEON, and AUGUST MEIER, eds. *Black Leaders of the Nineteenth Century.* Urbana and Chicago, Ill., 1988.

LUCAS, MARION B. *A History of Blacks in Kentucky: From Slavery to Segregation, 1760–1891.* Frankfort, Ky., 1992.

WRIGHT, GEORGE C. *A History of Blacks in Kentucky: In Pursuit of Equality, 1890–1980.* Frankfort, Ky., 1992.

———. *Life Behind A Veil: Blacks in Louisville, Kentucky, 1865–1930.* Baton Rouge, La., and London, 1985.

MARION B. LUCAS

Love, Emanuel King (July 27, 1850–April 24, 1900), minister and editor. Emanuel King Love, the son of Cumby Jarret and Maria Antoinette Love, was born into slavery near Marion, Perry County, Ala. His desire for an education was so great that after emancipation in 1865 he obtained private instruction from various whites on his farm. He was converted and baptized in July 1868, and began to preach. With his church's help, he entered Augusta Institute in Georgia in November 1872, graduating in 1877.

Love was ordained a Baptist minister on December 12, 1875, and served his church in Marion for six months, then returned to Augusta to finish school. He was appointed missionary for Georgia under the joint supervision of the American Baptist Home Mission Board and the Georgia Mission Board, both being predominantly white groups. From October 1881 to October 1885 he was supervisor of Sunday school mission work for African Americans in Georgia, with the support of the American Baptist Publication Society of Philadelphia. He then became the pastor at the First African Baptist Church of Savannah, Ga., where he remained for the rest of his life.

Love was one of the founders of the Baptist Foreign Mission Convention, and served one-year terms as its president in 1889, 1890, and 1893. In 1892 he and the church hosted its national meeting. In 1895 the organization joined with other black Baptist organizations to form the NATIONAL BAPTIST CONVENTION.

Love was an outspoken opponent of racial injustice. The most famous instance of his clashes with JIM CROW occurred on September 9, 1889, when Love and his entourage were going by train to a meeting of the Baptist Foreign Mission Convention. Ignoring the rules against integrated public transportation in Georgia, the group took seats among the whites in the train. This led to a violent attack on Love and the delegates. As the train reached Baxley, Ga., they were brutally assaulted by fifty or more white men with clubs, pieces of iron, and pistols. Despite their injuries from the attack, the group continued their way to the convention in Indianapolis. The "Baxley incident" was viewed by the Baptist and black newspapers as an unusually vicious instance of white Southern lawless-

ness against respectable blacks, and an ominous sign of the tightening grasp of segregation.

For many years until his death, Love was president of the Georgia Negro Baptists Convention and was founder and editor of the *Centennial Record* for Baptists of Georgia, and associate editor of the *Georgia Sentinel,* a Baptist paper based in Augusta.

Love was intensely interested in higher education for African Americans and was instrumental in the founding of the Georgia State Industrial College in Savannah. He died suddenly on April 24, 1900.

REFERENCES

MURPHY, LARRY G., J. GORDON MELTON, and GAY WARD, eds. *Encyclopedia of African American Religions.* New York, 1993.

WASHINGTON, JAMES MELVIN. *Frustrated Fellowship: The Black Baptists' Quest for Social Power.* Macon, Ga., 1986.

JO H. KIM

Love, Nat "Deadwood Dick" (June 1854–1921), cowboy. Born into slavery, Nat Love was the youngest child and second son of a slave foreman and a cook on the Davidson County, Tenn., plantation of Robert Love. After the Civil War, Nat's father farmed twenty acres he rented from his former master. At age fifteen, Nat became responsible for the family's meager finances after his father and brother-in-law died and his older brother left home.

Love worked briefly for a nearby farmer for $1.50 a month but returned to the family farm after the farmer tried to cheat him out of his pay. Love began supplementing his income by breaking horses for a neighbor. He also proved to be clever and lucky. In early 1869 Love won a horse in a raffle, sold it back to the owner for fifty dollars, and then rewon the horse when the owner raffled it off again. Love sold the horse again for fifty dollars, split his winnings with his mother, and like one of thousands of African Americans seeking opportunity, set off for the West.

Soon after going west, Love's horse-breaking skills won him a job with the cowboys from the Duval Ranch in the Texas panhandle. Love described himself in those days as "wild, reckless and free, afraid of nothing, that is nothing I ever saw, with a wide knowledge of the cattle country and the cattle business and of my guns with which I was getting better acquainted with every day, and not above taking my whisky straight or returning bullet for bullet in a scrimmage."

In July 1876 Love was in Deadwood, S.Dak., delivering three thousand head of three-year-old steers for his new ranch, the Pete Gallinger company from Arizona. The cowboys' route had taken them past Little Bighorn, Wyo., only two days behind Gen. George Armstrong Custer; they arrived in Deadwood on July 3, 1876, eight days after the Battle of Little Bighorn. The next day Love won the annual cowboy competition in Deadwood by roping, throwing, tying, bridling, saddling, and mounting an untamed bronco in nine minutes flat. This feat, along with his marksmanship, earned him the name Deadwood Dick. With his long hair, he cut a striking figure as an archetypal rough-and-tumble cowboy.

In 1890 Love left the range. He believed that the railroads had made his job obsolete, and he saw them as the wave of the future. Love became one of the first Pullman porters, working the Denver and Rio Grande Western Railroad. He published his autobiography, *The Life and Adventures of Nat Love, Better Known in Cattle Country as Deadwood Dick,* in 1907. By that time he had left the railroad and moved to Los Angeles, where he worked for the General Securities Company. Love died in Los Angeles in 1921.

REFERENCES

KATZ, WILLIAM LOREN. *The Black West.* 3rd ed. Seattle, Wash., 1987.

LOVE, NAT. *The Life and Adventures of Nat Love.* 1907. Reprint. Irvine, Calif., 1968.

NANCY YOUSEF

Loving, Alvin (September 19, 1935–), artist. Al Loving was born in Detroit, Mich. His mother, a Canadian, was a descendant of an UNDERGROUND RAILROAD survivor. His father, Alvin Demar Loving, was associate dean at the University of Michigan and an important figure in international education who established universities in Nigeria and India, and served as a consultant to the Indian government on the reorganization of their secondary school system. When young Loving traveled to India in 1955 with his father, he observed an artist working on large-scale murals and decided to become a painter. From 1958 to 1960, Loving served in the U.S. Army as a propaganda illustrator. He graduated from the University of Illinois with a B.F.A. in 1963, and taught at Eastern Michigan University from 1964 to 1965 while pursuing his M.F.A. in painting at the University of Michigan, which he completed in 1965.

During his years at Michigan, Loving developed many technical interests—in geometry, the illusionistic manipulation of space, and the organization of color—which became trademarks of his style by the 1970s. When he moved to New York City in 1968, geometric shapes, particularly the square, became the

central subjects of his paintings, allowing him to experiment with abstract problems in perspective while maintaining an interest in representational form. Images from this early period were known for their crisp geometric lines and their three-dimensional appearance (*Rational Irrationalism,* 1969; *Untitled,* 1970; *Time Trip I,* 1971; *Wyn . . . Time Trip II,* 1972).

Loving presented his first solo exhibition in 1969 at the Gertrude Kasle Gallery in Detroit, and Kasle helped him establish connections at the Whitney Museum of American Art, where Loving was invited to organize a solo show in the same year. In 1972, Loving was commissioned to paint a seventeen-story mural for the First National Bank Building in Detroit (*New Morning Detroit: Message to Damar and Laurie*). When a worker was seriously injured during construction of the piece, Loving shifted away from large-scale geometric painting and began to create smaller pieces using strips of cut, dyed, and sewn material. Loving's interest in the manipulation of canvas and cloth was influenced by his grandmother's work as a quilter, and he was captivated by the stylistic potential of strip painting over a ten-year period, creating his best known work in this genre in the early 1980s (*Self-Portrait,* series initiated in 1980; *Shades of '73: Composition for 1980,* 1980).

In the mid-1970s, Loving expanded his interest in manipulation of material by working with paper and cardboard to create large-scale corrugated collages (*Untitled* 1975; *Shelly, Fran, Susie, and Andrea,* 1976). During this period, he also created a series of works inspired by water lilies and some figurative compositions based on erotic subjects. From 1981 to 1985, after studying with lithographer Robert BLACKBURN, Loving created a number of monoprints (*Tropical Rain Forest,* 1985), and he also experimented with handmade paper works, including the production of paper pulp (*Mercer Street Series,* 1983–84).

Loving's work has been shown in solo exhibitions at William Zierler in New York (1971, 1972, 1973), the Fischbach Gallery in New York (1974, 1976), the Studio Museum in Harlem (1977, 1986), the Diane Brewer Gallery in New York (1980, 1983), and the Bronx Museum (1989). He has received grants from the National Endowment for the Arts, a CAPS grant, and a Guggenheim Fellowship. Loving has been associate professor of art at City College, City University of New York, since 1988.

REFERENCES

LITTLE, JAMES, "Alvin Loving." *Artist and Influence* 4 (1986): 59–68.
WRIGHT, BERYL. "Alvin Loving." In *The Appropriate Object: Maren Hassinger, Richard Hunt, Oliver Jackson, Alvin Loving, Betye Saar, Raymond Saunders, John Scott.* Buffalo, N.Y., 1989.

APRIL KINGSLEY

Lowery, Joseph Echols (October 6, 1924–), president, Southern Christian Leadership Conference. Born and raised in Huntsville, Ala., Joseph Lowery attended Knoxville College in Tennessee from 1939 to 1941. In the 1940s he studied theology at Paine Theological Seminary in Augusta, Ga., and was ordained a minister by the United Methodist Church. From 1952 to 1961 he served as pastor of the Warren Street Methodist Church in Mobile, Ala., where he developed a politically active ministry and helped sponsor lower- and middle-class housing developments for African Americans. In January 1957, Lowery was invited by the Rev. Dr. Martin Luther KING, Jr. and the Rev. Fred SHUTTLESWORTH to become a founding member of the SOUTHERN CHRISTIAN LEADERSHIP CONFERENCE (SCLC).

Lowery remained one of the SCLC's central leaders through the heyday of the CIVIL RIGHTS MOVEMENT. He first gained national attention, however, in 1962 when the city commissioners of Montgomery, Ala., successfully sued Lowery, three other SCLC leaders, and the *New York Times* for libel over the organization's advertisement in the newspaper attacking the racist policies of the Montgomery city government. The case, *New York Times Co.* v. *Sullivan* (1964), became a landmark in libel jurisprudence when the Supreme Court reversed the Alabama court's decision in favor of the plaintiffs. Lowery served as a chief organizer of the pivotal desegregation campaigns in Birmingham in 1963 and Selma in 1965. In 1965 he moved to Birmingham to become pastor of St. Paul's Methodist Church and assumed a leadership position in the Alabama Christian Movement for Human Rights, a civil rights organization allied with the SCLC.

In 1968 Lowery moved to Atlanta, where he became pastor of Central United Methodist Church and emerged as the leader of the moderate faction within the SCLC. In 1977 Lowery wrested control from the militant wing, led by Hosea WILLIAMS, and was elected president of the organization in 1977. As president he was accused by the Williams faction of transforming the SCLC into a "middle-class clique of blacks," yet under Lowery's leadership the organization underwent a period of revitalized activism.

In 1978 and 1979 Lowery led a protest of a Mississippi energy company for buying coal from South Africa and directed a support march for the "Wilmington Ten," a group of civil rights activists who had been jailed for alleged conspiracy to murder white segregationists. During this time the SCLC also led a support march for Tommie Lee Hines, a mentally retarded black youth who the organization believed was wrongly convicted of raping a white woman in Decatur, Ala. During the march for Hines, members of the KU KLUX KLAN opened fire on the marchers, injuring four and barely missing Lowery

Joseph Lowery, founder of the National Crusade for Religious Freedom, was director from 1977 to 1992 of the Southern Christian Leadership Conference, where he was active in issues of black economic empowerment and the ending of white minority rule in South Africa. In 1995 Lowery was a leader of a thirtieth-anniversary reenactment of the Selma-to-Montgomery march for civil rights. (Photographs and Prints Division, Schomburg Center for Research in Black Culture, The New York Public Library, Astor, Lenox and Tilden Foundations)

and his wife. In 1979 Lowery was severely criticized by American Jewish organizations after he led a delegation of African-American clergy to Lebanon, where they met with Palestine Liberation Organization (PLO) leader Yasir Arafat and called for the establishment of a Palestinian homeland, reduction of U.S. aid to Israel, and PLO recognition of Israel as a nation.

In the 1980s Lowery continued to broaden the SCLC's activities beyond traditional civil rights issues. He oversaw the organization's involvement with Haitian refugees seeking political asylum in the United States, protested U.S. policy in Central America, supported the antiapartheid movement, and reinitiated the Operation Breadbasket economic program, which raised money for black-owned enterprises. Through the decade the group also conducted Crusade for the Ballot, a program that significantly increased the black vote in the South through increased voter registrations. In 1986 Lowery transferred to the Cascade United Methodist Church, where he finished his career as a minister.

In the early 1990s the SCLC under Lowery's leadership continued to serve as a national coordinating agency for local civil rights organizations and conducted a national "Stop the Killing" campaign to protest gang violence. Lowery retired from the ministry in 1992, but nevertheless continued to serve as president of the SCLC.

REFERENCES

BRANCH, TAYLOR. *Parting the Waters: America in the King Years, 1954–1963.* New York, 1988.
Current Biography Yearbook. New York, 1982.
FAIRCLOUGH, ADAM. *To Redeem the Soul of America: The Southern Christian Leadership Conference and Martin Luther King, Jr.* Athens, Ga., 1987.

THADDEUS RUSSELL

Loyalists in the American Revolution.

Black Loyalists were free and enslaved men, women, and children who allied with the British in the AMERICAN REVOLUTION. Blacks in each of the thirteen colonies took part in this massive movement, whose numbers range from 100,000 to 250,000. Although the proximity of the English Army afforded opportunities for slave flight, African Americans joined forces with the British throughout the war. African-American alliance with the British Army officially began on November 7, 1775, when Lord Dunmore, royal governor of Virginia, promised freedom to all "indented servants, Negroes and others . . . joining His Majesty's troops . . . for reducing the Colony to a proper sense of duty to His Majesty's crown." A weapon of war in America since the early seventeenth century, enticement of enemy servants and slaves with promises of freedom had never before been used to such devastating effect. British commanders William Howe, in 1777, and Sir Henry Clinton, in 1779, repeated Dunmore's clarion cry of freedom.

Such promises of freedom were the fundamental reason for blacks' choosing loyalism. Harshness of servitude was also a factor. For example, over 120 people, 13 percent of the black population, in Dutch-dominated Bergen County, N.J., where existence was grim, fled to Anglo-controlled New York City. In contrast, fewer departed from neighboring, Presbyterian Essex County. Slaves with Anglican, Methodist, and Quaker masters tilted toward the English. Among the evacuees were 131 free blacks, who chose more reliable futures of freedom with the English.

Blacks pledged loyalty to the crown even though many Tories were slave holders; many American blacks recognized that opportunities for freedom were better among the British. One observer argued that "blacks generally want an English victory, for they believe it will secure freedom." Whereas during the colonial era the overwhelming number of fugitives were young men, black evacuees from New

York City in 1783 included 1,336 men, 914 women, and 750 children. Many departed in family units formed before the war or within the British lines. In New York and Charleston, blacks created a free culture. Ministers and churches emerged; blacks held dances and frolics with British soldiers and sailors.

The British offered sanctuary to blacks to disrupt the American society and economy. Although exploitative conditions at times resembled slavery, black workers received pay and were free to create their own private lives. Some served the British as servants, laborers, mariners, wagoneers; others worked in private concerns. About twenty, for example, labored for pay in a Loyalist brewery in New York City. But the primary function of Black Loyalists was military. They served as pilots, spies, and members of black regiments. The Black Pioneers and Guides mustered in North Carolina in 1777; the Black Brigade operated around Philadelphia and New York City after 1778. Black regiments were especially effective in small raids against Patriot militia forces. Irregular forces known as "followers of the flag" mounted offenses against the patriots in Monmouth and Bergen counties in New Jersey, and outside of Charleston, S.C. In Monmouth, the legendary black raider Colonel TYE led a "motley crew" that regularly seized food, fuel, and valuable goods, robbed and kidnapped Patriots, and controlled border posts.

Despite Patriot efforts to move slaves far from the theater of war, the number of fugitives increased late in the war. After Gen. Henry Clinton's Philipsburg Proclamation in 1779, blacks from the plantations of South Carolina and Georgia and from the "neutral zone" surrounding New York City fled into the English lines.

The most certain estimates of Black Loyalists are based on the numbers leaving British-controlled ports at the end of the war. In addition to the three thousand who left New York City in 1783, another seven thousand were evacuated from southern port towns of Norfolk, Va.; Savannah, Ga.; and Charleston, S.C. Not all found freedom. Gen. Cornwallis abandoned over four thousand former slaves in Virginia. The British sold many southern blacks into bondage in the West Indies. In New York City, however, Gen. Carleton maintained a promise and, ignoring the fury of the Americans, permitted three thousand blacks to migrate to freedom in Nova Scotia. There, though liberty was often tough, they received land, jobs, and financial grants. In 1791, over one thousand, under the leadership of Samuel Peters, migrated to Sierra Leone and initiated a black variant of republicanism. The remainder stayed in Nova Scotia, joined in the 1790s by Maroons from Jamaica, and, after the War of 1812, by more refugees who fought their way out of slavery in the United States.

During the nineteenth century, the Black Loyalists remained important symbols of a successful rebellion against slavery.

REFERENCES

FREY, SYLVIA. *Water from the Rock: Black Resistance in a Revolutionary Age.* Princeton, N.J., 1991.

QUARLES, BENJAMIN. *The Negro in the American Revolution.* Chapel Hill, N.C., 1960.

WILSON, ELLEN. *The Loyal Blacks.* New York, 1976.

GRAHAM RUSSELL HODGES

Loyal League. *See* Union League of America.

Luca Family Singers. The Luca Family Singers was one of the most prominent African-American musical ensembles of the pre–CIVIL WAR years, an era in which groups such as the Hutchinson Family Singers dominated the popular concert stage. The Luca Family Singers, who were active throughout the 1850s, modeled themselves on such ensembles, touring the country with an eclectic repertory of classical and religious music. Although many newspaper reviews of Luca Family concerts have survived, some aspects of the ensemble's history, and details of the biographies of its members, remain uncertain. The group was founded by John W. Luca (c. 1805–1877), a Milford, Conn., shoemaker who studied music in a local singing school before moving to New Haven. There he married Lisette Lewis, also a musician, and served as a chorister in New Haven's Congregational Church. Luca recruited his first two sons and his wife's sister, Diana, for a quartet to give local concerts. Eventually, Luca expanded the group to include instrumentalists. John, Jr. (c. 1820–1910), was bass-baritone, cellist, and string bassist, Simeon (c. 1830–1854) was first tenor and violinist, Alexander (c. 1830–?) was second tenor and violinist, and Cleveland (1838–1872) was soprano and pianist. Their programs consisted of both sacred and secular music, including temperance songs and opera arias. The group made its New York debut in the early 1850s at an Anti-Slavery Society concert at the Old Tabernacle before 5,000 people. Simeon died in 1854, and was replaced by the contralto and pianist Jennie Allen.

In 1857 the ensemble began a tour of New York, Pennsylvania, and Ohio. Despite being barred from using hotels and bathrooms, their tours were great successes, and the Luca Family Singers gained broad popularity. The three remaining brothers—John Jr.,

Cleveland, and Alexander—toured the Midwest in 1859 with the Hutchinson Family Singers, who were white. Cleveland moved to Africa in 1860, spelling the formal end of the group. He later composed the national anthem of Liberia, where he died in 1872. Alexander Luca remained in the United States, settling down in Zanesville, Ohio. John, Jr., eventually joined the Hyers Sisters Colored Minstrels, and lived in St. Paul, Minn., where he ran a music studio.

REFERENCES

LUCA, JOHN. Letter to the *Indianapolis Freeman,* November 27, 1909.

TROTTER, JAMES M. *Music and Some Highly Musical People.* New York, 1881. Reprint. New York, 1968.

JONATHAN GILL

Lucy Foster, Autherine (October 15, 1929–), student civil rights activist. Autherine Lucy was born in Shiloh, Ala. She attended public schools there and in Linden, Ala., before attending Selma University and Miles College in Birmingham, from which she graduated in 1952. In September of that year, she and a friend, Pollie Myers, a civil rights activist with the NAACP, applied to the University of Alabama. Lucy later said that she wanted a second undergraduate degree, not for political reasons but to get the best possible education in the state. Although the women were accepted, their admittance was rescinded when the authorities discovered they were not white.

Backed by the NAACP, Lucy and Myers charged the University of Alabama with racial discrimination, in a court case that took almost three years to resolve. While waiting, Lucy worked as an English teacher in Carthage, Miss., and as a secretary at an insurance company. In July 1955, in the wake of the 1954 U.S. Supreme Court decision in BROWN V. BOARD OF EDUCATION, the University of Alabama was ordered by a federal District Court to admit Myers and Lucy.

On January 30, 1956, the university admitted Lucy, but rejected Myers on the grounds that a child she had conceived before marriage made her an unsuitable student. Lucy registered on February 3, becoming the first African American to be accepted as a student at the 136-year-old University of Alabama.

The university's decision was met with resistance by many students, Tuscaloosa citizens, and the KU KLUX KLAN. Crosses were burned nightly on the campus grounds, and mobs rioted at the University in what was, to date, the most violent post–*Brown* anti-integration demonstration. On the third day of classes, after white student mobs pelted Lucy with rotten produce and threatened to kill her, she was suspended from school on the grounds that her own safety and that of other students required it. The NAACP filed suit protesting this, and the federal courts ordered that Lucy be reinstated after the university had taken adequate measures to protect her. However, on that same day, February 29, Lucy was expelled from the University of Alabama on the grounds that she had maligned its officials by taking them to court. The NACCP, feeling that further legal action was pointless, did not contest this decision. Lucy, tired and scared, acquiesced.

In April 1956, in Dallas, Lucy married Hugh Foster, a divinity student (and later a minister) whom she had met at Miles College. For some months afterward, she became a civil rights advocate, making speeches at NAACP meetings around the country. But, by the end of the year, her active involvement in the civil rights movement had ceased.

For the next seventeen years, Lucy and her family lived in various cities in Louisiana, Mississippi, and Texas. Her notoriety made it difficult at first for her to find employment as a teacher. The Fosters moved back to Alabama in 1974, and Lucy obtained a position in the Birmingham school system.

In April 1988, Autherine Lucy's expulsion was annulled by the University of Alabama. She enrolled in the graduate program in education the following year and received an M.A. degree in May 1992. In the course of the commencement ceremonies, the University of Alabama named an endowed fellowship in her honor.

REFERENCES

CLARK, E. CULPEPPER. *The Schoolhouse Door: Segregation's Last Stand at the University of Alabama.* New York, 1993.

KLUGER, RICHARD. *Simple Justice: The History of Brown v. Board of Education and Black America's Struggle for Equality.* New York, 1976.

QADRI ISMAIL

Lunceford, James Melvin "Jimmie" (June 6, 1902–July 7, 1947), big band leader. Jimmie Lunceford was born in Fulton, Mo., and grew up in Denver, Colo., where he learned to play reed instruments as a child, studying with Wilberforce Whiteman, the father of the bandleader Paul Whiteman. In his teens he played also saxophone in George Morrison's band in Denver. Lunceford studied music at FISK UNIVERSITY in Nashville, Tenn., receiving his B.A. in 1926. He then continued his studies at the City College of

New York, but also began to perform professionally in the bands led by Elmer Snowden and Wilbur Sweatman. Lunceford moved back to Fisk, where he served as an assistant professor of music, and in 1927 he began to lead a student band, known as the Chickasaw Syncopators. The band, which was eventually known as the Jimmie Lunceford Orchestra, first recorded in 1930 ("In Dat Mornin'," "Sweet Rhythm"), and toured the Midwest and New England before arriving in New York in 1933.

The Lunceford band's 1934 engagement at the Cotton Club, and their recordings the same year of "White Heat," "Jazznocracy," "Mood Indigo," and "Rhythm Is Our Business" helped make them one of the most popular and significant big bands of the swing era. Unlike the Duke ELLINGTON, Count BASIE, and Fletcher HENDERSON orchestras, which featured star soloists, Lunceford's was an arranger's band. During its peak, from 1934 to 1944, Sy Oliver, Edwin Wilcox, and Willie "the Lion" SMITH provided the charts that made the Lunceford band a paragon of precision and taste, with a polished charm and elegant stage presence that followed painstaking and meticulous rehearsals. Throughout the rest of the 1930s and well into the early 1940s, Lunceford's was among a handful of JAZZ orchestras that dominated the swing era. They toured throughout the United States, and in 1937 performed in Scandinavia. Their recordings, many of which were national hits, ranged from Lunceford's own futuristic "Stratosphere" (1934), to the straight-ahead "Organ Grinder's Swing" (1936), "For Dancers Only" (1937), "The Merry-Go-Round Broke Down" (1937), and "Margie" (1938), to the whimsical "I'm Nuts About Screwy Music" (1935). Arrangements for the Lunceford band displayed fastidious and richly developed writing for the reeds, and punchy brass sections. The best-known members of the Lunceford band included tenor saxophonist Joe Thomas, trombonists Trummy Young and Eddie Durham, trumpeter Snooky Young, and alto saxophonist Willie Smith. The orchestra also performed with vocalists, including the Dandridge Sisters trio on "Minnie the Moocher is Dead" (1940). Lunceford himself knew how to play saxophones, flute, guitar, and trombone, but he limited his professional work almost exclusively to conducting.

Continued changes in personnel, including the departures of Oliver in 1939 and Smith in 1942, and a mass walkout in 1942 to protest Lunceford's profligate spending habits, left the band much weakened. New arrangers, including Tadd DAMERON and George Duvivier, failed to revive the ensemble's popularity, although they continued to tour. Among the band's important later recordings are "Blues in the Night" (1941), "Knock Me a Kiss" (1942), and "Jeep Rhythm" (1944). Lunceford died in Seaside, Ore., in 1947, after collapsing while signing autographs at a record store.

REFERENCES

EDWARDS, E., JR., G. HALL, and B. KORST. *Jimmie Lunceford*. Whittier, Calif., 1965.
SCHULLER, GUNTHER. *The Swing Era*. New York, 1989, pp. 201–222.

JONATHAN GILL

Lutheranism. A Christian tradition born as a consequence of the sixteenth-century Protestant Reformation in Europe, Lutheranism has always been a small religious presence in the African-American community. In 1991, approximately 132,000 African Americans belonged to several predominantly Euro-American Lutheran denominations in the United States. By comparison, the historic African-American Baptist, Methodist, and Pentecostal denominations had memberships in the millions. Nevertheless, African-American Lutheranism has a rich history and heritage that dates back to the seventeenth century.

This history began on April 13, 1669, in a New York church. On that Palm Sunday morning, a free African American named Emmanuel was baptized and admitted into congregational membership by Rev. Jacob Fabricius, a Lutheran minister. Emmanuel thus became the first known African-American Lutheran. As with Emmanuel, the sacrament of baptism, rather than the conversion experience, proved to be the chief means through which African Americans became Lutherans in the seventeenth and eighteenth centuries. Particularly in the eighteenth century, such baptisms performed by Lutheran clergy took place in the Danish West Indies, where the Lutheran church was the state church, as well as in the British colonies. Through them, both slave and free African Americans became Lutherans. Indeed, the first Lutheran worship service held in New Jersey included the baptism of the granddaughter of Aree and Jora van Guinee, two free African-American Lutherans. Significantly, this worship service, held on August 1, 1714, was conducted in the van Guinee home. It led to the organization of the first Lutheran church in New Jersey, of which the van Guinees were charter members.

Although African Americans initially joined the Lutheran church in the colonial era, their numbers did not increase substantially until the Second Great Awakening. During the eighteenth century and into the first years of the nineteenth, numerous Lutherans of German descent emigrated to the American South,

either from North America's mid-Atlantic region or from Germany. There they settled in Virginia, Georgia, the Carolinas, and Tennessee and increasingly came into contact with large numbers of African Americans, the large majority of whom were slaves. Indeed, some of these African Americans became acquainted with these Lutherans because they were owned by them.

The antebellum period was important in the development of African-American Lutheranism. As a result of the North Carolina Synod's 1817 Five Point Plan, the South Carolina Synod's urban strategy, and the activity of Lutheran slavemasters intent upon mediating Christianity to their slaves, the number of African-American Lutherans grew. Lutherans of African descent, for example, constituted between one-sixth and one-fourth of the South Carolina Synod's membership prior to the Civil War. Other southern Lutheran synods recorded accessions as well. In addition, the first African-American Lutheran clergy—all of whom were connected to Rev. John Bachman's Saint John's Lutheran Church in Charleston, S.C.—were ordained in this period. Yet none of these three, the Reverends Jehu Jones, Boston Drayton, and Daniel A. PAYNE, served for any considerable time. Because of the racism that permeated Euro-American Christianity, these pioneers ultimately sought or were called to other positions. Jones left the church after founding Saint Paul's Lutheran Church in Philadelphia in 1836 and attempting to organize a second congregation in New York City. Drayton became not only a missionary to Liberia but chief justice of the Liberian Supreme Court. Payne left the Lutheran church and became an important educator at Wilberforce University and an influential bishop in the African Methodist Episcopal church.

The Civil War, which altered radically the social relations between African Americans and Euro-Americans, had particular consequence for the churches, including the Lutheran church. As occurred in other denominations, the war's aftermath witnessed newly emancipated African-American Lutherans forced to leave those joint parishes they had attended previously. This development temporarily halted the planting of Lutheranism among African Americans.

African-American Lutheranism experienced a renewed period of growth during Reconstruction. Under the auspices of such bodies as the North Carolina and Tennessee synods, the Synodical Conference, and the Joint Synod of Ohio, a number of African-American Lutheran churches were established throughout the South. In particular, those congregations affiliated with the Synodical Conference often founded parish-related Christian day schools as well. These church bodies also trained a number of African

Americans to pastor such congregations. Indeed, it was the need to train African-American Lutheran pastors and teachers that in 1903 brought into existence Immanuel Lutheran Seminary and College in Concord, N.C., and Luther College in New Orleans. A third institution, Alabama Lutheran Academy, opened its doors in 1922 in Selma, Ala., to prepare young women to teach in Christian day schools. By that time Rosa Young, an African-American laywoman, had distinguished herself for leadership in the Christian day-school movement.

The boldest move toward African-American Lutheran autonomy and identity took place in this postbellum period, when paternalism characterized the relationship of the various Lutheran bodies to their African-American clergy and congregations. This initiative eventuated in the formation in 1889 of the Alpha Synod, the first African-American Lutheran synod, by Revs. David J. Koontz (the synod's president), Philo W. Phifer, Samuel Holt, and Nathan Clapp. The synod, which consisted of five churches in North Carolina, experienced financial difficulties and disbanded in 1891.

The twentieth century witnessed several significant developments in the history and heritage of African-American Lutheranism. As a result of the migration of Lutherans from the West Indies and the southeastern United States that began in the 1920s, a substantial number of African-American congregations were established in the northern, midwestern, and western parts of the country. This geographic shift of "traditional Lutherans," plus the addition, beginning in the 1950s, of "new Lutherans"—who came into contact with Lutheran churches as they moved into previously Euro-American neighborhoods—made African-American Lutheranism an increasingly urban phenomenon.

A second development embodied a renewed assertion of African-American Lutheran autonomy and identity. This expressed itself in 1968 through the formation of the Association of Black Lutheran Clergymen (later changed to Churchmen), an inter-Lutheran organization that brought together African-American Lutherans from three church bodies. Although it existed for only four years, the ABLC both sensitized the Lutheran churches to the needs of African-American Lutherans and paved the way for various denominational African-American caucuses. Theologically, this renewed assertion of autonomy and identity resulted in 1986 in "A Harare Message by Black Lutherans." This document, issued by a group of African and African-American Lutheran theologians and church leaders, articulated a renewed understanding of black and Lutheran identity.

In the last third of the twentieth century, the number of African-American clergy and lay workers in-

creased steadily. Simultaneously, African Americans found themselves called to a variety of positions previously unavailable to them. Toward the end of the twentieth century, African-American Lutherans served as parish pastors, deaconesses, lay professionals, national and synodical/district staff, bishops, chaplains, and seminary professors. In addition, both African-American clergy and laity served on a host of denominational governing boards, particularly the Evangelical Lutheran Church in America and the Lutheran Church—Missouri Synod.

REFERENCES

COBBLER, MICHAEL L. "One Blood, Many Colors." In Wayne C. Stumme, ed. *Study of Black and Lutheran Congregations*. Columbus, Ohio, 1987, pp. 25–29.

DICKINSON, RICHARD C. *Roses and Thorns: The Centennial Edition of Black Lutheran Mission and Ministry in the Lutheran Church—Missouri Synod*. St. Louis, 1977.

"A Harare Message by Black Lutherans." In Albert Pero and Ambrose Moyo, eds., *Theology and the Black Experience; the Lutheran Heritage Interpreted by African-American Theologians*. Minneapolis, 1988.

JOHNSON, JEFF G. *Black Christians: The Untold Lutheran Story*. St. Louis, 1991.

KREBS, ERVIN E. *The Lutheran Church and the American Negro*. Columbus, Ohio, 1950.

JAMES KENNETH ECHOLS

Lynch, John Roy (1847–November 2, 1939), politician and lawyer. Lynch was born a slave on a Louisiana plantation, later moved to Mississippi with his mother, and became free when the Union forces occupied Natchez in 1863. At the end of the Civil War he was the proprietor of a thriving photographic business while attending evening classes. In 1867 he became active in politics, joining a REPUBLICAN club in Natchez and supporting the new state constitution (*see* RECONSTRUCTION). In 1869 he was elected to the lower house of the Mississippi legislature, where he made a quite favorable impression; three years later his colleagues elevated him to the position of speaker. In 1873 he ran for Congress and won.

As one of the vigorous supporters of the Civil Rights Bill of 1875, Lynch became widely known. Reelected in 1874, he was defeated in 1876. After successfully contesting the election in 1880, he returned to Congress, but was defeated once more in 1882. In 1884 he delivered the keynote address at the Republican National Convention, the first African American to be so honored. Subsequently he managed his Mississippi plantation, served as fourth au-

Born a Louisiana slave, John Roy Lynch served three terms in the U.S. House of Representatives and later wrote extensively about his experiences during Reconstruction. (Photographs and Prints Division, Schomburg Center for Research in Black Culture, The New York Public Library, Astor, Lenox and Tilden Foundations)

ditor of the Treasury, was paymaster of volunteers in the Spanish-American War, and practiced law in Mississippi, Washington, D.C., and Chicago. In 1913 he published *The Facts of Reconstruction* to refute the claims of so-called scientific historians of Reconstruction. Lynch died in his Chicago home and was buried with full military honors at Arlington National Cemetery.

REFERENCE

LYNCH, JOHN ROY. *Reminiscences of an Active Life: The Autobiography of John Roy Lynch*. Edited by John Hope Franklin. Chicago, 1970.

JOHN HOPE FRANKLIN

Lynching. Although rooted in an older and broader tradition of vigilantism, the term "lynching" is primarily associated with the killing of African Americans by white mobs in the period from the

Civil War to the middle of the twentieth century. By most accounts, the practice originated on the Revolutionary War frontier when Colonel Charles Lynch and other prominent citizens of Bedford County, Va., organized informally to apprehend and punish Tories and other lawless elements throughout the community.

"Lynch law" subsequently spread to other parts of the country, but became especially prevalent in less settled frontier areas with poorly developed legal institutions. Initially, lynch mobs punished alleged lawbreakers and enforced community mores through whippings, tarring and feathering, and, on occasion, extralegal executions by hanging or shooting. Victims were mostly white and ranged from outlaws and horse thieves in frontier areas to Catholics, immigrants, and abolitionists in northern cities.

Blacks were by no means immune to mob action and sometimes received harsher treatment than white victims, but lynching had not yet attained its special association with race. Even under slavery, the lynching of blacks was relatively infrequent. The economic self-interest and paternalistic attitudes of masters, combined with a rigid system of slave control, normally militated against widespread mob violence against slaves, although in the aftermath of slave rebellions, mobs sought out and ruthlessly punished suspected conspirators.

After the Civil War, lynching spread rapidly and became a systematic feature of the southern system of white supremacy. Mob-inflicted deaths increased during Reconstruction as southern whites resorted to violence to restore white control over ex-slaves. The practice reached epidemic proportions in the late 1880s and 1890s, averaging more than 150 incidents per year in the latter decade, then began to decline after the turn of the century.

Overall, between 1882, when the *Chicago Tribune* began recording lynchings, and 1968, an estimated 4,742 persons died at the hands of lynch mobs. Although whites continued to be victimized on occasion, African-American men and women accounted for the overwhelming majority (some 72 percent) of known lynchings after 1882. By the 1920s, 90 percent of all victims were black, and 95 percent of all lynchings occurred in southern states.

Southern whites justified lynching as a necessary response to black crime and an inefficient legal system, but virtually any perceived transgression of the racial boundaries or threat to the system of white supremacy could provoke mob action. The alleged offenses of lynching victims ranged from such actual crimes as murder, assault, theft, arson, and rape to such trivial breaches of the informal etiquette of race as "disrespect" toward whites and failing to give way to whites on the sidewalks.

The most frequent justification, however, was the charge of rape or sexual assault of white women by black men. Although fewer than 26 percent of all lynchings involved even the allegation of sexual assault, the mythology of rape and images of the "black beast" despoiling white womanhood dominated the southern rationale for lynching by the 1890s and inflamed mobs to ever-increasing brutality.

Lynchings took various forms ranging from hangings and shootings administered by small groups of men in secret, to posses meting out summary justice at the conclusion of a manhunt, to large public spectacles with broad community participation. The classic public lynchings for which the South became so notorious always involved torture and mutilation and ended in death for the victim, either by hanging, or, increasingly, by being burned alive. The lynching ritual characteristically included prior notice of the event, the selection of a symbolically significant location, and the gathering of a large crowd of onlookers, including women and children.

Mobs typically sought to elicit confessions from their victims and frequently allowed them to pray before the final act of the drama. Lynchers often left the bullet-ridden bodies of hanging victims on public display as a warning to other potential transgressors. In both hangings and burnings, mobs tortured, mutilated, castrated (in the case of males), and even dismembered their victims. The victim of the alleged crime or a victim's close relative often played a prominent role in the ritual. A particularly gruesome feature of lynchings was the taking of souvenirs in the form of body pieces, bone fragments salvaged from the ashes, or photographs.

The social composition of southern mobs remains obscure. Some have argued that lynch mobs were composed primarily of lower-class whites, but most scholars agree that the upper class and community leaders at the very least condoned the mob's actions and not uncommonly were themselves participants. Police were rarely effective in preventing lynchings, even when they tried, and mob members were almost never identified and prosecuted. Authorities typically attributed lynchings to "persons unknown."

Lynching was ultimately a product of racism and the caste system it sustained, but social, economic, and political conditions shaped the rhythms and geographical distribution of the practice. Early twentieth-century investigators linked lynchings to such factors as rural isolation, poorly developed legal institutions, broad economic fluctuations, the price of cotton, the ratio of blacks to whites in the population, the structure of county government, revivalism, and the seasonality of southern crops. In his classic study *The Tragedy of Lynching*, Arthur Raper concluded that lynchings were most likely to occur in

The lynching of Tom Shipp and Abe Smith at Marion, Ind., on August 7, 1930. These were two of the twenty reported lynchings in the United States that year. (Photographs and Prints Division, Schomburg Center for Research in Black Culture, The New York Public Library, Astor, Lenox and Tilden Foundations)

the poorest, most sparsely populated southern counties, and especially in recently settled ones where blacks constituted less than 25 percent of the population.

Extending these earlier findings, modern social scientists have viewed lynching variously as a form of "scapegoating" in which white aggression and frustration was displaced onto blacks during periods of economic decline, as a consequence of direct economic competition between whites and blacks, or as a manifestation of repressive justice in response to a "boundary crisis" precipitated by Populist Party efforts to unite lower-class whites and blacks in the 1890s.

While acknowledging some connection between lynching and populism, historians generally attribute the sudden emergence of lynching as a prominent

feature of race relations in the 1880s and 1890s to broader and more complex forces. Jacquelyn Dowd Hall has argued that in addition to being a form of "repressive justice" designed to preserve the caste system, lynching served to dramatize "hierarchical power relationships based on gender and race" (Hall 1979, p. 156). It reinforced racial boundaries for black men and helped maintain caste solidarity for whites generally, but it also reinforced notions of female vulnerability and subordination in a patriarchal society. Joel Williamson (1984) also stressed the association between lynching and sex roles, but he attributed the growth of lynching in the late nineteenth century to the convergence of a radical strain of racism, deep-seated economic trouble, and white male anxiety over the perceived erosion of their ability to provide materially for their women and families. The

pathological obsession with the black rapist, and the firestorm of lynchings it produced in the 1890s, thus constituted a kind of "psychic compensation" for male feelings of inadequacy (Williamson 1984, p. 115). Edward L. Ayers traced the epidemic of lynchings to a "widespread and multifaceted crisis" rooted in the economic depression of the 1890s. That depression contributed to the growth of crime and vagrancy, particularly among blacks, thereby feeding the submerged fears and anxieties of southern whites (Ayers 1984, pp. 250–253).

The number of lynchings declined gradually in the first three decades of the twentieth century, dropped dramatically after the early 1930s, but continued sporadically well into the 1950s. The emergence of vocal opposition to lynching, both inside and outside the South, contributed to its demise, as did fundamental changes in southern society and in race relations. Some blacks, and a few white liberals, spoke out against the horrors of lynching in the late nineteenth century, most notably Ida B. Wells (*see* Ida B. WELLS-BARNETT), a black woman activist from Memphis who sought to mobilize public opinion against mob violence through newspaper editorials and lectures. After 1909, the NATIONAL ASSOCIATION FOR THE ADVANCEMENT OF COLORED PEOPLE (NAACP), un-

der the leadership of W. E. B. DU BOIS, James Weldon JOHNSON, Walter WHITE, and others, investigated and publicized lynchings, pressured political leaders to speak out, and lobbied for antilynching legislation. Some states passed laws against lynching, but they were largely ineffective. Despite decades of effort, and near success in 1922, 1937, and 1940, no federal antilynching legislation was ever enacted. Within the South, opposition to lynching centered on two interracial organizations: the Commission on Interracial Cooperation, founded in 1919, and the Association of Southern Women for the Prevention of Lynching, founded by Jessie Daniel Ames in 1930.

The modernization of southern society and the institutionalization of other forms of repression also hastened the decline of lynching. New roads, electricity, telephones, automobiles, and other social changes transformed the most isolated and lynching-prone areas of the South. Business leaders worked to change the violent image of the region to encourage investment and economic development. And law enforcement officials became more effective in preventing lynchings. Beginning in the late nineteenth century, furthermore, the emergence of alternative forms of racial control—segregation, disfranchisement, and tenant farming—made lynching less essential to the preservation of white supremacy.

There is also evidence that the decline of lynching was accompanied by an increase in "legal" executions of blacks in the South, often with the mere formality of a trial, and that other forms of violence against blacks increased as the incidence of lynching waned in the twentieth century. African Americans would continue to be killed in the name of white supremacy, particularly at the height of the civil rights movement, but lynching, in the classic sense of the earlier era, appears to have ended with the murder of Emmett TILL in 1955 and of Mack Charles Parker in 1959.

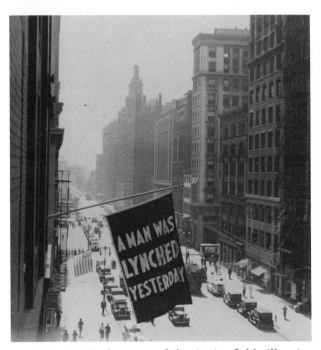

Between 1908, the year of the Springfield, Ill., riot that provided the initial impetus for the founding of the NAACP, and 1935, there were more than one thousand recorded lynchings in the United States. This banner flew from NAACP headquarters in New York City after every report. (Prints and Photographs Division, Library of Congress)

REFERENCES

AYERS, EDWARD L. *Vengeance and Justice: Crime and Punishment in the Nineteenth-Century South.* New York, 1984.

HALL, JACQUELYN DOWD. *Revolt Against Chivalry: Jessie Daniel Ames and the Women's Campaign Against Lynching.* New York, 1979.

McGOVERN, JAMES R. *Anatomy of a Lynching: The Killing of Claude Neal.* Baton Rouge, La., 1982.

RAPER, ARTHUR F. *The Tragedy of Lynching.* 1933. Reprint. New York, 1969.

WHITFIELD, STEPHEN J. *A Death in the Delta: The Story of Emmett Till.* New York, 1988.

WILLIAMSON, JOEL. *The Crucible of Race: Black-White Relations in the American South Since Emancipation.* New York, 1984.

ZANGRANDO, ROBERT L. *The NAACP Crusade Against Lynching, 1909–1950.* Philadelphia, 1980.

L. RAY GUNN

Lynk, Miles Vandahurst (June 3, 1871–December 29, 1957), physician and author. Born in Brownsville, Tex., the son of John and Mary Lynk, Miles V. Lynk was fatherless at six. At twelve he decided to be a doctor. Educated in public school, he supported himself as a teacher starting at age fourteen. Lynk worked his way through Maharry Medical College in Nashville, Tenn., where he received his M.D. in 1891. He then began a successful medical practice in Jackson, Tenn. In order to promote the advancement of African-American medical science, Lynk began editing and publishing the *Medical and Surgical Advisor* in December 1892. The *Advisor,* the first African-American medical journal, ran for eighteen months. In 1895, Lynk was a founder of the National Association of Colored Physicians, Dentists and Pharmacists of the United States (now the National Medical Association). He later founded and directed the Lyn-Crest Sanitarium in Nashville. In 1900, after receiving a master of science degree from Walden University in Nashville and from the A&M College in Norman, Ala., Lynk founded the University of West Tennessee in Memphis, and established a medical school there. At the same time, he attended law school at the University of Tennessee, and in 1902 received a bachelor of laws degree and was admitted to the Tennessee bar. He supported himself and his educational work through his medical practice. His wife, Beebe Steven Lynk, was a noted chemist.

Lynk was equally fascinated by literature. Sometime in the 1890s he began a publishing house. In 1898, four years after giving up the medical journal editorship, Lynk began *Lynk's Magazine,* a literary monthly. He later edited another magazine, *The Negro Outlook.* Lynk wrote a popular pamphlet, *Famous Negro Rulers,* in the 1890s, as well as several books. *The Afro-American School Speaker and Gems of Literature* (1905) was a textbook anthology of poetry and speeches that was sold door-to-door by Lynk's agents and went through ten editions. Equally popular was *The Black Troopers, or Daring Deeds of the Negro Soldiers in the Spanish-American War* (1906). One source estimated that Lynk sold 20,000 copies of the two books. Later, he wrote *The Negro Pictorial Review of the Great World War* (1919).

The University of West Tennessee closed in 1923, and Lynk went to live and practice medicine in Memphis. He remained active in the National Medical Association, which presented Lynk with a Distinguished Service Medal in 1952, the year after his autobiography was published. Lynk died in Memphis in 1957.

REFERENCES

LYNK, MILES V. *Sixty Years of Medicine.* Memphis, Tenn., 1951.
MORAIS, HERBERT MONTFORT. *History of the Negro in Medicine.* New York, 1967.

GREG ROBINSON

M

Mabley, Jackie "Moms" (March 19, 1897–May 23, 1975), comedienne. Born Loretta Mary Aiken in Brevard, N.C., Jackie "Moms" Mabley was one of twelve children, of mixed African-American, Cherokee, and Irish ancestry. During childhood and adolescence, she spent time in Anacostia (in Washington, D.C.) and Cleveland, Ohio. Mabley—who borrowed her name from Jack Mabley, an early boyfriend—began performing as a teenager, when she joined the black vaudeville circuit as a comedienne, singer, and dancer, appearing with such well-known performers as Dewey "Pigmeat" MARKHAM, Cootie WILLIAMS, Peg Leg BATES, and Bill "Bojangles" ROBINSON. In the mid-1920s, she was brought to New York by the dance team of Butterbeans and Suzie. After making her debut at Connie's Inn, Mabley became a favorite at Harlem's COTTON CLUB and at the Club Harlem in Atlantic City, where she played with Louis ARMSTRONG, Cab CALLOWAY, Duke ELLINGTON, and Count BASIE, among others. It was during this time that she began cultivating the frumpily dressed, granny-like stage personality for which she became famous. Trundling onto stage in a tacky housedress with a frilly nightcap, sagging stockings, and outsized shoes, "Moms"—as she was later known—would begin her ad-lib stand-up comedy routine, consisting of bawdy jokes ("The only thing an old man can do for me is bring a message from a young one") and songs, belted out in a gravelly "bullfrog" voice.

Mabley appeared in small parts in two motion pictures, *Jazz Heaven* (also distributed as *Boarding House Blues,* 1929) and *Emperor Jones* (1933), and collaborated with Zora Neale HURSTON in the Broadway play *Fast and Furious: A Colored Revue in 37 Scenes* (1931) before she started performing regularly at the APOLLO THEATER in Harlem. By the time she made the film *Killer Diller* (1948), she had cultivated a considerable following among black audiences, as well as among fellow performers; however, it was not until 1960, when she cut her first album for Chess Records, that she became known to white audiences. *Moms Mabley at the U.N.,* which sold over a million copies, was followed by several others, including *Moms Mabley at the Geneva Conference, Moms Mabley—The Funniest Woman in the World, Moms Live at Sing Sing,* and *Now Hear This.* In 1962 Mabley performed at Carnegie Hall in a program featuring Cannonball ADDERLEY and Nancy WILSON. She made her television debut five years later in an all-black comedy special, *A Time for Laughter,* produced by Harry BELAFONTE. Throughout the late 1960s and early 1970s, she was featured in frequent guest spots on television comedy and variety shows, hosted by Merv Griffin, the Smothers Brothers, Mike Douglas, Bill COSBY, Flip Wilson, and others. Mabley had a heart attack while starring in *Amazing Grace* (1974), a successful feature film, and died the following year.

REFERENCES

MORITZ, CHARLES, ed. *Current Biography Yearbook.* New York, 1975.

Obituary. *New York Times,* May 24, 1975, p. 26.

PAMELA WILKINSON

Mackey, John (September 24, 1941–), football player. Born in Brooklyn, N.Y., the son of Walter Raymond Mackey, a clergyman, and Dora Hill Mackey, John Mackey attended Hempstead High School, Long Island, N.Y., and went on to Syracuse College, where he received a B.A. in history and political science. He joined the football team as a halfback and played for three seasons. In 1963, Mackey joined the Baltimore Colts of the National Football League (NFL), playing tight end. A fine receiver and a speedy rusher, Mackey was the first great modern tight end. He made the All-Pro team from 1966 to 1968, and played in five Pro Bowls. In Super Bowl V, he scored a touchdown on a 75-yard pass play. In 1970 the NFL named him the greatest tight end in history, but a knee operation in 1970 and an elbow operation in 1971 limited his effectiveness. In 1972, Mackey was traded to the San Diego Chargers and finished his career that season, with a record lifetime average of 15.8 yards per reception. In later years, he headed John Mackey Enterprises, and from 1990 to 1992, was president of Pet Inc.'s Orval Kent and Food Service Group.

In 1970, Mackey was named head of the new NFL Players Association. Mackey gained respect for the association by leading players in a short strike. In 1972, he filed suit in federal court to overturn the (Pete) Rozelle Rule, which made it difficult for players to change teams as free agents by forcing their new clubs to offer compensation to their former ones. In 1975, the case was decided in Mackey's favor, revolutionizing NFL labor relations. In 1992, Mackey was elected to the Pro Football Hall of Fame, having been previously excluded, most likely, because of his labor activism.

REFERENCES

AASENG, NATHAN. *Football's Greatest Tight Ends.* Minneapolis, Minn., 1981.

"Football Legend John Mackey Gives Back to the Community." *Jet* (January 19, 1993): 47.

SHIPHERD REED

Mackey, William Wellington (May 28, 1937–), playwright. William Mackey was born in Miami, Fla., and attended Southern University in Baton Rouge, La. After graduating in 1958, he returned to Miami where he worked as a high school teacher. In 1964, he earned a master's degree in recreational and drama therapy from the University of Minnesota in Minneapolis. Shortly afterward, while working as a recreational therapist at Colorado State Hospital in Pueblo, he completed his first two plays, *Behold! Cometh the Vanderkellans* (1965) and *Requiem for Brother X* (1966). The first examines the effects of the rising black consciousness of the late 1950s on a privileged, upper-middle-class black family. The second explores how the lives of a black family living in the ghetto are shaped—and warped—by external factors. Mackey depicts the families of *Brother X* as trapped in the ghetto and conspicuously forgotten by affluent blacks. The use of the family play, a familiar American dramatic convention, to reveal and critique the aspirations, as well as the pretensions and hypocrisies of black family life, is characteristic of all Mackey's plays.

Shortly after his first two plays were produced in Denver, Mackey moved to Chicago and later to New York, where a number of his plays have been produced on Off-Broadway. Mackey's other plays include *Family Meeting* (1972), *Billy Noname* (1970, a musical), and *Love Me, Love Me Daddy, or I Swear I'm Gonna Kill You* (1982).

REFERENCE

PETERSON, BERNARD L., JR. *Contemporary Black American Playwrights and Their Plays.* New York, 1988.

MICHAEL PALLER

Madhubuti, Haki R. (Lee, Don L.) (1942–), poet and essayist. Born Don L. Lee in Little Rock, Ark., Madhubuti was raised in Detroit, Mich. His father deserted the family when Madhubuti was very young, and his mother died when he was sixteen. An unstable family life created hardship and forced Madhubuti to seek employment and overall self-reliance at an early age. Of the place of poetry in his childhood, Madhubuti comments that "poetry in my home was almost as strange as money."

In the late 1950s, Madhubuti attended a vocational high school in Chicago. He joined the U.S. Army for three years beginning in 1960. Between 1963 and 1967, while an apprentice curator at the DuSable Museum of African History, Madhubuti held jobs as a clerk in department stores and at the U.S. post office. During these years he also worked toward his Associate degree at Chicago City College. Two decades later, he received a Masters in Fine Arts from the University of Iowa.

With the publication of *Think Black!* (1967), *Black Pride* (1968), and *Don't Cry, Scream* (1969), Madhubuti quickly established himself as a leading poetic voice among his generation of black artists in America. His poetry generated critical acclaim, particularly among African-American commentators associated with the maturing BLACK ARTS MOVEMENT of the 1960s and early 1970s (the first major black artistic movement since the HARLEM RENAISSANCE).

Poet and publisher Haki Madhubuti, one of the leaders of the Black Arts movement, in Chicago in 1987, twenty years after he founded Third World Press. (AP/Wide World Photos)

His early literary criticism, included in *Dynamite Voices* (1971), was one of the first overviews of the new black poetry of the sixties. Here Madhubuti insists on the essential connection between the African-American experience and black art, and concludes with a call to black nation-building. In his own poetry, Madhubuti makes extensive use of black cultural forms, such as street talk and jazz music. His poetry also draws its inspiration from the work of Amiri BARAKA (LeRoi Jones), the most influential Black Arts practitioner of the sixties.

Judging simply by sales within the black community, no black poet in the Black Arts movement was more popular than Madhubuti. In the last few years of the 1960s, for instance, Madhubuti's slim paperbound books of poetry—each issued by the black publishing house Broadside Press—sold a remarkable one hundred thousand copies each without the benefit of a national distributor. His popularity and artistic promise made him a frequent writer-in-residence during this period at American universities such as Cornell and Howard.

In 1973, the poet rejected his "slave name" by changing it from Don L. Lee to the Swahili name Haki R. Madhubuti (which means "precise justice"). In the

same year, Madhubuti published two collections, *From Plan to Planet* and *Book of Life*. These volumes of essays and poetry illustrate his commitment to black cultural nationalism, a philosophy that combines political activism with cultural preservation in the drive toward racial awareness and black unity.

Although his artistic production declined during the mid- to late-seventies, the publication of another volume of essays and poetry, titled *Earthquakes and Sun Rise Missions* (1984), renewed Madhubuti's advocacy of black nationalism. The poet's most recent collection, titled *Killing Memory, Seeking Ancestors* (1987), speaks to the reader who loves and understands black vernacular.

Like his literary compatriots in the Black Arts movement, Madhubuti attempts to create an artistic form and content which best represents the black community, speaks to their needs, and promotes cultural institutions that serve the coming of the black nation. He eschews western notions of individualism in favor of collective self-sufficiency among blacks within the United States and throughout the world.

In 1978, when the author published *Enemies: The Clash of the Races*—a scathing critique of racism within white left as well as right political circles—Madhubuti was (what he calls) "whitelisted" and, as a result, lost anticipated income. Such experiences reinforced Madhubuti's commitment to black self-reliance. As founding editor of Third World Press and a founding member of the Organization of Black American Culture (OBAC) Writers Workshop (which includes black literary figures such as Gwendolyn BROOKS and Carolyn RODGERS), Madhubuti continues to be active in Chicago-based organizations. He is also cofounder and director of the Institute of Positive Education in Chicago, an organization committed to black nation-building through independent black institutions in areas such as education and publishing.

In 1990 Madhubuti published *Black Men: Obsolete, Single, Dangerous? (The Afrikan American Family in Transition)*, which addresses issues raised by the author's grassroots activism over the past quarter century. Essays in this collection speak specifically to black men, offering analyses and guidance on topics ranging from fatherhood to AIDS. The first printing of the book (7,500 copies) sold out within a month, and reconfirmed Madhubuti's popularity within a sizable portion of the black literary community in America and elsewhere.

REFERENCES

GIDDINGS, PAULA. "From a Black Perspective: The Poetry of Don L. Lee." In John A. Williams and Charles F. Harris, eds. *Amistad 2*. New York, 1971, pp. 296–318.

"HAKI R. MADHUBUTI (DON L. LEE)." In *The Black Aesthetic Movement*. Vol. 8 of the *Dictionary of Literary Biography Documentary Series*. Detroit, 1991, pp. 168–225.

LLORENS, DAVID. "Black Don Lee." *Ebony*, March 1969, pp. 72–78, 80.

MELHEM, D. H. "Interview with Haki R. Madhubuti." In *Heroism in the New Black Poetry*. Lexington, Ky., 1990, pp. 101–130.

TURNER, DARWIN T. "Afterword." In Haki R. Madhubuti. *Earthquakes and Sun Rise Missions*, Chicago, 1984, pp. 181–189.

WEST, HOLLIE I. "The Poetry of Black Experience." *Washington Post*, April 1971, pp. H1, H6.

JEFFREY LOUIS DECKER

Mahoney, Mary Eliza (May 7, 1845–January 4, 1926), nurse. Mary Eliza Mahoney was born in Dorchester, Mass. Little is known about her life before 1878, when she was accepted into the professional nursing program at the New England Hospital for Women and Children in Boston. After completing the highly competitive sixteen-month program in 1879, Mahoney graduated and began a forty-year career as a professional nurse. Mahoney seems to have spent her career as a nurse in private homes in Boston, probably because of the general unwillingness of hospitals to hire black nurses.

At the turn of the century Mahoney became one of the first African-American members of the newly organized American Nursing Association (ANA), most of whose state and local organizations excluded black nurses. In 1908 Mahoney supported the creation of the National Association of Colored Graduate Nurses (NACGN), which was established in order to integrate the profession and serve as a black alternative to the ANA. The following year she gave the opening address to the NACGN's first annual meeting in Boston where she was elected national chaplain, responsible for the induction of new officers. Mahoney was also active in the women's suffrage movement and publicly supported the ratification of the Nineteenth Amendment in 1920.

Mahoney retired in 1922 and died four years later in Boston. In 1936 the NACGN established in her honor the Mary Mahoney Medal in recognition of significant contributions to integration in nursing. The award continued to be awarded annually by the ANA, which officially desegregated in 1948, after the NACGN was dissolved in 1951.

REFERENCES

HINE, DARLENE CLARK. *Black Women in White: Racial Conflict and Cooperation in the Nursing Profession, 1890–1950*. New York, 1989.

Mary Eliza Mahoney. (Photographs and Prints Division, Schomburg Center for Research in Black Culture, The New York Public Library, Astor, Lenox and Tilden Foundations)

———, ed. *Black Women in America: An Historical Encyclopedia*. New York, 1993.

MILLER, HELEN S. *Mary Eliza Mahoney, 1845–1926: America's First Black Professional Nurse*. Atlanta, 1986.

MORAIS, HERBERT M. *The History of the Negro in Medicine*. New York, 1967.

THOMS, ADAH B. *Pathfinders: A History of the Progress of Colored Graduate Nurses*. New York, 1929.

THADDEUS RUSSELL

Mail Carriers. *See* Postal Service.

Maine. African Americans have lived in Maine for over 300 years. Although the percentage of African Americans in the entire population has probably not exceeded 1 percent, political disputes involving African Americans have played a surprisingly significant role in Maine's history. The issue of slavery dominated national political alignments from Maine's inception as a state (as part of the Missouri Compro-

mise in 1820) through to the CIVIL WAR. Several prominent Mainers took part in the struggle against the institution of SLAVERY. Abolitionist John Brown RUSSWURM, one of the first African-American college graduates in the United States and one of the founding editors of the first African-American newspaper, FREEDOM'S JOURNAL, lived much of his childhood in Maine and attended Maine's Bowdoin College. Harriet Beecher Stowe, the author of UNCLE TOM'S CABIN, wrote sections of her important work in Maine. Oliver Otis Howard, the head of the Freedman's Bureau that helped resettle African Americans after the Civil War, was born and lived in Maine.

In Maine, slavery existed at least as early as 1663, but it was confined to the small well-to-do strata and produced a slave population that never exceeded five or six hundred. Slavery in seventeenth- and eighteenth-century Maine was not an integral part of an economic system that depended on wage and family labor. Slavery was more a by-product of the SLAVE TRADE than an end unto itself. The growth of New England's commerce with the West Indies and the development of a wealthy class associated with that commerce led to an emulation of the aristocratic lifestyles of wealthy West Indies planters. Slavery became a privilege of the small upper class of colonial Maine, who lived in southern Maine between Portsmouth, N.H., and what is now Portland. Maine's slavery was more an aristocratic trapping than a mode of production.

Although slave labor was peripheral to the economy, Maine, as part of Massachusetts until 1820, had just as complex a legal system of "slave codes" as southern states (see BLACK CODES). For example, a 1705 law declared marriage and sexual relations between races illegal. A similar law banning interracial marriage would become one of the first laws passed by both the Massachusetts and Maine legislatures when each became a state—they were the only New England states to pass such legislation.

Slavery ended in Maine after the Massachusetts Supreme Court ruled in 1783 that the "free and equal" clause of the state constitution made the practice of slavery illegal. With the end of slavery, Maine's black population began to grow as free African Americans from other states were attracted to Maine. African Americans spread along and behind the coast northeast of Portland to towns like Yarmouth, Brunswick, and Warren, and eventually reached Machias near the Canadian border. Although they were limited to certain occupations, African Americans played important roles in Maine's economy. Many were farmers and fishermen, like most other Mainers, but several also worked in service occupations surrounding Maine's maritime and lumber industries. Forty-one percent of African Americans for whom jobs are listed in the 1850 census were seamen. If fishermen, shipwrights, stevedores, and stewards on the steamship lines are added to this, well over half of all black male workers in Maine in 1850 were directly involved in some phase of shipping. African Americans, therefore, contributed greatly to the growth of Portland as a major port in the first half of the nineteenth century. They served in the maritime industry directly as seamen and cooks, and in the ancillary service occupations as stevedores and shipwrights.

Black Mainers were active in the ABOLITION movement as well. There were, in essence, two abolitionist movements in Maine: one led by whites and one in which blacks played leading roles. The white abolitionist movement was centered in Bangor, in Portland, and at Bowdoin College in Brunswick. African Americans were excluded from leadership roles in the abolitionist movement and used only to provide evidence of the evils of slavery or to provide refuge for runaway slaves. Both nationally known speakers like Charles Lenox REMOND and local people who were former slaves toured Maine to lecture about slavery. When FUGITIVE SLAVES were smuggled into Maine, they would be sent to the nearest local black community either to join it, or, particularly after the Fugitive Slave Act (see FUGITIVE SLAVE LAWS), to pause briefly before continuing on to Canada.

Portland's Abyssinian Church (Congregationalist), founded in 1827, had a tenuous existence, but it emerged as the center for African-American political activity in Maine during the 1840s and the black abolitionist movement in particular. Under the leadership of the Rev. Amos Freeman, the Abyssinian Church hosted Maine and joint New Hampshire and Maine conventions of African Americans. These conventions promoted abolition and temperance as the two major political issues.

Reuben Ruby was Portland's most prominent antebellum African-American businessman and he donated the lot and the largest cash contribution to build the Abyssinian Church. Ruby was born in Maine in 1798, the son of a slave from North Africa. He worked as a waiter and a coachman and used his earnings to acquire a considerable amount of land. A staunch abolitionist, he knew William Lloyd Garrison and was active in the local as well as national abolitionist movement. He served as one of Maine's two delegates to the 1833 National Negro Convention and presided over the 1835 national convention in Philadelphia. He moved to New York City in 1837, where he lived until he went to California in the 1849 gold rush. He struck gold there and eventually returned to Maine. He remained a shrewd busi-

nessman until his death in 1878. His son, George Ruby, served in the Texas Legislature during Reconstruction and later became a newspaper publisher.

From 1870 to the end of the nineteenth century, African Americans withdrew from the direct production of food as farmers or fishermen and carved out a niche for themselves in service occupations. The greatest increase was in the number who worked as domestic servants in private homes or hotels. Many held other personal service occupations like gardeners, cooks, waiters, laundrymen and -women, and barbers. The expansion of these formerly domestic service jobs and their professionalization was an urban phenomenon, and African Americans began to cluster in Maine's largest cities: Portland, Lewiston, Bangor, and Augusta. By 1900, in addition to the increase in personal service occupations, African Americans became more involved in all aspects of food services. African Americans owned some restaurants and saloons, cooked in hotels and private homes, served as waiters, and worked in the retail food business.

The number of African Americans in Maine peaked at 1,606 (.26 percent of total state population) in 1870 and slowly declined until the opening of Loring Air Force base in the 1950s brought a new generation of African-American servicemen and -women to Maine. Maine's African-American population jumped from 1,221 in 1950 to 3,318 in 1960 with the influx of African-American individuals and families into towns near military installations.

In Maine's largest city, Portland, the African-American population stood at 371 (.51 percent) in 1960. The 1960s saw the growth of a more assertive spirit among Portland's African-American community with a revitalized NAACP participating in the 1963 March on Washington and protesting housing discrimination. The basic economic position for many African Americans had not changed much, however. A survey of Portland in the early 1960s showed that in general, African Americans outside the military held the same types of jobs as in 1870: common laborers, porters, janitors, custodians, clerks, seamstresses, and domestics. Only a handful owned their own businesses.

By 1990, however, the African-American population in the state had grown to 5,138 (.42 percent), and the population of Portland had increased to 720 (1.12 percent). Significantly, many of the new immigrants have been skilled professional and white-collar workers.

African-American life in Maine has been different from black life in other states because the black population is both small and thinly spread. Unable to create their own religious and social institutions, African Americans in Maine have come to depend on white institutions, where they have often encountered discriminatory treatment. With a small population and a limited economic base, African Americans in Maine have found it difficult to organize to combat the racism they face.

REFERENCES

STAKEMAN, RANDOLPH. "Slavery in Colonial Maine." *Maine Historical Society Quarterly* 27, no. 2 (Fall 1987): 58–81.

———. "The Black Population of Maine 1764–1900." *The New England Journal of Black Studies,* no. 8 (1989): 17–35.

RANDOLPH STAKEMAN

Mainor, Dorothy Leigh. *See* Maynor, Dorothy.

Major, Clarence (December 31, 1936–), writer. Born in Atlanta and raised in Chicago, Clarence Major developed a fascination with Impressionist art, especially the work of Vincent Van Gogh, while still in his teens, and decided to become a painter. A brief stay at the School at the Art Institute of Chicago in 1953, however, convinced him to set his sights on a career in writing instead. After a stint in the U.S. Air Force (1955–1957), Major returned to Chicago, where his work as editor of the *Coercion Review* brought him into contact with many of the literary innovators of his generation, including William Carlos Williams, Allen Ginsberg, and Robert Creely. It was during this period that Major worked on the poems that made up *Love Poems of a Black Man* (1965) and *Human Juices* (1966). Both volumes were brought out by Coercion Press, and many of the poems were included in the 1970 volume *Swallow the Lake*.

In 1966, Major relocated to New York, where he met many of the writers in the UMBRA WRITERS WORKSHOP, including Tom DENT, David Henderson, and Ishmael REED. Three years later, in 1969, his first novel, *All-Night Visitors,* was published in truncated form by Maurice Girodias's Olympia Press; in the same year, Major's *New Black Poetry,* an anthology which included the work of Amiri BARAKA, Nikki GIOVANNI, and Sonia SANCHEZ, appeared. The next year brought the release of his *Dictionary of Afro-American Slang* and *Swallow the Lake,* a poetry collection. These were followed by four more volumes of poetry, *Private Line* (1971), *Symptoms & Madness* (1971), *The Cotton Club* (1972), and *The Syncopated Cakewalk* (1974); a second novel, *NO* (1973); and

The Dark and Feeling (1974), a critical study of African-American literature. In 1975, Major's metafictional detective novel *Reflex and Bone Structure* (1975) was published by the Fiction Collective, a group established by Major and a number of other novelists with the intent of maintaining editorial control over their work.

In 1977, Major joined the faculty of the University of Colorado; he was promoted to full professor four years later after earning his Ph.D. from Union Graduate School in Ohio. Major's academic responsibilities did not, however, slacken his rate of literary production. The novel *Emergency Exit* was published by the Fiction Collective in 1979; *Inside Diameter: The France Poems* was released in 1985, following his return from a Fulbright lectureship at the University of Nice (1981–1982); and the novel *My Amputations,* winner of the Western States Book Award, appeared to considerable critical acclaim in 1986.

Major's ninth book of poems, *Some Observations of a Stranger at Zuni in the Latter Part of the Century,* and another novel, *Painted Turtle: Woman with Guitar,* followed in 1987 and 1988. The novel *Such Was the Season* (1987) and *Fun and Games* (1988), a collection of short stories, heralded Major's move away from his previous postmodernist experimentation and his return to more traditional modes of writing. In 1993, Major edited an anthology of stories entitled, *Calling the Wind: Twentieth Century African-American Short Stories.*

REFERENCES

KLINKOWITZ, JEROME. "The Self-Apparent Word: Clarence Major's Innovative Fiction." In Joe Weizmann and Chester J. Fontenot, eds. *Studies in Black American Literature.* Vol. 1, *Black American Prose Theory.* Greenwood, Fla., 1984, pp. 199–214.
WEIXLMANN, JOE. "Clarence Major." In *Dictionary of Literary Biography.* Vol. 33, *Afro-American Fiction Writers After 1955.* Detroit, Mich., 1984.

MICHEL FABRE

Majors, Monroe Alpheus (October 12, 1864–December 10, 1960), physician and writer. Born in Waco, Tex., Monroe Majors was educated in Austin public schools. He graduated in 1886 from Meharry Medical College in Nashville, Tenn. Excluded from the racially restrictive American Medical Association, he organized the Lone Star State Medical Association in 1886. In 1888, threatened by racist violence, he left for Los Angeles, where the following year he became the first African American to pass the California board medical exam.

In 1890, Majors returned to practice medicine in Waco, where the established the first black drugstore in the Southwest. In 1893, Majors's *Noted Negro Women,* unique for its time, appeared; its purpose was to inspire future generations. In addition, he lectured at Paul Quinn College (1891–1894) and edited the *Texas Searchlight* (1893–1895). In 1898, he moved to Decatur, Ill., where he was threatened once more; so he relocated, for the second time in 1898, to Indianapolis. Here he became associate editor and columnist for the highly regarded *Indianapolis Freeman.* He wrote on numerous topics, including antiblack violence in Texas, and encouraged intellectual pursuits by African Americans.

In 1899, Majors returned again to Waco, where he became superintendent of the hospital he had built during a previous residence. However, in 1901, he was forced to leave again and settled this time in Chicago. He continued to work as a physician and journalist and was editor of the *Chicago Conservator.* In 1908, he was a commissioner of the Lincoln Day centennial celebrations in Chicago.

Throughout his life, Majors was a prolific writer. In addition to his journalistic, medical, and biographical writings, he also published verse, notably "An Ode to Frederick Douglass" in 1917 and *First Steps to Nursery Rhymes* in 1921, one of the earliest books for black children.

Majors moved to California in 1933. He practiced medicine there for a while and is credited with adding the term "paralysis diabetes" to the medical vocabulary. Majors died of natural causes in Los Angeles.

REFERENCES

FOSTER, MARIE BOOTH. *Southern Black Creative Writers.* Westport, Conn., 1988.
MAJORS, MONROE A. *Noted Negro Women.* Jackson, Tenn., 1893.
MORAIS, HEBERT M. *The History of the Negro in Medicine.* New York, 1967.

LYDIA MCNEILL

Makeba, Miriam Zenzi (March 1932–) singer and diplomat. Miriam Makeba was born in Prospect, South Africa, on a date that has never been precisely determined. She spent the first six months of her life in prison with her mother, who had been arrested for illegally selling homemade beer. As a child she sang in school choruses, performing traditional and popular southern African songs. She attended the Kimerton Training Institute in Pretoria and was a domestic worker before touring southern Africa in 1954–1957 with the Black Mountain Brothers, a singing troupe.

In 1959 Makeba performed in the African opera *King Kong* in London, and with the encouragement of Harry BELAFONTE came to New York. That year she appeared in the anti-apartheid film *Come Back, Africa* (1959). In New York, Makeba began performing and recording the music of South Africa, in particular songs in her native Xhosa, which features a distinctive clicking sound.

Makeba, who struggled against cervical cancer in the early 1960s, came to national prominence as a political figure after she addressed a United Nations Special Committee on Apartheid in 1962. From 1962 until 1990, her music was banned in South Africa. The 1965 album she made with her mentor, *An Evening with Belafonte/Makeba,* won a Grammy award. Makeba, who became known as "Mama Africa" and "the click-click girl," was married from 1964 to 1966 to the South African jazz trumpeter Hugh Masekela before marrying the radical African-American activist Stokely CARMICHAEL (later known as Kwame Toure) in 1968. Because of Carmichael's politics, Makeba found herself shunned by the entertainment industry in the United States. Makeba and Carmichael moved to Guinea, where she continued to live after their 1978 divorce. Although her popularity declined, Makeba continued to record and perform, and remained politically active. She served a term as United Nations delegate from Guinea starting in 1975, and in 1986 won the Dag Hammarskjold Peace Prize. The next year she performed alongside Masekela in Paul Simon's *Graceland* tour. In 1990, after the ban on her music was lifted, she traveled to South Africa for the first time in three decades. In 1991 she recorded *Eyes on Tomorrow,* and the next year starred in the film version of the Broadway hit *Sarafina!* She toured in the United States in 1994 with fellow musician Hugh Masekela.

REFERENCES

BRACKER, M. "Xhosa Songstress." *New York Times Magazine,* February 28, 1960, p. 32.
MAKEBA, MIRIAM, with James Hall. *Makeba: My Story.* New York, 1987.

ROSITA M. SANDS

Malcolm X (May 19, 1925–February 21, 1965), nationalist leader. Malcolm X, born Malcolm Little and also known by his religious name, El-Hajj Malik El-Shabbazz, was the national representative of Elijah MUHAMMAD's NATION OF ISLAM, a prominent black nationalist, and the founder of the Organization of Afro-American Unity. He was born in Omaha, Nebr. His father, J. Early Little, was a Georgia-born Baptist preacher and an organizer for Marcus GARVEY's UNIVERSAL NEGRO IMPROVEMENT ASSOCIATION. His mother, M. Louise Norton, also a Garveyite, was from Grenada. At J. Early Little's murder, Malcolm's mother broke under the emotional and economic strain, and the children became wards of the state. Malcolm's delinquent behavior landed him in a detention home in Mason, Mich.

Malcolm journeyed to Boston and then to New York, where, as "Detroit Red," he became involved in a life of crime—numbers, peddling dope, con games of many kinds, and thievery of all sorts, including armed robbery. A few months before his twenty-first birthday, Malcolm was sentenced to a Massachusetts prison for burglary. While in prison, his life was transformed when he discovered through the influence of an inmate the liberating value of education, and through his family the empowering religious/cultural message of Elijah Muhammad's nation of Islam. Both gave him what he did not have: self-respect as a black person.

Malcolm X in a New York City restaurant, c. 1961. Behind him is a poster of Elijah Muhammad. (© Henri Cartier-Bresson/Magnum Photos)

After honing his reading and debating skills, Malcolm was released from prison in 1952. He soon became a minister in the Nation of Islam and its most effective recruiter and apologist, speaking against black self-hate and on behalf of black self-esteem. In June 1954, Elijah Muhammad appointed him minister of Temple Number 7 in Harlem. In the temple and from the platform on street corner rallies, Malcolm told Harlemites, "we are black first and everything else second." Initially his black nationalist message was unpopular in the African-American community. The media, both white and black, portrayed him as a teacher of hate and a promoter of violence. It was an age of integration, and love and nonviolence were advocated as the only way to achieve it.

Malcolm did not share the optimism of the CIVIL RIGHTS MOVEMENT and found himself speaking to unsympathetic audiences. "If you are afraid to tell truth," he told his audience, "why, you don't deserve freedom." Malcolm relished the odds against him; he saw his task as waking up "dead Negroes" by revealing the truth about America and about themselves.

The enormity of this challenge motivated Malcolm to attack the philosophy of the Rev. Dr. Martin Luther King, Jr. and the civil rights movement head-on. He rejected integration: "An integrated cup of coffee is insufficient pay for 400 years of slave labor." He denounced nonviolence as "the philosophy of a fool": "There is no philosophy more befitting to the white man's tactics for keeping his foot on the black man's neck." He ridiculed King's 1963 "I Have a Dream" speech: "While King was having a dream, the rest of us Negroes are having a nightmare." He also rejected King's command to love the enemy: "It is not possible to love a man whose chief purpose in life is to humiliate you and still be considered a normal human being." To blacks who accused Malcolm of teaching hate, he retorted: "It is the man who has made a slave out of you who is teaching hate."

As long as Malcolm stayed in the Black Muslim movement, he was not free to speak his own mind. He had to represent the "Messenger," Elijah Muhammad, who was the sole and absolute authority in the Nation of Islam. When Malcolm disobeyed Muhammad in December 1963 and described President John F. Kennedy's assassination as an instance of "chickens coming home to roost," Muhammad rebuked him and used the incident as an opportunity to silence his star pupil. Malcolm realized that more was involved in his silence than what he had said about the assassination. Jealousy and envy in Muhammad's family circle were the primary reasons for his silence and why it would never be lifted.

Malcolm reluctantly declared his independence in March 1964. His break with the Black Muslim move-

Malcolm X in Egypt, 1964. (© John Launois/Black Star)

ment represented another important turning point in his life. No longer bound by Muhammad's religious structures, he was free to develop his own philosophy of the black freedom struggle.

Malcolm had already begun to show independent thinking in his "Message to the Grass Roots" speech, given in Detroit three weeks before his silence. In that speech he endorsed black nationalism as his political philosophy, thereby separating himself not only from the civil rights movement, but more important, from Muhammad, who had defined the Nation as strictly religious and apolitical. Malcolm contrasted "the black revolution" with "the Negro revolution." The black revolution, he said, is international in scope, and it is "bloody" and "hostile" and "knows no compromise." But the so-called "Negro revolution," the civil rights movement, is not even a revolution. Malcolm mocked it: "The only revolution in which the goal is loving your enemy is the Negro revolution. It's the only revolution in which the goal is a desegregated lunch counter, a desegregated theater, a desegregated public park, a desegregated public toilet; you can sit down next to white folks on the toilet."

After his break, Malcolm developed his cultural and political philosophy of black nationalism in "The Ballot or the Bullet." Before audiences in New York, Cleveland, and Detroit, he urged blacks to acquire their constitutional right to vote, and move toward King and the civil rights movement. Later he became more explicit: "Dr. King wants the same thing I want—freedom." Malcolm went to Selma, Ala., while King was in jail in support of King's efforts to secure voting rights. Malcolm wanted to join the civil rights movement in order to expand it into a human rights movement, thereby internationalizing the black freedom struggle, making it more radical and more militant.

During his independence, which lasted for approximately one year before he was assassinated, nothing influenced Malcolm more than his travel abroad. His pilgrimage to Mecca transformed his theology. Malcolm became a Sunni Muslim, acquired the religious name El-Hajj Malik El-Shabbazz, and concluded that "Orthodox Islam" was incompatible with the racist teachings of Elijah Muhammad. The sight of "people of all races, colors, from all over the world coming together as one" had a profound effect upon him. "Brotherhood," and not racism, was seen as the essence of Islam.

Malcolm's experiences in Africa also transformed his political philosophy. He discovered the limitations of skin-nationalism, since he met whites who were creative participants in liberation struggles in African countries. In his travels abroad, Malcolm focused on explaining the black struggle for justice in the United States and linking it with other liberation struggles throughout the world. "Our problem is your problem," he told African heads of state: "It is not a Negro problem, nor an American problem. This is a world problem; a problem of humanity. It is not a problem of civil rights but a problem of human rights."

When Malcolm returned to the United States, he told blacks: "You can't understand what is going on in Mississippi, if you don't know what is going on in the Congo. They are both the same. The same interests are at stake." He founded the Organization of Afro-American Unity, patterned after the Organization of African Unity, in order to implement his ideas. He was hopeful of influencing African leaders "to recommend an immediate investigation into our problem by the United Nations Commission on Human Rights."

Malcolm X was not successful. On February 21, 1965, he was shot down by assassins as he spoke at the Audubon Ballroom in Harlem. He was thirty-nine years old.

No one made a greater impact upon the cultural consciousness of the African-American community during the second half of the twentieth century than Malcolm X. More than anyone else, he revolutionized the black mind, transforming docile Negroes and self-effacing colored people into proud blacks and self-confident African Americans. Preachers and religious scholars created a black theology and proclaimed God as liberator and Jesus Christ as black. College students demanded and got BLACK STUDIES. Artists created a new black esthetic and proclaimed, "Black is beautiful."

No area of the African-American community escaped Malcolm's influence. Even mainstream black leaders who first dismissed him as a rabble-rouser, embraced his cultural philosophy following his death. Malcolm's most far-reaching influence, however, was among the masses of African Americans in the ghettos of American cities. Malcolm loved black people deeply and taught them much about themselves. Before Malcolm, most blacks did not want to have anything to do with Africa. But he reminded them that "you can't hate the roots of the tree and not hate the tree; you can't hate your origin and not end up hating yourself; you can't hate Africa and not hate yourself."

Malcolm X was a cultural revolutionary. Poet Maya ANGELOU called him a "charismatic speaker who could play an audience as great musicians play instruments." Disciple Peter Bailey said he was a "master teacher." Writer Alfred Duckett called him "our sage and our saint." In his eulogy, actor Ossie Davis bestowed upon Malcolm the title "our shining black prince." Malcolm can be best understood as a cultural prophet of blackness. African Americans who are proud to be black should thank Malcolm X. Few have played as central a role as he in making it possible for African Americans to claim their African heritage.

REFERENCES

BREITMAN, GEORGE. *By Any Means Necessary.* New York, 1970.

——, ed. *Malcolm X Speaks.* New York, 1965.

CONE, JAMES H. *Martin & Malcolm & America: A Dream or a Nightmare.* Maryknoll, N.Y., 1991.

GOLDMAN, PETER. *The Death and Life of Malcolm X.* Urbana, Ill., 1979.

MALCOLM X, with Alex Haley. *Autobiography of Malcolm X.* New York, 1965.

JAMES H. CONE

Malone, Annie Turnbo (August 9, 1869–May 10, 1957), entrepreneur and philanthropist. Annie Turnbo Malone was born to Robert and Isabell Turnbo in Metropolis, Ill., and attended high school

in nearby Peoria. Orphaned at a young age, she was raised by her older brothers and sisters. In her twenties she began experimenting with chemicals to develop a hair straightener for African-American women. Living in Lovejoy, Ill., Turnbo invented and sold a hot pressing-iron as well as several lotions and creams, one for restoring lost hair. In 1902 she moved her business to 223 Market Street, in St. Louis, Mo. She and her trained assistants began selling her "Wonderful Hair Grower" and other products door-to-door. One of her agents was Madame C. J. WALKER who went on to found her own hair-care company. Turnbo copyrighted the name "Poro" for her products in 1906. On April 28, 1914, she married Aaron E. Malone, who became the chief manager and president of the Poro company.

Attaining success, Annie Malone built Poro College, a beauty school, in St. Louis in 1917. The college became a social center for the black community, housing for a time the National Negro Business League (see BLACK BUSINESS COMMUNITY) as well as other organizations. After a tornado hit the city in 1927, Poro College served as a principal relief facility for the Red Cross. Poro also trained women to be agents, teaching them the rudiments of salesmanship and beauty culture. The company enjoyed tremendous expansion in the early 1920s, employing thousands of agents. Toward the end of the decade, however, the company ran into trouble and began its decline. In 1927, Malone and her husband had a bitter divorce and struggled for control of the company. With the support of Mary McLeod BETHUNE and others, Annie Malone kept control of the enterprise and settled with her husband for $200,000. In 1930, Annie Malone relocated the business and the college to Chicago. She ran into further difficulties because of her refual to pay excise tax. Between 1943 and 1951 she was the subject of government suits. In the latter year the government seized control of the company and sold off most of Poro's property to pay taxes and fines.

Throughout her leadership of the Poro company, Malone distinguished herself as a philanthropist. In the 1920s, she gave over $25,000 to the HOWARD UNIVERSITY Medical School Fund. Malone also gave substantial sums to TUSKEGEE UNIVERSITY, the City-wide YMCA of St. Louis, and the St. Louis Colored Orphans' Home. The Annie Malone Crisis Center and the Annie Malone Children and Family Service Center, both in St. Louis, are named in her honor. She died in Chicago in 1957.

REFERENCES

COLLIER-THOMAS, BETTYE. "Annie Turnbo Malone." In *Notable Black American Women*. Detroit, Mich., 1992, p. 724.

YESNER, THOMAS. *Who's Who in Colored America, 1941–1944*. Brooklyn, N.Y., 1945.

WALTER FRIEDMAN

Mammy, Black. *See* Stereotypes.

Manning, Frankie (1914–), jazz dancer, choreographer. Frankie Manning, a native of Jacksonville, Fla., moved to Harlem at the age of three, and by the age of ten was a regular at Harlem's dance halls. By the early 1930s he was a regular at the SAVOY, and soon was recognized as one of the best Lindy Hoppers. His distinctive style combined horizontal and bent positions with elegant body movements and fancy footwork. He was a member of Whitey's Lindy Hoppers, one of the premier Savoy troupes, and became its main choreographer. With his partner, Frieda Washington, he developed the first "air step," a highly acrobatic lift called "Over the Top." In 1936 he developed ensemble routines, making it possible to adapt partner dancing to stage presentations. He choreographed and danced in Lindy Hop sequences in the films *Radio City Revels* (1936), *Hellzapoppin'* (1941) and *Hot Chocolate* (1941), a short featuring Duke ELLINGTON.

In the late 1930s, Manning danced with Duke Ellington, Count BASIE, Chick WEBB, and Cab CALLOWAY, and toured on four continents. He also appeared in such Broadway shows as *Swingin' the Dream* (1938) and *The Hot Mikado* (1939).

After serving in World War II, Manning formed his own company, the Congaroo Dancers in 1947. They lasted for seven years and appeared in the film *Killer Diller* in 1948. In 1954, when jobs became scarce, Manning took on a job as a postal clerk. After he retired in the 1980s, he began a second career as a dancer, sharing a Tony Award received in 1989 for his choreography in *Black and Blue*, and choreographing a section of *Opus McShann* for the Alvin AILEY American Dance Theater. He also choreographed for the American Ballroom Theatre Pat Cannon's Fool and Fiddle Dance Company, and the television movie *Stompin' at the Savoy*. He was a consultant for Spike Lee's film *Malcolm X*.

REFERENCES

CREASE, ROBERT P. "Last of the Lindy Hoppers." *Village Voice*, August 25, 1987, pp. 27–32.

———. "The Lindy Hop." Research Forum Papers: The 1988 International Early Dance Institute (June 1988): 1–11.

JACKIE MALONE

Manumission Societies. The manumission societies of the first half of the century after American independence were eventually eclipsed by the more radical antislavery organizations of the 1830s, '40s, and '50s. While the manumission societies looked to a day when the slave system (*see* SLAVERY) would be uprooted and destroyed, they, unlike the "immediatists" in the camp of William Lloyd GARRISON, were prepared to see EMANCIPATION proceed gradually. The rhetoric was also strikingly different. The later generation of ABOLITIONISTS would denounce slave owners as "man-stealers" and "woman-whippers," while the earlier generation saw them not as moral degenerates but as misguided individuals who needed to be shown the error of their ways.

There was also the issue of who should participate in the work of emancipation. The manumission societies were exclusively male and exclusively white. There was none of the involvement of white women and African Americans that would characterize Garrisonian abolition and outrage its opponents. And yet, despite the differences, the older organizations prepared the way for their more outspoken successors, while the "gradualist" impulse was not entirely absent from the later phase of the antislavery struggle.

The Pennsylvania Abolition Society was a Quaker monopoly when it was established in 1775. It initially focused on rescuing free people unlawfully held as slaves. Moribund during the Revolutionary War, it was revived in 1784 by individuals from various religious denominations. In the interval Pennsylvania had enacted a gradual-abolition law, and monitoring its enforcement became a major part of the society's work. Other states and cities followed the lead of Pennsylvania. Between 1784 and 1791, manumission societies were established in every state except the Carolinas and Georgia, and by 1814 societies could be found as far west as Tennessee and Kentucky.

The socioeconomic status of the abolitionists varied from region to region. In the North, Benjamin Franklin, John Jay, Alexander Hamilton, and Benjamin Rush joined the antislavery ranks. In contrast, the Kentucky Abolition Society was composed of men in "low or . . . middling circumstances." The Maryland Abolition Society was made up of local merchants and skilled craftsmen—those least likely to use slaves or to lose money and prestige if slavery were abolished.

Policy on admitting slaveholders to membership varied. The Pennsylvania and Providence, R.I., societies excluded them altogether. The Maryland society made them eligible for some offices. The Alexandria, Va., society admitted them, as did the New York Manumission Society. Indeed, as Shane White points out (1991) some New Yorkers acquired slaves

after joining. White contends that for some years the emphasis of the New Yorkers was not so much on challenging slavery as on removing the worst abuses in the slave system. They saw themselves as humane masters who were reacting against what they regarded as appalling acts of cruelty perpetrated by southern and Caribbean slave owners, and occasionally by those in their own state.

As the character of the membership varied so did the goals of the individual societies. On some things they were agreed. The foreign slave trade must be outlawed; abusive treatment of slaves should be punished; where they had been enacted, manumission laws should be enforced. In New York, New Jersey, and the upper South, where gradual-emancipation laws had not been passed, the societies attempted to exert pressure on lawmakers. There were some notable successes, although it is debatable how much was due to the humanitarian impulse. In the upper South, economic dislocation after the Revolutionary War had brought changes in labor requirements and patterns of agricultural production. In 1782 Virginia legislators repealed the ban on private manumissions, and Maryland and Delaware quickly followed suit.

The manumission societies made efforts to address the plight of the free people of color, since there was general agreement that their freedom must be safeguarded. Free blacks were offered advice about their conduct and encouraged to use their influence with slave kinfolk and friends to urge them to endure patiently. There was also practical assistance. The Pennsylvania and New York societies sponsored schools that trained a generation of African-American community leaders. The Pennsylvanians in particular developed a number of economic initiatives: would-be entrepreneurs received assistance, employment offices were established, and prosperous African Americans and sympathetic whites were encouraged to hire black indentured servants.

In 1791, there was a concerted effort by nine manumission societies to petition Congress to limit the foreign slave trade. When that effort failed, the New York society proposed the formation of a national convention to coordinate future action. In 1794 a convention was held in Philadelphia to organize the American Convention for Promoting the Abolition of Slavery and Improving the Condition of the African Race.

Conventions were annual until 1806, after which they became less frequent. At each meeting, member societies presented reports on their progress. Representatives from more distant societies were often unable to attend, but they submitted reports. There were contacts with foreign organizations such as the London-based African Institution and *les amis des noirs* in Paris. Delegates occasionally heard from influen-

tial African Americans, such as James FORTEN. As for policy decisions, in 1818 Forten denounced the work of the AMERICAN COLONIZATION SOCIETY (ACS) in an address to the convention. In 1821 the convention expressed its disapproval of the Liberian scheme, but in 1829, after many individual societies had already endorsed the ACS, the convention announced its approval of voluntary emigration.

Gradually the power and influence of the manumission societies declined. For more than two decades, the abolitionist impulse remained strong in the upper South. In 1827, for instance, the American Convention reported that while the free states had 24 societies, the slave states had 130. Many factors led to the demise of abolition societies in the region, including slave rebellions and the spread of the plantation economy south and west, which meant a lively market for "surplus" slaves.

In the North the crisis surrounding the MISSOURI COMPROMISE took a toll. The Pennsulvania Abolition Society, for instance, suffered a wave of resignations in the early 1820s. As for the American Convention, it met for the last time in 1832 and was formally dissolved in 1838, by which time it had been supplanted by a new and, in many respects, more radical antislavery movement.

REFERENCES

BERLIN, IRA. *Slaves without Masters: The Free Negro in the Antebellum South.* New York, 1974.

FOGEL, ROBERT. *Without Consent or Contract.* New York, 1989.

LITWACK, LEON. *North of Slavery: The Negro in the Free States, 1790–1860.* Chicago, 1961.

LOCKE, MARY S. *Anti-Slavery in America.* Boston, 1901.

QUARLES, BENJAMIN. *Black Abolitionists.* New York, 1969.

WHITE, SHANE. *Somewhat More Independent: The End of Slavery in New York City, 1770–1810.* Athens, Ga., 1991.

ZILVERSMIT, ARTHUR. *The First Emancipation: The Abolition of Slavery in the North.* Chicago, 1967.

JULIE WINCH

Marching Bands. Marching bands, with their spectacular assemblage of brass, woodwind, and percussion instruments contributing to ceremonial pomp and pageantry, represent one of the oldest and most pervasive forms of public music in American culture. Doubtlessly influenced by the presence of various German, French, and English bands stationed in the United States, American military bands began to make their appearances in the eighteenth century in Philadelphia, New York, and New Orleans. In 1792, Congress passed a law authorizing the formation of regular military bands as opposed to the older fife-and-drum corps.

As the American bands evolved, so did their scope and repertory. In addition to military functions, bands began to appear at civilian events, providing music for social affairs, shows, dances, concerts, and even religious events. The Moravians of the North Carolina Piedmont currently continue the practice of including bands in their liturgies.

The African-American marching band shares some commonalities with the white band tradition, yet maintains its own uniqueness. It reflects an eclectic admixture of influences drawn from within black communities, including churches, fraternal orders, and educational institutions, plus external impingements—primarily traveling shows and the military. From these environs have come a list of musical notables including Nat and Julian "Cannonball" ADDERLEY, W. C. HANDY, Louis ARMSTRONG, Erskine Hawkins, Perry G. Lowery, Anthony BRAXTON, St. Clair Cobb, Jordan "Chick" Chavis, Wayman Carver, John COLTRANE, and numerous others. These musicians represent excellence in the development of several genres including the only original music style in the United States.

More than five thousand African Americans fought in the colonial wars. Many were military musicians, including Nero Benson, a trumpeter; George Brown, a bugler; Barzillai Lew, Primus Lew, Cyrus Tiffany, Jessie Wall, and Richard Cozens, fifers; and drummers Jabez Jolly, William Nickens, and Nimrod Perkins. During this era the term *military band* was defined as any band of musicians that marched. Black civilian musicians, well known individually and by the bands with which they were associated, often hired out their musical services to military units.

In Philadelphia, composer and conductor Francis "Frank" JOHNSON was said to have one of the finest professional "colored" bands. With Johnson playing a keyed bugle, his band performed both "military" literature and some of the finest dance music of that era. He earned international recognition by performing in England for Queen Victoria. During the 1820s and '30s his band was also employed by the State Fencibles and Philadelphia Grays, organizations similar to our present National Guard and police reserve units. The Grays later became known as the "first Philadelphia Troop of City Cavalry." After Johnson's death, Joseph Anderson directed this band from 1840 to 1845.

Other noted black "military" bands in the first half of the nineteenth century included two other bands from Philadelphia: Matt Black's All Negro Marching

Band and Hazzard's Band. Also popular were Peter Guess's Band from Boston and Samuel Dixon's Brass Band from Newburgh, N.Y. There were also three recognized Ohio bands in the years before the Civil War: the Scioto Valley Brass Band, the Roberts Band, and the Union Valley Brass Band. Although not American, the Royal Hawaiian Band, which performed for government-sponsored events beginning in the early nineteenth century, made band member George Washington Hyatt, an escapee from Virginia slavery, its director from 1845 through 1848.

The outbreak of the CIVIL WAR provided additional opportunities for black "military" bands. General Order no. 143, dated May 22, 1863, authorized the formation of the Bureau for Colored Troops, which managed the enlistment and training of black soldiers. Black bandsmen began to serve with regiments of the "United States Colored Troops," including the Massachusetts fifty-fourth Regiment (see FIFTY-FOURTH MASSACHUSETTS COLORED REGIMENT), the New York fifty-eighth Regiment, the Kansas first Regiment, and several others. To this day debate continues over participation of blacks in the Confederate ranks and at what levels. During the course of the war, especially with the need for additional help in noncombatant areas, there were various proposals made concerning the use of blacks. There are some sketchy reports indicating irregular participation by blacks who were impressed into service as fifers and drummers.

Band members (foreground) of the Twenty-fifth Infantry, Fort Randall, Dakota Territory, c. 1880. (State Historical Society of North Dakota)

After the Civil War, southern civilians found a wealth of instruments abandoned by the confederate bands. Using these, augmented as necessary by fabricated instruments, black began to create their own bands, entertainment forms, and musical styles. The music was primarily a hybrid of marches, quick steps, dance, and popular forms previously composed yet combined with new materials sometimes created over the existing musical framework "on the spot." This compound was also inclusive of conservatory-trained and self-taught musicians. Now free, these performers began to travel the length and breadth of the United States and beyond, spreading their unique stylings inclusive of a swinging, "ragged" music that would evolve into what is now called JAZZ.

The most successful African-American bands could readily render quality presentations in three traditional performance styles: military, show, and ceremonial, inclusive of worship, weddings, funerals, and similar events. After the Civil War, a new generation of black soldier-musicians who served in the regular United States military came to prominence. Walter Loving's U.S. Philippine Constabulary Band and Wade Hammond's U.S. ninth Cavalry Band were among those musical groups attached to the handful of African-American regiments through the SPANISH-AMERICAN WAR.

Early jazz, which the musicians brought with them from the civilian arena, began to be infused into the martial ranks. By the beginnings of WORLD WAR I, band leaders such as James Reese EUROPE, who led the 369th Regimental Band, introduced the syncopated "swinging" style of playing combined with a relaxed but precisioned style of choreography on the march. Following this pattern were other band leaders, including Alton Augustus ADAMS, the first African-American bandmaster in the United States Navy. This style was continued during WORLD WAR II by Len Bowden (Navy), Warrant Officers Edward C. Lewis, Jr. (Army) and Leonard Proctor (Army Air Corps), who was active in the Air Force through Vietnam conflict (see VIETNAM WAR).

In the period after World War I, Adam Forepaugh, a Philadelphia butcher and horse trader, won a small circus in a poker game. Investing time and resources into its development, he created a circus that, through a later series of mergers and buyouts, became the basis of the modern Ringling Brothers, Barnum & Bailey Greatest Show on Earth. The Adam Forepaugh Circus (later Forepaugh & Sells Bros. Circus until 1912) became the model for the modern traveling shows. One of Forepaugh's innovations was the inclusion of vaudeville and minstrelsy into the side-show arena. This created another precursor of the contemporary marching bands, these show bands which provided the music for circus, vaudeville, min-

strel, medicine, and other traveling aggregations (*see* MINSTRELS/MINSTRELSY). The Ringlings devised the means for putting these shows on rails, thus more rapidly spreading them all across the country.

For a railroad show, the band's day routinely began with a mid-morning parade from their train through the town to the show site, playing and executing intricate steps. Their repertory would be technically challenging, as one bandsman described it, calling the John Philip Sousa marches "easier" music. Once at the site, they would play a full concert on the sideshow "bally" (the separate stage area in front of the big tent) and then go "under canvas" for the show.

By switching to or adding stringed and other "doubling" instruments, they would form the "stage band" or "orchestra," which played for the show acts—thus the term *show band*. The sideshow was the domain of the black performers, who, by "custom," were not allowed to play under the "Big Top" (the main show tent). In areas not exceptionally safe for black performers, there would be a second parade back to the train to ensure that everyone returned without harm.

The musicians hired into these bands were often selected for their performance skills on more than one instrument. A musician who, for example, played clarinet on the march and violin in the show was termed a "doubling" musician. Players who "doubled" well commanded higher salaries. It should be noted that all the musicians sought for these bands were highly skilled professionals.

Several of these shows were on the road, possibly traveling with a circus from April through Christmas (if the show remained successful) and as individual minstrel and entertainment troupes from New Year's Day through March. Some of the more noted groups were the Louisiana Slave Troupe and Brass Band, Smallwood's Great Contraband Minstrels and Brass Band, Rusco and Pringle's Georgia Minstrels, and W. I. Swain's Nashville Students Company with P. G. Lowery's Famous Colored Concert Band.

Tuskegee Institute marching band performing on Commencement Day, 1914. (Prints and Photographs Division, Library of Congress)

Lowery, who lived between 1869 and 1942 and was billed as the "World's Greatest 'Colored' Cornettist," was also recognized as the best of the circus and show band leaders. He began his career playing with several small shows before joining the Georgia Minstrels. Because of his friendship with Scott JOPLIN, who composed and arranged "rags" for his bands to play, Lowery was nicknamed "the Ragtime Cat." Early in his career Lowery caught the attention of W. C. Handy. Handy was band director of W. A. Mahara's Minstrels and was considered to be a very fine cornet player in the late nineteenth century. By Handy's own admission, this changed when he met and was soundly "blown away" by Lowery in an Omaha jam session in 1897. From his modest beginnings, Lowery became the most celebrated leader and manager of show bands. His groups, always in great demand, were known for their exceptionally high-quality performances. Other bandleaders attempted to pattern their bands after Lowery's. Organizing a management

business, "P. G. Lowery's Progressive Musical Enterprises," about 1907, he contracted to create and train bands for numerous traveling shows. At its peak, the business had an employment roster exceeding four hundred performers. Lowery appeared with the greatest shows of the time: Forepaugh & Sells Brothers; the Sparks Circus; the Ringling Brothers, Barnum & Bailey Circus; and the Cole Brothers Circus.

Community bands have been a long-standing staple of African-American civic life. Although there is evidence of their prior existence, churches and fraternal orders have been the strongest supporters of these bands throughout the twentieth century. They usually performed on various public occasions, including parades, holidays, funerals, and ceremonies of community importance. They represented the community's best talent and attracted "name" musicians to their ranks. Lowery and many of his musicians prized their memberships in the Knights of Pythias and the International Benevolent Protective Order of

James Reese Europe's 369th Infantry Regiment Band, also known as the Hell-Fighters, seen here on its February 1919 return to the United States. The band, which toured extensively in France and England, introduced its audiences to the sophisticated large-ensemble ragtime that was the immediate precursor and inspiration for the big band jazz of the 1920s. (Photographs and Prints Division, Schomburg Center for Research in Black Culture, The New York Public Library, Astor, Lenox and Tilden Foundations)

Elks (*see* FRATERNAL ORDERS AND MUTUAL AID ASSOCIATIONS), and participated in their bands in the Pittsburgh and Cleveland areas. Elk lodges throughout the country have sponsored marching bands that competed during their annual convention parades. The Tennessee Valley Lodge Band, directed by St. Clair Cobb of Knoxville, was the 1956 winner. Cobb was a pioneer in the training and development of these bands. The Shriners, veterans' organizations, and Oddfellows were also known to sponsor marching bands in various communities.

New Orleans has one of the best-known African-American community marching band traditions. Its products included the jazz pioneers King OLIVER and Louis Armstrong. In the 1870s, Kelly's Band and the St. Bernard Ensemble were popular in New Orleans. A dozen ensembles boasted of participation in an 1881 memorial parade for U.S. President James A. Garfield. The Excelsior Brass Band performed in 1885 at the Colored People's Exhibit of the New Orleans Cotton States Exhibition. The Eureka Brass Band was active from the 1920s through the '60s. Other well-known marching bands from that area, which began in the early twentieth century and lasted into the 1960s or later, include the E. Gibson Brass Band, the Olympia Brass Band, the Young Tuxedo Brass Band, and the Onward Brass Band. The Gibson band recorded "What a Friend We Have in Jesus" and "The Sheik of Araby" in 1963. As of the 1990s, the recognized band that continued this style was the Dirty Dozen Brass Band.

Nashville, the location of several African-American church-related publishing houses, and other cities throughout the South often hosted church conventions. Frequently, marching bands were integral parts of the pageantry, in the parades and in providing music for the meetings. Two such bands from Alabama made recordings: in 1954, the Lapsley Band's "Sing On" and "I Shall Not Be Moved," and the Laneville-Johnson Union Brass Band's "Precious Lord, Take My Hand." "Precious Lord . . ." was written by a former show pianist, Dr. Thomas A. DORSEY, whose stage name was Georgia Tom.

Professor N. C. Davis of Nashville was often contracted in the early 1900s to provide bands for the National Baptist Sunday School Congress. One of Davis' star performers was Jordan "Chick" Chavis, a phenomenal trumpeter-bandleader and Fisk University graduate. Studying along with Jimmy LUNCEFORD, Chavis formed and toured with his own orchestra, patterned after that of Earl "Fatha" HINES, and developed jazz and marching bands at Tennessee State University in the 1940s and early '50s.

The contemporary African-American marching show-oriented bands that play influential roles in the rich pageantry of the United States today represent the culmination of the historical and stylistic evolution of the military band, the show bands, and the community bands. Initially led by first- and second-generation musician-educators such as J. Paul Wyer of Pensacola, Fla., Wayman A. Carver of Atlanta, N. Clark Smith of Tuskegee, Ala., and W. C. Handy of Florence, Ala., these bands now have "homes" at the most revered institutions of black higher education, including Alabama's Tuskegee Institute, North Carolina A&T, Southern, Alabama A&M, Clark College in Atlanta, Tennessee State, Florida A&M, Howard, Bethune-Cookman, Morris Brown, and others. Although circus bands are now nearly nonexistent, and community, church, and fraternal bands are found infrequently, African-American colleges and universities have preserved, maintained, and elevated the standards set by their predecessors.

The names of these bands are as unique as their styles: the Sonic Boom, the Marching Machine, the Aristocrat of Bands, the Marching 101, the Tiger

Grambling State Marching Band in the African-American Day parade in Harlem, N.Y. (© Shawn Walker)

Band, and the Ocean of Soul. These names are indicators of how each band strives mightily not to look or sound like another. Their loyal cadres of fans rival those of athletic teams. Their principal domain is the football stadium at game time. The audience may come primarily to see the halftime "battle of the bands" and to watch the game as an afterthought. The bands present a smorgasbord of music that includes military marches, jazz, soul, salsa, and gospel, grandly packaged in colorful uniforms, precision drills, intricate maneuvers, and pageantry—all skillfully decorated with beautiful specialty dancers. The key words are *show and blow*. Intense competition and an abundance of pride are involved. A call-and-response playing contest often erupts in the grandstands either before the game ends or immediately afterward. Technical proficiency is a must: The bands might play through their whole repertory. The band that first exhausts its music and cannot answer—or begins to play badly—will reap derision by the fans. Although not judged by numerical scores, one band will certainly "win" and the other will "lose." That judgment is made by the audience. The reward is "bragging rights."

REFERENCES

BROOKS, TILFORD. *America's Black Musical Heritage.* Englewood Cliffs, N.J., 1984.

McINTYRE, CHARSEE L. *African and African-American Contributions to World Music.* Portland, Oreg., undated.

PLOWDEN, GENE. *Those Amazing Ringlings and Their Circus.* Caldwell, Idaho, 1967.

POWELL, ANTHONY L. "Keep Step to the Music of the Union: A History of Black Regular Army Bands, 1869–1930." *Black Heritage* (May-June 1980).

SOUTHERN, EILEEN J. *The Music of Black Americans: A History.* New York, 1983.

WATKINS, CLIFFORD E. *Jordan D. "Chick" Chavis: An Oral-Historical Biography.* Nashville, Tenn., 1979.

———. "Perry George Lowery, (1870–1942), the Big Horn on the Great Plains: The Nashville Students Tours." Greensboro, N.C., 1994.

———. "P. G. Lowery and His Progressive Musical Enterprises: The Formative Years." In George Keck and Sherrill V. Martin, eds. *Feel The Spirit, Studies in Nineteenth-Century Afro-American Music.* Westport, Conn., 1988.

———. *The Works of Three Selected Band Directors in Predominantly Black American Colleges and Universities.* Ann Arbor, Mich., 1975.

CLIFFORD E. WATKINS

Maritime Trades. Following in a long tradition of African seafarers and explorers, African Americans contributed greatly to the maritime trades in early America, shipping out both as crew members on merchant ships and on whalers. Black sailors contributed to the country's growing economy. Virginia slaves and other skilled black navigators played a part in the AMERICAN REVOLUTION, piloting troops down coastal and inland waterways. Before his death in the 1770 Boston Massacre, Crispus ATTUCKS had served as a whaleman for over twenty years.

Traditional maritime scholarship, such as that by Samuel Eliot Morrison, ignored the black presence at sea, but recent studies indicate that in the late eighteenth and early nineteenth centuries, African Americans often made up a significant portion of the seafaring crews on many ships. An 1807 report of the Massachusetts Historical Society found that nearly half the crew on local whaling boats was black. Historian Jeffrey W. Bolster concluded that between 17 percent and 22 percent of Philadelphia's seafaring jobs were filled by blacks from 1800 to 1820. This accounted for a higher proportion of blacks than that which was present in the population of that city—a demographic relationship that held true in other northern cities as well. Work aboard ship offered African Americans long periods of steady employment, room and board, and comparatively higher pay than most other occupations open to them in the early nineteenth century. Unlike their counterparts on shore, black seamen labored alongside whites and usually received equal wages. Slaves also labored on ships. Often they were the property of the ship owner or captain. Surviving ship registers in New Orleans occasionally list entire crews consisting of slaves.

In the colonial and early national periods, slaves and free blacks also worked in the on-shore maritime trades as shipbuilders and longshoremen. In the southern Atlantic and Gulf of Mexico ports, slaves loaded tobacco and cotton onto ships. In the Chesapeake Bay area, slave pilots navigated tobacco crops down the complex river system to the coast. In the North, a handful of free blacks became notable for their skill in maritime trades, among them harpoon crafter Lewis TEMPLE and shipbuilder John Mashow, both of Massachusetts, and sailmaker James FORTEN of Philadelphia. Paul CUFFE found success working as a whaler, boat builder, and international merchant. Black seamen were common enough to appear in several works of fiction by Herman Melville, including *Moby Dick* (1851) and "Benito Cereno" (1855), the latter of which included a description of a revolt aboard a slave ship.

The presence of black seamen and dock workers became a subject of growing concern among southern slave owners. Ships anchored in the ports of New Orleans, Charleston, and Baltimore—ironically the same vehicles which had once brought Africans into slavery—seemed now to offer avenues of escape. It

Black dockworkers on the Quartermaster's Wharf in the James River at Alexandria, Va., during the Civil War. In many southern port towns, both before and after the Civil War, dock work was one of the trades most closely associated with blacks. (Prints and Photographs Division, Library of Congress)

was common for announcements of runaways in New Orleans newspapers to mention that a slave had donned a sailor's garb to make escape. Slave owners also feared the presence of free black sailors who might distribute abolitionist literature among the enslaved population.

Southern lawmakers took numerous steps to curb the freedom of black seamen. Following Gabriel Prosser's attempted revolt in 1800 (*see* GABRIEL PROSSER CONSPIRACY)—Prosser was the slave of a Virginia tavernkeeper who labored as a blacksmith—the state of Virginia passed several restrictive laws, including one which condemned any black person caught commanding a vessel to thirty-nine lashes. Similarly, following the failed 1822 rebellion by Denmark Vesey (*see* DENMARK VESEY CONSPIRACY), a free black carpenter, South Carolina enacted its first Negro Seaman's Act. This act required that all black mariners—labeled as a "dangerous class of people"—who entered the state be jailed until the departure of their vessel. Similar laws proliferated in the deep South which had the effect of ostensibly closing southern ports to black sailors. Despite such restrictions, a handful of slaves still found freedom either by escaping aboard a ship or by masquerading as a sailor. The most famous instance of the latter occurred in 1838, when Frederick DOUGLASS borrowed

a sailor's clothes and protection certificate and rode the railway out of Baltimore to his freedom. During the Civil War, in 1862, Robert SMALLS, a slave impressed into service on the Confederate steamboat *The Planter,* went even further. After most of the crew had disembarked, Smalls seized the vessel and steered out of Charleston harbor to his freedom. Michael Healy (*see* the HEALY FAMILY) began his long maritime career during the Civil War working for a merchant vessel in 1864 and becoming a captain in the U.S. Revenue Cutter Service (the forerunner of the U.S. Coast Guard) a year later.

In the years after the Civil War, American shippers faced competition from foreign vessels operating at lower costs. Blacks struggled to maintain a presence at sea. California's prominent whaling captain, William T. Shorey, became an anomaly for more reasons than the drop in demand for whale oil. A decline in American shipping brought a general oversupply of labor, allowing shipmasters to be selective in their hiring. As a number of shippers chose to hire segregated crews, JIM CROW made an appearance offshore just as on land. The few vessels sailing with integrated crews became known as "checker-board" ships.

American shipping continued to give way to foreign competition in the final decades of the nine-

James Bibbons, one of more than six thousand black workers at the Bethlehem-Fairfield shipyards in Baltimore in 1943, during the construction of the SS *Frederick Douglass*. African Americans have been employed on the Baltimore waterfront since the time of Douglass himself, who worked there as a ship caulker before his escape from slavery in 1838. (Prints and Photographs Division, Library of Congress)

teenth century, as owners were slow to make the transition to iron ships with steam engines. Under these circumstances, crews were reduced in size, and conditions aboard ship worsened. A number of other factors brought difficulties for black sailors. Crews for ships were usually provided by boardinghouse keepers and ship masters—or "crimps" as they were called—who, through dock associations, controlled the sailor market. To assemble their crews, ship captains were forced to negotiate with crimps who often turned away black labor. Crimps and ship captains were also inclined to hire foreign hands who worked for lower wages. During the 1890s, only about 30 percent of seamen on American ships were American citizens.

Some of these foreign sailors, however, came from the Cape Verde islands off the coast of Africa. Cape Verdeans, of African-Portuguese ancestry, became favorite crew members of New England shipmasters. After their work as seamen, many settled in New England. Late in the nineteenth century, these Cape Verdeans began to pool their money to purchase outdated whalers and tradeships and began a successful passenger liner service between Massachusetts, Rhode Island, and Cape Verde, which lasted until restrictive immigration covenants in 1921 and 1924. (There were few other attempts by blacks to form their own shipping companies. The best known was Marcus GARVEY's short-lived Black Star Line founded in 1919).

Much of the difficulty for African Americans engaged in the maritime trades in the late nineteenth and early twentieth centuries came from the formation of discriminatory labor unions. The harshness and irregularity of employment in the longshoremen, shipbuilding, and off-shore maritime trades encouraged the formation of unions. Unfortunately, rather than enforcing class solidarity, unions were more often formed for purposes of racial exclusion, as white maritime workers aimed at keeping work for themselves. This was true in many industries in the mid-to late nineteenth century. The National Labor Union (1866–1872), a federation of trade unions, largely excluded blacks.

In the off-shore trades, the largest national organization, the International Seamen's Union (ISU)—founded in 1892 by a merger of the Atlantic Coast Seamen's Union, the Lake Seamen's Union, and the Sailors' Union of the Pacific—resolved to organize blacks into separate branches in 1907, although this was not accomplished. The only effective means of black sailor organization in the early twentieth century was a separate branch of the Marine Cooks and Stewards' Association of the Atlantic, formed in 1908. The majority of blacks laboring aboard white-owned ships worked as stewards. Even with the passage of New Deal legislation in 1933, when union membership increased, the ISU continued its discriminatory practices. In 1937, dissatisfaction on a number of grounds with the ISU led maritime workers to form the National Maritime Union (NMU), which successfully organized seamen across the color line. The membership of the NMU swelled during World War II to 100,000. During the war, a number of blacks chose to serve in the merchant marine rather than in a segregated navy.

Despite these advances, however, individual black sailors often faced discrimination. Captain Hugh N. Mulzac, who had been a trained sailor in Great Britain, was only able to attain a post as a steward upon his immigration to the United States. Finally in 1942, twenty years after receiving a masters's license, with pressure from the NMU, he was given command of the transport vessel, or Liberty ship, *Booker T. Washington*—promoted from chief cook to captain in one day. Three other blacks were made captains on other such transport vessels during the course of the war.

Black laborers in on-shore maritime trades experienced similar difficulties with organized labor as had black sailors. In both the longshoremen and shipbuilding industries, blacks were most successful in the southern Atlantic and Gulf of Mexico ports, where their numerical strength was greatest. For most of the twentieth century, African Americans made up from two-thirds to three-quarters of the longshoremen industry in most ports along the coast from Maryland to Louisiana. Longshoremen work was often a contest between white and black unions, however, and whites controlled most docks. Thus, for example, the all-white Galveston Screwmen's Benevolent Association (screwmen were skilled workers who loaded cotton on ships), founded in 1866, refused to service any ship owner employing blacks. In 1870, African Americans formed the Galveston Negro Longshoremen's Benevolent Association to work the same harbor. Other black dockworkers' unions included the Longshoremen's Protective Union Association organized in Charleston, S.C., in 1867 and in Port Royal, S.C., in 1874. With the founding of the white-organized International Longshoremen's Association (ILA) the color line was lowered but not discarded. Starting in Chicago in 1877, but spreading through the country after 1892, the ILA had no official discriminatory policy barring blacks. However, it refused to interfere with the racial policies of affiliated unions.

One notable exception to segregated unions in the longshoremen industry was the Dock and Cotton Council in New Orleans, which was formed in 1901 after the failure of white unions to drive blacks from the docks. Pledged to integration—although it maintained segregated seating at meetings and always had a white president—the Council would prove to be successful, improving the level of wages and working conditions for both white and black workers. It grew to include some 15,000 members before its demise after a defeat in the strike of 1923—one of a series of losses for organized labor in the 1920s. This was followed by a period of declining wages and deteriorating relations among dockworkers, and a return of segregated unions. Some of the all-black unions in these southern ports were successful and resisted including white members up to the era of the CIVIL RIGHTS MOVEMENT. They finally were required to do so by a federal court order in 1983.

In the shipbuilding trades, blacks were similarly excluded from union organization, prompting some to form their own organizations. Baltimore ship caulker Isaac MYERS formed the Colored Caulkers' Trades Union in 1866 and later the short-lived black National Labor Union in 1869. In the twentieth century, skilled shipbuilders were organized under the Metal Trades Department of the American Federation of Labor, which was composed of separate craft unions such as the Boilmakers and Machinists. Most of these affiliated unions excluded blacks. The CIO's Industrial Union of Marine and Shipbuilding Workers of America (IUMSWA), founded in 1933, generally welcomed black membership, but did not interfere with discrimination of local affiliating unions. As in the longshoremen industry, blacks in the shipbuilding trades found greatest success in the South, where their presence was strongest. African Americans worked in large numbers at the Newport News shipbuilding facility in Virginia, which remained nonunion. At Newport News, two-thirds of the 5,000 employees in 1902 were black. African-American labor would continue to dominate the plant through the twentieth century.

In other regions of the country, blacks faced similar discriminatory treatment from maritime unions. Their plight was made worse because of their smaller numbers. In West coast ports, few blacks found work on docks until the 1930s. In San Francisco, blacks entered the longshoremen trade as strikebreakers during a series of strikes in 1901, 1916, and 1919. The 1934 strike prompted the rise of white labor leader Harry Bridges of the ILA. Bridges, understanding the importance of organizing across racial lines, insured blacks access to the union even though several affiliated local dock unions continued to discriminate. For this and other reasons, Bridges led many West coast longshoremen out of the ILA to form the International Longshoremen's and Warehousemen's Union (ILWU). In the Northeast ports in the late nineteenth century, where blacks held relatively few longshoremen jobs, unions organized along ethnic lines which excluded blacks. As in West coast ports, blacks entered the longshoremen trade largely as strikebreakers in New York and Philadelphia.

Despite temporary sharp increases during war years, the percentage of blacks employed in the shipbuilding industry rose only gradually through the first six decades of the twentieth century. In 1910, 4,347 blacks worked in the shipbuilding trades throughout the United States, accounting for 6.5 percent of the total employment in the industry. In 1960, 21,445 African Americans (or 9.2 percent of the industry) had employment in the shipbuilding industry. The increase (largely coming from 1940 to 1960) was in part due to the continued success of the Newport News Company and the opening of several unions to blacks, including the Boilmakers in 1957.

In the latter half of the twentieth century, the size of the U.S. merchant fleet declined in both real terms and relative to the size of the world merchant fleet. From 1948 to 1970, the U.S. fleet fell from 5,225 ships to 2,938 ships. Potential jobs for blacks were eliminated by foreign competition. Nonetheless, de-

spite a decrease in the number of merchant flagships since World War II, the percentage of African Americans listed as crew members rose from 5.2 percent in 1950 to 7.5 percent in 1970. Of these, roughly 40 percent worked as unlicensed sailors and deck hands.

The longshoremen industry has faced similar difficulties. After the introduction of container shipping in 1958, the manpower required for longshoremen's trade was greatly reduced. In 1986, the International Longshoremen's Association was forced to make concessions in both pay and guaranteed work hours for all its workers. The 1990 census revealed that blacks made up 6.2 percent (4,153) of those included in the "water transportation" category—including ship captains and mates, sailors and deck hands, marine engineers, and bridge lock and lighthouse attendants. The presence of blacks was strongest in the category of "sailors and deckhands" (constituting 11 percent of the trade), while the lowest was "ship captains and mates" (2.5 percent).

The experiences of African Americans in the maritime trades has thus been marked by great changes. In the colonial and early national period, the skill of black seamen placed them in demand as pilots, harpoonists, and crew members. Free blacks and slaves made up significant portions of the longshoremen and shipbuilding industries. With the advent of restrictionist unions in the latter half of the nineteenth century, blacks were often kept from the docks, and segregated on shipboard. Only in southern ports were blacks able to occasionally organize effectively or find work in significant numbers at independent yards. The gradual decline in the American maritime trades, the tendency of shipmasters to hire foreign crew members, and the slow-dying prejudice at local shipyards diminished the lure of an industry which once offered free blacks decent wages and slaves a chance of escape.

REFERENCES

APTHEKER, HERBERT, ed. *A Documentary History of the Negro People in the United States*. 3 vols. New York, 1969.

BOLSTER, W. JEFFREY. "To Feel Like a Man: Black Seamen in the Northern States, 1800–1869." *Journal of American History* 76 (1990): 1173–1195.

FONER, PHILIP S., and RONALD LEWIS, eds. *The Black Workers, A Documentary History from Colonial Times to the Present*. Philadelphia, 1978.

GREENE, LORENZO J. *The Negro in Colonial New England*. 1947. Reprint. New York, 1969.

PUTNEY, MARTHA. *Black Sailors: Afro-American Merchant Seamen and Whalemen Prior to the Civil War*. New York, 1987.

RUBIN, LESTER, WILLIAM SWIFT, and HERBERT NORTHRUP. *Negro Employment in the Maritime Industries*. Philadelphia, 1974.

LAMONT D. THOMAS

Markham, Dewey "Pigmeat" (April 18, 1906–December 13, 1981), comedian. Dewey Markham was born in Durham, N.C., in 1906. At age thirteen he ran away from home to join a traveling circus. Markham left the carnival circuit to join the Florida Blossoms Minstrel Show, from which he eventually departed to become the star comic of Gonzelle White's Minstrel Show (*see* MINSTRELS/MINSTRELSY). It was with White's company that he acquired the nickname "Pigmeat" from a song used in his act entitled, "Sweet Papa Pigmeat."

From 1925 through 1927, Markham toured with A. D. Price's "Sugar Cane" revue. In the late 1920s, he appeared at the Alhambra Theatre for a year and a half. Markham then appeared on Broadway in *Hot Rhythm* in 1930 and in *Cocktails of 1932*. He then played at the fledgling APOLLO THEATER from 1935 through 1938. In 1940, Markham performed in the revues *Sugar Cane* and *Ecstatic Ebony,* produced by the host at the Apollo, Ralph COOPER.

Markham moved to Hollywood in 1938, where he was featured in such all-black films as *Mr. Smith Goes Ghost* (1940), *Am I Guilty?* (1940) with Ralph Cooper, and *That's My Baby* (1944). He also appeared in the feature studio production *Moonlight and Cactus* (1944) with the Andrews Sisters. He worked with the singers again on their radio show, *Eight to the Bar,* playing Alamo, the chief cook. A talented vocal performer, Markham made sixteen records of blues and comedy, including an album with Jackie "Moms" MABLEY, *The Best of Moms and Pigmeat.*

Markham made numerous television appearances in the 1950s and 1960s, performing on *The Tonight Show* with Johnny Carson, *The Merv Griffin Show,* and *The Mike Douglas Show*. He was a guest on *The Ed Sullivan Show* more than thirty times during its twenty-three-year run. Markham was also a regular performer on the television show *Laugh-In,* during its run from 1968 through 1973. Markham was famed for his comedy sketch "Here Come de Judge," which was popularized on *Laugh-In* for a mainstream audience.

Markham continued to perform at various New York City venues through the early 1970s until illness forced him to retire. He died in New York City of cancer in 1981.

REFERENCE

SAMPSON, HENRY T. *Blacks in Blackface*. Metuchen, N.J., 1980.

KENYA DILDAY

Maroonage. The area of the United States did not have the same kind of maroon (*marron, cimarron,* or *quilombolo*) tradition as was evidenced in such places as Jamaica, Surinam, St. Domingue, Brazil, or Spanish America. In these regions, sizable groups of runaway African communities maintained their independence for decades or longer (almost 100 years in the case of the Brazilian northeast coastal *quilombo* of Palmares) and occasionally forced colonizing powers to recognize it in formal treaties. By contrast, some have suggested that there is no maroon tradition in the United States at all. Herbert Aptheker attempted to contradict this assumption in the 1939 publication "Maroons Within the Present Limits of the United States," identifying fifty or more maroon communities of various sizes in North and South Carolina, Virginia, Louisiana, Florida, Georgia, Mississippi, and Alabama. Modern historians incline more toward Aptheker than his detractors in accepting his evidence of slave unrest, yet they show uncertainty over whether to minimize or magnify its character as maroonage. If what is meant by the term includes every small group of FUGITIVE SLAVES who stayed out for a period of time, alarmed the planter class, and subsisted upon the slave community, whether the support was voluntarily offered or forcefully secured, then the number of maroons counted and the significance attached to them will be greater than if one limits the term to large groups of self-sustaining, reconstituted African or African-American communities. Of course, one can identify several permutations of these extremes: small, mobile, unstable, male-dominated groups who depended upon raids for their livelihood and whose acquisitiveness might antagonize slave communities as much as slave owners; more stable groups of fugitive men and women who tried to establish self-sustaining communities, produced their own crops, and depended for safety upon anonymity in hidden or inaccessible locations; some combination of the first two, depending upon stage of development and status of relationship with the planters; and communities large and strong enough to sustain both agricultural production and trade, and to have these and other rights acknowledged by colonial power, secured through effective military resistance. The first type was more common in North America; the latter more common in Latin America and the Caribbean. The issue has a political dimension because many view evidence of maroonage as indicative of African cultural vitality and irrepressibility, and its absence as suggestive of a certain supineness and African cultural loss.

In fact, preconditions for the most striking forms of maroonage were lacking in North America. There needed to be an extended, inaccessible, and largely empty wilderness. It helped if the region was tropical, or semitropical, possessing a climate that facilitated survival with little shelter or clothing much of the time, and whose environment provided or permitted varied food sources for sustenance. A demographic disproportion in favor of blacks also helped—as source and support, and providing reason to come to quick terms when a military solution failed. Moreover, maroon communities were normally associated with large African populations rather than Creole ones. Caribbean locales that lacked these perquisites, such as Antigua, whose arid climate did not permit forest cover, and Barbados, whose woodlands fell to agricultural production, did not have maroons either. In British North America the wilderness was inhabited, initially by Native Americans, later by white settlers. Physically and psychologically, colonial authorities tried to separate blacks and Indians as much as possible. They achieved remarkable success in pitting the two groups against each other, paying Indians to return runaway slaves or their scalps, and using blacks as troops against the Indians. Their success was by no means complete, but when slaves escaped, singly or in groups, they could count on neither Native American support nor neutrality. Most important, however, fugitives faced a planter class determined to prevent sustained independent black activity, in the wilderness or elsewhere, and who, supported by a disproportionately large white population, were in a much better position to prevent it than their island or Latin-American counterparts. Indeed, Jamaica, in particular, was exhibited as an objectionable example of what Americans must avoid. Thus South Carolina's governor in 1760 counseled vigilance, for "the Overhill [Cherokee] country, like the mountains of Jamaica, might become a refuge for fugitive Negroes" (Porter, "Negroes on the Southern Frontier," p. 70), and a maroon threat in Virginia (1729) was pursued to destruction because the "design . . . might have proved as dangerous to this Country, as is that of the Negroes in the Mountains of Jamaica" (Mullin, *Africa in America*, p. 45). Eighteenth-century British North Americans suffered no lack of maroon threats but permitted none to survive for very long.

The most successful avenues for maroon activity occurred on the borderlands between English and Spanish territory in Florida. The Spanish at St. Augustine promised freedom to escaped English slaves and permitted them to form separate, allied communities. They obliged them to become at least nominal Catholics, circumscribing their opportunities for totally independent cultural existence, although more autonomous communities also developed within the pale of a not very effective Spanish authority. These

communities normally formed in association with Native Americans. Within the colony and along the borders of French (later Spanish) Louisiana, fugitives also had opportunities to form maroon communities—with less cultural dictation, since they formed entirely without authorization, but they possessed, perhaps, no less cultural hybridization. Maroon settlements in the Caribbean probably were culturally more homogeneous than these North American aggregations, influenced by Europeans but lacking significant Native American input, at least by the eighteenth century. In this instance, however, they differed as well from various maroon communities in Latin America.

In the nineteenth-century United States, with an even larger white population and a more highly developed hinterland, the space for fugitive communities diminished. Only in Florida, initially under Spanish control and then after American acquisition, was a group of blacks, in alliance with Seminoles, able to hold its own. During the Second and Third Seminole Wars, they forced the United States to recognize their right to move with Seminoles to Oklahoma rather than return to the white owners they had fled. Their case illustrated that under similar circumstances, Africans in North America acted very much like their compatriots elsewhere. The differences were a function of the environment, and they were differences of degree more than of kind.

REFERENCES

APTHEKER, HERBERT. "Maroons Within the Present Limits of the United States." *Journal of Negro History* 24 (April 1939): 167–184.

GENOVESE, EUGENE D. *From Rebellion to Revolution: Afro-American Revolts in the Making of the Modern World.* Baton Rouge, La., 1979.

HALL, GWENDOLYN M. *Africans in Colonial Louisiana: The Development of Afro-Creole Culture in the Eighteenth Century.* Baton Rouge, La., 1992.

LITTLEFIELD, DANIEL C. "Continuity and Change in Slave Culture: South Carolina and the West Indies." *Southern Studies* 26 (Fall 1987): 202–216.

MULLIN, MICHAEL. *Africa in America: Slave Acculturation and Resistance in the American South and the British Caribbean, 1736–1831.* Urbana, Ill., 1992.

PORTER, KENNETH. "Negroes on the Southern Frontier, 1670–1763." *Journal of Negro History* 33 (January 1948): 53–78.

DANIEL C. LITTLEFIELD

Marrant, John (June 15, 1775–c. 1797), writer. What little is known about John Marrant's life comes mainly from his publications. Born to free black parents in New York, he was four years old when his father died. His mother then moved with her four children to the South. There they lived in St. Augustine, Fla., Georgia, and Charleston, S.C., where John went to school. He became interested in music and was influenced by Rev. George Whitefield, the English preacher of the Great Awakening. For some time Marrant lived among Cherokee Indians, learned their language, and converted some to Christianity. During the Revolutionary War he served in the British Royal Navy, spending almost seven years at sea.

After his discharge, Marrant resided for a while in London, sponsored by the Countess of Huntington. She persuaded him to go as a Methodist missionary to Nova Scotia, where he preached in and around Halifax for nearly four years. In 1784 he joined the Masons under Prince Hall and by 1789 became chaplain of the African Lodge in Boston. Marrant's *A Narrative of the Lord's Wonderful Dealings with John Marrant, A Black, (Now Going to Preach the Gospel in Nova Scotia) Born in New York, in North America. Taken Down from His Own Relation, Arranged, Corrected, and Published, by the late Rev. Mr. Aldridge* (London, 1785) is one of the earliest African-American narratives, and one of the most popular of the eighteenth century. Editor-librarian Dorothy Porter lists nineteen different printed versions of the *Narrative,* the latest published in 1835.

Marrant's *A Journal of the Rev. Marrant, From August the 18th, 1785, to the 16th of March, 1790. To which are added, Two Sermons* (London, 1790) is a reflection of his preaching and missionary experiences in Nova Scotia. A third publication, *A Sermon Preached on the 24th Day of June 1789 Being the Festival of St. John the Baptist at the Request of the Right Worshipful Grand Master Prince Hall and the rest of the Brethren of the African Lodge of the Honorable Society of Free and Accepted Masons in Boston* (Boston, 1789), is significant because of Marrant's interpretation of the Bible and his short note indicating that both speaker and audience were black. Arthur A. Schomburg, who reprinted the Masonic *Sermon,* considered Marrant among the first African-American ministers in North America as well as among the first to bring the Christian religion to the Native Americans.

REFERENCE

LOGAN, RAYFORD, and MICHAEL R. WINSTON, eds. *Dictionary of American Negro Biography.* New York and London, 1982.

DORIS DZIWAS

Marsalis, Wynton (October 18, 1961–), jazz trumpeter and composer. Born in New Orleans, Wynton Marsalis grew up in a musical family. His

father, Ellis (pianist), and brothers, Branford (tenor and soprano saxophonist), Delfeayo (trombonist), and Jason (drummer), are themselves well-known jazz artists. From an early age, he studied privately and played in a children's marching band directed by the eminent New Orleans musician/scholar Danny Barker. As a youngster, Marsalis made notable contributions in both classical and jazz genres. He performed at the New Orleans Jazz and Heritage Festival, and at the age of fourteen he performed Haydn's *Trumpet Concerto in E-flat* with the New Orleans Philharmonic Orchestra. He attended the Berkshire Music Center at Tanglewood and enrolled at Juilliard in 1980. While a student at Juilliard, he joined Art BLAKEY's Jazz Messengers (1980) and toured in a quartet with former Miles DAVIS personnel Herbie HANCOCK, Ron CARTER, and Tony Williams. He recorded his first album as a leader, *Wynton Marsalis,* in 1981.

After leaving Blakey in 1982, Marsalis formed his first group, a quintet that included several young and extremely talented musicians—his brother Branford (tenor saxophone), Kenny Kirkland (piano), Charles Fambrough (bass), and Jeff Watts (drums). In addition to performing with his own group, Marsalis replaced Freddie Hubbard for the V.S.O.P. II tour (1983). In 1984, he became the first musician to win Grammy Awards for both jazz (*Think of One,* 1982) and classical (Haydn, Hummel, and Leopold Mozart trumpet concertos, 1984) recordings. Since the late 1980s, Marsalis has concentrated on jazz performance with a group consisting of Wes Anderson and Todd Williams (saxophones), Reginald Veal (bass), Wycliffe Gordon (trombone), Herlin Riley (drums), and Eric Reed (piano). Marsalis has won critical acclaim for his virtuosic technique, musical sensitivity, and gift for improvisation. He has become an articulate spokesperson for the preservation of "mainstream" jazz (a style rooted in bop and hard bop) through his performances and writings, and, beginning in 1991, as artistic director of the classical jazz program at Lincoln Center in New York.

REFERENCES

CROUCH, STANLEY. "Wynton Marsalis: 1987." *Downbeat* 54, no. 11 (1987): 17–19.

GIDDINS, GARY. "Wynton Marsalis and Other Neoclassical Lions." In *Rhythm-a-ning.* New York, 1985, pp. 156–161.

EDDIE S. MEADOWS

Marshall, Albert P. (September 5, 1914–), librarian. Albert Marshall was born in Texarkana, Tex., in 1914, to Early and Mary Bland Marshall. He grew up in Muskogee, Okla., and Kansas City, Mo., and attended Lincoln University in Jefferson City, Mo., and the University of Illinois. He served as a librarian at Lincoln University, Winston-Salem State University, and Eastern Michigan University, where he was appointed Dean of Academic Services.

Marshall pioneered the indexing of African-American serials by creating *A Guide to Negro Periodical Literature,* which first appeared in February 1941. Working alone, Marshall indexed a dozen leading African-American journals and magazines, adapting subject headings from *A Readers Guide to Periodical Literature,* and filing 3 × 5 cards in a shoebox. He typed stencils, mimeographed copies, and mailed his *Guide* to a handful of subscribers. It was issued quarterly until Marshall entered the Coast Guard in 1943 during World War II, but by that time some black periodicals were being indexed in the standard sources, and Marshall ceased publication of the first index to African-American serials. In 1950, the standard reference in the field, *Index to Selected Negro Periodicals* received by the Hallie Q. Brown Library, College of Education and Industrial Arts, WILBERFORCE UNIVERSITY (Ohio), began to appear quarterly. Marshall also founded the North Carolina Index, a guide to all periodicals published within the state.

REFERENCE

Interview. June 22, 1992.

RICHARD NEWMAN

Marshall, Andrew Cox (c. 1755–December 8, 1856), minister. Andrew Marshall was born a slave in Savannah, Ga. When his father, an English plantation overseer, died in England, plans for young Marshall's manumission were never enacted. However, the last in a series of owners advanced him $200 toward the purchase of freedom for himself and his family. As a free man, Marshall operated a successful hauling-and-drayage business, becoming the wealthiest black in the area. In 1785, he joined Savannah's First African Baptist Church, one of the earliest independent black churches in the United States, where he served as an assistant to his uncle, the Rev. Andrew Bryan, and was later licensed to preach. Bryan died in 1812, and, the following year, Marshall replaced him as pastor.

In 1831 Marshall invited the unorthodox and confrontational Christian restorationist, Alexander Campbell, to preach at Savannah First. The Sunbury Association, a council of Baptist churches whose membership was almost entirely black, but which was actually dominated by whites, accused Marshall of

doctrinal deviation and declared his church dissolved. In defiance of the association, Marshall continued to preach and, with the majority of his old congregation, founded the New First Colored Church. Although pressure from white authorities was a constant threat to its membership rolls, First Colored survived, with congregational autonomy, for six years. In 1837 Marshall officially recanted and was readmitted to the Sunbury Association. He returned to Savannah First, and in the years that followed, his influence and his congregation flourished.

Andrew Marshall's oratory earned him a substantial reputation among whites, and his sermons attracted visitors from the North as well as Europe. In hopes of constructing a new building for his church, Marshall embarked on a tour of the North to raise funds. Along the way his health failed; he died in Richmond, Va., on December 8, 1856. His body was returned to Savannah, where the funeral procession for the pioneer black Baptist was said to have been a mile long.

REFERENCES

HOSKINS, CHARLES LWANGA. *Black Episcopalians in Savannah.* Savannah, Ga., 1983.
SOBEL, MECHAL. *Trabelin' On: The Slave Journey to an Afro-Baptist Faith.* Westport, Conn., 1979.

BENJAMIN K. SCOTT

Marshall, Harriet Gibbs (February 18, 1869–February 25, 1941), music educator. Harriet Gibbs Marshall was born in Vancouver, British Columbia, the daughter of Marie A. Alexander and Judge Mifflin W. Gibbs. The first African American to complete the course in piano at the Oberlin Conservatory of Music in Ohio (1889), she gave piano recitals and began her teaching career as director of music at Eckstein-Norton College in Cane Springs, Ky. In Washington, D.C., she served as music supervisor of black students in the public schools beginning in 1900, and in 1903 she established the Washington Conservatory of Music. Under her management and, from 1941 to 1960, that of her cousin Victoria Muse, the institution stood out as the country's most successful black-owned and -operated music school offering conservatory-level training. The conservatory drew students from all parts of the country as well as from the Washington area and, in addition, made an important contribution to the community through an annual concert series that presented nationally known artists. In keeping with the philosophy of the Harlem Renaissance, Marshall promoted the African-American musical heritage by opening a National

Negro Music Center (1936), for which she collected published works by African-American composers. During a leave of absence spent in Haiti with her husband, she cofounded an industrial school and completed research for *A Story of Haiti,* published in 1930.

REFERENCE

MCGINTY, DORIS EVANS. "The Washington Conservatory of Music and School of Expression." *Black Perspective in Music* 7, no. 2 (Spring 1979): 59–74.

DORIS EVANS MCGINTY

Marshall, Paule (April 9, 1929–), novelist. Paule Marshall was born in Brooklyn, N.Y., the daughter of Samuel and Ada (Clement) Burke, who had emigrated from Barbados shortly after World War I. Marshall lived in a richly ethnic "Bajan" neighborhood in Brooklyn, and visited Barbados for the first time when she was only nine years old. She graduated from Brooklyn College, cum laude and Phi Beta Kappa, in 1953; while attending New York's Hunter College in the mid-1950s, she began her first novel—*Brown Girl, Brownstones.* Its publication in 1959 was followed by a Guggenheim Fellowship (1960). Later awards include the Rosenthal award of the National Institute for Arts and Letters (1962) for *Soul Clap Hands and Sing,* a Ford Foundation grant (1964–1965), a National Endowment for the Arts grant (1967–1968), and the American Book Award of the Before Columbus Foundation for *Praisesong for the Widow* (1983).

During the 1950s, Marshall was a staff writer for a small magazine, *Our World,* which sent her on assignments to Brazil and the Caribbean. Since the publication of *Brown Girl, Brownstones* in 1959, Marshall has been a full-time writer and a part-time teacher. She has taught African-American literature and creative writing at Yale, Columbia, Iowa, and, since 1987, at Virginia Commonwealth University in Richmond, Va.

Marshall's writing explores the interaction between the materialist and individualistic values of white America and the spiritual and communal values of the African diaspora. With the exception of *Soul Clap Hands and Sing* (1961), a collection of four long stories about aging men, Marshall's work is focused on African-American and Caribbean women. Each of her novels presents a black woman in search of an identity that is threatened or compromised by modern society. Marshall's narratives locate that search within black communities that are still connected to ancient spiritual traditions, sharpening the

Paule Marshall in 1991, after the publication of her novel *Daughters*. (AP/Wide World Photos)

contrast between Americanized Africans and various diasporic modes of Africanizing the New World.

In her essays and interviews, Marshall has explained the influence of the Bajan community of her childhood on her work. Listening to the "poets in the kitchen," as she called her mother's women friends and neighbors in a *New York Times Book Review* essay, she learned the basic skills that characterize her writing—trenchant imagery and idiom, relentless character analysis, and a strong sense of ritual. In "Shaping the World of My Art," Marshall speculates that the verbal power of the women gathered around her mother's kitchen table so intimidated her that she may have conceived of writing "to see if, on paper, I couldn't have some of that power." Marshall's development of her poetic relationship to the community of storytelling Bajan women has made her an intensely ethnic writer, one whose themes and manner measure the difference between the homeland (the West Indies and Africa) and the new land (the United States).

Marshall's fiction explores the divided immigrant or colonized self. In *Brown Girl, Brownstones* (1959), her protagonist Selina Boyce is an adolescent girl torn between the assimilationist materialism of her mother, Silla, and the dreamy resistance to Americanization of her father, Deighton. As she matures, Selina learns from both the Bajan community and the world at large how to be her own woman. Each of the four stories in *Soul Clap Hands and Sing* explores a man in old age who reaches out toward a woman in the hope of transforming a failed and empty life. The stories contrast men defeated by materialism, colonialism, and internal compromise with young women full of vitality and hope. Like the men in numerous stories by Henry James, Marshall's old men cannot connect, and the young women serve as the painful instruments of their self-realization.

Marshall's second novel, *The Chosen Place, The Timeless People* (1969), is her largest literary conception. The major figure is Merle Kinbona, a middle-aged West Indian woman educated in Britain and psychologically divided in a number of ways. The struggle to resolve the divided self is very fully elaborated, here again seen as inextricably related to a community and its history. The rituals of recovery are more broadly drawn here, for they are more self-consciously communal in nature. Merle wants to be a leader in the development of her community, but she is almost literally catatonic with impotence until she comes to terms with her personal past and its relationship to the colonial order which is her communal past. As Merle is both the product and emblem of her divided community, her self-healing and newly found clarity of purpose prefigure the possibilities for the community as well. Her third novel, *Praisesong for the Widow* (1983), presents a middle-class black American woman who, like the old men of the four long stories, realizes the depth of her spiritual emptiness. Unlike the old men, Avatara is able, through dream and ritual, to recover her spiritual past. *Daughters* (1991) is the complex story of how Ursa McKenzie, the only child of a Caribbean politician father and an African-American mother, comes to grips with her ambivalent feelings about her father's emotional domination. Ursa's liberation involves every aspect of her life—her past in her island homeland, her professional life in New York City, her love-life and friendships, her understanding of political and economic relations between the United States and the island nations of the Caribbean.

In all her works, Marshall develops a rich psychological analysis, making use of powerful scenes of confrontation, revelation and self-realization. Her style, while essentially realistic, is always capable of expressionist and surrealist scenes and descriptions, which are seamlessly integrated in the fabric of the narrative. Marshall's originality—her prototypical black feminism, her exploration of "the international theme" arising from the African diaspora, her control of a wide range of narrative techniques—places her in the first rank of twentieth-century African-American writers.

REFERENCES

CHRISTIAN, BARBARA. "Paule Marshall: A Literary Biography." *Black Feminist Criticism.* New York, 1985.
COLLIER, EUGENIA. "The Closing of the Circle: Movement from Division to Wholeness in Paule Marshall's Fiction." In Mari Evans, ed. *Black Women Writers, 1950–1980.* Garden City, N.Y., 1984.

MARSHALL, PAULE. "Shaping the World of My Art." *Newsletters* 40 (October 1973): 97–112.

McCLUSKEY, JOHN, JR. " 'And Called Every Generation Blessed': Theme, Setting and Ritual in the Works of Paule Marshall." In Mari Evans, ed. *Black Women Writers, 1950–1980.* Garden City, N.Y., 1984.

JOSEPH T. SKERRETT, JR.

Marshall, Thurgood (July 2, 1908–January 24, 1993), civil rights lawyer, associate justice of U. S. Supreme Court. Thurgood Marshall distinguished himself as a jurist in a wide array of settings. As the leading attorney for the NATIONAL ASSOCIATION FOR THE ADVANCEMENT OF COLORED PEOPLE (NAACP) between 1938 and 1961, he pioneered the role of professional civil rights advocate. As the principal architect of the legal attack against *de jure* racial segregation, Marshall oversaw the most successful campaign of social reform litigation in American history. As a judge on the United States Court of Appeals, solicitor general of the United States, and associate justice of the Supreme Court, he amassed a remarkable record as a public servant. Given the influence of his achievements over a long span of time, one can reasonably argue that Thurgood Marshall may have been the outstanding attorney of twentieth-century America.

Marshall was born in Baltimore, Md., where his father was a steward at an exclusive, all-white boat club, and his mother was an elementary school teacher. He attended public schools in Baltimore before proceeding to Lincoln University in Pennsylvania where he shared classes with, among others, Cabell "Cab" CALLOWAY, the entertainer, Kwame Nkrumah, who became president of Ghana, and Nnamdi Azikiwe, who became president of Nigeria. After graduating, he was excluded from the University of Maryland School of Law because of racial segregation. Marshall attended the HOWARD UNIVERSITY School of Law, where he fell under the tutelage of Charles Hamilton HOUSTON. Houston elevated academic standards at Howard, turning it into a veritable hothouse of legal education, where he trained many of those who would later play important roles in the campaign against racial discrimination. Marshall graduated in 1933, first in his class.

After engaging in a general law practice for a brief period, Marshall was persuaded by Houston to pursue a career working as an attorney on behalf of the NAACP. Initially he worked as Houston's deputy and then, in 1939, he took over from his mentor as the NAACP's special counsel. In that position, Mar-shall confronted an extraordinary array of legal problems that took him from local courthouses, where he served as a trial attorney, to the Supreme Court of the United States, where he developed his skills as an appellate advocate. Over a span of two decades, he argued thirty-two cases before the Supreme Court, winning twenty-nine of them. He convinced the Court to invalidate practices that excluded blacks from primary elections (*Smith* v. *Allwright*, 1944), to prohibit segregation in interstate transportation (*Morgan* v. *Virginia*, 1946), to nullify convictions obtained from juries from which African Americans had been barred on the basis of their race (*Patton* v. *Mississippi*, 1947), and to prohibit state courts from enforcing racially restrictive real estate covenants (*Shelley* v. *Kraemer*, 1948).

Marshall's greatest triumphs arose, however, in the context of struggles against racial discrimination in public education. In 1950, in *Sweatt* v. *Painter*, he successfully argued that a state could not fulfill its federal constitutional obligation by hurriedly constructing a "Negro" law school that was inferior in tangible and intangible ways to the state's "white" law school. That same year he successfully argued in *McLaurin* v. *Oklahoma State Regents* that a state university violated the federal constitution by admitting an African-American student and then confining that student, on the basis of his race, to a specified seat in classrooms and a specified table in the school cafeteria. In 1954, in *Brown* v. *Board of Education*, Marshall culminated his campaign by convincing the Court to rule that racial segregation is invidious racial discrimination and thus invalid under the FOURTEENTH AMENDMENT to the federal constitution.

In 1961, over the objections of white supremacist southern politicians, President John F. Kennedy nominated Marshall to a seat on the United States Court of Appeals for the Second Circuit in New York. Later, President Lyndon B. Johnson appointed Marshall to two positions that had never previously been occupied by an African American. In 1965, President Johnson appointed Marshall as Solicitor General, and in 1967 he nominated him to a seat on the Supreme Court.

Throughout his twenty-four years on the Court, Marshall was the most insistently liberal of the Justices, a stance that often drove him into dissent. His judgments gave broad scope to individual liberties (except in cases involving asserted claims to rights of property). Typically he supported claims of freedom of expression over competing concerns and scrutinized skeptically the claims of law enforcement officers in cases implicating federal constitutional provisions that limit the police powers of government. In the context of civil liberties, the most controversial positions that Marshall took involved rights over re-

Thurgood Marshall, associate justice of the U.S. Supreme Court (1965–1991), in 1976. (Prints and Photographs Division, Library of Congress)

productive capacities and the death penalty. He viewed as unconstitutional laws that prohibit women from exercising considerable discretion over the choice to continue a pregnancy or to terminate it through abortion. Marshall also viewed as unconstitutional all laws permitting the imposition of capital punishment.

The other side of Marshall's jurisprudential liberalism was manifested by an approach to statutory and constitutional interpretation that generally advanced egalitarian policies. His judgments displayed an unstinting solicitude for the rights of labor, the interests of women, the struggles of oppressed minorities, and the condition of the poor. One particularly memorable expression of Marshall's empathy for the indigent is his dissent in *United States* v. *Kras* (1973), a case in which the Court held that a federal statute did not violate the Constitution by requiring a $50 fee of persons seeking the protection of bankruptcy. Objecting to the Court's assumption that, with a little self-discipline, the petitioner could readily accumulate the required fee, Marshall wrote that

> It may be easy for some people to think that weekly savings of less than $2 are no burden. But no one who has had close contact with poor people can fail to understand how close to the mar-

gin of survival many of them are . . . It is perfectly proper for judges to disagree about what the Constitution requires. But it is disgraceful for an interpretation of the Constitution to be premised upon unfounded assumptions about how people live.

Marshall retired from the Court in 1991, precipitating the most contentious confirmation battle in the nation's history when President George Bush nominated as Marshall's successor Clarence Thomas, an ultraconservative African-American jurist.

Marshall died on January 24, 1993. His extraordinary contributions to American life were memorialized in an outpouring of popular grief and adulation greater than that expressed for any previous justice.

REFERENCES

BLAND, RANDALL W. *Private Pressure on Public Law: The Legal Career of Justice Thurgood Marshall*, 1973.
KLUGER, RICHARD. *Simple Justice: The History of Brown* v. *Board of Education and Black America's Struggle for Equality*. New York, 1977.

RANDALL KENNEDY

Marshall, William Horace (August 19, 1924–), actor. William Marshall was born in Gary, Ind., and attended the Chicago Art Institute. He studied acting and voice in New York, Los Angeles, and Paris. Marshall lived in New York in the 1940s and 1950s and acted in numerous plays, most notably *When We Dead Awaken* (1944), *Set My People Free* (1948), and the 1951 revival of *The Green Pastures*.

Marshall's rich, powerful voice and commanding presence caught the attention of Hollywood, and he went to California to make films. Although he played such parts as King Dick in *Lydia Bailey* (1952), and the African king in *Demetrius and the Gladiators* (1954), his sophisticated performances elevated the characters he played above the stereotyped roles Hollywood wrote for African-American men. In the 1950s and 1960s Marshall also remained a stage performer, starring in *Othello* and *Oedipus Rex* several times in New York and Europe. During this time Marshall began working more on television. He appeared in a London television production of *The Green Pastures* in 1958, and performed in episodes of *Star Trek, The Harlem Detective,* and *The Jeffersons*. Marshall also translated Aimé Cesaire's *The Tragedy of King Christophe of Haiti* (1970), and directed the play's first English-language production the same year, before acting in the two movies for which he is best remembered: *Blackula* (1972) and *Scream, Blackula, Scream* (1973). (*See* BLAXPLOITATION FILMS.)

Marshall, who worked as an instructor in black theater in 1969 at San Fernando State College, in Northridge, Calif., returned to school in his fifties, receiving his B.A. from Governor's State University in Park Forest South, Ill., in 1978, and his Ph.D. in theater arts from Golden State University in San Francisco in 1983. The NAACP awarded Marshall its Benjamin J. Hooks Distinguished Achievement Award in 1983. In 1989 he played the lead role in Chicago's ETA Theater version of *Paul Robeson: American.*

REFERENCES

"Blackula Without the Fangs." *Sepia* (February 1974): 28–35.
BOGLE, DONALD. *Blacks in American Film and Television.* New York, 1988.

SHIPHERD REED
PETER SCHILLING

Martial Arts. African Americans first began practicing martial arts when the Asian arts were introduced as a form of hand-to-hand combat training in the United States military after World War II. Jujitsu was the first martial art to be practiced, but in the 1950s and 1960s other forms became popular among African Americans as well, such as tae kwon do, karate, and kung fu. African Americans played a central role in the development of martial arts in the United States in professional competition, self-defense schools, and as a cultural phenomenon.

In 1971, Jim Kelly became the first prominent black martial artist by winning the International Middleweight Karate Championship. That same year, he went on to the notable feat of winning four Grand Championship competitions in a thirty-day period. In 1977, Rodney Batiste won the middleweight championship of the National Karate Association and then in 1979 became the middleweight champion of the Professional Karate Association. Howard University developed a reputation for a consistently strong tae kwon do team in the 1980s, winning the National Collegiate Championship in 1983. Lynette Love, an African-American heavyweight contender, was a nine-time national champion before becoming the world heavyweight champion in 1988.

Martial arts first gained wide popularity among African Americans in the late 1960s, and by the early 1970s, black-owned self-defense schools began opening in many cities. Moreover, new forms of martial arts were developed by African Americans in a number of schools, such as Karreim Abdul Allah's K.A. System in Washington, D.C., and Ferdinand Bigard's Bushi-Kai Karate-Do System in Chicago. The

Harlem-based Mosque of Islamic Brotherhood began including a form of martial art, called Kushite Boxing, after the ancient African kingdom of Kush, in their educational program. In the 1990s, Capoeira, an Afro-Brazilian martial art created by slaves in the nineteenth century (masked as a form of dance after it was banned as a fighting form), became popular among African-American martial artists.

As a staple of popular culture, martial arts have thrived more in African-American communities than anywhere else. When martial arts films were first popularized in the United States in the late 1960s, they had enthusiastic African-American audiences. Within a few years, black martial artists were starring in these films. In 1973, Jim Kelly gained international fame for his role in the Bruce Lee film *Enter the Dragon.* He went on to do more than twenty martial arts films, including *Black Belt Jones, Golden Needles,* and *Hot Potato.* Basketball legend Kareem ABDUL-JABBAR played opposite Bruce Lee in Lee's last film, *Game of Death,* made in 1973 and released in 1978.

Martial arts have been a subject in black popular music as well. Carl Douglas had a hit in 1975 with "Kung Fu Fighting," and Curtis MAYFIELD recorded a tribute to the spiritual dimension of martial arts with "Kung Fu." In the early 1990s, many hip-hop artists including Biz Markie, Ice T, Das EFX, and Wu Tang Clan often sampled bits from martial arts movies in their songs.

REFERENCES

SALAAM, YUSEF ABDUL. *The African/Bilalian and the Martial Arts: The Black Man's Contribution to the Fighting Arts.* New York, 1977.
DIAMOND, MICHAEL. "A Conversation With Kareem: Thoughts on his Friend and Sensei, Bruce Lee." *Grand Royal* (Fall/Winter 1993).
TENLEY-ANN, JACKSON, and LINDA VILLAROSA. "Lynette Love." *Essence* (September 1988).

JOSEPH W. LOWNDES

Martin, John Sella (September 1832–August 1876), minister and lecturer. John Sella Martin was born a slave in Charlotte, N.C., in 1832, the child of a mulatto slave and her owner's nephew. Sold with his mother to people in Columbia, Ga., Martin remained a slave until his escape on a Mississippi riverboat in December 1855.

In January 1856, Martin arrived in Chicago where he associated with abolitionists (*see* ABOLITION) and began his long career of oratory. His friend Frederick DOUGLASS, in particular, was known to have admired his oratorical skills. In the latter part of 1856, he moved to Detroit, where he studied for the Baptist

ministry (*see* BAPTISTS). In 1857, he was ordained to preach and received the pastorate at Michigan Street Baptist Church in Buffalo, N.Y. In 1859, Martin moved to Boston and substituted for the vacationing preacher of Tremont Temple, drawing large, approving crowds. He then spent eight months as pastor of the Baptist Church in Lawrence, Mass., which had a large white congregation, before accepting the pulpit of the Joy Street Church, one of the oldest black Baptist churches in Boston. During this same year, Martin published a poem, "The Sentinel of Freedom," in *Anglo-African Magazine.*

In August 1861, Martin made the first of several trips to England on a speaking tour sponsored by Massachusetts Gov. John Andrew to gain support for the Union during the Civil War. He returned to the United States in February 1862. On the occasion of Abraham Lincoln's signing of the Emancipation Proclamation on January 1, 1863 (*see* EMANCIPATION), he addressed a famous meeting at Tremont Temple, as did Frederick Douglass. Later that month, Martin returned to Europe to preach in London at the behest of industrialist Harper Twelvetrees. In April 1864, having journeyed back from England, he began to preach at Shiloh Presbyterian Church in New York. The following April, he returned to Great Britain in a fund-raising capacity for the AMERICAN MISSIONARY ASSOCIATION (AMA). As a delegate of the AMA, he delivered an address to the Paris Anti-Slavery Conference on August 27, 1867.

One year later, Martin accepted the pastorate of the Fifteenth Street Presbyterian Church in Washington, D.C. He attended the formation meeting of the Colored National Labor Union (CNLU) in Washington, D.C., in December 1869, was appointed to its executive board, and was named editor of the CNLU's short-lived official organ *The New Era.* When the publication foundered shortly afterward, he moved to New Orleans, where he was involved in local politics and earned his living as a lecturer. In 1875, he was a founding member and president of the New Orleans Atheneum Club and a member of the Louisiana Progressive Club. He died in Louisiana in 1876.

REFERENCE

BLACKETT, R. J. M. *Beating Against the Barriers: Biographical Essays in Nineteenth-Century Afro-American History.* Baton Rouge, La., 1986.

LYDIA MCNEILL

Martin, Roberta Winston (February 12, 1907–January 18, 1969), gospel singer. Born in Helena, Ark., Martin began piano lessons at age six and con-

tinued studying after her family moved to Chicago in 1917. At Wendell Phillips High School she studied with choral director Mildred Bryant Jones. During this time Martin was also pianist for the young people's choir at the Ebenezer Baptist Church, where she worked with Thomas A. DORSEY and Theodore Frye. In 1932 she served as pianist at Chicago's Pilgrim Baptist Church and the next year organized the Martin-Frye Singers.

Starting in the mid-1930s, Martin introduced many important developments in gospel music, particularly through her ensemble the Roberta Martin Singers, which became in the 1940s and 1950s one of the most traveled and recorded gospel choirs. Martin's influential piano style is marked by a subtle and refined approach, while her composing and arranging for solo and vocal ensemble utilizes a clear-voiced lead singer with subdued background vocal accompanists. Martin was also a successful entrepreneur, in 1939 founding the Roberta Martin Studio of Music, which would become the largest and most prolific of all the Chicago gospel publishing houses. Among her most significant and popular recordings are "He Knows How Much We Can Bear" (1941), "Try Jesus, He Satisfies" (1943), "Only a Look" (1948), "Certainly Lord" (1958), "God Is Still on the Throne" (1959), and "No Other Help I Know" (1961).

In the years before her death Martin continued to perform and record. She sang in 1963 at the Spoleto Festival in Italy, the same year that she released "Teach Me Lord." Martin also served from 1956 until 1968 as music director of the Mount Pisgah Baptist Church in Chicago. When she died in 1969, her funeral was reportedly attended by more than 50,000 people.

REFERENCES

BOYER, HORACE CLARENCE. "Roberta Martin: Innovator of Modern Gospel." In Bernice Johnson Reagon, ed. *We'll Understand it Better By and By.* Washington, 1992.

JACKSON, IRENE V. Afro-American Gospel Music and its Social Setting with Special Attention to Roberta Martin. Ph.D. diss., Wesleyan University, 1974.

WILLIAMS-JONES, PEARL. "Roberta Martin: Spirit of an Era." In Bernice Johnson Reagon, ed. *We'll Understand it Better By and By.* Washington, 1992.

IRENE V. JACKSON

Martin, Sallie (November 20, 1896–June 8, 1988), gospel singer. Born in Pittfield, Ga., Sallie Martin was a pioneer in the development of gospel music. Settling in Chicago in 1932, she met and became an

associate of gospel-music pioneer Thomas A. DORSEY. They created the first Gospel Singers Convention, later called the National Convention of Gospel Choirs and Choruses. For the next eight years they traveled, performing Dorsey's works, organizing new gospel choruses, fostering such singers as Willie Mae Ford SMITH and Clara Ward, and creating new avenues for gospel music. In 1940, Martin left Dorsey and formed the Martin and Morris Publishing Company with songwriter Kenneth Morris. "Just a Closer Walk with Thee" was one of their popular arrangements. For a brief period, Sallie Martin teamed with Roberta MARTIN (not related) to form the Martin and Martin singers. Sallie Martin then organized the Sallie Martin Singers, one of the first all-female gospel groups. The successful ensemble included Dinah WASHINGTON (then known as Ruth Jones) among its original singers. With songs like "He'll Wash You Whiter Than Snow" (1955), Martin demonstrated performance and leadership that influenced many, particularly the gospel artists J. Earl Hines, Alex Bradford, and Jessy Dixon.

REFERENCES

BROUGHTON, VIV. *Black Gospel.* New York, 1985.
HEILBUT, ANTHONY. *The Gospel Sound: Good News and Bad Times.* New York, 1971.

KATHY WHITE BULLOCK

Martinez, Vincente. *See* Tizol, Juan.

Marvin X (May 29, 1944–), playwright, poet. Born Marvin Ellis Jackmon in Fowler, Calif., in 1944, he adopted the name of Marvin X on joining the NATION OF ISLAM during the 1960s. With playwright Ed BULLINS he founded the Black Arts/West Theatre in San Francisco in 1966, a storefront theater modeled after the Black Arts Repertory Theatre/School of Harlem. The first home for black theater in San Francisco, Black Arts/West was succeeded in 1967 by Black House, which Marvin X cofounded with Bullins and writer-activist Eldridge CLEAVER. Black House served as a center for black culture and politics and as an arena for the BLACK PANTHER PARTY. In 1972, Marvin X founded Your Black Educational Theatre, also in San Francisco.

Marvin X's 1965 play, *Flowers for the Trashman,* reflected the growth of radical nationalism among blacks by depicting the confrontation between a young black college student and a middle-aged white man in a prison detention cell. A member of the Nation of Islam, Marvin X refused military induction in 1967 and served five months in a federal prison for evading the draft. With an A.A. from Oakland City College (1964), Marvin X taught black studies at both California State University in Fresno (1969) and the University of California at Berkeley (1972). He later obtained a B.A. in English (1974) and an M.A. in theater (1975) from San Francisco State College (now University).

Marvin X has been a fervent proponent of Arabic as the proper language for blacks, believing that a people cannot be free so long as it speaks the language of its oppressors. This has put him at odds with much of his English-speaking theater audience. He has written several volumes of poetry, in both Arabic and English, including *Fly to Allah: Poems* (1967) and *Black Man Listen: Poems and Proverbs* (1969), which was published by Broadside Press, a leading publisher for the BLACK ARTS MOVEMENT. In 1972, the National Endowment for the Arts awarded him a creative writing fellowship. That year, he wrote two plays: *The Blackbird* and *Resurrection of the Dead.* Marvin X served as an associate editor of *Black Theatre* magazine (1969–1972), and as a contributing editor to *Journal of Black Poetry.* In 1982, he published *Liberation Poems for North American Africans.* In recent years he has published very little.

REFERENCES

DAVIS, THADIOUS M., and TRUDIER HARRIS, eds. *Dictionary of Literary Biography.* Vol. 38, *Afro-American Writers After 1955: Dramatists and Prose Writers.* Detroit, 1985.
PETERSON, BERNARD L., JR. *Contemporary Black American Playwrights and Their Plays.* New York, 1988.

MICHAEL PALLER

Maryland. African Americans have been present in Maryland since the mid-seventeenth century. Men and women—slave and free—helped build the economy, participated in politics whenever they were able to, and fought continuously to improve their position in society. Because of Maryland's location, their experiences often typified those of blacks in both the industrial North and the slave South.

Mathias de Sousa, who arrived in 1634 at St. Mary's City in southern Maryland with the first colonists on the *Ark* (the ship sent by Lord Baltimore), was the first black in Maryland. Of mixed African and European descent, he was an indentured servant of a Jesuit priest sent to this officially Roman Catholic colony. After his term of service was completed, he worked as a skipper of a vessel and engaged in trade

with local Native Americans. Like all freemen, he voted in the colonial assembly.

Maryland soon developed an economy based on agricultural slave labor, and laws were passed reflecting the hardening of racial lines in the colony. In 1663 Maryland became the first colony to rule that all Africans brought into the colony, as well as their children, be slaves for life. Since some considered Christianity reason for manumission, the Assembly ruled in 1664 that baptism should not affect a slave's status.

There were relatively few blacks in Maryland until after 1690, when the supply of European indentured servants declined and large numbers of Africans were brought to Maryland. Thereafter, the increase was rapid. In 1704 only 4,000 blacks, most of them slaves, lived in Maryland; by 1755 approximately one half of all white Maryland families owned slaves, and the colony's black population numbered some 45,000. The African-American population of the tobacco-producing companies in southern Maryland was 40 or 50 percent of the total, but in the northern and western wheat-producing counties it was only 13 to 14 percent. Approximately 1 percent of blacks of pure African ancestry and 40 percent of mulattos were free. Free blacks often worked as field hands or servants. Some were craftsmen or independent landowning farmers or worked in towns. When the AMERICAN REVOLUTION began, some African Americans joined Loyalist forces because the governor of Virginia, Lord Dunmore, offered freedom as an incentive. Others served on the colonists' side as ship pilots patrolling Chesapeake Bay and its tributary rivers. When white enlistments fell off in 1780, Maryland permitted African Americans to enlist in the militia, the only heavily slave state to do so. Many blacks served.

By the end of the eighteenth century, the revolutionary ethic led many Maryland whites to oppose slavery. Among them was Andrew Ellicott, the sponsor and friend of renowned African-American almanac-maker and scientist Benjamin BANNEKER. Still, Maryland's General Assembly defeated all attempts to outlaw slavery. Nevertheless, many African Americans gained freedom at this time—because of military service, because they escaped during the wartime confusion, and because many owners, especially Quakers and Methodists, manumitted their slaves. During the WAR OF 1812, other slaves fled to freedom behind British lines. The state's first constitution allowed free black men who met the same property qualifications as whites to vote, which they did until 1810 when a law prohibited it.

During the antebellum years, Maryland was a unique "middle ground" between slavery and freedom. As soils became exhausted, large numbers of farmers changed from tobacco to wheat cultivation, for which slave labor was inefficient. Slaveowners reduced their holdings by manumission or sale of slaves to cotton-growing states, and they hired black labor during the harvest season. By 1860, 45 percent of the state's African Americans were free, the majority in western Maryland, Baltimore, and the Eastern Shore. Many lived in integrated areas, while others remained in separate free black communities with churches and, occasionally, schools of their own. The black community of Annapolis, established in the eighteenth century, remained cohesive. According to archeological discoveries made in the 1990s, Annapolis blacks retained many African objects and rituals.

During the antebellum period, Maryland was sometimes thought to be relatively moderate in its treatment of slaves, but there is strong evidence to the contrary. As Frederick DOUGLASS noted in his *Autobiography,* slavemasters were just as brutal in Maryland as elsewhere, and the state's slave code was harsh. Abolitionism, a potent force in the 1820s under such groups as Daniel Raymond's Maryland Anti-Slavery Society, declined in the 1830s. Many Marylanders supported slavery and feared slave rebellions. Others feared a national conflict would harm the state. However, African-American abolitionists Frederick Douglass and Harriet TUBMAN, who escaped slavery on Maryland's Eastern Shore, gained national prominence in the North. Other Maryland blacks, such as Samuel Ringgold WARD, were active in the freedom movement.

In 1860, the state still had 90,000 slaves. During the CIVIL WAR Maryland remained in the Union. Legislators refused President Abraham Lincoln's offer of compensated EMANCIPATION, although many slaves escaped to freedom by claiming their masters were disloyal. The state was not included in the 1863 Emancipation Proclamation; however, after it was promulgated the federal government began massive recruitment of African Americans into the Union Army—first free blacks, then the slaves of consenting owners. Eventually at least one third of Maryland's enslaved black men fought in the military. In 1864 Maryland took up the question of ABOLITION. With the aid of a large soldier vote, slavery was narrowly abolished. However, the state passed a stringent BLACK CODE, limiting African Americans' freedom of travel and forbidding court testimony. Slaveowners retained control over at least 2,500 children under the "apprentice" system, and through them their parents. Also, judges routinely sentenced blacks guilty of minor offenses to terms of slavery. Only federal civil rights laws and black activism in succeeding years ended these abuses.

In 1865 approximately 25 percent of the state's population was black. A slow and steady migration began to Baltimore, and to lesser cities such as Cam-

bridge. It remained significant through the mid-1880s. African-American men gained the right to vote with the passage of the FIFTEENTH AMENDMENT in 1870. Elijah Quigley, in Towson, became the first African American in Maryland to vote in sixty years. Democrats tried repeatedly to disenfanchise the black voters, who were mostly members of the REPUBLICAN PARTY, but were defeated by a coalition of black and white Republicans, western Marylanders, and immigrants who also would have been affected by literacy tests and grandfather clauses. In 1904 black leaders formed the powerful Negro Suffrage Association to help defeat the Poe Amendment, which would have limited black voting. Maryland remained one of the few places where African Americans represented a significant portion of the population and also continued to vote. In the late nineteenth and early twentieth centuries, voters elected black Republicans to the city councils of large cities; one notable example was Baltimore's Harry Cummings, first elected in 1890. H. Maynadier St. Clair was a member of the Cambridge's city council from 1912 to 1946.

Gloria Richardson speaking to reporters in front of the headquarters of the Department of Justice in Washington, D.C., in June 1963. The chief organizer of demonstrations to desegregate Cambridge, Md., she continued her efforts in the face of violence, political recalcitrance, and even criticism by Attorney General Robert Kennedy. Richardson and the Cambridge Non-Violent Action Committee eventually won most of their demands. (AP/Wide World Photos)

Nevertheless, the turn of the century brought hard times to many black Marylanders. Public schools had long been segregated, and a public transportation law in 1905 began the movement toward near-universal segregation in Maryland. Public education for blacks was inferior at best. In the entire state, only Morgan College offered a four-year liberal arts education for African Americans. By 1920 blacks formed only 17 percent of the state's population. In 1927 a Committee on Interracial Cooperation was founded, but it achieved little. During the 1920s, the KU KLUX KLAN became a major force in Maryland. In 1929 racial tensions exploded in Princess Anne, after blacks insisted on their right to congregate peacefully on Saturday nights in the business district. Whites went on a killing and looting rampage. Three hundred blacks were forced to leave the area. There were LYNCHINGS in Salisbury in 1931 and in Princess Anne in 1933.

The GREAT DEPRESSION of the 1930s in Maryland hit African Americans especially hard. New Deal programs gave jobs to many unemployed blacks, and large numbers of African Americans switched to the DEMOCRATIC PARTY for the first time. The Baltimore branch of the NATIONAL ASSOCIATION FOR THE ADVANCEMENT OF COLORED PEOPLE (NAACP), mostly dormant since its founding in the 1910s, was revived in 1935 by Lillie May Carroll Jackson following a spate of lynchings on the Eastern Shore. She led a "Don't-Buy-Where-You-Can't-Work" campaign and other protests against discrimination. In 1935, NAACP lawyer Charles H. HOUSTON represented Donald Murray in his successful court suit to gain admission to the all-white University of Maryland Law School. Victory made Murray the first black student in the twentieth century to integrate a state university in the South. Two years later, NAACP lawyer Thurgood MARSHALL, who had earlier been part of the team representing Murray, won a salary equalization suit in Montgomery County, paving the way for equal pay for teachers throughout the state by 1941. However, most Maryland schools and universities did not integrate until 1955, following the U.S. Supreme Court's BROWN V. BOARD OF EDUCATION ruling. In tribute to Maryland's important role in the civil rights struggle, the NAACP moved its national headquarters to Baltimore in the 1980s.

During World War II, many blacks from southern and eastern Maryland moved to the cities to take advantage of the growth of industrial jobs previously closed to them. In April 1942, thousands of blacks converged on Baltimore in a protest march, and sent 2,000 delegates to Annapolis to meet with state authorities. The state developed a powerful Fair Employment Practices Commission. Many Maryland blacks served in the military, and subsequently took

advantage of the G.I. Bill of Rights to obtain education and training. During the 1940s, a black policeman was promoted to sergeant, a plumber licensed, and black doctors allowed to practice in formerly segregated hospitals.

In 1951 unified black support helped elect a liberal Republican governor, Theodore McKeldin. He named blacks to state commissions, and made symbolic appointments. For example, Robert Watts became traffic court magistrate and George Russell was named Magistrate-at-large in Baltimore. In 1956 McKeldin pushed an Equal Employment Ordinance through the legislature. In 1954 a black Republican, Harry Cole, won election to the state Senate, while voters sent another black Republican and a black Democrat to the House of Delegates. In 1958 Democrats Verda Welcome and Irma Dixon became the first African-American women elected to the state legislature.

Integration still lagged, however, though in Baltimore and western Maryland some restaurants and recreation facilities integrated during the 1950s. During the 1960s the CIVIL RIGHTS MOVEMENT transformed black life in the state. In 1960 SIT-INS were inaugurated in Baltimore, Salisbury, College Park, and other towns. The next year, after Kennedy administration officials complained about African diplomats experiencing discrimination on Maryland's highways, Gov. Millard Tawes promised to introduce an Open Accommodations law. The legislature rejected it, but a law covering half the state's counties passed in 1963. The following year, under pressure from the governor, the rest of Maryland passed a desegregation law. Segregationist candidate George Wallace won 42 percent of the vote in that year's Democratic presidential primary.

In 1963 the Cambridge Nonviolent Action Committee (CNAC), led by activist Gloria RICHARDSON, demanded immediate integration in Cambridge and began civil rights demonstrations and economic boycotts. The demonstrators were arrested, and fined a penny. Demonstrations continued, and city officials organized a Committee on Interracial Understanding to implement protesters' demands. However, protests continued. This time, harsh sentences were meted out to demonstrators. On June 11, violent disturbances broke out in Cambridge. The National Guard was called in, and martial law declared. Eventually, with the aid of U.S. Attorney General Robert Kennedy, a truce was reached, and demonstrations stopped while the city council voted on a strong public accommodation law. However, after passage the measure was put to a voter referendum. Richardson, angered at having to fight for already-established gains, refused to rally black support for it, and the

law failed. Troops remained in Cambridge until 1965. In 1967, amid renewed racial tension, a fire burned down much of the city's black area as white firefighters looked on.

In 1967, following the election of Gov. Spiro T. Agnew on a liberal, pro–civil rights platform, the legislature passed an Open Housing law, but it was defeated in a referendum in 1968. The same year, following the assassination of the Rev. Dr. Martin Luther KING, Jr. rioting broke out in Baltimore and other areas.

A "white backlash," which Agnew represented, destroyed black hopes for further progress. While the Commission on Interracial Cooperation, reorganized as the Maryland Commission on Human Relations, had strong authority to investigate complaints of employment, housing, and other discrimination, it eventually spent much of its time handling the complaints of white minorities.

During the 1970s, Maryland's black community became sharply polarized. Inner-city blacks, notably in Baltimore, continued to experience high unemployment and housing discrimination. Meanwhile, the state's black middle class rapidly grew, due in part to better educational opportunities and successful black entrepreneurship, and partly to employment in the public sector. The polarization has affected political life. While Maryland's first black congressman, Parren Mitchell, was elected in 1972 with overwhelming support from the state's African Americans, by the 1990s there were sharp political differences between cities and suburbs. Kweisi Mfume, elected from Baltimore in 1986 and named chair of the CONGRESSIONAL BLACK CAUCUS in 1992, is a former black activist from the inner city who made his reputation by challenging the city's white power structure. Meanwhile, Alan Keyes, an African American who won the Republican primary for U.S. Senator in 1992, and Albert R. Wynn, a Democrat elected to Congress in 1992 from the new Fourth Congressional District (Prince George's County), ran on significantly more conservative platforms.

By 1990, Maryland's backs had the highest per capita income and education of those in any state with a population at least ten percent African American, and income growth in black households exceeded that in white households. Prince George's County, outside Washington, D.C., has been the symbol of the new black middle class. Developed as a black area in the 1970s, it became an unusual example of a wealthy, integrated, black majority suburb. Black and white income and school performance were essentially identical in the 1990s.

Maryland has been the home of a large number of well-known African Americans in many different

fields. Some of the most notable African American natives of the last hundred years include Episcopal priest Pauli MURRAY; boxer Sugar Ray LEONARD; lawyer and U.S. Supreme Court justice Thurgood Marshall; pioneer legislator Crystal Bird FAUSET; entertainer Cab CALLOWAY; scholar Waters Turpin; poet Samuel CORNISH; religious cult leader FATHER DIVINE (George Baker); and diplomat Clifton Wharton, Sr.

REFERENCES

BRUGGER, ROBERT J. *Maryland: A Middle Temperament, 1634–1980.* Baltimore, 1988.

CALLCOTT, GEORGE H. *Maryland and America, 1940–1980.* Baltimore, 1985.

CALLCOTT, MARGARET LAW. *The Negro In Maryland Politics, 1870–1912.* Baltimore, 1969.

CHAPELLE, SUZANNE ELLERY GREENE. *Baltimore: An Illustrated History.* Woodland Hills, Calif., 1980.

———, ET AL. *Maryland: A History of Its People.* Baltimore, 1986.

FIELDS, BARBARA JEANNE. *Slavery and Freedom on the Middle Ground: Maryland During the Nineteenth Century.* New Haven, Conn., 1985.

SUZANNE ELLERY GREENE CHAPELLE

A midwife and former Mississippi slave, Biddy Mason moved to Southern California in the 1850s and was leader of religious and philanthropic efforts of the black residents of Los Angeles for much of the remainder of the century. (Moorland-Spingarn Research Center, Howard University)

Mason, Biddy Bridget (August 5, 1818–January 15, 1891), philanthropist. Biddy Mason was born and raised on the slave plantation of John Smithson in Hancock County, Miss., and was given as a wedding present to Robert Marion Smith and Rebecca Crosby Smith in 1836. When her owner converted to Mormonism (see MORMONS) in 1847, she moved along with him and his other slaves to Utah, where they lived for four years. In 1851, Smith and his slaves moved west by caravan to San Bernadino, Calif. When Smith learned that California had been declared a free state in 1850, he made plans to move to Texas with his fourteen slaves. Meanwhile, with the aid of local free blacks, Mason escaped from captivity and arrange to have Smith put on trial for owning slaves. Smith failed to appear in court, and Mason and her family were manumitted on January 1, 1856.

Biddy Mason settled in Los Angeles, where she worked as a midwife and nurse, using skills she had learned on the plantation and perfected on her journey westward. By 1866, she had saved enough money to be one of the first African-American women to purchase her own property in downtown Los Angeles. She established a house at 331 South Spring Street, where poor people and minorities could find a safe haven. She later sold part of her land at great profit and built a commercial building from which she collected rent. She eventually bought large sections of downtown property, and died wealthy.

Mason's primary renown comes from her achievements as the first black philanthropist in Los Angeles. In 1872 she helped found Los Angeles's First African Methodist Episcopal Church, the city's oldest black church. From this church came other community organizations. Mason also operated a day nursery for orphans and poor children, and supplied needy families with food.

Mason died in 1891 and was buried in an unmarked grave. In 1988, a tombstone was erected by Los Angeles Mayor Tom Bradley and members of the First AME Church. Mason was further honored by the declaration of Biddy Mason Day in Los Angeles on November 16, 1989.

REFERENCES

LOGAN, RAYFORD W., and MICHAEL R. WINSTON, eds. *Dictionary of American Negro Biography.* New York, 1982.

SMITH, JESSIE CARNEY, ed. *Notable Black American Women.* Detroit, 1992.

SABRINA FUCHS

Mason, Charles Harrison (September 8, 1866–November 17, 1961), religious leader. Charles Mason was born to former slaves on a farm near what is

now Bartlett, Tenn. Inspired as a boy by the piety of the older ex-slaves he knew, he was converted and began to preach as a Baptist when he was twelve years old. He studied for three months in 1894 at Arkansas Baptist College in Little Rock, but left, discouraged that these Baptists were not concerned with maintaining the spirit of Christianity that sustained blacks during slavery.

Mason and a small band of followers were drawn to the Holiness movement, which maintained that sanctification was a necessary act of grace after conversion. They were ejected from the Baptist church in Conway, Ark., in 1895, where their unorthodox form of worship was not approved. That same year Mason and Charles P. JONES proceeded to found the Church of God, whose members sought sanctification in the blessing of the Holy Spirit. Their first service, held in an abandoned Mississippi cotton gin, was fired upon by hostile whites. This incident was reported in newspapers and brought fame and new followers to the church. In 1897, while in Little Rock, Mason had a vision in which God told him to call his group the Church of God in Christ (COGIC). The church continued to grow and in 1907 Mason visited Los Angeles to witness the revival of Azusa Street, which taught that speaking in tongues, or glossolalia, was evidence of baptism in the Holy Spirit. Mason returned to COGIC in Memphis, convinced of the spiritual validity of speaking in tongues. Jones disagreed, and with other worshippers thereupon left the group to form the Church of Christ (Holiness) U.S.A.

COGIC, like other holiness and Pentecostal churches, enjoyed an interracial membership until about 1913. White membership in predominantly black congregations had evaporated slowly since the church's inception. Mason had ordained ministers of all races from every region in the country, and the resulting diffusion of authority enabled white ministers to start their own churches. In 1914 a largely autonomous all-white association was formed from members of COGIC. Mason addressed the group and gave it his blessing, signifying a larger consensual parting of blacks and whites in the early Pentecostal movement.

Mason sold war bonds during WORLD WAR I, but he was imprisoned in 1918 in Lexington, Miss., for advocating pacifism and aiding conscientious objectors. The Department of Justice considered him dangerous enough to investigate him and his church. Under Mason's charismatic leadership, groups for young people and Sunday schools were established. By 1926, COGIC had a foreign missionary service. In 1933 Mason was named senior bishop and chief apostle, leading the church through years of tremendous growth. In 1938 the church built the largest

temple owned by African Americans, the Mason Temple in Memphis, at a cost of $2 million. (It was the site of the Rev. Dr. Martin Luther KING Jr.'s final speech in 1968.) In 1958 Mason received an honorary Doctor of Divinity degree from Trinity Hall College. He died in 1961 in Detroit, when membership in the church was nearly 400,000. By the early 1990s it approached 4,000,000, making it the second largest African-American Protestant denomination in the United States, second only to the Baptists.

REFERENCES

ANDERSON, ROBERT MAPES. *Vision of the Disinherited: The Making of American Pentecostalism.* New York, 1979.

DuPree, SHERRY SHERROD, ed. *Biographical Dictionary of African-American Holiness-Pentecostals.* Washington, D.C., 1989.

MELTON, J. GORDON. *Religious Leaders of America.* Detroit, 1991.

LYDIA McNEILL
ALLISON X. MILLER

Massachusetts. The first blacks brought to Massachusetts came as slaves in 1638 to Noodles Island, or what is now East Boston. They came to a Puritan colony that was already attempting to deal with the problem of how to relate to another group of people who were very different from themselves, the Indians. In 1641 the Bay colony's leaders produced the Massachusetts Body of Liberties which, among other things, paved the way for the possible future enslavement not only of Indians, but also blacks. Section 91 of the document claimed the colony's right to enslave any "lawful captives taken in just wars" (meaning primarily Indians), but also broadened their powers so that blacks might easily be included, noting that "this exempts none from servitude who shall be judged thereto by authority." While in 1646 the Puritan leadership, based largely on religious concerns, took a strong stand against what they termed "man-stealing," this did not prevent Massachusetts merchants from eventually becoming actively involved in the SLAVE TRADE. However, the number of blacks in the colony would never be large. The rocky soil was not suited to large-scale agriculture, and there was sufficient free or indentured white labor for most farming and artisinal tasks. Those blacks who were brought became either house servants or farm laborers who lived with their masters.

Whether enslaved or free, blacks tended to be clustered together near river settlements, or along the

Atlantic coast. Massachusetts, similar to other colonies, early began to pass laws to regulate their conduct. In 1656 the Bay colony followed Virginia and Maryland's lead, taking away from all blacks the right to bear arms. Then, based on their own notions of racial differences, Massachusetts in 1705 passed a strict law prohibiting racial intermarriage. However, blacks could own property, serve as witnesses, and sue in court, a right of importance in the bringing of freedom suits. Although they never made up more than 2 percent of the population, by 1720 there were 2,000 blacks in the colony, the vast majority unfree. By 1776, the number of blacks had increased to 5,249, out of a total Massachusetts population of 349,094.

There had long been scattered sentiment in Massachusetts against slavery and the slave trade. In 1700 Samuel Sewall campaigned for an import duty on slaves in the vain hope of ending the trade. The £4 duty that Massachusetts imposed in 1705 was widely evaded. As the rebellion against English rule drew near, Americans attacking British tyranny began to take action against slavery. Inspired by James Otis, reformers argued that there was no law permitting slavery in Massachusetts. They passed a bill banning the slave trade in 1771, but Royal Governor Thomas Hutchinson vetoed it. At the same time, Massachusetts blacks, led by Prince HALL, began to petition for the end of slavery in the colony. These petitions were ignored by legislators, who wished to maintain white unity against the British. Many Massachusetts blacks actively supported the revolutionary cause, including Crispus ATTUCKS, a mulatto who was killed in the Boston Massacre of March 5, 1770, the traditional "first casualty" of the Revolution. Soldiers Salem POOR and Peter SALEM distinguished themselves at the Battle of Bunker Hill on June 17, 1775. Among the most unusual patriots was Deborah Sampson Gannett, who dressed as a man and was decorated for bravery in combat.

In 1780, Massachusetts adopted a new state constitution, which included a declaration of natural rights. In 1781, Quock Walker of Worcester County sued successfully for his freedom. When his former owner prosecuted him as a "runaway" in 1783, Massachusetts Chief Justice William Cushing ruled that Walker, and therefore every other African-American in the Commonwealth of Massachusetts, was free. The decision went largely unnoticed, and slaves continued to be sold. However, public opinion had formed solidly against slavery in Massachusetts, and as blacks and white sympathizers began to press freedom suits based on Cushing's precedent, and owners manumitted their slaves rather than lose them in legal challenges, slavery came to an end in the state. In 1790 Massachusetts reported 5,369 free blacks and no slaves in the state.

African Americans, although free, faced discrimination in Massachusetts. Blacks were denied voting rights. In 1786 the law banning intermarriage was strengthened. In 1821, the state legislature appointed a committee to investigate methods of restricting free blacks from entering Massachusetts. Education, when it existed for blacks, remained segregated. Paul CUFFE, a wealthy black merchant and ship owner from the southeastern part of the state, vowed not to pay his taxes until granted suffrage rights. Eventually he gave up hope of equal treatment and became involved in black colonization schemes in Sierra Leone.

In 1825, blacks led by William G. Nell established the Massachusetts General Colored Association, an abolitionist group which also defended the rights of free Massachusetts blacks. The organization was soon joined by the fiery David WALKER, whose *Appeal to the Colored Citizens of the World,* published in 1829, called for the violent overturn of slavery. Walker questioned the exclusion of blacks from Massachusetts juries and government, and attacked the law against intermarriage as perpetuating caste. By 1830, Boston had become the center of America's fledgling abolitionist movement (see ABOLITION). In 1833, black abolitionists such as Robert PURVIS, James MC-CRUMMELL, John B. Vashon, and Peter WILLIAMS worked with whites led by William Lloyd Garrison and Arthur Tappan to form the interracial AMERICAN ANTI-SLAVERY SOCIETY, based in Boston, which was crucial in the organizing of abolitionist newspapers and meetings. Meanwhile, radical black leaders such as Walker and Henry Highland GARNET spoke against slavery in African-American churches and community meetings. In 1841 Frederick DOUGLASS started his career as an activist when he was hired as an agent by the Massachusetts Anti-Slavery Society.

Massachusetts' activist black community, backed by white abolitionists such as William Lloyd Garrison, also led the drive for racial equality in the state in the years before the CIVIL WAR. Agitation centered on Boston, where about 25 percent of Massachusetts blacks lived, and where African Americans faced the harshest bigotry from white merchants with Southern connections and Irish immigrants in competition with blacks for jobs. Still, as a result of black and white pressure, racial intermarriage was legalized in 1843, and the same year, state railroads ceased running JIM CROW cars. In 1855, following a fifteen-year struggle led by the militant integrationist William Cooper NELL, the state legislature passed a bill banning Boston's Jim Crow schools, the state's only segregated schools at the time. Not all such efforts were successful. In 1857, Boston blacks, continually refused permission to serve in the state militia despite repeated petitions, purchased their own uniforms and arms and paraded through the streets of Boston. The

resulting uproar was quelled only with difficulty by white authorities.

When the Civil War broke out, Massachusetts blacks raised money for the Union cause. In 1863, blacks were recruited as soldiers for the Union Army. Blacks from across the state volunteered, although many of Boston's black residents, bitter from the militia struggles and angry at being forced to serve in segregated units, refused to join. The 54th Massachusetts Regiment was one of the first black units formed, and the 54th distinguished itself by a courageous charge at Fort Wagner in November, 1863. Augustus Saint-Gaudens' 1893 memorial to the 54th remains one of Boston's leading monuments and a landmark of civic black pride.

In 1865, a year before the first federal Civil Rights Act, Massachusetts passsed a comprehensive Civil Rights Bill. Blacks were guaranteed the right to vote and to be admitted to all "licensed" public establishments. Unlicensed establishments were added in 1874, and other facilities in 1895. These laws were laxly enforced, however, and even Civil War hero Robert SMALLS had difficulty obtaining a hotel room when he visited Boston in the 1880s. The first blacks were elected to the Massachusetts legislature in 1866 (one of them, Edwin Garrison Walker of Charleston, was thought to be the son of David Walker), and continued serving, usually one or two at a time, until the turn of the century. African-Americans at first voted a solid REPUBLICAN PARTY ticket; however, when Gov. Benjamin Butler broke with the party in 1883, blacks voted for him in large numbers, and he rewarded his supporters by appointing a black municipal judge in Charlestown. African-Americans also served as Customs collectors and held other political patronage positions.

By the turn of the century, Massachusetts had largely abandoned its commitment to black equality, but even so the state was one of the least difficult places for an African American to be at the turn of the century. White sympathizers, including abolitionists and their descendants, fought along with blacks for civil rights. When the SPANISH-AMERICAN WAR broke out in 1898, Massachusetts blacks formed a militia company. When southern whites protested the inclusion of black troops, white Massachusetts supported the African-American unit. The soldiers went to Cuba, and were the only black volunteer troops to see action in the conflict.

In the decades following the Civil War, Massachusetts' black population coalesced into two distinct and sometimes antagonistic groups. One was the small "colored elite," led by such figures as Archibald GRIMKÉ, William Monroe TROTTER, Maria Louise BALDWIN, and William H. LEWIS. W. E. B. DU BOIS, born in Great Barrington, was closely associated with this group during his years at Harvard University. The "colored elite," as they referred to themselves, were composed of native-born Massachusetts residents, most of whom were brought up in largely white towns and suburbs. They were Massachusetts college graduates (Harvard being their favored institution, so much so that some white Southerners refused to attend), and they usually worked in prestigious professions such as the law or higher education. They felt strongly the need to uplift African Americans, and they defended the rights of blacks' civil rights against white attacks. The elite spoke in Trotter's Boston newspaper, the GUARDIAN, and helped organize political groups, notably the NIAGARA MOVEMENT, to effect change.

The other group of blacks in Massachusetts was composed of the masses who migrated north in the latter part of the nineteenth century, and who settled mostly in Boston. These blacks had been slaves or were children of slaves, and they were fleeing the hardships of the South. Most were poor, and few had much education. Even in the North, they faced hardship and discrimination. Outnumbered by the large number of immigrants, from Ireland and later from other places, they were excluded from unions, denied jobs in factories, victimized by *de facto* segregation, and crowded into dilapidated, unhealthy housing and poor schools. As the state's economy declined, at the turn of the century, black political and economic power were further reduced.

Although there were class tensions among Massachusetts' African Americans, the two groups did unite for common objectives. One notable success they scored was the boycott of the film BIRTH OF A NATION in 1915. Boston's Mayor Michael Curley refused to go along with the boycott, although he ordered some of the most objectionable material excised. Gov. Edward Walsh, however, ordered the film banned in Massachusetts outside Boston.

A third group of African Americans in nineteenth- and twentieth-century Massachusetts is the community of immigrants—the only large group of voluntary African travelers to the New World—from the Cape Verde Islands, a group of Portuguese-owned islands off the coast of Africa, and their descendants. They may have come to Massachusetts as early as the 1780s, to work on the whaling ships that sailed the Atlantic Ocean and in maritime trades. Later, many Cape Verdeans migrated to Massachusetts as seasonal laborers, working in the cranberry bogs. Most settled in the old whaling towns such as New Bedford and Fall River. The Cape Verdeans are mainly Roman Catholic and speak Crioulo, a mixture of Portuguese and African languages. They fit oddly into American racial patterns, since their dark skin has caused them to suffer discrimination, yet their culture

and history differs from that of black Americans. Many Cape Verdeans, who saw the stigma placed on blackness in the United States, tended at first to call themselves "Portuguese" rather than "black." The experience of Cape Verdeans has been close to that of other immigrants. They have worked at heavy labor for low pay, socialized predominantly within their own communities, and struggled to educate their children and enable them to enter the middle class. In the wake of the CIVIL RIGHTS MOVEMENT, many Cape Verdeans have since taken a new pride in their blackness.

In the years since WORLD WAR II, Massachusetts' black population has increased fivefold, but blacks still represent less than 5 percent of the state's population. Most still live in Boston, trapped in inner-city poverty. Other blacks have settled in such places as Springfield, Worcester, and Williamstown, all of which were sites of racial conflict during the 1960s. Massachusetts faces a paradox—the state is reputedly one of the most liberal in the Union, yet Boston harbors many racial animosities. In 1966, Massachusetts Republican Edward BROOKE became the first black U.S. senator since Reconstruction. He won re-election in 1972, both times relying heavily on white votes. In 1980, black leader Mel King came in a strong second in Boston's mayoral election, forcing a runoff with Raymond Flynn. Flynn's moderation on racial issues has helped set a statewide pattern.

Nevertheless, serious racial problems remain in Massachusetts. During the 1960s and '70s, demands by Boston's black community for quality education led to court-ordered school integration and forced busing of schoolchildren. The resulting white rioting and violence inflamed racial tensions, but media coverage exposed a national audience to the problems of blacks in Massachusetts, much as the Charles Stuart affair, in which a community of blacks falsely suspected of murdering a white woman were harassed by police, would do in the 1980s. Welfare and the highly publicized debate over workfare in the early 1990s continued to focus attention on the problems of African Americans finding adequate employment, even in a state as relatively successful and wealthy as Massachusetts.

REFERENCES

GREENE, LORENZO. *The Negro in Colonial New England.* New York, 1942.

LITWACK, LEON F. *North of Slavery: The Negro in the Free States, 1790–1860.* Chicago, 1961.

LOGAN, RAYFORD W. *The Negro in American Life and Thought: The Nadir, 1877–1901.* New York, 1954.

PIERSEN, WILLIAM D. *Black Yankees: The Development of an Afro-American Subculture in Eighteenth Century New England.* Amherst, Mass., 1988.

ZILVERSMIT, ARTHUR. *The First Emancipation: The Abolition of Slavery in the North.* Chicago, 1967.

DONALD M. JACOBS

Massey, Walter E. (1938–), physicist and scientific administrator. In March 1991 this theoretical physicist began a six-year term as director of the National Science Foundation (NSF). Previous to this appointment he served as vice president for research at the University of Chicago and the Argonne National Laboratory. Prior to this he was director of the laboratory and professor of PHYSICS at the University of Chicago.

Born in Hattiesburg, Miss., Massey received a bachelor's degree in physics and mathematics from Morehouse College in 1958, and completed graduate studies there for a master's degree in 1959. He received his doctoral degree in 1966 from Washington University in St. Louis. Following seven years of research at the Argonne National Laboratory—operated by the University of Chicago for the U.S. Department of Energy—he was professor of physics and later a college dean at Brown University in Providence, R.I. His own research has focused on the

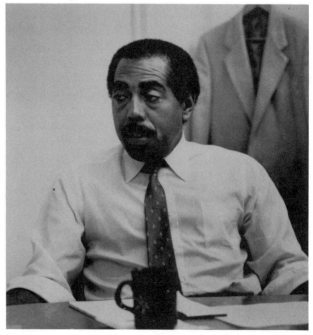

Walter E. Massey, a particle physicist and the former president of the National Science Foundation, was named provost (the second-highest position) of the University of California system in 1993. (Photographs and Prints Division, Schomburg Center for Research in Black Culture, The New York Public Library, Astor, Lenox and Tilden Foundations)

many-body theories of quantum liquids and solids—more specifically, examining the behavior of various substances at very low temperatures.

Upon his return to the Argonne National Laboratory as its director in 1979, he was responsible for overseeing a wide array of basic and applied energy research projects, involving nuclear fission, solar energy, fossil fuels, and the effects of energy production on the environment. As Argonne's director he managed a staff of 5,000, including 2,000 scientists and engineers, with an annual budget of $233 million.

Walter Massey has lectured and written widely on the teaching of science and mathematics in the nation's public schools and colleges and on the role of science and technology in society. He is an ardent advocate of African-American involvement in science. "More and more, science and technology will influence our life, and people who are not able to deal with or understand such issues will not be able to play meaningful roles in society," says Dr. Massey.

In 1974 he received the Outstanding Educator in America award; the next year, the Distinguished Service Citation of the American Association of Physics Teachers was bestowed upon him.

REFERENCES

"Walter Massey: America's Pointperson in Science and Research." *Black Issues in Higher Education* (May 9, 1991): 8–13.

"Walter Massey: The Scientist as Manager." *Black Enterprise* (February 1981): 32.

ROBERT C. HAYDEN

Massie, Samuel Proctor, Jr. (July 3, 1919–), chemist and educator. Born in Little Rock, Ark., Samuel Massie graduated from high school at the age of thirteen. He received a B.S. in chemistry from the Agricultural, Mechanical and Normal College (now known as the University of Arkansas at Pine Bluff) in 1938, an M.S. in chemistry from FISK UNIVERSITY in Nashville, Tenn., in 1940, and a Ph.D. in organic chemistry from Iowa State University in 1946.

During World War II, Massie helped conduct military research projects on chemical-warfare agents, the atomic bomb, and antimalarial drugs. From 1946 to 1947, he worked as a chemist at the Eastman Kodak Company. He was then named chairman of the department of chemistry at Langston University in Oklahoma. In 1953, he assumed the same position at Fisk University. After seven years at Fisk, Massie moved to Washington, D.C., and became chairman of the department of pharmaceutical chemistry at HOWARD UNIVERSITY. He left that position to serve

as president of North Carolina College at Durham in 1963. In 1966, Massie became the first African-American faculty member at the U.S. Naval Academy at Annapolis, Md. He chaired the academy's chemistry department from 1977 through 1981, when he retired. In his final year there, he was recognized as one of the top six college chemistry teachers in the United States by the Manufacturing Chemists Association. Massie was inducted into the National Black College Hall of Fame in 1989. His fraternity, Kappa Alpha Psi, gave him its highest award, the Laurel Wreath.

REFERENCE

"Training Young Minds." *All Hands Magazine of the U.S. Navy.* (January 1990): 40.

ROBERT C. HAYDEN

Mathematicians. Mathematics was the first scientific field in which African Americans made significant contributions. In the late eighteenth century, Benjamin BANNEKER applied his knowledge of mathematics in the fields of surveying, clockmaking, and astronomy. His calculations of the positions of celestial bodies, published in a series of almanacs between 1792 and 1797, were noted for their accuracy. A free black, Banneker was a counterexample to the widely held belief that blacks lacked reasoning and other intellectual abilities. Although many slaves used such skills as part of their daily routine, their work generally went unrecognized.

Mathematics provided a basis for the work of Edward BOUCHET, the first black to be awarded a Ph.D. at an American university. Bouchet earned a doctorate in physics at Yale University in 1876 with a dissertation entitled "Measuring Refractive Indices." The first African American to earn a Ph.D. in pure mathematics was Elbert Frank COX, at Cornell University in 1925. Cox's work on polynomial solutions, differential equations, and interpolation theory was highly regarded. He taught at Shaw University, West Virginia State College, and HOWARD UNIVERSITY.

Before World War II, at least five other African Americans earned Ph.D.s in mathematics. Dudley Weldon Woodard took his degree at the University of Pennsylvania in 1928; William Waldron Schieffelin CLAYTOR, University of Pennsylvania, 1933; Walter Richard Talbot, University of Pittsburgh, 1934; Reuben Roosevelt McDaniel, Cornell University, 1938; and Joseph Alphonso Pierce, University of Michigan, 1938. Like Cox, they taught principally at black colleges and universities. In 1949, Evelyn Boyd (she later took the married names Granville and Collins)

and Marjorie Lee BROWNE became the first African-American women to earn doctorates in mathematics, from Yale University and the University of Michigan, respectively. Browne taught at North Carolina Central University. In addition to teaching, Boyd's career included a period (1963–1967) as research specialist in celestial mechanics and orbit computation with the Apollo Project. J. Ernest WILKINS, Jr., worked on the Manhattan Project (1944–1946) after earning a Ph.D. in mathematics at the University of Chicago in 1942. David Harold BLACKWELL, who was awarded a Ph.D. at the University of Illinois in 1941, became internationally known for his work in statistics and was elected to the National Academy of Sciences in 1965.

Although few in number, black mathematicians were in the vanguard of the struggle against racial discrimination in science. Their efforts to participate in the field—at meetings of professional associations, for example—prompted changes in institutional policy and shifts in attitude and outlook within the scientific community during the 1950s. While some associations had admitted members regardless of race prior to that period, meetings were still convened in cities where African Americans experienced difficulty with accommodations and access to social events. In 1951, Evelyn Boyd and other members of the mathematics department at Fisk University helped motivate the American Mathematical Society and the Mathematical Association of America to adopt guidelines prohibiting the use of segregated sites and facilities for meetings.

With the passage of the Civil Rights Bill in 1964, graduate departments in mathematics at white universities became more open to admitting African Americans. The numbers, however, have remained small. During the 1980s, for example, less than 2 percent of all Ph.D.s in mathematics were awarded to African Americans.

REFERENCES

BOZEMAN, SYLVIA T. "Black Women Mathematicians: In Short Supply." *Sage* 6 (Fall 1989): 18–23.

NEWELL, VIRGINIA K., JOELLA H. GIPSON, L. WALDO RICH, and BEAUREGARD STUBBLEFIELD, eds. *Black Mathematicians and Their Works.* Ardmore, Pa., 1980.

KENNETH R. MANNING

Mathematician David Blackwell, an expert in game theory and probability theory, was the first African-American president of the National Institute of Statistics. (Photographs and Prints Division, Schomburg Center for Research in Black Culture, The New York Public Library, Astor, Lenox and Tilden Foundations)

Matheus, John Frederick (September 10, 1887–February 19, 1983), writer. Born in 1887 into a working-class family in Keyser, W.Va., John Frederick Matheus received an A.B. degree from Western Reserve University in Cleveland in 1910 and an A.M. from Columbia University in 1921; after traveling to Cuba, he pursued graduate study in romance languages at the Sorbonne (1925) and at the University of Chicago (1927). Matheus taught at Florida A&M College in Tallahassee from 1910 until 1922, after which he became a professor of foreign languages at West Virginia State College, where he remained from 1922 until his retirement in 1958. In 1931 he spent six months in Sierra Leone and Liberia as secretary to Charles S. Johnson, a member of a commission sent by the League of Nations to investigate charges of forced labor. Matheus also spent a year teaching English in Haiti (1945–1946) and taught briefly at Hampton Institute in Virginia (1961–1962) and at Kentucky State College (1962). He served as treasurer of the College Language Association from 1942 until his retirement from teaching.

The literary career of this widely traveled man of the HARLEM RENAISSANCE was distinguished. His short story "Fog" was awarded first prize in the 1925 *Opportunity* contest and anthologized in Alain LOCKE's *New Negro* (1925). The story "Swamp Moccasin" won first prize in the 1926 *Crisis* contest, and *'Cruiter* the prize for one-act plays. His essay "Sand" won first prize for a sketch from personal experience in the 1929 *Opportunity* competition. Matheus was the librettist for *Ouanga,* a full-length opera with music by Clarence Cameron WHITE, which was pro-

duced in South Bend, Ind. in 1949. In the opera, the attempt of Haiti's leader Dessalines to eradicate VOODOO, the native religion, leads to his downfall. Matheus' literary output also includes a pageant celebrating the 25th Anniversary of the NAACP and numerous critical essays, translations, book reviews, and poems contributed to such periodicals as *Opportunity, Crisis, Journal of Negro History,* and *Modern Language Journal.* Although Matheus published little in the last decades of his life, his short stories were compiled and privately printed in 1974 as *A Collection of Short Stories.*

In his fiction, Matheus typically confronts the problems faced by African Americans in a society riven with racial hatred and resistant to change; in much of his work, he holds out hope for reconciliation through understanding born of experience. His short story "Fog" deals not only with racial prejudice, but with the making of multiethnic America, a theme also treated in "Anthropoi" (1928), a story that contrasts the careers of a Greek immigrant and an African American. Other subjects Matheus portrays include African-American history, migration, and most important, the African cultural heritage. Haitian voodoo is the basis for the story "Coulev' Endormi" (1929) and the one-act play *Tambour* (1929). Matheus was married twice, the first time at age twenty-one, the second (some years after his first wife's death) at eighty-five years of age. He died at ninety-five, in Tallahassee, Fla.

REFERENCES

MATHEUS, JOHN F. "*Ounga:* My Venture in Libretto Creation." *College Language Association Journal* 15 (1972): 428–440.

METZGER, LINDA, ed. *Black Writers: A Selection of Sketches from Contemporary Authors.* Detroit, Mich., 1989.

PERRY, MARGARET. "John F. Matheus." In *Dictionary of Literary Biography.* Vol. 51, *Afro-American Writers from the Harlem Renaissance to 1940.* Detroit, Mich., 1987.

MICHEL FABRE

Mathis, Johnny (Mathias, John Royce)

(September 30, 1935–), singer. Born in San Francisco, Mathis took an early interest in sports, and it was as an outstanding high jumper that he gained recognition at San Francisco State College. During that time he also began singing in a jazz sextet. In 1955 he sang in nightclubs in San Francisco and New York, where his smooth, mellow ballad style led to his first recording, "Wonderful, Wonderful" (1956), which was a huge hit. In 1957 he recorded two more

million-selling records, "Chances Are," and "It's Not for Me to Say," as well as the popular "Twelfth of Never." In 1958, his album *Johnny Mathis's Greatest Hits* sold more than 2 million copies, and remained on the charts for almost 10 years. During this time, Mathis also appeared in two films, *Lizzie* (1957) and *A Certain Smile* (1958).

With a style derived more from popular crooning traditions than jazz or blues, Mathis was one of the great "crossover" singers of the 1950s and 1960s, extremely popular with both white and black audiences. In the 1960s and 1970s he toured widely, and recorded prolifically ("Too Much, Too Little, Too Late," with Deniece Williams, 1978; "Friends in Love," with Dionne Warwick, 1982). Mathis has maintained his popularity into the 1990s with numerous successful recordings, concert tours, and radio and television appearances.

REFERENCE

"In Step with Johnny Mathis." *Washington Post,* November 15, 1992.

JAMES E. MUMFORD

Matthews, Victoria Earle (Smith) (May 27, 1861–March 10, 1907), writer, journalist, social reformer. Victoria Smith was born a slave in Fort Valley, Ga. During the Civil War, her mother, Caroline Smith, fled to New York, but she returned to Georgia after Emancipation to reestablish contact with her nine children. She regained custody of four of her children and moved with them to Richmond and then Norfolk, Va. The family lived there for four years before going to New York City in 1873. Smith attended Grammar School 48 in New York, but was forced to begin working as a domestic to help support her family. She developed a deep interest in learning and borrowed books to read from the library of one of her employers. In 1879, she married William Matthews, a coachman, and they had a son.

Shortly after her marriage, Matthews began to write stories that were published in the *Waverly, New York Weekly,* and other literary journals. In 1893, under the pen name Victoria Earle, she published *Aunt Lindy,* a novel about a former slave in Georgia after the Civil War. She thereafter used the name Victoria Earle Matthews in most of her writings and public engagements. She wrote articles for a variety of black and white newspapers, including the *Boston Advocate* and the *New York Times,* before becoming a journalist for the *New York Age.* In 1898, with the support of T. Thomas Fortune, Matthews compiled and edited

Black Belt Diamonds, a collection of quotations by Booker T. Washington.

Matthews was a dedicated social reformer and played a leading role in the club movement. She helped organize a testimonial for the antilynching crusader Ida B. Wells in 1892 (see Ida B. WELLS-BARNETT). The event brought together 250 women from Boston, Philadelphia, and New York, and inspired the founding of black women's clubs in these cities. In New York Matthews helped found the Woman's Loyal Union Club and became its first president. The club was committed to social and political improvement of the African-American community, including better schools and employment opportunities.

In 1895, Matthews attended the first national conference of black women, which led to creation of the NATIONAL FEDERATION OF AFRO-AMERICAN WOMEN (NFAAW). She spoke on "The Value of Race Literature," praising the creative abilities of black women and men. Matthews was the first chair

Born into slavery in Georgia, Victoria Earle Matthews became a prominent social reformer in late nineteenth-century New York City and was founder of the White Rose Mission for young women in 1879. (Photographs and Prints Division, Schomburg Center for Research in Black Culture, The New York Public Library, Astor, Lenox and Tilden Foundations)

of NFAAW and was on the editorial staff of its journal, THE WOMAN'S ERA. In 1896 she helped consolidate the NFAAW and the Colored Women's League into the NATIONAL ASSOCIATION OF COLORED WOMEN, a coalition of women's clubs across the country, and served as national organizer from 1897 to 1899.

In 1897, after the death of her sixteen-year-old son, Matthews's interest in social welfare increased. During that year she founded the White Rose Mission, which provided food, shelter, and employment for migrants from the South, and served as a social space for young black women and children. The goals of the White Rose Mission included "establishing and maintaining a Christian, nonsectarian Home for Colored Girls and Women, where they may be trained in the principles of practical self-help and right living." Women were trained in such domestic activities as cooking and sewing, while boys were trained in vocational activities. Matthews taught black history at the White Rose Mission and helped create a library there of books by and about African Americans.

Like most clubwomen of her time, Matthews was motivated by deep religious convictions and advocated both self-improvement and social reform to assist the less fortunate. She was an active member of the Episcopal Church and lectured on uplift and the political and social responsibilities of African Americans. At the same time, she and other clubwomen provided services and support to young women to prevent them from becoming victims of a "white slave" traffic.

Matthews continued to work at the White Rose Mission until her health began to fail. Although she was only in her forties when this happened, she left behind an important legacy. Her idea of service centers spread, and travelers' aid societies were formed all along the eastern seaboard. In 1905, Matthews formed the White Rose Travelers' Aid Society, a chain of service centers from Virginia to New York, designed to support and protect young women. Two years later, Matthews died of tuberculosis at the age of forty-five.

REFERENCES

DAVIS, ELIZABETH, comp. *Lifting As They Climb: An Historical Record of the National Association of Colored Women.* Washington, D.C., 1933.

MEIER, AUGUST. *Negro Thought in America, 1880–1915: Racial Ideologies in the Age of Booker T. Washington.* Ann Arbor, Mich., 1963.

SMITH, JESSIE CARNEY, ed. *Notable Black American Women.* Detroit, 1992.

SABRINA FUCHS
PAM NADASEN

Matzeliger, Jan Earnst (September 15, 1852–August 24, 1889), inventor. Born in 1852 in Paramaribo, Suriname, then a Dutch colony on the northern coast of South America, Jan Matzeliger began working at the age of ten in a government machine shop, where his father was a superintendent. In 1871 he left Suriname aboard an East Indian freighter; after about two years, he disembarked in Philadelphia. He then traveled around the Northeast for several years, finally settling in 1877 in Lynn, Mass., the center of the New England shoe industry.

Matzeliger quickly acclimated himself to the United States, teaching himself English, studying science, and joining the North Congregational Church in Lynn. After several unsuccessful attempts at inventing various devices, including a machine that wrapped oranges, Matzeliger set his sights on creating an effective mechanical laster. The lasting process involved stretching and pulling leather shoe uppers to conform to the contours of the last, a foot-shaped model. After stretching it into the proper position, the leather would then be attached to the inner sole. While various inventors had attempted to mechanize the lasting process before, none had succeeded in creating a machine that could efficiently accommodate leathers of all grades and thickness.

After many disappointments and the construction of extremely crude models, Matzeliger pooled his meager resources with those of C. H. Delnow and M. S. Nichols, two Lynn investors, and was able to get enough money to put together a working model of his laster. In return, Delnow and Nichols received two-thirds ownership of the device. By March 1883, Matzeliger secured a patent; the mechanical plans were so complex that an official from the patent office had to go to Lynn in order to personally examine the machine.

Two years later, Matzeliger had a laster that was ready for a factory test. In one day, the machine lasted seventy-five pairs of shoes, 50 percent more than a hand laster could accomplish in a similar ten hour period. After further refinement, the machine could produce, depending on the quality of the leather, anywhere from 150 to 700 pairs in one day. For mass production, however, further capital was required, and several investors formed the Consolidated Lasting Machine Company. In return for selling his patents to the company, Matzeliger received a significant amount of company stock.

Like many mechanical improvements of the nineteenth century, Matzeliger's lasting machine threatened the livelihood of skilled craft workers; it is hardly surprising that hand-lasters exhibited animosity towards the introduction of such a device. Not only were they at risk of losing skills considered vital

Jan Matzeliger, born in Suriname (Dutch Guiana), became an apprentice cobbler in Lynn, Mass. In 1883 he patented an automatic shoe-laster. (Photographs and Prints Division, Schomburg Center for Research in Black Culture, The New York Public Library, Astor, Lenox and Tilden Foundations)

to their craft, but they were also in danger of losing their positions to boys or unskilled workers who could be taught to operate the machine and paid less than the hand lasters. Perhaps it was this animosity, along with the general bigotry of the period, that caused Matzeliger's invention to be dubbed the "niggerhead laster."

Matzeliger would only be able to enjoy his success for a short time; he died in 1889 after contracting tuberculosis. His estate, which had become quite valuable, was distributed among his church and close friends. The will specified that while the bulk of the money left to the church should go to the "Christian poor," it clearly stated that it should not "knowingly be given or expended for any member of the Roman Catholic, Unitarian, and Episcopal Churches," the churches that had rejected Matzeliger when he first arrived in Lynn.

Matzeliger's laster became the industry standard. In 1899, several companies combined to form the

United Shoe Manufacturing Corporation, capitalized originally at $20 million. Within twelve years, the company controlled 98 percent of the shoe machinery business; by 1955, the company was capitalized at over $1 billion.

REFERENCES

HABER, LOUIS. *Black Pioneers of Science and Invention.* New York, 1970.

HAYDEN, ROBERT C. *Eight Black American Inventors.* Reading, Mass., 1972.

JAMES, PORTIA P. *The Real McCoy: African-American Invention and Innovations, 1619–1930.* Washington, D.C., 1989.

KAPLAN, SIDNEY. "Jan Earnst Matzeliger and the Making of the Shoe." *Journal of Negro History* 40, no. 1 (January 1955): 8–33.

SIRAJ AHMED

Mayfield, Curtis (June 3, 1942–), singer and songwriter. Born and raised in Chicago, Curtis Mayfield sang with the Northern Jubilees GOSPEL choir as a child. He left high school in 1956 to form his first singing group, the Alphatones. The following year Mayfield, along with childhood friends Jerry Butler, Richard Brooks, Arthur Brooks, and Sam Gooden, formed a group called the Roosters that eventually evolved into the first version of the Impressions. It was this quintet that recorded the RHYTHM AND BLUES hit "For Your Precious Love" on Vee Jay Records, with Butler on lead vocals; the record sold 150,000 copies during a two-week period in 1958. When promoters decided to change the band's name to Jerry Butler and the Impressions, internal dissension caused the group to disband the following year.

In 1961 the Impressions reunited as a trio with Gooden, the Brooks brothers, and new member, Fred Cash, backing up Mayfield, the group's new lead singer, songwriter, and guitar player. That year the group signed with ABC-Paramount and recorded the Top Twenty hit "Gypsy Woman." Soon thereafter the Brooks brothers left the group, which remained the trio of Mayfield, Cash, and Gooden through the decade. The Impressions' next big hit came in 1963 when "It's All Right" reached number one on the rhythm and blues charts and number four on the pop charts.

Through the 1960s the group recorded numerous hit singles and became one of the most successful non-Motown R&B acts. Mayfield's gospel-influenced songs and soft, breathy tenor voice gave the Impressions a distinctively earnest and intimate sound. Mayfield was also one of the first songwriters to merge soul music with political lyrics, and the CIVIL RIGHTS MOVEMENT served as inspiration for many of the Impressions' most popular singles, such as "Keep on Pushing" and "Amen" in 1964, "People Get Ready" in 1965, and "We're a Winner" in 1968.

In 1970 Mayfield left the group to pursue a solo career and established the Custom record label. Although he made numerous albums on the Custom label in the early 1970s, such as *Curtis* (1970), *Curtis Live!* (1971), and *Roots* (1971), Mayfield is best remembered for the soundtrack of the BLAXPLOITATION FILM *Superfly*, which was the number-one-selling album in the United States for four weeks in 1972. The *Superfly* soundtrack, which is often considered one of the finest examples of orchestral soul music, included the hit singles "Freddie's Dead," "Superfly," and "Pusherman."

After *Superfly,* Mayfield wrote a number of successful film scores. In 1975 his score for the movie *Claudine* was nominated for an Academy Award, and the following year the title track from the film *Let's Do It Again* reached number one on *Billboard*'s pop singles list when it was recorded by the Staple Singers. Through the 1970s Mayfield recorded several solo albums on Custom that achieved limited success, including *Sweet Exorcist* (1974), *There's No Place Like America Today* (1975), and *Give, Get, Take and Have* (1976). In 1981 he signed with the Boardwalk label for which he recorded the album *Honesty.* In 1983 he was reunited with former Impressions Butler, Cash, and Sam Gooden for a concert tour.

In 1990 Mayfield was paralyzed from the neck down when sudden winds knocked over a lighting rig just before his performance at a free outdoor concert in Brooklyn. In 1994 he was honored at the Grammy Awards show with a Grammy Legend Award.

REFERENCES

Curtis Mayfield and the Impressions: The Anthology, 1961–1977. Liner notes, MCA Records, 1992.

LIGHT, ALAN. "A Lasting Impression: The Rolling Stone Interview with Curtis Mayfield." *Rolling Stone* (October 28, 1993): 62–66.

PRUTER, ROBERT. *Chicago Soul.* Urbana, Ill., 1991.

THADDEUS RUSSELL

Mayfield, Julian H. (June 6, 1928–October 20, 1984), actor, writer, activist. Julian Mayfield was born in Greer, S.C., and grew up in Washington, D.C. After graduating from Dunbar High School, he entered the Army and served briefly in the Pacific theater before receiving a medical discharge. Mayfield then enrolled at Lincoln University in Pennsylvania, but gave up his studies to move to New York City in 1949.

In New York, Mayfield held many jobs to make ends meet—from washing dishes to writing for the leftist black newspaper *Freedom*. At the newspaper, he met Paul ROBESON, Lorraine HANSBERRY, Langston HUGHES, and other black leftists—meetings that deeply influenced his intellectual formation. Mayfield soon became an actor, debuting on Broadway as Absalom, the juvenile lead in *Lost in the Stars* (1949), Kurt Weill's adaptation of Alan Paton's novel *Cry, the Beloved Country* (1948). In 1952, Mayfield coproduced Ossie DAVIS's first play, *Alice in Wonder*. While in New York, he became a member of the Harlem Writers Guild, a cooperative enterprise where members critiqued each other's work.

In 1954 Mayfield married Ana Livia Cordero, and the couple moved to Puerto Rico. Mayfield helped establish the first English-language radio station on the island and, in 1956, founded the Puerto Rico *World Journal*, a magazine about international affairs. While in Puerto Rico, Mayfield wrote his first novel, *The Hit* (1957), based on *417,* a one-act play he had written earlier about the numbers game in Harlem. *The Long Night* (1958) also centered on the numbers game, but presented a much bleaker, less romantic view of Harlem than its predecessor.

By the time his third novel, *The Grand Parade* (1961), was published, Mayfield—who had met MALCOLM X and W. E. B. DU BOIS—had become a radical black nationalist. This was reflected in the novel, which fosued on the efforts to integrate a school in a "nowhere" city, situated between the northern and southern United States. The novel's vision was deeply pessimistic and expressed his advocacy of "Blackist Marxism."

In 1960, Mayfield visited Cuba after Fidel Castro's revolution, in the company of Le Roi Jones (*see* Amiri BARAKA), Robert WILLIAMS, and others. In this period, he published many magazine articles on African-American affairs and was active in black nationalist circles. In 1961, after Williams was accused of kidnapping a white couple, Mayfield, who was with Williams at the time, was wanted for questioning by the FBI. Mayfield fled to Canada, then England, before arriving in Ghana in 1962.

In Ghana, Mayfield served as a speech writer and aide to President Kwame Nkrumah and founded and edited the *African Review*. In keeping with his internationalism, Mayfield edited *The World Without the Bomb* (1963), the report of a conference on disarmament held in Ghana and attended mostly by Third World scientists. He was in Spain in 1966 when Nkrumah was overthrown in a coup. Mayfield moved to England for a while, then returned to the United States in 1968.

In 1968, Mayfield was given a fellowship at New York University. Two years later, he became the first Distinguished W. E. B. Du Bois Fellow at Cornell University. That same year, he edited *Ten Times Black,* a collection of stories by younger African-American authors. During this time, he cowrote the screenplay for *Uptight* (1968), about life inside a black nationalist organization, in which he played the lead; this was his much acclaimed film debut. Mayfield also wrote the screenplays for *The Hitch* (1969), *Children of Anger* (1971), and, with Woodie KING, *The Long Night* (1976).

In 1971, Mayfield moved to Guyana in South America as an adviser to the minister of information and later functioned as an assistant to Prime Minister Forbes Burnham. Mayfield returned to the United States in 1974 and taught for two years at the University of Maryland in College Park. He later served as a senior Fulbright-Hays Fellow, teaching in Europe and Tunisia. In 1977, he relocated to the University of Maryland, and the next year, he accepted an appointment as writer-in-residence at Howard University, a position he maintained until his death of a heart ailment in Takoma Park, Md., in 1984.

REFERENCES

DAVIS, ARTHUR P. *From the Dark Tower: Afro-American Writers.* Washington, D.C., 1981.

FORMAN, ROBERT. *The Making of Black Revolutionaries.* New York, 1972.

MAYFIELD, JULIAN. "Into the Mainstream and Oblivion." In *The American Negro Writer and His Roots.* New York, 1960.

RICHARDS, PHILLIP M. Foreword. In *The Hit and the Long Night.* Boston, 1989.

WILLIAMS, ROBERT. *Negroes With Guns.* New York, 1962.

PETER SCHILLING

Maynard, Aubre de Lambert (1901–), surgeon. A native of British Guiana (now Guyana), Maynard first came to the United States in 1906 with his parents, Percival Conrad Maynard and Gertrude (Johnson) Maynard. He attended schools in Barbados and New York before entering the College of the City of New York in 1918. Graduating with a B.S. in 1922, he was admitted to the College of Physicians and Surgeons of New York, Columbia University. For racial reasons, the dean there discouraged him from enrolling. Maynard transferred to New York University, graduating with an M.D. in 1926. That year he was in the first group of blacks admitted to internships at Harlem Hospital.

In 1928, Maynard was appointed to the surgical staff of Harlem Hospital. He became surgical director in 1952, holding that position until his retirement in

1967. In 1954, he became the second black (after Louis T. WRIGHT) elected to the New York Surgical Society. A specialist in thoracic surgery, he supervised the removal of a knife from the chest of the Rev. Dr. Martin Luther KING, Jr., following a 1958 assassination attempt. His study of heart wounds became one of the classics in the field. As his international reputation grew, Maynard was invited to address the Académie de Chirurgie de France and other distinguished professional bodies. From 1962 to 1967, he served as clinical professor of surgery at Columbia University. In 1972, the cardiac operating suite at Harlem Hospital was named in his honor.

REFERENCES

MAYNARD, AUBRE DE L. *Surgeons to the Poor: The Harlem Hospital Story*. New York, 1978.

MAYNARD, AUBRE DE L., JOHN W. V. CORDICE, JR., and EMIL A. NACLERIO. "Penetrating Wounds of the Heart: A Report of 81 Cases." *Surgery, Gynecology and Obstetrics* 94 (May 1952): 605–618.

PHILIP N. ALEXANDER

Maynard, Robert Clyde (June 17, 1937–August 17, 1993), journalist and newspaper owner. Robert Maynard was born in Bedford-Stuyvesant, in Brooklyn, N.Y., to Samuel and Robertine (Greaves) Maynard, two Barbadian immigrants. Maynard, a high school dropout, worked as a teenager at *The New York Age*, a weekly African-American newspaper; in 1956, he joined the *Afro-American News* in Baltimore as a full-time reporter. Five years later, he became a reporter for the *York Gazette and Daily* in Pennsylvania.

Although Maynard never graduated from high school, he was accepted to the prestigious Nieman Fellowship Program at Harvard in 1966, and afterward joined the *Washington Post,* becoming its first black national correspondent, eventually serving as a White House correspondent. From 1972 to 1974 he was an associate editor at the *Post,* and served as ombudsman for an eighteen-month period. He then served as an editorial writer for the paper between 1974 and 1977. In 1976, Maynard was selected to be one of the three questioners in the final televised presidential campaign debate between President Gerald Ford and Democratic candidate Jimmy Carter.

The following year, Maynard and his wife, Nancy Hicks, formed the Institute for Journalism Education (IJE)—a program to train minority journalists—at the University of California at Berkeley. Maynard served as IJE's chairperson until 1979. (IJE was renamed the Maynard Institute in 1993.) That same year, 1979,

Maynard joined the *Oakland Tribune* in California and became the first African American to direct editorial operations for a major daily newspaper. In 1983 he waged an eight-month struggle to buy the flagging *Tribune* from Gannett Co., a giant newspaper chain, for $22 million, using largely borrowed funds. Upon obtaining the *Tribune,* Maynard became the first African American to be editor, publisher, and owner of a major metropolitan daily newspaper. He sold the *Tribune* in 1992.

Maynard's prominence grew from his ownership of the *Oakland Tribune,* writing a syndicated column, and appearing as a frequent commentator on both *This Week with David Brinkley* and the *MacNeil-Lehrer News Hour* television programs. In addition, he served on the board of the Associated Press, was a trustee of the Rockefeller Foundation, and from 1986 to 1993 was a member of the Pulitzer Prize Board. Maynard died of prostate cancer in Oakland, Calif., in August 1993.

REFERENCES

COSE, ELLIS. *The Press.* New York, 1989.

LAMBERT, BRUCE. Obituary. *New York Times,* August 19, 1993, p. B12.

KAREN E. REARDON

Maynor, Dorothy Leigh (September 3, 1910–), concert singer. Born in Norfolk, Va., soprano Dorothy Maynor was one of the most successful singers of the 1940s and 1950s. She attended Hampton Institute College Preparatory School (where she was under the guidance of R. Nathaniel DETT) from 1924 until her college graduation (B.S., 1933). She later attended Westminster Choir School in Princeton, N.J. (B.M., 1935). In the summer of 1939 at the Berkshire Music Festival in Massachusetts, she sang for Serge Koussevitzky, who commented, "Her voice is a miracle, a musical revelation that the world must hear," and immediately arranged concerts and a recording with the Boston Symphony.

In the fall of 1939, Maynor had a critically acclaimed New York Town Hall debut. The success of that performance launched a twenty-five-year career that included extensive tours and recordings, radio and television shows, and appearances with major orchestras. In 1945, she became the director of Bennett College in Greensboro, N.C.; in 1959 she received an honorary doctor of music degree from Howard University. Upon her retirement from singing in 1965, she started a music-education program for children at Saint James Presbyterian Church in Harlem, where her husband, Shelby Rooks, was the

minister. This program expanded into the Harlem School for the Arts, and she began a new career as its first director (1964–1979). About her work in Harlem, Maynor said, "What I dream of is changing the image held by the children. We have made them believe that everything beautiful is outside the community. I want them to make beauty *in* this community!" Since her retirement in 1992 Dorothy Maynor has lived in Pennsylvania.

REFERENCES

GRAY, JOHN. *Blacks in Classical Music: A Bibliographical Guide to Composers, Performers, and Ensembles.* Westport, Conn., 1988.

TURNER, PATRICIA. *Dictionary of Afro-American Performers.* New York, 1990, pp. 262–265.

A. LOUISE TOPPIN

Mayors. The area in which African Americans made the greatest political gains during the late-twentieth century was in city government. By 1990, most of the large cities in the United States, including four of the top five, had elected African-American mayors. This political shift took place with astounding swiftness. While a few black mayors were elected in small southern towns during RECONSTRUCTION, and numerous all-black towns (*see* BLACK TOWNS) during the JIM CROW era had black chief executives, the first African-American mayors of large cities were elected only in 1967, with the elections of Carl STOKES in Cleveland, Ohio, and Richard HATCHER in Gary, Ind. That same year, Walter Washington was appointed mayor of Washington, D.C., although he was not elected to that office until 1974.

The institution of black political control in the urban areas of the United States at the end of the twentieth century was the product of several factors, including the shifting racial demography of cities. As the industrial sector of the American economy declined, unemployment as well as taxes increased while city services declined. As a result, many affluent city residents, overwhelmingly white, moved from cities to adjacent suburbs, and black-majority or near-majority populations were created within city limits.

The other important factors were the Civil Rights and Black Power movements of the 1960s. The effects were most evident in the South, where movement efforts inspired passage of the VOTING RIGHTS ACT of 1965 and other measures that ensured full political participation and provided federal protection to blacks attempting to exercise their right to vote.

However, even in the areas of the country where blacks were able to vote throughout the twentieth century, the CIVIL RIGHTS MOVEMENT provided an inspiring ideology and model for black political action. Many of the black activists who went south returned as cadres and organizers responsible for voter registration and the formation of alliances. The Black Power movement, with its emphasis on black control of black areas, also proved influential. The URBAN RIOTS AND REBELLIONS of the 1960s, which publicized black powerlessness and at the same time hastened white outmigration, accelerated the election of African-American mayors.

Another factor that shaped the early black urban governments was the federal government. Federal civil rights legislation and affirmative-action programs improved the political and economic status of black communities. In addition, Great Society antipoverty programs provided black communities with sources of organization and patronage outside the control of white-dominated urban political machines and stimulated black interest in electoral politics.

African-American mayors can be divided into two main types: those from black-majority or near-majority cities (including virtually all southern cities with black mayors) and those with predominantly white electorates. The first wave of mayors, with the exception of Carl Stokes, came from black-majority industrial cities in the North and Midwest that had previously been the site of riots and other racial tensions. Elected with the help of black communities and movement organizations, they generally had little or no white voting support. Richard Hatcher (1933–), the first of these mayors, was elected mayor in the declining steel town of Gary, Ind., where blacks represented just over 50 percent of the population. Another notable figure, Coleman YOUNG (1918–), of Deroit, a former United Auto Workers activist, was elected in 1973.

One model of this type of mayor is Kenneth Gibson (1932–) of Newark, N.J., who was elected in 1970. Newark's industrial core and population had declined through the postwar period and by the late 1960s, had a black-majority population. The city's notoriously corrupt machine-dominated government had traditionally excluded blacks. In 1967, one year after Gibson, a city councilman, ran unsuccessfully for mayor, a major racial uprising in the city occurred. In 1969, Newark's mayor, Hugh Addonizio, was convicted on federal corruption charges and removed from office. Meanwhile, black militants led by writer Amiri BARAKA organized a coalition of African-American and Puerto Rican voters and selected Gibson as a consensus candidate. In 1970, with the help of heavy black voter-registration efforts and

bloc voting, Gibson was narrowly elected. Once in office, Gibson reached out to the white business community to counteract economic decline and attempted to assure a black majority on the city school board. He drew heavy criticism from black radicals over his perceived inattention to black community problems and from whites over municipal corruption, but remained a popular figure and was reelected for several terms before being defeated by another African American.

Gibson's experience in office typifies the problems of mayors of black-majority cities. Black mayors come to office amid high expectations of policy reforms in the police department, school board, and welfare agency. However, administrative change is difficult and hard to finance, particularly in declining "rust belt" cities with straitened budgets. Mayoral power over city agencies is often limited, and the health of city economies depends on relations between mayors and white-dominated business interests, state, and federal government officials. However, while dis-

appointment is inevitable, African-American mayors of black cities tend to be reelected for several terms, and then are usually followed by other African Americans.

African-American mayors of southern cities, such as Atlanta's Maynard JACKSON, elected in 1973; Ernest "Dutch" Morial of New Orleans, elected in 1978; Richard Arrington of Birmingham, elected in 1979; and Willie Herenton of Memphis, elected in 1992, have also come from black majority or near-majority cities. Little Rock, Ark., was the only predominantly white southern city of any size to elect black mayors during the 1970s and 1980s. However, they have differed in a few respects from their northern counterparts. First, not surprisingly, given the electoral history of the South, these candidates had little or no prior experience in electoral politics. Also, while some came from declining "New South" industrial cities, the southern mayors tended to inherit more viable city economies. Thus, while these mayors were elected by a united black vote, they have

Three African-American mayors talk with Housing and Urban Development Secretary Robert Weaver, December 1, 1967. (Left to right) Weaver; Mayor Carl B. Stokes of Cleveland; Mayor-Commissioner Walter Washington of Washington, D.C.; and Mayor Richard G. Hatcher of Gary, Ind. (UPI/Bettmann)

often run as moderates, hoping to cement links with white business interests. Also, southern black mayors, particularly in Atlanta, have developed affirmative-action programs and provided assistance that has helped expand and solidify the black middle class in their cities.

The other major type of black mayor has been the "crossover" mayor: chief executives elected with significant white support, usually in cities without dominant black populations. The best-known members of this group include Carl STOKES of Cleveland, elected in 1967; Tom BRADLEY of Los Angeles, elected in 1973; Wilson Goode of Philadelphia, elected in 1983; Harold WASHINGTON of Chicago, elected in 1983; and David DINKINS of New York City, elected in 1989. To this list might be added Sidney Barthelemy of New Orleans, who, in 1986, was elected mayor of a black-majority city over another African-American candidate. While Barthelemy's opponent gained a majority of the black vote, Barthelemy won with a small black vote and a solid white vote.

The "crossover" mayors form a diverse group. Many of these mayors, of whom David Dinkins is the most celebrated example, came to office in cities torn by racial tension, campaigned as peacemakers, and convinced white voters that a black mayor could more effectively "control" crime and urban rebellions. Through personal charisma and skill in reaching out to diverse minority and interest groups (Latinos, Jews, gays and lesbians, labor unions, women's groups, etc.), these candidates were able to forge successful coalitions.

By the early 1990s, black mayoral politics had entered a new stage of development. Black mayors were being elected to office in greater numbers of cities. Among them were several black women, representing both major cities (Sharon Sayles Belton of Minneapolis, elected in 1994; and Sharon Pratt Dixon of Washington, D.C., elected in 1990) and smaller cities (Carrie Perry of Hartford, Conn., elected in 1987; Jessie Rattley of Newport News, Va., elected in 1986; and Lottie Shackleford of Little Rock, Ark., elected in 1987).

Furthermore, by the 1990s, greater numbers of African Americans were coming to office in cities in which African Americans represented only a small percentage of the population. For example, Norman Rice of Seattle, elected in 1990; and Sharon Sayles Belton of Minneapolis presided in cities where blacks were, respectively, some 10 percent and 13 percent of the population. Previously (with the exception of Tom Bradley of Los Angeles), only a few cities without significant black populations, such as Boulder, Colo.; Spokane, Wash.; and Santa Monica, Calif.— university towns and other "liberal" areas—had had black mayors.

In some cases black mayors in nonblack majority cities were succeeded by other African Americans, but in many cities black electoral power was far from assured. By 1993, several black-majority cities, including Jackson, Miss.; Savannah and Macon, Ga.; and Harrisburg, Pa., had never elected black mayors. Moreover, most black mayors in racially mixed cities were elected by very narrow margins; their victories consisted of overwhelming percentages of the black vote along with a split white vote. For example, in his successful mayoral bid in 1983, Harold Washington won 51 percent of the vote, gaining 99 percent of the black vote, 60 percent of the Hispanic vote, and 19 percent of the white vote. Similarly, David Dinkins won the 1989 election by 47,080 votes, the closest election in city history, with 92 percent of the black vote, 65 percent of the Hispanic vote, and 27 percent of the white vote. Their electoral majorities remained vulnerable, and many of these mayors were defeated following small shifts in voter support in subsequent elections, while increasing racial polarization in large nonblack majority cities made the election of future black mayors extremely difficult. By 1993, white mayors had succeeded blacks in the nation's four largest cities—New York City, Los Angeles, Chicago, and Philadelphia. That year, follow-

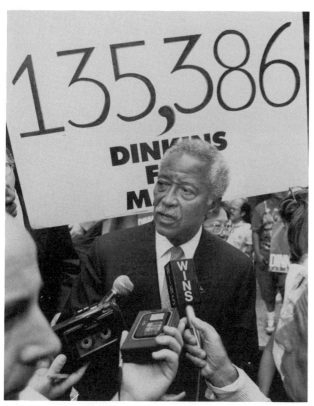

Democratic mayoral candidate David Dinkins, July 13, 1989. (UPI/Bettmann)

ing a shift of fewer than 100,000 votes, New York
Mayor David Dinkins lost a close mayoral race, be-
coming the first big-city black mayor to fail to be
reelected. Despite the setbacks, the office of mayor
continues to be a main focus of black political aspi-
ration, and African Americans have established them-
selves as solid, responsible chief executives in cities in
every part of the country.

REFERENCES

BROWNING, RUFUS, ed. *Racial Politics in American
Cities*. New York, 1990.

CURVIN, ROBERT. The Persistent Minority: The Black
Political Experience in Newark. Ph.D. diss. New-
ark, N.J., 1975.

GREER, EDWARD. *Big Steel: Black Politics and Corporate
Power in Gary, Indiana*. New York, 1979.

KARNIG, ALBERT, and SUSAN WELCH. *Black Represen-
tation and Urban Policy*. Chicago, 1980.

MOSS, LARRY EDWARD. *Black Political Ascendancy in
Urban Centers, and Black Control of the Local Police*.
San Francisco, 1977.

GREG ROBINSON

Mays, Benjamin Elijah (August 1, 1894–March
28, 1984), educator, clergyman. Benjamin Mays was
born in Ninety-Six, S.C., the eighth and youngest
child of Hezekiah and Louvenia Carter Mays. His fa-
ther supported the family as a sharecropper. A year at
Virginia Union University in Richmond preceded
Mays's matriculation at Bates College in Maine, from
which he graduated with honors in 1920. At the Di-
vinity School of the University of Chicago, he earned
an M.A. degree in 1925. Ten years later, while en-
gaged in teaching, social work, and educational ad-
ministration, Mays received a Ph.D. from the Divin-
ity School.

Mays lived in Tampa, Fla., in the early 1920s,
where he was active in social work in the Tampa Ur-
ban League, exposing police brutality and attacking
discrimination in public places. However, higher ed-
ucation soon became his principal vocation. Teaching
stints at Morehouse College in ATLANTA and South
Carolina State College in Orangeburg between 1921
and 1926 put Mays in the classroom as an instructor in
mathematics, psychology, religious education, and
English.

In 1934, with his Ph.D. nearly finished, Mays went
to HOWARD UNIVERSITY in Washington, D.C., as
dean of the School of Religion. He served for six
years, and during that time graduate enrollment in-
creased, the quality of the faculty improved, and its
library was substantially augmented. During his ten-
ure the seminary gained accreditation from the Amer-
ican Association of Theological Schools.

Benjamin E. Mays. (Photographs and Prints Divi-
sion, Schomburg Center for Research in Black Cul-
ture, The New York Public Library, Astor, Lenox
and Tilden Foundations)

Mays's administrative successes at Howard Uni-
versity convinced the trustees of MOREHOUSE COL-
LEGE to elect him in 1940 as the new president of their
institution. He served until 1967. During his tenure
the percentage of faculty with Ph.D.s increased from
8.7 percent to 54 percent and the physical plant
and campus underwent numerous improvements.
One of Mays's proteges at Morehouse was Martin
Luther KING, Jr., who attended the college from
1944—when he entered as a fifteen-year-old—
through 1948. Mays, both by example and personal
influence, helped persuade young King to seek a ca-
reer in the ministry. Mays remained a friend of King
throughout his career, urging King to persevere in
the MONTGOMERY BUS BOYCOTT. In 1965, Mays was
instrumental in the election of King to the More-
house Board of Trustees.

In addition to his activities in higher education,
Mays remained involved in religious affairs. Though
he was active as a pastor for only a few years in the
early 1920s, he became a familiar presence in the af-
fairs of the National Baptist Convention Inc. and in

several ecumenical organizations. In 1944 he became vice president of the Federal Council of Churches of Christ, a national organization of mainline Protestant denominations. In 1948 Mays helped to organize the World Council of Churches (WCC) in Amsterdam, Holland, where he successfully pushed a resolution to acknowledge racism as a divisive force among Christians. When a delegate from the Dutch Reformed Church proposed that an all-white delegation from the WCC investigate apartheid in South Africa, Mays argued convincingly for an interracial team to report on race relations in that country.

Mays was a distinguished scholar of the black church and black religion. In 1930 the Institute of Social and Religious Research in New York City requested Mays and Joseph W. Nicholson, a minister in the Colored Methodist Episcopal Church, to survey black churches in twelve cities and four rural areas. In their study, *The Negro's Church* (1933), they argued that black churches represented "the failure of American Christianity." They found that there was an oversupply of black churches, too many with untrained clergy, and too much indebtedness. These shortcomings deprived the members and the communities that they served of adequate programs to deal with the broad range of social and economic ills they faced. Nonetheless, Mays and Nicholson praised the autonomy of black churches and their promotion of education, economic development, and leadership opportunities for African Americans.

In 1938 Mays produced a second important volume. *The Negro's God as Reflected in His Literature,* a study of how blacks conceptualized God and related the deity to their temporal circumstances. Mays argued that many blacks believed God to be intimately involved in and mindful of their condition as an oppressed group. Even those who doubted or rejected either the notion of God or the social dimension of the deity, Mays argued, were still influenced by their understanding of the social purpose of God. In later years Mays wrote an autobiography, *Born to Rebel* (1971), which was published in an abridged version in 1981 as *Lord, the People Have Driven Me On.*

After his retirement in 1967, Mays won election to the Atlanta Board of Education in 1969. He also became president of that body in 1970.

Mays married twice. His first wife, Ellen Harvin Mays, died in 1923. His second wife, whom he married in 1926, was Sadie Gray Mays. She died on October 11, 1969. In 1982 Mays was awarded the NAACP's SPINGARN MEDAL. Benjamin E. Mays died in Atlanta, Ga., on March 28, 1984.

REFERENCES

CARSON, CLAYBORNE, RALPH E. LUKER, and PENNY A. RUSSELL, eds. *The Papers of Martin Luther King, Jr.* Vol. 1, *January 1929–June 1951.* Berkeley, Calif., 1992.

MAYS, BENJAMIN E. *Born to Rebel.* New York, 1971.

———. *Lord, the People Have Driven Me On.* New York, 1981.

———. *The Negro's God.* Boston, 1938.

MAYS, BENJAMIN E. and JOSEPH W. NICHOLSON. *The Negro's Church.* New York, 1933.

DENNIS C. DICKERSON

Mays, Willie Howard (May 6, 1931–), baseball player. The son of steel-mill worker William Mays and Ann Mays, Willie Mays was born in Westfield, Ala. After his parents divorced soon after his birth, Mays was raised by an aunt in Fairfield, Ala. At Fairfield Industrial High School, Mays starred in basketball, football, and baseball.

At the age of seventeen, he began his professional career, joining the Birmingham Black Barons of the Negro National League. During three seasons with the Black Barons, he played 130 games in the outfield and compiled a batting average of .263. In 1950, he started the season with the Black Barons, but he was soon signed by the New York Giants. Mays played on the Giants' minor league teams until early in the 1951 season, when he joined the major league club. Mays was voted the NL Rookie of the Year, and acquired the nickname "the 'Say Hey' kid" when he forgot a Giants' teammate's name in 1951 and used the phrase.

In 1952 and 1953 Mays served in the U. S. Army, but he returned to baseball in 1954 to play one of his best seasons ever. He led the National League with a .345 batting average and had 41 home runs and 110 runs batted in. Mays led the Giants to the 1954 National League pennant and world championship. In the first game of the World Series with the Cleveland Indians at the Polo Grounds in New York City, Mays made one of the most famous catches in baseball history: With his back to home plate, he ran down Vic Wertz's 440-foot drive to center field, wheeled around, and fired a perfect throw to the infield, thus preventing the Indians from scoring. Mays was named the National League's Most Valuable Player for 1954. He won the award a second time in 1965.

Mays is often considered the most complete ballplayer of the postwar era, if not of all time. He excelled in every aspect of the game. He hit over .300 in ten seasons. His total of 660 career home runs is the third best to date. He was one of the game's great baserunners and a superlative fielder. (His fielding earned him twelve consecutive Gold Gloves, from 1957 to 1968). Mays played in every All-Star game from 1954 to 1973 and in four World Series (in 1951

Returning to the New York Giants in 1954 after two years of military service, Mays responded by hitting .345 with 41 home runs. Equally adept at bat, on the base paths, and in the field, and often thought to be the best all-around player in the history of baseball, Mays capped the season with a celebrated face-to-the-wall catch of a liner by Cleveland's Vic Wertz in the 1954 World Series as the Giants swept the Cleveland Indians in four games. (Photographs and Prints Division, Schomburg Center for Research in Black Culture, The New York Public Library, Astor, Lenox and Tilden Foundations)

and 1954 with the New York Giants; in 1962 with the San Francisco Giants; and in 1973 with the New York Mets).

Because of his formidable abilities, and because of racism, Mays was also the target of an inordinate number of "bean balls"—pitches thrown at the batter's head. However, Mays was one of the first black superstars to receive widespread adulation from white fans. In the 1960s, Mays was among the many black athletes who were criticized for not publicly supporting the CIVIL RIGHTS MOVEMENT. As on most controversial issues, Mays projected a naive innocence when confronted about his political silence.

"I don't picket in the streets of Birmingham," he said. "I'm not mad at the people who do. Maybe they shouldn't be mad at the people who don't."

Mays played with the Giants (the team moved to San Francisco in 1958) until 1972, when he was traded to the New York Mets. The following year he retired as a player but was retained by the Mets as a part-time coach. Mays was inducted into the National Baseball Hall of Fame in 1979. Three months later, he was ordered by Major League Baseball Commissioner Bowie Kuhn to choose between his job with the Mets and fulfilling a public relations contract with the Bally's Casino Hotel. Mays, along with Mickey

Mantle, chose the latter and was banned from any affiliation with professional baseball. In 1985, the new Commissioner, Peter Ueberroth, lifted the ban.

REFERENCE

MAYS, WILLIE, and CHARLES EINSTEIN. *Willie Mays: My Life In and Out of Baseball.* Greenwich, Conn., 1972.

THADDEUS RUSSELL

McBay, Henry Cecil Ransom

McBay, Henry Cecil Ransom (May 29, 1914–), research chemist and educator. McBay was born in Mexia, Texas, the son of William Cecil McBay, a druggist and embalmer, and Roberta (Ransom) McBay, a seamstress. Following his graduation from Paul Laurence Dunbar High School in Mexia, he attended Wiley College in Marshall, Tex., where he planned to prepare for medical school. By the time he finished Wiley in 1934, however, he had decided to go into chemistry. He earned a master's degree in chemistry at Atlanta University in 1936, and saved money for further study by teaching and by working at odd jobs. In 1941, he became the first fellow of the George Washington Carver Research Foundation at Tuskegee, Ala. He earned a Ph.D. in chemistry at the University of Chicago in 1945.

McBay's research on acetyl peroxide, an organic free radical, helped expedite the synthesis of a hormone used in treating prostate cancer. The procedure was patented by his doctoral thesis supervisor, Morris Kharasch, and licensed to Eli Lilly and Company. McBay was one of the few chemists willing to work on acetyl peroxide, which is dangerously explosive under certain conditions.

In 1945, McBay settled into a career of teaching and research at Morehouse College and Atlanta University. While continuing to work with acetyl peroxide and its derivatives, he acquired a reputation as a demanding and effective teacher. He inspired over forty African-American college students to earn doctorates in chemistry. In 1989, a new science building at Morehouse was named for him and two other black scientists.

REFERENCES

MANNING, KENNETH R. "Henry C. McBay: Reflections of a Chemist." In *Massachusetts Institute of Technology Special Symposium to Honor Henry C. McBay, Professor of Chemistry Emeritus, Morehouse College . . . January 23–24, 1991.* Cambridge, Mass., 1991, pp. 15–42.

"Morehouse College and Henry McBay: A Case of Good Chemistry." *Alumnus* (Morehouse College Alumni Magazine) (Fall/Winter 1988–89): 12–13.

PHILIP N. ALEXANDER

McCarroll, Ernest Mae

McCarroll, Ernest Mae (November 29, 1898– February 20, 1990), physician. Born in Birmingham, Ala., E. Mae McCarroll received her B.A. in 1917 from Talladega College, Ala. She then studied physics and chemistry for a time at FISK UNIVERISTY, and in 1925 received an M.D. from Women's Medical College of Pennsylvania.

After an internship at Kansas City General Hospital, McCarroll practiced privately for two years in Philadelphia. In 1929 she married a dentist, Leroy Baxter. The couple moved to Newark, N.J., where McCarroll practiced medicine for forty-four years, maintaining a private office and holding a position with the Newark Department of Health's Venereal Disease Division. In 1939 she was awarded an M.S. in public health from the College of Physicians of Columbia University. In 1946, when World War II had created a shortage of physicians, McCarroll was the first African American appointed to the medical staff at Newark City Hospital. In 1953 she was appointed Deputy Health Officer of Newark. In addition, she was a member of the Board of Trustees and of the Publications Committee of the National Medical Association for many years. She published an article, "Standard Curative Treatment of Early and Late Syphilis" in the *Journal of the National Medical Association* in July 1941. Twenty-two years later, she was featured on the cover of this same journal, the first female physician ever so honored. She served for a time as president of the North Jersey Medical Society, and was a member of the American Medical Association, the American Public Health Association, the League of Women Voters, and many other organizations.

McCarroll's marriage to Leroy Baxter ended in 1939. In 1958 she married Robert E. Hunter. In 1983, some time after Hunter's death, she married Dr. Joseph L. Johnson, a former dean of HOWARD UNIVERSITY's Medical School.

In 1955 McCarroll was honored by the North Jersey Medical Association as its first "General Practitioner of the Year." She retired from practice in 1973. In 1982 her years of public service were remembered by Newark, when the city named its new $4 million public health facility, the Haskins/McCarroll building, in her honor.

REFERENCES

BURSTYN, JOAN B., ed. *Past and Promise: Lives of New Jersey Women.* Metuchen, N.J., 1990.

Sammons, Vivian Ovelton. *Blacks in Science and Medicine.* New York, 1990.

Lydia McNeill

McClane, Kenneth (February 19, 1951–), poet. Kenneth McClane was born in New York City, but his poetic sensibility was formed in three locales: Harlem, his home; Cape Cod, where he was deeply impressed by the ocean; and Ithaca, N.Y., where he entered Cornell University in 1969. His interest in natural phenomena began in a park in Harlem, extended to Cape Cod, and intensified in Ithaca to figure prominently in his prolific poetic output, which began in 1972, and to a certain extent in his autobiographical essays collected in *Walls* (1991).

Take Five: Collected Poems, 1971–1986 (1988) contains poems from his five earlier works and two chapbooks. It shows McClane emerging as an erudite postmodernist neo-romantic poet immersed in the African-American vernacular and African-American and Anglo-European literary traditions. Most of the poems are situated in nature but with a strong pull toward "the city." Their persona's "eye" seeks "logic in the universe," aimed especially at offsetting the disintegrative dualism found in customary thematic linkages of the natural and the man-made. For McClane, nature rightly apprehended reveals its tutelary powers and proffers rectification and healing of personal and social ills in its insistence on a holistic view of things. Beginning with *Moons and Low Times* (1978), which was a nominee for the Lamont Poetry Prize, the poems gradually assimilate the questing nature imagery generated in the poet's earlier efforts to reconcile "woods" and "city," as their progressively unified persona closes in on "the whole." His persistent quest results in poems that issue from a comprehensive intelligence and knowledgeableness, a finely tuned sensibility, an equitable multiculturalism, and a resourceful thematic foregrounding of the complementary localities of nature and society.

McClane began teaching at Cornell University in 1976. In 1983 he was awarded the University's Clark Distinguished Teaching Award; in 1992 he was appointed W. E. B. du bois Professor of Literature.

REFERENCES

Aubert, Alvin. "Variations on a Theme of James Baldwin." Review of *To Hear the River,* by Kenneth McClane. *Callaloo* 4 (1981): 1–3.
———. Review of *Take Five: Collected Poems, 1971–1986. Black American Literature Forum* 23 (1989): 3.

Alvin Aubert

McClendon, Rose (August 27, 1884–July 12, 1936), actress. Rose McClendon was born Rosalie Virginia Scott in Greenville, S.C., the daughter of Sandy and Lena Jenkins Scott. At a young age she moved to New York City, where she attended public schools. McClendon began her acting career in church productions—notably at St. Mark's African Methodist Episcopal Church. In 1904 she married Henry Pruden McClendon, a chiropractor who doubled as a Pullman porter for extra income. Around 1916, she accepted a scholarship from the American Academy of Dramatic Arts in Cargenie Hall. Her first major theatrical role was in *Justice* (1919–1920).

It was McClendon's Broadway appearance in *Deep River* in 1926 that first brought her to the attention of New York critics. She was best known for her serious roles, achieving acclaim for what one contemporary critic called her "serene, silent, queenly" performances. In December of 1926, McClendon starred in Paul Green's Pulitzer Prize–winning play, *In Abraham's Bosom,* for which she was given an award by the *Morning Telegraph.* The following year, she played Serena in Dorothy and Du Bose Heyward's *Porgy,* which ran for over 230 performances in New York. She had significant roles in *The House of Connelly* (1931), *Never No More* (1932), *Black Souls* (1932), *Roll Sweet Chariot* (1934), *Brainsweat* (1934), and *Panic* (1935), among other productions. In her final role, from which she withdrew after catching pleurisy, McClendon starred in Langston hughes's *Mulatto* (1935) the first play by an African American to appear on Broadway.

Throughout her career, McClendon actively encouraged African-American involvement in theater; she served as a board member for the Theatre Union, which governed the Civic Repertory Theatre on West 14th St., and she directed plays for the Harlem Experimental Theater. McClendon and actor Dick Campbell organized the Negro People's Theatre, with the aim of developing "a long line of first-rate [black] actors." In 1935, it was incorporated into the works project administration's Negro Theatre Project. McClendon died of pneumonia in New York City in 1936. After her death, Campbell founded the McClendon Players, a community theater group. In an obituary, a columnist for *Opportunity* called McClendon one "who gave to the American theatre its first real, authentic depiction of the Negro woman."

REFERENCES

Mitchell, Lofton. *Black Drama.* New York, 1967.
Smith, Jessie Carney, ed. *Notable Black American Women.* Detroit, 1992.

Elizabeth Muther

McCone Commission. In response to the violence that erupted in the Watts section of Los Angeles in August 1965 (*see* LOS ANGELES, WATTS RIOT), California Gov. Edmund G. "Pat" Brown established a committee of eight prominent local citizens, chaired by John A. McCone, a former director of the Central Intelligence Agency, to investigate the causes of rebellion and recommend means of preventing further crises. Two of the eight commission members, the Rev. James Edward Jones of the California Board of Education and Superior Court Judge Earl C. Broady, were African American.

The commission's report applied what has been called the "riffraff theory" to explain the violence, laying most of the blame on a minor fraction of the population, caught up in "an insensate rage of destruction," and consisting largely of the urban underclass and recent migrants from the South, frustrated at the lack of opportunity they found in California. While it dismissed the idea that the violence was directed by communists or other external political forces, the commission blamed the activities of a small number of black leaders for escalating the conflict. To combat what it termed the "dull, devastating spiral of failure," the commission recommended new programs to provide jobs and vocational training, an emergency plan to raise the level of scholastic achievement in inner-city schools, and increased funding for public transportation. Although it found the actions of the Los Angeles Police Department and the National Guard appropriate, the report urged that the police department improve its relations with the community through the establishment of a more efficient procedure for addressing citizens' complaints.

The report's conclusions were widely criticized. Writing in dissent, the Rev. James Edward Jones argued that the report relied too heavily on theories blaming Southern migrants and paid too little attention to the ways in which American society fostered the conditions conducive to urban violence. In addition, Jones warned the commission that the right of Americans to protest social injustices must not be ignored. The California Advisory Committee to the U.S. Commission on Civil Rights went further, charging Los Angeles Mayor Samuel Yorty and Police Chief William Parker with gross negligence and calling the McCone report a "whitewash." Civil rights leaders, among them Bayard RUSTIN, argued that the commission's proposed remedies were little more than restatements of old, inadequate programs. In 1968 the National Commission on Civil Disorders, known as the Kerner Commission (*see* KERNER REPORT), challenged the assumptions of the McCone Commission. The Kerner Commission argued that despair and disaffection were widespread in the black community and could be traced to deeply embedded patterns of discrimination.

REFERENCES

California Governor's Commission on the Los Angeles Riots. *Violence in the City—An End or a Beginning?* Los Angeles, 1965.
SEARS, DAVID O., and JOHN B. MCCONAHAY. *The Politics of Violence: The New Urban Blacks and the Watts Riot.* Boston, 1973.

BENJAMIN K. SCOTT

McCoy, Elijah J. (May 2, 1843–October 10, 1929), inventor. Elijah McCoy was born in Colchester, Canada West (now Ontario), the third of twelve children, to former slaves who had fled Kentucky. After attending grammar school, McCoy moved to Scotland, where as an engineer's apprentice he acquired technical training that was hard for blacks to obtain in North America. Moving to Ypsilanti, Mich., after the Civil War, the only railroad work he could find was as a locomotive fireman, despite his background in engineering. His duties led him to consider the limitations in existing lubrication technology. Railroad engines were lubricated only periodically, so they tended to overheat and cause the entire train to stop. Relubrication was awkward and wasted oil, labor, and time.

After two years of experimenting, McCoy developed a "lubricating cup" for steam engines that would, in his words, "provid[e] for the continuous flow of oil on the gears . . . and thereby do away with the necessity of shutting down the machine." His next three patents, issued in 1872, 1873, and 1874, were for improvements on the lubricator. In order to fiance a machine shop to advance his research, McCoy assigned his patents to various companies and individuals. While this enabled him to work continuously on his own inventions and assured him due credit, it meant that almost all of the profits made from his machines went to others. McCoy was only a minor stockholder in the Elijah McCoy Manufacturing Company of Detroit.

In 1883 McCoy designed a lubricating device to be used with air pump brakes. Previously, oil had been depleted in the brakes whenever the steam was cut off. McCoy placed an additional lubricator on top of the brake cylinder, assuring a continuous flow of oil into the system. The patent for this device, known as the hydrostatic oil lubricator, was assigned to the Hodges Company of Detroit. In 1892 McCoy introduced a system that soon lubricated most locomotive engines in the West and those on steam ships of the Great Lakes. He also experimented with solid lubri-

After years of working on trains, Elijah J. McCoy developed and patented numerous improvements in the lubrication of railroad cars and founded the Elijah McCoy Manufacturing Company. (Photographs and Prints Division, Schomburg Center for Research in Black Culture, The New York Public Library, Astor, Lenox and Tilden Foundations)

cants, such as graphite, which, when applied to machine gears, enabled them to glide smoothly over one another.

By the time of his death in 1929 in Eloise, Mich., McCoy held over fifty-eight patents, including a folding iron table and an automatic sprinkler and was known as the "father of lubrication." Many believe that his reputation for quality and authenticity was the source for the phrase "the real McCoy," but conclusive evidence for its origins is lacking.

REFERENCES

HABER, LOUIS. *Black Pioneers of Science and Innovation.* New York, 1970.

JAMES, PORTIA. *The Real McCoy: African American Invention and Innovation, 1619–1930.* Washington, D.C., 1989.

ALLISON X. MILLER

McCrummill, James (?–c. 1867), abolitionist. Born a free black in Virginia, probably in the early years of the nineteenth century, James McCrummill moved to Philadelphia, where he worked as a barber and dentist. McCrummill also made a living as a printer, publishing the *Philadelphia Elevator.*

McCrummill was one of the founders of the National Negro Convention movement, organized in Philadelphia in 1830 to protest the colonization movement, which met annually through 1835. McCrummill was active in the ABOLITION movement and worked closely with William Lloyd Garrison, serving as one of the first agents for the LIBERATOR (1831–1865).

In 1833, McCrummill, along with Robert PURVIS and James G. BARBADOES, was one of three blacks to serve as delegates to the convention to establish the AMERICAN ANTI-SLAVERY SOCIETY, a racially integrated group formed in Philadelphia by Garrison to launch a renewed attack on slaveholding, the colonization movement, and discrimination against free blacks. McCrummill was one of the sixty-two signers of the society's Declaration of Sentiments, drafted by Garrison at McCrummill's home, and he served on the society's board of managers in 1834 and 1835. McCrummill was active in other antislavery societies as well, including the Female Anti-Slavery Society of Philadelphia, founded in 1833, and the Philadelphia Young Men's Anti-Slavery Society, founded in May of 1836.

In 1836, McCrummill was chosen as a delegate to the founding convention of the AMERICAN MORAL REFORM SOCIETY and served on the society's board of managers. He was one of three founding members of Philadelphia's Vigilance Committee, organized in 1837 to aid black fugitives in the city, and he served as its president until 1839. He also was elected as a delegate to the State Convention of Colored Citizens of Pennsylvania that convened in Harrisburg in 1848 to devise a plan for regaining the franchise for the state's blacks. In 1855 McCrummill coauthored *Memorial of Thirty Thousand Disenfranchised Citizens of Philadelphia to the Honorable Senate and House of Representatives,* deploring the lack of rights allowed blacks in Pennsylvania.

During the 1850s, McCrummill remained active in the struggles against slavery and colonization. Though little is known about his later years, he was elected in 1865 to the executive committee of the National Equal Rights' League. He died in the Philadelphia area around 1867.

REFERENCES

QUARLES, BENJAMIN. *Black Abolitionists.* New York, 1969.

WINCH, JULIE. *Philadelphia's Black Elite: Activism, Accommodation, and the Struggle for Autonomy, 1787–1848.* Philadelphia, 1988.

LOUISE P. MAXWELL

LYDIA McNEILL

McDaniel, Elias. *See* Diddley, Bo.

McDaniel, Hattie (June 10, 1895–October 26, 1952), singer and actress. Hattie McDaniel was born in Wichita, Kans. Her father, Henry McDaniel, was a Baptist preacher and an entertainer, and her mother, Susan (Holbert) McDaniel, was a choir singer. McDaniel was one of thirteen children. Soon after her birth the family moved to Colorado, and in 1901 they settled in Denver. In 1910, at the age of fifteen, she was awarded a gold medal by the Women's Christian Temperance Union for excellence in "the dramatic art" for her recital of "Convict Joe," which reportedly "moved the house to tears." On the strength of this success, McDaniel persuaded her family to allow her to leave school and to join her brothers in her father's newly formed traveling company, the Henry McDaniel Minstrel Show. Over the next decade she traveled and performed on the West coast, mostly with her father's company, and she began at this time to develop her abilities as a song-writer and singer.

Around 1920 McDaniel came to the notice of George Morrison, one of Denver's notable popular musicians. Taken on as a singer with Morrison's orchestra, McDaniel became increasingly well known throughout the West coast vaudeville circuit. She also appeared with the orchestra on Denver radio during this time, and she is reputed to be the first black woman soloist to sing on the radio. In 1929 she secured a place with a traveling production of *Show Boat,* but the stock market crash of October 1929 (*see* GREAT DEPRESSION) eliminated the show's financing.

After the crash, McDaniel moved to Milwaukee, where she worked in the coat room of the Club Madrid and eventually got an opportunity to perform. Encouraged by her success, McDaniel moved to Hollywood in 1931 and soon began working regularly in radio and film. Over the course of the next two decades she appeared in more than three hundred films, though mostly in minor, uncredited roles. Her debut was in *The Golden West* (1932). The first film for which she received screen credit was *Blonde Venus* (1932), in which she played the affectionate, loyal, but willful domestic, a type character that was virtually the only role available at the time to large black women in Hollywood. Over the course of the next two decades McDaniel successfully established herself in this role, gaining substantial, credited parts in over fifty films, including *Alice Adams* (1935), *The Mad Miss Manton* (1935), *Show Boat* (1936, with Paul ROBESON), *Affectionately Yours* (1941), *Since You Went Away* (1944), and Walt Disney's animated *Song of the South* (1946).

McDaniel's career reached its high point in 1939 when she won an Academy Award, the first ever

Fay Bainter presents Hattie McDaniel (left) with the 1939 Academy Award for Best Supporting Actress for her role in *Gone with the Wind.* (AP/Wide World Photos)

given to a black performer, for her portrayal of Mammy in *Gone with the Wind*. Praised by some and maligned by others for the image she portrayed, McDaniel in her Oscar acceptance speech (said to have been written by her studio) announced that she hoped always to be a credit to her race and to her industry. Despite Hollywood's evident self-satisfaction with this award, it is important to note that McDaniel (along with the other black cast members) had been excluded from the Atlanta premiere of the film and that her portrait was removed from the promotional programs that the studio distributed in the South.

McDaniel continued to play similar roles throughout the 1940s despite increased criticism from the NAACP, which felt that McDaniel and the other black actors who played servile stereotypes were helping to perpetuate them. In 1947, after the controversy with the NAACP had passed, McDaniel signed her first contract for the radio show *Beulah,* in which she once again played a southern maid. In the contract McDaniel insisted that she would not use dialect, and she demanded the right to alter any script that did not meet her approval. Both of her demands were met.

McDaniel died in Los Angeles in 1952, after completing the first six episodes of the television version of *Beulah.*

REFERENCE

JACKSON, CARLTON. *Hattie: the Life of Hattie McDaniel.* Boston, 1990.

MATTHEW BUCKLEY

McElroy, Colleen J.

McElroy, Colleen J. (October 30, 1935–), poet and fiction writer. Colleen McElroy was born in St. Louis, Mo., and educated at Kansas State University, where she received a B.S. degree (1958) and an M.A. degree (1963). After beginning a career in speech pathology, McElroy went on to get a Ph.D. in cultural linguistics and language arts from the University of Washington at Seattle in 1973. That same year, she joined its faculty as an assistant professor of English and was named full professor in 1983.

McElroy published her first collection of poetry, *The Mules Done Long Since Gone,* in 1972. Seven more volumes of her poems have since been published, including *Queen of the Ebony Isles* (1984) and *Bone Flames* (1987), both of which won prizes. Her early poetry, shaped by childhood memories of southern racism, addressed questions of race and gender. Her later writings, especially *What Madness Brought Me Here* (1990), evinced a more international perspective on social issues, but also revealed a bleaker vision of life.

McElroy's first compilation of short stories, *Jesus and Fat Tuesday,* appeared in 1987, and her second, *Driving Under the Cardboard Pines,* in 1990. Set in black, midwestern towns, they were somber, like her later poetry, featuring ordinary women trying to cope and create a community in tough situations.

The author of numerous scripts for educational television programs and films, McElroy has written two plays: *Follow the Drinking Gourd* and, with Ishmael REED, *The Wild Gardens of the Loup Garou.* Colleen McElroy has received many prizes and awards for her work, including the Pushcart: Best of Small Presses Award in poetry (1976), a National Endowment for the Arts Creative Writing Fellowship (1978), and a Fulbright Creative Writing Fellowship (1988).

REFERENCES

BROUGHTON, IRV, ed. *The Writer's Mind: Interviews with American Writers.* Vol. 3. Fayetteville, Ark., 1990, pp. 39–67.
GOMEZ, JEWELLE. "Homeward Bound." *Kenyon Review* 13, no. 4 (Fall 1991): 226–230.

RENEE TURSI

McFerrin, Robert, Jr., "Bobby"

McFerrin, Robert, Jr., "Bobby" (March 11, 1950–), jazz vocalist. Bobby McFerrin was born in New York City, the son of two distinguished opera singers, Sara and Robert MCFERRIN. He began his musical studies on piano at the preparatory division of the Juilliard School of Music, in New York City, and later studied at California State University, in Sacramento. Before attending college, he played piano in several local bands in Fullerton, Calif. Beginning in 1977, McFerrin concentrated on singing. His repertory is eclectic, ranging from the Top 10 hit "Don't Worry, Be Happy" (1988) to jazz classics like "'Round Midnight."

McFerrin's ability to emulate jazz giants like Miles DAVIS and Wayne SHORTER in his vocal improvisations was the most important factor contributing to his winning a 1984 and 1985 *Downbeat* "Best Male Vocalist" poll. He also received the 1985 and 1986 Grammy Award for "Best Male Jazz Vocalist." Since 1983, McFerrin's vocal improvisations have focused on timbre differences, a musical repertory that encompasses classical, jazz, and popular genres, and a vocal range that extends over three octaves. In addition, he likes to involve his audience in improvised performance, and uses a variety of vocal and body-percussion sounds in his recordings and live perfor-

mances. In unaccompanied songs, McFerrin performs all the musical parts, in a multilayered texture.

McFerrin has organized an a cappella vocal group entitled "Voicestra," a group that ranges from eight to fourteen voices. The group generates its musical ideas from melodies, harmonies, and rhythms that are fed to it by McFerrin. McFerrin has explored many performance avenues. He has recorded *Hush* (1992), an album with classical cellist Yo-Yo Ma, and in 1990 McFerrin made his conducting debut with the San Francisco Symphony. His most successful albums include *Simple Pleasures* (1988), *Medicine Man* (1990), and *Hugs* (1992).

REFERENCES

AITKEN, G. "Bobby McFerrin: Expect the Unexpected." *Jazz Educators Journal* 20:1 (October/November 1987): 12–14.

POTTER, J. "Bobby McFerrin: The Unpredictable Voice." *Jazz Times* (December 1985): 11.

EDDIE S. MEADOWS

McFerrin, Robert, Sr. (March 19, 1921–), baritone. McFerrin was born in Marianna, Ark., but grew up in St. Louis, where he received his early musical education singing in the choir of his father's church and attending public school. He studied at FISK UNIVERSITY (1940–1941); at the Chicago Musical College, where he received his bachelor of music degree (1948); and at the Kathryn Turney Long School in New York (1953). During the 1940s and early 1950s, McFerrin sang in Broadway productions in New York, including musical theater performances of *Lost in the Stars* (1949), *The Green Pastures* (1951), and *My Darlin' Aida* (1952). He also performed with several opera companies, including the national Negro Opera Company and the New England Opera Company. With the New York City Opera Company, he performed in William Grant STILL's *Trouble Island* (1949). In 1953, he was a national winner in the Metropolitan Opera auditions. When he made his debut with the Metropolitan Opera as Amonasro in *Aida* (1955), McFerrin was the first black male hired as a member of the company. He sang with the Met until 1957 and performed in ten operas during three seasons.

McFerrin is best remembered for his performances of Orestes in Gluck's *Iphigenia in Taurus* and Tonio in Leoncavallo's *I Pagliacci*. In 1959, he sang the title role of Porgy on the soundtrack for the film of George and Ira Gershwin's *Porgy and Bess*. In the 1960s, McFerrin resettled in St. Louis, where he opened a private studio and taught at a local commu-

nity college. He continued to perform professionally throughout the 1970s with orchestras, in oratorios, and as a recitalist. Throughout his career he taught at institutions as diverse as the Sibelius Academy in Helsinki, Finland (1959), the New School of Fine Arts in British Columbia (1961), and Roosevelt University in Chicago (1976–1977). Although McFerrin suffered a stroke in the 1980s, he continued to perform. In the late 1980s and early 1990s he sang occasionally at St. Louis University, and in 1993 he performed at Washington University in a concert honoring Marian ANDERSON. McFerrin was featured on the album *Medicine Man* (1990) in a duet with his son Bobby MCFERRIN, who is an internationally acclaimed pop and jazz singer.

REFERENCES

CLEATHAM, WALLACE. "Black Male Singers at the Metropolitan." *Black Perspective in Music* (Spring 1988): 3–19.

DE LERMA, DOMINIQUE-RENÉ. "McFerrin, Robert." *The New Grove Dictionary of American Music,* vol. 3. New York, 1986, p. 147.

SOUTHERN, EILEEN. *Biographical Dictionary of Afro-American and African Musicians.* Westport, Conn., 1982, p. 258.

A. LOUISE TOPPIN

McGhee, Walter Brown "Brownie" (November 30, 1915–), blues guitarist. A self-taught guitarist from a musical family, Brownie McGhee was born in Knoxville, Tenn. and left home at eighteen. He played in medicine shows and juke joints for six years, his wanderlust undeterred by the polio that had left him lame. He first recorded in 1939, and his style was often compared to that of Blind Boy Fuller. After Fuller's death, McGhee was briefly billed as Blind Boy Fuller No. 2.

Moving to New York in the early 1940s, McGhee began to collaborate with Sonny TERRY. The two lived with blues singer Huddie "Leadbelly" LEDBETTER, joined the blues/fold music scene, and performed with the Woody Guthrie Singers. In 1948, McGhee founded a blues guitar school in Harlem, Brownie McGhee's Home of the Blues. In the 1950s, he appeared in films and in such plays as Tennessee Williams's *Cat on a Hot Tin Roof* (1954) and Langston Hughes's *Simply Heavenly* (1957). In the 1960s, he and Sonny Terry were prominent in the blues and folk music revival, touring widely in the United States and in Europe. His partnership with Terry was often disrupted by disagreements, and McGhee pursued his own career as a session guitarist for electric blues bands. However, he and Terry rejoined to per-

form together in the 1970s and '80s. In June 1982 McGhee was one of the fifteen artists named to receive the first National Heritage Fellowships awarded by the National Endowment for the Arts.

REFERENCES

McGHEE, BROWNIE, and HAPPY TRAUM. *Guitar Styles of Brownie McGhee*. New York, n.d.

OLIVER, PAUL. *Blues Off the Record: Thirty Years of Blues Commentary*. New York, 1984.

ERNEST BROWN

McGuire, George Alexander (March 26, 1866–November 10, 1934), clergyman. George Alexander McGuire was the founding prelate of the AFRICAN ORTHODOX CHURCH (AOC), a black nationalist religious body associated with the GARVEY movement. He was born in Sweets, Antigua, and was educated in a Moravian Seminary on St. Thomas, Danish West Indies (now the U.S. Virgin Islands). After serving as pastor of a Moravian church on St. Croix, he came to the United States in 1893. McGuire was ordained as an Episcopal clergyman in 1897. He served in several historic black Episcopal churches, in Cincinnati, Richmond, Va., and Philadelphia, where he worked in St. Thomas African Episcopal Church, the oldest black Episcopal parish in the United States. He was named Archdeacon for Colored Work in the Diocese of Arkansas in 1905.

While in Arkansas, McGuire was influenced by the "Arkansas Plan" of his white superior, Bishop William Montgomery Brown, which called for the exclusion of blacks from the Episcopal Church and the establishment of a separate black denomination. McGuire gradually came to agree that separation was essential for African-American religious independence and self-esteem. In 1909, he moved to St. Bartholemew's Church in Cambridge, Mass., to serve a congregation of West Indians excluded from white churches. The church grew rapidly, but was denied self-supporting status by the diocese, and McGuire left in 1911. He spent two years as Field Secretary of the American Church Institute for Negroes in New York City, then returned to Antigua, where he served as an Anglican rector and as a medical doctor.

It is not clear how McGuire and Marcus Garvey first came into contact, but following the rise of Garvey's UNIVERSAL NEGRO IMPROVEMENT ASSOCIATION (UNIA), McGuire visualized an allied religious movement in the episcopal tradition, with himself at its head. He returned to the United States in 1919, and joined the Reformed Episcopal Church in 1920. In August 1920, after McGuire made a stirring speech

in favor of black religious autonomy at the UNIA convention, the UNIA elected him its Chaplain-General and titular Archbishop of Ethiopia. McGuire saw this as a call to organize a church and began ordaining priests. Garvey did not wish to alienate UNIA members of other denominations, however, and in July the UNIA officially rejected the idea of creating a church or religious movement.

McGuire resigned from the UNIA and established the AOC in September. Desiring a source of legitimacy for his "Church Ethiopic," McGuire sought consecration to make him a bishop in the apostolic succession. Following rejection by the mainstream churches, he was consecrated by Joseph René Vilatte, a Catholic "wandering bishop" whose orders may have been valid but were certainly irregular. McGuire spent considerable time over the next years defending the legitimacy of the AOC and its episcopacy.

Meanwhile, having split from the UNIA, McGuire temporarily joined Cyril BRIGGS's rival AFRICAN BLOOD BROTHERHOOD. In 1923 he was reconciled with Garvey and resumed UNIA activities. At the 1924 convention, he spoke against blacks worshiping a Caucasian deity and advocated the creation of images of a black Christ and Madonna. The AOC grew rapidly, but peaked at some 6,000 members, many of Caribbean origin. It expanded to Africa, where its cultural and religious nationalism attracted an extremely large membership. McGuire provided statesmanlike leadership of the denomination he founded until his death in New York in 1934.

REFERENCE

NEWMAN, RICHARD. "The Origins of the African Orthodox Church." *The Negro Churchman: The Official Organ of the African Orthodox Church*. Millwood, N.Y., 1977.

RICHARD NEWMAN

McIntyre, Diane (c. 1936–), dancer, teacher, choreographer. Diane McIntyre was born in Cleveland, Ohio, where she studied dance from childhood. She continued her training at Ohio State University. She moved to New York City in 1970; among the dancers she studied and worked with were such avant-garde dancers as Viola Farber, Alwin Nikolais and Company, and Gus SOLOMONS. In the early 1970s, she formed her own company, Sounds in Motion, in which she put the sounds of jazz music and spoken poetry into dance. She used movement, music, and voices in a contemporary modern dance context. Touring extensively throughout the United States and Europe, Sounds In Motion performed

McIntyre's most important pieces, including *Lost Sun* (1973), *Deep South Suite* (1976), and *Journey to Forever* (1977).

McIntyre has choreographed for theater productions in New York and London, and her dances are in the repertories of the Alvin AILEY American Dance Theater, Dayton Contemporary Dance Company, and other dance ensembles. She was honored with a 1989 "Bessie" (New York Dance and Performance Award); in 1990 she was granted a prestigious three-year Choreographer's Fellowship from the National Endowment for the Arts; and in 1953, she received the Helen Hayes Award for Outstanding Theater Choreography.

McIntyre's career has been marked by her resilience, resolve, and choreographic curiosity. In 1991, she premiered a vibrant and painstakingly researched reconstruction of Helen Tamiris' 1937 work *How Long Brethren?*, a socially militant dance drawing on African-American themes. As she matures, McIntyre's choreographic interests keep expanding, renewing respect for herself as an innovative interpreter of the African-American experience.

REFERENCES

EMERY, LYNNE FAULEY. *Black Dance from 1619 to Today*. 2nd rev. ed. Princeton, N.J., 1988.

LONG, RICHARD. *The Black Tradition in American Dance*. 1989.

KIMBERLY PITTMAN

A powerful poet and novelist, Jamaica-born Claude McKay was one of the first major figures to emerge in the Harlem Renaissance. (Prints and Photographs Division, Library of Congress)

McKay, Claude (September 15, 1889–May 22, 1948), poet and novelist. Claude McKay was the child of independent small farmers. In 1912 he published two volumes of Jamaican dialect poetry, *Songs of Jamaica* and *Constab Ballads*. They reflect the British imperial influences of his youth and reveal that the rebellion that characterized McKay's American poetry lay in both his Jamaican experience and his later experience of white racism in the United States. His Jamaican poetry also contains early versions of his pastoral longing for childhood innocence and his primal faith in the self-sufficiency and enduring virtues of the rural black community of his childhood and youth.

McKay left Jamaica in 1912 to study agriculture at Tuskegee Institute and Kansas State University, but in 1914 he moved to New York City, where he began again to write poetry. In 1919, he became a regular contributor to the revolutionary literary monthly the LIBERATOR, and he achieved fame among black Americans for his sonnet "If We Must Die," which exhorted African Americans to fight bravely against the violence directed against them in the reactionary aftermath of World War I. Although expressed in traditional sonnet form, McKay's post–World War I poetry heralded modern black expressions of anger, alienation, and rebellion, and he quickly became a disturbing, seminal voice in the HARLEM RENAISSANCE of the 1920s. His collected American poetry includes *Spring in New Hampshire and Other Poems* (1920) and *Harlem Shadows* (1922).

The years between 1919 and 1922 marked the height of McKay's political radicalism. In 1922 he journeyed to Moscow, where he attended the Fourth Congress of the Third Communist International, but his independence and his criticisms of American and British Communists led to his abandonment of communism. In the 1930s, he became a vocal critic of international communism because of its anti-democratic dominance by the Soviet Union.

From 1923 until 1934, McKay lived in western Europe and Tangiers. While abroad, he published three novels—*Home to Harlem* (1928), *Banjo* (1929), and *Banana Bottom* (1933)—plus one collection of

short stories, *Gingertown* (1932). In his novels, McKay rebelled against the genteel traditions of older black writers, and he offended leaders of black protest by writing in *Home to Harlem* and *Banjo* of essentially leaderless rural black migrants and their predicaments in the modern, mechanistic, urban West. Both were picaresque novels that celebrated the natural resilience and ingenuity of "primitive" black heroes. To McKay's critics, his characters were irresponsible degenerates, not exemplary models of racial wisdom; black critics accused him of pandering to the worst white stereotypes of African Americans.

In *Gingertown* and *Banana Bottom*, McKay retreated to the Jamaica of his childhood to recapture a lost pastoral world of blacks governed by their own rural community values. Although critics still debate the merits of McKay's fiction, it provided encouragement to younger black writers. *Banjo,* in particular, by stressing that blacks should build upon their own cultural values, influenced the founding generation of the Francophone NÉGRITUDE MOVEMENT.

In 1934, the Great Depression forced McKay back to the United States, and for the rest of his life he wrote primarily as a journalist critical of international communism, middle-class black integrationism, and white American racial and political hypocrisy. He continued to champion in his essays working-class African Americans, who he believed understood better than their leaders the necessity of community development. He published a memoir, *A Long Way from Home* (1937), and a collection of essays, *Harlem, Negro Metropolis* (1940), based largely on materials about Harlem folk life he collected as a member of New York City's Federal Writers Project. In 1944— ill, broke, and intellectually isolated—he joined the Roman Catholic church, and spent the last years of his life in Chicago working for the Catholic Youth Organization.

Although he is best known as a poet and novelist of the Harlem Renaissance, McKay's social criticism in the 1930s and 1940s was not negligible, but it was controversial, and has since remained hard to grasp because he was neither a black nationalist, an internationalist, nor a traditional integrationist. He instead believed deeply that blacks in their various American ethnicities had much to contribute as ethnic groups and as a race to the collective American life, and that in the future a recognition, acceptance, and celebration of differences between peoples—and not simply individual integration—would best strengthen and bring together the American populace.

REFERENCES

COOPER, WAYNE F., ed. *The Passion of Claude McKay: Selected Poetry and Prose, 1912–1948.* New York, 1973.

————. *Claude McKay: Rebel Sojourner in the Harlem Renaissance: A Biography.* Baton Rouge, La., 1987.
GILES, JAMES R. *Claude McKay.* Boston, 1976.

WAYNE F. COOPER

McKayle, Donald (July 6, 1930–), dancer, choreographer, teacher. Inspired by a Pearl PRIMUS performance, New York–born Donald McKayle began dancing in his senior year in high school, winning a scholarship to the New Dance Group. There he studied with Primus, Sophie Maslow, Jean Erdman, and others. He made his professional debut in 1948, and choreographed his first pieces with the New Dance Group when he was eighteen years old. In 1951, he, along with Daniel Nagrin and others, founded the Contemporary Dance Group, which premiered McKayle's *Games* in 1951. Perhaps his best-known piece, *Games*, juxtaposes the innocent imaginings of urban children with the real dangers they face. McKayle received a scholarship to the Martha Graham school and then joined her company from 1955–1956. In addition to his work with Graham, he danced with Merce Cunningham, Anna Sokolow, and Charles Wiedman, among others. A free agent, McKayle danced as a guest artist with various companies, as well as in Broadway musicals.

But McKayle's central focus was always choreography, and though he was a well-known choreographer, he never maintained a permanent company. He choreographed for other companies or assembled dancers as he needed them for specific concert seasons; two popular examples are *Rainbow 'Round My Shoulder* (1959) and *District Storyville* (1962), both in the repertory of the AILEY company.

Successful in the worlds of dance and theater, McKayle created dances for concert stages, Broadway, television, and film. His Broadway credits include *Golden Boy* (1964), *I'm Solomon* (1969), *Raisin* (1974), and *Dr. Jazz* (1975); he was also one of the four choreographers for *Sophisticated Ladies* (1981). Beginning in 1963, McKayle choreographed for television programs about once a year, including "The Ed Sullivan Show" (1966–1967), "The Bill Cosby Special" (1968), the 1970 Oscar presentations, and the Marlo Thomas special "Free To Be You and Me" (1974). He created dances for films in *The Great White Hope* (1970), Disney's *Bedknobs and Broomsticks* (1971), and *Charlie and the Angel* (1972). In the field of popular music, he has choreographed stage acts for singers such as Harry Belafonte and Tina Turner.

McKayle's sensibilities were formed by the theatrical dance of the 1950s. A humanistic choreographer, he uses narratives and deals with potent emo-

tion conveyed through dramatic characters. At times his stories are specific to the African-American experience, as in his protest dance *Rainbow 'Round My Shoulder*, but his choreography is universal in its implications.

McKayle has taught at Bennington College, the Juilliard School, the American Dance Festival, and in Europe. His closest associations are with the repertory group at the Los Angeles Inner City Cultural Center and with the School of Dance at the California Institute of the Arts, to which he was appointed artistic director in 1975. As a prolific craftsman whose dances exist in many repertories and in many mediums, Donald McKayle has been one of the most influential African-American choreographers of the postwar era.

REFERENCES

EMERY, LYNNE FAULEY. *Black Dance From 1619 to Today*. 2nd rev. ed. Princeton, N.J., 1988.
HASKINS, JAMES. *Black Dance in America*. 1990.
LONG, RICHARD. *The Black Tradition in American Dance*. 1989.

KIMBERLY PITTMAN

McKinney, Nina Mae (June 12, 1912 or 1913–May 3, 1967), actress, dancer, and singer. Nina Mae McKinney was born in Lancaster, S.C., and moved to New York City when she was twelve to live with her parents. A self-taught dancer, McKinney won the lead of Chick in King Vidor's all-black film *Hallelujah* (1929) while dancing in the chorus line of Lew Leslie's musical revue "Blackbirds of 1928." With her striking film debut, McKinney became at seventeen the first black sex symbol of cinema. She was quickly signed to a five-year contract with Metro-Goldwyn-Mayer (MGM), but only two films resulted: *Safe in Hell* (1931) and *Reckless* (1935). McKinney's roles in both films were disappointingly small, reflecting Hollywood's inability or unwillingness to feature black actresses in leading parts. She appeared in a number of independent black cast films during this time, including *Pie, Pie Blackbird* (1932) with Eubie BLAKE, though none of these films were widely distributed.

In contrast, McKinney received a warm welcome on her arrival in Europe in December 1932, where she was billed as the "Black Garbo." Accompanied by her pianist Garland Wilson, she sang in nightclubs and cafes throughout the Continent during the 1930s. In England, she starred opposite Paul Robeson in the film *Sanders of the River* (1935), and for a brief time the two were lovers. In 1940, McKinney returned

permanently to the United States, where she married Jimmy Monroe, a jazz musician, and toured the country with her own band. She continued to act in independently produced black-cast films during this time, including *Gang Smashers* (1938), *The Devil's Daughter* (1939), and *Mantan Messes the Nicholas Brothers Up* (1946). During the 1940s she appeared in supporting roles in two more Hollywood films, *Night Train to Memphis* (1946) and *Pinky* (1949). Her last appearance on stage was in the Broadway play *Rain* (1951), after which she retired. McKinney died in New York City on May 3, 1967. In 1978, she was inducted into the Black Filmmakers Hall of Fame.

REFERENCES

BOGLE, DONALD. *Blacks in American Films and Television*. New York, 1988.
BOURNE, STEPHEN. "Nina Mae McKinney." *Films in Review* 42 (January–February 1991): 24–28.
DUBERMAN, MARTIN. *Paul Robeson*. New York, 1989.

SARAH M. KEISLING

McKinney, Roscoe Lewis (February 8, 1900–September 30, 1978), anatomist. Roscoe McKinney was born in Washington, D.C., in 1900, the son of Lewis Bradner McKinney, an employee of the U.S. Printing Office, and Blanche Elaine Hunt McKinney. A 1917 graduate of Dunbar High School, he earned a bachelor's degree at Bates College in 1921 and a Ph.D. in anatomy at the University of Chicago in 1930. His doctoral thesis, a study of fibers in tissue culture, was published in a major German scientific journal.

At Chicago, McKinney worked on various projects in tissue culture under the Russian histologist Alexander A. Maximow. When Maximow died in 1928, McKinney helped complete Maximow's histology textbook. This work, *A Textbook of Histology*, went into several editions and became a standard reference source for medical students. McKinney's contribution, acknowledged in the preface, included preparation of the figures and manuscript for publication.

McKinney served as professor of anatomy and department head (1930–1947) and as vice dean of the HOWARD UNIVERSITY School of Medicine (1944–1946). He maintained an active research program despite a heavy administrative and teaching load. Although he did not publish widely, he worked on several projects in tissue culture, microcinematography, radioactive isotopes in cells and tissues, and the origin and development of connective tissue *in vitro*. He retired from Howard with emeritus rank in 1968,

but continued to teach there (1968–1969, 1971–1976). His career also took him overseas. He served two years as professor of microscopic anatomy at the Royal Iraq Medical College in Baghdad (first as a Fulbright fellow in 1955 and 1956, then on the invitation of the Iraqi government in 1956 and 1957. He taught under the auspices of the U.S. State Department at Osmania Medical College, Hyderabad, India (1960–1962), and was a consultant in anatomy to the medical faculty, University of Saigon (1969–1971).

McKinney was a member of the American Association for the Advancement of Science, American Association of Anatomists, and Tissue Culture Association. He died in 1978.

REFERENCES

"McKinney, Roscoe Lewis." In *National Cyclopedia of American Biography*, 62, Clifton, N.J., 1984, p. 28.

McKinney, Roscoe L. "Studies on Fibers in Tissue Culture. III. The Development of Reticulum into Collagenous Fibers in Cultures of Adult Rabbit Lymph Nodes." *Archiv für experimentelle Zellforschung besonders Gewebezüchtung* 9 (1929): 14–35.

KENNETH R. MANNING

McKinney-Steward, Susan Maria Smith

(1847–March 7, 1918), physician. Susan McKinney-Steward was born in Brooklyn, N.Y., the daughter of Sylvanus Smith, a pig farmer, and his wife, Anne (Springsteel). A serious student of the organ in her youth, she taught music for two years in Washington, D.C., before entering the New York Medical College for Women in 1867. She graduated with an M.D. in 1870, the third African-American woman to earn this degree (after Rebecca LEE in 1864 and Rebecca COLE in 1867). In 1887–1888, she was the only woman in the postgraduate course at the Long Island College Hospital.

McKinney-Steward began her practice in Brooklyn in 1870, developing an interracial clientele and becoming, according to one report, "the most successful practitioner of medicine of her sex or race in the United States." In 1881, she helped organize the Brooklyn Woman's Homeopathic Hospital and Dispensary and served on its staff until 1895. She was also physician to the Brooklyn Home for Aged Colored People. Her first husband, the Rev. William Guillard McKinney, died in 1895, and a year later she married the Rev. Theophilus Gould Steward, a U.S. Army chaplain. She traveled extensively with Steward, practicing in Montana, Nebraska, and perhaps

Susan McKinney-Steward graduated from the New York Medical College for Women in 1870, making her the first black female doctor in New York State. In her later life she was also active in the suffrage and temperance movements. (Photographs and Prints Division, Schomburg Center for Research in Black Culture, The New York Public Library, Astor, Lenox and Tilden Foundations)

briefly in Texas (1906). She was employed as school physician at WILBERFORCE UNIVERSITY in Xenia, Ohio, almost continuously (except for periods away with her husband) from 1898 until her death.

A community leader and organizer, McKinney-Steward was active in the women's suffrage and temperance movements. In 1892, she helped lay the groundwork for the first black women's club in New York, the Women's Loyal Union of New York and Brooklyn. At the Interracial Conference in London in 1911, she spoke on "Women in Medicine in the United States" and on "Colored Women in America."

REFERENCE

SERAILE, WILLIAM. "Susan McKinney-Steward: New York State's First African-American Woman Physician." *Afro-Americans in New York Life and History* 9 (July 1985): 27–44.

PHILIP N. ALEXANDER

McKissick, Floyd B. (March 9, 1922–April 28, 1991), civil rights activist. Floyd McKissick was born in Asheville, N.C., on March 9, 1922. His father, Ernest Boyce McKissick, worked as a bellhop and was committed to providing his son with educational opportunities to ensure him a better economic future. After serving in the Army during World War II, McKissick attended MOREHOUSE COLLEGE and graduated from North Carolina College (now North Carolina Central University) with a bachelor of arts degree in 1951. He became the first African-American student to attend the University of North Carolina Law School at Chapel Hill after NAACP lawyer Thurgood MARSHALL successfully filed suit on his behalf. Subsequently, McKissick challenged segregation laws by filing suits to gain admission for his five children into all-white schools.

McKissick had taken part in civil rights activism that was spreading throughout the South as early as 1947 when he challenged segregated interstate travel laws by participating in the Journey of Reconciliation sponsored by the Fellowship of Reconciliation (FOR), a pacifist organization committed to integration. In 1960, McKissick established a legal practice in Durham, N.C., and became a key legal advisor for the CONGRESS OF RACIAL EQUALITY (CORE)—an interracial civil rights organization that grew out of FOR. McKissick served as legal advisor for CORE and often defended CORE activists who had been arrested for civil disobedience. He played a central role in organizing the Durham chapter of CORE and was appointed head of the chapter in 1962.

As time progressed, McKissick and other black activists in CORE, who had faced unyielding southern white violence and become increasingly disillusioned with white liberalism, began to question the integrationist goals of the movement. McKissick's disillusionment was fueled by the harassment that his children had faced in the "integrated" school setting that he had fought so hard to place them in. Influenced by the rising tide of black nationalism that characterized the BLACK POWER movement, he led the call for black economic empowerment and black control over black institutions within CORE. By 1966, when he replaced James FARMER as national director,

Floyd McKissick in early 1966, shortly after he became national director of CORE. (AP/Wide World Photos)

McKissick had become a militant advocate of Black Power and steered CORE toward black economic development and a repudiation of interracialism. Two years later, he was replaced as national director by Roy INNIS.

After leaving CORE, McKissick established his own consulting firm, Floyd B. McKissick Enterprises, to promote his philosophy of black capitalism. In 1969, he authored *Three-Fifths of a Man,* a book that suggested a combination of nationalist strategies and government assistance to assist African Americans economically. He led a Ford Foundation project to help African Americans attain positions of responsibility in the cities where they were approaching a majority of the population. In culmination of these efforts, McKissick founded the "Soul City" Corporation in Warren County, N.C. (an area just south of the Virginia border), in 1974. His aim was to create a community in which African Americans would have political and economic control that could serve as a prototype for the creation of other black-controlled cities and, eventually, states. However, outside funding was cut and the city was not able to attract enough business to become self-sufficient. By June 1980 all of the corporation's property and assets—except eighty-eight acres of the project which

contained the headquarters—were taken over by the federal government.

McKissick remained active in public life. He began a successful law firm, called McKissick and McKissick (with his son Floyd McKissick, Jr.) in Durham, N.C., served as pastor of Soul City's First Baptist Church, and in 1990 was appointed District Court Judge for North Carolina's ninth district by Gov. Jim Martin. The following year, McKissick, who had been suffering from lung cancer, died in his Soul City home on April 28, 1991.

REFERENCES

MEIER, AUGUST, and ELLIOT RUDWICK. *CORE: A Study in the Civil Rights Movement, 1942–1968.* New York, 1973.

VANDEBURG, WILLIAM. *A New Day in Babylon: The Black Power Movement and American Culture, 1965–1975.* Chicago, 1992.

ROBYN SPENCER

McLean, John Lenwood, Jr., "Jackie" (May 17, 1932–), alto saxophonist and composer. Born in New York City, Jackie McLean grew up in Harlem, the son of a jazz guitarist and the stepson of a record-store owner. He began to play alto saxophone at the age of fifteen. He was at first much influenced by the tenor saxophone tone of Lester YOUNG and was considered a child prodigy, studying and practicing with many of the rising giants of bebop, including Charlie PARKER, Thelonious MONK, Bud POWELL, Sonny ROLLINS, and Kenny Drew. McLean made his first recordings in 1951 with Miles DAVIS, soloing on "Bluing" and "Dig," and eventually recorded as a leader in 1955. By this time he had gained renown as a fluent, aggressive hard-bop soloist who also possessed a sensitive, lyrical side. From 1955 to 1958 he played for short periods with pianists Paul Bley and George Wallington, and for longer periods with Art BLAKEY's Jazz Messengers and Charles MINGUS, who gave McLean extended solos on "Love Chant" and "Pithecanthropus Erectus," and wrote "Portrait of Jackie" for him. Monk also wrote a song, "Jackie-ing," about McLean, who himself composed "Dr. Jackle," which became a jazz standard.

In the late 1940s, McLean became a heroin addict. He was arrested in 1957 and was thereafter denied the cabaret card required in order to perform in New York City nightclubs. Nonetheless, in the late 1950s he began developing a more modal, exploratory style, evident on *New Soil* and *Jackie's Bag* (both 1959). In 1959–1960, McLean was player and actor in Jack Gelber's Off-Broadway drama about drug use,

The Connection, and he later appeared in the film version, as well as recording the sound track. From 1960 to 1963 McLean toured Germany and Belgium with his own group, and recorded *Bluesnik* (1961), *Let Freedom Ring* (1962), *One Step Beyond* (1963), and *Destination Out* (1963), albums that featured his raw tone and proved enormously influential to the developing avant-garde jazz movement.

A turning point in McLean's life came in 1967, when he kicked his drug habit and recorded *New and Old Gospel* with Ornette COLEMAN on trumpet. McLean became a drug counselor for the New York State Department of Corrections and began teaching at the University of Hartford in Connecticut. In 1971 he joined the faculty of the university's Hartt School of Music and helped found its African-American Music Department; he also started the Artists' Collective, a cultural center in Hartford's inner city. During this time McLean settled into a more conventional playing style, though he retained his commanding tone and recorded *The Meeting* with Dexter GORDON (1973), *Antiquity* (1974), and duets with pianist Michael Carvin; he also led the Cosmic Brotherhood, a musicians' collective that included his son René, also a saxophonist. He recorded *New Wine in Old Bottles* (1978), *It's About Time* (with McCoy Tyner, 1985), and *Rhythm of the Earth* (1992). McLean, the subject of a 1982 documentary, *Jackie McLean on Mars,* continues to teach at Hartford, and frequently performs at jazz festivals in Europe and Japan.

REFERENCES

JESKE, LEE. "Jackie and René McLean." *Downbeat* 1, no. 9 (1983): 53.

SPELLMAN, A. B. *Four Lives in the Bebop Business.* New York, 1971.

WILMER, VALERIE. *Jazz People.* 1970. Revised. New York, 1985.

RON WELBURN

McMillan, Terry (October 18, 1951–), novelist and short story writer. The eldest of five children, Terry McMillan was born in Point Huron, Mich., where she spent much of her adolescence in a household headed by her mother. At seventeen, she left Point Huron for Los Angeles, and in 1978 received a bachelor's degree in journalism from the University of California at Berkeley. While she was at Berkeley, author and teacher Ishmael REED convinced her to pursue a career in writing. She left California to pursue a master's degree in film at Columbia University, but she left there in 1979 still several credits short of the degree to join the HARLEM WRITERS GUILD.

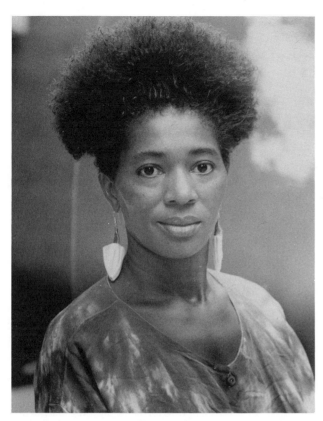

Novelist Terry McMillan at the time of the publication of her novel *Disappearing Acts* in 1989. (AP/Wide World Photos)

The first story McMillan read aloud to the guild became the opening chapter of her first novel, *Mama* (1987), which thrust her into prominence. A semi-autobiographical work, *Mama* earned critical praise for its depiction of one woman's struggle to provide for her family during the 1960s and 1970s. The success of the novel is largely due to its realistic, gritty portrayal of Mildred's attempts to cope with the care of five children single-handedly at the age of twenty-seven. McMillan established her reputation further in the genre of the popular novel through her second novel, *Disappearing Acts* (1989). In *Disappearing Acts,* McMillan continues to present strong African-American characters in a New York City setting. The work is a love story that manages to address numerous issues facing many urban African-American communities. The love story of Zora and Franklin becomes a vehicle for an exploration of the complex issues of class and culture that affect relationships between black professionals and working-class partners.

McMillan's third novel, *Waiting to Exhale* (1992), became a bestseller within the first week of its release. Though this novel deals with many African-American themes, McMillan's treatment of male-female relationships in a gripping narrative ensures a wide readership. The novel centers on the friendships among four African-American women in Phoenix, Ariz., and how each of them looks for and hides from love. McMillan's tough, sexy style clearly has a wide appeal; the paperback rights for *Waiting to Exhale* were auctioned in the sixth week of its hardcover publication for $2.64 million.

The commercial success of *Waiting to Exhale* has confirmed for some critics the belief that McMillan is more a writer of potboilers than she is a serious novelist. But McMillan, who lives in the San Francisco Bay area, hopes her success will open doors for other African-American writers. To this end, in 1991 McMillan edited *Breaking Ice: An Anthology of Contemporary African-American Fiction,* which includes short stories and book excerpts by fifty-seven African-American writers, ranging from well-known to new voices.

REFERENCES

Awkward, Michael. "Chronicling Everyday Travails and Triumphs." *Callaloo* 2, no. 3 (Summer 1988): 649–650.
Edwards, Audrey. "Terry McMillan: Waiting to Inhale." *Essence* (October 1992): 77–78, 82, 118.

Amritjit Singh

McNair, Ronald Erwin (October 21, 1950–January 28, 1986), astronaut. Ronald McNair became the first African-American scientist-astronaut to go into space when he orbited the earth in February 1984 as a crew member aboard the space shuttle *Challenger.* Two years later, on January 28, 1986, McNair was killed when the *Challenger* exploded at the start of what would have been his second mission as a scientist in space exploration.

Born and raised in Lake City, S.C., McNair was the second of three sons born to Pearl M. McNair, an elementary school teacher, and Carl C. McNair, an auto mechanic. Born into a segregated society of the American rural South, he faced and overcame barriers set by racial segregation and low-quality schools. When his high school did not have the supplies needed for laboratory experiments, he brought common household chemicals from home to help him complete his studies. He graduated as valedictorian from George Washington Carver High School in Lake City in 1967.

Upon graduation, he received a college scholarship from the state of South Carolina. His academic interest was physics, but none of the black state colleges in South Carolina offered degrees in the field or in engineering. Rather than admit a black student to

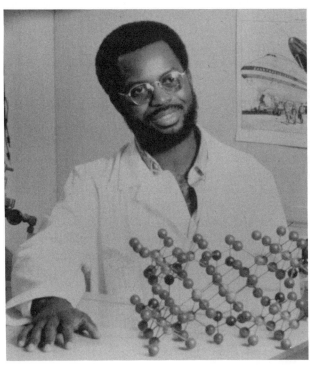

Ron McNair, 1978 (© Gene Daniels/Black Star)

a white school, South Carolina granted him funds to attend college in another state where he could study physics. As a result he attended the predominately black North Carolina Agricultural and Technical State University. At college he began the study of karate, which became a principal extracurricular activity for him.

In 1976 McNair received a doctorate in physics from the Massachusetts Institute of Technology (MIT) for his research in laser physics. His connections with MIT began early in 1970, when he was in his junior year at North Carolina Agricultural and Technical State University and took part in an exchange program between MIT and a consortium of ten historically black colleges. After graduating with a B.S. degree in physics *magna cum laude,* he entered MIT in the fall of 1971. Throughout his years of graduate study at MIT, he held a Ford Foundation Fellowship, and in 1975 he also received a traveling fellowship from the North American Treaty Organization, which he used to study laser physics at the French Institute for Theoretical Physics at Les Houches.

After graduating from MIT, McNair became a staff physicist with Hughes Research Laboratories in Malibu, Calif. He learned that NASA was seeking scientists as astronaut candidates who could manage scientific experiments in space. In January 1978 he was selected by NASA from among 8,000 applicants as one of 35 new astronauts. By August 1979 he had completed a one-year training course and became eligible for a space assignment. Four years of additional study, training, and preparation followed before he received his first assignment in 1983. In February 1984 he was mission specialist astronaut aboard the *Challenger.* In February 1986, the building that houses MIT's Center for Space Research was named after McNair.

REFERENCES

Ebony. May 1986, pp. 82–84, 88, 90, 92, 94.
CLENDINEN, DUDLEY. "Two Paths to the Stars: Turnings and Triumphs—Ronald McNair." *New York Times,* February 9, 1986, p. 1.

ROBERT C. HAYDEN

McNeil, Claudia (August 13, 1917–), actress. Born in Baltimore, Md., Claudia McNeil's most famous role was Lena Younger in the play and subsequent film *A Raisin in the Sun* (1959, 1961). While still a teenager, McNeil began a singing career at the Black Cat, a Greenwich Village nightclub. Eventually she toured as a vocalist in "Hot from Harlem" with Bill "Bojangles" ROBINSON and in Katherine DUNHAM's dance troupe. McNeil's acting break came when Langston HUGHES invited her to audition for his play *Simply Heavenly* (1957); she became a Broadway star. Her other credits include *Winesburg, Ohio* (1958), *A Member of the Wedding* (1958, television), *Tiger, Tiger Burning Bright* (1962, Tony Award nomination), *Nurses* (1963, Emmy Award nomination), *The Amen Corner* (1965), *Contribution* (1970), *To Be Young, Gifted, and Black* (1972), and *Raisin* (1981).

REFERENCE

MAPP, EDWARD. "Claudia McNeil." In *Directory of Blacks in the Performing Arts.* Metuchen, N.J., 1990.

SARAH M. KEISLING

McPhatter, Clyde Lensley (November 15, 1932–June 13, 1972), rhythm and blues singer. Born in Durham, N.C., Clyde McPhatter grew up in Teaneck, N.J., and went on to found the Drifters, one of the greatest of the early ROCK AND ROLL vocal groups. McPhatter, the son of a Baptist minister, formed a GOSPEL singing group, the Mount Lebanon Singers, in his early teens. By the age of eighteen he was performing with Bill Ward and his Dominoes, a pioneering RHYTHM AND BLUES vocal group. McPhatter's reputation grew during his three years with the Dominoes, particularly due to their recording of "Have Mercy, Baby," and by the time he

formed the Drifters in 1953 he was poised for success. Although the personnel of the group underwent some changes in its early days, the most important original members were McPhatter, Billy Pinkney, Andrew Thrasher, and Gerhart Thrasher. The group, whose gospel-influenced close harmonies complemented McPhatter's emotionally charged tenor began producing hit records almost immediately. They recorded "Seven Days," "Treasure of Love," "Without Love," "A Lover's Question," "Money Honey," "Honey Love," "White Christmas," "Bip Bam," "Such a Night," and "Lucille" before McPhatter entered the air force in 1954. After McPhatter's departure, the Drifters continued performing and recording, eventually completely changing their personnel. Under the leadership of Ben E. King the group recorded such hits as "There Goes My Baby" (1959), "Save the Last Dance for Me" (1960), and "This Magic Moment" (1960). Rudy Lewis led the Drifters on "Up On The Roof" (1963), and Johnnie Moore led them on "Under the Boardwalk" (1964).

After his discharge from the air force in 1955, McPhatter embarked on a solo career. His single recordings, including "Lover Please" (1962), sold well, and he recorded the albums *Rhythm and Soul* (1963) and *Live at the Apollo* (1965). However, McPhatter never again matched the brief but extraordinary successes of 1953–1954. He moved to England in 1968, and returned to the U.S. in 1970, when his residency papers expired. That year he recorded a final album, *Welcome Home*. McPhatter died in 1972 in Teaneck, N.J., of a heart attack. In 1987 McPhatter was posthumously inducted into the Rock 'n Roll Hall of Fame, and in 1993 his image appeared on a U.S. postage stamp. The group McPhatter formed, the Drifters, continued to record and perform, although with different personnel, into the 1980s.

REFERENCES

GOLDBERG, M., and M. REDMOND. "Drifters Discography." *Record Exchange* 4, no. 2 (1974): 14.

MILLAR, B. *The Drifters: The Rise and Fall of the Black Vocal Group*. New York, 1971.

JONATHAN GILL

McPherson, James Alan (September 16, 1943–), writer. Born in Savannah, Ga., James McPherson is the son of James A. McPherson, an electrician, and Mabel Smalls McPherson, a domestic. He attended Morris Brown College and received a law degree from Harvard University and an M.F.A. in creative writing from the Iowa Writers Workshop. Between academic years he worked as a dining car waiter. All of McPherson's fiction is in short story form. In 1978 he won a Pulitzer Prize for the collection *Elbow Room*. He received a Guggenheim Fellowship for 1972–1973 and a MacArthur Prize Fellowship in 1981.

While many African-American writers in the BLACK ARTS MOVEMENT were denouncing Euro-American influences in literary expression, preferring to write out of an aesthetic that emblazoned black rage and injury, McPherson chose to portray instances in American life where African Americans were as quickly exploited by other blacks as by whites. In stories like "Of Cabbages and Kings," "Private Domain," "Hue and Cry," "The Silver Bullet," and "Widows and Orphans," African-American characters, because of their delusions, self-hatred, or rage, throw off their old identities only to find that a newer, more comfortable identity is difficult to assume. In their turn they often victimize those with whom they come in contact.

In a story entitled "Why I Like Country Music," McPherson challenges the notion of an exclusively white culture by utilizing a narrator who recalls a square dance and a youthful crush experienced during a southern upbringing, both of which symbolize the blackness of country music. In stories like "A Solo Song: For Doc" (thought by many to be a masterwork), "The Story of a Scar," and "The Story of a Dead Man," McPherson makes use of African-American folklore and oral storytelling, working out, as Ralph Ellison did in *Invisible Man*, the tension between upward mobility and self-discovery.

McPherson's fiction manifests his desire to present the contradictions in American life, with class warfare, political debacles, and scandal serving as a complex set of possibilities. He is deeply concerned with the intricacy and intensity of American identity politics, and so his stories often explore the madcap attempts to establish a set of rules that are ever changing. His work speaks of the "delicious ironies" that seem to point to despair but that finally "beget heroic hope, absurd hope, mad hope."

REFERENCE

McPHERSON, JAMES ALAN. "On Becoming an American Writer." *Atlantic Monthly*, December 1978.

HERMAN BEAVERS

McQueen, Thelma "Butterfly" (1911–), actress. Born in Tampa, Fla., Thelma McQueen grew up in New York City and Augusta, Ga. She began her acting career in New York as part of Venezuela Jones's Theater Group for Negro Youth, appearing

as part of the Butterfly Ballet in *A Midsummer Night's Dream*. From this ballet she earned the nickname Butterfly. In 1937 she made her Broadway debut in *Brown Sugar*, then went on to appear in other shows, including *What a Life* and *You Can't Take It with You*.

McQueen is best known for her Hollywood debut as the silly maid Prissy in *Gone with the Wind* (1939). McQueen was aware of the stereotypical nature of the role and worked successfully to lessen the offensive nature of the role, refusing, for example, to eat watermelon on camera. She was similarly reluctant to deliver her notorious line, "Lawdy, Miz Scarlett . . . I don't know nuthin' 'bout birthin' babies," feeling it was demeaning. McQueen played a variety of similar roles during the following years, in such films as *Duel in the Sun* (1945) and *Mildred Pierce* (1946), as well as in the independently produced, all-black film *Killer Diller* (1948). She also acted in radio and television roles. However, McQueen was so frustrated by being typecast in stereotypical black servant roles that in 1947, after walking out of the *Jack Benny Show*, she quit acting for a year, and in the 1950s gave up acting entirely. For some years she worked in factories and as a waitress; eventually she opened her own restaurant in Augusta, Ga., where she also ran a radio talk show.

In 1968 McQueen made a well-publicized and well-received return to acting when she appeared in the off-Broadway play *Curly McDimple*. In 1972 she returned to school, and in 1976, at the age of sixty-four, McQueen received her bachelor's degree from the City College of New York. Beginning in 1978, she toured in a one-woman nightclub act. She also wrote, produced, and starred in a bilingual play tribute to Mary McLeod BETHUNE. Although she occasionally appeared in films such as *Mosquito Coast* (1986), during the 1980s and early 1990s McQueen was deeply involved in teaching drama to African-American and Latino children in projects at the Marcus Garvey Mount Morris Welfare Center and P.S. 153 in the Bronx.

REFERENCES

BOGLE, DONALD. *Blacks in American Film and Television: An Illustrated Encyclopedia*. New York, 1988.

HINE, DARLENE CLARK, ed. *Black Women in America*. New York, 1993.

EVAN A. SHORE

McRae, Carmen (April 8, 1922–November 10, 1994), jazz singer. Born in New York City, Carmen McRae studied piano as a child and won an APOLLO THEATER amateur night contest as a pianist-singer.

She began her singer career with Benny CARTER's orchestra in 1944. In 1948 she began performing regularly in Chicago, where she lived for nearly four years before returning to New York. By 1952 she was the intermission pianist at Minton's in Harlem, a birthplace of bebop (*see* JAZZ). Married briefly to bop drummer Kenny CLARKE, she made her first records under the name Carmen Clarke. Influenced by both Billie HOLIDAY and Sarah VAUGHAN, she was named "best new female singer" by *Downbeat* in 1954, after which she signed a recording contract with Decca Records, for whom she recorded until 1959. Following a move to Los Angeles in the 1960s, McRae made recordings for a number of different labels including Columbia, Mainstream, Atlantic, Concord, and Novus.

McRae remained an active presence on the international jazz scene, appearing regularly at clubs and festivals until May 1991, when she withdrew from public performance because of failing health. She is one of the important singers who integrated bebop into her vocal style, combining bop phrasing and inflection with sensitivity for the lyrics and dynamics of her material. Among her notable recordings are collections of songs associated with other jazz greats including Billie Holiday (released in 1962), Nat "King" COLE (1984), Thelonious MONK (1991), and Sarah Vaughan (1991). She died at her home in Beverly Hills Calif., after suffering a stroke.

REFERENCE

GIDDINS, GARY. *Rhythm-a-ning: Jazz Tradition and Innovation in the 80s*. New York, 1985.

BUD KLIMENT

Meachum, John Berry (May 3, 1789–February 19, 1854), businessman, minister. Born a slave in Virginia, the son of a Baptist slave preacher, John Berry Meachum was apprenticed to a carpenter and barrelmaker at an early age. By hiring out his labor, he eventually earned enough money to buy his freedom. He then moved to Kentucky, where he married an enslaved African-American woman. In 1815, after his wife's master moved to Missouri, Meachum followed. He saved enough to buy his wife and children, and the family settled in St. Louis.

Once in St. Louis, Meachum entered the profession of barrelmaking. A devout Baptist, he also became active in religious affairs. In 1818 he became an assistant to John Mason Peck, a white Baptist minister, and taught Sunday school for black worshipers. After 1822 the black congregation, with Meachum at

its head, became increasingly autonomous, and ultimately sought independence.

In 1825, following his ordination by Peck as a Baptist minister, Meachum established the First African Baptist Church, located at Third and Almond Streets, the first black Baptist church west of the Mississippi River. Meachum set up temperance and missionary societies, and he and Peck operated a clandestine day school in defiance of Missouri's ban on black education, until they were discovered and the school was closed. Meachum remained as pastor for thirty-eight years, and in 1853 he helped form the Western Colored Baptist Convention.

Meanwhile, Meachum's business affairs prospered. Beginning in the late 1820s, he operated a thriving barrel factory, and staffed it with enslaved black workers, to whom he taught the trade and who bought their freedom by their wages. In this way, Meachum liberated at least twenty African Americans. He also owned two brick houses, an Illinois farm, and two steamboats (which he ran as alcohol-free "temperance steamboats"), in all reputedly worth over $25,000. In 1847, following passage of a state law forbidding blacks to learn how to read, Meachum set up a "School for Freedom" on one of his steamboats, which he moored in the middle of the Mississippi River, technically outside Missouri jurisdiction. Meachum ferried students to and from class every day in a skiff.

In his last years, Meachum, a dedicated abolitionist, became increasingly pessimistic about the possibilities for free blacks in the United States. He endorsed the efforts of the AMERICAN COLONIZATION SOCIETY to resettle blacks in Africa and began organizing a mission to Liberia. He died of a heart attack in February, 1854, while preaching in the pulpit of his church.

REFERENCE

MOORE, N. WEBSTER. "John Berry Meachum: St. Louis Pioneer, Black Abolitionist, Educator, and Preacher." *Bulletin of the Missouri Historical Society* (January 1973): 96–103.

GREG ROBINSON

Medical Associations. These professional organizations of physicians—whose goals are to promote the science and art of medicine and to improve the public health—serve as major components of the health-care infrastructure in the United States. Medical associations have as their mission the establishment and maintenance of a scientifically rigorous, occupationally specific, professional educational training and standards; defining medical ethical codes of practice and behavior; and establishing internal mechanisms for evaluating, disciplining, and sanctioning physicians on technical and ethical grounds. This professional authority is grounded in a culture-based belief in science and medicine, and the general acceptance of medical progress as a perceived public good. In the United States, the influence of the medical association grew tremendously after the nineteenth century. Organized medicine gained the authority to write most of the nation's public-health and medical-licensing laws; to control its medical-education system; to guide its local, regional, and national health policy; and to influence public attitudes about health.

The country's health system is burdened with a history of racial and medical-social problems. Examples include an increasing health-system apartheid based on race and class, and the unequal state of the nation's medical associations. The American Medical Association (AMA) is the better-known medical professional association. It is influential, wealthy, and largely white, and represents the country's traditional health interests. Since its founding in 1847, it has become the anchor and focal point of American organized medicine. African-American physicians and patients, and other medically poor and disadvantaged groups, are represented by the less well known, largely minority National Medical Association (NMA), which was founded in 1895. These two medical associations' policies, ideologies, and perspectives are startlingly different.

The Western medical profession originated from Egyptian, Sub-Saharan African, and Mesopotamian roots. Early unsuccessful attempts to establish medicine as a profession were based on an increasingly specialized body of knowledge, spiritual authority related to medicine's early ties with religious and priestly functions, and the taking of an oath. During the Renaissance the European medical profession became a highly prestigious, university-affiliated "calling," which gained formal professional recognition by the sixteenth century. The first professional associations began in Italy in the Middle Ages, and memberships were built around the faculties of early medical schools. As this practice spread northward, the English physician Thomas Linacre obtained what may have been the first official charter for a medical association. At his request, King Henry VIII of England granted a charter for the College of Physicians in 1518. Other European nations followed this precedent.

In comparison, American medicine gained professional status, authority, and prestige only in the nineteenth century. The low status of the medical professional was demonstrated by the late formation of

stable, functional professional associations and the absence of medical-licensing laws until the late nineteenth century. Despite the emergence of a few well-trained black physicians before the Civil War, such as James McCune SMITH, John Sweat ROCK, and Martin Robison DELANY, the professional exclusion of African Americans was a routine aspect of American medical subculture (see HEALTH AND HEALTH CARE PROVIDERS).

After the institutionalization of the Atlantic slave trade in the fifteenth and sixteenth centuries, the participation of blacks as health care–givers in Western-oriented slave-based cultures was restricted to the functions of traditional healers, root doctors, and granny midwives. They worked in an inferior, slave-based health subsystem that matured in the New World. African-American attainment of formal Western MEDICAL EDUCATION in this era was virtually unknown. After the Civil War, the country's medical profession helped strengthen a dual and unequal health system. The inferior lower tier was reserved for blacks and the poor; the compelling health needs of the newly freed slaves, and their already poor and deteriorating health status, were virtually ignored by the profession. White medical associations and their infrastructure continued to exclude African Americans from training and participation in the medical profession. These policies generated an African-American health crisis after the Civil War. The alarming black death rates and the health outcomes that resulted led to emergency passage of legislation enacting the Freedmen's Bureau health programs and the opening of race-, gender-, and class-neutral medical schools. The first of the sixteen multiracial medical schools in America was at HOWARD UNIVERSITY of Washington, D.C. (founded in 1868), and the second was Meharry Medical College of Nashville, Tenn. (founded in 1876). The subsequent development of a cadre of black health professionals (this included physicians, dentists, nurses, pharmacists, and allied health professionals) had salutary effects on the health status of African Americans and increased their access to high-quality health and hospital care. The African-American health professionals produced by the black schools functioned as the sole professionally trained advocates for black health progress; started sorely needed black hospital, clinic, and health-professional-training movements; organized medical associations; and offered the African American community access to the most up-to-date medical care.

Beginning in the 1870s, black physicians began efforts to correct the AMA's exclusionary and discriminatory racial policies. Howard University's racially integrated medical school faculty struggled unsuccessfully to desegregate the AMA at local levels, through litigation and by means of pressure from the U.S. Congress, in a campaign lasting several years. These actions pressured white organized medicine to declare racial segregation as its official national policy by 1872. In frustration, black physicians, dentists, and pharmacists established more than fifty local, state, and regional black medical associations organized around the NMA by the 1920s. The NMA is now a multicomponent national organization representing approximately 15,000 physicians. The earliest desegregated medical professional associations were the National Medical Society of the District of Columbia (1870), the Academy of Medicine (1872), and the State Colored Medical Association in Nashville, Tennessee (1880). African-American health-professions associations became permanent fixtures with the founding of the Medical Chirurgical Society of the District of Columbia in 1884, the Lone Star State Medical Association in Galveston, Tex., in 1886, and the NMA in Atlanta, on November 18, 1895.

The Civil War dramatically exposed the inadequacies of America's medical-education system. Therefore, a great deal of pressure was generated within the white medical profession and by the AMA for medical-education reform. This reform era, lasting from the late nineteenth century through the 1920s, focused on rigorous scientific standards and technology, bedside clinical training, higher entry requirements, and the limitation of physician supply.

The AMA and the corporate-based educational infrastructure closed six of the eight extant black health-professions schools between 1910 and 1923 and underfunded the remainder. This resulted from an educational reform movement led by Abraham Flexner, an educational consultant hired by the Carnegie Foundation and the AMA to coordinate an upgrading of the nation's medical schools, based on European models. Throughout the "Flexner era," the NMA fought vigorously, but unsuccessfully, to improve and maintain existing entry points for African Americans into the health professions. Flexner reform adversely impacted black health status and outcomes, cut African-American access to basic services, and decreased black representation in the health professions. Though Meharry and Howard were forced to serve as virtually the sole sources of black health-care personnel from 1910 to 1970 on shoestring financing, they were also excluded from the stewardship white medical schools were obtaining over America's government and city hospitals and clinics. Control of these institutions provided clinical training bases critical to the new accreditation processes and requirements. Yet the racially segregated health system supported the survival of the remaining black health-professions schools. The NMA was crucial in

maintaining the accreditation and financing of these schools and allied hospitals and health facilities. Despite vigorous campaigns by the NMA, black representation in the medical profession in America has remained tenuous, ranging between 2 percent and 3 percent of physicians since the turn of the twentieth century.

From its beginnings, the NMA was forced to function as a civil rights organization. It has worked in concert with the NAACP, the National Urban League, and many other black civil rights and service organizations to further the cause of African-American health concerns. This was a natural development, since African Americans are the only racial or ethnic group forced to view health care as a civil rights issue. On several levels, the NMA's policies represent a positive response to the AMA's traditional policies of racial segregation, massively funded campaigns against progressive health-care legislation, health discrimination based on race and class, and insensitivity to the health status, needs, and concerns of the nation's African-American, poor, and other underserved patient populations. The NMA has been singular at both the community and national levels in supporting progressive healthcare legislation—from before the Wagner Plan in the 1930s through Medicare and Medicaid in 1965 to a fair national health plan in the 1990s. The NMA continues its history-based struggle to end race and class discrimination in the health system, to form a socially responsible covenant between the medical profession and American society, and to obtain justice and equity in health care for African Americans.

REFERENCES

BULLOUGH, VERN L. *The Development of Medicine as a Profession: The Contribution of the Medieval University to Modern Medicine.* New York, 1966.

BYRD, W. MICHAEL. "Race, Biology, and Health Care: Reassessing a Relationship." *Journal of Health Care for the Poor and Underserved* 1 (1990): 278–296.

———. *A Black Health Trilogy* [videotape and learning package]. Nashville, Tenn., 1991.

BYRD, W. MICHAEL, and LINDA A. CLAYTON. "The 'Slave Health Deficit': Racism and Health Outcomes." *Health/PAC Bulletin* 21 (1991): 25–28.

CASH, P. "Pride, Prejudice, and Politics." *Harvard Medical Alumni Bulletin* 54 (1980): 20–25.

COBB, W. MONTAGUE. "The Black American in Medicine." *Journal of the National Medical Association* 73 (1981, Supplement 1): 1183–1244.

GREENBERG, DANIEL S. "Black Health: Grim Statistics." *Lancet* 355 (1990): 780–781.

HEALTH POLICY ADVISORY CENTER. "The Emerging Health Apartheid in the United States." *Health/PAC Bulletin* 21 (1991): 3–4.

KONALD, DONALD E. *A History of American Medical Ethics, 1847–1912.* Madison, Wis., 1962.

LUNDBERG, GEORGE D. "National Health Care Reform: An Aura of Inevitability Is Upon Us." *Journal of the American Medical Association* 265 (1991): 2566–2567.

MORAIS, HERBERT M. *The History of the Negro in Medicine.* New York, 1967.

W. MICHAEL BYRD

Medical Committee for Human Rights. During the late 1950s and early 1960s the CIVIL RIGHTS MOVEMENT gained momentum throughout the American South. Groups of black and white physicians and other health workers in the North began developing formal organizations to challenge discrimination in medical care of their local cities, as well as to assist with the southern voter-registration protests breaking out in the deep South. In 1964 the Medical Committee for Human Rights (MCHR) was started by a group of New York City physicians responding to an urgent appeal by civil rights organizations in Mississippi. Small groups of these physicians, along with nurses and medical students, began regular trips to Mississippi.

In the South, MCHR members provided medical assistance to local communities and civil rights groups involved in the FREEDOM SUMMER projects. The northern health workers learned firsthand of the climate of racial hatred that had culminated with brutal killings of three young civil rights workers—James CHANEY, Andrew Goodman, and Michael Schwerner. Indeed, when these youths' bodies were discovered months after their murders, it was the MCHR which sponsored their autopsies to keep the "Mississippi story" in the national limelight.

The major objectives of the MCHR were to: (1) give medical aid to civil rights workers; (2) provide a "medical presence" at demonstrations and marches to minimize physical attacks against marchers; (3) mobilize health professionals to become more supportive of the civil rights movement; and (4) raise financial contributions for civil rights activities and organizations. MCHR personnel served as observers and medical aides during the famous march from Selma to Montgomery, Ala., which occurred in March 1965.

By the summer of 1965 there were local branches of the MCHR in eight major cities. In addition to nurses and medical students, MCHR membership grew to include dentists and psychologists. Prominent leaders or sponsors of the MCHR included John L. S. Holloman, Jr., Leslie A. Falk, Paul CORNELY, Benjamin Spock, and Walsh McDermott. Its first na-

tional chairman was the African-American physician Aaron O. Wells of New York City.

In later years the MCHR also became a tool against discrimination in health care throughout northern locales. Its members were involved in starting health programs for children living in urban poor neighborhoods, protesting discriminatory practices in local hospitals, and supporting programs to attract minority youth to medical fields. At its peak, the MCHR entailed local groups in some thirty cities. But by the mid-1970s, when federal government initiatives in health and welfare for the black poor, north and south, underwent explosive growth, the MCHR activities waned. Still the MCHR left a legacy of medical activism within the recurrent civil rights movement that has yet to be matched in contemporary American history.

REFERENCES

AUSTER, S. L., and T. LEVIN. "Special Reports on Selma." *American Journal of Orthopsychiatry* 35 (1965): 972–980.

FALK, L. A. "The Negro American's Health and the Medical Committee for Human Rights." In R. H. Elling, ed. *National Health Care: Issues and Problems in Socialized Medicine.* Chicago, 1971.

KOTELCHUK, B., and H. LEVY. "The Medical Committee for Human Rights." In A. Reed, Jr. *Race, Politics and Culture: Critical Essays on the Radicalism of the 1960s.* Westport, Conn., 1986.

MCBRIDE, DAVID. *From TB to AIDS: Epidemics Among Urban Blacks Since 1900.* Albany, N.Y., 1991.

MORAIS, HERBERT. *The History of the Negro in Medicine.* New York, 1968.

DAVID MCBRIDE

Medical Education. African Americans had little opportunity to study conventional medicine as practiced in the United States until after EMANCIPATION. Most free blacks living in the antebellum North who practiced the healing arts were self-taught; several earned wide reputations, like James STILL and hydropath David RUGGLES (hydropaths used water for therapeutic purposes). Other African-American Northerners—for example, Martin R. DELANY, John S. ROCK, David J. PECK, John V. De Grasse, and James McCune SMITH—managed to obtain more standard training through the apprentice system and/or at a handful of medical schools, including Bowdoin College in Maine, the University of Glasgow in Scotland, Rush Medical School in Chicago, and the Eclectic Medical School in Philadelphia. Harvard University's medical school admitted

three black students (Martin Delany, Daniel Laing, Jr., and Isaac H. Snowden) along with one white female student (Harriot Kezia Hunt) as a trial in 1850, only to dismiss them at the end of the term when school authorities ran into trouble with unhappy and irate white male students. Those blacks who practiced medicine in the antebellum South, either openly or clandestinely, were necessarily educated less formally. They gained their knowledge from experience, from mistresses and masters (or overseers), from the teachings of other black and white healers, and from folk traditions brought from Africa or developed and passed down in the West Indies and North America.

Emancipation brought an end to the medical-care system of slavery days, wherein white owners had ultimate responsibility—in financial as well as other terms—for the health of their human chattel. As whites in the South felt released from the commitment to provide medical care to former slaves, newly freed black women and men felt a need for healers of color. But in the postbellum era, African Americans had virtually no access to southern private or state tax-supported public medical schools, and only very occasional access in the North. Though they were paying taxes like all other citizens, they could not reap the same educational benefits as whites. No system existed routinely to train black physicians. During the late nineteenth century a few northern schools—such as Yale, the University of Pennsylvania, Detroit Medical College, Long Island College Hospital, Women's Medical College of Pennsylvania, Bennett Medical College, and the Medical College of Indiana—sometimes admitted blacks, but not in numbers sufficient to satisfy either the growing need for African-American physicians among the medically underserved former slaves or the increasing desire of men and women of color to enter the medical profession.

Help in satisfying those needs and desires came first primarily from groups of northern whites. These people represented various Protestant denominations that came south after the Civil War to provide educational opportunities for newly freed blacks. Leaders at several of the colleges and universities founded by organizations like the Baptist Home Mission Society and the Freedmen's Aid Society of the Methodist Episcopal Church felt strongly that their schools ought to provide interested freedmen and freedwomen with professional training, in addition to basic and religious education. As a result, between 1868 and 1895, seven "missionary" medical schools opened their doors to black students (see Table 1).

Beginning later in the century, a second group of medical schools opened their doors to black students. These schools, founded by members of the first gen-

TABLE 1. BLACK MEDICAL COLLEGES, 1868–1923

Name	City	Year Opened	Year Discontinued	Affiliation
Howard University Medical Dept.	Washington, D.C.	1868	——	None
Lincoln University Medical Dept.	Oxford, Pa.	1870	1874	Presbyterian (local)
Straight University Medical Dept.	New Orleans	1873	1874	American Missionary Association
Meharry Medical College	Nashville	1876	——	Methodist Episcopal
Leonard Medical School of Shaw University	Raleigh	1882	1918	Baptist
Louisville National Medical College	Louisville	1888	1912	Independent
Flint Medical College of New Orleans University	New Orleans	1889	1911	Methodist Episcopal
Hannibal Medical College	Memphis	1889	1896	Independent
Knoxville College Medical Dept.	Knoxville	1895	1900	Presbyterian
Chattanooga National Medical College	Chattanooga	1899	1904	Independent
State University Medical Dept.	Louisville	1899	1903*	Colored Baptist (Kentucky)
Knoxville Medical College	Knoxville	1900	1910	Independent
University of West Tennessee College of Medicine and Surgery	Memphis	1907	1923	Independent
Medico-Chirurgical and Theological College of Christ's Institution	Baltimore	1900	c. 1908	Independent

* Merged in 1903 with Louisville National Medical College.

eration of black physicians, were private institutions similar to the many so-called proprietary schools white physicians were opening around the country. Six African-American-owned-and-operated schools, unaffiliated with any religious organization or collegiate institution, began operation between 1888 and 1900 (see Table 1).

Survival of these schools depended on sufficient funds, an annual problem. The missionary boards contributed only small amounts to professional schools, arguing that their major commitment was to basic and religious education. Philanthropists like the Meharry brothers, Judson Wade Leonard, and John D. Flint helped start and partially maintain the schools named after them. Oliver Otis Howard used his position as head of the BUREAU OF REFUGEES, FREEDMEN, AND ABANDONED LANDS (the Freedmen's Bureau), an agency of the federal government, to give the medical department at newly founded Howard University (named for him) both funds and facilities. The Freedmen's Bureau directly funded or provided indirect assistance to two other medical

schools between 1869 and 1873. Philanthropic foundations like the Slater Fund, the Carnegie Foundation, and the General Education Board (Rockefeller family) also aided some of the black missionary medical schools. The colleges relied most heavily, however, on the fees students paid for their education and on the many small donations made by whites and blacks sympathetic to the cause in both the North and South.

The independent black medical schools functioned with tiny budgets, poor facilities, less-well-educated faculties, and none of the advantages available to schools with ties to universities. Having limited access to funds beyond the small fees collected from students, black unaffiliated schools generally provided a poorer education than their missionary counterparts and gained little recognition from white or black medical organizations or individual physicians.

In the fall of 1900, a prospective African-American medical student could apply to any of ten black medical schools. By 1912, the number of choices was four, and by 1918, three. The rise of scientific med-

icine and of a reform movement in medical education spelled the doom of dollar-poor medical schools, white and black, unwilling or unable to upgrade facilities and faculties to meet the ever-rising standards of state medical licensing boards. Abraham Flexner, an educator commissioned by the American Medical Association and the Carnegie Foundation for the Advancement of Teaching to visit and rate every medical school in the country, published a report in 1910 (*see* FLEXNER REPORT) that set a higher standard for education than the black schools could afford to meet. He also denigrated the abilities and commitment of African-American physicians and recommended the elimination of all but two of the black schools.

Flexner ultimately had his way. Only Howard and Meharry survived the assault. They were able to upgrade their programs and facilities to the higher standards Flexner demanded only because they received financial assistance from the Carnegie and Rockefeller family philanthropic foundations. Even this help came reluctantly and begrudgingly, however. Leaders of organized medicine and the large granting foundations agreed, as Flexner expressed it to an American Medical Association official in a 1918 letter: "[B]efore the Negro medical schools can be endowed [by major philanthropies], adequate endowment will have to be procured by the high grade white schools."

With just two schools regularly accepting African Americans for medical training from the 1920s through the 1970s, the rate of increase of black physicians in the United States slowed considerably. The percentage of African-American physicians remained at between 2.5 and 3 percent of all physicians during that period. Black medical graduates also had few alternatives in internship and residency training. Only a few hospitals around the country accepted blacks as house officers. As that system of postgraduate education became a standard, even mandatory, part of every physician's training, African Americans found themselves at a great disadvantage. Opportunities for advanced medical training were not available to them.

The civil rights era and the coming of integration opened predominantly white medical schools to black students and white hospitals to black house officers in large numbers for the first time. In addition, the Charles R. Drew Postgraduate Medical School (later renamed the Charles R. Drew University of Medicine and Science) in Los Angeles and the Morehouse School of Medicine in Atlanta opened their doors in 1978. Despite this broadening of opportunity for African Americans to obtain a medical education, the percentage of black physicians in the United States registered no significant change during this period from the sub–3 percent that had existed in

1920. Affirmative-action programs produced gains in minority medical-student admissions, though the Bakke case and the DeFunis reverse-discrimination case somewhat dampened such programs' effects. During the late 1970s, throughout the '80s, and into the early '90s, the annual number of black matriculants to medical schools rose slowly from just under 1,000 to just over that number, actually representing a decline compared to the growth of the general African-American population. Furthermore, that increase in black medical matriculants was attributable primarily to the admission of black women; the number of black male students barely increased during that period.

REFERENCES

DYSON, WALTER. *Howard University, the Capstone of Negro Education, a History: 1867–1940.* Washington, D.C., 1941.

HINE, DARLENE CLARK. "The Pursuit of Professional Equality: Meharry Medical College, 1921–1938, a Case Study." In V. P. Franklin and J. D. Anderson, eds. *New Perspectives on Black Educational History.* Boston, 1978, pp. 173–192.

MORAIS, HERBERT M. *The History of the Negro in Medicine.* New York, 1967.

READY, TIMOTHY, and HERBERT W. WICKENS. "Black Men in the Medical Education Pipeline: Past, Present, and Future." *Academic Medicine* 66 (1991): 181–187.

SAVITT, TODD L. "Abraham Flexner and the Black Medical Schools." In Barbara Barzansky and Norman Gevitz, eds. *Beyond Flexner: Medical Education in the Twentieth Century.* New York, 1992, pp. 65–81.

SHEA, STEVEN, and MINDY THOMPSON FULLILOVE. "Entry of Black and Other Minority Students into U.S. Medical Schools: Historical Perspective and Recent Trends." *New England Journal of Medicine* 313 (1985): 933–940.

SUMMERVILLE, JAMES. *Educating Black Doctors: A History of Meharry Medical College.* University, Ala., 1983.

TODD L. SAVITT

Medicine. *See* Health and Health Care Providers.

Memphis Minnie (Douglas, Lizzie "Kid") (June 3, 1897–August 6, 1973), composer and singer. Considered the greatest female singer of country blues, Memphis Minnie was born in Algiers, La., the eldest of thirteen children of sharecroppers Abe and Gertrude Wells Douglas. A wild child who hated

farm work, she ran away from home to sing on Memphis street corners, playing a guitar she had been given at the age of eight. Memphis Minnie spent her life traveling from rural Mississippi to Memphis to Chicago and back again, playing and singing in working-class bars, juke joints, house parties, and country fish fries, venues with little separation between performer and audience. She was married at least twice, to fellow blues singers and guitar players who worked with her: Joe "Kansas Joe" McCoy and Ernest "Little Son Joe" Lawlars.

Memphis Minnie was a rough, gambling, hard-drinking, tobacco-chewing, tough-talking woman who excelled in the almost exclusively male world of down-home rural blues. Her artistry set a standard that influenced, among others, Big Bill BROONZY, Homesick James, Roosevelt Sykes, Sunnyland Slim, Sonny Boy Williamson, and MUDDY WATERS. Billed as "Vocalian's Greatest Star," she made nearly two hundred race records, usually singing her own compositions and accompanying herself on the guitar. Among her most important recordings were "Bumble Bee," "Me and My Chauffeur Blues," "What's the Matter with the Mill?," "Dirty Mother for You," and "She Wouldn't Give Me None." Memphis Minnie's witty and irreverent lyrics, her elaborate picking technique, and her clear, vivid voice personified the earthy vitality of country blues and made her one of the outstanding artists of African-American vernacular music. She died in Memphis.

REFERENCE

GARON, PAUL, and BETH GARON. *Woman with Guitar: Memphis Minnie's Blues.* New York, 1992.

RICHARD NEWMAN

Memphis, Tennessee. Located on a bluff overlooking the Mississippi River, Memphis, Tenn., received its first African-American settlers shortly after its founding in 1819. Its early black population was largely free, and Shelby County's state representatives opposed slavery. African Americans worked as domestics, stevedores, draymen, blacksmiths, and artisans.

As the town grew into a major port city, racial attitudes began to change. In 1834 Tennessee enacted a new state constitution, which stripped blacks of citizenship rights. The town's African-American population, which previously had enjoyed voting rights, was disenfranchised and forced to observe a curfew. Black clergymen were not allowed to preach. In the 1840s, Tennessee repealed its ban—adopted in 1812—on the domestic slave trade. Memphis, with

its large port, became a center for slave trading. Nevertheless, Memphis was more cosmopolitan than most southern cities in that a large number of immigrants—mostly Irish, Italians, and Germans—had settled there. By 1860 the city's population was 17 percent black and more than 36 percent foreign-born.

As the CIVIL WAR lurked on the horizon, Memphis initially did not endorse secession, and even though local support for the Confederacy built once the war began, the city fell to advancing Union troops in 1862 and remained occupied and largely undamaged throughout the war. The Union Army established a large freedpeople's camp near Memphis, and many blacks migrated there, remaining after the end of the war. Yet, EMANCIPATION spawned economic competition between black and white immigrants; and despite efforts by the Freedmens' Bureau, interracial strife developed, particularly between the blacks and Irish who resided in many of the same neighborhoods. In 1866, for instance, struggling Irish residents turned their frustrations on many of their newly arrived black neighbors in a riot that left forty-six blacks dead, nearly twice that many injured, five women raped, approximately 100 blacks robbed, and ninety-one homes, four churches, and all twelve black schools destroyed.

Once the United States Congress enacted civil rights laws in 1866, the political situation improved. By 1875, a coalition of blacks, Irish, and Italians dominated Memphis politics. The blacks were led by the likes of militant saloon-keeper Ed Shaw and the more conciliatory Hezekiah Henley. African Americans held seats on both the elected city council and school board as well as appointed positions such as wharfmaster and coal inspector. Yet, as the JIM CROW era dawned, no African American would hold elective office from 1888 until 1960. As a matter of fact, with the exception of a few Republican primaries, no black would even seek an elected position until 1951.

Due to black in-migration as well as successive yellow fever epidemics, which took a heavy toll on the white population of Memphis and caused a white out-migration, blacks remained a significant voting bloc. Although blocked from holding public office, black suffrage was never formally restricted except by selective enforcement of a poll tax. Thus, even after southern Democrats regained political control of Tennessee, they were compelled to court black votes. Furthermore, black Republican leaders retained influence over policy and the awarding of city and federal patronage jobs.

Despite this limited political power, the social conditions of blacks in Memphis grew steadily worse as the nineteenth century drew to a close. The better-off, more cosmopolitan whites had fled the yellow fever epidemics of the 1880s and been replaced by

poorer, more parochial whites from surrounding areas of rural Tennessee, Mississippi, and Arkansas. Blacks' civil and property rights were violated, and the city became increasingly segregated. In 1892, for instance, a white grocery storekeeper facing competition from the black-owned Peoples' Grocery tried to intimidate its owners, claiming a white mob would attack their neighborhood that evening. He then warned the police that blacks were intent on causing trouble. When the black store owners, their homes barricaded, were visited that evening by deputy sheriffs, they mistook the deputies for a mob and fired, fatally wounding them. Arrested the next day, they were taken from prison by a white mob and brutally lynched. When Ida B. Wells (see Ida B. WELLS-BARNETT) denounced the lynching in her newspaper, the *Memphis Free Speech,* a mob burned her press and forced her to flee the city, providing the impetus for her subsequent career as a crusader for African-American rights.

Memphis blacks were anything but passive in the face of the encroachment of segregation. A number of Memphis blacks resisted the day-to-day degradations of Jim Crow. In 1881, for example, prominent musician and schoolteacher Julia Hooks was arrested for her vociferous protest over not being seated in the theater's white section. And, beyond protest, when Mary Morrison was arrested for resisting streetcar segregation in 1905, a huge rally followed in Church Park and several thousand dollars was raised for her legal defense.

There were also forms of even more direct resistance. The following incidents occurred in 1915 and 1916 alone. When white men tried physically to remove Charley Park and John Knox from their trolley seats, Park stabbed one, and Knox ended up in a gun battle with another. A white trolley conductor was stabbed when he tried to collect extra fare from a black rider. Retaliatory ambush shootings and arson took place on occasion. Furthermore, lower-class blacks used a variety of physical means to resist local white police officers.

Meanwhile, despite such turmoil, Beale Street became known as the "Main Street of Negro America." The size and segregation of the black community early on had created a need for a number of black professionals and businesspersons. Black doctors, lawyers, and teachers provided essential services; while black entrepreneurs owned many of the groceries, barbershops, hair salons, funeral parlors, and even banks, open for black patronage. Beale Street, the black commercial center in its Jim Crow heyday, was lined with real estate and baking offices, dry goods and clothing stores, theaters, saloons, gambling joints, and a variety of other small shops (in the 1970s and 1980s, after decades of decline and neglect,

city officials began to renovate the Beale Street area as an historic district and tourist attraction.)

In the business realm, in the early twentieth century, Bert Roddy founded the city's first black grocery chain and subsequently organized the Supreme Liberty Life Insurance Company. Included in his effort an attempt to build on W. E. B. Du Bois's notion of developing community cooperative businesses, in this case Roddy's "Citizens' Coop" grocery stores. Roddy also was the first head of the Memphis branch of the NAACP. Thomas H. Hayes, another example, was a successful grocer who also started the T. H. Hayes and Sons Funeral Home, the longest continuously running black business in Memphis. Other prominent black businessmen included James Clouston, Clarence Gilliss, Phillip Nicholson, David Woodruff, and N. J. Ford.

Robert CHURCH, SR., however, was the best known. A former slave, he arrived in Memphis in 1863. By the time of his death in 1912, he had amassed more than $1 million dollars' worth of real estate and other holdings. He was most likely the nation's first black millionaire. His Solvent Savings Bank, founded in 1906, was the first black-owned bank in the city's history; and his donations of Church Park and the adjacent Church Auditorium provided major focal points for black social and cultural life, especially during the Jim Crow period.

Memphis gradually became an African-American cultural center. The city boasted several black theaters; concerts were held in the Church Auditorium. Memphis also contained the Julia Hooks Music School, a black-owned, interracial institution. Beale Street's saloons and gambling clubs were known for their "blues" music, and bands such as John R. Love's Letter Carrier's Band and Jim Turner's Band popularized the sound. Turner's pupil, W. C. HANDY, wrote down much of this music and brought it to the rest of the country. His "Memphis Blues," originally written as a campaign song, became the city's unofficial anthem. In more recent years, the Beale Street milieu has fostered many leading blues musicians such as B. B. KING and Memphis Slim.

The Mississippi-born Irishman, Edward H. "Boss" Crump, first won city office in 1905. Although an avowed segregationist, he successfully registered large numbers of black voters, and he turned them out to vote with the help of prominent blacks such as W. C. Handy. By the late 1920s, Crump had consolidated his political power. Thereafter, although no longer actually holding the mayor's office himself, he proceeded to dominate Memphis politics until his death in 1954. Between 1928 and 1948, for instance, his mayoral candidates lost a total of two precincts, which were subsequently abolished upon redistricting. Crump's base of support

was an odd mix of blacks and Irish; like most bosses of the day, he held his coalition together with selective patronage.

Blacks, then, although not allowed to rise to positions of authority within the party structure or the bureaucracy, still were marshalled to the polls and, in return, received a share of the city's largesse for delivering a critical voting bloc for the Crump machine. Black leaders such as Harry PACE, Robert CHURCH JR., J. B. Martin, and Matthew Thornton brokered black political support for patronage benefits. Although Republicans, as were many of the businessmen and professionals in the black leadership elite, they were able to work effectively with Boss Crump—especially while the large majority of blacks apparently remained loyal to the "Party of Lincoln."

Then, as a combination of Crump's efforts and Franklin Roosevelt's emerging coalition lured many blacks from their traditional allegiance to the Republican party, Dr. J. E. Walker organized the Shelby County Democratic Club as an independent political base for black Memphians. Although organizationally separate from the Crump machine, Walker worked with Crump until the early 1950s, when the two had a falling-out over the issue of social segregation. This drove Walker into the camp of a number of white "reformers" who emerged around the successful machine-challenging senatorial bid of Estes Kefauver.

In 1951 Walker challenged the machine himself by running for a position on the school board. In the course of the campaign, the first of many aggressive voter-registration drives was launched within the black community. Although Walker was soundly defeated, he was the first black candidate in decades, and black voter registration nearly tripled in 1951 alone. Then, as Crump died, the poll tax was eliminated and registration drives continued in earnest, and the percentage of registered blacks would triple again over the course of this decade, leaving more than 60 percent of the city's African Americans registered by 1960. By 1963, as blacks struggled for the right to vote across the South, black Memphians were already registered at the same rate as white Memphians.

Two additional pieces of the electoral puzzle were George W. Lee and O. Z. Evers. Lee, a prominent black Republican who led a local group called the "Lincoln League," was helpful in rallying black Republicans, mostly businessmen and ministers. Evers, on the other hand, headed a small group of independents, calling themselves the "Unity League." In addition, none of this should be seen as understating the central political role played by local black churches from Emancipation to the present day. In 1955, as just one example, dozens of churchmen representing every black denomination came together to form the "Ministers and Citizens League." They adopted a $2,000 registration budget, hired three full-time secretaries, and pledged themselves to utilizing other resources at their disposal to increase black voter registration. The black ministers used the pulpit to preach the need to register; they held mass meetings; and they even drove unregistered voters to the courthouse.

Throughout the 1950s, black candidates ran unsuccessfully for citywide and statewide office. Then, in 1959, Russell Sugarmon led a field of black candidates, pulling together black Republicans, Democrats and independents to support a "Volunteer Ticket." His campaign manager was law partner and emerging political leader A. W. Willis. Along with others like Benjamin HOOKS, they represented a new political generation. As it turned out, this became a racially divisive election marred by much uncharacteristically overt racist rhetoric. For example, the white "Citizens for Progress" ran under the banner "Keep Memphis Down in Dixie." Meanwhile, prominent African Americans such as the Rev. Dr. Martin Luther KING, Jr. and Mahalia JACKSON appeared to help rally the black vote. Although all black candidates were defeated, Sugarmon had made a strong run for a seat on the city commission. In addition, each of the Volunteer candidates finished second, and nearly two-thirds of black voters were now registered. Sugarmon concluded, "We won everything but the election."

Finally, in 1960, Jesse Turner, also head of the Memphis NAACP, became the first African American since Reconstruction to win an elective post, winning a seat on the Democratic Executive Committee. In the same year, a number of student sit-ins took place, and a successful boycott was launched against downtown retailers. By the mid-1960s, the city of Memphis had a population that was approximately 34 percent black, and two-thirds of them were registered. Then, in 1964, A. W. Williss won a seat in the state legislature, and Charles Ware won a constable position—both plurality votes. Thus, it was not long before a runoff provision was added in order to preclude such developments. In addition, other forms of racial discrimination persisted. For example, Republican "election challenges" focused on the black community, where registrations were reviewed carefully, and this obviously intimidated some legitimately registered blacks. Or, extra field wages would be offered on election day, with the field hands being brought back from the fields too late to vote.

Nevertheless, despite the fact that Memphis elections remained exceptionally polarized by race—especially because whites so seldom voted for black

candidates—victories began to occur in districts with large black constituencies. From 1963 onward, as the black voting bloc increased to nearly 100,000 voters, prospects for success increased. They increased despite fairly regular annexations of predominantly white suburbs, a practice that had begun as early as 1909. In 1974, for example, Harold FORD became the first black Tennessean ever elected to the United States Congress, while seats also were being won on the city council, school board, and the judiciary.

Since his election to Congress, Ford has developed the reputation of having the most effective political operation in Memphis. Besides personally paying overdue rents, distributing food at Christmas, contributing to church bazaars, giving graduation presents, and so on, his local congressional staff is also quite proficient at helping constituents through the maze of the federal bureaucracy. In addition, his congressional seniority and consequent committee assignments put him in a position to bring a respectable share of federal funds to Memphis. The word is that "Harold delivers," and his "deliveries" are well chronicled both in his newsletters and in the *Tri-State Defender*. Such service has helped build a core of very loyal supporters; they remained loyal to Ford during his protracted trials and eventual vindication on charges of bank fraud in the 1990s. In addition, the congressman, his staff, and a small group of loyalists regularly compose and distribute a sample ballot endorsing a variety of candidacies. Such endorsements, which often appear to require a financial contribution to the congressman's campaign fund, are believed to generate a sizable number of votes for the endorsed candidates.

Still, it has been the norm for black leaders to split—especially over which mayoral candidate to support. Over the years, these splits have been based on a variety of issues such as gender and intergenerational differences as well as personal rivalries. Such disunity has diluted the influence of the black community. This has been particularly problematic in a city where whites have managed to remain a majority, much of the black population has remained exceptionally poor and consequently difficult to mobilize, and where white allies have been few and far between.

Following the 1987 election, black union leader James Smith called for a leadership summit before the next mayoral election. In the spring of 1991, two "unity conferences" were held, one at the grass-roots level led by City Councilman Shep Wilbun and one at the leadership level led by Rep. Harold Ford. The result was a consensus black candidate, W. W. Herenton, whose Herenton campaign succeeded in uniting the various elite and mass groups under the banner of an uncompromising black political crusade.

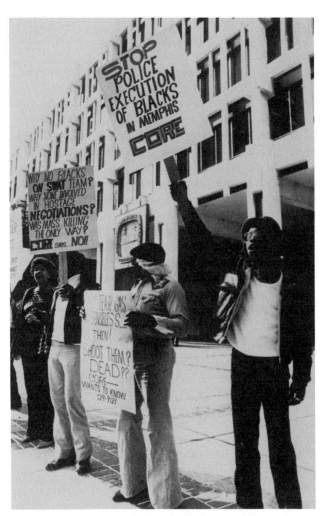

Supporters of the Congress of Racial Equality (CORE) demonstrate before the Memphis, Tenn., city hall to protest the slaying of seven African Americans following a thirty-hour siege at a North Memphis home, January 13, 1983. The siege began when members of a religious sect took a policeman hostage. The officer was found beaten to death after police attacked the house. During the demonstration march, CORE's national director, Roy Innes, accused police of killing the seven to punish them for the officer's death. (AP/Wide World Photos)

For the Memphis African-American community, Herenton's election—albeit by an extremely narrow margin of less than 200 votes—marked a high point in a political struggle that has spanned generations. That same year, blacks won a majority of seats on the city's school board and ended up only one vote shy of a majority on the city council.

Yet, despite political victories, the city's commerce and service-oriented economy has offered African Americans far more low-wage positions than higher-paying ones. This has left Memphis with arguably the poorest black underclass of any large U.S. city. By 1990, more than a third of that population was

still impoverished; and as for the intensity of the poverty, six Census tracts had a median household income below $5,500. Consequently, a sizable number of black Memphians have ended up disproportionately poor, disillusioned, and militant as well as suspicious of political leaders, including many of their own black leaders.

Labor activism by black Memphians, protesting both their poverty and maltreatment, led to the best-remembered and most tragic event in the recent history of Memphis, the assassination of the Rev. Dr. Martin Luther King, Jr., on April 4, 1968. King was in Memphis to support a strike by the city's largely black staff of sanitation workers. The strikers' grievances went beyond economic issues and involved claims of maltreatment by white supervisors. The strike, which began in February 1968, became bitter and protracted. King encountered much hostility during his stay in Memphis, and the night before he died, in the city's largest black church, the Mason Temple, he seemed to publicly contemplate his own mortality. On the evening of April 4, King was fatally wounded by a rifle shot at the Lorraine Motel. In 1991 the motel reopened as a civil rights museum, dedicated to the memory of Dr. King.

REFERENCES

BILES, ROGER. *Memphis in the Great Depression.* Knoxville, Tenn., 1986.
CAPERS, GERALD. *The Biography of a River Town.* New York, 1966.
CRAWFORD, CHARLES. *Yesterday's Memphis.* Miami, 1976.
JALENAK, JAMES. *Beale Street Politics.* New Haven, Conn., 1961.
LAMON, LESTER. *Blacks in Tennessee, 1791–1970.* Knoxville, Tenn., 1981.
LEE, GEORGE. *Beale Street, Where the Blues Began.* College Park, Md., 1969.
MCKEE, MARGARET. *Beale Black and Blue.* Baton Rouge, La., 1961.
MILLER, WILLIAM. *Mr. Crump of Memphis.* Baton Rouge, La., 1964.
SIGAFOOS, ROBERT. *Cotton Row to Beale Street.* Memphis, 1979.
TUCKER, DAVID. *Memphis Since Crump.* Knoxville, Tenn., 1980.
WRIGHT, WILLIAM. *Memphis Politics.* New York, 1962.

MARCUS D. POHLMANN

Mennonites. A radical product of the sixteenth-century Reformation in Switzerland and Germany, Mennonites opposed the authority of the state church as well as the doctrine of the Lutheran and Reformed church. Mennonite leader Menno Simons (1496–1561), from whom the religion took its name, espoused pacifism, religious toleration, and adult baptism. Due to increasing religious persecution in Europe during the late seventeenth century, many Mennonites fled to North America, where in 1683 they established the first permanent Mennonite settlement in the New World at Germantown, just north of Philadelphia. It was here in 1688 that Mennonites, along with their Quaker neighbors, lodged the first formal anti-slavery protest noted in American history.

Mennonites subsequently spread north and west from Germantown. The early nineteenth century found them settling in Canada's Northwest Territory, Pennsylvania's Lancaster county, and, after the CIVIL WAR, the Western Plain states. Due in part to this settlement pattern, few Mennonites became slaveowners. Although rarely active in the ABOLITION movement, Mennonite disdain for SLAVERY was nonetheless well known and cited as an example of community opposition to the institution.

Mennonite missionaries first began proselytizing African-Americans as early as 1886, when Heinrich V. Weibe established a number of schools for black children in the poor mining town of Elk Park, N.C. In little over a decade, the Mennonite church, the oldest of several American Mennonite factions, received its first black members when, in 1897, Robert and Mary Elizabeth Carter and their son Cloyd joined the Lauver Mennonite Church in Cocolamus, Pa. Black membership was again bolstered the following year when Mennonites in Lancaster county opened the Welsh Mountain Industrial Mission for African Americans.

The Mennonite message was further spread throughout the black communities of North Carolina and eastern Tennessee by Peter H. Siemens, who in 1925 was instrumental in founding eleven Mennonite churches and a high school for blacks said to be the first of its kind in that region. During Siemens's tenure ten African-American ministers were ordained, among them Rondo Horton, who succeeded Siemens as leader of the North Carolina Mennonite district.

While a number of Mennonites were active in recruiting African-American members before World War II, it was not until the civil rights movement of the 1960s that the denomination as a whole attempted to substantially increase its black membership. This new effort was led by James Henry Lark (1888–1978), the leading African-American Mennonite of the postwar period. A dynamic leader who continually promoted the interests of African Americans, Lark helped establish Mennonite churches in the black communities of such cities as Chicago, Ill.; St. Louis,

Mo.; Sarasota, Fla.; Youngstown, Ohio; Saginaw, Mich.; and Los Angeles, Calif. Lark was also the driving force behind the 1976 decision to designate Allensworth, Calif.—a black community founded, financed, and governed by African Americans from 1908 until the early 1960s—as a state historic park.

Of today's 350,000 Mennonites living in the United States approximately 3,500 are African American. The Afro-American Mennonite Association, which works with both black and integrated congregations, strives to create partnerships between Mennonites and the larger African-American community.

REFERENCES

BECHLER, LEROY. *The Black Mennonite Church in North America, 1886–1986.* Scottdale, Pa., 1986.

BROWN, HUBERT L. *Black and Mennonite.* Scottdale, Pa., 1976.

DYCK, CORNELIUS. *An Introduction to Mennonite History.* Scottdale, Pa., 1967.

GIESBRECHT, HERBERT. *The Mennonite Brethren Church: A Bibliographic Guide.* Fresno, Calif., 1983.

LEROY BECHLER

Mercer, Mabel Alice Wadham (February 3, 1900–April 20, 1984), cabaret singer. Mabel Mercer was born in Burton-on-Trent, England, to an African-American jazz musician and a British singer. She attended a convent school until the age of fourteen, when she went on tour with a group of musicians in her family. Mercer sang and danced in musicals and stage comedies in England, and after World War I in Paris, where she became a popular cabaret attraction. From 1931 to 1938 she performed at Bricktop's, an African-American–owned nightclub, and gained a large following because of her precise yet emotive renditions of jazz and pop standards, which she performed seated on a straight-backed chair. In 1938 Mercer came to the United States, where she soon made a central place for herself in what has come to be known as the golden age of cabaret music. For the next three decades Mercer performed in clubs such as Tony's, the Byline Room, the St. Regis, and the Café Carlyle. The sensitivity and restraint of Mercer's mezzo-soprano and the tranquility of her performance style never gained her a mass following in the United States, but she was a favorite of pop and jazz singers such as Billie HOLIDAY, Frank Sinatra, Nat "King" COLE, and opera singer Leontyne PRICE. Her recordings from this time include *Mabel Mercer Sings Cole Porter* (1955), *Once in a Blue Moon* (1959), *Mabel Mercer Sings* (1964), *At Town Hall* (with Bobby Short, 1968).

A resurgence of interest in Mercer's music in the early 1970s led to a 1972 television special, "An Evening with Mabel Mercer and Bobby Short and Friends." In 1977 she appeared in Carnegie Hall and was the subject of a BBC film, *Miss Mercer in Mayfair.* In 1982 she sang songs by Alec Wilder at the Kool Jazz Festival in New York and in 1983 she was awarded the Presidential Medal of Freedom at the White House. Mercer, who lived in East Chatham, N.Y., died the following year in Pittsfield, Mass. A video of her mid-1970s performances, *Mabel Mercer: A Singer's Singer,* was released in 1986.

REFERENCES

GAVIN, JAMES. *Intimate Nights: The Golden Age of New York Cabaret.* New York, 1991.

HASKINS, JAMES. *Mabel Mercer: A Life.* New York, 1987.

JONATHAN GILL

Meredith, James H. (June 25, 1933–), civil rights activist. Born in Kosciusko, Miss., James Meredith became the central figure in two major events of the CIVIL RIGHTS MOVEMENT. He had studied at Jackson State University in Jackson, Miss., when in September 1962 he sought to enroll in the University of Mississippi to complete his bachelor's degree. The state university system was segregated, and though a court order confirmed Meredith's right to enter the school, Mississippi Gov. Ross Barnett led the opposition and personally stood in the doorway of the registrar's office to block Meredith's enrollment. In response, the Kennedy administration dispatched federal marshals to escort Meredith to classes. To quell the subsequent rioting, U.S. troops policed the campus, where they remained until Meredith graduated in 1963.

During the next year, Meredith studied at Ibadan University in Nigeria, and on his return to the United States he began taking courses for a law degree at Columbia University. In the summer of 1966, Meredith announced he would set out on a sixteen-day "walk against fear," which would take him from Memphis to the Mississippi state capital in Jackson. He sought both to spur African-American voter registration for the upcoming primary election and to show that blacks could overcome the white violence that had so long stifled aspirations.

On the second day of the hike, an assailant shot Meredith with two shotgun blasts. His wounds were not serious, but the attack sparked great outrage and the major civil rights organizations carried on a

march to Jackson from the place where Meredith had been shot. This procession was marked by Stokely CARMICHAEL's call for black power and a resulting rift between the moderate and militant wings of the movement. Meredith left the hospital after several days and was able to join the marchers before they reached Jackson.

Later in 1966, Meredith published *Three Years in Mississippi* and lectured on racial justice. Returning to law school, Meredith received his degree from Columbia University in 1968. That same year he ran unsuccessfully for Adam Clayton POWELL, JR.'s Harlem seat in the U.S. House of Representatives, then returned to Mississippi, where he became involved in several business ventures. In 1984 and 1985 he taught a course on blacks and the law at the University of Mississippi. In September 1989, he joined the staff of North Carolina Sen. Jesse Helms, an arch-conservative, as domestic policy adviser.

REFERENCES

GARROW, DAVID J. *Bearing the Cross: Martin Luther King Jr., and the Southern Christian Leadership Conference.* New York, 1986.

PEAKE, THOMAS R. *Keeping the Dream Alive: A History of the Nineteen-eighties.* New York, 1987.

STEVEN J. LESLIE

Meriwether, Louise (May 8, 1923–), author. Louise Meriwether, the daughter of Marion Lloyd Jenkins and Julia Jenkins, was born in Haverstraw, N.Y. Her parents had moved from South Carolina for greater opportunities, but the GREAT DEPRESSION reduced them to marginal jobs and welfare. During her childhood in Brooklyn and Harlem, Meriwether experienced the despair of the ghetto. The debilitating effects of prejudice formed the basis of her fiction, nonfiction, teaching, and social activism.

Educated at New York University and UCLA (M.S. in Journalism, 1965), Meriwether has taught at such schools as Sarah Lawrence College and the University of Houston. During the 1950s and early '60s, she worked in various legal and reporting jobs. In 1965 she became the first African-American story analyst at Universal Studios. She also began writing book reviews, but found that she often had to initialize her first name to get work past sexist editors.

Meriwether joined the Watts Writers' Workshop, organized in the wake of the 1965 riots, and in 1967 published a short story that would develop into a novel, *Daddy Was a Number Runner* (1970). This book is the story of Harlem adolescent Francie Coffin, who watches her family fall apart during the Great Depression. Critics credited Meriwether for her vivid and painful portrayal of desperate people who have almost no chance for secure and fulfilling lives.

In addition to stories and essays published in such periodicals as *Negro Digest, The Antioch Review,* and *Essence,* Meriwether has written three biographies of pioneering African Americans for young readers: *The Freedom Ship of Robert Smalls* (1971), *The Heart Man: Dr. Daniel Hale Williams* (1972), and *Don't Ride the Bus on Monday: The Rosa Parks Story* (1973).

Meriwether has frequently taken time from writing to devote herself to causes. In 1967 she joined other civil rights activists in preventing the film adaptation of William Styron's *The Confessions of Nat Turner,* which Meriwether found historically inaccurate. (*See* NAT TURNER CONTROVERSY.) In the early 1970s, angered by the African-American entertainers who were performing in South Africa, she worked to publicize the appalling conditions that minorities suffered under apartheid. She has also actively opposed American interventions abroad, from Vietnam to the Persian Gulf.

In 1994 Meriwether published a long-awaited historical novel, *Fragments of the Ark,* an epic based on the life of CIVIL WAR hero Robert SMALLS, a slave who captures a Confederate gunboat for the Union Navy. This novel is the latest chapter in her ongoing effort to instill in readers a panoramic sense of the role of African Americans in American history.

REFERENCES

MARSHALL, PAULE. *New York Times Book Review,* June 28, 1970, p. 31.

SISSMAN, L. E. "Growing Up Black." *The New Yorker* (July 11, 1970): 77–79.

DEREK SCHEIPS

Messenger, The (1917–1928), national African-American monthly magazine. The *Messenger* was founded by A. Philip RANDOLPH and Chandler OWEN, both active in New York City's radical and socialist circles. Hired in 1917 to edit the *Hotel Messenger* for the Headwaiters and Sidewaiters Society of Greater New York, the pair was fired after eight months on the job for exposing exploitative treatment of common waiters and pantry workers by the more established union members themselves. With initial support from the Socialist party and Socialist-led unions, they launched the independent *Messenger.*

The *Messenger* alarmed the white and black establishments by both advocating socialism and heralding the advent of the "New Crowd Negro," who

promised an aggressive challenge to both post-RECONSTRUCTION "reactionaries" such as Booker T. WASHINGTON and mainstream civil rights leaders such as W. E. B. DU BOIS. The self-styled "Only Radical Negro Magazine in America" opposed World War I, championed the Russian Revolution of 1917, hailed the radical interracial organizing of the Industrial Workers of the World, and advocated armed self-defense by black people against racist attacks.

In 1919, during the rising wave of racial disturbances and labor unrest, the *Messenger* was caught in the sweep of federal repression that followed. Of all the black publications investigated by the Justice Department for "radicalism and sedition," it was the *Messenger* that Attorney General A. Mitchell Palmer termed "the most able and the most dangerous." Its second-class mailing permit, revoked by the U.S. Post Office in 1918 after publication of an article entitled, "Pro Germanism Among Negroes," was not restored until 1921.

With the weakening of both the socialist movement and the IWW in the early 1920s, the word "Radical" disappeared from the *Messenger*'s masthead. The magazine sought to preserve its influence in the black community by campaigning actively against Marcus GARVEY and promoting the independent organization of black workers. Owen left the magazine in 1923, and Randolph, though technically still at the helm, turned his attention to the Brotherhood of Sleeping Car Porters, which he hoped to affiliate with the American Federation of Labor.

With Owen's departure and Randolph's union activities, effective editorial control was shifted to George SCHUYLER and Theophilis LEWIS. Under their tutelage, the *Messenger*'s political and economic radicalism gave way to celebrations of black entrepreneurs and appeals to the mainstream (and racially exclusionary) labor movement. In addition to a "Business and Industry" page, the magazine began to feature society items, sports news and articles directed at women and children. In 1925, when the *Messenger* became the official organ of the Brotherhood, it also began to carry union-related news and commentary.

Schuyler and Lewis left another indelible mark on the magazine. While the *Messenger* had published socialist-oriented literary contributions in the past by figures such as Claude MCKAY, it had not explicitly allied itself with the HARLEM RENAISSANCE. Now, it became more directly concerned with black arts and culture, including theater, and solicited the work of leading luminaries, among them Langston HUGHES and Georgia Douglas JOHNSON. This approach gained even greater currency when Wallace THURMAN filled in briefly for Schuyler in 1926. By late 1927, the *Messenger*'s motto had become "The New Opinion of the New Negro."

Still, the *Messenger,* as a union publication, continued to reach an audience comprised largely of black trade unionists. It folded in 1928, when Randolph determined the BSCP could no longer afford the drain on its limited resources.

REFERENCES

JOHNSON, ABBY ARTHUR, and RONALD MABERRY JOHNSON. *Propaganda and Aesthetics: The Literary Politics of African-American Magazines in the Twentieth Century.* Amherst, Mass., 1979.

KORNWEIBEL, JR., THEODORE. *No Crystal Stair: Black Life and the Messenger, 1917–1928.* Westport, Conn., 1975.

VINCENT, THEODORE G., ed. *Voices of a Black Nation: Political Journalism in the Harlem Renaissance.* Trenton, N.J., 1973.

WOLSELEY, ROLAND E. *The Black Press, U.S.A.*, 2nd ed. Ames, Iowa, 1990.

RENEE TURSI
TAMI J. FRIEDMAN

Messianism. Messianism, although defined in many ways by various scholars, generally is used to describe populist religious movements among marginalized populations, usually characterized by a founding, charismatic prophet figure to whom divine knowledge is believed to have been revealed. Such founders offer spiritual redemption while advocating freedom from subjugation. Historically such movements often emphasize a return to a presubjugation social order. Many also posit imminent, divinely inspired upheaval in society. A wide range of African-American religious communities has been identified as messianic. Such groups include the Black Hebrew Israelite Nation, the Church of God and Saints in Christ, the Moorish Science Temple, and the Rastafarians. Different communities draw from Islamic, Hebraic, or Christian bodies of messianic belief. The core concept of an original African homeland to which African Americans should turn, both spiritually and culturally, is common to most of these groups. Many messianic groups such as the "Peace Mission" of FATHER DIVINE, or Elijah MUHAMMAD's NATION OF ISLAM, have gained general respect in the ghettoes by working successfully with the marginalized portions of the African-American population that have not been reached by the mainstream churches.

Many observers believe that the messianic emphasis on charismatic leadership, African origins, and

opposition to white domination, often intermeshed with a chiliastic prediction of a coming new age for black people, demarcates such organizations from the apparently more instrumentally oriented, mainstream African-American churches with their routinized organization and engagement with the wider society. However, this distinction between the "mainstream" and "messianic" groups is not always so clear-cut in practice. Key elements found in one, are also to varying degrees found in the other. There are three major ways in which African-American messianic mainstream religious organizations overlap. First, mainstream African-American religion is itself notably infused with charismatic forms of leadership, the Rev. Martin Luther KING, Jr., being a well-known case in point. Many mainstream African-American ministers, often citing from the Old Testament prophetic books, will condemn materialistic society and oppression in ways much like those found in the messianic communities. Consequently, many who join the messianic organizations will have had previous exposure to these charismatic and prophetic elements within the overall African-American religious culture. Second, the messianic Black Pride emphasis on rediscovery of African ancestral culture as a means of liberation, as found in groups such as the Nation of Islam and the Shrines of the Black Madonna during the 1960s and early 1970s, has itself influenced, to varying degrees, the mainstream of African-American Protestant and some Roman Catholic Churches. For example, increasingly in the early 1970s, organizations of African-American priests and lay Catholics began calling for greater incorporation of Black Pride/African elements into the liturgy: use of images of black saints and Madonna figures, and more focus by the Church on the black community. Third, along with and despite their charisma-infused prophetic assertions, most African-American messianic communities tend to be quite pragmatic and instrumentally oriented. In this sense many messianic communities are no less "instrumental" than the mainstream churches from which they are usually distinguished. For example, the Nation of Islam's efforts to literally construct an entire autonomous economic infrastructure of farms, factories, and stores went hand in hand with the messianic thrust of the message.

Overall, although these messianic communities visibly distinguish themselves and are distinguished from mainstream churches, both share some key elements and consequently flow together within broader, African-American religious culture.

REFERENCES

BAER, HANS A., and MERRILL SINGER. *African-American Religion in the Twentieth Century: Varieties of Protest and Accommodation.* Knoxville, Tenn., 1992.

LANTERNARI, VITTORIO. *The Religions of the Oppressed.* New York, 1965.

LINCOLN, C. ERIC. *Race, Religion, and the Continuing American Dilemma.* New York, 1984.

JOHN BROWN CHILDS

Metcalfe, Ralph Horace (May 30, 1910–October 10, 1978), athlete and congressman. Ralph Metcalfe was born in Atlanta, but moved to Chicago at an early age. While an undergraduate at Marquette University, in Milwaukee, Metcalfe was the National Collegiate Athletic Association (NCAA) champion in the 100 yards and 220 yards three years in a row (1932–1934). During the same period, he won the Amateur Athletic Union (AAU) championship in the 100-meters (1932–1934) and the 200 meters (1932–1936). He also won the silver medal in the 100 meters at the 1932 Olympics in Los Angeles, running in the same official time (10.3) as the winner (officials declared Metcalfe second after a lengthy study of a film of the finish) and the bronze medal in the 200 meters. Although he was the dominant sprinter in the world during the early 1930s and set or tied the world records in the 40 yards, 60 yards, 60 meters, 100 yards, 100 meters, 220 yards, and the 200 meters, he again finished second in the 100 meters at the 1936 Olympics in Berlin, this time behind Jesse OWENS. Metcalfe won an Olympic gold medal as a member of the 1936 U.S. 4 by 100-meter relay team.

In 1936 Metcalfe retired from sprinting and graduated from Marquette. While teaching political science and coaching the track team at Xavier University in New Orleans from 1936 to 1942, he also completed work for an M.A. in political science from the University of Southern California (1939). He joined the army in 1942, and after the war returned to Chicago to become the director of the Department of Civil Rights for the Chicago Commission on Human Rights (1945). From 1949 to 1952 he was the Illinois State athletic commissioner, the first African American to hold this position. He became active in Democratic politics in Chicago, and was the Democratic Party committeeman for the 3rd Ward of Chicago (1952–1972), and later alderman (1955–1969). In 1970 he was elected to the U.S. House of Representatives. As a congressman, Metcalfe worked to make more loans for homes and businesses available to minority communities. He served on the Interstate and Foreign Commerce Committee as well as the Committee on Merchant Marine and Fisheries, where as Chairman of the Subcommittee on the Panama Canal

he supported the 1978 treaty which turned control of the canal over to Panama.

During his long political career in Chicago, Metcalfe became a political insider and a part of Mayor Richard Daley's political machine. But in 1972 he broke with Daley, challenging him on the issue of police brutality toward blacks. Daley ran a candidate against Metcalfe in the Democratic primary, but with the assistance of the CONGRESSIONAL BLACK CAUCUS, Metcalfe defeated Daley's candidate. Metcalfe was in his fourth term as a congressman and running unopposed for a fifth when he died of a heart attack in 1978.

REFERENCES

ASHE, ARTHUR R., JR. *A Hard Road to Glory: A History of the African-American Athlete, 1919–1945.* New York, 1988.

Obituary. *New York Times*, November 6, 1978.

RAGSDALE, BRUCE A., and JOEL D. TREECE. *Black Americans in Congress, 1870–1989.* Washington, D.C., 1990.

PETER SCHILLING

Methodist Church. Since its appearance in the British colonies of North America, Methodism has been one of the most influential Christian denominations among African Americans—only the Baptist church has generally surpassed it in terms of black adherents. The majority of African-American Methodists have worshipped within all-black denominations: the AFRICAN METHODIST EPISCOPAL ZION CHURCH (1801), THE AFRICAN METHODIST EPISCOPAL CHURCH (1814), and the Colored Methodist Episcopal church (1870, known since 1954 as the CHRISTIAN METHODIST EPISCOPAL CHURCH). A number of black Methodists, however, chose to remain within the original, racially mixed Methodist Episcopal church (1794) and its subsequent incarnations, such as the METHODIST CHURCH (1940) and the United Methodist church (1968).

Africans who were brought to colonial North America as slaves—with few exceptions—had not previously been exposed to Christianity. While some Anglicans and Quakers made attempts to convert blacks, they met with resistance, not only from southern slave owners, but also from within their own ranks. The evangelical revivals of the Great Awakening (1730 to 1760), which split older denominations and later helped the spread of Methodism and the Baptist faith, helped to change this. Often not formally educated in theology, Methodist preachers traveled on horseback and delivered highly moving sermons wherever they could assemble a crowd. Methodism, an independent denomination which arose out of the Wesleyan revival in the Church of England, proved extremely successful at gaining adherents in America. John Wesley and his followers were ardent Arminians. They opposed the predestination of Calvinism and believed in the possibility of salvation for all. Their message was one of redemption: Life was a quest for sanctification. It proved to be as powerful for free blacks in the North and slaves in the South as it was for white Americans.

Between 1766, when the first American Methodist Society was organized in New York City, and the conclusion of the American Revolution in 1783, Methodism spread to several northern cities, including New York and Philadelphia and to the southern states of Maryland and Virginia. Methodist preachers sent from England to the colonies often sought out black audiences on their travels. Robert Williams (1745–1775) and Joseph Pilmore (1739–1825) both spread their evangelical preaching to blacks, as did Richard Boardman (1738–1782) and Thomas Rankin (1738–1816). Rankin introduced John Wesley's antislavery tract, "Thoughts on Slavery," to the Continental Congress. George Shadford (1739–1816) converted many slaves to Methodism while traveling on the Brunswick circuit through Virginia and North Carolina. It was Francis Asbury (1745–1816), however, who did the most to establish Methodism in America and to include blacks within the denomination. Ashbury's desire for a racially inclusive church helped to transform Methodism from a small group of societies into a national religious movement. Asbury preached understanding and acceptance of other races and recognized the need for indigenous evangelism. The extent of black involvement in early American Methodism is shown by the fact that thirty-six of the fifty-one societies represented at the 1784 constituting meeting (which established Methodism as a denomination independent of the Anglican church) reported black members. Asbury himself ordained the earliest African-American Methodist preacher, Harry HOSIER, who was selected exclusively to promote the "black work" at St. George's Church in Philadelphia, Pa.

The evangelical efforts of Methodist preachers among African Americans did not by themselves mean that black converts would be accorded equality of treatment. In fact, the increase of African-American membership in the Methodist church went hand in hand with a rise in racial discrimination within the denomination. In attempting to solve this racial disharmony, the Methodist church explored various patterns of relationships between their white and black followers: simultaneous segregated worship, separate worship at different times, and separate

worship in separate churches. None of these arrangements proved satisfactory. They failed to engage the issues of racism and the resulting lack of black ministerial and administrative participation. Schemes for voluntary separation and independent black churches emerged. African-American Methodists, already worshiping in segregated "classes," created small black church fellowships which often met in private homes and eventually began holding their own Sunday services. Two independent black churches—the Bethel Church in Philadelphia (founded in 1793) and the Zion Church in New York City (founded in 1801)—formed separate denominations which operated independently of the Methodist Episcopal church. These became, respectively, the African Methodist Episcopal church (AME) and the African Methodist Episcopal Zion church (AMEZ).

In the South, Wesley's strictures against slavery were ignored. With the rise of cotton and westward expansion of plantation agriculture, the Methodist church became conspicuously silent on the issue of slavery. Southern membership included a large number of slaveholders and slaves. Slaves modified the lessons of Methodism to suit their own circumstances, finding solace in promises of redemption in the afterlife. Their faith often found strongest expression in hymns and SPIRITUALS.

As divisions between northern and southern society deepened from the 1830s through the 1850s, sectional divisions arose within the Methodist Episcopal church. Antislavery members of the Methodist church broke from the denomination and formed the Welseyan Methodist church in Michigan (1841) and the Methodist Wesleyan Connection in New York (1842). A formal split in the denomination occurred after the 1844 General Conference in New York City, with the "Methodist Episcopal church, South" convening separately from the "Methodist Episcopal church" the following year.

During the Civil War the Methodist Episcopal church, South emerged as an arch defender of the Confederacy and all its institutions. The defeat of the South proved devastating for the church. The black membership of the Methodist Episcopal church, South, had stood at 207,766 in 1860; by 1866, it had fallen to 78,742. In 1870, the remaining black constituency of the Methodist Episcopal church, South requested and received a separate denominational status and formed the Colored Methodist Episcopal church (CME). Most freedmen who left the Methodist Episcopal church, South, joined one of the three all-black Methodist denominations: the AMEZ, AME, and the CME. Many others, however, joined the northern Methodist Episcopal church as it traveled south to seek converts. These northern Methodists formed clubs and societies in the south to aid the freedmen. In 1871, the Woman's Home Missionary Society was founded in New Orleans to work with needy black women and children. Other organizations providing financial and educational aid to African Americans included I. Garland Penn's Epworth League, the Bureau of Negro Work, and later in the 1920s, the Gulfside Assembly.

The Methodist Episcopal church also formed dozens of elementary and normal schools between 1866 and 1896 through its Freedman's Aid Society. Several of these later became accredited colleges. These included: Bennett College in Greensboro, N.C. (1873); Meharry Medical College in Nashville, Tenn. (1876); and Gammon Theological Seminary in Atlanta, Ga. (1888), now part of the INTERDENOMINATIONAL THEOLOGICAL CENTER. African-American Methodists founded their own newspaper, the *Southwestern Christian Advocate* (originally the *New Orleans Christian Advocate*). It was edited and published privately for a decade before authorization by the 1876 General Conference. It became the *Central Christian Advocate* in 1940.

The result of the missionary thrust into the South by the northern Methodist Episcopal church was notable. At the end of the Civil War black membership had been roughly 26,000; by 1896 it had increased to 250,000. The Methodist Episcopal church expanded opportunities to some black members, though often in carefully selected roles. In 1852 the church had elected Francis Burns as its first black bishop. He was chosen to serve as a missionary bishop in Africa. In 1866, Burns was succeeded by John W. Roberts.

Toward the end of the Civil War, the Methodist Episcopal church began organizing separate black conferences. The first of these were in Delaware (1864); Washington, D.C. (1864); Mississippi (1867); Lexington, Ky. (1869); and South Carolina (1870). In 1868 the status of these organizations was changed from "mission conferences" to "annual conferences," which allowed them to elect representation to the denomination's General Conference. At the 1920 General Conference, two black bishops, Robert E. Jones (1872–1960) and Matthew W. Clair, Sr. (1865–1943), were elected to serve black Episcopal areas.

By the late 1930s, the record of growth, expansion and progress of the black constituency of the Methodist Episcopal church had been impressive in spite of its segregated structure. This scenario may have continued except for the movement to reunite the three branches of Methodism: the northern and southern divisions, as well as the Methodist Protestants, who had withdrawn in 1830 over the issue of lay rights and the power of the episcopacy. (The Methodist Protestants had relatively few black members—just over two thousand in 1936.)

Beginning in 1916, efforts had been made to reconcile the differences in the three branches by a General Conference. The future status and role of black people in the proposed church was important to the debate. In the 1939 Plan of Union the issue was settled by placing all African-American Methodists in a Central Jurisdiction. This decision, which literally wrote segregation into the constitution of the denomination, was considered disagreeable by many Methodists, both black and white. The general euphoria that pervaded the Uniting General Conference that gave birth to the new "Methodist church" obscured the fact that it was now the largest racially segregated Protestant body in the nation. African-American Methodists faced the future with faith that this anomaly would ultimately be eliminated.

Despite its obvious limitations, the Plan of Union did include provisions for the election of black bishops. From 1940 to 1968, fourteen Central Jurisdiction ministers were selected for this office. African Americans also attained the office of district superintendency. This occurred first on a temporary basis in New York, in 1962, and then in two full term appointments (one in New York and one in Chicago) in 1964. The ministerial leadership situation in the Central Jurisdiction was more problematic. The church faced a critical shortage of qualified candidates for the ministry. Fewer college-educated black youths expressed interest in becoming ministers because career promotions were limited and support benefits, such as salary, pension, and housing provisions, were unattractive and often inadequate.

The membership of the Central Jurisdiction resulting from reunion in 1939 topped 315,000. The size of this Central Jurisdiction, however, did not increase after 1939, despite an annual national black population increase. Similarly, the growth in the number of black churches declined in this period. Black urban Methodist churches were unable to attract southern rural immigrants, or meet the widening spectrum of needs of urban dwellers in their midst. The Division of Home Missions tried to confront this crisis through technical and financial support to black (and other) disadvantaged communities. Also, the Woman's Division of Christian Service launched a program of spiritual and social uplift, through local church units across the nation. Finally, and most importantly, the General Board of Education through its several divisions designed and implemented a five-point program in the Central Jurisdiction. This included the improvement of church schools, the organization and development of the Methodist Youth Fellowship, the institution of a leadership education program, the development of a new approach to student work, and a new and critical look a ministerial education.

The Central Jurisdiction was never considered a satisfactory or final arrangement for race relations in the Methodist church. It functioned from 1940 to 1968 holding quadrennial sessions, electing bishops and board and agency representatives and performing the requirements of the church's Book of Discipline. From its beginning, it was an anomaly and steps were taken toward its elimination. In 1956, the General Conference decided to eradicate rather than correct the jurisdictional system. In 1962 a Central Jurisdiction "Committee of Five" developed a transfer-merger procedure which was subsequently authorized by a special meeting of the General Conference (1966). On August 20, 1967, the Central Jurisdiction ceased to be, and was merged into other Methodist jurisdictions.

Difficult challenges confronted the United Methodist church when it came into being at the Uniting Conference in Dallas, Tex., in May 1968. It had, first of all, to unite the Methodist church (1939–1968) and the Evangelical United Brethren church (1946–1968). It also had to confront the issue of inclusiveness—that is, intentionally including African Americans, Asian Americans, Latino Americans and Native Americans in the life and work of the church. Despite episodic increases, black membership in the United Methodist church declined after the merger. The new denomination began in 1968 with a black membership of about 370,000. Between 1968 and 1974 it showed small increases periodically, but began to decline after 1980 (in proportion to the decline in total membership). The African-American United Methodist churches which grew have shared several common characteristics: commitment to ministry from a black perspective; spiritually moving and highly spirited preaching, worship and music; a high degree of community accountability and involvement; a pluralistic approach to programming; and an open and fully inclusive membership.

Despite the problems, however, significant progress was made toward the goal of racial inclusiveness throughout the denomination following merger. Since 1972 all five of the geographic jurisdictions of the church have had one or more African-American bishops; and sixteen African-American bishops have been elected since 1968, including one woman. In 1984, the United Methodists elected their first black woman bishop—the Rev. Leontine Kelly, a pastor from Richmond, Va. Scores of African-American district superintendents have been appointed to serve districts on a nonracial basis in practically every annual conference of the church. Black general and annual elected positions and staff positions (including World Division missionary appointments) have tripled since merger with the former Evangelical United Brethren. The most dra-

matic progress has come from the Black Methodists for Church Renewal (BMCR). Founded on February 6, 1968, this group literally "renewed" the church's commitment to social justice. With its slogan, "Our Time Under God Is Now," the BMCR pursued a policy of racial inclusiveness that was legislated by the General Conference. All church bodies were made accountable to the General Conference for their race relations policies, and the use of church facilities "to preserve racially segregated education" was prohibited. General church funds were made available for black community development, and church school curriculum materials and educational programs were revised to be more inclusive. Finally, a black college fund was established to assist African-American schools in providing more adequate programs, and new loan and scholarship programs were instituted in higher and theological education institutions of the church. The actions stemming from the creation of the United Methodist church have marked a beneficient change in the long and complicated relationship between the Methodist church and its African-American members.

REFERENCES

BARCLAY, WILLIAM C. *History of Methodist Missions.* 3 vols. New York, 1949.

BURKE, EMORY S., ed. *The History of American Methodism.* 3 vols. New York, 1958.

CLARK, ELMER T., ed. *The Journals and Letters of Francis Asbury.* 3 vols. New York, 1958.

GRAHAM, JOHN H. *Black United Methodists: Retrospect and Prospect.* New York, 1979.

MORROW, RALPH E. *Northern Methodism and Reconstruction.* East Lansing, Mich., 1956.

NORWOOD, FREDERICK A. *The Story of American Methodism.* Nashville, 1974.

SHOCKLEY, GRANT S., ed. *Heritage and Hope: The African American Presence in United Methodism.* Nashville, 1991.

THOMAS, JAMES S. *Methodism's Racial Dilemma: The Story of the Central Jurisdiction.* Nashville, 1992.

GRANT S. SHOCKLEY

Mexican Punitive Expedition. The last great horse cavalry action of the United States army involved a number of African-American officers and enlisted men. In response to Pancho Villa's raid on Columbus, N. Mex., the U.S. government authorized a punitive expedition to move into Mexico and punish the offenders. A number of African-American officers and men participated, and some were killed at the skirmish at Carrizal.

After the outbreak of the Mexican Revolution in 1910, the United States often took sides in the complex factional disputes in that country. Trying to provoke an American response, rebel leader Pancho Villa led a raid on the evening of March 9, 1916, at the border town of Columbus, N. Mex. The raiders killed fifteen Americans, including seven soldiers. Pres. Woodrow Wilson authorized a military response, headed by Brig. Gen. John J. Pershing. The punitive expedition eventually numbered fifteen thousand men, including the Tenth Cavalry and its African-American officer, Lt. Col. CHARLES YOUNG. The attitude of the Mexican government toward the mission was not very enthusiastic to begin with, turning hostile as the expedition went far into Mexico.

The campaign began with two columns trying to capture the elusive Villa. The Tenth, part of the western group, rendezvoused with the other column at Colonia Dublan on March 20. Then Pershing split the expedition into three parallel columns, with troopers from the Tenth making up important parts of two of the columns. At the end of the month the unit encountered some Villistas on the outskirts of Aguascalientes. After a brief firefight, which included the use of machine guns, the Mexicans fled. The Americans pursued for seven miles but made no contact with the enemy. Two weeks later the members of the Tenth helped to rescue their comrades of the Thirteenth, who had been attacked by troops of the Mexican government at the town of Parral. The Mexicans retreated when the African Americans arrived.

Though the active pursuit of Villa had ended with the incident at Parral, the expedition did not leave Mexico until early 1917. During those months the soldiers and officers remained at the encampment at Colonia Dublan, conducted a series of practice maneuvers, and participated in patrols of the surrounding area. Reinforcements, including the Twenty-fourth Infantry, another African-American unit, then joined the cavalry units. The Mexican government did not like the presence of this American expedition on Mexican soil, but Pershing felt that the patrols were necessary for the training of the troops and to control local Mexican forces.

One such patrol led to a major international incident and the possibility of war between the United States and Mexico. Toward the end of June 1916, Pershing learned of a concentration of Mexican government forces that seemed to threaten his supply line back to Columbus. To ascertain the size and location of the forces, he dispatched a patrol made up of members of Troops C and K, Tenth Cavalry, commanded by Capt. Charles Boyd. Apparently Pershing instructed Boyd to locate the Mexicans but to avoid a clash. On the morning of June 21, the patrol advanced toward the town of Carrizal, where they encountered a body of government troops

Members of M troop of the 10th Cavalry after release from detention by Mexico and upon their return to U.S. soil, 1916. (Prints and Photographs Division, Library of Congress)

blocking their road forward. Boyd asked permission of the commander to proceed on his mission, but he refused. Tension mounted. Both the Americans and Mexicans assumed defensive positions, but Boyd decided that bravado would carry them through and ordered his men to move toward the Mexican positions. The Mexicans began to fire. Two of the officers, including Boyd, and eleven of the enlisted men were killed, one officer and ten enlisted men were wounded, and twenty-four soldiers were captured. Approximately seventy-five Mexicans were killed or wounded. A number of the African-American cavalrymen killed in the incident were buried in Arlington Cemetery and accorded full military honors. The expedition ended in February 1917 when the camp at Colonia Dublan was abandoned and the units returned to the United States.

REFERENCES

FLETCHER, MARVIN E. *The Black Soldier and Officer in the United States Army, 1891–1917.* Columbia, Mo., 1971.
NALTY, BERNARD C. *Strength for the Fight: A History of Black Americans in the Military.* New York, 1986.
WHARFIELD, H. B. "The Affair at Carrizal: Pershing's Punitive Expedition." *Montana* 18 (1968): 24–39.

MARVIN E. FLETCHER

Mexican War. The U.S. Army did not admit black Americans at the time of the Mexican War (1846–1848), although blacks had served in the AMERICAN REVOLUTION and the WAR OF 1812. A handful of African Americans served in the U.S. Navy, which had a 5 percent quota on Free Black enlistment. Despite such exclusion, African Americans made an invaluable contribution to the war as servants to white army officers. Most officers brought servants—some slaves, others free—with them to war; while not all servants were black, the vast majority were. Gens. Zachary Taylor and Winfield Scott were each attended by four servants. Ulysses S. Grant brought a "black boy" with him who spoken Spanish, French, and English. As servants, blacks were part of every contingent of American troops involved in the war. They cooked, tended to the wounded, drove wagons, and otherwise assisted their masters on the battlefield.

There was a great deal of irony in the efforts of black servants in the Mexican War, who found themselves aiding in the defeat of a nation that had previously abolished slavery. Furthermore, the aftermath of that war opened national debates about the expansion of slavery through the reaffirmation by the United States of its annexation of Texas and through the acquisition of the territories of New Mexico and California. Abolitionists and free labor advocates had opposed the war from its outbreak, seeing it as a plot by southern politicians to increase the number of slave states in the Union, thereby enhancing their strength in Congress. Frederick DOUGLASS had asked the American people not to support their government in its "murderous plans." Hoping to preserve western land for free white labor, David Wilmot, a

Democratic congressmen from Pennsylvania, proposed on August 8, 1846, that slavery be banned from all land acquired from the war. After the Wilmot Proviso was blocked by southern congressmen, the debate over what to do with the new territory continued. The Compromise of 1850 admitted California as a free state, and left the status of slavery in the territories of Utah and New Mexico to be determined by popular sovereignty. The territory acquired by the war sparked the debates about the expansion of slavery that would eventually tear the nation apart.

REFERENCES

JOHANNSEN, ROBERT WALTER. *To the Halls of Montezuma: The Mexican War in the American Imagination.* New York, 1985.

KATZ, WILLIAM LOREN. *The Black West.* Seattle, Wash., 1987.

MAY, ROBERT E. "Invisible Men: Blacks and the U.S. Army in the Mexican War." *The Historian: A Journal of History* 49 (August 1987): 463.

McCAFFREY, JAMES M. *Army of Manifest Destiny: The American Soldier in the Mexican War, 1846–1848.* New York, 1992.

WALTER FRIEDMAN

Mexico. During the early colonial period New Spain, or Mexico, played a significant role in defining the African-American experience. For about a century beginning in 1521 more black slaves disembarked at the colony's port of Veracruz than at any place else on the American mainland. Once in Mexico the African-American population was dispersed throughout the viceroyalty instead of being confined to coastal regions. In an environmentally varied area like Mexico with correspondingly parochial living conditions and lifestyles, this dispersion resulted in multiple African-American experiences.

Moreover, because of New Spain's material and human resources, all Europe considered it the model colony, especially during the sixteenth and early seventeenth centuries. When Old World settlers moved into other mainland American areas they often tried to emulate precedents set in Mexico or set in the Caribbean and maintained in Mexico. Antecedents involving Afro-Mexicans proved no exception to this general rule. And Mexico's multiple regional experiences provided viable sets of precedents for many settings in the Americas. Thus Mexico served as an important early colonial proving ground for the varied and broader black economic, social, and political experiences that sprang up throughout the post-1521 Western Hemisphere.

Sweeping impersonal structural conditions dictated Mexico's heavy involvement in the Atlantic slave trade. Silver production exploded within the northern zones of the colony after 1546 with the discovery of rich veins of ore from Zacatecas to Parral and the implementation of European mining techniques. This came on the heels of a dramatic decline in the native Indian populations due to the introduction of such European diseases as smallpox, bubonic plague, measles, and a host of respiratory maladies for which the indigenous population had little natural defense.

Many scholars estimate that the viceroyalty lost over 70 percent of its Indian population between 1543 and 1610 alone. Faced with a demographic crisis at a time when the area's colonial economy had just begun rapidly to expand, Spaniards opted to import large numbers of African slaves. Iberians had resorted to this strategy during the depopulation of their Caribbean island possessions about a half century earlier. Black slaves would ensure against a potential labor shortage at this critical stage in New Spain's colonial economic growth.

Over 100,000 Africans contributed their labor to the material development of Mexico. The period of heaviest importation lasted from about 1570 to 1620. Growth in Mexico's silver and sugar industries, as well as the rise of Spanish-American cities, created demand for slave workers and the capital to pay for them as well.

Concurrent events in Europe and Africa made it easier to meet Mexico's demand for slaves. Between 1580 and 1640 Portugal came under Spanish rule. This gave Spaniards access to the machinery of the Portuguese slave trade that had grown up along the west coast of Africa during the two previous centuries. At the same time this Spanish control created friction among both Europeans and their respective African allies.

Eventually this friction erupted into violence in the form of the so-called Angolan wars, which raged from 1595 to 1624 in the Luanda region of west-central Africa. Resident Portuguese traders on the island of Sao Tome and the Mbundan allies on the adjacent African mainland bristled at heightened Iberian economic and political involvement in the Luanda region and decided to resist militarily. European-based Portuguese and Spaniards, along with their Angolan allies, successfully wore down the malcontents by force of their greater human and material resources. Given the rising need for slaves in the Americas, principally Mexico, the cost of defeat for the Mbundans was enslavement and an Atlantic passage to Veracruz. Indeed, over 80 percent of the African slaves who landed on Mexican shores between 1595 and 1630 came from the war-torn Luanda

region of Africa. Once in Mexico, however, local conditions dominated in shaping the bond persons' experiences.

Spaniards clustered in urban settings. There they employed African slaves as domestic servants. Slave labor contributed to public works projects. Owners rented Africans for day labor. And blacks toiled in ubiquitous *obrajes,* small urban-based textile shops that produced cheap cloth for local consumption by the colony's poor. Craftsmen made apprentices of slaves and assigned native Mexicans less skilled tasks. Professionals such as architects and engineers favored black slaves to execute skilled menial tasks; these Spaniards expected Indians to complete less skilled assignments.

In the countryside black slaves took up positions as skilled workers and livestock husbandmen on the plantations and haciendas that sprang up in many parts of the viceroyalty. They served as blacksmiths, carpenters, and field labor bosses. Some Indians also lived on Spanish estates, but the majority of native workers continued to reside in their own villages. On sugar plantations blacks worked in the oppressively hot and demanding refining houses where temperatures normally topped 100 degrees Fahrenheit, and a mistake could cause loss of product, limb, and life. After 1550 Indians could not legally engage in refining tasks. Whites feared that the harsh working conditions would raise Indian death rates. Finally, black slaves significantly contributed to the skilled labor force within the Mexican mining industry, especially in the refining process.

Africans toiled at occupations that linked the urban and rural dimensions of the Hispanic colonial economy. Slaves disproportionately served in the ranks of the legendary muleteers and itinerant merchants who urged animals along the roads and pathways that linked locales with one another throughout the viceroyalty.

In all these urban and rural occupations African slaves worked alongside Indians, supplementing rather than replacing them as black slaves had on the Caribbean islands during the generation after initial European contact with the islands. Slaves also assumed more skilled and even supervisory positions over Indians because slave laborers proved more fixed and reliable. In response to high native mortality rates Spaniards abolished Indian slavery in 1542. That left only Indian tribute and wage laborers, and the former rotated service to Spanish overlords among individual villagers, while the latter group frequently came and went.

Just as important, Indians died in alarming numbers during the first century of Spanish settlement in Mexico. African slaves provided a much more dependable labor force in both these respects. They generally stayed wherever their masters wanted them to stay, and, previously exposed to Old World diseases, they died no more frequently than Europeans in epidemics that ravaged the colony's indigenous population.

Afro-Mexicans' social experience proved both negative and positive in nature from the perspective of the colony's development. Whites had to control vast numbers of blacks and Indians in a setting thousands of miles removed from Spain at a time when such distances translated into months of travel. For this reason the Europeans required local mechanisms to order subordinate peoples. To meet this need whites developed the *sistema de las castas,* where caste identification was equated with physical racial identification. By primarily dividing blacks, whites, and Indians on the basis of their skin color, and then using these divisions to rank groups within the society, white Spaniards effectively controlled Indians and blacks. This ordering had an inherent logic since whites had conquered Indians and enslaved Africans.

This logic, backed at times by force, eventually compelled both subordinate groups to accept Spaniards' elevated positions of power as the natural order of things. This important social development was then transferred throughout the Americas by colonizers from all over Europe. This concept of social ordering by race made possible the sole association of blacks with slavery in the Americas, an innovation that represented the most negative social heritage that racial pluralism in areas like Mexico left to the modern American societies. Blacks, by their mere presence in New Spain, unwillingly contributed to this precedent.

By 1630 whites realized that Mexico's Indian population decline had ceased. Spaniards no longer saw the need to import expensive African slaves. And from that point onward Mexico steadily withdrew from participation in the Atlantic slave trade. The absence of new African arrivals forced blacks to interact socially with other racial groups within the society. This interaction represented the most positive social contribution that African Americans made to Mexico's social growth. From at least 1630 onward an average of 25 to 35 percent of all Afro-Mexicans crossed racial lines in establishing social ties like marriage, godparenting, and marriage witnessing, three to four times the percentage of whites and five to six times the percentage of Indians.

In this sense Afro-Mexicans worked harder to break down the caste system and slowly create the more ethnically and class-based system that came to dominate Mexican social life from the late nineteenth century to the present. Blacks' association with whites in the initial conquest of the region and, more

important, their position within the colonial labor force facilitated racially outgoing social activity.

As expensive skilled slave laborers, Africans and their descendants came into contact with large numbers of Indians in the work place. Under such labor market conditions blacks enjoyed status over more transient Indian workers. This afforded blacks the opportunity to interact not only with the dominant white population but with the Indian population, which was subordinate to blacks, as well. Black males especially took advantage of the social opportunities their labor status afforded them. A high level of MISCEGENATION, or race mixture, occurred as blacks mixed not only with whites but more frequently with Indians. The fact that children from the latter unions followed the station of their Indian mothers and enjoyed freedom from slavery under Spanish law gave black males added incentive to seek these matches.

Extraordinary consequences arose from Afro-Mexicans' somewhat intermediate social position between whites and Indians. With one foot chained in the Spanish world as slaves, and the other striding into the Indian world as co-workers, blacks inevitably provided a link between the Iberian and native communities. In this capacity they played an important role in the racial and cultural amalgamation of Mexican society; they helped lay the foundations for what later scholars labeled *mestizaje*. This racial and cultural amalgamation eventually blurred color and ethnic lines. By 1900, after nearly four centuries of racial miscegenation with whites, Indians, and the racial hybrids that resulted, and after nearly 300 years of cultural isolation from Africa, Afro-Mexicans became physically and culturally nearly indistinguishable from the rest of the Mexican population. By this time they had ceased being Afro-Mexicans and became Mexicans.

Blacks' political life proved perhaps the most uneven dimension of their experience in the Mexican context. Throughout the colonial period whites politically disfranchised their slave and free black counterparts. Laws denied Afro-Mexicans the right to vote or hold political office. Blacks did, however, exert some measure of political influence. As members of local racially segregated militia companies they often wrested political concessions from whites during times of military crisis.

Such measures proved especially effective in the eastern coastal regions, which were more exposed to French, Dutch, and English seaborne attack. For example, in 1768 members of the Afro-Mexican militia company of San Lorenzo de los Negros, Veracruz, won crown approval for the legal incorporation of their village in return for the blacks' services in the defense of the Port of Veracruz against a threatened

English attack that never materialized. Other Afro-Mexicans exerted political influence through illegal action such as slave rebellion or the foundation of runaway slave communities (*palenques*) such as Yanga and Coyolillo in the present state of Veracruz, Mandinga in eastern Oaxaca, and Cuijla on the Pacific shores of modern Guerrero.

In these strongholds they set up their own rival political orders, some with heavy west-African influences. From *palenques* they exercised political influence over surrounding Indian populations; this political influence competed with the Spanish political order. Blacks threatened Spanish political authority even more directly through revolt. Slave uprisings occurred throughout the colonial period, but they represented the greatest danger in the sixteenth century when black slaves outnumbered white settlers in New Spain. The incidence of revolt remained high throughout the entire three centuries of Spanish rule. For example, the district of Córdoba, Veracruz, experienced five major slave revolts between 1725 and 1768 involving over two thousand bondsmen on each occasion. As Bishop Alonso de la Mota y Escobar put it, "Bad to have them (blacks), but much worse not to have them."

Afro-Mexicans did not receive the right to participate legally in Mexico's political life until after independence. The caste system was outlawed in 1822 and slavery abolished seven years later. Afro-Mexicans bought these concessions with their blood in the struggle to break from Spain. Slaves and free *Afro-castas* (persons of mixed African ancestry) served in disproportionately high numbers among the insurgent ranks in the struggle for independence. Afro-Mexicans were prominently represented in the rebel forces that operated all along the eastern and western coastal regions. José María Morelos and Vicente Guerrero both reportedly had African ancestry. After independence "El negro Guerrero" went on to become the third president of Mexico. During his administration Mexico outlawed slavery. Indeed, he and his Afro-Mexican constituents made up one of the most important factions in the populist Yorkino political upsurge between 1827 and 1829 within the new republic.

By the end of the nineteenth century the African presence in Mexico had all but slipped from the popular mind. Three centuries of extensive miscegenation with Indians and racially mixed individuals had so blurred the groups' physical distinctiveness that they were indistinguishable from the country's "mestizo" majority. And the same chronological separation from west-African cultural influences had all but obliterated the group's cultural identity. Yet this largely forgotten people had made significant contributions to the historical growth of the Mexican na-

tion and by extension the development of the Americas in general.

Mexican slaves during the late sixteenth and early seventeenth centuries provided critical incentive for the institutionalization of the Atlantic slave trade. Successful implementation of African slave labor in New Spain encouraged its use elsewhere. The Caribbean precedent of identifying slavery with the black race alone received critical legitimization within the exemplary Mexican setting.

Afro-Mexicans provided extralegal political input during the colonial period through flight and rebellion. They contributed heavily, for their numbers, to the independence struggle with Spain. And they played an important role in increasing popular participation in politics during the first decade after the break with the mother country.

Economically, Africans provided essential labor input into the colonial Mexican economy just as it boomed. Wealth produced in New Spain attracted European settlement in other parts of the Americas. This, in turn, greatly accelerated New World development.

The social resistance of blacks to racist and cultural barriers created hybrid racial and ethnic ties between Spaniards and Indians. The resulting racial and cultural mix laid the foundations for modern Mexican society. Other areas of Spanish America like Peru, Bolivia, Colombia, and Ecuador built on this Mexican precedent and forged their national societies in the same manner.

Mexico was the first setting where whites, blacks, and Indians came together in large numbers. Blacks in this setting helped to provide much of the blueprint for the building of modern Latin America and to a lesser degree non–Ibero North America. Columbus may have discovered the New World in 1492, but African Americans in places like Mexico helped to shape it in the centuries that followed.

REFERENCES

AGUIRRE BELTRÁN, GONZALO. *Población negra de México*. 2nd ed. Mexico City, 1972.

CARROLL, PATRICK J. *Blacks in Colonial Veracruz: Race, Ethnicity, and Regional Development*. Austin, Tex., 1991.

CHANCE, JOHN. *Race and Class in Colonial Oaxaca*. Stanford, 1978.

CURTIN, PHILIP. *The Atlantic Slave Trade*. Madison, Wis., 1969.

KILSON, MARTIN, and ROBERT ROTBERG, eds. *The African Diaspora*. Cambridge, Mass., 1976.

MILLER, JOSEPH. *Way of Death*. Madison, Wis., 1988.

PALMER, COLIN. *Slave of the White God, 1570–1650*. Cambridge, Mass., 1976.

ROUT, LESLIE B., JR. *The African Experience in Spanish America, 1502 to the Present*. London, 1976.

PATRICK J. CARROLL